ROYAL TREASURES

A Golden Jubilee
Celebration

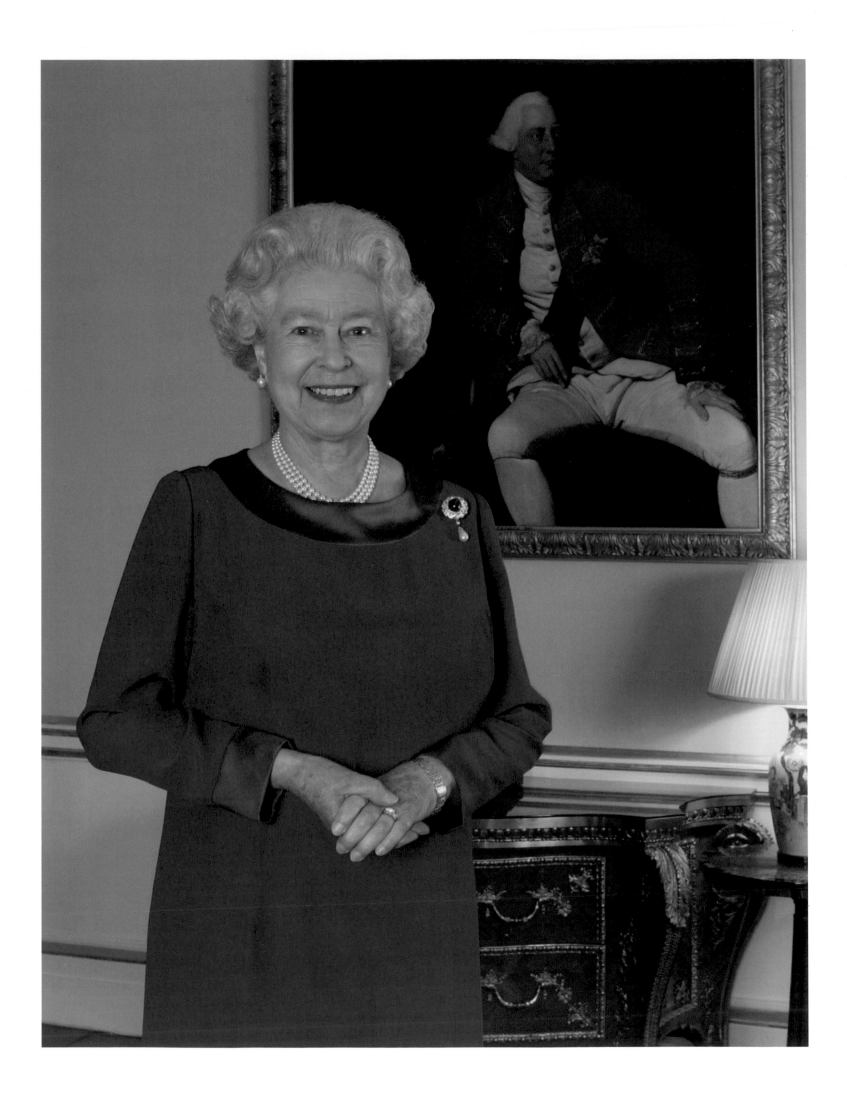

It is now almost forty years since the first gallery at Buckingham Palace was opened to the public in what had been the old private chapel of the palace until its destruction in the Second World War. The idea of creating an exhibition space in this area to show works from the Royal Collection was Prince Philip's, and it was a measure of the success of the original gallery that nearly five million people came to see the exhibitions held there up to the time the gallery closed for rebuilding in 1999.

I am delighted that it has been possible, in this Golden Jubilee year, to create a new and more spacious gallery where visitors will be able to see and enjoy a wider variety of works of art from the Collection, and in the best possible conditions. I very much hope this book will provide not only a fitting accompaniment to the opening exhibition but also a lasting record of some of the finest works in the Collection.

Elizabeth R

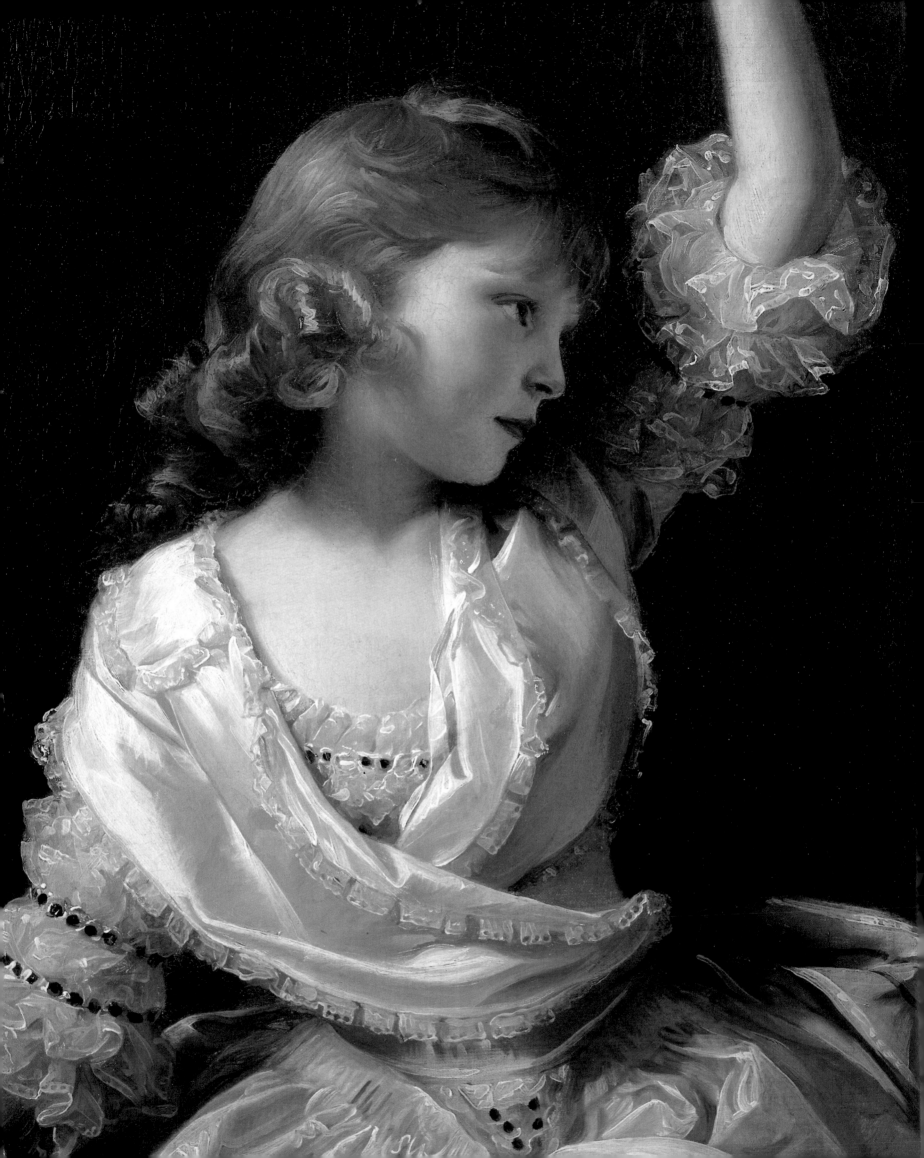

ROYAL TREASURES

A Golden Jubilee Celebration

EDITED BY

Jane Roberts

The Royal Collection

This publication has been generously supported by
MR BERNARD MATTHEWS, CBE, QSM

Published by
Royal Collection Enterprises Limited
St James's Palace
London SW1A 1JR

For a complete catalogue of current publications, please write to the address
above, or visit our website on www.royal.gov.uk

ISBN (h/b UK) 1 902163 49 4
ISBN (p/b UK) 1 902163 52 4

British Library Cataloguing in Publication Data
A catalogue record of this book is available from the British Library.

Designed by Tim Harvey
Produced by Book Production Consultants plc, Cambridge
Printed and bound by Balding + Mansell, Norwich
Distributed by Thames & Hudson Ltd, London

Issued to accompany the exhibition Royal Treasures at
The Queen's Gallery, Buckingham Palace, London,
from 22 May 2002 to 12 January 2003

Front cover: The Diamond Diadem, 1820 (no. 154)

Frontispiece: HM The Queen in the Eighteenth Century Room,
Buckingham Palace, November 2001, in front of Zoffany's portrait of
George III, painted in 1771 (© Fiona Hanson / Press Association)

Facing title page: John Singleton Copley, The three youngest daughters of
George III, 1785 (no. 25; detail)

CONTENTS

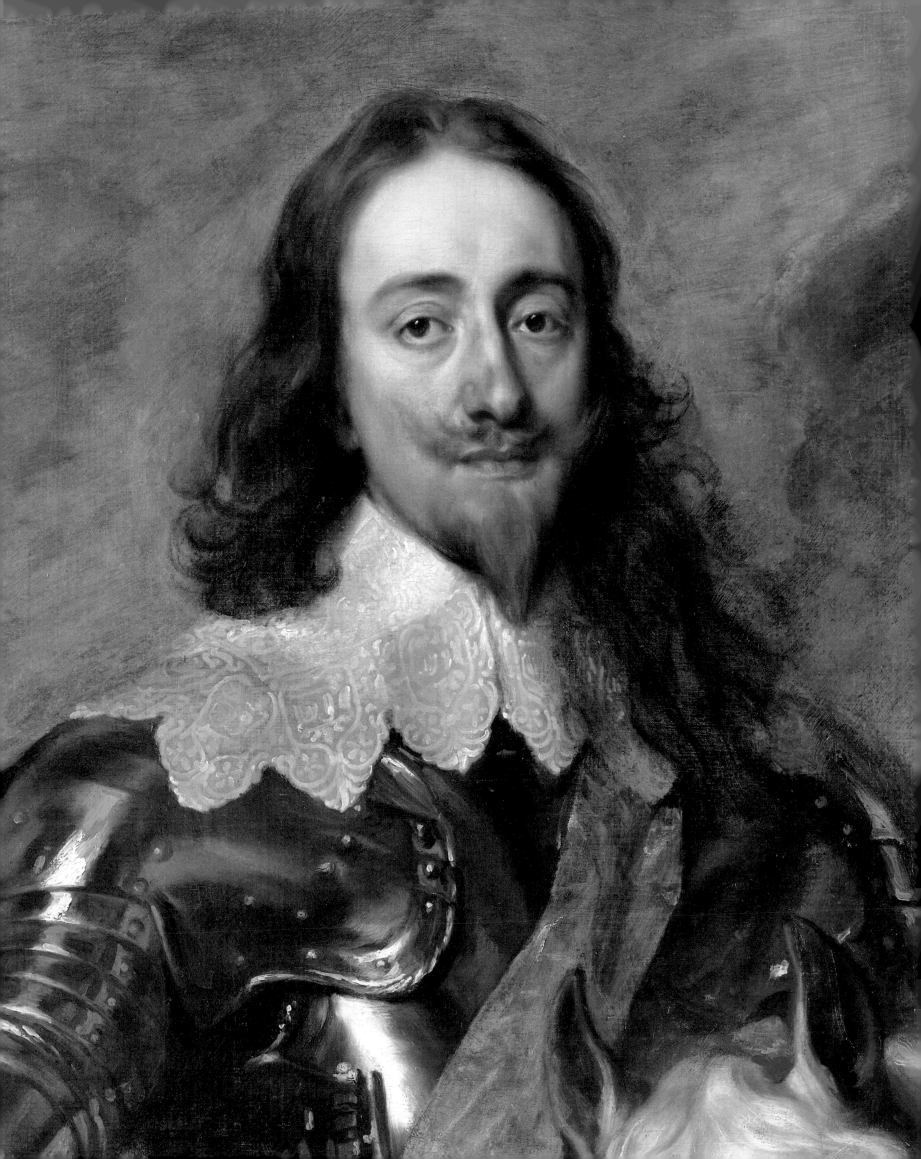

The Royal Collection

HUGH ROBERTS

WHAT IS THE ROYAL COLLECTION? For many people, the answer to this deceptively simple but hydra-headed question might come in a phrase such as 'one of the world's great picture collections'.[1] Images of paintings from the Royal Collection, made familiar through countless reproductions and loans to exhibitions, spring easily to mind, and a seasoned visitor to Windsor Castle, Buckingham Palace, Hampton Court Palace or Kensington Palace – or to exhibitions at The Queen's Gallery over the last forty years – would probably have no difficulty in putting together a list from remembered masterpieces, perhaps including the jewel-like Duccio *Crucifixion* (no. 1), Van Dyck's haunting images of Charles I, the matchless Rembrandt double portrait of the *Shipbuilder and his Wife*, Vermeer's perfectly balanced *Lady at the virginal* (no. 17) and Canaletto's miraculous views of Venice. The list might well go on to include some of the stupendous drawings at Windsor – masterpieces by Leonardo da Vinci, Michelangelo, Raphael or Hans Holbein the Younger, for example. But only for a very small percentage of visitors would the infinitely more numerous splendours of the decorative arts in the Royal Collection – Sèvres porcelain, French furniture, Fabergé, gold plate, jewellery or armour, for example – figure in any way. And books and manuscripts – intrinsic to most long-established collections – would probably not even rate a mention.

Views such as this reflect not only the traditional supremacy of painting over the other arts but a widely shared difficulty in grasping the complexity, let alone the context, of such an historic and extensive accumulation of works of art – in fact the last great European dynastic collection still to survive in royal ownership. It is not just that the Royal Collection is very large, very widely spread and exceptionally varied (all of which simple statements are true). More than anything it has the character of a 'collection of collections' typical of an ancient and (in origin) essentially private assemblage of works of art. These sub-groups or 'collections within' vary considerably: some are of a single category of object assiduously brought together by one or more individuals; others are entirely disparate in character and linked purely by date of acquisition; and each one bears to some degree the imprint of the personality of the collector or collectors responsible. Distinct collections of this type that still carry the name of, or an associa-tion with, a former owner are to be found in most of the principal categories or sub-divisions of the Royal Collection including drawings, paintings and books, gems, tapestries, silver, porcelain and furniture. Many of these sub-groups have been assembled piecemeal or in small consignments, but some have arrived ready-made, *en bloc*. In this extended accumulative process, purchase, gift, exchange, sale, debt, confiscation and destruction have all played their part. Over time, these collections have all been assimilated, layer upon layer, by succeeding generations of the royal family, to coalesce in an almost organic way with the generality of royal possessions ('all the old trash belonging to the crown'[2]) in the various royal residences, masterpieces mingling with the 'rubbishy pictures of kings and queens' that Hazlitt so deplored at Windsor.[3]

In this respect at least, the Royal Collection is wholly unlike a museum collection. With few exceptions, the British national collections have been formed deliberately and selectively to provide as nearly as possible a comprehensive representation of the arts and sciences, with the specific purpose of satisfying in an educational manner the requirements of the public. Additional pressures, such as the need to bolster national pride and (occasionally) to burnish the reputation of an incumbent director, may also have played a part in this process. The Royal Collection by contrast remains above all else a testament to the personal collecting quirks and acquisitive instincts (or lack of them) of the royal family of this country from the late Middle Ages to the present day. It also reflects the fact that the existence of an hereditary monarchy, repository over a long period of time of an enormous quantity of accumulated possessions, has (on the whole) helped to ensure the safe passage of such possessions from one generation to the next.

Of course it has not always been a safe or easy passage; and gains and accumulation have been more than matched by loss and dispersal. Changes of rule or of dynasty have been the usual cause of loss, as a brief survey of the principal collectors will make clear. Chief among such losses was the dispersal of the incomparable collection of Charles I during the Interregnum (1649–60), a blow from which it seemed for a long time the Royal Collection would never recover. Charles I is acknowledged as the most perceptive collector ever to have sat on the throne of this country. His numerous acquisitions of paintings and sculpture prove the point beyond any argument. If these acquisitions are added to the distinguished

collection that Charles I inherited from his elder brother Henry, Prince of Wales (d. 1612), and to the possessions passed down from their Tudor forebears, chiefly Netherlandish paintings, tapestries and jewellery, it is clear that the Royal Collection as it existed in the 1630s was for the first time in its history on an equal footing with any of the great royal collections of continental Europe.

But what is more difficult to discover – and this is true of all royal collectors from Charles I to the present day – is the degree of personal taste and interest that lies behind the process of making such acquisitions. For a royal collector there are, as Francis Haskell put it, 'certain obligations – to the expectations of their courtiers and subjects, to the traditions of their ancestors, to the Church, even to the cause of ostentation itself – which may stand in the way of expressing a more personal discrimination'.4 And if this is true of individual acquisitions, how much more so when it comes to the purchase of a collection *en bloc*, especially a foreign collection such as that of the Gonzaga of Mantua, which Charles I acquired in 1627–8 and which included one of the most important series of Italian pictures ever acquired by a European monarch, the *Triumphs of Caesar* by Andrea Mantegna, as well as a celebrated collection of antique and Renaissance sculpture.

There is a further aspect of royal acquisitions: the influential role played by advisers, agents and diplomats, which is often equally difficult to pinpoint, but which is of great importance in determining the character of this – or probably any – collection. Very few post-Renaissance English monarchs before Queen Victoria were able to travel abroad – even before they acceded to the throne – so inevitably much of the scouting for works of art was done by others on their behalf. In this respect Charles I, when Prince of Wales, was exceptionally fortunate in being able to visit Spain in the company of the Duke of Buckingham, also a serious and adventurous collector of pictures. This visit in 1623 to negotiate a marriage with Philip IV's sister, the Infanta Maria, was to give the Prince a first-hand view of the splendours of the Spanish royal collection and a lasting love of the paintings of Titian, whose works were magnificently represented in the Spanish royal collection. Although the marriage negotiations were unsuccessful, two masterpieces by Titian were acquired, the *Venus del Pardo* (now in the Louvre) and the *Emperor Charles V with a hound* (now in the Prado). These paintings, which came as gifts from the Spanish King, set the standard for Charles I's later acquisition of works by Titian; and, by the same token, they occupy a significant place in the long history of art and diplomacy, by which the composition of the Royal Collection (and most ancient collections) has been radically altered from time to time. It was also while he was in Spain that Charles I – perhaps on the advice of Rubens – concluded negotiations for the purchase of the Raphael tapestry

cartoons from Genoa. Other major figures in Charles I's circle who worked directly or indirectly as agents and advisers included Nicholas Lanier (who assisted with the Gonzaga negotiations), Sir Balthasar Gerbier, Sir Dudley Carleton and Lord Arundel (who among other things was responsible for the acquisition of two important Dürer portraits). Such a pattern of assistance, involving artists, courtiers and diplomats, was often to be repeated with later monarchs.

The example of Charles I's collecting highlights the question of personal royal taste, although in his case the evidence from contemporaries is unusually clear and the objects tend to speak for themselves. He was not only a knowledgeable connoisseur of Old Masters in his own right, but a discerning patron of contemporary artists, above all of Rubens and Van Dyck. The spectacular Rubens ceiling in the Banqueting House and the series of glamorous portraits of the King, his family and court by Van Dyck, bear eloquent testimony to his distinction as a patron. He was also prepared to back his judgement in the way that only a true collector will in exchanging one work of art for another that he considered more desirable. In this way, the exquisite Raphael *St George and the Dragon* (now in the National Gallery of Art, Washington) entered the collection in 1627/8 by exchange with Lord Pembroke, who received in return the valuable volume of Holbein portrait drawings of Henry VIII's family and court (including nos 348–9). Although the Raphael left royal possession permanently in the Interregnum, the Holbein drawings (which passed from Lord Pembroke to Lord Arundel) fortunately re-entered the collection in the reign of Charles II.

The calamitous sale of Charles I's collection scattered to the winds not only pictures, miniatures, drawings and sculpture of supreme quality, but examples of the majority of decorative arts as well – including the King's insignia and personal jewellery, silver, armour, furniture and many of the tapestries. Some of these treasures were recovered at the time of the Restoration, given back by loyal monarchists, or forcibly repossessed. They rejoined those parts of the old Royal Collection that had been reserved from sale by Cromwell for the decoration of the palaces which he had continued to occupy. Well before 1660, however, many of the greatest masterpieces from Charles I's collection had become prized – and permanent – possessions of the French and Spanish courts.

Some of the gaps were filled by the arrival of seventy-two paintings bought by Charles II in the Netherlands, and by the handsome gift of pictures and sculpture from the States-General of Holland in 1660, which included a powerful portrait by Lorenzo Lotto (no. 5) and a possible Giorgione (no. 4). The King also managed to retrieve the important group of pictures – amongst which was Holbein's 'Noli me tangere' (no. 6) – that his mother,

Queen Henrietta Maria, had apparently taken to France in her widowhood. In doing so, he had to fight off the claims of his redoubtable sister, the Duchess of Orléans – not the last occasion on which family disputes threatened to damage the integrity of the collection. To all these were added in due course a considerable number of newly acquired contemporary works by Lely, Kneller and others, and the volume containing around six hundred drawings by Leonardo da Vinci.

The decorative arts in the Royal Collection, most notably silver and jewellery, had suffered catastrophic losses during the Civil War and Interregnum. With the exception of the twelfth-century Anointing Spoon, all the ancient coronation regalia had been melted down in the year following Charles I's execution. Earlier on, much royal plate had also been melted to support the King's straitened finances, as had masterpieces 'tainted' by religious practices deemed unacceptable by Puritan extremists. The magnificent Garter altar plate by Christian van Vianen, seized in 1642 from St George's Chapel, Windsor, was probably the worst casualty of this type. Immediately following the Restoration, orders were placed for new regalia and for substantial quantities of new plate, both ecclesiastical and secular (see nos 170–2). This was supplemented by gifts from those individuals or bodies (such as the cities of Exeter and Plymouth) wishing to re-establish or underline their loyalty to the Crown. Large orders were placed with the royal banker and goldsmith, Sir Robert Vyner, and this great influx of Baroque silver, much of it made by immigrants attracted to London by the prospect of lucrative commissions from the new court, remains at the heart of the present collection.

Despite all these attempts to repair the damage inflicted during the Interregnum, the overwhelming impression was of irretrievable loss; and while the King's building projects – which included new palaces at Winchester and Greenwich, the remodelling of Windsor Castle and the rebuilding of the Palace of Holyroodhouse in Edinburgh – achieved the aim of re-establishing the prestige of the monarchy, it was not for another hundred years that the contents of the royal residences could begin to compare with the splendours of Charles I's day.

By contrast, the second revolution of the seventeenth century, the deposition of the Catholic James II by the Protestant William III in 1688, brought about comparatively few changes to the collection. The exiled Stuarts took little with them except Mary of Modena's extremely valuable personal jewellery, most of which was subsequently sold in France.[5] The incoming King moved his focus of interest from Whitehall to the newly acquired Kensington Palace and to Hampton Court Palace, shortly to be transformed by Christopher Wren from a Tudor rabbit warren into one of the finest Baroque palaces of Europe. But architectural gains of this

kind, accompanied by substantial orders for grand new furniture and furnishings, were balanced by grievous losses. In 1698 the ancient and historic Palace of Whitehall – principal seat of the English monarchy since 1530, when Henry VIII appropriated it from Cardinal Wolsey – was destroyed by fire; the only substantial part of the palace to survive was the Banqueting House. In the flames perished one of the very few surviving pieces of Charles I's magnificent collection of contemporary sculpture, the celebrated bust of the King by Gianlorenzo Bernini. This was arguably the single greatest total loss of any work of art from the collection. Further inroads occurred when William III transferred an important group of paintings to his palace in Holland, Het Loo. These were subsequently claimed back by his sister-in-law and successor Queen Anne, but in vain – a pertinent example (of which there were to be many more after the arrival of the Hanoverian dynasty) of the potential danger to the collection of having a British monarch with sovereign territories overseas.

William III's consort and co-sovereign, Queen Mary II, was the first member of the royal family to show a serious interest in ceramics. Her apartments at Het Loo and Honselaarsdijk in Holland and later at Kensington Palace were filled with great quantities of highly fashionable oriental porcelain (both Japanese and Chinese); and in the Water Gallery overlooking the Thames at Hampton Court she kept her collection of Delft, some of which remains at Hampton Court Palace to this day. However, a large part of the oriental collection was lost when it was given after Queen Mary's death to William III's favourite, the Earl of Albemarle. This was by no means the only occasion on which a generous (or infatuated) sovereign made inroads into the collection. Such losses were often compounded by the system of perquisites, by which leading courtiers were entitled to lay claim by virtue of their office to certain valuable royal possessions, for instance at the death or coronation of a monarch.

For the Royal Collection, this fluctuating pattern of gains and losses established at the end of the seventeenth century continued into the eighteenth century, although for the first fifty years the pace was slower, with the balance overall in favour of gains. The arrival of the Hanoverians in 1714 in the person of George I signalled the start of almost half a century of inactivity, during which the spotlight fell first on Caroline of Ansbach (1683–1737), consort of George II, and then on her elder son Frederick, Prince of Wales (1707–51). Queen Caroline's intellectual interests, demonstrated by the construction of a library for her personal use at St James's, included a deep interest in English history, particularly of the Tudor period. She rediscovered at Kensington the long-forgotten Holbein drawings, probably instigated the purchase of the superb Holbein oil portrait of Sir Henry

Guildford and commissioned from Rysbrack the remarkable series of terracotta busts of kings and queens of England, all but three of which were accidentally destroyed at Windsor in the early part of the twentieth century. She also brought together a distinguished collection of cameos and intaglios, some part of which may have survived from the sixteenth-century royal collection and which, with later purchases, forms the nucleus of the present collection of gems and jewels (see nos 144, 147, 150).

George II and Queen Caroline's eldest son, Frederick, Prince of Wales, was the first of the Hanoverian dynasty to show any real artistic sensibility and the first from whose collecting activities a clear indication of personal taste emerges. Although Prince Frederick was estranged from his parents and living separately from their court, his choices – particularly of paintings by Rubens and Van Dyck – could be seen as a tribute to the royal collector whom he most closely resembled, and whom he most admired, Charles I. With advice from a circle of friends who included General John Guise and Sir Luke Schaub, and with the assistance of the painters Philippe Mercier and Joseph Goupy, Prince Frederick formed a significant collection of French, Flemish and Italian paintings including major works of the seventeenth century by Claude (no. 12), Gaspar Poussin, Le Sueur, Jan Brueghel the Elder, Rubens, Van Dyck and Guido Reni. In the contemporary field he patronised artists such as Mercier, Amigoni and Van Loo, whose light interpretation of the rococo style – very much at variance with the prevailing taste at his father's court – the Prince clearly admired.

In other areas too, Prince Frederick made important additions including an album of drawings by Poussin from the collections of Cardinal Massimi and Dr Richard Mead, and a superb group of miniatures by Isaac Oliver (including nos 47, 48) also from Dr Mead. The Prince's taste for the rococo – not a style that was widely taken up in England – found further expression in his adventurous patronage of goldsmiths such as Paul Crespin and Nicholas Sprimont, and of the frame-maker Paul Petit. His commissions for furniture indicate a more conventional taste, for the restrained Palladianism of cabinet-makers and carvers in the Burlington–Kent circle, such as Benjamin Goodison and John Boson.

Following Prince Frederick's death in 1751 and that of his widow Augusta in 1772, the Prince's collections, which had at different times been scattered between Leicester House and Carlton House in London, the White House at Kew and Cliveden in Buckinghamshire, were merged with those of their son, by then reigning as George III. With George III's accession in 1760, a long period of stagnation in the Royal Collection came to an end. A rather serious-minded young man, nurtured by his widowed

mother Augusta and by the cultivated but dry magnifico, the Earl of Bute, George III emerges early in the reign as the monarch who made the most significant additions to the collection since Charles I.

In 1762, two months after purchasing one of the finest houses in London, Buckingham House, for his young bride Charlotte of Mecklenburg, George III acquired the celebrated collection of paintings and drawings, books, manuscripts, medals and gems formed by the British consul in Venice, Joseph Smith. As had happened in Charles I's time, agents and diplomats necessarily played the most significant part in the negotiation of this major foreign purchase. Richard Dalton, the King's unscrupulous Librarian and protégé of Lord Bute, and Bute's brother, the British Minister at Turin, were closely involved in the sale and their enthusiasm persuaded a cautious monarch to part with the enormous sum of £20,000 without having seen any of the collection. This coup brought to the Royal Collection a superb series of modern Venetian paintings and drawings by Canaletto (nos 19, 384), Sebastiano (no. 376) and Marco Ricci, Zuccarelli, Rosalba (no. 378) and Piazzetta (no. 379); earlier Italian works by Bellini, Strozzi and Guercino; drawings by Raphael, Castiglione (no. 369) and others; and an important group of Northern pictures including the incomparable Lady at the virginal by Vermeer (then attributed to Frans van Mieris; no. 17). Many of these splendid new arrivals were put to immediate practical use – indeed practicality seems to a large extent to have driven the acquisition – to furnish the empty walls of Buckingham House. The newly hung pictures were shown to the public in December of the same year.

Smith's library, in which the bibliophile King was especially interested, contained an important group of early printed books and manuscripts, as well as fine gems, coins and medals. These were to be absorbed into George III's steadily growing collection which eventually filled five large library rooms, added to Buckingham House for this specific purpose. By the early nineteenth century, the King's library was regarded as one of the finest in Europe. In his pursuit of books – verging almost on mania – George III was successfully filling the void left after the public-spirited if historically regrettable disposal of the old Royal Library (its contents dating back to the reign of Edward IV in the fifteenth century) by George II. This great collection had been given to the newly founded British Museum in 1757.

Consul Smith's gems (nos 139, 145) – a mixed bag of ancient and seventeenth- and eighteenth-century Italian cameos and intaglios, made famous by the publication in 1767 of a catalogue by A.F. Gori (the Dactylioteca Smithiana) – added significantly to the existing collection, as did Smith's coins and medals. The latter were included with the majority of Smith's books and manuscripts

27 (detail) ▷

(but not the gems) in the second (and in some ways more unexpected) royal gift to the British Museum, that of George III's enormous and important library, presented by George IV in 1823.

George III's patronage of contemporary artists such as Ramsay, West, Zoffany (no. 24), Gainsborough, Hoppner, Copley (no. 25) and Beechey (no. 26) – but not Reynolds, whom the King and Queen disliked – was predominantly geared to portraiture, although in the case of the most highly favoured of these, the American-born Benjamin West, the King also commissioned a series of exemplary compositions, designed to illustrate virtues that he particularly admired such as honour, fortitude and chivalry. While West's reputation has declined, George III's other commissions have usually been seen as more successful: Zoffany's intimate portraits of the Queen and her children at Buckingham House, for example, and the felicitous full lengths of the King and Queen by Gainsborough – who also painted the enchanting set of portraits of the royal children – vividly establish in the mind's eye the character and personalities of George III's court.

George III's taste – thoughtful, sober and in many ways the epitome of the Augustan age – commended itself to many; but not every visitor to Buckingham House would have echoed the American John Adams's praise of the elegance and simplicity, 'without the smallest affectation, ostentation, profusion or meanness',[6] of the restrained neo-classical interiors devised by the King's architect and architectural tutor, Sir William Chambers. Nor would all have accepted Adams's favourable comparison of the principal residence of the King of England with that of the King of France at Versailles. The supporting cast of decorative arts at Buckingham House positively radiates quality and meticulous attention to detail, and (in addition) demonstrates the King's concern to support British manufacturers and entrepreneurs. Here was to be seen superb mahogany furniture by Vile & Cobb, Bradburn, and France & Beckwith (but not by Thomas Chippendale, who was never awarded a Royal Warrant); silver by Heming; porcelain from Chelsea, Derby, Wedgwood and Worcester; ornamental metalwork from Matthew Boulton (nos 86, 87); and clocks, barometers and scientific instruments by Vulliamy, Eardley Norton, Pinchbeck, Adams and Cumming (no. 83).

In Queen Charlotte's apartments at Buckingham House, Windsor Castle and, especially, at Frogmore House – the retreat in the Home Park at Windsor purchased for her by the King in 1792 – a different and lighter taste emerges. A liking for the Orient – lacquer, ivory (especially furniture), porcelain and embroidered silk – and a dash of continental *brio* (Meissen and Sèvres porcelain, jewelled *objets de vertu* and painted furniture) characterised her taste in the decorative arts. For the Queen, the arts and sciences (particularly the study and practice of botany) provided a solace and a constant source of pleasure through the difficult years of the King's illness, and the extent and diversity of her interests are vividly evoked in Christie's catalogue of her collection, the sale of which took place the year after her death, in May and June 1819.

This dispersal – the first time that a collection with such direct royal associations had been sold at public auction since the time of Charles I – was designed, with laudable intent, to benefit the Queen's four youngest surviving daughters, Mary, Augusta, Elizabeth and Sophia, for whom none but the most meagre provision would otherwise have been made. By prior agreement, a number of items were reserved from the sale, and the Prince Regent bought back some important pieces including the suite of Indian ivory furniture acquired by George III for Queen Charlotte (see no. 85). But none the less a very great quantity of fine objects, including all the Queen's personal jewellery (mainly diamonds) and her considerable library, was dispersed.

By chance, the disposal of this jewellery in 1819 set in train a sequence of events which was to reverberate through the later history of the Royal Collection. George IV had high-handedly disregarded that part of his mother's will by which she left to Hanover certain important state jewels, deemed by her to be Hanoverian in origin. Until the separation of Hanover from the British Crown in 1837, this impropriety remained unchallenged but thereafter her fifth son, Ernest, Duke of Cumberland – by then King of Hanover – initiated a claim against his niece Queen Victoria which eventually resulted in the forced return to Hanover of some of the most prized of the royal jewels.

These losses were to be recouped from a source which, from the late eighteenth century, was to play an increasingly important part in the shaping of the collection – the newly emerging empire overseas, in particular India. From time immemorial vassal states had paid tribute in jewels and precious metals to the seat of empire. Ironically the 1819 sale of Queen Charlotte's property had included the celebrated Arcot diamonds, given to the Queen by the Nabob of Arcot and considered to be among the earliest 'treasures of empire'. The flow of jewels and precious objects to the Crown increased dramatically after the annexation of the Punjab in 1849 and the establishment of British rule, and continued well into the twentieth century (see no. 157).

George IV's love of jewellery, vividly and lavishly proclaimed at the time of his coronation in 1821, was not the only one of Queen Charlotte's tastes that he had inherited. Her continental outlook, expressed in the acquisition of French and German porcelain and perhaps the occasional piece of French furniture, in the commissioning of Zoffany's masterpiece *The Tribuna of the Uffizi* (no. 24) and in her fondness for decorating, blossomed in the case of her eldest son into an all-consuming passion for collecting and

an obsessive concern with architecture and interior decoration.

Not since the time of Charles I had there been a monarch with such an approach to the arts: the contrast with the sober and cautious habits of his father, George III, could not have been more extreme or more widely noted by contemporary observers. From the moment of his coming of age in 1783 and taking possession of his London residence, Carlton House, George IV set out on a spending spree without parallel and within ten years he had run up debts to the colossal tune of £400,000. Whether or not it is the case that 'Total disregard of any kind of financial prudence ... is a prime asset in a collector',7 George IV's additions to the collection at all levels and in all branches – pictures, furniture, porcelain, silver and armour especially – were fundamentally and completely transforming; and never before or since has the collection – or its various settings – been in such a state of continuous change or under the eye of such a deeply art-loving monarch.

Some idea of this relentless activity emerges in the meticulously kept receipt and despatch records of the King's inventory clerk, Benjamin Jutsham, who was charged with the unenviable responsibility of keeping track of George IV's collection. Disposal as well as acquisition played a significant part in the shaping of the character and content of the collection. Like many of his predecessors, notably Charles I, George IV delighted in giving works of art to especially favoured friends (Lord Yarmouth, later third Marquess of Hertford, and the Marchioness Conyngham were particular beneficiaries), and he was not afraid to cull in the interests of refining and improving. Thus, when he acquired Sir Thomas Baring's collection of superlative Dutch pictures *en bloc* in 1814, a number of lesser items (mainly still lifes) from this haul were sent for sale; and when negotiating in the same year for the Rubens *Landscape with St George*, the balance of the price was made up with four lesser pictures including two from the Baring purchase. Other more disinterested – if regrettable – disposals included the gift to Greenwich Hospital of Turner's *Battle of Trafalgar*, the only oil painting by this greatest of English artists in the collection, painted for George IV in 1823; and the prodigious gift (already mentioned) of George III's large and celebrated library to the British Museum, also in 1823.

Like many of his predecessors, George IV relied heavily on a circle of agents, dealers and friends to keep him abreast of the art market and to search out possible acquisitions. In the early years at Carlton House, he depended on the Anglo-French *coterie* revolving round Dominique Daguerre, the fashionable Parisian *marchand-mercier* whom he had summoned with the express purpose of superintending the decoration and furnishing of Carlton House after its architectural transformation (the first of many) by Henry Holland. Daguerre's influence can be seen in the influx of substantial quantities of smart Parisian furniture and *objets d'art* in the 1780s and 90s (including nos 106, 126, 164), providing the foundation of French decorative art which so decisively marked the character of the Royal Collection thereafter.

The upheavals on the Continent in the wake of the French Revolution provided George IV – in common with all the leading collectors of the period – with remarkable opportunities to acquire works of art of the finest quality, and these he seized with enthusiasm. His taste for Dutch and Flemish pictures in particular was fed by the appearance on the market of some of the greatest continental collections, notably those of Braamcamp and Gildemeester, and by the activities of dealers such as Michael Bryan, William Buchanan and Alexis Delahante. At the same moment, superb furniture from the French royal collections flooded onto the market and in the first three decades of the nineteenth century George IV was able to amass an astonishing range of French eighteenth-century decorative art, extraordinarily rich in Boulle furniture, pietra dura, gilt bronze and, above all, Sèvres porcelain. To achieve this, he used a network of agents loosely connected to his personal servants Jean-Baptiste Watier (officially Clerk-Comptroller of the Kitchen) and François Benois (officially Confectioner), while also relying on friends such as Lord Yarmouth, Sir Harry Featherstonhaugh, Sir Wathen Waller, Sir Thomas Liddell (later Lord Ravensworth) and Sir Charles Long (later Lord Farnborough) to seek out objects which they knew would delight or intrigue him.

As with Charles I, there is enough direct and indirect evidence of George IV's personal tastes to be able to form a view of the way his likes and dislikes shaped the collection. Religious art and still lifes played only a small part, although the former category included such masterpieces as the Rembrandt *Christ and the Magdalen at the Tomb* and the Rubens sketch of the *Assumption of the Virgin*. One of the great masterpieces of Northern painting, Van Eyck's *Arnolfini Marriage*, was sent on approval to Carlton House and turned down; it was perhaps considered too severe. Even more surprisingly, negotiations to buy Rubens's ravishing *Châpeau de paille* broke down because the King was advised that it was too expensive – one of the very few occasions in his collecting career when such a consideration seems to have carried any weight. Italian pictures, which had figured strongly at Carlton House in the 1790s, had virtually disappeared from display by the 1820s, whereas Dutch and Flemish pictures of superb quality had been added in considerable numbers. Works with a strong family connection were keenly sought; in the same way that George III had bought back the Van Dyck *Five children of Charles I* (while turning down the same painter's marvellous *Roi à la Chasse*, now in the Louvre), George IV added the famous Van Dyck *Charles I in*

three positions after protracted negotiations with its reluctant seller.

George IV's patronage of contemporary artists is well documented. The traditional royal appetite for sporting art was met by the most distinguished equestrian artist of the eighteenth century, George Stubbs, in a series of superb canvases (including no. 22) and, on a lesser plane, by Ben Marshall, Sawrey Gilpin and George Garrard. In portraiture, always among the strongest and most numerous parts of the collection, George IV had an unparalleled choice of artists. Unlike his father, George IV had an easy manner that promoted good relations with painters and sculptors and he was served well by Reynolds, Gainsborough, Beechey and, pre-eminently, by Thomas Lawrence. As Van Dyck was to Charles I and his court, so Lawrence became to George IV, expressing in a great series of bravura portraits the character and style of this beguiling monarch and that of his family, friends and contemporaries. In no setting is George IV's patronage of Lawrence seen to better advantage than in the Waterloo Chamber at Windsor Castle, where portraits of the allied sovereigns and military and political leaders involved in the overthrow of Napoleon are gathered in one great Valhalla (see nos 28, 407). On a smaller and more intimate scale, genre painters such as David Wilkie (no. 29), Edward Bird and William Mulready were especially favoured, their style and anecdotal subject matter blending well with the Dutch and Flemish cabinet pictures of the kind that the King had assembled in quantity.

Carlton House, regarded by many as one of the most perfect houses in Europe, was demolished in 1826, the King having decided that Buckingham House had greater potential as the principal royal residence in London. The magnificent contents – including such features as chimneypieces, pier-glasses, doors and architectural carvings – were packed up for division between Windsor Castle, then undergoing transformation at the hands of Jeffry Wyatville, and Buckingham House, eventually to emerge almost unrecognisably as Buckingham Palace.

The work of modernising the Private Apartments at Windsor, begun in 1824, gave George IV his last and in many ways greatest opportunity to stamp his personality on the Royal Collection. He had ensured the appointment first of Wyatville as architect and then of the French cabinet-maker Nicholas Morel, who had formerly been employed at Carlton House, to oversee the decoration and furnishing of the east and south ranges of the Upper Ward of the castle. Between them they managed to transform an uncomfortable and cold house into a royal residence that even the notoriously critical Princess Lieven, the wife of the Russian Ambassador, found 'magnificent in the extreme' and a place where 'luxury can hardly be carried further, and comfort is equally well looked to; in short nothing is left to be desired'.[8]

George IV spent much of his last years at Windsor, first at Royal Lodge, his house in the Great Park, then moving to the castle at the end of 1828. He took the closest possible interest in the work of renovation there, spending hours visiting the site and looking at plans and drawings provided by his architect and decorator. His ministers at this time found him 'not to be the least interested in public affairs & to be thinking of nothing but his improvements & alterations at Windsor'.[9]

In anticipation of the splendid new spaces that would be available to him, the King continued to acquire paintings and works of art of all kinds at an undiminished pace and almost entirely regardless of expense. His single greatest purchase of French decorative art and sculpture – the acquisition of thirty-one lots from the sale of the collector George Watson Taylor (including nos 104, 105) – took place in 1825, and important works (paintings, furniture and silver especially) continued to be added to the collection to within a month or two of the King's death in June 1830. In 1828, with work on the Private Apartments close to completion, George IV spent two happy days with his favourite artists, David Wilkie and Francis Chantrey, arranging some of his best pictures and sculpture in the newly completed Grand Corridor. Although the sculpture did not include any of the King's three superb pieces by Canova (which were reserved for Buckingham Palace; see nos 72, 73), a telling display of likenesses of friends and contemporaries, mainly by Nollekens and Chantrey, was arranged along both sides of the Corridor, mingling happily with portraits by Gainsborough, Reynolds and Lawrence, sporting pictures by Stubbs and Wootton and Italian views by Canaletto and by Sebastiano and Marco Ricci (see nos 409, 410). By the time of his New Year party at the end of 1828, at which the Lievens were present, the King had tactfully arranged that the large malachite urn recently sent by Tsar Nicholas I should be in a prime position, even though this meant displacing another diplomatic gift, the marble and gilt bronze centrepiece presented in 1816 by Pope Pius VII in gratitude for help in the return to Rome of works of art looted by Napoleon (see no. 404).

This glorious period of expansion came to a dramatic halt with the death of George IV and the accession of his brother William IV in 1830. The new King had none of his brother's interest in the arts – indeed his only pronouncements on such matters tend to support the popular view of him as an ignorant philistine. Although he established the Royal Library in its present form, he evidently cared little for paintings and still less for their settings. He hated Buckingham Palace and did everything in his power to avoid having to live there, preferring to continue to reside in the more domestic setting of Clarence House. His lack of affinity with his stupendous inheritance makes it all the more

surprising that this unpromising monarch was responsible for acquiring some of the most impressive porcelain in the Royal Collection, including two of the finest services ever made by the Worcester and Rockingham factories (see nos 112, 113). He also added to the already enormous assemblage of silver-gilt banqueting plate, although the cost of this was offset by the sale (to Rundells, the royal goldsmiths) of the majority of George IV's collection of bibelots. These disposals included more than three hundred gold boxes and the same number of watches, seals and rings; over a hundred miniatures and a quantity of medals and coins.

The focus of the collection shifted again – and decisively – with the accession of Queen Victoria in 1837. In the course of her reign of sixty-three years, and in particular in the twenty-one years of her marriage to Prince Albert (1840–61), the Queen added substantially and comprehensively to all parts of the Royal Collection at all levels; and of these activities there is, for the first time in the history of the collection, a very substantial and detailed record in the form of bills, accounts, correspondence and journals. The paintings collection (certainly in square footage of canvas) grew more than at any other time before or since. In terms of quality, however, the results were mixed. As far as contemporary painters were concerned, the Queen at first responded enthusiastically to the romantic bravura of Wilkie, Grant and the early Landseer. After marriage, her more adventurous instincts seem to have become submerged in Prince Albert's drier and more serious approach to art. They shared an appreciation of good likenesses (whether of people or animals) and a fondness for the anecdotal or narrative elements in a picture; and as patrons, the royal couple appeared interested and well informed, enjoying cordial relations with most of the painters they employed. Hayter, Leslie, Landseer, Frith and Winterhalter, skilful in the accurate representation of royal personages and events, found frequent employment. Of these, Landseer held a special place in the Queen's affection as the painter who had so memorably captured images of people, places and (especially) animals from the early, happy part of her life in both England and Scotland, before Prince Albert's death in 1861. It was the cosy domesticity of much of the Queen's and the Prince's taste in contemporary art that gave it its special character – but which also aroused the fierce criticism of commentators such as Thackeray.[10] Winterhalter on the other hand perfectly responded to the Queen's and the Prince's traditional royal taste for fashionable and elegant portraiture, and from the early 1840s over a period of almost twenty immensely productive years, he created the iconic images of the Queen, her handsome consort, their growing brood of children and their immense network of relations.

While the favoured painters were heavily (perhaps too heavily) patronised, whole movements in the nineteenth-century art world passed the Queen and Prince by: the Pre-Raphaelites, for example, are virtually unrepresented; there are few French nineteenth-century paintings of distinction; and (less surprisingly) there were no Impressionists. While their patronage of contemporary artists may have been restricted, Queen Victoria and Prince Albert more than made up for this by the attention they paid to the historic collection of which they found themselves possessed. Prince Albert's rational and ordered mind rose to the challenge of sorting out the chaotic state of the picture collection, particularly the paintings at Hampton Court Palace, and the work he began definitively laid the pattern for the care of the collection down to the present day. Inventories were compiled, photographic records were made for the first time (see fig. 10), programmes of cleaning and repair were organised and picture displays in all the royal residences were overhauled and rearranged. At the same time order was instilled in the newly created Print Room at Windsor where Prince Albert and the Queen spent much time sorting through drawings and prints, arranging their growing collection of watercolours in souvenir albums and organising the collection of portrait miniatures.

Prince Albert also instigated a number of important additions to the historic collection, for which Queen Victoria usually paid. The largest acquisition came with the Öttingen Wallerstein collection of early Italian, German and Flemish pictures, accepted by the Prince as repayment of an outstanding loan. Other purchases, mostly achieved with the help of the Prince's artistic adviser Ludwig Gruner, included significant works by Fra Angelico, Daddi (no. 2), Gozzoli and – outstandingly – a triptych by Duccio (no. 1). These early Italian works were mostly kept at Osborne House (see no. 437). After the Prince's death, twenty-two of the best pictures from the Öttingen Wallerstein collection were given by the Queen to the National Gallery in his memory.

Prince Albert's influence on the collection was lasting and profound. Apart from the activities charted above, he was the first member of the royal family to encourage scholarship and publications about the collection (especially the paintings and drawings) and he supported vigorously the view that exhibitions were of value in raising awareness of art and design in this country. For the Great Exhibition of 1851, in the planning of which Prince Albert played the decisive role, he arranged for several important works, commissioned by him or the Queen, to be displayed. He also championed the extraordinarily comprehensive Art Treasures Exhibition at Manchester in 1857, to which the Queen lent extensively, and which attracted 1.3 million visitors in the five and a half months of its opening.

In the decorative arts, both the Queen and Prince bought extensively, but on the whole conventionally. Their purchases, many again overseen by Gruner, ranged from the utilitarian and domestic to the elaborate and specially designed. The former category included large quantities of new furniture and furnishings for Osborne House and Balmoral Castle, their holiday homes in the Isle of Wight and Scotland. For Osborne plain mahogany furniture was chosen; for Balmoral pale maple, all supplied by the Mayfair firm of Holland & Sons (see nos 437, 431). In the older palaces and residences, especially after Prince Albert's death, there was a conservative programme of replacement and renewal, but only as required and apparently without any attempt to reflect – let alone influence – prevailing fashion. Occasionally, the Queen branched out, buying modern French furniture from Kreisser and Grohé and gilt bronzes from Barbedienne; and as sovereign of the most powerful country in the world and (eventually) ruler of a vast empire, she was in receipt of a never-ending stream of diplomatic gifts from foreign rulers which ranged from jewels, tapestries, furniture, metalwork and porcelain to quaint curiosities and mementoes of every description and nationality (see nos 299, 300, 302).

Some of the decorative arts lent themselves more directly to the Queen's and Prince's personal involvement than others. Next to painting, sculpture was the area in which the royal couple most concerned themselves; and rather in the same way that their commissions to painters reflected their desire for good likenesses, uplifting allegory or attractive genre subjects, so their sculptors were patronised according to their skill in rendering these subject categories in an acceptable manner. The artists employed by Queen Victoria – from Francis Chantrey and William Behnes at the beginning of the reign to Onslow Ford at the end, via R.J. Wyatt, John Gibson, William Theed and Joseph Boehm (among others) – constitute a pantheon of nineteenth-century British sculpture, to which was added, under Prince Albert's and Gruner's guidance, a sprinkling of favoured continental (mostly German) sculptors.

The Queen's interest in the historical aspects of the collection, sharpened no doubt by Prince Albert and perhaps by the example of her predecessors, led her to acquire a number of objects which she felt were of special relevance to the collection. Chief among these was the celebrated Darnley Jewel (no. 143) which she purchased, together with the so-called Anne Boleyn clock, at the sale of Horace Walpole's famous collection from Strawberry Hill in 1842. Later in the reign, she acquired a handful of notable historic pictures and miniatures (including nos 38, 45, 51, 54) and, with the encouragement of her Librarian, a small number of Old Master drawings and an outstanding group of Sandby watercolours of Windsor. Such acquisitions were, however, rare.

In the closing decade of Queen Victoria's long reign nothing was allowed to disturb the settled stillness of the collection, the arrangement of which had been sanctified by the omnipresent taste and judgement of the long-dead Prince. Such programmes of restoration and rehanging of the pictures and reordering of other parts of the collection as Prince Albert had initiated had come almost to a standstill and by the time that Edward VII succeeded to the throne in 1901, much needed to be done. The fact that the new King knew little about art meant that the sweeping changes he initiated were in many instances too briefly considered and came to be regretted later, not least by his daughter-in-law Queen Mary. Among such changes were the obliteration of Gruner's spectacular polychrome decorations at Buckingham Palace (see no. 420), the culling of the displays in the Guard Chamber at Windsor and the disposal of Osborne House.

King Edward's additions to the collection strongly reflect his personal interests, among them the family, the sea, racehorses, shooting and attractive women. These subjects are well represented in painted and sculpted form at Sandringham House, the aesthetically deficient but characteristically comfortable new house he had built in north Norfolk. Marriage in 1863 to Princess Alexandra of Denmark prompted the arrival of a crop of interesting Danish paintings, porcelain and sculpture and, through the Princess's interest, led in time to the formation of what was to become one of the finest collections of Fabergé in the world (see p. 283). Royal tours – King Edward was an active and enthusiastic traveller – produced the inevitable shower of gifts of all kinds from foreign potentates. Of these travels, the most remarkable – and for the Royal Collection the most productive – was the tour of India in 1875–6 on behalf of the Queen-Empress, which resulted in the acquisition of an enormous and magnificent collection of Indian works of art, consisting principally of arms and armour, much of it heavily jewel-encrusted. This lavish gift was divided under the King's supervision between Sandringham, where it adorned the Ballroom, and Marlborough House, his London residence when Prince of Wales, where special display cases were constructed. The Marlborough House display, containing the most valuable part of the collection, was transferred *en bloc* to Buckingham Palace in 1901.

Within this context of jovial philistinism, the King's commission to the most original and advanced sculptor of the age, Alfred Gilbert, to create the tomb of his elder son, the Duke of Clarence (1864–92), comes as something of a surprise. The Clarence Tomb, in the Albert Memorial Chapel at Windsor, is one of the great masterpieces of the Art Nouveau style and in its bold originality, enormous scale and heady symbolism ranks as one of the finest royal tombs ever made. The contrast with the sober

conventionality of Queen Victoria and Prince Albert's tomb in the Mausoleum at Frogmore could hardly be greater.

Diplomacy continued into the twentieth century to play a part, as it had over previous centuries, in the shaping of the collection. Of the 'diplomatic' losses to the collection that occurred in Edward VII's short reign, the most significant was that of twelve fifteenth-century French illuminated miniatures, given to the French government in 1906 with the manuscript from which they had been cut.[11] This was the King's contribution to the *Entente Cordiale*, the treaty of friendship with France for which he saw himself as chiefly responsible. However, as had happened in the reign of Queen Victoria, losses were often matched – even exceeded – by gains in the form of tribute of empire, particularly jewels. By far the most significant of such offerings was the Cullinan diamond, the largest diamond ever found, which was presented to Edward VII in 1907 by the Government of the Transvaal on his sixty-sixth birthday. In many quarters, this gift was seen as a welcome and generous gesture towards re-establishing good relations after the bitterness of the Boer War.

The pattern for the early part of the twentieth century, so far as the Royal Collection was concerned, was set more firmly in the reign of King George V, who succeeded to the throne in 1910. Like some of his early Hanoverian predecessors, King George combined a considerable lack of interest in art and a general disapproval of scholarship (which was shared by many royal and aristocratic owners at this period) with a strongly proprietorial view of the collection. These characteristics no doubt eased the departure of five superb late seventeenth-century French bronzes from the collection to the City of Paris during a State Visit to France in April 1914 – almost the last occasion on which works of art from the Royal Collection were alienated in the interests of diplomacy. Even so, further changes to the balance of the collection took place when, on the advice of the Librarian Sir John Fortescue, arrangements were made for the disposal of a portion of the celebrated Paper Museum of Cassiano dal Pozzo, acquired by George III, together with George IV's collection of political and personal caricatures and Queen Victoria's complete set of Whistler etchings. More storage space was required for the newly mounted Old Master drawings and it was thought that the items to be disposed of were unlikely to serve any useful purpose in the foreseeable future. Income generated by these disposals was paid into the newly established Royal Library Trust Fund (see p. 391).

The approach of the King's consort, Queen Mary, was rather different. Though no scholar herself, she took the liveliest possible interest in the decoration and contents of the royal houses, rearranging furniture and pictures and assembling objects by type into 'collections within'. While much of this classifying and sorting was of value, it resulted in some unfortunate losses. Like many of her contemporaries, Queen Mary had a strong prejudice against what she thought of as 'heavy' or 'Victorian' objects (anything, in other words, post-Regency), and it was in this spirit that much of the Gothic furniture and furnishings designed for Windsor Castle by the younger Pugin, and significant pieces of historicist plate made for George IV, were disposed of.

If it is true that Queen Mary 'never bought a really good or important picture',[12] she certainly added substantially to other areas of the collection, concentrating above all on objects of family interest. These included such major items as the carved mahogany bookcase and the inlaid jewel-cabinet by William Vile, made for Queen Charlotte in the 1760s, which had descended in the family of Queen Mary's mother, Princess Mary Adelaide of Cambridge. Her interest in 'family' is typified by the delight she felt at being able to give her great-grandson Prince Charles (HRH The Prince of Wales) for his christening in 1948 a silver-gilt cup which had been given by her great-grandfather George III to a godson in 1780.

Queen Mary's own collections came eventually to cover a very wide range. They included Fabergé, piqué, jade, lacquer, silver, enamels, rings, seals, Stuart memorabilia, fans, gems and jewels and gold boxes; and while the pursuit of quality was sometimes sacrificed to family sentiment, the additions are for the most part interesting and often impressive. Perhaps the most piquant – certainly the most elaborate – addition was the magnificent Dolls' House, designed by Sir Edwin Lutyens and presented to Queen Mary in 1924. In its decoration and range of content – pictures, works of art, books and household paraphernalia including wine, linen and motor cars – it has come to be seen as the epitome in miniature of a way of living entirely familiar to Queen Mary's generation, but now almost entirely vanished.

Provenance and history were all-important to Queen Mary and in consequence a great many of her possessions acquired little hand-written notes describing their origin and date of acquisition. The almost obsessive importance the Queen attached to list-making and ownership, which may have been an effect of her peripatetic and impoverished childhood, was no doubt heightened by awareness of the fate of other European royal collections at the end of the First World War. It resulted in the production of a series of leather-bound volumes in which her collections were described, illustrated and personally annotated. These volumes were drawn up at the Victoria and Albert Museum under the direction of Sir Cecil Harcourt Smith, one of a number of museum and gallery directors and writers on the decorative arts with whom Queen Mary remained on friendly terms. She was equally familiar to the fraternity of West End dealers and auction houses and liked to be kept abreast of art world news by figures such as Sir Alec Martin

28 (detail) ▷

of Christie's and Sir Owen Morshead, the Librarian at Windsor Castle. On Queen Mary's death in 1953, the vast majority of her acquisitions was absorbed into the main body of the Royal Collection. The surplus from Marlborough House, consisting for the most part of pieces that the Queen had acquired, was sold by Christie's in 1957.

The rather dutiful tradition of acquiring or reacquiring objects with a family connection, so marked through the history of the Royal Collection, reached a high point with Queen Mary. In the case of Queen Mary's daughter-in-law Queen Elizabeth (Her Majesty Queen Elizabeth The Queen Mother), such interests have been tempered by a lighter touch. With the support of King George VI and advice from a wide range of friends interested in the arts – including Sir Kenneth Clark, Sir Jasper Ridley and Sir Arthur Penn – Queen Elizabeth assembled her own collection of paintings and works of art reflecting her interests in a highly personal way. Her good natural eye, coupled with 'an infectious pleasure in pictures and objects',[13] brought together a collection strong in twentieth-century British art (William Nicholson, Augustus John, Matthew Smith, Walter Sickert, Duncan Grant, Paul Nash, John Piper and Graham Sutherland), but which also embraces important works by Monet and Millais, as well as more traditional royal interests – superb examples of Fabergé, English (notably Chelsea) porcelain, silver (especially relating to the Bowes-Lyon family), miniatures and bibelots (see nos 33, 34, 172, 254, 255, 265, 272). In King George VI's reign, heavily overshadowed by the Second World War, a few significant paintings were added (with Queen Elizabeth's encouragement) to the main Royal Collection including works by Sebastiano Ricci, Kneller, Knyff and Bower, together with some historically important sculpture (no. 67) and a handful of distinguished pieces of furniture.

The steps taken to ensure the survival of the collection – or at least the most important parts of it – during the Second World War may have been of more significance than any acquisitions made at this period. In 1942, as the fate of Europe hung in the balance, the finest paintings from Buckingham Palace and Windsor Castle – together with the Leonardo and Holbein drawings, the best of the miniatures and some books – were sent to join the National Gallery's pictures in the Manod slate quarry at Blaenau Ffestiniog in north Wales, where they remained until the end of the war. This operation was supervised by Kenneth Clark, who at the time held the positions of Director of the National Gallery and Surveyor of the King's Pictures, and Owen Morshead, the Royal Librarian. At the same time, the principal stones from the coronation regalia were removed from their settings and stored in great secrecy away from London.

With the benefit of a long perspective, the accession of Her Majesty Queen Elizabeth II in February 1952 can now be seen to have marked the beginning of a period of change – usually quiet and unhurried, sometimes sudden and dramatic – which has been without parallel in the long and complicated history of this remarkable collection. During these fifty years, the emphasis has gradually but certainly moved from the notion of the Royal Collection as essentially a private one, to which the public were occasionally allowed access, to a generous commitment to make as much of the collection available as possible and to bring its extraordinary history to life through interpretation, exhibitions – at The Queen's Gallery and elsewhere – and, very significantly, through publications. Beginning with The Queen's decision to open to the public Queen Victoria's private rooms at Osborne House in 1954, this process has gone on to encompass virtually every occupied and unoccupied royal residence, most recently (in 1998) the private drawing rooms at Windsor Castle restored after extensive fire damage in 1992 (see Essay 2 and no. 412).

This change of perception has moved hand in hand with the development of a new and much more rigorous approach to the conservation and care of objects in the collection (see Essay 3) – a far cry from the scrubbing and daubing of previous centuries – and a much keener awareness of the value of sound historical research and imagination in the decoration and presentation of rooms open to the public. In their different ways, Frogmore House, the Palace of Holyroodhouse and Windsor Castle have all shown these new skills to considerable advantage. Much the same pattern of imaginative and well-researched restoration and re-presentation has been seen at Hampton Court Palace, Kensington Palace and the Tower of London. These latter palaces, which contain important parts of the Royal Collection, are maintained and managed by the Historic Royal Palaces Trust – originally set up in 1991 and re-established in 1998 as a trustee body.

Over the last fifteen years, all aspects of the care and display of the collection have been greatly assisted by the creation of a new computerised inventory, a massive labour begun in 1987 and completed at considerable cost ten years later. This new resource, containing basic custodial information on every object in the collection (running to more than half a million entries), replaces the previous manual systems of inventory books and card indexes and for the first time allows an overview of the collection. In due course the inventory will be further enhanced for public access, and will also include images.

While the twin themes of access and conservation have run strongly through the recent history of the collection, new acquisitions have continued to play their time-honoured part. Neither so numerous nor so wide ranging as those of some previous sovereigns, the additions to the collection in the present reign have been

sometimes adventurous, frequently distinguished and always interesting. In the suggestion of possible purchases (but not necessarily in the final decision), The Queen has often depended on advice from her Surveyors. The thrust of such advice has generally been in the direction of works which complement existing objects or groups of objects, or which have a powerful association with past sovereigns or members of the Royal Family. Thus in the picture collection historic portraiture has almost inevitably come to dominate. Important additions to date have included images by Blanchet of the Young Pretender (no. 20) and his brother; the children of the King and Queen of Bohemia by Honthorst; and miniatures by Hoskins of Henrietta Maria (no. 52), and by Cooper of the architect Hugh May. Among the hundreds of drawings and watercolours acquired have been outstanding views of Windsor by Paul Sandby (including no. 388), Joris Hoefnagel and J.M.W. Turner, as well as a large group of designs for Windsor dating from the late 1820s (including nos 404, 405). Gifts arising from official or state occasions continue to swell the numbers, especially of drawings – for example the selection given by the Royal Academicians to mark the Coronation and the Silver Jubilee (no. 396); and the practice of giving away works of art from the collection ceased after the presentation of a group of Russian watercolours from Queen Victoria's collection to President Khruschev and Marshal Bulganin during their visit to Britain in 1955.

Acquisitions of contemporary paintings – for the most part by British or Commonwealth artists – have not greatly changed the overwhelmingly historical face of the collection, although the additions in this area, significantly encouraged by Prince Philip's interest in the subject, have included a fine group of paintings by Sydney Nolan, Barbara Hepworth, Ivon Hitchens, Russell Drysdale and Graham Sutherland (no. 35). The ongoing sequence of portrait drawings of members of the Order of Merit (including no. 398) has provided The Queen with an opportunity to commission work by a wide cross-section of artists; and the recent arrival of Lucian Freud's portrait of The Queen (no. 36) is a very notable addition to royal iconography. The equally strong tradition of recording royal residences has continued with the commission to Alexander Creswell to draw Windsor Castle after the fire of 1992 and then after the restoration in 1997 (see no. 412).

Much the same processes have guided the addition of works of art to other parts of the collection. Great historical interest, rarity and high aesthetic quality determined the acquisition of the caddinet that had belonged to William III (no. 176); the same considerations applied to Queen Mary's patch box (no. 281) and, more recently, to the Young Pretender's Sèvres ecuelle and stand (no. 117). Equally, state or official gifts still play a part in enriching the collection and belong to a tradition which flowered

prodigiously in the reign of The Queen's great-great-grandmother, Queen Victoria.

With the enormously inflated value of major works of art today, the opportunities for purchase that were readily available to previous sovereigns have now greatly diminished; and while traditional representational work is likely to continue to be commissioned – as can be seen in the burgeoning collection of The Prince of Wales[14] – cutting-edge contemporary art does not look as though it will easily find a place in the Royal Collection. While a few may regret this, the focus has in any case moved decisively in the present reign towards the care, conservation and display of the treasures that already exist in the collection. Such work is now funded by the Royal Collection Trust, a body set up by Her Majesty The Queen in 1993 under the chairmanship of The Prince of Wales to safeguard the independence and viability of the Royal Collection. This decisive and far-reaching change followed the establishment in 1987 of the Royal Collection Department as one of the five departments of the Royal Household, which brought together the various strands of curatorial and commercial activity under a single head. In pursuit of the Royal Collection Trust's objectives, income from the public opening of Windsor Castle, Buckingham Palace and the Palace of Holyroodhouse and from associated retail activities which together provide the funding for the Royal Collection, has been allocated to a number of major projects. These have included the restoration of Windsor Castle after the fire in 1992 and, most recently, the rebuilding of The Queen's Gallery at Buckingham Palace and the construction of a new gallery at the Palace of Holyroodhouse. These two gallery projects are intended to mark in a permanent way the Golden Jubilee of Her Majesty The Queen, while at the same time demonstrating the continuing commitment of the Royal Family to share with the public the extraordinary riches and variety of this unsurpassed collection.

1 Neil McGregor, Foreword to Lloyd 1991, p. 9.
2 Jameson 1842, II, p. 283.
3 Hazlitt 1873, p. 415.
4 Haskell 1989, p. 215.
5 E. Gregg, 'Monarchs without a Crown' in Oresko et al. 1997, p. 389.
6 Quoted in Millar (O.) 1977, p. 128.
7 Millar (O.) 1977, p. 129.
8 Lieven Correspondence, I, p. 216.
9 Arbuthnot Journal, I, p. 295.
10 Levey 1971, p. 186.
11 Stratford 2000, pp. 131–3.
12 Millar (O.) 1977, p. 208.
13 Cornforth 1996, p. 21.
14 See exh. cat. Cardiff 1998, nos 185–259.

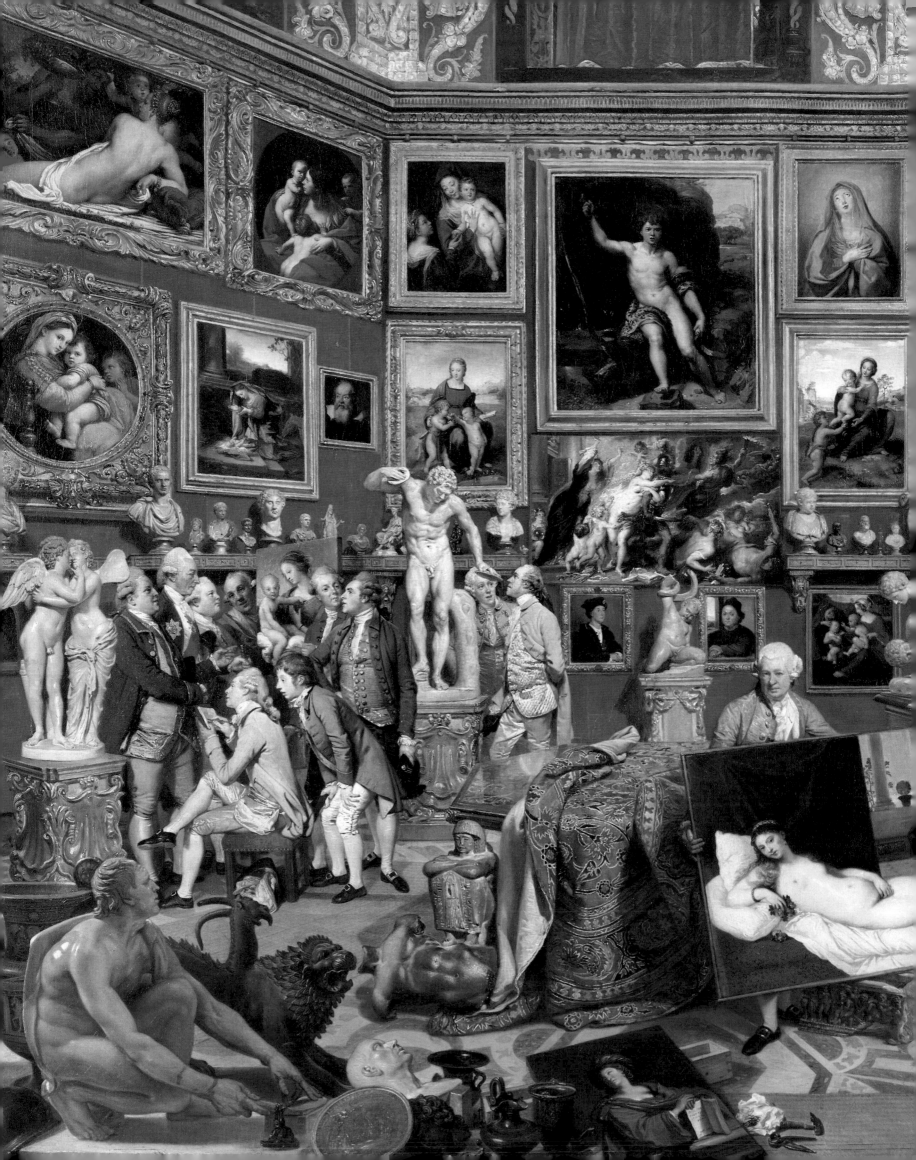

The Collection on show

JONATHAN MARSDEN

IN OCTOBER 1946, long before the country had recovered from the effects of the Second World War, the Royal Academy of Arts mounted an exhibition of 500 pictures from the Royal Collection (fig. 1). This was the 118th Royal Academy exhibition to have included royal loans, but it was the first to be devoted entirely to paintings from the Royal Collection.[1] By the time it had closed in March the following year, the exhibition had been seen by 366,832 people from all parts of the country. In a leading article to mark the opening, The Times characterised the Royal Collection as 'an inheritance which the nation can share with its owner as it can share no other private collection ... this is a treasure over and above the collections owned by the state, much of it always accessible, none of it unfamiliar to any serious student of art'. The half-century that followed – coinciding very nearly with the fifty years of Her Majesty's reign that are celebrated by this volume – was a golden age of art exhibitions and museum-building. Most great pictures and works of art in Europe and North America are now displayed to a very high standard in modern museum conditions. A much smaller number of collections retain something of the display conventions of the past, which have themselves become the subject of serious study.[2]

The history of the display of the Royal Collection is interwoven with that of the monarchy itself and also with that of the palaces in which it has been shown. Far from having been a mere appendage to the Crown, the collection has provided (and continues to provide) the setting for the very business of monarchy. Over the last 500 years there has been a shift of emphasis in the purpose of the collection. The display of great works of art as an expression of power, so dominant a motive in the time of Henry VIII, has become secondary to art appreciation as an end in itself. Equally fundamentally, it is only since the late seventeenth century that the court has remained in one part of the country for any length of time. During the reign of Elizabeth I, for example, curious visitors to Windsor Castle, Greenwich Palace or the Tower of London described not the sequence of richly stocked state rooms and galleries familiar from later periods, but store rooms containing large numbers of beds with costly upholstery, dismantled canopies, folded tapestries, and trunks full of fringed and embroidered cushions;[3] the contents, in fact, of the Great Wardrobe – the storehouse of movable furnishings.

Palaces that were intended for more continuous use demanded permanent furniture, and architectural settings in which pictures, statuary, tapestries, arms and armour could be permanently placed. Even then, arrangements of works of art either remained static or changed with remarkable frequency depending on the intensity of royal occupancy and use. Kensington Palace was purchased and enlarged by William III, who lived there for large parts of the year, but for well over a century – from the early years of the reign of George III until 1899 – its State Apartments were never used by the royal family; they served instead either as stores or as quarries from which works of art could be removed to other palaces. The Palace of Holyroodhouse in Edinburgh, the official residence of the monarch in Scotland, provides the most marked example of the effects of infrequent occupation on displays of art, while an opposite case can be found at Carlton House, where the rearrangement of George IV's collections went hand-in-hand with the most hectic redecorations more or less continuously for thirty-five years, until the building's demolition in 1826.

When considering visitors to the royal palaces, it should be borne in mind that they have included countless thousands whose

Fig. 1 Princess Elizabeth, Princess Margaret and Queen Elizabeth with Sir Alfred Munnings, President of the Royal Academy, at the exhibition of The King's Pictures at the Royal Academy, November 1946.

objective was not the appreciation of works of art at all. Among them were the aristocratic crowds who attended the fashionable assemblies known as Drawing Rooms from the reign of George III onwards, and the 50,000 people who now pass through Buckingham Palace each year for official or ceremonial reasons outside the months of August and September when the State Rooms are open to the public.

Evidence for the appearance of palace interiors since the time of Henry VIII comes in many forms. The written accounts of visitors provide invaluable glimpses of what can otherwise only be imagined from the pages of inventories, but they none the less vary in their reliability. Not every visitor was a Gustav Waagen, the German museum director and appraiser of British art collections during the mid-nineteenth century, who inspected each palace specifically to make a detailed record of the pictures and other works of art. Some merely transcribed the accounts of those who preceded them, while others copied out extracts from printed guides. The authors of the guidebooks themselves often resorted to this ploy.[4] From the early nineteenth century onwards there is a rich visual record of displays in the palaces, beginning with the plates of William Henry Pyne's *History of the Royal Residences*, which appeared in instalments between February 1816 and September 1819.[5] Pyne's illustrations have their counterparts in a series of watercolours by Joseph Nash, some of which were published as lithographs in his *Views of the Interior and Exterior of Windsor Castle* (1848), and in the views of other palaces commissioned by Queen Victoria from Douglas Morison, Louis Haghe and others, all of which are remarkably trustworthy in their depiction of works of art.[6]

PICTURES

Picture galleries are now such a widespread means of display that their comparatively short history is liable to be forgotten. The first royal gallery to be devoted primarily to the display of pictures seems to have been the Long Gallery at St James's Palace as remodelled for Henry, Prince of Wales, in 1609–10.[7] Although Henry VIII and his daughter Elizabeth I built a number of long galleries, these were not primarily for the display of paintings, which in any case played a less important role in their palaces than tapestries or murals. They were first of all functional passages, linking the King's and Queen's apartments, serving as places for exercise in bad weather and providing continuous vantage points from which to admire what was outside, such as the river (at Richmond and Whitehall), gardens or tiltyards. Nor were they among the common or public spaces; most were adjacent to the private, or privy lodgings.[8]

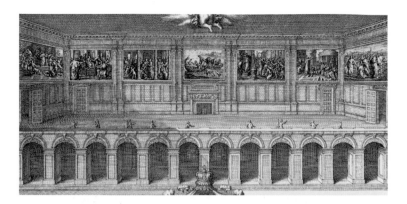

Fig. 2 Simon Gribelin, *The Cartoon Gallery, Hampton Court*, 1707 (detail of frontispiece to the engravings of the Raphael Cartoons)

An accurate record of the pictures in Charles I's galleries at Whitehall, Greenwich and St James's Palaces and Denmark House (formerly – and latterly – Somerset House) can be obtained from Abraham van der Doort's inventory, completed in 1639, and from the sale inventories compiled after the King's execution. The pictures in these galleries seem to have been hung without much regard to subject matter,[9] but there are the first signs of a more thematic approach. Van Dyck's great imperial image of the King (no. 11) was designed to be hung at one end of the Gallery at St James's, where it was deliberately associated with the series of twelve portraits of Roman emperors by Titian hanging along the side walls.[10] Van Dyck's later equestrian portrait, now in the National Gallery, was also placed at the end of a gallery, at Hampton Court Palace, while the life-size family group known as the 'Great Piece' of 1632, which hung at the end of the Matted Gallery at Whitehall, with its painted vista of the Thames as if seen from that spot, was the most 'site specific' of the three.[11]

Charles I's inventory lists seventy-three pictures in the Privy Gallery at Whitehall, of which seventy were historical, mostly royal, portraits. Beginning with a supposed portrait of Edward III, there was an almost complete run of English kings, interspersed with a number of foreigners. This form of portrait hang, perhaps the most obvious arrangement for a royal palace, was also adopted in the Cross Gallery at Denmark House.[12] Here were portraits of royal ancestors in a series for which Van Dyck provided posthumous likenesses of James I and Henry, Prince of Wales. The sequence probably culminated in the new State Portrait of Charles I by Van Dyck, painted in 1636.[13] It was no doubt in order to demonstrate his secure title to the throne that the future James II commissioned Jacob de Wet in 1682 to paint more than a hundred largely fictitious portraits of the kings of Scotland for insertion into the panelling of the Gallery at Holyroodhouse. The tradition was continued by the sequences of portraits hung by Queen Caroline (consort of George II) in the Queen's Gallery at

Kensington, by George IV in St George's Hall at Windsor, and by Queen Victoria at Buckingham Palace and St James's (see nos 406, 415–16).

William III, though no great collector, was none the less very concerned with the arrangement of pictures,[14] which at Hampton Court included the two most renowned series of paintings in the collection, Mantegna's *Triumphs of Caesar* and Raphael's cartoons for tapestries of the Acts of the Apostles. This was the first time that the cartoons were presented as works of art in their own right, in a gallery designed for them by Christopher Wren (fig. 2). George III, having decided to abandon Hampton Court as a royal residence, removed the cartoons to the house he had purchased for Queen Charlotte, Buckingham House. Here they were hung edge-to-edge in the Queen's Saloon on the first floor of the east front.[15] This move prompted an outburst in 1777 from the radical MP John Wilkes that initiated what might be termed the political career of the cartoons, which lasted well into the nineteenth century. In a somewhat biased assessment of William III as a connoisseur, Wilkes reminded the House of Commons that in his reign the English nation had been admitted to the 'rapturous enjoyment' of the cartoons, which were now languishing 'in a late baronet's smoky house at the end of a great smoky town'.[16]

The Raphael Cartoons made a brief appearance in the King's Apartments at Windsor before returning to Hampton Court in 1804 (see no. 433). By the middle of the nineteenth century, cries were being heard once again to bring them to a public building in London, and in 1850 the architect Sir James Pennethorne submitted a scheme for their incorporation (with the Mantegnas) into a 'great central gallery' leading north from Wilkins's National Gallery in Trafalgar Square.[17] In 1865 they were placed on loan to the Victoria and Albert (then South Kensington) Museum, where they remain today. To those who objected to that final move from Hampton Court, a solution was available which was in fact only applied in 1992, when a set of copies of the cartoons, made in oil on canvas in the 1690s by Henry Cooke, was hung at Hampton Court in place of the originals, after many years in store at the Ashmolean Museum in Oxford.[18]

The two last and most significant picture galleries to be added to the royal palaces before the present reign were both built for George IV in the second half of the 1820s. For such a voracious collector of pictures, George IV had very little space for their display at Carlton House, and even less at his remarkable seaside residence in Sussex, Brighton Pavilion. Pyne's illustrations of the interior of Carlton House (see nos 421–4) show choice masterpieces hanging singly or in small groups, and large numbers of the most important pictures spent long periods in store. John Nash's designs for the new Buckingham Palace revealed an entirely new

approach, with a substantial picture gallery at the centre of the State Rooms. Its position on the principal floor dictated the use of top-lighting, which Nash had already used to great effect elsewhere. Here, he divided the ceiling into seventeen arched compartments along both walls, each of them glazed with a low saucer-dome (see fig. 3).[19] The centre was plain plaster, and it was only when pictures were actually hung in the gallery that the design was found to be ineffective, lighting the floor but not the pictures.[20] Later, Edward Blore was commissioned to introduce a row of larger skylights which restored daylight to the centre of the ceiling but which also in due course began to let in the rain. The final revision of the ceiling was undertaken by the Board of Works architect Frank Baines in 1914 for King George V and Queen Mary.[21]

Despite its defects, Nash's gallery was innovative in two important respects. First, its position at the very heart of the principal floor meant that the picture collection played a central part in royal entertaining. Secondly, by placing in the centre of each of the five chimneypieces garlanded profiles of Dürer, Rembrandt, Titian, Van Dyck and Leonardo da Vinci, supported by winged personifications of the art of painting, Nash anticipated the cult status that was to be afforded to these and other great artists in the architecture of public galleries of the next generation and beyond.[22]

George IV's new palace was incomplete at the time of his death in June 1830 and the Picture Gallery does not seem to have been fully hung before the reign of Queen Victoria.[23] The arrangement was fixed after Blore's work in the early 1850s, when Prince Albert had new reverse-moulded composition frames fitted to all the pictures, which were then anchored to the walls rather than suspended on chains (fig. 3 and no. 420).[24] Both of these measures were intended to eliminate 'frame-shadow', a common

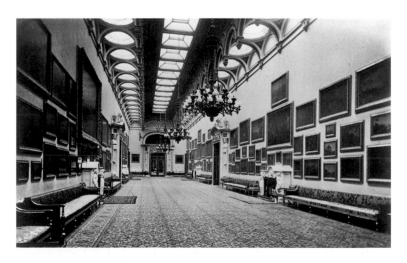

Fig. 3 The Picture Gallery at Buckingham Palace, 1873 (RCIN 1114809)

problem in top-lit galleries before the advent of electric light.

The 'Long Gallery or Corridor' at Windsor Castle was born of more practical considerations.[25] Since the late Middle Ages there had been no suitably dignified access from the apartments on the north side to those on the south and east, and the new gallery was intended first of all to resolve this, by running for a total length of 450 feet [137 m] along the inside of the south and east ranges. It was in fact a 'communication gallery'[26] of the kind already familiar from Henry VIII's palaces. Only as the designs were evolving did it begin to be seen as an important space for the display of pictures and other works of art.[27] The arrangement was devised by the Surveyor of the King's Pictures, William Seguier, and was refined by the King himself with the help of the painter David Wilkie and the sculptor Francis Chantrey. No precise record exists of these first arrangements, but they were most probably little altered by the mid-1840s when Joseph Nash depicted the Corridor (here for the first time called the *Grand Corridor*) for his book of lithographs (see nos 409, 410). The pictures included many portraits, not of royal ancestors but more distinctly those of the King's friends and acquaintances, military heroes, and 'worthies' such as the composers Handel and Haydn. These were interspersed with some of the Consul Smith Canalettos, whose original, slender Venetian frames were enlarged and emboldened by the carver and gilder Joseph Crouzet so as to register more strongly in the long views.[28]

The majority of pictures in the Royal Collection have spent most of their lives not in galleries or cabinets but in less regimented arrangements. Even after the dispersal of Charles I's pictures, as reign has succeeded reign the Surveyors have increasingly had to deal with problems of growth. Mrs Jameson began her *Handbook to the Public Galleries of Art in and near London*, published in 1842, with a diatribe at the way in which hundreds of pictures which she had remembered 'lying in heaps one against another' at Kensington Palace were now dispersed throughout the State Apartments at Hampton Court Palace. They included an 'immense quantity of nameless rubbish and strange old remnants of royalty' as well as pictures bearing the names of Titian, Correggio and Parmigianino that were hung high or between windows and were thus invisible.[29] She added hopefully that the arrangement, so hastily done, was unlikely to be permanent, and yet for most of the nineteenth century the rooms were beset by the effects of overcrowding, as can be clearly judged from photographs (fig. 4). The situation was partly alleviated in 1882 when 150 pictures were taken from Hampton Court to Holyroodhouse, followed in 1899 by a similar transfer to Kensington Palace. More recently, in the course of the restoration of the King's Apartments by the Historic Royal Palaces Agency after the fire of 1986, the

Fig. 4 The Queen's Guard Chamber, Hampton Court, *c*.1904

study of inventories and allied evidence has brought a proper historical logic to the presentation of Hampton Court. Some of Mrs Jameson's other criticisms were answered by the establishment in 1976 of the Renaissance Gallery, created within a redundant set of apartments, which enabled the earliest and most fragile of the pictures – including works by Titian, Raphael and Holbein – to be shown under conditions of lighting, labelling and climatic control similar to those in purpose-built art galleries.

During the nineteenth century several rooms in the State Apartments at Windsor were devoted to the work of a particular artist. The first of these seems to have been the Queen's Drawing Room, in which six upright landscapes by Francesco Zuccarelli from the Consul Smith collection were hung in an arrangement recorded in Pyne's *Royal Residences*. This was all the more distinctive for the fact that the pictures were hung strictly symmetrically against a set of Mortlake tapestries of *The Months*, obscuring their central panels completely but allowing their 'richly ornamented borders [to] appear as margins to the picture-frames, and produce an agreeable effect'.[30] The adjoining Queen's Ballroom, which until George III's time had also been clad with tapestry, was transformed during his last years by the importation of the portraits and landscapes, brought from other palaces, which can be seen in Charles Wild's view (no. 402) published by Pyne in 1817. By 1835 the room was hung with twenty-two works by (or thought to be by) Van Dyck, with the large family group of 1632 and the equestrian portrait of 1633 (no. 11) hanging at either end (see no. 408).[31] Subsequently, this approach was followed in the King's Drawing Room, which by 1845 was known as the Rubens Room and hung with eleven large canvases brought from elsewhere. These latter two arrangements have endured, with refinements, to the present day.

It is not clear precisely when these single-artist hangs were

first conceived, but the Rubens and Van Dyck arrangements were probably the work of William Seguier, Surveyor of Pictures to George IV, William IV and Queen Victoria. In the earlier case of the Zuccarellis, George III's Surveyor, Benjamin West, the second President of the Royal Academy, was probably responsible. The King's patronage of West's own work as a painter is an episode without parallel in the history of the collection, not only in terms of numbers (some sixty paintings were commissioned at a cost of £34,187) but in the proposed or actual hanging of the pictures. Outline drawings of the picture arrangements at Buckingham House in 1796 show that the Warm Room (one of the King's apartments on the ground floor) was exclusively given to seven of West's historical canvases.[32] At Windsor Castle, the architect William Chambers was commissioned to redesign the Chapel in the north range of the Upper Ward, to accommodate a large series of religious paintings. When Chambers was succeeded by James Wyatt, this scheme was supplanted by an altogether more ambitious plan, to fill in the medieval Horn Court with a 'Chapel of Revealed Religion', for which West was to paint thirty-six very large canvases.[33] This scheme was abandoned after the onset of George III's final illness, but the idea of building within Horn Court was to reappear (in quite a different form) in the 1820s, with George IV's Waterloo Chamber.

This enormous room (see no. 407) was completed to the designs of Wyatville in the mid-1830s. An early plan for two large group portraits of the allied sovereigns developed into a series of individual images, not only of the sovereigns but also of their chief ministers and general officers. There are now thirty-eight portraits, of which twenty-eight are by Sir Thomas Lawrence (see no. 28). The Waterloo Chamber was the last and most ambitious of the schemes devised by George IV to celebrate Britain's naval and military victories. The full-length portraits he had commissioned for Carlton House from Hoppner and Reynolds of Admirals Keppel, Rodney, Nelson and St Vincent[34] were subsequently moved by William IV to the State Apartments at St James's Palace, which had been rebuilt by John Nash in the 1820s. They were hung in the Ante Room in place of two colossal naval pieces, P.J. de Loutherbourg's *Glorious First of June*, and the huge canvas of Trafalgar commissioned from J.M.W. Turner by George IV but soon afterwards presented to the Naval Hospital at Greenwich. In the adjoining Throne Room at St James's, George IV hung two large extensive landscapes of the battlefields of Waterloo and Vittoria by George Jones, this time flanking the State Portrait of the King himself by Lawrence, an arrangement that has recently been reinstated. The military theme can also be found in George IV's placement of portrait sculpture at Carlton House. In the Armouries, bronze busts of Condé and Turenne were joined by marbles of Blücher and Platoff commissioned from Peter Turnerelli, the sculptural counterparts of Lawrence's portraits.

SCULPTURE

The first notable arrangements of sculpture in the royal palaces resulted from Charles I's importation of the antique statuary from the palaces of the Dukes of Mantua in a series of consignments ending in 1632,[35] and in his employment of the French bronze founder Hubert Le Sueur to take moulds of antique statues in Rome so that bronze casts could be made for his gardens at St James's and Greenwich.[36] Many of the antique statues from Mantua were placed in a new colonnade at St James's designed by Inigo Jones,[37] while others stood outside with Le Sueur's bronze casts after the Antique in the Privy Garden bordering St James's Park.

Some of what remained of Charles I's sculpture after the sales of 1649–51 was pressed into service in Hugh May's new State Apartments at Windsor in the 1670s. The Grand Staircase, decorated with murals by Thornhill, was entered through an Ionic portico in Horn Court with niches containing antique busts, probably from the Mantua collection. On the staircase itself were Le Sueur's cast of the *Spinario* and a seventeenth-century bronze bust of a Roman vestal.[38] The latter piece was probably the one which – with other 'recycled' statues of Bacchus and Ceres, Apollo and Flora, Mercury and Diana and a series of bronze heads of Greek poets and philosophers by Le Sueur – was installed in the Cupola Room at Kensington Palace, designed by William Kent for George I. That scheme also included Michael Rysbrack's first royal commission, a large overmantel tablet of *Roman Marriage*. In 1735 Queen Caroline commissioned from Rysbrack a set of busts of kings and queens of England from William the Conqueror onwards, which seems to have been intended for one of the garden buildings designed by William Kent at Richmond Lodge.[39] This was never completed, but ten of the busts reached the terracotta stage and were placed in the library which was added in 1736–7, to Kent's designs, to St James's Palace, where they can be seen in Pyne's illustration on bold scroll brackets along the side walls;[40] they were subsequently removed to George III's new library rooms at Buckingham House. Queen Caroline also ordered a group of busts of 'worthies' for Richmond which reflected her scientific and philosophical interests. Those selected were Newton, Boyle, Locke, Clarke, Wollaston and Bacon.[41] Five of the busts, by Rysbrack and Giovanni Battista Guelfi, are now at Kensington Palace, but for most of the nineteenth century they were in the Grand Corridor at Windsor.

It was in the Grand Corridor that George IV set up the most extensive of all such sculptural parades. Thirty-three busts were

taken from Carlton House to Windsor in 1828 for display in the Grand Corridor. The names of the sitters were incised on discs of statuary marble inserted between the busts and their uniform bases, many of which were newly supplied by Francis Chantrey (see no. 68). During Queen Victoria's reign the series of portrait busts in the Corridor grew to more than sixty. A thinning operation was carried out by Lionel Cust, Surveyor of Pictures and Works of Art from 1901 to 1927, who instituted a new series, of royal Knights of the Garter, along the walls of St George's Hall.

Osborne House, Queen Victoria and Prince Albert's private home on the Isle of Wight, was the destination of the large and influential group of statues and busts commissioned from English and German sculptors working in Rome, including John Gibson, William Theed, Richard Wyatt, Emil Wolff and Joseph Engel. They were arranged on Siena marble socles and on brackets in the L-shaped corridor on the ground floor. This arrangement, which partly survives, can be seen in a watercolour of 1852 by James Roberts.[42] The white marble statuary contrasts with the polychrome decoration devised by Prince Albert's adviser Ludwig Gruner and the tiled floor by Minton, while the only ancient sculpture to be added to the collection under Queen Victoria, the so-called 'Marine Venus' purchased by the Queen at the Stowe sale of 1848, occupies a place of honour in a shell-headed niche, lined with a crimson velvet curtain. The direct precedents for this scheme were to be found in Germany, and in particular in the Sculpture Gallery (Glyptothek) at Munich, where the collection of antique sculpture was arranged against frescoed walls designed by Peter von Cornelius. Nash's Grand Entrance and Sculpture Gallery at Buckingham Palace also received an elaborate polychrome scheme, and when a broad top-lit corridor – the East Gallery – was added to provide access to the new Ballroom, completed in 1855, its walls were again painted in a neo-Renaissance manner of Gruner's devising, which provided a backdrop for six colossal heads ordered for the purpose by Prince Albert from William Theed and placed on tall marble columns.[43]

ARMS AND ARMOUR

Of all forms of display that have been employed in the royal palaces, the use of arms and armour must claim the oldest pedigree, as the most direct demonstration of a ruler's power. In the modern period this long tradition has been joined by a secondary one in the exhibition of highly wrought armour and weaponry as works of art. The ornamental display of weapons in guard chambers in the English palaces began after Charles II's restoration in 1660. It was directly linked with the establishment of the regiments of the Royal Guards as a separate contingent of the army,

Fig. 5 James Stephanoff, *The Guard Chamber in the Round Tower, Windsor Castle*, 1818 (watercolour; RL 22117)

and must be seen as an important instrument in the very process of Restoration.[44] The first such installation was in place by 1670 in the residence of the Governor (Prince Rupert) in the Round Tower at Windsor (see fig. 5),[45] illustrating the continuing practical importance of the guard chamber as an arsenal. This was followed by displays in the two Guard Chambers located at the entrances to the King's and Queen's Apartments. All three were designed and installed by one John Harris, working for the Board of Ordnance. Further displays of this kind were included in William III's new State Apartments at Hampton Court. In the King's Guard Chamber at Windsor, drums and bayonets were hung at cornice level in imitation of a classical entablature. Antonio Verrio's *trompe-l'oeil* paintings of martial trophies on the walls of the King's Stair acted as a prelude.[46] Harris worked in a similar style at Whitehall and St James's Palaces, but his masterpiece was the Small Armoury at the Tower of London, in which he deployed some 60,000 weapons, mingled with wooden carvings to create a pictorial fantasy whose subjects included a fiery serpent and a seven-headed monster.[47] When this *pièce de resistance* was destroyed by fire in 1841, a rather less picturesque but equally numerous display of rifles was mounted in the old Banqueting Hall and Council Chamber of the White Tower, to the designs of Prince Albert.[48]

It was also at the Tower of London that weaponry was first displayed for its historical interest or 'curiosity' as distinct from a mere show of power. Sixteenth-century visitors were shown outstanding armours and weapons from Henry VIII's armouries. The collection was first arranged specifically for the general public

in the seventeenth century, with the so-called Spanish Armoury (assorted material said to have been captured from the Spanish Armada and selected for its ability to curdle the blood rather than on strictly historical grounds) and the Line of Kings, in which armoured figures representing successive monarchs were placed on wooden horses. The Horse Armoury, as it came to be known, was extended to include the Hanoverian monarchs. The resulting motley assembly was recorded by Ackermann, as was the Armoury at Carlton House, where the Prince of Wales had begun to arrange his own collection of militaria in the 1780s.[49] By 1819, when another view was published by Pyne, this collection occupied five rooms on the Attic Floor, the largest of which, shown in the plate, included a row of mounted armours reminiscent of the Tower Horse Armoury, except that these all formerly belonged (or were presumed to have done) to Tipu, the Sultan of Mysore who was defeated by the British at Seringapatam in 1799. By 1826 the collection had grown to more than three thousand items, not only of historic weaponry, British and foreign uniforms and militaria, but also of ethnographic material given to the Prince by travellers and collectors.

On the demolition of Carlton House, the contents of the Armoury were destined for the new Buckingham Palace, but the new rooms designated to receive the arms and armour were found to be large enough only for one-third of the collection.[50] It was therefore placed in store in the indoor riding school known as Carlton Ride, the only part of Carlton House to be left standing. Here the collection remained until 1842 when it was brought to the attention of Prince Albert. The Prince promptly removed the arms to Windsor, and arranged them in 1847–8 in tall showcases lining both sides of the corridor overlooking the North Terrace.

In Wyatville's scheme for the State Apartments at Windsor, the King's Guard Chamber was transformed into a new ballroom known as the Grand Reception Room, but the Queen's Guard Chamber survived relatively unscathed. Here, and in the new St George's Hall, Sir Samuel Rush Meyrick, Bt, the first great English scholar of antique weaponry and the owner of a famous collection, was called upon to advise on the arrangements. In the Guard Chamber, weapons were displayed for the first time as works of art in their own right. The place of honour was given to the 'Cellini Shield' (no. 160), which was fitted behind glass into the panelling above the chimneypiece, and mounted on a pivot so that the battle scenes and inscription could be read.[51] In St George's Hall, trophies of pole arms were set up on the piers, centred on imitation close-helms, an idea first put into effect by George Bullock at Cholmondeley Castle in 1805. It was also Meyrick who restored some measure of historical respectability to the Horse Armoury at the Tower when it was moved into new purpose-built accommo-

dation in 1825; he found that the figure representing Edward III was in fact wearing an armour made for Henry VIII, and the horseman representing William the Conqueror was brandishing a musket.[52]

William IV made a series of adjustments to the Queen's Guard Chamber at Windsor. For his library at Bushey he had commissioned from Anne Seymour Damer a bronze bust of his particular hero, Lord Nelson, which was placed on a fragmented stump of the foremast of his flagship, the *Victory*. On his accession in 1830, the bust and its battle-scarred pedestal were brought to Windsor and placed in the centre of the Guard Chamber. In 1835 the Damer bust was replaced by a more imposing one in marble by Sir Francis Chantrey, flanked by marble busts of Wellington and Marlborough.

During the nineteenth century the Queen's Guard Chamber became the repository of more and more large-scale acquisitions, whether appropriately martial (such as a pair of Indian field guns captured in the Sutlej campaign) or not (the travelling litters and parasols presented by the King of Siam in 1855), while weaponry of widely various origins continued to fill the wall-cases in the ground-floor vestibule known as the Museum to the north of the Grand Staircase.

By the time of Queen Victoria's death in 1901 the Guard Chamber at Windsor had become so congested that Sir Guy Laking, appointed Keeper of the King's Armoury by Edward VII in 1902, had to undertake something of a cull. Working with the Surveyor of the King's Works of Art, Lionel Cust, Laking emptied the Queen's Guard Chamber, placing some of the exhibits on long-term loan to other institutions while consigning others to destruction by fire in the centre of the Quadrangle.[53] Prince Albert's displays in the North Corridor and the contents of the 'Museum' were also dismantled, and divided between oak showcases newly installed in the Queen's Guard Chamber, and those which had been introduced to the Grand Vestibule to receive the Queen's Golden Jubilee presents in 1887. Laking's finishing touch was to place at the centre of the Guard Chamber the sixteenth-century armour of the hereditary King's Champion, which was presented to Edward VII in 1902.

THE CROWN JEWELS

In addition to its role as an arsenal, the Tower of London has been, from the reign of Henry VIII onwards, the repository of the Crown Jewels or regalia. From that time also they have been accessible to visitors, at first on application to the Governor of the Tower, but since the late seventeenth century on a more general basis.[54] The regalia and coronation plate, created for Charles II to

Fig. 6 Buffet display of silver-gilt plate for the state banquet at Buckingham Palace for President Poincaré of France, 1913 (RCIN 1114821)

replace those destroyed during the Interregnum, were the responsibility of a new official, the Master of the Jewel House, but the conditions in which they were shown were far from advantageous. Their home was described in 1710 as a 'gloomy and cramped den', and it was in such surroundings that the German traveller C.A.G. Goede saw them during a journey through Britain in 1802–03. He was shocked to find the regalia produced from a series of old wooden boxes in a gloomy basement by one of the long line of female 'Exhibitors' employed for the purpose; a figure who to his eyes resembled the Witch of Endor and who chanted 'with a shrill voice the list and story of these wonderful curiosities'.[55] A new Jewel House was eventually prepared for opening, but this had to be abandoned after the fire of October 1841. Visitors were still admitted in parties of twelve every half-hour during the afternoon (except on Sunday) to see the regalia, but it was not until 1869 that a new Jewel Room was built in Wakefield Tower to the designs of Anthony Salvin. The present display, in the former Waterloo Barracks, was installed in 1994 following the removal of a large part of the Royal Armouries to a new museum in Leeds. Moving walkways now convey the visitor at close range past well-lit showcases containing the regalia, to a further area where the coronation plate is set out.

GOLD AND SILVER PLATE

Temporary displays of gold and silver at coronations or when important guests were received in state can be found from the time of Solomon and beyond. Of all forms of display that have been used in the royal palaces, the ceremonial 'buffet' of silver and gold plate has endured perhaps the longest. At state banquets in the present reign a grand display is still mounted in the same spirit and fashion, though not quite to the same extent, that applied in 1468 when Princess Margaret, sister of Edward IV, was married to the Duke of Burgundy. At their wedding feast a buffet of nine stages was laden with covered cups, flagons and other vessels in the middle of a hall lit by chandeliers placed on a 'roke of precious stones, marvelously wrought, envyroned abowt wt. wallis of golde'.[56] Though temporary, such displays were often thrown open for a wider audience over a period of one or two days. When Henry VIII, the greatest acquirer and confiscator of plate among English kings, dined in state at Greenwich in 1527, the two buffet displays of seven and nine tiers set with standing cups and flagons, and jewelled vessels were left in place at the King's order so that 'all honest persons' might come and admire them.[57]

Although William III mounted impressive temporary displays in the type of arrangement based on the designs of Daniel Marot, the buffet never achieved in the English palaces the permanent architectural form that was seen to great effect in the Prussian royal castle at Berlin, where Andreas Schluter's towering composition of dishes, cups, flagons and cisterns by Augsburg silversmiths dominated one wall of the *Rittersaal*. An eccentric derivative could, however, be seen in the Gothic Dining Room at Carlton House, where permanent velvet-covered brackets and shelves were fitted to the walls by Tatham, Bailey & Sanders in 1817 (see no. 424).

Temporary and ceremonial displays demanded purpose-built staging (fig. 6). For George IV's coronation banquet in June 1821

a temporary framework backed with crimson velvet was set up at the dais end of Westminster Hall by the royal cabinet-makers Bailey & Sanders for the display of old and newly made buffet plate. In the latter category was the Shield of Achilles (no. 188) designed by John Flaxman, which was placed on one side of the throne canopy as a pendant to the great alms dish of 1660 (no. 171). The partly gilt Gothic oak surround used at the state banquet for Louis-Philippe at Windsor in 1844 (no. 406) must have stood at least 15 feet [4.5 m] high.

The restoration of Windsor Castle following the 1992 fire created an opportunity for the first permanent display of royal plate at Windsor, in the new octagonal Lantern Lobby designed by Giles Downes. By careful selection it has been possible to show an imposing group of historic standing cups and examples from the buffet, together with liturgical and toilet plate, without disrupting the provision of plate for state use.

CERAMICS

The general use of porcelain vessels as part of decorative schemes in this country may be said to have begun with the importation by Queen Mary II, the wife of William III, of large quantities of Chinese and Japanese porcelain to ornament her apartments at Kensington Palace in the manner she had adopted in her husband's Dutch palaces. Daniel Defoe described the spread of 'China-mania' to noble houses where porcelain was piled 'upon the Tops of Cabinets, Scrutores, and every Chymney-Piece, to the Tops of the Cielings',[58] an effect that can be seen in the engravings of Daniel Marot. The inventories of the Queen's collection at Kensington at around the time of her death in 1694 reveal not only the sheer quantities of porcelain involved but the care that evidently went into the groupings of vessels on chimneypieces, door surrounds and in cabinets.[59] After the Queen's death her oriental porcelain collection was given away by William III, but it is interesting to note from Pyne's views of Kensington (see no. 435) and Hampton Court the persistence of the massed display of porcelain in royal interiors in the eighteenth and early nineteenth centuries. Much of Queen Mary II's collection of blue and white Delft vases, ewers and pyramids (see nos 115, 116) remained in the Royal Collection and can still be seen at Hampton Court.

In her Breakfast Room at Buckingham House and in the Green Closet at Frogmore, Queen Charlotte deployed both oriental and orientalising Delft wares as the basis for an all-embracing chinoiserie scheme[60] of the kind that George IV was to take to new levels of elaboration and finesse at Carlton House and Brighton Pavilion. At Brighton, George IV employed mounted Chinese and Japanese vases to provide most of the illumination. Celadon vases were made into candelabra and a set of tall dark blue Chinese vases was mounted to create the extraordinary luminaires for the Banqueting Room.[61] The Music Room set (see no. 427), which has been at Buckingham Palace since 1848, employed very large Chinese Imari-pattern beaker vases on chinoiserie bases made by the English firm of Spode. These were placed with the tall Chinese export pagodas (see no. 317), for which Spode bases were also supplied.

George IV's display of Sèvres vases in the reception rooms at Carlton House achieved an unprecedented degree of sophistication; while the scenes painted on the vases were often based on engravings after Dutch Old Masters and so harmonised with the Dutch pictures which hung above and to either side of them, in several instances the ground colours of the vases also matched the hangings of the walls.

During the reign of Queen Victoria the number of porcelain services steadily rose, through presentation as well as patronage, and as the stores reached capacity a virtue was made of necessity. The great Louis XVI service of Sèvres was arranged in what were formerly bookcases in the Green Drawing Room at Windsor, and at Buckingham Palace the Bow Room and Household Breakfast Room were fitted with large wall-cases. As part of his general re-presentation of the State Apartments at Windsor in the first years of Edward VII's reign, Lionel Cust arranged extensive displays of porcelain services in the 'Museum' (thenceforth known as the China Museum) and in the cases that had been installed by Prince Albert for arms and armour in the North Corridor (which became the China Corridor). Large portions of seventeen royal services are now on permanent display at Windsor, while at Buckingham Palace the gold-anchor Chelsea service of 1763 (no. 108) occupies the four large cases in the Bow Room.

TAPESTRIES

The German traveller Paul Hentzner, when describing the 'excessively rich' tapestries he saw at Hampton Court in 1598, noted that they were only hung when the Queen gave audiences to foreign ambassadors,[62] and by this date the temporary cladding of rooms with rich hangings had already been the standard way of marking the royal presence for centuries, as the monarch moved about the country. No fewer than two thousand pieces are listed in the inventory taken after Henry VIII's death in 1547.[63] Of these, only twenty-eight remain in the Royal Collection today (including no. 95), and the survival even of this tiny proportion is largely due to their infrequent use.

The continuing importance of tapestries in the palaces of the early Stuart monarchs is clear from Inigo Jones's design for the

Banqueting House at Whitehall, completed in 1622. The whole of the lower wall surface was to be covered with tapestries when the King was present.[64] Sixteen hundred pieces of tapestry were listed for sale from the collection in 1649–51, but a great number were retained for use in the palaces or in government offices under Cromwell.[65]

The first permanent installations of tapestry can be found at Hampton Court Palace and Windsor Castle after the Restoration of Charles II. During the Interregnum, sets had been displaced and disrupted, and the need to create permanent wall-coverings gave rise to the practice of cutting and reducing individual panels to fit rooms. Tapestries and wall-paintings combined to create the large-scale figurative backdrops in William III's new State Apartments at Hampton Court. It is clear from Wren's estimate of April 1699 that tapestries, as well as the great cartoons of Raphael, were intended from the start as a major component of the interiors.[66] The two Tudor sets of the *History of Abraham* and the *Story of Joshua*, which had been by some margin the most valuable in the Commonwealth inventories, were hung in the Presence Chamber and Great Bedchamber. While it seems always to have been tolerable for large parts of the pictorial field of a tapestry to be obscured by a throne canopy and cloth of estate or by a state bed, by the time of Pyne's *Royal Residences* the relative importance of paintings can be judged from the number of times they are hung across the centre of a tapestry.

In 1825 George IV acquired for his refurnishing of Windsor Castle thirty pieces of French tapestry that had become available as the result of the French Revolution. All of them included the French form of border woven to resemble a picture frame, and they were hung from the start in the French manner, in fixed frames of which the most elaborate were in the Grand Reception Room. Here, wide gilt plaster borders were set into the imported French panelling to receive six pieces from the set of the *Story of Jason*. Elsewhere, the frames were simple oak mouldings, and this system became the norm for the hanging of tapestries at Windsor and Buckingham Palace during the nineteenth century.

When Queen Victoria decided on the refurbishment of the State Apartments at Holyroodhouse in 1882, fifteen tapestries were sent from the South Kensington Museum, and the set of embroidered hangings from Queen Mary's Closet at Hampton Court (by this time in store) were also sent.[67] The tapestries had been lent to South Kensington by Queen Victoria in 1858 and included several from the recently demolished Newmarket Palace. The Surveyor of the Queen's Pictures, J.C. Robinson, who was also Superintendent of the South Kensington Museum, reported in 1886 that the unsightly gaps that had previously appeared around the edges of several of the walls in the State Apartments at Holyroodhouse had been 'closed up and filled in with *ancient tapestries*, mainly from old pieces at South Kensington'.[68]

VISITORS

It is one of the chief objectives of the Royal Collection Trust to make the Royal Collection accessible to as many people, and by as many means, as possible. Access to the royal palaces tended in the past to be governed not by the disposition of the collection but by the royal presence. The very architecture of the palaces was designed to embody the degrees of access that were laid down in the Household regulations. None the less, the number of written descriptions of the interiors from the end of the sixteenth century onwards indicates the comparative ease with which interested visitors, often foreigners, could see each of the royal residences.

Carlton House was an exception, and for most travellers as well as Londoners the plates of the interiors in Ackermann's *Microcosm of London* and Pyne's *Royal Residences* had to suffice. The Prince Regent made one experiment in opening his house to successive groups of the 'well-dressed' public over three days shortly after the *fête* there on 19 June 1811, which itself had been attended by 3,000 guests. It was intended that 200 people should be admitted every half-hour from eleven o'clock until three, but such was the demand that by the end of the first day there was a crowd estimated at 30,000 extending from Carlton House to Haymarket and along Pall Mall to St James's Street. A large proportion of those wishing to see the rooms were 'females, whose screams and shrieks became so distressing that the gate was opened; which instead of giving relief, increased the evil, for many were thrown down, and trampled upon by those behind. One lady had her leg broken, and others were carried away apparently dead. Even such as were fortunate enough to escape personal injury, suffered in their dress; and few of them could leave Carlton House, until they had obtained fresh garments.'[69]

The opening of the State Apartments at Hampton Court to the general public on an organised basis but without charge began in 1838. Until that point the showing of the apartments had been the responsibility of the resident housekeeper, and a charge was made to provide her with an income and the means to pay the guides. With the death of the incumbent, Lady Emily Montagu, in that year, the opportunity arose for a change in the system. This brought about a dramatic rise in the number of visitors and a major change of atmosphere in the palace. In the first full year, 115,971 visitors were admitted, rising to 179,743 by 1842, and to a steady state around 220,000 between 1850 and 1870.[70] In order to maximise her income the housekeeper had begun to

1 (detail) ▷

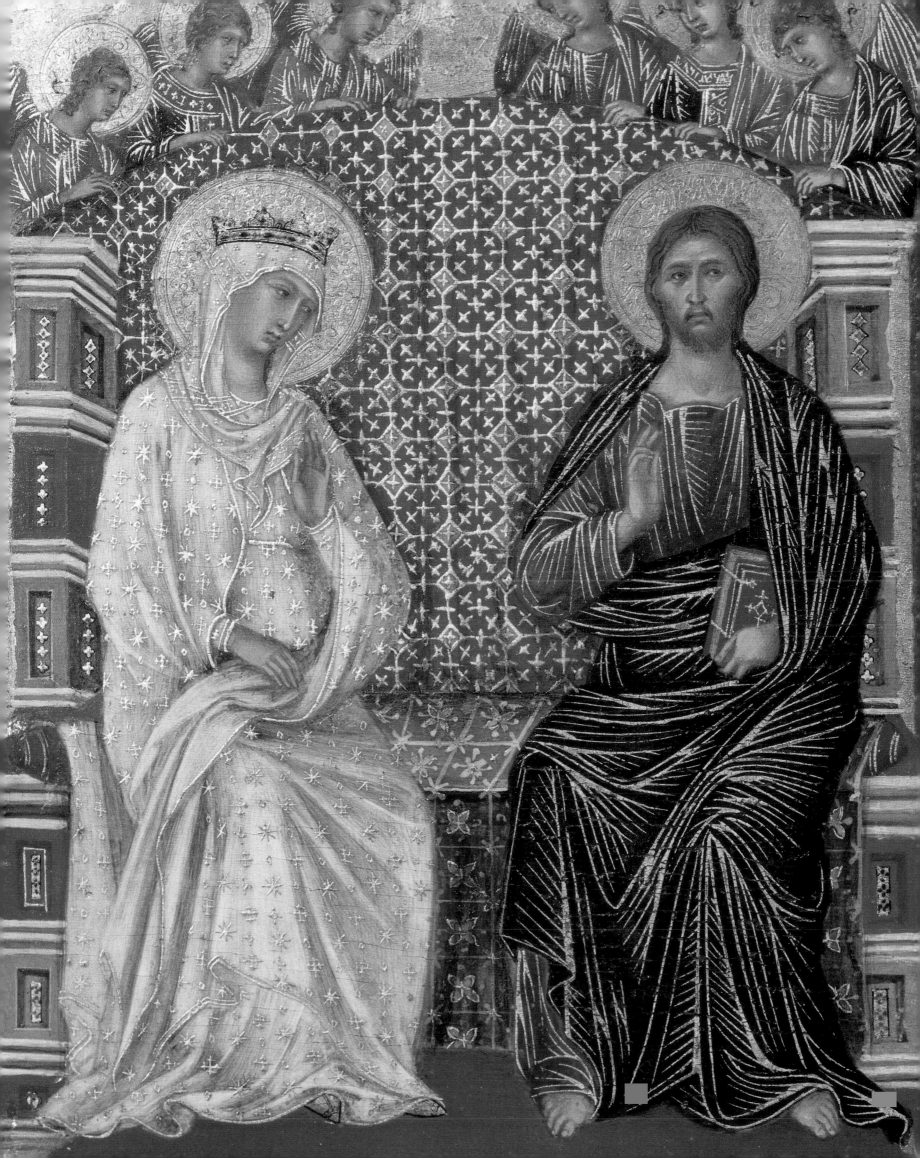

admit parties of visitors on Sundays, and with the change to free admission in 1838 this became by far the most popular day, giving rise to complaints from ecclesiastical quarters that Queen Victoria was injuring the sanctity of the Sabbath by encouraging the working people of London to spend their Sunday mornings travelling to Hampton Court.

The official in charge of the presentation of Hampton Court to its new public was Edward Jesse, who was appointed in 1832 as Itinerant Surveyor to the Hampton Court District, and to whom was attributed the 'happy knack, in all the regulations he laid down, of combining that freedom from vexatious restraint, so essential to the public enjoyment of a popular resort, with the respect and dignity, which should invest a Royal Palace ... Nothing that could have detracted from, or impaired, the old-fashioned charm of the Palace and gardens, or might have given it a cockney, suburban, tea-garden air, was tolerated.'[71] These concerns were also keenly felt at the National Gallery at this time, where much larger numbers (averaging around 700,000 per year) were the norm, and where it was proposed that charging should be introduced on certain days to exclude visitors 'without occupation or vocation', who seemed more intent on eating picnic lunches than looking at the pictures, and who brought large quantities of dust into the building.[72]

Following the success of the general opening of Hampton Court it was decided to introduce similar arrangements at Windsor Castle, where – until 1845 – visits to the State Apartments had been possible only by appointment with the housekeeper, whose salary was met, as at Hampton Court, from admission fees. At the suggestion of the Prime Minister, Robert Peel, the Lord Chamberlain Lord De La Warr submitted proposals to Prince Albert.[73] He stressed that he was fully conscious of the difference in status between Windsor, as an occupied palace, and Hampton Court, which had not been used for purposes of state since the reign of George II.[74] The experiment he proposed was therefore 'as narrow, and as little hazardous' as possible. Conscious of the need to respect the royal family's privacy at weekends, the Lord Chamberlain advised against Sunday opening, adding that the Dowager Queen Adelaide had found this vexatious at Hampton Court (even though she was in fact secreted in the middle of Bushey Park). The castle was therefore to be opened on only four days a week. The Lord Chamberlain advised the Prince that 'a very considerable check on the numbers and description of the visitors, would be obtained by following the system adopted by the Trustees of Dulwich College'. Tickets were accordingly to be issued not at the castle itself or even in the town, but only from 'certain of Her Majesty's Principal Tradespeople' in London, including the art dealers Colnaghi, who already issued advance tickets for

Fig. 7 Ticket for the State Apartments, Windsor Castle, 1848 (RA C 60/94)

Dulwich Picture Gallery.[75] Each ticket bore the signature of the Lord Chamberlain and the stamp of the issuer, and was valid for the admission of a party of unspecified size. The average number visiting on a single ticket was estimated at 3.5, but since many tickets were issued but never presented at the castle, the precise number who actually visited was not calculable. The best estimates seem to show that from an annual average of 59,000 in the last years of the old system under the housekeeper, the total fell to 41,056 in the first year of opening under the new arrangements, rising to 63,238 by 1877.[76]

With the advent of organised visiting, the presentation of Windsor and Hampton Court underwent certain important changes. At the Palace of Holyroodhouse the rooms associated with Mary, Queen of Scots, in the most ancient part of the palace had for many years been presented without any regard to historical accuracy but with a heavy dose of romance. Neither Windsor nor Hampton Court was affected to quite this extent, but at Windsor the introduction of a new route through the State Apartments entailed certain compromises. The tour began in the porch adjacent to King John's Tower in the Upper Ward. Visitors mounted a narrow service stair to emerge in the Queen's Audience Room, and progressed via the Queen's Ballroom through a curtailed sequence of rooms that obfuscated the Baroque arrangement of paired sets of apartments; Charles II's Dining Room, for example, was emptied of its contents and renamed the State Ante Room. Similar tricks were employed at Hampton Court, where the Baroque apartments, though full to bursting with pictures, were demoted in favour of those of the Tudor period. The sense of Hampton Court as a complete Tudor survival was promoted by large-scale architectural changes including refenestration and the

reordering of panelling. Few of the 'excursionists' who passed through the great gatehouse in such numbers would have realised that it was largely built in the 1880s.

Windsor and Hampton Court were among the first historic places to become accessible by rail. To the painter and diarist B.R. Haydon this represented no improvement: 'You went to Windsor as an exploit for two days. Now, down you go in an hour, see it in another, and home in a third. It is painfully attainable, and therefore to be despised.'[77] When the South Western Railway came to Hampton Court in 1849 there was no immediate increase in the number of visitors to the palace, although most of those who came from then onwards did so by train.[78]

For the next fifty years there was no further extension of public access to the royal palaces. At Holyroodhouse, the historic apartments associated with Mary, Queen of Scots, had been shown since the mid-eighteenth century by successive housekeepers to the Duke of Hamilton, the Hereditary Keeper of the Palace. From 1852 these arrangements were brought under the official management of the Commissioners of Works.[79] Consideration was given to opening the State Rooms on the same basis as those at Windsor, but this was held up by the lack of funds to pay for wardens. Reviewing the proposal in 1888, soon after J.C. Robinson had refurnished many of the rooms, Sir Spencer Ponsonby Fane of the Lord Chamberlain's Department reported to the Queen's Private Secretary that there was still 'very little to see in the Rooms, & there can be no doubt that there must be inconvenience from dirt and dust which large numbers of visitors would carry into the small rooms'.[80] For good measure he added that there was in fact 'very little demand' from visitors to see more than the 'Mary Queen of Scots' apartments, and it was not until 1925 that the State Rooms were regularly opened. In 1995 a new display of Stuart relics was established in Mary, Queen of Scots' Outer Chamber.[81]

Queen Victoria's decision to open some of the State Apartments at Kensington Palace was announced in January 1898. For nearly eighty years since her own birth there, the Private Apartments had been under-occupied and the State Rooms were used for the storage of pictures. Now it was proposed to restore the apartments and to open them every day except Wednesday, with much the same hours as Hampton Court, from May 1899. The restoration and arrangement of the rooms and their contents for public showing was undertaken in a didactic spirit which acknowledged the impossibility of full historical reconstruction (chiefly on architectural grounds, but also those of partially continued occupancy and the availability of pictures and works of art). The King's Gallery, therefore, was devoted to marine painting – 'Georgian sea-pieces, sea-fights and dockyards', by

Pocock, Monamy, Serres and others; the Queen's Closet became a cabinet of views of 'Old London', and in the Presence Chamber was arranged a series of canvases illustrating the ceremonial events of Queen Victoria's reign. As Ernest Law willingly confessed in the new guidebook, 'anyone who expects to behold in this Palace a fine collection of choice works of art will be disappointed'.[82] None the less, 341,462 visitors came in its first year.[83] Shortly before they were opened, the Queen herself visited the State Apartments for the first time. Despite having been born in the palace, she had not seen them before.[84]

The new initiative at Kensington may have given rise to a Parliamentary Question which was laid before the First Commissioner of Works in the House of Commons in April 1898 by Mr W. Hazell, MP for Leicester, as to why the public were not admitted to the State Apartments of Buckingham Palace. A reply was sent by the Lord Chamberlain to the effect that the 'almost daily' use of the palace by the royal family would preclude such general access. A further question from Mr Samuel Young, MP for Cavan East, in July 1899 met with a similar response, and a firm rebuttal of his assertion that the continued denial of general public access to the palace made it 'an exception to all the state palaces of Europe'.[85]

In fact, the Lord Chamberlain was right. In respect of the general opening of royal (or state) palaces to the public, Britain's history is comparable with that of the rest of Europe. Mr Young may perhaps have had in mind the famous national and royal picture galleries for, since the early eighteenth century, travellers had found themselves welcome in princely galleries such as those of the Elector Palatine at Mannheim, or the Grand Duke of Tuscany at the Uffizi in Florence. The latter was the first such collection to pass into state hands, when it was made over to the Tuscan government by the Grand Duchess Anna Maria Luisa, in 1737 (see no. 24). But these collections were shown in discreet galleries and did not entail the generalised opening of the palaces to which they were attached. The opening of the picture galleries at the Luxembourg Palace in 1750 and of parts of the royal palace in Stockholm in 1792 have rightly been seen as pioneering cases, but the Louvre itself only became a public museum after the abolition of the monarchy.[86] In Stockholm, early visitors to the palace saw only the private collection bequeathed by King Gustav III to the state, and it was not until the early twentieth century that the state apartments were regularly opened. In Vienna, the state apartments of the Hofburg remained firmly closed until 1920, after the final dissolution of the Austrian Empire. The royal palace at Madrid was first generally opened in 1950 under the Franco regime, when the Spanish throne was vacant, but has remained open following the return of the monarchy.

Fig. 8 The Picture Gallery, Buckingham Palace, during the Summer Opening, August 1994

The regular opening of the State Rooms at Buckingham Palace during August and September was inaugurated by Her Majesty The Queen in 1993. This limited season is the only part of the year when the palace is not in daily use for ceremonial or state events. While the pictures and works of art on display remain exactly as they are at other times, the annual influx of 300,000 visitors in eight weeks entails the temporary replacement of all the carpets and the installation of rope barriers and other forms of protection against accidental damage, a transformation that is effected in a matter of days at the beginning and end of each season.

In the present reign, public access to the other residences has also been granted to an unprecedented degree, beginning in 1954 when The Queen lifted the restriction imposed by Edward VII on admission to Queen Victoria and Prince Albert's private rooms at Osborne. Since then, access has been granted to Sandringham House (1977), to parts of Balmoral Castle (1980), to Frogmore House (1990) and to the newly restored semi-state rooms at Windsor (1998).

EXHIBITIONS

The tradition of royal loans to temporary exhibitions is now almost 250 years old. During 1999–2000, 486 items were lent to 60 exhibitions in the United Kingdom and overseas. The tradition began more modestly, when the young King George III lent two paintings and four miniatures to the third exhibition of the Free Society of Artists held at Spring Gardens in London in 1762. Loan exhibitions did not form part of the early activities of the Royal Academy of Arts, founded in 1768 under George III's patronage, until the introduction of the winter loan exhibition in

1870. It was instead the British Institution, of which George IV was successively Vice President, President and Patron, which organised the first regular exhibitions of Old Masters. From 1815, when four pictures (including no. 15) were lent from Carlton House, much larger numbers of royal loans featured in almost all of the Institution's exhibitions.[87]

Prince Albert's leading role in the conception and organisation of the Great Exhibition of 1851 led directly to further involvement in the development of the South Kensington Museum and its forerunners. A temporary exhibition of *Historic Cabinet Work* was staged in 1853 at Gore House in Kensington, which included seventy-four of the finest pieces of English and continental furniture, gilt bronze and tapestry from Buckingham Palace, Windsor and Hampton Court. In the same year the Department of Practical Art established a 'Museum' at Marlborough House of purchases from the Great Exhibition, to which Queen Victoria added – as loans – selections of lace and Sèvres porcelain from the Royal Collection.[88] While the South Kensington Museum's own collections were growing, between 1852 and 1882 the Queen agreed to the long-term loan to the Museum of 173 works of art, including Chinese and European porcelain, *cloisonné* vases, musical instruments and tapestries. Today, more than 3,000 items from the collection are on long-term loan in 160 locations.[89]

The international exhibitions held throughout Europe and North America following the Great Exhibition were essentially concerned with manufactures, but they invariably included fine art sections devoted to contemporary art. Queen Victoria lent pictures to those held in Paris (1855), Vienna (1873), Philadelphia (1876), Sydney and Brisbane (1879) and Melbourne (1881), as well as to the New Zealand and South Seas Exhibition held at Dunedin in 1889. These were mostly dutiful and representative loans of paintings by Winterhalter, Wilkie and Landseer. Far more significant were the royal loans to the two greatest art exhibitions of the nineteenth century, the Manchester Art Treasures Exhibition of 1857, and the Special Loan Exhibition of Works of Art held at South Kensington in conjunction with the London International Exhibition of 1862. The Art Treasures Exhibition, held at Old Trafford, was masterminded by a committee of seven Manchester businessmen. The venture was supported from the start by the Prince Consort, who lent the entire collection of thirty-nine pictures which he had purchased from his Öttingen Wallerstein relations. The Queen lent a further forty-seven pictures, including the very large Van Dyck equestrian portrait of Charles I (no. 11) and Frederic Leighton's 5-metre-wide *Cimabue's Madonna Carried in Procession*.[90] The delivery of the royal loans, which also included tapestries, furniture, silver, arms and armour, required 139 crates. A total of 1.3 million visitors saw the

exhibition in five and a half months.[91]

Ten years later it was the turn of Leeds. When the city's new Infirmary was completed in 1868 to the Gothic designs of George Gilbert Scott, it was decided to inaugurate the building with a National Exhibition of Works of Art, for which its halls and passages were hung with over four thousand exhibits. Forty-five items were lent from the Royal Collection (including the 'Cellini Shield' – no. 160; oriental weapons; and twenty-seven pictures, amongst them Van Dyck's triple portrait of Charles I). The Prince of Wales, who performed the opening ceremony, lent contemporary pictures from his own collection.

The Special Loan Exhibition held at South Kensington in 1862 was on an epic scale. The catalogue contained more than eight thousand entries, many of them covering groups of objects. The Queen lent ninety items, including the terracotta head by Mazzoni (no. 59), the 'Cellini Shield' (no. 160), eighteen Sèvres vases (including nos 120, 122, 125, 127, 128, 133), and eleven pieces from the Louis XVI service. A group of approximately three hundred antique and Renaissance gems (almost the entire collection) was also lent.

The impetus for these exhibitions was, as with the South Kensington Museum itself, twofold. In thanking the Queen and Prince Consort for their loans to the Art Treasures Exhibition, the Mayor of Manchester referred not only to the 'peculiar interest' shown by the working classes in the royal loans, but to the 'practical value which has been derived by several Manufacturers and Designers in Manchester from the samples of oriental embroidery and workmanship, copies of which have frequently been taken with a view of bringing into service portions of the designs'.[92] Much the same motivation lay behind the future Edward VII's decision to mount a display at the India Museum in 1876 of the extraordinarily rich collection of works of art which had been presented to him by the 'native princes' during his tour of the subcontinent in 1875–6 (including nos 301 and 303–05). Part of this collection was subsequently shown in Paris, Edinburgh, Glasgow, Penzance, Aberdeen and York.[93] This initiated the practice of exhibiting state gifts from far-flung lands which continued with the fruits of Alfred, Duke of Edinburgh's pioneering tour of the Far East at much the same period.

During the present reign, the number of loans has increased considerably, notably because of work undertaken in the Print Room since the 1970s. Many of the 40,000 drawings and watercolours that were once stuck down into albums have been released from their backings and transferred to mounts for storage in specially constructed boxes. Works of art on paper are especially susceptible to damage from light, and cannot be permanently exhibited. At the same time their small scale makes for ease and economy of transport. Since the 1930s, visitors to Windsor Castle have enjoyed temporary selections of drawings from the Royal Library in an evolving series of presentations, and loans have frequently been made over the last two centuries.[94] With the appointment of specialist exhibition staff in more recent years, the Print Room has become both the most frequent source of loans from the collection and the basis for thirty-five exhibitions formed entirely from its own holdings. These exhibitions, shown in over 100 cities around the world, have been seen by more than 6.5 million people. In addition, during the last fifty years more than 3,500 drawings and watercolours have been lent to over 600 exhibitions organised by other institutions.

The opening in 1962 of The Queen's Gallery at Buckingham Palace was a watershed in the history of public access to the collection. Until that time the principle which had been cited in response to the Parliamentary Question of 1899, that the general public should not be admitted to the palace, had been upheld. In 1957, at the personal instigation of Her Majesty The Queen and His Royal Highness The Duke of Edinburgh, it was decided that the building at the south-western corner of Buckingham Palace, originally designed by Nash as a conservatory but converted for use as a chapel under Queen Victoria, should become a public gallery for the temporary showing of works of art from the Royal Collection. The Private Chapel had received a direct hit from an enemy bomb in 1940 and remained a ruin. As rebuilt, it was truncated by approximately three-quarters to provide two display areas, with larger exhibits occupying the larger, lower area and smaller items, chiefly graphics, on a mezzanine.[95] The inaugural

Fig. 9 The Queen's Gallery, Buckingham Palace, at the time of the Leonardo exhibition, 1969

exhibition, *Treasures from the Royal Collection*, opened in July 1962 and remained on view until September of the following year, by which time it had been seen by more than 200,000 visitors. A further thirty-seven exhibitions were held in the gallery, on thematic subjects as diverse as *Royal Children* (1963–4), *Animal Painting* (1966–7) and *Landscapes* (1975–6) as well as monographic surveys devoted to Van Dyck (1968–9), Gainsborough (1970–1), Holbein (1978–9), Canaletto (1980–2), and Leonardo da Vinci (1969–70 – see fig. 9 – and 1996–7). The final exhibition, in 1999, presented a selection of drawings by Raphael in the context of his collaborators and followers.

As well as providing a location in central London in which to display the riches of the Print Room at Windsor Castle, the advent of The Queen's Gallery has also enabled paintings and works of art of all kinds to be brought temporarily from diverse locations in the palaces and placed under close scrutiny; to be seen, both literally and figuratively, in a new light, in exhibitions such as *George IV and the Arts of France* (1966), *George III, Collector and Patron* (1974–5), and *Carlton House. The Past Glories of George IV's Palace* (1991–2).[96] The Royal Collection is probably unique in this ability to present works of art both in their historic settings and under modern display conditions, a capacity that has now been greatly extended by the completion of the new gallery designed by John Simpson & Partners.

1 A smaller selection was also shown at the Royal Scottish Academy (Edinburgh 1947). Subsequently, exhibitions of paintings drawn exclusively from the Royal Collection have been held in Cardiff, Norwich, Plymouth, Bristol, Sheffield, Newcastle and Aberdeen (1989–91), for the inauguration of the Sainsbury Wing of the National Gallery in London in 1991 (London 1991a), and in Wellington, Canberra and Ottawa (1994–5).

2 The most useful recent survey of the subject as a whole is C. Rowell, 'Display of Art', in *Grove Dictionary* 1996, IX, pp. 11–33.

3 *Hentzner Journey*; *Platter Travels*.

4 An almost complete run of printed guides to Windsor Castle, from the earliest, Bickham 1742, is held in the Royal Library.

5 See p. 440 and nos 400–03, 413–14, 421–4, 429 and 433–6.

6 See Millar (D.) 1995, and nos 406–11, 415–20, 430–1 and 437.

7 *King's Works*, IV, part II, p. 245.

8 Thurley 1993, pp. 141–3, and pp. 212–17.

9 Haskell 1989, p. 204.

10 Millar (O.) 1963, no. 143.

11 Millar (O.) 1963, pp. 17–18.

12 For earlier examples of 'lines of kings' elsewhere in Europe see Bazin 1963, pp. 102–03.

13 Millar (O.) 1963, no. 145.

14 Jenkins 1994.

15 See Russell (F.) 1987, fig. 55; the Saloon was later transformed into the Green Drawing Room (see no. 415).

16 Shearman 1972, p. 152.

17 Tyack 1992, pp. 195–7.

18 Cooke had been one of those responsible for reassembling the separate strips of the cartoons for display in Wren's gallery.

19 Nash built a picture gallery at the back of Benjamin West's house in Newman Street for the painter's sons in 1820–1, which seems to have been a sort of half-way house in his development of top-lighting. The entire ceiling was glazed, but the centre was masked by a continuous canopy supported on slender pillars. See London/Edinburgh 1991–2, no. A19.

20 The opinion of the Surveyor of the King's Pictures, William Seguier, was given in a letter to Sir B.C. Stephenson, 23 June 1831, printed in *Second Report* 1831, Appendix, p. 231. See also Noble 1993.

21 Noble 1993.

22 Further artists, including Raphael and Michelangelo, were originally represented by plaster busts modelled by William Pitts in the overdoors, with similar garlands and supporters.

23 After the demolition of Carlton House and before the completion of Buckingham Palace, many of George IV's pictures were exhibited at the British Institution. He lent 185 pictures in 1826 and 145 in 1827.

24 Many of these frames, which were made by William Thomas, can still be seen in the Picture Gallery.

25 The two alternative names appear on Sir Jeffry Wyatville's General Plan of 1824 (RL 18413). For George IV's restoration of Windsor see Roberts (H.A.) 2001.

26 It is called 'the gallery of communication' in Ashton 1841, p. 18.

27 For the history of displays in the Corridor at Windsor see the Introduction by Christopher Lloyd in WC Paintings 1990.

28 See P. Mason, 'Smith's Picture Frames' in QG 1993, exh. cat. pp. 59–63.

29 Jameson 1842, I, pp. 220–1; II, p. 282.

30 Pyne 1819, I, *Windsor Castle*, p. 106.

31 For these transformations see London/Edinburgh 1991–2, nos A4–6.

32 See Russell (F.) 1987, p. 528 and fig. 49.

33 See Von Erffa & Staley 1986, pp. 577–81 (with further references).

34 The four admirals may have been intended to hang in the Admiral's Room in what had been the Princess of Wales's apartments, but this remained unrealised. See *Carlton House* 1991, pp. 26–7.

35 See Scott-Elliot 1959.

36 There were also 120 statues in the gallery at Somerset House and 20 in the garden. See Avery 1982, and Howarth 1989, pp. 73–113.

37 *King's Works*, IV, pp. 249–51, 268–9.

38 Bickham 1742, p. 143.

39 Webb 1954, pp. 145–6.

40 Pyne 1819, III, *St James's*, opposite p. 60. The Library was demolished in 1825 to make way for York (now Lancaster) House. All but three of the terracottas were destroyed in 1906 when the shelf on which they were resting in store at Windsor collapsed.

41 Giometti 1999, pp. 26–43.

42 Millar (D.) 1995, no. 4636.

43 See Millar (D.) 1986.

44 See Mansel 1984.

45 This 'very singular' arrangement was seen by John Evelyn on 28 August 1670: the walls were 'invested with … martial furniture, … set with such study, as to represent, Pillasters, Cornishes, Architraves, Freezes' (*Evelyn Diary*, III, p. 560). Fig. 5 was published in Pyne 1819, I, *Windsor Castle*,

opposite p. 188.

46 Verrio painted similar murals on the staircase of the Royal Hospital, Chelsea, in 1687.

47 For Harris's thirty-year career as an arranger of arms see Parnell 1993, Parnell 1994, and Blackmore 1968, pp. 2–3.

48 Timbs 1885, p. 799.

49 Ackermann's Repository, I, 1809, no. 6. The preliminary drawing for this plate is in the Royal Collection (see QG 1991–2, no. 202). The 'Line of Kings' at the Tower was finally abolished by Lord Dillon in 1895.

50 Letter from Benjamin Jutsham to Sir B.C. Stephenson (Second Report 1831, Appendix, p. 232).

51 According to Waagen 1838, I, p. 168, the glass made the shield invisible.

52 Impey & Parnell 2000, p. 65.

53 Cust 1930, pp. 36–44.

54 For the history of the Jewel House in the Tower, see Crown Jewels 1998, I, pp. 681–728.

55 Crown Jewels 1998, I, pp. 84–5. For the history of visiting the Tower of London see Impey & Parnell 2000.

56 Phillipps 1846, p. 333.

57 Edward Hall, Chronicle, cited in London 1991b, exh. cat. p. 131.

58 Defoe Tour, I, p. 166.

59 For the most recent research on the collection of Queen Mary II see Hinton & Impey 1998, and for the influence of the Queen's displays see Somers Cocks 1989.

60 See Pyne 1819, II, Buckingham House, opposite p. 20 and I, Frogmore, opposite p. 21.

61 See De Bellaigue (G.) 1997.

62 Hentzner Journey.

63 Henry VIII Inventory.

64 Thurley 1999, pp. 84–5. Henry VIII's magnificent Brussels set of the History of Abraham (c.1545) was used in the Banqueting House in Charles I's time.

65 See King in MacGregor 1989, pp. 307–21, and Campbell (T.) 1994.

66 Law 1891, III, p. 65. See Campbell (T.) 1998a.

67 The hangings were returned to the Queen's Closet at Hampton Court in 1998.

68 Letter from J.C. Robinson, 15 August 1886 (RA VIC/L 10/163).

69 Wright 1837, II, pp. 420–1; Joseph Farington managed to get in, and noticed that 'hundreds of ladies' gained admittance via the ground-floor windows (Farington Diary, IX, p. 3958).

70 Law 1891, III, pp. 361–2. Law notes that the numbers at Hampton Court were swelled by approximately 150,000 in the two exhibition years of 1851 and 1862. The palace was open every day except Friday, from ten o'clock until six in the summer, and until four in the winter.

71 Law 1891, III, p. 369. Jesse was an employee of the reformed Board of Works. For Hampton Court in the nineteenth century see Thurley 1995. I am most grateful to Susanne Groom, Assistant Curator, Historic Royal Palaces, for allowing me to read the text of a lecture given at Versailles in 2000: 'Hampton Court, Le Palais et Le Public'.

72 Report of the Select Committee on the National Gallery, 25 July 1850, p. iv.

73 'Outline of an Arrangement for the Admission of the Publick to the State Apartments of Windsor Castle' (RA VIC/C 60/67).

74 At this time the State Apartments at Windsor were still used periodically for the accommodation of state visitors. See for example no. 411.

75 Tickets were sold in Windsor from 1848. Residents of the town are now admitted to the castle free of charge.

76 RA VIC/C 60/92. The public were not admitted for approximately twelve weeks in each year when the court was at Windsor.

77 Haydon Memoirs 1926, II, p. 731. Haydon visited on 21 June 1842. He must have travelled to Slough by train and onwards by road to the castle, since the railway did not reach Windsor itself until 1849.

78 Law 1891, III, p. 362.

79 Gow 1992, p. 80.

80 RA VIC/L 5/86, letter of 20 June 1888.

81 This collection was largely assembled by Queen Mary in the 1920s for a closet in the Private Apartments at Windsor, which became known as the Stuart Room. The room was destroyed in the 1992 fire, but its contents, and the early panel paintings gathered nearby in the 'Holbein Room' (and now mostly at Hampton Court), were spared. See Gow 1995.

82 Law 1903, p. 45.

83 Law 1903, Preface. The numbers averaged approximately 150,000 per year after the first year.

84 RA VIC/L 5/108. Edward VII likewise did not visit Hampton Court until after his accession.

85 Hansard, Parliamentary Debates, LXXIV, p. 877 (14 July 1899).

86 See especially Maclelland 1994.

87 Details of royal loans of paintings and decorative arts to exhibitions from 1762 to the present day were researched and collated for this catalogue during 2000 by Miss Nicola Turner Inman. David Wilkie's The Penny Wedding of 1818 emerges as the most frequently exhibited picture in the collection, having been lent twenty one times. For the British Institution and the history of loan exhibitions see Haskell 2000.

88 Cole 1884, I, pp. 284–5.

89 These range from the Raphael Cartoons at the Victoria and Albert Museum and the Hugo van der Goes Trinity Altarpiece at the National Gallery of Scotland, to a double bass presented to Prince Albert by the great virtuoso Dragonetti, now on loan to the Royal Military School of Music.

90 Millar (O.) 1992, no. 451. This picture is now on long-term loan to the National Gallery in London.

91 Scharf 1858, pp. 269–331. See also Haskell 2000, pp. 82–9. The first overseas loan of paintings or drawings by Old Masters seems to have been to the Holbein exhibition at Dresden in 1870.

92 Letter dated 30 November 1859 from Mr Weston, Mayor of Manchester, to the Keeper of the Privy Purse (RA PP/VIC/Add 1184).

93 See Clarke 1898, Introduction.

94 Notably, in the early days of drawings exhibitions, over eighty drawings, mainly by Holbein, to the Exhibition of the Royal House of Tudor and over fifty early Italian drawings to the Exhibition of Early Italian Art, at the New Gallery, in 1890 (including nos 348–9) and 1893–4 (including nos 345–6) respectively.

95 See Hussey 1962.

96 Exhibitions at The Queen's Gallery (QG) between 1962 and 1999 are noted under QG within the Exhibition abbreviations (p. 472).

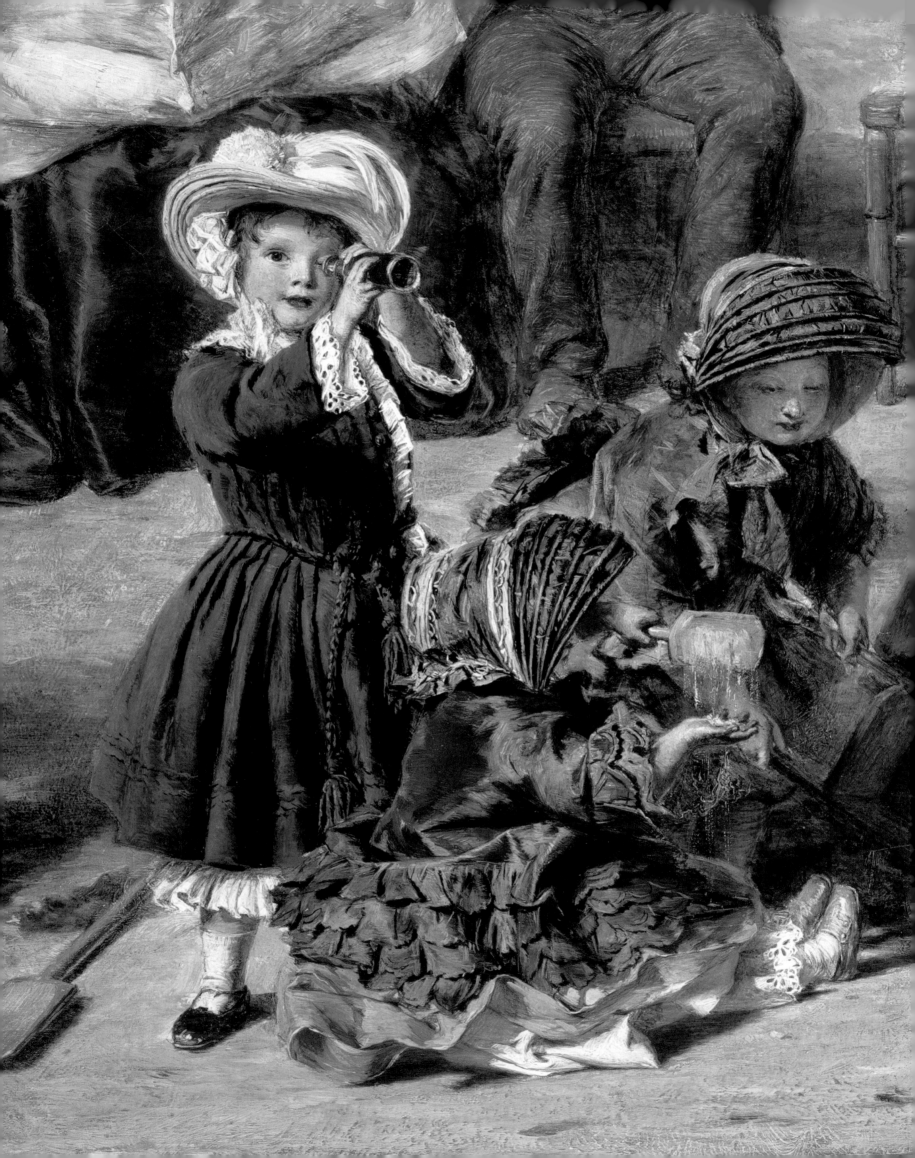

Care and conservation of the Collection

Christopher Lloyd

THE CARE AND CONSERVATION of the numerous works of art comprising the Royal Collection is an awesome responsibility. Abundance and diversity are overlaid by a veneer of history that few other collections can rival. Indeed, the historical dimension is in all respects the essence of the Royal Collection and is an important consideration in any account of its conservation. Whenever works of art are shown in a museum or gallery they are divorced from their historical context, but if – as in the case of the Royal Collection – they are displayed in the buildings, or even the very rooms, for which they were created, then they are within the embrace of history. Far from being silent witnesses, the paintings, sculpture, porcelain, plate, furniture and jewellery are active participants.

The emphasis in the royal residences has always been – and in most cases continues to be – on a working environment in which works of art play a relevant part in the day-to-day activities of monarchy. The carefully monitored conditions of purpose-built museums or art galleries which establish the ideal requirements for atmosphere, heat or light, according to the standards of the latest scientific research, can only rarely be created and maintained. Such a situation does not of course suggest that the Royal Collection, which is in many ways comparable with the National Trust in these respects, is exonerated from any responsibility for conservation. Rather, as this essay will demonstrate, a great deal has been achieved in this area on different fronts over the course of several centuries, but always in accordance with the needs and functions of the collection and always in the light of the technical standards applicable at any particular time.

The history of conservation in the Royal Collection, therefore, reveals in the first place a balance between aesthetic considerations and practical needs. Related to this is another equation between the monarch's official role and personal taste. This can be illustrated by reference to some of the most important works associated with the collection. The famous ceiling painting by Sir Peter Paul Rubens, commissioned by Charles I for the Banqueting House at Whitehall Palace, is the only elaborate decorative scheme by the artist to remain in its original setting. The theme is the glorification of the King's father, James I, but the building as a whole, designed in a Palladian style by Inigo Jones (1619–22), was used for a variety of purposes – the procession of the Order of the Garter, the reception of ambassadors and also court entertainment, including masques. The enactment of masques required a great deal of stage machinery such as hoists and elaborate lifting devices, as well as illumination from candles or tapers. After the ceiling canvases were installed, Charles I evidently feared for their safety and duly instructed that masques should no longer be performed there in order to avoid damage from 'the smoke of many lights'.[1]

Before he acceded to the throne in 1625, Charles I had acquired the seven painted cartoons of scenes from the Acts of the Apostles by Raphael; these had been made in 1515–16 for Leo X as full-size models to be copied by the Flemish manufacturers of the tapestries hung on special occasions in the Sistine Chapel in Rome.[2] The ostensible reason for such an acquisition was the practical use that could be made of the cartoons at the newly established royal tapestry workshops at Mortlake, but even before the end of the seventeenth century the significance of the Raphael Cartoons as works of art in their own right had been recognised. Therefore when they were displayed by William III in the King's Gallery at Hampton Court Palace, the piecemeal state of the cartoons that had been necessary for the weaving process was abandoned in favour of reassembling each of the narrative scenes on separate canvases (see fig. 2). This was done principally by Parry Walton, a former Surveyor who was retained as 'Mender and Repairer' of pictures.

During the eighteenth century the cartoons became the touchstone of classical art as exemplars of composition, drawing and colour. Considered almost as an academy of art in themselves and of singular importance for the evolution of a British school of art, the location and condition of the cartoons became a matter of public concern.[3] Although they were frequently engraved and copied, the removal of the cartoons by George III from Hampton Court Palace – first of all to Buckingham House and then to Windsor Castle – was criticised not only because this made them less accessible (see p. 29) but also because they began to show signs of serious deterioration. Only in 1804 were the cartoons returned to Hampton Court Palace where during the first half of the nineteenth century they were put on permanent display (see no. 433) and sometimes loaned to exhibitions or institutions. A Select Committee of the House of Commons in 1836 initiated a debate

on the future of the cartoons since they were to be excluded from the National Gallery (founded in 1824). A wide spectrum of people was consulted, including scientists such as Michael Faraday, on such aspects as the effects of urban pollution on works of art.[4] The matter was eventually settled by Queen Victoria, who placed them on long-term loan at the South Kensington Museum (later the Victoria and Albert Museum) in 1865, in accordance with the wishes of Prince Albert who had died four years previously. The most detailed account of the condition of the cartoons was prepared by Richard Redgrave (Surveyor of Pictures) at this time. He advocated a policy of non-interventionist conservation with no repairs being carried out on the paper but simply relaying detached areas and creating the right environmental conditions – glazing, backing, restricting light, temperature control – to ensure the safety of the cartoons in their new home. Redgrave's report reads like a modern condition report and it is accompanied by an annotated set of the photographs taken in 1850 indicating old retouching, dirt, damp and losses. So sophisticated were these recorded observations that they played an important part in the recent campaign of treatment of the cartoons undertaken by the Victoria and Albert Museum in 1992–6.[5]

Another major large-scale work of art acquired by Charles I holds a similarly instructive place in the history of conservation in the Royal Collection. The nine canvases of *The Triumphs of Caesar* were painted in tempera on canvas by Andrea Mantegna (c.1485–94), probably for Francesco II Gonzaga, fourth Marquis of Mantua, where the paintings remained until the Gonzaga collection was sold to Charles I in 1629.[6] Considered to be one of the masterpieces of Renaissance painting – indeed the greatest sequence of narrative art of that date now to be seen anywhere in the world outside Italy – the exact purpose of the *Triumphs* has so far not been ascertained and this is undoubtedly reflected in the history of their condition. It is, for example, likely that this processional triumph re-creating the practices of Roman antiquity may have been a temporary decorative scheme set up only on special festive occasions. Like tapestries, therefore, the nine canvases may have been frequently rolled up and moved about as opposed to being displayed in a fixed position while in Mantua. On their arrival in England it was initially thought that the *Triumphs* might be used as designs for tapestries like the Raphael Cartoons, but by the time of the Restoration the canvases had been installed at Hampton Court Palace, where they have been for over three centuries.

Already during the seventeenth century the condition of the *Triumphs* was giving cause for alarm and this factor, together with the problem of their presentation, has led to a long history of attempts to arrest the process of deterioration. No fewer than seven distinct campaigns incorporating the whole work or a portion of it are known. Parry Walton began work in c.1690–3 and carried out the first relining of the canvases. He was soon followed by the French artist Louis Laguerre (c.1694–1702), whose treatment almost certainly involved substantial over-painting in oil. After a further attempt by Jean Goupy in 1717, the *Triumphs* remained untouched until the mid-nineteenth century when Anna Brownell Jameson described them as in a 'defaced and dilapidated condition'.[7] Where Redgrave during the 1860s was restrained, Roger Fry (c.1910–21) appears to have been heavy handed and insensitive. His efforts have been described as 'the last in a tradition of artist-restorers who sought to improve the original by implanting on them his own individual artistic style'.[8] Subsequently, between 1931 and 1934, Kennedy North relined all nine canvases using a heavy wax adhesive in such huge quantities and applied in such a primitive way that the surfaces became uneven and unsightly. The responsibility for negating the effects of all these earlier treatments fell to John Brealey between 1962 and 1974. His task was to remove all the old retouchings and wherever possible to reveal Mantegna's original paint. This was done successfully in all except one of the scenes (Canvas VII – *The Captives*), which was left untouched on the grounds that there was no original paint left on it at all. Thus today it remains alongside the other canvases as visual testimony to the passing phases in the history of conservation.[9]

No monarch could surpass George IV in the demonstration of royal taste. He was essentially conservative by nature, his interests extending across a wide range of objects gathered from a number of different sources, but what was of equal significance for George IV was the presentation of his collection as an ensemble. This concern found its first, and possibly finest, expression in Carlton House,[10] his chief residence from c.1783 until 1826, but also later in Buckingham Palace and Windsor Castle. The surviving documentation in the form of inventories, bills and receipt books shows the panache with which George IV made his acquisitions and the frenzied activity with which he ceaselessly ordered, arranged and rearranged the collection. This was not just a matter of display, but often of modification or embellishment in an interventionist way that is difficult to comprehend at the present time when the integrity of the original work of art is carefully safeguarded. George IV's reordering and re-presentation involved extensive regilding of the mounts on his furniture, the replacement of French clock dials and movements with new English ones, the reframing of paintings, the reglazing of mirrors, the marriage of different pieces of furniture, and the embellishment of arms, all in accordance with his preference for a high finish and glowing effects heightened by the reflective qualities of the objects themselves – 'a Mahomet's Paradise' as Lady Elizabeth Feilding

remarked.[11] Firms such as Marsh & Tatham, Vulliamy, and Rundell, Bridge & Rundell were constantly at work for George IV, often in a number of capacities. Vulliamy, for instance, could at one moment be ornamenting four matching pier tables attributed to Adam Weisweiler with gilt bronze panels of pierced scrolls and at another be replacing the French movement of the monumental pedestal clock attributed to Jean-Pierre Latz.[12]

Such activities meant constant vigilance and the establishment of certain practices. First, there was a regular cleaning programme. Under George IV, tapestries, curtains, draperies and seat covers were cleaned with cloths, flannels and bread. Furniture was polished, veneer relaid and distressed gilding redone. Secondly, preventive measures were put in place. The cleaning of rooms – bills were submitted for 'Loaves to Clean the Ceiling of the Apartments with' – was an important aspect of housekeeping. There was an ample provision of lined covers of various types for seat furniture, tables, chests of drawers, bookcases and candelabra; carpets were fitted with druggets; and clocks were protected by glass domes. Light was excluded from rooms by the use of Venetian blinds and muslin curtains to prevent the fabrics from fading, and even individual paintings were fitted with curtains in order to avoid damage by light – a practice adopted in earlier centuries. These routines can be gleaned from documentation, including the claims of creditors. Amongst these was George Simpson, who undertook the cleaning and varnishing of numerous paintings – often of considerable importance. Simpson also did structural work on panels, relined canvases, and renewed stretchers.[13]

These practices were to a certain extent codified during the reign of Queen Victoria by Prince Albert, who in 1846 instituted the post of Inspector – one for Buckingham Palace and another for Windsor Castle. Both Inspectors reported to the Master of the Household, who in turn answered to the Lord Chamberlain, and they were responsible for overseeing the activities of all the craftsmen and workmen. The annual reports prepared by the Inspectors for the Lord Chamberlain constitute a huge body of evidence for the maintenance and development of all aspects of these two royal residences during the second half of the nineteenth century.

Queen Mary combined George IV's enthusiasm for collecting with Prince Albert's powers of organisation. Her instinct was not only to extend and preserve the collection, but also to record it. Although she described her interest as 'my one great hobby', Queen Mary's concerns reveal her more in a curatorial light and significantly she established close connections with professional museum staff.[14] Accordingly, an organising principle was set in motion that presented many parts of the Royal Collection in a more modern and informed way. 'To collect, to preserve, to docket, to tidy and to put in order were primary objectives all through her life.'[15] Books and catalogues in Queen Mary's own working library were annotated and cross-referenced and even today volumes inscribed simply but authoritatively Mary R not only prompt historical associations but instil a certain discipline in the reader.

Regardless of a monarch's particular interest in the collection, it was always likely that – for reasons beyond personal control – works of art were frequently at risk. This applied to paintings as much as to objects. The portraits of the kings of Scotland by Jacob de Wet in the Great Gallery at the Palace of Holyroodhouse in Edinburgh, for example, were 'slashed by the sabres' of English troops under the command of General Hawley in retribution for the Jacobite rebellion of 1745.[16]

Even when moved from one royal residence to another, or even from one room to another, works of art were endangered. The Holy Family with St Francis by Rubens, which seems to have been acquired during the reign of George I, was hung in the King's Drawing Rooms in three different royal residences: Kensington Palace, Buckingham House and – from early in the nineteenth century – Windsor Castle. Either when the painting was at Kensington Palace or when it was at Buckingham House it was extended by about 56.5 centimetres at the upper edge, presumably to allow it to fit more dramatically over a fireplace. It can be seen in that extended format at Windsor in W.H. Pyne's History of the Royal Residences (1819) and later again in Joseph Nash's Views of the Interior and Exterior of Windsor Castle (1848). Such alterations have to be carefully assessed in any modern conservation treatment, as in that of 1990–1 before the painting was shown in The Queen's Pictures exhibition in the National Gallery. The addition to the canvas at the upper edge was not part of the original composition but it is, none the less, part of its subsequent history. To remove that addition entirely would not be acceptable by the conservation standards of today and so this portion has been retained by turning it over the stretcher. However, the result of this decision was to reduce the overall size of the canvas, which in turn meant that the frame – designed by William Kent in the early eighteenth century – had to be cut down.[17]

This kind of alteration – to form pairs, to create a series, or to balance a hang – was often undertaken by the superintendent of a palace, or a member of his staff. A dramatic example of a particularly ruthless act occurred with The three eldest princesses: Charlotte, Princess Royal, Augusta and Elizabeth, which had been painted by Gainsborough in 1784 with the figures in whole length, as seen in the mezzotint by Gainsborough Dupont. The Victorian artist Sir Edwin Landseer reported in 1868 that early in the reign of Queen Victoria he had seen an 'Inspector of Palaces' cutting the canvas

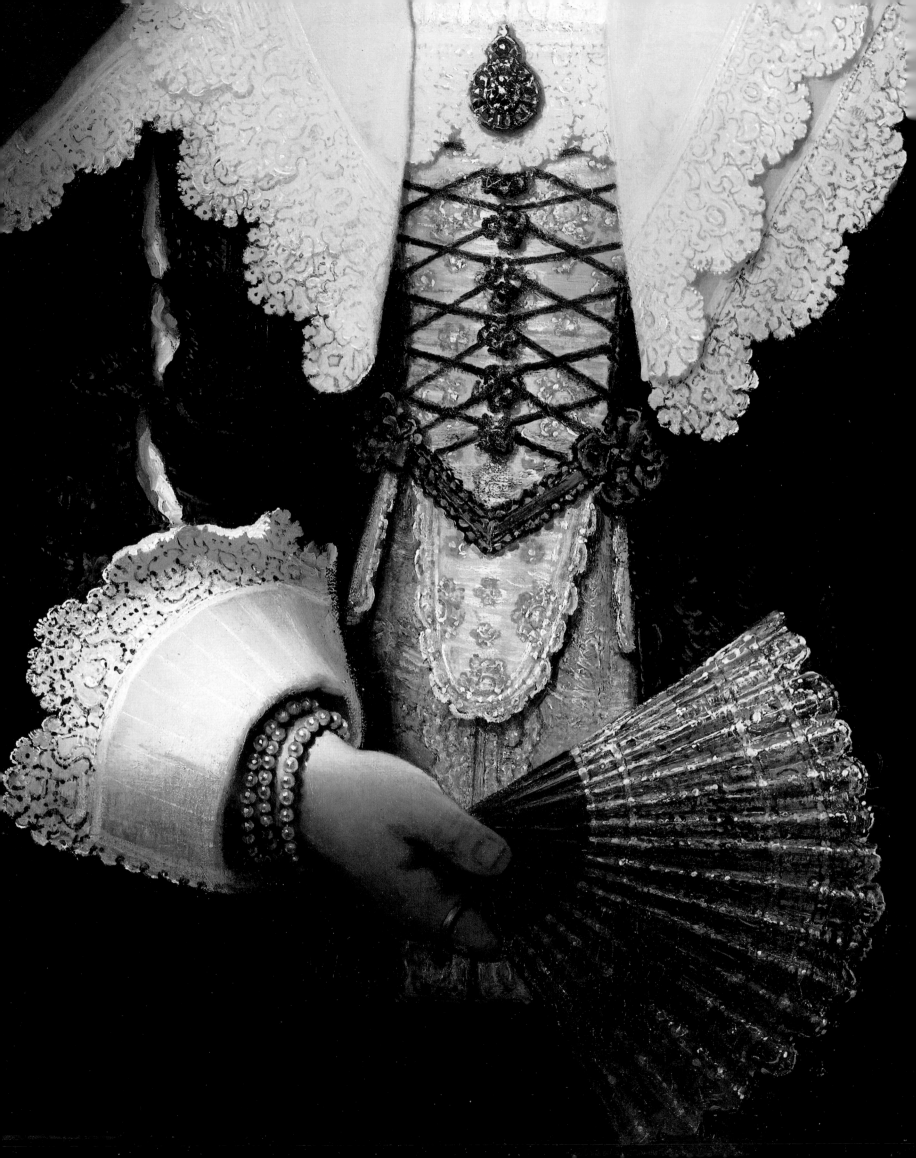

down so that the painting could hang as an overdoor with the figures in half-length. In fact, the canvas was cut at the upper and lower edges, as well as having been extended on the left. It seems that Landseer was too late to save the discarded pieces from the flames.[18]

The abandonment of an object could prove similarly damaging. The superb marquetry writing table by Gerrit Jensen (RCIN 35317) made for William III is visible in the illustration of the King's Closet at Windsor Castle chosen to accompany Pyne's *Royal Residences* (see no. 400) and was considered important enough to be included in exhibitions during the nineteenth century. Even so, it was 'rediscovered' in store at Windsor Castle at the beginning of the twentieth century in a parlous state – 'the veneering of marqueterie had risen, and partly disappeared, and the woodworm had so severely attacked it that it could scarcely bear the weight of its body upon the tottering legs'.[19]

Public attention became more focused on aspects of conservation during the first half of the nineteenth century when Hampton Court Palace was fully opened to the public. Previously it had tended to be a repository for paintings not required at Kensington Palace, Buckingham Palace and Windsor Castle. Queen Victoria, however, was not content just to open the palace, but was concerned about the impression that the paintings might make. Early in her reign the Queen was 'thunderstruck & shocked ... at the way in which the pictures, many fine ones amongst them, & of interesting value, have been thrown about & kept in lumber rooms at Hampton Court'. It was, Queen Victoria stated, 'My care, or rather more my dearest Albert's, for he delights in these things, ... to have them restored, to find places for them, & to prevent, as much as it is in our power, pictures of the Family, or others of interest and value, from being thrown about again'.[20] Thirty years later Queen Victoria's eldest daughter, the Crown Princess Frederick of Germany, was still concerned:

> The pictures at Hampton Court are not cared for as they should be. Dozens are misnamed – the good and the bad are muddled together many in dark rooms where one cannot see them properly and the best would be so much better seen, enjoyed, known and cared for if they were in the National Gallery (as your property) where I know they would ever remain!
>
> ... The Hampton Court Gallery wants fresh varnish and fresh frames for some pictures, then a great weeding out of the very valuable and beautiful pictures from the trash and the right names and dates put on the pictures because there are some awful blunders in the names and it only misleads the public, besides being a disgrace in our day where learning and

science have done so much for gaining an accurate knowledge of art and artists of bygone days.[21]

Ernest Law, who wrote the first extended catalogue of the paintings at Hampton Court Palace (1898), reminded his readers that 'It is necessary, however, to bear in mind that the rooms in which the pictures are now crowded – for there are many too many for the space available – were not built as art galleries; and it would be a task of some difficulty to arrange every picture according to its period and school, and at the same time in an appropriate position. Nevertheless, in spite of certain obvious drawbacks, there are very few collections of pictures which can be inspected with such ease and freedom as this.'[22] Hampton Court Palace, therefore, is one area where the Royal Collection entered the public domain at an early stage and where consequently it begins to be judged according to different standards.

For the present day, one of the main measures by which any collection has to be judged is conservation. This impinges on both presentation in the short term and preservation in the long term. Owing to the great diversity that characterises the Royal Collection, a wide range of skills is required. As will be seen, conservation in the modern sense has developed alongside that practised in related institutions – particularly the National Gallery, the British Museum, the British Library, the Victoria and Albert Museum and the Wallace Collection – and to a certain extent it has been dependent upon these institutions in the introduction of the sort of modern facilities that are required to safeguard the collection for future generations. Yet in reality conservation, sometimes of a fairly uninformed kind, has been undertaken in the Royal Collection since the seventeenth century, if not before. Accordingly there is an accumulation of evidence that in many respects reflects the history of the development of conservation in Britain as a whole over a considerable period of time. It is easy to condemn the methods of earlier practitioners when in all areas there has been such a fundamental change of approach. Where previously the term used was 'restoration', implying an act of intervention to repair damage by making good, now the preferred term is 'conservation' denoting restraint with as little interference as possible. Obviously in each case the amount of damage to a work of art has to be carefully assessed and its visual integrity respected, just as the artist's original intentions have to be honoured. This change of approach – a comparatively modern development – has come about in part as a result of scientific advances. The conservators of today straddle the divide between science and art – chemistry applies as much as art history – and their studios are equipped with a whole range of scientific instruments to aid their work, as well as easels, pigments and palettes.

This degree of technical sophistication has led to the recognition of the significance of conservation and of conservators in museums and galleries throughout the world, in addition to the establishment of a code of practice now applied by all curators.

The earliest restorers in the Royal Collection were nearly always those with immediate responsibility for the objects, usually the Surveyors or Keepers, who until the end of the nineteenth century were almost invariably artists in their own right. Symptomatic of the emphasis placed on the paintings is the fact that a surveyorship with sole responsibility for the decorative arts was not created until 1928. During the earlier centuries a distinction is sometimes made between the role of Surveyor and of 'Picture Mender and Cleaner', as in the cases of George Geldorp in 1662 and Parry Walton in 1682, who come into the latter category. On the other hand, there can be no doubt that Surveyors such as Stephen Slaughter, George Knapton and Benjamin West combined the roles of Surveyor and restorer. During the reign of George III, however, there was a rare instance of a Surveyor who by virtue of his earlier appointment as Librarian played a major role in a variety of ways for George III. This was Richard Dalton, a figure not much liked in his time but who, none the less, travelled extensively on behalf of the King and made some major acquisitions including the collection of Consul Joseph Smith in 1762.[23] The last of these Surveyors with widely defined responsibilities was William Seguier (1771–1843), who was trained as an artist but soon became a dealer and adviser to some of the leading collectors of the day. Appointed Superintendent of the British Institution in 1805, he then became Surveyor to George IV (from 1820) and was the first keeper of the National Gallery, founded in 1824. As Surveyor he also served William IV and Queen Victoria at a critical time for the Royal Collection. It seems that Seguier undertook a prodigious amount of relining, cleaning and varnishing, both for the Royal Collection and at the National Gallery. This is most noticeable in the background toning applied to many of the Venetian pictures in the collection – notably those by Canaletto and Zuccarelli – most probably while they were being prepared during the late 1820s for display in the Grand Corridor in Windsor Castle. But Seguier also treated works by Zoffany and Lawrence, while wisely avoiding paintings by Reynolds. It is clear that Seguier, together with his younger brother John, was very active as a restorer and the controversy that ensued in the 1840s and 1850s over the cleaning of the National Gallery's pictures was sparked by his activities.[24]

The diversity of duties to be undertaken by a Surveyor is apparent from the wording of the appointment of Abraham van der Doort by Charles I in 1625.[25] Referring to the paintings, the terms of appointment include the words 'to prevent and keepe them (soe much as in him lyeth) from being spoiled or defaced'. As it happens, the catalogue of Charles I's collection made by Van der Doort and completed c.1639/40 records additional information on provenance, framing, condition and subsequent movements. It is in its way an extremely sophisticated document and repays close study in so far as it is the earliest such record in existence for a British, possibly a European, collection. Van der Doort was of Dutch origin and spoke little English. Consequently his observations, often additions in the margin, are written phonetically, but the terminology is familiar – split or worm-eaten panels, flaking or blistering paint surfaces. Evidence of an earlier treatment is commented upon in the entry for *St John the Baptist* by Leonardo da Vinci (now Paris, Louvre) where in the margin Van der Doort writes 'whereof the Arme and the hand hath – bin wronged by some washing – before it came to your Matie'.[26] Another early treatment is recorded in the case of the *Sacra Conversazione* (*Virgin and Child with Saints Catherine of Alexandria and John the Baptist*) by Palma Vecchio, which may have suffered 'from standing in a warm room'. Consequently, the panel 'was warped and cracked and was thinned and taken [?out of] its frame Was set upon a new strong panel therefore and in a new gilded frame'. This whole process can still be detected on examination of the original panel.[27]

The acquisition of the Gonzaga collection by Charles I seems to have galvanised interest in conservation matters. Thought was clearly given to the condition of the paintings before they were transported from Mantua to London as the more delicate were sent overland (for example the *Allegories of Virtue and Vice* by Correggio, both in tempera and now in Paris, Louvre) whilst the majority were shipped. It was a fateful voyage as, perhaps due to shifting cargo, many of the works were damaged or, as Richard Symonds reported, 'quicksilver was gott in among them and made them all black'.[28] Consequently Van der Doort assiduously recorded that some were so badly affected that they were 'utterly ruined and spoyled'[29] and there are numerous entries referring to the damage caused by quicksilver (mercury). According to the physician Sir Theodore de Mayerne, who was called in to advise, the ship was loaded 'with currants where there were several barrels of Mercury, the vapour of which activated by the heat of the currants blackened like ink all the paintings both in oil as well as tempera'. The treatment for this rather alarming condition was carried out by Jerome Lanier, uncle of Nicholas, Master of the King's Music, who had helped to negotiate the acquisition of the Gonzaga collection. Jerome Lanier (for whom see also nos 144 and 352) told Richard Symonds in 1644 that 'to cleanse them first he tryed fasting spittle, then he mixt iit with warm milke, & those would not doe at last he cleansd them with Acqua Vita alone being warmd & that

took off all the spotts & blackens & he says twill take old varnishes'.[30] A host of restorers – Richard Greenbury, John de Critz, Daniel Soreau – worked to save the pictures, with De Critz, Edward Pierce, Matthew Gooderick and Zachary Taylor concentrating on the frames.[31] The effects of the mercury resulted in a campaign of urgent restoration during the mid-seventeenth century. The modern conservator of any of the Gonzaga pictures has to be mindful of these earlier mishaps.

The activity generated by Van der Doort is paralleled during the early eighteenth century by the concerns of Frederick, Prince of Wales. The Prince was acutely aware of Charles I's abilities and achievements as a collector and both George Knapton and George Vertue, in whose company he examined the Royal Collection, acknowledged the comparison. The acquisition of major works was matched by a concern for their upkeep and appearance which was fostered by personal example. On 15 July 1732 the Prince and his entourage embarked in William Kent's Royal Barge at the Royal Hospital at Chelsea 'and being attended by the Officers and Ladies in Waiting of the Court in another Barge, and a set of Musik in the third Barge, they proceded to Somerset House ... there they viewed Mr. Waltons progress in cleaning and repairing the Royal Pictures'.[32] As it happens, the documentation for this part of the history of the Royal Collection is particularly rich. The accounts record payments to numerous people, some of them artists, involved with the maintenance of the collection – Joseph Goupy, John Wootton, John Griffier, Isaac Collivre and John Anderson were amongst those paid for lining, cleaning and restoring pictures for Frederick, Prince of Wales. Money was also spent on framing and a prodigious number of craftsmen were involved in this enterprise, notably Paul Petit.[33]

In terms of individuals, Van der Doort's true successor was Richard Redgrave (1804–88), who was appointed Surveyor by Queen Victoria in 1857.[34] Although famous in his day as a painter, mainly of genre and landscapes (*The Governess* of 1844 was one of his most popular compositions), Redgrave played an influential part in organising the Great Exhibition in 1851 and in establishing the principles behind the founding of the South Kensington Museum (now the Victoria and Albert Museum) and the Science Museum. His remarkable report on the condition of the Raphael Cartoons has already been noted (p. 46). As an administrator he was involved with the Government Schools of Design and as a curator he was instrumental in the deployment of the Sheepshanks collection of British paintings – a project to which the publication of *A Century of British Painters* (1866), with his brother, Samuel, was clearly related.[35]

Redgrave was an outstanding Surveyor, introducing a degree of professionalism and a capacity for hard work that had not been

Fig. 10 The page from the inventory compiled by Richard Redgrave concerning Gainsborough's portrait of J.C. Fischer (no. 23), 1862

a feature of the post since the mid-seventeenth century. He introduced modern standards to the preservation, presentation and recording of the paintings which he intended to extend to the decorative arts in the collection. The inventory that Redgrave initiated in 1858 is a prototype for museum documentation (fig. 10). It comprises some 4,500 sheets measuring 43 × 27 centimetres with full cataloguing information as it is understood today, as well as a photographic record of the painting concerned and observations on condition, attribution and framing. References to the literature and scholarly opinions are also given. The sheets cover all the main royal residences except for the Palace of Holyroodhouse, which was added later by Redgrave's successor, Sir J.C. Robinson. On the whole, Redgrave concentrated his efforts on Hampton

Court Palace which was by now in the public domain, technically administered by the government department known as the Office of Works, although the contents remained part of the Royal Collection. With Queen Victoria's approval he maintained a proper programme of conservation involving commercial restorers, at the same time showing an awareness of the need for preventive measures such as controlling the fluctuating atmospheric conditions. Redgrave was in all these respects a modern curator in both his methodology and his concerns. He omitted the words 'Repairer and Cleaner' from his title and advocated either the establishment of a conservation studio for the Royal Collection or access to that established by the National Gallery. His years in office (1857–79) usher in the modern age of the conservation of the pictures in the Royal Collection.

Although the various conservation studios now responsible for the different areas of the Royal Collection have been set up fairly recently – in most instances during the present reign – their origins lie in the distant past. A significant role in these developments has been played by the Royal Bindery in the Royal Library at Windsor Castle, founded by the bibliophile George III.[36] The first Royal Bindery was in fact located in Buckingham House, where Sir William Chambers built a whole library wing for George III between 1762 and 1773. The Bindery was established by the mid-1780s, but there is evidence that binders had been employed earlier, William Shropshire having held the post of Binder in Ordinary from 1760 to 1785.[37] George III took a particular interest not just in the content of his books but also in their condition and appearance. Thomas de Quincey reported that the King's concern

> extended even to the dressing of the books in appropriate bindings, and (as one man told me) to their *health*; explaining himself to mean, that in any case where a book was worm-eaten, or touched however slightly with worm, the King was anxious to prevent the injury from extending, or from infecting others by close neighbourhood; for it is supposed by many that such injuries spread rapidly in favourable situations … Not a day passed, whenever the King happened to be at Buckingham House, without his coming into the binding-room, and minutely inspecting the progress of the binder and his allies – the gilders, toolers, etc.[38]

Some of the tools used during George III's reign are now at Windsor and form the nucleus of the equipment used today (fig. 11). It was William IV who re-established the Royal Library and relocated it, with the Royal Bindery, at Windsor Castle in the early 1830s.

The binding of a book demands a range of additional skills beyond the making and design of the cover itself. When an old binding has been replaced, owing to its poor condition, the overall condition of the volume is also taken into account. The effects of damp, the deterioration of the paper, and the nature of the stitching may at this stage necessitate some conservation. A great deal of the conservation work on a library of any substantial size has now to be combined with preventive measures. These last include the oiling of leather bindings, the dry cleaning of the constituent elements, the removal of stains that might induce further deterioration, and the supplying of boxes for extra protection.

The Royal Library also houses the prints, drawings and watercolours in the Royal Collection in a series of rooms overlooking the North Terrace at Windsor Castle. Because of the concentration of drawings and prints of the highest quality, and in vast numbers, within a single storage area, the history of the Print Room collections provides a good example of changing attitudes to the storage, care and conservation of a collection. The majority of the works of art on paper are kept in the Print Room itself which was equipped

Fig. 11 The Bindery, Windsor Castle, with some of the tools used in George III's bindery in the foreground, May 2001

Fig. 12 The Print Room at Windsor Castle, May 2001

with fitted glass-fronted cupboards to the specification of Prince Albert and his librarians in the 1850s (fig. 12). Since the late 1970s this room and the adjacent Victoria Room (similarly equipped shortly after 1901) have been air-conditioned. In the 1990s a third room, the Lower Library – which had also been furnished with glass-fronted storage cupboards in the nineteenth century – was likewise air-conditioned and returned to its original purpose. This is where maps and plans are now kept.

The close association of the graphic arts collection with the Royal Library has resulted from the identity of materials (paper) and from the traditional method of keeping drawings and prints in leather-bound albums located on the shelves of libraries, along-side other printed or manuscript volumes. Originally the extensive seventeenth- and eighteenth-century collections were almost all

kept in bound volumes. These included the drawings by Leonardo da Vinci and by Hans Holbein the Younger, acquired by Charles II; and the extraordinary purchases of drawings and prints made by George III in the 1760s, including those from the collections of Consul Smith and of Cardinal Albani. With the addition of these new collections, which were stored in the King's new library rooms at Buckingham House (see pp. 357, 390), George III found himself the proud owner, for example, of drawings by Raphael and Michelangelo, scattered through the pages of five or six different volumes. In order to rationalise this situation much of the collection was disbound and reorganised into new series of albums, as recorded in manuscript inventories made for the King c.1800. Occasionally, a portfolio containing loose sheets is mentioned and indeed this was how many of the architectural

designs and other large sheets of drawings were kept. In addition, it is likely that part at least of the print collection was kept in portfolios, since in an illustration in Pyne's *Royal Residences* of one of George III's library rooms in Buckingham House a portfolio marked 'Hollar' is shown propped up against one of the plan chests. The work on the drawings and prints carried out in George III's time included laying down loose drawings on backing sheets, applying wash borders around the drawn sheet (see nos 363, 364), and binding or rebinding groups of drawings. A certain amount of basic repair work was probably also carried out, such as filling in and toning missing portions of drawings.

George III also formed an important collection of topographical and military maps and plans. The larger items in these collections were once stored in roll form and some of these retain the small rings (attached to their eighteenth-century linen backings) with which they were hung up for examination. The smaller items were kept either flat or folded in a series of paper-covered wooden solander boxes. While the boxes containing the topographical collection (now called 'K. Top') went to the British Museum in the 1820s, the fifteen boxes containing the 4,000 items which make up the military collection ('K. Mil') have remained with the maps and plans in the Royal Library at Windsor. Following the refurbishment of the Lower Library in 1997, the maps and plans were unfolded and transferred to a series of portfolios and large metal plan chests, but the empty boxes have been preserved.

At the time of George IV's gift of his father's library to the nation, the drawings and prints were retained in royal ownership; although these were transferred to Windsor with the rest of the Royal Library in the early 1830s, it was only after Queen Victoria's marriage to Prince Albert that the collection again came under scrutiny. The cupboards in the newly created Print Room area contained portfolios of prints organised in a number of different sequences whilst the drawings were still contained in albums. In his first report on the Print Room as Royal Librarian, the Reverend B.B. Woodward proposed that the drawings be 'laid down with mounts or "passepartouts," – so as to preserve the surface ... from all risk of injury' and that 'The whole of the engravings must be dismounted ... to be laid down ... by a simple process which will allow them, in case of necessity, to be removed without injury.'[39] In the following year, 1862, Woodward was able to report that 'progress of a satisfactory nature and extent has been made in the dismounting and cleaning of the prints', but no mention is made of the remounting of the drawings.[40] There is evidence that some remounting and conservation work was done at this period, but it is likely that the project as a whole lost impetus after the death of Prince Albert in 1861.

Another part of the Prince Consort's legacy that remains physically in the Royal Library today is the desk he designed for the safe-keeping of the collection of miniatures with its supreme examples by Tudor, Stuart and Georgian artists. The desk comprises six sets of shallow drawers in which the miniatures were laid and where they are still housed. Queen Victoria and Prince Albert took particular pleasure in ordering the collection as well as adding to it. Furthermore, payments were made to Guglielmo Faija for numerous repairs to miniatures and nearly the whole collection was fitted out with uniform frames supplied by H.J. Hatfield & Sons during the late 1850s. These are the frames in which all the miniatures included in the present selection are still kept; the exceptions are nos 46, 52 and 54 which were later additions (or returns) to the collection, and the large-format miniature by Holbein (no. 39).

The collection of prints was again reorganised during the early twentieth century. Royal portraits (sorted first by country and then chronologically), and prints by Dürer, Stefano della Bella, Hogarth and others, were rearranged in large bound albums. However, British portraits (sorted alphabetically by sitter); historical subjects; the collections of mezzotints, of sporting and naval prints; and engravings after the paintings of Reynolds, Landseer, Winterhalter and others, remained loose in portfolios, as did Prince Albert's 'Raphael Collection'.[41] More recently, the magnificent collection of etchings by Wenceslaus Hollar has been placed in individual mounts – a project begun in 1951 and completed in the 1970s.

One of the main activities in the Print Room during the later twentieth century was the mounting and conservation of the drawings and watercolours. This came about as a result of a number of considerations: first, the condition of individual items; secondly, the desire to create greater access through exhibitions; and thirdly, for scholastic purposes in connection with the publication of a series of catalogues raisonnés.[42] Thus the albums containing the Old Master drawings gradually began to be dismantled and during the reign of Edward VII an operation to mount the majority of the drawings dating from the fifteenth to the early nineteenth centuries was set in train. Some 12,000 drawings were remounted between 1905 and 1914 and the process was resumed after the First World War.[43] At this time very little remedial conservation was undertaken. The drawings were merely cut out of the eighteenth-century album pages and pasted – still on their backings – into cardboard window mounts with the original wash-line border pasted to the front board. It is likely that these mounts were originally cut in the bindery, but during the 1920s the task was sub-contracted to a local firm, J. Manley (of Windsor, and latterly Eton), although the actual mounting was

undertaken by the bindery staff. A few of the original albums escaped this process, notably the majority of Cassiano dal Pozzo's seventeenth-century 'Paper Museum',[44] Carlo Fontana's architectural studies, and Consul Smith's volumes of drawings by Ambrogio Figino, Sebastiano Ricci, Antonio Visentini, and his collection of caricatures.

Similarly, it was not thought appropriate to include the Victorian and military watercolours in this operation. This material was therefore reorganised and inserted into a new series of (even larger) albums. Once again, a small number of original albums were exempted, specifically several volumes from Queen Victoria's collection, including her Theatrical Album and those containing drawings of her animals, and the sketchbooks and volumes of 'royal art', extending from George III's childhood studies to those presented to Queen Victoria and Prince Albert by their children. With the growing interest in the nineteenth century and numerous loan requests for these watercolours, more and more of the Victorian collection in particular is now being permanently removed from volumes and mounted, although where original albums have survived, these are retained undisturbed.

What was once a 'library collection', therefore, has become a 'Print Room collection', in parallel with the example of the British Museum. The dismantling of the old volumes and the remounting of the individual drawings was initially carried out in the Royal Bindery, where at least 30 per cent of the binders' time was once spent on Print Room work. This did not stop short of mounting, but also involved framing and the making of solander boxes. After the decision was made in the early 1900s to begin breaking up the remaining albums of Old Master drawings, the then Librarian – John Fortescue – ordered a new type of box made to his own design, with an oxidised copper frame incorporating the front and back covers of the George III albums. The first of these was ordered in 1912 and in all some 350 were made for the sequence of Italian drawings.[45] From 1928 a more conventional type of box was used for keeping drawings of the remaining schools. These were made by the King's Binder, Frank Vaughan (binder 1914–39), of wooden construction and half-bound in brown pigskin and brown cloth.[46] A few of these are still in use, but the metal boxes have gradually been replaced since the 1970s. The majority of the mounted drawings are now housed in commercially made archival-quality solander boxes.

Until 1972 conservation work on the more important drawings was undertaken with the assistance of the conservators in the Department of Prints and Drawings of the British Museum. Thereafter the first Restorer of Drawings was appointed at Windsor and three additional members of staff have since been recruited to the Drawings Conservation Studio (fig. 13). From the

Fig. 13 The Drawings Conservation Studio at Windsor, April 2001

early 1970s the conservation programme for the Print Room collection was dominated by the lifting and remounting of all the drawings by Leonardo da Vinci, Holbein and Michelangelo in special double-sided mounts. This work involved the removal of the sixty-year-old mounts and of the associated glue and debris. The drawings were then encapsulated between two transparent acrylic sheets using fine silk gauze strips to suspend them at the corners. Each drawing was then placed in an acid-free cardboard mount with windows cut in both sides. The double-sided construction allowed the drawing to be viewed and exhibited from either side and made the examination of any watermarks possible.[47] This method of mounting, first developed at the British Museum during the 1960s, has since been extended to works by other artists and has become the usual method in the Royal Library for double-sided drawings and for fragile items generally.

The establishment of the Paper Conservation Studio at Windsor coincided with the increase in the number of exhibition loans. This provided the opportunity to undertake remedial conservation work, including the removal of old backings and repairs, the treatment of stains and discolouration, the reversing of darkened white lead pigment and the repair of fractures caused by acidic inks. Frequently, inscriptions and other historical information, and even 'hidden' drawings, have been discovered on the backs of sheets which had been laid down in the eighteenth century. As a matter of principle the conservation needs of each drawing are assessed on an individual basis and only the minimum treatment necessary is carried out.

In addition to the 'Print Room collection', there are also a number of drawings, watercolours and prints which have been

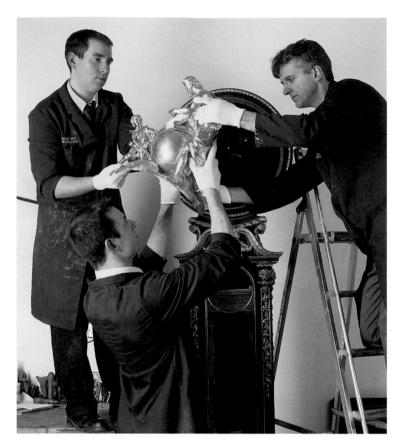

Fig. 14 The Cumming barograph (no. 83) being reassembled in the Marlborough House Workshops in the course of conservation, March 2001

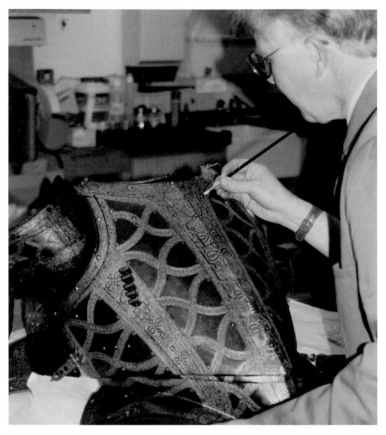

Fig. 15 Conservation work under way on the Greenwich armour made in 1585 for Sir Christopher Hatton, 1996

framed throughout their time in the Royal Collection. This category includes outsize drawings such as the series of cartoons by Raphael and by Cignani, but also pastels by Rosalba Carriera (for example no. 378) and Liotard (for example nos 386, 387), gouaches by Marco Ricci and watercolours by Paul Sandby.[48] Inevitably these works have been affected by exposure to light over the years. Since the late 1980s UV-filtration has been applied to the windows at Windsor, Buckingham Palace and elsewhere. This will protect both the works of art on paper and the textiles from further damage caused by light exposure.

There are a number of conservation issues which are shared between the Print Room and the Royal Archives; in both cases, the raw materials are chiefly paper and ink. The archives, housed in the Round Tower at Windsor since 1913, comprise the official, private and family correspondence and papers of the monarchs from George III to King George VI, with the exception of William IV whose papers have not survived.[49] They also include the papers of members of the royal family and the administrative records of the Royal Household. In addition to these records is the Royal Photograph Collection which includes over 300,000 images collected by the royal family since the early 1840s and assembled in the Round Tower over the past thirty years. The majority of

these photographs are kept in albums but many are loose. An even greater challenge is presented by the storage of negatives, thousands of the older ones being glass plate.

The spur to the creation of the Royal Archives was the accumulation of three different sets of papers that had previously been scattered – those of George III and George IV, those of the exiled Stuarts, and those of William, Duke of Cumberland – together with the formidable archives resulting from the long reign of Queen Victoria. Prince Albert had supervised the Queen's papers until his death in 1861, and it was he who brought in the services of the Royal Bindery to place Queen Victoria's papers into volumes. The papers, although protected from light, dirt and excessive handling, thus became subject to the same dangers as books, with the additional hazard of documents sometimes being folded or trimmed in order to fit into a uniform series of volumes. The introduction of new documents also posed a problem, and as a result many of the volumes were broken down into loose-leaf bindings in the 1920s. The Stuart papers were also bound into volumes in the early twentieth century. Such practices have now been superseded by modern conservation methods. Since 1977 there has been a specially appointed Paper Conservator in the Royal Archives whose task is to carry out a rolling programme of

conservation of the papers and photographs and to monitor storage conditions for both. Placing documents and photographs in polyester sleeves, housed in acid-free boxes, and the provision of specialised cabinets for glass negatives, have been major advances.[50] The acidity in papers of different quality is monitored; outsize documents are stored separately to avoid folding and where possible papers are kept flat to prevent buckling. For both documents and photographs low light levels, even temperatures and correct relative humidity are essential, and care is taken to maintain these by an air-conditioning system installed in the Round Tower in 1993.

All the items held by the Royal Library and the Royal Archives could be damaged by handling and a balance has to be maintained between preservation and accessibility. For exhibition purposes, while it would be invidious to display facsimiles of prints or drawings, it is often acceptable to use modern copies of old photographs and documents. For purposes of study, frequently consulted sections of the archives and the photograph collection have been microfilmed and are available for consultation in other institutions, while editions of several of the correspondence series have been published.

The two other conservation studios in the Royal Collection have evolved in parallel, although at different times, and fulfil similar requirements. These are, first, the workshops for the decorative arts – furniture, porcelain, metalwork, armour, sculpture and giltwood – established in 1953 and now located in a newly converted part of Marlborough House Mews (figs 14–16); and secondly, the studio for paintings, which was brought into being in 1981 in a space in Friary Court, St James's Palace, that had

been used as a studio by Princess Louise, Countess Gleichen, Sir Martin Charteris (The Queen's Private Secretary) and – at Sir Martin's invitation – the sculptor Oscar Nemon. At the same time an outpost to the Friary Court Studio was created at Hampton Court Palace. In 1999 a larger studio in a newly converted building in the Home Park at Windsor was opened where all aspects of picture conservation can be undertaken within a single area (fig. 17). Before the establishment of these new studios a great deal of work had been contracted to outside firms or individuals. The quarterly invoices for Windsor Castle submitted during the reign of Queen Victoria, for example, record not only the names of the craftsmen and suppliers, but also the nature and extent of their work towards the upkeep of the rooms in the castle. Thus, William Bartlett of No. 18 Blenheim Street, London, on 30 September 1858 itemises 'An oriental vase cemented together modelled up and repaired in the red white, Blue and Gold' and also 'A Royal Blue Sèvres Vase with Mounts cemented together in 10 Pieces and modelled up and repaired in the Blue'. Apart from different levels of technical knowledge, each firm or independent conservator brought their own approach to the tasks allotted to them. The result was that degrees of finish varied dramatically. The establishment of the Royal Collection's own studios has encouraged a more balanced approach to conservation which is dictated by the special nature of the collection, as well as submitting it to a constant appraisal.

The impetus for the creation of the two studios in Marlborough House Mews and St James's Palace came from different directions. The close historical association between the Royal Collection and the Wallace Collection in Manchester Square was

Fig. 16 The painted chest-of-drawers (no. 84) in the course of conservation in the Marlborough House Workshops, March 2001

Fig. 17 The Paintings Conservation Studio at Windsor with work under way on nos 12 and 16, June 2000

underscored by the dual appointment of two successive Directors of the Wallace Collection in the twentieth century – Sir James Mann and Sir Francis Watson – as Surveyors of Works of Art. The workshops of the Wallace Collection were in effect the model for the Royal Collection studio when it was first established at Marlborough House Mews. Indeed, the first two conservators began in the Wallace Collection's own workshops working solely on items from the Royal Collection before transferring to Marlborough House Mews. Correspondingly, the acknowledgement of the need for a conservation studio for the paintings in the Royal Collection was in part inspired by the lead given by other institutions such as the National Gallery, but also by another influential body with which close relations are still maintained, namely the Hamilton Kerr Institute founded in 1976 by Herbert Lank in the University of Cambridge, for the purpose of training conservators.

In the context of a working palace, furniture and porcelain are especially vulnerable. Furniture in particular suffers from being frequently moved in order to meet varying demands and by definition its very mobility endangers it. Accidents will inevitably occur and vigilance is a prime curatorial duty. Yet, despite these intrinsic difficulties, a pragmatic conservation regime is in place in which the specialists work closely with housekeepers and palace attendants – an elite corps as regards royal residences – in the setting of standards. The ethics of conservation are dictated by utilitarian needs in so far as the objects are presented in a working environment. Such an approach is not governed unduly by the needs of the exhibition circuit or solely by scholarship, but by the need to offset deterioration. Similarly, the degree of finish is dictated as much by the setting as by the history of the object, on the basis that the ensemble is almost always more important than any single item.

The nature of the Royal Collection is such that specialist knowledge in all the studios has to be diverse. The skills at the Marlborough House Workshops range across wood, metal, porcelain and any combination of these materials. Treatment is undertaken on the basis of minimum intervention. Among the major pieces from the collection that have been conserved in the studio in recent years, the elaborate *Temple and Oracle of Apollo* (RCIN 30037), which is now on view in the State Apartments at Windsor Castle, well exemplifies this approach. This outstanding object – which was acquired either by Frederick, Prince of Wales, or by his wife Augusta, Princess of Wales – is, in effect, a sophisticated musical toy, incorporating a casket made by Melchior Baumgartner of Augsburg in 1664. The organ clock in the base, devised by Charles Clay during the first half of the eighteenth century, plays ten tunes, five of which were specially arranged by

Handel. George IV later added, amongst other embellishments, the gilt bronze group of *St George and the Dragon* attributed to Francesco Fanelli to the top of the casket, into which Queen Victoria placed General Gordon's Bible. Another considerable undertaking has been the conservation of the three white marble and gilt bronze models of Roman triumphal arches by Giovacchino and Pietro Belli (1808–15; nos 69–71) for the *Royal Miscellany* exhibition in The Queen's Gallery in 1990–1. Over a longer period work has been proceeding on an extensive set of ivory-veneered furniture carved and engraved with European and oriental motifs. Probably made in Madras for Alexander Wynch, Governor of Fort St George, these intriguing pieces (including no. 85) were acquired by George III for Queen Charlotte, a passionate collector of ivory furniture.

Similar advances have been made in the Paintings Conservation Studio where structural work and scientific examination now form part of carefully co-ordinated treatments. As elsewhere in the collection, conservation involves – and is to a certain extent determined by – examination of previous restoration. The surface of many of the paintings and objects in the Royal Collection resembles an archaeological site in the traces of earlier treatments, all now forming part of the history of the work. The most protracted and complicated treatments that have been undertaken on paintings in recent years include Pieter Bruegel the Elder's *The Massacre of the Innocents*, Lucas Cranach the Elder's *Apollo and Diana* (no. 3), Rubens's *The Holy Family with St Francis*, Van Dyck's *St Martin dividing his Cloak*, and Rembrandt's *Self Portrait*. Of these, *The Massacre of the Innocents* (c.1556–7) has one of the most interesting conservation histories of any picture in the collection, having been altered at an early date, possibly while in the collection of Rudolf II at Prague in the seventeenth century. The alterations chiefly involved substituting animals and bundles of clothes for the children, thereby converting the subject into the sacking of a village as opposed to a blood-thirsty massacre. For the purpose of the treatment undertaken in 1987–8 it was decided to retain the animals and shapes of the bundles of clothes, partly because such alterations were central to the history of the picture and partly because of the danger of removing the remaining forms of the images of the children emerging from below the upper layers of paint. This was a difficult balance to maintain. The overlaying of forms may have led to a loss of visual clarity but, on the other hand, the history of the painting remains intact. *St Martin dividing his Cloak* by the young Van Dyck, painted while the artist was still working closely with Rubens, posed problems because of the numerous changes made to the design and format. Such matters are resolved as much by the conservator's judgement, in consultation with art historians, as by technical analysis. The

complications of the *Self Portrait* of 1642 by Rembrandt, however, have been revealed over several years with the aid of X-rays and infra-red examination; beneath the visible surface of the picture there are at least two other earlier genuine self portraits.

There are two further independent conservation sections that relate to the decorative arts in the Royal Collection. The royal residences contain about 1,400 clocks (excluding watches, barometers and sundials) and it is the duty of three specialist conservators divided between Buckingham Palace and Windsor Castle to keep them in working order. Previously sub-contracted to such firms as Vulliamy (1754–1854) and Charles Frodsham & Co. (1854–1983), responsibility for the upkeep of the clocks passed from the Master of the Household to the Royal Collection in the mid-1980s. Until that time, the concern had been for accurate time keeping and general maintenance, but the administrative change signalled a more considered approach to conservation. Clock movements are now systematically and regularly cleaned but, in addition, many of the striking mechanisms have been reinstated.

Within the Marlborough House Workshops one conservator has sole responsibility for the arms and armour, of which the Royal Collection has one of the outstanding collections in the country. As with all other works of art, arms and armour suffer in adverse environmental conditions, especially damp. A list of 'Recommendations for the preservation of the Armour and Arms'[51] made in 1831 states that 'it is expected if the following directions are attended to no cleaning will be required for several years'. This advice is tabulated as follows:

1. To keep the Windows of the Room closed in damp or wet weather and as much as possible the Doors also
2. When dusting becomes necessary to use a soft feather Brush, carefully endeavouring in beating off the dust not to disturb the Varnish
3. If rust should appear or other damage should take place, the proper Officer to make application to the Board of Ordnance to have articles removed and when repaired and varnished restored to their places

Most of the early restoration work on the arms and armour in the Royal Collection was undertaken by the Tower of London Armouries (now the Royal Armouries); only in 1958 was a full conservation programme initiated with the appointment of a specialist. Scholarship has been a spur to activity, notably in the preparation of a forthcoming catalogue raisonné of swords and edged weapons by the late A.V.B. Norman. However, the display of arms and armour has been a vital and continuous element in the interiors of royal residences (see pp. 32–3). In addition to important suits of armour made for Henry VIII and the early Stuarts at Greenwich, now on display at Windsor Castle, there are numerous swords – their bejewelled hilts much appreciated by George IV – sporting guns and a certain amount of oriental armour which require regular care. The challenge for the conservator is the wide range of materials associated with arms and armour – metal, leather, fabric, jewellery, wood, silver wire – and the different shapes, as well as the variety of finishes.

The pattern for the development of the emerging specialist studios in the Royal Collection outlined above is perhaps best and most dramatically exemplified by the Textile Conservation Studio located at Hampton Court Palace, the headquarters of the Historic Royal Palaces Trust.[52] The close historical association of textiles with royal residences or grand houses, the nature and quality of the materials, and the size of the collection (some 250 items) are factors that have been instrumental in devising a realistic policy for their conservation. The studio is not only concerned with tapestries, but also treats historic furnishings, bed-hangings, embroideries and costumes. A workshop for the treatment of textiles was officially established at Hampton Court Palace in 1912. Until 1940 this was under the control of Morris & Co. Subsequently it was maintained by a series of seamstresses and embroideresses answerable to the Ministry of Works with a member of the staff of the Victoria and Albert Museum acting as adviser. During the 1960s great concern began to be expressed about the deterioration of the collection of tapestries and the inadequacy of the resources at Hampton Court Palace to cope with such a prestigious group of works. By the late 1970s there was a division of labour between those responsible for the tapestries and the needlework studio working on bed-hangings and embroideries, but both sections were overwhelmed by the amount of work. This situation needed to be rationalised, the staff to be properly trained in modern techniques, the facilities to be improved, and a programme of work to be agreed.

The Textile Conservation Studio in its modern form (fig. 18) was established in 1980 with the assistance of the Crown Suppliers. A carefully considered policy of conservation as opposed to restoration (which had often involved reweaving or replacement) was established at the outset, and a rolling programme of conservation commenced. The urgency of the problem could be demonstrated statistically as it was soon calculated that to treat the major textiles in the collection on the basis of a rolling programme would involve a staff of seven for forty-three years. Before this recent initiative the only major sustained campaign to restore tapestries had occurred during the reign of William III and Mary II when work was undertaken by the Great Wardrobe,

Fig. 18 The Textile Conservation Studio at Hampton Court, with work under way on tapestries from the *Dido and Aeneas* set (foreground), the *History of Abraham* set (right background), and the *Vulcan and Venus* set (left background), April 2001

notably on the two series illustrating the lives of Abraham and Joshua. For two hundred years or so little if any work was carried out on the textiles until the Hampton Court fire of 1884 highlighted the degree of neglect. The Surveyor, Sir J.C. Robinson, wrote then that 'the tapestries at Hampton Court are very ancient and that they must now be regarded rather as curious relics of antiquity than decorative furniture. I do not think that any attempt should be made to renovate or systematically "restore" them, but that whatever is done should be confined to arresting further decay and disintegration.'[53] Treatment, therefore, until the establishment of a proper studio in 1912, was piecemeal and unsystematic.

Textiles are more vulnerable than most works of art mainly because of their size and physical properties. They were frequently moved from palace to palace, which involved rolling and unrolling them followed by constant rehanging. Handling has always been an occupational hazard. Other less obvious problems arise from the accumulation of dust caused by visitors, the invasion of insects – particularly moths – and the presence of moisture in the atmosphere. Changing conditions cause textiles to increase or decrease in weight which in turn causes bulging or sagging that puts pressure on the threads. The greatest danger, however, remains exposure to light which results not only in fading but – in the case of tapestries made with gold and silver thread (including the

Abraham and Joshua sets) – also in chemical change. The Abraham set, for instance, has been on almost continuous view in Hampton Court Palace for over three hundred years.

The creation of a modern studio in 1980, which was due in no small part to the prompting of Sir Geoffrey de Bellaigue, Surveyor of The Queen's Works of Art (1972–96), amounted to recognition of an inherited problem. However, it was only with the provision a few years later of a properly equipped workshop – a space divided between textiles and furnishings – that major advances could begin to be made. The fire of 1986 at Hampton Court Palace gave further impetus to the work of the studio. Distinguished sets of tapestries – *The History of Alexander*, *Dido and Aeneas*, *Triumphs of the Gods*, *The Battle of Solebay* – were all treated in preparation for the reopening of the King's Apartments in the Palace in 1992. Since that time the public has been able to enjoy a superb display of one of the outstanding collections of tapestries in the world. Other furnishings such as throne canopies and state beds also received extensive attention following the fire. The experience gained after 1986 was also beneficial in the aftermath of the fire at Windsor Castle later in 1992 when the *Jason* tapestries from the Grand Reception Room were cleaned and conserved. The staff of the Textile Conservation Studio, from 1991 under the umbrella of the Historic Royal Palaces Agency (later Trust), now includes a scientist to undertake research on the materials and to monitor display conditions. A major development also occurred with the conversion of a large disused greenhouse at Hampton Court Palace into a wash building. Washing a large tapestry is a hazardous business because of the weight of the material, the strain on the threads, and the need for controlled drying, all of which can now be managed in scientifically monitored conditions. As a result, the expertise in the studio is now widely recognised and includes the wet cleaning of large textiles, the conservation and display of costumes, and research into all aspects of textiles. Work on tapestries from other collections – the Palace of Westminster, the Cleveland Museum of Art, the collection of the Duke of Buccleuch and the Government Art Collection – is also undertaken by the studio.

The various integrated studios now in place to conserve different parts of the Royal Collection have become centres of excellence. The standard of work and the range of skills displayed in these studios complement both the historical significance of the collection as a whole and the high quality of many of the individual works of art. The emphasis placed on conservation in the context of national heritage is widespread, but nowhere is it more axiomatic than in the Royal Collection. The achievement, which has come to fruition during the present reign, at once honours the past and bodes well for the future.

1 Quoted by White 1987, p. 258. On the twentieth-century conservation history of the ceiling paintings by Rubens see Bryant 2001, pp. 132–4, an article that includes details of conservation projects in other royal buildings.

2 For a full account of the cartoons see Shearman 1972.

3 Shearman 1972, pp. 148–64 and Meyer 1996.

4 Faraday Correspondence 1993, II, nos 1099, 1101, 1103, pp. 510, 511, 513.

5 Fermor 1996 and Fermor & Derbyshire 1998, and for the photographs Casteras & Parkinson 1988, no. 163.

6 For a full account of the Triumphs of Caesar see Martindale 1979.

7 Jameson 1842, II, p. 372.

8 Martindale 1979, p. 127.

9 Martindale 1979, pp. 109–22 and 125–8.

10 See Carlton House 1991, pp. 9–50.

11 Quoted in Carlton House 1991, p. 40.

12 De Bellaigue (G.) 1985, pp. 203–07.

13 The above passage is based on Carlton House 1991, pp. 39–40. For George IV's debts see Millar (O.) 1986, pp. 589–91.

14 Pope-Hennessy 1959, p. 410.

15 Pope-Hennessy 1959, p. 412.

16 The set comprises 100 portraits painted by De Wet between 1684 and 1686. At present 89 are on display in the King's Gallery; 53 were restored by Historic Scotland between 1973 and 1986; and the remaining 36 (on the south wall) are in the process of being restored.

17 Lloyd 1991, no. 39.

18 Millar (O.) 1969, no. 798.

19 Laking 1905, pp. 24–5.

20 Quoted by Lloyd 1992, pp. 72–3.

21 Quoted by Levey 1990, p. 9.

22 Law 1898, p. xxxvii.

23 On Dalton's activities see Millar (O.) 1977, pp. 118–21 and Mahon & Turner 1989, pp. xxii–xxxiv. For Consul Smith see QG 1993, exh. cat.

24 For an assessment of Seguier see Egerton 1998, pp. 388–98 and also Laing in Sitwell & Staniforth 1998, pp. 97–120. The principal document for the National Gallery in the mid-nineteenth century is the Report from the Select Committee on the National Gallery with Minutes of Evidence, Appendix, and Index, 1852–53 which provoked much discussion (see Edinburgh Review 1853, pp. 390–420 and 1854, pp. 526–56 both by James Dennistoun).

25 For Van der Doort and Charles I see Millar (O.) 1960, pp. xiii–xvii.

26 Millar (O.) 1960, p. 89.

27 Millar (O.) 1960, p. 191 and McClure 1998a, p. 244. The painting is Shearman 1983, no. 181.

28 McClure 1998b, p. 88.

29 Millar (O.) 1960, p. 173.

30 McClure 1998b, p. 88.

31 References given by Millar (O.) 1977, p. 47.

32 Beard 1970, p. 492.

33 Millar (O.) 1977, pp. 103–05.

34 Millar (O.) in Casteras & Parkinson 1988, pp. 86–92; McClure 1998a, pp. 245–9, and McClure 1998b, pp. 92–4.

35 Heleniak 2000, pp. 99–104.

36 For the Royal Library see QG 1990–1, exh. cat.

37 QG 1974–5, exh. cat., p. 9 referring to Ramsden 1958.

38 De Quincey 1853, I, pp. 169–70.

39 Woodward 1861.

40 Woodward 1862.

41 On the 'Raphael Collection' see Ruland 1876 and Gere & Turner 1983, pp. 10–11. The collection was returned to the Print Room from the British Museum in January 2001.

42 There are twenty-four volumes in the series so far; the first Windsor catalogue raisonné was published in 1935 (K. Clark, The Drawings of Leonardo da Vinci in the Collection of His Majesty the King at Windsor Castle, 2 vols, Cambridge (revised as Clark & Pedretti 1968–9)) and the most recent in 2000 (Leith-Ross 2000). In addition, many of the volumes in the two series of catalogues that comprise The Paper Museum of Cassiano dal Pozzo (abbreviated as CDP) are concerned with drawings in the Royal Collection.

43 Fortescue 1933, p. 202.

44 On the Cassiano dal Pozzo 'Paper Museum' see CDP.

45 J. Fortescue, memorandum to the Keeper of the Privy Purse, 12 October 1923 (RA PP/TREAS/GV/27/2); Fortescue 1933, p. 200.

46 O. Morshead, memorandum to the Deputy Treasurer to the King, 20 November 1928 (RA PP/TREAS).

47 Donnithorne & Warnes 2001. For watermarks see, for example, Roberts (J.) 1988.

48 Both the Cignani cartoons and the gouaches by Ricci are catalogued by Levey 1991, nos 449–55 and nos 591–622. For Sandby see Oppé 1947.

49 De Bellaigue (S.) 1998, pp. 10–21.

50 Gray & Gent 1999.

51 In 'An Account of the Armour and Arms in the Guard-chamber at Windsor Castle' (MS; RCIN 113352).

52 The following is based in part on two documents kindly made available by Jenny Band: Notes on the History of the Textile Conservation Studios at Hampton Court Palace (11 February 2000) and also Chronological Report on the Conservation of Textile Contents by the TCS since 1928.

53 Quoted by Jenny Band in Notes on the History of the Textile Conservation Studios at Hampton Court Palace (11 February 2000), p. 2.

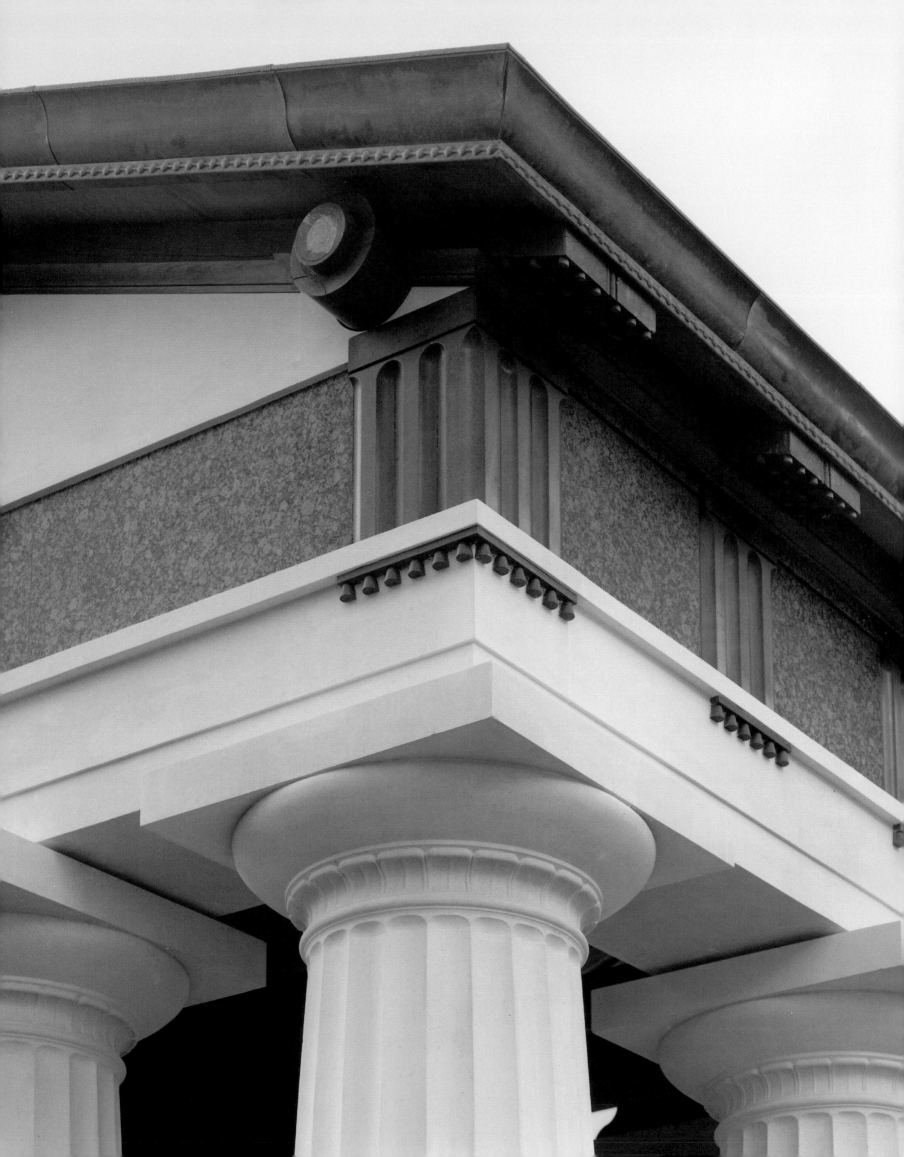

The Queen's Gallery rebuilt

David Watkin

HE NEW QUEEN'S GALLERY, built to mark the Golden Jubilee of Her Majesty The Queen, does more than simply replace the old gallery of 1962. It effectively provides a new centre for the visual arts in the heart of London. Containing three and a half times as much gallery space as before, it is approached through a striking Doric portico leading to a magnificent double-height entrance gallery and staircase. Additional facilities include an education room, a lecture theatre which can also be used for receptions, and a greatly extended shop. In a striking departure from the minimalist treatment of many modern museums, the interiors designed by John Simpson are rich with ornament, colour and relief, in harmony with those of the palace itself, so that, like the great galleries of the past, they complement the rich works of art which they contain.

In creating Buckingham Palace in the 1820s, John Nash effortlessly incorporated Buckingham House, built in 1702–06 and altered by Sir William Chambers from the 1760s. In adding new galleries and associated spaces, John Simpson has similarly had to work within the complex building as remodelled after Nash's time by Edward Blore in 1832–43, Sir James Pennethorne in 1853–5, Sir Aston Webb in 1913, and the Office of Works in 1962. On all these occasions except the last, versions of the classical language of the original building were adopted. John Simpson's new façades and interiors, inventive yet sympathetic to the traditions of the palace, triumphantly demonstrate the wisdom of responding to the *genius loci*. The new gallery spaces are named after the three principal architects involved in the creation of Buckingham Palace: Chambers, Nash and Pennethorne.

During the dominance of Modernism in architecture, architects ignored the advice offered by Leon Battista Alberti, the greatest architectural theorist of the Renaissance. He urged that an architect called on to continue an existing building should not show pride by indulging in innovation but should accept that 'the original intentions of the author, the product of mature reflection, must be upheld'. The new Queen's Gallery shows that an architect who follows the spirit of these recommendations is in no way prevented from producing designs of startling freshness and beauty. This new work owes much to a sensitive response to the work of two early nineteenth-century architects, John Nash and John Soane, from whom Simpson feels that we have much to

learn; both were pioneers in the display of works of art in public and private galleries, and both were employed by the government in the reign of George IV, frequently being obliged to work within existing buildings. The new galleries and lecture theatre are, indeed, partly situated on top of the Palace Kitchens, and partly behind an existing Victorian screen wall.

A limited competition was held in 1997 to provide designs to replace the existing Queen's Gallery of 1962 (see fig. 9), the impetus for which had owed much to the imagination of the Duke of Edinburgh. Not surprisingly, the air-conditioning and services of that gallery had become inadequate and outdated, there was no access for the disabled, and no proper serving areas for functions and parties. Even more significantly, it was felt necessary to respond to the way in which the expectations of the exhibition-going public had expanded since 1962. It was thus important to provide a more flexible and intelligible series of exhibition spaces with the capacity to show a far wider range of objects from the Royal Collection.

Those invited to submit designs in 1997 were Jeremy Dixon, Piers Gough, who declined, Michael Hopkins, Sidell Gibson, John Simpson and Bowyer Langlands Batchelor. With the exception of Simpson's, the designs tended to be somewhat neutral, whether in a Modernist or traditional direction. This may have been because historic buildings have come to present a problem for modern architects, for the view has often been promoted that additions should not be made to them, and that all parts of them, regardless of aesthetic merit, should be preserved equally as a faithful record of their historical development. Simpson believed that if an architect was prepared to work with the grain of the existing building, he could afford to be quite bold. He had been well prepared for this task, having just carried out a scheme of similar complexity within historic buildings at Gonville and Caius College, Cambridge.

At The Queen's Gallery his sensitivity to local traditions is evidenced in the new entrance portico which, appropriately, recalls the Greek Doric columns of the screen walls flanking the entrance front of the palace. Much thought was given to the important question of this new entrance, for an unsatisfactory feature of the former gallery was that the approach was through a mean side door off Buckingham Palace Road. Visible from a distance, the

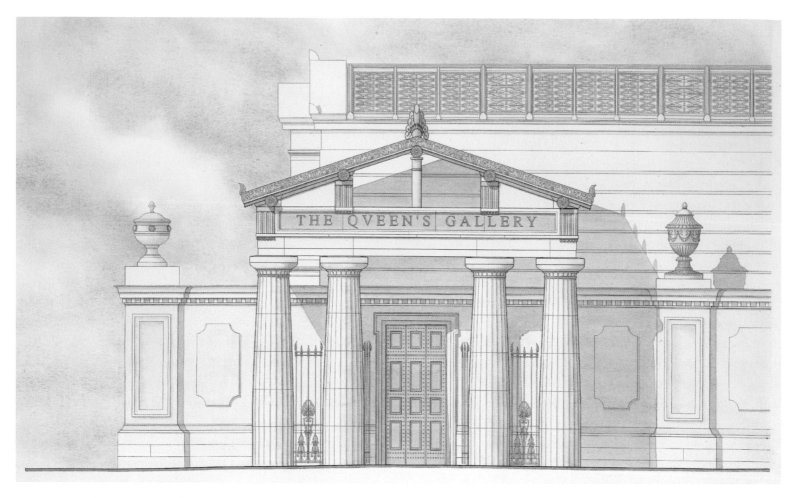

Fig. 20 Design by John Simpson for the Doric portico which forms the entrance to the new Queen's Gallery, 2000 (RL 33727)

new portico and higher pedimented entrance hall behind it beckon visitors towards the gallery, the existence of which had previously been scarcely indicated. By moving back the railings from Buckingham Palace Road, a modest public piazza has been created on a space formerly used as a car park.

The arresting entrance (fig. 20) is of Portland stone, like the entrance front of the palace which was added in 1913. Columns in the Greek Doric order, the most solemn of the ancient Greek orders, proclaim the significance of the space to which the portico gives access. The frieze in red granite and green Westmorland stone includes the customary triglyphs and metopes of the Doric order. Two triglyphs are unusually raised up above the frieze to act as brackets supporting the open pediment with its raking cornices in richly ornamented copper, the kind of ornament which has now disappeared from ancient Greek temples. The ceiling within is similarly ornamented with painted decoration of the kind originally applied to Greek temples.

The portico leads into an imposing entrance hall, two storeys high, conceived as a temple of the arts. It features fluted, baseless, Greek Doric columns with the swelling profiles of those of the Temple of Hera I, long known as the 'Basilica', at Paestum. Dating

from the mid-sixth century BC, it is one of the earliest Doric temples, its columns boasting unique capitals, carved with palmette and lotus ornament which Simpson has echoed in his own capitals. A finely lettered inscription on the left of the entrance, carved by Tom Perkins, records the opening of the new gallery. High above the columns run two great figured friezes modelled in clay and cast in plaster by the Scottish sculptor, Alexander Stoddart. Drawing on themes from the epics of Homer, the Odyssey and the Iliad, they symbolise and celebrate the reign of Her Majesty The Queen. They are framed on each side by smaller panels representing the patron saints of England, Scotland, Wales and Ireland.

From the entrance hall the visitor passes below two life-size genii by Stoddart (fig. 21); these surmount the columns flanking the entrance to the dramatic staircase hall. Here, the landing is dominated by a bronze bust of The Queen at the time of her Coronation, since the building celebrates her Golden Jubilee. This bust is also the work of Alexander Stoddart. Like Simpson's architecture, Stoddart's sculpture complements Nash's existing building which also features narrative figured friezes, including those in the Throne Room, Grand Staircase and Blue Drawing Room, designed

by Thomas Stothard; and on the garden front by Richard Westmacott. Simpson and Stoddart have here brilliantly revived the tradition, needlessly lost in the twentieth century, of uniting architecture and sculpture in a way which celebrates architecture as the mistress art with painting and sculpture as her handmaidens. The cost of the sculpture was generously borne by the Royal Warrant Holders as their Jubilee gift to The Queen.

Lighter in mood than the entrance hall, the staircase hall has walls adorned with Ionic columns and pilasters of green scagliola and a staircase with graceful cast bronze banisters sporting floral classical ornament. These recall the great staircase at the Altes Museum, Berlin, designed in 1823 by Schinkel to house the Prussian royal collection in a new building that was always intended to be open to the public.

From the landing, visitors have a choice of direction: they can turn left into a space designed both for educational use and for small, specialised exhibitions; right, up a short flight of stairs into the lecture theatre (the Redgrave Room, named after Richard Redgrave: see p. 51); or they could proceed to the three new galleries. The two principal galleries are top-lit in a way inspired both by Nash and by Sir John Soane who was the master of top-lighting, as in his own house and museum at No. 13, Lincoln's Inn Fields. The new gallery spaces and the theatre are also all on the same level so as to ensure ease of access.

The design of the galleries varies so as to relate to the display of different types of objects. The first (the Chambers Gallery) has been primarily designed for the exhibition of works on paper from the incomparable collection of the Royal Library at Windsor Castle. It thus has movable screens and no natural light, though it can also be used to display a mixture of other objects. The source of the artificial lighting is discreetly concealed, as in many of the new rooms, from within the elegantly coffered ceiling; as often in Simpson's work, what appears to be pure decoration also serves a modern technological role. Similarly, the beautiful cast-iron grilles in the floor are part of the heating and cooling system.

Parallel to this graphic gallery is the Pennethorne Gallery with an elaborate tripartite roof inspired by the work of Nash. This top-lit gallery provides a handsome space for a display of works of art from the Royal Collection which will be open all the year round. From time to time, depending on the exhibition programme, it will also be used in conjunction with the other galleries for larger themed exhibitions. Leading off the Pennethorne Gallery are two cabinet rooms for the display of small objects such as miniatures, Fabergé, silver and jewellery; or for the mounting of small 'object in focus' exhibitions. The Soanean element in the domed ceilings of these intimate interiors reappears on a larger scale in the lecture theatre which contains columns bearing capitals adorned with

lotus leaves inspired by those at the Hellenistic city of Pergamon in Asia Minor. The rosettes in the coffered ceiling panels conceal the equipment for the air-conditioning system.

Further on, there is a substantial lobby lined with cabinets for the display of objects such as silver and porcelain. It has glazed doors allowing views into the Buckingham Palace gardens when The Queen is not in residence. This welcome feature will enable visitors to orient themselves in relation to the rest of the palace and its gardens. From this lobby we reach the final room: the Nash Gallery which replaces the original Queen's Gallery of 1962.

Simpson has here taken the opportunity of creating a new interior which, unlike the gallery of 1962, is in harmony with the exterior of the Nash pavilion in which it is contained (see no. 417). That pavilion was one of three which Nash designed at the corners of the palace. Simpson studied the contribution to gallery

Fig. 21 The sculptor Alexander Stoddart in his studio in Paisley with the clay models of the two genii, for the entrance hall of the new gallery, December 2000. The figures are waiting to have their hands finally positioned to receive the torches. Two plaster studies are seen on a stand.

Fig. 22 Detail of the ceiling of the Nash Gallery

The shop on the ground floor is another important feature, generating income for the care and maintenance of the Royal Collection. Though it was considered inappropriate for visitors to have to walk through the shop on arrival, it can be approached directly from the entrance hall. Containing a series of shallow Soanean domes, it is twice the size of the previous shop, having expanded into the enclosure created in the 1980s for the police who serve the palace. Adjacent to the shop is a 'virtual gallery' or multimedia gallery with electronic information about items in the Royal Collection. Resolving the awkward external junction between the Victorian buildings and the 1980s police base above the shop, Simpson has created on the garden side of the palace a building containing the education room and the end of the graphic art gallery. Built in Bath stone, this substantial addition to the west front of the palace resembles a garden pavilion, its pedimented north front featuring an arch breaking into the entablature. This form echoes a building in the precinct of the Temple of Isis at Pompeii, while the unusual floral ornament of the capitals of the engaged Greek Doric columns was inspired by that in the peristyle at the same precinct. There are engraved views of this temple in the Royal Collection which Simpson found helpful, while he also took measurements on site at Pompeii.

Visitors will be struck by the beauty of the detail in areas such as cloakrooms, lavatories and lifts – so often ignored in modern public buildings. Ornament, regrettably abandoned in the last century, is everywhere present. Frequently based on plant forms such as flowers, buds and leaves, it is gracefully and imaginatively stylised in a range of materials, including cast iron, bronze, copper, stone, marble, fibrous plaster, stencil, scagliola and etched glass.

The whole architectural system adopted by Simpson also differs from the throwaway approach to building which developed in the Modern movement with its energy-intensive materials and its short lifespan. Simpson's walls of brick and stone, with roofs of lead and copper, are durable and low in maintenance costs; and naturally chilled water, extracted from below the palace gardens, is used to support the air-conditioning system. The Queen's Gallery rebuilt is both beautiful and functional; an enduring triumph of modern craftsmanship, it will inspire future generations as well as provide a fitting tribute to the Golden Jubilee of Her Majesty The Queen.

design of Soane from whom Nash borrowed the idea of ceilings with hanging arches and little glazed saucer domes or lanterns. In the 1820s, Nash adopted this in his Picture Gallery at Buckingham Palace (see no. 420), since altered, as well as in two other galleries, both now demolished: for the sons of Benjamin West in Newman Street, and in his own house in Lower Regent Street, an interior admired by Schinkel on his visit to London in 1826. Simpson's massive ceiling beams in the Nash Gallery are carried on brackets richly adorned with acanthus leaves, echoing those by Nash elsewhere in the palace. As well as being beautiful, the beams are functional for they double as walkways enabling technicians to reach the lights without recourse to scaffolding.

Catalogue

In the following entries George IV, Edward VII and King George V are normally referred to by these titles, although before accession they were correctly known as either Prince of Wales or (for George IV, from 1811) Prince Regent, or (for King George V, from 1865 to 1901) Duke of York. Dates preceded by r. indicate extent of reign. Normal conventions are adopted for descriptions of media and measurements. For manuscripts, books and works of art on paper, the support is white paper unless otherwise stated. In all the measurements, height precedes width. RCIN indicates the unique number of the object concerned in the Royal Collection's inventory system; for drawings and watercolours the RL number is that of the old (Print Room) inventory. The bibliographic references included under LITERATURE may be supplemented with information included in the catalogues published to accompany the EXHIBITIONS cited; archival (including inventory) references are given where relevant, particularly for unpublished items. Whereas all recorded loans are noted under EXHIBITIONS (with reference to the Exhibition abbreviations listed on p. 472), LITERATURE cites basic bibliography only. Small exhibits (miniatures, gems and jewels, gold boxes, etc.) are reproduced actual size unless otherwise captioned.

I

PAINTINGS (nos 1–36)

The paintings in the Royal Collection constitute one of the greatest and most remarkable groups of such works ever assembled. This distinction arises not so much from the number (some 7,000) or the location in royal residences as from the variety of works. The collection ranges from masterpieces by the most famous names in European art to indifferent versions and lowly copies, clearly mirroring the heterogeneous way in which it has been assembled over five centuries. The Royal Collection does not have a stated duty to provide a comprehensive display of European painting in the manner of the National Gallery. Rather, its primary function is to complement the status of monarchy. In addition it illustrates the interests of the different dynasties as well as celebrating the achievements of royal connoisseurs.

Of all the schools of painting the most extensively represented is the British. The paucity of indigenous talent at the outset led to the employment by the Tudor and Stuart courts of artists of the calibre of Hans Holbein the Younger (no. 6), Rubens (no. 8) and Van Dyck (no. 11). Their example helped to nurture a British school of painting which had by the eighteenth century achieved a true identity of its own in the work of Sir Joshua Reynolds (no. 21), Thomas Gainsborough (no. 23) and Johan Zoffany (no. 24). The traditions of eighteenth-century British painting – associated mainly with portraiture, conversation pieces, landscape and narrative scenes – were carried into the following century and developed further by artists such as Sir William Beechey (no. 26), William Powell Frith (no. 32) and Sir Edwin Landseer (no. 30). The twentieth and early twenty-first centuries, which have seen a revival of British painting, are represented by Paul Nash (no. 34), Graham Sutherland (no. 35) and Lucian Freud (no. 36). The paintings of the British school include eight royal commissions, each of which is associated with portraiture. However, Zoffany's *Tribuna* (no. 24) is as much concerned with recording art as it is with recording connoisseurs, and George IV was principally interested in the likenesses of his horses created by Stubbs (no. 22), rather than in that of his groom.

Charles I was a particularly avid admirer of Italian painting and during his reign the quantity and quality of his pictures, particularly after the acquisition of the Gonzaga collection in Mantua, justified a favourable comparison of the British palaces with those of other European courts. The representation of works

5 (detail)

by Raphael, Leonardo da Vinci, Titian, Tintoretto and Correggio – as well as of contemporary painters such as Annibale Carracci (no. 7), Guido Reni and Orazio Gentileschi – was a high point in the history of the collection, which was irrevocably shattered by the dispersal of many paintings after the death of Charles I. The King had a penchant for the Venetian school and he owned a notable group of pictures by Titian. One of the consequences of forming such a collection was the reputation that the court of Charles I established for connoisseurship. Thus painters such as Rubens and Van Dyck – both distinguished collectors in their own right and fully aware of the holdings of the major European courts – could be relatively easily persuaded to work in London.

Although Charles II was aware of the significance of his father's achievements as a collector, the endeavours to restock the

palaces with pictures after 1660 – which resulted in nos 4, 5 and 10 entering the collection – could hardly equal Charles I's magnificent purchases, even if Charles II's acquisitions included such remarkable works as The Massacre of the Innocents by Pieter Bruegel the Elder. Later acquisitions of Italian paintings, during the reign of George III, again created a nucleus of the Venetian school, this time of eighteenth-century works, with incomparable examples by Sebastiano Ricci and Canaletto (no. 19). Mingling among the Italian paintings acquired in 1762 from Joseph Smith – the British Consul in Venice – were some examples by artists belonging to the Dutch and Flemish schools, including A lady at the virginal with a gentleman by Vermeer (no. 17), then attributed to Frans van Mieris. Primitive art of the early Italian, German and Netherlandish schools was a particular interest of Prince Albert who, with Queen Victoria, acquired nos 1, 2 and 3 in the 1840s.

The greatest collector of Dutch and Flemish paintings was George IV, who was able to acquire distinguished examples by Netherlandish artists during the Napoleonic wars when so many works of art became available, in effect creating the modern art market. Perhaps inspired by his grandfather, Frederick, Prince of Wales, who acquired some excellent paintings by Flemish (no. 9) and French (no. 12) artists, George IV shared the taste of his contemporaries for pictures of painterly quality with a high degree of finish and strong narrative content often on a small scale and usually obtained for high prices (nos 13, 15). The Shipbuilder and his Wife by Rembrandt (White 1982, no. 160) – one of the finest works in the artist's oeuvre – was the most expensive painting purchased by George IV, who also acquired outstanding pictures by Rubens (no. 8) and Teniers. The acquisition in 1814 of the Dutch pictures belonging to Sir Francis Baring brought the total of George IV's Dutch and Flemish paintings to some 200, including examples of consummate quality by Aelbert Cuyp (no. 16), Gerrit Dou, Nicolaes Berchem, Philips Wouwermans and Adriaen van Ostade. A number of these are seen in Pyne's views of the interior of Carlton House (including nos 421–2). Although George IV's enthusiasm for French art – so notable in the decorative arts – is not so apparent in his acquisitions of paintings, some important purchases were made in the early nineteenth century (see no. 27). In more recent times the French school has also been successfully enriched, both by eighteenth-century works (no. 20) and by an Impressionist masterpiece (no. 33).

The pictures in the Royal Collection are testament to a continuity that is now unique in the history of collecting. When Rubens visited London in 1629 he remarked of Charles I's collection that 'when it comes to the pictures by the hands of first-class masters, I have never seen such a large number in one place as in the royal palace in England'. Even with the loss of so much of Charles I's collection, this comment by Rubens still remains relevant for the collection as it is constituted today.

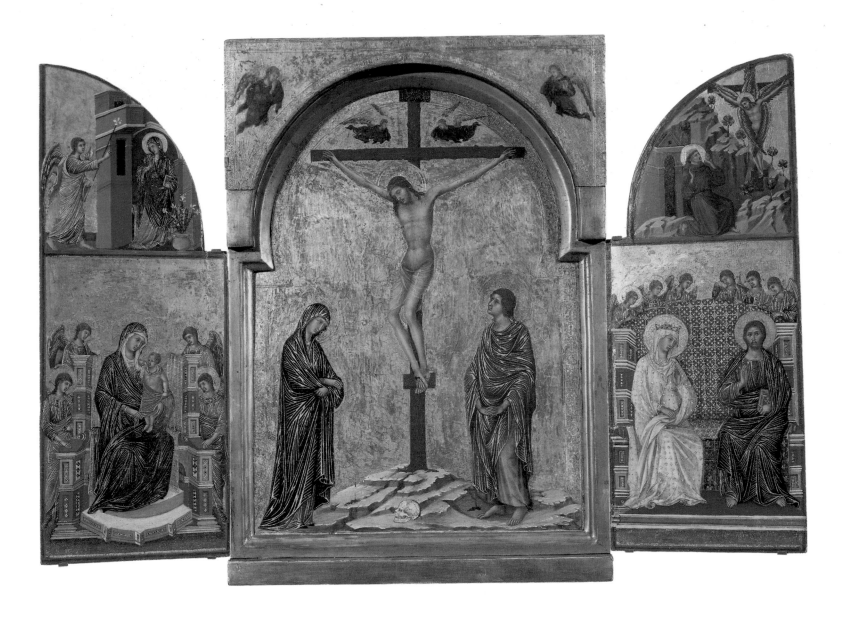

I

DUCCIO (fl.1278–before 1319) and assistants
Triptych: the Crucifixion and other scenes, c.1308–11

The Sienese artist Duccio was one of the most innovative painters of the fourteenth century. His most important work is the *Maestà*, the large double-sided altarpiece completed for the high altar of Siena Cathedral in 1311. There are many parallels between the narrative panels of the life of Christ on the back of the *Maestà* and those in this small triptych (three linked panels), which would have served as a portable devotional image. The scenes are intended to be read in sequence, commencing with the *Annunciation* and *Virgin and Child Enthroned* to the left of the central *Crucifixion*, and continuing with *Christ and the Virgin Enthroned* and the *Stigmatisation of St Francis* on the right. The two enthronements are carefully balanced, neatly linking Christ, the Virgin Mary, who appears four times, and St Francis, who was regarded as the second Christ. It is likely that the triptych was commissioned for a Franciscan patron.

Reconstituted before its acquisition by Prince Albert, no. 1 was reframed by him in one plane and was only reconstructed as an integral triptych (with a base block) during conservation in 1988. On that occasion it was noticed that the internal perspective had been adjusted by the artist to correct the apparent distortion that resulted from the angle of the wings. Such a sophisticated approach, combined with the high quality of many of the figures, suggests that Duccio planned the painting himself, although he may have shared the execution with his assistants at a time when his workshop was helping to complete the *Maestà*. The triptych, a work of great richness and complexity, was heralded in the nineteenth century as one of the finest works by the master.

Tempera on panel. Central panel 44.9 × 31.4 cm, round headed (painted area 41.5 × 30.4 cm); spandrel above 13.9 × 34.9 cm; wings 44.8 × 16.9 cm
RCIN 400095
PROVENANCE Johann Baptist Metzger (d. 1844); from whom bought by Prince Albert, through Ludwig Gruner, 7 April 1846 (£190, with Shearman 1983, no. 252)
LITERATURE Shearman 1983, no. 86
EXHIBITIONS Manchester 1857, no. 11; London 1904a, no. 5; London 1930, no. 1; London 1946–7, no. 183; London 1959–60, no. 309; QG 1964, no. 8; QG 1977–8, no. 43; QG 1988–9, no. 49; London 1991a, no. 80

2

BERNARDO DADDI (fl.c.1320–1348)
The Marriage of the Virgin, c.1330–42

This panel by the Florentine artist Bernardo Daddi formed part of the predella (the lowest row of panels) of the high altarpiece of the church of San Pancrazio in Florence, the most complete surviving full-scale work substantially painted by the artist. The multi-tiered altarpiece had been dismembered before the end of the eighteenth century, but nearly all the surviving panels are today on display in the Uffizi, Florence. *The Virgin and Child Enthroned* in the centre is flanked by standing saints to left and right. Above are half-length apostles with angels and prophets. The predella of eight panels illustrated the early life of the Virgin. *The Marriage of the Virgin* was the sixth in the sequence. It was evidently cut down after it was separated from the altarpiece and the small areas of its upper corners were repainted. (Each of the predella panels still in the Uffizi measures 50 × 38 cm, including an arched top.) No. 2 is,

however, the best preserved of the surviving predella panels.

The source for the scene can be traced to the apocryphal gospel *The Protoevangelium of James* (AD 8–9) and *The Golden Legend* by Jacobus Voragine (c.1229–98), in which the Virgin's suitors were instructed to bring rods to the Temple altar. The rod belonging to Joseph flowered. When the Holy Spirit (in the form of a dove) perched on the tip of Joseph's rod, it was clear that Joseph had been chosen to be the Virgin's spouse. Here the bare-headed High Priest joins the hands of Joseph and Mary while disappointed suitors break their rods. The dignified weight of the figures shows the influence of Giotto, with whom Daddi probably trained, but the severity of Giotto's style has been reduced by other influences. The intense bright colours, delicate modelling and decorative details derive from the work of Sienese artists such as Ambrogio and Pietro Lorenzetti. Daddi belonged to the group of artists who introduced 'the miniaturist tendency' into Florentine art, a lyrical style which continued to the end of the fourteenth century.

Tempera on panel. 25.5 × 30.7 cm
RCIN 406768
PROVENANCE Painted for San Pancrazio, Florence; Uffizi, Florence, by 1808; Accademia, Florence, 1810; given, in exchange, to the dealer Luigi Marzocchi, 1817; Johann Baptist Metzger (d. 1844); from whose son, Ludwig, bought, through Ludwig Gruner, by Queen Victoria, 1845; by whom given to Prince Albert, 26 August 1846
LITERATURE Shearman 1983, no. 79; Offner 1989, pp. 268–70
EXHIBITIONS London 1930, no. 15; London 1946–7, no. 185; Edinburgh 1947, no. 22; London 1959–60, no. 276; London 1991a, no. 81

3
LUCAS CRANACH THE ELDER (1472–1553)
Apollo and Diana, c.1530

Together with Hans Holbein and Albrecht Dürer, Lucas Cranach was the principal artist of the German Renaissance. As court artist to the electors of Saxony at Wittenberg, he was closely involved with the Protestant Reformation and was a friend of Martin Luther. The incisive clarity and linear energy of Cranach's brushwork reflect his calligraphic skills as a draughtsman.

This painting is one of three versions of the subject showing the sun god Apollo with his sister Diana, moon goddess and virgin huntress. The date 1530 on the version in the Gemäldegalerie Berlin gives an approx-

imate date for this painting and the one in the Musée des Beaux-Arts, Brussels. Each is subtly different, illustrating the way in which Cranach's successful workshop varied ideas without exact repetition. All three versions show the influence of engravings of the same subject by Dürer (c.1502) and by Jacopo de' Barbari (c.1500–06). Diana's pose also echoes that of the antique bronze known as the *Spinario* ('thorn-remover'). Her domain of night is suggested by the depth of the forest and the dark blue of the upper limits of the sky; that of Apollo, day, by the clarity of the light describing the multiplicity of detail and the minutely rendered landscape. Cranach links the figures seen in relief with their setting so that Diana's precisely rendered hair curls around the stag's antlers, which in turn are deliberately confused with the branches of the trees behind. In this taut style the delicate figures combine formal courtly elegance with a naïve sensuousness, giving the scene a particular intensity.

Oil on panel. 83.8 × 56.5 cm
Signed with black winged serpent, lower left
RCIN 407294
PROVENANCE Friedrich Campe, Nuremberg; from whom bought by Prince Albert, on the advice of Ludwig Gruner, 1844 or 1846
LITERATURE Friedländer & Rosenberg 1978, pp. 122–3; Grimm, Ericksen & Brockhoff 1994, p. 350
EXHIBITIONS London 1946–7, no. 140; Manchester 1961, no. 86; QG 1977–8, no. 47; London 1991a, no. 83

4
Attributed to GIORGIONE (c.1477–1510)
The Concert, c.1505

Compositions with half-length figures grouped informally began to appear in Venetian painting during the mid-fifteenth century. The innovator was most probably Andrea Mantegna, the brother-in-law of Giovanni Bellini, in whose orbit artists explored the possibilities of this rectangular format in both religious and secular contexts. The combination of the development of secular art and the emergence of a new generation of painters at the beginning of the sixteenth century led to a particularly sophisticated use of this type of composition in which the relationship between the figures and the charged atmosphere creates an enigmatic mood.

The Concert may not be accurately titled since the figures are not actually performing but, none the less, music is the dominant theme, perhaps with an allegorical significance expressive of love or passing time. Giorgione who, according to Vasari, was a good musician himself, often painted in this vein and it is unlikely that these are specific portraits or that the group reflects formal Venetian musical customs. Rather, the participation of four individuals – one of whom is a woman – in a joint activity not only provides a compositional unity but may also suggest that the painting depicts the pleasure of the momentary sensation as opposed to engagement with an intellectual idea.

The attribution of *The Concert* has been the subject of much debate, so that the recent treatment, which has revealed the true quality of the painting in the undamaged areas, is an important step forward. Thinly painted with several small changes of mind by the artist, but with no evidence of underdrawing, the strong characterisation, subtle relationship between figures, firm rendering of the hands and vibrancy of

3

4

colour, are not unworthy of Giorgione as evidenced especially in *The Three Ages of Man* (*Education of the Young Marcus Aurelius*) in the Palazzo Pitti, Florence, *Portrait of a woman* (*Laura*), or *Young boy with an arrow* – these last both in the Kunsthistorisches Museum, Vienna.

Like no. 5, *The Concert* once belonged to Gerard Reynst (1599–1658), whose collection was acquired by the States-General of Holland for presentation to Charles II in 1660. The picture had probably been acquired in Venice by Gerard's brother, Jan Reynst (1601–46), and was engraved in the seventeenth century with an attribution to Giorgione.

Oil on canvas. 76.2 × 98 cm

RCIN 400025

PROVENANCE Gerard and Jan Reynst, Amsterdam; States-General of Holland; by whom presented to Charles II, 1660

LITERATURE Shearman 1983, no. 38; Anderson 1997, pp. 309–10; Pignatti & Pedrocco 1999, pp. 203–04, no. A9

EXHIBITIONS London 1946–7, no. 202; Edinburgh 1947, no. 36; Venice 1955, no. 42; London 1959–60, no. 9; Amsterdam 1965, no. 1

5
LORENZO LOTTO (c.1480–c.1556)
Andrea Odoni, 1527

This portrait of Andrea Odoni (1488–1545) is one of the most innovative and dynamic portraits of the Italian Renaissance. Lorenzo Lotto was born in Venice but worked for much of his career outside the city, mostly in the Venetian provinces and the Marches. The portrait was recorded in Odoni's bedroom in his house on the Fondamenta del Gaffero, Venice, and in the 1555 inventory of his brother Alvise. Odoni was a successful Venetian merchant who formed a renowned collection of paintings, sculpture, antique vases, coins, gems and natural history objects. One piece shown here, the head lower right, can be identified with a cast of Hadrian noted in the Odoni inventory in 1555. Most of the other objects appear to be versions, probably casts, of well-known originals included by the artist to suggest a particular meaning, rather than to record specific items in Odoni's collection. In his outstretched right hand Odoni holds a statuette of Diana of the Ephesians, as a symbol of nature or earth. The contrast between this complete object

and the antique fragments may refer to the enduring power of nature compared with the transitoriness of art and human endeavour. However, the crucifix between the sitter's left hand and his breast suggests that for Odoni the true religion of Christianity will always take precedence over nature and the pagan worship of antiquity.

Odoni's gaze is made more arresting by his powerful gesture, bulked out by his coat, and by the weight of sculpture around him in a wide-format canvas. Often unconventional and surprising in his portraiture, in this painting Lotto, newly returned to Venice, successfully challenges his great rival Titian.

Oil on canvas. 104.6 × 116.6 cm

Inscribed *Laurentius lotus / 1527*

RCIN 405776

PROVENANCE Andrea Odoni (according to Marcantonio Michiel, 1532); his brother, Alvise Odoni, by 1555; Lucas van Uffelen, probably by 1623; Gerard Reynst, 1639; States-General of Holland; by whom presented to Charles II, 1660

LITERATURE Shearman 1983, no. 143; Humfrey 1997, pp. 106–07

EXHIBITIONS London 1822, no. 4; Manchester 1857, no. 221; Leeds 1868, no. 212; London 1872, no. 108; London 1894–5, no. 222; London 1946–7, no. 217; Edinburgh 1947, no. 60; Venice 1953, no. 67; London 1959–60, no. 8; Stockholm 1962–3, no. 81; QG 1964, no. 7; London 1975b, no. 21; QG 1977–8, no. 24; London 1983–4b, no. 46; QG 1988–9, no. 7; London 1991a, no. 4; Washington/Bergamo/Paris 1997–9, no. 28

6

HANS HOLBEIN THE YOUNGER (1497/8–1543)
'Noli me tangere', c.1524

When the diarist John Evelyn saw this painting in Charles II's Private Lodgings at Whitehall in 1680 he recorded that he 'never saw so much reverence & kind of Heavenly astonishment, expressed in Picture' (*Evelyn*

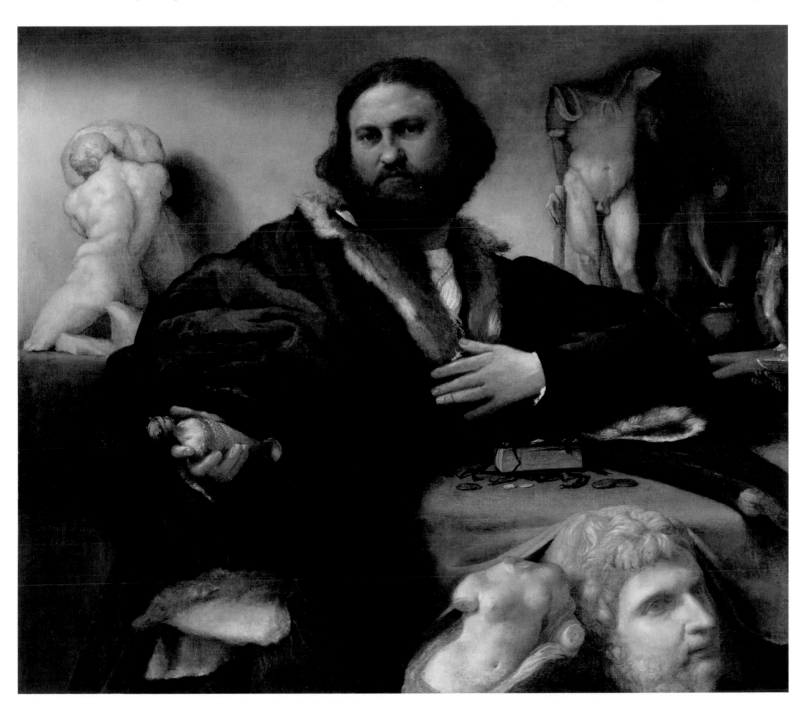

5

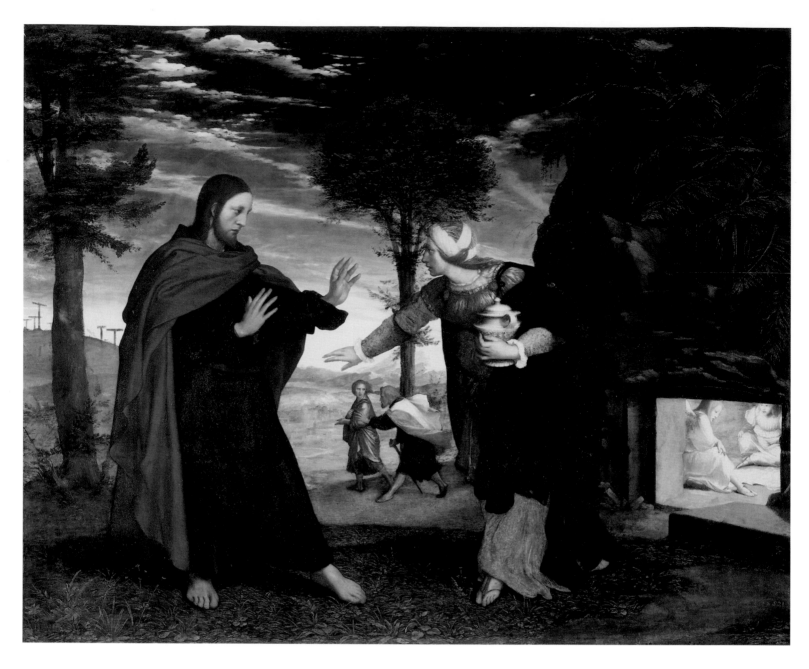

Diary, IV, pp. 216–17). It is possible that it entered the King's collection in 1669 on the death of Queen Henrietta Maria, who had a painting of this subject over the mantel in her bedchamber at Colombes in France, to which she returned after the execution of Charles I.

The majority of Holbein's religious paintings were intended as large altarpieces. This is a smaller, more intimate narrative scene, depicting the moment described in the Gospel of St John (20: 14–18) when Christ forbids Mary Magdalene's touch. Behind the principal figures, Saints Peter and John, who are shown returning to Jerusalem in order to announce their discovery of the empty tomb, echo their gestures. Light radiates from the tomb where two angels in white guard the grave clothes, and in the distance a number of crosses can be seen on the hill at Calvary. By this means more than one episode of the Passion is contained within the image.

This painting is associated with Holbein's visit to France of 1524 and it has been suggested that his encounter with Italian art at the court of Francis I is evident in this work. The ointment jar held by Mary Magdalene is decorated with winged satyrs and inscribed MARIA around the rim of the lid. Although comparisons can be made with

contemporary French earthenware (from Saint Porchaire, for example), it appears closer to the wares produced in Antwerp at that time and there is no reason to doubt that it is an object of Holbein's own design. Holbein's interest in costume is well documented and the Magdalene's clothing may be compared to the costume of the women in the foreground of the *Solomon and the Queen of Sheba* miniature (no. 39).

This is the only religious painting by Holbein in the Royal Collection. In addition to the five miniatures (including nos 39–42) and eighty drawings (including nos 348, 349), there are seven painted portraits, all of them dating from Holbein's two stays in England.

Oil on panel. 76.7 × 95.8 cm
Inscribed (when in James II's collection), bottom right corner 521
RCIN 400001
PROVENANCE Queen Henrietta Maria; Charles II, by 1680
LITERATURE Millar (O.) 1963, no. 32; Rowlands 1985, no. 17; Bätschmann & Griener 1997, pp. 134–45
EXHIBITIONS London 1880, no. 187; London 1946–7, no. 158; Edinburgh 1947, no. 23; Basel 1960, no. 186; Manchester 1961, no. 97; QG 1977–8, no. 25; London 1991a, no. 2

7

ANNIBALE CARRACCI (1560–1609)
Allegory of Truth and Time, c.1584–5

This painting is an early work by Annibale Carracci, the most famous of the Carracci family of artists who were the determining influences on the development of Baroque art in the seventeenth century. It is generally dated to the period when Annibale, his elder brother Agostino (1557–1602) and their cousin Ludovico (1555–1619) had formed their own academy in Bologna, aiming to reform the current style of Mannerist painting by studying nature and the work of North Italian artists such as Correggio, Titian and Veronese. They collaborated on projects and in 1583–4 were working on the frescoed frieze consisting of scenes illustrating the story of Jason in the Palazzo Fava, Bologna. The facial types, the elegant, boneless hands and the slightly acidic colours in both the *Allegory* and Annibale's Jason scenes show the influence of Federico Barocci as well as of Correggio.

The precise meaning and origin of this painting, and its early history, are not known. Winged Time (holding an hourglass) is shown having drawn up his daughter Truth (haloed and holding a mirror) from the depths of a well to reveal her in the light of day. She triumphs by

trampling underfoot a figure personifying Deceit (also called Fraud, Hypocrisy or Calumny). On the right is Bonus Eventus (happy issue of enterprises), holding his attributes of corn and poppies and pouring a libation of flowers; the figure on the left is either Felicity, with cornucopia and winged staff (the *caduceus*, signifying peace) or, because she has wings, Fortune. Some of the changes made by Annibale as he adjusted the composition are visible today.

The weighty naturalism of the figures in the *Allegory*, particularly the two standing, counteracts its allegorical complexity. Annibale's directness combined with the inventiveness of his composition and bold colours transform the North Italian influences and herald his future achievements in the Palazzo Farnese in Rome (see no. 356).

Oil on canvas. 130 × 169.6 cm
RCIN 404770
PROVENANCE Possibly recorded at Hampton Court Palace in reign of Queen Anne, c.1710; at Buckingham Palace, 1876
LITERATURE Boschloo 1974, I, pp. 71–2, II, pp. 176, 191, 211; Dempsey 1986, p. 249; Levey 1991, no. 433
EXHIBITIONS London 1946–7, no. 248; Bologna 1956, no. 53; London 1959–60, no. 129; Newcastle 1961, no. 198; QG 1988–9, no. 10

SIR PETER PAUL RUBENS (1577–1640)
Milkmaids with cattle in a landscape: 'The Farm at Laeken',
c.1617–18

The bucolic abundance and diversity of plant and animal life in this painting admirably demonstrate Rubens's life-long love of his native countryside. This is one of a small group of early landscapes painted in Antwerp between 1614 and 1618 after the artist's return from Italy. Later he was to acquire various country estates, particularly Het Steen outside Antwerp, which he recorded in other, larger canvases. The classical pose of the standing milkmaid could be interpreted as Rubens's expression of the nobility of rural life.

The composition is loosely based on a painting of a similar subject by Titian, known to Rubens through a woodcut. The painting demonstrates Rubens's patriotic sentiment, which had been strengthened by the recent restoration of peace under the Habsburg Regents Albert and Isabella. The church at Laeken north of Brussels (demolished 1894/5) seen in the upper right corner is a specific topographical feature. It was one of the principal Marian shrines and pilgrimage sites of the Catholic Southern Netherlands and its deliberate inclusion would have had religious and patriotic associations for Rubens's contemporaries. It contained a revered statue of the Virgin and was the site of various miracles.

Damaged by Calvinist iconoclasts in 1581, the church was restored and rededicated during the reign of Albert and Isabella, who made an elaborate pilgrimage there in 1623.

This picture remained in the possession of an Antwerp family related to Rubens until the nineteenth century. It was delivered to Carlton House in 1821 and was considered one of the finest works in George IV's collection. The Royal Collection contains a significant group of paintings by Rubens, whose strong relationship with the Stuart court led to his visit to England in 1629–30. The ceiling of the Banqueting House at Whitehall (installed in 1636) was his most important royal commission in this country.

Oil on panel. 86.4 × 128.2 cm
RCIN 405333
PROVENANCE Arnold Lunden (Antwerp), after 1639; his descendants; from whom bought by L.J. Nieuwenhuys, 1817 (30,000 francs); Aynard collection; from whom bought by George IV, 1821
LITERATURE Adler 1982, no. 20; Brown (C.) 1996, pp. 35–47
EXHIBITIONS London 1826, no. 60; London 1827, no. 29; London 1884, no. 74; Paris 1936, no. 62; London 1938, no. 82; London 1946–7, no. 289; Edinburgh 1947, no. 39; London 1953–4, no. 171; QG 1962–3, no. 33; QG 1975–6, no. 8; QG 1988–9, no. 19; London 1996a, no. 17

9

FRANS HALS (1580–1666)
Portrait of a man, 1630

Hals is celebrated for his distinctive animated portraits in which the character of his sitters appears momentarily captured through his use of vivid brushwork and lively expression. His works appear to have been painted with a rapid technique, but he was not an especially prolific painter. However, his contribution to the genre of portraiture was of the greatest significance and Hals is placed second only to Rembrandt in the development of Dutch painting. He began his career in Antwerp but had moved to Haarlem by 1591, where he remained for the rest of his life.

Here, the sitter's relaxed pose and elegant dress might suggest a successful merchant in his prime. The image captures the confidence and vitality of the burghers who made the newly created Dutch Republic the richest and most powerful nation in Europe during the first half of the seventeenth century.

This work demonstrates the emergence of Hals's mature style, as his portraits gradually acquired a greater sense of unity and simplicity of structure. For instance, the manipulation of the plain background through the aura of light behind the head is used to create a sharp silhouette and to give the body a genuine solidity. The figure seems to emerge from the lower edge of the picture plane, whilst the jutting elbow and taut clothing only serve to increase the viewer's sense of animation.

The sombre fashion for black garments was popular during the 1630s and Hals's monochromatic palette is relieved only by the restrained splash of colour of the ochre gloves. The treatment of this passage is particularly virtuoso, employing broken, angular and seemingly disconnected strokes. Amongst the artist's contemporaries, only Rembrandt or Velázquez could match such a dazzling display of visual pyrotechnics. It was this aspect of his work that particularly appealed to nineteenth-century French painters such as Manet, whose interest in his work encouraged the eventual reassessment of Hals's art.

Oil on canvas. 115.5 × 88.5 cm
Inscribed upper right AETAT SVAE 36 / AN. 1630
RCIN 405349
PROVENANCE Acquired by either Frederick, Prince of Wales, or George III; Royal Collection by 1795
LITERATURE White 1982, no. 56; Slive 1989, no. 38
EXHIBITIONS London 1875, no. 102; London 1892, no. 124; London 1946–7, no. 358; Edinburgh 1947, no. 8; Haarlem 1962, no. 26; QG 1971–2, no. 5; QG 1988–9, no. 16; London 1989b, no. 38; Wellington/Canberra/Ottawa 1994–5, no. 6

10

GEORGES DE LA TOUR (1593–1652)
St Jerome, c.1621–3

This atmospheric painting is one of very few works in the United Kingdom by the renowned seventeenth-century French artist Georges de La Tour. At the time of acquisition it was described as 'St Jerome with spectacles of the manner of Albert Durer', but the identification of the figure was then forgotten. Similarly, the painting was not ascribed to La Tour until 1939, when his oeuvre was beginning to be established. There are only a limited number of signed or dated pictures by La Tour, whose stylistic development remains unclear. In spite of some surface wear in the figure of St Jerome, the less damaged areas – such as the shadowy folds of paper and wrinkled forehead – contain passages of such brilliant quality that his authorship cannot be doubted.

La Tour's work is distinctive in both style and subject. He is most celebrated for his mysterious candle-lit compositions. His art reveals knowledge of Caravaggio, particularly in the use of chiaroscuro, although this may have been gleaned through the works of that artist's Northern followers. Here the source of light is outside the composition and is used to intensify the luminous red clothing and to render the paper almost transparent. This painting demonstrates La Tour's characteristic sensitivity to the texture of human hair and skin and his ability to endow the humblest figure with religious authority. His love of genre detail is demonstrated in the spectacles, which give the aged saint an air of added concentration.

This is not a typical representation of St Jerome, who wrote the Latin Vulgate translation of the Bible. His prominent red robes signify his traditional role as the first cardinal, but the other more usual attributes, such as a skull or cardinal's hat, are omitted.

Until recently, the present canvas support was adhered to a branded oak panel. This technique, known as *marouflage*, was used in Antwerp workshops in the middle of the seventeenth century; it is probable that the painting was sold to Charles II in that state.

10

◁ 11

Oil on canvas. 63.8 × 47.2 cm

RCIN 405462

PROVENANCE William Frizell (Breda); from whom bought by Charles II, 1662 (150 florins)

LITERATURE Cuzin & Rosenberg 1997, no. 14

EXHIBITIONS London 1946–7, no. 408; Paris 1972a, no. 7; Leicester 1985–6, no. 10; London 1991a, no. 26

11
SIR ANTHONY VAN DYCK (1599–1641)
Charles I with M. de St Antoine, 1633

On his appointment as Principal Painter to Charles I in 1632, the Flemish artist Van Dyck – Rubens's most gifted follower – was required to specialise in portraiture. This is one of the chief paintings to result from his appointment, which revolutionised British painting and provided us with the enduring image of the Stuart court. With great fluency Van Dyck here portrays Charles I on horseback on an unprecedented scale, as ruler, warrior and knight, in the long tradition of antique and Renaissance equestrian monuments. The prominent display of the crowned royal arms and the triumphal arch framing the armed King reinforce his image as ruler of Great Britain, while the King's refined features, loose hair and the sash of the Order of the Garter worn over his armour convey the impression of a chivalrous knight. Van Dyck may have designed the painting for its first position at the end of the Gallery at St James's Palace, where its theatrical effect impressed visitors (see p. 28). Both artist and patron admired and collected works by Titian, but a more direct influence was Rubens's 1603 portrait of the Duke of Lerma (Madrid, Prado) which Charles I would have seen on his visit to Spain as Prince of Wales in 1623.

Skilled horsemanship was regarded as the epitome of *virtu* and here Pierre Antoine Bourdin, Seigneur de St Antoine, a master in the art of horsemanship, carries the King's helmet. Sent by Henry IV of France to James I with a present of six horses for Henry, Prince of Wales, in 1603, he remained in the service of the Prince and later of Charles I, as riding master and equerry. He looks up at the King, whose poise stabilises a scene filled with baroque movement.

Van Dyck went on to paint two other major portraits of the King with a horse: *Charles I on horseback*, c.1636–8 (London, National Gallery) and *Le Roi à la Chasse*, c.1635 (Paris, Louvre). The present painting hung at Windsor Castle for much of the nineteenth century; it is recorded in the Queen's Presence Chamber and the Queen's Ballroom (also known as the Van Dyck Room) in nos 401 and 408.

Oil on canvas. 368.4 × 269.9 cm

Dated 1633

RCIN 405322

PROVENANCE Painted for Charles I, 1633; valued at £150 by the Trustees for Sale and sold to 'Pope', 22 December 1652; Remigius van Leemput; recovered for Charles II, 1660

LITERATURE Millar (O.) 1963, no. 143

EXHIBITIONS Manchester 1857, no. 599; London 1946–7, no. 96; Edinburgh 1947, no. 52; QG 1968–9, no. 9; London 1972–3, no. 93; London 1982–3, no. 11

12
CLAUDE GELLÉE, called LE LORRAIN (1604/5–1682)
A view of the Roman Campagna from Tivoli, evening, 1645/6

The rich intensity of this evening landscape has been revealed by the recent conservation of this little-known painting. Unlike the majority of Claude's works, the picture has no other subject matter than the drama and beauty of the Campagna – the countryside around Rome.

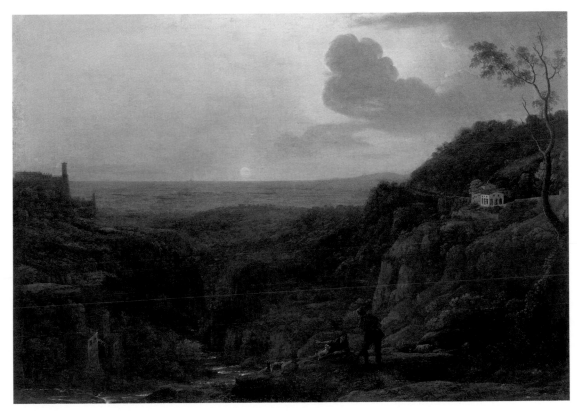

12

This is Claude's last, and most accurate, topographical composition. A modern visitor to the site, which lies on the Via Quintilio Varo above the town of Tivoli, could appreciate a similar view of Rome today. However, Claude has subtly manipulated the view; for instance the familiar dome of St Peter's, the most prominent of various outcrops on the horizon, is actually located much further to the left. Similarly, the circular Temple of Sibyl, which should be included at the very left edge in this view, has been omitted. However, it is included in a painting in Grenoble which may have been intended as the pair to this work. Both pictures were commissioned by the same patron, Michel Passart. The cascades that are so prominent in Claude's composition were diverted from the site in 1826.

The landscape around Tivoli had been a popular sketching spot, particularly with Northern artists, since the end of the sixteenth century, and Claude's visits to the Roman Campagna were part of a well-established artistic pattern. The landscape was filled with medieval and ancient ruins that were particularly attractive to artists. Claude frequently included elements of these in his works, many of which were painted in Rome where he spent most of his career.

Frederick, Prince of Wales, whose collection included a number of Italianate landscape views by Claude and Gaspar Dughet, probably purchased this work. The painting hung at Buckingham House under George III, c.1774 in the King's dressing room (see Russell (F.) 1987, p. 528) and by 1817 in the Blue Velvet Room (see no. 413). By 1855 it had moved to the King's Bedroom, Windsor Castle (see no. 411). It is one of five paintings by Claude in the Royal Collection, which also includes a significant group of drawings (including no. 367).

Oil on canvas. 98.1 × 135.1 cm
Signed and dated lower right CLAVD / ROM 164[6]
RCIN 404688
PROVENANCE Painted for Michel Passart; no longer in his collection by 1684; purchased by Frederick, Prince of Wales by 1750 (?); George III by c.1774
LITERATURE Roethlisberger 1961, LV 89; Kitson 1978, no. 89; Chomer 2000, no. 44
EXHIBITIONS London 1819b, no. 70; London 1949–50, no. 72

13
Attributed to LOUIS LE NAIN (1600/10–1648)
The Young Cardplayers, c.1630–40(?)

When purchased at auction in 1803 by the future George IV, this picture was described as an 'exquisite jewel' and attributed to Caravaggio. Indeed, recent restoration has revealed that the composition had been altered dramatically to enhance its Caravaggesque elements. Such changes, which were probably made during the eighteenth century, included the removal of the bandage around the head of the seated boy in the right foreground, and the omission of the standing woman and the signature. The restored composition is now closer to other known versions of the same piece in the Louvre and Worcester (Massachusetts), but it is still unclear which of the three Le Nain brothers was the artist.

To the modern eye, this painting has a compositional directness and a strong tonal range that are immediately appealing. The central group are playing Primero or Primiera, a forerunner of poker. The theatrical lighting, falling sharply from the left, defines the objects and clothes, and the enigmatic gesture of the boy entering the room on the right adds an air of mystery.

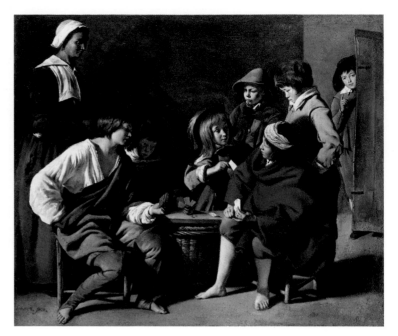

13

The three Le Nain brothers – Antoine, Louis and Mathieu – were born in Laon and by 1629 had settled permanently in Paris, where they became founding members of the Académie des Beaux-Arts in 1648. Despite gaining respect in their own day for paintings of religious and mythological subjects, as well as portraits, they are best known for their dignified pictures of peasant life. Although the popularity of the Le Nain brothers waned during the eighteenth century, their distinctive style has appealed to modern taste, possibly owing to the interest shown in similar subjects by nineteenth-century French artists such as Manet.

Oil on canvas. 55 × 64.2 cm
Inscribed lower left Le Nain. fecit.
RCIN 405944
PROVENANCE [Reputedly: Palazzo Aldobrandini, Rome; Castiglione (Roman dealer); from whom acquired by Thomas Lister Parker; from whom bought by Walsh Porter;] Walsh Porter sale, Christie's, London, 22 March 1803 (48); bought by George IV (£388 10s.; RA GEO/26926)
LITERATURE Thuillier 1978, no. 17; Rosenberg 1993, no. 22
EXHIBITIONS London 1818, no. 79 (as by Le Nain); London 1826, no. 65; London 1827, no. 125; London 1946–7, no. 425; Edinburgh 1947, no. 9; QG 1966, no. 11; Paris 1978–9, no. 17; QG 1988–9, no. 44; Wellington/Canberra/ Ottawa 1994–5, no. 8

14
REMBRANDT VAN RIJN (1606–1669)
Agatha Bas, 1641

This is one of the most beautiful portraits in the Royal Collection. Its companion, in the Musée Royal des Beaux-Arts, Brussels, depicts Nicolaes van Bembeeck (1596–1661), a wool merchant who had married Agatha Bas (1611–58) in 1638. It is also signed and dated 1641. The couple lived in the Sint Anthoniesbreestraat, where Rembrandt himself lived from 1631; they were almost certainly known to the artist.

Rembrandt introduced a new compositional device in this painting: the figure is posed within a painted ebony frame which blurs the

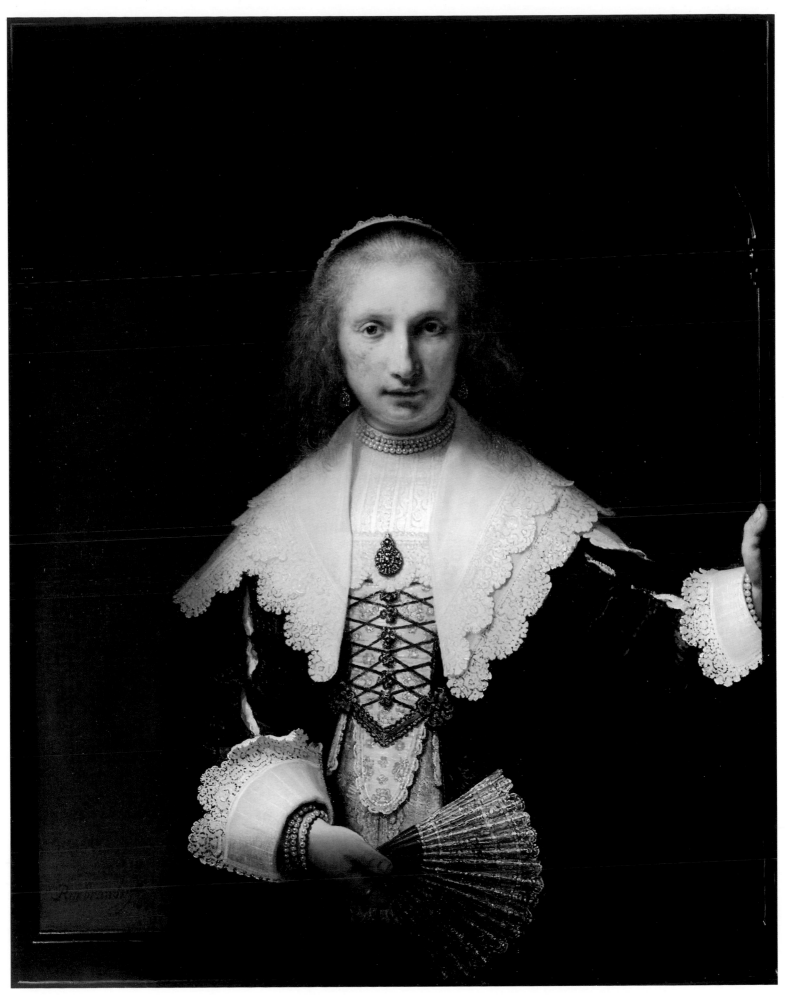

boundaries between the imaginary space within the composition and the real world outside. The sense of direct contact with the sitter is achieved partly through the striking gesture of the hand resting against the frame and partly by showing the fan protruding over the edge towards the viewer's space. An earlier reduction in the size of the canvas has considerably reduced this illusionistic effect. The different levels of finish in the painting are particularly striking. For instance, Rembrandt portrays the fine hairs at the edge of the hairline through curling lines incised into the paint with the end of the brush, and in contrast to such direct handling the depiction of Agatha Bas's skin and eyes is remarkably subtle and delicate.

There are five paintings by Rembrandt in the Royal Collection, the earliest of which, *The Artist's Mother*(?) (White 1982, no. 158), was presented to Charles I before 1633, and was thus one of the first works by Rembrandt to reach England. Of the three Rembrandts collected by George IV, *The Shipbuilder and his Wife* (White 1982, no. 160), purchased for 5,000 guineas in 1811, was perhaps his most famous single acquisition.

Oil on canvas. 105.2 × 83.9 cm
Signed and dated *Rembrandt f.* / 1641 and inscribed AE 29
RCIN 405352
PROVENANCE Louis Bernard Coclers (Amsterdam), 1805; imported into England by Nieuwenhuys and offered at Christie's, London, 29 June 1814 (76); bought in; subsequently bought by John Smith; by whom sold to Lord Charles Townshend; his sale, Robins, London, 4 June 1819 (32); bought by Lord Yarmouth for George IV (£74 10s.)
LITERATURE White 1982, no. 162; Brown, Kelch & Van Thiel 1991, no. 35
EXHIBITIONS London 1821, no. 9; London 1826, no. 19; London 1827, no. 116; London 1889c, no. 160; Amsterdam 1898, no. 51; London 1899, no. 48; London 1946–7, no. 360; The Hague 1948, no. 7; London 1952–3, no. 181; QG 1962–3, no. 32; QG 1971–2, no. 13; QG 1988–9, no. 15; Berlin/Amsterdam/London 1991–2, no. 35

15
GERARD TER BORCH (1617–1681)
The Letter, c.1660–2

The Dutch painter Gerard ter Borch is best known for his tranquil genre scenes mostly painted in the Dutch town of Deventer. He was one of three children, all of whom were trained by their father (also an artist) and pursued artistic careers. Here the boy has much in common with portraits of Gerard's half-brother Moses, while the woman reading the letter may be the artist's step-sister Gesina ter Borch.

The simplicity of this domestic scene encourages the viewer to delight in the beauty and detail of the objects that it contains. The interaction between the three participants is left open to interpretation and the significance of the letter is not explained. Ter Borch delights in metallic surfaces, for instance the reflections in the candelabrum and the inkwell and stand. The use of deep blue ultramarine edging around the woman's neckline and the rendering of the embroidery around the edge of her skirt are masterly touches. Similarly, the painting of the woman's silk skirt, which is in excellent condition, is a passage of mesmerising beauty.

At the end of the eighteenth century *The Letter* belonged to the Amsterdam merchant and art collector Jan Gildemeester. In the painting of his art gallery by Adriaan de Lelie (Amsterdam, Rijksmuseum), *The Letter* can clearly be seen hanging on the left-hand wall. This is one

of two paintings by Ter Borch in the Royal Collection, both of which were purchased by George IV, an enthusiastic collector of the work of seventeenth-century Dutch masters.

Oil on canvas. 81.9 × 68.2 cm
Traces of a signature are visible on the letter under high magnification
RCIN 405532
PROVENANCE Beaujon sale, Paris, 25 April 1787 (25); bought by Dubois; Jan Gildemeester (Amsterdam), by c.1800; his sale, 11 June 1800 (28); Heathcote sale, London, 5 April 1805 (42); bought for Sir Francis Baring; Sir Thomas Baring; from whom bought by George IV, 1814 (45)
LITERATURE White 1982, no. 29
EXHIBITIONS London 1815, no. 44; London 1826, no. 118; London 1827, no. 60; London 1884, no. 122; London 1891c, no. 92; London 1929a, no. 62; London 1946–7, no. 296; Edinburgh 1947, no. 12; Birmingham 1950, no. 62; London 1952–3, no. 379; QG 1962–3, no. 20; QG 1971–2, no. 26; The Hague 1974, no. 47; QG 1991–2, no. 149; Amsterdam 2000, no. 121

16
AELBERT CUYP (1620–1691)
The Passage Boat, c.1650

Cuyp's work, which had been little known outside his native Dordrecht until the end of the eighteenth century, became so popular in England during the Napoleonic period that by about 1825 'a near monopoly' of his pictures had been established here (see exh. cat. QG 1988–9, no. 18). George IV owned six important pictures by Cuyp in addition to this example which was shown hanging in the Blue Velvet Room at Carlton House in 1816 (no. 421), two years after its purchase.

Cuyp lived almost all of his life in Dordrecht and painted a number of magnificent shipping scenes of the river traffic on the rivers Merwede and Maas. This painting shows the arrival of the daily passage boat that plied between Rotterdam and Dordrecht. A drummer plays and the Dutch flag flutters in the wind. The vessels in the background may be an

16 (detail)

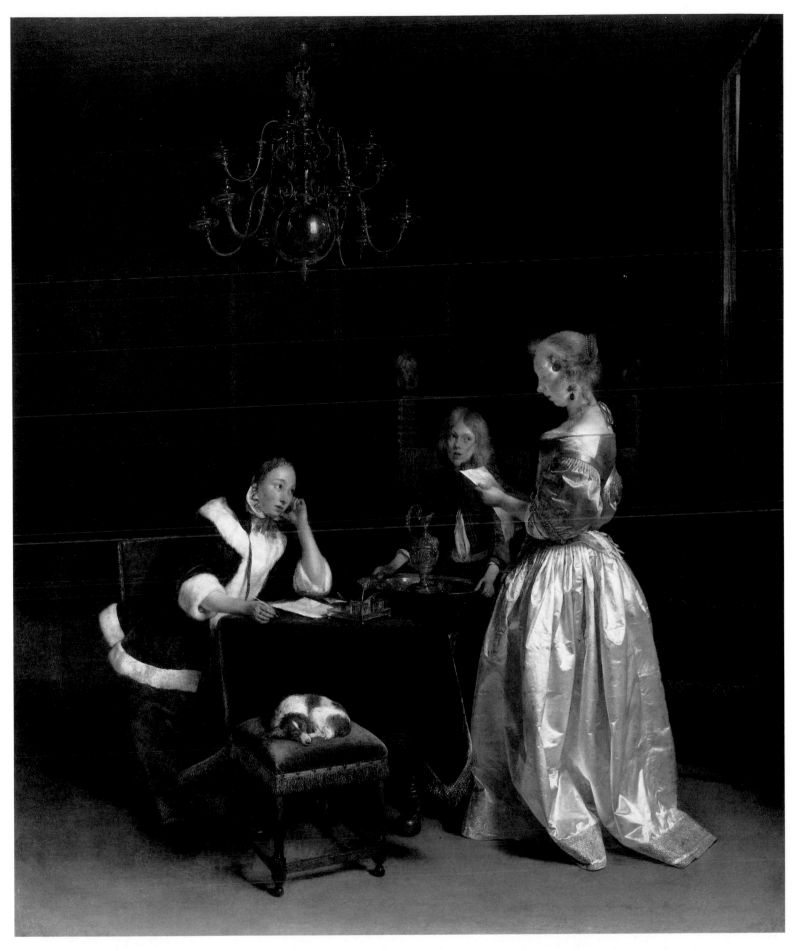

15

allusion to the visit of the Dutch fleet to Dordrecht in the summer of 1647. Although similar shipping scenes by Cuyp represent the embarkation or landing of some dignitary, the figure clothed in red at the prow of the passage boat does not seem to represent a particular individual.

This painting is notable above all for the rendering of the relationship between water, sky and shipping against a low horizon. The atmosphere is almost palpable as the golden evening light casts long shadows and a gentle breeze fills the sails of the boats in the background. The vigorous rendition of the clouds and the superb handling of the reflections in the foreground contrast with the sharp lines of the rigging and the strong silhouettes of the figures on the pier. Cuyp's alterations to the angle of the rigging and the lower of the two Dutch flags are clearly visible. Paintings like this made a powerful impression on J.M.W. Turner.

Oil on canvas. 124.4 × 144.2 cm
Signed on the rudder A. *cüyp*

RCIN 405344
PROVENANCE Sir Francis Baring; Sir Thomas Baring; from whom bought by George IV, 1814 (91)
LITERATURE White 1982, no. 39
EXHIBITIONS London 1819b, no. 14; London 1826, no. 12; London 1827, no. 61; London 1946–7, no. 357; Edinburgh 1947, no. 11; QG 1962–3, no. 26; London 1973, no. 12; Dordrecht 1977–8, no. 90; QG 1988–9, no. 18

17

JOHANNES VERMEER (1632–1675)
A lady at the virginal with a gentleman, c.1662–5

Only thirty-four paintings by Vermeer are known today and few biographical details are recorded concerning the artist, who was based for most of his life in Delft. The meanings behind his paintings are

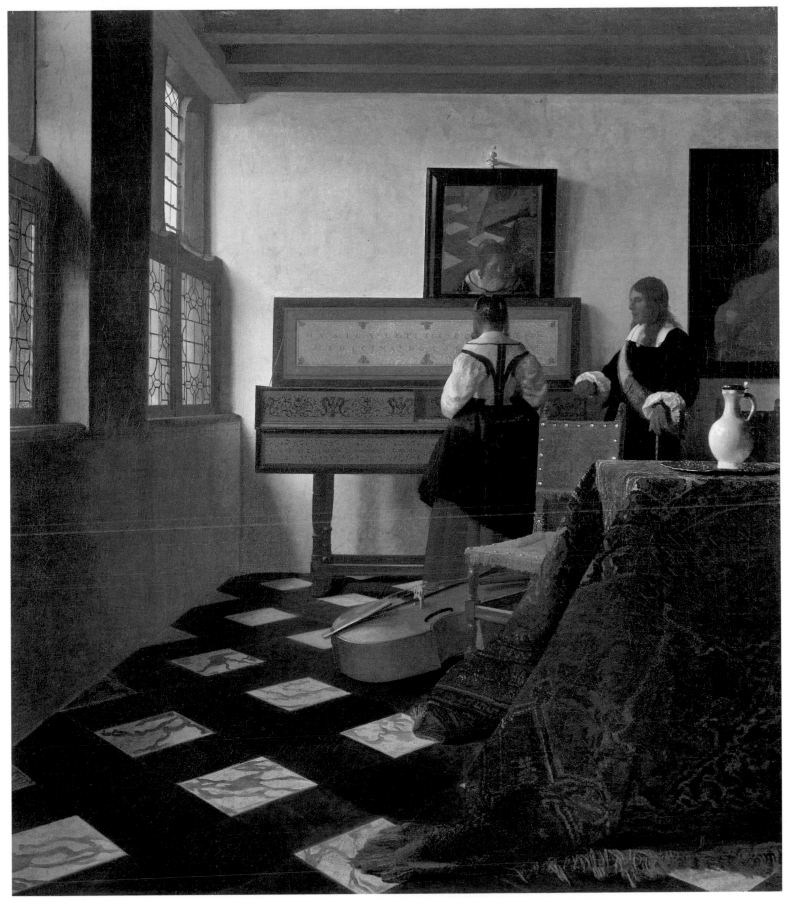

17

◁ 16

similarly enigmatic. Here a woman plays a Dutch variety of the virginal, called a muselar, made by the Ruckers family, the famous Antwerp harpsichord-makers. The inscription on the lid – MVSICA . LETITIAE CO[ME]S / MEDICINA . DOLOR[VM] – can be translated as 'Music, pleasure's companion and remedy for sorrow'. The bass-viol laid on the floor may belong to the richly attired man who listens intently to the music. Behind him hangs the painting *Roman Charity* by the Dutch artist Dirck van Baburen (*c*.1595–1624) in which Cymon, condemned to starve to death, is being suckled by his daughter Pero (see Weber 2000); this is one of several allusions to love that can be found in the painting.

The painting attests to Vermeer's extraordinary technical skills in his search for verisimilitude. The perspective construction and experimentation with paint reveal his knowledge of the optical system and the visual effects obtained by the camera obscura. At the same time Vermeer manipulates the light effects to reinforce the composition's structure. Similarly the mirror's reflection looks optically correct, yet does not match reality. Only in her reflection does the woman turn to the man, but their intimacy is undermined by a surprising glimpse of the artist's easel, reminding us that the whole scene is Vermeer's sophisticated creation.

Only recognised as the work of Vermeer in 1866, the painting was previously attributed to Frans van Mieris, owing to a misreading of the signature. In its eighteenth-century Venetian frame it is shown hanging over the chimneypiece in the King's Closet at Windsor in 1816 (see no. 400).

Oil on canvas. 74 × 64.6 cm
Signed *IV Meer* (IVM in monogram)
RCIN 405346
PROVENANCE Jacob Dissius, before 1696; acquired by Giovanni Antonio Pellegrini (d. 1741), probably in the Low Countries, *c*.1718; bought (from Pellegrini's widow?) by Joseph Smith, 1742; from whom bought by George III, 1762
LITERATURE White 1982, no. 230; Broos (p. 51) and Wadum (pp. 69–73) in The Hague/Washington 1995–6 exh. cat.; Gaskell & Jonker 1998, pp. 111–23, 185–223; Harman 1999, pp. 161–6; Weber 2000, pp. 225–8
EXHIBITIONS London 1876, no. 211; London 1895b, no. 127; London 1929a, no. 305; London 1946–7, no. 305; The Hague 1948, no. 10; London 1952–3, no. 515; QG 1971–2, no. 10; Philadelphia/Berlin/London 1984, no. 119; QG 1988–9, no. 17; London 1991a, no. 53; The Hague/Washington 1995–6, no. 8

18

WILLIAM HOGARTH (1697–1764)
David Garrick and his wife, Eva-Maria Veigel, 1757

The celebrated actor-manager David Garrick (1717–79) was one of the most frequently painted subjects in eighteenth-century Britain. Despite their close friendship, formed after Hogarth painted Garrick as the King in William Shakespeare's *Richard III* in 1745 (Liverpool, Walker Art Gallery), tradition has it that artist and sitter quarrelled over this portrait. Garrick was displeased with his likeness and there are signs that Hogarth scored through the eyes. X-rays reveal that the sitters were originally placed in a domestic interior which was replaced by a column with a hanging cord. Although Garrick paid £15 for the painting in 1763, it was in Hogarth's studio at the time of the artist's death in the following year.

The precedents for the composition lay both in an earlier iconographical tradition, that of genius inspired by a muse, and also in contemporary French painting which was similarly rococo in spirit. Hogarth has depicted Garrick's wife, the Viennese dancer Eva-Maria Veigel (1725–1822), known as Violetti, in a coquettish pose which could be seen as either inspiring or distracting the great actor from his work composing a prologue to a satire on connoisseurship (Samuel Foote's comedy entitled *Taste*).

Hogarth (for whom see also nos 382–3) was appointed Serjeant-Painter to George II in 1757, but his relationship with the royal family was always unsatisfactory. His preliminary oil-sketch for a conversation piece of the family (Millar (O.) 1963, no. 559) was never realised on a larger scale.

Oil on canvas. 132.6 × 104.2 cm
Signed and dated W *Hogarth* / [p]inx^t 1757 and inscribed (on the book above the desk) SHAKE/SPEARE and (on the paper on which Garrick writes) *The Prologue to / Taste*
RCIN 405682
PROVENANCE Commissioned by David Garrick; presented by Mrs Hogarth to Mrs Garrick; her sale Christie's, London, 23 June 1823 (64); bought by E.H. Locker; from whom bought by George IV, before 1826
LITERATURE Millar (O.) 1963, no. 560; Paulson 1993, pp. 285–9; Uglow 1997, pp. 588–91
EXHIBITIONS London 1814, no. 98 (lent by Mrs Garrick); London 1826, no. 134; London 1827, no. 145; London 1853a, no. 167; London 1876, no. 88; London 1888, no. 27; London 1891a, no. 252; London 1934, no. 154; Chicago/Toronto/New York/London 1946–7, no. 6; Port Sunlight 1949, no. 92; London 1951a, no. 68; Manchester 1954, no. 37; London 1971–2, no. 200; London 1975c, no. 86; Stockholm 1979–80, no. 124; Nottingham/Edinburgh 1987, no. 17; Venice 1989, no. 156; QG 1991–2, no. 53; Wellington/Canberra/Ottawa 1994–5, no. 21; London 1997a, no. 27

19

GIOVANNI ANTONIO CANAL, called
CANALETTO (1697–1768)
Venice: Piazza S. Marco with the Basilica and Campanile, *c*.1725

The painting forms one of a set of six views of the Piazza San Marco and the Piazzetta, perhaps the earliest commission to Canaletto from Joseph Smith, who sold his outstanding group of paintings, prints and drawings by that artist to George III in 1762 (see no. 384). The set is all of the same size and, judging from the compositions and broad handling of paint, was probably intended to be incorporated symmetrically into the decoration of a single Venetian room. Four of the views are upright in format while this painting and its pendant are horizontal; the pendant (Levey 1991, no. 379) shows the opposite view of Piazza San Marco, looking west, in morning as opposed to evening light.

Canaletto's training as a painter of theatrical scenery can be recognised in the creation of a clearly defined architectural space in subdued colours, animated by the brightly coloured figures and temporary booths. A ruling instrument was used for the Campanile and Procuratie Nuove and dividers for the arches on the façade of the Basilica. The late afternoon light brilliantly highlights the Palazzo Ducale, in contrast to the Procuratie Nuove, whose diagonal shadow throws the lower part of the Campanile and part of the Piazza into darkness, catching two strategically placed groups of bystanders in half-shadow. Canaletto distorts the topography and the principal architectural features for dramatic effect,

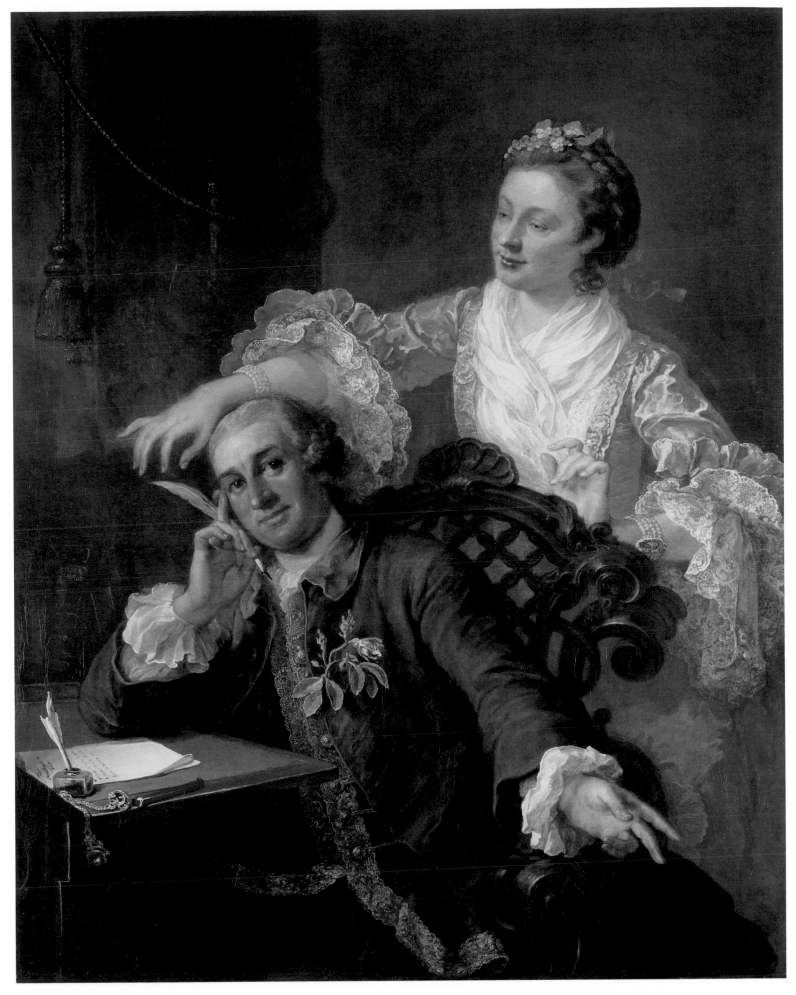

developing ideas already evident in the preparatory drawing, also in the Royal Collection (Parker 1948, no. 5).

The striking contrasts of light, the expansive skies with swirling clouds, the emphasis on diagonals, and the broad fluid strokes defining the figures have been compared to those in *The Stonemason's Yard* (London, National Gallery) painted before August 1725 (see Kowalczyk 1998) and the series of four paintings commissioned by Stefano Conti (private collection) dated 1725–6. The scale and visual impact of this painting are in marked contrast with Canaletto's later work when size and overall effect were tailored to the British market.

Oil on canvas. 135 × 172.8 cm

RCIN 405934

PROVENANCE Joseph Smith; from whom bought by George III, 1762

LITERATURE Baetjer & Links 1989, pp. 54–5, 132–7; Levey 1991, no. 378; Links 1994, pp. 56–7, 64–72; Kowalczyk 1998, pp. 73–99

EXHIBITIONS London 1946–7, no. 443; London 1954–5, no. 60; QG 1980–2, no. 4

20

LOUIS-GABRIEL BLANCHET (1701–1772)
Prince Charles Edward Stuart, 1739

This distinguished portrait and its pair (RCIN 401209), of the sitter's brother Henry Benedict Stuart (1725–1807), are arguably Blanchet's most memorable creations. They combine exciting handling and colour with direct characterisation. They were part of a group of four portraits, the other pair depicting the brothers' parents, which was commissioned by William Hay, Prince Charles Edward's Groom of the Bedchamber, and sent from Rome to Scotland in 1741, via James Edgar, the Prince's secretary. This portrait and its pair were acquired from Hay's descendants by Her Majesty The Queen in 1966.

Prince Charles Edward Stuart (1720–88), the Young Pretender, embodied the hopes of the Stuart cause in exile. His portrait was reproduced in numerous forms that could be disseminated widely, both as propaganda and as gifts for supporters. Here he is shown in breastplate and pauldron (shoulder-plate), an ermine cape around him, wearing the Orders of the Garter and the Thistle. He was 19 years old at the time of the sitting and is portrayed as a confident warrior-prince.

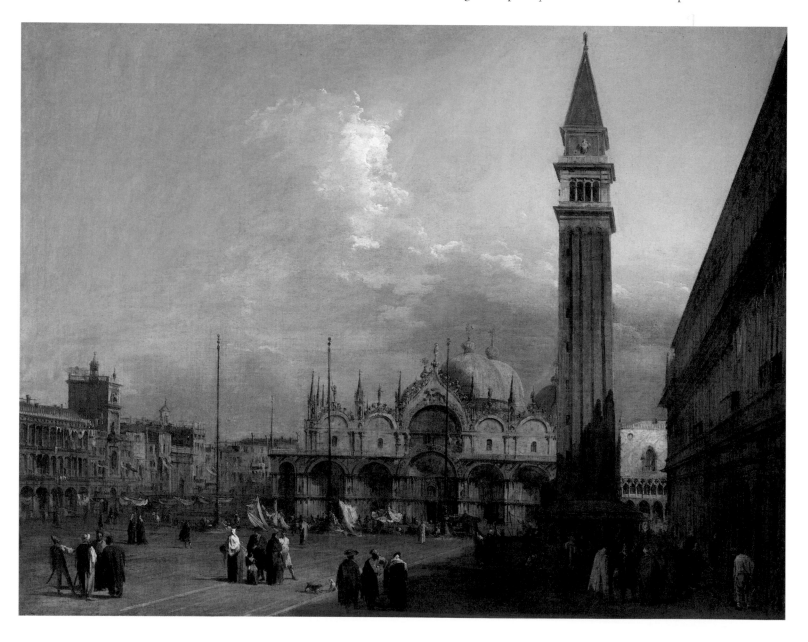

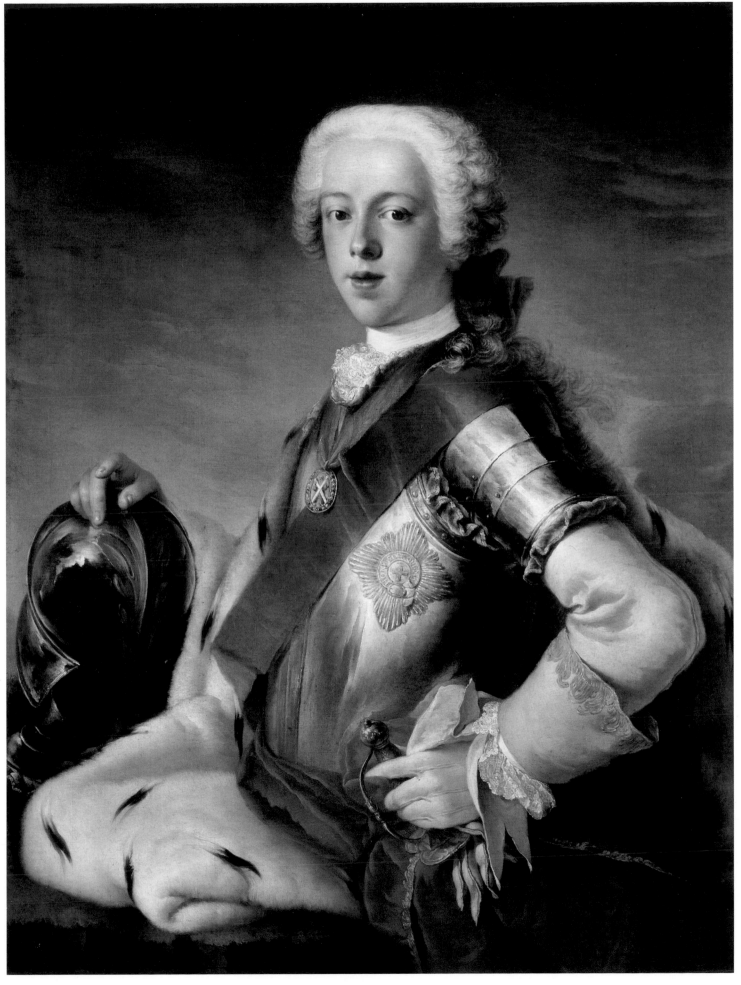

◁ 19
20

Born and brought up in Rome, the Prince made several efforts to regain the British throne for his father James Francis Edward Stuart (the Old Pretender), the son of the exiled King James II. The King had been forced to flee England during the Glorious Revolution of 1688 when his Protestant daughter Mary and her husband William of Orange replaced him on the throne. Prince Charles Edward Stuart was finally defeated at Culloden in 1746 and lived in exile in France and Italy for the rest of his life.

Louis-Gabriel Blanchet was one of the most important French painters to make his career entirely in Rome during the eighteenth century. He participated in the transition from the late Baroque style to the revival of the more severe classicising manner that marked the end of the century.

21

Oil on canvas. 98.4 × 75.6 cm

Signed and dated *LG Blanchet / fecit* 1739

RCIN 401208

PROVENANCE Commissioned in Rome by William Hay (of Edington, Scotland); by descent to Lt-Col. G.H. Hay (of Duns Castle, Berwickshire); his sale, Christie's, London, 25 March 1966 (83); acquired by HM The Queen

LITERATURE Bowron & Rishel 2000, pp. 327–30; Corp 2001, pp. 78, 108 (Blanchet 3)

EXHIBITIONS Edinburgh 1883, no. 3; London 1889b, no. 177; Edinburgh 1950, no. 149c; QG 1983–4, no. 43; Philadelphia/Houston 2000, no. 184

21

SIR JOSHUA REYNOLDS (1723–1792)
Francis Rawdon-Hastings, second Earl of Moira and first Marquess of Hastings, 1789–90

Both Frederick, Duke of York, and his elder brother George, Prince of Wales (later George IV), were close friends of the Marquess of Hastings (1754–1826). A contemporary report suggests that Hastings commissioned this portrait as a gift for the Duke of York, who gave Hastings his portrait in return. George IV, who had already exchanged portraits with Hastings as a mark of friendship, purchased this painting at the posthumous sale of the Duke of York's collection in 1827.

Hastings's appointments as Governor-General of Bengal in 1813 and Governor of Malta in 1824 were the culmination of a successful military career. He is depicted wearing the undress uniform of a colonel while ADC to George III, an appointment he held from 1782 until 1793.

This is one of the last portraits that Reynolds painted with a sitter posed in front of him. Six sittings are recorded in the artist's sitter-book in June and July 1789. On 13 July, the day after the last sitting, Reynolds recorded that his eye 'began to be obscured'. However, a newspaper critic wrote on 28 September that the portrait would be 'safely as well as easily finished'. Reynolds's difficulties in seeing are not apparent in this heroic image in which the sitter's pose and stance suggest intelligence and confidence in the face of danger. The portrait is one of Reynolds's most impressive achievements in a career which saw him appointed the first President of the Royal Academy in 1768 and during which he painted many portraits of the leading figures of British society. His keen intellect is reflected in the *Discourses on Art* addressed to the students of the Royal Academy between 1769 and 1790. However, Reynolds was not able to please George III and Queen Charlotte who disliked him, even though he was appointed Principal Painter to the King in 1784.

Oil on canvas. 240 × 147.9 cm

RCIN 407508

PROVENANCE Painted for the sitter and given by him to Frederick, Duke of York, 1790; his sale Christie's, London, 7 April 1827 (107); bought by George IV (£72 9s.)

LITERATURE Millar (O.) 1969, no. 1023; Mannings 2000, no. 859

EXHIBITIONS London 1790, no. 94; London 1813, no. 92; London 1827, no. 144; London 1846, no. 50; London 1862b, no. 111; London 1946–7, no. 107; Birmingham 1961, no. 88; Paris/London 1985–6, no. 153; London 1991a, no. 65

22

GEORGE STUBBS (1724–1806)
William Anderson with two saddle horses, 1793

George IV was a keen horseman, commissioning or purchasing eighteen works from the celebrated equestrian artist George Stubbs, almost all of which date from the 1790s. A bill addressed to the Prince of Wales on 14 February 1793 by the frame-maker Thomas Allwood of No. 35

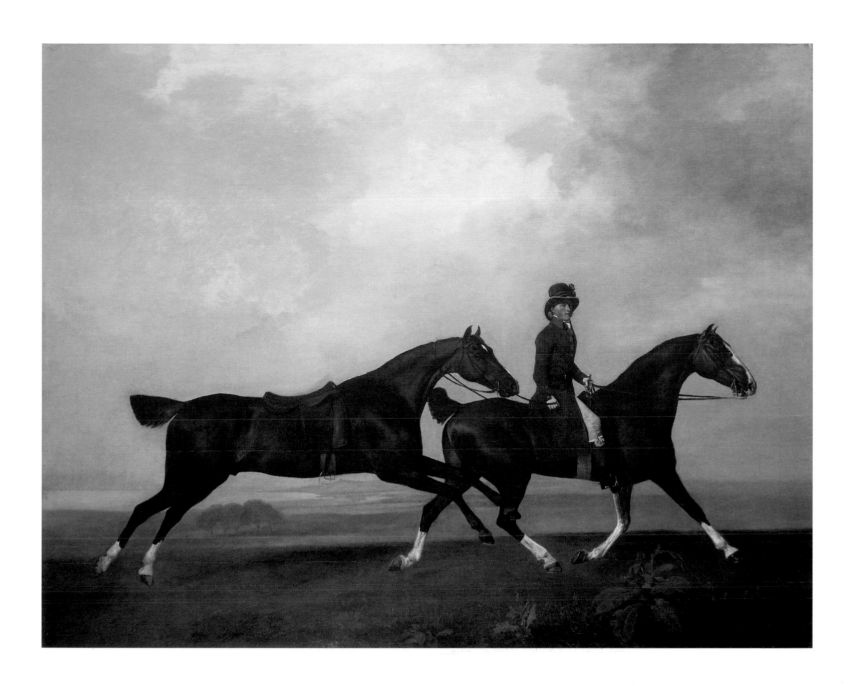

Great Russell Street, London, reads 'To Carving & Gilding eight Picture frames of half length size for Sundry Pictures painted by Mr. Stubbs, all of one pattern'. The present painting is surrounded by one of these frames.

William Anderson's career began in 1788 as a helper and hack-groom to George IV when Prince of Wales, but he was appointed Head Groom in 1804 and finally Groom of the Stables in 1812. He is shown wearing the royal livery of scarlet with blue collar and cuffs and it has been suggested that the presence of his master is implied by the empty saddle of the chestnut horse he is leading. The setting is probably the coastal downs near Brighton, where the Prince was to spend £55,000 adding a stable block to the Royal Pavilion in 1807–08. When Anderson stayed at Brighton for twelve days during 1793 he was paid one shilling a day for board and lodging.

The Prince of Wales expressed his appreciation of chestnut horses in a letter from Brighton in 1793: 'I have driven every day of late the chest-nut horses wh. go better than any horses I have belonging to me' (Aspinall 1963–71, II, p. 247). Stubbs's lengthy study of the anatomy

of the horse is reflected in the detailed observation in this painting. The composition is simple, with the two overlapping horses creating a strong horizontal emphasis, broken by Anderson's rigid vertical figure. The large expanse of sky, pink around the horses and blue in the empty corners, and rolling landscape, are broadly observed in contrast to the sharp focus of the main group.

Oil on canvas. 102.2 × 127.9 cm
Signed and dated *Geo: Stubbs p: / 1793*
RCIN 400106
PROVENANCE Commissioned by George IV when Prince of Wales, 1793
LITERATURE Millar (O.) 1969, no. 1110
EXHIBITIONS London 1946–7, no. 484; Liverpool 1951, no. 54; QG 1966–7, no. 18; QG 1977–8, no. 35; London 1984–5, no. 133; Bristol/Cardiff 1989–90, no. 46; London 1991a, no. 66

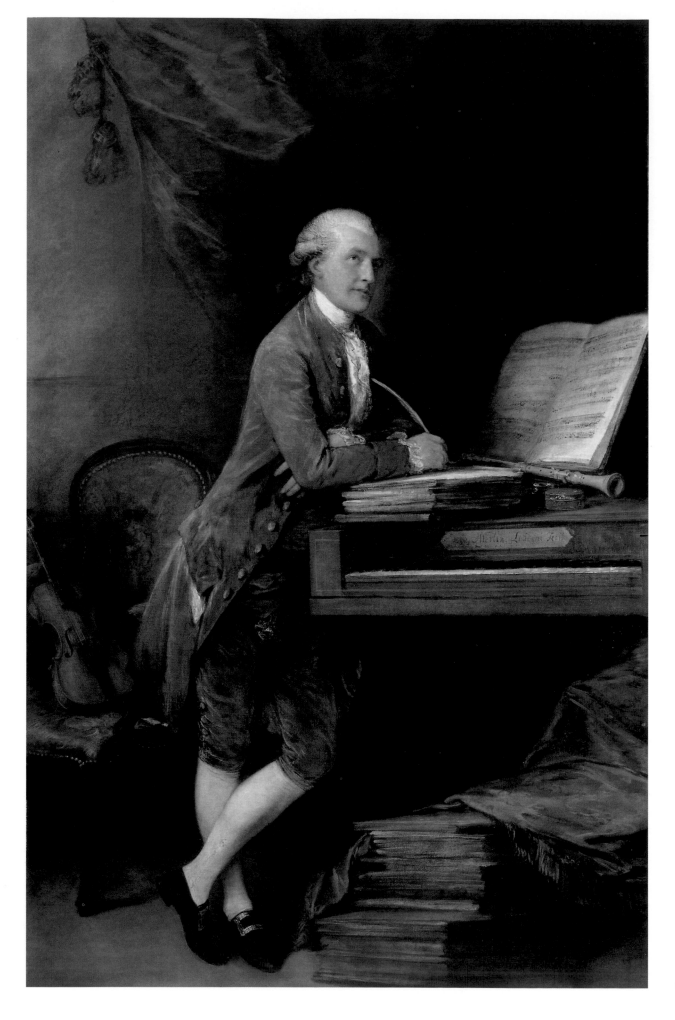

◁ 23

24 (detail) ▷

23
THOMAS GAINSBOROUGH (1727–1788)
Johann Christian Fischer, c.1774

Johann Christian Fischer (1733–1800), the German composer and virtuoso oboe player, made his first public appearance in London in June 1768, his superb performing technique described by Fanny Burney as 'the sweet-flowing, melting, celestial notes of Fischer's hautboy'. He wrote for the oboe and flute and was also skilled at the violin. It is likely that the piano (inscribed *Merlin Londini Fecit*) on which he leans in this painting is a pianoforte-harpsichord, as patented by John Joseph Merlin (originally from the Netherlands) in 1774; Fischer settled permanently in London in the same year. He played frequently at court and became a member of the Queen's Band; however, he failed to secure the post of Master of the King's Band in 1786.

Gainsborough, himself an accomplished musician, had met Fischer by 1773. This portrait, painted out of friendship rather than as a commission, was recorded in Gainsborough's Bath studio the following year. X-rays reveal that the canvas was reused: Fischer's portrait was painted over an abandoned imaginary portrait of Shakespeare between Tragedy and Comedy, commissioned by David Garrick (see no. 18) in the summer of 1768. Fischer's elegant pose, developed from that of Shakespeare beneath, relates to Peter Scheemakers's famous sculpture of Shakespeare (1740) in Westminster Abbey; with his upward glance and pen in hand he seems to be seeking poetical inspiration. In 1780 Gainsborough gave unwilling consent to Fischer's marriage to his elder daughter Mary (1748–1826), correctly predicting that the union would not be a success.

For the manuscript inventory record of this painting, made by Richard Redgrave in 1862, see fig. 10.

Oil on canvas. 229 × 150.8 cm
RCIN 407298

PROVENANCE Probably painted for Willoughby Bertie, fourth Earl of Abingdon; sold by Montagu, fifth Earl of Abingdon, Wytham Abbey, 1802; sold B. Blackden, 3 June 1803 (32); bought by Morland; presented by Ernest, Duke of Cumberland, to George IV, 1809
LITERATURE Millar (O.) 1969, no. 800; Wilson 1977, pp. 107–10; French 1985, pp. 29–32; Postle 1991, pp. 374–9
EXHIBITIONS London 1780, no. 222; Dublin 1861, no. 196; London 1862b, no. 29; London 1877, no. 22; London 1946–7, no. 110; QG 1970–1, no. 1; London 1977c, no. 10; London 1980–1b, no. 126; London 1991a, no. 63; London 1992a, pp. 80–1; QG 1994, no. 12

24
JOHAN ZOFFANY (1733–1810)
The Tribuna of the Uffizi, c.1772–8

Zoffany arrived in London from his native Germany in 1760, having previously visited Italy. He was patronised by George III and Queen Charlotte from c.1765 and over the next ten years produced a series of portraits of the King and Queen and their family. In the summer of 1772 Zoffany arrived in Florence with a commission from the Queen to paint 'the Florence Gallery'. He was still working on The Tribuna late in 1777, not returning to England until 1779.

The Tribuna is an octagonal room in the Uffizi designed by Bernardo Buontalenti for Francesco de' Medici in the late 1580s to house the most important antiquities and High Renaissance and Bolognese paintings in the grand-ducal collection. In 1737 the collection was ceded to the Tuscan government by the Grand Duchess Anna Maria Luisa. The Uffizi, and in particular the Tribuna, became the focal point for visitors to Florence. By the 1770s it was arguably the most famous room in the world. Zoffany has portrayed the north-east section but has varied the arrangement and introduced other grand-ducal works to create his own Tribuna. Assisted by George, third Earl Cowper

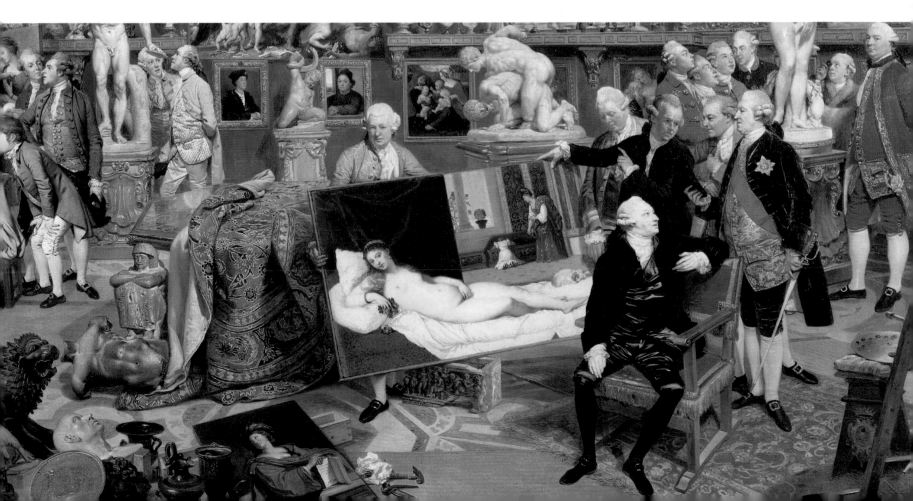

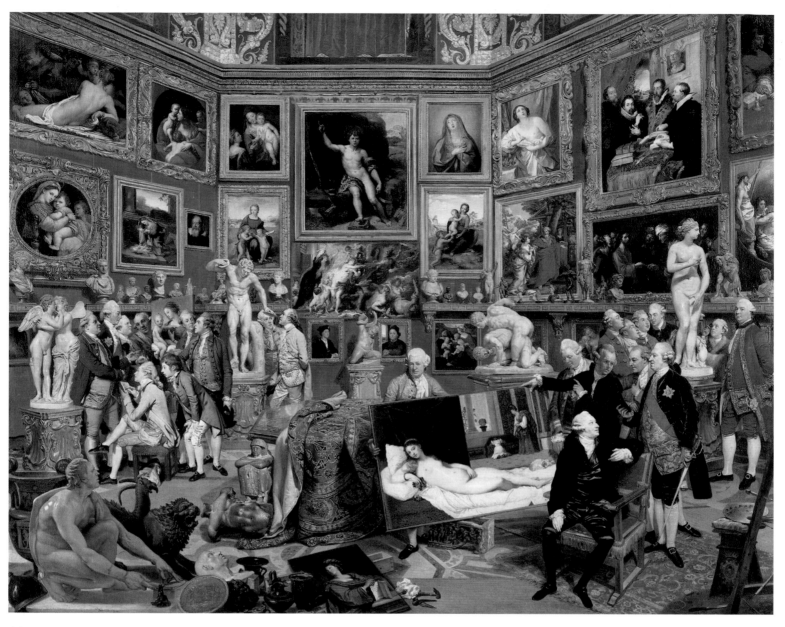

24

(1738–80), and Sir Horace Mann (1706–86), Zoffany was granted special privileges as, for example, when seven paintings, including the famous Raphael *Madonna della Sedia*, were brought in from the Pitti.

Admiring the works of art are connoisseurs, diplomats and visitors to Florence, all identifiable, so that the predominantly Flemish seventeenth-century tradition of gallery views is combined with the British eighteenth-century conversation piece or informal group portrait. One of several changes made by the artist was to show in the left background Lord Cowper admiring a painting from his own collection, Raphael's *Niccolini-Cowper Madonna* (Washington, National Gallery of Art). This is held by Zoffany himself as Lord Cowper hoped to sell it to George III.

The King and Queen were critical of the inclusion of so many recognisable portraits, described by Horace Walpole as 'a flock of travelling boys, and one does not know nor care whom'. Even so, *The Tribuna* is an outstanding example of Zoffany's technique and the consummate portrayal of the Grand Tour and eighteenth-century taste.

Oil on canvas. 123.5 × 155 cm
RCIN 406983

PROVENANCE Commissioned by Queen Charlotte, 1772
LITERATURE Millar (O.) 1967; Millar (O.) 1969, no. 1211; Paulson 1975, pp. 138–48; Barocchi & Ragionieri 1983, 1, pp. 367–93, 2, pp. 287–317; Pressly 1987, pp. 96–7
EXHIBITIONS London 1780, no. 68; London 1814, no. 2; London 1826, no. 162; London 1827, no. 151; London 1862b, no. 155; London 1895a, no. 95; London 1946–7, no. 48; London 1951–2, no. 50; London 1959–60, no. 125; Glasgow 1962–3, no. 54; QG 1974–5, no. 47; London 1977b, no. 76; Norwich 1985, no. 109; QG 1988–9, no. 26; London 1991a, no. 61; London/Rome 1996–7, no. 91

25

JOHN SINGLETON COPLEY (1738–1815)
The three youngest daughters of George III, 1785

Copley, the foremost artist in colonial America, was virtually self-taught as a portraitist. Having established a successful practice in Boston, he was encouraged to visit Europe in 1774. After a year's travel he settled in London and began to specialise in religious and historical subjects,

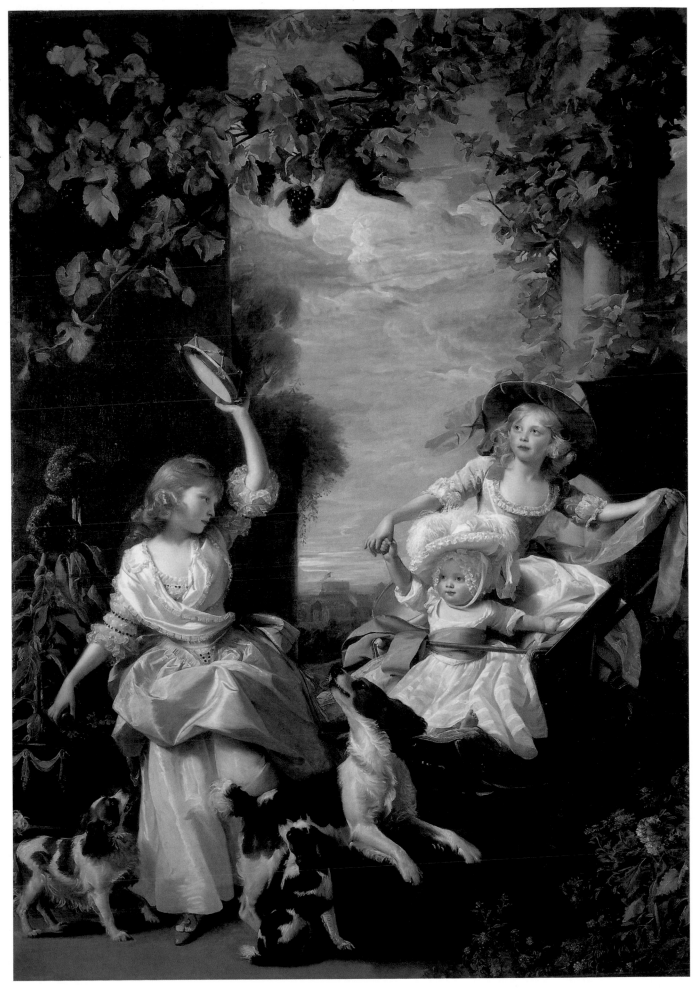

25

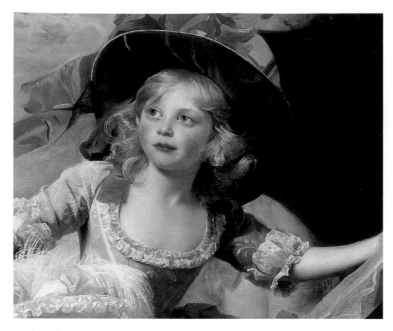

25 (detail)

SIR WILLIAM BEECHEY (1753–1839)
Princess Augusta, c.1802

Princess Augusta Sophia (1768–1840) was the sixth child and second daughter of George III and Queen Charlotte. The enamel anchor pendant on her necklace also appears in an earlier half-length portrait of Augusta by Beechey in the Royal Collection (Millar (O.) 1969, no. 666) and in a number of drawings of her by Henry Edridge, also in the Royal Collection (Oppé 1950, nos 203–08). It has been suggested that the anchor pendant might relate to the Princess's devotion to her brother William, Duke of Clarence (later William IV), or to her love of the sea. It is known that the Princess, who remained unmarried, was particularly fond of visiting the bathing resort of Weymouth in Dorset and one of the Edridge drawings represents her standing at Weymouth Bay. It is possible that Weymouth is the setting for this portrait, which was exhibited at the Royal Academy in 1802 with a full length of Augusta's brother Ernest, Duke of Cumberland, of the same size (Millar (O.) 1969, no. 673). These pictures may have been conceived as a pair;

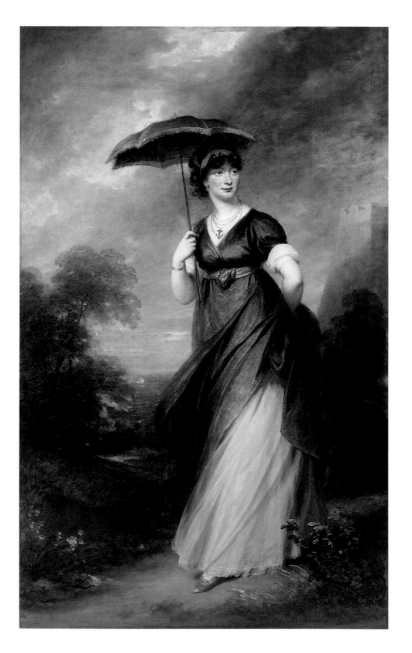

becoming a member of the Royal Academy in 1779. A fellow American artist, Benjamin West, who had become Historical Painter to the King in 1772, helped Copley to obtain the commission from George III to paint the three youngest royal princesses. Copley's sense of the significance of the opportunity is reflected in the sheer scale of the painting, for which he made many studies. As the royal children and pets grew tired of the numerous sittings they had to endure, West had to reassure the King that Copley 'must be allowed to proceed in his own way' (Millar (O.) 1969, p. 20).

On the left is 9-year-old Princess Mary (1776–1817) striking a tambourine to amuse her 2-year-old sister, Princess Amelia (1783–1810), who is seated in the carriage (adorned with her monogram PA), beyond which is the 8-year-old Princess Sophia (1777–1848). They are playing beneath a vine-covered arbour with parrots picking at grapes above them; in the distance the Round Tower of Windsor Castle is visible in the evening landscape.

The painting is full of carefully observed detail of surfaces and textures and captures the affectionate relationship between the sisters and their natural high spirits. However, it was judged harshly by contemporary critics, most of whom found its ebullience unsuited to royalty and considered the composition unfashionably cluttered. To the modern eye, Copley has managed to capture the energetic spirit of childhood in a painting that is undeniably rococo in spirit. By the end of George III's reign the painting hung in the Queen's Ballroom at Windsor (see under no. 402). In 1843 it was recorded hanging in the Green Drawing Room in Buckingham Palace (see no. 415).

Oil on canvas. 265.5 × 186 cm
Signed and dated J. S. Copley 1785
RCIN 401405
PROVENANCE Commissioned by George III and Queen Charlotte
LITERATURE Millar (O.) 1969, no. 712; Ballew Neff 1995, pp. 23–59, 155–8
EXHIBITIONS London 1785, no. 80; London 1862b, no. 129; London 1881, no. 133; London 1891a, no. 67; New York 1937, no. 42; London 1946, no. 237; London 1946–7, no. 113; QG 1963–4, no. 22; Washington/New York/Boston 1965–6, no. 80; London 1968–9, no. 63; London 1992b, no. 44; Wellington/Canberra/Ottawa 1994–5, no. 25; Washington/Houston 1995–6, no. 33

they were hanging together in the King's Dining-Room at Kew three years later.

George III and Queen Charlotte's admiration for Beechey's work led to numerous commissions for royal portraits and to his appointment as Portrait Painter to the Queen in 1793, the year in which he was elected an associate member of the Royal Academy. Although he seems to have fallen out of favour with the King and Queen by 1804, he continued to paint other members of the royal family until the end of his career.

Beechey's early training was with Johan Zoffany (see no. 24) but the loose handling and dexterous brushwork of his later paintings is closer to the work of his rival Sir Thomas Lawrence (see no. 28). Of the previous generation of British artists, Thomas Gainsborough's painterly style, seen in his earlier portraits of Augusta – particularly the full length (cut down) with her two closest sisters (Millar (O.) 1969, no. 798) – appears to have been an obvious influence upon Beechey. The recent cleaning of this unlined painting has revealed the loose, rapid technique and use of rich colouring.

Oil on canvas. 240.2 × 148.7 cm
RCIN 404556
PROVENANCE Presumably commissioned by George III
LITERATURE Stuart 1939, pp. 71–138; Millar (O.) 1969, no. 672
EXHIBITIONS London 1802, no. 192; London 1819a, no. 97; London 1891a, no. 66; London 1956–7, no. 409

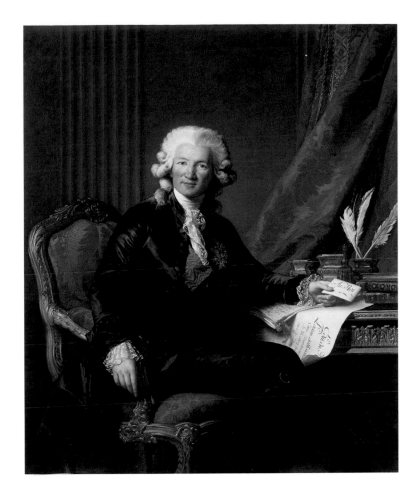

27
ELISABETH VIGÉE LE BRUN (1755–1842)
Charles-Alexandre de Calonne, 1784

Charles-Alexandre de Calonne (1734–1802) became Controller General of Finance to Louis XVI in 1783. His unsuccessful efforts to reform the structure of France's finance and administration precipitated the governmental crisis that led to the French Revolution of 1789. Unable to push through his plans for restoring solvency, he was dismissed in 1787 and retired to England where he became the chief adviser to the *émigrés*, selling his extensive art collections to finance their cause. His conviction that the French Revolution represented a threat to every established government was fully shared by George, Prince of Wales, who owned this painting before 1806.

Taught by her father, the artist Louis Vigée, Madame Vigée Le Brun earned an international reputation for her stylish portrayals of royalty and aristocratic society throughout Europe. In her *Memoirs*, written towards the end of her life, the artist strongly denied rumours of an affair with Calonne: 'I have never thought of M. de Calonne as particularly seductive for he used to wear a fiscal wig. Can you imagine that I, with my love of the picturesque, could ever tolerate a wig?' (Vigée Le Brun 1989, p. 47). Similarly, her husband, the art dealer Jean-Baptiste-Pierre Le Brun, in a pamphlet defending Elisabeth's right to remain a French citizen, refuted the scandal that surrounded the payment for this portrait.

This is one of the more complex of Vigée Le Brun's male portraits in terms both of setting and iconography. The sitter is wearing the dress of the Noblesse de Robe and the ribbon and star of the Order of the Saint-Esprit; he holds a letter addressed to Louis XVI (inscribed *Au Roi*). Such details demonstrate his powerful position and close relationship with the monarch. Dated August 1784, the charter that eventually led to his downfall rests upon the table. There is a surprising formality about the setting and costume but Le Brun has none the less included the powder that has fallen from Calonne's wig onto his shoulders.

Oil on canvas. 155.5 × 130.3 cm
Signed and dated *Le Brun. f. 1784.*
RCIN 406988
PROVENANCE Commissioned by the sitter; acquired by George IV when Prince of Wales, before 1806
LITERATURE Vigée Le Brun 1989, pp. 43–8
EXHIBITIONS Paris 1785, no. 87; London 1946–7, no. 406; London 1954–5, no. 339; Glasgow 1962–3, no. 40; QG 1966, no. 6; London 1968a, no. 711; Washington 1976, no. 227; QG 1979–80, no. 47; QG 1988–9, no. 31; Cardiff 1998, no. 79

28
SIR THOMAS LAWRENCE (1769–1830)
Pope Pius VII, 1819

Thomas Lawrence dominated the art of portrait painting in England for forty years, undertaking commissions for the future George IV from 1814. After 1818 Lawrence was largely occupied in the major royal commission for a series of portraits of the European leaders who had combined to defeat Napoleon. The series was initially proposed for Carlton House, but George IV's plans for Windsor Castle latterly came to include a new room specially created (from an open courtyard) for the display of Lawrence's portraits, the Waterloo Chamber (see p. 31 and no. 407). This portrait is arguably the most magnificent of that series.

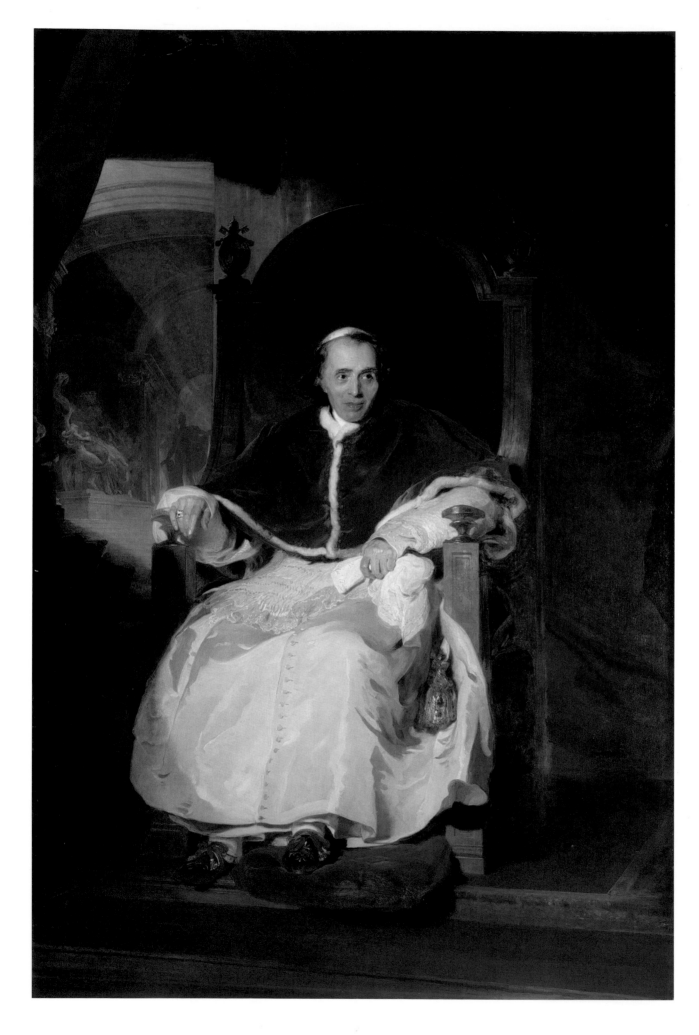

◁ 28

Luigi Barnaba Chiaramonti (1742–1843), elected Pope in 1800, was imprisoned by Napoleon in 1809 for opposing his plans for the annexation of the Papal States. After his triumphant return to Rome in 1814, Pius VII became a focus for the political and spiritual regeneration of Europe. Lawrence arrived in Rome in May 1819 and was accommodated in the Quirinal Palace. He was given nine sittings by the Pope.

Lawrence must have recalled his great predecessors in the tradition of papal portraiture: Raphael's *Julius II* (London, National Gallery), Titian's *Paul III* (Naples, Capodimonte) and Velázquez's *Innocent X* (Rome, Galleria Doria-Pamphili), as well as contemporary portraits. Here, in contrast to those examples, the Pope is shown full length. His pale face, set off by jet-black hair, is made more vulnerable by the play of vivid red and white and the magnificent portable papal throne (the *sedia gestatoria*). With dazzling surface effects Lawrence portrays the Pope, a symbol in his time for the victory of peace over war, as a spiritual ruler with temporal power and all the trappings of authority.

In the left background notable pieces of classical sculpture in the papal collections are shown in the *Braccio Nuovo*, created for their display under the supervision of the sculptor Canova, who had secured the return of the collection from Paris (see no. 72). The paper held by the Pope is inscribed *Per Ant°. Canova* (for Antonio Canova). The portrait has long been regarded as Lawrence's crowning achievement.

Oil on canvas. 269.4 × 178.3 cm
RCIN 404946

PROVENANCE Commissioned by George IV, 1819 (£525)
LITERATURE Millar (O.) 1969, no. 909; Garlick 1989, no. 650
EXHIBITIONS London 1830, no. 10; London 1862b, no. 141; London 1904b, no. 67; London 1946–7, no. 131; London 1961, no. 5; London 1968–9, no. 186; Paris 1972b, no. 161; London 1979–80, no. 38; London 1991a, no. 67

29

SIR DAVID WILKIE (1785–1841)
The Defence of Saragossa, 1828

The Edinburgh-trained artist David Wilkie settled in London in 1805 and soon won acclaim for his paintings, many of which used Romantic continental subject matter. In 1825 he visited France for the third time, at the start of a three-year visit which included an extended stay in Spain. His first-hand experiences are combined here with contemporary interest in the Spanish struggle for independence from Napoleon. The two-month siege of Saragossa in 1808, when the local guerrilla leader Don José de Palafox y Melci led heroic, ill-equipped citizens to victory, had been commemorated in poetry and prose, most notably by Byron in *Childe Harold's Pilgrimage* (canto I, 54–9). Here Agostina Zaragoza (the 'Maid of Saragossa') lights the fuse in the cannon which Palafox, dressed as a volunteer, directs with Father Consolaçion, an Augustinian friar.

Wilkie had planned the composition by 19 November 1827, the date on a preparatory study (Blackburn Museum and Art Gallery). Through

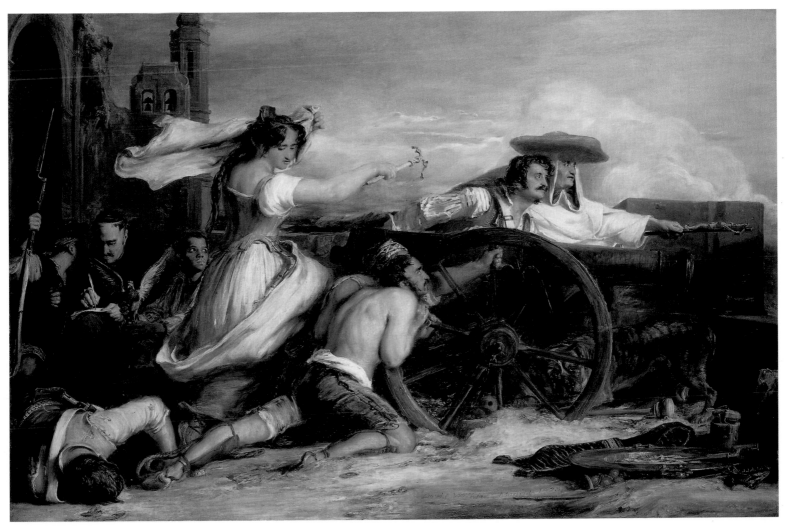

29

Prince Dolgoruki of the Russian Legation at Madrid, Wilkie had sittings from Palafox himself, but letters as late as 15 April 1828 reveal that the painting remained unfinished. The success of Wilkie's early genre and history paintings, much influenced by seventeenth-century Dutch and Flemish artists, now gives way to a bolder style redolent of his careful study of Correggio, Titian and Rubens, and of Velázquez and Murillo in Spain. On his return journey from Spain, Wilkie met the French history painter Delacroix whose famous *Liberty Leading the People* (1830; Paris, Louvre) takes up many of the themes of this painting.

George IV acquired six paintings (including no. 29) from Wilkie following his return to London. The King's collection already contained two paintings by Wilkie, who had served as King's Limner in Scotland since 1823. Away from London for three years, and painting in a new style, such generous support came at a crucial moment in Wilkie's career and confirmed his reputation in the eyes of the British public. In 1830 he succeeded Lawrence as Principal Painter to the King; he continued to serve William IV and the young Queen Victoria in this capacity.

Oil on canvas. 94.2 × 141.5 cm
RCIN 405091
PROVENANCE Bought by George IV, 1829 (2,000 gns, with two other paintings by Wilkie)
LITERATURE Millar (O.) 1969, no. 1180; Altick 1985, p. 438; Brown (D.) 1985, pp. 9–13

EXHIBITIONS London 1829, no. 128; Edinburgh 1840, no. 50; London 1842a, no. 2; London 1862b, no. 275; Dublin 1865, no. 162; London 1946–7, no. 480; Edinburgh 1958, no. 70; London 1958, no. 36; London 1959, no. 376; Moscow/Leningrad 1960, no. 70; Raleigh/New Haven 1987, no. 30; QG 1988–9, no. 68; London 1991a, no. 68

30
SIR EDWIN LANDSEER (1803–1873)
Eos, 1841

Eos, a greyhound bitch, was Prince Albert's favourite dog. She accompanied her master when he travelled from Germany to marry Queen Victoria in 1840. The portrait was commissioned by the Queen as a Christmas present in 1841. Her Journal records the Prince's delight and complete surprise on receiving the gift, which contrasted markedly with the great sadness caused by the death of Eos on 31 July 1844. The bronze memorial statue to Eos on her tomb in the Home Park at Windsor, partly worked on by the Prince, was modelled on this portrait.

Both artist and patron had a deep sympathy for animals, particularly dogs. Precociously gifted, Landseer learnt his accuracy of drawing from the study of anatomy and animal dissections in emulation of artists such as George Stubbs, some of whose anatomical drawings he owned.

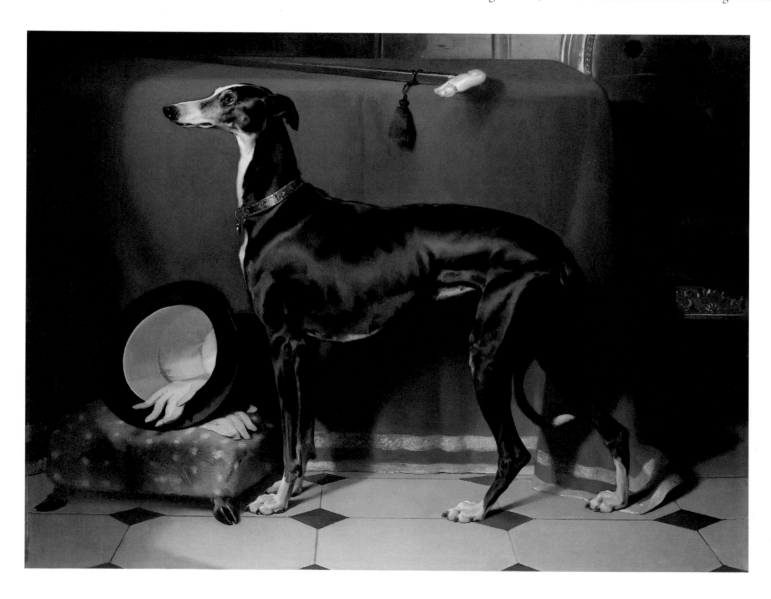

◁ 30

On a grand scale, the nobility and tense energy of the greyhound are intensified by the rigorous profile pose and the austere but striking play of black against red throughout the composition. Landseer, unlike Stubbs, invested animals with anthropomorphic qualities and hints at a story. Eos appears to express steadfast loyalty for her absent owner, who may just be out of view. The deerskin footstool alludes to prowess on the hunting field, but the expensive silver collar, hat, gloves and cane refer to the noble Prince of the modern world. Until the ascendancy of Franz Xaver Winterhalter, Landseer was in effect an unofficial court painter. Queen Victoria expressed her admiration for his work in the late 1830s and her first commissions date from 1838; she remained a loyal and steadfast patron, acquiring around a hundred paintings and drawings from him in the following two decades.

Oil on canvas. 111.8 × 142.9 cm
Inscribed on the back with the names of artist and sitter and the date *December 1841*
RCIN 403219
PROVENANCE Commissioned by Queen Victoria as a Christmas present for Prince Albert, 1841 (£150 or 150 gns)
LITERATURE Ormond 1981, pp. 152–6; Millar (O.) 1992, no. 424
EXHIBITIONS London 1842b, no. 266; London 1874, no. 323; Sheffield 1972, no. 74; Philadelphia/London 1981–2, no. 106; London 1983–4c, p. 121, pl. 118; Washington 1997, no. 3

31
FRANZ XAVER WINTERHALTER (1805–1873)
The Maharaja Dalip Singh, 1854

Winterhalter, who was born in the Black Forest in Germany, was the principal portrait painter at the court of Queen Victoria during the first half of her reign. He first came to London in 1842 on the recommendation of Louise, Queen of the Belgians, and he continued to work for Queen Victoria at intervals until his death, painting well over a hundred pictures. He was an artist of international status and managed to sustain a high level of productivity, amassing a substantial fortune in the process. Queen Victoria admired the light, fresh colours of his work, and frequently commissioned him to paint subjects of private significance.

Queen Victoria was captivated by Dalip Singh (1838–93) when first introduced to him in 1854, the year in which he was brought to England, having surrendered his sovereignty of the Punjab in 1849. She recorded that 'Winterhalter was in ecstasies at the beauty and nobility of bearing of the young Maharaja. He was very amiable and patient, standing so still and giving a sitting of upwards of 2 hrs' (QVJ, 10 July 1854). Queen Victoria's fascination with India continued throughout her life and this was one of many portraits that she commissioned of Indian sitters. However, Winterhalter's male portraits are rarely as romantic or exotic as this image, which places the young Maharaja in an imaginary landscape in Indian dress.

The Maharaja is shown wearing his diamond aigrette and star in his turban and a jewel-framed miniature of Queen Victoria by Emily Eden. During one of the sittings he was shown the Koh-i Nûr diamond that he had surrendered in 1849. Queen Victoria recorded how she had given him the newly recut jewel to inspect and that he then handed it back to her, saying how much pleasure it gave him to be able to make the gift in person. He quickly became a close friend of the royal family, visiting

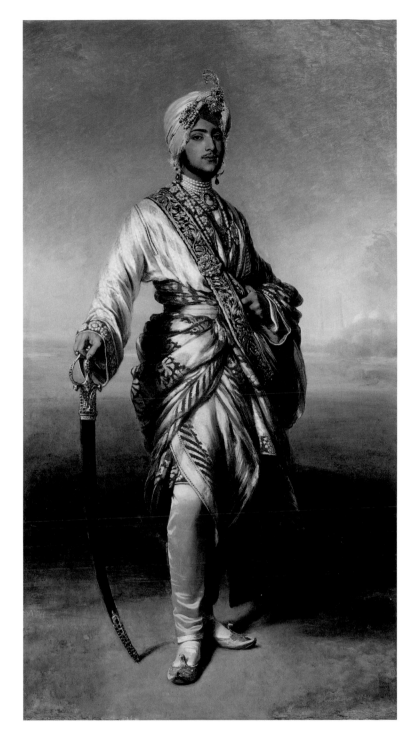

them at Osborne and inviting the Prince of Wales to shooting parties on his estate at Elveden Hall in Suffolk. However, Dalip Singh's financial difficulties and disaffection with British politics led him to become involved in various international intrigues in an attempt to regain his throne and he died in exile in Paris.

Oil on canvas. 204 × 110 cm
Signed and dated *F Winterhalter 1854*
RCIN 403843
PROVENANCE Commissioned by Queen Victoria, 1854
LITERATURE Millar (O.) 1992, no. 916; Stronge 1999, pp. 152–63; Campbell (C.) 2000, pp. 61–9
EXHIBITIONS Baden 1873, no. 15; London/Paris 1987–8, no. 40; London 1990–1, no. 208; London 1999b, no. 172

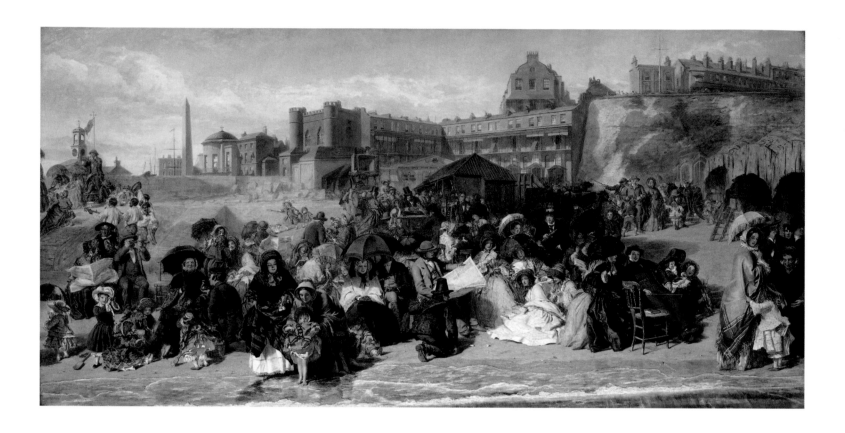

32

WILLIAM POWELL FRITH (1819–1909)
Ramsgate Sands: 'Life at the Seaside', 1852–4

On holiday at Ramsgate in 1851, Frith recorded in his autobiography that, weary of costume painting, 'I had determined to try my hand on modern life.' After three years' work, *Ramsgate Sands* was exhibited at the Royal Academy in 1854 and was so well received that Frith went on to paint his other major narrative compositions of contemporary life, *Derby Day* (1858; Tate Britain) and *The Railway Station* (1862; Egham, Royal Holloway and Bedford New College).

The development of the railways in the 1840s transformed quiet dignified towns into crowded resorts as Londoners started to enjoy day trips to the sea. Frith, inspired by the 'variety of character on Ramsgate Sands', shows the way in which predominantly middle-class families were forced into close proximity with other classes, tradesmen selling wares and entertainers, and the resulting humorous encounters. He was painstakingly accurate in his recording of both the setting and the characters, returning to Ramsgate several times. His studies of real-life characters and models and numerous pencil sketches of groups of figures were progressed to an oil-sketch of the whole composition (Dunedin Public Art Gallery).

Frith's skill at composing the scene is most obvious when compared with contemporary photographs of beach scenes. From our dramatic viewpoint out at sea, watched by the girl paddling and the girl with a telescope on the left, we are invited to explore a series of carefully interlocking and endlessly varied episodes. Dickens's account of the seaside in 'The Tuggses at Ramsgate' in *Sketches by Boz* (1836) could be a verbal description of Frith's painting. Contemporary reviews show that the public 'read' Frith's paintings like a novel.

Despite contracting typhoid there in 1835, Queen Victoria had happy memories of childhood visits to Ramsgate which broke the lonely routine of the London schoolroom. There are six other oils by Frith in the Royal Collection, including *The Marriage of the Prince of Wales*, commissioned by Queen Victoria in 1863.

Oil on canvas. 77 × 155.1 cm
Inscribed on the back with the title (*Life at the Sea side*) and the name of the artist
RCIN 405068
PROVENANCE Bought from the artist by Messrs Lloyd, 1854; from whom bought by Queen Victoria, 1854 (£1,000)
LITERATURE Cowling 1989, pp. 219–31; Millar (O.) 1992, no. 242
EXHIBITIONS London 1854, no. 157; London 1862b, no. 665; Brussels 1866, no. 327; Manchester 1887, no. 349; London 1897, no. 15; London 1911, no. 50; London 1946–7, no. 502; Harrogate/London 1951, no. 23; London 1951–2, no. 364; London 1953e, no. 17; Ottawa 1965, no. 41; Sheffield 1968, no. 80; London 1968–9, no. 325; London 1970, no. F44; Leeds 1986; London 1991a, no. 74; QG/Barnard Castle 1998–9, no. 37

33

CLAUDE MONET (1840–1926)
Study of rocks, the Creuse: 'Le Bloc', 1889

The French Impressionist painter Claude Monet's famous series paintings of the 1890s (of subjects such as haystacks, poplars and Rouen Cathedral) were anticipated by the group of twenty-four canvases he produced between March and May 1889 while staying in the village of Fresselines in central France. Although the main subject of the series is the nearby confluence of two sources of the river Creuse, this view shows the rocky outcrop that rises above the convergence of the rivers. The uncompromising composition is dominated by the massive rock, whose colours and textures are explored in brilliant sunlight.

Many of Monet's letters survive from his stay at Fresselines. He

33

described the wintry landscape of the area as lugubrious and his promising start to the series was soon interrupted by severe weather. As the season changed, his fears that the appearance of spring greenery would change the colours of his 'sombre and sinister' subjects were well founded. He paid a local landowner to have new leaves removed from an oak tree that was the focus of a group of paintings in order to maintain its earlier wintry appearance.

The present painting, along with thirteen others of the same series, was exhibited at a joint exhibition with Auguste Rodin at Georges Petit's gallery in Paris in June 1889. By 1899 Monet had given it to his friend the statesman Georges Clemenceau. Clemenceau provided the nickname 'Le Bloc' (The Rock) which was to be the title of a political journal he was to establish. It is one of a small but important group of modern paintings in the collection of Queen Elizabeth The Queen Mother, which also includes works by Henri Fantin-Latour, Walter Sickert and Paul Nash (see no. 34).

Oil on canvas. 72.4 × 91.4 cm
Signed *Claude Monet 89*

RCIN 100001
PROVENANCE Given by the artist to Georges Clemenceau, by 1899; by descent; bought by Galerie Wildenstein, 1937; from whom bought by HM Queen Elizabeth The Queen Mother, 1945
LITERATURE Wormser 1984, pp. 191–200; Hayes Tucker 1989, pp. 40–57; Kendall 1989, pp. 129–32; Levine 1994, pp. 103–22; Stuckey 1995, pp. 217–20; Wildenstein 1996, no. 1228 (see also nos 1218–32)
EXHIBITIONS Paris 1889; Paris 1928, no. 56; Paris 1931, no. 90; London 1954b, no. 36; Edinburgh/London 1957, no. 89; QG 1977–8, no. 58; Boston/Chicago/London 1989–90, no. 6; Chicago 1995, no. 91; London 1997b, no. 15

34
PAUL NASH (1889–1946)
Landscape of the vernal equinox, 1943

This painting is one of Nash's most celebrated works and its purchase by Queen Elizabeth The Queen Mother in 1943 – the year of its completion – was given great publicity. A close friend of hers, the collector

Sir Jasper Ridley, advised on its acquisition. Ridley was also involved in the commission to John Piper to record Windsor Castle during the Second World War (see no. 394).

Paul Nash's art maintained a balance between European Modernism and a strong attachment to nature that is particularly English in spirit. His landscapes of the trenches, produced when he was an official War Artist during the 1914–18 war, are particularly moving, although his work of the 1920s and 30s became more experimental and semi-abstract. His later landscapes, such as this one, have an intense visionary character.

Nash described this magical scene as 'a landscape of the imagination which has evolved in two ways: on the one hand through a personal interpretation of the phenomenon of the equinox, on the other through the inspiration derived from an actual place' (Bertram 1955, p. 292). The two tree-covered mounds dominating the spring skyline are Wittenham Clumps, an ancient British camp near Dorchester on Thames that fascinated Nash throughout his life. He described them as 'the Pyramids of my small world' (Nash (P.) 1988, p. 122). Nash was able to see them with the aid of binoculars whilst staying at Boar's Hill near Oxford during the Second World War and he created a series of paintings based on the view from his bedroom window. Here, one of the Clumps is lit by the moon, the other by the sun, and the contrasting lights they throw illuminate each side of the painting differently. The right foreground contains a structure of bare posts (the supports for tennis-court netting) representing the rational nature of sunlight; while on the moonlit side, a snake comes out of the woods, symbolic of primitive energy. At the time of the vernal (spring) equinox, when the sun crosses the equator around 21 March, the night and day are equal in length.

Oil on canvas. 71.2 × 91.4 cm
Signed Paul Nash
RCIN 100000
PROVENANCE Arthur Tooth Gallery, London; from whom bought by HM Queen Elizabeth The Queen Mother, 1 December 1943
LITERATURE Bertram 1955, pp. 291–3; Causey 1980, no. 1118; Nash (P.) 1988, p. 122; Cornforth 1996, p. 101
EXHIBITIONS London 1943; Paris/Prague 1945, no. 28; Arts Council 1946, no. 38; London 1948b, no. 63; London 1951c; London 1975d, no. 203; QG 1977–8, no. 63; London 1998; Salford 2001, p. 25

35
GRAHAM SUTHERLAND (1903–1980)
Armillary sphere, 1957

Graham Sutherland's early neo-Romantic works, similar in some ways to those of Paul Nash (see no. 34), gave way to more abstracted Modernist forms during the 1930s. He painted scenes of urban devastation as an official War Artist and turned to the depiction of natural forms, portraiture and religious works after the war.

Sutherland's first royal commission came about through Lord Plunket (1923–75), whom he had met while struggling with his portrait of Winston Churchill (since destroyed). At this time Plunket was Equerry to Her Majesty The Queen. He later became Deputy Master of the Household, playing an important part in the conception and construction of the first Queen's Gallery at Buckingham Palace as well as being The Queen's unofficial adviser on artistic matters. He telephoned Sutherland on 10 December 1956 to ask whether the artist would undertake a picture for The Queen to present to President Craveiro Lopes of Portugal during his State Visit to Britain the following spring. The picture should symbolise the common interests of the two nations, in particular exploration and trade.

Sutherland submitted two finished versions for approval in February 1957, both similar in composition. The Duke of Edinburgh expressed an interest in acquiring the picture that was not chosen by The Queen for Portugal.

One of the earliest astronomical instruments, the armillary sphere is essentially a dynamic model of the universe demonstrating the motions of the heavens as observed from the Earth. The artist's notes on the symbolism of the painting are still attached to the reverse: 'Navigation. Astronomical instruments (Henry the Navigator co-ordinated and utilised all the colonising and trade expansion tendencies of 1415–99. He placed at the disposal of his captains the best information and the most accurate instruments and maps which could be attained) ... The panel in the centre of this canvas shows the armillary sphere with case based on those in the Barberini Collection in the Maritime Museum at

Greenwich. In the right-hand panel is Drake's dial. In the left-hand panel the English rose. Through the background the sea and a ship. Above grapes as symbolic of the wine trade. Maps complete the centre panel.' Thus he ingeniously incorporated national and maritime elements without compromising his distinctive painting style.

Oil on canvas. 54 × 64.3 cm
Signed and dated *Sutherland* 1957
RCIN 407252
PROVENANCE Given by the artist to HRH The Duke of Edinburgh, 1957
LITERATURE Berthoud 1982, p. 232
EXHIBITIONS QG 1977–8, no. 92; London 1992a, p. 83

36
LUCIAN FREUD (b. 1922)
Her Majesty The Queen, 2000–01

The suggestion that Lucian Freud might paint The Queen arose in conversations between the artist and Her Majesty's former Private Secretary, Sir Robert (now Lord) Fellowes, whose own portrait – now in the Nelson-Atkins Museum of Art, Kansas City, Missouri – was painted by Freud in 1999–2000. Exceptionally for both sitter and artist, The Queen was painted in Friary Court Studio, St James's Palace, which is normally used for the conservation of Royal Collection pictures. The sittings took place between May 2000 and December 2001.

Given that his sitters in the past have nearly all been chosen from a small circle of friends and relations, Freud likened the task in advance to a polar expedition. He was concerned at the potential difficulty of focusing on the interior life or 'inner likeness' behind such an instantly recognisable face. In settling his approach to this painting, it was an early decision to adopt the small scale to which he has returned for a number of recent portraits and to show The Queen wearing the Diamond Diadem: the canvas was extended in height by 3.5 cm to accommodate this famous and emphatically regal piece of jewellery (see no. 154).

Freud's latest 'small large paintings', requiring fewer sittings and painted more rapidly than in the past, are defined by their monumental presence and intensity of vision, enhanced in the case of this powerful and unsentimental portrait by characteristically rich and dense brushwork and precise, almost sculptural use of paint.

Lucian Freud was born in Berlin and left Germany with his family in 1933 to settle in London. An artist of international stature and renown (dubbed 'the Ingres of Existentialism' by the critic Herbert Read), his status as England's most eminent living painter was recognised by his appointment as a Companion of Honour in 1983 and his award of the Order of Merit in 1993.

Oil on canvas. 23.5 × 15.2 cm
RCIN 100130
PROVENANCE Presented by the artist to HM The Queen, 2001

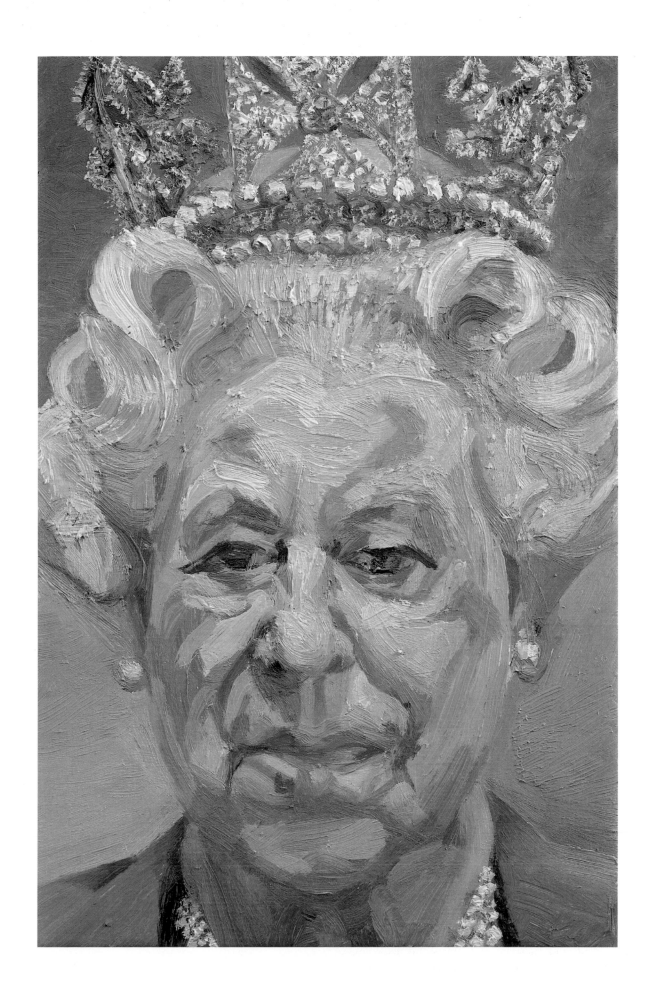

MINIATURES (nos 37–58)

There are some three thousand miniatures in the Royal Collection, ranging in date from the sixteenth to the nineteenth centuries. These provide an overview of the development of the art of the miniature in England from its inception during the reign of Henry VIII to its decline following the invention of photography during the reign of Queen Victoria. Examples by the greatest practitioners – Lucas Horenbout, Hans Holbein the Younger, Nicholas Hilliard, Isaac Oliver, Samuel Cooper, Jeremiah Meyer, Richard Cosway, Andrew Robertson, Sir William Ross and Robert Thorburn – are to be found in the Royal Collection, mostly as a result of the close association of monarchs with the miniaturists concerned. Just as painters were granted royal appointments, miniaturists and enamellists were able to secure royal patronage. Twenty-two miniatures dating from the sixteenth and seventeenth centuries are included in the present selection, to indicate the greatest strengths of the miniatures collection.

The private nature of the art form was a particular advantage to monarchs. Charles I's Cabinet Room in Whitehall Palace included a selection of seventy-six miniatures and Caroline of Ansbach, the wife of George II, pursued her personal interest in historical portraiture through miniatures. Queen Caroline's son, Frederick, Prince of Wales, no doubt derived great pleasure from acquiring a group of outstanding examples (see nos 47, 48) from the well-known physician Dr Richard Mead. George III and Queen Charlotte commissioned jewellery and bibelots containing portraits of themselves or members of their family, and Queen Victoria and Prince Albert delighted in arranging, reframing and cataloguing the collection, while appreciating the particular insight it gave into family and dynastic interests. During Queen Victoria's reign a number of miniatures closely associated with the Tudors and the Stuarts were acquired, including nos 38, 45, 51 and 54. Important acquisitions have continued to be made in modern times (nos 46, 52).

On a purely practical basis the small scale of miniatures engendered from the outset a feeling of privacy. As objects, they were small enough to be portable or to be incorporated in jewellery. Often they were attached to garments or worn in the hair. If not so displayed, miniatures were secreted away in the drawers of cabinets in small rooms or closets, to be shared with only the closest friends or the most important visitors. Contemporary accounts reveal, for example, how artful Elizabeth I was in her deployment of miniatures as part of the political or diplomatic process.

From an early date artists were prepared to extend the format beyond the original circular or oval shape so that more of the figure could be included and a more elaborate composition, including a background, might be developed. François Clouet (no. 43), Nicholas Hilliard (no. 45) and Isaac Oliver (nos 48, 50) all devised compositions with figures seen in varying lengths, including full length. Larger miniatures of this type were intended for display on the walls of cabinet rooms. However, already in the seventeenth century there are instances of smaller miniatures (for example nos 43, 44) being set into frames and hung on the wall. A century later, Caroline of Ansbach included several miniatures in a display of historical portraits in her closet at Kensington Palace: and subsequently Queen Victoria, together with Prince Albert, devised similar arrangements in the Audience Room and Holbein Room at Windsor Castle.

Queen Victoria and Prince Albert paid particular attention to the collection of miniatures. Being practical, Prince Albert designed a special cabinet fitted with sliding drawers for the storage of the miniatures, which were at the same time given frames (made by H.J. Hatfield & Sons) of a uniform pattern. The miniatures cabinet was placed in the Royal Library at Windsor Castle and is still in use today. The restoration following the fire at Windsor allowed for the installation of four display cases in the upper level of the Lantern Lobby where there is space for a changing selection of about a hundred miniatures. The lists which recorded the individual works included in the different historical arrangements of miniatures are now being superseded by illustrated catalogues. The first two volumes, covering the miniatures to c.1820, were published in the 1990s (see Walker 1992 and Reynolds 1999).

The origins of the miniature lie in the Renaissance. The circular format is related to certain other works of art such as ancient glass, coins and bronze medals, but the closest connections are found in illuminated manuscripts. The second volume of François du Montin's *Les Commentaires de la guerre gallique* (London, British Library), made as a gift for Francis I in 1519, includes within the text painted portraits very close in style to the work of Jean Clouet. The likenesses are shown in three-quarters profile set in roundels

against blue backgrounds; they are extraordinarily similar in both type and format to the earliest portrait miniatures, whether in France (e.g. no. 44) or England (for example nos 37, 38, 40–2). Significantly, the first recorded miniaturist, Lucas Horenbout, was a leading figure in the Ghent–Bruges school of illuminators before coming to work for Henry VIII in London. He was the first of a number of foreign practitioners to take up residence in England, where the art of the miniaturist has been particularly appreciated.

The original derivation of the word from the Latin *minium* refers to the red lead pigment used in the art of manuscript illumination, as opposed to the small scale of the object implied in the modern sense. During the sixteenth and seventeenth centuries miniatures were customarily called limnings, thus stressing their relationship with drawings. Technically, the earliest miniatures also retained close links with illuminated manuscripts. The support was vellum, which was normally laid down on a piece of cut-down playing card or specially gessoed card. The medium for painting was watercolour with a clear glue or white of egg as a binding agent; the powdered pigments used were limited – blue, black, red and yellow – with gold or silver for highlights or inscriptions. The finish was matt until the introduction of ivory as a support at the very beginning of the eighteenth century.

The art of the miniature was in practical terms conservative. The materials and technical processes hardly varied over four centuries. Many of the tenets of the miniaturist are enshrined in the *Treatise concerning the Arte of Limning* of c.1600, written by Nicholas Hilliard, the first English-born artist of European significance. Apart from the technical information recorded in the *Treatise*, Hilliard concerned himself with the status of miniature painting. He refers to the miniature as 'a thing apart from all other painting or drawing' and asserts that 'none should meddle with Limning but gentlemen alone' because it is 'for the service of noble persons'. Above all, the *Treatise* emphasises the skills of the miniaturist in creating works of such intricate beauty to depict 'the face of mankind'. Such skills were described by William Shakespeare in *The Merchant of Venice* (Act III, Scene II), written c.1594:

> ... Here in her hairs
> The painter plays the spider, and hath woven
> A golden mesh t'entrap the hearts of men
> Faster than gnats in cobwebs ...

37
LUCAS HORENBOUT (1490/5?–1544)
Henry VIII, c.1526–7

This is one of the first independent portrait miniatures ever produced. Significantly, the artist came from a successful family of painters and illuminators active in Ghent, but he appears to have reached London by 1524; he is mentioned in Henry VIII's accounts from 1525 onwards. Lucas Horenbout was appointed King's Painter in 1534 and, although he no doubt continued to illuminate manuscripts and documents, he was the originator of miniature painting in this country. The earliest examples of his work coincide with the arrival in London in 1526 of two miniature portraits, probably by Jean Clouet, sent to Henry VIII by Madame d'Alençon, the sister of the French King, Francis I. Whether, therefore, Clouet or Horenbout should take credit for originating the miniature as an art form cannot be clearly established.

Horenbout's portraits of Henry VIII (1491–1547; r. 1509–47) are of great significance for the personal iconography of the King. There are four other miniatures by the artist closely related to the present example: in Cambridge (Fitzwilliam Museum), Paris (Louvre), another in the Royal Collection (Reynolds 1999, no. 3), and one in the collection of the Duke of Buccleuch. Three of these give the King's age as 35. It is not easy to establish an exact sequence for these miniatures. Although in three of them Henry VIII is unbearded and in two of them he has a short beard, contemporary evidence records that the King frequently grew a beard and then shaved it off again. Not all of these portraits would have been made from life, but Henry VIII spoke of having personal knowledge of Horenbout and it is likely that the King granted him sittings. Indeed, the high regard in which Horenbout was held is indicated by the fact that he received a larger annual salary than Hans Holbein the Younger.

Watercolour and bodycolour on vellum laid on card. Diameter 4.7 cm
Inscribed : H · R · / · VIII : · and · AЙ · ETATIS · / · XXXV̂ : ·
RCIN 420640
PROVENANCE Theophilus Howard, second Earl of Suffolk (1584–1640); by whom presented to Charles I, by c.1639; Charles II
LITERATURE Reynolds 1999, no. 2
EXHIBITIONS London 1950–1, no. 193; London 1953a, no. 70; Edinburgh 1965, no. 2; QG 1977–8, no. 99; QG 1978–9, no. 90; QG 1983–4, no. 11; Hampton Court 1990–1, no. 35; London 1991b, V.45; London 1993b, no. 1; New York/ San Marino/Richmond/QG 1996–7, no. 1

38
LUCAS HORENBOUT (1490/5?–1544)
Henry Fitzroy, Duke of Richmond and Somerset, c.1534

The miniature is a typical work by Horenbout, whose style is detectable in the modelling of the features, the prominent shadows under the eyes and mouth, and the form of the inscription seen against a blue background. The sitter is vividly characterised in what is in essence an informal portrait, one of the first in British art. The casual clothes, probably a nightcap and chemise, may be associated with his physical frailty.

Henry Fitzroy, Duke of Richmond and Somerset (1519–36), was the illegitimate son of Henry VIII by Elizabeth Blount, a lady-in-waiting to Catherine of Aragon. The child was officially acknowledged by the King after the early deaths of the three sons born to the Queen. Following his divorce from Catherine of Aragon and his subsequent marriage to Anne Boleyn, Henry VIII's attachment to Henry Fitzroy assumed a greater significance, particularly when his second wife also failed to produce a male heir. Appointed Knight of the Garter in 1525 and made Duke of Richmond and Somerset in the same year, Henry Fitzroy was given several important positions, including that of Lord Lieutenant of Ireland. His education was entrusted to the distinguished classical scholar Richard Croke, who had taught Greek to Henry VIII, and was extended by attendance at the court of Francis I in France for eleven months in 1532. It appears that Henry VIII contemplated making Henry Fitzroy his heir, but whatever the King's intentions may have been, the plan was spoilt by Henry Fitzroy's premature death of tuberculosis at the age of 17. It is possible that no. 38 was painted at the time of Fitzroy's marriage in 1534 to Mary Howard, daughter of the third Duke of Norfolk, Treasurer of the Household and Earl Marshal.

Watercolour and bodycolour on vellum laid on card. Diameter 4.4 cm
Inscribed HENRY DVCK·OFF RICHEMŌD and ÆTATIS SVÆ·XV°
RCIN 420019
PROVENANCE Lord George Stuart, ninth Seigneur d'Aubigny (d. 1642)(?); by whom given to Charles I(?); Charles II; left the Royal Collection c.1700; Horace Walpole (d. 1797); by descent; sale of the contents of Strawberry Hill, George Robins, 17 May 1842 (31); bought for the second Duke of Buckingham; Stowe sale, Christie's, London, 15 March 1849 (49); Charles Sackville Bale; by whom sold Christie's, London, 24 May 1881 (1418); bought by Queen Victoria (£36 15s.)
LITERATURE Reynolds 1999, no. 4
EXHIBITIONS London 1862a, no. 1934; London 1865, no. 1643; London 1956–7, no. 605; London 1983a, no. 15; London 1991b, no. V.50; New York/San Marino/Richmond/QG 1996–7, no. 2

39
HANS HOLBEIN THE YOUNGER (1497/8–1543)
Solomon and the Queen of Sheba, c.1534

The subject of this miniature is of the greatest significance for England's history. It refers to the establishment of the Church of England with Henry VIII as Supreme Governor in whom both temporal and spiritual power were vested. This development coincided with the spread of the Reformation elsewhere in Europe but was closely connected to the difficulties that the King had encountered in obtaining a divorce from his first wife, Catherine of Aragon. After all links with the authority of the Pope in Rome were severed, the King's divorce was finalised in May 1533 and the Church of England was formally established by the Act of Supremacy in the following year.

Holbein's composition uses biblical narrative (I Kings 10: 1–13 and II Chronicles 9: 1–12) to illustrate the redefinition of Henry VIII's power. The central figure of the King is shown as Solomon enthroned wearing a crown and holding a sceptre. On the steps of the throne, seen in profile, is the Queen of Sheba (the personification of the Church) in the act of addressing the King. Her salutation is inscribed in Latin on either side of the throne and on the curtain. It ordains that the power which is given to Solomon – and so by extension to Henry VIII himself – comes from God alone. The inscription on the steps is also composed of words spoken by the Queen of Sheba. The figures in the foreground represent the retinue of the Queen of Sheba, while those on either side of the throne are members of Solomon's court.

Although always described as a miniature, *Solomon and the Queen of Sheba* has a strong narrative element which should be seen in the context

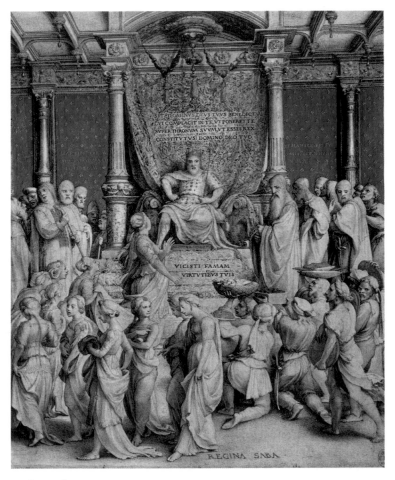

39 (reduced)

of manuscript illumination (compare no. 319). The high degree of finish, together with the plentiful use of silver (now sulphided to black) and gold, suggests that it may have been intended for presentation, probably to the King himself. This image of Henry VIII may be the first portrait by Holbein of the King whose court he so vividly portrayed during his second visit to London, beginning in 1532 (see also no. 349). It is the only original likeness of Henry VIII by Holbein to have survived in the Royal Collection. The Renaissance style of the architecture is similar to that used by Holbein in the *Whitehall Mural* of 1537 (destroyed 1698 but known through a copy).

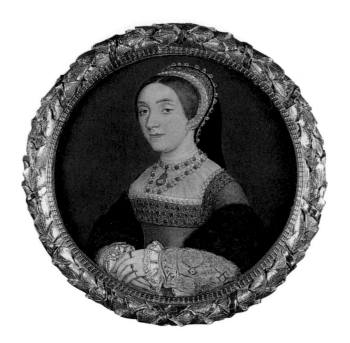

Watercolour and bodycolour with ink (applied with both point of brush and pen) and gold and silver, over black chalk, on vellum laid on card. 22.9 × 18.3 cm
Inscribed in the foreground REGINA SABA (Queen of Sheba); and on either side of the throne BEATI VIRI TVI ... ET BEATI SERVI HI TVI / QVI ASSISTVNT CORAM TE ... OMNITPE ET AVDIVNT / SAPIENTIAM ... TVAM (Happy are thy men, and happy are these thy servants, who stand continually before thee, and hear thy wisdom: II Chronicles 9: 7); on the curtain behind Solomon SIT DOMINVS DEVS TVVS BENEDICTVS, / CVI COMPLACIT IN TE, VT PONERET TE / SVPER THRONVM SVVM, VT ESSES REX / CONSTITVTVS DOMINO DEO TVO (Blessed be the Lord thy God, who delighted in thee, to set thee upon his throne to be King elected by the Lord thy God: adapted from II Chronicles 9: 8); on the steps VICISTI FAMAM / VIRTVTIBVS TVIS (By your virtues you have exceeded your reputation: II Chronicles 9: 6)
RL 12188
PROVENANCE Henry VIII; Thomas Howard, Earl of Arundel, by 1642; Royal Collection, by 1688
LITERATURE Parker 1945, p. 35; Rowlands 1985, no. M.1; King 1989, pp. 81–3
EXHIBITIONS Dresden 1870, no. 335; London 1950–1, no. 131; QG 1978–9, no. 88; QG 1986–7, no. 43; Edinburgh/Cambridge/London 1993–4, no. 29; London 1997–8, no. 60

40

HANS HOLBEIN THE YOUNGER (1497/8–1543)
Portrait of a lady, perhaps Catherine Howard, c.1540

Catherine Howard (c.1521–42) was the niece of Thomas Howard, third Duke of Norfolk. She was a maid-of-honour to Anne of Cleves, Henry VIII's fourth wife. After Anne's divorce, Catherine married the King – as his fifth wife – on 28 July 1540 at Oatlands Palace. Accused of adultery, she was beheaded at the Tower of London on 12 February 1542. The identification of the sitter in no. 40 as Catherine Howard remains tentative, although the autograph version of this portrait in the collection of the Duke of Buccleuch has been described as a portrait of Catherine Howard since the early eighteenth century. In the absence of an authentic likeness of Catherine Howard, other evidence has been adduced to support this royal identification, namely the jewellery. The necklace and gold jewel with pendant ruby, emerald and pearl are also shown in Holbein's portrait of Henry VIII's third wife Jane Seymour (Vienna, Kunsthistorisches Museum) and this, together with the richly jewelled bands in the head-dress and around the bodice, may be identified among the King's gifts to Catherine at the time of their marriage.

No more than twenty miniatures by Holbein are known today, of which five are in the Royal Collection. Holbein's activity as a portrait miniaturist commenced during his second visit to England, c.1535. He appears to have been taught by Lucas Horenbout, another foreign artist based at the court of Henry VIII, but soon surpassed his master 'in drawing, arrangement, understanding, and execution, as the sun surpasses

the moon in brightness' (Carel van Mander, quoted in Reynolds 1999, p. 49). In particular, the way in which Holbein modelled interior form with a series of short strokes of colour, as is so clearly seen in his portrait drawings (for instance, no. 349), is repeated, with extraordinary precision, on a miniature scale.

Watercolour and bodycolour on vellum laid on playing card. Diameter 6.3 cm
RCIN 422293
PROVENANCE Charles II(?); first certainly recognisable in Royal Collection inventories, c.1837
LITERATURE Reynolds 1999, no. 6
EXHIBITIONS London 1879, gallery VII, case I, no. 3; London 1890, no. 1067; London 1901–2, no. 217; London 1950–1, no. 192; London 1953a, no. 79; QG 1978–9, no. 84; London 1980–1a, no. P6; London 1983a, no. 33; QG 1988–9, no. 73; Edinburgh/Cambridge/London 1993–4, no. 31; New York/San Marino/Richmond/QG 1996–7, no. 6

41

HANS HOLBEIN THE YOUNGER (1497/8–1543)
Henry Brandon, second Duke of Suffolk, 1541

Henry Brandon (1535–51), here shown at the age of 5, was the elder brother of Charles Brandon whose portrait (aged 3) was also painted in miniature by Holbein (no. 42). It is likely that both miniatures were executed at the same date, although compositionally they seem not to have been conceived as a pair. The details of age and date of birth given in the inscription on the present miniature are not strictly speaking correct, as Henry Brandon was apparently born on either 16 or 18 September 1535. None the less, this type of inscription often occurs in Renaissance portraiture, supplying additional information about the sitter. The nonchalant pose is also a Renaissance device, enabling the artist to suggest a sense of spatial recession, as in Titian's *Portrait of a man* ('*Ariosto*') in the National Gallery, London, or in Holbein's *Portrait of Derich Born* in the Royal Collection (Millar (O.) 1963, no. 26).

Henry Brandon was the elder son of Charles Brandon, first Duke of Suffolk, by his fourth wife, Katherine, daughter of Lord Willoughby

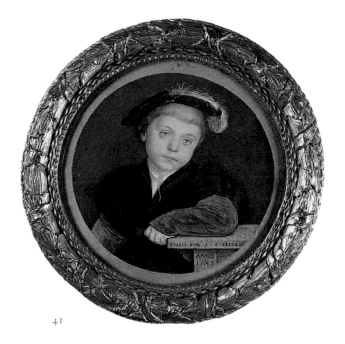

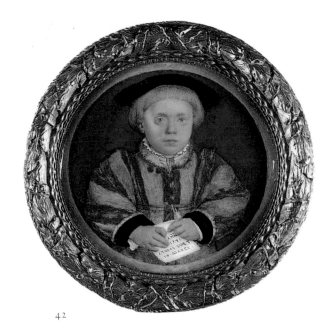

41

42

d'Eresby. He succeeded his father as Duke of Suffolk in March 1545. Henry and his younger brother were educated with the Prince of Wales (later Edward VI) before being sent at an early age to St John's College, Cambridge. Henry Brandon carried the orb at Edward VI's coronation in 1547, after which both he and his brother were admitted to the Order of the Bath. Both died young (Henry aged 16 and Charles aged 14 or 15) of sweating sickness within half an hour of one another in 1551.

Watercolour and bodycolour on vellum laid on playing card. Diameter 5.6 cm
Inscribed ETATIS.SVÆ.5.6.SEPDEM. / ANNO. / 1535
RCIN 422294
PROVENANCE With no. 42: Sir Henry Fanshawe (1569–1616; Remembrancer to the Exchequer from 1601); by whom presented to Charles I, before 1616; Charles II
LITERATURE Reynolds 1999, no. 7
EXHIBITIONS London 1879, gallery VII, case I, no. 4; London 1889a, case XII, no. 1; London 1950–1, no. 194; London 1956–7, no. 611; QG 1978–9, no. 85; London 1983a, no. 34; QG 1988–9, no. 71; Edinburgh/Cambridge/London 1993–4, no. 32; New York/San Marino/Richmond/QG 1996–7, no. 3

42
HANS HOLBEIN THE YOUNGER (1497/8–1543)
Charles Brandon, third Duke of Suffolk, 1541

The miniature is dated March 1541, when in all probability the portrait of the sitter's elder brother, Henry (no. 41), was also made. Charles Brandon (1537/8–51) was two years younger than Henry and is shown here at the age of 3. Both brothers died in 1551, Henry predeceasing his younger brother by half an hour. Charles was thus third Duke of Suffolk, in succession to his brother, for an exceedingly short time.

The portraits of the Brandon brothers are incomparable for their vivid characterisation of children. The difference in age of two or three years is perhaps consciously suggested by Holbein in the contrasting poses. Henry Brandon's insouciance implies that he is older, whereas the directness of Charles affects greater innocence. The frontal pose echoes that of Holbein's *Portrait of Edward VI when a child* (Washington, National Gallery of Art). The inscribed paper held by Charles fittingly anticipates

the academic learning for which both brothers were renowned later in their short lives. Interestingly, the deaths of Henry and Charles Brandon prompted a volume of tributes – one of the earliest examples of this form of literature – by their Cambridge tutor, Thomas Wilson. The descriptions of Henry as humorous and strong with a natural military air, and of Charles by contrast as being not particularly strong but elegant, allow the viewer to measure Holbein's skill as a portraitist in capturing these characteristics while the sitters were still so young. The irresistible charm of these two promising members of the Tudor court is still evident today.

Watercolour and bodycolour on vellum laid on playing card. Diameter 5.5 cm
Inscribed ANN / 1541 / ETATIS.SVÆ.3. / .10.MARCI
RCIN 422295
PROVENANCE See no. 41
LITERATURE Reynolds 1999, no. 8
EXHIBITIONS London 1879, gallery VII, case I, no. 5; London 1950–1, no. 186; London 1956–7, no. 606; Edinburgh 1965, no. 5; QG 1978–9, no. 86; London 1983a, no. 35; QG 1988–9, no. 70; Edinburgh/Cambridge/London 1993–4, no. 33; New York/San Marino/Richmond/QG 1996–7, no. 4

43
FRANÇOIS CLOUET (c.1520–1572)
Mary, Queen of Scots, 1558

Mary, Queen of Scots (1542–87), the daughter of James V of Scotland and Mary of Guise, is depicted placing a ring on the fourth finger of her right hand. In all probability this portrait refers to her marriage in 1558 to the Dauphin of France, who succeeded his father, Henry II, on the throne in 1559 as Francis II of France. The likeness seems to be based on a bust-length drawing by Clouet (Paris, Bibliothèque Nationale), in which the sitter is shown when slightly younger. A Book of Hours (Paris, Bibliothèque Nationale) made for Francis II's mother, Catherine de' Medici, includes a double portrait of Francis II and Mary, Queen of Scots, crowned and dressed in coronation robes; the image of Mary in

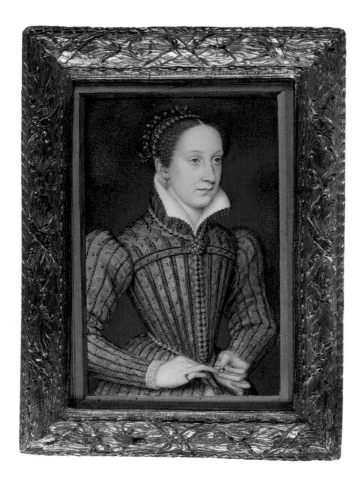

portraitist in oil and in coloured chalks. A prolific artist with a thriving workshop, François Clouet has provided a wonderful visual record of the leading personalities of the French court, comparable with the achievement of Hans Holbein the Younger at the court of Henry VIII.

Watercolour and bodycolour on vellum rebacked with card. 8.3 × 5.7 cm
RCIN 401229
PROVENANCE Elizabeth I(?); Charles I, by c.1639; Charles II
LITERATURE Reynolds 1999, no. 16 and p. 15
EXHIBITIONS London 1879, gallery VII, case I, no. 1; London 1889b, no. 212; London 1901–2, no. 197; London 1956–7, no. 614; Edinburgh 1965, no. 7; London 1972a, p. 11; QG 1983–4, no. 19; Edinburgh 1987, no. 9; New York/San Marino/Richmond/QG 1996–7, no. 8

44
FRANÇOIS CLOUET (c.1520–1572)
Charles IX, King of France, c.1561

Charles IX (1550–74; r. 1560–74), second son of Henry II of France, succeeded to the throne at the age of 10, on the death of his brother Francis II, the first husband of Mary, Queen of Scots. He was much influenced by his mother, Catherine de' Medici, who acted as Regent during his minority. The Wars of Religion in France erupted during his reign, leading to the Massacre of St Bartholomew (1572) when several thousand Protestants were killed.

The miniature belonged to Charles I and, with no. 43, formed part of the group of eight images of the King's forebears specially framed in the Cabinet Room at Whitehall Palace. At the time, and for several centuries after, it was believed that no. 44 depicted Francis II, the husband of Mary, Queen of Scots. During the nineteenth century it was correctly suggested that the sitter was Francis II's younger brother and successor, Charles IX. Comparison with other images of Charles IX by Clouet – a drawing of 1561 in the Bibliothèque Nationale, Paris, and a painting of the same date in the Kunsthistorisches Museum, Vienna – confirms both the identification and the date.

Watercolour and bodycolour on vellum laid on playing card. Diameter 4.3 cm
RCIN 420931
PROVENANCE Charles I, by c.1639; Charles II
LITERATURE Reynolds 1999, no. 18
EXHIBITIONS London 1879, gallery VII, case I, no. 2; New York/San Marino/Richmond/QG 1996–7, no. 7

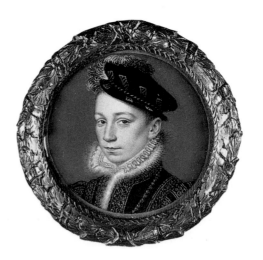

that portrait is closely related to this miniature, in which she is depicted at the height of her physical beauty. After the death of Mary's father James V, in the year of her birth, Mary of Guise took the infant Queen of Scots to France, where she spent her childhood. It was only after the death of Francis II in 1560 that his widow returned to Scotland, eventually to claim the English throne too as the granddaughter of Henry VIII's sister, Margaret Tudor. This led to her confrontation with Elizabeth I, resulting in a long imprisonment and ultimately to her execution in 1587 at Fotheringhay Castle, Northamptonshire. Mary's son by her second marriage, to Lord Darnley, became James VI of Scotland after his mother's abdication in 1567, and James I of England on Elizabeth I's death in 1603.

The miniature is pertinent to the relationship between Mary, Queen of Scots, and Elizabeth I as it may be the one shown in private by the English Queen to Mary's ambassador, Sir James Melville, in 1564. It was kept in a small cabinet in the Queen's bedchamber and was wrapped in paper. Melville reported that Elizabeth I took out the miniature and kissed it. Subsequently, the portrait belonged to Charles I, who had it mounted in a frame of eight miniatures of his forebears kept in the Cabinet Room at Whitehall Palace. Six of these miniatures, including nos 43 and 44, are still in the Royal Collection, but are no longer in the special frame, which may have been removed during the reign of George II. There is no finer example of the qualities of the miniature as an art form through its draughtsmanship, the private nature of the object, and its historical associations.

François Clouet was court painter to a succession of French kings – Francis I, Henry II, Francis II and Charles IX. He was the son of Jean Clouet (c.1485/90–1541), who was instrumental in the evolution of the miniature as an independent art form, and was also a superb

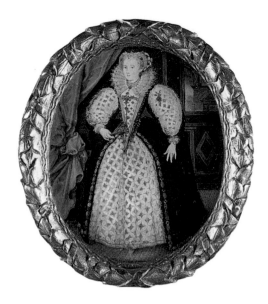

45
NICHOLAS HILLIARD (1547–1619)
Portrait of a lady, possibly Penelope, Lady Rich, c.1590

Nicholas Hilliard, the son of an Exeter goldsmith, was apprenticed to Elizabeth I's goldsmith and jeweller, Robert Brandon, whose daughter he married in 1576. He began to paint miniatures in 1560, later claiming that he was in general terms influenced by Hans Holbein the Younger and Albrecht Dürer. Although he worked for the English court, Hilliard travelled to France (1576–9) in search of additional patronage and would have encountered the work of François Clouet during that visit. Regardless of these particular formative influences and of others cited in his *Treatise concerning the Arte of Limning* (c.1600), Hilliard's style – based on sophisticated technical knowledge – is distinctive; it incorporates a glorious sense of design most evident in the treatment of costume with all its accessories, and the calligraphic flourishes of his inscriptions. Most closely associated with the court of Elizabeth I, Hilliard's appointment as Court Limner was renewed during the reign of James I, although it is often argued that by that time his style had become old fashioned. There are eighteen autograph miniatures by Hilliard in the Royal Collection, including five portraits of Elizabeth I (see no. 46) and three of James I.

Hilliard's introduction of a full-length figure within the small oval format was an important development in the history of the miniature. Here the figure is shown in a first-floor interior framed on the left by a curtain with a view of another wing of the building beyond on the right. The liveliness of the portrait stems as much from the pose, particularly of the arms and the hands with long fingers, as from the placing of the figure within the composition.

Lady Rich was born Penelope Devereux (?1563–1607), the sister of Elizabeth I's favourite, Robert Devereux, second Earl of Essex. She married Robert, Lord Rich, later Earl of Warwick, in 1581, but they were legally separated in 1605. Several years before that, her great beauty – sparkling dark eyes and fair hair ('waves of gold') – had been a source of inspiration for Sir Philip Sidney's Stella in his poem *Astrophil and Stella* (1591). Hilliard named one of his daughters after Lady Rich.

The identification of the sitter in no. 45 has however been the subject of some discussion. It is known that Hilliard painted two miniatures of Lady Rich, in 1589 and 1590 respectively, the earlier of which was the

subject of a sonnet by Henry Constable. This first miniature was given to James VI of Scotland (later James I of England) and the second to the French ambassador. It is possible that no. 45 may be identified with one of these.

Watercolour and bodycolour on vellum laid on card. Oval, 5.7 × 4.6 cm
RCIN 420020
PROVENANCE Lord de Roos; probably his sale Christie's, London, 4 June 1839 (102); Queen Victoria by 1870
LITERATURE Reynolds 1999, no. 30
EXHIBITIONS London 1947, no. 46; New York/San Marino/Richmond/QG 1996–7, no. 15

46
NICHOLAS HILLIARD (1547–1619)
Elizabeth I, c.1595–1600

The full range of Hilliard's capabilities as an artist is evident in his portraits of Elizabeth I (1533–1603; r. 1558–1603), who occupied the English throne for much of his active life. Queen Elizabeth was the daughter of Henry VIII by his second wife, Anne Boleyn, and succeeded her Catholic half-sister Mary I (the daughter of Henry VIII and Catherine of Aragon) as Queen in 1558. She was a considerable scholar in her own right and never married.

Although in favour at court from the 1570s, Hilliard only began to receive an annuity in 1599. There are a large number of images of Elizabeth I painted or designed by Hilliard in a variety of media – oil, plaquettes, prints, wax seals, illuminated manuscripts and miniatures. Examination of this outpouring shows how Hilliard was given responsibility for the personal iconography of the Queen, of which he came to hold a virtual monopoly. The earliest miniature dates from 1572 (London, National Portrait Gallery) when the artist was still allowed to portray Elizabeth I as she appeared in life. For such portraits Hilliard may have been granted sittings, although no doubt one pattern could serve as the basis for many replicas. In his *Treatise concerning the Arte of Limning* (c.1600) Hilliard describes such sittings; his text reveals a great deal about the technique of miniature painting as well as demonstrating on what good terms the artist was with the Queen. Hilliard was also asked to devise a standard likeness of the Queen as she grew older.

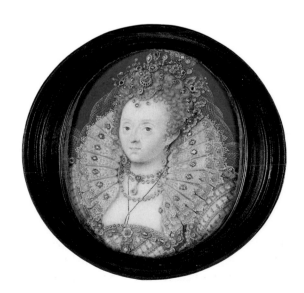

Younger painters had begun to depict Elizabeth I with increasing realism that all too readily exposed her ageing features – wrinkled skin, black teeth, false auburn hair. To counteract this, from c.1595 Hilliard created the 'Mask of Youth' image in which one set of the Queen's features is rigidly adhered to with no hint of her age and only the arrangements of hair, dress and jewellery changing. Sixteen or so miniatures of this type, including the present one, are known. These idealised portraits were often set into medallions or jewels intended to be given away by the Queen. There was a counterpart to this kind of portraiture with the literary creation of the 'Virgin Queen' in which reference is made to arcane symbolism. The result was to make the Queen into an icon.

Watercolour and bodycolour on vellum laid on card. Oval, 5.4 × 4.5 cm
RCIN 421029
PROVENANCE Mrs Clark-Kennedy; from whom purchased by King George V, 1912
LITERATURE Reynolds 1999, no. 25
EXHIBITIONS New York/San Marino/Richmond/QG 1996–7, no. 10

47
ISAAC OLIVER (c.1565–1617)
Self portrait, c.1590

Isaac Oliver was the pupil of Hilliard and his earliest known portrait miniatures date from the 1580s. Like Hilliard, he was the son of a goldsmith; Oliver's father, Pierre Olivier, was of Huguenot descent. Although Oliver worked all his life in England, he retained close artistic links with the Continent and visited Venice in 1596. His cosmopolitan approach to portraiture and his broader terms of visual reference gave his output a more sophisticated appearance that appealed to a younger generation of patrons. In 1605 Oliver was appointed Limner to Anne of Denmark, Queen of James I; and he was Painter (1608–12) to their eldest son, Henry, Prince of Wales. Although he predeceased Hilliard by two years, his reputation had long since eclipsed that of his master. There are seventeen portrait miniatures by Isaac Oliver in the Royal Collection and two drawings (see no. 357). Ten of the miniatures are of royal subjects; five of these (including nos 49 and 50) can be traced to Charles I's collection.

This vivid self portrait was made when the artist was aged about 25. It derives its dynamism from the pose, notably the angle of the shoulders, the position of the arms, and the tilt of the hat. Oliver's style is

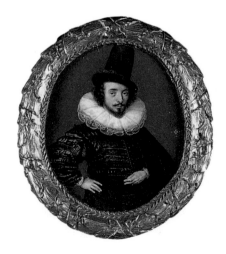

distinguished by stark contrasts in lighting, emphasised here by the use of black against the white ruff and the paler flesh tones, and by short neat brushstrokes for the features. The format, with the figure seen almost three-quarters length, was only used sparingly by the artist and coincides with Hilliard's small full-length miniatures of the same date (see no. 45). The success of this self portrait – its bristling self-confidence and air of assertiveness – lies in the scale of the figure seen within the restricted space. The face is particularly diminutive. Another self-portrait miniature, larger in size but close in date to the present example, is in the National Portrait Gallery, London. Oliver continued to emphasise his French origins and, interestingly, the playwright John Webster refers to him as 'A very formal Frenchman in ... habit' (The Duchess of Malfi, Act I, Scene I). This implies a certain elegance of style that the artist was perhaps keen to portray in this miniature.

Watercolour and bodycolour on vellum laid on card. Oval, 4.5 × 3.7 cm
Signed at right IO (in monogram)
RCIN 420034
PROVENANCE Dr Richard Mead (1673–1754); from whom bought by Frederick, Prince of Wales, by 1751
LITERATURE Reynolds 1999, no. 48
EXHIBITIONS London 1879, gallery VII, case I, no. 6; London 1889a, case XII, no. 2; London 1938, no. 748; London 1947, no. 136; Edinburgh 1965, no. 21; QG 1968–9, no. 84; Edinburgh 1975, no. 52; London 1983a, no. 134; QG 1988–9, no. 75; New York/San Marino/Richmond/QG 1996–7, no. 23; Cardiff 1998, no. 35

48
ISAAC OLIVER (c.1565–1617)
Portrait of a young man, c.1590–5

One of the finest miniatures in Oliver's oeuvre and one of the most famous images in British art, Portrait of a young man reveals the artist elaborating on the full-length format first developed by Hilliard in the 1580s (see no. 45). The increased dimensions and the inclusion of the full-length figure extended the possibilities of the portrait miniature by allowing for the depiction of a detailed background and the introduction of a narrative element. Oliver always demonstrated particular skill in placing the figure in its setting and this miniature is in many respects comparable with Hilliard's Young man among roses of c.1587 (London, Victoria and Albert Museum). Both miniatures have been variously interpreted, but in each case the identification of the sitter has remained elusive. The suggestion made by Horace Walpole in the eighteenth century that the youth in no. 48 may be identified with Sir Philip Sidney (1554–86), soldier, statesman and poet, at Wilton House in Wiltshire while composing his poem Arcadia, cannot be sustained. It is now known that the background is based on an engraving in the architectural pattern book, Artis Perspectivae ... multigenis Fontibus Liber Primus, by Hans Vredeman de Vries (1568). Oliver has added to the narrative content by introducing two figures walking in the garden. The pattern book by Vredeman de Vries may not have been widely known to artists in late sixteenth-century Britain, but a copy apparently belonged to Marcus Gheeraedts the Elder – whose daughter, Sara, Oliver was to marry in 1602.

Apart from the identification of the figures and setting, Portrait of a young man has also been discussed in the context of the 'Elizabethan Malady', as analysed in Robert Burton's Anatomy of Melancholy (1621).

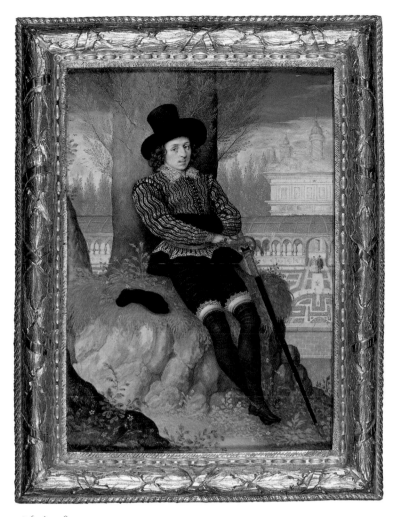

48 (reduced)

Characterised as a state of mind associated with creativity that veered towards low spirits (or in today's parlance, depression) and the yearning for isolation, melancholy was much affected by the aristocracy. However, apart from the distant forlorn expression and the discarded glove, other attributes of melancholy such as dishevelment are not portrayed here, and for the moment the *Portrait of a young man* retains its mystery.

Watercolour and bodycolour on vellum laid on card. 12.4 × 8.9 cm
Signed on right IO (in monogram)
RCIN 420639
PROVENANCE 'Mr. Correy', by c.1725; Dr Richard Mead (1673–1754); from whom bought by Frederick, Prince of Wales, between 1745 and 1751
LITERATURE Reynolds 1999, no. 50
EXHIBITIONS London 1879, gallery VII, case I, no. 8; London 1890, no. 1101; London 1934, no. 942; Arts Council 1945–6, no. 30; London 1947, no. 124; London 1956–7, no. 635; QG 1968–9, no. 85; London 1969–70, no. 141; London 1983a, no. 268; QG 1988–9, no. 76; New York/San Marino/Richmond/QG 1996–7, no. 20; Cardiff 1998, no. 33

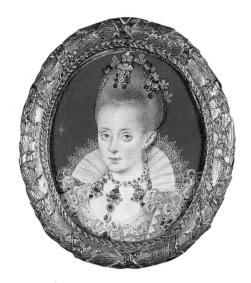

She is depicted here aged about 14. After her marriage in 1613 to the Elector Palatine, Frederick V of Bohemia (1596–1632), the couple came to personify the Protestant cause in Europe. However, in 1619 Frederick antagonised the Holy Roman Emperor by accepting the crown of Bohemia. The Emperor's troops marched on Prague, defeated Frederick at the Battle of the White Mountain (1620) and ignited the Thirty Years' War. Known thereafter as the 'Winter Queen', Elizabeth of Bohemia – and Frederick – lived the rest of their lives in exile, first in The Hague (see no. 198) and then in London. She had numerous children – including Princess Sophia, through whom the Hanoverian kings of England claimed descent, and Prince Rupert of the Rhine.

There are few miniatures that exemplify Isaac Oliver's skills so fully as the present portrait. Significantly, Van der Doort gives it a detailed description in his inventory of Charles I's collection of c.1639, referring to it as an image 'when she was younger in her high time past' and describing the coiffure, the jewels, the flowers and the dress. He adds that it was made from life.

A miniature by Hilliard showing Princess Elizabeth slightly younger is in the Victoria and Albert Museum, London. Isaac Oliver made further miniatures of the Princess at the time of her marriage in 1613; his son, Peter Oliver, followed his example in later decades.

Watercolour and bodycolour on vellum laid on card. Oval, 4.9 × 4.1 cm
Signed at left IO (in monogram)
RCIN 420031
PROVENANCE James I or Anne of Denmark(?); Charles I, by c.1639; probably Charles II, certainly James II
LITERATURE Reynolds 1999, no. 59
EXHIBITIONS London 1938, no. 749; London 1947, no. 158; QG 1963–4, no. 60; QG 1968–9, no. 90; London 1972–3, no. 181; Edinburgh 1975, no. 70; QG 1977–8, no. 109; London 1983a, no. 262; QG 1988–9, no. 80; New York/San Marino/Richmond/QG 1996–7, no. 18; Cardiff 1998, no. 4

49
ISAAC OLIVER (c.1565–1617)
Princess Elizabeth, later Queen of Bohemia, c.1610

Princess Elizabeth (1596–1662), the only daughter of James VI and I, was the sister of Henry, Prince of Wales (no. 50), and Charles I (no. 53).

50
ISAAC OLIVER (c.1565–1617)
Henry, Prince of Wales, c.1610–12

Henry, Prince of Wales (1594–1612), was the eldest child of James VI of Scotland and Anne of Denmark. On the death of Queen Elizabeth I in

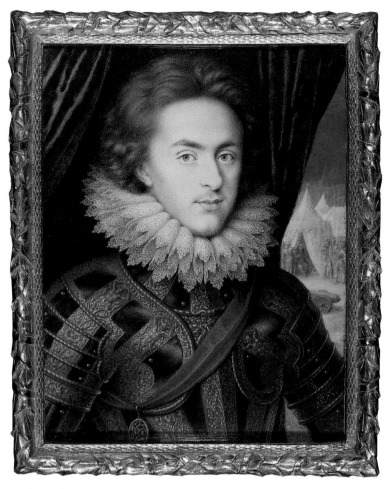

50 (reduced)

Fontainebleau. The significance of this miniature becomes apparent when it is appreciated that Prince Henry himself took part in tournaments and masques. One such example was the *Barriers* devised by Ben Jonson and designed by Inigo Jones. This was performed on Twelfth Night 1610, in the Banqueting House at Whitehall, and was set in the time of King Arthur.

Watercolour and bodycolour on vellum laid on card. 13.2 × 10.0 cm
RCIN 420058
PROVENANCE Probably commissioned by Henry, Prince of Wales; Charles I, by c.1639; Charles II; left the Royal Collection some time during the early eighteenth century; unknown sale, April 1751; where bought by James West; Rundell, Bridge & Rundell; from whom acquired by George IV, 7 August 1807; left the Royal Collection again at an uncertain date; recovered by Sir John Cowell (Master of the Household) from a cottage near Windsor, 1863
LITERATURE Reynolds 1999, no. 54
EXHIBITIONS London 1879, gallery VII, case I, no. 9; London 1934, no. 923; London 1938, no. 752; London 1947, no. 175; London 1953a, no. 132; London 1968b, no. 88; London 1969–70, no. 181; London 1972–3, no. 179; Edinburgh 1975, no. 71; QG 1977–8, no. 107; London 1983a, no. 257 (photo exhibited); QG 1983–4, no. 25; QG 1988–9, no. 78; New York/San Marino/Richmond/QG 1996–7, no. 17; Cardiff 1998, no. 2

51
ISAAC OLIVER (c.1565–1617)
Dr John Donne, 1616

The poet John Donne (1573–1631) had a particular interest in the fine arts. His collection of twenty or so paintings included a work attributed to Titian. He also appreciated miniature painting, praising Nicholas Hilliard in his poem 'The Storme' (1597). In this respect it is interesting that the present straightforward likeness is by Oliver's standards a fairly orthodox treatment, as though he were deliberately emulating Hilliard. Oliver's image was frequently replicated in miniature (Buccleuch collection), in oil (London, National Portrait Gallery), or in engravings, as various editions of his collected works were published.

Donne was the most famous of the metaphysical poets, his recurrent themes being love and religion. He was educated at Oxford and admitted to Lincoln's Inn in 1592. Although brought up as a Catholic, he became a Protestant and was appointed Chaplain to James I (1615) and Dean of St Paul's (1621). He established a reputation as a preacher and

1603 he travelled south to London with his father, who succeeded to the English throne as James I, the first monarch of the Stuart dynasty. In July of the same year he was invested with the Order of the Garter; he is shown wearing the blue ribbon and badge of the Order in the majority of his portraits, including this miniature.

Although Hilliard made two miniatures of Henry, Prince of Wales (both in the Royal Collection), the present example is the principal image in this medium. It is one of Oliver's outstanding works and is the basis of numerous versions. The conjunction of sitter and artist symbolises an important moment in British art. Henry, Prince of Wales, as a keen young patron, collected Netherlandish and Italian paintings and sculpture, as well as coins, medals and books. Isaac Oliver was an important catalyst in Britain's adoption of the advances made on the Continent during the Renaissance, both as regards his technique and his knowledge of European – mainly Mannerist – art. Henry, Prince of Wales, died when only 18 and his funeral was in itself a cultural spectacle.

Van der Doort described the present miniature in the collection of the sitter's younger brother, Charles I, as 'the biggest lim'd Picture that was made' of Henry, Prince of Wales, and indeed in the choice of format Oliver rises to the challenge presented by the new possibilities at court. The sitter wears a suit of gilt armour (c.1570) with embossed ornament notable for its classicising motifs. Set against a curtain behind the figure on the right is a military encampment with soldiers and an artillery piece. These figures may be in medieval or even antique dress, although there is a possible connection with the more recent art of the school of

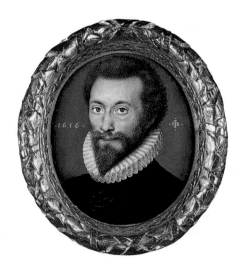

his sermons were as widely read as his poems, amongst which were a funeral elegy for Henry, Prince of Wales (no. 50), and a celebratory poem on the marriage of Princess Elizabeth (no. 49).

Watercolour and bodycolour on vellum laid on card. Oval, 4.5 × 3.5 cm
Signed at right IO (in monogram) and dated at left 1616
RCIN 420026
PROVENANCE Edward Harman; his sale, Christie's, London, 27 May 1847 (51); Lord Northwick; his sale, Thirlstane House, Cheltenham, 5 August 1859 (740); Charles Sackville Bale; his sale, Christie's, London, 24 May 1881 (1426); bought by Queen Victoria (£33 12s.)
LITERATURE Reynolds 1999, no. 62
EXHIBITIONS London 1865, no. 1640; London 1938, no. 756; London 1947, no. 194; Edinburgh 1965, no. 33; QG 1968–9, no. 86; Edinburgh 1975, no. 77; London 1983a, no. 178; QG 1988–9, no. 79; New York/San Marino/Richmond/QG 1996–7, no. 24

52
JOHN HOSKINS (c.1590–1665)
Queen Henrietta Maria, c.1632

John Hoskins holds a pivotal position in the history of the miniature. His early output refers back to Nicholas Hilliard and Isaac Oliver, while his pupil and nephew Samuel Cooper gained a European reputation for his own work. Hoskins was trained as a portrait painter in oils, possibly by William Larkin, but he seems to have specialised in miniatures from early in his career, during the reign of James I. He rose to prominence at the court of Charles I. Although he was granted royal sittings in the 1620s and 30s, Hoskins was only appointed King's Limner in 1640, with an annuity of £200; the appointment was made on the condition that he only undertook work for other patrons with the King's express permission. In addition to portrait miniatures, Hoskins made copies after paintings by Mytens, Van Dyck and others, who in turn influenced his style. During the Civil War the artist remained loyal to Charles I, but after the Restoration he was forced to appeal for payment of his annuity, which he had not received for many years. He died in relative poverty. Van der Doort listed nine limnings by Hoskins in Charles I's collection. There are eleven miniatures by Hoskins in the Royal Collection today, two of which were in Charles I's collection.

The miniatures of Queen Henrietta Maria by Hoskins add considerably to her personal iconography, just as the miniature of Charles I (no. 53) does to his. The present example, one of four recorded in Charles I's collection by Van der Doort, was made from life and is independent of the Queen's portraiture as devised by Van Dyck. Both the composition and the technique make this an outstanding portrait. The figure is seen against a classicising niche of a type that Isaac Oliver had used in his miniature of *Edward Herbert, first Baron Herbert of Cherbury*, also in the Royal Collection (Reynolds 1999, no. 64). The sobriety of the setting contrasts with the sensual treatment of the flesh and the elaborate costume culminating in a jewelled head-dress, from which a feather extends down the right side of her face. The costume is similar to the 'blue dress with spangled stars' worn by Henrietta Maria for the masque, *Tempe Restor'd*, performed at Whitehall Palace on Twelfth Night in 1632. The decorative nature of the costume is echoed by the treatment of the hair. The present frame probably dates from the early nineteenth century.

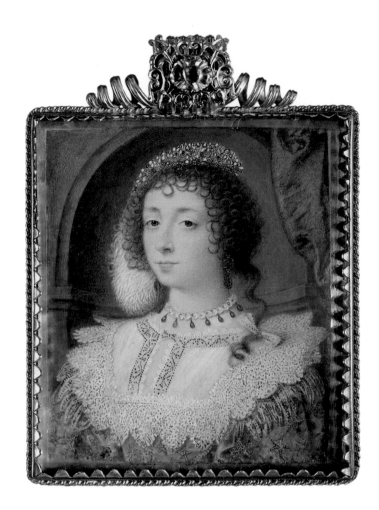

Henrietta Maria (1609–69) was the daughter of Henry IV of France and Marie de' Medici; she married Charles I in 1625. At the time of the Civil War, Henrietta Maria fled to France, but at the Restoration she returned to London and lived in Somerset House for a short time. She died in France at Colombes. She was small in height and not regarded as a great beauty; contemporary artists were not so much flattering the Queen in their portraits of her as responding to her effervescent character, spontaneous humour and unaffected demeanour.

Watercolour and bodycolour on vellum. 8.9 × 7.6 cm
RCIN 420891
PROVENANCE Charles I, by c.1639; left the Royal Collection after the King's death; Dowager Countess of Gosford; her sale, Sotheby's, London, 14 May 1925 (302); Revd E.M.W.O. and Major R.M.O. de la Hey; the latter's sale, Sotheby's, London, 27 May 1968 (51); bought by HM The Queen
LITERATURE Reynolds 1999, no. 81
EXHIBITIONS London 1865, no. 1384; London 1932, no. 100; London 1934, no. 968; London 1938, no. 779; London 1960–1, no. 655; Edinburgh 1965, no. 59; QG 1968–9, no. 128 (ex-cat.); London 1972–3, no. 196; London 1974, no. 146; QG 1977–8, no. 113; QG 1983–4, no. 32; New York/San Marino/Richmond/QG 1996–7, no. 28

53
JOHN HOSKINS (c.1590–1665)
Charles I, c.1640–5

This portrait dates from Hoskins's period as King's Limner (appointed 1640). It is made from life and shows Charles I (1600–49, r. 1625–49) at a time when his political troubles were mounting – a

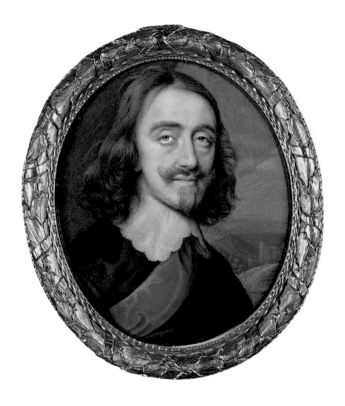

commissioned to make copies of paintings, mostly of those in Charles I's collection. Van der Doort lists thirteen such examples in the Cabinet Room at Whitehall Palace, where they were greatly valued. The copies, ten of which were by Peter Oliver, were after paintings by Raphael, Titian, Correggio, Hans Holbein the Younger and 'young Breighill' (*sic*). Today, the status of copies of this type is not particularly high, but as royal commissions – after important paintings in one of the greatest collections in Europe – they have some significance, particularly after the dispersal of Charles I's collection following his execution in 1649. The Royal Collection still has eight copies after Old Masters by Peter Oliver and these include five known to have been in Charles I's collection. Correggio's painting of *Jupiter and Antiope*, acquired by Charles I from the Duke of Mantua's collection in 1628, is now in the Louvre, Paris.

Watercolour and bodycolour on vellum. 21.2 × 14.4 cm
Signed and inscribed An°. Do. 1633 / *Anton: Coregium. Imitatus est. / Petr: Olivarius.*
RCIN 452457
PROVENANCE Painted for Charles I; Henry George Bohn; his sale, Christie's, London, 26 March 1885 (1176); bought by Queen Victoria (£265)
LITERATURE Oppé 1950, no. 463; Reynolds 1999, p. 301, Appendix no. 7
EXHIBITIONS QG 1964, no. 147; London 1972–3, no. 190

situation that is hinted at here by the expression of wearied resignation in the face. Hoskins can be seen as the counterpart in miniature of Van Dyck in his representations of the King, although there can be no doubt that the Flemish artist was responsible for the definitive image of Charles I (see no. 11). The present image is the last independent portrait of the King made by Hoskins. Over his left shoulder is a particularly beautiful landscape of shimmering blue tones. Such passages are a particular feature of miniatures by Hoskins.

Watercolour and bodycolour on vellum laid on card. Oval, 7.5 × 6.2 cm
Signed at left IH *fe*
RCIN 420060
PROVENANCE Royal Collection by 1734
LITERATURE Reynolds 1999, no. 80
EXHIBITIONS London 1879, gallery VII, case I, no. 14; London 1938, no. 746; London 1953a, no. 137; QG 1968–9, no. 104; London 1972–3, no. 197; QG 1977–8, no. 114; QG 1983–4, no. 33; New York/San Marino/Richmond/QG 1996–7, no. 27; QG/Edinburgh 1999–2000, no. 18

54
PETER OLIVER (c.1594–1647)
Jupiter and Antiope (after Correggio), 1633

Peter Oliver was the eldest son of Isaac Oliver by his first wife Elizabeth and was trained by his father, from whom he inherited in 1617 an important group of unfinished drawings and limnings, including *The Entombment* (Angers, Musée des Beaux-Arts). Peter Oliver quickly established himself in court circles, in particular with Charles I, both when he was Prince of Wales and after his accession as King in 1625. There were also close links with Charles I's sister, Elizabeth of Bohemia (see no. 49).

Peter Oliver was not a miniaturist of the first rank and his portraiture is often derivative in both style and content. From 1627 he received an annuity as 'his Ma^ts Lymner', in which capacity he was frequently

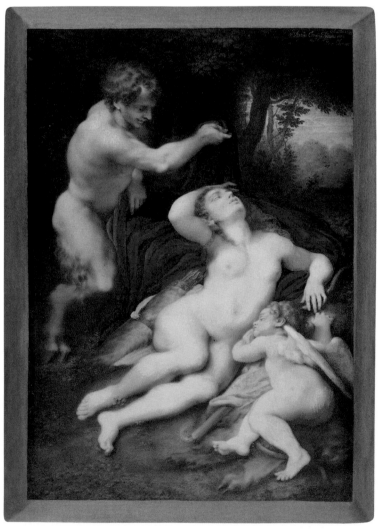

54 (reduced)

55

Attributed to PETER OLIVER (c.1594–1647)
Alexander the Great, c.1630–40

The attribution to Peter Oliver is based on stylistic grounds, the warm tones and undulating light having perhaps been learnt from those Italian painters whose works the artist copied for Charles I (no. 54). This profile image is clearly based on an antique intaglio, although no prototype has yet been found. It should also be borne in mind that such imitations were included in illuminated manuscripts; several, for example, being found in *Les Commentaires de la guerre gallique* (1519–20). This miniature thus maintains important links with the origins of the art form that Isaac Oliver also emulated on other occasions. Similarly it may reflect an interest in aspects of Italian Renaissance culture; for example, the elaborate helmet decorated with Pegasus and the treatment of the hair are in the tradition of the sculpted reliefs associated with the workshop of Andrea Verrocchio. Although such portraits are generally assumed to represent Alexander the Great (whose name is inscribed on the present miniature), an elaborate helmet is also associated with Pallas Athena, the personification of wisdom and the goddess of the arts. The source for the main inscription on the miniature is unknown.

Alexander the Great (356–323 BC) was the son of Philip II of Macedon. His tutor was Aristotle, but his fame rests upon his military exploits, which included the defeat of the Persian Empire ruled by Darius and the invasion of India by the age of 33. Alexander's reputation was such that his exploits were not only described by classical authors, but were also depicted during the Middle Ages and the Renaissance. Plutarch's *Parallel Lives* was an influential source for knowledge of Alexander the Great during the Renaissance.

Watercolour and bodycolour on vellum laid on card. Oval, 5.5 × 4.5 cm
Inscribed *ΑΛΕΞΑΝΔΡΟΣ* *ΔΙΝΟΣ* (the god Alexander) and *Illa ingentia animi bona illā / indolem qua omnes Reges / antecessit illam in sub/eundis pe.&c.* (Those great goodnesses of mind, that character in which he outstripped all kings, that ...)
RCIN 420045
PROVENANCE Royal Collection by 1743
LITERATURE Reynolds 1999, no. 75

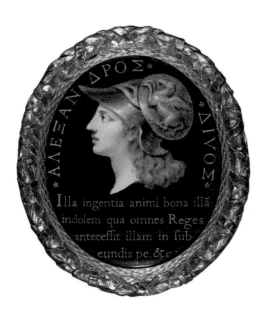

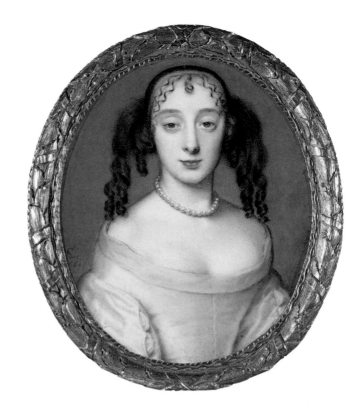

56

SAMUEL COOPER (1608?–1672)
Barbara Villiers, Duchess of Cleveland, 1661

Cooper was a miniaturist of supreme quality, renowned throughout Europe as the ablest exponent of his day. There are eighteen autograph portraits by Cooper in the Royal Collection, and two drawings. After being brought up and trained by his uncle John Hoskins (nos 52, 53), with whom he was in partnership until c.1641–2, Cooper established his own studio as the Civil War was starting. During the Commonwealth, when he made official portraits of Oliver Cromwell, Cooper benefited from the patronage of royalists and parliamentarians alike. After the Restoration he was appointed King's Limner by Charles II. Cooper's style is notable for its breadth of handling and for its remarkable assurance in characterisation. In these respects he may have benefited from travel in Europe during the 1630s. He was a gifted linguist and musician, and his friends included many of the luminaries of the seventeenth century, notably Thomas Hobbes, John Aubrey, Samuel Pepys, John Evelyn and John Milton. His wife Christiana was Alexander Pope's aunt.

In this miniature the tonal qualities of the pale flesh and the white silk dress offset by the dark hair and the blue ground show Cooper at his best, just as the placement of the figure within the oval – the ringlets echoing the curvature and the shoulders set slightly at an angle – exemplifies his compositional strengths. The direct gaze of the sitter, the oval face with the hint of a somewhat pendulous jaw, the sensuous mouth and the décolletage leave the viewer in no doubt about the charms of the Duchess of Cleveland, which even an artist as adroit as Sir Peter Lely found it difficult to capture in paint. Cooper's portrait is based on a slightly larger unfinished sketch made in miniature which is also in the Royal Collection (Reynolds 1999, no. 112). Like Lely, he depicted the sitter several times, just as the diarist Samuel Pepys frequently observed her.

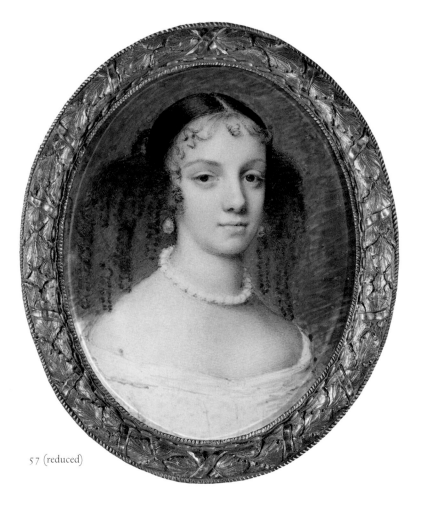

57 (reduced)

Barbara Villiers (1641–1709), the daughter of the second Viscount Grandison, was the most celebrated and politically influential of the beauties at the court of Charles II. She became the King's mistress in 1660. In the previous year she had married Roger Palmer, who was created Earl of Castlemaine in 1661. She had six children by Charles II, but was, none the less, appointed Lady of the Bedchamber to Catherine of Braganza (no. 57) after the King's marriage to her in 1662. Having fallen from favour by 1670, Barbara Villiers was created Duchess of Cleveland, given the royal palace of Nonsuch at Cheam for her personal use, and provided with ample funds. She had earned both fame and fortune by the age of 30. She later lived in Paris and in 1705 was married (unsuccessfully) for a second time, dying at Chiswick.

Watercolour and bodycolour on vellum laid on card. Oval, 8.0 × 6.5 cm
Signed at left (in monogram) and dated 1661
RCIN 420088
PROVENANCE Royal Collection by c.1837
LITERATURE Reynolds 1999, no. 117
EXHIBITIONS London 1938, no. 812; London 1956–7, no. 100; London 1960–1, no. 563; Edinburgh 1965, no. 80; London 1974, no. 81; New York/San Marino/ Richmond/QG 1996–7, no. 40

57
SAMUEL COOPER (1608?–1672)
Catherine of Braganza, c.1662

The miniature is unfinished and is best described as a sketch. On comparison with other examples in Cooper's oeuvre, including some in the Royal Collection, it is apparent that it is one of several sketches retained by the artist as the basis for making fully finished portraits on demand, possibly in considerable numbers. However, no finished miniature of Catherine of Braganza by Cooper following this pattern, or indeed any other, survives. It seems that the sketches were originally made on rectangular pieces of vellum and that they were later shaped as ovals, probably while they remained in the possession of the artist's widow. In the 1670s there was considerable interest in obtaining examples of Cooper's work. Cosimo III, Grand Duke of Tuscany, who had been painted by Cooper in 1669, opened negotiations for the purchase of the sketches belonging to Mrs Cooper in 1674 but declined to buy, because of the price. In 1673 Charles II had agreed to pay the artist's widow an annuity of £200 for life in return for some examples. The fact that he defaulted on his payment may have caused her to withhold items, including some of the unfinished sketches; these are not recorded in the Royal Collection until the reign of James II.

Catherine of Braganza (1638–1705), the daughter of John IV of Portugal, married Charles II in 1662. This miniature probably dates from shortly after her arrival in London. Her appearance gave rise to some comment since she was small and sallow, and she dressed in an old-fashioned manner. John Evelyn remarked that her teeth jutted out too far, but that her eyes were 'languishing and excellent'. The King referred

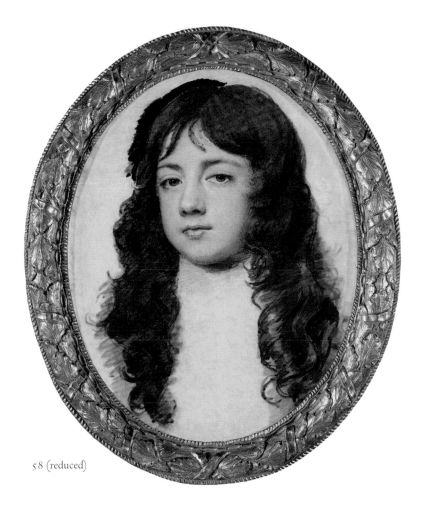

58 (reduced)

to her at one moment as resembling a bat, but later described her 'as good a woman as ever was born'.

The Queen's dowry was good and included the cities of Tangiers and Bombay. There were no children of the marriage and the Queen retained her Catholic affiliations which made her unpopular. She lived at Somerset House and after Charles II's death remained in England until the reign of William III and Mary II, when she returned to Portugal.

Watercolour and bodycolour on vellum laid on card. Oval, 12.3 × 9.8 cm
RCIN 420644
PROVENANCE The artist's widow; from whom bought by Charles II or James II; Royal Collection by 1706 at latest
LITERATURE Reynolds 1999, no. 113
EXHIBITIONS London 1879, gallery VII, case I, no. 13; London 1934, no. 977; London 1938, no. 811; London 1953a, no. 191; London 1960–1, no. 564; London 1974, no. 79; QG 1977–8, no. 118; QG 1983–4, no. 38; QG 1988–9, no. 84; QG 1990–1, no. 152; London 1993b, no. 37; New York/San Marino/ Richmond/QG 1996–7, no. 38

58
SAMUEL COOPER (1608?–1672)
James Scott, Duke of Monmouth and Buccleuch, c.1664–5

Like no. 57, this miniature is one of the unfinished sketches that remained in the artist's studio at his death. Such sketches were patterns for portraits that might be commissioned from Cooper, although no finished portrait has survived based on this sketch. This portrait of the young Duke of Monmouth is particularly free and vivid. The artist has concentrated on the face and the hair without even suggesting the form of dress. The lack of finish equates with a certain spontaneity which was appreciated in the seventeenth century as evidence of the artist's technical skill, but is particularly appealing to modern sensibilities. The freshness of the image is striking and is enhanced by the youthfulness of the sitter who, according to the earliest sources, was only 15 or 16 at the time. Another miniature by Cooper of the Duke at the age of 18 is in the Buccleuch collection. The poet John Dryden praised the sitter for his beauty in *Absalom and Achitophel*, asserting that it 'seem'd as he were only born for love'.

James Scott (1649–85) was the illegitimate son of Charles II. He was born to Lucy Walters at The Hague during the years in exile before the Restoration. Acknowledged as the King's son in 1663 when he was created Duke of Monmouth, he married Lady Anne Scott (whose surname he took) in the same year and was made Duke of Buccleuch. Attempting to establish his claim to the throne after the death of Charles II, he led a rebellion against the Catholic James II, but was defeated at the Battle of Sedgemoor in 1685 and duly beheaded for treason.

Watercolour and bodycolour on vellum laid on card. Oval, 12.2 × 9.8 cm
RCIN 420645
PROVENANCE The artist's widow; from whom bought by Charles II or James II; Royal Collection by 1706 at latest
LITERATURE Reynolds 1999, no. 115
EXHIBITIONS London 1879, gallery VII, case I, no. 12; London 1889a, case XII, no. 5; London 1934, no. 970; London 1938, no. 817; London 1956–7, no. 93; London 1960–1, no. 568; Edinburgh 1965, no. 84; London 1974, no. 78; QG 1988–9, no. 88; London 1993b, no. 39; New York/San Marino/Richmond/QG 1996–7, no. 36

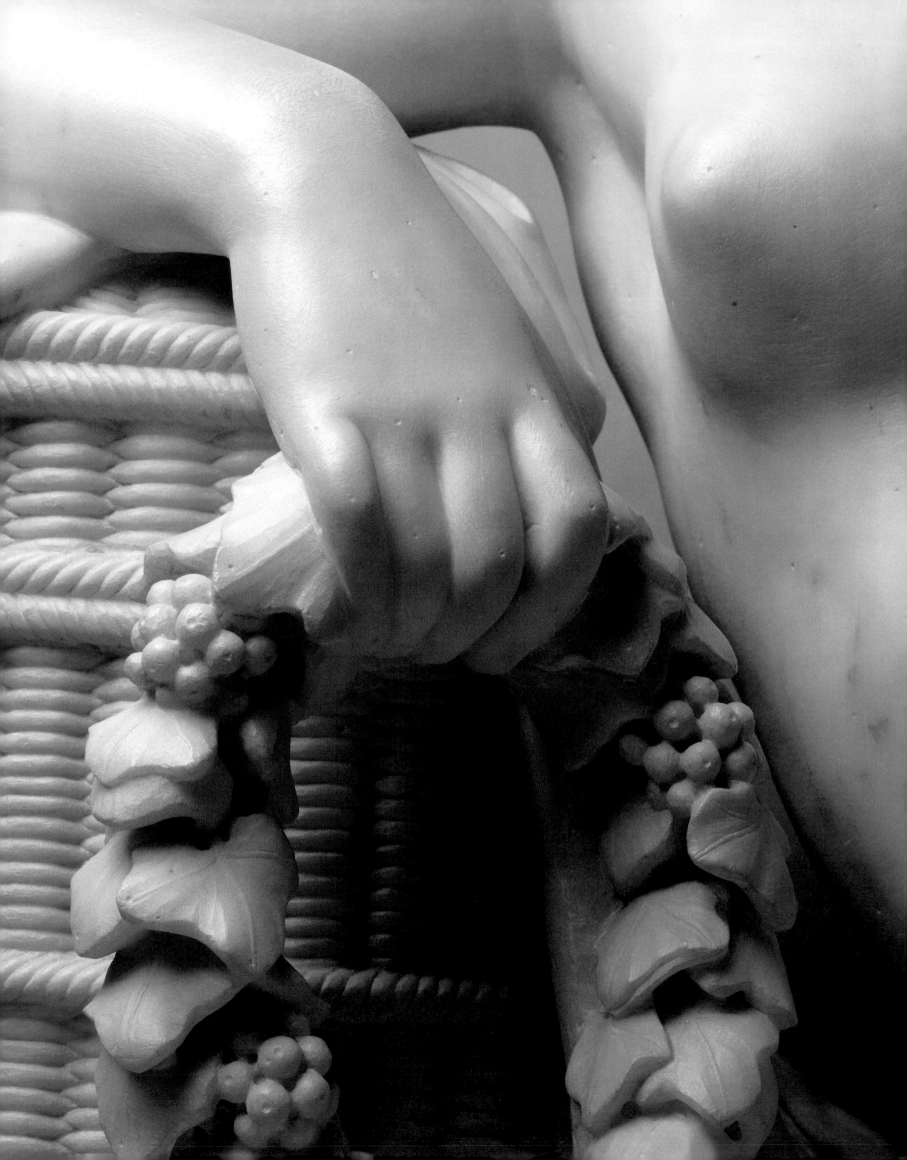

III

SCULPTURE (nos 59–76)

There are approximately 1,400 pieces of sculpture in the Royal Collection. Of these the earliest (excluding ancient sculptures) is the terracotta head of a laughing boy of c.1498 by Guido Mazzoni (no. 59). The collection is divided, like the picture collection, into those pieces that were commissioned and those that were purchased as 'old masters'. The former is by far the larger category. In addition to portraits (particularly portrait busts), it includes funerary monuments, architectural sculpture and coinage patterns, each of which has a long tradition of royal patronage. In funerary sculpture the tradition extends from Pietro Torrigiano's tomb of Henry VII in Westminster Abbey, completed in 1512, to Alfred Gilbert's monuments to the Duke of Clarence and Avondale (in the Albert Memorial Chapel, Windsor, completed 1926) and to Queen Alexandra (Marlborough House, completed 1932). The tradition of architectural sculpture is equally strong, ranging from the terracotta reliefs by Giovanni da Maiano at Hampton Court Palace to the friezes in plaster and carved stonework by Pitts, Baily and Westmacott which play such an important role in John Nash's designs for Buckingham Palace. To these have been added in the present reign the remarkable plaster friezes by Alexander Stoddart in the entrance hall of the new Queen's Gallery (see fig. 21). Royal commissions have often provided the impetus for technical developments in British sculpture (in bronze casting, for example, through the employment of Torrigiano and Hubert Le Sueur), and have helped foreign artists to gain a footing in this country (including Le Sueur, Francesco Fanelli, Grinling Gibbons, Michael Rysbrack, Carlo Marochetti, Jules Dalou and Joseph Edgar Boehm). The title of 'Sculptor in Ordinary' has from time to time been bestowed on sculptors, but the precise status of such appointments has varied from reign to reign.

Both Henry VIII and Charles I imported antique statues and casts into England. In 1598 the traveller Paul Hentzner noticed at Nonsuch Palace in Surrey 'so many statues that seem to breathe, ... so many casts that rival even the performance of Roman antiquity', but none of these seems to have survived. The antique marbles purchased by Charles I from the collection of the Duke of Mantua, which arrived in consignments between 1628 and 1632, were dispersed in the Commonwealth sales of 1649–51; only ten Roman marble busts and one statue – the so-called 'Lely Venus' – survive in the Royal Collection today from this source.

As in so many other fields, the collection of sculpture was greatly enriched by the acquisitions made by George IV between the 1780s and his death in 1830. His purchases included approximately seventy eighteenth-century French bronze statuettes and groups (see nos 64–6), which were arranged on chimneypieces with oriental and Sèvres porcelain vases, and were often mounted on Louis XV and Louis XVI ormolu bases. These had passed through the revolutionary sales which dispersed the contents of the major French collections. They were purchased from dealers in Paris or at auctions in London, through intermediaries such as François Benois (George IV's confectioner, who frequently acted as his agent for purchases in Paris) and Lord Yarmouth, later third Marquess of Hertford. George IV's taste for martial portraiture led to the acquisition in 1825 of the group of three magnificent bronze busts by Leone Leoni (see nos 60, 61) and what is thought to be the only bronze portrait bust by Massimiliano Soldani-Benzi, now known to represent Enea Caprara (RCIN 1146). A set of reliefs of the *Four Seasons* (RCIN 21932.1–.4), also by Soldani, was joined in George IV's collection by one of the supreme masterpieces of this genre, Adriaen de Vries's *Rudolph II introducing the Liberal Arts into Bohemia* (RCIN 35858), which came from the imperial collection at Prague. George IV probably also acquired the two-figure group by De Vries, *Theseus and Antiope* (no. 62).

The Royal Collection contains very few bronze statuettes of the Italian Renaissance. Charles I possessed eighteen small bronzes cast by Pietro Tacca from models by Giambologna, of which fifteen had been presented to his elder brother Prince Henry by the Grand Duke of Tuscany in 1611, and in 1627–8 he acquired with the Gonzaga collection a number of bronzes made for the Duke of Mantua by Antico. These, and others by Francesco Fanelli, were sold by the Commissioners of the Late King's Goods after 1649, and nothing comparable has since entered the collection. George IV was not alone among English collectors of the early nineteenth century in his lack of interest in Italian Renaissance bronzes. When demand eventually did reach a peak at the end of that century and the beginning of the twentieth, English and German collectors such as C.D.E. Fortnum, Richard Wallace and Wilhelm von Bode, and Americans such as Pierpont Morgan, faced no English royal rival.

British monarchs have often looked to Rome, not only as the source of antique sculpture but for work by the best contemporary artists. Thus in 1636 Charles I commissioned from Gianlorenzo Bernini the portrait for which Van Dyck supplied the famous triple likeness of the King. Van Dyck also made three separate portraits, from the same viewpoints, of Queen Henrietta Maria, through whom the commission to Bernini was transmitted. These were intended as models for a bust of the Queen by Bernini, but this was never progressed. The bust of the King was destroyed in the fire at Whitehall Palace in 1698. George IV, who eventually bought the Van Dyck portrait for the Royal Collection in 1822, also turned to the greatest Roman (though Venetian-born) sculptor of his time, Antonio Canova, for large-scale marble statues of the kind that his friends the Dukes of Devonshire and Bedford had commissioned. He was thwarted in his attempts to secure an example of the *Three Graces*, but none the less acquired three other works (see nos 72, 73).

Sculpture had a special appeal for Queen Victoria and her husband, Prince Albert, and invariably featured among their birthday and Christmas gifts to one another. Together they took a close interest in the career of John Gibson (1790–1866) and the British sculptors working in his circle in Rome. Gibson's own statue of the young Queen Victoria, completed in 1846 (RCIN 2071), was followed by commissions to Richard James Wyatt, Lawrence Macdonald and William Theed the Younger. Prince Albert also showed a keen interest in the work of German and Austro-Hungarian sculptors such as Emil Wolff, Carl Steinhauser, Julius Tröschel and Josef Engel, examples of whose work can be seen in their original settings in the Grand Corridor at Osborne. Of the sculptors patronised by Queen Victoria and Prince Albert those best represented in the Royal Collection today are Sir Joseph Edgar Boehm (1834–90; 87 works) and Mary Thornycroft (1814–95; 50 works), whose father John Francis (1780–1861) instructed Prince Albert in modelling.

Edward VII visited Rome at the age of 18 in 1859, and was led round the sculptors' studios by the elderly John Gibson. The Prince purchased works from the American sculptress Harriet Hosmer (1830–1908) and from Lawrence Macdonald, and continued to add to his collection for the next fifty years. It included works by Jules Dalou, Sarah Bernhardt, Alfred Gilbert, Frederick Pomeroy, and by the Prince's relatives Victor and Feodora Gleichen (the son and granddaughter of Queen Victoria's half-sister, Feodora). In view of Edward VII's sporting interests it is perhaps not surprising that a large group of nineteenth- and early twentieth-century equestrian bronzes entered the collection during his reign. These, by artists such as Adrian Jones and J. Willis Goode, have been joined by further horse bronzes during subsequent reigns, which have also seen the addition of portrait sculpture by Arthur Walker, Gilbert Ledward, Oscar Nemon and Franta Belsky.

59
GUIDO MAZZONI (d. 1518)
Laughing child, possibly Henry VIII, c.1498

This fragile bust seems to have remained in the Royal Collection since it was made. It is probably identifiable with the 'Head of a laughing boy' noted at Whitehall Palace in the reign of James II (Bathoe 1758, p. 102, no. 1258) and in the Store Room at Whitehall Palace in an inventory made for William III; also with the 'Cast of a Chinese boy – laughing countenance' that was sent to Brighton Pavilion on 4 September 1815 (Jutsham I). It has subsequently been described as a laughing girl (exh. cat. London 1862a), a German dwarf (Bode 1902), and as a portrait of Henry VIII (1491–1547) as a 7-year-old boy (Dow 1960).

In 1925 Lionel Cust, Surveyor of the King's Pictures and Works of Art, attributed the bust to the Modenese sculptor Guido Mazzoni, also known as Paganino. Mazzoni's surviving work consists almost entirely of life-size painted terracottas of the same strikingly realistic character, forming groups of the Nativity and Lamentation. A second, equally consistent mark of his work is a very high degree of technical proficiency, which is fully evident here. The bust was formed of clay pressed into a mould to a maximum thickness of 5 millimetres, and the boy's open mouth, ears and nostrils served to allow steam to escape during firing. Paint analysis was carried out in 1964 and in 1985–8, when the bust was cleaned, and nineteenth-century overpaint was removed from the child's tunic, revealing the original scheme – a green glaze over an incised layer of tin foil, perhaps intended to imitate cloth of gold.

When Mazzoni was working on the tomb of the French King Charles VIII in Paris in the late 1490s, he submitted designs and an estimate for the tomb of Henry VII for Westminster Abbey, which were later rejected in favour of those by Pietro Torrigiano. The estimate does not indicate whether Mazzoni (who is called 'Master Pageny' in the English accounts) ever came to London, and no commission for the bust has come to light. Its identification as Prince Henry remains conjectural, supported only by its royal provenance and by the child's apparent age.

Painted and gilded terracotta. 31.8 cm high
RCIN 73197
PROVENANCE Perhaps commissioned by or presented to Henry VII
LITERATURE Bode 1902; Cust 1925; Dow 1960; Verdon 1978, p. 342, no. 15; Larson 1989; Lugli 1990, pp. 331–2
EXHIBITIONS London 1862a, no. 8; London 1903; QG 1964, no. 53; QG 1988–9, no. 121; London 1992a

60
LEONE LEONI (1509–1590)
Emperor Charles V, c.1554–5

The Habsburg Emperor Charles V (1500–58; r. 1516–56) is one of the most recognisable of all European historical figures, thanks to his employment of Titian as his court painter and of Leone Leoni, the goldsmith, medallist and sculptor from Arezzo, as his court sculptor. Their most imposing and ambitious portraits celebrated the Emperor's victory over the Protestant princes of Germany at Mühlberg in 1548.

This bust is of a type which was used by Leoni and the sculptors of the next generation (including Adriaen de Vries), as if to emphasise the

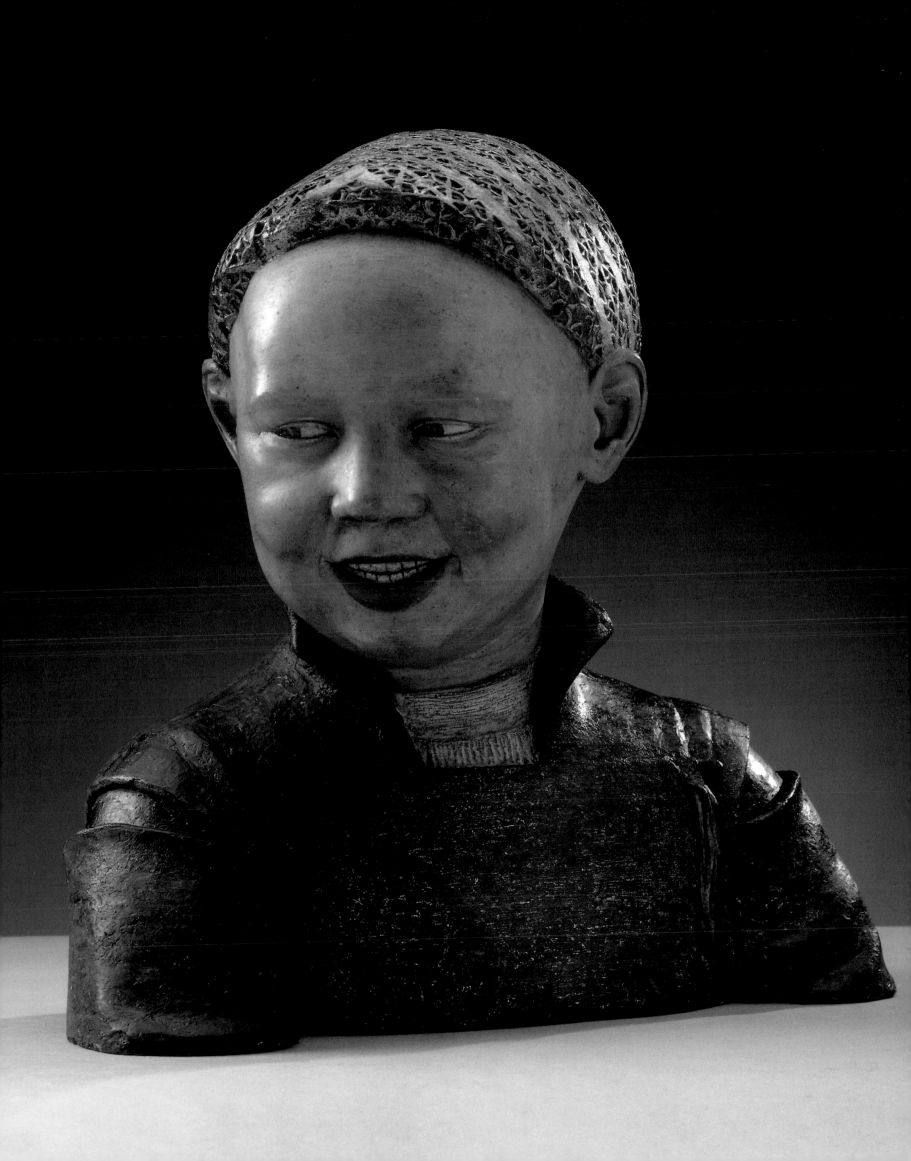

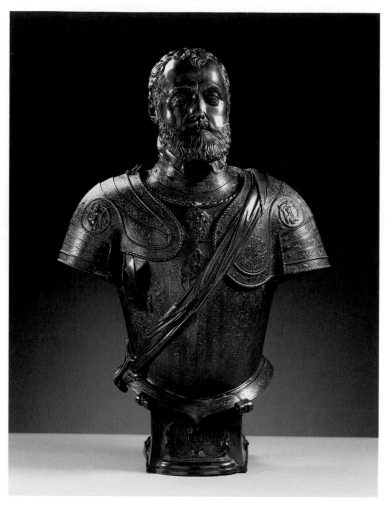

60

continuity of the Habsburg dynasty: Charles V's grandfather and predecessor Maximilian, his son Philip (see no. 61) and his great-nephew Rudolf II were all portrayed in the same constrained format, wearing Italian parade armours with the insignia of the Order of the Golden Fleece. In the more elaborate variations, such as those of Charles V in the Prado (1553; inv. E–271; Coppel Aréizaga 1998, no. 12) and in the Kunsthistorisches Museum, Vienna (inv. 5504), the armoured bust is supported by an eagle flanked by crouching male and female nude figures.

While the busts in Madrid and Vienna were made for the Emperor himself, the present bronze has been identified as one of three that were ordered from Leoni by the imperial general and Viceroy of the Netherlands, Fernando Álvarez de Toledo, Duke of Alba (1507–82), for his castle at Alba de Tormes near Salamanca. The commission – for portraits of Charles V (no. 60), Philip II (no. 61) and of the Duke himself (RCIN 35337) – is recorded by Vasari, and the busts were seen on pedestals in the gallery of the castle by Ceán Bermudez in 1800 (see Middeldorf 1975, p. 89). The castle was destroyed by fire after the Battle of Salamanca in 1813 and the Leoni busts only reappeared in George Watson Taylor's sale in May 1825, when they were acquired by George IV. The sale catalogue claimed that the busts had been brought from Spain 'by a French officer of distinction, and were purchased at Paris'. Another bronze bust of the Duke of Alba, by Jacques Jonghelinck, which is known to have stood next to the three by Leoni at Alba de Tormes, was removed in 1810 by Marshal Ney and brought to the

Château des Coudreaux, near Châteaudun. It was sold with the house after Ney's execution in 1815 (New York, Frick collection, no. 16.2.61). Tempting as it is to identify Ney as the 'French officer' of the 1825 Watson Taylor sale catalogue entry, the Leonis do not appear to have belonged to him. By the 1840s (if not before) they were in the Grand Corridor at Windsor (see no. 409).

The delicately etched surface of the armour on the present bronze and its companions is markedly different from the boldly raised decoration which is found on all of Leoni's other armoured portraits. This might be explained by their having been cast in the Low Countries rather than in the sculptor's own foundry at Milan. All three Windsor busts do, however, include on the breastplates the oval reliefs with Christian emblems which are present on the Italian casts of Charles V and Philip II.

Leoni's life has several ingredients in common with other great Renaissance sculptors, notably Benvenuto Cellini. While working in the papal mint he was sentenced to the galleys for a violent assault on the Pope's German jeweller, and later on in his career he made an attempt on the life of Titian's son. Notoriously dilatory and awkward when dealing with imperial ministers and officials, he spent hours in conversation with the Emperor himself in the workshops provided for him on his visits to Brussels. His son and pupil Pompeo (c.1533–1608), who was responsible for the figures of Charles V and Philip II in the Escorial, owned the volume of 600 drawings by Leonardo da Vinci which is now in the Royal Collection (see nos 338–44).

Bronze. 95.3 cm high
Inscribed IMP CAES / V / CAR AVG.
RCIN 35325
PROVENANCE Commissioned by Fernando Alvarez de Toledo, third Duke of Alba; George Watson Taylor; his sale, Christie's, London, 28 May 1825 (65); bought by Robert Fogg for George IV (£89 5s.)
LITERATURE Vasari, VII, p. 538; Plon 1887, pp. 296–8; Middeldorf 1975, pp. 89–91; Coppel Aréizaga 1998, pp. 64, 75; Roberts (H.A.) 2000, p. 120
EXHIBITIONS QG 1964, no. 34; QG 1988–9, no. 105

61
LEONE LEONI (1509–1590)
Philip II, King of Spain, c.1554–6

While Charles V (no. 60) travelled repeatedly across Europe with his imperial court, almost continuously engaged in war, his only son and successor as King of Spain, Philip II (1527–98; r. 1556–97), remained rooted firmly in Spain, at the palace of the Escorial, where Leone Leoni's son Pompeo was occupied with large-scale commissions including altar and tomb sculptures.

This bronze, which can be dated fairly precisely on the evidence of its inscription, was one of the three ordered from Leone Leoni by the Duke of Alba (see no. 60). It must have been made between 1554, when Philip married the English Queen Mary (Tudor) at Winchester, and 1556, when he succeeded his father on the Spanish throne. Despite the title *Rex Angliae* (King of England), he is shown wearing the Habsburg Order of the Golden Fleece rather than that of the Garter of which both he and his father were members. Leoni was frequently late with his work, and this narrow time span should probably not be applied to all three busts ordered by the Duke of Alba.

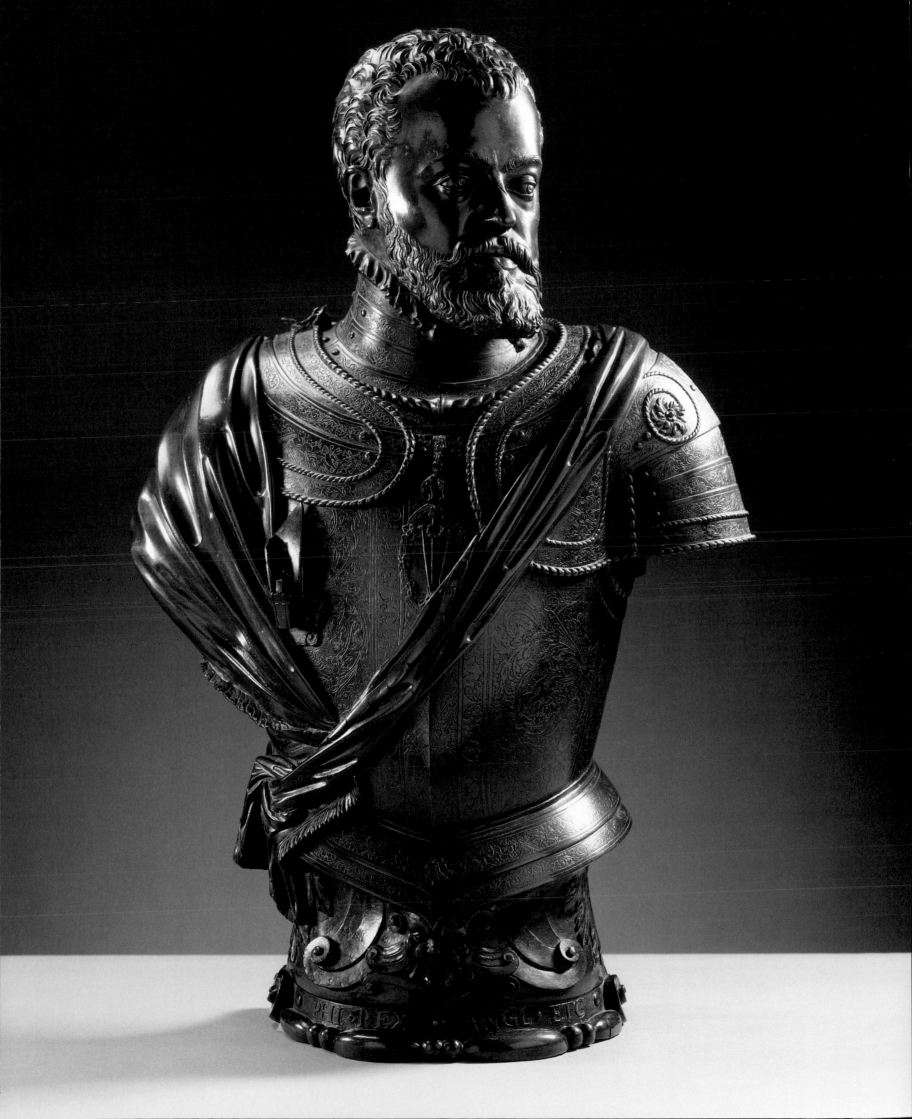

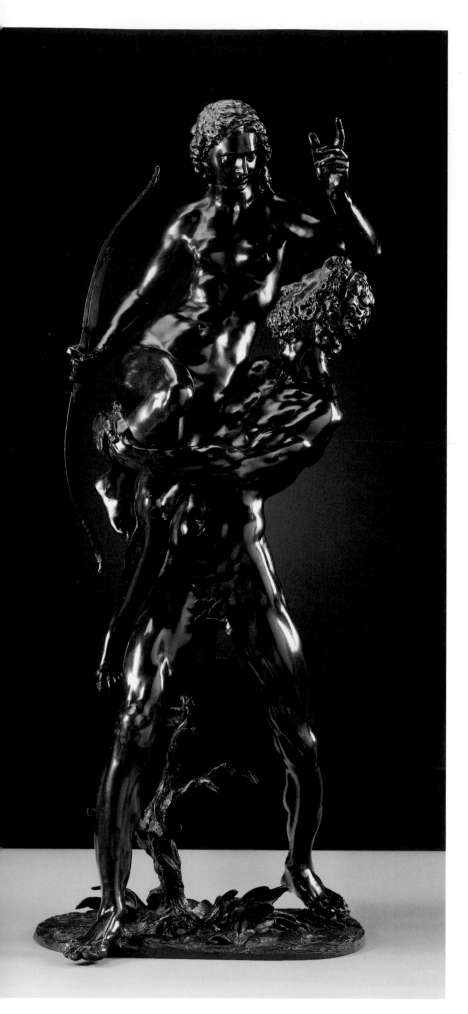

Like no. 60, this bronze differs from Leoni's other productions in the technique of the arabesque decoration to the armour. Here and on the bust of the Duke of Alba (RCIN 35337) one side of the breastplate is etched with simple linear scrolling foliage, while on the other side the background has been much more extensively etched. This difference is not seen on the bust of Charles V, which is also the only one of the three in which the sitter is looking directly forward. This suggests an attempt on the sculptor's part to emphasise the orientation of the other two heads by creating a sense of directional light falling on the armour. A more elaborate explanation might lie in the intended placing of the three busts in the Duke of Alba's gallery; precedence would certainly dictate that the Emperor be given pride of place at one end, while his son and the Duke looked across at him from a side wall.

Bronze. 88.9 cm high
Inscribed PHI. REX. ANGL. ETC.
RCIN 35323
PROVENANCE As for no. 60; George Watson Taylor sale, Christie's, London, 28 May 1825 (67); bought by Robert Fogg for George IV (£52 10s.)
LITERATURE As for no. 60; Coppel Aréizaga 1998, p. 94
EXHIBITIONS London 1862a, no. 450; QG 1964, no. 32; London 1988a, no. 1.18; Brussels 1998–9, no. 9

62
ADRIAEN DE VRIES (1556–1626)
Theseus and Antiope, c.1600–01

The Dutch-born sculptor Adriaen de Vries was trained in the workshop of the great Florentine master Giovanni Bologna (Giambologna; 1529–1608) and travelled between several of the major courts of Europe. His best-known works were the colossal outdoor groups and fountains in Augsburg, Prague, and Frederiksborg in Denmark. Many of his compositions share the elongated proportions and sense of upward movement that are strongly evident in no. 62.

From Giambologna onwards, subjects involving male figures carrying off females were regarded as particularly suitable for contrasting types of figures which could be viewed in the round. The identity of these two is by no means certain, but they are generally thought to represent Theseus, legendary King of Athens, abducting Antiope, Queen of the Amazons. This subject epitomises the battle of the sexes, although in this case the conflict ended unusually harmoniously in marriage. De Vries used an almost identical composition in his more widely known and repeated group of Hercules, Nessus and Deianira of 1603–08 (Paris, Louvre), where the space between the male figure's widely spaced legs is occupied by the defeated centaur, Nessus, instead of the stunted plant included here. This element, contrasting with high finish of the figures, clearly played a part in the casting of the group, upside-down and in one 'pour' from the original wax model; the plant would have served as a vent to allow air to escape as the molten bronze entered the mould.

The attribution of the Theseus and Antiope group to De Vries has recently been strengthened by detailed scientific examination of the bronze (including X-ray photography) in preparation for the major exhibition of the sculptor's work in 1998–2000. Nevertheless, it remains unclear precisely when the group was made and for whom. The

◁ 62

unusual form of signature (a monogram AF), recalling that of Albrecht Dürer, also appears on the relief tablets of De Vries's *Hercules* fountain in Augsburg (1597–1602).

Bronze. 95 cm high
Signed (cast in the bronze in the base) AF in monogram
RCIN 57961
PROVENANCE Probably acquired by George IV
LITERATURE Bewer 2001, pp. 165–70
EXHIBITIONS QG 1988–9, no. 122; Amsterdam/Stockholm/Los Angeles 1998–9, no. 8 (not exhibited in Los Angeles); Augsburg 2000, no. 12

63
HUBERT LE SUEUR (c.1585–c.1658)
Charles I, mid-seventeenth century

Hubert Le Sueur came to London in the retinue of Charles I's bride Henrietta Maria, the daughter of Henry IV of France, in 1625. He was a skilled bronze founder and among the earliest of approximately fifty commissions that he undertook for Charles I was a series of bronze casts after the Antique for the King's gardens at St James's Palace (now at Windsor Castle). His portrait busts of the King derive from the armoured equestrian statue now in Trafalgar Square, which was completed by Le Sueur in 1633 for the Lord Treasurer, Sir Richard Weston. The earliest of this pattern was ordered by Archbishop Laud in 1636 for presentation to Oxford University and remains in the Bodleian

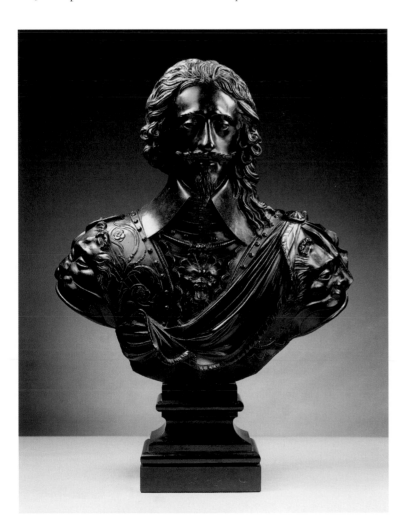

Library. The present bronze, though not as fine as the Bodleian example, was evidently cast in the seventeenth century and has the same touch-stone socle. Abraham van der Doort recorded three busts of the King by Le Sueur at Whitehall Palace in 1639, of which one (Millar (O.) 1960, p. 97, item 35), in the Cabinet Room, may have been of this type.

The first unmistakable reference to this bust is in Benjamin Jutsham's *Receipts* ledger for 1820, when it arrived at Carlton House, probably as a new acquisition. Further examples of the bust continued to be made in the eighteenth and nineteenth centuries, including two others in the Royal Collection (RCIN 2126 and 2129). One of these busts, probably no. 63, is recorded in the Grand Corridor at Windsor in 1846 (see no. 410).

Bronze. 83 cm high
RCIN 33467
PROVENANCE Probably acquired by George IV, 1820 (Jutsham II, p. 97)
LITERATURE Avery 1982, pp. 153–9
EXHIBITIONS QG/Edinburgh 1999–2000, no. 111

64
FRANÇOIS GIRARDON (1628–1715)
The Abduction of Proserpina by Pluto, first decade of eighteenth century

François Girardon was the pre-eminent sculptor of the reign of Louis XIV. His best-known works are the colossal bronze equestrian statue of the King, cast in 1692 for the Place Louis-le-Grand (Place Vendôme) in Paris, and those which formed part of the *Grande Commande* of 1674 for twenty-four statues to ornament the gardens of Versailles. His marble statue of *The Abduction of Proserpina* was one of four groups of similar subjects intended to represent the four elements at the four corners of the Parterre d'Eau. (The others were of Boreas and Orytheia – Air – by Marsy, Saturn and Cybele – Fire – by Regnaudin, and Neptune and Coronis – Water – commissioned from Tuby.) The choice of subjects was an invitation to the French sculptors to surpass the famous two- and three-figure groups of Giambologna and Bernini. Girardon's group, which was completed in 1699, was the most direct challenge to Bernini, whose version of the same subject (of 1622, Rome, Villa Borghese) he no doubt knew at first hand, having twice visited Rome. Since they were to occupy corners of the parterre, the Versailles groups were designed to be seen chiefly from the front.

Girardon's marble was reproduced as a small bronze from the late seventeenth century onwards. Many examples, measuring approximately 53 centimetres high – often paired with either Marsy's *Boreas and Orytheia* or Giambologna's *Rape of a Sabine*, and mounted on ormolu bases – were made during the eighteenth century as *bronzes d'ameublement* for fashionable apartments; the Royal Collection also includes one such small bronze (RCIN 2172). The present bronze is one of only six known casts of a larger size, two of which were in the possession of the sculptor at the time of his death in 1715 (Souchal 1973, p. 84, no. 214), and which probably derive from his small model for the marble group. Some of these larger bronzes, including the signed and dated version at Strasbourg (Château des Rohan) and another now at Versailles (MV 7952) were cast in 1693 (see Baratte et al. 1999, no. 174). The signed bronze in the J. Paul Getty Museum (Los Angeles) which, like the

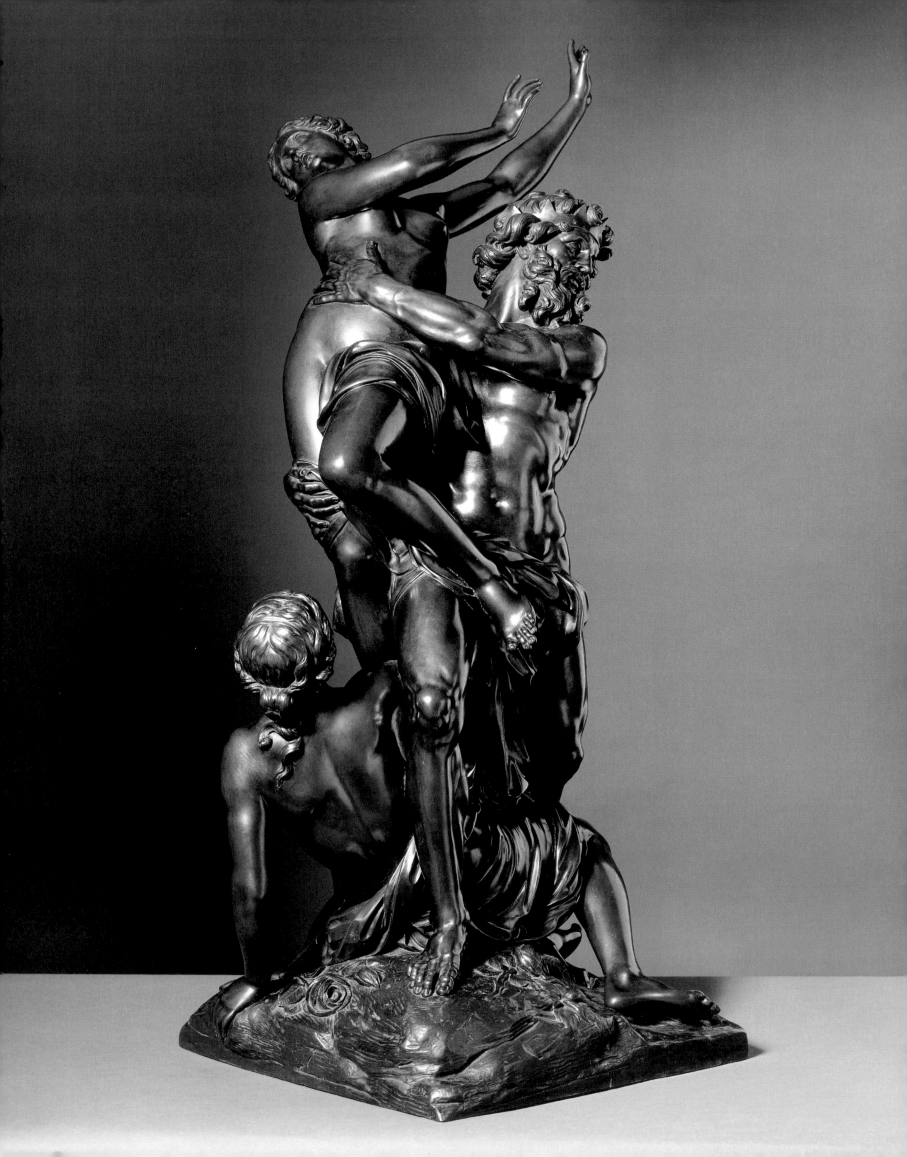

Versailles marble, has a circular base, is probably the finest of the known casts in this size. Only the present cast and another (Dresden, Staatliche Kunstsammlungen, inv. IX 66), which was purchased for Augustus the Strong, Elector of Saxony, in Paris in 1715, have square bases, which was apparently the form of those that belonged to the sculptor.

The subject is taken from Book V of Ovid's *Metamorphoses*. Pluto, having risen from his underground realm to inspect the damage caused by an earthquake in Sicily, is struck by Cupid's dart and compelled to carry the nymph Proserpina (Persephone) back to the underworld. The third figure is probably Cyane, another nymph who attempted to resist Pluto; she found herself transformed into a river, dissolved by her own tears.

George IV acquired a number of bronze statuettes of this subject. This is probably the 'large Bronze Group, the Rape of Proserpine mounted on an Ormolu Stand' which arrived at Carlton House in May 1811 (Jutsham I, p. 159).

Bronze. 97.4 cm high
RCIN 44191
PROVENANCE Probably acquired by George IV, May 1811
LITERATURE Souchal 1977–93, IV, pp. 102–04

65

PHILIPPE BERTRAND (1663–1724)
Prometheus Bound, 1703

Ovid relates how Zeus condemned the titan Prometheus to perpetual agony for having betrayed to mortals the secret of fire; he was chained to a rock on Mount Caucasus to which each day an eagle would descend to feed on his liver, which was restored overnight. Ever a popular subject with artists, it was one of those prescribed by the French Academy for the final exercise in the process of admission, the *morceau de reception*. The pose of the stricken titan, leaning steeply backwards and with one knee sharply flexed, may ultimately derive from Michelangelo's figure of Adam on the ceiling of the Sistine Chapel. The composition was probably first used for a bronze group of this subject (with an additional, free-standing figure of Mercury) by the Florentine Giambattista Foggini (1652–1725) around 1700. (That group, which was presented to the French painter Hyacinthe Rigaud in 1716, is now in the Victoria and Albert Museum, inv. A.3–1967.) It was used again by François Dumont for his bronze of the same subject in 1710 (RCIN 72636). Bertrand made this bronze, which is not only signed but is dated specifically *aoust* 1703, having already been accepted as Academician in 1701. The *livret* for the Salon of 1704 includes *une figure de Prométhée sur son scabellon par M. Bertrand* which was most probably the present bronze. The model is known in only one other cast, which is neither signed nor dated (sold Sotheby's, London, 9 July 1992 (156)).

Like most of his contemporaries, Bertrand also undertook architectural carving (at Versailles and in the choir of Notre Dame) and life-size marble and lead figures in collaboration with René Frémin (1672–1722). His small bronzes and terracottas are often animated with the strong facial characterisation visible here.

Bronze. 49.2 cm high
Signed and dated (cast in the bronze at the rear) *Bertrand / aoust 1703*
RCIN 33464

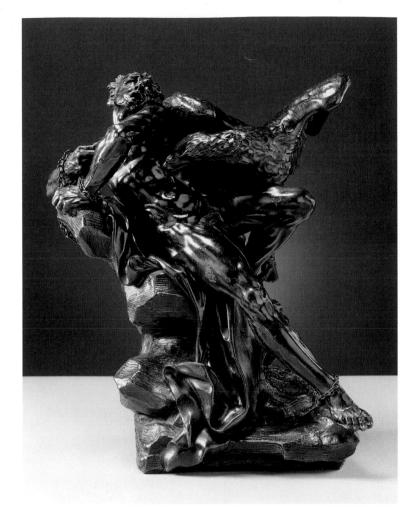

65

PROVENANCE Rundell, Bridge & Rundell; from whom bought by George IV, 16 August 1824 (£68 5s.; RA GEO/26059)
LITERATURE Souchal 1977–93, I, p. 52
EXHIBITIONS (?)Paris 1704; London 1968a, no. 794; Düsseldorf 1971, no. 321

66

PHILIPPE BERTRAND (1663–1724)
Psyche and Mercury, c.1700

Philippe Bertrand exhibited a bronze of *L'Enlèvement de Psyché* at the Salon of 1704; the group was paired with the *Enlèvement d'Hélène* (now at Fontainebleau) which had been submitted as Bertrand's reception piece for the French Academy in 1701; his *Prometheus* (see no. 65) was in the same exhibition. The composition of no. 66 has also been identified by Levey as the *Mercure qui enlève Pandore* which was shown at the 1704 Salon by René Frémin (1672–1722). If this were correct, the lidded vase which the female figure holds up in her left hand would be Pandora's famous box. However, in other representations of the Psyche episode, not least the two famous groups by Adriaen de Vries in Stockholm and Paris, she is carrying in a similar way the vase in which she kept a portion of Proserpina's beauty. What is represented here is not strictly an abduction (*enlèvement*), since the female figure would appear to be travelling on a seat of clouds with the assistance of Mercury. In neither scenario is the third figure – a hideous serpent-crowned crone

clutching a flaming torch – readily identifiable, but in the most recent discussion of the groups, François Souchal suggests that she may represent a Fury from the underworld, from whom Psyche had victoriously succeeded in escaping. Another cast, with variations, is in the Hermitage, St Petersburg.

Bronze. 61.6 (with caduceus 78.7) cm high
RCIN 21641
PROVENANCE Rundell, Bridge & Rundell; from whom bought by George IV, 16 August 1824 (£145; RA GEO/26059)
LITERATURE Levey 1972, p. 45; Souchal 1977–93, IV, pp. 14–15
EXHIBITIONS QG 1988–9, no. 109

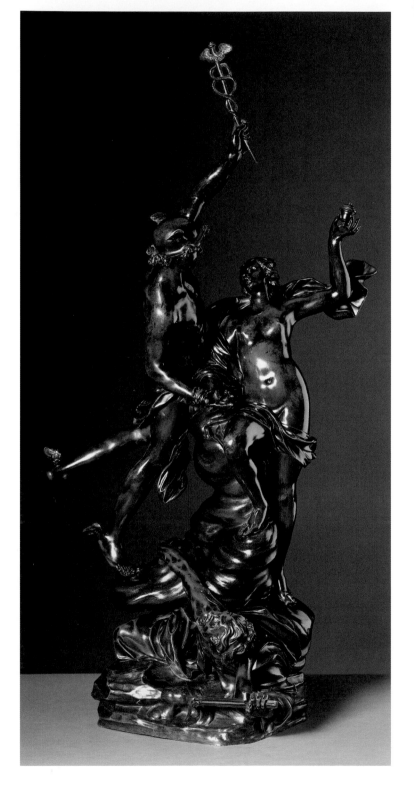

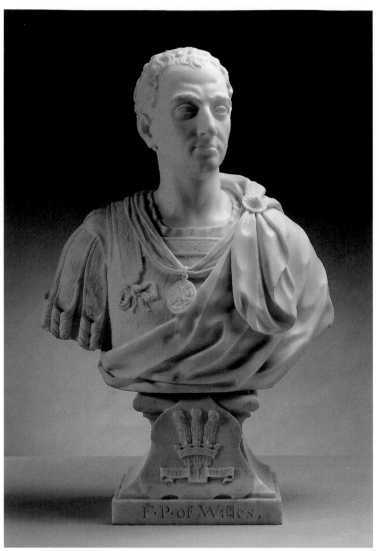

67
PETER SCHEEMAKERS (1691–1781)
Frederick, Prince of Wales, 1741

The eldest son of George II and father of George III, Frederick, Prince of Wales (1707–51), is the only individual included in this series of portrait busts of the 'founding collectors' who did not ascend the throne. His premature death in 1751 came as the result of having been caught in a rainstorm while inspecting the latest plantings in his garden at Kew. In gardening and almost every other branch of the arts, he was the first great Hanoverian patron and collector (see Rorschach 1990).

Although the Flemish immigrant sculptor Peter Scheemakers worked for Prince Frederick himself at Carlton House (see Roscoe 1999, pp. 277, 284), this bust only entered the Royal Collection in 1941, when it was purchased by Her Majesty Queen Elizabeth The Queen Mother. It had been commissioned by Viscount Cobham for the Temple of Friendship, designed by James Gibbs and erected in 1739 in Cobham's garden at Stowe in Buckinghamshire to commemorate a visit by the Prince of Wales two years earlier. The temple contained ten busts of Lord Cobham's political associates, members of the Whig opposition who

◁ 66

looked to the Prince as their figurehead. All of the busts, of which Scheemakers carved at least three, were rendered in the antique manner in armour of the kind shown here, with square tapering socles carved with the arms or crest of each individual. The bust of Prince Frederick, in particular, reveals Scheemakers's studies of ancient sculpture in Rome.

Marble. 59.7 cm high
RCIN 31169
PROVENANCE Commissioned by Richard Temple, Viscount Cobham, 1741; by descent to second Duke of Buckingham; sold Christie's, Stowe, 15 August 1848 (765); bought Rainey; fifth Earl Temple; by whom sold Sotheby's, London, 9 May 1941 (65); bought by HM Queen Elizabeth The Queen Mother
LITERATURE Rorschach 1990, pp. 29–32; Roscoe 1999, p. 273, no. 177
EXHIBITIONS Cardiff 1998, no. 21

68
JOHN BACON (1740–1799)
George III, 1775

This likeness of George III (1738–1820), in robes of state and wearing the collar of the Order of the Garter, originated in 1770 with a commission from William Markham (1719–1807), Dean of Christ Church, Oxford, for a bust for the Hall of the college. Markham was appointed Preceptor to the future George IV in 1771 and subsequently became Archbishop of York. The sculptor John Bacon began his career as a modeller in the service of the porcelain manufactories of Bow and

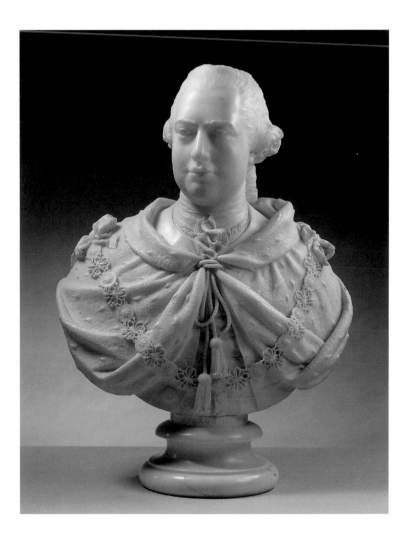

Wedgwood (Clifford 1985). He entered the Royal Academy Schools in the foundation year of 1768, was awarded its first gold medal for sculpture in 1769 and became an associate in 1770. During the sittings with the King, Bacon made use of a silver syringe in order to keep the clay moist while he worked, rather than squirting water from his mouth like the rather less inhibited Joseph Nollekens (Smith (J.T.) 1895, pp. 90–1).

The King's satisfaction with the Christ Church portrait was reflected in orders for repetitions of the bust for the University of Göttingen (1775), for the Society of Antiquaries (1780) and for the Prince of Wales (the present bust, dated 1775 on the inserted disc). George IV included no. 68 among those first placed in the Grand Corridor at Windsor Castle in 1828 (see no. 410). In 1837 a copy (RCIN 2034) was commissioned from Sir Francis Chantrey by William IV for his Temple of Military Fame at Kew (Harris, De Bellaigue & Millar 1968, p. 184). A version which is neither signed nor dated is in the collection of Eton College. Another was included in the Portrait Gallery of the Crystal Palace after its reopening at Sydenham in 1854 (Phillips (S.) 1854, p. 224, no. 492).

Marble. 64.1 cm high
RCIN 31610
PROVENANCE Commissioned by George III, as a gift for the Prince of Wales (later George IV)
LITERATURE Whinney 1964, p. 166; Gunnis 1968, p. 25
EXHIBITIONS QG 1974–5, no. 1

69–71
GIOVACCHINO BELLI (1756–1822) and
PIETRO BELLI (1780–1828)
Models of the Arches of Titus, Septimius Severus and Constantine, 1808–15

George IV never experienced what had become a standard component of the education of English gentlemen of his generation, the Grand Tour to Italy, of which the culmination was invariably Rome. Here, in the Forum, at that time an only partly excavated field known as the *Campo Vaccino*, the English *milordi* were shown the three partly ruined triumphal arches set up by the Emperors Titus (erected on the summit of the Velia overlooking the Forum in AD 81), Septimius Severus (erected in AD 203 in honour of the Emperor and his sons Caracalla and Geta) and Constantine (built to commemorate his victory over Maxentius in AD 312). Models of the arches in their semi-ruined condition (often effectively imitated in cork) were among the souvenirs with which the tourists returned to England. However, these marble models are reconstructions of the original form of the arches, complete with figurative sculpture. A cork model of the Arch of Titus made by Antonio Chichi in around 1787 (exhibited London 1996–7, no. 260) records its actual appearance, with only the central arch and part of one side surviving, the other side having been incorporated into the fortress of the Frangipani during the Middle Ages. It was restored by the architect Giuseppe Valadier in 1822.

These three models were made under the auspices of the Roman Academy of St Luke by the silversmiths Giovacchino Belli and his son Pietro. Pietro Santi Ammendola, who also signed all three arches, was a Roman merchant who probably financed the Bellis during their

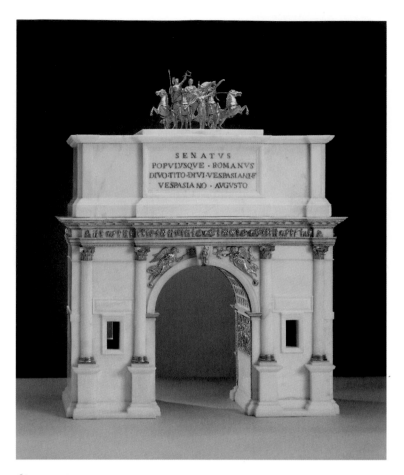

69

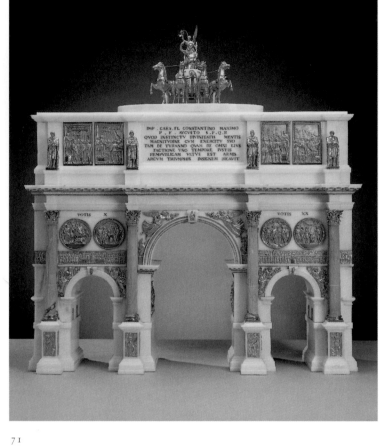

71

seven-year task. In a printed description of the arches published in 1815, the secretary of the Academy of St Luke, Giuseppe Antonio Guattani, praised the artists for their 'seraphic patience'. This publication, which is tantamount to a sale brochure, ends with a testimonial from the Perpetual Principal of the Academy, Antonio Canova, praising the 'genius, accuracy and infinite precision' of the models. This was not unjustified; more than a thousand individual gilt bronze plaques in various sizes were used to ornament the vaults of the Arch of Septimius Severus, which are largely invisible in normal circumstances.

In the course of his description, Guattani suggested that no ornaments more beautiful than these models could be found 'for the tables of the Great or the cabinets of Princes'. In view of the recent defeat and exile of Napoleon, to whom this comment might formerly have been directed, Ammendola brought the completed models to London where, according to Joseph Farington, they were offered to George IV for 3,000 guineas on 10 November 1816. The price was eventually reduced to 500 guineas, the sum recorded by Benjamin Jutsham in his Day Book for 8 November. The arches were placed on Boulle pedestals in the window reveals of the library at Carlton House, where they were noticed by Pyne as 'most ingenious specimens of sculpture in miniature'. Certain repairs to the metalwork were undertaken by Charles Brandt in January 1818 (PRO LC11/24), and later the same year B.L. Vulliamy replaced some of the ornaments, apparently in silver gilt, and made glass covers for the three arches (PRO LC11/25, 5 April and 5 July 1818). Following the demolition of Carlton House in 1826 the models were taken to Buckingham Palace; they were subsequently transferred to Windsor Castle, where they can be seen in Joseph Nash's watercolour of the Grand Corridor (no. 410).

Marble and gilt bronze. 49.5 × 48.7 × 21 cm (Titus: no. 69); 49.5 × 57 × 26.5 cm (Septimius Severus: no. 70); 45 × 55.5 × 22.5 cm (Constantine: no. 71)
All three arches are signed on an inset gilt bronze plaque (concealed in the case of the Arch of Septimius Severus) IOACH. ET PETR. BELLI. ROM. F.F. / PETR. SANCTES AMMENDOLA ROM. / I. ET. F. I. A.D. MDCCCXV., with insignificant variations
RCIN 43917 (Titus: no. 69); 43916 (Septimius Severus: no. 70); 43918 (Constantine: no. 71)
PROVENANCE Bought by George IV from P.S. Ammendola of Rome, November 1816 (500 gns; Jutsham II, p. 8)
LITERATURE Guattani 1815; Pyne 1819, III, Carlton House, p. 57; Farington Diary, XIV, p. 4921; Roberts (H.A.) 1990a
EXHIBITIONS QG 1990–1, nos 8–10

72
ANTONIO CANOVA (1757–1822)
Fountain Nymph (Ninfa delle fontane), 1815–17

For much of the last seven years of his life, Canova was preoccupied with orders which resulted from his visit to London in 1815. There he had been fêted not only as the greatest sculptor of the age, but for his official role in supervising the return from Paris to Rome of antiquities carried off by Napoleon (Watson 1957; see no. 28). During the visit Canova was received at Windsor Castle by Queen Charlotte and the royal princesses, and at Carlton House by the future George IV, who commissioned the colossal group of Mars and Venus (RCIN 2038) and presented the sculptor with a gold snuff box containing £500.

The Fountain Nymph, which Hugh Honour has aptly called 'a poetic expression of languorous voluptuousness' (exh. cat. London 1972b),

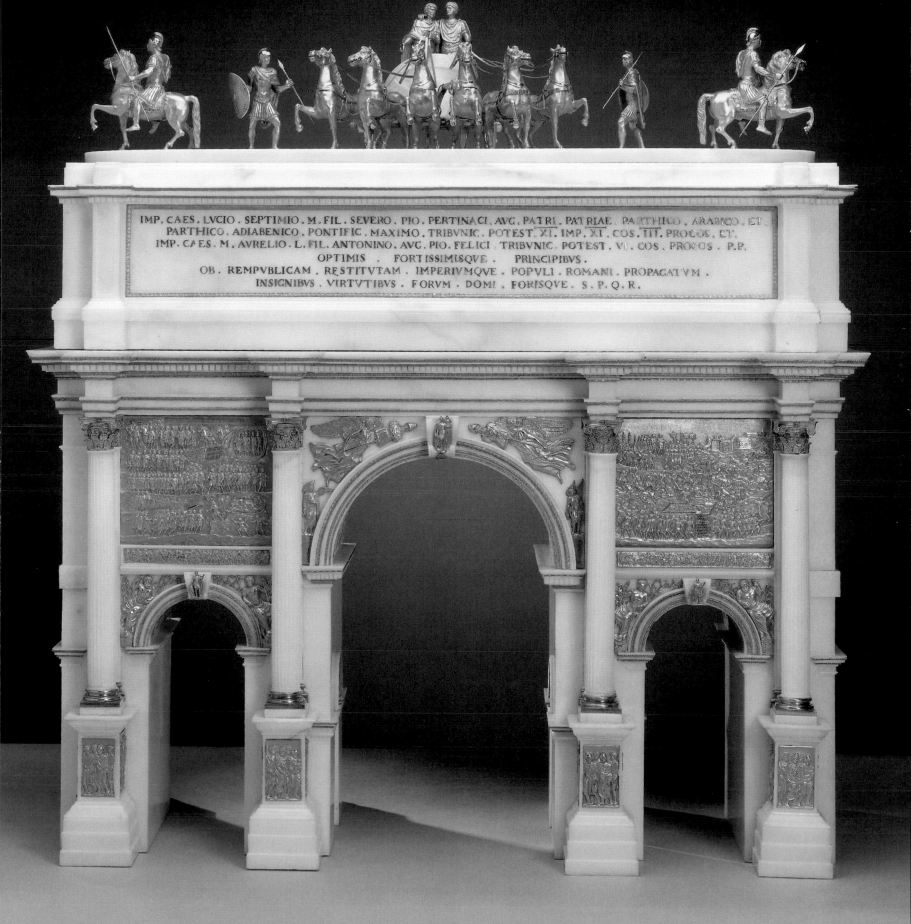

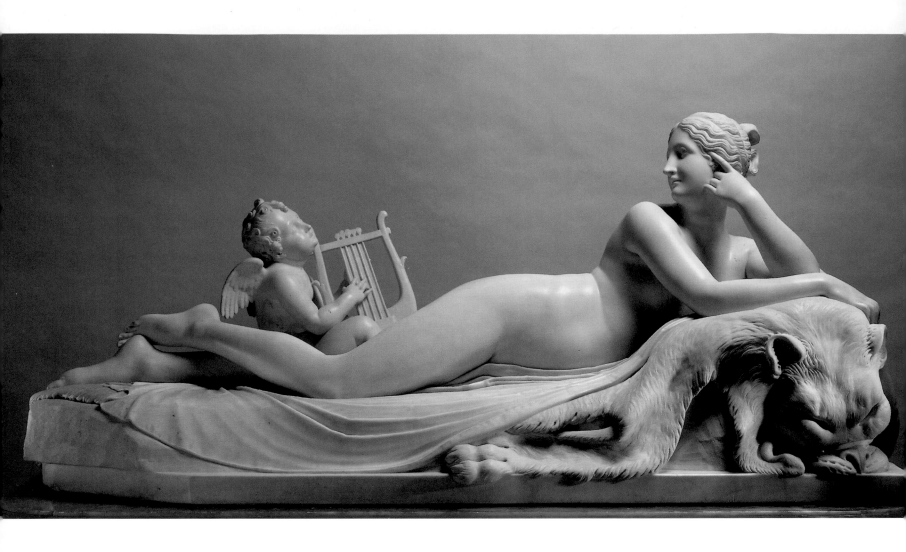

originated in a request made to Canova by John Campbell, first Baron Cawdor, as early as 1802 (Ingamells 1997, p. 176). Campbell, who had travelled extensively in Italy, was Canova's first yet least successful British patron; two of his commissions – including the *Cupid and Psyche* (Paris, Louvre) – were pre-empted by Napoleon's brother-in-law, Joachim Murat. In 1815, after the completion of a full-size model for the *Fountain Nymph* (it survives, with the small model, in the Gipsoteca Canoviana at Possagno), Canova agreed to the request of Sir Charles Long (later Lord Farnborough), George IV's artistic adviser, to carve the first marble for the Prince. A drawing was sent to London in June 1816, and in August Long conveyed the Prince's approval (Museo Civico Bassano, Manoscritti Canoviani II – 107/1607; this letter was kindly brought to our attention by Hugh Honour). By that time, work was already under way; when Lady Murray visited Canova's studio on 25 July she found him at work on the nymph, and rejoicing 'in the peculiarly fine quality and purity of the marble' (Murray (?)1836, II, p. 294). The group was completed in 1817 and shipped to Portsmouth on the vessel that carried the Duke of Bedford's version of Canova's *Three Graces*. Arriving at Carlton House on 12 June 1819 (Jutsham II, p. 78), it was installed in the unlikely setting of the Gothic Conservatory by the English sculptor Richard Westmacott, who subsequently received written instructions from Canova as to its placing and lighting. The plinth was to be 2 feet [60 cm] high, and capable of rotating so that the sculpture could be seen from all sides. It should be lit from above (letter dated 12 August 1819; London, National Art Library, MSL/1998/7/2). The

'large brass guard ornamented with spikes' that was erected to surround it may have proved necessary in the light of the *fêtes* regularly held at Carlton House, when it must have been the focus of much attention.

The subject, a naiad lying on a lion's pelt beside a spring, awakened by the sound of a lyre plucked by Cupid, is described in the *Dionysiaca* by the Greek poet Nonnus, but the composition is more likely to have occurred to Canova from the adaptation of antique models such as the Capitoline *Hermaphrodite*. A second version of the group (New York, Metropolitan Museum of Art), lacking the Cupid, was commissioned by Lord Darnley for Cobham Hall in Kent. The marble for that version was found to be faulty; it was completed by studio assistants in 1824, two years after Canova's death (Phillips (J.G.) 1970). There are several parallels with Canova's notorious *Venere vincitrice* of 1805–08, in which Pauline Borghese is portrayed as Venus (Rome, Villa Borghese). The musical Cupid assumed a career of its own in the nineteenth century through copies by Canova's assistant Leandro Biglioschi and by Bertel Thorwaldsen.

Marble. 81 × 182 × 81 cm

RCIN 2039

PROVENANCE Commissioned 1815 by John Campbell, first Baron Cawdor, who relinquished the commission to George IV; delivered to George IV, 1819

EXHIBITIONS London 1972b, no. 325

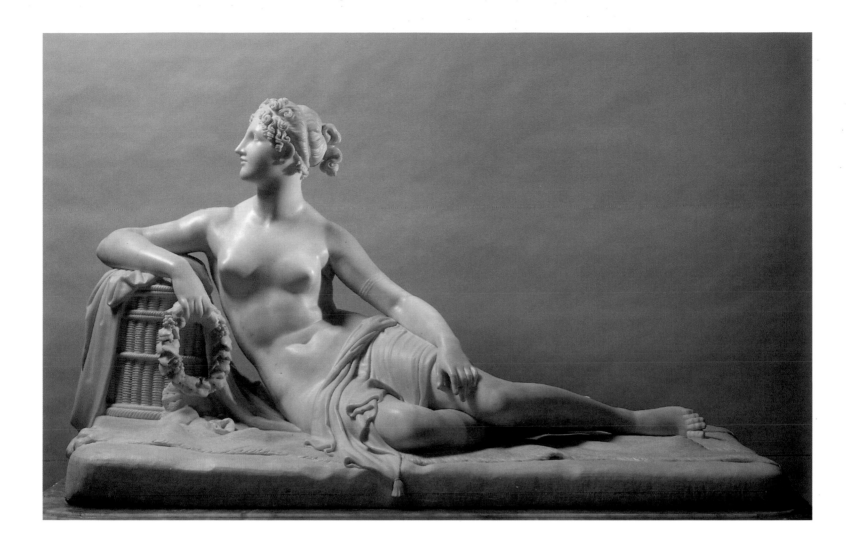

73
ANTONIO CANOVA (1757–1822)
Dirce, 1820–4

The presence of a second nymph by Canova in the Royal Collection testi-
fies to the sculptor's talent for promoting sales of his work to established
clients. Having commissioned the colossal group of *Mars and Venus* and
pre-empted Lord Cawdor in the purchase of the *Ninfa delle fontane* (no.
72), George IV remained anxious to secure a version of the *Three Graces*
for the centre of the Circular Room at Carlton House. In February 1820
Canova wrote to offer the present nymph – *Dirce, nutrice di Bacco* – which
he had just completed in plaster at full size, as a companion for no. 72,
which had been installed at Carlton House the previous June. The
subject, Dirce, was one of the nymphs of Mount Nysa who nurtured the
infant Bacchus. Sir Charles Long replied with enthusiasm on the King's
behalf and the marble seems to have been roughed out by 16 December.
Although the statue was engraved (with a dedication to Sir Thomas
Lawrence) in 1822, only the head seems to have been finished at the
time of Canova's death the same year; the rest was completed by the
studio assistant Cincinnato Baruzzi.

In a letter to the sculptor, Lawrence described the plaster model
(which he had seen in Rome) as 'the most perfect of your productions'.
However, the turn of the head creates such an awkwardness in the pose
of the figure as she leans weightlessly against a draped beehive that it
suffers by comparison with the true touchstone among Canova's

reclining nudes, the Borghese *Venere vincitrice*. The completed statue was
sent to England in 1824 with the *Mars and Venus*, and installed at
Carlton House by Westmacott. In August 1825 William Richard
Hamilton, the British Minister at Naples who had played a leading part
in the post-war negotiations over the return of looted ancient sculpture
to Rome, wrote to Sir Charles Long on behalf of the Abbate Canova, the
sculptor's brother and executor, accepting (without complete satisfac-
tion) the offer of 5,000 guineas in payment for the two groups delivered
in the previous year. Hamilton wrote that the Abbate was none the less
'highly flattered that these his brother's latest finished works, should be
deposited in the palace of the King of Great Britain, to whom he consid-
ers himself, as his brother did during his lifetime, so mainly indebted
for the halo of glory which shed fresh lustre over Canova's last days'
(Aspinall 1938, III, pp. 123–4).

Marble. 96 × 175 × 78 cm
RCIN 2042
PROVENANCE Commissioned by George IV, 1820 (delivered 1824; 5,000 gns, with
Mars and Venus)
EXHIBITIONS London 1972b, no. 329

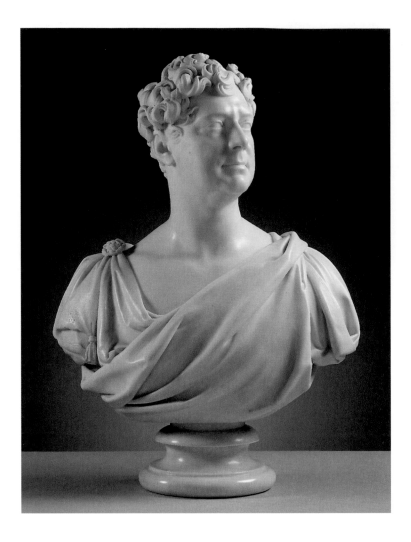

p. 158). One of these was presented to Lady Conyngham and remains in the possession of her descendants. The other was immediately sent for exhibition at the Royal Academy but is no longer in the Royal Collection (see *Chantrey Ledger*, no. 141b). The present bust was commissioned by the King in 1825 as a gift to his brother Frederick, Duke of York, but it was not ready until after the Duke's death in January 1827. It was given instead to his one-time secretary, Lieutenant-General Sir Herbert Taylor (1775–1839), who subsequently served William IV and Queen Victoria in the same capacity.

Marble. 69 cm high
Inscribed CHANTREY . SC . 1826 / THIS BUST INTENDED TO HAVE BEEN PRESENTED BY KING GEORGE / THE FOURTH TO HIS LATE BELOVED BROTHER THE DUKE OF / YORK WAS MOST GRACIOUSLY GIVEN BY HIS MAJESTY TO / SIR HERBERT TAYLOR ON THE 23D. OF APRIL 1827
RCIN 2136
PROVENANCE Commissioned by George IV, 1825 (£210; paid 1 February 1825); intended for his brother, Frederick, Duke of York (d. 1827), but given to Sir Herbert Taylor, 1827; presumably given by his widow to Queen Victoria; Royal Collection by 1914 at latest
LITERATURE *Chantrey Ledger*, nos 141b and 162a
EXHIBITIONS QG 1991–2, no. 1

74
SIR FRANCIS CHANTREY (1781–1841)
George IV, 1826

This famous image originated in 1821, the year of the coronation of George IV (1762–1830); with Sir Thomas Lawrence's full-length portraits in oils it established the King's 'official' likeness throughout his ten-year reign. It epitomises Chantrey's ability to idealise without losing a resemblance. The King appears both lofty and amiable, cloaked as an ancient field-marshal but wearing one of his own curled brown wigs. In Chantrey's opinion the King 'had a very fine throat without the great dewlaps which he gives himself by tying up his neckcloth so tightly' (Broughton 1909, II, p. 177 for 4 January 1822).

Fifteen other marble versions of the bust are known, of which two are also in the Royal Collection (RCIN 31617, dated 1828; and RCIN 2010, dated 1837); the first of these is probably the one shown in Nash's view of the Grand Corridor (no. 410). Miniature replicas were made in bronze and silver-gilt by Rundell, Bridge & Rundell. The medallist Alfred Stothard copied it for his standard profile relief of the King. Engravings of the bust were published by S.W. Reynolds in 1823, and Chantrey was portrayed in the act of carving it in Andrew Robertson's miniature dated 1831 (Walker 1992, no. 903). The plaster model is in the Ashmolean Museum, Oxford (Penny 1992, III, no. 709). Chantrey's ledger records an order for two marble busts from the King, both of which were received at Carlton House in April 1822 (Jutsham II,

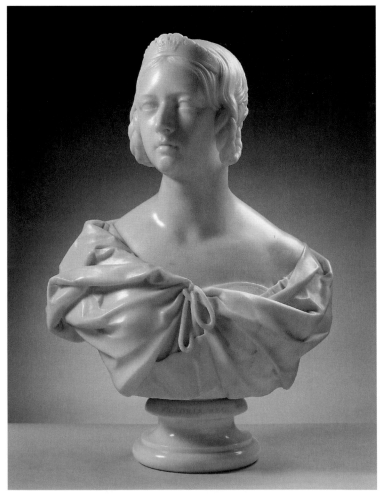

75

75
SIR FRANCIS CHANTREY (1781–1841)
Queen Victoria, 1839

It was Chantrey's distinction to portray four successive sovereigns during their lifetimes. Queen Victoria declared her intention of sitting to him on 14 October 1838 (QVJ) when she was still only 19. The commission, delivered via the Marquess Conyngham, is recorded in the sculptor's ledger for 1838. Despite his great experience the sculptor was daunted by the Queen's tender age and the need to give the portrait a proper sense of majesty. There were seven sittings in all, concluding on 1 February 1840 when Chantrey made the finishing touches to the marble. Two of his initial pencil studies of the Queen are in the National Portrait Gallery (Ormond 1973, II, pls 943–4) and the plaster model is in the Ashmolean Museum, Oxford (Penny 1992, III, no. 774). The resulting bust, probably the last that Chantrey touched with his own chisel, became widely known through reproduction on coins and medals, and in a miniature bronze version published by the Art Union in 1848. It is shown in the Grand Corridor in 1846 (no. 410).

Further versions were ordered by Queen Victoria for her father-in-law (now in the Fürstenbau in the Veste Coburg) and for Sir Robert Peel (now London, National Portrait Gallery; Ormond 1973, II, pls 945–6).

Marble. 58.4 cm high
Inscribed SIR F. CHANTREY, SCULPTOR, 1839
RCIN 31618
PROVENANCE Commissioned by Queen Victoria, 1838 (£210)
LITERATURE *Chantrey Ledger*, no. 294a
EXHIBITIONS London 1840, no. 1070; QG 1983–4, no. 97

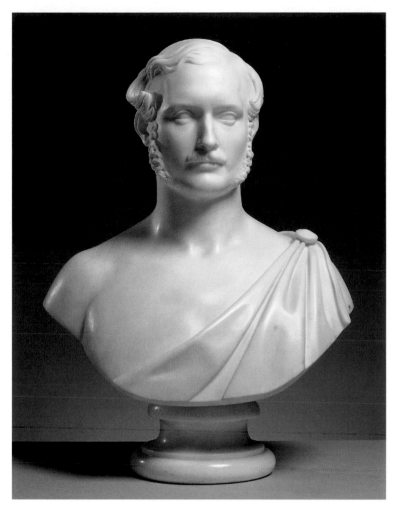

76

76
CARLO, BARON MAROCHETTI (1805–1867)
Prince Albert, 1849

This was the first of fifteen works acquired or commissioned from the Piedmontese sculptor Carlo Marochetti by Queen Victoria and Prince Albert (1819–61). Marochetti – who inherited his title in the nobility of Sardinia from his father – had studied in Paris and Rome before settling in England in 1848, at the same time as his former patron, the recently deposed French King Louis-Philippe. It was largely due to the close links between the French and English royal families that Marochetti soon became the favourite sculptor of the Queen and Prince Albert (see Ward-Jackson 1993). Their friendship is clearly evident in correspondence, and after the Prince Consort's sudden death in 1861 it was Marochetti who was asked to carve his marble effigy – and that of the Queen (added to the monument after her death forty years later) – for the Royal Mausoleum at Frogmore. The Baron's privileged position created resentment among British-born sculptors, especially when in 1856 he received the valuable commission for a monument at Scutari to the fallen of the Crimea without a preliminary competition (see Physick 1970, pp. 25–9).

Sittings for the present bust began in July 1848. The Queen found the likeness 'extremely successful' and the artist 'very agreeable, pleasant and gentlemanlike' (QVJ, 1 July 1848). Completed in marble the following year, it was subsequently reproduced in miniature, both in bronze and in Minton's Parian ware. After the Prince's death the bust took his place in Sir Joseph Noel Paton's group portrait of the royal family, *In Memoriam* (1863; Millar (O.) 1992, no. 542). The same substitution was made in photographs, although it was more often William Theed's bust of 1862 (RCIN 13100) that was used. Comparing the two busts, the Prince's eldest daughter Victoria, Crown Princess of Prussia, considered Marochetti's 'a better work of art' than Theed's, which was none the less in her opinion 'much more like' her father (letter to Queen Victoria, 24 March 1863; see Fulford 1968, p. 185).

Marble. 74.5 cm high
Inscribed C. *Marochetti* 1849
RCIN 31628
PROVENANCE Commissioned by Prince Albert, 1848 (£120); by whom presented to Queen Victoria
EXHIBITIONS London 1851a; London 1851b, no. 1253; QG 1983–4, no. 105

ENGLISH FURNITURE (nos 77–94)

The English furniture in the Royal Collection runs to many thousands of pieces spread among more than a dozen residences. Nearly all of it was commissioned or acquired for a specific purpose or function and for a particular context. It is not therefore in the modern sense of the word a collection, but a large and very varied assemblage which owes its unique identity to the simple fact of royal patronage.

Over the past four hundred years – roughly the span of the English furniture now in the collection – royal residences have been acquired and disposed of, extended, destroyed and rebuilt in an unceasing cycle. As a direct consequence of these changes, the court official responsible for furnishing the royal residences, the Master of the Great Wardrobe (who was succeeded in this role by the Lord Chamberlain in 1782), was under almost continuous instruction to supply new furniture or dispose of worn-out or old and unfashionable pieces. These activities, which are charted in detail in the extensive bill books and accounts of the Great Wardrobe and of the Lord Chamberlain's Office, stretch from the sixteenth to the nineteenth centuries and cover almost every aspect of court life, from the supply of the grandest parade furniture for state rooms to that of the most ordinary domestic equipment such as bell-pulls and hearth brushes.

Well-documented campaigns of refurnishing – such as those at Hampton Court and Kensington Palaces in the late seventeenth century; at Buckingham House, Brighton Pavilion and Carlton House in the eighteenth and early nineteenth centuries; and at Windsor and Balmoral Castles later in the nineteenth century – are not unlike those undertaken periodically by owners of great estates elsewhere in this country. What distinguishes these royal commissions is the much greater frequency and larger scale of operations and the continuity of ownership embodied in the institution of monarchy. For the most part, this continuity has ensured that even through periods of great social and political change, the principal furnishings of the surviving residences have been kept together.

The roll-call of cabinet-makers, clock-makers, tapestry-makers, upholsterers and other suppliers both to the Great Wardrobe and to individual members of the royal family (the latter usually funded by the sovereign's Privy Purse), includes many familiar and unfamiliar names. Some, such as the Huguenot Pelletier family (nos 79, 80), the mysterious John Carrack with his immigrant connections (no. 84) and the Frenchman Nicholas Morel (nos 90–2) – were responsible for introducing the latest continental fashions to their royal patrons. Others, such as James Moore (nos 81, 82), Benjamin Goodison, William Vile, John Cobb and John Bradburn, provided outstandingly well-made objects and a comprehensive furnishing service without generally stepping very far outside the conservative norms of the period. Occasionally a specific royal interest in a particular area, such as that shown by William III and George III in barometers and clocks (nos 77, 83, 87), brought innovation in design, materials or technology to the collection. Equally, important family events occasionally generated the need for something well out of the ordinary: Queen Charlotte's spectacular ivory-inlaid jewel-cabinet, made by Vile & Cobb at George III's order in 1762 (RCIN 35487), was a significant exception to the general rule of brown furniture. Leaving aside George IV's collecting activities, which began when he came of age in 1783, the vast majority of English furniture made for the court was of relatively utilitarian and functional character. This probably accounts for the fact that of the various categories of English furniture now in the collection, chairs and tables vastly outnumber any other.

George III, whose reign (1760–1820) coincided neatly with the period that is generally regarded as the golden age of English furniture-making, particularly disliked grandiose display, always preferring elegance, practicality and simplicity to ostentation. His son George IV, whose principal interest lay in French furniture, adopted an entirely different approach. For him the emphasis was invariably on high fashion, rich style and constant change; and the English furniture at Carlton House and Brighton Pavilion was required to blend with its setting, whether French-inspired neo-classical, Chinese or Gothic. To achieve this he relied principally on two large firms – Tatham, Bailey & Sanders (no. 89) for the first two decades of the nineteenth century, and Morel & Seddon (nos 90–2) in the 1820s. Both were well equipped to deal with this most demanding of patrons.

From early days at Carlton House in the 1780s, George IV had happily mixed contemporary French and English neo-classical furniture in the principal rooms. In the early nineteenth century, influenced to some degree by the new spirit of antiquarianism in

the world of discriminating connoisseurs to which he belonged, he not only acquired (or singled out from the existing stock) good pieces of mid-eighteenth-century English furniture, but he began to think of displaying old and new together in a far more radically eclectic mix. Thus in the mid-1820s we see the King selecting from stores of old furniture at Windsor Castle, Hampton Court Palace, Kensington Palace and elsewhere some of the more interesting early eighteenth-century English pieces (for instance, no. 80) to mingle with his French furniture and with the fashionable new pieces ordered from Morel & Seddon for his rebuilt apartments at Windsor (including nos 90–2).

By contrast Queen Victoria and Prince Albert seem to have preferred the unadorned and functional style when ordering new furniture, especially for their private residences. For Osborne House on the Isle of Wight, Holland & Sons, the fashionable Mount Street decorators and furnishers, supplied large quantities of unpretentious mahogany pieces, much of it reminiscent of the *Biedermeier* style of Prince Albert's homeland (see no. 437). For Balmoral Castle in Aberdeenshire the effect was equally plain and simple, although here Holland used pale maple, birch and oak (see no. 431). Occasionally, as in previous reigns, an important event was commemorated by an exceptional commission: the 1851 jewel-cabinet (no. 93) demonstrates this point.

In the older residences – Windsor Castle and Buckingham Palace – the eclectic approach to acquisition and arrangement of furniture, initiated by George IV, continued through the nineteenth century. Queen Mary (consort of King George V), the first member of the royal family to take a specific and informed interest in English furniture, devoted much energy in the period 1910–30 to sorting out what she considered the muddle of previous generations, especially in the arrangement and use of the eighteenth- and early nineteenth-century furniture that she particularly admired. As a collector in the modern sense, with many collector friends, Queen Mary was well attuned to the art market and made some notable additions to the collection. These included Queen Charlotte's jewel-cabinet (RCIN 35487) and a magnificent mahogany bookcase made by Vile & Cobb (RCIN 252), both of which had descended in her mother's family from George III's seventh son Adolphus, Duke of Cambridge. Recognising the unique importance of the English furniture, Queen Mary was also greatly occupied in identifying and recording provenances, thereby in many cases laying the foundations for modern research on the furniture collection.

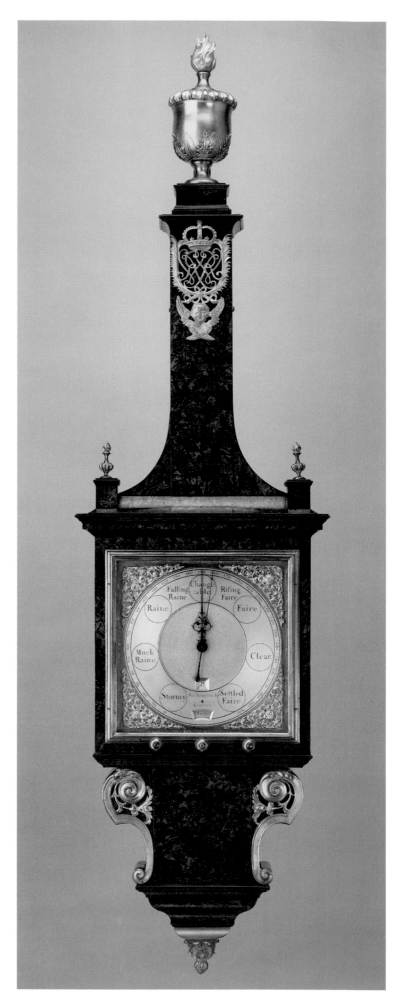

77

THOMAS TOMPION (1639–1713)
Siphon wheel barometer, c.1700

The siphon wheel barometer, registering changes in atmospheric pressure on a clearly marked clock-like dial, was the invention of the eminent English scientist Robert Hooke (1635–1703). The first examples were made in about 1665 and over the next thirteen years Hooke devised improvements in discussion with two distinguished fellow members of the newly founded Royal Society, his former teacher the physicist Robert Boyle (1627–91), and the celebrated architect and mathematician Sir Christopher Wren (1632–1723). The craftsman chosen to turn these experiments into physical reality was the foremost clock-maker of the age, Thomas Tompion, whom Hooke visited twice in 1676 and again, with Boyle, in 1678. Further refinements had no doubt been made by the time that the order for no. 77 was placed. This is likely to have coincided with the completion of William III's new apartments at Hampton Court Palace in 1699–1700. No. 77 was probably the barometer 'in the form of a clock ... made by Tomson [sic]' seen by a visitor to the Palace in 1710 and is likely always to have remained at Hampton Court (QG 1988–9, no. 91). Since the restoration of the King's Apartments after the fire of 1986 it has been on view in William III's Closet.

There are two other barometers by Tompion in the Royal Collection, also made for William III around 1700. Both cases are of walnut. One (RCIN 1377) had a wheel mechanism (now changed) and an exceptionally large circular dial; the other (RCIN 1078) has a straight siphon mechanism in a Doric pillar case. All three barometers have a similar architectural personality and incorporate some of the same gilt bronze mounts (the flaming urn, cypher of the King and scrolling brackets). The most individual feature of no. 77 is the opulent and distinctive veneer. Often wrongly described as mulberry, it is almost certainly stained burr maple, treated by the method recommended by J. Stalker and G. Parker in their manual *A Treatise of Japanning and Varnishing*, published in 1688. This process involved the application of aqua-fortis (nitric acid) and heat to produce the rich yellow colour, followed by lamp black to heighten the grain. (Information kindly communicated by Adam Bowett.)

Oak, pine, burr maple, kingwood, gilt bronze, brass. 110 × 29.5 × 11.4 cm
Engraved on dial *Tho: Tompion fe Londini*
RCIN 1233
PROVENANCE Made for William III, *c.*1700
LITERATURE Symonds 1951, pp. 248–9 and 295–6; Goodison 1968, pp. 232–5
EXHIBITIONS QG 1988–9, no. 91

78

Attributed to ANDREW MOORE (1640–1706)
Silver table and mirror, 1699

This magnificent table and mirror are exceptionally rare examples of High Baroque silver furniture. Such pieces were among the ultimate symbols of power and wealth in the late seventeenth century: Louis XIV famously spent vast amounts on solid silver furnishings for the palace of Versailles in the 1660s. However, almost all such pieces were

78 (mirror)

subsequently melted (Louis XIV's as early as 1689, to pay for his wars). In England the only comparable pieces are another table and mirror (with stands) bearing the cypher of Charles II (RCIN 35298–300) and a set at Knole, supplied by Gerrit Jensen (d. 1715) to the sixth Earl of Dorset.

Until recently it was thought that no. 78 had been presented to William III by the Corporation of London. In fact the Jewel House records reveal that the pieces were part of an important commission for new silver furnishings (refashioned from an earlier set) for Kensington Palace. These were ordered by William III in 1698 and were delivered the following year.

A warrant dated 25 July 1698 addressed to Charles Godfrey, Master of the Jewel House, specified that he 'give order for making the Silver

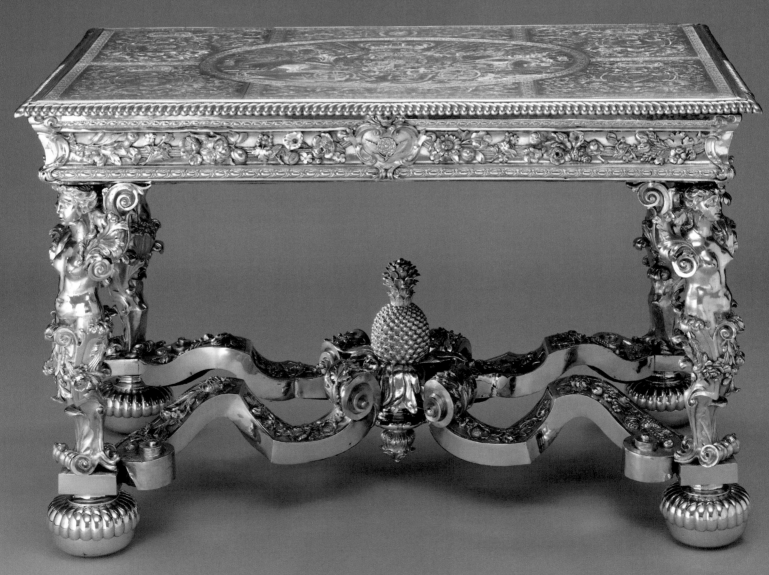

Table Stands and Frame of Glass in the Drawing room att Kensington of a newer fashion and that the frame of the Glass be made fit to contain a larger glass'. A further warrant of 19 August added that he 'give order for the making the silver Branch in the Privy Chamber and the andirons [fire-dogs] in the Bedchamber att Kensington of a new fashion and very strong'. The old suite was not delivered to the goldsmiths to be 'new made' until the following July (PRO LC9/44). This huge commission, one of the most important of the seventeenth century, came to a total cost of nearly £3,660. The finished pieces were much heavier than those they replaced and were delivered throughout October and November 1699. The 'large Enchased & Engraved table' (£1,016 7s.) arrived on 3 October and the 'large Looking glass Frame curiously wrought and enriched' (£1,024 4s.) on 23 November. They were complemented by a pair of stands 'curiously Enchased and Engraved on the tops' (£678 18s. 6d.), a 'pair of large andirons' (£372 18s.) and 'large branch [chandelier]' (£567 10s. 6d.). The table and mirror appear to be the only survivors of this impressive suite. By 1721 they had been moved from Kensington Palace to Windsor Castle, where they were listed in the Jewel House inventory together with two other silver tables, mirrors and stands. One of these latter sets also survives in the Royal Collection (RCIN 35298–300); of the third set only the mirror survives.

The table top is splendidly engraved with the arms and motto of William III, surrounded by the emblems of the four kingdoms. It is signed by the unidentified engraver R. H. The table itself bears the maker's mark attributed to Andrew Moore (free 1664, i.e. granted his membership – known as freedom – of the Goldsmiths' Company after serving an apprenticeship), as used after 1697 when the new Britannia standard of silver was introduced. Moore worked as a silver chaser in the Bridewell district of London and several other pieces of silver furniture and andirons have been attributed to him. The mirror is identically marked by Moore. In 1699 Gerrit Jensen, Cabinet Maker in Ordinary to the King, submitted a bill for £100 'For a Looking glass Plate 52 Inches and for the Silver frame' in the King's Drawing Room at Kensington. Whilst this undoubtedly refers to no. 78, the price suggests that Jensen supplied the mirrored glass only.

In February 1805 'the novel and grand appearance' of the silver furnishings at Windsor Castle, 'repaired and beautified' for 'Their Majesties Fête', was noted (*Gentleman's Magazine*, 25 February 1805, pp. 262–3). This magnificent arrangement, which included four tables and mirrors, stands, chandeliers and andirons, is recorded in a view of the Queen's Ballroom at Windsor in 1817 (see no. 402). In 1902 the mirror (no. 78) was 'discovered' in a lumber room at Windsor Castle where it had been languishing for much of the nineteenth century. It was subsequently restored and redisplayed, with the table, in the Queen's Ballroom.

Silver; table 85 × 122 × 75.5 cm; mirror 227.3 × 120.6 cm
Struck with maker's mark attributed to Andrew Moore; the engraved top signed R. H. *Scup*.
RCIN 35301 (table), 35302 (mirror)
PROVENANCE Part of a suite of silver furnishings commissioned by William III for Kensington Palace in 1698 (PRO LC5/109, f. 279) and delivered in 1699 (PRO LC9/46, 3 October and 23 November); mirror glass supplied by Gerrit Jensen, 1699 (£100; PRO LC9/280, no. 55)
LITERATURE Laking 1905, pp. 29–30; Hussey 1930, p. 752; Oman 1934, pp. 300–03; Oman 1978, p. 64; Mitchell 1999, pp. 168–77; Deelder 1999, pp. 178–84
EXHIBITIONS London 1934, no. 1602 (table); London 1957 (table); QG 1962–3, nos 29–30; QG 1977–8; New York 1988, no. 85

79
JEAN PELLETIER (fl.1680–1704)
Pair of candle-stands, c.1701

The Pelletier family of carvers and gilders left France in the early 1680s, probably to escape persecution as Huguenots, and settled in Amsterdam. By 1682 Jean Pelletier was established in London and by the end of the decade his two sons René and Thomas (see no. 80), both active until 1712, had joined him. Their introduction to royal service was due to the patronage of the francophile Duke of Montagu, the courtier responsible, as Master of the Great Wardrobe, for the furnishing of all royal palaces. Montagu held office from 1671 to 1685 and from 1689 to 1709.

For tables, mirrors and stands – the principal furniture types in which they specialised – the Pelletiers drew heavily on the designs of French contemporaries employed by Louis XIV; the engraved furniture of Jean Le Pautre (1618–82) and his son Pierre (1660–1744), for example, finds numerous echoes in the Pelletiers' work for the English Crown. On the technical side, the Pelletiers introduced many subtleties and refinements to the preparation, cutting, gilding and burnishing of carved surfaces. In the rare cases where gilded surfaces survive

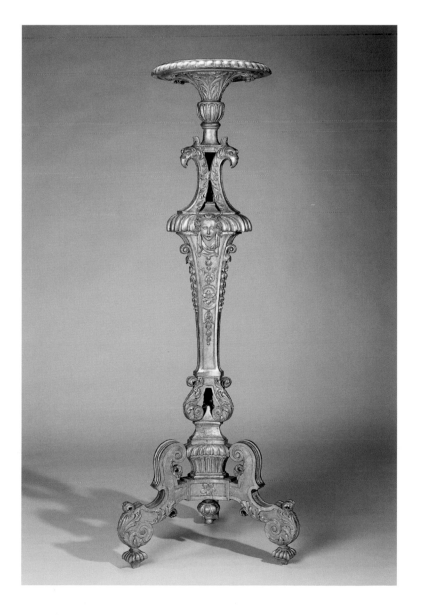

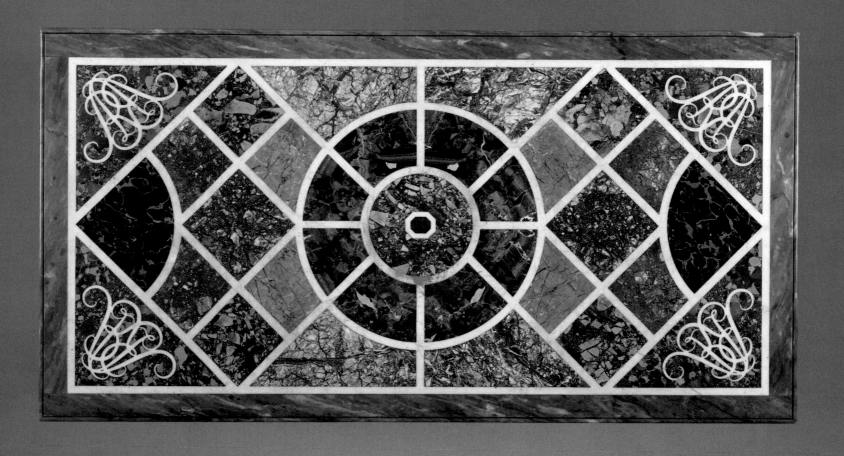

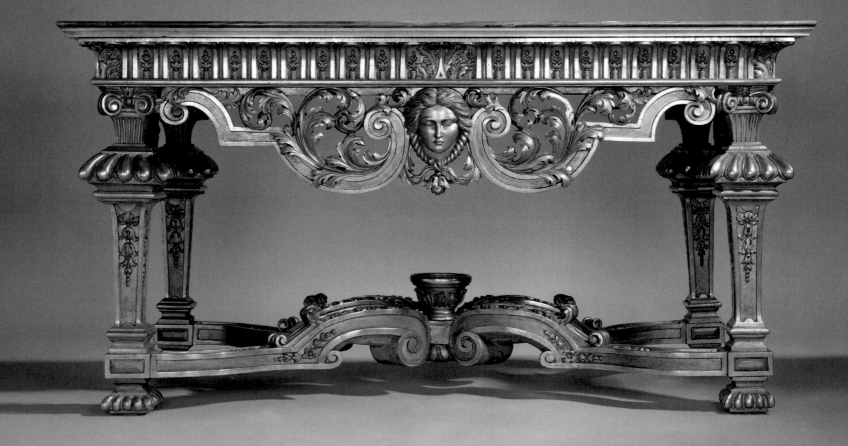

unscathed, such innovations suggest an attempt to simulate the decorative effect of gilded metal.

These candle-stands, two from a set of four, form part of the important commission to furnish William III's State Apartments at Hampton Court Palace which Montagu obtained for Jean Pelletier. Between 1699 and 1702 furniture costing nearly £600 was delivered. Towards the end of the commission, Pelletier supplied a pair of gilded table frames costing £35 each and two pairs of stands costing £35 per pair for the 'New Gallery' (i.e. the Queen's Gallery) at Hampton Court, left unfinished at the time of Queen Mary's sudden death in 1694. The tables and stands are shown by Pyne, still in situ over a century later (no. 434). The tables were taken to Windsor Castle by George IV in the late 1820s and are now at Buckingham Palace (RCIN 21597). The stands (no. 79), which were also taken to Windsor, were moved to Hampton Court after the fire of 1986 and are now displayed in the King's Apartments, together with five pairs of Pelletier candle-stands of slightly simpler design costing £30 per pair and dating from c.1699.

Gilded lime and oak. 164.8 × 60.5 cm
RCIN 57029.1–2
PROVENANCE Made for William III, c.1701 (RA Wardrobe Bills, Michaelmas 1701 – Michaelmas 1702, 80641ᵛ)
LITERATURE Murdoch 1997, pp. 736–7 and 742

80

Attributed to THOMAS PELLETIER (fl.1690–1712)
Pier table, c.1704

Thomas Pelletier, son of Jean and younger brother of René (d. 1726), was appointed Cabinet Maker in Ordinary to Queen Anne in 1704. In spite of this royal appointment, and Jean Pelletier's royal commissions (including no. 79), very little furniture by any member of the Pelletier family has until now been satisfactorily identified. Recently a number of pieces linked by style and documentary evidence, mostly still in the Royal Collection, have been grouped together (Murdoch 1997, 1998), and a picture has begun to emerge of the Pelletiers' work for the Crown in the first decade of the eighteenth century.

Thomas Pelletier's apparent anonymity may be due in part to his having worked as a sub-contractor (with his brother René) for the older royal cabinet-maker, Gerrit Jensen. For example, a pair of highly sophisticated gilt stands for Japanese cabinets, which seem certain to have been carved by the Pelletiers, were probably supplied by Jensen to Queen Anne for Kensington Palace in c.1704 (RCIN 35485). Several other pieces bearing Queen Anne's monogram are likely to have been supplied in the same manner, including no. 80. Although it has not been possible to identify a specific order for this table, the fine specimen marble top inlaid with Queen Anne's monogram at the four corners could be related to the 'Marble inlayd Table upon a Carved guilded frame' supplied for Queen Anne at Kensington by the sculptor John Nost in 1704 and valued at £80 (King's Works, V, p. 194).

No. 80 was removed by George IV from Kensington Palace – either from the King's Gallery or from the Queen's Drawing Room (see nos 435–6) – to help furnish the newly created Private Apartments at Windsor Castle in the late 1820s. After the stripping of the original surface (confirmed during recent conservation), complete regessoing

and somewhat metallic regilding by Morel & Seddon (Roberts (H.A.) 2001, p. 255), it joined a group of early eighteenth-century giltwood taken from Kensington and Hampton Court Palaces as part of the highly eclectic furnishing of the Grand Corridor (see no. 410).

Gilded pine and beech (?). 82.5 × 154 × 80 cm
RCIN 600
PROVENANCE Made for Queen Anne, c.1705
LITERATURE Murdoch 1998, pp. 366–7

81

JAMES MOORE (c.1670–1726)
Pier table, c.1715

James Moore supplied furniture to the Royal Household during the reign of Queen Anne (1702–14), but it was only with the retirement from active business of Thomas and René Pelletier in 1712 (no. 80) and the death of the royal cabinet-maker Gerrit Jensen in 1715 that he became the official supplier to the Crown. Perhaps in anticipation of this event, Moore had become a partner of the looking-glass manufacturer John Gumley (fl.1691–1727) in 1714, and from about this date both names appear in the Great Wardrobe accounts.

Moore specialised in carved and gilded furniture, much of it of relatively simple and four-square outline. His finest and most original work involved the use of large areas of gesso (a compound of whiting, linseed oil and glue), usually applied to flat surfaces such as table tops and then cut into very fine patterns. With the advent of the Hanoverian dynasty, Moore frequently used royal and national emblems for royal commissions – in this case the crowned monogram of George I encircled by the Garter motto. Unusually for an English maker, Moore often signed his work as well (see no. 82). His table tops in particular, which usually incorporate a geometric framework of interlaced C-scrolls, highly burnished and set off against a punched ground, suggest comparison with contemporary silver chasing and in their precision and jewel-like surface treatment they reflect the technical innovations brought to this country by the Pelletier family.

In 1715, at the start of George I's reign, new furniture costing over £1,000 was ordered from Gumley and Moore for Hampton Court Palace, principally for the apartment occupied by the Prince and Princess of Wales. These orders included seven giltwood suites consisting of pier glass, table and candle-stands, ranging in price from £70 10s. to £206. While the descriptions of these suites in the Great Wardrobe bills are too brief to allow certain identification, it may be that no. 81 (which is one of a pair of tables in the Royal Collection) and no. 82 (of which only two stands survive in the Royal Collection) can be linked to one of the two suites supplied for the Prince of Wales's Drawing Room and Bedchamber. These were priced at £206 and £199 respectively, the difference being accounted for by the larger dimensions of the Drawing Room pier glass (11 ft 10½ in. by 4 ft 9½ in. compared to 10 ft 7 in. by 4 ft 6 in.). In both cases, the table and stands were priced together at £50.

Gilded and gessoed oak, pine and lime. 86 × 150.5 × 59 cm
RCIN 597.2
PROVENANCE Made for George I, c.1715 (RA Wardrobe Bills 81174ᵛ and 81175, authorised 15 September 1715)

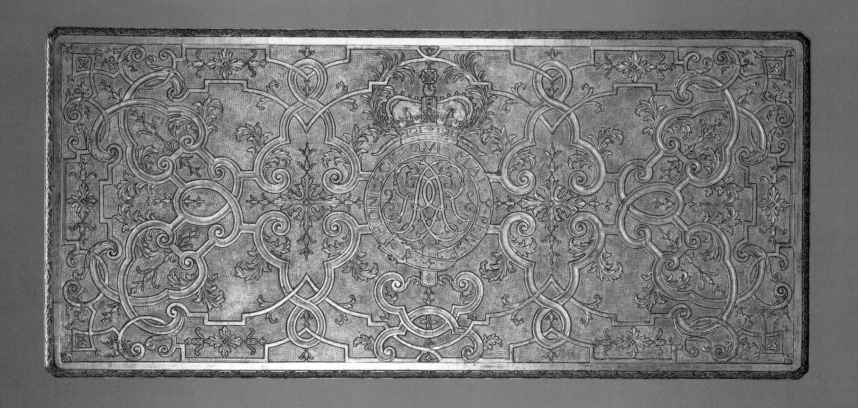

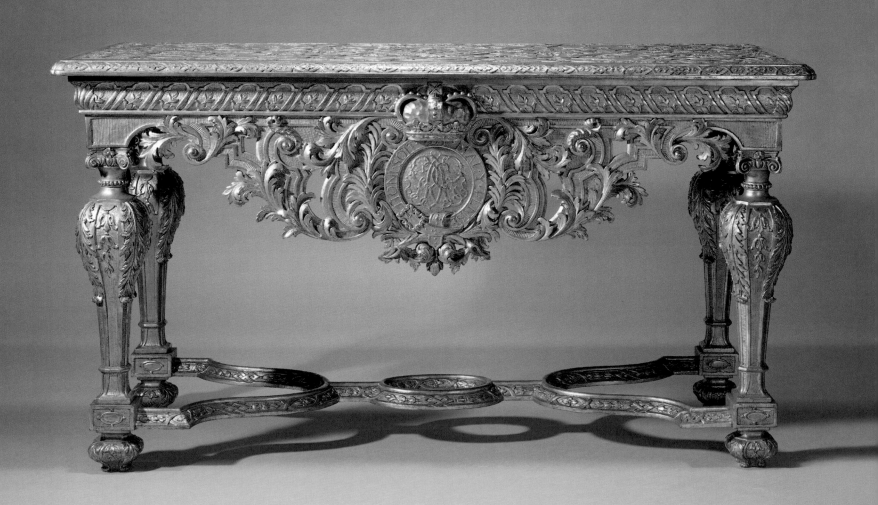

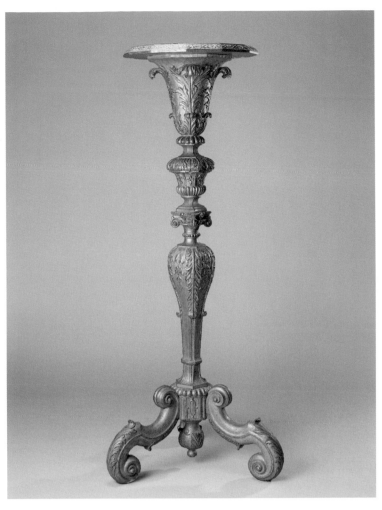

82

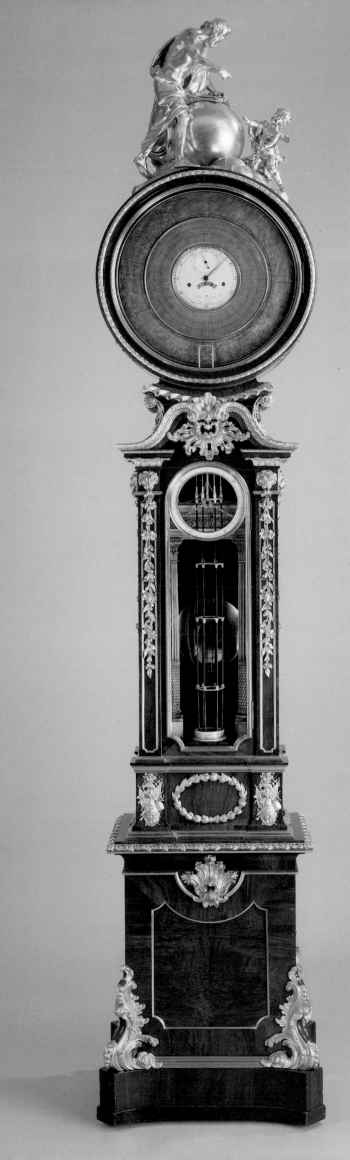

82

JAMES MOORE (c.1670–1726)
Pair of candle-stands, c.1715

Stands of this form were usually placed either side of a pier table to allow lighted candles to reflect in the pier glass that would normally have hung on the wall behind. This convention was established in France in the 1670s as the most appropriate way of articulating the window walls in a Baroque interior, as well as providing lighting at a high level. From the time of William III's rebuilding of Hampton Court Palace in the 1690s until well into the second decade of the eighteenth century, this was the furnishing pattern adopted for all the principal rooms in the new royal apartments.

No. 82, which are *en suite* with the pier table (no. 81), may have been supplied as part of the refurnishing of the apartment of the Prince of Wales (the future George II) at Hampton Court by Gumley and Moore. The stands (although not the table) are signed by Moore on the tops above the crowned monogram of George I.

Gilded and gessoed oak, pine and lime. 143 × 59 cm
Inscribed on each top MOORE
RCIN 1087.1–2
PROVENANCE Made for George I, c.1715
LITERATURE Edwards & Jourdain 1955, pp. 143–5; Gilbert 1996, figs 657–8

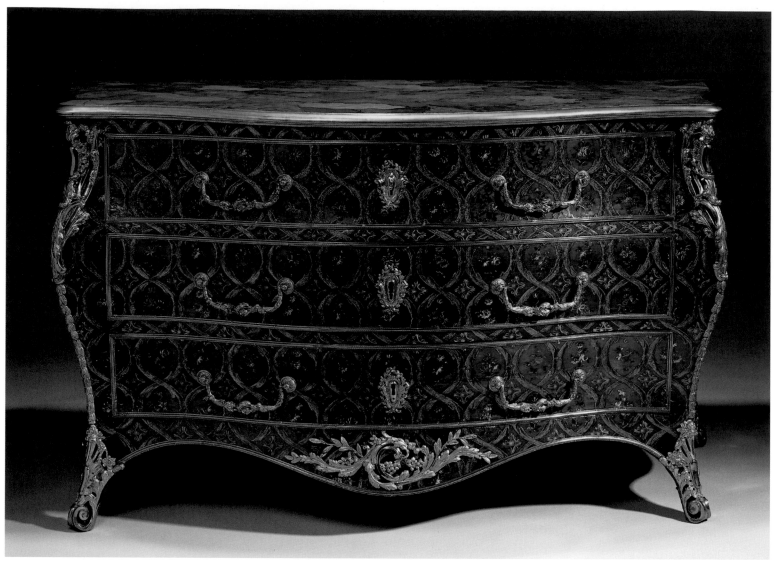

84

83

ALEXANDER CUMMING (c.1732–1814)
Barograph, 1763–5

The Edinburgh-born clock-maker Alexander Cumming, a founder member of the Scottish Royal Society, had established himself sufficiently well in the London clock-making world by 1763 to be appointed one of the expert examiners of John Harrison's longitude watch known as H4. In the same year Cumming was also at work on no. 83 for George III, which was completed in 1765 for the substantial sum of £1,178. This commission may have come about through his fellow Scot, the King's intimate friend and adviser the Earl of Bute, for whom Cumming provided a similar but rather plainer mahogany barograph (Bute collection). The King rewarded Cumming with a generous retainer – in effect a pension – of £150 per annum to maintain no. 83. This benefaction enabled him to publish in 1766 The Elements of Clock and Watch-work, adapted to Practice, which he dedicated to George III.

The elaborate mechanism of no. 83, which reflects the King's profoundly practical interest in horology, consists of a month-going regulator clock with Cumming's own escapement and an Ellicott compensating pendulum. Surrounding the clock dial are two concentric removable parchment disc charts of six and twelve months' duration recording changes in barometric pressure. A siphon wheel barometer, incorporated into the glazed trunk door below and connected mechanically to the charts, is supported by a pair of Corinthian columns and an entablature of carved ivory.

The outstanding quality of the case, especially of the mounts, points to the involvement of a leading London cabinet-maker with access to highly sophisticated bronze-making techniques – for the flower-drops and military trophies, for instance – as well as to larger-scale casting in the round for the sculptural group above the dial. This group appears to show Time (though lacking most of his usual attributes) assisted by Cupid recording barometric changes on a globe. Although the identity of Cumming's cabinet-maker remains obscure, the unusual pierced angle-scrolls at the base and the pierced shell motif below the dial strongly recall the mounts on a commode of about the same date (RCIN 39228) which has been attributed to George III's cabinet-makers William Vile (c.1700–67) and John Cobb (c.1715–78). If Cumming joined forces with Vile & Cobb in the early 1760s, which is a possibility, he was certainly working in collaboration with Thomas Chippendale by the time he made the comparably luxurious Lowther barograph in c.1770 (Gilbert 1978, II, fig. 35).

For the reassembly of the barograph during its recent conservation, see fig. 14.

Rosewood, padouk, oak, ivory, gilt bronze. 243.2 × 57.8 × 45.7 cm
Inscribed on the upper dial *Alex Cumming London* and GR; and on the lower dial
ALEXANDER CUMMING LONDON
RCIN 2752
PROVENANCE Made for George III, 1763–5 (£1,178; RA GEO/17132)
LITERATURE Harris, De Bellaigue & Millar 1968, pp. 148–9
EXHIBITIONS QG 1974–5, no. 35

84
JOHN CARRACK'S CABINET-MAKER (fl.1760–80)
Chest-of-drawers, c.1770

This highly distinctive piece of furniture, together with a matching pair of corner cupboards (RCIN 21219), is likely to have been acquired by Queen Charlotte. The unusual decorative scheme of flowers framed by a simulated trellis may reflect the Queen's known love of botanical decoration, and the probable identification of this piece with the chest seen in the Pyne view of her State Bedchamber at Windsor in 1818 (no. 403) seems to support the suggested provenance. The lack of documentation may indicate that it was a private purchase by Queen Charlotte, very few

of whose accounts have survived.

Recent analysis of a closely related piece (a two-door cabinet with painted neo-classical decoration in the Lady Lever Art Gallery; Wood 1994, no. 6) has shed some light on the possible origin of the royal suite. The Lever cabinet, with a pair of corner cabinets (now lost), was sold in 1776 by one John Carrack, through the agency of the former royal cabinet-maker John Cobb, to Sir John Hussey Delaval of Seaton Delaval. Carrack evidently traded in similar goods with the Empress Catherine the Great and may be presumed to have been involved with the Windsor suite also.

Carrack's precise role and his relationship with Cobb are not known. The picture is complicated by the appearance on some of Cobb's documented work of certain features found on the royal chest-of-drawers and corner cupboards. Carrack, who otherwise appears to have traded as a hosier and haberdasher, was evidently acting as agent for the maker of this extremely luxurious group of furniture. The identity of the maker himself remains to be discovered, but should almost certainly be sought among the immigrant cabinet-makers working in London at this period. As has been noted, both English and continental features are found in the construction of the royal and Lever pieces. The shape and style of decoration, of the royal pieces especially – including the marbling of the tops – is clearly modelled on French examples of the Louis XV period. The vividness of the colour scheme, until recently obscured by layers of

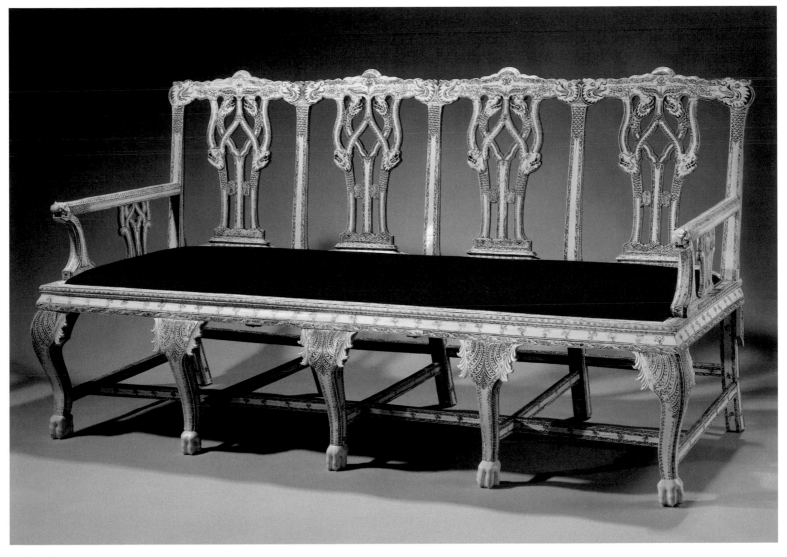

85 (settee)

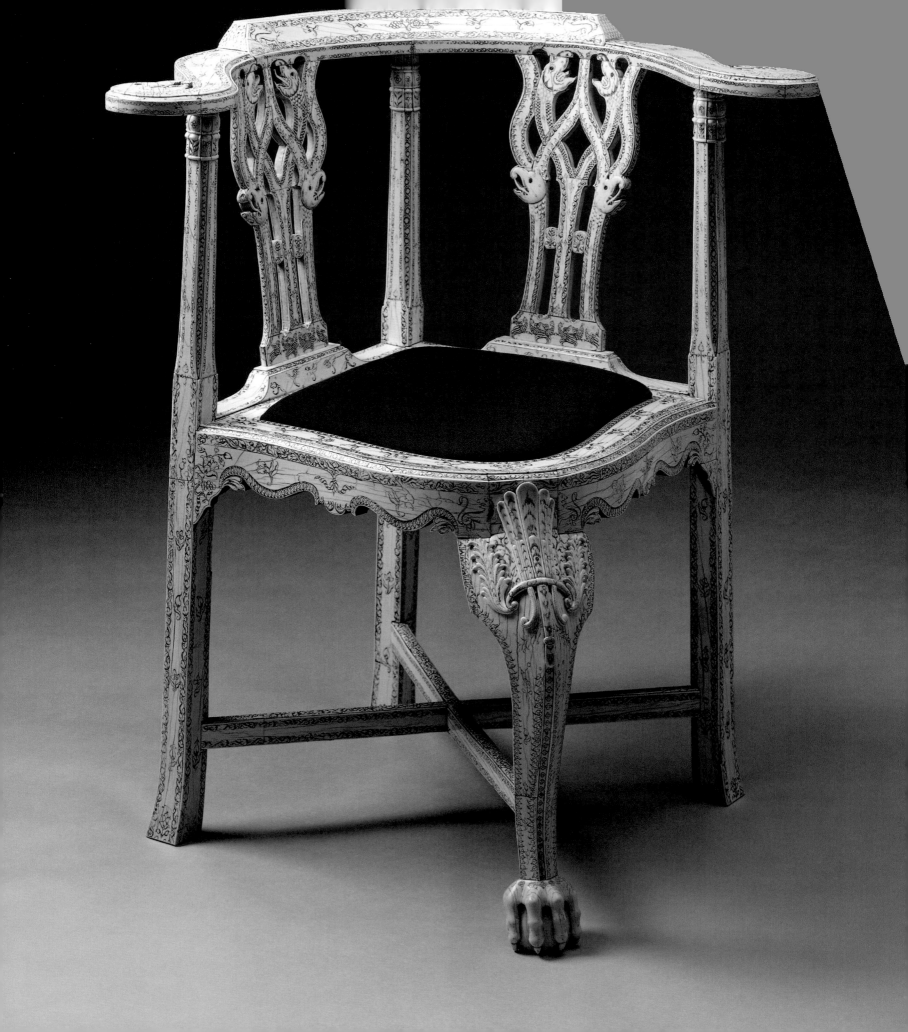

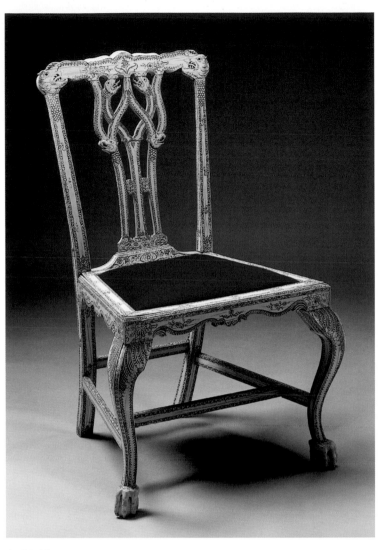

of Warren Hastings and by the Marquess Wellesley; both Hastings and Wellesley had been Governors-General of India. However, the pieces shown here are made of sandalwood veneered with thin sheets of ivory decorated with dragon heads and floral ornaments. Their design must have been based on a Chippendale-style prototype, no doubt exported by the English colonial administrators. The ornament was incised into the ivory and the engraved lines were then filled with black and red lac (resin) which had first been softened by heating. The seats were originally caned, but have subsequently been fitted with independent caned sub-frames and later with the present stuffed drop-in cushions.

This set was acquired in India by Alexander Wynch (d. 1781), while he was Governor of Fort St George, Madras, a post that he occupied from 1773 to 1775. It was made at Vizagapatam, further up the east coast, which was an important centre for veneered furniture of this kind. Furniture of the same design with minor variations survives in other collections (e.g. a chair in the Peabody Essex Museum, Salem, Massachusetts; and six chairs formerly in the Wrightsman collection, Watson 1970, no. 290 A–E). Parts of the present set were included in the posthumous sale of the contents of Wynch's villa, Westhorpe House, at Little Marlow in Buckinghamshire which, according to one account, George III took the opportunity of viewing while he happened to be passing (Whitley 1928, I, p. 364). He purchased the chairs for 14½ guineas each, and one settee for 48 guineas. At Queen Charlotte's posthumous sales in 1819, the set was bought by her son George IV. The furniture can be seen in Augustus Pugin's view of the Gallery at Brighton Pavilion published in 1824 (see no. 426); and it is listed in the Brighton inventory of 1826 (RCIN 1114926; all the pieces are noted as having tufted red morocco squab cushions).

Sandalwood, ivory, lac. Chair 99 × 62 × 60.5 cm; settee 101 × 184 × 82.5 cm; corner chairs 83 × 78.5 × 71.5 cm
RCIN 487.12 (chair), 489.1 (settee), 488.1–2 (corner chairs)
PROVENANCE Alexander Wynch; his sale, Christie and Ansell, Westhorpe House, 6 October 1781 (54 and 55: one settee and ten chairs); bought for George III and presented to Queen Charlotte; her sale, Christie's, London, 7 May 1819 (107: settee, 108: corner chair and eight single chairs), ditto 8 May 1819 (104: settee, 108: corner chair and 105: six single chairs); bought by Messrs Loving (7 May lots) and Paten (8 May lots); from whom bought by George IV
LITERATURE Smith (H.C.) 1931, pp. 218–19; Harris, De Bellaigue & Millar 1968, p. 119; Jaffer 2001, pp. 197–200
EXHIBITIONS Side chairs only: QG 1962–3, nos 42–3; QG 1974–5, no. 7; QG 1988–9, no. 106

discoloured varnish (see fig. 16), results from the use of transparent coloured glazes over a ground of silver leaf and (in the trellis) particles of metal foil in imitation of mica.

Walnut, pine, mahogany, painted decoration, gilt bronze mounts. 87 × 153.7 × 73 cm
RCIN 21220
PROVENANCE Probably acquired by Queen Charlotte
LITERATURE Pyne 1819, I, *Windsor Castle*, opposite p. 116; Laking 1905, p. 131; Wood 1994, pp. 83–6
EXHIBITIONS London 1853b, no. 36

85
INDIAN (VIZAGAPATAM)
Chair, settee and two corner chairs, c.1770

These pieces are from a set of fourteen chairs, two settees and two corner chairs which was purchased by George III for his wife Queen Charlotte. Her taste for oriental art – which embraced porcelain, jade, lacquer and carved ivory ornaments – can be deduced from the catalogues of the sales of her collections which took place in the year after her death (Christie's, London, 7–10, 17–19 and 24–6 May 1819). The Queen possessed examples of solid ivory furniture, presented to her by the wife

86
MATTHEW BOULTON (1728–1809) and
SIR WILLIAM CHAMBERS (1723–1795)
Pair of candle and perfume vases ('King's Vases'), 1770–1

Matthew Boulton's career as the partner of James Watt (1736–1819) and pioneering manufacturer of steam-engines is well known. But in 1765, before he became immersed in heavy engineering, he had built a factory at Soho on the outskirts of Birmingham for the manufacture of toys, buttons, buckles, silver plate and other metal goods. In the late 1760s, Boulton added ormolu-mounted ornamental vases to his repertoire. Almost from the start he seems to have decided to make the bodies of the finest vases from Derbyshire fluorspar (blue john). This distinctive crystalline stone, though brittle and easily damaged, could be turned

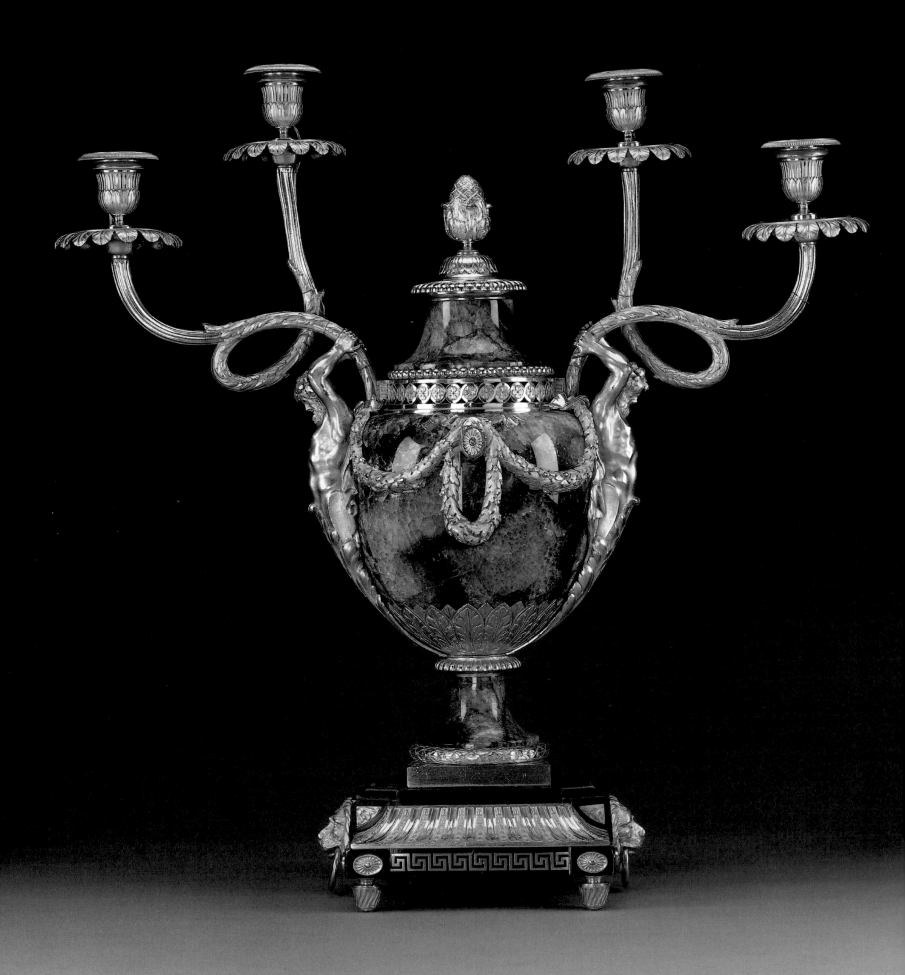

and polished to bring out an astonishing range and depth of colour. It also provided an excellent foil for the richly chased and gilded bronze mounts in which the factory specialised.

No. 86 formed part of the order given to Boulton after his audience with George III and Queen Charlotte at Buckingham House in February 1770. The King's interest in Boulton as an inventor, man of science and entrepreneur appears to have been at least equalled by the Queen's interest in acquiring a selection of fashionable new wares for her own rooms. According to Boulton's account of the historic encounter, the Queen was particularly anxious to know how many vases would be needed to replace the china – then the fashionable norm – on the chimneypiece in her bedroom. The resulting order, which established a striking new formula for chimneypiece garnitures, included a pair of sphinx vases (RCIN 21668), a 'King's Clock' (no. 87) and two pairs of 'King's Vases'. Only one pair of the latter was for the Queen's chimneypiece; the second pair is probably that shown on pedestals in the Blue Velvet Room at Buckingham House in 1817 (see no. 413).

At a meeting following the royal audience, William Chambers, the King's influential architect and chief adviser on design matters, gave Boulton some 'valuable usefull and acceptable Modells' (Goodison 1974, p. 52) and indicated that he would provide a better design for the foot of a candle-vase, using a sketch made by the King himself. Shortly afterwards, Chambers exhibited at the Royal Academy designs for 'Various vases, &c, to be executed in or moulu, by Mr. Bolton, for their Majesties'. One of these, drawn by John Yenn, shows a variant design for a 'King's Vase' (Chambers 1996, fig. 231). The inference is that the design of the new garniture was – at the very least – strongly influenced by, and in certain respects entirely the responsibility of, William Chambers. Surprisingly, neither the 'King's Vase' nor the 'King's Clock' designs were deemed by Boulton to be exclusive to the royal family; both were repeated by him, the former becoming something of a standard line.

Blue john, gilt bronze, ebony. 57.1 × 55.2 × 17.8 cm
RCIN 21669.1-2
PROVENANCE Made for George III and Queen Charlotte, 1770-1
LITERATURE Goodison 1974, pp. 51-2, 158-61, 224-5 and figs 77-8; Goodison 1990, p. 77 and fig. 24; Chambers 1996, pp. 155-7
EXHIBITIONS QG 1974-5, no. 26; QG 1988-9, no. 96; London 1996-7, no. 119

87

MATTHEW BOULTON (1728–1809),
SIR WILLIAM CHAMBERS (1723–1795) and
THOMAS WRIGHT (d. 1792)
Mantel clock ('King's Clock'), 1770–1

The commission for this uncompromisingly neo-classical clock came about as a result of Matthew Boulton's audience at the end of February 1770 with George III and Queen Charlotte at Buckingham House (see no. 86). This meeting was followed by discussions with William Chambers, whose responsibility for the design of the clock case is confirmed in correspondence early in 1771 between Boulton's firm at Soho, Birmingham, and the clock-maker Thomas Wright, of Poultry in the City of London. A preliminary version of this design, perhaps

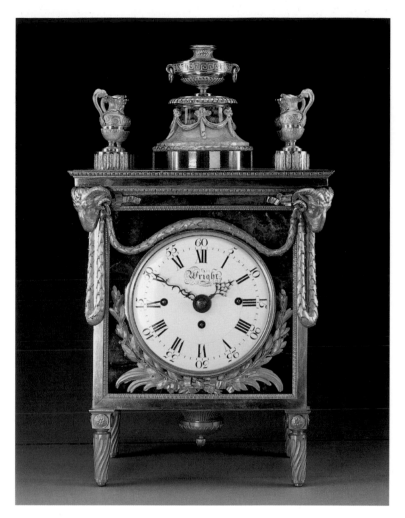

87

worked up from a sketch by the King himself, survives in the Royal Collection (RL 18366).

The commission did not proceed smoothly. According to Boulton, Wright behaved 'd——d shabily' (Goodison 1974, p. 115) over the fitting of the movement to the case, a process which involved sending the incomplete case twice from Birmingham to London and making some quite significant alterations before it could be returned for presentation to the King in April 1771.

As with the 'King's Vases' (see no. 86), Boulton seems to have felt no compunction in making further versions of the 'King's Clock' for general sale – apparently more than six over the next decade – although he was warned by William Matthews, his chief London agent, that he should first have asked the King's permission to make these copies. In reality, they were – like many of his ormolu products – too expensive and most failed to find buyers.

The clock is recorded by Pyne in the Crimson Drawing Room at Buckingham House in 1817 (no. 414) and was still in situ in 1822, when it was repaired by the royal clock-maker Benjamin Lewis Vulliamy (1780–1854). By November 1826 George IV had removed it to the Throne Room at St James's Palace where it was repaired again by Vulliamy and drawn for George IV's Pictorial Inventory (vol. B, f. 26). On 26 January 1829 Vulliamy removed the entire garniture to the newly rebuilt and refurnished Private Apartments at Windsor Castle and at some stage thereafter modified the movement.

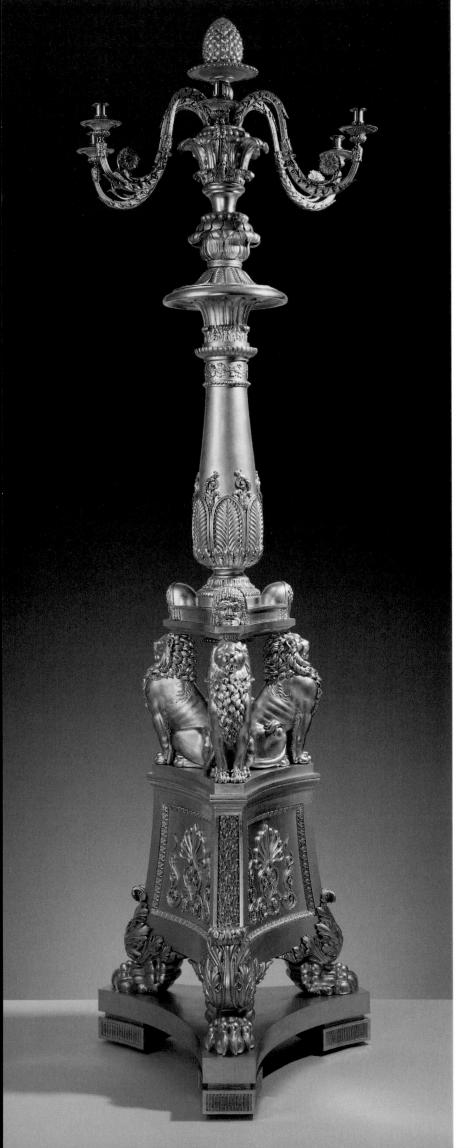

Blue john, gilt bronze, enamel. 48.7 × 28.3 × 21.4 cm
Inscribed on the dial and engraved on the backplate *Wright*
RCIN 30028
PROVENANCE Made for George III and Queen Charlotte, 1770–1; the movement
altered by B.L. Vulliamy (PRO LC11/35, quarter to 5 April 1822 and LC11/54, quar-
ter to 5 January 1827)
LITERATURE Goodison 1974, pp. 112–18, 224–5 and figs 16–18, 22–5; *Chambers*
1996, pp. 156–7
EXHIBITIONS Birmingham 1966, no. 101; QG 1974–5, no. 24; QG 1988–9, no.
98; London 1996–7, no. 117

88
PETER BOGAERTS (fl.1792–1819) and
PAUL STORR (1771–1844)
Pair of candelabra, 1807

In the years around 1807–14 Paul Storr, the celebrated Regency gold-
smith, was in partnership with the carver and gilder Peter Bogaerts at
No. 22 or 23 Air Street, Piccadilly (DOEFM 1986, p. 83). This part-
nership, which seems to have been largely independent of Storr's
principal career as a goldsmith, presumably originated in his need for
carved models from which to cast in silver, although it also extended to
a limited production of furniture and architectural carving (QG
1991–2, no. 189). In December 1809 Storr took Peter Bogerts (sic) –
perhaps a son of his partner – as an apprentice (Grimwade 1990,
p. 768). This may have been the same man as the 'Bogearts' who was
working for Morel & Seddon in 1827 (Roberts (H.A.) 2001, pp. 33,
430–1, n. 195).

The newly identified invoice for no. 88, dated December 1807, indi-
cates that the candelabra (described as '9 foot high, each to hold 9
lights') were ordered by Walsh Porter, from c.1805 to 1809 the future
George IV's interior decorator at Carlton House. They cost the substan-
tial sum of £410 and were intended 'to stand one on each side of the
Throne' in the original Throne Room at Carlton House (later the Ante
Room to the new Throne Room). They were eventually displaced by two
from a set of six candelabra by Thomire, purchased in 1814 (RCIN
31362–3).

The design of no. 88 reflects the archaeological influence of *Etchings
... of Ancient Ornamental Architecture* by Charles Heathcote Tatham
(1772–1842), published in 1799, especially in features such as the
seated lions and the antique heads. Without the evidence of the bill, an
attribution to the cabinet-making firm of Tatham's brother, Thomas (d.
1818) – Tatham, Bailey & Sanders – would have been quite plausible,
especially as this firm was extensively employed by George IV (see no.
89).

The candelabra were removed from store at Carlton House in 1827
and sent to Morel & Seddon to be refurbished for use in George IV's new
rooms at Windsor. They were intended for Room 207 (then the King's
Writing Room, subsequently Bedroom) but were actually used in Room
197 (then the Small Drawing Room) where they were matched with a
duplicate pair made by Morel & Seddon (Morel & Seddon Accounts, nos
220–1). Not meeting the King's approval, all four were removed to St
James's Palace in May 1829. Later in the nineteenth century, the
number of branches on both pairs was reduced from nine to five.

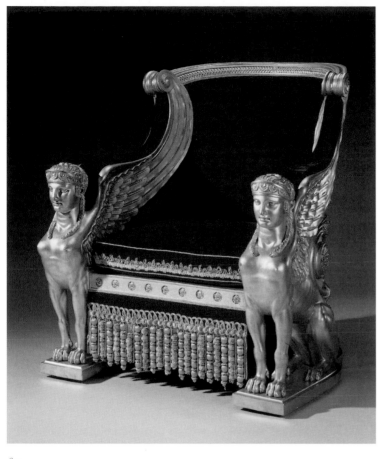

Giltwood and gilt bronze. 282 × 85 × 43 cm
RCIN 588.1–2
PROVENANCE Made for George IV, 1807 (£410; RA GEO/25282)
LITERATURE Harris, De Bellaigue & Millar 1968, p. 137; Roberts (H.A.) 2001, p. 127

89
TATHAM, BAILEY & SANDERS
Pair of council chairs, 1812

These magnificent chairs epitomise the fully developed Roman manner that George IV adopted for the interiors at Carlton House from c.1805 using the leading Mayfair cabinet-makers and interior decorators, Marsh & Tatham (subsequently Tatham, Bailey & Sanders). The introduction of this grandiose style, which gathered pace after the establishment of the Regency in 1812, eventually obliterated the majority of Henry Holland's sophisticated and chaste neo-classical interiors which had been the hallmark of Carlton House in the late eighteenth century. The inspiration for no. 89, part throne, part triumphal chariot, comes from three ancient marble chairs, drawn in Rome by C.H. Tatham, brother of Thomas Tatham, and published in 1800. The impeccably Roman origin of the design, much embellished by Tatham, is underlined by the use of the word 'Antique' in the bill. Originally upholstered in a luxurious pale blue and gold fleur-de-lis satin, the

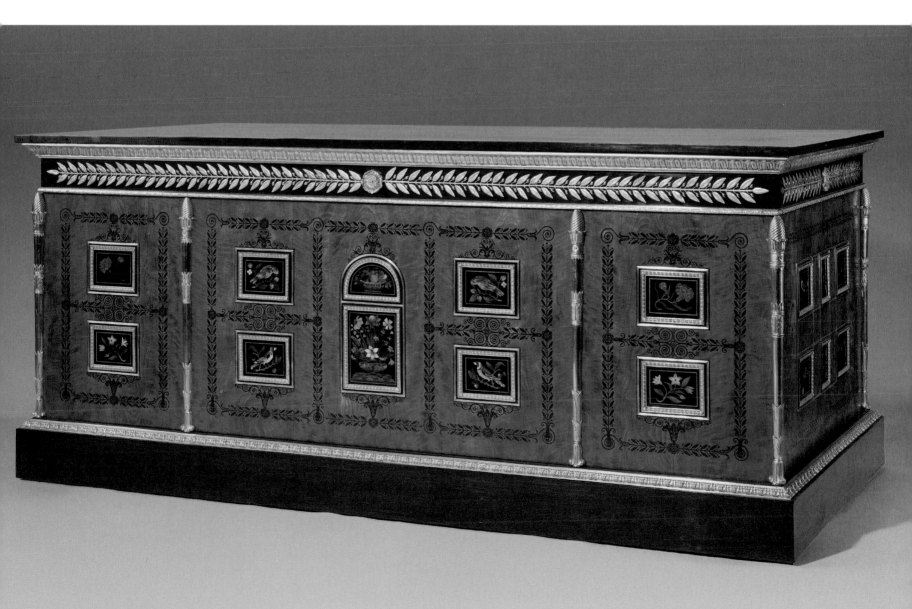

chairs were part of a large and expensive group of seat furniture supplied by Tatham for the Blue Velvet Room (see no. 421) in December 1812. The curtains of the room were made of the same fleur-de-lis satin and had been installed in time for George IV to receive the exiled French royal family there for the spectacular *fête* held on 19 June 1811 to inaugurate the Regency.

Early in 1813, George IV indulged in one of the sudden changes of mind which had always characterised his attitude to decoration: the new seat furniture was ordered to be re-covered in blue velvet and moved to the Old Throne Room. Later still, the coverings of no. 89 were changed again to crimson velvet and the chairs moved to the new Throne Room (formerly the Great Drawing Room) where the Regent's Council met (see no. 423). After the demolition of Carlton House, the chairs were used by George IV in the State Apartments of St James's Palace.

More than twenty-five years later, the same round-backed chair design with sphinx arms was chosen for Queen Victoria's Homage Chair, made for her coronation in 1838 by Tatham's successor Edward Bailey at a cost of £86 (PRO Work 21/19). This chair, which is shown in Hayter's portrait of the Queen (Millar (O.) 1992, no. 308), was taken as a perquisite after the coronation by the Lord Chamberlain, the second Marquess Conyngham. It was subsequently destroyed in a fire at Slane Castle.

Giltwood, velvet upholstery. 108.6 × 94 × 96.5 cm
RCIN 2629.1–2
PROVENANCE Made for George IV, 1812 (£587 12s.; PRO LC9/396, quarter to 5 January 1813)
LITERATURE Harris, De Bellaigue & Millar 1968, p. 195
EXHIBITIONS London 1972b, no. 1640; QG 1991–2, no. 42

90
MOREL & SEDDON
Bath cabinet, 1828

The French cabinet-maker and upholsterer Nicholas Morel (fl.1790–1830), who had first worked for George IV at Carlton House in the 1790s, was appointed in July 1826 to furnish the new royal apartments at Windsor Castle, then being extensively remodelled by Sir Jeffry Wyatville. Less than a year later Morel had dissolved his old partnership with Robert Hughes (fl.1805–30) and formed a new one with George Seddon (1769–1857) whose well-established family firm, based at Aldersgate Street, was probably the only one large enough to cope with this immense commission. Over the next three years, the partners' bills totalled £203,963 6s. 8d. This was easily the largest sum ever devoted to a single furnishing scheme in this country. The ensuing Parliamentary Select Committee strongly criticised the way the commission had been supervised and reduced Morel & Seddon's bill by £24,662 7s. 6d.

George IV's combined bedroom and bathroom, on the east side of the Upper Ward of the Castle, was one of the most adventurously planned and decorated of all the new rooms. It was hung like a tent with blue silk, and both bed and bath were contained in mirror-lined recesses, the design of which (no. 405) was approved by the King in July 1827. The 'late Empire' elements in the design of both the bed and the bath cabinet reflect the involvement at Windsor of the distinguished Parisian

cabinet-maker F.H.G. Jacob-Desmalter (1770–1841), whose firm had earlier supplied a cylinder desk – also selected for the new bedroom – in a closely related style (RCIN 11107). However, the King's highly eclectic approach to interior decoration, involving Italian, French and English pieces, frustrated any further attempts to bring coherence to the furnishings of the room.

For the decoration of the bath cabinet, in effect a three-sided box on rollers covering the actual bath, it seems likely that Morel & Seddon used the eighteenth-century pietra dura panels from a rosewood cabinet made in 1810 by Tatham & Bailey for Carlton House. In 1829 the King decided to move his bed into an adjacent room. The bath cabinet, which must always have been awkward to use, was put into store and by 1866 it had been converted into a folio cabinet. It was loaned to the Victoria and Albert Museum from 1976 to 1999.

Purplewood, satinwood, pietra dura, gilt bronze. 102 × 231 × 115 cm
RCIN 74428
PROVENANCE Made for George IV (£924, with a table; Morel & Seddon Accounts, no. 294)
LITERATURE De Bellaigue & Kirkham 1972, p. 32; Roberts (H.A.) 2001, p. 157

91
MOREL & SEDDON
Pair of armchairs, 1828

These armchairs form part of a very extensive suite of seat furniture made for George IV's new Private Apartments at Windsor Castle (see no. 92). Originally consisting of fifty-six pieces (twelve sofas, sixteen armchairs and twenty-eight side chairs), the suite was divided between the Crimson Drawing Room and the Small or White Drawing Room and cost the enormous sum of £13,886 (not including the material for upholstery). By 1830, a number of pieces from both rooms had been removed to the State Apartments or to store, owing to lack of space. Some of the excess pieces were used to complete the refurnishing of Buckingham Palace in the 1830s and 1840s (see no. 415).

The French inspiration for the design of the suite, seen at an early stage in the room elevations prepared for George IV (e.g. no. 404), points clearly to the influence of F.H.G. Jacob-Desmalter. One of the leading furniture-makers of the First Empire, Jacob-Desmalter was invited over from Paris, probably in 1826, to assist Morel in designing furniture for the Windsor project.

The pieces for the Crimson Drawing Room were originally upholstered *en suite* with the walls and curtains in an expensive poppy-coloured striped velvet, supplied by the mercer W.E. King (see no. 404). The velvet was replaced in 1869 with a crimson silk brocatelle of the same pattern which in turn was changed by Queen Mary in the early twentieth century to a bold Italianate design in pink silk. Following the fire of 1992, the upholstery (including curtains and wall-hangings) was changed back to crimson silk in the original striped pattern.

The Crimson Drawing Room, designed by Wyatville in a rich late classical style, was intended as the principal reception room of the new Private Apartments. It consciously evokes the room of the same name at Carlton House and incorporates furniture and fittings from that room. The Crimson Drawing Room was almost totally destroyed during the fire of 1992, but has since been meticulously reconstructed and houses

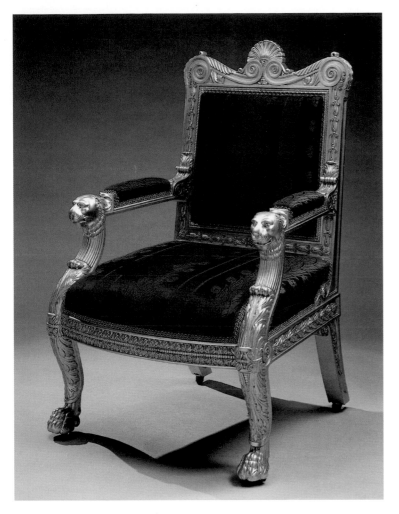

91

have antique precedents and were relatively common in the repertoire of English and French furniture design from the beginning of the nineteenth century; plate 7 of Thomas Hope's *Household Furniture* (1807) shows a typical example of this form.

The Green Drawing Room was reckoned by all who visited Windsor to be the most successful of the new suite of drawing rooms built and furnished for George IV on the east side of the Castle between 1826 and 1830. Like the adjacent rooms, it combined furniture and fittings from Carlton House with new pieces supplied by Morel & Seddon. Badly damaged in the fire of 1992, the room has since been restored and new silk of the original pattern has been woven for walls, curtains and upholstery of the seat furniture, including no. 92.

Gilded mahogany, silk damask. 99.1 × 80 × 64.8 cm
RCIN 2412.9–10
PROVENANCE Made for George IV, 1828 (Morel & Seddon Accounts, no. 98)
LITERATURE Roberts (H.A.) 2001, p. 108

93
ELKINGTON, MASON & CO.;
LUDWIG GRUNER (1801–1882), designer
Jewel-cabinet, 1851

Built in the form of a large reliquary, this elaborate object embodies – perhaps better than any other single work of art – the highly eclectic

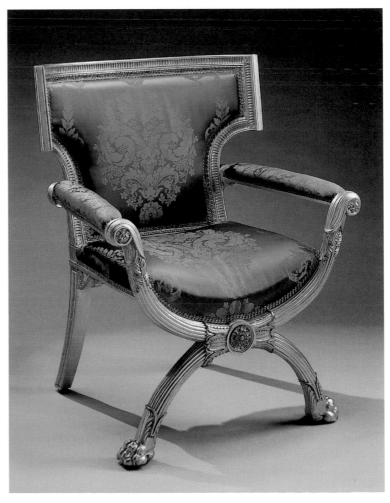

92

the original furniture, in store at the time of the fire. This and the adjoining rooms were first opened to the public in 1998.

Gilded mahogany, silk damask. 109.2 × 74.9 × 71.1 cm
RCIN 2582.8–9
PROVENANCE Made for George IV, 1828 (Morel & Seddon Accounts, no. 58)
LITERATURE De Bellaigue & Kirkham 1972, p. 29; Roberts (H.A.) 2001, p. 84

92
MOREL & SEDDON
Pair of armchairs, 1828

These armchairs share the same provenance as no. 91, and like them come from a very large suite of seat furniture, consisting of seven sofas, twelve armchairs, thirty-one side chairs, two reading chairs and a writing chair. Forty-one of the fifty-three pieces were intended for the Green Drawing Room at Windsor Castle, the remainder for the King's Writing Room. Those for the Green Drawing Room were covered in green silk supplied by W.E. King at a cost of £2 5s. per yard. Exclusive of the silk, the cost of the entire suite was £6,956. As in the case of the suite for the Crimson Drawing Room, the excessive quantity supplied by Morel & Seddon resulted in the removal of some pieces by the early 1830s and their reuse at Buckingham Palace.

The distinctive x-frame front support and deeply curved back both

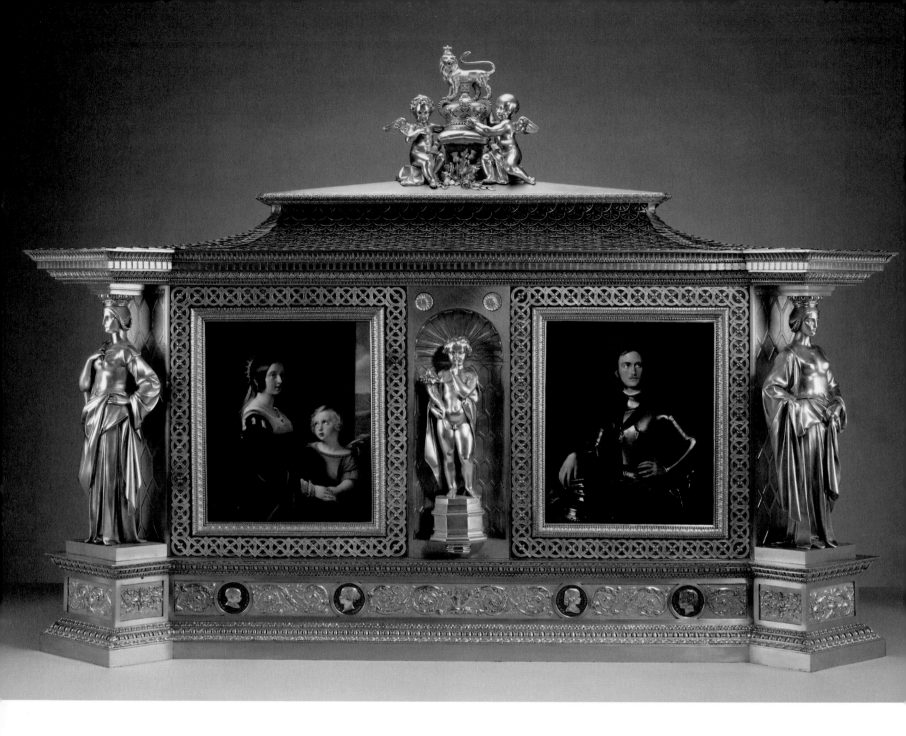

taste of Queen Victoria and Prince Albert. It was manufactured by the Birmingham silversmiths Elkington, using their own patent electro-forming process, to the designs of the Prince's adviser on art, Ludwig Gruner of Dresden, and was first shown at the Great Exhibition of 1851.

While ostensibly functioning as a jewel-cabinet, its main purpose was undoubtedly to celebrate and commemorate the happy and successful union of the royal couple. To this end, the doors at the front incorporate Berlin porcelain panels painted with copies of Robert Thorburn's sentimental miniatures of the Queen with the young Prince of Wales, and of Prince Albert in armour. The original of the latter (RCIN 421665), her favourite likeness of her adored husband, was a birthday present from the Prince in 1844; the original of the former (RCIN 421666) was painted a year later, and a number of copies on porcelain were made of both. The family theme is enhanced by the inclusion around the base of silvered portrait medallions by Leonard Wyon (1826–91) of six of the royal children (excluding Leopold and Beatrice, who were born after

1851) and, on the back, Meissen porcelain panels painted with the arms of the Queen and Prince surrounded by the national emblems. The latter, together with the porcelain side panels, were evidently created to Gruner's design, whereas the Berlin panels may already have been in existence.

The Queen greatly admired Elkington's work and purchased a number of the firm's creations from the Great Exhibition: 'none struck us so much, & as likely to be useful for the taste of the country, as Elkington's beautiful specimens of electro plate', she wrote on a visit in July 1851. A month later she was admiring 'our beautiful jewel case' in the nave of the Crystal Palace: 'It is really exquisite' (QVJ, 12 July and 8 August 1851). No bill has been found, although a payment on 5 January 1852 to Elkington & Co. of £242 2s. in the Prince's personal accounts could well refer to this commission (RA PP/VIC/PA/Cash Book 1850–5). The Queen eventually placed it in the Grand Corridor at Windsor.

Oak, electro-formed and silver-plated white metal, enamelled copper, porcelain.
97 × 132 × 81 cm
Plaques of Queen Victoria and Prince Albert signed DECKELMANN (for Andreas Deckelmann, 1820–82) and *Wustlich* (for Otto Wustlich, 1819–96) respectively; one medallion dated MDCCCLI
RCIN 1562
PROVENANCE Made for Queen Victoria, 1851
EXHIBITIONS London 1851a, Class 23 (*Official Catalogue*, I, p. 109 and II, p. 672, no. 1)

94
HERBERT MINTON & CO. and R.W. WINFIELD & CO., after designs by SIR EDWIN LANDSEER (1802–1873)
Pair of Highlander candelabra, 1854

Queen Victoria and Prince Albert's enduring love of all things Scottish began with their first visit to Scotland in September 1842. Six years later, the Queen bought the lease of the Balmoral estate and in 1852 she acquired the freehold. Thereafter, the castle was rebuilt on a larger scale and newly furnished in the Scottish style by the fashionable London firm of Holland & Sons of Mount Street.

The Queen's great admiration for Highlanders dated from her first visit. She noted their fine dress and romantic appearance when they assembled to greet her at Dunkeld and then at Taymouth Castle, where she and the Prince stayed with the Marquess of Breadalbane. Writing in later years to her daughter, the Crown Princess of Germany, she referred to them as 'friends & not servants' (Millar (D.) 1985, p. 10). This admiration was given visible expression in her new Drawing Room (see no. 431), where the light was provided by six identical pairs of candelabra incorporating porcelain figures of Highlanders. These were made by Mintons of Stoke-on-Trent in Parian ware, an unglazed white hard-paste first introduced by Mintons' rival Copelands, the successors to Spode, c.1846. The silver-plated light-fittings, in the form of trophies with deer heads and hunting horns, were provided by the Birmingham silversmith R.W. Winfield; they were originally patinated and gilded.

In the Minton archives there is a note and sketch of 22 February 1854 from Sir Edwin Landseer recording his proposed change to one of the dogs accompanying the Highlanders from deerhound to blood-hound. This note makes clear his responsibility for the design of the Highlander figures, if not for the overall conception of the candelabra. Landseer was the first major artist to work extensively for Queen Victoria on Scottish subjects at Balmoral, and his studies of her four gillies Macdonald, Grant, Coutts and Duncan (which may have served as an inspiration for the candelabra figures) were executed during his first visit there in September 1850 (Millar (D.) 1995, nos 3182–5).

Parian porcelain, silver-plated bronze. 94 × 38 cm
RCIN 12143.1–2
PROVENANCE Made for Queen Victoria, 1854 (£468 for six pairs, including £4 16s. for twelve cases; RA PP/VIC/2/8/5137)
LITERATURE Jones (J.) 1993, pp. 125–6
EXHIBITIONS Washington 1985–6, no. 543; London 1992a

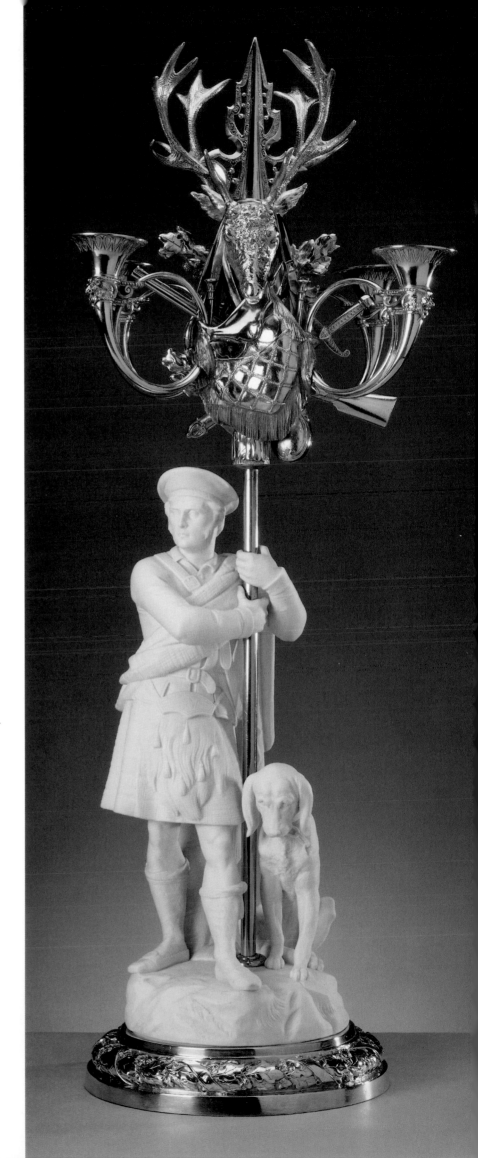

CONTINENTAL FURNITURE (nos 95–107)

From the restoration of the monarchy in 1660 until the accession of George I in 1714, in which period a large amount of new furniture was acquired by the English court, the modern distinction between English- and French-made furniture would probably have been considered largely meaningless. This was partly because Charles II, who knew at first hand the style and grandeur of the court of his cousin Louis XIV, deliberately fostered the introduction of the French court style to England by employing French craftsmen, many of them Huguenots. Both before and after the Revocation of the Edict of Nantes in 1685, so much positive encouragement was given to Huguenots to settle in England that many areas of British life, especially the arts, were heavily colonised by French immigrant artists and artisans. A further impetus to this process was given by the ousting of the Catholic James II and the arrival of the Protestant sovereigns William and Mary in 1688, bringing with them more Huguenot artists who had fled in the first instance to Amsterdam.

These artists may have included Gerrit Jensen, cabinet-maker to the Great Wardrobe from c.1680, and certainly included the Pelletier dynasty. The latter were responsible for the introduction to the London cabinet-making and upholstery trade of the latest in Parisian design and technique, especially in the use of metal inlays and wood marquetry, of silver (no. 79), and of sophisticated cutting and burnishing of gilded surfaces (nos 79, 80). In consequence, the finest furniture of this type was often virtually indistinguishable from pieces actually made in Paris.

It is not known when the first pieces of furniture of wholly French origin entered the collection. 'Dutch William' may have been responsible for acquiring a number of early pieces still in the collection, including the small folding-top writing table attributed to Pierre Gole (RCIN 35489; see no. 401), or even the magnificent mid-seventeenth-century carved ebony cabinet-on-stand (RCIN 35309) which George III kept at Buckingham House and is now in the State Apartments at Windsor. Although George III himself does not seem to have been particularly interested in French furniture, he is likely to have acquired the mid-eighteenth-century regulator clock by Berthoud and Cressent (no. 100) for his wife Queen Charlotte – an early collector of Sèvres porcelain.

As with almost every aspect of George IV's collecting activities, his purchases of French furniture completely transformed this area

of the Royal Collection. In a manner that is curiously reminiscent of Charles II a hundred years earlier, George IV surrounded himself with French craftsmen and designers from the moment he started to modernise Carlton House in 1783. Under the general direction first of the interior decorator Guillaume Gaubert, then of the prince of *marchands-merciers* (dealer-decorators), Dominique Daguerre, he secured a superb group of *à la mode* Parisian furniture, clocks, porcelain and *objets d'art* (no. 106), all of which contributed to the creation of a series of interiors that were widely regarded as among the most handsome in Europe.

George IV, whose passion for all things French, particularly for the furniture of the *ancien régime*, endured to the end of his life, occupies a Janus-like position in the history of the collection, looking simultaneously backwards and forwards. He was as likely to buy a piece of neo-classical furniture by Martin Carlin in the late 1820s as he had been in the early 1780s – in the latter case no doubt through Daguerre and at the height of fashion, in the former through one of his many scouts such as his confectioner François Benois and as an 'antique' (no. 103). Equally, certain types of decoration remained constantly popular with the King. He shared with many of his contemporary collectors, such as Lord Hertford, a particular liking for eighteenth- and nineteenth-century Boulle marquetry (nos 96, 97, 99) and for furniture of either date mounted with porcelain or pietra dura plaques (no. 103). Ahead of most of his contemporaries, he also developed a taste in the early years of the nineteenth century for elaborate rococo furniture – a style which he was too young to have known in its heyday. His eye for quality was highly developed, but he depended on a group of well-informed advisers and, with their help, he took advantage of the riches flooding onto the art market in the wake of revolutionary and Napoleonic upheavals on the Continent. He continued to make adventurous acquisitions, which included modern French furniture by Bellangé, Jacob-Desmalter and others, to within a few months of his death. Probably his most spectacular purchases came from the Watson Taylor sale in 1825 where at a stroke he transformed the significance of his collection of French furniture by adding a number of masterpieces made originally for the French royal family (nos 104, 105).

In terms of both quantity and quality of acquisitions, no subsequent monarch could hope to match the riches that George IV

added to the collection. By comparison, the intriguing gifts of modern French furniture that Queen Victoria received from King Louis-Philippe in 1843 and the purchases made during her visit to Emperor Napoleon III in 1855 pale into insignificance. In the twentieth century there have been a small number of interesting additions (for example nos 101, 107), but the collection today is for the most part a tribute to George IV's remarkable discrimination and adventurously acquisitive spirit.

95

NETHERLANDISH or ENGLISH
Armorial panel, early sixteenth century

This is one of a small number of fragments of the detached borders of tapestries from the collection of Henry VIII. They are woven with repeating motifs of the royal arms and a crowned portcullis, separated by balusters, against a diapered ground. During the late nineteenth-century re-presentation of the Tudor apartments at Hampton Court Palace these borders were hung against the gallery of the Great Hall and around the walls of the Great Watching Chamber. It is not known which tapestries they were originally intended to surround.

Tapestries played a fundamental role in the decoration of Henry VIII's palaces. At his death in 1547 his collection contained over two thousand pieces. These were hung for short periods wherever the court was in residence, and were carried about the country as it progressed between palaces. From the late seventeenth century the disposition of tapestries in the royal palaces became more permanent, but there were none the less periodic rearrangements involving reduction or enlargement, either by detaching the borders or, more drastically, by cutting the pictorial field itself.

These borders were probably woven in the Netherlands, but it is also possible that the royal 'arras maker' responsible for the upkeep of the royal tapestries had workmen capable of producing tapestry of this quality. Because the royal Tudor arms remained unchanged after the accession of Henry VIII in 1509, the borders may conceivably date from the reign of his father, Henry VII. Similar strips with the arms of Cardinal Wolsey also survive at Hampton Court.

Wool. 80 × 227 cm
RCIN 1269.2
LITERATURE Marillier 1962, p. 12, pl. 18; Campbell (T.) 1998b, I, pp. 143–4, II, fig. 32
PROVENANCE Probably made for Henry VIII

▽ 95 (detail)

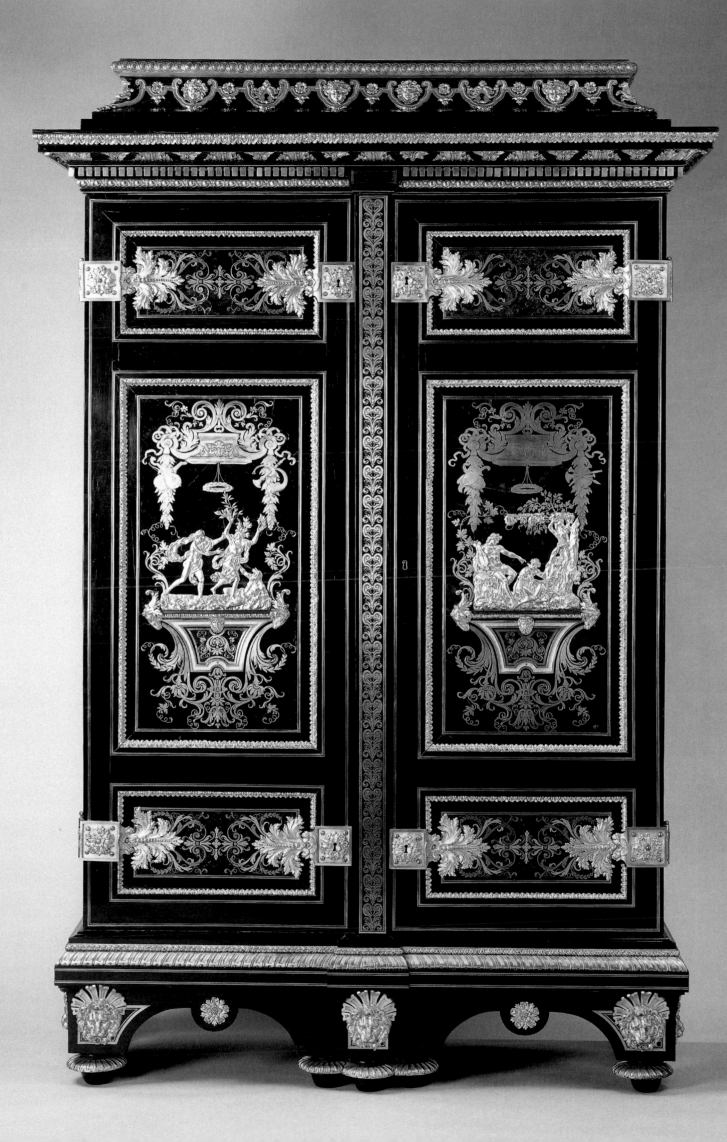

96

ANDRÉ-CHARLES BOULLE (1642–1732)
Wardrobe, c.1700

As furniture-maker, chaser, gilder and sculptor to Louis XIV, André-Charles Boulle enjoyed the privilege of workshops and lodgings in the Galeries du Louvre from 1672 until his death sixty years later. Monumental wardrobes (*armoires*) of this type were intended principally for display and are among the most magnificent and harmonious of Boulle's creations. The large flat surfaces provided a perfect vehicle for the display of Boulle's extraordinary skills as a designer and technician, allowing him to combine intricate marquetry of rich materials and finely modelled gilt bronze mounts (which he also designed and made) within a grand architectural framework. As on many of the finest pieces by Boulle, the bronzes of no. 96 are very carefully integrated with the marquetry.

Nineteen Boulle *armoires* from the late seventeenth century have been identified. Features common to most of them include certain mounts and patterns of inlay. Seven *armoires* (including no. 96) are linked by the use of bronze reliefs of Apollo and Daphne and of Apollo and Marsyas on the doors. The design for these may derive from drawings of subjects from Ovid's *Metamorphoses* that Boulle himself once owned. Of this group of seven wardrobes, two now in the Wallace Collection share many additional features with no. 96 (Hughes (P.) 1996, II, nos 172–3).

George IV had a particular fondness for Boulle furniture but it was not until he began the refurnishing of Windsor Castle in the 1820s that he acquired no. 96 and another wardrobe of similar large dimensions (RCIN 21630). Nothing is known of the provenance of no. 96 except that it was said to have come from the *Garde Meuble* (the French royal furniture store). The presence of the crowned C *poinçon* (tax stamp) on virtually all the bronzes indicates that the *armoire* was in the Paris trade in the period 1745–9. After thorough restoration by Morel & Seddon in 1828, which included the insertion of a mahogany lining and new locks, the King intended to place the *armoire* and its companion piece in his Sitting Room at Windsor (Room 200). Perhaps on account of their overwhelming scale, they were actually installed at the angle of the Grand Corridor (see no. 409), where they have remained to this day.

Oak, ebony, tortoiseshell, brass, pewter, kingwood, rosewood, mahogany, gilt bronze.
262.6 × 167 × 62.8 cm
The bronzes extensively stamped with the crowned C
RCIN 21642
PROVENANCE Phillips sale (anon.), London, 25 June 1825 (375); bought by George IV (£199 10s.; Jutsham II, p. 205)
LITERATURE Laking 1905, p. 112; Pradère 1989, p. 100; Hughes (P.) 1996, II, p. 824; Roberts (H.A.) 2001, p. 248

97

NETHERLANDISH (?ANTWERP)
Boulle secretaire-cabinet, c.1700

The imposing scale and highly elaborate decoration of this cabinet, consisting of geometric marquetry of brass, pewter, copper and tortoiseshell enriched with agate and jasper panels, place it firmly in the category of 'parade' furniture of the kind made fashionable by Louis XIV. These 'parade' characteristics stand out when comparisons are made between no. 97 and the furniture with which it has most in common, a group of Flemish Boulle secretaire-cabinets which are now usually attributed to the Antwerp workshop of Hendrick van Soest (fl.1648–1716). One of the most elaborate of these, a desk made for the Elector Max Emanuel of Bavaria (r. 1680–1726) and now in the Munich Residenz (inv. no. Res Mü M 148), shares with no. 97 the same general form (raised back, enclosed writing surface supported on giltwood legs and elaborately shaped base) and a similar technique of decoration. However, it is approximately half the size and does not use hardstones.

No. 97 was purchased by George IV from the well-known dealer and restorer E.H. Baldock (1777–1845). The grandeur and style of decoration (then considered to be French) no doubt appealed to the King and he originally intended it for Windsor Castle. With that destination in mind, no. 97 was sent direct to Morel & Seddon but the following year it was returned to store in London (Jutsham II, 31 July 1829, pp. 269–71). On that occasion, it was noted that the cabinet had been 'many Years in the State Bedroom at Clandon Park, the Seat of the Earls of Onslow, and disposed of by the Present Earl, soon after coming to The Title'. This provenance is confirmed by the 1778 inventory of Clandon (information from John Hardy). Its date of acquisition by the Onslows is not recorded but the cabinet itself may well have been known at first hand by George IV, who was a frequent visitor to Clandon in the time of George, fourth Baron and first Earl of Onslow (1731–1814), and of

◁ 96 (detail)

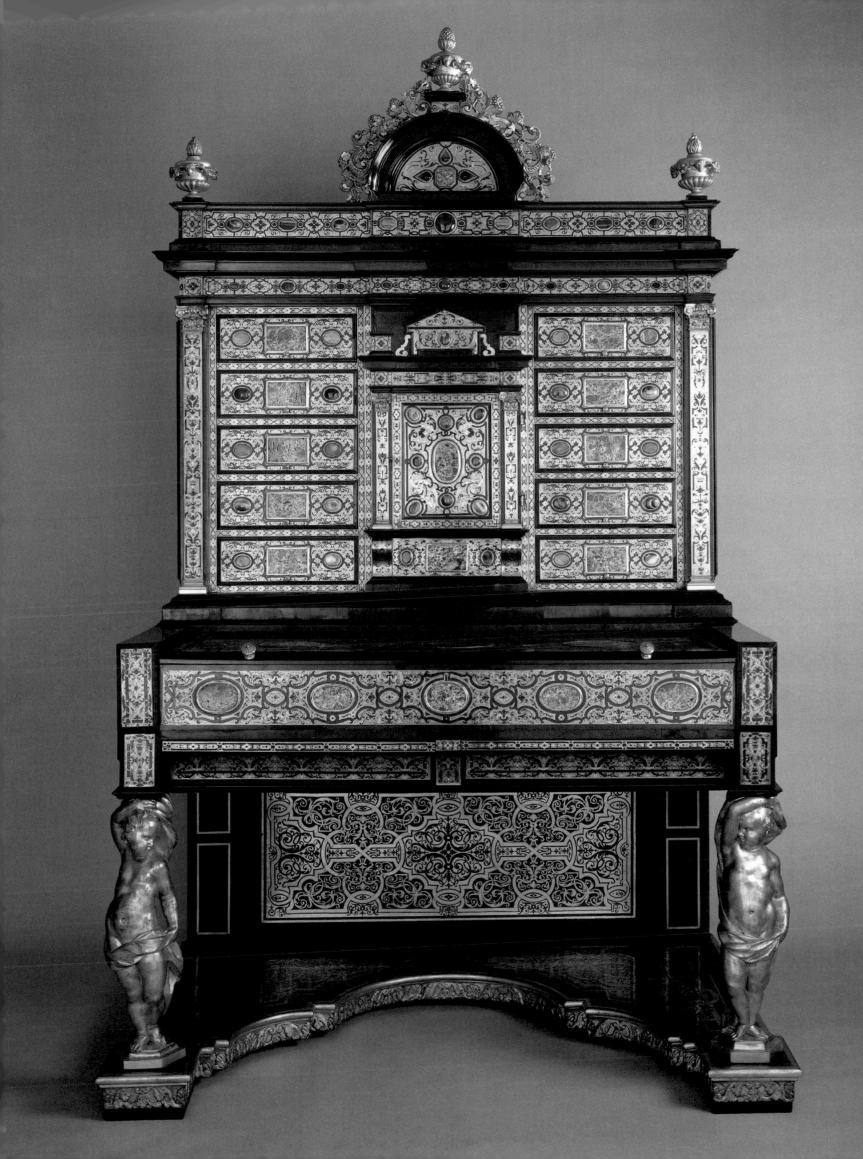

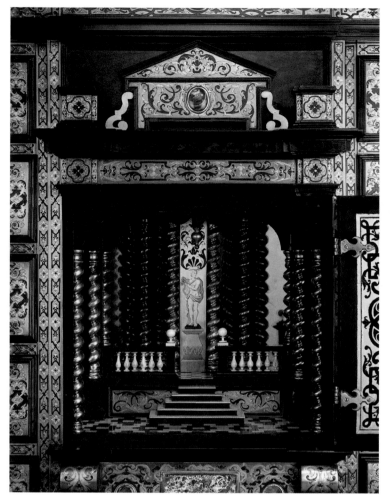

97 (detail)

kind used to veneer no. 98 was rarely used on this scale, partly no doubt because of its relative vulnerability to damage. It was imported from Egypt.

The early history of these pedestals, two from a set of four, seems to be closely connected with the arrival in this country of the four marble groups of *The Seasons* (RCIN 71424–27) by Camillo Rusconi (1658–1728). These sculptures are thought to have been acquired, probably for George I, some time between 1721 and 1730 (Martin (F.) 2000, p. 58), and may well have been installed in the King's Gallery at Kensington Palace as part of the decorations carried out under the direction of William Kent in the late 1720s. A further two pedestals of the same design, but in pink and grey marble, formed part of the display on the window wall of this imposing Palladian room. From the evidence of the view of the room in 1816 (no. 435), the latter two pedestals were apparently used to support busts. The Rusconi groups were taken to Windsor Castle in 1828, and the pedestals were sent at the same time to Morel & Seddon for refurbishment before being placed in the Grand Corridor. Since the early twentieth century, they have been used in the Queen's Guard Chamber at Windsor to support the bronze busts by Leone Leoni (nos 60, 61) acquired by George IV in 1825.

Onyx marble and stone. 123 × 59.5 × 59 cm
RCIN 35322.1, .3
PROVENANCE Probably acquired by George I, c.1725
LITERATURE Roberts (H.A.) 2001, p. 247

his son Thomas, second Earl (1754–1827). The third Earl never occupied Clandon and disposed of much of the contents.

No. 97 was incorrectly identified by Clifford Smith as the cabinet which had belonged to Queen Mary II and in which Queen Caroline, consort of George II, had found the 'lost' drawings by Holbein and Leonardo.

Pine, oak, brass, copper, pewter, tortoiseshell, hardstones, ebony, rosewood, ivory, gilt bronze, giltwood. 270 × 160 × 105 cm
RCIN 1382
PROVENANCE The Earls of Onslow, Clandon Park, by 1778; E.H. Baldock; from whom bought by George IV, 17(?) May 1828 (£350; RA GEO/25429)
LITERATURE Smith (H.C.) 1931, p. 211

98
ITALIAN (?)
Pair of pedestals, c.1720

From the Renaissance onwards the placing of sculpture in an interior almost always involved careful consideration of the form, materials and colour of plinths and pedestals, which were themselves often treated as significant architectural elements. Richly coloured marbles were frequently used for this purpose in Italian (particularly Florentine and Roman) interiors. Elaborately figured onyx marble (*alabastro onice*) of the

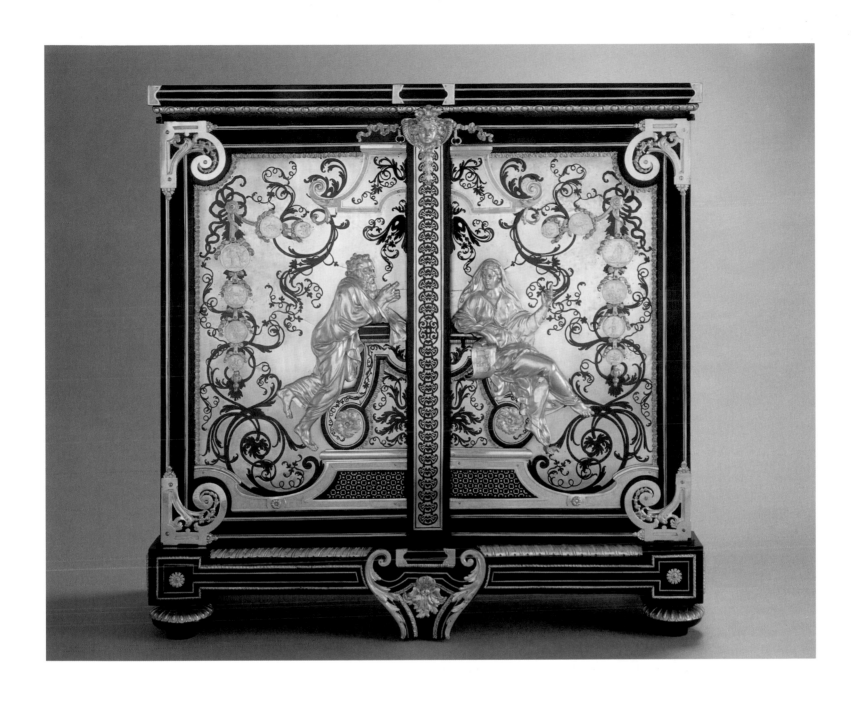

99
Workshop of ANDRÉ-CHARLES BOULLE (1642–1732)
Pair of medal-cabinets, c.1735

Twenty-five of these cabinets, dating from three distinct periods in the eighteenth century, have been identified. The first group, made under the direction of André-Charles Boulle himself, probably dates from 1705–15; the second, to which no. 99 belongs, are repetitions from Boulle's workshop of the 1720s and 1730s. A third group dates from the period after 1760 when a number of new versions were made and several existing examples, from the first or second periods, were restored.

Although the earliest of these cabinets were certainly intended for medals, probably for use by Louis XIV as diplomatic gifts (*Présents du Roi*), by the 1730s they were as likely to have been used – in spite of their very specific decoration – simply as cabinets for books or other articles. In the case of no. 99 and several others of this second group,

there is no physical evidence that they ever contained medal shelves, though they retain the central foot which was originally designed to support the weight of medals.

The figures of Socrates and Aspasia (the mistress of Pericles), constant features of the decoration of these cabinets, derive either from Michel Corneille's painting of 1673 on the ceiling of the *Salon des Nobles* at Versailles or perhaps from a drawing by Corneille of the same subject in Boulle's possession. Both figures of Aspasia on no. 99 are signed on the reverse by an unidentified bronze-maker, C(?) Richar[d]. The casts of medals on the doors, which on no. 99 are dated between 1643 and 1697, record the principal events of Louis XIV's reign and are often (as in the present case) of surprisingly low quality.

George IV shared to the full the contemporary passion for Boulle furniture and acquired many splendid examples (see no. 96). These cabinets may have been purchased from the dealer Robert Fogg in 1813. They were at Carlton House in the Blue Velvet Closet in 1818 (see no. 422) and in the library by 1826. Despatched in 1828 to Morel &

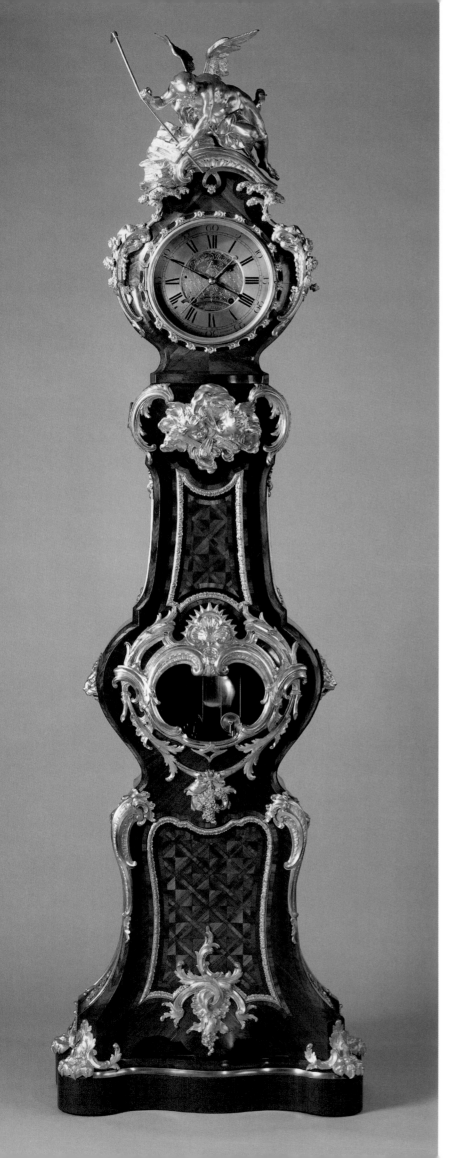

Seddon for restoration and placed in the King's Writing Room at Windsor Castle, they were subsequently transferred to the Grand Corridor (see no. 410).

Oak, tortoiseshell, brass. 126 × 125 × 45 cm
One stamped DELORME (for J.L.F. Delorme, maître 1763, as restorer); two bronzes stamped FAIT par C [?] Richar.
RCIN 35486.1–2
PROVENANCE Possibly Robert Fogg; (?)from whom acquired by George IV, 2 February 1813 (PRO LC11/14, quarter to 5 April 1813)
LITERATURE Pradère 1997; Roberts (H.A.) 2001, p. 173

100
FERDINAND BERTHOUD (1727–1807),
CHARLES CRESSENT (1685–1768) and
B.L. VULLIAMY (1780–1854)
Longcase equation clock, c.1755

Ferdinand Berthoud, clock-maker to Louis XV and to the French navy, was accorded the unusual distinction for a foreigner of election in 1764 to a Fellowship of the Royal Society of London in recognition of his contribution to horological theory, particularly in the area of marine chronometers and equation movements (i.e. those which automatically correct the difference between solar and mean time).

Berthoud's original equation and calendar movement for no. 100, of which only the centre part of the dial survives, cannot have been made before 1753, the year Berthoud became *maître-horloger*. The case, which is unquestionably by the sculptor and cabinet-maker Charles Cressent, is therefore likely to be a fairly late repetition of a model he had first devised in the 1730s. The perfectly integrated gilt bronze mounts, notably the elegantly poised figure of Time, betray Cressent's training as a sculptor, a skill which he continued to practise in defiance of the strict Parisian guild rules which prohibited cabinet-makers from manufacturing their own bronze mounts.

Although the early provenance of no. 100 has not been established with certainty, it may have been owned by M. de Selle, *Trésorier-général* of the French navy, whose distinguished collection of furniture by Cressent, sold in Paris in 1761, included a clock, with movement by Berthoud, exactly fitting the description of no. 100 (Ballot 1919, p. 240). It is first recorded in the Royal Collection in the background of the celebrated portrait of Queen Charlotte in Buckingham House with her two eldest sons, painted by Johann Zoffany c.1765 (Millar (O.) 1969, no. 1199). George III presumably acquired the clock for the Queen in deference to her taste for French works of art; but, given his own special interest in horology, he would also have recognised it as a notable addition to the growing collection of important timepieces at Buckingham House (see nos 83, 87).

The present eight-day equation movement, numbered 783, was inserted by George IV's clock-maker B.L. Vulliamy in 1821 (while the clock was at Kew) at a cost of £37 16s.; the case was restored at the same time for £12 12s. (PRO LC11/34, quarter to 5 January 1822). No. 100 was sent to Windsor Castle on 10 December 1828 where it joined a clock of the same model (but earlier date; RCIN 30036) in the Grand Corridor (see no. 409). That clock, which had been purchased by George IV, has an equation movement of 1736 by Berthoud's great rival Julien Le Roy.

◁ 100

Oak, pine, purplewood, mahogany, gilt bronze. 236.2 × 70.5 × 35 cm
Inscribed on the dial *Ferdinand Berthoud AParis* and *Vulliamy LONDON A.D. 1821*;
movement inscribed *783 Vulliamy LONDON*
RCIN 30035
PROVENANCE Possibly M. de Selle, sale Paris, 1761; acquired by George III, c.1764
LITERATURE Ronfort 1984, pp. 108–09; Pradère 1989, fig. 96
EXHIBITIONS QG 1974–5, no. 44

101
Follower of ANDRÉ-CHARLES BOULLE (1642–1732)
Two pairs of pedestals, c.1770

Pedestals of this sturdy form, with the characteristic scrolled and fringed apron at the front (often veneered with blue-tinted tortoiseshell and pewter marquetry) and bold gilt bronze foliage mounts at the side, are among the most familiar and often repeated of the furniture designs of André-Charles Boulle. The design for the model appears on the engraved title page of Jean Mariette's *Nouveaux Deisseins ... Inventés*

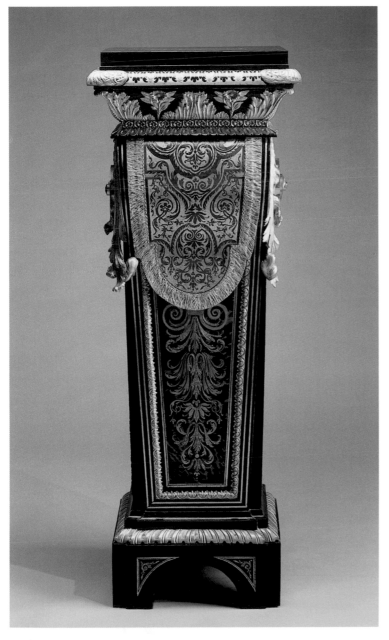

101

et gravés par André-Charles Boulle, published after 1707 and before c.1720; and from the evidence of Boulle's workshop records and eighteenth-century sale catalogues, it never entirely fell out of fashion. Mariette's engraving shows pedestals lined up against pilasters along the side of a room, supporting pairs of vases, and their continuing popularity was no doubt due to their adaptable, semi-architectural function. They could equally well be used for busts, bronzes or candelabra. A number of later eighteenth-century versions also exist, some stamped by makers such as E. Levasseur or N.-P. Séverin who specialised in the manufacture and repair of Boulle furniture. The Royal Collection pedestals, which are unstamped, appear to belong to this second, later group.

George IV's enjoyment of Boulle furniture, of which nos 96 and 99 are witness, did not extend to the acquisition of any pedestals of this model. However, his brother Frederick, Duke of York, who shared many of his tastes, possessed three pairs (sold after his death in 1827) and the first Duke of Wellington, also a great devotee of Boulle furniture, in 1818 acquired four of this model which are still at Stratfield Saye. These pedestals were presented to King George V and Queen Mary by Sir Richard Molyneux (1873–1954), Groom-in-Waiting to the King from 1919 to 1936 and Extra Equerry to Queen Mary from 1936; the gift may have been suggested by Lord Gerald Wellesley, later seventh Duke of Wellington (1885–1972), who was Surveyor of the King's Works of Art from 1936 to 1943. The pedestals had been acquired from Partridge in 1935 and, from the evidence of French customs labels, were in a French collection in the early part of the twentieth century.

Oak, ebony, brass, pewter, tortoiseshell, gilt bronze. 128 × 49 × 34.2 cm
RCIN 20549, 20559
PROVENANCE Unknown French collection; Messrs Partridge, London; from whom purchased by Major the Hon. Sir Richard Molyneux, 27 May 1935 (£525); by whom presented to King George V and Queen Mary, 1936
LITERATURE: Pradère 1989, pp. 105–06 (related examples)

102
FRENCH
Perfume vase and cover, c.1770

Porphyry has been valued since antiquity for its rarity and for its purple-red colour, sometimes associated with royal or imperial rank. In Florence and Rome in the sixteenth century the technique of cutting this extremely hard and intractable stone – virtually lost in the Middle Ages – was once again mastered, and the fashion for decorative objects in this exotic material was almost immediately established.

Towards the end of the reign of Louis XV, the royal workshops of the Hôtel des Menus-Plaisirs in Paris, controlled from 1770 to 1774 by the King's close friend the Duc d'Aumont (1709–82), produced magnificent hardstone objects, including vases of porphyry. François-Joseph Belanger (1744–1818) provided designs and the work was executed by the marble-cutter Augustin Bocciardi (fl.1760–90). A number of these objects, mounted in gilt bronze by Pierre Gouthière (1732–1813/14), were acquired personally by D'Aumont. Other Parisian stone-cutters who were able to work the material included Jacques Adam (fl. 1745–65), maker of the Marquis de Voyer's splendid vase of

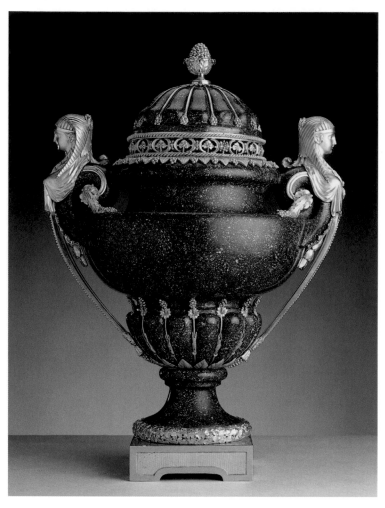

102

103

MARTIN CARLIN (c.1730–1785) and DOMINIQUE DAGUERRE (fl.1772–d. 1796)
Cabinet (commode à vantaux), *c.1778*

Above all else this cabinet is a vehicle for the display of the pietra dura panels that adorn its front and sides. The ostentatious massing of these panels, seven carved in relief with fruit on the front and six inlaid panels at either end, consciously evokes the luxury and splendour of the *grand siècle*, as do the unusually densely modelled gilt bronze mounts. The panels themselves almost certainly come from one of the great cabinets made for Louis XIV in the royal workshops at the Gobelins; during conservation, two of the relief panels were found to be signed on the back *Gachetti* [sic], for Gian Ambrogio Giachetti, a Florentine lapidary working at the Gobelins between 1670 and 1675.

Most of these royal cabinets were broken up in the eighteenth century as they went out of fashion, but the pietra dura panels were preserved as precious objects in their own right. With the revival of interest in the Louis XIV period during the 1760s and 1770s, these panels began to be recycled on neo-classical furniture. Among the *marchands-merciers* (dealer-decorators) who specialised in this field were P.-F. Julliot and Dominique Daguerre. It was almost certainly the latter who commissioned this ambitious piece from Martin Carlin, one of a group of cabinet-makers who worked more or less exclusively for Daguerre.

The first owner of this cabinet was the notorious Parisian opera singer Marie-Joséphine Laguerre (1754–82), whose dissolute life led her to an early grave. It appeared in the sale of her collection, among other furniture by Carlin and Weisweiler. Subsequently it belonged to Baron de Besenval (see also no. 314), Colonel of the Swiss Guards and friend of Marie-Antoinette, at whose sale in 1795 Daguerre's connection with its manufacture was first noted.

George IV, whose liking for pietra dura was almost as marked and long lived as his love of Sèvres porcelain, acquired the cabinet in Paris in 1828 through his confectioner François Benois. It may first have been placed in the King's temporary apartments in St James's Palace, but was intended eventually for the rebuilt Buckingham Palace.

Oak, ebony, pietra dura, gilt bronze, marble. 105.2 × 152.5 × 58.4 cm
Stamped four times M. CARLIN JME
RCIN 2588
PROVENANCE Probably made for Marie-Joséphine Laguerre, c.1778; her sale, Paris, 1782; Baron de Besenval sale, Paris, 1795; J.-J.-P.-A. Lapeyrière sale, Paris, 1825; bought in Paris for George IV, May 1828 (£375; Jutsham II, p. 251)
LITERATURE Harris, De Bellaigue & Millar 1968, p. 146
EXHIBITIONS QG 1966, no. 38

104

JEAN-HENRI RIESENER (1734–1806)
Chest-of-drawers (commode), *1774*

The history of this imposing piece of furniture was discovered by Pierre Verlet, whose pioneering researches in the 1930s first re-established the link between the numbers painted on certain pieces of French furniture and surviving royal inventories. No. 104 was ordered for the Chambre

1763–4 in the Wallace Collection (Hughes (P.) 1996, no. 284). In Rome the production of worked porphyry continued with stone-cutters such as Lorenzo Cardelli (fl.1750–1800) and A.-G. Grandjacquet (1731–1801). Some of this work was undoubtedly exported to France.

The porphyry body of no. 102 may well have been fashioned in Paris in the late 1760s, although features such as the scrolled handles (now concealed by the mounts) might suggest a slightly earlier date. In form it is not unlike a pair of porphyry vases with gilt bronze mounts in the Wallace Collection (Hughes (P.) 1996, no. 287), of c.1765–70. However, the delicately chased *style étrusque* mounts of no. 102, the handles cast with Egyptian sphinx heads, are very different in character to those of the Wallace vases and may be compared to the documented work of Pierre Gouthière or François Rémond (1747–1812) in the 1770s.

No. 102 may have been acquired for George IV by his confectioner and part-time agent François Benois, together with a pair of porphyry and gilt bronze tripods (RCIN 35237). The three porphyry objects were on display in the Gothic Dining Room at Carlton House in the late 1820s (no. 424).

Porphyry and gilt bronze. 49.5 × 35.1 × 25 cm
RCIN 4605
PROVENANCE Possibly acquired by George IV (through F. Benois) in 1814 (£270 16s. 8d. for '3 large Porphyry vases finely mounted'; PRO LC11/18, quarter to 10 October 1814)
EXHIBITIONS London 1862a, no. 7861

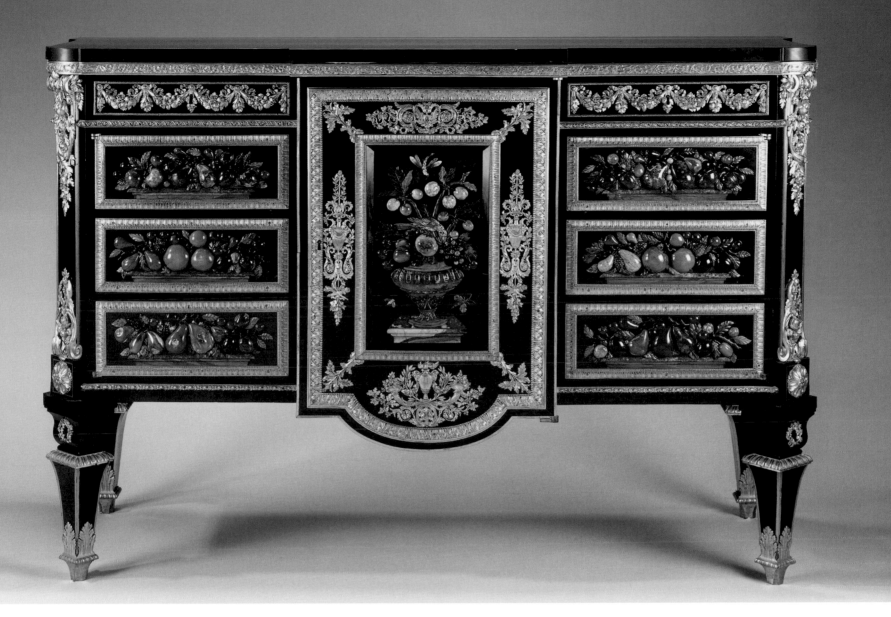

103

du Roi at Versailles shortly after the death of Louis XV in May 1774. It replaced the old-fashioned rococo commode (now in the Wallace Collection: Hughes (P.) 1996, no. 178), made by Gaudreaus and Caffiéri in 1739, which had been taken as a perquisite of office by the Duc d'Aumont (see no. 102). In design and price (7,800 livres reduced to 7,180 livres), no. 104 compares very closely with several other commodes in a similarly restrained neo-classical idiom made by Riesener for the French royal family in the 1770s. The careful construction, which includes central locking for the three short drawers in the frieze and two long drawers below, is typical of Riesener's best work.

No. 104 was completed in slightly over three months and was in place before the return of the court at the beginning of September 1774. To achieve this, Riesener may have had to use some 'stock' elements, for example partly prefabricated marquetry panels (though presumably not the highly characteristic and exquisitely finished central panel representing la *poésie pastorale*), and perhaps some mounts. Whatever the case, the new commode was itself displaced a year later by a considerably more lavish example, which took Riesener fourteen months to make and cost the enormous sum of 25,356 livres. No. 104 was then transferred to the adjoining Arrière-Cabinet du Roi before moving in 1780 to one of the most important rooms at Versailles, the

Cabinet Intérieur du Roi. At this point the original white marble top was changed to the present *griotte d'Italie* to harmonise with the existing chimneypiece in that room, and a pair of corner cupboards (RCIN 21212) were made to match. The ensemble was sold in 1794, with a writing table from the same room (now at Waddesdon Manor), for the negligible sum of 5,000 livres. George IV bought no. 104, the corner cupboards and three other pieces by Riesener thirty-one years later at the sale of George Watson Taylor's celebrated collection, for use at Windsor (see no. 105). In 1855 it was recorded in the King's Bedroom, which was used during the State Visit of the Emperor Napoleon III and the Empress Eugénie to Windsor (no. 411).

Oak and marquetry, gilt bronze, marble. 91 × 153 × 63 cm
Inscribed Nᵒ 2777
RCIN 21213
PROVENANCE Louis XVI, made for the Chambre du Roi, Versailles, 1774; sold 1794; George Watson Taylor; his sale, Christie's, London, 28 May 1825 (58); bought by Robert Fogg for George IV (56 gns; Jutsham II, pp. 195–6)
LITERATURE Verlet 1990, p. 21; Verlet 1994, no. 13, pp. 144–8; Roberts (H.A.) 2000, p. 119
EXHIBITIONS London 1853b, no. 62; QG 1966, no. 7

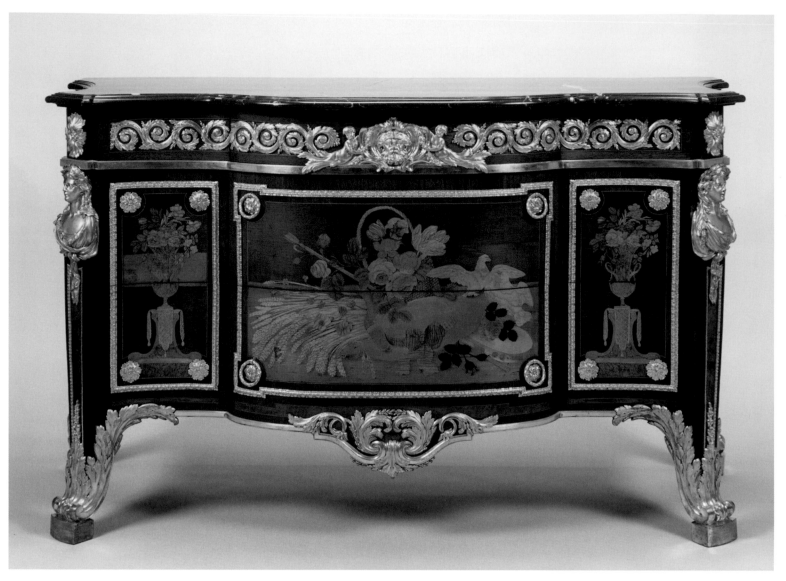

104

105

JEAN-HENRI RIESENER (1734–1806)
Jewel-cabinet, c.1787

Long regarded as one of the greatest masterpieces of furniture in the Louis XVI style, this *objet de luxe* combines cabinet-making virtuosity of a high order with quite exceptional gilt bronze mounts. The well-figured, plain mahogany veneers, characteristic of Riesener's output in the later 1780s, provide a deliberate foil to the mounts, jewel-like on the doors (as befits the purpose of the cabinet) and treated as sculpture-in-the-round at the front angles and on the cresting.

Although signed, the cabinet bears no French royal inventory number (see no. 104). However, the prominent coat of arms identifies the first owner as Marie-Joséphine-Louise of Savoy, who married Louis XVI's younger brother, the Comte de Provence (the future Louis XVIII), in 1771. We know that, as *ébéniste du roi*, Riesener supplied furniture for the royal couple in the 1770s, and that he was working for them directly in the early 1780s. The jewel-cabinet stood in their apartments in the Palais du Petit-Luxembourg, but no documents relating to its commission have yet come to light. The maker of the bronzes is also

unknown, although the *bronzier* François Rémond, who certainly worked for Riesener, is a possible candidate.

The subsequent history of the cabinet provides a fascinating commentary on changing tastes. Confiscated with the rest of the Provence property in 1793, it was initially reserved for display in a national museum. Three years later, as the financial situation in France worsened, the cabinet was sold off. In 1809 it was offered to the imperial household for 30,000 francs by the then owner, who was said to have paid over 60,000 francs for it. Napoleon was strongly encouraged to acquire the cabinet for Saint-Cloud, but this advice was unequivocally rejected in 1811: 'S.M. veut faire du neuf et non acheter du vieux' (QG 1988–9, exh. cat., p. 109). George IV had no such inhibitions when it came up for sale in the Watson Taylor collection; he purchased it for 400 guineas with the intention of using it at Windsor Castle. In 1853 Queen Victoria allowed the fourth Marquess of Hertford to have a copy made. Executed by John Webb in 1855–7, it cost the enormous sum of £2,500 (Hughes (P.) 1996, I, pp. 32–3).

Oak, mahogany, gilt bronze. 246 × 147 × 54.6 cm
Stamped J.H. RIESENER
RCIN 31207

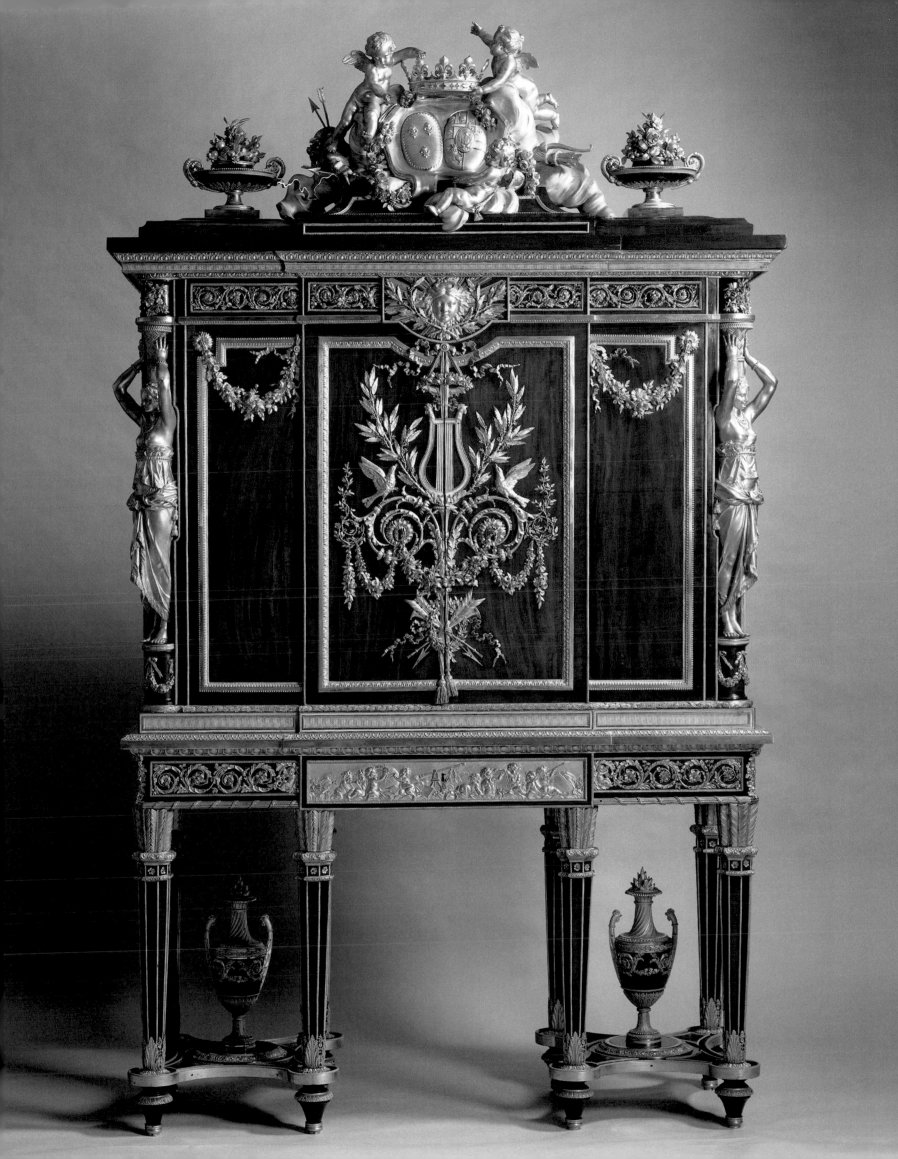

PROVENANCE Made for the Comtesse de Provence, c.1787; confiscated 1793; sold 1796; femme Aulmont, by 1809; George Watson Taylor; his sale, Christie's, London, 28 May 1825 (76); bought by Robert Fogg for George IV (400 gns; Jutsham II, p. 200)
LITERATURE Verlet 1955, p. 23; Roberts (H.A.) 2000, p. 119
EXHIBITIONS London 1853b, no. 71; Manchester 1857; London 1863, no. 843; QG 1966, no. 45; QG 1988–9, no. 103

106

FRENCH
Pair of tripod vases, c.1785

The Duc d'Aumont's numerous commissions at the Menus-Plaisirs in the 1770s and early 1780s (see no. 102) clearly show the Parisian taste for mounting richly coloured marbles or hardstones in gilt bronze to make fashionable ornaments. The Duc employed Pierre Gouthière to make mounts for him and the magnificent results can be seen in such pieces as the pair of jasper and gilt bronze tripod perfume burners now in the Wallace Collection (Hughes (P.) 1996, no. 275). The maker of the very finely chased and gilded mounts of no. 106, with goats' heads terminating in spirally twisted 'horns', probably worked – like Gouthière – in the circle of the *marchand-mercier* Dominique Daguerre (Verlet 1987, p. 355). A possible candidate is Pierre-Philippe Thomire (1751–1843), who from 1783 was the principal maker of mounts for Sèvres vases (see nos 134–5) and whose documented work for Daguerre included mounts which closely resemble those on no. 106 (Savill 1988, no. C340–2).

The design of these tripods, which include supports with goats' heads and hooves surrounding a coiled serpent, derives from J.-M. Vien's influential neo-classical masterpiece *Une Prêtresse qui brûle de l'encens sur un trépied* of 1763, engraved in 1765 as *La Vertueuse Athénienne*. The picture was owned by J.-H. Eberts, publisher of the engraving, who issued a design of his own in about 1773 for a tripod based on that in Vien's painting. He described this object as an *Athénienne*, a name that has since generally attached itself to tripods of this type (Eriksen 1974, p. 403).

These vases were probably among the large quantity of fashionable Parisian furniture and *objets d'art* supplied by Dominique Daguerre to George IV for Carlton House in the late 1780s or early 1790s. They are first recorded at Carlton House in the Admiral's (later Blue Velvet) Room (see no. 421) in June 1807 (Jutsham I, p. 11). Eventually they were sent from store to Buckingham Palace in July 1837, the first month of Queen Victoria's reign (CHI, vol. H1, p. 175).

Marble, gilt bronze. 42.6 × 19 cm diameter
RCIN 237
PROVENANCE Probably Dominique Daguerre; by whom supplied to George IV, c.1790
EXHIBITIONS QG 1991–2, no. 70

107

ERNST ANTON PLISCHKE (1903–1992)
Writing desk, 1947–9

This desk was the wedding present of the government of New Zealand to Princess Elizabeth and Prince Philip. It was made in the Auckland workshop of E.H. Foster, to the designs of the Austrian *émigré* architect Ernst Plischke. Like his fellow architects Richard Neutra (1892–1970) and Rudolph Schindler (1887–1953), Plischke left Austria in 1939 in the wake of Hitler's *Anschluss*. While Neutra and Schindler settled in the United States, Plischke moved with his family to New Zealand, where he worked as an architectural draughtsman in the Department of Housing and Construction. He was perhaps the key figure in the introduction of Modernist architecture in New Zealand, designing forty houses in and around Wellington, and founding the city's Architectural Centre in 1946. He returned to Vienna in 1963 to take up a chair in the Architecture School of the Academy of Fine Arts.

Plischke had made numerous designs for furniture and interiors before leaving Austria, notably an entire apartment for the ceramic artist Lucie Rie (1902–95), which was completed in 1928 (see no. 114). The panelled interior with all its furnishings was moved to London when Rie also fled from Austria in 1938, and installed in her house in Kensington. Following her death in 1995 they were acquired by the Austrian state and reinstalled in the museum of the Bundesmobiliendepot in Vienna.

It was the express wish of the then Prime Minister of New Zealand, Peter Fraser, that the wedding present should be the result of a collaboration between as many competent craftsmen as possible, and that it should make full use of the rich palette of native woods and incorporate traditional Maori craftsmanship. The upper surfaces of the desk are veneered in a richly figured mottled totara, while the drawer fronts are

◁ 106

in mottled puriri. The pictorial marquetry on the cupboard doors (each of which conceals four drawers) was executed by H.C. Osborne of Auckland to the designs of S.M. Williams of Wellington, and represents some of the birds and flowers of New Zealand; on the left the flowers are rata, clematis, manuka, fern, violet and fuchsia, with a miro-miro bird and a shining cuckoo. On the right the flowers are hoheria, pohutukawa, kowhai, celmisia and veronica, with the bell bird and the fantail. The central recess of the cupboard section was worked in the traditional Maori tukutuku technique by Miss E. Mitchell and Mrs H.T. Morrison of Ohinemutu, Rotorua, while Maori carvings inset with paua shell ornament its supports.

The decorative potential of New Zealand timbers (especially of totara 'knot' or burr veneer used extensively on the writing desk) was first brought to the attention of Northern cabinet-makers by the enterprise of the Pomeranian-born Johann Martin Levien (b. 1811), whose workshop in London employed a range of New Zealand woods on French-inspired drawing-room furniture during the 1840s and 50s. A jewel casket on stand which combined New Zealand veneers and Sèvres porcelain plaques was exhibited by Levien at the Great Exhibition in 1851 and was acquired by Queen Victoria (RCIN 169).

Many of the same woods were used for the marquetry decoration of an imposing bureau-cabinet presented to Queen Victoria in 1861 by the people of Auckland and exhibited at South Kensington in the following year (RCIN 100). It was the masterpiece of another Austrian *émigré*, the cabinet-maker Anton Seuffert (1815–87).

Various woods including mottled totara, mottled puriri, stripe mangeao, kauri, towal, rata, kohekohe and pukatea; paua shell. 122.6 × 140.2 × 96.3 cm
RCIN 33401
PROVENANCE Commissioned by the government of New Zealand; by whom presented to TRH Princess Elizabeth and Prince Philip, 1949

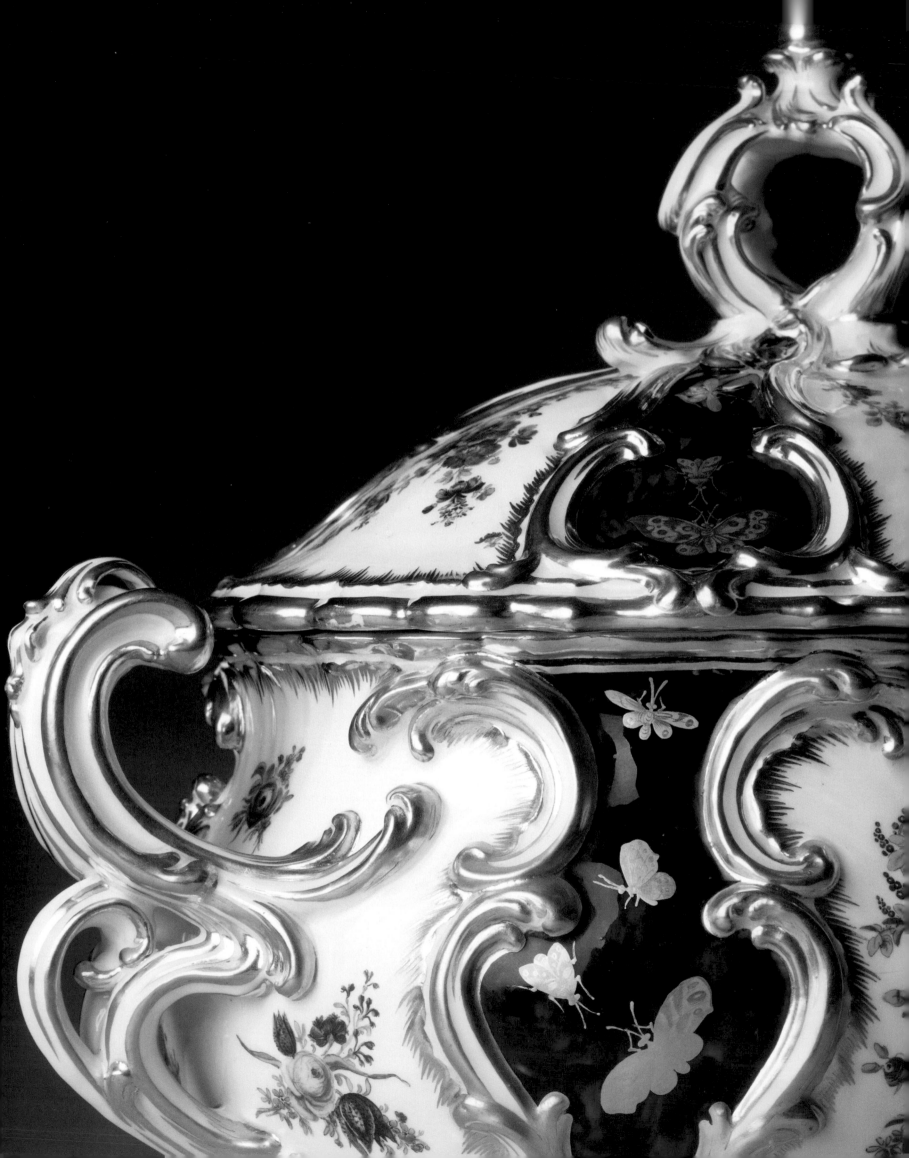

ENGLISH CERAMICS (nos 108–114)

British monarchs, unlike those of Prussia, Saxony, Naples and, above all, France (see p. 197), have never taken a direct controlling interest in a porcelain factory, although royal patronage has played an important role throughout the history of porcelain production in England. Porcelain factories began to be established in this country in the first half of the eighteenth century, often by immigrant continental artists and craftsmen. The artists employed in the Lawrence Street works in Chelsea from 1749 were almost all of French or Flemish origin. The proprietor and manager, Nicholas Sprimont (1716–71), had practised successfully as a goldsmith (see nos 178–80) and one of the characteristics of his productions at Chelsea is their close similarity to forms familiar from silver. Much of what is known about the factory comes from research into contemporary newspapers and sale catalogues. In 1763 one newspaper announced that the King's uncle William, Duke of Cumberland, was to purchase the factory, but although the Duke was a regular purchaser of Chelsea wares and was financially involved with Sprimont, there seems to have been no factual basis for the report. None the less, the order for the Mecklenburg Service (no. 108) enabled the factory to associate its productions with royal patronage, referring to wares produced with the same 'mazarine' blue and floral decoration as 'of the pattern of the royal service'.

Sprimont eventually sold his business to the Derby concern of William Duesbury, which became renowned for its unglazed 'biscuit' productions, rivalling those of the Sèvres factory. Several mantel and pedestal clocks made for George III and George IV by Benjamin Vulliamy feature groups in Derby biscuit porcelain modelled by George III's favourite sculptor John Bacon (see no. 68). Bacon provided the patterns for jasper medallions of George III and Queen Charlotte produced by Josiah Wedgwood in 1777, and modelled a group of figures based on Johan Zoffany's group portrait of the royal family in 'Van Dyck' costume (Millar (O.) 1969, no. 1201) for production in biscuit porcelain at Derby around the same date (RCIN 37020–2).

Queen Charlotte, who was among the first in this country to collect Sèvres porcelain, was equally active in the purchase of English wares. In 1765 the Queen ordered an elaborate tea service from Josiah Wedgwood (1730–95), and in the following year she allowed Wedgwood to use the words 'Potter to Her Majesty' on his billheads and to refer to his new creamware as 'Queen's Ware'. Queen Charlotte's collection of Wedgwood was dispersed in her posthumous sale in 1819 but many pieces, or their equivalents, were purchased in the first half of the twentieth century by Queen Mary, who made a systematic but largely unsuccessful attempt to reacquire for the collection what had been sold in 1819.

During the first years of the nineteenth century the factories at Worcester and in the district of Stoke-on-Trent began to compete for royal patronage in their attempts to take advantage of the interruptions in the supply of Sèvres due to the protracted hostilities between England and France. George IV and his brother William IV visited the Worcester, Wedgwood and other Staffordshire factories. Many pieces from the resulting commissions remain in the Royal Collection (see nos 110–12, etc.). These factories made as much capital as possible from the royal orders, using new marks and billheads to proclaim their royal associations, and the Rockingham Works placed their great royal service (no. 113) on public exhibition in London before it was delivered.

During the middle of the nineteenth century English ceramic manufacture was dominated by the enterprise of Herbert Minton, whose father Thomas had founded a factory at Stoke in 1796. Herbert Minton was one of the moving spirits of the Great Exhibition of 1851 and his Parian productions included not only royal portraits but a number of reductions of full-size marble statues in the Royal Collection (see also no. 94). The majority of the Minton service which won a gold medal at the exhibition was purchased by Queen Victoria for presentation to the Emperor Joseph I (Vienna, Hofburg; inv. no. 180441), and this was followed by orders for a very extensive service with *bleu celeste* borders and biscuit table ornaments (RCIN 9153), a service reproducing the paintings of Landseer (RCIN 15898) and another to mark the marriage of the Prince of Wales and Princess Alexandra in 1863 (RCIN 58229). Minton also supplied the tiles for the walls and floor of the Royal Dairy at Frogmore, and encaustic tiles for the Grand Corridor at Osborne, where many of the later productions of the factory can still be seen. The Minton factory is still in production and made the large heraldic vase presented to Her Majesty The Queen to mark the Coronation in 1953 (RCIN 57141).

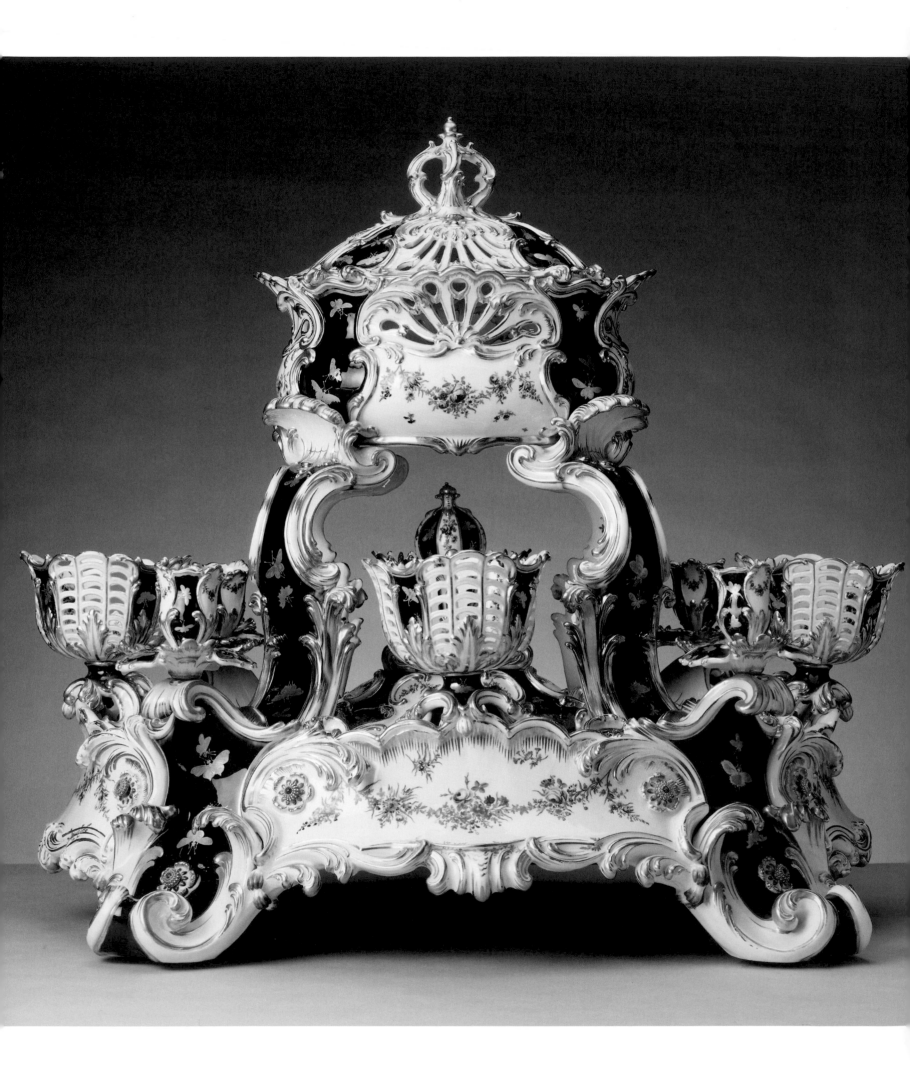

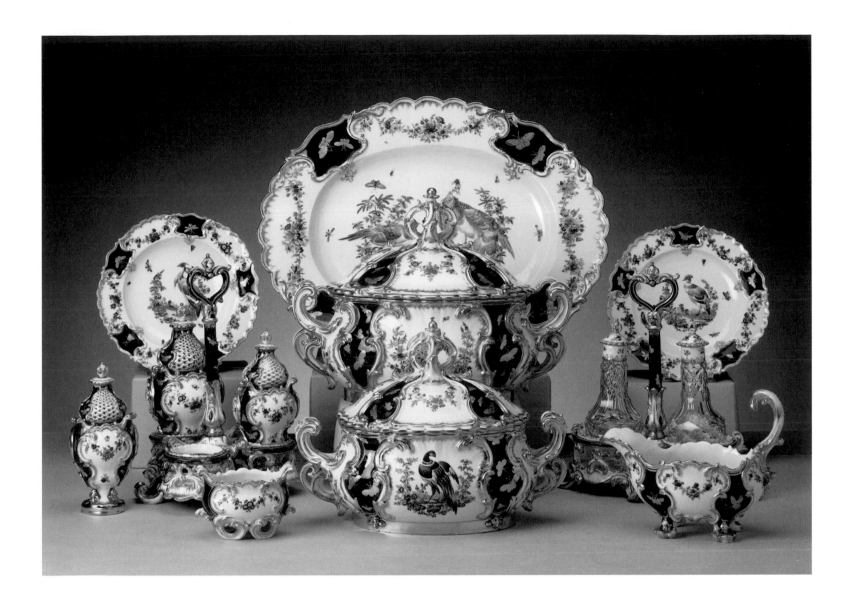

108

CHELSEA
Pieces from a dinner and dessert service, 1763

This combined dinner and dessert service, which originally also included tea and coffee wares, was presented by George III and Queen Charlotte to the Queen's elder brother, Adolphus Frederick IV, Duke of Mecklenburg-Strelitz (1738–94; see also no. 288). The service – known as the Mecklenburg Service – was completed by March 1763, when it was described by Horace Walpole in a letter to Horace Mann: 'There are dishes and plates without number, an epergne, candlesticks, salt-sellers, sauceboats, tea and coffee equipages, in short, it is complete, and costs twelve hundred pounds! I cannot boast of our taste; the forms are neither new, beautiful, nor various. Yet Sprimont, the manufacturer, is a Frenchman. It seems their taste will not bear transplanting' (*Walpole Correspondence*, XXII, pp. 121–2). Factual inaccuracies aside – Nicholas Sprimont was in fact from Liège in Flanders – this was a misleading and probably not widely held assessment. Another who saw the service before its departure, Queen Charlotte's biographer John Watkins, declared that he 'never saw any Dresden near so fine' (Jewitt 1878, I, p. 171).

As indicated by Walpole, the plates do indeed follow an existing pattern, first used at Chelsea in around 1757 for a service decorated

with fruit and flowers, of which a large number of pieces are in the Royal Collection (for instance, RCIN 58781). However, precedents for the Mecklenburg Service are more likely to be found in silver than in porcelain. When Nicholas Sprimont – a professional goldsmith and designer – arrived to manage the Chelsea works in 1749, the table services in the fashionable aristocratic houses were all of silver, and the difference in quality and refinement between English silver and English porcelain was vast (Mallet 1969). From the 1750s his annual sales of new wares featured 'useful' items such as 'Lustres and Epargnes ... Girandols, Candlesticks and Branches' (Nightingale 1881, p. xiii), which were clearly intended to supplant their silver equivalents. The silver ancestry of the Mecklenburg Service can be seen in the design of the plates – with scalloped edges and reserves within raised borders around the rim – the cruets, candelabra and, above all, the epergne or centrepiece, a type of object previously confined exclusively to silver (see no. 178).

For the decoration of the service Sprimont employed the deep cobalt pigment known as 'mazarine' blue which had first appeared at Chelsea in 1756, probably as a response to the French *bleu lapis* (Mallet 1996). It was applied thickly and fused to the glaze. Although it must have been intended to remain within the barrier formed by the borders of the reserves, in several instances the colour seems to have escaped. These

faults were disguised by butterflies and other insects applied in gold, following the practice of earlier Meissen decorators. The gilding is everywhere carefully burnished. The painted centres, with pheasants and other exotic but unspecific birds, also recall in their palette and style the work of the Meissen painters.

When Queen Victoria's first cousin Princess Augusta of Cambridge married the Grand Duke of Mecklenburg-Strelitz (himself a second cousin of both Victoria and Augusta) in 1843, she found the service in use below stairs by the castle servants at Neu Strelitz (MS memorandum by Queen Mary; RA GV/CC 55/324). Having redeemed it for the Duke's dining table, the Princess commissioned a number of replacement pieces in 1847 and 1849 from the Prussian royal factory (Königliche Porzellan-Manufaktur) at Berlin. A pair of broken candelabra was disposed of somewhat later by the castle steward and entered the Schreiber collection in London in 1867 (now Victoria and Albert Museum; Rackham 1928, no. 210).

Queen Mary (Princess Augusta's niece) herself saw the service at Neu Strelitz in 1904 and arranged it in two display cabinets in the dining room. However, after the end of the First World War the Mecklenburg family were forced to dispose of it. Although the service was offered to King George V by Duveen, it was not until 1947 that it entered the Royal Collection through the gift of Mr James Oakes. There are 137 Chelsea pieces and 5 Berlin replacements.

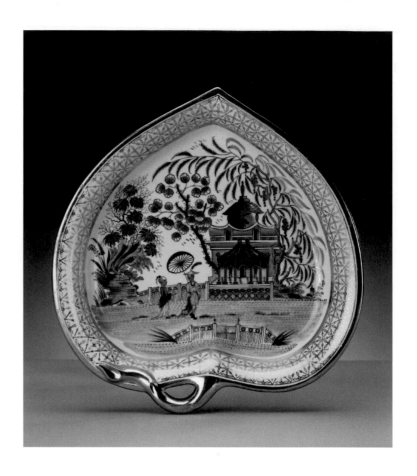

Soft-paste bone-ash porcelain. Centrepiece 42.5 × 66.7 × 59 cm; large tureen 24.3 × 27.2 × 21.2 cm; small tureen 14.2 × 27.2 × 21.2 cm; cruet set (porcelain bottles) 31.8 × 21.9 × 22.7 cm; cruet set (glass bottles) 30 × 28 × 15.3 cm; sauceboat 17.2 × 21.7 × 11.6 cm; salt 8.2 × 11.6 × 8.3 cm; oval platter 41 × 51 cm; plates diameter 23.5 cm

Inscribed in gold with anchor, on the underside of each piece

RCIN 57012.2 (large tureen), 57012.3 (small tureen), 57013.1 (sauceboat), 57014.2 (porcelain cruet set), 57015.8, .28, .44, .48 (plates), 57022.1 (oval platter), 57023.1 (glass cruet set), 57024.6 (salt), 57028 (centrepiece)

PROVENANCE Commissioned by George III and Queen Charlotte; by whom presented to her brother Adolphus Frederick IV, Duke of Mecklenburg-Strelitz, 1763; by descent until 1919; Sir Joseph (later Lord) Duveen; James Oakes; by whom presented to HM Queen Elizabeth The Queen Mother, 1947

LITERATURE Severne MacKenna 1952, pp. 13, 15–16, 65–6; Hughes (G.B.) 1960

EXHIBITIONS London 1955; Paris 1959, no. 183; QG 1966–7, no. 50; QG 1974–5, no. 50; London 1984, no. O39; QG 1988–9, no. 111; Mecklenburg 1995, no. 6.30; London 1999c, no. 110

109
LONGPORT, STAFFORDSHIRE (JOHN & JAMES DAVENPORT)
Pieces from a dessert service, 1806–07

In September 1806 the Prince of Wales (later George IV) and his brother William, Duke of Clarence (later William IV), made a tour of several porcelain factories while staying at Trentham in Staffordshire as the

▽ 110 (plates)

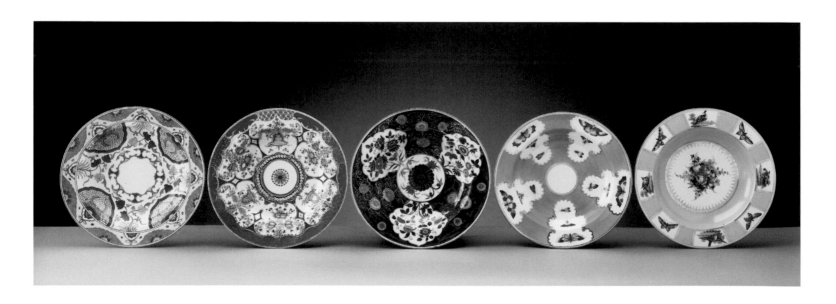

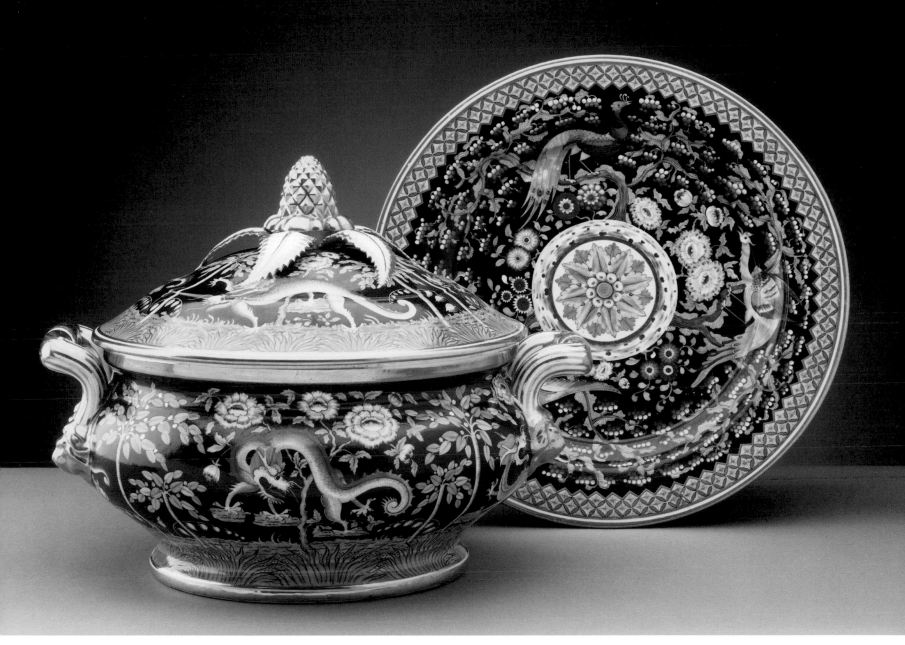

110 (tureen and tureen stand)

guests of Lord Gower. Having taken in the Spode and Wedgwood premises, the royal tourists went to Longport near Newcastle under Lyme to inspect the small factory which John Davenport (1765–1848) had purchased in 1794 for the production of glass and pottery. By the time of the royal visit, John Davenport was in partnership with his cousin James. According to the *Staffordshire Advertiser* of 20 September, George IV provided great encouragement for the enterprise by observing that the factory's productions were 'in texture and execution equal to the Old Seve [Sèvres], that the Colours and Paintings did great credit to the Artists, and that he should feel proud in exhibiting them to his Foreign Visitors, to shew them, that their boasted superiority was now nearly, if not entirely, at an end' (see Lockett & Godden 1989, p. 200). The visit resulted in substantial orders for the factory, including a 'full Dinner & Desert Service & Tea & Coffee Service to Match, of fine China, Painted Chinese Temple & rich burnished Gold Mosaic Border' which together comprised over six hundred pieces; no. 109 is part of that dessert service. The decoration is rather less dependent than the Worcester 'Harlequin' service (no. 110) on actual Chinese designs, and the 'temple' motif seems more like a thinly disguised Western classical building. George IV's visit also resulted in the purchase of a quantity of glasses and decanters, and ornamental vases.

Bone china. Leaf-shaped dishes 23.7 × 25 × 4.9 cm; lobed dishes 26.2 × 18.3 × 3.4 cm
Inscribed in red on the underside of each piece LONGPORT (written in a curve) over an anchor
RCIN 57215.1–2 (leaf-shaped dishes), 57208.2, .8 (lobed dishes)
PROVENANCE Commissioned by George IV, 1806 (£847 1s., part of a service of over 600 pieces; invoice dated December 1807; RA GEO/26381)
LITERATURE Lockett & Godden 1989, pp. 200–02

110

WORCESTER (H. & R. CHAMBERLAIN)
Pieces from a dinner service and dessert service, 1807–16

During a visit to Worcester in September 1807, the future George IV toured both of the principal porcelain factories – Barr, Flight & Barr and H. & R. Chamberlain – and granted each of them his Royal Warrant. From the Chamberlain factory he ordered dinner, dessert and breakfast services; each piece was to be decorated in a completely different pattern, described by Chamberlain as 'copied from old India and other China' (invoice of 31 July 1811, RA GEO/26398). The 140-piece harlequin dessert service was the first to be delivered, in July 1811. The matching dinner service, which took a further five years to complete, consisted of

six large round soup tureens (as here), two tureens for vegetables and six for sauce (all with stands), twelve dozen dinner plates, eight dozen soup plates (as here), one hundred and forty-seven dishes of varying shapes and sizes, and sixteen candlesticks. The painted decoration considerably extended the repertoire of 'Old Japan' patterns developed by Chamberlain from around 1800, to encompass Chinese *famille rose* and other styles in addition to countless variations on Japanese Imari designs. Several hundred of the original watercolour designs survive in a pattern book in the Royal Worcester Porcelain Museum. The total order, including the breakfast wares (which were delivered in October 1816), came to more than £4,000 (Binns 1877, p. 243).

Several members of the Chamberlain family were associated with the early history of porcelain manufacture at Worcester. Robert Chamberlain served his apprenticeship in the factory begun by Dr John Wall in 1751, and he and his two sons Robert and Humphrey were employed as decorators by Thomas Flight before starting their own production in around 1791. Following the elder Robert's death in 1798, this firm belonged to his sons and traded as H. & R. Chamberlain. Royal patronage helped to bring their productions to a wider public and on the strength of George IV's order they decided to open a showroom in London, where they promoted their new porcelain body known as 'The Regent'.

Hybrid paste porcelain ('The Regent' body). Tureen 24 × 32.2 × 26.5 cm; tureen stand diameter 30.7 cm; soup plates diameter 23.4 cm
Painted in red script under the lid of the tureen *Chamberlains / Worcester*; printed in puce script within a leafy cartouche on the underside of the tureen stand *Chamberlains / Worcester / & 155 / New Bond Street / London*; painted in red script on the underside of the plates *Chamberlains / Worcester*
RCIN 58401.1, .11, .31, .36, .40 (plates), 58403 (tureen and tureen stand)
PROVENANCE Commissioned by George IV, 1807 (£2,539 1s. for the dinner service; invoice dated 31 July 1816, RA GEO/26431)
LITERATURE Binns 1877, pp. 238–43; Sandon (J.) 1993, pp. 269–70
EXHIBITIONS Essen 1992, no. 501; Cardiff 1998, no. 113

111
LONGPORT, STAFFORDSHIRE (HENRY & WILLIAM DAVENPORT & CO.)
Pieces from a dessert service, c.1830–1

During the quarter of a century following the royal visit of 1806 (see no. 109), the Davenport factory underwent a huge expansion. By 1843 the combined pottery, porcelain and glass works employed about 1,500 people. There had been 'growing pains' as the firm established itself in the market, and the manufactory changed its name several times as the level of the various partners' interests altered. By 1830 the firm was in the hands of William and Henry Davenport, sons of the founder John Davenport, whose remaining years were devoted to politics, as Member of Parliament for Stoke from 1832.

William IV, who for many years had been an important patron of English porcelain manufacturers, decided to mark his coronation with expensive orders to Flight, Barr & Barr at Worcester (see no. 112), the Bramelds' Rockingham Works (see no. 113), and the Davenport factory. There was some competition between the factories to be the first to complete their services; John Davenport wrote anxiously to his son William on 22 November 1830, 'we shall I fear be the last to complete

[the King's] orders', but in fact his service seems to have been the first to be delivered.

The design and decoration of all the coronation services made use to some degree of the national emblems or royal coats of arms, but Davenport's was the most subtle, with a bouquet consisting of a red and a white rose, a shamrock, thistle and leek, tied with a 'Union Riband' at the centre of each plate, dish and comport. According to a further letter from John Davenport to his son of November 1830, the King 'wished the flowers as he had got *Arms and Crowns* enough on his other *Setts* – and that he wanted something more like the old *Seve* as ours was' (Lockett 1972, p. 80). In 1830 designs were submitted to the King's secretary Sir Herbert Taylor. John Davenport took great pains to ensure the highest standards, examining each trial piece before writing at length of its imperfections to his sons (Lockett 1972, pp. 79–82). The flower painting in the reserves (including roses, tulips, paeonies and auriculas), as well as the emblematic bouquets in the centres, was carried out by one Gould, probably the factory's chief flower painter. The service now consists of one hundred and four plates (as here); six round (as here), seven rectangular and four oval comports; eight shell-shaped comports; three covered comports with 'dolphin' supports, and three ice pails. Four of the plates were purchased by HM The Queen, in 1991 and 1996.

'Stone china'. Round comport 29 × diameter 29.5 cm; 'dolphin' comport 29.3 × diameter 21 cm; plates diameter 25.5 cm
Marked with pale blue overglaze transfer on underside of each piece DAVENPORT / LONGPORT / STAFFORDSHIRE
RCIN 57201.8, .9, .12, .16 (plates), 57203.1 ('dolphin' comport), 73279.1 (round comport)
PROVENANCE Commissioned by William IV, 1830
LITERATURE Lockett 1972, pp. 78–84; Lockett 1973, p. 33 and pls 26–7; Lockett & Godden 1989, pp. 43–5, 244–5

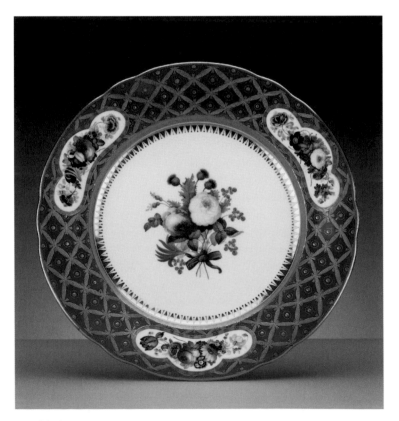

111 (plate)

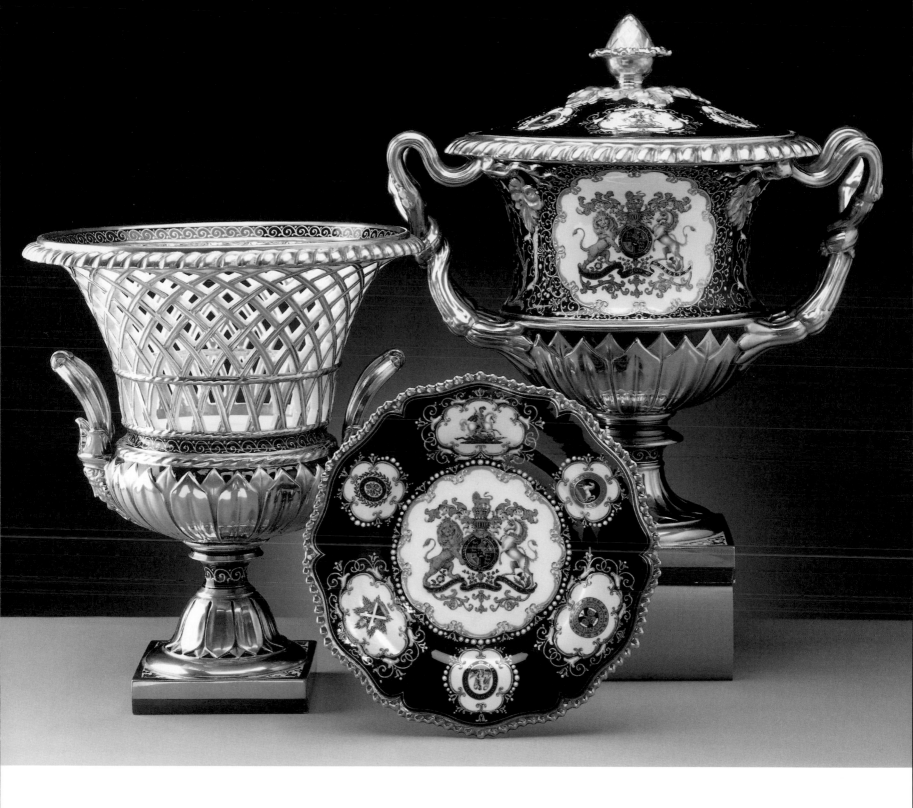

112

WORCESTER (FLIGHT, BARR & BARR)
Pieces from a dessert service, 1831–3

William IV was a patron of the Worcester porcelain factories for more than forty years. In 1789 he commissioned from the Flight factory a dessert service with a ribboned border inspired by Sèvres patterns, and decorated in honour of his elevation to the dukedom of Clarence and St Andrews; a small number of pieces from that service remain in the Royal Collection (RCIN 58103). In the following year he ordered from the same factory a large dinner service decorated with figures of Hope

and Patience, which became known as the 'Hope' Service. (A substantial portion of the 'Hope' Service was sold at Christie's, London, 24 February 1997 (65).)

It was the successor of the original Flight firm at Worcester – now under the ownership of Joseph Flight and the brothers Martin and George Barr – that received the order for this grand dessert service, commissioned at the time of William IV's coronation in 1831. The service, which was delivered in 1833, now consists of 116 pieces. They are decorated with a very rich underglaze blue ground, with six reserves painted with the insignia of the Orders of the Garter, Thistle, St Patrick, Bath, St Michael and St George; and of the Guelphic Order, surrounding

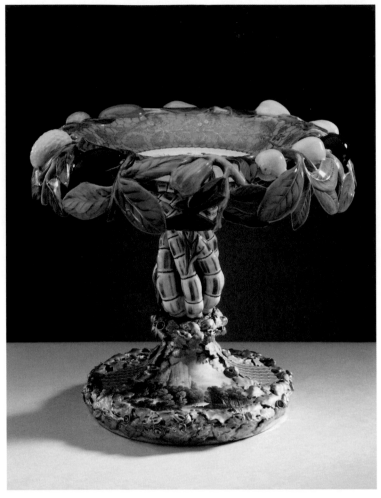

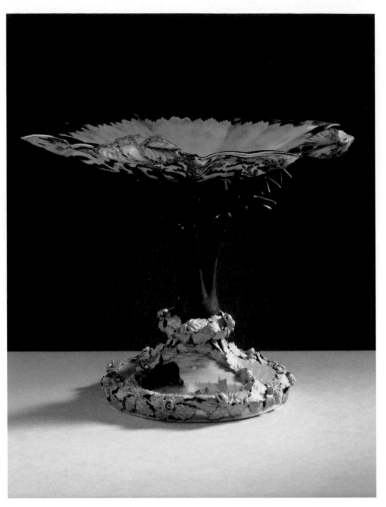

113 ('tropical' dessert stand)

113 ('shell' comport)

the royal arms, the work of the painter John Bly. The shapes employed owed much to those of classical antiquity. The ice pail is closely based on the Warwick Vase, discovered in Rome in 1770 (Glasgow, Burrell Collection). The raised gilding and 'jewelled' decoration were no doubt inspired by Vincennes and Sèvres porcelain, although the techniques were quite different. At the French factories, gilding was built up in successive layers to achieve a degree of relief, whereas in this case a single layer of gold was applied over raised slip decoration. The jewelling was the work of Ishmael Sherwin. Among English manufacturers, the Barr brothers alone seem to have followed Sèvres in restricting the employment of women to the burnishing of gold. Pieces from this service are regularly used to ornament the table for the annual luncheon of the Knights and Ladies of the Garter at Windsor.

Soft-paste porcelain. Ice pail 44 × 37 × 28.8 cm; dessert stand 34.1 × diameter 30.5 cm; dessert plates diameter 25.6 cm
Printed in gold on the underside of plates and lid of ice pail ROYAL PORCELAIN WORKS / FLIGHT BARR & BARR / WORCESTER & COVENTRY ST LONDON below a crown; stamped under the foot of the ice pail and dessert stand FBB below a crown (Sandon (J.) 1993, no. 37); painted in puce script under the foot of the dessert stand Flight Barr & Barr / Royal Porcelain Works / Worcester / & / Coventry St London; numbered in gold on the underside of the ice pail lid and liner 3
RCIN 58393.4, .6, .60, .66 (dessert plates), 58394.2 (ice pail), 58396.3 (dessert stand)
PROVENANCE Commissioned by William IV, 1831
LITERATURE Sandon (H.) 1978, pp. 101–03, 185–6; Sandon (J.) 1993, p. 365

113
ROCKINGHAM WORKS (BRAMELD)
Pieces from a dessert service, 1830–7

This service, originally consisting of fifty-six large pieces and twelve dozen plates, may claim to be the most ambitious ever produced by an English factory. The Rockingham Works was established in 1825 at Swinton in Yorkshire under the patronage of the second Earl Fitzwilliam (nephew and heir of the Marquis of Rockingham) by the brothers Thomas, George Frederick and John Wager Brameld. By far the youngest of the factories from which services were ordered by William IV following his accession in 1830, the Rockingham Works quickly established a reputation for producing wares of outstanding quality.

Designs for the service were in hand during the autumn of 1830, and samples were sent to the King for approval: a plate resembling the final pattern, but with an orange ground to the rim instead of the chosen 'Brunswick' blue, is one such sample (RCIN 58123). As with the Davenport and Worcester services (see nos 111, 112), national symbols formed part of the decorative imagery: the centres of the plates were painted with the royal arms, and the national flowers occupy those of some of the comports; while raised and gilded roses, thistles and shamrocks, as well as oak leaves and acorns, are entwined and encrusted around the painted reserves of the shaped pieces. (According to the York Courant for 13 July 1837, the inclusion of oak leaves was at the King's own suggestion.) But in addition, the Rockingham service evoked

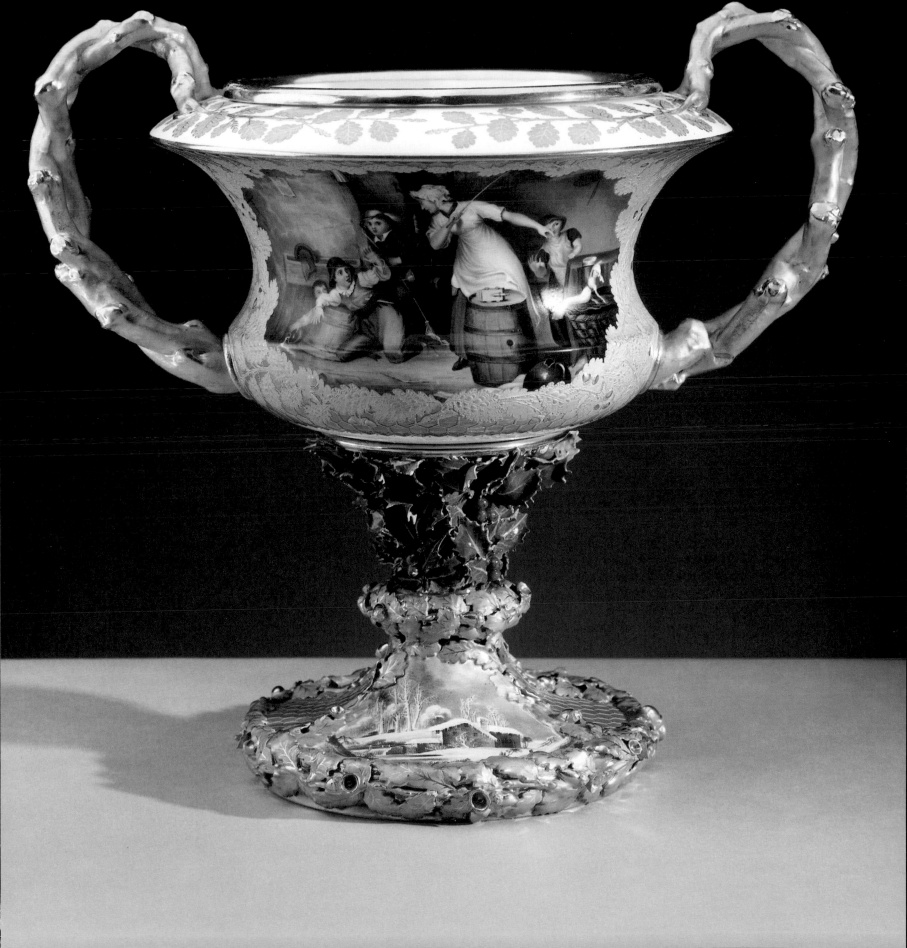

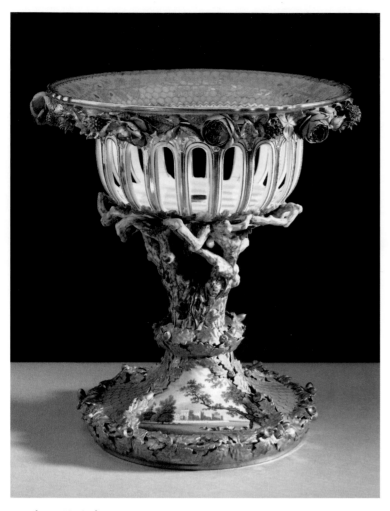

113 ('Grand basket')

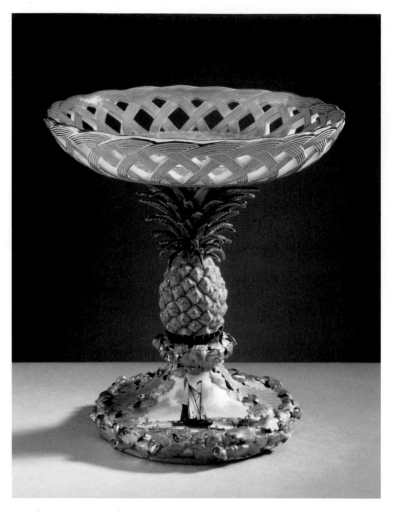

113 ('pineapple' comport)

Britain's maritime achievements and foreign dominions. In the 760 painted reserves there are Indian and Caribbean scenes as well as British landscapes, castles and country houses; and the wonderfully modelled pineapples, sugar-cane stems, exotic fruits, corals and shells also evoke Britain's more distant possessions. The designs were made by John Wager Brameld. All of the artists responsible came from within the Rockingham factory's own workforce of around six hundred. They included the modeller Thomas Griffin and the painters George Speight (royal arms), Thomas Brentnall (flowers), William Willis Bayley, William Corden and (probably) Henry Pedley. The factory's chief gilder was Isaac Baguley.

The 'ice-cellars' or pails and the small vases forming finials to the 'triple dress plates' are variations on the antique Warwick Vase (see no. 112), decorated with scenes after Reynolds, Teniers, Wilkie and William Collins. The ice pail shown here was a trial piece which until 1998 belonged to the descendants of Earl Fitzwilliam. The two reserves on the base are painted with snow scenes, *Bothwell Castle, Lanarkshire*, and *Mill of Gowrie*.

The tiered 'triple dress plates' (of which eight were made) were intended for almond pastry. Four 'double dress plates' with only two tiers were also supplied, as well as eight 'grand baskets' for fruit. The foot of the example shown here was painted with reserves of *Virginia Water* and *Windsor Gate*. The smaller 'shell comports' modelled as limpets with clinging mussels and samphire, supported on red coral and mostly decorated with maritime scenes around the feet, were intended for preserves.

The foot of the comport exhibited here was painted with reserves of *White Rock, Hastings*, and *East Hill from the Battery, Hastings*. The eight 'tropical' comports with sugar-cane supports are surrounded by a wreath of East and West Indian fruits which are identified by inscriptions under each as mango, white guava, malay apple, mangotan, mammee, akee, alligator pear, custard apple and longan. These were probably derived from the plates in F.R. de Tussac's *Flores des Antilles* (Paris, 1808–27) and M.E. Descourtilz's *Flore pittoresque et medicale des Antilles* (Paris, 1821–9). The reserves on the foot of the tropical comport are painted with *Matlock High Tor Derbyshire* and *Downe Castle*. The pineapple comport included here was a trial piece in which the lower leaves of the pineapple are formed of stained leather. The reserves on the base are *A calm* and *A view near Derwent Water, Lodore*.

The service was not completed until 1837, when it was placed on show at the Bramelds' London showroom in Tichborne Street. It was still on display there at the time of the King's death in June, and remained unused until Queen Victoria's coronation the following year. Despite widespread contemporary praise for the service, its protracted manufacture brought about the Bramelds' ruin. As Jewitt remarked in his monumental *Ceramic Art of Great Britain*, the brothers 'looked to Art instead of commerce, and the result was embarrassment and loss' (Jewitt 1878, I, p. 506).

Bone china. Ice pail 35 × 37.6 cm; 'pineapple' comport 26 × 23.9 cm; 'shell' comport 19.8 × 25 × 24 cm; 'tropical' dessert stand 24.5 × diameter 37 cm; 'Grand basket' 40.3 × diameter 27 cm; plates diameter 23.6 cm

Incised in script on base of 'Grand basket' No. 1 / *Triple Assiette*; printed in puce script within a cartouche on underside of plates and (twice) under the foot of comports *Rockingham Works / Brameld / Manufacturer to the King / Queen and Royal Family* below a griffin; inscribed under the foot of the comports with the names of fruits and the titles of the reserve scenes as above. The reserve scenes on the comports are also briefly titled in white within the reserves or with a burnishing tool on the gilt borders.

RCIN 29761.80, .86, .89, .100 (plates), 58377.8 ('Grand basket'), 58381.2 ('shell' comport), 58382.3 ('tropical' dessert stand), 90208 (ice pail), 90209 ('pineapple' comport)

PROVENANCE Commissioned by William IV, 1830; delivered 1837. Ice pail: Christie's, London, 8 July 1998 (76). 'Pineapple' comport: Neale's, Nottingham, 8 July 1998 (34). Both purchased by HM The Queen

LITERATURE Cox 1975

EXHIBITIONS Rotherham 1976, nos 124–9; Essen 1992, no. 510; Rotherham 1997, no. 201

114
LUCIE RIE (1902–1995)
Three bowls, c.1959

The Austrian-born ceramic artist Lucie Rie was the outstanding potter working in England in the second half of the twentieth century. Born Lucie Gomperz in 1902, she had studied at the Vienna Kunstgewerbe-Schule between 1922 and 1926, marrying in the latter year the businessman Hans Rie. Their apartment in Vienna was designed for them by the young architect Ernst Plischke (see no. 107), who had also recently qualified. Like Plischke, the Ries were forced to leave Austria in the autumn of 1938, but their departure resulted in separation; they headed first for London, which Hans Rie had regarded as a stepping-stone to the United States. When he embarked on this second journey,

Lucie – who had already begun to re-establish her career in England and had spent a period of time working with Bernard Leach in Devon – stayed behind. The furnishings from her Vienna apartment were moved to London, to the studio she was to retain for the rest of her life in Albion Mews, Kensington. The Ries' marriage was dissolved in 1940.

Soon after the war, Lucie Rie engaged as an assistant the German refugee Hans Coper, who was to become an outstanding potter himself and remained a long-standing and important artistic companion. They often exhibited their works together.

These three bowls form part of a group of pictures and works of art which were acquired to ornament a new suite of guest rooms at Windsor Castle created for The Queen and Duke of Edinburgh by Sir Hugh Casson (1910–99) within the thirteenth-century Edward III Tower at the south-west corner of the Upper Ward.

The large vessel and the shallower, delicately potted bowl with a wide rim are decorated with Rie's own bronze (manganese and copper carbonate) glaze and demonstrate her mastery – attained over nearly twenty years between the 1940s and 1960 – of a painstaking *sgraffito* (scratched) technique. The smallest bowl, with its irregular shape, displays the soft, brilliant yellow uranium oxide glaze which was equally characteristic of Rie's work in the 1960s.

Lucie Rie was three times honoured by The Queen, with the OBE in 1968, CBE in 1981 and DBE in 1991.

Porcelain. Large *sgraffito* vessel 13.5 × 18 × 16.5 cm; *sgraffito* bowl 8 × diameter 20.6 cm; yellow bowl 5.5 × 14.2 × 13.2 cm
Impressed with LR seal under the base of each piece
RCIN 35060 (*sgraffito* bowl), 35064 (yellow bowl), 93145 (large *sgraffito* vessel)
PROVENANCE Craft Centre of Great Britain; from whom bought by HRH The Duke of Edinburgh, 9 June 1960

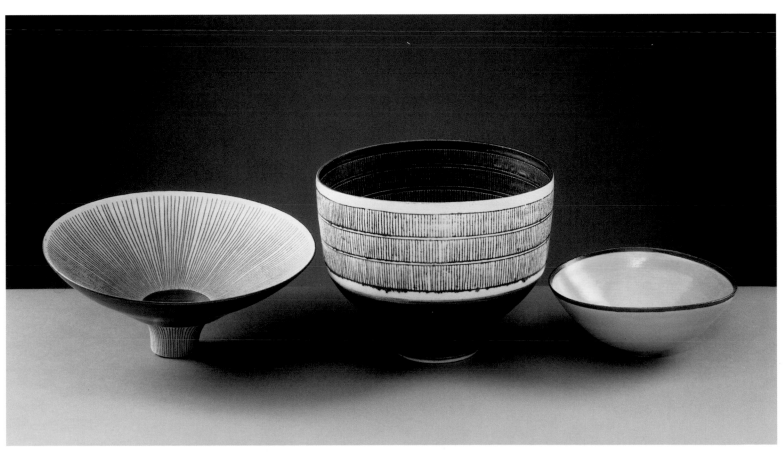

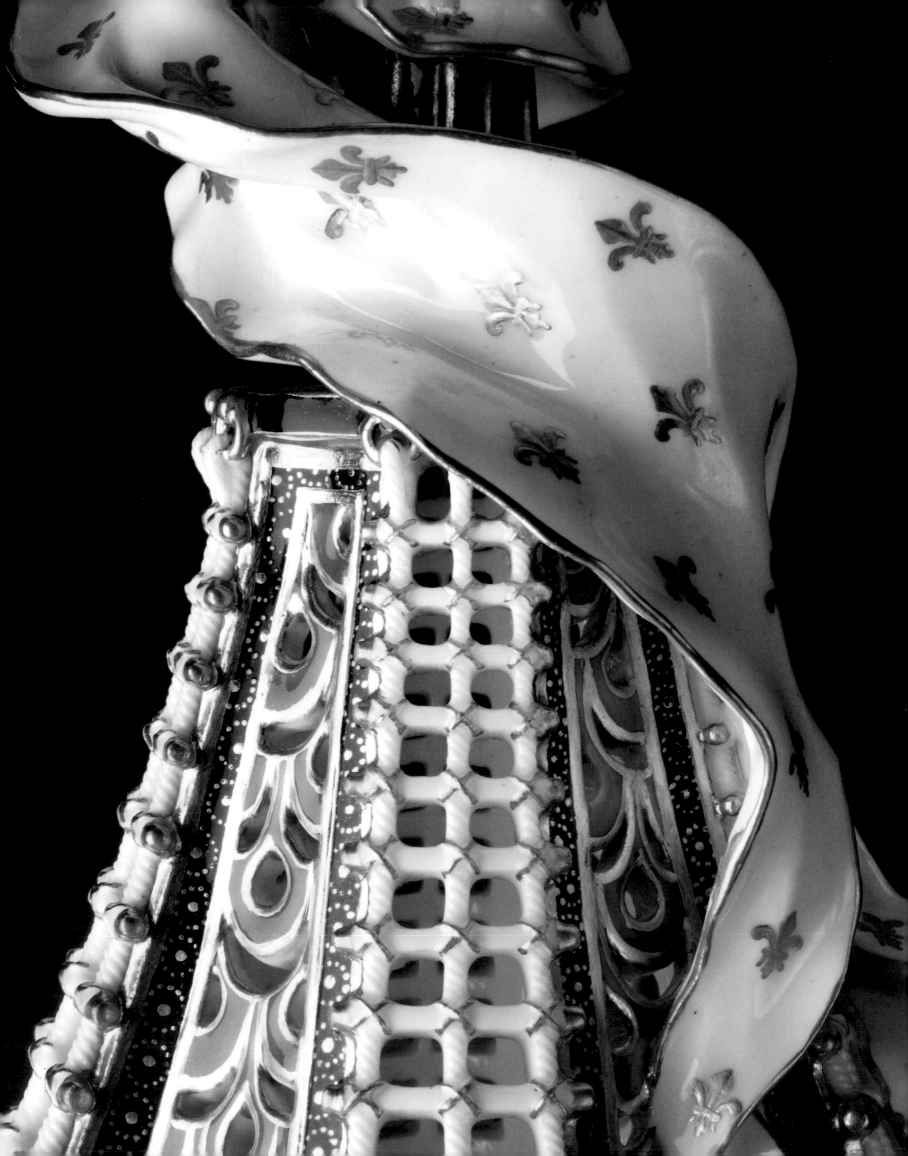

CONTINENTAL CERAMICS (nos 115–138)

The abiding theme in any account of the history of ceramics in the West is the search for the formula (and ingredients) for making hard-paste porcelain (true porcelain, as it was sometimes called) in imitation of the ceramics first produced in China in the seventh or eighth centuries. Composed of petunse, a feldspathic rock, mixed with kaolin (white china clay), it was fired at a very high temperature. It was admired for its transparency, the whiteness of its glaze, its reliability in the kiln, its resistance to sudden changes in temperature and its hardness. The secret of its manufacture was not discovered in Europe until 1708 at Meissen, while at Sèvres the first hard-paste porcelain was produced in 1769.

Until then, production in Europe was confined to three broad categories: earthenware, stone ware (a form of hard pottery) and 'artificial' porcelain (soft-paste) of varying degrees of resemblance to true porcelain. At one end of the scale manufactories were producing opaque unvitrified porous earthenware covered with a thick cream-coloured glaze, such as late seventeenth-century Delftware, which bore little relation to hard-paste. Closer in appearance to hard-paste is the soft-paste porcelain such as was produced at the Vincennes–Sèvres manufactory (at Vincennes from c.1740, and then at Sèvres from 1756 to 1804 when soft-paste production was discontinued). Compared to hard-paste, soft-paste has a number of disadvantages. It is less plastic, more difficult to fire (resulting in heavy wastage), more harmful to the health of those who work it, less resistant to heat, more prone to damage from scratching and more costly to produce. In aesthetic terms, however, it is sometimes judged superior because of the softness of its creamy white surface and the richness of its gilding.

The Vincennes–Sèvres manufactory, wholly owned by the French crown from 1759, was run as a highly professional and specialist organisation. A minister directly answerable to the French crown was placed in charge. He could command the services of the most talented artists in the land to design the shapes and decoration. The laboratories which perfected the composition of the paste, the glazes and enamel colours were run by chemists and scientists of established reputation. Below them worked the artisans and potters divided according to their skills into distinct categories. In the course of manufacture each piece had to pass through the hands of a multiplicity of craftsmen: the thrower or moulder; the *répareur* (repairer or chaser of sculptural details); the glaze painter; the painter of flowers and/or birds, trophies, landscapes and figures; the gilder and the burnisher. After each major process the piece had to be fired, followed by additional firings when retouching or a second application of gold was required. It is this professionalism and specialisation which, translated into actual wares, created highly finished and technically accomplished pieces where nothing was left to chance.

Among royal collectors of ceramics Queen Mary II, consort of William III, was one of the most enthusiastic. She brought together an important collection of oriental porcelain (for the most part no longer in the Royal Collection), to which she added Delftware flower vases and ornamental vases commissioned from the 'Greek A' manufactory of Adriaen Kocks (see nos 115–16). These pieces were chosen primarily for their decorative quality. The porcelain was an important element of the interior decoration of the apartments at Hampton Court and Kensington Palace, complementing the rich tapestries, the fine paintings in gilded frames and the sparkling chandeliers and candelabra.

George IV collected Sèvres porcelain for the same reason. The flamboyant character of the grandest pieces made in this manufactory contributed to the richness of his apartments at Carlton House, where he held his glittering receptions. In addition to these display pieces, however, George IV also made extensive purchases of 'useful' wares, such as cups and saucers, broth basins, *déjeuners* and entire services. These were clearly intended for his table. To this day they continue to be used for State Visits and ceremonial occasions.

William IV's accession to the throne heralded a period of retrenchment. The King was no collector and he took little pleasure in display, although he commissioned a number of fine English services (nos 111–13). The Sèvres porcelain disappeared from view, only to resurface some twenty years later. At the Gore House Exhibition in 1853 one piece of porcelain was included, namely the 'Sunflower Clock' (no. 118). For the 'Museum' of the Department of Practical Art at Marlborough House (see p. 40), Queen Victoria lent lace and Sèvres porcelain. Henry Cole, the organiser of the Museum, describes how the porcelain was chosen. 'Later on, Her Majesty gave me permission to search Buckingham Palace for Sèvres china. Mr John Webb assisted me, and we brought away Sèvres worth many thousands of pounds. No inventory of it

could be found, and I took away many pieces, each now worth £1000, from housemaids' closets in bedrooms' (Cole 1884, I, p. 285).

Although both George IV and Queen Victoria regarded French porcelain as suitable for show, their underlying aims were totally different. Whereas George IV's displays were designed to dazzle the visitor to Carlton House, Queen Victoria's loans to Marlborough House were intended to instruct, by serving as models for craftsmen and inspiration for students. This didactic approach informed Queen Victoria's loans to temporary exhibitions and her long-term loans to museums, notably the South Kensington Museum, throughout the rest of her reign.

Porcelain has often featured among royal gifts, offered for diplomatic or celebratory reasons, and the Royal Collection has been greatly enriched by this means. For instance, in 1774 Prince Carl Wilhelm Ferdinand of Brunswick presented to his brother-in-law George III an extensive dinner service of Fürstenberg porcelain (RCIN 58406 etc.) exquisitely painted in the centres with land-scapes of his north German domains. In 1787, King Ferdinand IV of Naples presented a uniquely precious gift to George III in the form of a service made at the royal factory in Naples, depicting King Ferdinand's collection of antique vases (RCIN 58204 etc.). Queen Victoria's German connections brought into the collection a number of outstanding pieces of Berlin porcelain from the Königliche Porzellan-Manufaktur (KPM), including two large and impressive vases designed by the architect Karl Friedrich Schinkel (RCIN 41306 and 59183). These were joined in 1863 by two Royal Copenhagen services presented to Albert Edward, Prince of Wales, and his wife Princess Alexandra of Denmark, on the occasion of their marriage. Alexandra's parents, the King and Queen of Denmark, sent a very large combined service of the 'Flora Danica' pattern first introduced during the eighteenth century (RCIN 58000 etc.), while the 'noble ladies of Denmark' presented a dessert service with views of the noble houses of their country (RCIN 15608 etc.).

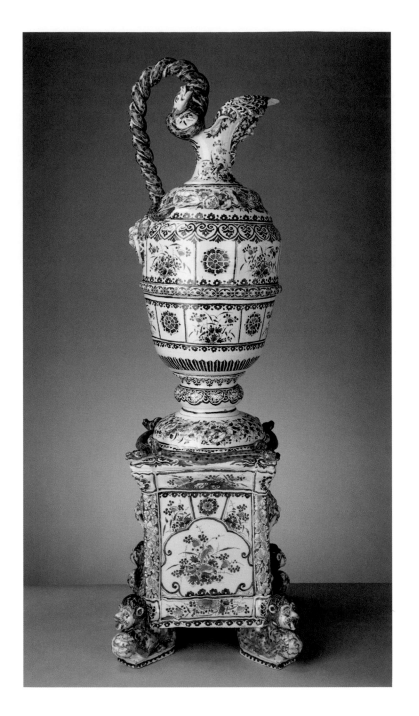

115
DELFT ('Greek A' factory of ADRIAEN KOCKS)
Pair of ewers and stands, c.1694

The production of blue and white tin-glazed earthenware at Delft in the Netherlands in the mid-seventeenth century was stimulated in part by interruptions (caused by hostilities in China) in the supply of the orien-tal porcelain that had been imported in very large quantities by the Dutch East India Company since the beginning of the century. Although it is referred to in contemporary sources as Delffs porcelijn, the material produced at Delft is quite different, retaining the grey colour of the clay after firing at much lower temperatures than true porcelain. This material was then whitened with a thick glaze based on lead oxide with the important addition of tin, which produced the milky opacity required to imitate porcelain. Various factories were established, often in

disused breweries whose names they retained, such as *De Metalen Pot* (the Metal Pot) or, in this instance, *De Griexe A* (the Greek 'A').

The 'Greek A' factory was founded in 1658 by Wouter van Eenhoorn, taken over by his son Samuel in 1678, and sold after the latter's death in 1686 to his brother-in-law, Adriaen Kocks (d. 1701), who was in charge when both nos 115 and 116 were made. Queen Mary II (1662–94) was the factory's most important customer, ordering numerous vessels for her Dutch palaces of Honselaarsdijk and Het Loo, as well as for Hampton Court. A clear difference can be seen between the decoration of those pieces that were ordered for the Dutch and for the English palaces. The Dutch pieces, many of which date from the Samuel van Eenhoorn period, are generally painted with *chinoiseries* in imitation of their Chinese prototypes, whereas those supplied for Hampton Court have purely Western, stylised floral decoration between bands of loosely classical ornament. There are still ten large vessels (including the two pairs shown here) and three smaller pieces at Hampton Court, all of which were supplied directly to Queen Mary by Adriaen Kocks's factory. (A bill for £122 14s. 9d. for 'Dutch China ware' supplied by Kocks was paid after the Queen's death in 1694. BL Add. MS 5751A.) They were probably designed by William and Mary's court architect, Daniel Marot (1663–1752), who may have been inspired by seventeenth-century French silver for some of the shapes.

Many of Queen Mary's vases must have been ordered for the 'Delft-Ware Closett' adjoining the Water Gallery, a remodelling of a range of Tudor buildings overlooking the Thames at Hampton Court, which was probably intended as a retreat for the Queen's use during the rebuilding of the State Apartments. The gallery was demolished by William III in around 1700, when the vases were moved to the State Apartments.

Tin-glazed earthenware. 117 cm high
Marked with conjoined AK in blue under the foot of each ewer and under the base of RCIN 1083.1
RCIN 1083.1–2
PROVENANCE Commissioned by Queen Mary II
LITERATURE Lane 1949, pp. 20–1; Archer 1984, pp. 18–19; Erkelens 1996, p. 118
EXHIBITIONS QG 1988–9, no. 93

116
DELFT ('Greek A' factory of ADRIAEN KOCKS)
Pair of tulip vases, c.1694

Many of Queen Mary II's Delft vases are described in the inventories of her palaces at Het Loo and Hampton Court as standing on the hearth. Flower vases such as these were used to ornament the fireplace during the spring and summer when fires were not lit. Each of the nine hexagonal stages was made separately, with a sealed water reservoir and six protruding grotesque animal mouths, into which the cut stems of tulips or other flowers could be placed. There may originally have been a pointed finial or stopper in the top of each vase. The lowest stage is attached to the backs of six recumbent cows placed at the angles of the hexagonal base. Two sides of the base are painted with a youthful bust of William III; two have a winged putto seated on an overturned ewer, holding a lead which is attached by a collar to a standing stork; the remaining two have a peacock displaying its tail plumage and standing on a rocky fountain ornamented with shells, suggestive of a garden

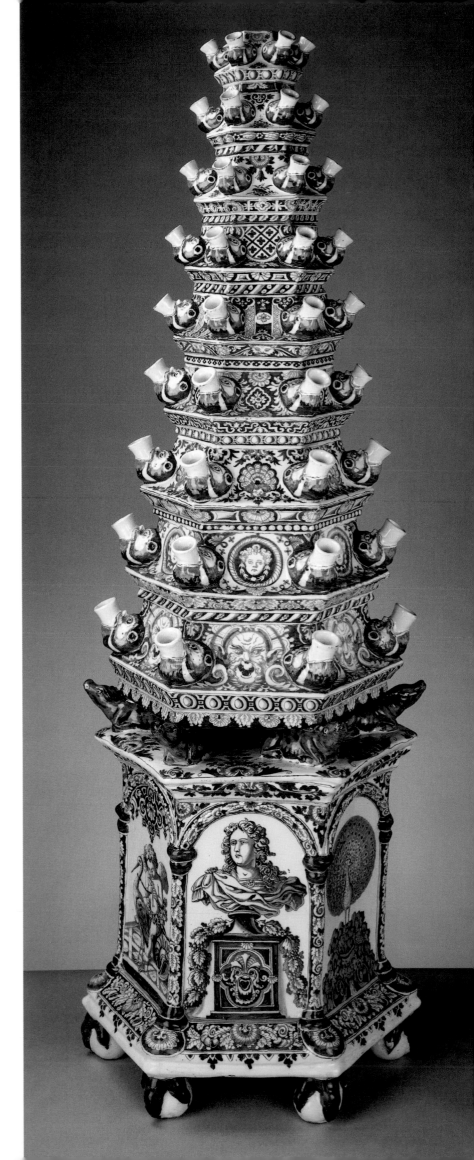

grotto. The forms and ornaments of these and similar vases are distinctly playful; the six tiers of a hexagonal pyramid at Williamsburg (exh. New York 1988, no. 161), for example, rest on the backs of snails. A pyramid vase of this general design and bearing the mark of Adriaen Kocks is at Chatsworth House (Archer 1976a, fig. 9); a pair of square examples painted in the base with architectural *capricci* (exh. Washington 1985–6, no. 104), and another pair of the same shape with allegorical figures, are at Dyrham Park in Gloucestershire (Archer 1976b, p. 12). Delft vases which formerly belonged to William and Mary survive in other collections, the most important being an orange-tree pot at Erddig in Clwyd (exh. Washington 1985–6, no. 102) which bears the royal arms and cypher.

Tin-glazed earthenware. 97.5 cm high
Marked with conjoined AK in blue on the side of one cow on each base. Each stage of both vases bears an identifying mark A (RCIN 1085.2) or B (RCIN 1085.1) inscribed in blue, inside and underneath, and in most cases also incised beneath the glaze on the underside. The incised A marks on 1085.2 are mostly in the form Ã
RCIN 1085.1–2
PROVENANCE Commissioned by Queen Mary II
LITERATURE Lane 1949, pp. 19 and 23; Archer 1984, p. 15
EXHIBITIONS Manchester 1857

117
VINCENNES
Basin, cover and stand, c.1748–52

It would have come as no surprise to learn that this broth basin and stand bearing the royal Stuart arms had been bought by George IV, such was his enthusiasm for collecting Vincennes–Sèvres porcelain and his keen interest in all things Stuart. In fact no. 117 is a recent acquisition which was made in the present reign in two stages, the bowl and cover being purchased in 1964 and the stand in 1997. By this purchase The Queen has enriched the collection of French porcelain in a spectacular manner, strengthening it in an area where it was least well represented.

Broth basins with their covers and stands are among the wares which were produced in the greatest variety and quantity at Vincennes. Seven, possibly eight, different models were recorded in the inventory dated

1 October 1752, and nearly four hundred versions were listed in varying stages of production. Among the most elaborate were the models with fish knobs such as no. 117, which, as Rosalind Savill has plausibly suggested, may have been intended for fish *bouillons* served on Fridays and Holy Days and drunk at the time of the morning toilet. Within this category Vincennes produced a number of variant designs. They can be confidently attributed to the goldsmith Jean-Claude Duplessis, who supplied designs for new models at the manufactory from around 1748 to his death in 1774.

One of the most striking aspects of the decoration of no. 117, is the beauty of its painting of birds and animals which, by virtue of Bernard Dragesco's researches, can now be attributed to Louis-Denis Armand the Elder (fl.1745–82). No. 117 provides an example of the distinctive style of handwriting he adopted when inscribing his pieces with the manufactory's LL mark.

Notwithstanding the distinctive decoration of no. 117, incorporating the Stuart royal arms, the basin and stand have not been traced in the manufactory's records. The most likely owner was Charles Edward Stuart, the Young Pretender (1720–88), who spent many years in exile in France. Yet at the time when no. 117 is most likely to have been produced, c.1748–52, his father, James Edward, the Old Pretender (1688–1766), was still alive. In such a situation the son's arms should have been differentiated from those of the father.

Soft-paste porcelain. Basin and cover 12.2 × 22.2 × 21.5 cm. Stand 4.7 × 29 × 21.5 cm
Inscribed in blue with elaborate foliate interlaced LLs on both bowl and stand
RCIN 19605
PROVENANCE Probably made for Prince Charles Edward Stuart. *Basin and cover*: Sotheby's, London, 21 April 1964 (43); bought by HM The Queen. *Stand*: Paris art market; bought by HM The Queen, 1997
LITERATURE Savill 1988, II, p. 642

118
VINCENNES
'The Sunflower Clock', c.1752

The vase (*vase Le Boiteux*) is filled with a bouquet of flowers. Concealed within the bouquet is a clock, whose eccentrically designed dial is formed by the seeding centre of a sunflower. In its original state the vase with its bouquet and clock must have been less elaborately mounted. It would have stood directly on the gilt bronze terrace, flanked very probably by Vincennes porcelain figures. By the time of George IV's purchase of the clock in 1819 gilt bronze additions had been made, namely foliate handles, a drum, and candelabra in the place of figures. The white porcelain had been enriched with later polychrome jewelling. It had also acquired a suitably impressive provenance – Madame de Pompadour.

Even if there are no grounds for believing that no. 118 ever belonged to Louis XV's illustrious mistress, who filled the role of the King's unofficial minister of the arts, it closely matches the porcelain bouquet presented by the King's daughter-in-law, the Dauphine Marie-Josèphe de Saxe, to her father Augustus III, Elector of Saxony, in 1749 (now in the Zwinger, Dresden). Her blooms were contained in a white porcelain vase flanked by glazed porcelain figures, the whole resting on a gilt bronze terrace identical to that of no. 118. The two terraces could well have

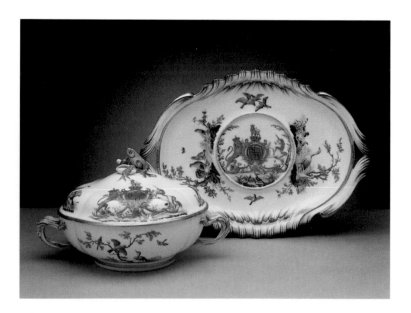

◁ 117

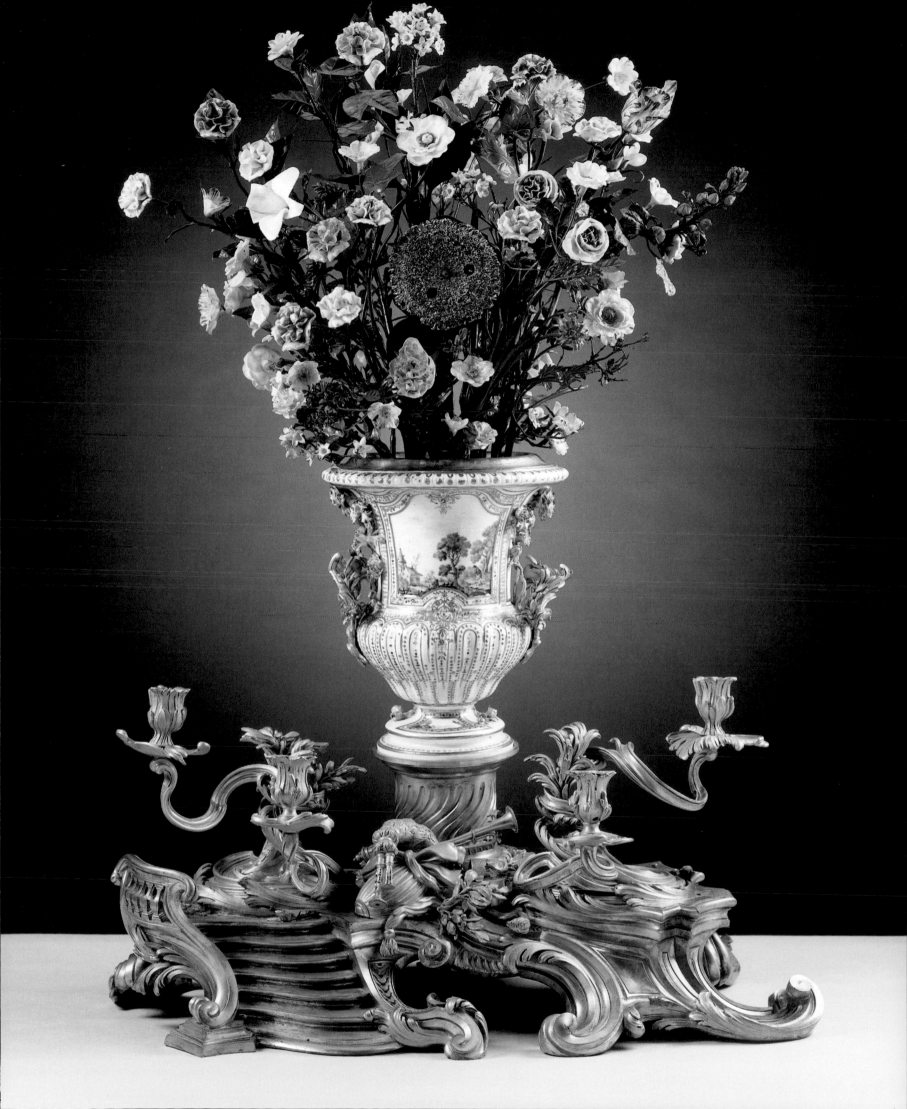

been supplied by the goldsmith Jean-Claude Duplessis, who is known to have made terraces for bouquets presented to Louis XV and Queen Marie-Leszczynska in 1748.

After George IV's death the vase became separated from its bouquet and clock, to which it was only reunited in the first decade of the twentieth century. By that time many of the original flowers had been lost or broken. H.J. Hatfield & Sons were employed to replace them with others plundered from a Meissen vase and yet others made in imitation of Vincennes by Hatfields themselves. The restoration was made with the help of the record drawing in George IV's Pictorial Inventory of the contents of Carlton House (Pictorial Inventory, vol. A, f. 38).

Despite its chequered history, no. 118 retains much of its former glory. The two painted scenes, which recall Meissen painting, are of the finest quality. The gilt bronze terrace is characteristic of the Louis XV style at its most exuberant, while the floral bouquet, notwithstanding the many replacement flowers, still evokes the charm of the Vincennes blooms.

Soft-paste porcelain; green-lacquered brass wire (for the stems); gilt bronze. Overall 105.4 × 66.7 × 54 cm; vase 30 × 13.9 cm
Vase inscribed in blue with interlaced LLs enclosing a dot; backplate engraved by the clock-maker Benoist Gérard (died 1758); strike spring signed by the spring manufacturer Missier, and dated February 1752
RCIN 30240
PROVENANCE Bought for George IV in Paris, November 1819 (5,500 francs; RA GEO/26437)
LITERATURE Laking 1907, no. 1
EXHIBITIONS London 1853b, no. 58 (bouquet and clock omitted); QG 1979–80, no. 144

119
SÈVRES
Flower vase (vase hollandois), c.1757

Vases hollandois were among the most popular flower vases produced in the Vincennes–Sèvres manufactory. Made in two parts, the fan-shaped upper section is perforated in its foot so that water can percolate from the reservoir or stand into which it slots. The upper ledge of the reservoir is pierced to allow for the replenishing of the water. Models in three sizes date from 1754. No. 119, which is an example of the intermediate size, possibly dates from 1757. It corresponds to similarly decorated pink-ground vases which were likewise produced in 1757. They too are painted with wave-like motifs along the top and slanted lobed panels along the bottom.

This ingenious two-part formula for flower vases may have been based on a Dutch prototype, as its name implies. It proved popular in the French manufactory, being used for three other models: a combined pot-pourri and flower vase with dolphin stoppers (pot-pourri fontaine à dauphins) – with the difference that there are no holes pierced in the foot of the upper section; a circular flower vase with dolphins (vase à dauphin); and a modified taller version of the vase hollandois, known as vase hollandois nouvelle forme, of which the earliest version dates from 1757/8.

These flower vases were multi-purpose, in the sense that they were designed both for cut flowers and for growing plants. When none was available, or to vary the effect, artificial porcelain flowers might replace the fresh flowers.

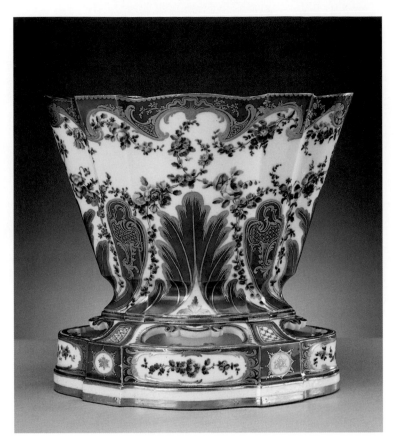

119

Soft-paste porcelain. 19 × 19.8 × 14.5 cm
Lower section inscribed in blue with the mark of the flower painter Jean-Baptiste Noualhier the Elder (fl. 1753–4, 1757–66). Upper section incised c; lower section incised 5
RCIN 21653
PROVENANCE Royal Collection by 1907
LITERATURE Laking 1907, no. 43; Savill 1988, I, pp. 69–91; Sèvres 1989, pp. 8–9
EXHIBITIONS QG 1979–80, no. 108

120
SÈVRES
Pot-pourri vase and cover (pot-pourri gondole), 1757/8

This vase owes its name to its (generic) similarity of shape – with upward turning ends – to that of a Venetian gondola. It bears a close family resemblance to two other Sèvres models: the cuvette à masques and the pot-pourri à vaisseau (nos 121 and 122) and is among the most ambitious vases produced at Sèvres; of particular complexity is the pierced onion-shaped floral cover, with four circular holes intended for hyacinth bulbs. Each of the three vase shapes is based on the same composite plaster model, which is still preserved at Sèvres. The main reserves are here decorated on the front with putti in clouds, with flaming torches and other attributes of love, and on the back with a bunch of fruit and flowers; the subsidiary reserves at either end contain trophies mingled with flower garlands.

Despite the richness of the decoration of no. 120 and the quality of its modelling, it may not have found an immediate buyer. The vase can probably be identified in the inventory of the contents of the manufactory's sale room dated 1 January 1774. It is not known when or by

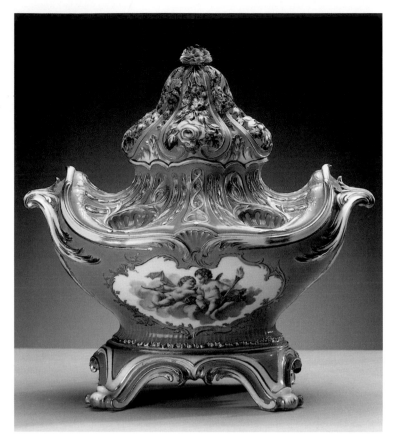

120

Soft-paste porcelain. 35.5 × 35.8 × 19.4 cm
Inscribed in blue with interlaced LLs enclosing the date-letter E for 1757/8. Incised D (scrolling)
RCIN 36099
PROVENANCE Robert Fogg; from whom bought by George IV, 30 June 1809 (£189, with two other vases; RA GEO/26394)
LITERATURE Laking 1907, no. 14; Savill 1988, I, pp. 163–72
EXHIBITIONS Manchester 1857, case C; London 1862a, no. 1277; QG 1966, no. 67; Paris 1974, no. 530; QG 1979–80, no. 59

121

SÈVRES
Flower vase (cuvette à masques), 1757/8

This shape, which was probably designed by Jean-Claude Duplessis, was named after the masks of marine monsters at either end. It was originally created in 1754/5 without scrolled feet. Two examples without feet are known. One, now in the Fasanerie, Fulda, was identified by Rosalind Savill; it formed part of a garniture which was presented by Louis XV to Count Moltke on 14 July 1757. The other, now at Houghton House, Norfolk, was part of the table centrepiece bought by Lord Bolingbroke from Lazare Duvaux on 20 August 1756. That piece, dated 1755, is fitted with porcelain flowers and rests on a stepped gilt bronze plinth. The date when versions were first made with an attached base resting on scroll feet was probably 1757, the year that the model and mould of the *pot-pourri gondole* complete with base was created.

This gondola-shaped vase, with its ends hipped like those of a saddle, is among the most aesthetically pleasing shapes to have been made in the manufactory. Of particular appeal is the spirited and imaginative gilding, allied to the miniature-like painting of the hunting scene rendered

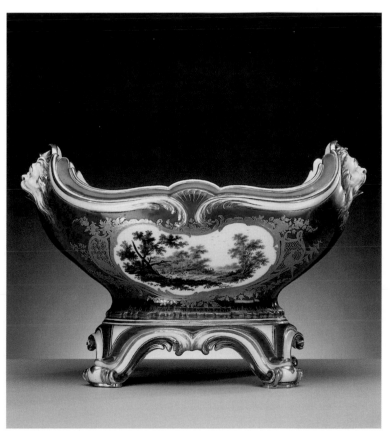

121

whom it was bought. By the time of its purchase by the future George IV in June 1809, it had been allied to a pair of pink-ground pot-pourri vases (*vase à cartels, modèle de Hébert*; RCIN 36100), which are similarly painted and are likewise dated 1757/8. This judicious and happy marriage, which has stood the test of time, may have been made by Fogg himself. A further strengthening of the bond dates from 1906, when the three pieces were fitted with elaborately chased gilt bronze bases by H.J. Hatfield & Sons (not shown here), at a cost of £76 11s. 2d.

Somewhat surprisingly, the three pieces composing the garniture are the only authentic pink-ground Sèvres vases still in the Royal Collection. The colour evidently did not find particular favour with George IV, despite the vogue it enjoyed among fastidious connoisseurs after it was first introduced at Sèvres in the late 1750s, and notwithstanding its continued appeal in the early nineteenth century. As early as the 1750s the colour was being called in England 'rose Pompadour' in honour of Louis XV's mistress. Later, as a tribute to another of Louis XV's mistresses, it was called 'rose Du Barry', and more rarely 'rose Trianon', an allusion to the Petit Trianon built by Louis XV for Madame de Pompadour in the early 1760s.

Pot-pourri was originally a term to describe a stew. It was only in the late seventeenth century that it acquired another connotation, when it was applied to pots and their sweet-smelling contents intended to fill a room with a fragrant perfume. Recipes were carefully studied by ladies of fashion in order to find the scent most appropriate to their particular type of beauty.

Copies of this vase were made in the late nineteenth century by both Minton (as 'Oval Queen's vase') and Coalport, following the 1862 South Kensington exhibition.

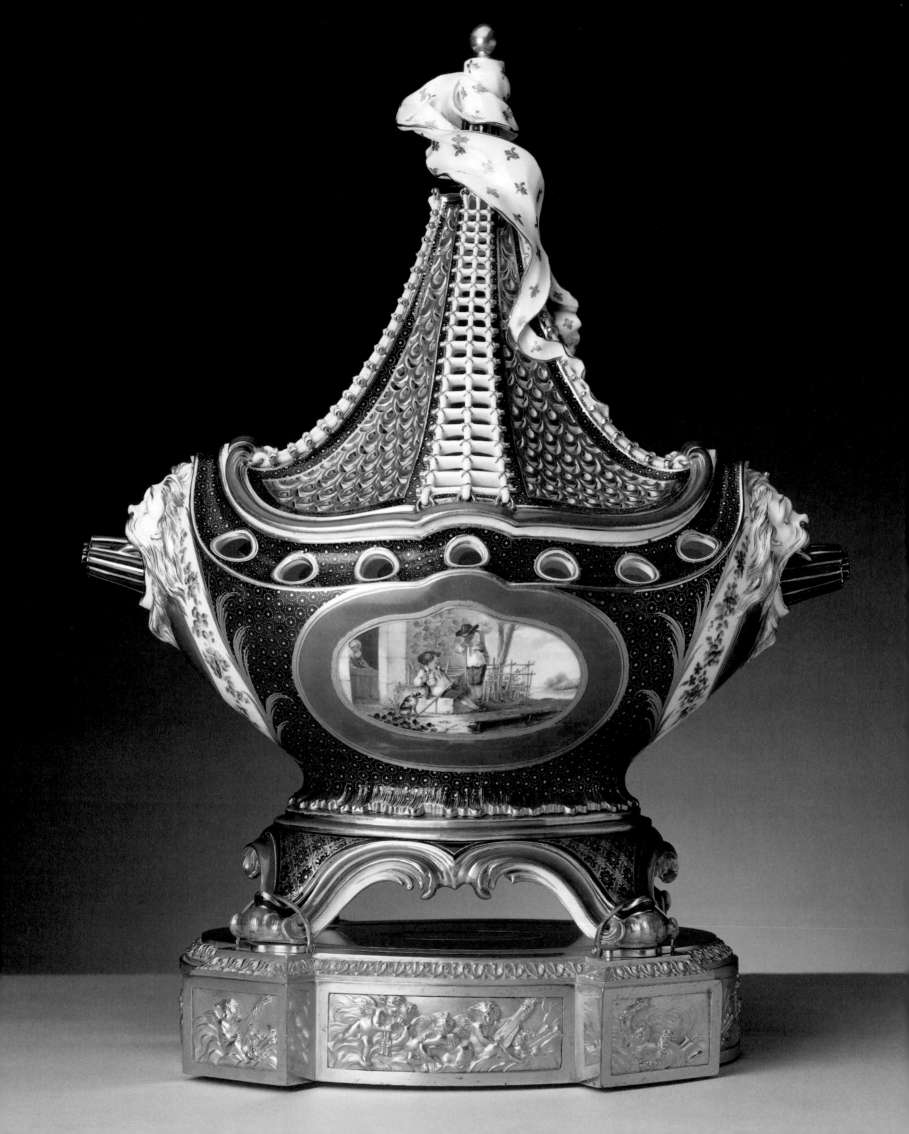

in strong cool colours by Mutel, a fan painter by training, who specialised in landscapes at Sèvres; fruit and flowers are painted in the back reserve.

Like the *pot-pourri gondole* (no. 120), no. 121 may not have found a buyer at the time it was made. Listed among the unsold stock in the inventory dated 1 January 1774 was '1 Cuvette à Masques fond verd Paysage' valued at 432 livres.

Soft-paste porcelain. 24.2 × 33.9 × 17.8 cm
Inscribed in blue with interlaced LLs enclosing the date letter E for 1757/8, and a pair of callipers, the mark of the painter Mutel (fl.1754–74)
RCIN 36071
PROVENANCE Lafontaine (Parisian dealer); from whom bought in Paris by François Benois for George IV, October 1817 (2,500 francs; RA GEO/26432)
LITERATURE Laking 1907, no. 15; Brunet & Préaud 1978, p. 152, fig. 87; Savill 1988, I, pp. 92–7; Sèvres 1989, pp. 10–11
EXHIBITIONS QG 1979–80, no. 106

122
SÈVRES
Pot-pourri vase and cover (vase pot-pourri à vaisseau), 1758/9

For many admirers of Sèvres porcelain the *pot-pourri à vaisseau* represents the height of sophistication. The panache of the finished work, which depends as much on the technical mastery displayed by the modellers and repairers, as on the skill of the painters and gilders, remains a constant source of wonder and admiration. Such may have been Madame de Pompadour's sentiments when she saw, admired and then bought no. 122 at the end-of-year sale staged in Versailles in December 1759. She may also have acquired the two matching *pots-pourris fontaine à dauphins*, now in the collection of the Duke of Buccleuch at Boughton House, Northamptonshire, with which to form a garniture. (See also no. 118.)

Madame de Pompadour is known to have owned as many as three *pots-pourris à vaisseau*. She clearly regarded them as important components in her interior schemes of decoration. It is only when they are considered in their architectural and historical context that one can best judge the importance of these pieces, whose pennants, fluttering from the mast-heads and decorated in gold with fleurs-de-lis, so proudly proclaim their association with the King, the owner of the manufactory.

Ten versions are known today with dates ranging from 1757 to 1764. They, together with the *pot-pourri gondole*, derive ultimately from the *cuvette à masques*, of which the earliest example dates from 1754/5 (see nos 120, 121). A composite plaster model, still preserved at Sèvres, offers alternative designs for the *cuvette à masques* and the *pot-pourri à vaisseau*. The base resting on out-turned scroll feet is common to most versions of all three shapes.

The *pot-pourri à vaisseau* was produced in three variant designs and in two sizes. No. 122 is an example of the most frequently reproduced model, in the larger size. The two reserves of this example contain a Teniers scene (front) and a bunch of flowers (back). The date of its entry into the Royal Collection is not known. It has previously been mistakenly associated with an entry in a bill to George IV from the Parisian dealer Lafontaine, dated October 1817, which in fact applies to the *cuvette à masques* (no. 121). The gilt bronze stand in the Louis XVI style was supplied by H.J. Hatfield & Sons in May 1904 at a cost of £29 5s.

Soft-paste porcelain; gilt bronze stand. Overall height 51.2 cm; dimensions excluding stand 45.2 × 37.8 × 19.3 cm
Inscribed in blue with interlaced LLs enclosing the date-letter F for 1758/9
RCIN 2360
PROVENANCE Bought by Madame de Pompadour, December 1759 (960 livres); George IV, by 1826 (CHPI, no. 73)
LITERATURE Laking 1907, no. 18; Savill 1988, I, pp. 191–7; Sèvres 1989, pp. 14–15; Sassoon 1991, pp. 191–7
EXHIBITIONS London 1862a, no. 1375; QG 1962–3, no. 37; QG 1979–80, no. 55; London 1992a

123
SÈVRES
Flower vase (cuvette Mahon), c.1760

The design of this model, which has been attributed to Jean-Claude Duplessis, is in the full Louis XV style. The swirling roundel on the back, composed of green acanthus branches edged with gold, enclosing a *rocaille* motif on a gold-stippled ground, admirably complements the serpentine silhouette and *bombé* shape of this model. Its uncompromisingly rococo shape may be one reason why production seems to have been confined to the years 1757 to 1761. The one exception was a special commission. Dated 1776, it was made to match a version sixteen years earlier in date (sold, Sotheby's, New York, 5–7 December 1974 (70)). Produced in three sizes, models and moulds of the first size were made in 1756 and of the other two in 1760. No. 123 is a rare example of the second size.

As first noted by Svend Eriksen, the model was launched at a time of patriotic fervour following the capture of the town of Mahon on the island of Minorca from the British by a French expeditionary force in

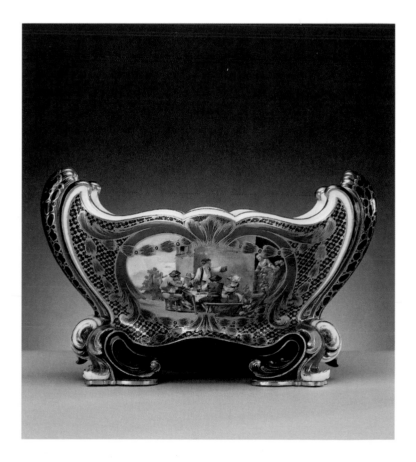

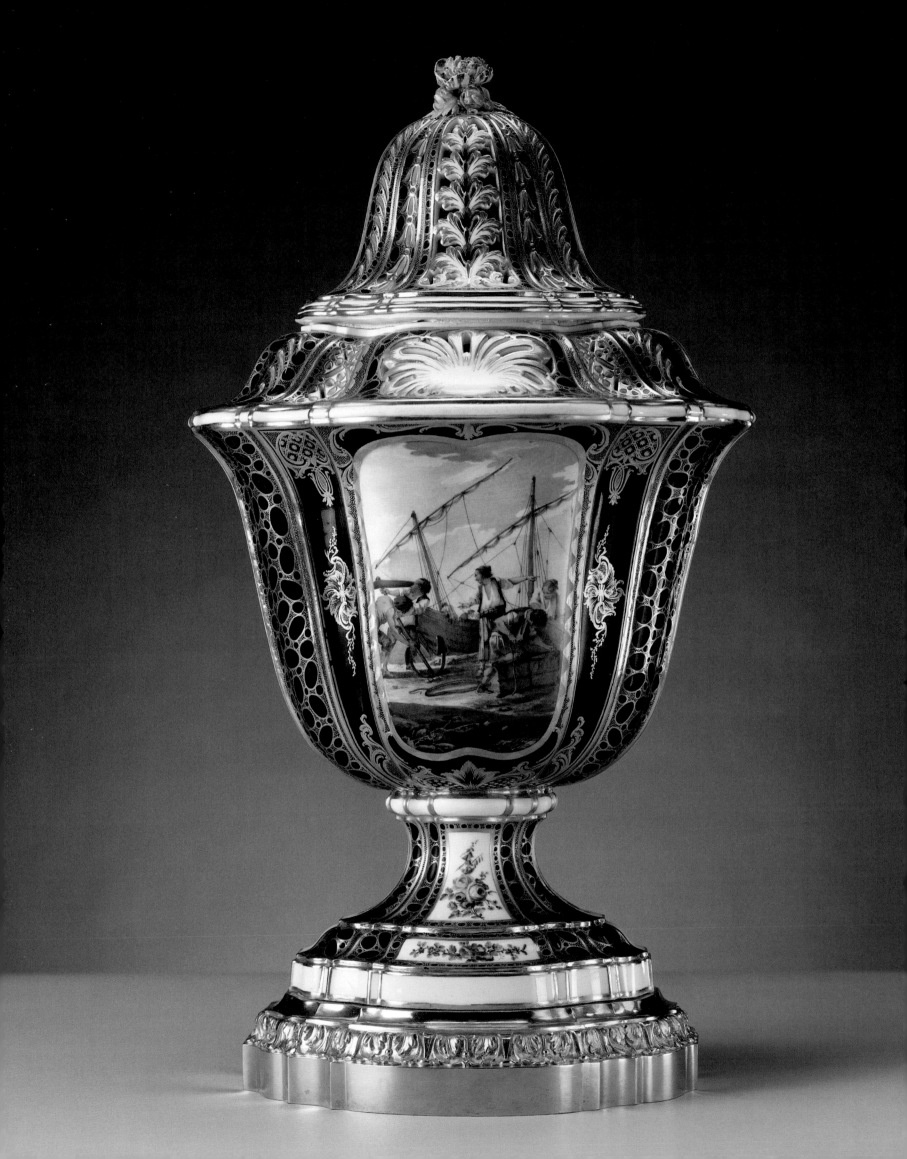

May 1756. This early success in the Seven Years' War caught the imagination of Parisian tradesmen. Sword knots à la Mahon were produced as favours, which Madame de Pompadour distributed to the deserving in July 1756. Cooks and snuff-box makers were quick to add the name Mahon to their vocabulary, thus ensuring, in the case of the sauce named mayonnaise, that the memory of this victory continues to be celebrated gastronomically some two and a half centuries after the event.

The front reserve is painted with a scene of figures drinking. The two figures seen from behind were copied in reverse from the engraving entitled *La Quatrième fête flamande*, by J.-P. Le Bas after David Teniers the Younger. This scene proved to be one of the most popular sources for reproduction at Sèvres. It was interpreted and copied by at least four artists in the period c.1759–63, namely Jean-Louis Morin, Charles-Nicolas Dodin, Antoine Caton and André-Vincent Vielliard. No engraved sources have been identified for the other figures.

Soft-paste porcelain. 17.3 × 27.2 × 15.4 cm
Not marked
RCIN 36073
PROVENANCE George IV, by 1826 (CHPI, no. 123)
LITERATURE Laking 1907, no. 34; Eriksen 1968, p. 88
EXHIBITIONS QG 1979–80, no. 98

124
SÈVRES
Pot-pourri vase and cover (vase Boileau), c.1761

This majestic vase, with its curving shape and asymmetric decoration, is still very rococo in style. Its model and moulds date from 1758. No. 124, in which piercings in the shoulders and cover have transformed the original non-utilitarian ornamental vase into a pot-pourri vase, may be associated with the documented modification to the original model made in 1761. The model was named after Jacques-René Boileau de Picardie, who was Director of the Sèvres manufactory from 1 July 1751 until his death in 1772.

No. 124 cannot be identified in the sales ledgers, in which only three *vases Boileau* are listed by name, priced at the high figures of 960, 840 and 720 livres respectively. It must therefore have been sold 'anonymously' under the generic term *vase d'ornement*, probably for an equally large sum. The complexity of the shape accounts for its rarity and price. Only five versions are known, of which two are in the Royal Collection. No. 124 is the richer of the two; the second is Laking 1907, no. 37 (QG 1979–80, no. 87; RCIN 36081). The painting of the marine scene, which is possibly the work of Jean-Louis Morin, and of the loosely drawn cluster of flowers and fruit on the back, is of high quality. Of particular beauty is the richly tooled and burnished gilding which accords perfectly with the sinuous lines of the vase and cover.

Soft-paste porcelain; gilt bronze base. Overall height 51 cm; dimensions excluding base 46.4 × 28 × 23.1 cm
Inscribed in blue with interlaced LLs. Incised 5
RCIN 2299
PROVENANCE George IV, by 1826 (CHPI, no. 120)
LITERATURE Laking 1907, no. 35; Sèvres 1989, pp. 16–17
EXHIBITIONS QG 1979–80, no. 95

125
SÈVRES
Vase and cover (vase à médaillon du roi), c.1768

Of the four versions of this shape known today, three – with a dark blue ground – are in the Royal Collection, while a fourth – which has a green ground – is in the Wallace Collection. They may all once have belonged to George IV.

The model, which dates from 1767, has plausibly been attributed to Jean-Claude Duplessis because of the similarity of its crown lid with the crown that he designed for an inkstand made in 1758 for Louis XV's daughter Madame Adélaïde. This vase combines many of the qualities which George IV admired most in Sèvres porcelain: bold modelling, fine decoration characterised by subtle variations in the tooling of the flutes of the stem and a French royal association symbolised both by the profile medallion heads of Louis XV (fitted to the front and back) and by the closed crown surmounted by the lily, the emblem of the Bourbon dynasty.

Notwithstanding the royal associations, there are no grounds for believing that Louis XV (r. 1715–74) ever owned a version personally, although he evidently regarded it as a suitable choice for a present. In November 1768 he gave a green ground version, priced at 600 livres, to Christian VII, King of Denmark. As noted by Rosalind Savill, the Danish gift is probably the fourth surviving version of the vase, which is now in the Wallace Collection. It is conceivable that no. 125 (or one of the other two versions in the Royal Collection; Laking 1907, nos 66,

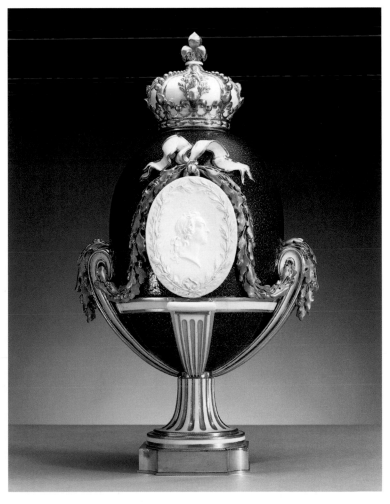

125

197; RCIN 30160, 36108) may also have had a near-royal pedigree. In December 1768 Madame Du Barry, who was shortly to be received at court and acknowledged as the King's mistress, bought a version for 504 livres – a delicate gesture, one may feel, in anticipation of this happy turn in her fortunes. The medallion of Louis XV was designed by Edmé Bouchardon and was first cast in bronze in 1738. It was used subsequently on coinage and on commemorative medallions.

Soft-paste porcelain; medallion portraits of biscuit porcelain; gilt bronze base. Overall height 39.8 cm; dimensions excluding base 37.6 × 21.7 × 16.5 cm
Incised CD (in script) and Bl (in script)
RCIN 4966
PROVENANCE [Possibly bought by Madame Du Barry, December 1768 (504 livres);] Robert Fogg; from whom bought by George IV, October 1812 (£63, together with a green ground version similarly priced; PRO LC11/16)
LITERATURE Laking 1907, no. 42; Savill 1988, I, pp. 343–7; Sèvres 1989, pp. 22–3
EXHIBITIONS London 1862a, no. 1433; QG 1979–80, no. 115

126
SÈVRES
Water jug, cover and basin (pot à l'eau ordinaire), 1771

No. 126, which is among the least elaborately decorated Sèvres wares acquired by George IV, may have been bought at auction in London in 1790. As part of a sales promotion tour, the Comte d'Angiviller authorised the Parisian *marchand-mercier* Dominique Daguerre to bring to London consignments of Sèvres porcelain in the spring of 1788 and of succeeding years for sale over the counter or by auction. In the catalogue of 'a most capital and valuable assortment of the Production of the Royal Manufactory', sold at Christie's between 15 and 17 March 1790, lot 35 of the first day was described as 'An elegant ewer and basin with blue

festoons of flowers'. The annotated copy of the catalogue at Christie's is marked '£2 17s. 6d. PW', suggesting that the purchaser was the Prince of Wales, later George IV.

Water jugs and basins produced at Vincennes and Sèvres were for use in the dressing room. The lids were supplied initially without hinges or thumb-pieces; these would have been added subsequently by the dealers through whose hands they passed or by the owners themselves. By the 1770s and 80s the manufactory was, however, employing jewellers and silversmiths – such as Grandin, Pierre-François Drais and Jean-Nicolas Bastin – to equip the jugs with these fittings. However, a number of jugs, of which no. 126 is an example, were never fitted with such mounts.

Much of the charm of no. 126 lies in its blue monochrome decoration, which was particularly in fashion in the 1760s and early 1770s. Following the identification by David Peters of Sioux's mark as a stippled crown, it is possible to attribute to him the painting of no. 126.

Soft-paste porcelain. Jug and cover 19.3 × 15.2 × 12.2 cm. Basin, oval 7.9 × 27.4 × 21.4 cm
Both pieces inscribed in blue with interlaced LLs, with (below) the date-letter S for 1771, and (above) a stippled crown, the mark of the flower painter Jean-Charles Sioux (fl.1752–92). Basin incised Th (in script)
RCIN 35548
PROVENANCE (?)Dominique Daguerre sale, Christie's, London, 15 March 1790 (35; £2 17s. 6d.; bought by 'PW', presumably the Prince of Wales, later George IV)
LITERATURE Laking 1907, no. 21; Savill 1988, II, p. 691; Sèvres 1989, pp. 20–1; Peters 1997, p. 68
EXHIBITIONS QG 1979–80, no. 63

127
SÈVRES
Pair of vases (vases fontaine Du Barry), c.1772–8

The model for these vases, which probably dates from 1771, appears to have borne a variety of names at Sèvres: *vase Du Barry à guirlandes*; *vase fontaine Du Barry*; *vase Borrie* [? *Barry*] *à 4 mascarons*. The 'fountain' could be an oblique association of ideas connected with the bulrushes round the stem. The reference to 4 *mascarons* (masks) firmly links the name with the model and adds validity to the Du Barry connection, if it is conceded that Borrie is a corruption of Barry.

The distinctive feature of this model is the four heads – two male, two female – emerging out of ruffs, over each of which is looped a floral garland suspended between their heads to studs tied in a bow with a ribbon. The refinement in the modelling of no. 127 and the crispness of detail recall the work of the finest gilt bronze chasers working in the Louis XVI style. It is as if the *répareur* (repairer who chased the sculptural details and provided handles, spouts, knobs etc.) at Sèvres had set up in competition with the *ciseleur* (chaser) in Paris. A similar challenge accounts perhaps for the modelling of the *vases des âges* (see no. 133).

Both vases lack their covers. Only one other pair of vases of this rare shape is known. Dated 1776, they are of hard-paste porcelain and form part of the collections of the Boston Museum of Fine Arts.

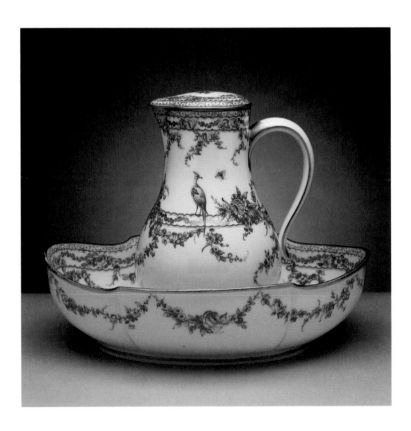

◁ 126

127 ▷

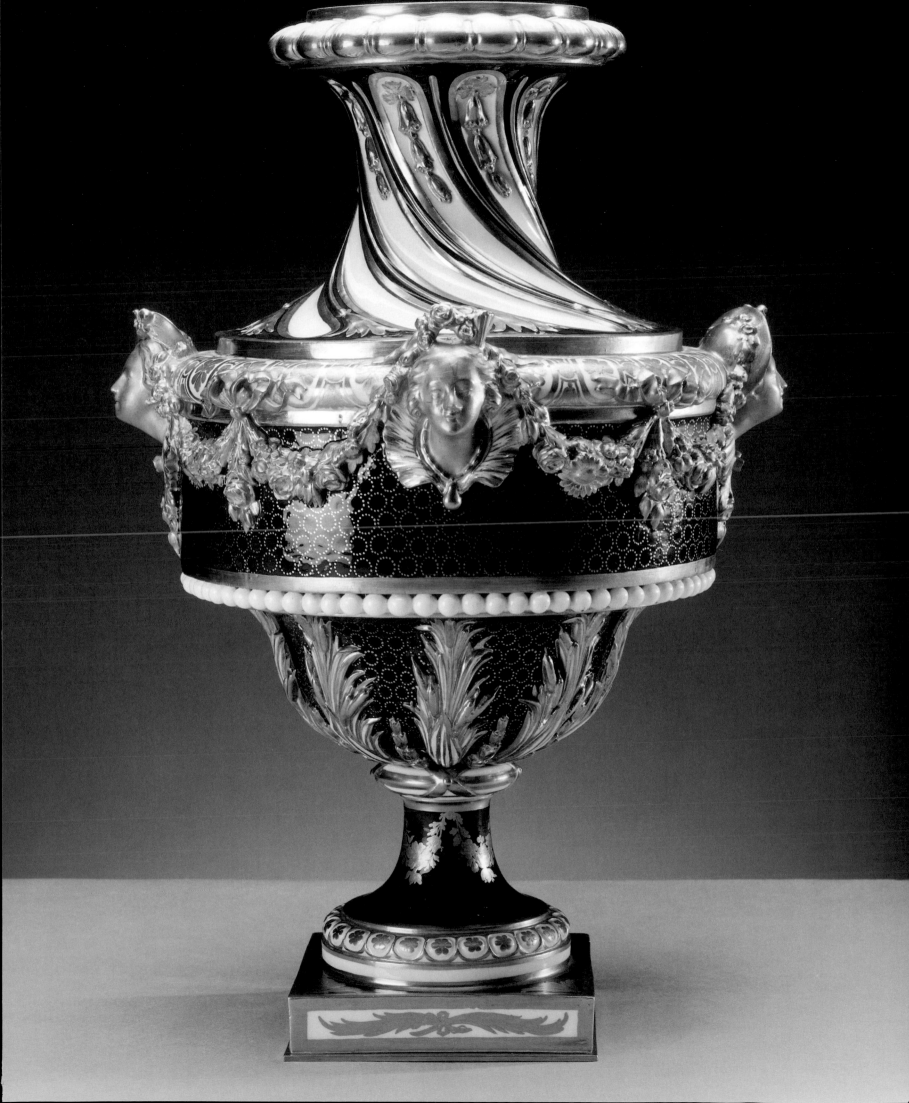

Soft-paste porcelain. 40.1 × 26.2 × 25.8 cm
Inscribed in blue with interlaced LLs, with (below) the mark of the gilder Jean-Pierre Boulanger (fl.1754–85)
RCIN 298.1–2
PROVENANCE George IV, by 1826 (CHPI, no. 3)
LITERATURE Laking 1907, nos 111, 112; Brunet & Préaud 1978, p. 188, fig. 192; Sèvres 1989, pp. 28–9
EXHIBITIONS London 1862a, nos 1306–7; QG 1979–80, no. 111; London 1992a

128

SÈVRES

Vase (vase à gorges or vase à trois gorges), c.1773

The unusual feature, which justifies the naming of this model vase à gorges or vase à trois gorges, is the three cavetto mouldings of the neck. Another unexpected detail in the design of the vase is the manner in which the reeded moulding separating the middle from the upper cavetto moulding, seemingly bound with a gold ribbon, is looped at either end round the acanthus branch handle where it breaks away to form a plume.

When George IV bought this vase and its pair from the London dealer Robert Fogg, they were part of a three-piece garniture (with Laking 1907, no. 81; RCIN 4967). While it is possible that the garniture was artificially constituted by Fogg himself, there are some grounds for believing that all three pieces may have been designed to go together from the outset. Their decoration corresponds: Turkish scenes on the

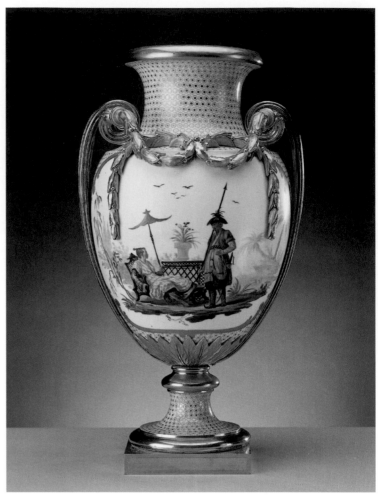

129

front and pastoral trophies incorporating Turkish motifs on the back (in this case a quiver decorated with a crescent moon), all in matching oval gilded frames; matching gilding on both the stems, around the reserves and on the cavetto mouldings; and identical plinths. As the versions in the Royal Collection are the only ones to be painted with Turkish scenes, it is tempting to identify them with the two vases à gorges fond pourpre sujet turc, priced at 600 livres each, which – together with a vase jardin identically described and valued at 720 livres – were bought by Louis XV on 23 December 1773. All three components of this garniture have integral plinths, a feature which was not regularly incorporated in vases until 1779, although (as noted by Rosalind Savill) there are vases of earlier date with similar plinths, such as a pair of vases syrènes dated 1776 and a pair of vases urne antique à feuillage, datable c.1771–6, all four of which are in the Wallace Collection. On balance the identification of no. 128 with Louis XV's purchase would seem plausible.

Soft-paste porcelain. 34.6 × 18.6 × 15.4 cm
RCIN 36109.1
PROVENANCE [Bought by Louis XV, 23 December 1773 (600 livres with its pair);] Robert Fogg; from whom bought by George IV, 1818 (£210; as part of a three-piece garniture; PRO LC11/26)
LITERATURE Laking 1907, no. 95; Brunet & Préaud 1978, p. 194, fig. 211
EXHIBITIONS London 1862a, no. 1308/9

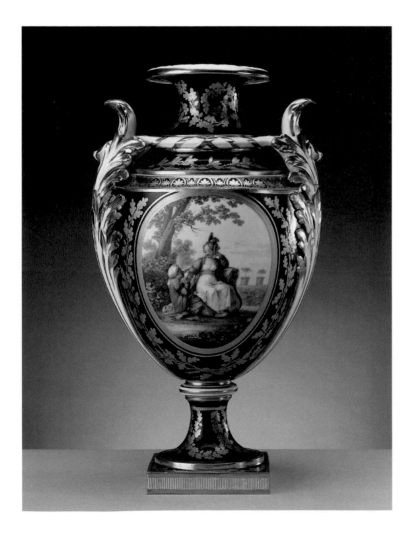

◁ 128

129

SÈVRES

Mounted vase (vase Duplessis à monter), 1779

This vase and its pair (also in the Royal Collection), together with a third of different shape (present location unknown), formed a garniture which was purchased by Marie-Antoinette in December 1779 at the end-of-year sale held in Versailles. The collective name by which the vases were known in the artists' ledger and kiln records – *vases Duplessis à monter* – clearly indicates that they were made to be fitted with mounts. The reference is to Jean-Claude-Thomas Duplessis (son of Jean-Claude), who supplied mounts to the manufactory from 1774 to 1783. The full significance of the inclusion of his name in the title is not, however, clear. It is possible that he designed the shapes in addition to supplying the finely chased mounts.

The Sèvres records provide details of manufacture. Vincent Taillandier painted the mosaic pattern (*fond pointillé*), Charles-Eloi Asselin the figure scenes on the front and Fallot the exotic birds on the back. The garniture was fired in the enamel kiln on 21 November 1779. For the painting of the figures and birds, selective use of prints seems to have been made by both Asselin and Fallot. On the companion vase, one of the figures was clearly based on an engraving by Gabriel Huquier after François Boucher, while one of the birds on the back of no. 129 derives from an engraving by François-Nicolas Martinet entitled *L'Honoré de Cayenne*, which accompanied the Comte de Buffon's folio and quarto editions of *Histoire Naturelle des Oiseaux* (1770–86).

Although less enthusiastic about Sèvres porcelain than Louis XVI, Marie-Antoinette nevertheless made some important and expensive purchases. As is usual in her commissions she brooked no delay. 'Her Majesty is in a great hurry', Antoine Régnier wrote to the Comte d'Angiviller on 12 February 1784 about a service she had ordered. White and gold being her favourite colours in interior decoration, this garniture, with its white ground and gilt bronze mounts, accorded well with her taste and would have fitted in well in her private apartments at Versailles.

Hard-paste porcelain; gilt bronze mounts. Overall height 33.6 cm; dimensions excluding stand 32.9 × 18 × 16.8 cm
Inscribed in gold with crowned interlaced LLs enclosing *bb*, the date-letters for 1779, with (below) the mark of the gilder Henri-Martin Prévost (fl.1757–97)
RCIN 35594.2
PROVENANCE Part of the garniture bought by Queen Marie-Antoinette, December 1779 (24,000 livres); Robert Fogg; from whom bought by George IV (£55; bill dated 5 April 1817; PRO LC11/23)
LITERATURE Laking 1907, no. 181
EXHIBITIONS QG 1966, no. 71; QG 1979–80, no. 38; QG 1991–2, no. 158

130

SÈVRES

Vase and cover (vase à panneaux or vase à perles), (?)1780

Vases à panneaux are among the most imposing shapes of vases produced at Sèvres in the eighteenth century. The earliest known example dates from 1766. No. 130 is a later simplified version which closely resembles a vase of the same size and decoration in the Wallace Collection (no.

C299). That vase, together with two *vases ferrés*, formed part of a garniture which Rosalind Savill has traced in the Sèvres records. Painted on the front with marine scenes by Jean-Baptiste-Etienne Genest, on the back with trophies by Charles Buteux, and gilded by Etienne-Henry Le Guay, they were fired in the enamel kiln on 14 September 1779. In the quayside scene on the front, in which sailors are handling cargo, one of the bundles is marked 79. Savill plausibly interprets this figure as the last two digits of the date 1779.

On no. 130 one of the bundles in the quayside scene is marked 80, which could be intended to represent the last two digits of the year 1780. It is perhaps significant that another garniture, painted by Genest and Buteux and gilded by Le Guay (shapes of vases not, however, specified), was fired in the enamel kiln on 13 November 1780. Notwithstanding the imprecision as to shapes, no. 130 could well be the centrepiece of this second garniture, bearing in mind the close stylistic affinities it has with the Wallace Collection vase. The back reserve in the present vase is also decorated with marine trophies.

Soft-paste porcelain; gilt bronze stand. Overall height 55 cm; dimensions excluding stand 49.2 × 26.7 × 21.1 cm
Inscribed in blue with interlaced LLs, with (below) the mark of the gilder Etienne-Henry Le Guay (fl.1748–96). Incised within the foot 41, and on the underside of the base 1^{er} (i.e. first size) and *Bono* (the mark of the *répareur* Etienne-Henry Bono, fl. 1754–81)
RCIN 2292
PROVENANCE George IV, by 1826 (CHPI, no. 43)
LITERATURE (Not in Laking 1907;) Savill 1988, I, pp. 316–33

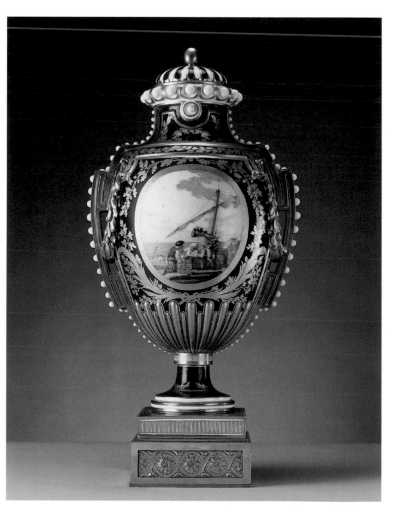

130

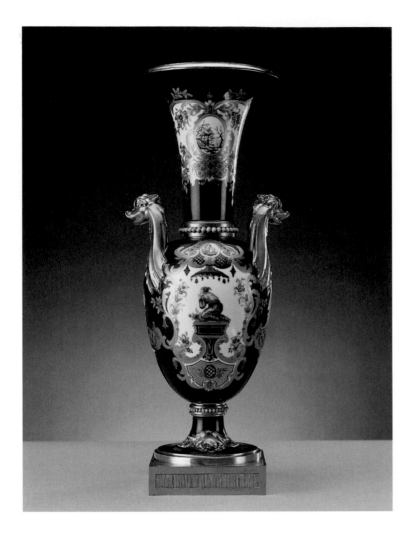

their delicate decoration and miniature-like scenes clashed with the plain celadon vases enriched with elaborate gilt bronze mounts, which formed the principal ornaments at Brighton. By 1826 the garniture was back at Carlton House, in company with the rest of George IV's collection of Sèvres porcelain.

Hard-paste porcelain; gilt bronze base. Overall height 38.4 cm; dimensions excluding plinth 35.7 × 15.1 × 12.8 cm
Inscribed in red with crowned interlaced LLs enclosing CC, the date-letters for 1780, with (below) the mark of the painter Nicolas Schradre (fl.1773–85)
RCIN 36076.2
PROVENANCE Sèvres manufactory sale, Versailles, 3 January 1781; unnamed buyer (1,920 livres, with rest of garniture); P.-J. Lafontaine; from whom bought by George IV, 1818 (Jutsham II, p. 38)
LITERATURE Laking 1907, no. 283 or 284; Préaud 1989, pp. 44–5; Sèvres 1989, pp. 32–3
EXHIBITIONS QG 1979–80, no. 41; QG 1991–2, no. 156; Cardiff 1998, no. 110

132
SÈVRES
Vase (vase chinois), 1781

With the exception of the rings (each composed of a serpent biting its own tail, a symbol of eternity) suspended from the handles, no. 132 is the same shape as no. 131. The handles, which are gilded and burnished, are formed of monster heads on bat's wing supports. As three differently

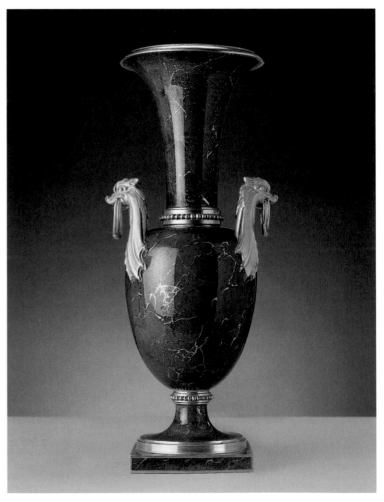

131
SÈVRES
Vase (vase chinois), 1780

The model for this shape, which was also used in no. 132, probably dates from c.1779. No. 131 is part of a three-piece garniture, incorporating this vase and its pair with a third (larger) vase, the manufacture of which is recorded in the Sèvres archives. In 1780 Nicolas Schradre was paid 480 livres for decorating the three vases. They were fired in the kiln for painted decoration on 10 December 1780 and were then offered for sale at the end-of-year sale held in Versailles; they were acquired by an anonymous buyer for 1,920 livres on 3 January 1781.

The most distinctive features in the decoration of the vases are the chinoiserie figures and diminutive scenes in the roundels and ovals on the neck, which seem almost to have been inspired by Meissen designs of the 1720s. The actual sources of inspiration are, however, French: Aléxis Peyrotte for the figures (from Gabriel Huquier's Second livre de cartouches chinois), and Jean Pillement for the miniature scenes.

Part of the attraction of these vases for George IV must have been their Chinese appearance: chinoiserie scenes in the reserves, and handles formed by the heads of mandarins on the centre vase. In 1818 they were despatched by the Parisian dealer Lafontaine to Carlton House for the inspection of George IV; he promptly had them sent to Brighton Pavilion, which he was busy transforming into a 'vision of Cathay'. Subsequently he had a change of mind. Perhaps on reflection he felt that

shaped vases were called *vases chinois* in the eighteenth century at Sèvres, it is sometimes difficult to establish which records refer to which models. In this instance the ground colour – blue striated in gold (*bleu lapissé d'or*) – provides a clue as it did not come into fashion until *c*.1778, the approximate date of introduction of vases of this particular pattern.

In December 1780 Nicolas Schradre received for decoration a garniture of three *vases chinois*, which he painted *en lapis* at a cost of 72 livres. A flanking pair of *vases chinois*, painted by Schradre with a lapis lazuli ground and gilded by Vincent, was fired on 20 November 1781. It seems very likely that these entries refer to no. 132 and its pair.

Christian Baulez has suggested that they, together with an undated centre *vase chinois* bearing Vincent's mark, now in Versailles, and two *vases cygnes à roseaux* in the Royal Collection (RCIN 4965.1–2), dated 1781 and bearing Vincent's mark, formed part of a garniture acquired by Louis XVI's aunt, Madame Adélaïde, on 29 July 1783. Within a year she exchanged them for other vases because, as suggested by Baulez, she objected to the differences in their ground colours. While this suggestion remains a possibility, the difference in colour is so marked that it is difficult to imagine the Director sanctioning their sale as a set, unless it was intended all along to introduce variety into the ground colour of the five vases. This, however, seems unlikely as uniformity of ground colour is the basic unifying factor in the concept of a garniture.

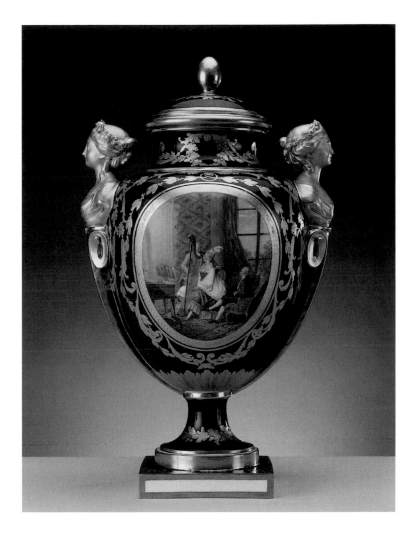

Hard-paste porcelain. 36.5 × 15 × 12.8 cm
Inscribed in gold with interlaced LLs between D and D, the date-letters for 1781, and (below) the mark of the gilder Henry-François Vincent (fl.1753–1800)
RCIN 4962.2
PROVENANCE Royal Collection by 1907
LITERATURE Laking 1907, no. 213; Baulez 1995, pp. 70–3

133
SÈVRES
Vase and cover (vase des âges), 1782

Produced in three sizes to form a garniture of five pieces, the *vases des âges* vary from size to size in the design of their herm-like handles: bearded heads for the first size, female heads for the second size and boys' heads for the third size. The models date from 1776 at the latest. No. 133 is one of a pair belonging to the second size. The heads are richly burnished in imitation of gilt bronze.

George IV evidently liked this shape. Of the twenty-three versions known today, seven are in the Royal Collection. Louis XVI also had a liking for the model. In 1781 he acquired a garniture of five jewelled pieces and in 1788 a further single vase of the second size, which presupposes the existence of other vases of matching design already in his possession. Records reveal that on 11 January 1782 Dodin received for decoration five *vases des âges* which he painted with scenes after Jean-Michel Moreau the Younger; on 22 March 1782 they were passed on to Edmé-François Bouillat, who added the flowers; on 16 December 1782 they were successfully fired. It is inviting to relate these vases to a purchase made by Louis XVI at the end-of-year sale at Versailles that year, which included five vases described as of dark blue ground and painted with miniature scenes. They, together with a coffee pot, cost the King 3,000 francs.

For the scene in the reserve, Dodin has faithfully copied an engraving entitled *L'Accord parfait* by Isidore-Stanislas-Henri Helman (after Moreau), which is dated 1777 and was taken from the second of three *Suites d'Estampes, pour servir à l'Histoire des Modes et du Costume* (1775–83). The reserve on the back is painted with flowers on a marble shelf.

Soft-paste porcelain. 41 × 23.5 × 18.9 cm
Inscribed in blue with interlaced LLs enclosing EE, the date-letters for 1782, with (below) the mark of the painter Charles-Nicolas Dodin (fl.1754–1803), and in gold the mark of the gilder Henri-Martin Prévost (fl.1757–97). Incised within the foot *age 2 me* and *25*; within the neck *Bono* (see no. 130) and B (in script)
RCIN 36096
PROVENANCE [Possibly part of the five-piece garniture bought by Louis XVI, December 1782 (3,000 francs, with a coffee pot);] Robert Fogg; from whom bought by George IV, October 1812 (Jutsham I, f. 227)
LITERATURE Laking 1907, no. 224; Brunet & Préaud 1978, p. 205, fig. 242; exh. cat. QG 1979–80, no. 100 (pair of *vases troisième âge* from same garniture)
EXHIBITIONS London 1862a, no. 1311

134
SÈVRES
Mounted vase (vase à monter), *c*.1785

The beauty of this piece lies in its simplicity of shape and delicacy of colouring – a clouded brown-black ground in imitation of lacquer – which sets off to full advantage the finely chased gilt bronze mounts.

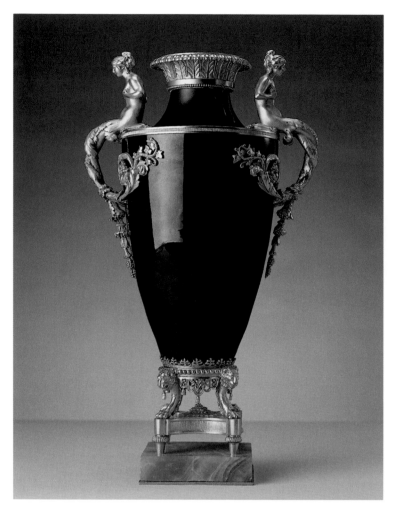

134

RCIN 253.2
PROVENANCE Coquille (Parisian dealer); from whom bought by François Benois for George IV (500 francs; bill dated 13 November 1815; RA GEO/26421)
LITERATURE Laking 1907, no. 301 or 302; Brunet & Préaud 1978, p. 211, fig. 262
EXHIBITIONS QG 1991–2, no. 166

135
SÈVRES
Mounted vase (?vase Boizot), 1787

Although the date of George IV's purchase of this vase and its pair is not known, it evidently pre-dates 9 July 1803 when Benjamin Vulliamy submitted a bill for the regilding of their bases. Bearing in mind that the works of art bought by George IV in Paris during the interlude in the Napoleonic wars in 1802–03 were all in the emerging Empire style, these vases, which are strikingly Louis XVI in style, must belong to an earlier period of his collecting. Perhaps they were among the pieces acquired by the *marchand-mercier* Dominique Daguerre in the late 1780s and early 1790s when he was engaged in furnishing Carlton House.

It is possible that this classically shaped vase was based on one which formed part of the collections of the Natural History Museum (the Musée Homme) in Paris. A drawing which is closely related to the shape of no. 135 is inscribed 'Vase Boizot que Monsieur Regnier a Choisie au Muséhomme por le faire Monté En Cuivre ce 4 juin 1787'. On this evidence the Sèvres copy was modelled by Louis-Simon Boizot (Director

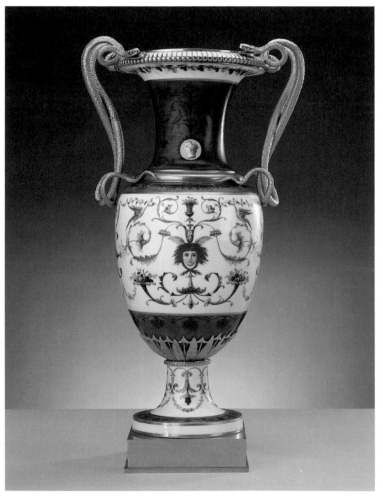

These include mermaid figures, lion's paw monopode legs and pierced and tasselled lambrequins. The fitting of mounts to porcelain, which was introduced at Sèvres *c.*1764, was no doubt inspired, in a spirit of emulation, by the popularity of mounted oriental porcelain vases in the first half of the eighteenth century. No. 134 and its pair (also in the Royal Collection) were clearly designed for mounts. The hole in the bottom through which the spindle passes was pierced when the vase was still in its biscuit state whereas, paradoxically, the two holes in the shoulders for the attachment of mounts were drilled after glazing.

The shape of no. 134 resembles a drawing of a vase dated 4 March 1785 which, on the evidence of the annotations, was designed by Louis-Simon Boizot and was intended to be fitted with mounts supplied by Pierre-Philippe Thomire. An attribution of the mounts to Thomire is tempting. In a bill dated 26 January 1784, he supplied the manufactory with mounts for a vase priced at 500 livres; these included mermaids ('Garniture à petite femme en queux de Poissons dorés au matte') and may well have borne a resemblance to those on no. 134.

The vases were recorded by Pyne on the chimneypiece of the Golden Drawing Room at Carlton House in 1817 (Pyne 1819, III, *Carlton House*, opposite p. 58). They were still at Carlton House when the Pictorial Inventory was made ten years later (see QG 1979–80, no. 166).

Hard-paste porcelain; gilt bronze mounts; onyx stand. Overall height 35 cm; dimensions excluding stand 32.7 × 19.2 × 12.8 cm
Not marked

135

of Sculpture at Sèvres from 1773) at the request of the Director of the Sèvres manufactory, Antoine Régnier, with a view to having the vases fitted with gilt bronze mounts.

The manufacturer most likely to have been commissioned to supply the mounts on no. 135, with snakes forming the two handles, was Pierre-Philippe Thomire. Following the death of Jean-Claude-Thomas Duplessis on 24 August 1783, Thomire became the Sèvres manufactory's accredited bronze supplier. It is perhaps significant that on 24 September 1785 Thomire supplied the manufactory with 'une garniture de Vases à Petits Serpents Chinois'. Whether they bore any relation to those on no. 135 is impossible to tell. The reference to small serpents does however suggest a link. An overtime payment of 336 livres to Le Bel in November 1787 for painting arabesques on two vases could apply to the Raphaelesque decoration on no. 135.

Soft-paste porcelain; gilt bronze mounts. Overall height 33.5 cm; dimensions excluding base 31.5 × 17.5 × 12.1 cm
Inscribed in gold with interlaced LLs enclosing KK, the date-letters for 1787, with (to the right) the mark of the painter Jean-Nicolas Lebel (fl.1765–93)
RCIN 45040.2
PROVENANCE Bought by George IV, by 9 July 1803 (RA GEO/25145)
LITERATURE Laking 1907, no. 314 or 315
EXHIBITIONS QG 1991–2, no. 157

136
SÈVRES
Mounted vase (?vase étrusque), c.1792

The shape of this vase (and its pair, also in the Royal Collection) may derive from a classical prototype in the so-called Etruscan collection of vases bought in Naples by Dominique Vivant-Denon and sold to Louis XVI. In 1786 the vases were deposited at Sèvres by the Comte d'Angiviller, the minister in charge of the manufactory, to serve as models or to provide inspiration for the potters. No. 136 closely resembles a drawing in the Sèvres archives dated 30 July 1788 which is described as 'Vase de forme Etrusque Pris D'apres une terre Entique'. It differs only in the stem, which is taller in the drawing than on the vase.

The striking feature of these vases is their decoration. Platinum, first introduced at Sèvres c.1790, was preferred to silver as it does not tarnish. No doubt inspired by the dark ground of classical vessels, a short-lived but popular line was developed at Sèvres in the early 1790s of black ground wares which set off to advantage exotic figure scenes in white metal (platinum) and gold.

The combination on no. 136 of a classical shape and wildly fanciful oriental figure scenes may seem curious. The diversity of sources is particularly marked in the scene in which a haloed monkey holding a wreath and seated on a column is being worshipped by two Chinamen; this is based on a design that is entirely rococo in spirit, engraved by P.-C. Canot after Jean Pillement and published in London on 1 March 1759. The decoration round the neck of the vase, combining a scrolling arabesque band and symmetrically disposed garlands and swags suspended from studs, acts, however, as a sobering corrective to the exuberant scenes enacted round the body.

Between December 1817 and December 1818 the vases were introduced to the Rose Satin Drawing Room at Carlton House, where they

136

are shown on a pier table in the second view of that room made for Pyne's Royal Residences (Pyne 1819, III, Carlton House, opposite p. 32).

Hard-paste porcelain; gilt bronze mounts. Overall height 33.7 cm; dimensions excluding mounts 32.2 × 11.5 cm
Traces of inscription in gold; on the companion vase (not shown) these have been interpreted as the date-letters nn for 1792
RCIN 2344.2
PROVENANCE Robert Fogg; from whom bought by George IV (£84; bill dated 25 May 1812; PRO LC11/13)
LITERATURE Laking 1907, no. 286 or 287; Brunet & Préaud 1978, p. 124, fig. 271
EXHIBITIONS QG 1991–2, no. 167

137
ST PETERSBURG
Vase, 1844

The Russian Emperor Nicholas I (r. 1825–55) made a State Visit to Britain in June 1844, staying at both Buckingham Palace and Windsor Castle (see no. 407). This was the first visit of a ruling Tsar since that of Alexander I in 1814 at the time of the allied celebrations after the defeat of Napoleon. He arrived at Woolwich (having travelled incognito as 'Count Orlov') on 1 June and was determined to make the most of his short visit. He called on the Duke of Wellington at Apsley House, and

attended a banquet given in his honour at Chiswick by the Duke of Devonshire (see Lincoln 1975). He twice attended Ascot races, donating a cup worth £500 to be run for annually, and contributed towards the completion of Nelson's Column. Having resisted the proposed visit for some time, the Queen warmed to the Tsar but found him humourless and lacking in education. Subsequently, when a number of the ground floor reception rooms at Buckingham Palace were refitted in 1849, one of them was named the 1844 Room in honour of the visit, with the double-headed eagle prominent in the heraldic plasterwork of the ceiling.

Following his return to Russia, the Tsar despatched this vase (together with its marble pedestal) and a mosaic table to the Queen and Prince Albert. The gifts were transported in eight cases on the steamer *Mermaid* and arrived at Windsor in early December, when the Queen pronounced the vase 'splendid and immense'. It is of 'Medici' form and was made at the Imperial Porcelain Manufactory in St Petersburg, decorated with matt and burnished gold, with large-scale views of the imperial palaces of Peterhof and Tsarskoe Selo on either side, painted by N. Korniloff (d. 1852). The handles and the moulding around the rim are of gilt bronze. The porcelain factory was founded by the Tsarina Elizabeth in 1744, when the first pieces of hard-paste porcelain were produced. Under Catherine the Great (r. 1762–96) the factory worked mainly for the imperial court and the craftsmen were exclusively Russian.

The vase was placed in the window bay of the Green Drawing Room at Windsor Castle, where it stood until soon after Queen Victoria's death, when it was removed to Osborne. During the restoration of Windsor Castle after the 1992 fire, the vase and its pedestal were returned to Windsor and placed against the north window of the State Dining Room.

Hard-paste porcelain; gilt bronze mounts. 142 × 108 cm
Painted (in black inside the bell) with an imperial crown above JTC. Signed and dated within each reserve scene N. *Korniloff* / 1844. Inscribed (with a burnishing tool) on the gilt borders of the painted reserves *Peterhoff L'an* 1844 and *Czarskoe Selo L'an* 1844
RCIN 41230
PROVENANCE Presented to Queen Victoria and Prince Albert by Tsar Nicholas I, 1844

138
SÈVRES
Pair of vases (vase Aubert No. 40), 1924–37

The history of the manufacture of the two vases has been partially reconstituted by Tamara Préaud, based on a search of the manufactory's records. While the vases themselves were produced as early as 1924, they were evidently left undecorated. One (see reproduction) was painted in 1928 by Henry-Joseph Lasserre with a tiger hunt in the Indian subcontinent: huntsmen seated in howdahs on the backs of elephants are represented shooting at tigers in a rich jungle and interspersed with buildings. The other was painted in 1930 by Louis-Jules Trager with an evocation of Africa: antelopes, camels and native dancers parade in front of pyramids. Both artists were copying designs by Jean-Georges Beaumont. In May 1937, after the English royal arms had been added at a cost of 6,000 francs, the two vases, each valued at 40,000 francs, were despatched to the Minister of Foreign Affairs for presentation to

King George VI and Queen Elizabeth by the President of the French Republic, Monsieur Albert Lebrun. The occasion was the coronation of the King and Queen, which was held on 12 May 1937.

A slight difficulty arose as the King had announced that as a general rule he would not accept coronation gifts. To avoid embarrassment, the French ambassador was informed by Lord Hardinge, the King's Private Secretary, that the gift would be treated as personal rather than as official. It was in this context that King George VI, in his letter of thanks to the President, dated 6 May 1937, expressed his great pleasure at receiving the 'magnificent gifts of Sèvres porcelain'.

Hard-paste porcelain. 'Africa' 99 × 47 cm; 'India' 98 × 47 cm
Inscribed in black with the mark of the manufactory; on 'India' *d'après* J. BeauMONT H. LASSERRE; on 'Africa' L *Trager d'après* JEAN BEAVMONT. Incised on 'India' LG (in script), the mark of the potter Lucien Edouard Goron, followed by 24, 6 PN (i.e. June 1924 *pâte nouvelle*); on 'Africa' identical mark, but with the date for September 1926
RCIN 100002.1–2
PROVENANCE Presented by the President of the French Republic to King George VI and Queen Elizabeth on the occasion of their coronation, 12 May 1937

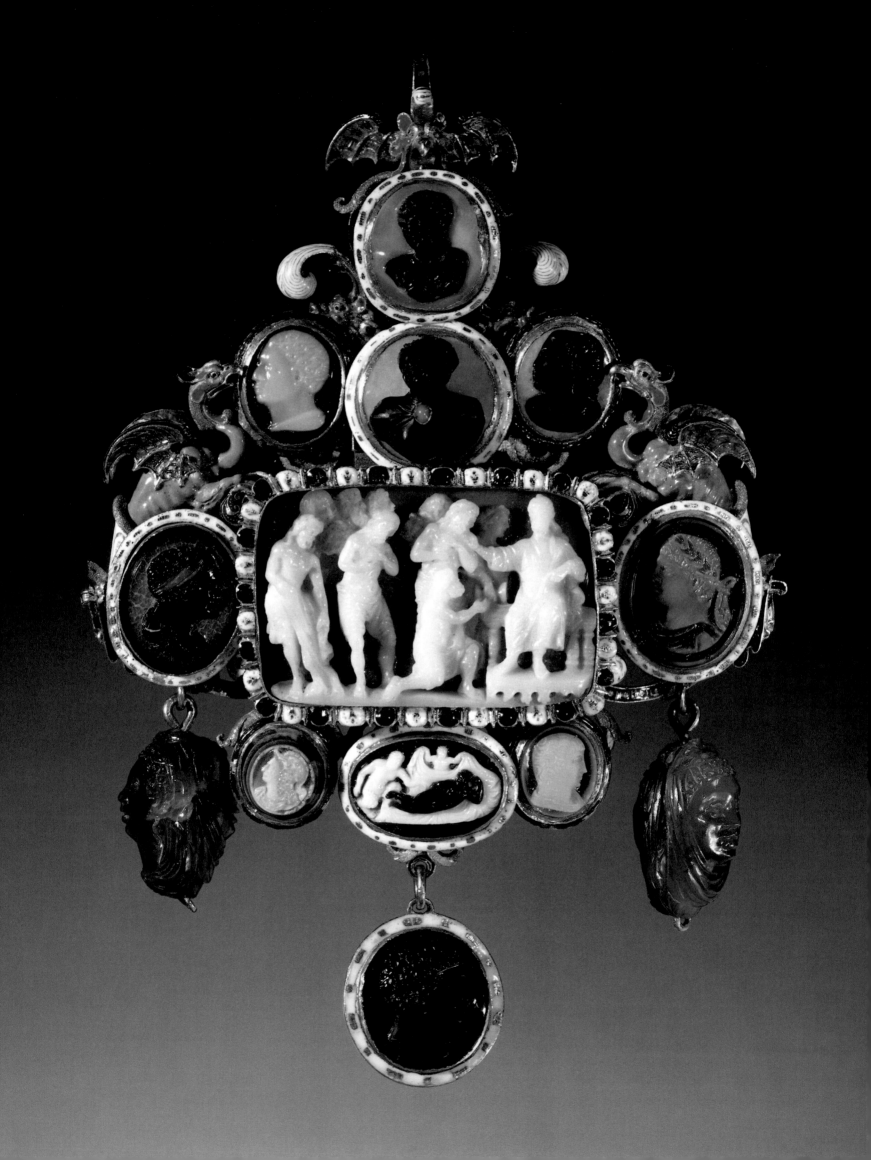

ANTIQUE AND RENAISSANCE GEMS AND JEWELS (nos 139–151)

The European gems and jewels, by which is meant the precious objects distinct both from the Crown Jewels in the Tower of London and from Her Majesty The Queen's personal jewellery in use, have been kept at Windsor Castle since the beginning of Queen Victoria's reign in 1837. Although by no means as extensive or coherent as some of the great European royal and princely collections, the gems (cameos and intaglios) and historic jewels at Windsor none the less include several individual pieces and groups of objects of international importance. While there have been no British royal collectors of gems and jewels to rival Catherine the Great of Russia, the Medici of Florence or the Electors of Saxony, important additions to this part of the Royal Collection were made by Charles I, Queen Caroline (consort of George II), George III and George IV.

The collection of gems ranges from classical antiquity to the nineteenth century. The finest early piece is undoubtedly the first-century AD cameo portrait of the Emperor Claudius (no. 140), which is known to have been in the collection of Charles I. This wonderful example of the gem-cutter's art provides a perfect demonstration of the way in which the image is 'revealed' by judicious cutting away and polishing of parts of the four differently coloured layers or strata of the great onyx pebble from which it was fashioned. The Claudius cameo was probably spared the fate of the majority of Charles I's collection – dispersal by sale during the Interregnum (1649–60) – because it had been badly damaged at the beginning of the seventeenth century. The majority of the cameos and intaglios date from the sixteenth to the eighteenth centuries and include virtuoso carvings such as no. 147 as well as superb portraits (for example no. 144) and many examples of the work of later Milanese and Roman gem-cutters.

The jewels are equally varied and range from precious survivals such as the sixteenth-century enamelled gold hat badge traditionally associated with Henry VIII (no. 141) and the spectacular Darnley Jewel (no. 143), to the so-called Queen Elizabeth emerald with its nineteenth-century Holbein-style setting (no. 151). Most of the cameos and intaglios are framed, some very simply in plain gold mounts, others in elaborate enamelled settings which transform them into pieces of jewellery. No. 150, a rich confection from Queen Caroline's collection, falls into this category.

Documentary evidence about the formation of the collection is patchy. We know that Henry VIII possessed important examples, but none of these survives in the Royal Collection today. Charles I's collection – which probably included pieces inherited from his elder brother Henry, Prince of Wales, from his mother Anne of Denmark and from the old Tudor collection – was largely dispersed. However, Charles II reassembled a considerable collection of gems and jewels, seen by the diarist John Evelyn in the autumn of 1660 in the King's 'cabinet and closet of rarities' at Whitehall Palace. Recent research has shown that Queen Caroline was also a discriminating collector of cameos (nos 144, 147, 150), with a particular eye for and interest in images of the Tudor dynasty; George III added a major group of gems when he purchased the collection of Consul Smith in 1762, including the superb Hellenistic fragmentary head of Zeus (no. 139); and George IV purchased numerous contemporary and historic cameos, many of which were set into wearing jewellery (principally brooches, rings and insignia of the Order of the Garter).

As well as adding important and historic pieces to the collection, most notably the Darnley Jewel from Horace Walpole's collection at Strawberry Hill (no. 143), Queen Victoria was the first sovereign to organise the collection in a consciously historical manner. In this she was encouraged by Prince Albert and, no doubt partly in recognition of his interest, the Queen lent the whole collection (some 292 pieces) to the Special Exhibition of Works of Art at the South Kensington Museum in June 1862, six months after the Prince's death. Ten years later the leading Victorian scholar C.D.E. Fortnum drew up a report on the collection for the Queen, in which each piece was described and illustrated and the first attempt at serious categorisation of the gems was made (RCIN 1114738). A typescript catalogue of the gems and jewels was completed in 1909 (here referred to as G&J). Five years later Queen Mary commissioned a catalogue of additional items; this incorporated pieces such as no. 151 which she had acquired. She also had special stands made for the gems and jewels, which for much of the twentieth century were displayed in the Stuart Room at Windsor Castle. Following the fire at Windsor in 1992, display cabinets for the collection were created in the newly built Lantern Lobby.

Frequent references have been made to the collection of gems

and jewels in scholarly publications since the early twentieth century, and many pieces have been lent to exhibitions, but it is only with the planned publication of the catalogue raisonné of the collection, the result of many years' research by Dr Kirsten Aschengreen Piacenti and Sir John Boardman, that the collection will be available to a wider audience. The summary entries which follow are based, with grateful acknowledgement, on the much fuller entries from this forthcoming publication.

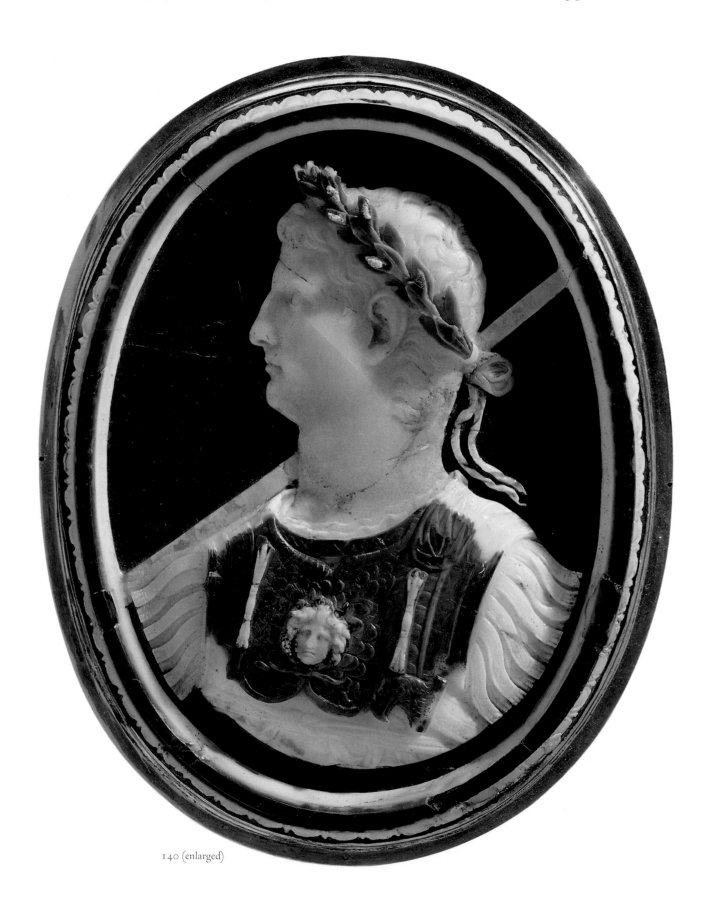

140 (enlarged)

139

139

HELLENISTIC
Cameo head of Zeus, second/first century BC

Although only fragmentary (about two-thirds of the oval is missing), enough detail survives in this cameo, considered one of the finest surviving from the Hellenistic period, to identify the bearded figure as that of Zeus, father of the gods. The naturalistic carving of the hair and beard in particular, and the undercutting of certain details such as the nose, emphasise the highly accomplished use of the three differently coloured strata of the stone by the unknown gem-cutter.

No. 139 was acquired by George III with the Consul Smith collection in 1762. Smith's gems, made famous by the publication in 1767 of Antonio Gori's catalogue, *Dactyliotheca Smithiana*, consisted principally of North Italian sixteenth- and early seventeenth-century cameos, with some Roman eighteenth-century intaglios and a few antique stones, of which no. 139 was by far the most important. It has a plain gold mount, probably added after the stone entered the Royal Collection.

Onyx, gold mount. 6 × 4.9 cm
RCIN 65600
PROVENANCE Joseph Smith, Venice; from whom bought by George III, 1762
LITERATURE Gori 1767, I, pl. 1; G&J, no. 215; Piacenti & Boardman (forthcoming)
EXHIBITIONS London 1862a, no. 6641(1); QG 1962–3, no. 90; QG 1990–1, no. 178; QG 1993, no. 83

140

ROMAN
Cameo head of the Emperor Claudius, c.43–5 AD

This idealised portrait of Claudius, who reigned from 41 to 54 AD, is the finest ancient cameo in the Royal Collection. The monumental grandeur and formality of the image, combined with the crisp and highly polished cutting of the four strata or layers of this unusually large stone, place it in the top rank of surviving portrait cameos from imperial Rome. It has been suggested that the stone may have been cut to celebrate Claudius's victory in Britain in 44 AD.

The entry of this cameo into the Royal Collection is unrecorded, but it was certainly in Charles I's collection and could have been inherited from his elder brother, Henry, Prince of Wales. If this was so, it may have come to Henry from the famous collection of Abraham Gorlaeus of Delft. However, an alternative route via Henry VIII's collection cannot entirely be ruled out.

We know from Abraham van der Doort's inventory of Charles I's collection, completed in 1639, that the cameo was broken by Lady Somerset during her husband's tenure as Lord Chamberlain to James I (1613–15). She was the notorious Frances Howard, divorced wife of the third Earl of Essex, who married James I's favourite, Robert Carr, Earl of Somerset, in 1613. Three years later, Somerset and his wife were arrested, tried and convicted of the poisoning of their erstwhile friend, the poet and courtier Sir Thomas Overbury shortly before their marriage; they were later pardoned.

The damaged state of the stone may have prevented its sale during the Interregnum (1649–60) and ensured its survival in the Royal Collection, although two other cameos (portrait heads of Philip II of Spain: RCIN 65201 and 65199), which are undamaged, also appear to have come from Charles I's collection and to have escaped the dispersal sales in 1649 and 1651. No. 140 was seen by John Evelyn at Whitehall in 1660 and may be identified with the broken antique cameo seen by Horace Walpole at Kensington Palace in 1764 (RA GEO/Add 16/27).

Onyx, gilt copper mount. 19 × 14.6 cm (excluding mount)
RCIN 65238
PROVENANCE [Possibly Abraham Gorlaeus of Delft; from whom perhaps acquired by Henry, Prince of Wales (d. 1612); from whom inherited by] Charles I when Prince of Wales; Royal Collection by c.1613–15
LITERATURE G&J, no. 205; Vollenweider 1966, no. 79; Megow 1987, no. A76; Piacenti & Boardman (forthcoming)
EXHIBITIONS London 1861; London 1862a, no. 6641(2); Birmingham 1960, no. 175; QG 1962–3, no. 99; Australia 1977, no. 25; QG 1990–1, no. 179

141

FLEMISH(?)
Hat badge, c.1520

The very fine detail and delicate high relief enamelling of this exceptional jewel, depicting an equestrian St George in armour slaying the dragon, suggest that it may have been made in the Southern Netherlands, perhaps in the region of Antwerp. In this area, the great Burgundian tradition of enamelling survived into the period of

141

Habsburg rule, as seen on a small number of similarly decorated early sixteenth-century reliefs using the same enamelling technique (known as *émail en ronde bosse*). In no. 141, it may be that the unusual iconography of the saint, shown bearded and with flowing hair, is a deliberate reference to the twelfth-century Emperor Frederick Barbarossa, whose cult as a pattern of imperial virtue flowered significantly during the reign of the Emperor Maximilian I (r. 1493–1519). The badge would have been fixed to a hat or cap in the manner shown in Horenbout's portrait of Henry VIII (no. 37).

The badge is supposed to have been given to Henry VIII by Maximilian, who had been the English King's ally during the campaign against the French in Flanders in 1513. Although such a gift, incorporating the patron saint of England and reminiscent of the badge of the Order of the Garter, would have been highly appropriate, there is no supporting documentary evidence. Furthermore, it seems that this traditional account dates only from the nineteenth century, at which period the badge was set into a rectangular glass and enamel case. The first reference to the jewel (sometimes known confusingly as the 'Holbein George') appears to be 1830; its date of acquisition is unknown, but it is the type of object that would have had a strong appeal for George IV.

Gold, enamel. Diameter 4.3 × 0.9 cm
RCIN 442208
PROVENANCE By tradition Henry VIII; first apparently recorded in the Royal Collection in 1830 (copy list by Rundell, Bridge & Co., 16 September 1830: RCIN 1114749, f. 13)
LITERATURE G&J, no. 192; Evans 1970, p. 95; Hackenbroch 1979, fig. 299; Piacenti & Boardman (forthcoming)
EXHIBITIONS London 1862a, no. 6641(10); London 1895a, no. G51; Birmingham 1960, no. 297; QG 1978–9, no. 87; QG 1990–1, no. 185

142
FRENCH (or ?ENGLISH)
Pendant, c.1550–60

The place of manufacture of composite jewels of this kind (known as *commessi*) remains uncertain. A sixteenth-century French court workshop is considered a strong possibility, although it has also been suggested that the enamelling of the back recalls English work of the same date. Typically, in the case of no. 142 a contemporary Italian cameo fragment (perhaps representing Omphale, a queen of Lydia) has been used in combination with gemstones and gold to create a new image (possibly of Dido, Queen of Carthage) and an altogether more luxurious object.

This jewel and no. 147 appear to be identifiable in the posthumous inventory of the possessions of Queen Caroline (d. 1737), drawn up before 1755.

Gold, cornelian, amethyst, rubies, enamel. 4.8 × 3.5 cm
RCIN 65249
PROVENANCE Probably acquired by Queen Caroline (d. 1737; BL Add. MS 20101, f. 60)
LITERATURE G&J, no. 180; Tait 1962, pl. XLIIc and d; Hackenbroch 1979, p. 90; Piacenti & Boardman (forthcoming)
EXHIBITIONS Probably London 1862a, no. 6641; QG 1990–1, no. 183

142 (enlarged)

143
SCOTTISH(?)
The Darnley Jewel, c.1571–8

This celebrated jewel or 'tablet' (in the language of the sixteenth century), which was intended to be worn at the neck or on the breast, was probably made for Lady Margaret Douglas (1515–78) following the death in 1571 of her husband Matthew, Earl of Lennox, Regent of Scotland. Lady Margaret was the granddaughter of Henry VII, half-sister of James V of Scotland and first cousin of Elizabeth I. Through her elder son Henry Stewart, Lord Darnley, who married her niece Mary, Queen of Scots, in 1565, Lady Margaret was the grandmother of James VI of Scotland and I of England.

The iconography of the jewel is unusually complex. Twenty-eight emblems and six inscriptions in old Scots alluding to the turbulent history of the Lennox family and perhaps to the hopes and ambitions of Matthew and Margaret Lennox for their grandson James, born in 1566, are incorporated in the design. The decoration, mainly in translucent enamel over a textured gold surface (*basse-taille*), and the construction, with interior compartments concealing further emblematic devices, are equally elaborate. The place of origin of the jewel is not known but workmanship of this quality was certainly available in Edinburgh in the mid-sixteenth century.

The first serious research into the history and iconography of the jewel took place only after it was acquired by Queen Victoria from Horace Walpole's famous collection at Strawberry Hill in 1842. The Queen, alerted to the sale by her Prime Minister Lord Melbourne, purchased both the Darnley Jewel and Anne Boleyn's clock (RCIN 30018). Walpole, who described the early provenance of the jewel correctly, never revealed how he had come by it. He valued it so highly ('I never let it go out of my own hands') that he refused even to allow it to be drawn for the Society of Antiquaries of Scotland. By contrast, the

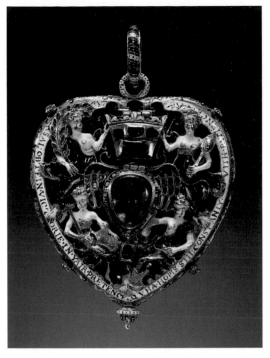

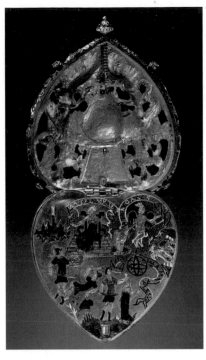

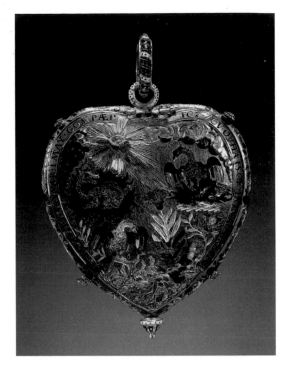

143 (front) 143 (open, reduced) 143 (back)

Queen commissioned an illustrated account from the antiquarian P. Fraser Tytler, published in 1843. Fraser Tytler suggested that the jewel might either have been made for James VI and I – unlikely in view of its feminine nature – or have passed by will from Lady Margaret to her granddaughter, the unfortunate Lady Arabella Stewart (d. 1615), and thence perhaps to Arabella's widower, William Seymour, second Duke of Somerset (d. 1660). In 1855, on a visit to the British Museum, it was suggested to Prince Albert that the jewel could have been the 'Poor Remembrance' bequeathed by Elizabeth (née Talbot), Countess of Lennox (daughter-in-law of the original owner and mother of Arabella), to Elizabeth I in 1582. This intriguing suggestion remains unsubstantiated.

Gold, enamel, rubies, emerald and a false sapphire. 6.6 × 5.2 cm

RCIN 28181

PROVENANCE Probably made for Lady Margaret Douglas (d. 1578); Horace Walpole (d. 1797); by descent; sale of the contents of Strawberry Hill, George Robins, 11 May 1842 (60); bought by Queen Victoria (130 gns)

LITERATURE Fraser Tytler 1843; G&J, no. 184; Marshall 1991, no. 5; Piacenti & Boardman (forthcoming)

EXHIBITIONS London 1934, no. 1440; Birmingham 1960, no. 302; London 1980–1a, no. 31; Edinburgh 1991, no. 5

144
ENGLISH(?)
Cameo of Elizabeth I, c.1575–85

Sardonyx cameos showing Elizabeth I in profile have survived in considerable numbers: six (including no. 144) of this large size and superb quality are known. These cameos (and the smaller versions of them) were distributed by the Queen as diplomatic presents or as a sign of high favour to members of her court. In this respect such apparently

unageing images, which are always of the same general format, would certainly have contributed to the burgeoning cult of the Virgin Queen (see no. 46). Their place of manufacture and the gem-cutter or cutters responsible are, however, still unidentified. If an English workshop was involved, as seems likely, it must have been under the direction of an experienced foreign artist or, at the very least, an English artist trained abroad. Julien de Fontenay (fl.1575–1600), who is known to have been sent from France by Henry IV to portray Queen Elizabeth, is one of a number of possible candidates. The artist and musician Jerome Lanier (for whom see p. 50) owned a version 'cut by a famous Italian' which he showed to the diarist John Evelyn in 1653; according to Evelyn, Lanier

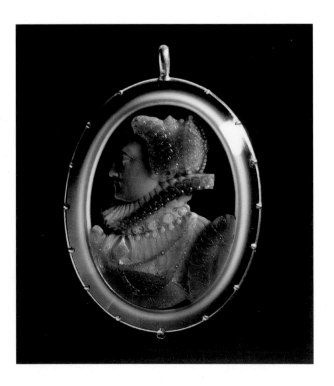

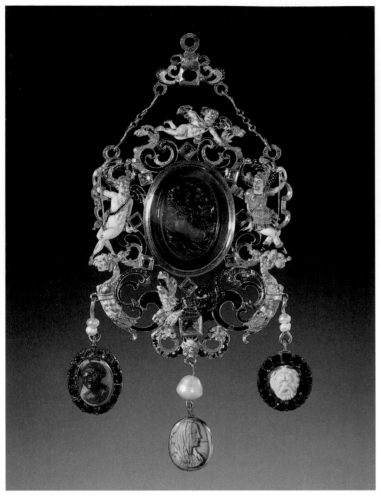

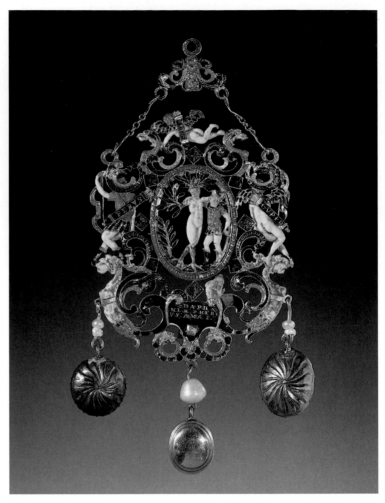

145 (front)

145 (back)

had been a domestic of Queen Elizabeth (*Evelyn Diary*, III, pp. 79–80).

Together with several other cameos still in the Royal Collection (see nos 147 and 150), it appears that no. 144 belonged to Queen Caroline, consort of George II. It was noted by Horace Walpole in 1764 at Kensington Palace among a group of gems which are known to have formed part of the collection of this cultivated and learned Queen (who also owned cameo images of other members of the Tudor dynasty). It was probably while in her possession that no. 144 acquired the present eighteenth-century mount.

Sardonyx, gold mount. 6.7 × 5.5 cm
RCIN 65186
PROVENANCE Queen Caroline (d. 1737)
LITERATURE G&J, no. 27; Kagan 1996, p. 141; Piacenti & Boardman (forthcoming)
EXHIBITIONS London 1862a, no. 6641(7); London 1934, no. 1437; London 1956–7, no. 602; Birmingham 1960, no. 298

145
ENGLISH(?)
Pendant jewel, second half of the sixteenth century

In its original form, this elegant Mannerist-style jewel would almost certainly have held a locket in the centre, perhaps containing a miniature, in place of the present late eighteenth-century onyx cameo of a

bearded male head. The iconography of the enamelled openwork frame – incorporating the figures of Apollo and Daphne in the centre of the reverse and Cupid at the top – taken with the inscriptions, suggests the theme of unrequited love, and this theme was presumably echoed in the original contents of the locket. The place of manufacture of the pendant is uncertain; the design owes something to the court style of Etienne Delaune (c.1518–83), but features such as the setting of jewels on the enamel may point to an English origin.

Although nothing is known of the early history of the jewel, the three pendant cameos, two of onyx of probable sixteenth-century date, and one of turquoise possibly slightly later, belonged to Consul Smith, whose collection was acquired by George III in 1762. They were probably added to the jewel in the reign of George IV.

Gold, enamel, diamonds, pearls, emeralds, rubies, onyx, turquoise. 11.8 × 5.5 cm
The back inscribed DAPH / NEM: PHEB / VS: AMAT; FERVS; CVPID; and CPID
RCIN 65254
PROVENANCE Possibly assembled in its present form for George IV; the pendant cameos acquired by George III from Joseph Smith, 1762
LITERATURE G&J, no. 187; Piacenti & Boardman (forthcoming)
EXHIBITIONS Birmingham 1960, no. 300; QG 1990–1, no. 166

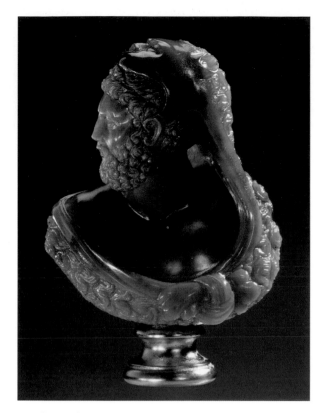

146 (enlarged)

146
NORTH ITALIAN
Bust of Hercules, second half of the sixteenth century

Although executed as a bust in the round, the carving technique employed for this piece is the same as that for gem-cutting. Similar small-scale busts were made in the grand ducal workshops of Florence to decorate cabinets and other pieces of furniture. The image of the Greek hero Hercules was often used to symbolise either the city of Florence or Grand Duke Cosimo I de' Medici (r. 1537–74).

Horace Walpole noted an agate bust of Hercules – almost certainly identifiable with this piece – at Kensington Palace in 1764. The date of acquisition is unknown but it is likely that this piece had formed part of the gem collection of Queen Caroline (d. 1737).

Agate, gilt metal socle. 4.7 × 3.8 × 3 cm
RCIN 65740
PROVENANCE Possibly Queen Caroline; George III, by 1764
LITERATURE G&J, no. 285; Piacenti & Boardman (forthcoming)
EXHIBITIONS Probably London 1862a, no. 6641; QG 1990–1, no. 187

147
NORTH ITALIAN
Cameo of the Adoration of the Magi, sixteenth century

This exceptional cameo exploits to the full the three contrasting strata – yellow, white and dark brown – of the oval agate from which it is made. Deep undercutting and careful use of the darker and lighter veins produce an extraordinary illusion – on a miniature scale – of space and perspective. The kings, their pages, a horse and a camel process from the right

background to the left foreground, towards the Virgin and Child, giving a convincing sense of movement and animation to the familiar scene.

One of only a small number of religious subjects in the Royal Collection of cameos (see no. 150), this *tour-de-force* of the gem-cutter's art belonged to Queen Caroline (d. 1737) and is first recorded in a posthumous inventory of her collection drawn up before 1755 (see no. 142).

Agate, silver-gilt mount. 3.5 × 6.5 cm
RCIN 65175
PROVENANCE Queen Caroline (d. 1737; BL Add. MS 20101, f. 60)
LITERATURE G&J, no. 16; Piacenti & Boardman (forthcoming)
EXHIBITIONS Probably London 1862a, no. 6641; QG 1962–3, no. 93; QG 1990–1, no. 181

148
ENGLISH(?)
Locket, c.1610

The delicate 'pea-pod' enamelling (so called because of the resemblance of certain features to peas in a pod) on the pierced symmetrical scroll-work of the front of this locket relates it closely to a group of spectacular Stuart jewellery, of which the best-known example is probably the Lyte Jewel. That *de luxe* object (now in the British Museum) contains a miniature by Nicholas Hilliard of James I, by whom it was given to Thomas Lyte in 1610. No. 148 is less richly jewelled but has the unusual feature of a delicately enamelled back asymmetrically pierced with an all-over naturalistic design. Like the Lyte Jewel, no. 148 originally held a miniature, but its subject and date of removal are unknown.

The plain gold interior fitting now contains a lock of Charles I's hair, 'cut' (as the inscription on it notes) 'from his head on April 1st 1813'. Charles I's burial place was discovered by accident during preparations for the interment in the royal vault in St George's Chapel, Windsor Castle, of George IV's mother-in-law and aunt, Augusta, Duchess of Brunswick, who had died suddenly on 23 March 1813. The King's coffin was opened in the Prince Regent's presence by his physician, Sir Henry Halford (1766–1844), who conducted an examination of the remains and analysed the hair. It seems that the locket, which is also inscribed 'given to me by the Prince Regent' (without identifying the recipient), was given to Princess Charlotte (d. 1817), the only child of George IV by his wife, Caroline of Brunswick. It was in Queen Victoria's

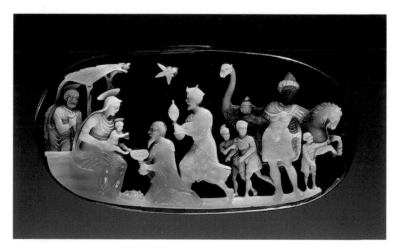

147 (enlarged)

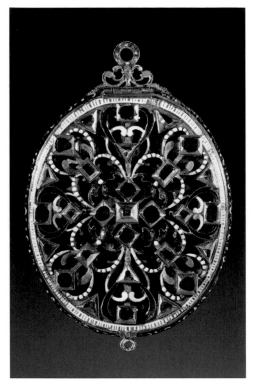

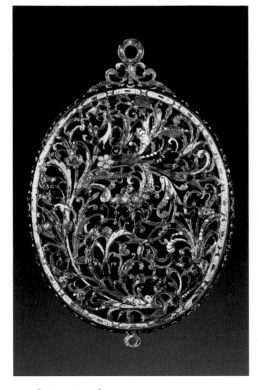

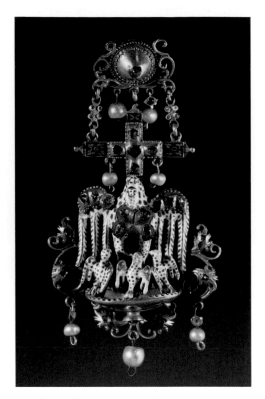

148 (front, enlarged) 148 (back, enlarged) 149 (enlarged)

possession in 1896 when it was recorded in Garrard's Inventory of her jewels.

George IV was fascinated by Charles I, both as King and as collector. Parallels between the two, at least as collectors, can easily be drawn, and George IV's conscious attempts to reacquire paintings which had once belonged to the Martyr King (not least the celebrated *Head of Charles I in three positions* by Van Dyck) are but one aspect of this.

Gold, enamel, rubies, diamonds. 7.5 × 5 cm
RCIN 43778
PROVENANCE George IV, until 1813; Princess Charlotte (d. 1817); Queen Victoria, by 1896 (Garrard's Inventory, RCIN 1114856, f. 518)
LITERATURE G&J, no. 255; Piacenti & Boardman (forthcoming)
EXHIBITIONS QG 1990–1, no. 167

149
SPANISH(?)
Devotional pendant, c.1630–40

The pelican in her piety, scoring her breast to feed her young with her own blood to symbolise either Christ's sacrifice or Charity, together with the phoenix, symbol of the Resurrection or of Chastity, were among the most familiar and potent of devotional images in Christian (especially Catholic) Europe from the late Middle Ages to the seventeenth century. Both birds were regularly used on personal jewellery. Henry VIII and Elizabeth I, for example, owned pelican or phoenix jewels. In no. 149, features such as the design of the scrollwork and the manner of setting the gems point to a continental, probably Spanish origin.

Gold, enamel, silver, rubies, diamonds, pearls. 6.5 × 3.7 × 1.3 cm
RCIN 65255
PROVENANCE First recorded in the collection of Queen Victoria, 1872 (MS inventory of gems, 1872: RCIN 1114738, no. 134).
LITERATURE G&J, no. 188; Piacenti & Boardman (forthcoming)

150
ENGLISH(?)
Pendant with cameos, early eighteenth century (with antique, sixteenth- and seventeenth-century elements)

Originally a seventeenth-century enamelled pendant with a central scene surrounded by jewels (the fixings for which are visible beneath the present arrangement of cameos), no. 150 presumably became damaged and was reused as a vehicle for the display of thirteen assorted cameos, probably in the early eighteenth century (certainly before 1737). An English (or possibly French) origin for the enamel (of which the dragons are the principal survivors) has been proposed. The cameos vary in date and quality. The large chalcedony central relief, representing Joseph and his brothers, is probably a sixteenth-century version of the thirteenth-century cameo of the same subject in the Hermitage, and may have been cut in the Veneto. The head of the Emperor Commodus (d. 193 AD), immediately to the right of centre, is antique. The remainder – portraying emperors, negroes, Minerva, goddess of Wisdom, and a nymph with satyrs – are Italian, sixteenth century.

Until recently it was thought likely that no. 150 was a nineteenth-century confection, although a possible connection with a jewel listed by Horace Walpole in 1764 at Kensington Palace had been suggested. With the recent rediscovery of the posthumous inventory of the possessions of

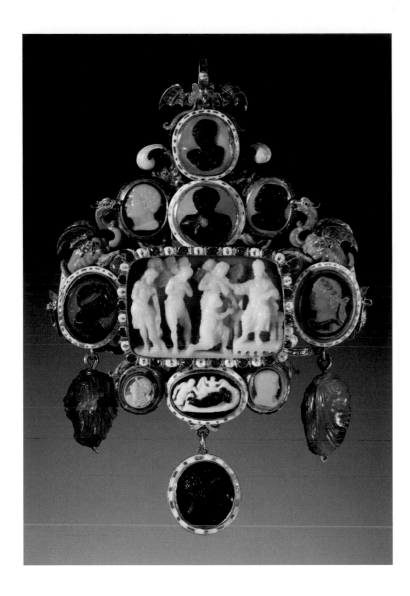

Queen Caroline (d. 1737), drawn up before 1755, the connection of the jewel in its present form with Queen Caroline is now firmly established (see also nos 142 and 147). It is not impossible that the transformation was carried out for her.

Gold, enamel, chalcedony, onyx. 12.5 × 8.9 cm
RCIN 65256
PROVENANCE Queen Caroline (d. 1737)
LITERATURE G&J, no. 189; Piacenti & Boardman (forthcoming)
EXHIBITIONS Birmingham 1960, no. 301; QG 1990–1, no. 184

151
ENGLISH
Emerald pendant, c.1860

The large table-cut hexagonal emerald, backed with gold and engraved Elizabeth R, is traditionally supposed to have belonged to Elizabeth I. The stone itself is likely to be Mughal in origin, though its early history is undocumented. In the early nineteenth century the stone is supposed to have belonged to Frederick, Duke of York (d. 1827), by whom it was apparently given (for unspecified reasons, but perhaps in part exchange) to the jeweller John Bridge (1755–1834) of Rundell, Bridge & Rundell.

While in the possession of Bridge's descendants, with whom the stone remained until its sale in 1916, it was mounted in a so-called 'Holbein' enamelled and jewelled frame, possibly based on a design of c.1860–70 by the London jeweller John Brogden. The fashion for 'Holbein' jewellery began with the creation of the celebrated Devonshire parure, made by the firm of C.F. Hancock to the designs of H.H. Armstead in 1856. By the time of the 1862 International Exhibition, this style of jewellery was very much in vogue; it remained popular at least until the 1880s.

Characteristically, the pendant was purchased by Queen Mary on the basis of its supposed associations. It was placed by her with the other historic gems in the Royal Collection.

Gold, enamel, emerald and diamonds. 6.8 × 3.7 × 0.7 cm
RCIN 52283
PROVENANCE By tradition Queen Elizabeth I; Frederick, Duke of York (d. 1827); by whom apparently given to John Bridge; by descent; sale Knight Frank & Rutley, London, 3 February 1916 (76); bought by Queen Mary (Add. Cat., no. 2a)
LITERATURE Piacenti & Boardman (forthcoming)
EXHIBITIONS QG 1990–1, no. 188

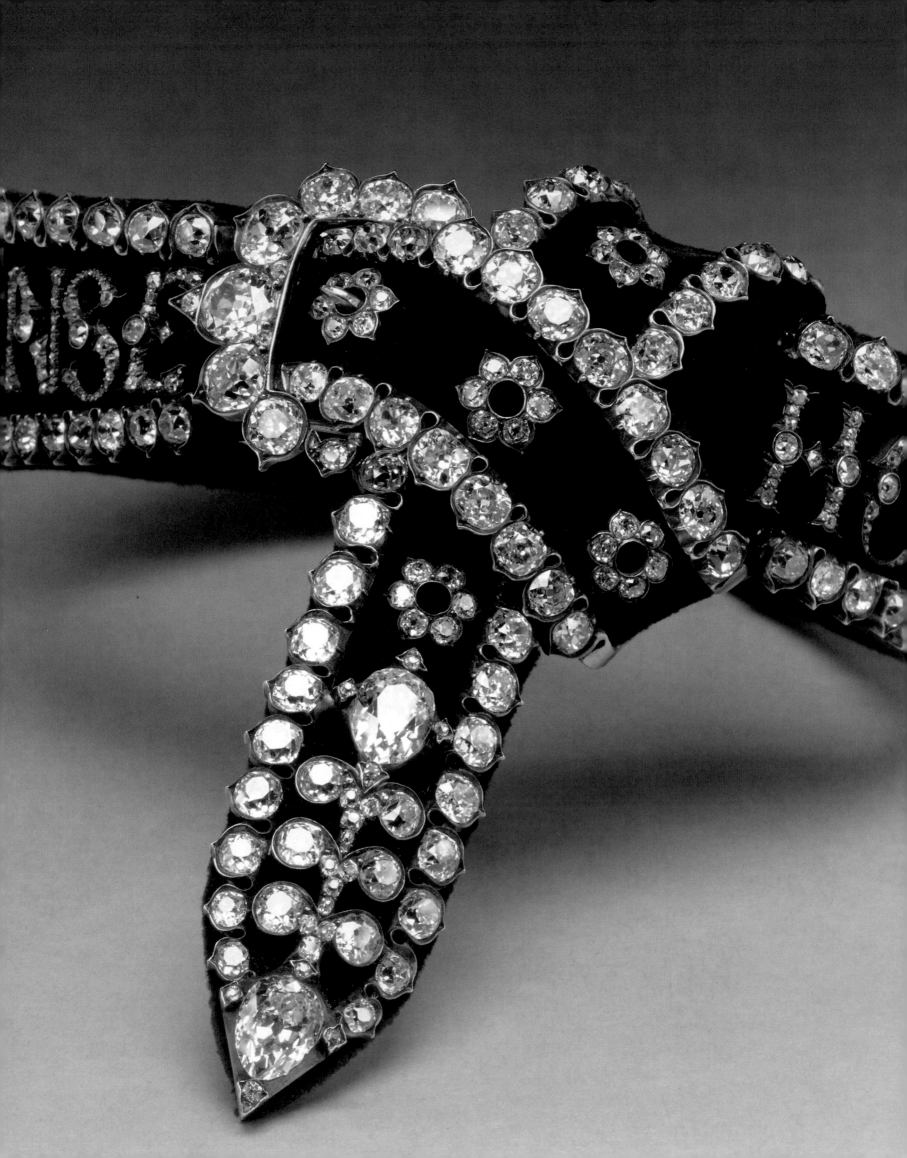

PERSONAL JEWELLERY AND INSIGNIA (nos 152–157)

The tradition of magnificent display, especially of personal jewellery, has been part of the history of the monarchy of this country from the earliest times. Henry VIII was said to have had more jewels than most of the princes of Christendom; Elizabeth I was never seen or depicted without a formidable display of jewellery and the court of James I and Anne of Denmark outshone the rest of Europe in splendour. This tradition of magnificence continued with Charles I, though the royal jewels were dispersed with the rest of his collection during the Interregnum. The later Stuarts and early Hanoverians continued to amass great quantities of personal jewellery, although in each generation additions seem to have been matched by depletions and dispersals as dynasties and fashions changed or as children married and were suitably endowed with jewels. Queen Caroline (consort of George II) formed a notable collection which she bequeathed to her husband. Some of this collection passed eventually to George III (no. 152) and to Queen Charlotte. This Queen's diamonds were considered remarkably fine and in the course of time her jewels, supplemented by further sumptuous gifts from the King and from foreign rulers (notably the Arcot diamonds), were reckoned to equal those of any continental court.

In addition to amassing very large quantities of personal jewellery, some of it of extraordinary splendour (for example nos 153, 154), George IV appropriated the best part of his mother's collection, including many stones deemed by her to belong to Hanover. This violation of Queen Charlotte's will gave rise to the lawsuit which eventually caused George IV's niece Queen Victoria to lose some of the best jewellery in her collection to her first cousin (George IV's nephew) the King of Hanover (see no. 156). The reign of Queen Victoria (1837–1901) also saw many additions to the royal jewels. As ruler of the largest empire the world had seen, the Queen received an incessant flow of tribute. From India came the celebrated Koh-i Nûr, the 'Timur Ruby' (no. 300) and the Lahore Diamond (no. 156), Ranjit Singh's emeralds (no. 299) and many other stones from rulers and potentates wishing to cement their relationship with the British Crown. For the Queen, the arrival of such marvels from India made some amends for the loss of her grandmother's jewels.

Apart from a handful of celebrated stones incorporated into the regalia, very few precious stones from the pre-Victorian royal collection are recognisable today. Changes in fashion and especially in techniques of stone-cutting and setting have ensured that jewels have been constantly recycled. Today Her Majesty The Queen's personal jewellery consists mainly of nineteenth- and twentieth-century settings of precious stones (principally diamonds, sapphires, rubies, emeralds and pearls). Some of these were acquired by Queen Alexandra and Queen Mary, both passionate collectors of jewellery; and a considerable number have been added – as gifts or mementoes of family events – in the present reign. These jewels are distinct both from the historic gems and jewels (see nos 139–57) and from the Crown Jewels, kept in the Tower of London. Almost inevitably, however, the division in some areas is fairly arbitrary and the history of certain pieces in one category of jewellery, or of the stones that go to make them up, overlaps or merges with another. Thus, the history of the Cullinan Brooch (no. 157) is now inextricably tied to that of the Imperial State Crown and the Sovereign's Sceptre in the Jewel House. By the same token, the history of the stones now forming Queen Victoria's collet diamond necklace and earrings (no. 156) reaches back to the period of George II and George III, at the same time embracing important chapters in the history of Britain and Hanover on the one hand and of the Indian Empire on the other. The extraordinary and complex history of many of these pieces has only recently been fully researched for the comprehensive catalogue of the contents of the Jewel House, The Crown Jewels, published in 1998.

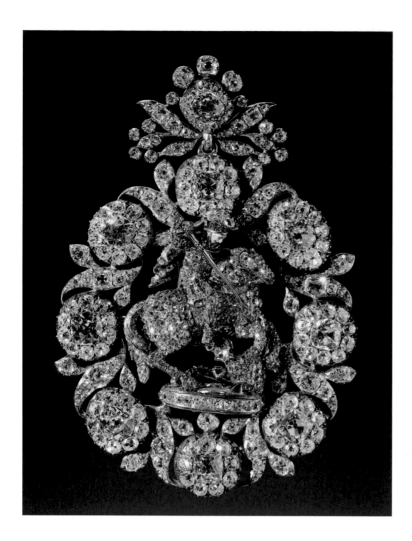

when they were valued at £4,500 and £2,300 respectively. In 1765 two pieces of George III's insignia (perhaps including no. 152) were altered and enriched by his Swiss-born jeweller, John Duval (fl.1748–1800). The fine 'paving' of the figure of St George with small diamonds may date from this period.

Following the success of the Hanoverian claim against Queen Victoria in 1857 (see no. 156), the nine large brilliant-cut diamonds surrounding the figure of St George were removed by R. & S. Garrard & Co. (successors to Rundells as Crown Jewellers). They were used either for the new collet diamond necklace (no. 156) or in the reconstituted Regal Circlet (dismantled in 1937 to form the new crown of Queen Elizabeth, now The Queen Mother). The badge itself was then remade with the present clusters, using lesser stones from the Queen's collection. This operation and a similar one involving a single stone from another Garter badge (possibly no. 153) was carried out by Garrards. No. 152, one of a number of jewelled Georges in the Royal Collection, was worn by King George VI at his coronation.

Diamonds, sapphires, rubies, amethysts, gold. 11.6 × 7.8 cm
RCIN 441145
PROVENANCE Probably made for George II, before 1752 (RA GEO/15738–40); possibly partly remounted for George III, 1765 (£16 16s.; RA GEO/16805–6); altered for Queen Victoria, 1858 (£30, with alterations to another badge; RA PP/VIC/2/30/9119)
LITERATURE Scarisbrick 1994, p. 229; Crown Jewels 1998, II, p. 149
EXHIBITIONS QG 1990–1, no. 39; Paris/Windsor/Edinburgh 1996–8, no. 52

152

ENGLISH

Garter collar badge (Great George), before 1750(?); altered 1764(?) and 1858

Founded in 1348 by King Edward III, the Order of the Garter is the oldest surviving order of chivalry in continuous existence anywhere in the world. Knights and Lady Companions are appointed personally by the sovereign; there are a maximum of twenty-four at any one time (excluding royal and foreign members of the Order). The insignia of the Order consist of a garter (worn on the left leg by men and on the left arm by ladies) bearing the motto *Honi Soit Qui Mal Y Pense* (Shame on him who thinks evil of it; see no. 155), a collar suspending a badge (the Great George), a star (worn on the left breast), a blue sash and a sash badge (the Lesser George; see no. 153). Star, badge and garter could be (and frequently were) elaborately jewelled at the expense of the recipient.

George III had a particular reverence for the Order. Appointed by his grandfather George II on 22 June 1749 at the age of 11, he attended his first installation and banquet as sovereign in September 1762 and his last, an unusually magnificent affair, on St George's Day (23 April) 1805. The King's insignia included no. 152, which in origin is likely to have been one of George II's two jewelled Georges, each set round with nine large brilliants. They were listed in 1752 and more fully in 1761,

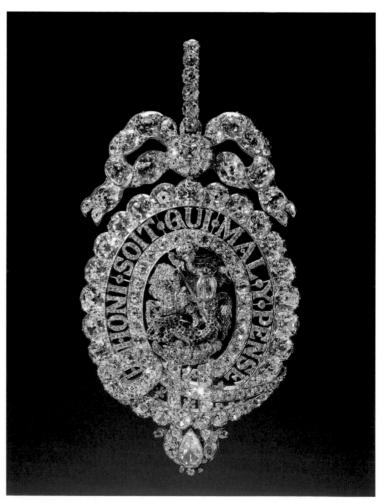

153

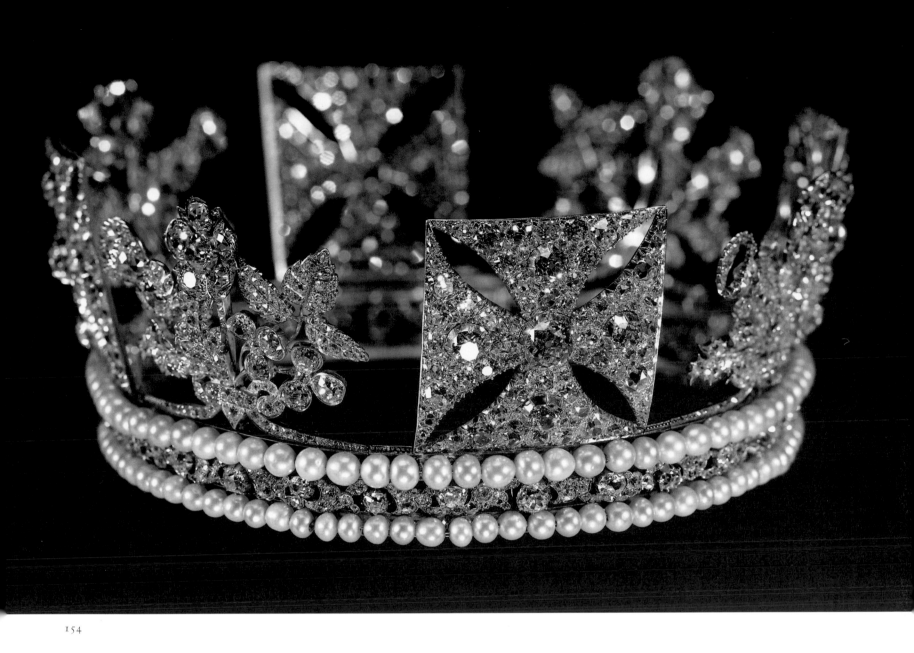

153
THOMAS GRAY (fl.1780–1800)
Sash badge (Lesser George) of George IV when Prince of Wales,
1787–8

George IV's association with the Order of the Garter began remarkably early. He was invested at the age of 3 by his father George III on 26 December 1765 and installed at Windsor just before his ninth birthday on 25 July 1771. That he enjoyed everything to do with the Order – when Prince of Wales, Regent or King – may be safely inferred from his possession of no fewer than fifty-five jewelled or enamelled Garter badges. Among them was this spectacularly lavish example, made by the fashionable London jeweller Thomas Gray of No. 41 Sackville Street. When first supplied to the Prince in 1787, the badge cost £403 15s. 6d. Gray reset it the following year, adding a further substantial number of diamonds at a cost of £420, managing at the same time to maintain the attractive lightness and transparency of the setting.

At this period Gray's firm stood high in the favour of the Prince of Wales; between 1786 and 1789 the Prince spent the colossal sum of £21,201 11s. 2d. with him, having only recently transferred his

patronage from his father's jeweller, John Duval. On Gray's retirement around 1800, the Prince moved to Rundells, with whom he remained for the rest of his life.

The central cluster of the ribbon tie may have been replaced by Garrards in 1858 (see no. 156).

Diamonds, rubies, sapphires, emeralds, gold. 11.6 × 8.2 cm
RCIN 441151
PROVENANCE Made for George IV (when Prince of Wales), 1787–8 (£403 15s. 6d., and £420; RA GEO/25667, 25670)
LITERATURE Bury 1991, I, pp. 79–80
EXHIBITIONS Paris/Windsor/Edinburgh 1996–8, no. 56

154
RUNDELL, BRIDGE & RUNDELL
The Diamond Diadem, 1820

From its frequent appearance on postage stamps and coins, this exceptionally beautiful head ornament, incorporating the national emblems of England, Scotland and Ireland, is probably the most familiar piece

of Her Majesty The Queen's jewellery. Set with 1,333 diamonds, including a four-carat pale yellow brilliant in the centre of the front cross, the diadem has been regularly worn (and slightly modified) by queens regnant and consort from Queen Adelaide onwards. This feminine association belies its origin, since it was made for George IV's use at his famously extravagant coronation in 1821 (see no. 333). On that occasion, he wore it over a large velvet 'Spanish' hat at the ceremonies in Westminster Hall and during the walking procession to Westminster Abbey.

The order for the diadem was placed with Rundells in 1820 and work was complete by May of that year. The design, probably by Rundells' chief designer Philip Liebart, reflects something of the discarded plan for George IV's Imperial State Crown, which was drawn up by Liebart in the same period and was to have included the national emblems in place of the traditional fleurs-de-lis.

Together with a diamond-studded loop (which was broken up to help make Queen Victoria's Garter armlet) the bill for the diadem amounted to the large sum of £8,216. This included an £800 hire charge for the diamonds – stones were regularly hired for use at coronations up to 1837 – computed on a percentage of the value of the stones. When the coronation had to be postponed for a year on account of Queen Caroline's trial, a further hire charge was levied. Normally the stones would have been returned to Rundells after the coronation, but in this case there is no sign that the delicately worked diamond sprays and crosses, a masterpiece of the new transparent style of setting, have been disturbed. Equally, there is no evidence that the King purchased the stones outright, so it could be that the bill was met by a discreet barter of old stones from George IV's extensive collection.

Today the diadem is worn by Her Majesty The Queen when travelling to and from the State Opening of Parliament.

Diamonds, pearls, silver, gold. Diameter 19 cm; 7.5 cm high
RCIN 31702
PROVENANCE Made for George IV, 1820 (£8,216, adjusted to £7,126; RA GEO/25994)
LITERATURE Field 1987, pp. 163–5; *Crown Jewels* 1998, II, pp. 42, 91, 130–1 and 305–16
EXHIBITIONS QG 1962–3, no. 61(12)

155
RUNDELL, BRIDGE & CO.
Garter of Prince Albert, 1840

From earliest times the insignia of the Order of the Garter have included a garter. The origins of this tradition are obscure. The garter may be a reference to the military strap or band worn by soldiers in armour in the Middle Ages. Such an object would have been familiar to Edward III's knights on their victorious French campaign that culminated in the Battle of Crécy in 1346, two years before the foundation of the Order.

In its design, with the motto, edges and buckle lavishly mounted with diamonds, Prince Albert's garter followed those made for George III and George IV. These were broken up in 1837–8 to furnish stones for other pieces of Queen Victoria's jewellery, including her own new Garter insignia. Although individual bills do not survive, no. 155 was probably included among the Queen's payments to Rundells in 1840, which

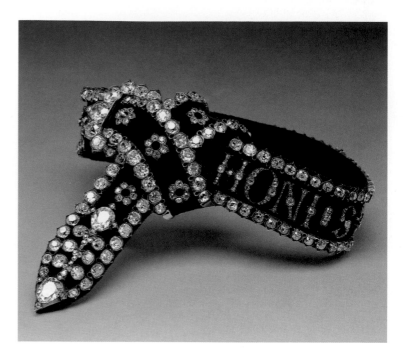

155

amounted to over £4,600. Prince Albert was invested with the Order at Coburg in January 1840. The Queen gave no. 155 to the Prince on his arrival in London two days before their wedding on 10 February 1840. At a meeting on 8 February with her Prime Minister, Lord Melbourne, she noted 'Lord M. admired the diamond Garter which Albert had on, and said "Very handsome"' (QVJ, 8 February 1840). Prince Albert wore his uniforms and orders well, as can be seen in the Winterhalter portrait showing him in Garter robes (and clearly wearing no. 155), painted in 1843 (Millar (O.) 1992, no. 812). No. 155 was subsequently worn by King George V (who had it partly remade for his coronation) and by King George VI (who had it newly mounted on blue velvet).

Diamonds, velvet. 35.5 × 11.5 cm
RCIN 441143
PROVENANCE Commissioned by Queen Victoria and given to Prince Albert, 1840 (probably included in the consolidated payment to Rundells of £1,819 4s., 28 March 1840; RA PP/VIC/Ledger I, p. 25)
EXHIBITIONS QG 1990–1, no. 41; Paris/Windsor/Edinburgh 1996–8, no. 50

156
R. & S. GARRARD & CO.
Queen Victoria's diamond necklace and drop earrings, 1858

This spectacular necklace is formed of twenty-five graduated cushion-shape brilliant-cut diamonds set in cut-down silver collets (settings) with gold spiral links, and a central drop-shaped pendant set in platinum. The nine largest stones in the necklace weigh between 11.25 and 8.25 carats and the pendant weighs 22.48 carats. The earrings comprise two larger cushion-cut stones matching those of the necklace, two smaller stones and two non-matching drop-shaped pendants, the latter of approximately 12 and 7 carats.

Like almost all royal jewellery, the stones in this necklace and accompanying earrings have undergone a series of complicated transformations. The story begins in December 1857 when, as a result of a

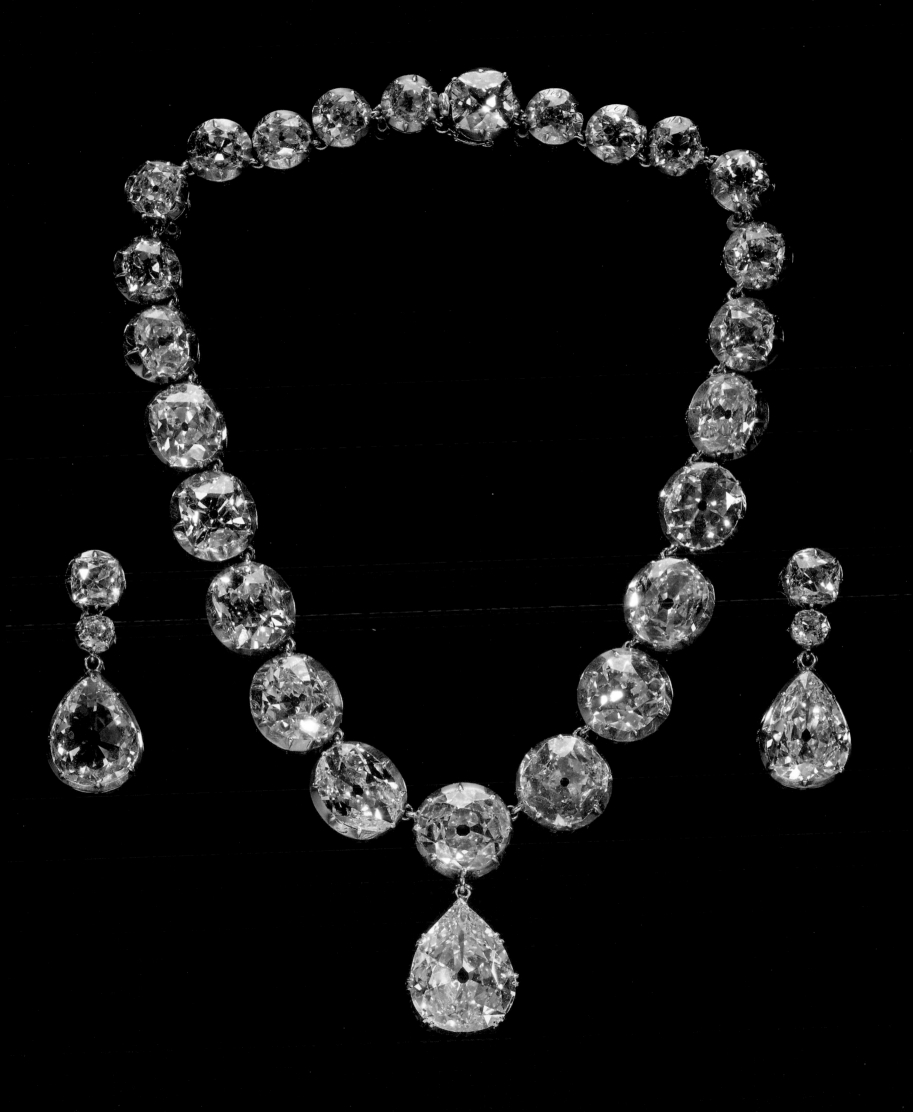

claim initiated by George III's fifth son, Ernest, Duke of Cumberland (from 1837 King of Hanover), Queen Victoria lost to Hanover a significant part of the family jewels she had regarded as her own. Greatly chagrined, she ordered Garrards to replace the lost jewels by taking stones from 'swords and useless things'. For this necklace, twenty-eight stones were removed from two Garter badges (nos 152, 153) and a sword hilt. At the same time, the central pendant of the 'Timur Ruby' necklace (no. 300), known as the Lahore Diamond, was made detachable for use as the pendant on this necklace; and two of the smaller pendants from the same necklace, originally the side stones in the Indian setting of the Koh-i Nûr, were made detachable for use as earrings (with additional stones taken from an aigrette and a Garter star). The charge for making the necklace was £65 and for making up the earrings £23 10s.

In 1911, Queen Mary removed two stones from Queen Victoria's necklace to make solitaire earrings. She replaced them with three stones from another necklace of 158 collets, probably one that Queen Victoria had inherited in 1837. For the 1937 coronation, the Lahore Diamond was marginally recut, losing 0.12 of a carat, and set temporarily on the new crown made for Queen Elizabeth by Garrards. After the coronation, it was returned to the necklace. Either at this time or subsequently the necklace was reduced in length by four stones.

Both necklace and earrings were often worn by Queen Victoria, who bequeathed them to the Crown. Queen Alexandra and Queen Mary wore the necklace at their coronations (1901 and 1911). Queen Elizabeth wore both necklace and earrings in 1937, as did Her Majesty The Queen in 1953.

Diamonds, gold, silver, platinum. The necklace 38.1 cm long; the earrings 4.5 cm long
RCIN 100003, 100004.1–2
PROVENANCE Commissioned by Queen Victoria, 1858 (RA PP/2/30/9119); altered by Queen Mary, 1911 (RA QEII/Garrard/Ledger 1901–11, p. 165)
LITERATURE Young 1968, pp. 12–14 and 55; Field 1987, pp. 54–5; Bury 1991, I, pp. 321 and 323; Crown Jewels 1998, II, pp. 143, 144, 157 and 163

157
JOSEPH ASSCHER & CO.
The Cullinan Brooch, 1908–10

The brooch consists of the third and fourth largest stones cut from the largest diamond ever found, the celebrated Cullinan. This stone, which weighed 3,106 carats in its uncut state, was discovered at the Premier Mine near Pretoria in 1905 and named after the chairman of the mining company, Thomas Cullinan. In 1907, still uncut, it was given by the government of the Transvaal to Edward VII for his sixty-sixth birthday. In January 1908 it was sent to Asscher of Amsterdam and on 10 February the stone was split into two pieces. Over the next eight months these pieces were further split and polished, eventually producing nine numbered stones. Cullinan I and II, the two largest colourless and flawless cut diamonds in the world, known as the First and Second Stars of Africa, were reserved for King Edward and in 1909 they were temporarily mounted as a somewhat oversized pendant brooch. After Edward VII's death in 1910, Cullinan I and II were set respectively in the head of the Sovereign's Sceptre and on the band of the Imperial State Crown,

although they were still detachable and were occasionally worn as a brooch by Queen Mary.

Asscher meanwhile had retained the stones numbered III–V and VII–IX (King Edward having purchased VI in a separate transaction), together with the ninety-six smaller stones and fragments, as the fee for cutting and polishing the Cullinan. All of these, including the numbered stones, collectively known as the 'chippings', were acquired by the South African government and were given to Queen Mary in 1910. Queen Mary had Cullinan III and IV – a pear-shaped drop of 94.4 carats and a square-cut stone of 63.6 carats – set temporarily in her new crown for the coronation of 1911, but generally she wore the stones hooked together as a brooch (now known as the Cullinan Brooch) in their fine lattice-work setting. She also used them occasionally as a pendant to Queen Victoria's collet necklace (no. 156) in place of the Lahore Diamond and at least once wore this arrangement with Cullinan I and II as a brooch.

Her Majesty The Queen, who inherited the Cullinan Brooch from Queen Mary, wore it while touring Asscher's premises during the State Visit to Holland in 1958, and it was on this occasion that the brooch was famously referred to as 'Granny's Chips'.

Diamonds, silver. 7 × 2.8 cm
RCIN 100005
PROVENANCE Given to Queen Mary by the government of South Africa, 1910
LITERATURE Field 1987, pp. 72–5; Crown Jewels 1998, II, pp. 73–8, 133–41 and 197

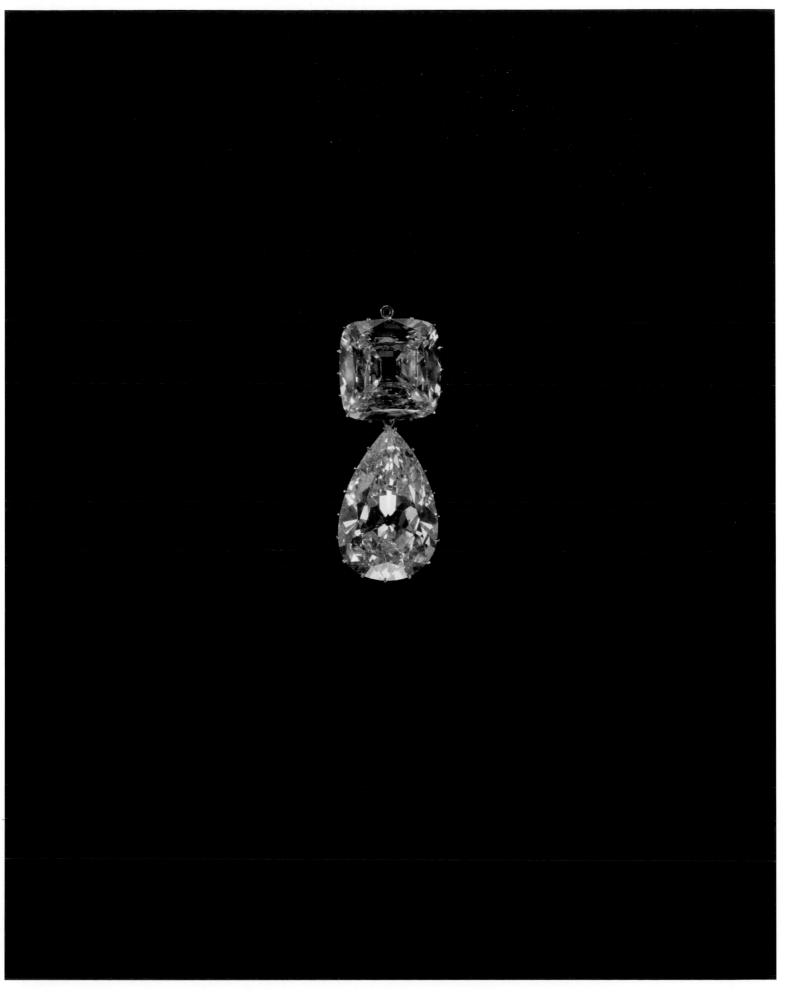

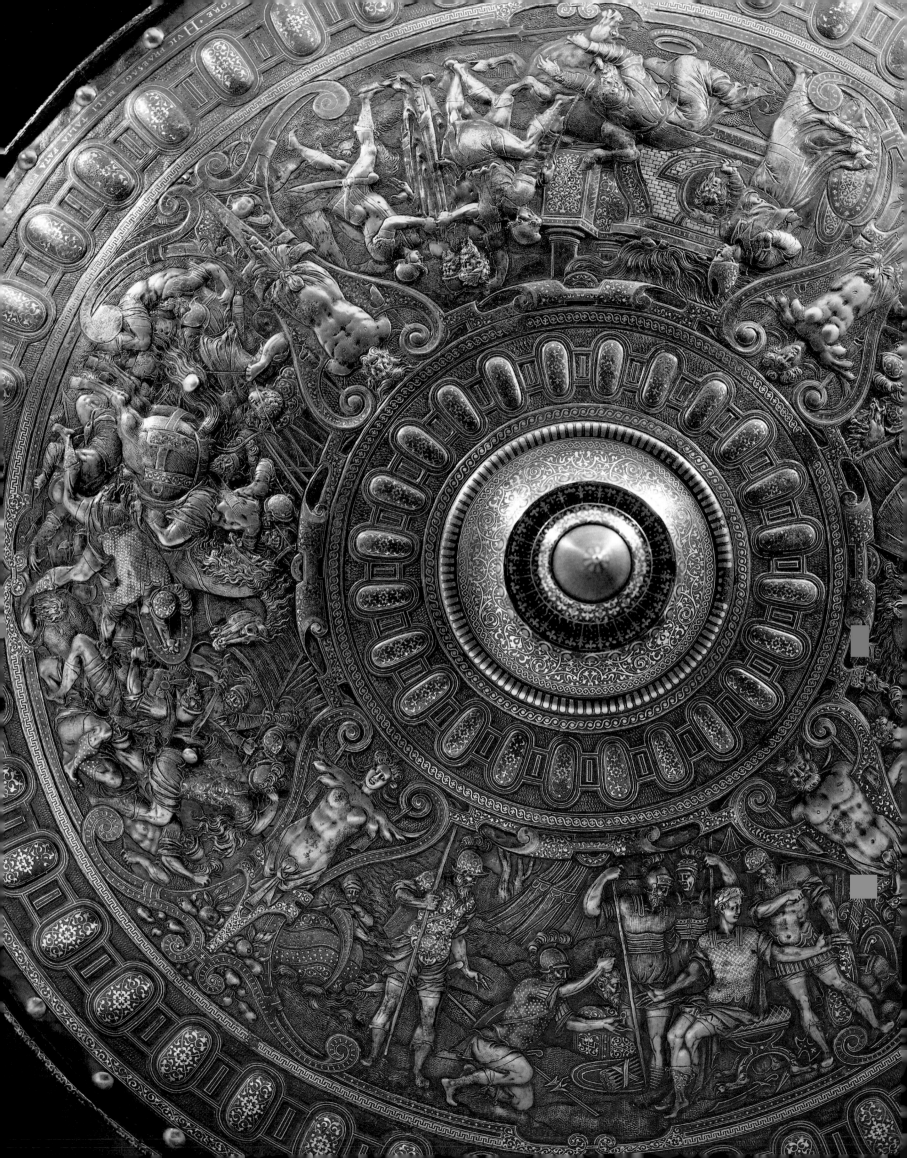

EUROPEAN ARMS AND ARMOUR (nos 158–164)

The European arms, armour and militaria in the Royal Collection can be divided into two categories: those pieces that formed part of the useful armoury of the sovereign at the time they were made, and those which have been acquired by either gift or purchase as antique or presentation pieces. Such a distinction between the useful and ornamental should not, however, be applied too strictly. The exceptionally beautiful armour made for Henry, Prince of Wales, at Greenwich in around 1608 (RCIN 72831) was of a kind designated for 'barriers, field, tourney and tilt', in other words an all-purpose armour that could be adapted for chivalric exercises as well as for combat. The collection also includes a large number of highly wrought sporting weapons, such as those which belonged to Frederick, Prince of Wales; George IV and his brother Frederick, Duke of York; Prince Albert; and Edward VII.

The execution of Charles I in 1649 did not have the same effect on arms and armour as it did on many of the other contents of the royal residences. The bulk of the arms and armour that were seized in the palaces by the officials of the new regime were not offered for sale but were retained for use. Thus, one set of armour made for Henry VIII in around 1540 in the workshops he established at Greenwich (RCIN 72834) can still be found on display at Windsor Castle, and two other sets remain in the Royal Armouries, the main repository of historic royal arms and weapons. However, it would be erroneous to suggest that the collection has survived intact in its pre-Civil War state. Henry VIII's hunting sword (no. 159) is one of a very small number of weapons of any Tudor or Stuart monarch to survive in either the Royal Collection or the Armouries, and even this spent 350 years in other collections before returning in 1966. The extraordinary fifteenth-century agate mace (no. 158) was presented to Her Majesty The Queen in 1978. It was said to have belonged to Charles I's sister, Elizabeth of Bohemia, the 'Winter Queen', and in this case entered the Royal Collection for the first time. The early provenance of the so-called 'Cellini Shield' (no. 160) remains unclear. It was certainly not, as was once claimed, presented to Henry VIII by Francis I of France at the Field of Cloth of Gold in 1520; having been made in around 1562, it cannot have belonged to either monarch (both of whom died in 1547). In the past, two of the swords (nos 162, 164) have been attributed to Benvenuto Cellini (1500–71), whose very detailed autobiography does not refer to the manufacture of weapons or armour of any kind. They are the finest examples of a group of very sculptural swords that were acquired by George IV. His taste, not surprisingly perhaps, also favoured swords with heavily jewelled hilts, along with the luxurious products of the Versailles workshops of Nicolas-Noël Boutet, which formed part of his collection of objects with Napoleonic associations.

George IV's collection of arms and armour was documented as it grew, in a cumulative catalogue made by Benjamin Jutsham over a period of approximately thirty years up to 1827. This remained in use until some time after the collection was transferred to Windsor in the 1840s, but was supplanted in 1868 by a new inventory. The first modern catalogue of arms and armour in the collection was published by Sir Guy Laking, Keeper of the King's Armoury, in 1904. A new and comprehensive catalogue has been in preparation for some years; the first two volumes (dealing with swords and armours) by the late A.V.B. Norman are forthcoming, and these, with further suggestions from Ian Eaves, have provided the basis for the entries that follow here.

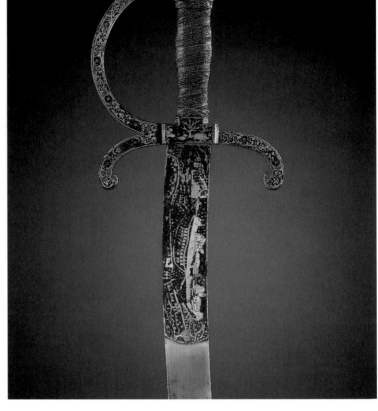

159 (detail)

158

EUROPEAN

Horseman's parade mace, (?)late fifteenth century

Maces for use in battle were made in this form in Europe from the earliest times, with varying degrees of ornamentation. The 'flanged' head of the kind seen here first appeared in the fourteenth century, but was rare before the fifteenth. In this instance both the head and the grip are made of agate, a semi-precious stone used to an extent which clearly denotes a ceremonial or parade weapon. The haft (stem) was probably also originally of agate, replaced at some early date in russeted iron, overlaid with gold.

Other maces carved from semi-precious stones are in the Kunsthistorisches Museum, Vienna (inv. no. 1713), and in Munich, Modena and Brussels. A comparable mace in the Kunstgewerbemuseum, Berlin (inv. no. K 6979) was traditionally called the 'Sceptre of Charlemagne'. The present example has also been mistaken for a sceptre, that is a staff or baton borne as an emblem of kingship. Perhaps because of its small – but not exceptional – size, it has been associated with Elizabeth Stuart, Queen of Bohemia (1596–1662), the 'Winter Queen', and was thought to have been included in the bequest to her protector, William, Earl of Craven (1606–97). However, no trace of such a sceptre or mace has been found either in the Queen's will or in that of Lord Craven.

Agate, iron and gold. 53 cm long
RCIN 67259
PROVENANCE Walter Keppel, ninth Earl of Albemarle; by whom presented to HM The Queen, 1978
LITERATURE Norman (forthcoming)
EXHIBITIONS QG 1988–9, no. 129

159

DIEGO DE ÇAIAS (fl.c.1535–1552)

Hunting sword, by-knife and scabbard, 1544

This is the only known surviving work made by the Spanish decorator of arms Diego de Çaias while he was employed by Henry VIII between 1543 and 1547. It was probably one of the items described in the inventory of the King's possessions taken after his death in the latter year as 'iij longe woodknives ij of them of Dego his makinge' (*Henry VIII Inventory*, no. 14511). The sword is in the form of a hunting weapon, with an auxiliary knife decorated in the same style of 'counterfeit' damascening (in which thin gold wires are pressed into lines incised on a hatched background). The wooden scabbard, covered in tooled black leather, is probably an eighteenth-century replacement, with the original iron mounts reapplied. The grip of the sword, which is made of wood and bound with iron wire, is also thought to be a replacement.

The decoration includes hunting scenes of a kind to be expected on a

weapon of this type, but the great interest lies in the miniature topographical scene at the top of the sword blade. It depicts with some accuracy the siege of Boulogne, which began on 19 July 1544 and was conducted under Henry VIII's direct command from 26 July; the French defenders eventually capitulated on 14 September. The city of Boulogne appears to the upper right, while on the left can be seen the offensive mound on which the English artillery was arranged. The Latin elegiac inscription on the other side of the blade may have been written by a court poet in celebration of the victory; the sword was presumably made soon afterwards. It is unsigned, but the style of the gold decoration is extremely close to signed examples of Diego de Çaias's work, in particular the mace made for Henry II of France now in the Metropolitan Museum of Art, New York (Rogers Fund, inv. 04.3.59).

Iron and gold. Sword 65.4 cm long
The sword inscribed on one side of the blade, damascened in gold HENRICI OCTAVI / LETARE BOLONIA / DVCTV PVRPVREIS / TVRRES CONSPICIE / NDA ROSIS IAM / TRACTA IACEN [sic] / MALE OLENTIA / LILIA PVLSVS G / ALLVS ET INVI[C]TA / REGNAT IN ARCE / LEO SIC TIBI NEC / VIRT[V]S DEERIT / NE[C GR]ATIA FOR / MAE [CV]M LEO / TVTELA CVM / ROSA [S]IT DECORI (Rejoice Boulogne in the rule of the eighth Henry. Thy towers are now seen to be adorned with crimson roses, now are the ill-scented lilies uprooted and prostrate, the cock is expelled, and the lion reigns in the invincible citadel. Thus, neither valour nor grace of beauty will fail thee, since the lion is thy protection and the rose thy ornament [translation by Claude Blair])
RCIN 61316
PROVENANCE Made for Henry VIII; George Wallis, Hull, by 1798; Earl of Londesborough, by 1857; his sale, Christie's, London, 4–11 July 1888 (172); Frédéric Spitzer sale, Paris, 10–14 July 1895 (212); Prince Ladislao Odescalchi, Rome; Collezione Odescalchi, Rome; whence acquired by HM The Queen, 1966
LITERATURE Blair 1970, pp. 166–72; Norman (forthcoming)
EXHIBITIONS London 1862a, no. 4649 (lent by the Earl of Londesborough); Australia 1977, no. 11; QG 1978–9, no. 98; QG 1988–9, no. 127; London 1991b, no. XI.33

160

Attributed to ELISEUS LIBAERTS (fl.1557–1572)
Parade shield ('The Cellini Shield'), c.1562–3

The superb quality of this embossed and chased iron shield gave rise to its traditional attribution to Benvenuto Cellini (1500–71), and to the further supposition that it must have been a gift to Henry VIII from the French patron of the great Florentine goldsmith, Francis I. However, since at least 1862 – when the shield was exhibited at the South Kensington Museum – it has been recognised that, for all his versatility in various arts, Cellini did not in fact make any armour.

The shield is embossed with four episodes from the life of Julius Caesar: 1. The Battle of Dyrrachium: Caesar's armour-bearer cuts off the arm of his assailant; 2. The defilement of Caesar's robe by the blood of the sacrifice; 3. (?)The Battle of Pharsalus and death of one of Pompey's generals; and 4. The head and ring of Pompey brought to Caesar on his arrival in Egypt. The long inscription applied in gold around the edge attributes the fall of both Pompey and Caesar to ambition, 'than which there is no more weighty evil'. Further episodes featuring the same protagonists were embossed on an armour made for the French King Henry II (r. 1547–59) now in the Louvre (inv. no. MR.427) and on another shield in the Deutsches Historisches Museum, Berlin (inv. no. PC.934), both of which bear the French King's emblems and

monogram. These are thought to have been made in Antwerp by Eliseus Libaerts, who sold a similar group of armour between 1561 and 1563 to Erik XIV of Sweden (now in the Livrustkammer of the royal palace in Stockholm). Libaerts was a goldsmith who also made medals, and there remains an element of doubt as to whether he was responsible for fashioning the armours or for decorating and supplying them (see Blair 1974, no. 9, with further literature). The design of these armours has been associated convincingly with a large group of drawings by Étienne Delaune (1518/19–83), medallist, draughtsman and engraver to the court of Henry II of France (Thomas 1962, pp. 143–5).

The first mention of the shield in England dates from 1783, when Horace Walpole noticed it at Buckingham House, hanging over a chimneypiece in the Marine Gallery – the second-floor library room in which George III kept his drawings, coins and medals, in addition to models of ships. Walpole described it as 'a shield of bronze and Silver exhibiting the battle of Pharsalia excellently executed by Benvenuto Cellini. It was a present from the Lord Bute' (Walpole 1928, p. 79). However, there is no other record of the shield in the possession of John Stuart, third Earl of Bute (1713–92), who had been appointed Preceptor to the young George III in 1755 and was the King's first Prime Minister. As the sole example of Renaissance parade armour in the Royal Collection at this date, the shield was probably valued more as a piece of *histoire métallique* of a kind that both Edward Gibbon and Dr Johnson, who are known to have used the King's libraries, would also have appreciated. For the display of the shield at Windsor see p. 33.

Blued iron overlaid with silver and gold. 58.5 cm diameter
Inscribed +AMBITUS HIC MINIMVS MAGNAM CAPIT AMBITIONEM · QVAE REGNA EVERTIT DESTRVIT IMPERIA · SVSTVLIT E MEDIO MAGNI VITAMQVE DECVSQVE · POMPEII EVEXIT CAESARIS IMPERIVM · CAESARIS IN COELVM MITIS CLEMENTIA FERTVR · QVAE TAMEN HVIC TANDEM PERNICIOSA FVIT · ANNVLVS EXCIT EI LACHRYMAS CERVIXQVE RESECTA · POMPEII HINC PATVIT QVAM PROBVS ILLE FORET · IN SACRIS DOCVIT VESTIS CONSPERSA CRVORE · HVIC PRAESAGA MALI TALIA FATA FORE · SI VIRES IGITVR SPECTAVENS [sic] AMBITIONIS · NON GRAVIVS VIDEAS AMBITIONE MALVM (This circuit, though very small, holds great ambition, which overturns kingdoms and destroys empires. It took from sight the life and glory of Great Pompey, and raised up the Empire of Caesar. The mild clemency of Caesar is famed to the heavens, but in the end it brought about his destruction. The ring and severed neck of Pompey aroused his tears: from this it became clear how virtuous he was. The clothing sprinkled with blood at the sacrifice taught him that such a fate would be prophetic of evil. If therefore you consider the power of ambition, you may see that there is no more weighty evil [translation by Peter Howell])
RCIN 62978
PROVENANCE Said to have been given by John Stuart, third Earl of Bute, to George III, by 1783
LITERATURE Laking 1904, pp. 35–7, no. 71; Thomas 1962, pp. 143–5; Blair 1974, under no. 9; Norman (forthcoming)
EXHIBITIONS London 1853c; Manchester 1857, no. 71; London 1861, no. 1; London 1862a, no. 4618; Leeds 1868, no. 1563; Glasgow 1882, no. 1; London 1890, no. 911; London 1896; Paris/Ottawa 1973, no. 583; Australia 1977, no. 10; QG 1988–9, no. 131

161

GERMAN
Superimposed charge wheel-lock rifle, 1606

George IV maintained an interest in firearms and shooting from his childhood onwards. In the early 1780s his correspondence with his brother Frederick, Duke of York, who was undergoing military training

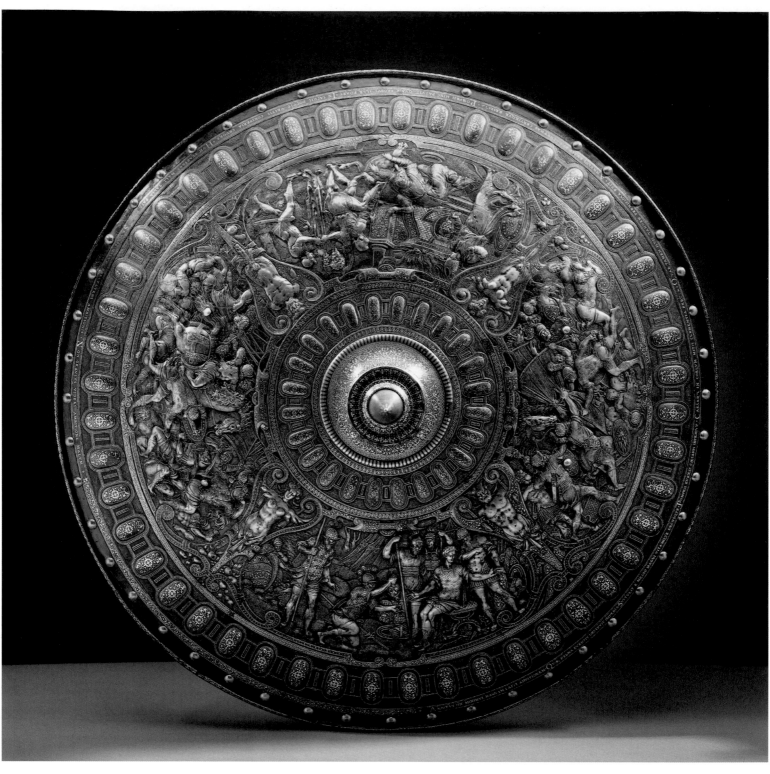

160

in Germany, contains many references to sporting triumphs and to newly bespoke weapons for the chase (Aspinall 1938; 12 October 1781 and 1 March 1782). Debarred from military service by his status as heir to the throne, the Prince of Wales began to assemble a collection of antique and 'curious' weapons in the Armoury at Carlton House. This included a number of guns with technical idiosyncrasies which he no doubt valued as much as their ornamental design. This gun was one of a small group of antique pieces that he purchased from one Colonel Benningson in 1807, including one other example by the same stock-maker, Hans Fleischer of Dresden.

The double wheel-lock enabled two shots to be fired from a single loading. The first pull of the trigger fired the first charge, and the second (rear) lock was then set by pressing the button between the arms of the dog spring. The trigger could then be pulled again. The sides of the butt are finely inlaid with arabesques including, somewhat surprisingly, fish and winged horses, as well as terrestrial quarry including bears, elephants and foxes. The manuscript catalogue of the Carlton House collection notes that 'on the under part of the Stock is an engraving not very moral', but this is no longer present.

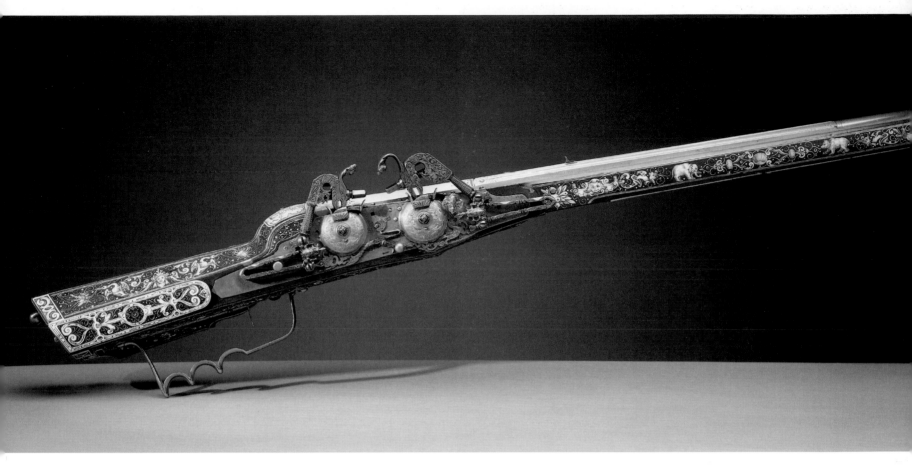

161

Walnut, staghorn, mother-of-pearl, iron, steel, gilt brass. 113 × 8 × 22 cm
The barrel incised 1606 and stamped twice with the maker's mark, a lion rampant
facing right (Støckel, 5511); engraved on the stock with the mark HF (for Hans Fleischer)
RCIN 61101
PROVENANCE Colonel Benningson; from whom bought by George IV, 1807 (CHAC,
no. 1871)
LITERATURE Laking 1904, no. 347; Blackmore 1968, no. I.347
EXHIBITIONS Cardiff 1998, no. 114

162

NORTH EUROPEAN

Rapier, c.1640

This sword, with its superbly sculptural hilt, was once thought to be the
work of the Florentine goldsmith and sculptor Benvenuto Cellini. As
with the 'Cellini Shield' (no. 160), the tradition was refuted when historic
arms and armour came under more serious scrutiny in the last quarter
of the nineteenth century (see Plon 1883, pp. 351–2). Nevertheless, the
work of the anonymous sculptor of the forged and chiselled iron hilt is
of very high quality. The subjects are from the Old Testament Book of
Samuel. On one side of the pear-shaped pommel David is depicted
beheading Goliath, while on the other he brings his giant opponent's
head to Saul. These two scenes are separated by male and female herms.
The oval grip has a scene of Samuel anointing David. Next, on one side
of the quillon-block (the central point of the two guards or quillons)
David is shown making a libation or sacrifice with water brought from
the well by the gates of Bethlehem, and on the other Abigail, the wife of
Nabal, brings David two flasks. At the centre of the side ring is an oval

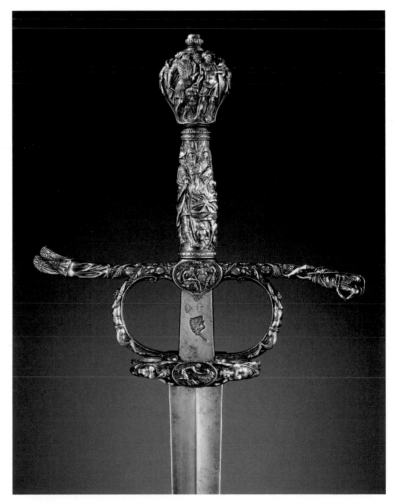

162 (detail)

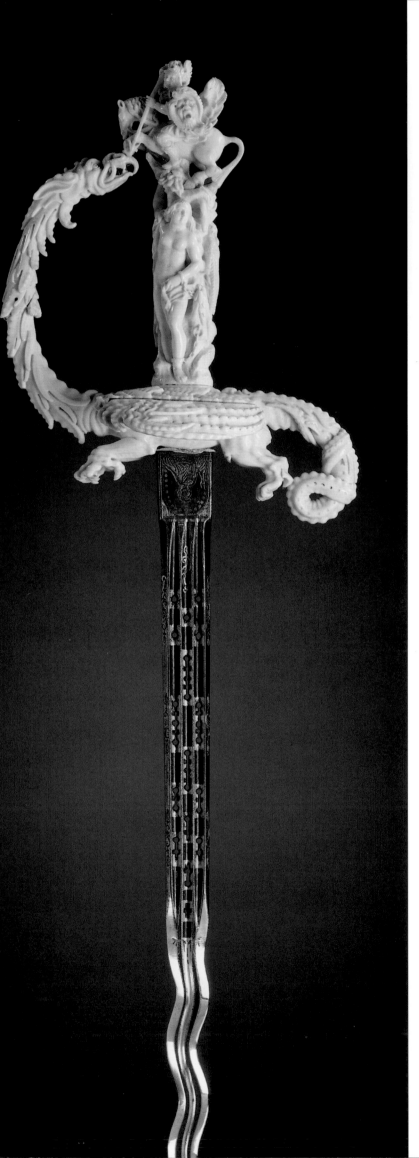

cartouche with the young David slaying the lion. The quillons terminate in hunched and winged figures of Fame and Time. The details of the figurative scenes are picked out in gold, overlaid on the iron ground.

A second tradition attaching to this sword is that it belonged to John Hampden (1594–1643), one of the leaders of the parliamentary opposition to Charles I, who was mortally wounded at the Battle of Chalgrove Field. This was claimed by another former owner, the author Pryse Lockhart Gordon (?d. 1834), who had casts made from the reliefs of the hilt by the prolific Scottish cameo artist James Tassie (1735–99); he presented these to friends 'as memoirs of the patriot' (i.e. Hampden). Gordon sold the sword to 'a royal purveyer of *virtu*, a man of fine taste', namely Walsh Porter (d. 1809), the writer, collector and connoisseur who advised George IV on the decoration of Carlton House.

Iron and gold. 107.6 cm long overall
Stamped on the blade with the marks of Clemens Horn of Solingen
RCIN 62994
PROVENANCE [?John Hampden;] Pryse Lockhart Gordon; by whom sold to Walsh Porter; by whom presented to George IV, 12 August 1807 (CHAC, no. 1868)
LITERATURE Ackermann 1808–11, I, p. 400; Gordon 1830, II, pp. 77–81; Laking 1904, no. 65; Norman & Barne 1980, pp. 103, 105 and 373; Norman (forthcoming)
EXHIBITIONS London 1853c; Manchester 1857; London 1861, no. 3; London 1862a, no. 4614; Leeds 1868, no. 1564; London 1898 (exh. cat. p. 56); Birmingham 1900; QG 1967–8, no. 38

163

NETHERLANDISH (?MAASTRICHT)
Dress sword, (?)mid-seventeenth century (blade c.1700)

The elaborately carved hilt of this sword depicts the rescue of Andromeda by Perseus, who descends on his winged horse Pegasus to destroy the fierce dragon tormenting his captive. It resembles ivory carvings produced at Maastricht in Holland during the mid-seventeenth century, when ivory was being imported in quantity by the Dutch East India Company. The hilt consists of four separate pieces: the pommel and grip (with Perseus and the chained Andromeda), the knuckle-guard (with the long neck and mouth of the dragon); the quillon-block and rear quillon (the dragon's back and tail); and the somewhat diminished shells, carved with the dragon's wings and feet. A.V.B. Norman related it in style to the work of Maastricht carvers, in particular on the stocks of a pair of pistols in the Wallace Collection (Mann 1962, p. 585).

The wavy-edged blade, which was added after the hilt entered George IV's collection in 1820, is etched on one side with the half-length figure of a woman in the fashionable dress of around 1700, and on the other side with a bust of a man, similarly dressed. It was probably made in Germany around that date. The blade was waved during forging rather than by the more usual method of filing the edges of a conventional blade.

Ivory and steel. 96.5 cm long overall
RCIN 67142
PROVENANCE Hilt: Rundell, Bridge & Rundell; from whom bought by George IV, 1820 (£21, invoice dated 9 July, RA GEO/26264)
LITERATURE Norman (forthcoming)
EXHIBITIONS Manchester 1857; QG 1991–2, no. 134

◁ 163

164
FRENCH (probably PARIS)
Small-sword, c.1655

This magnificent sword was purchased by the future George IV in 1789 to further enhance what was already a substantial collection of historic weapons. In the manuscript catalogue of his Armoury at Carlton House this sword is said to have been given by the Emperor Charles VI (1685–1740) to the first Duke of Marlborough (1650–1722) and its hilt – like that of the so-called Hampden sword (no. 162) and the embossed parade shield (no. 160) – was attributed to Benvenuto Cellini. While the second of these claims can be set aside on the simple grounds that Cellini made no swords, the supposed provenance, though uncorroborated, is not so implausible; Charles VI did indeed present a sword to the Duke of Marlborough in 1703, but that sword had a hilt set with diamonds (Churchill 1933–8, II, p. 250).

The iron hilt demonstrates a range of techniques executed to the highest standard. The pommel, with its four-headed tang-button (or finial), shells and quillons, is forged, chiselled and pierced; while the grip, which is made of wood cut with spiralling grooves in two directions, is bound with steel wire and overlaid by a further network of twisted wire.

The precise subject matter of the figurative decoration has not been identified. On one side of the pommel is a scene of soldiers in Roman dress approaching a town, and on the other is a group of captives led before an officer standing in a chariot. The larger scenes on the shells are the same on both sides, one in the opposite direction to the other; they comprise a cavalry combat with a commander in a cartouche, and soldiers presenting captured colours to a commander. The quillons are in the form of satyrs, and the other secondary motifs include serpents, masks and naked, winged children. The blade is probably a near-contemporary replacement.

Iron. 101.4 cm long overall
RCIN 62995
PROVENANCE Bought by George IV from Bland, 4 March 1789 (£26 15s.; CHAC, no. 272)
LITERATURE Laking 1904, no. 59; Laking 1922, V, pp. 97–101; Norman & Barne 1980, pp. 200, 383; Norman (forthcoming)
EXHIBITIONS Manchester 1857; QG 1967–8, no. 39; QG 1988–9, no. 130

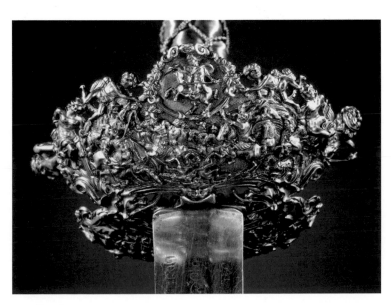

164 (detail)

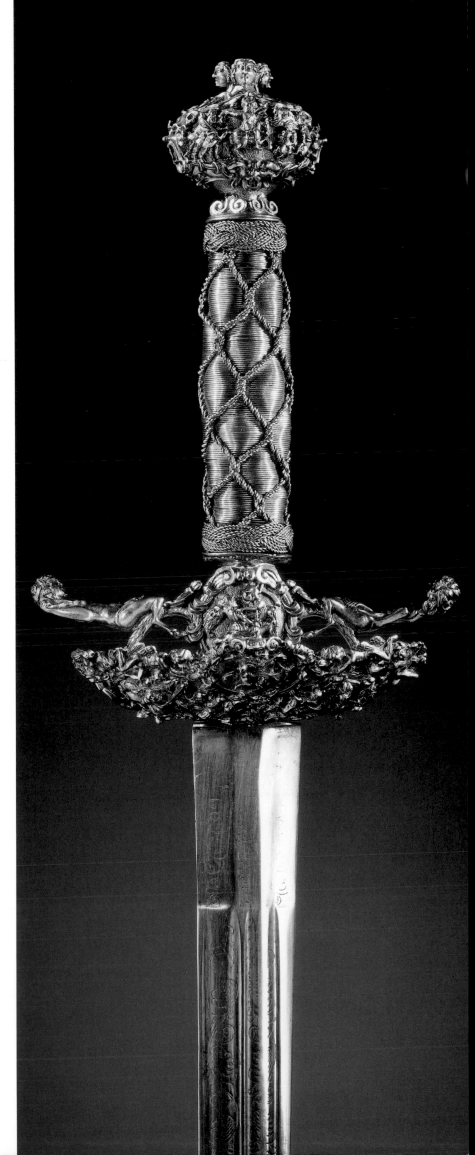

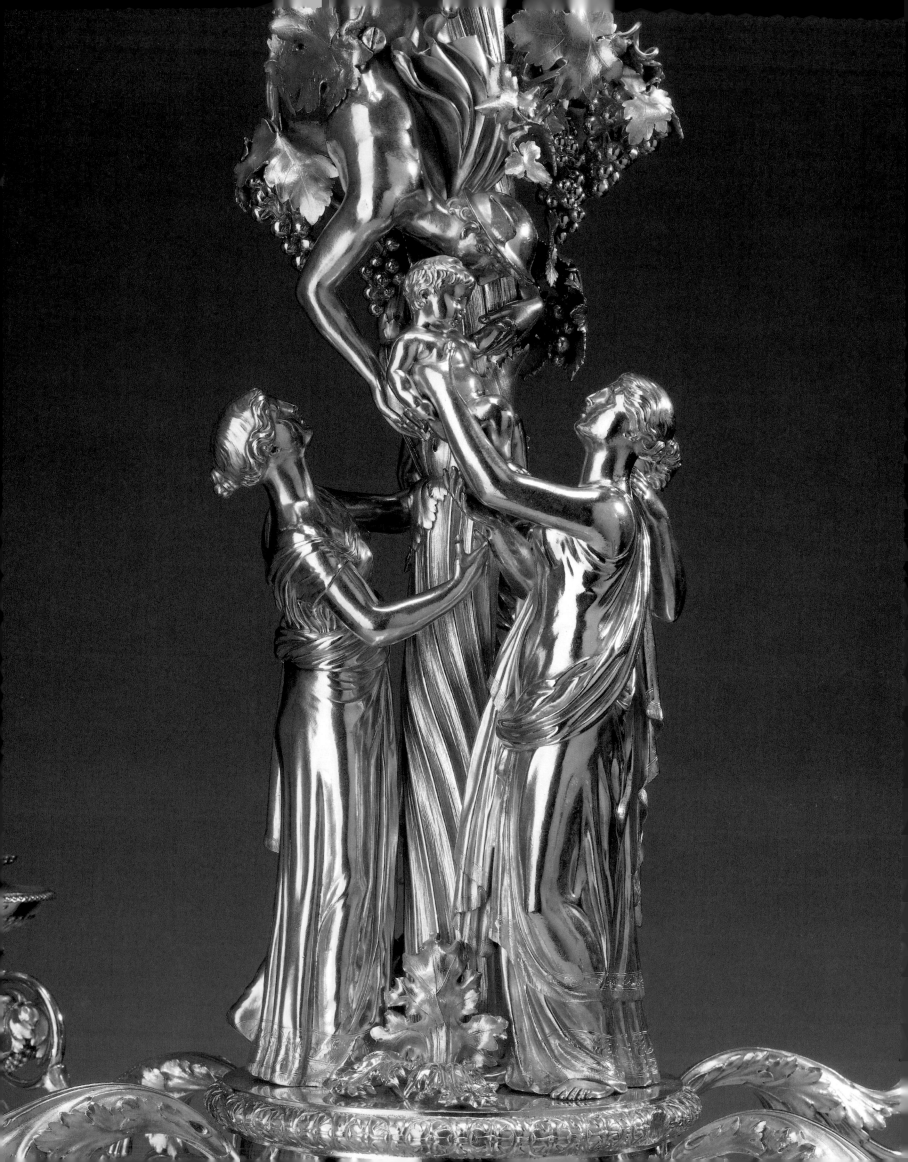

VIII

EUROPEAN SILVER AND GOLD

The silver in the Royal Collection today was largely assembled following the restoration of the monarchy in 1660. The remnants of Henry VIII's, Elizabeth I's and James I's splendid treasuries, together with much of Charles I's silver, had been melted for coinage during the Civil War and Interregnum with the result that Charles II was obliged to restock an empty Jewel House. Three warrants issued in quick succession between 1660 and 1663 provided a total weight of nearly 73,000 ounces troy of white and gilt plate costing £30,420 14s. 1½d. Most was new made in London, although some earlier continental pieces were acquired, continental silver often being considered superior in craftsmanship and design. Both secular and ecclesiastical silver was required for the restored monarchy. The superb altar silver supplied for Charles II's coronation ceremony in Westminster Abbey and for use in the Chapel Royal at Whitehall Palace has survived largely intact and is either displayed with the coronation regalia in the Tower of London (see no. 165) or is still used in the Chapel Royal in St James's Palace (no. 171). By contrast, little of the secular dining, buffet and domestic silver survived subsequent losses, meltings and refashioning, although a small number of outstanding examples remain in the collection (no. 172). Silver was also presented to the king by individuals and institutions eager to prove their loyalty or as New Year's gifts (a tradition that ceased in 1680).

The royal silver was safeguarded by the Jewel House, a medieval sub-division of the Lord Chamberlain's department, based in Whitehall Palace and the Tower of London. The Jewel House was responsible for the provision of silver and jewels to the royal family and court and also to ambassadors and other officers of state. At the beginning of a new reign it was usual for the cyphers and arms of the previous monarch to be replaced on the silver held by the Jewel House. The Master of the Jewel House kept meticulous records of issues of and repairs to silver, and of warrants for new pieces. Warrants were sent to the royal goldsmith, usually a banker-goldsmith who sub-contracted to working London goldsmiths. This arrangement ceased in 1782 when the responsibilities of the Jewel House passed to the Lord Chamberlain.

The later Stuarts continued to acquire silver, although on a smaller scale. James II while Duke of York ordered a remarkable group of altar silver in the 1660s (no. 173) and commissioned the first post-Restoration Jewel House inventory, completed during his brief reign (1685–8). William III and Mary II are represented by several superb survivals including the exceptionally rare caddinet used at their coronation banquet in 1689. This was sold from the Jewel House in the early nineteenth century and was reacquired for the Royal Collection by Her Majesty The Queen in 1975 (no. 176). Mary II furnished her apartments at Kensington Palace with magnificent Baroque silver furnishings after the French and Dutch fashion, although very few pieces commissioned by the Queen remain in the collection (no. 175). The most outstanding examples of silver furniture to survive are the cast and wrought silver table and mirror refashioned from an earlier set for William III in 1699 (no. 78).

Queen Anne appears to have been content with her inheritance and added little to the collection. Equally, during the reigns of George I and George II, the British royal silver remained largely unchanged, although an important Jewel House inventory was completed in 1721. George II's most significant addition was the splendid German silver furniture which he acquired in the 1730s for Herrenhausen, his summer palace near Hanover. This was lost to the collection in 1837 (see below).

Frederick, Prince of Wales, son of George II and father of George III, was – unlike his father – an important patron of the arts and was responsible for commissioning some of the most inspired and important English rococo silver of the eighteenth century (nos 178–80). George III inherited many of his father's artistic interests and, although he disliked lavish entertaining, began his reign by commissioning the so-called Coronation Service of plate from the royal goldsmith Thomas Heming (the first working royal goldsmith since the early seventeenth century). Among George III's finest acquisitions was a pair of neo-classical tureens by the Parisian goldsmith Henri Auguste (1759–1816) purchased for him (by Rundells) at the sale of the effects of the Neapolitan Ambassador in 1801 (RCIN 51694.1–2). Perhaps George III's most significant indirect contribution to the collection was his transferral of royal patronage to the enterprising goldsmiths Rundell & Bridge in 1797. This established a royal relationship with the firm that was to be of profound importance over the following decades.

Despite the additions of the eighteenth century, the royal silver collection was, at the beginning of the nineteenth century, unremarkable and could not bear comparison with other European royal treasuries. The enormous breadth and richness of the silver in the Royal Collection today is due to the concerted efforts of George IV and the royal goldsmiths and jewellers Rundell, Bridge & Rundell. George IV's interest appears to have been fostered by John Bridge when he was still Prince of Wales. As early as 1806 the Prince ordered silver costing £70,000 for Carlton House from Rundells. This huge sum was never again to be exceeded in a single bill. Following the establishment of the Regency in 1811, George IV embarked on further lavish expenditure on splendid silver and again bought heavily in the years after Waterloo. The majority of silver was supplied for the so-called Grand Service. This assemblage, which was initially reserved for use at Carlton House, was started c.1804 and added to for the rest of George IV's life. Most pieces were in the fashionable Antique style derived from ancient Greek and Roman sources (no. 183). However, Rundells also supplied a number of objects – including nos 184, 185, 189 – in the rococo revival style inspired by the Marine Service of Frederick, Prince of Wales. The quality of all the pieces was superb and the Royal Collection remains unsurpassed in its extensive holdings of early nineteenth-century silver.

From around 1816 George IV began accumulating an impressive collection of historic sideboard pieces which included some splendid continental *Kunstkammer* objects of the seventeenth and eighteenth centuries (nos 196, 201). These were displayed together with contemporary works in a range of historicist styles from Baroque to Gothic Revival. Rundell, Bridge & Rundell were the most successful retailers of the early nineteenth century. Philip Rundell (1743–1827) became a partner in the firm of goldsmiths and jewellers Theed & Picket in 1772, eventually obtaining sole ownership in 1786. He was joined in 1788 by John Bridge (1755–1834), whose suave manners were in direct contrast to Rundell's often outrageous rudeness, reflected in their nicknames Oil (Bridge) and Vinegar (Rundell). The pair were later joined by Rundell's nephew Edmund Walter Rundell. The firm's appointment as jewellers and goldsmiths to the Crown in 1797 was an immense stroke of good fortune and was followed by warrants from both the Prince of Wales and the Duke of York. As neither Rundell nor Bridge was a working goldsmith (both had served apprenticeships as jewellers) commissions were undertaken by workshops run by working goldsmiths including Benjamin Smith and Paul Storr. The firm's huge success was partly due to its use of leading artists such as John Flaxman and Thomas Stothard to supply designs and models. It is a measure of this success that Philip Rundell, the senior partner, died worth £1,250,000 – all the more remarkable given George IV's notorious tardiness in settling his debts.

Such was George IV's legacy that there has been little need for his successors to add substantially to the collection, although silver and gold have remained a popular choice for gifts to the royal family (nos 193–4, 202–3). A great loss to the collection occurred on Queen Victoria's accession in 1837 when all the Hanoverian possessions passed to George III's third son, Ernest, Duke of Cumberland, who became King of Hanover in that year. This included the magnificent German silver furniture acquired by George II in the 1730s together with some important late seventeenth-century English plate.

Prince Albert's interest in the arts extended to silver and he was responsible for commissioning and designing a number of pieces (including no. 192). In 1911 the first major study of the royal silver, by E. Alfred Jones, was published, followed by an extensive inventory of the entire collection by Garrard in 1914. King George V and (especially) Queen Mary took a close interest in the subject and contemporary photographs show the dining tables and buffets for state banquets loaded with many of George IV's superb acquisitions (see fig. 6). While some of these pieces have continued to be used for state banquets during the present reign, the preference has been for less ostentatious display. The Queen and the Duke of Edinburgh's patronage of contemporary goldsmiths includes Gerald Benney, one of the leading British goldsmiths of the post-war period (no. 194). Major acquisitions of historic silver by The Queen include the Hutton Cup, said to have been a marriage gift from Elizabeth I to her goddaughter in 1592 (no. 166), and the caddinet used at the coronation banquet of William and Mary in 1689 (no. 176).

ENGLISH SILVER AND GOLD (nos 165–194)

165

Attributed to AFFABEL PARTRIDGE (fl.1554–1579)
'Queen Elizabeth's Salt', 1572–3

Ceremonial standing salts, often of elaborate and intricate construction, were used on royal and aristocratic dining tables from the medieval period into the eighteenth century to mark the status of those dining by reference to their position at table in relation to the salt (i.e. 'above' or 'below'). No. 165 is normally displayed with the banqueting plate and coronation regalia in the Tower of London. Its association with Queen Elizabeth I appears to be a nineteenth-century invention and was probably suggested by the Tudor rose inside the cover. It is not identifiable in any royal inventories or Jewel House records until the 1680s. Charles II's cypher engraved under one of the feet suggests that it was acquired around 1660, probably from Sir Robert Vyner, who held the warrant to replace the royal plate and crown jewels sold or melted during the Interregnum (1649–60). With the exception of this salt and two German tankards (RCIN 31770 and 31771), all the replacements were new made in London.

Of the salt's earlier history nothing is known. It is struck with the maker's mark attributed to Affabel Partridge (goldsmith to Queen Elizabeth from about 1558 to 1576), whose work is characterised by its exceptional quality and lavish decoration. No. 165 is closely related to a salt belonging to the Vintners' Company, with the same maker's mark and dated 1569–70. Both incorporate panels depicting the Virtues after plaquettes by the German sculptor Peter Flötner (master 1522). The domed cover is cast with panels depicting Ceres, Lucretia and Cleopatra. This originally sat directly upon the main body of the salt; in around 1610 an open ring frame with scrolled brackets was introduced, converting the cover to a canopy raised above the cellar bowl.

'Queen Elizabeth's Salt' appears to have been added to the set known as the St George's Salts following the loss of one of their number after 1688. The ceremonial use of the St George's Salts remains unclear. They were perhaps used at the lavish banquets held in Westminster Hall following coronation ceremonies in Westminster Abbey. It has also been suggested that they were originally part of a larger set of salts ordered for the banquet of the Garter Knights held before Charles II's coronation in 1661 and used at subsequent Garter banquets at Windsor Castle.

Silver-gilt. 35 cm high
Hallmarks for London, 1572–3 and maker's mark attributed to Affabel Partridge
RCIN 31773
PROVENANCE Probably supplied to Charles II by Sir Robert Vyner, c.1660
LITERATURE Crown Jewels 1998, II, pp. 388–92
EXHIBITIONS London 1890, no. 918

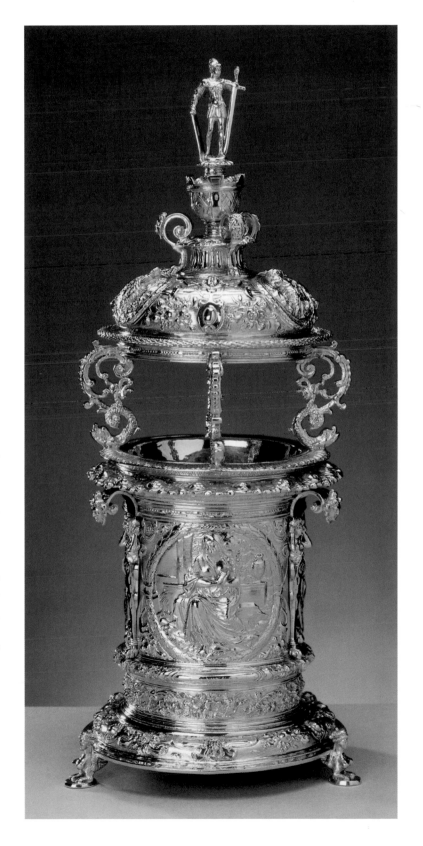

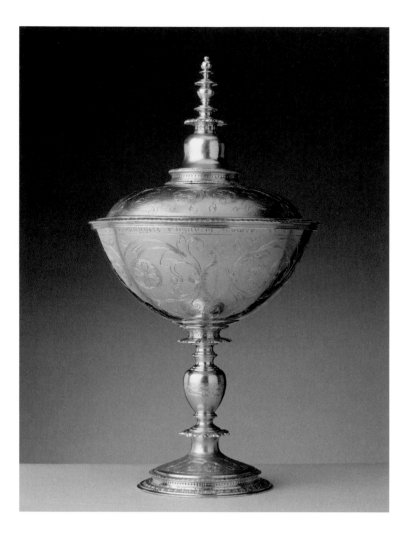

Silver-gilt. 34 × diameter 18.4 cm
London hallmarks for 1589–90 and maker's mark IS in monogram; engraved on lip with later inscription *From Queen Elizabeth to her Goddaughter Elizabeth Bowes 1570*
RCIN 15956
PROVENANCE Reputedly given by Elizabeth I to her goddaughter Elizabeth Bowes; thence by descent to J.T. D'Arcy Hutton; from whose estate sold Christie's, London, 27 November 1957 (138); bought by HM The Queen
LITERATURE Oman 1931, pp. 194 and 199

167
ENGLISH
Ewer and basin, 1617–18 and 1595–6

Ewers and basins were among the most important and impressive items of Tudor and early Stuart sideboard plate and were used for the ceremonial washing of hands in warm, perfumed water during and after dining. These examples are of typical form: this shape of ewer emerged in the mid-sixteenth century and remained popular into the 1620s. Both ewer and basin are elaborately embossed with strapwork panels incorporating vegetable and marine motifs, a popular combination at this time. The late sixteenth-century basin is struck with the maker's mark T.N above a flower head. The same mark occurs on the finely chased Hugh Hamersley salt (Haberdashers' Company) and has been attributed to T. Newton. The early seventeenth-century ewer bears the mark WC with an arrow between, possibly for William Cook, a London goldsmith who moved to Dublin in 1637.

The elaborate if somewhat naïve decoration of these pieces may have appealed to the antiquarian tastes of George IV, who added them to his growing collection of early sideboard plate in 1816. The Carlton House Inventory of Plate described them as 'a richly chased deep Gothic Dish and Ewer with Cherubim, Lions Heads, Dolphins etc'. It is a measure of George IV's eclecticism that in the same year he also acquired Elizabeth of Bohemia's ewer and basin (no. 198) with its very different emphasis on form rather than surface decoration.

Silver-gilt. Ewer 38 × 13 × 21.2 cm; basin 6.2 × diameter 48.8 cm
Ewer hallmarked for London 1617–18 with maker's mark WC with arrow between, engraved with badge of George IV, when Prince of Wales; basin hallmarked for London 1595–6 with maker's mark T.N above a flower head, with engraved badge of George IV, when Prince of Wales
RCIN 51491 (ewer), 51492 (basin)
PROVENANCE Rundell, Bridge & Rundell; from whom purchased by George IV, 1816 (£94 10s.; bill untraced, but see RA GEO/Add 19/8, f. 23)
LITERATURE Cripps 1899, p. 286; Jones (E.A.) 1911, p. 2; Garrard 1914, no. 511
EXHIBITIONS London 1890, no. 928 (basin); London 1901, case I, nos 11 and 12; London 1954c, nos 115 and 116; Johannesburg 1960, no. 1

168
UNKNOWN MAKER (fl.1570–1630)
Ostrich egg cup and cover, 1623/4

An engraved inscription records that no. 168 was presented to the Reverend John Stopes in 1623/4 by the parishioners of St Mary

166
Attributed to JOHN SPILMAN (fl.1588–c.1605)
The Hutton Cup, 1589–90

Queen Elizabeth I is thought to have given this important late sixteenth-century cup and cover to her goddaughter Elizabeth Bowes (1570–1625), who was the third daughter of Sir George Bowes (an ancestor of Her Majesty Queen Elizabeth The Queen Mother) of Streatlam, Co. Durham. It was for Sir George's services to the Crown during the Catholic insurrection of 1569 (in which his castle was destroyed) that the Queen agreed to stand as godmother to the infant Elizabeth in 1570. It is possible that this cup was the Queen's gift to Elizabeth Bowes on her marriage to Sir Timothy Hutton, Alderman of Richmond and Sheriff of York, in March 1592.

The reputed royal provenance of no. 166 is strengthened by the attribution of the maker's mark (IS in monogram) to John Spilman or Speilam. Spilman, a native of Lindau in Germany, was jeweller to Elizabeth I and was knighted by James I in 1605. He also helped introduce the paper-making industry into England, establishing paper mills at Dartford before 1588. The surviving royal charters for these describe him as 'our well-beloved naturell denizen, John Spylman, Goldsmyth of our Jewelles'.

A cylindrical salt in the Armourers' and Braziers' Company hallmarked 1588–9 is struck with the same maker's mark and incorporates cast ornament from the same stamps as no. 166. The Hutton Cup is

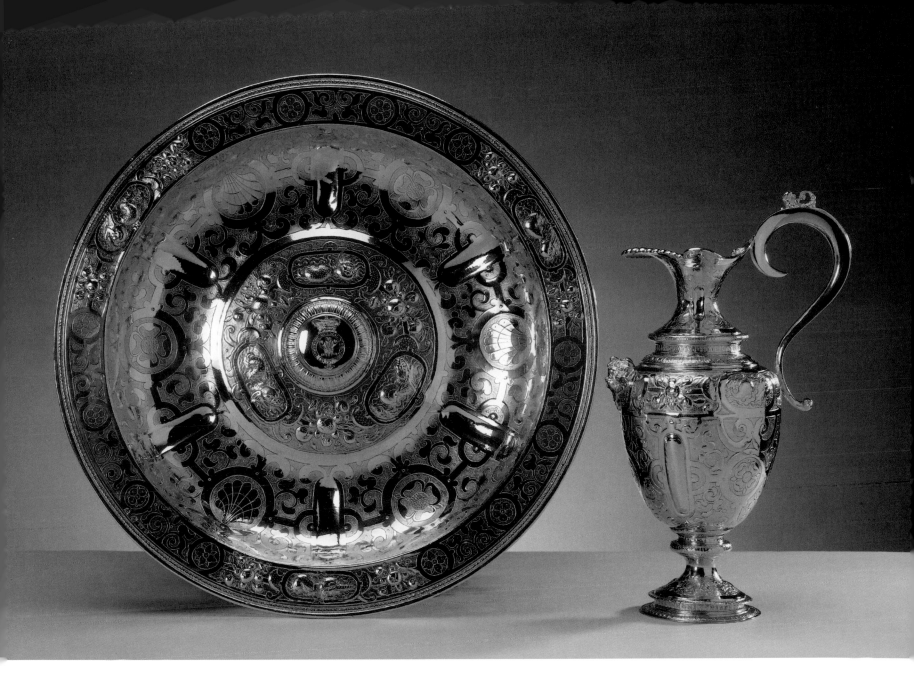

167

Magdalen in Old Fish Street, City of London. The surmounting figure of Minerva formerly held a banner engraved with the Magdalen and bearing the additional inscription *The 4 of october 1577 Mr James Stopes came to be our parson*. The banner was still in place at the time of the 1924 sale and was described in the sale catalogue; it had become detached before the cup entered the Royal Collection. James Stopes was rector of St Mary Magdalen from 1577 until his death in 1624. James's son John, ordained priest in 1608/09, initially assisted as curate but in 1621 he became rector of Crowell, Oxfordshire (Venn 1924, p. 170). St Mary Magdalen was destroyed in the Great Fire of London and was rebuilt by Sir Christopher Wren.

The affection felt for John Stopes by his father's congregation is perhaps indicated by the exceptional quality of this cup. It belongs to a small group of objects all struck with the maker's mark known as the trefoil slipped. This goldsmith, who was active from about 1570 to 1630, produced work that is noteworthy for its chasing and stamped decoration. He appears to have specialised in applying mounts to highly prized exotic materials such as ostrich eggs, mother-of-pearl and alabaster. The quality of the mounts, together with the close similarity between the maker's mark and those used in Ghent and Bruges, may

indicate a Flemish goldsmith working in London (Glanville 1990, nos 52, 75, 110). This rare survival of pre-Civil War secular plate was presented to Her Majesty The Queen by the American branch of the English-Speaking Union to mark her Coronation in 1953.

Ostrich egg with silver-gilt mounts. 44.6 × diameter 13.2 cm
London hallmark for 1623–4 and maker's mark the trefoil slipped; engraved on the rim of the bowl *This Cupp was given to Mʳ John Stopes our parsonns sonne by the Parishioners of the Parish of St Mary Magdalenes In or neere Olde Fishstreete London for his paines takinge / with vs by his often preaching with vs hoping that he will so friendly accept it as we most franckly and willing meane it The firste day of January 1623*
RCIN 50044
PROVENANCE Presented by the parishioners of St Mary Magdalen, Old Fish Street, London, to the Revd John Stopes, 1623/4; acquired by Henry Willet; acquired by Rt Hon. Samuel Montagu, first Baron Swaythling; by descent to the second Baron Swaythling; by whom sold Christie's, London, 6 May 1924 (95); presented to HM The Queen by William Griffin, President of the American Branch of the English-Speaking Union, 27 November 1953
LITERATURE Jackson 1911, I, p. 212
EXHIBITIONS London 1901, no. 1, case C, p. 20

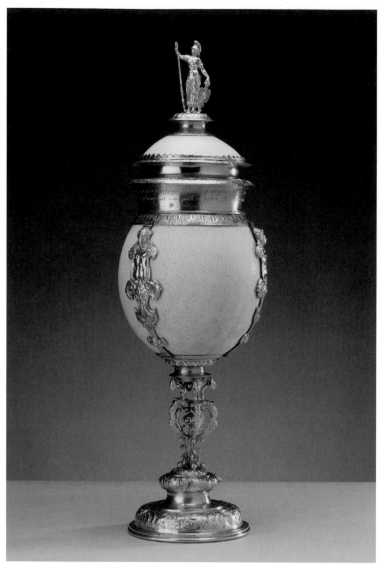

168

flowers may have been derived from *Hortus Eystettensis* by Basilius Besler (Nuremberg, 1613).

The date-letter sequence used in York before 1701 is still not fully understood and it is therefore difficult to establish with any certainty the exact year in which no. 169 was made. It was presented to William IV by Lord Ducie in 1834 and was one of the few pieces of early plate acquired by that monarch. Its earlier provenance is unknown although the lid is engraved with an early version of the Lytton family arms.

Silver-gilt. 18 × 13 × 18.5 cm
York town mark, date-letter Z (1654–5; see Jackson 1988) and maker's mark of John Plummer; engraved on lid *Presented to his Majesty William the Fourth* / BY THE LORD DUCIE / 19ᵗʰ *Decr.* 1834; lid engraved with the arms of Lytton; side engraved with the arms of William IV and the arms and motto of Ducie; scratched on base *E. Arnold* / 1824 / *G. N. Mimms* [?] / 1831
RCIN 51277
PROVENANCE [Lytton family;] presented by Thomas Reynolds, fourth Baron Ducie (later first Earl of Ducie and Baron Moreton of Tortworth) to William IV, 19 December 1834
LITERATURE Jones (E.A.) 1911, p. 24
EXHIBITIONS London 1862a, no. 5863; London 1954c, no. 118

170
ENGLISH
'Feathered' flagon, 1660–1

No. 170, which is one of a pair, formed part of the new altar plate supplied to the Chapel Royal at Whitehall Palace following the restoration of the monarchy in 1660. The front of the flagon is embossed with the 'rose slipped' with crown above, an emblem found on other plate

169
JOHN PLUMMER (fl.1648–1681)
Peg tankard, 1654–5 (or 1656–7)

The low squat form, pomegranate feet and thumb-piece of no. 169 are closely paralleled in seventeenth-century Baltic and Scandinavian tankards. In England peg tankards were made from the mid-1650s through to the 1680s in York, Hull and other north-eastern towns with close cultural links with northern Europe. The name 'peg tankard' is derived from the vertical row of pegs inside the tankard, used to measure the amount of alcohol drunk as the tankard was passed around the table.

No. 169 belongs to a group of peg tankards made by the York goldsmith John Plummer, many of which (like no. 169) are finely engraved with highly accomplished botanical decoration (Oman 1970, p. 20; Glanville 1990, pp. 270, 437). John Plummer (free 1648) was York's leading goldsmith, his work is comparable in quality (if not in style) to that found in London-made pieces. The engraved decoration on many of his tankards was almost certainly the work of a continental journeyman, described by Oman as 'the most imaginative engraver' of the Caroline period. It has been suggested that the finely observed tulips and other

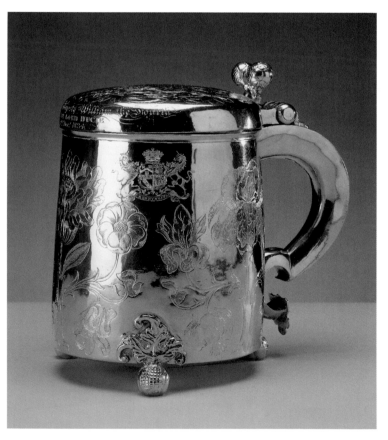

169

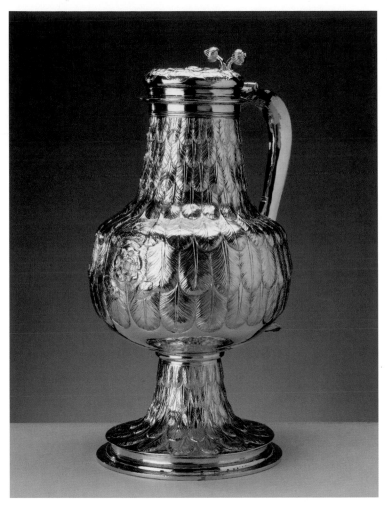

170

No. 170 is struck with the maker's mark read as either JB or TB, which may be that of James Beacham or Beauchamp from whom Pepys purchased a tankard in 1660 but of whom little else is known. The maker was evidently highly skilled: no. 170 and its pair are only a few pennyweights different from each other, a remarkable achievement at a time when such vessels were still raised by hand from ingots of silver.

Silver-gilt. 52 cm high
London hallmarks for 1660–1 and maker's mark JB or TB in script cypher
RCIN 31756.1
PROVENANCE One of a pair supplied to Charles II, 1660–1
LITERATURE Baldwin 1990, p. 205; Crown Jewels 1998, II, pp. 424–5

171
Attributed to HENRY GREENWAY (fl.1648–1670) and WOLFGANG HOUSER (fl.1652–1688)
Altar dish, 1660–1

This magnificent dish, one of the largest of its type in existence, first adorned the high altar of Westminster Abbey for Charles II's coronation ceremony in 1661. It was almost certainly also used at later coronations and since the early eighteenth century it has formed part of the altar plate of the Chapel Royal, St James's Palace. There it witnessed the marriages of George III, George IV, Queen Victoria and King George V. It is still in regular use for major religious events in the Chapel Royal.

The centre of the dish is deeply embossed with a representation of the Last Supper and with the royal arms and crown of Charles II prominently displayed to the right of Christ's head. Four panels in the outer rim depict The Washing of the Apostles' Feet (from a woodcut of 1574 by Jan Wierix), The Road to Emmaus (from a woodcut by A. Wierix after Martin de Vos), Christ's Commission to the Apostles and The Coming of the Holy Ghost.

The chased decoration can be attributed with some confidence to Wolfgang Houser – originally from Zurich (free of the Zurich Goldsmiths' Guild 1652) – who also appears to have chased an almost identical companion piece (RCIN 31745) bearing the arms of the Duke of York, later James II. This latter dish was perhaps supplied for the Duke's private chapel in the Palace of Whitehall in 1664 and is struck with the maker's mark attributed to Henry Greenway (Crown Jewels 1998, II, pp. 433–5).

There are close similarities between these dishes and one supplied by Houser for the chapel at Bishop Auckland Castle, County Durham in 1660–1 (for which Houser charged 9s. per ounce: Oman 1957, p. 185). In 1664 Houser presented a letter from Charles II to the wardens of the Goldsmiths' Company, ordering them to assay and mark his work. Prior to this Houser appears to have decorated plain dishes supplied already hallmarked by various London goldsmiths (Oman 1970, pp. 33–4). On no. 171 all the hallmarks with the exception of the London date-letter for 1660–1 have been obliterated by his work.

Silver-gilt. Diameter 94.5 cm
Marked with London date-letter for 1660–1
RCIN 92012
PROVENANCE Supplied to Charles II, 1660–1
LITERATURE Grimwade 1977, p. 113; Crown Jewels 1998, II, pp. 433–5

supplied for Charles II around 1660 (see no. 172). In 1664–5 a very similar pair of pear-shaped 'feathered' flagons was supplied for the Duke of York (RCIN 31755).

The unusual form and feather decoration of these two pairs of flagons appear to be a deliberate and perhaps symbolic re-creation of early sixteenth-century feathered flagons: the 1521 Jewel House inventory included 'two great gilte pottis chased wt fethers'. The 1649 Jewel House inventory listed 'one great fether pott' and 'one old fethered ewer with a broken handle'. These may have been part of the new plate ordered by James I to replace the 14,000 ounces of Jewel House plate given to the Tsar of Russia in 1604. Many of these pieces reproduced the portcullises, roses and 'feather fashion' of the Tudor plate they replaced.

No. 170 and its pair were often described as 'potts' rather than flagons in Jewel House inventories, a reference to their anachronistic pear-shaped form. The 1688 inventory records them under 'Chappel plate' at Whitehall Palace. Following the destruction of Whitehall Palace in 1698 they were moved to the Chapel Royal in St James's Palace, where they are listed in 1721.

In the instructions for use in the chapel in 1676, the flagons were described as part of the altar furnishings, flanking the great altar dish (no. 171): 'On Holy day Eves and Holy days the Altar is to be covered with a Carpet partly velvet, and partly white Gold Flower'd Sattin ... A great Charger set on, three Basons, one bigger two less, two ffeathered flagons, and two less of the same work, two fflaggons with chac'd work, two Candlesticks with Tapers' (Baldwin 1990, p. 213).

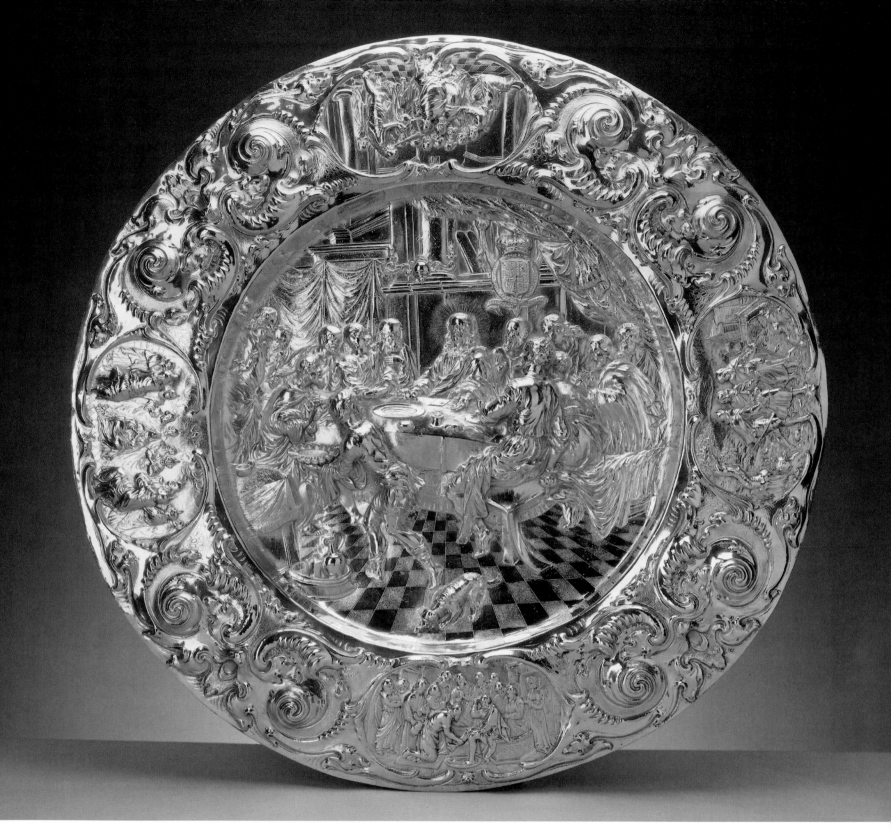

172
UNKNOWN MAKER (fl.1660–1661) and GEORGE
GARTHORNE (fl.1680–1700)
Basin, 1660–1 and ewer, 1690–1

Remarkably, this ewer and basin have been twice separated and twice
reunited between leaving the Royal Collection in 1808 and entering the
collection of Her Majesty Queen Elizabeth The Queen Mother in the
mid-twentieth century. The ewer was made for William III and Mary II
in 1691, as a companion to the basin. It replaced an earlier ewer,

presumably supplied for Charles II with the basin in 1660.

The Jewel House Deliveries Book records that in February 1690/1 the
basin was sent to the goldsmith 'to be new gilt' together with '1 gilt
Helmett Ewer to be new made'. The Accounts and Receipts Book further
records that the 'new making and gilding' of the 'Helmett Ewer with
trophys' cost £13 15s. 3d.

The form of the ewer is unique. The domed lid resembles a closed
helmet and the spout is fashioned like a visor. The embossed military
trophies echo those around the outer rim of the basin. On the inner rim
of the basin, four panels contain depictions of the Labours of Hercules.

The basin is struck with an indeterminate maker's mark variously

described as an orb and cross, orb and star, or grenade (*Crown Jewels* 1998, II, p. 402). The use of a device mark possibly indicates an alien goldsmith working in London. It has been suggested that the similarities between this dish and the altar dish in the Chapel Royal (no. 171) make it possible to attribute the embossed decoration to Wolfgang Houser (Oman 1970, p. 34). The ewer is struck with the mark associated with George Garthorne, apprenticed in 1669 and 'turned over' to his probable elder brother Francis. A considerable number of pieces of royal plate bear the same mark, including two covered ewers (*Crown Jewels* 1998, II, pp. 455–6).

After the basin's appearance at the coronation of Queen Anne in 1702 (PRO LC9/44), the ewer and basin seem to have been little used and by 1808 were among the royal silver then considered unserviceable which was sold to Rundells (see no. 175). It was at this moment that the two pieces were first separated. The basin was sold to the great collector William Beckford (1760–1844), who wrote to his agent 'the old pieces from the Royal silver are divine … these salvers and this plate etc. will give me great pleasure'. Beckford believed that the basin had belonged to Charles I: 'it isn't likely that this fine ornament [the rose in the centre of the basin] is found on silver as modern as the reign of Charles II, who only died 120 years ago' (Alexander 1957, p. 85). In fact, the emblem of the crowned rose 'slipped on the stalk' is thought to represent the restored bloom from the royal stem and is found on other silver supplied to Charles II shortly after the Restoration (see no. 170).

The basin was sold, together with most of Beckford's celebrated collection at Fonthill Abbey, in 1823. It was acquired by George IV's brother the Duke of Sussex, whose important collection of old plate was sold following his death in 1843. The basin appears to have been reunited by chance with the ewer, by then in the collection of Baron Lionel Nathan de Rothschild (1808–79). The link between them was not however recognised and they were displayed separately at the 1862 South Kensington Loan Exhibition. They subsequently passed through the collections of Leopold de Rothschild (1845–1917) and Anthony de Rothschild (1887–1961). They were again sold separately in 1940 when Queen Elizabeth The Queen Mother purchased the ewer; eighteen years later they were reunited once again when Her Majesty acquired the basin.

Silver-gilt. Basin 3.2 × diameter 52.7 cm; ewer 26.7 cm high
Basin hallmarked for London, 1660–1 and maker's mark an orb and cross; ewer hallmarked for London 1690–1 and maker's mark of George Garthorne
RCIN 100006 (ewer), 100007 (basin)
PROVENANCE *Basin:* made for Charles II, 1660–1; by descent; sold to Rundell, Bridge & Rundell, 1808 (PRO LC9/351, ff. 89–90); from whom purchased by William Beckford; sold Phillips, Fonthill Abbey, Wiltshire, 2 October 1823 (824); acquired by the Duke of Sussex; by whose executors sold Christie's, London, 23 June 1843 (305).

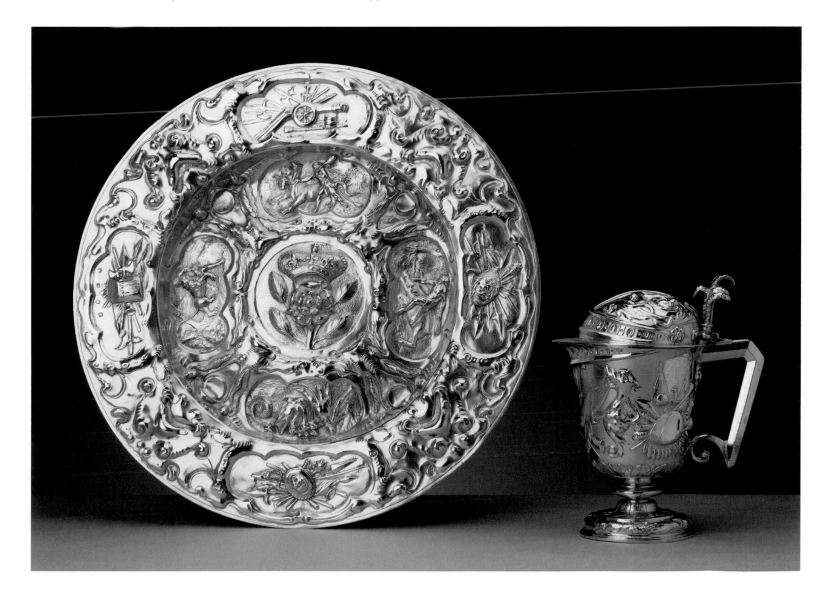

Ewer: made for William III and Mary II, 1690/1 (PRO LC9/43, 2 February and LC9/46, 28 February 1690/1, f. 83); by descent; sold to Rundell, Bridge & Rundell, 1808 (PRO LC9/351, ff. 89–90).

Ewer and basin: acquired by Baron Lionel Nathan de Rothschild; thence by descent to Leopold de Rothschild and Anthony de Rothschild; by whom sold Christie's, London, 23 October 1940 (97–8); ewer purchased by HM Queen Elizabeth The Queen Mother; basin sold (anonymously) Christie's, London, 4 June 1958 (103); purchased by HM Queen Elizabeth The Queen Mother

LITERATURE Jones (E.A.) 1907, pp. 4, 7, pls IIII and VII; Cornforth 1996, p. 145, figs 95 and 133

EXHIBITIONS London 1862a, nos 5794 and 5813; London 1901, case I, no. 61 and case K, no. 8; London 1929c, no. 417 (ewer); London 1968b, p. 7 (ewer); Brighton 1971 (ewer)

173
UNKNOWN ENGLISH MAKER (fl.1646–1666)
Pricket candlestick, 1661–2

No. 173 belongs to a small group of communion plate which appears to have been supplied for James II when Duke of York in the 1660s. The base is engraved with the Stuart arms within a garter, and a royal ducal coronet; it also bears a mysterious cypher, again surmounted by a royal ducal coronet, which appears to be DL conjoined. The Duke of York was the only Prince entitled to this form of coronet but much debate has surrounded the cypher and whom it represents. The same cypher appears on the seals of some of the Duke's letters and also on various bookbindings, including a group of books formerly at Welbeck Abbey.

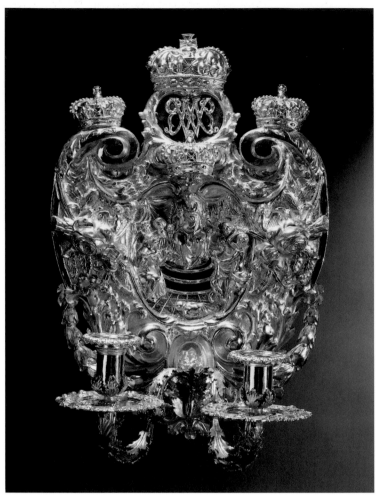

174

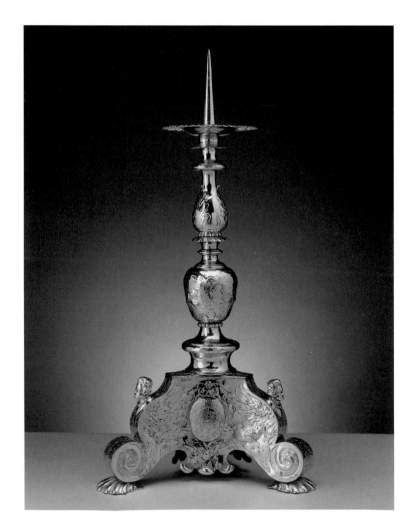

These are thought to have been given to the first Earl of Portland by William III from James II's library at Whitehall Palace. The cypher is therefore almost certainly the Duke of York's and probably represents a conjoined D and inverted J for Dux Jacobus (Duke James). The Duke was perhaps emulating Louis XIV, who used a similar conceit for his cypher (Hobson 1935, pp. 134–43).

The maker of no. 173 was the most important goldsmith working in England during the mid-seventeenth century. He remains unidentified and is known only by his maker's mark: the greyhound *sejant*. Much of his work was made during the Interregnum for the private chapels of royalist Anglicans. It is therefore unsurprising that this maker should have received several important royal commissions following the Restoration in 1660.

This form of candlestick is based on continental Catholic examples. Two other pairs of the same pattern and by the same maker are known: the pair supplied to the Duke of Lennox in 1653–4 are the earliest surviving English altar candlesticks (Rochester Cathedral). A second pair was supplied for Sir Robert Shirley's chapel at Staunton Harold in 1654–5 (Oman 1957, p. 243).

No. 173 and its pair do not appear in either the 1688 or 1721 Jewel House inventories. However, by 1832 they are listed in the Queen's Chapel, St James's Palace, designed by Inigo Jones for Henrietta Maria. The candlesticks now form part of the altar plate used in the Chapel Royal in St James's Palace.

◁ 173

Silver-gilt. 62.5 × 27.8 × 27.6 cm

London hallmarks for 1661–2 and maker's mark a hound *sejant*

RCIN 92009.1

PROVENANCE One of a pair probably supplied to James II, 1661–2

LITERATURE Oman 1957, p. 180; Grimwade 1977, p. 111; Baldwin 1990, pp. 207–08

174
ROBERT SMYTHIER (fl.1660–c.1686)
Sconce, 1686

Silver sconces were an essential part of the fashionable baroque interior; the Jewel House inventory of 1721 lists 191 of them in the royal palaces. This sconce is from a set of six embossed with the Judgement of Solomon. They are almost certainly the 'six silver chaced sconces' weighing 881 ounces troy 15 pennyweights delivered to the 'deputy keeper of his Majs Councell Chamber' at Whitehall Palace on 26 November 1686. Warrants dated 13 September and 16 October 1686 for 'four Silver Sconces wth double Socketts' and 'Two Silver Sconces of the same fashion & largness as the other foure' show that the set was ordered in two stages. The Jewel House Accounts and Receipts Book reveals that the total cost came to £396 11s. 3d. The new Council Chamber formed part of Sir Christopher Wren's substantial rebuilding of Whitehall Palace for James II. There the King would have met the Ministers of his Privy Council; the Judgement of Solomon, symbolic of wisdom, embossed on the back of the sconces was therefore a particularly appropriate subject.

The cyphers of William and Mary were added later. On 28 September 1691 the Accounts and Receipts Book records that the cost of 'Boyling of 6 Large Sconces [weighing 881 ounces troy] & ye making of 6 wrought cyphers' came to £10 15s. 2d. (PRO LC9/46, f. 99). It was usual for the cyphers and arms of the previous monarch to be replaced on royal plate at the beginning of a new reign.

The Solomon sconces are listed in the Council Chamber at Whitehall Palace in the 1688 inventory and were probably the six sconces weighing 880 ounces used – with no. 175 – to furnish the room where Queen Mary II lay in State in February 1694/5. In 1742 the sconces 'chas'd, with the Judgement of Solomon upon them' were noted in the State Bedchamber at Hampton Court (Bickham 1742, p. 53). In 1812 the set was shown to George IV (see no. 175); they were subsequently restored and gilded by Rundells for use at Carlton House. New nozzles costing £25 5s. 3d. were added in 1816.

Silver-gilt. 51.5 × 26 × 24.5 cm

Maker's mark attributed to Robert Smythier (free 1660); nozzles struck with London hallmarks for 1816–17 and maker's mark of Paul Storr

RCIN 51539.3

PROVENANCE Supplied to James II, 1686 (PRO LC5/108, ff. 71, 76; LC9/43, f. 41; and LC9/46, f. 86); restored and gilt by Rundell, Bridge & Rundell, 1812 (£359 2s.; bill untraced); new nozzles added 1816 (£25 5s. 3d.; bill untraced)

LITERATURE Jones (E.A.) 1911, p. 44; Garrard 1914, no. 216; Oman 1970, p. 55, pl. 63B

EXHIBITIONS London 1862a, nos 5861 and 5862; London 1954c, no. 13; Amsterdam/Rome/Geneva 1957–8, no. 5; Stockholm 1958, no. 5; Copenhagen 1958, no. 5; QG 1991–2, no. 183

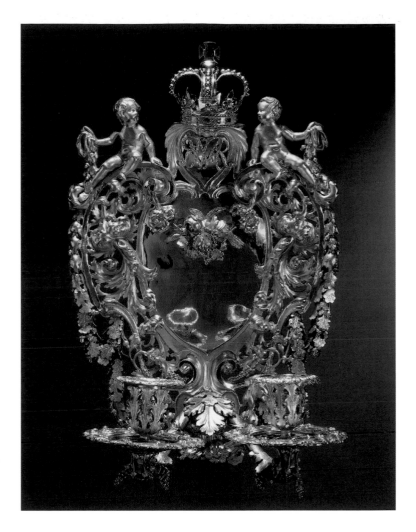

175
ENGLISH
Sconce, c.1686–90

No. 175 belonged to a set of seventeen sconces, only four of which still remain in the Royal Collection. This set, known as the 'oken' or acorn sconces, was ordered in stages. A warrant of 12 March 1686 requested 'seaven new silver sconces with two socketts' for Mary of Modena's new apartments in Whitehall Palace. They were 'to be chased and made after the manner and fashion of the great Branch [chandelier] with oake leaves and acorns'. The Jewel House Deliveries Book records that these cost £427 11d. A second warrant of 5 September 1686 for 'three new silver sconces of the same manner and largnesse as the other seven … which hang in that Roome [the Queen's Drawing Room]' completed the original set.

After the deposition of James II and the proclamation of William and Mary as joint sovereigns in February 1689 a further warrant dated 20 September 1689 ordered 'for the Queen Majtys [Mary II] service … five Acorn Sconces of the fashion as those that were made therefore'. These cost £401 10s. A further pair was delivered the following December. Several of Mary of Modena's original set appear to have been either replaced or repaired in 1690, following damage by thieves (PRO LC9/43, ff. 118 and 123). The '17 oaken Sconces' were among the many chandeliers and sconces used to furnish the velvet draped bedchamber in Whitehall Palace where the Queen lay in State in February 1694/5 (PRO LC9/46, 11 February 1694/5).

The sconces appear to have survived in the Jewel House until 1812, when they were among the numerous damaged old sconces 'taken to Carlton House ... for the Prince Regent to see' (PRO LC9/351, f. 1). The set was listed separately in two groups: '12 Single Sconces Cupid Backs' and '5 [Double Sconces] Cupid Backs'. Although the Prince evidently 'highly approved' of some of them, it appears he required only four of the double-branched sconces. These were subsequently restored and gilded for use at Carlton House in 1816. The unwanted sconces were returned to the Jewel Office where they remained until 1816–17, when they were among the 4,286 ounces troy of old royal silver sold at melt value to Rundells to defray the costs of the new service for Princess Charlotte of Wales (PRO LC9/351, f. 91). Eight of the set (missing their oak garlands) were acquired by Walter Sneyd (1752–1829) together with other royal plate. They are now at Colonial Williamsburg. A further pair was subsequently in the collections of H.H. Mulliner and William Randolph Hearst (Sotheby's, London, 27–8 June 1974 (1)).

Silver-gilt. 49 × 32 × 26 cm
Unmarked; nozzles struck with London hallmarks for 1816–17 and maker's mark of Paul Storr
RCIN 49162.1
PROVENANCE From a set of seventeen supplied to Mary of Modena, 1686, and to William and Mary, 1689–90 (PRO LC5/108, ff. 36, 69, 72, 107; LC9/43, ff. 44, 108, 123, 156; LC9/46, ff. 35, 56, 67); restored by Rundell, Bridge and Rundell for George IV, 1816 (£303 12s. 8d. including two 'lion and boy sconces'; bill untraced)
LITERATURE Jones (E.A.) 1911, p. 28; Garrard 1914, no. 214; Oman 1970, p. 55
EXHIBITIONS London 1954c, no. 12; London 1988b, no. M10

176
ANTHONY NELME (fl.1680–1720)
Caddinet, 1688–9

Caddinets first appeared in France in the sixteenth century where their use was restricted to the tables of the aristocracy. Salt and cutlery were kept in the compartments and prior to dining a napkin was laid on the tray and set with bread. The name is derived from *cadenas* (padlock) and suggests that the salt compartments on early examples were originally locked to guard against poisoning. Caddinets were first used in Britain at the coronation banquet of Charles II in 1661 and their use remained strictly a royal prerogative. No. 176 is one of only three surviving English caddinets. It is normally displayed (with the second surviving example) in the Tower of London. An Italian caddinet by Luigi Valadier, made in the 1780s for Henry Benedict Stuart, Cardinal York (son of the Old Pretender), is also in the Royal Collection (RCIN 45182).

No. 176 was supplied for the coronation banquet of William and Mary held on 11 April 1689. It is probably the 'Gilt Caddanett' weighing 104 ounces troy, 15 dwt (pennyweights), received by the Jewel House on 9 April, charged at £64 11s. 11d. (including 'engraving it extra'). The magnificent engraved arms of William and Mary prior to their recognition as sovereigns by Scotland are almost certainly the work of the Frenchman Blaise Gentot. The English Parliament formally offered the Crown to William and Mary on 13 February 1689. The Scottish Parliament did not meet until 4 March and their decision was not known until the day of the coronation ceremony. The Scottish arms have therefore been tactfully omitted and the arms of Ireland inserted twice.

No. 176 was probably one of three caddinets described as '3 Old

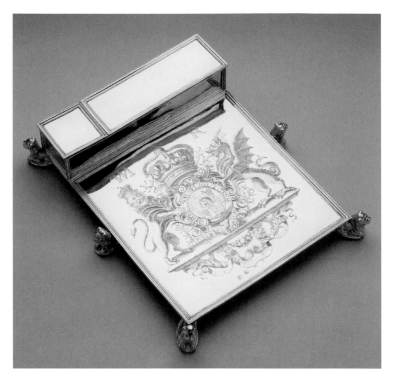

176

Silver Inkstands' weighing 306 ounces troy 10 pennyweight included in 'A List of the Articles of Old Plate which have been Melted in aid of the Expences of New Services provided', compiled between 1808 and 1832 (PRO LC9/351, ff. 89–96; see also nos 172 and 175). The caddinets formed part of the 2,656 ounces troy of old silver disposed of in 1808 to Rundells to defray the expenses of the Princess of Wales's new service (PRO LC1/3 letter 34). Many of the more historic pieces were spared the melting pot and sold by Rundells to collectors of old plate. No. 176 together with a second caddinet (RCIN 31735) was bought by the first Earl of Lonsdale (1757–1844). It was acquired by Her Majesty The Queen from the seventh Earl of Lonsdale in 1975, having been on loan to the Victoria and Albert Museum 1958–75. The third caddinet listed in 1808 is probably that in a private collection (see New York 1988, exh. cat. no. 77).

Silver-gilt. 13.3 × 39.4 × 31.1 cm
London hallmarks for 1688–9 and maker's mark of Anthony Nelme; engraved with the arms and cypher of William and Mary (as used 13 February–11 April 1689)
RCIN 31736
PROVENANCE Made for William III and Mary II, 1688–9 (£64 11s. 11d.; PRO LC9/46, 9 April 1689); sold from the Jewel House to Rundell, Bridge & Rundell, 1808; by whom sold to William Lowther, first Earl of Lonsdale (1757–1844); thence by descent to James, seventh Earl of Lonsdale (b. 1922); by whom sold by private treaty to HM The Queen, 1975
LITERATURE Oman 1958; Crown Jewels 1998, II, pp. 453–4
EXHIBITIONS London 1992a

177
BENJAMIN PYNE (d. 1732)
Pricket candlestick, 1717–18

This altar candlestick is one of a pair listed at Whitehall Chapel in the Jewel House inventory of 1721 (PRO LC5/114). Although made in the

reign of George I (whose cypher is on the base), this shape of candlestick with its triangular base and baluster stem is of a type which emerged during the previous century (see no. 173). No. 177 and its pair have been described as the 'last really important Baroque candlesticks' of the early eighteenth century (Oman 1957, p. 244). They remain the only major examples of plate commissioned for the Chapel Royal in the reigns of George I and George II.

The old Chapel Royal was destroyed in the Whitehall fire of 1698. Thereafter a new Chapel Royal, designed by Christopher Wren, was established in Inigo Jones's Banqueting House, the only important element of Whitehall Palace to survive the fire. Although Queen Anne moved the choral headquarters of the Chapel Royal to the King's Chapel at St James's Palace in 1702, private services for the royal family continued at Whitehall into the reign of George I. The Royal Maundy service was celebrated there for much of the eighteenth and nineteenth centuries. No. 177 appears to have been used on the high altar of the chapel together with the large altar dish and feathered flagons supplied to Charles II in the 1660s (see nos 171, 170). Following the closure of Whitehall Chapel in 1890, the candlesticks were used in the chapel at Marlborough House before being moved to Buckingham Palace. Today they form part of the magnificent altar plate used in the Chapel Royal and the Queen's Chapel at St James's Palace.

Benjamin Pyne (free 1676) was one of the few native English goldsmiths of the period who was able to compete successfully with the Huguenots. One of his earliest commissions was for a 'chocolate dish of Esqr Peyps [sic]' in 1685. By the early eighteenth century he had become one of the leading London goldsmiths and in 1714 was appointed Subordinate Goldsmith to the King for the coronation of George I.

Silver-gilt. 103.6 × 32 × 32 cm
London hallmarks for 1717–18 and maker's mark of Benjamin Pyne, with the applied cypher of George I
RCIN 92008.1
PROVENANCE Supplied for the Chapel Royal, Whitehall, 1717–18
LITERATURE Garrard 1914, no. 1315; Grimwade 1977, p. 114

178
PAUL CRESPIN (1694–1770) and NICHOLAS SPRIMONT (1716–1771); JOHN BRIDGE (1755–1834), for RUNDELL, BRIDGE & RUNDELL
The Neptune centrepiece, 1741–2 (and 1826–7)

This unique centrepiece, described as 'the purest rococo creation in English silver' (Grimwade 1974, p. 30), forms part of the superb Marine Service of rococo plate which was almost certainly supplied for Frederick, Prince of Wales, in the early 1740s (see also nos 179–80). This association is based on the listing of all the pieces in the 1832 Inventory of Plate under the heading of 'Frederick Prince of Wales'. The highly fashionable design of no. 178 shows a strong continental influence and reflects the sophisticated tastes and inspired patronage of the Prince, who played a significant role in introducing the rococo style into England. Although no. 178 bears the mark of Paul Crespin, the involvement of the Liègeois Nicholas Sprimont is suggested by stylistic similarities with his work (see nos 179–80). It is possible that the centrepiece was made by Sprimont shortly after his arrival in London

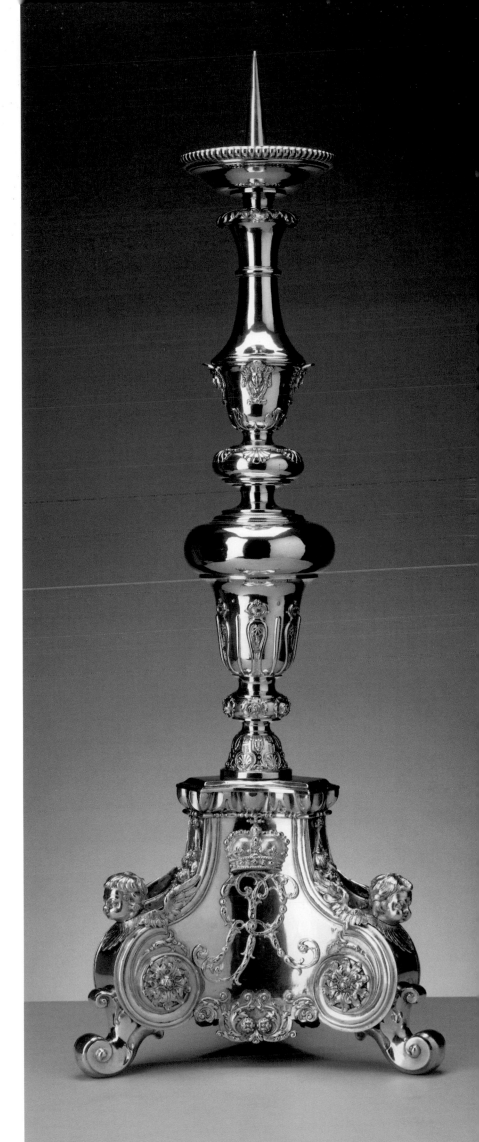

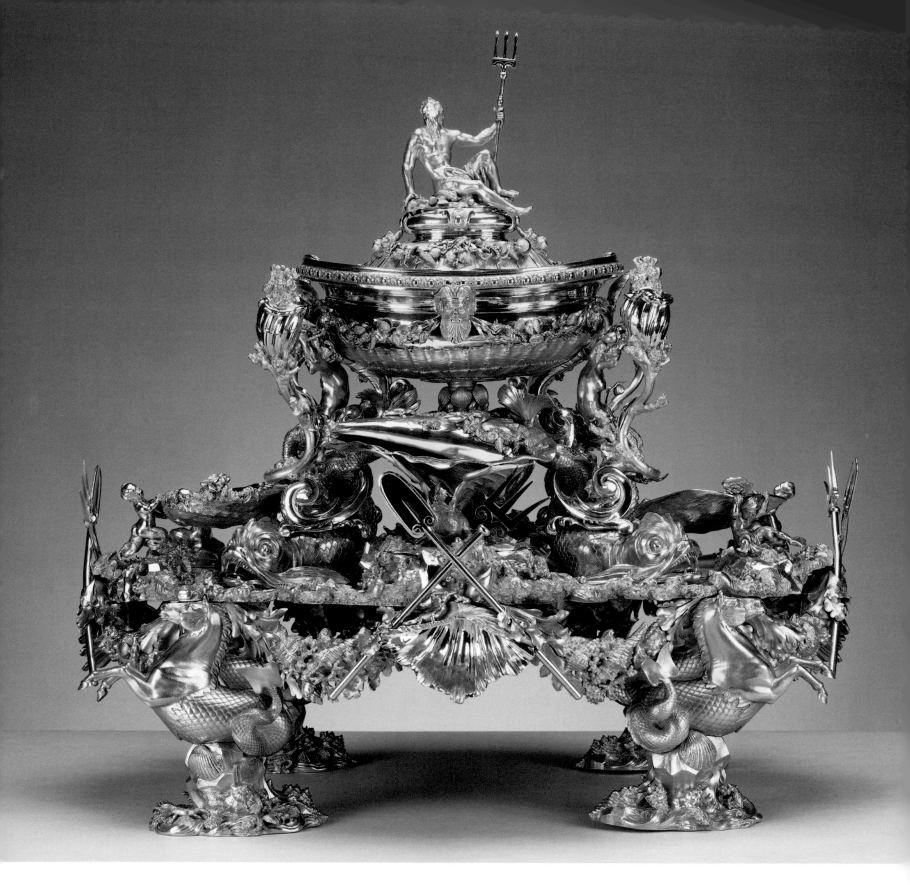

but marked by Crespin, a fellow Huguenot and neighbour in Compton Street, Soho; Sprimont's own mark was not registered until 1743.

During recent detailed examination of the centrepiece it was discovered that the two pairs of entrée dishes with dragon and mer-figure supports, located on the base, previously thought to be separate 'salts', formed an integral part of the design of the centrepiece. It was also discovered that at least two pre-existing elements had been incorporated, perhaps because of the need to complete the object quickly: the shallow shell which supports the tureen and bears the mark of Andrea

Boucheron (1701–61), goldsmith to the court of Turin; and the tureen, cover and S-scroll legs, which are slightly earlier and are perhaps of French origin.

In 1780 James Young and Robert Henley copied the centrepiece, sauceboats and salts from the Marine Service for Charles, fourth Duke of Rutland – a clear instance of the enduring appeal of Sprimont's inspired rococo creations, long after the style went out of fashion. During the early nineteenth century the service was used by George IV at Carlton House and in 1827 Rundells added the 'very richly chased silver Stand

to receive Centre Marine Ornament with festoons of shells, Sea Horses &c' for George IV. The marine decoration and forms of the service inspired many of the pieces of plate supplied for George IV by Rundells in the 1810s and 20s (for instance, nos 184, 185).

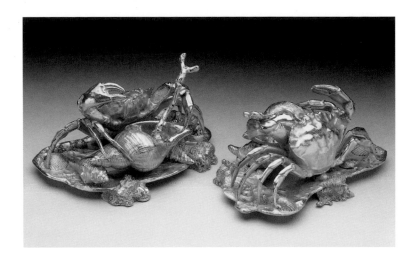

Silver-gilt. 68 × 66 × 47 cm
London hallmarks for 1741–2 and maker's mark of Paul Crespin; the shell mount below the tureen with Turin townmark and maker's mark of Andrea Boucheron; the later hippocamp (seahorse) base with hallmarks for London, 1826–7 and maker's mark of John Bridge
RCIN 50282
PROVENANCE Almost certainly made for Frederick, Prince of Wales, 1741–2; hippocamp base added by Rundell, Bridge & Rundell for George IV, 1827 (£484 1s. 7d.; RA GEO/26324; PRO LC9/351, f. 41)
LITERATURE Jones (E.A.) 1911, pp. 72 and 98; Garrard 1914, nos 163, 207, 210; Grimwade 1969; Grimwade 1974, pp. 30–4, 47–8; Barr 1980, pp. 170–2
EXHIBITIONS London 1954c, nos 39, 43, 44; Paris 1959, no. 170; Johannesburg 1960, no. 16; London 1965; London 1984, no. G17; QG 1988–9, nos 114 and 118–19; London 1992a; Cardiff 1998, no. 45

179
NICHOLAS SPRIMONT (1716–1771)
Two pairs of salts, 1742–3

The salts are struck with the maker's mark of Nicholas Sprimont, a Liègeois Huguenot who appears to have moved to London early in 1742, where he became a leading practitioner of the rococo style. Sprimont's silver is exceptionally rare and no. 179 are among the best-known examples of his work. It has been suggested that the striking naturalism of these two pairs of salts was achieved by casting actual seashells, crabs and crayfish from life. They were almost certainly supplied for the Marine Service of Frederick, Prince of Wales, in the early 1740s (see no. 178). Sprimont appears to have worked only with silver for six or seven years. From c.1745 he was involved with the establishment of the Chelsea porcelain factory (see no. 108). The cray-fish salt served as a model for porcelain versions subsequently reproduced by the factory.

The accompanying spoons are modelled as branches of coral with cockleshell bowls; they are illustrated here resting inside the bowls of the salts. The spoons, which are unmarked, appear on an undated sheet of designs attributed to Sprimont for a salt cellar with alternate spoons discovered in a collection of seventy-eight sheets of drawings in the Victoria and Albert Museum.

Silver-gilt. Crab salts 8.9 × 17.8 × 11.7 cm; crayfish salts 8.7 × 14 × 14.1; spoons 11 cm long
London hallmarks for 1742–3 and maker's mark of Nicholas Sprimont; spoons unmarked
RCIN 51368.1–4 (spoons), 51392.1–2 (crab salts), 51393.1–2 (crayfish salts)
PROVENANCE Almost certainly made for Frederick, Prince of Wales, 1742–3
LITERATURE Jones (E.A.) 1911, p. 98; Garrard 1914, nos 208, 209; Grimwade 1974, pp. 4, 16, 31, 45, pl. 37B
EXHIBITIONS London 1954c, nos 40, 41; Amsterdam/Rome/Geneva 1957–8, no. 62 (crab salt and spoon); Stockholm 1958, no. 66 (crab salt and spoon); Copenhagen 1958, no. 64 (crab salt and spoon); Johannesburg 1960, no. 7 (crab salt); Birmingham 1963 (crayfish salt); London 1984, no. G17; QG 1988–9, nos 116, 117; London 1992a; Cardiff 1998, no. 47

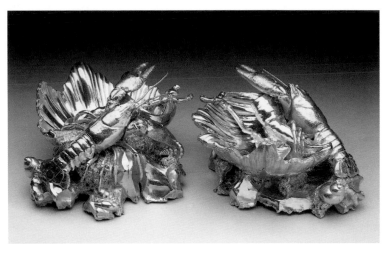

179

180
NICHOLAS SPRIMONT (1716–1771)
Two sauceboats, ladles and stands, 1743–4 and 1744–5

These exuberantly modelled sauceboats and stands by the leading rococo goldsmith Nicholas Sprimont are two from a set of four. Like no. 179 they were almost certainly supplied for the Marine Service of Frederick, Prince of Wales, between 1743 and 1745 (see no. 178). The modelling and chasing are of exceptional quality and these pieces rank among the finest of Sprimont's creations. The handles are ingeniously formed as seated figures – a water nymph and her companion – which recall Baroque fountain sculpture. The figures sit at the 'stern' of the raised boat-shaped bowl which is supported by cast dolphins. These dolphins closely resemble those on the Neptune centrepiece (no. 178), which, although struck with the mark of Paul Crespin, has also been attributed to Sprimont. For many years the stands were thought to be separate dessert dishes and they have only recently been reunited with the sauceboats.

During the nineteenth century Garrards made a number of copies of the sauceboats, including versions with different figures.

Silver-gilt. Sauceboats 22.7 × 23.2 × 13 cm; stands 28 × 22.4 × 3 cm; ladles 19.9 × 5.9 cm
Both stands and one sauceboat hallmarked for London 1743–4, the other sauceboat hallmarked for 1744–5, all with maker's mark of Nicholas Sprimont; ladles unmarked

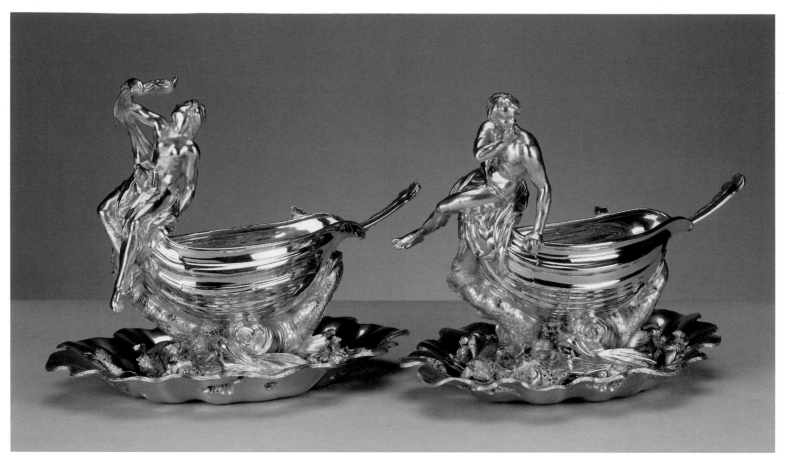

180

RCIN 51259.1–2 (ladles), 51271.2–3 (sauceboats and stands)
PROVENANCE From a set of four almost certainly made for Frederick, Prince of Wales
LITERATURE Jones (E.A.) 1911, p. 100; Garrard 1914, nos 117, 228; Grimwade 1974, pp. 16, 31, 45, pl. 33A
EXHIBITIONS London 1954c, no. 42; Amsterdam/Rome/Geneva 1957–8, no. 63; Stockholm 1958, no. 67; Copenhagen 1958, no. 65; Johannesburg 1960, no. 8; Birmingham 1963; London 1984, no. G17; Cardiff 1998, no. 46

181

PAUL STORR (1771–1844) for RUNDELL, BRIDGE & RUNDELL; JOHN FLAXMAN (1755–1826), designer
The Mercury and Bacchus candelabrum, 1809–10 and 1816–17

This monumental candelabrum and its pair (no. 182) were the largest and most magnificent candelabra in George IV's splendid Grand Service of banqueting plate. The sculptural group around the stem of no. 181 depicts Mercury presenting the infant Bacchus to the nymphs of Nysa after he was born from the thigh of his father Jupiter; Mercury had sewn him into Jupiter's thigh after his mother Semele had been consumed by a thunderbolt during her pregnancy.

The stems and the upper branches of nos 181 and 182 were added by Rundells in 1816–17 to a pair of smaller centrepieces also made by Paul Storr (for Rundells) about seven years earlier. The base and lower candle branches of no. 181, described as 'a very large and superb Ornament for Centre of the Table', were supplied by Rundells to George IV and invoiced in June 1811 for the huge sum of £2,017 16s. The figures of piping fauns and panthers were almost certainly modelled by the sculptor William Theed (1764–1817; see no. 184) and show a surprising naturalism which anticipates silver of the Victorian period. The centre was originally occupied with '3 dancing Nymphs, and a Basket for flowers'.

The enrichment of nos 181 and 182 in 1816–17, involving the stems and everything above the level of the lower candle branches, was made at a total cost of £1,365. The invoice describes '2 elegant richly chased Candelabra to fit occasionally the gilt Tripod Stands with the piping Fauns, composed from Designs made by FLAXMAN on the subject of Mercury presenting Bacchus to the Nymphs, the other the Serpent guarding the Tree of Hesperides with elegant falling Branches and Ornamental devices'.

John Flaxman began designing plate for Rundells around 1805 and continued until his death over twenty years later. Designs for the Mercury and Bacchus stem survive in the British Museum and the Victoria and Albert Museum. Because Flaxman was rarely concerned with functional components the candle branches are omitted from the design; his figure groups would have been worked up by Rundells later. The figures are likely to have been modelled by either William Theed or Edward Hodges Baily (1788–1867), a former pupil of Flaxman who joined Rundells in 1815. Rundells' artists made use of both Renaissance and ancient sources. The form of nos 181–2 recalls the richly sculptural bronze tripod candelabra made in Venice during the sixteenth century. Likewise, the piping fauns at the angles resemble bronze statuettes such as the *Pan listening to Echo*, traditionally attributed to Riccio, in the Ashmolean Museum, Oxford.

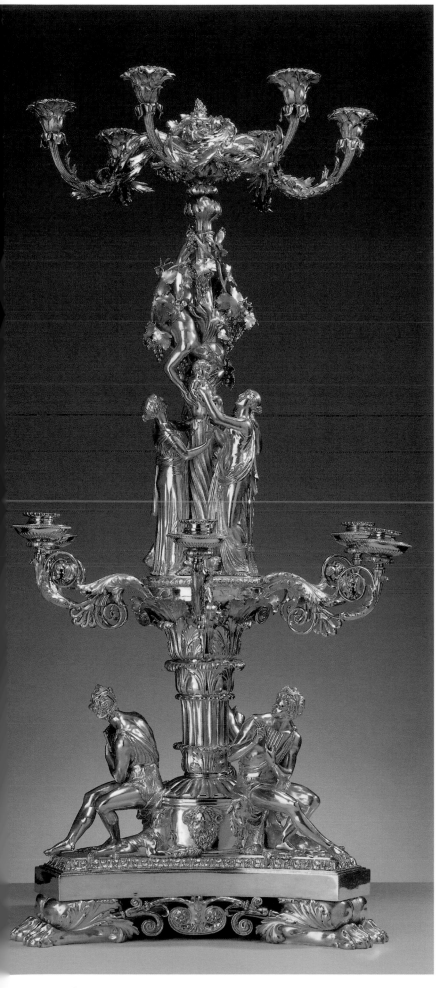

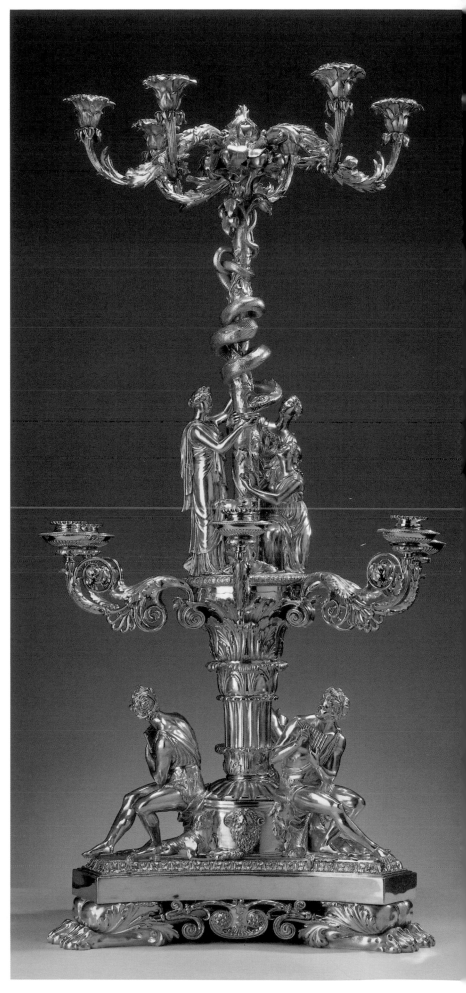

Silver-gilt. 125 × 66 × 66 cm
Base struck with London hallmarks for 1809–10 and maker's mark of Paul Storr,
engraved RUNDELL BRIDGE ET RUNDELL AURIFICES REGIS ET PRINCIPIS
WALLIÆ LONDINI FECERUNT and with the Prince of Wales's feathers and motto
within crowned Garter; stem and upper branches struck with London hallmarks for
1816–17 and maker's mark of Paul Storr
RCIN 51977
PROVENANCE Base and lower branches supplied by Rundell, Bridge & Rundell to
George IV, invoiced 4 June 1811 (£2,017 16s.; RA GEO/26284); stem and upper
branches added by Rundells, 1816–17 (£1,365; PRO LC11/23 quarter to 5 July
1817, cost included stem and branches to no. 182)
LITERATURE Jones (E.A.) 1911, p. 116; Garrard 1914, no. 11; Irwin 1979, pp.
191–3
EXHIBITIONS London 1954c, no. 80; London 1979a, no. 185b

182
PAUL STORR (1771–1844) for RUNDELL, BRIDGE & RUNDELL; JOHN FLAXMAN (1755–1826), designer
The Apples of the Hesperides candelabrum, 1810–11 and 1816–17

Like its pair, no. 181, the upper tier of this candelabrum was designed
by John Flaxman and added to a slightly earlier centrepiece. The sculp-
tural group encircling the stem depicts an episode from the last of
the Twelve Labours of Hercules: the serpent Ladon guards the golden
apples of the Hesperides which are tended by three daughters of Erebus
and Night. Like the story of Mercury and Bacchus depicted on the
stem of no. 181, this was one of the most popular tales from classical
mythology.

The base, like that of no. 181, was invoiced by Rundells in June
1811. It was described as 'A large and elegant Ornament to match the
one delivered with Piping Fauns and dancing Nymphs' and was charged
at the slightly lower price of £1,985 19s. Nos 181 and 182 were
among the most expensive items of plate purchased by George IV; the
final cost for the two, including the bases invoiced in 1811 and the
addition of the upper tiers in 1817, was £5,368 15s.

A candelabrum in the collection of the Goldsmiths' Company has an
identical stem and upper tier to no. 182; it is hallmarked for 1821–2
(London 1979a, exh. cat. no. 185a).

Silver-gilt. 122 × 69 × 69 cm
Base struck with London hallmarks for 1810–11 and maker's mark of Paul Storr,
engraved RUNDELL BRIDGE ET RUNDELL AURIFICES REGIS ET PRINCIPIS
WALLIÆ LONDINI, and with the Prince of Wales's feathers and motto within crowned
Garter motto; stem and upper branches struck with London hallmarks for 1816–17
and maker's mark of Paul Storr
RCIN 51976
PROVENANCE Base and lower branches supplied by Rundell, Bridge & Rundell to
George IV, invoiced 4 June 1811 (£1,985 19s.; RA GEO/26290); stem and upper
branches added by Rundells 1816–17 (£1,365; PRO LC11/23 quarter to 5 July
1817, cost included stem and branches to no. 181)
LITERATURE Jones (E.A.) 1911, p. 118; Garrard 1914, no. 10; Irwin 1979, pp.
191–2
EXHIBITIONS Brighton 1954, no. 38; London 1954c, no. 79

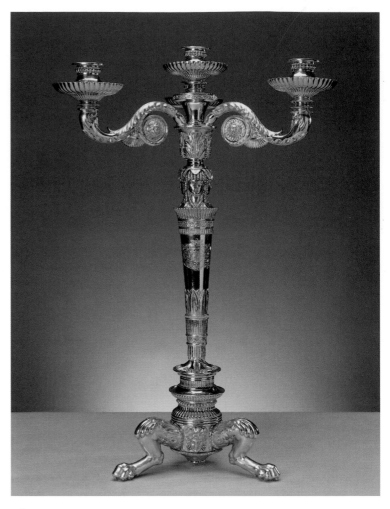

183

183
PAUL STORR (1771–1844) for RUNDELL, BRIDGE & RUNDELL
Candelabrum, 1812–13

No. 183 is one of eight candelabra bearing the maker's mark of Paul
Storr which were supplied to George IV by Rundells in 1812–13.
Rundells had previously supplied him with a set of twelve candelabra of
the same model but bearing the makers' marks of Benjamin Smith and
Digby Scott in 1804–05. This earlier set was invoiced together with a
further pair supplied in 1807–08 (mark of Smith alone) by Rundells on
4 June 1811 for £2,871 7s. (RA GEO/26287). In 1810–11 another
pair was supplied, struck with Smith's mark when in partnership with
his brother James. Smith's and Storr's marks are frequently found on the
same models of plate; it was common practice for Rundells to supply its
various out-workers' workshops with the same patterns.

With its fashionable and eclectic mix of Greek, Roman and Egyptian
motifs the design of no. 183 was perhaps influenced by the Anglo-
Dutch designer and arbiter of taste, Thomas Hope (1769–1831). Hope
did much to promote the Greek revival and Egyptian styles in England.
His London mansion in Duchess Street, which housed his extensive
collections, was opened to the public in 1804, the year in which no.
183 was probably designed.

Silver-gilt. 64.5 × 43 × 43 cm
London hallmarks obscured, maker's mark of Paul Storr; engraved with the royal arms
RCIN 50827.14
PROVENANCE From a set of twenty-four candelabra, made by various makers and supplied by Rundell, Bridge & Rundell to George IV, 1804–13
LITERATURE Jones (E.A.) 1911, p. 158; Garrard 1914, no. 14
EXHIBITIONS London 1992a; Cardiff 1998, no. 102; York/London/Norwich 2000–01

184
PAUL STORR (1771–1844) for
RUNDELL, BRIDGE & RUNDELL
Triton salt, 1810–11

It has been suggested that the sculptor William Theed (1764–1817) was responsible for the design of no. 184 on the basis of its similarity to his figure group *Thetis returning from Vulcan with Arms for Achilles*, cast in bronze by Rundells in 1829 (RCIN 71833). Theed joined Rundells as head of the design department and chief modeller in 1803, after working for Josiah Wedgwood. He remained with the firm until his death in 1817, eventually becoming a partner. He was responsible for modelling many of John Flaxman's designs for plate but was also capable of his own highly competent compositions. Perhaps his best-known work is the group of *Hercules capturing the Dacian Horses* on the pediment of the Royal Mews, Buckingham Palace.

A drawing in an undated album entitled *Designs for Plate etc by John Flaxman* in the Victoria and Albert Museum appears to depict no. 184. Despite the album's title, Charles Oman attributed the majority of the designs to Edward Hodges Baily (1788–1867), a pupil of Flaxman (Oman 1966, pp. 174–83). Baily joined Rundells as a modeller and designer in 1815 and therefore cannot have been responsible for the design of no. 184, made five years earlier. It appears that many of the

drawings in the album are Baily's reworkings of earlier work by other designers.

The design incorporating a triton bearing away a nautilus shell was almost certainly inspired by the Marine Service supplied to Frederick, Prince of Wales, in the 1740s (see nos 178–80). Rundells supplied a number of pieces of similar inspiration to go with this outstanding rococo service (see no. 189). In addition to the twenty-four salts supplied to George IV, many others are known – including examples in the Audrey Love and the Al-Tajir collections – demonstrating the popularity of the model.

Silver-gilt. 10.2 × 12.5 × 6.2 cm
London hallmarks for 1810–11 and maker's mark of Paul Storr; liner with hallmarks for London and maker's mark of Elkington & Co., 1909–10
RCIN 50825.3
PROVENANCE One of twenty-four salts supplied by Rundell, Bridge & Rundell to George IV, invoiced 4 June 1811 (£902 12s.; RA GEO/26287)
LITERATURE Garrard 1914, no. 196; Phillips & Sloane 1997, pp. 48–9
EXHIBITIONS QG 1991–2, no. 95; Cardiff 1998, no. 103

185
PAUL STORR (1771–1844) and PHILIP RUNDELL
(1743–1827) for RUNDELL, BRIDGE & RUNDELL
Dessert stand, 1812–13; *rockwork plinth*, 1820–1

The Inventory of Plate belonging to George IV at Carlton House (c.1825) records '4 very large & elegant Dessert Ornaments each consisting of 2 large chased Tritons supporting shells chased from Nature, on circular chased Stands, with rich claw feet & 4 Stands in form of Rocks &c'. The stands had been supplied (without the rockwork bases) for George IV's Grand Service in 1812–13. Although Rundells' bill has not been traced, they are probably the '4 superb Ornaments for Dessert' whose arrival at Carlton House on 10 October 1813 was recorded in the continuous inventory of plate (PRO LC9/351, f. 29). In the same year a set of twenty-four salts similarly incorporating clam shells supported by tritons was also supplied at a cost of £1,485 11s. 2d. (RCIN 51262). Both designs are probably attributable to the sculptor William Theed, head of Rundells' design department from 1803 until 1817 (see no. 184).

Nos 184 and 185 are early examples of the rococo revival style pioneered by Rundells in the early nineteenth century. The asymmetric marine forms 'chased from nature' were inspired by the 1740s Marine Service of plate already in the Royal Collection (see nos 178–80).

Rundells added the naturalistic rockwork base in 1820–1, presumably to satisfy George IV's increasingly elaborate tastes. Both the stand and base are depicted in a drawing in the Victoria and Albert Museum attributed to Edward Hodges Baily, who joined Rundells' design team in 1815 (see nos 184 and 190).

Silver-gilt. 34.5 × 29.5 × 27 cm
London hallmarks for 1812–13 and maker's mark of Paul Storr; engraved with the badge of George IV when Prince of Wales, and the Garter; rockwork plinth hallmarked for London, 1820–1, maker's mark of Philip Rundell; engraved RUNDELL BRIDGE ET RUNDELL AURIFICES REGIS / LONDINI
RCIN 46984.2
PROVENANCE One of four dessert stands supplied by Rundell, Bridge & Rundell to George IV, 1812–13; rockwork plinths added 1820–1

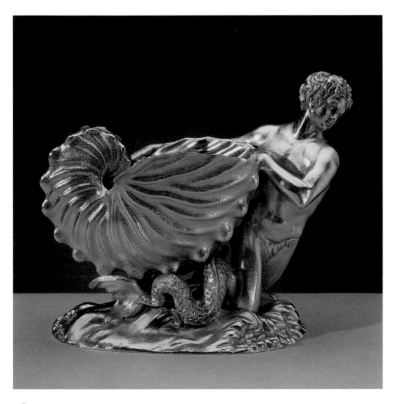

184

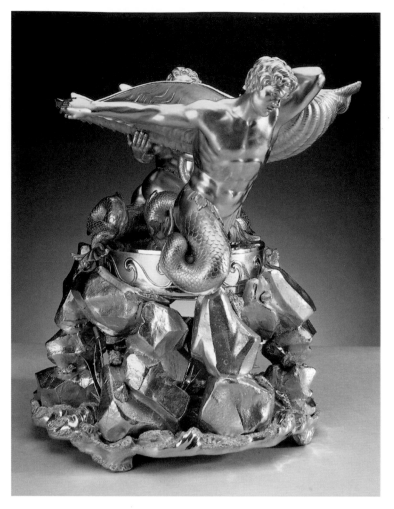

185

LITERATURE Jones (E.A.) 1911, no. 180; Garrard 1914, no. 160; Oman 1966, p. 182
EXHIBITIONS London 1954c, no. 86

186

PAUL STORR (1771–1844) for RUNDELL, BRIDGE & RUNDELL
Phoenix lamp, 1813; base, 1817

The Carlton House Inventory of Plate (c.1825) lists no. 186 and its pair (RCIN 50278.2) as '2 elegant Ornaments to ... receive Plates or Basons, for the Sideboard or Centre of Table, with device of Phoenix rising from the flames'. Dishes of hot food supported on the head and outstretched wings of the phoenix would have been kept warm by the naphtha oil lamp underneath. Such heating devices were essential at a time when diners still served themselves from tureens and dishes of food placed on the table, a practice known as *service à la française*.

The arrival of the two lamps at Carlton House on 5 July 1813 is recorded in the continuous inventory of plate. Jones states that Rundells charged £505 1s. 9d. for both lamps, but this bill remains untraced. In the following year '2 fluted Pedestals for Phoenixes' were added. However, by 1817 these had been adapted to take two Warwick vases. The present bases were added by Rundells in 1817 at a total cost of £202. They are listed in the continuous inventory on 5 January 1818

as '2 chased Silver gilt stands to receive two phoenix Lamps in form of Rocks & Sea Weeds &c'.

Silver-gilt. 24.3 × 29.1 × 28.5 cm
London hallmarks for 1813–14 and maker's mark of Paul Storr; the bases with London hallmarks for 1817–18 and maker's mark of Paul Storr; engraved RUNDELL BRIDGE ET RUNDELL AURIFICES REGIS ET PRINCIPIS WALLIÆ REGENTIS BRITANNIAS; and with Prince of Wales's feathers and motto within crowned Garter motto
RCIN 50278.1
PROVENANCE One of a pair supplied by Rundell, Bridge & Rundell to George IV, 1813 (£505 1s. 9d.; bill untraced); the bases added in 1817 (£202; PRO LC11/24, quarter to 5 January 1818)
LITERATURE Jones (E.A.) 1911, p. 218; Garrard 1914, no. 587
EXHIBITIONS London 1954c, no. 99; QG 1991–2, no. 77

187

PAUL STORR (1771–1844) for RUNDELL, BRIDGE & RUNDELL; THOMAS STOTHARD (1755–1834), designer
Triumph of Bacchus and Ariadne dish, 1814–15

The centre of this massive sideboard dish is boldly cast with a relief depicting Bacchus and Ariadne after a design by Thomas Stothard (1755–1834) now in the Victoria and Albert Museum. Like his lifelong friend John Flaxman, Stothard produced many designs for plate for Rundells throughout the Regency period. Until recently the design was thought to have been of Stothard's own composition. In her biography of 1851, Stothard's daughter-in-law wrote that he 'chose for his subject Bacchus and Ariadne, drawn in a chariot by Satyrs. This was imagined and delineated with true classic taste and feeling'. However, as Phillips & Sloane have recently pointed out, the composition is in fact derived from an antique Roman cameo discovered in the Via Aurelia in 1661. This

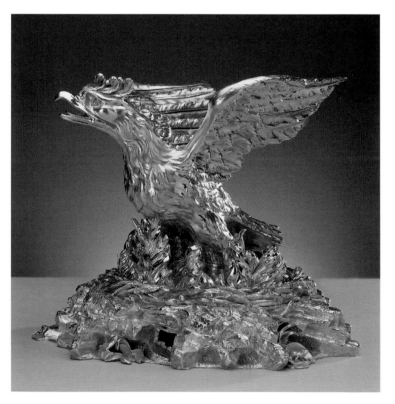

186

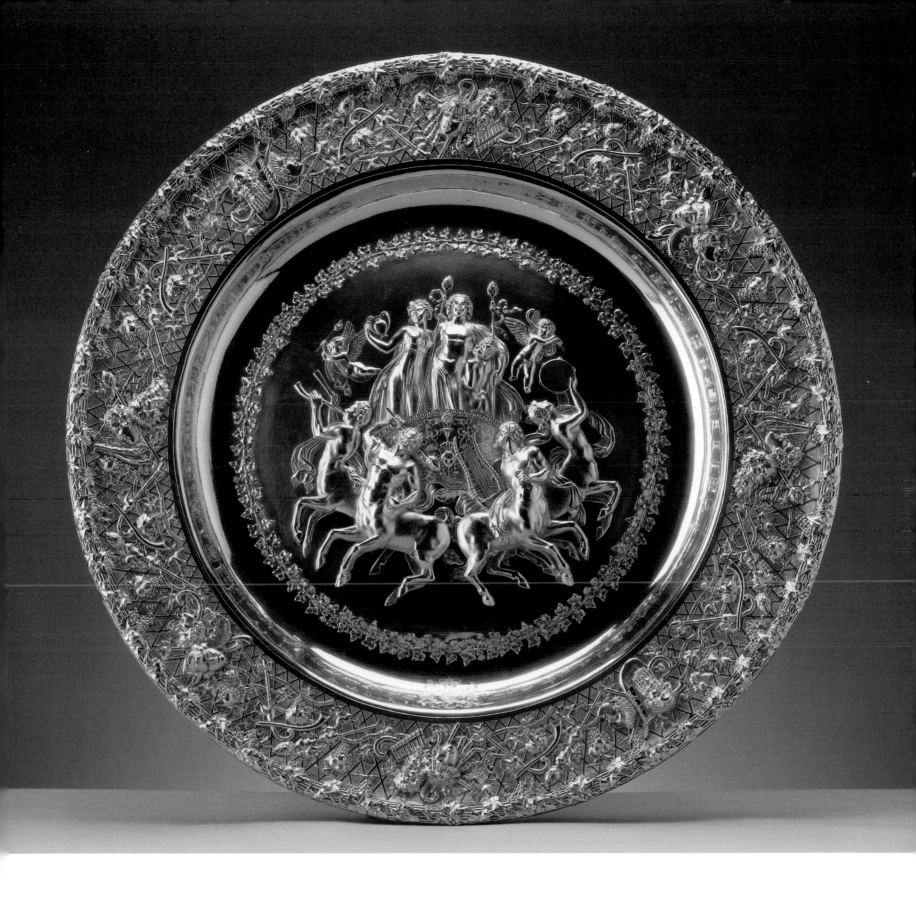

was engraved by F. Buonarotti in 1698 and included in Bernard de Montfaucon's *L'Antiquité expliquée* of 1719. In 1798 the cameo was seized from the Vatican by Napoleon and taken to the Louvre, where it was probably seen by Flaxman. It remains in the Louvre today.

According to Jones, no. 187 was invoiced for £616 5s. 7d. in 1815 (bill untraced). A pair of dishes now in the Al-Tajir collection has the same central composition but slightly different borders. These bear the earlier hallmark of 1813–14 and appear to be the first in a series of Bacchus dishes made in the workshop of Paul Storr for Rundells.

Another dish of identical pattern to no. 187 was supplied to the Earl of Ailesbury in 1817–18 (Audrey Love collection).

The success of Stothard's design led to his commission to design the Wellington Shield, presented to the first Duke of Wellington by the Merchants and Bankers of the City of London in 1822 and still in the Wellington collection (Apsley House).

Silver-gilt. 7.5 × diameter 79.7 cm
London hallmarks for 1814–15 and maker's mark of Paul Storr; engraved on rim

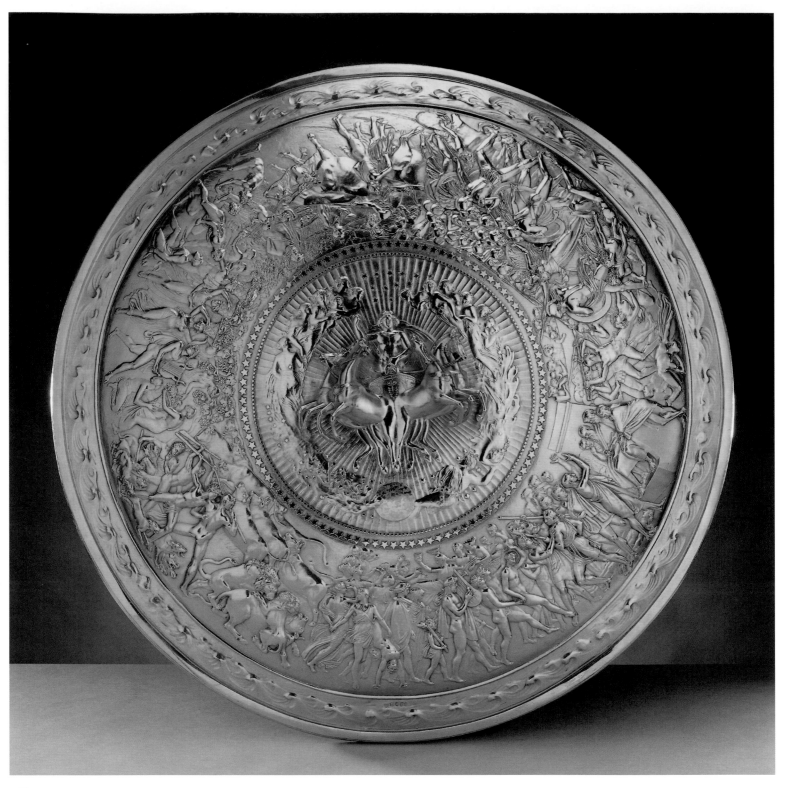

188

RUNDELL BRIDGE ET RUNDELL AURIFICES REGIS ET PRINCIPIS WALLIÆ
REGENTIS BRITANNIAS with Prince of Wales's arms within crowned Garter motto
RCIN 51654
PROVENANCE Supplied by Rundell, Bridge & Rundell to George IV (£616 5s. 7d.;
bill untraced), delivered 5 April 1814 (PRO LC9/351, f. 31)
LITERATURE Bray 1851, pp. 161–2; Jones (E.A.) 1911, p. 124; Garrard 1914,
no. 486; Penzer 1954, p. 178; Phillips & Sloane 1997, pp. 52–7
EXHIBITIONS London 1862a, no. 6002; London 1954c, no. 91; QG 1991–2,
no. 84

188
PHILIP RUNDELL (1743–1827) for RUNDELL, BRIDGE
& RUNDELL; JOHN FLAXMAN (1755–1826), designer
The Shield of Achilles, 1821

In the eighteenth book of the *Iliad*, Homer vividly described a legendary
shield made for Achilles by the lame god Hephaestus and brought down
to Earth by Thetis, together with other specially forged armour. The shield

was said to have been a mirror of the world of gods and men and although Homer described its appearance in great detail, the precise relationship of the various elements was unclear. In 1810 John Flaxman received the first of a number of payments from Rundells to 'reconstruct' this mythological shield from Homer's description. Although Flaxman was said to be a keen Greek scholar who spent many evenings reading aloud (in Greek) from the *Iliad*, it is probable that his chief source for the design was the narrative in Pope's translation of 1715–20. The final design was not completed until 1817; somewhat unusually, Flaxman then modelled and cast it in plaster himself. No. 188, the first in a series of silver-gilt and bronze casts, was only completed in 1821, when it was prominently displayed at George IV's coronation banquet. At least one of the bronze versions is known to have been chased by the sculptor William Pitts.

In Flaxman's design the centre of the shield is cast in high relief with Apollo driving his chariot surrounded by the constellations and the moon. The low relief border portrays seven different scenes depicted as a continuous story: a marriage procession and banquet; quarrel and judicial appeal; siege, ambush and engagement; harvest field; vintage; oxherds defending their beasts; and Cretan dance. These are surrounded by a rim embossed with the 'mighty Stream of Ocean' as described by Homer.

Flaxman was said to have been 'justly proud' of his design, which was subsequently described by Rundells as a 'masterpiece of modern art' and 'considered by many as one of the artist's most successful works'. Other silver-gilt versions of the shield were made in 1821–2 for the Duke of York (now Huntington Collection, San Marino), and in 1822–3 for the Duke of Northumberland (now Al-Tajir collection) and the Earl of Lonsdale (now National Trust, Anglesey Abbey). Although Rundells' account for George IV's version has not been traced, that made for the Duke of Northumberland cost £2,100. There is also an early bronze cast of the shield, subsequently electro-gilt, in the Royal Collection (RCIN 31606).

Silver-gilt. Diameter 90.7 cm
London hallmarks for 1821–2 and maker's mark of Philip Rundell; engraved on back DESIGNED & MODELLED BY JOHN FLAXMAN R.A. EXECUTED & PUBLISHED BY RUNDELL BRIDGE & RUNDELL, GOLDSMITHS & JEWELLERS TO HIS MAJESTY, LONDON MDCCCXXI, and with cypher of George IV within crowned Garter motto
RCIN 51266
PROVENANCE Supplied by Rundell, Bridge & Rundell to George IV, 1821 (bill untraced)
LITERATURE Jones (E.A.) 1911, p. 106; Garrard 1914, no. 485; Bury & Snodin 1984
EXHIBITIONS London 1862b; Dublin 1872, no. 1; London 1954c, no. 104; London 1979a, no. 187; QG 1991–2, no. 185

189

JOHN BRIDGE (1755–1834) for RUNDELL, BRIDGE & RUNDELL; JOHN FLAXMAN (1755–1826), designer
Tureen, 1826–7

This impressive tureen was one of four supplied by Rundells for George IV's Grand Service in 1826–7 and described as '4 richly chased gilt shell pattern Soup Tureens supported by Sea Horses with Triton handle'. With nos 184 and 185 they were designed to match the superb Marine Service of rococo silver made for Frederick, Prince of Wales, in the 1740s; the extreme naturalism of their design parallels Nicholas

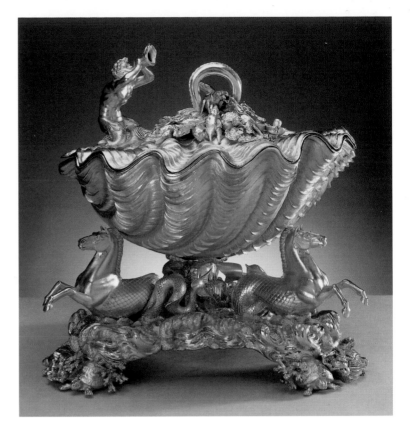

189

Sprimont's crayfish and crab salts made in 1743 (no. 179). However, the massive scale and weight of the tureens is quite unlike mid-eighteenth-century silver and reflects the increasingly opulent tastes of George IV.

Rundells pioneered organic naturalism and the rococo revival style in silver in the early nineteenth century, largely by means of the plate that they supplied for George IV. They also drew inspiration from sixteenth- and seventeenth-century plate: the hippocamps or seahorses which support the bowl of no. 189 are derived from an early seventeenth-century nautilus cup, considered by Flaxman to be by Cellini, sold to George IV by Rundells in 1823 (no. 196). These revivalist styles of the 1820s were revolutionary departures after decades of classicism.

Further versions of the tureen are known: uncovered versions made in 1823–4 (Art Institute of Chicago) and 1824–5 (Sotheby's, New York, 14 April 1999 (213)) were perhaps prototypes for those made for George IV; Hunt & Roskell made another uncovered tureen for the Royal Hunt Cup awarded at Ascot races in 1848, when the design was said to be after John Flaxman (St Petersburg, Florida, Museum of Fine Arts). The attribution of the design for the model to Flaxman is supported by two sheets of designs by that artist, in the Victoria and Albert Museum and the British Museum, which echo the marine themes of the tureens.

Silver-gilt. 42 × 41 × 38 cm
London hallmarks for 1826–7 and maker's mark of John Bridge; the crowned Garter and motto engraved inside
RCIN 50279.4
PROVENANCE From a set of four delivered, with a wainscot case, by Rundell, Bridge & Rundell to George IV, before 5 November 1829 (£2,452 16s. 9d.; RA GEO/26245, 26250)
LITERATURE Jones (E.A.) 1911, p. 160; Garrard 1914, no. 234; Bury 1966, pp. 152–8
EXHIBITIONS London 1954c, no. 109; London 1979a, no. 189; Essen 1992, no. 467

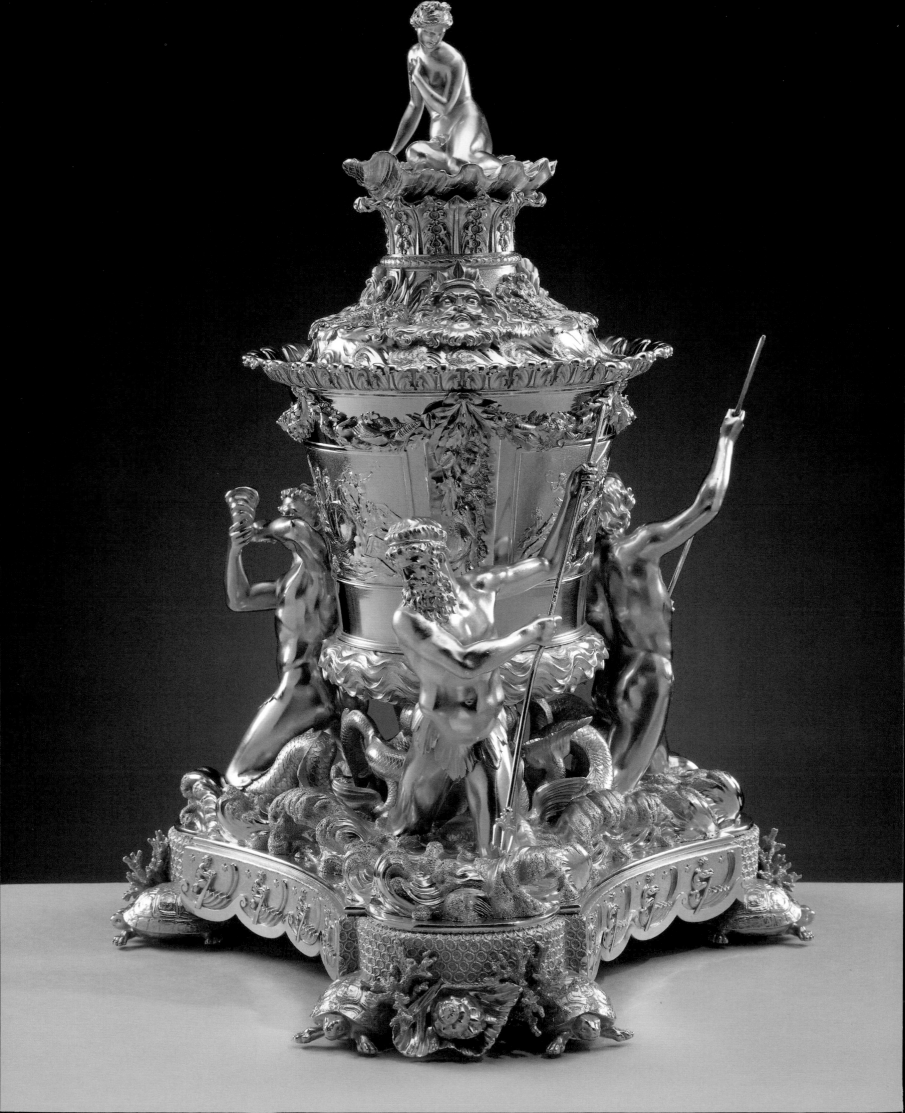

190

JOHN BRIDGE (1755–1834) for
RUNDELL, BRIDGE & RUNDELL
Bottle cooler, 1827–8

The design for this magnificent bottle cooler has been attributed to John Flaxman (1755–1826), chief modeller at Rundells from 1809 until his death. Flaxman is perhaps better known for his severely classical designs after the Antique. However, this cooler, like the other marine plate supplied by Rundells for George IV's Grand Service in the 1820s, reflects an interest in Renaissance and rococo plate which foreshadowed the eclecticism of the Victorian period. This interest was almost certainly influenced by the examples of early plate in George IV's collection. The design of no. 190, with three tritons supporting a vase surmounted by Venus rising from the waves, is clearly inspired by continental sixteenth-century plate (see no. 196). A similar figure of a triton blowing a conch is found on four tureens supplied for the Grand Service in 1826–7 (no. 189).

No. 190 is one of four bottle coolers supplied to George IV in 1828–9 for £2,814 16s. 8d. and described in Rundells' invoice as '4 large superbly chased Ice pails with fine figure of Venus on Covers with fine chased antique devices'. Similar coolers of the same form were supplied in 1821 to George IV's brother Ernest Augustus, Duke of Cumberland (Christie's, London, 19 March 1986 (267)), and to Thomas Coutts (Christie's, London, 27 March 1985 (124)).

The surmounting figure of Venus appears to have been the conception of Edward Hodges Baily (1788–1867), who carved a full-scale marble version of it in 1855 (Bristol, City Museum and Art Gallery). Baily joined Rundells in 1815 and was responsible for interpreting, modelling and adapting Flaxman's designs. He succeeded Flaxman as chief modeller in 1826.

Silver-gilt. 57.8 × 40 × 40 cm
London hallmarks for 1827–8 and maker's mark of John Bridge; engraved with the Garter and RUNDELL BRIDGE ET RUNDELL AURIFICES REGIS LONDINI
RCIN 50843.1
PROVENANCE From a set of four supplied by Rundell, Bridge & Rundell to George IV in 1828–9 (£2,814 16s. 8d.; RA GEO/26245, 26250, 26300)
LITERATURE Jones (E.A.) 1911, p. 110; Garrard 1914, no. 139; Irwin 1979, p. 191
EXHIBITIONS London 1954c, no. 111

191

JOHN BRIDGE (1755–1834) for
RUNDELL, BRIDGE & RUNDELL
Four-light candelabrum, 1828–9

In an undated list entitled 'Articles which are finished but not yet delivered to His Majesty' (c.1829), this richly chased candelabrum, one of a set of sixteen, is described as 'after the pattern of His Majesties Ormoulu *ditto*'. The ormolu set was invoiced by Rundells on 4 June 1811 and described as '8 large antique Candelabrums with rich scroll branches, figured Pillars and chased Feet, to match The Marquis of Hertford's ... 75 Gs ea'. George IV was a great admirer of Lady Hertford (1760–1834) and was said to dine frequently *en famille* with her and

her husband, the second Marquess (1743–1822), at Hertford House. It was probably on one of these occasions that he saw the candelabra which he subsequently had copied by Rundells. It is a reflection of the King's improved finances and increased extravagance following his accession to the throne that in 1828–9 he augmented the gilt bronze set supplied to him in 1811 with silver-gilt examples, at more than three times the cost. According to the invoice from Rundells, this additional set had been supplied 'to complete the Coronation Service for the use of his Majesty'. The costs were partly defrayed by the sale of 913 ounces troy of old plate 'from Windsor' (PRO LC9/351, f. 95).

The stem of no. 191 is chased with low relief panels depicting female figures emblematic of Temperance, Hope and Flora. It is struck with the maker's mark of John Bridge – who although a jeweller by training was forced to register his own mark as a plate worker following the retirement of his partner Philip Rundell in 1823.

Silver-gilt. 63.4 × 42.3 × 37.2 cm
London hallmarks for 1828–9 and maker's mark of John Bridge; base engraved RUNDELL BRIDGE ET RUNDELL AURIFICES REGIS LONDINI; and with the Garter
RCIN 51102.1
PROVENANCE From a set of sixteen supplied by Rundell, Bridge & Rundell to George IV in 1828–9 (£4,483 4s.; RA GEO/26250, undated folio; PRO LC9/351, f. 41; PRO LC11/63 quarter to 5 April 1829 and LC11/65 quarter to 5 January 1830)
LITERATURE Jones (E.A.) 1911, p. 178; Garrard 1914, no. 17
EXHIBITIONS London 1954c, no. 112; Brighton 1954, no. 40

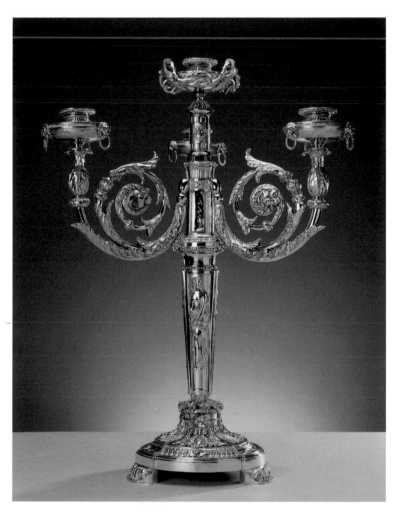

191

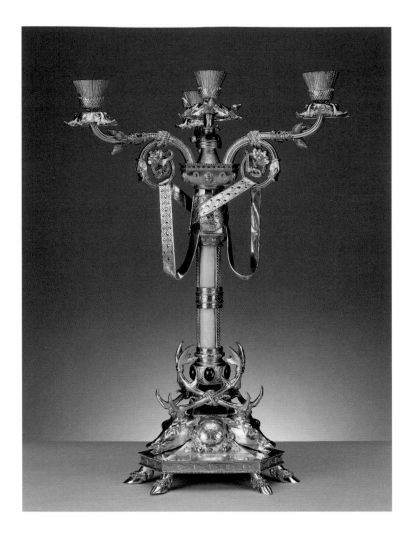

arrived in England around 1845 to work as a designer for Minton's. His salary of £450 per annum from Elkington's reflected his considerable skills as a designer and modeller. He also designed a statuette of Lady Godiva given by Queen Victoria to Prince Albert on his birthday in 1857 (RCIN 1571). Jeannest's obituary in the *Art Journal* noted that his work 'did much to elevate the production of Messrs Elkington to the position now universally assigned to them' (*Art Journal*, 1857, p. 227). See also no. 93.

Gilt and silvered metal, cairngorms, stag's horn. 53.5 × 35 × 35 cm
Inscribed PUBD BY / ELKINGTON MASON & CO / EJEANNEST / *Fecit*
RCIN 15941.1–2
PROVENANCE From a set of eleven made for Balmoral Castle by Elkington & Co. after a design suggested by Prince Albert, c.1855 (two pairs £160; RA PP/VIC/15/6180; remaining bills untraced)
LITERATURE Wallis 1862, p. 26; Waring 1863, pl. 82; Bury 1962
EXHIBITIONS London 1862b; Birmingham 1973, no. D4; London 2001b

193
LESLIE DURBIN (b. 1913)
Pair of salts, 1959

These salts (from a set of four) were presented to Her Majesty Queen Elizabeth The Queen Mother when she officially opened the Kariba Dam in the former colony of Rhodesia and Nyasaland, in May 1960. Each salt is formed as a trochus shell supported on a group of fish, a suitably watery theme to commemorate the creation of the world's largest man-made lake. Such symbolism is characteristic of Leslie Durbin: 'In all my work, I have tried to include a motif personal to the donor or recipient, a symbol appropriate to the occasion or the use' (exh. cat. London

192
ELKINGTON & CO.; EMILE JEANNEST (1813–1857), modeller; PRINCE ALBERT (1819–1861), designer
Two *candelabra*, c.1855

These candelabra are from a set of eleven supplied by Elkington's for Balmoral Castle: two pairs, described as 'Gilt & Oxidised Candelabra, with stag's horn & cairngorms', were invoiced on 19 December 1855. The overtly Scottish character of the design – the thistles, stags' heads, folds of 'plaid', cairngorms and real stag's horn – is typical of the furnishings supplied for Balmoral in the 1850s (see nos 94, 431).

Two of the candelabra were shown at the 1862 International Exhibition, when the naturalism and use of mixed media were favourably noticed. In *Masterpieces of Industrial Art and Sculpture at the International Exhibition*, J.B. Waring noted they 'are peculiarly interesting as having been modelled by the late Emile Jeannest, from a design suggested by His Royal Highness, the late Prince Consort ... A striking feature, and one especially suggestive of Scottish associations is the introduction of a plaid in pendant folds, from the arms of the three lights, these arms partaking of the character of Celtic ornament found in Ireland and Scotland.' Although now burnished, the silvered areas were originally given a fashionable blackened 'oxidised' finish.

Emile Jeannest superintended the various French workers at Elkington's manufactory in Birmingham. Originally from Paris, he first

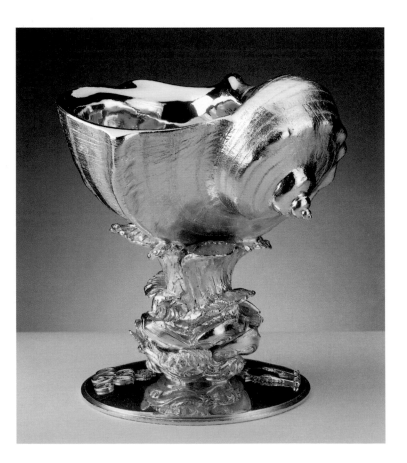

1982a, p. 3). The design also echoes the great standing cups of the sixteenth and seventeenth centuries, which incorporate real nautilus and trochus shells within elaborate silver-gilt mounts (see no. 196).

Leslie Durbin, who trained in the workshop of Omar Ramsden, is one of the finest British goldsmiths of the post-war period. His work is notable for its combination of innovative design with a mastery of traditional techniques. These salts admirably demonstrate his skills as a modeller and chaser. Durbin has received many important public and private commissions throughout his long and productive career and a number of his works are in the collection of The Queen Mother and in the Royal Collection.

Silver-gilt. 16 × 14 cm
Hallmarks for London, 1959, and maker's marks of Leslie Durbin; engraved on bases
Kariba 1960
RCIN 100008.1–2
PROVENANCE Commissioned by the Anglo-American Corporation; by whom presented to HM Queen Elizabeth The Queen Mother on opening the Kariba Dam South Bank Hydroelectric Power Station, 17 May 1960
LITERATURE Cornforth 1996, p. 41, pl. 5
EXHIBITIONS London 1982a, no. 79

194
GERALD BENNEY (b. 1930)
Gold goblet, 1978

This gold and enamel goblet was presented to Her Majesty The Queen by Viscount Weir, Chairman of the Weir Group, at the opening of a water desalination plant in the United Arab Emirates in 1979. The thistle-shaped bowl, delicately enamelled in shades of green and mauve, boldly proclaims Lord Weir's Scottish ancestry.

The goldsmith Gerald Benney trained at the Royal College of Art and under Dunstan Pruden in the workshop complex founded by Eric Gill (see no. 336) in Ditchling, Surrey. He established his own workshop in 1955 and has since become one of the leading goldsmiths and designers of the post-war period. He has been responsible for many important public and private commissions over the last forty years, including many pieces for the Royal Family.

Benney's work is notable for its strong geometric forms and the innovative use of texture and enamels. In Switzerland during the late 1960s he learnt the almost forgotten technique of enamelling and subsequently spent over two years mastering this difficult art form, experimenting with different techniques and colours.

The Duke of Edinburgh began acquiring pieces by Benney in the 1950s and his work has remained popular with members of the Royal Family ever since. Benney has the unique distinction of being the first craftsman to hold four royal warrants (in one trade): to The Queen, the Duke of Edinburgh, Queen Elizabeth The Queen Mother and the Prince of Wales.

18 carat gold, enamel. 23.2 × diameter 9 cm
London hallmarks for 1978 and maker's mark of Gerald Benney
RCIN 29115
PROVENANCE Commissioned by the third Viscount Weir (b. 1933); by whom presented to HM The Queen on behalf of the Weir Group on opening a water desalination plant in the United Arab Emirates, February 1979
LITERATURE Hughes (G.) 1998, p. 109

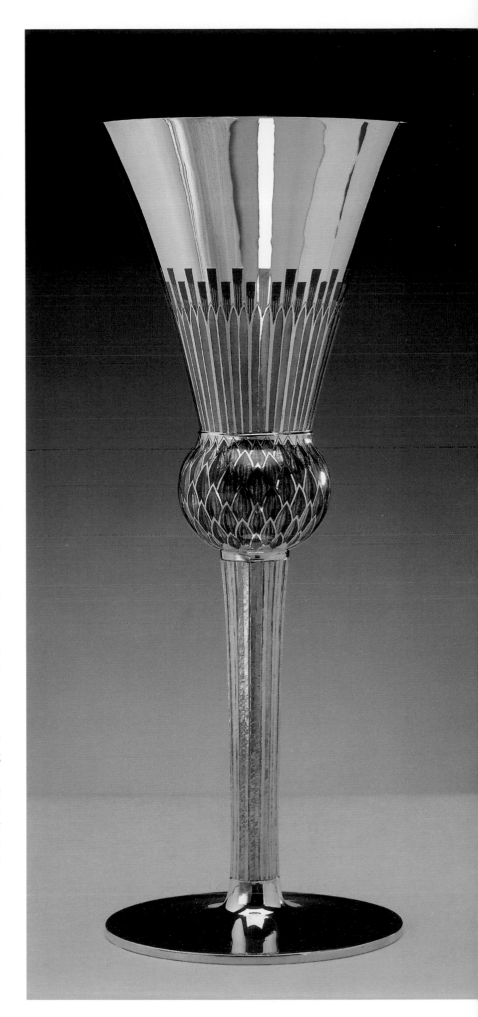

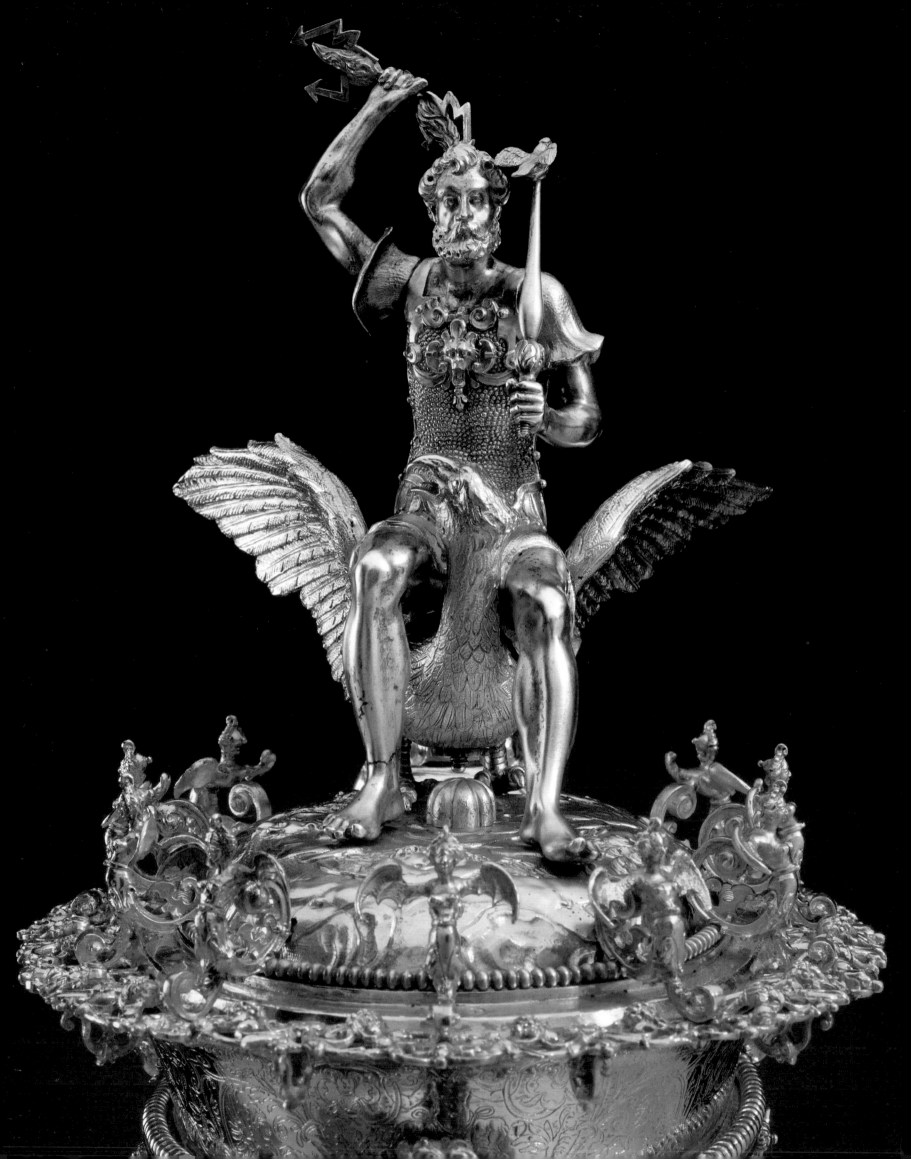

Continental silver and gold (nos 195–203)

195

INDIAN (GUJARAT); mounts attributed to
ELIAS BALDTAUFF (fl.1600)
Casket, c.1600

Her Majesty Queen Elizabeth The Queen Mother was presented with this casket when she launched the liner *Queen Elizabeth* at Clydebank in 1938. For over three hundred years before that it had been kept in the Grünes Gewölbe (Green Vaults) in Dresden, the celebrated treasury assembled by the electors of Saxony.

The casket was made in Gujarat, western India, specifically for export to Europe, via Portuguese traders. Mother-of-pearl was one of the most highly prized natural rarities in Renaissance Europe; the value placed upon this casket is reflected in the elaborate silver-gilt mounts, added around 1600 by the German goldsmith Elias Baldtauff of Torgau, Saxony. It appears to have been purchased for the Green Vaults from the dealer Veit Böttiger at the Leipzig Easter Fair in 1602 (Schröder 1935, pp. 238–9). Other mother-of-pearl objects, including two further caskets, were also acquired from Böttiger at a total cost of 8,500 thaler. The latter two caskets remain in the Green Vaults collection (GG inv. nr. III 243, 247). One of them, known as the *Torgauer Apotheke* (GG inv. nr. III 243), is very similar to no. 195 and, although unmarked, almost certainly has mounts by the same goldsmith. The attribution of the maker's mark to Elias Baldtauff is based on identification in the *Buch der Torgauer Goldschmiede-Innung*, formerly in the Grünes Gewölbe archives.

After the First World War the kingdom of Saxony became a republic and the royal house of Wettin, formerly electors of Saxony, was deposed.

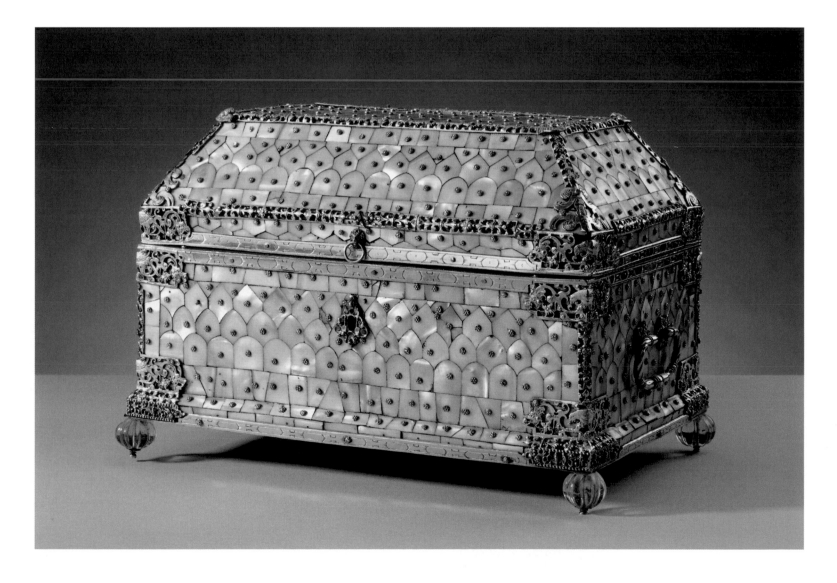

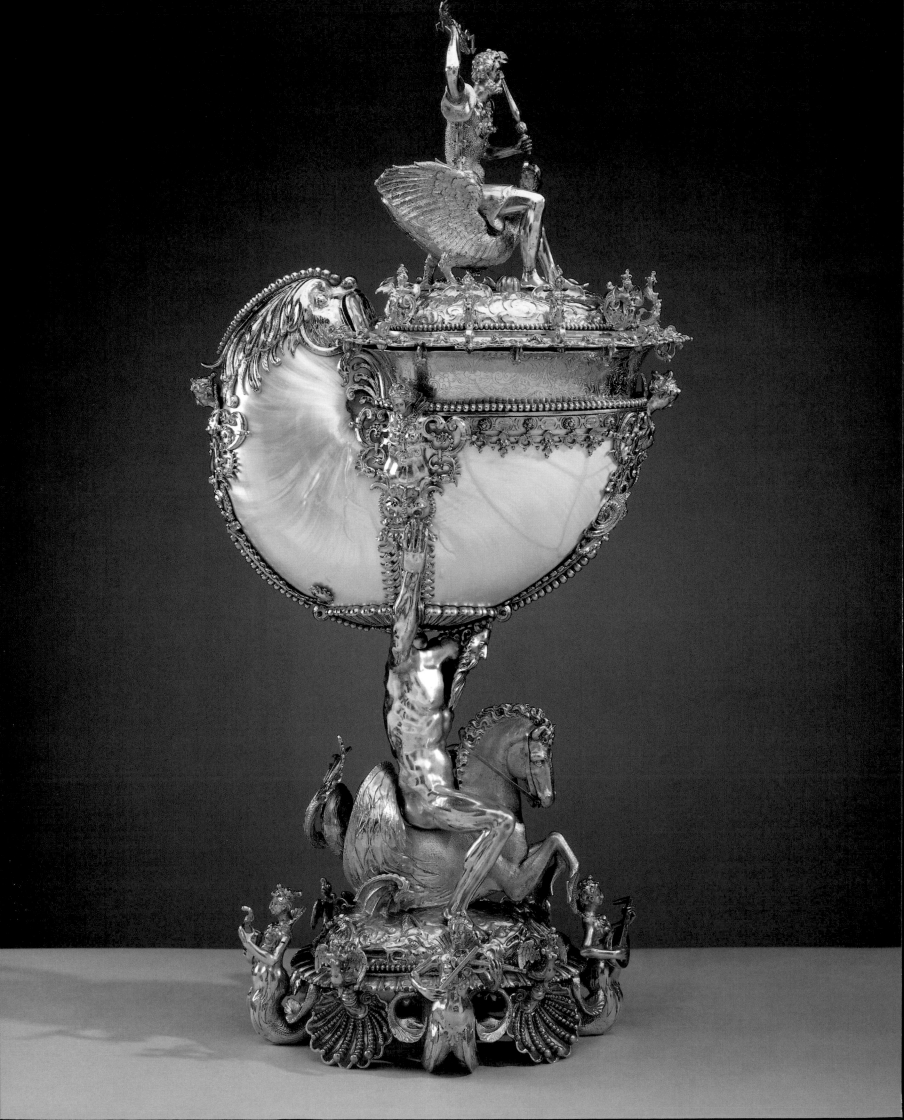

As compensation they were awarded a number of treasures from the Green Vaults including this casket, which appears to have been sold shortly afterwards. Other treasures were buried by the family on their estate during the Second World War and were only recently recovered ('The Moritzburg Treasure', sold Sotheby's, London, 17 December 1998).

Mother-of-pearl, teak, silver-gilt, rock crystal feet, velvet. 19.2 × 28.6 × 18.1 cm
Torgau townmark and maker's mark attributed to Elias Baldtauff
RCIN 100009
PROVENANCE Probably Veit Bottiger, at Leipzig Easter Fair, 1602; where purchased by Christian II, Elector of Saxony (1583–1611); by descent (former GG inv. nr. III 246); awarded to the Wettin family, 1924; Pollak & Winternitz, Vienna; by whom sold to S.J. Phillips, 1933; by whom sold to John Brown & Co., 1938 (£320; information courtesy of S.J. Phillips, London); by whom presented to HM Queen Elizabeth The Queen Mother on launching Queen Elizabeth, 27 September 1938
EXHIBITIONS Amsterdam 1936, no. 1151

196
NIKOLAUS SCHMIDT (c.1550/5–1609)
Nautilus cup, c.1600

This spectacular *Kunstkammer* object is one of the finest examples of antiquarian plate acquired by George IV. On its arrival in 1823, it joined a growing collection of virtuoso sideboard cups of varying dates and nationalities. Although once considered to be the work of Benvenuto Cellini, it bears the mark of Nikolaus Schmidt (master 1582), a Nuremberg goldsmith trained in the workshop of Wenzel Jamnitzer (1508–85). This is one of Schmidt's most celebrated pieces, although other important works by him survive in the treasuries in Vienna and Dresden. His work is notable for its superb quality, fine sculptural elements and frequent incorporation of natural rarities. From the sixteenth century, nautilus shells from the western Pacific were highly prized by collectors and in consequence they were often very richly mounted. The outer layer of this shell has been stripped away to reveal the nacreous surface below and the heel has been elaborately carved. The marine origins of the nautilus are echoed in the supporting figures of Neptune, mermaids and hippocamps (seahorses). An anonymous drawing in Nuremberg (Germanisches National Museum, inv. nr. Hz 6134) depicts the cup shortly after it was made. An inscription on the back, dated 1610, implies that the cup was a recent gift, presented to the writer by a relation, for his new house. It has been suggested that the cup may have belonged to the wealthy Peller family, whose Nuremberg house, built in 1610, had a gable decorated, like this cup, with a figure of Jupiter (communication from Dr Ursula Timann, Germanisches National Museum).

Nothing more is known of the history of the cup until it appeared in the celebrated 32-day sale at Wanstead House, Essex, in 1822. Wanstead's heiress Catherine Tylney Long (d. 1825) had married the Duke of Wellington's disreputable nephew William Pole Wellesley (1788–1857) in 1812. Within ten years his reckless extravagance had reduced the estate to ruin; Wanstead's fabulous treasures were sold and the house demolished.

Nautilus shell with parcel-gilt silver mounts. 52 × 17 × 24 cm
Nuremberg townmark and maker's mark of Nikolaus Schmidt

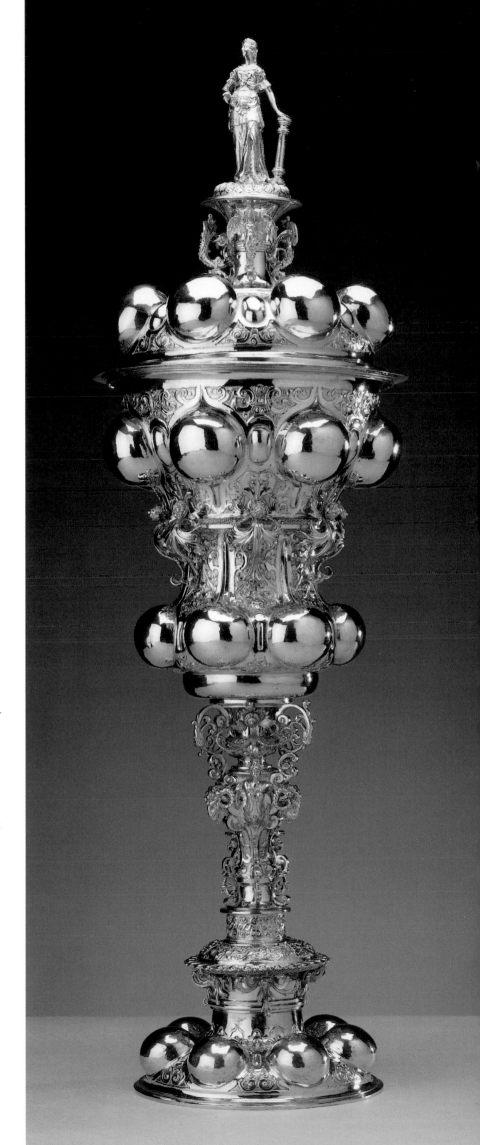

RCIN 50603
PROVENANCE Possibly a member of the Peller family, Nuremberg, c.1610; William
Pole-Tylney-Long-Wellesley, fourth Earl of Mornington, second Baron Maryborough,
probably acquired post-1812; for whom sold G. Robins, Wanstead House, Essex,
18 June 1822 (331); purchased by Rundell, Bridge & Rundell (£120); by whom sold
to George IV, 1823 (250 gns; RA GEO/26060)
LITERATURE Hayward 1976, pp. 217–18, pl. 473; Pechstein 1981, pp. 360–1;
Mette 1995, pp. 154–6 and 254–5
EXHIBITIONS Manchester 1857; London 1901, no. 1, case P, pl. LXXVI; London
1954c, no. 135; QG 1991–2, no. 161

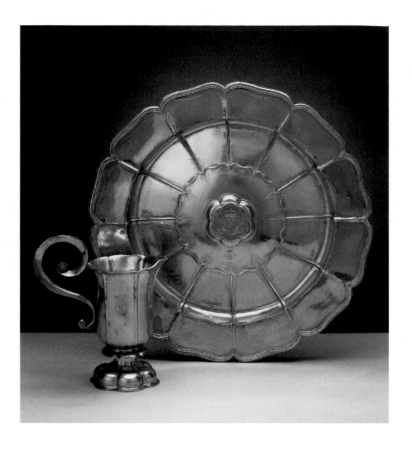

197
MICHEL HAUSSNER (1573–c.1638)
Standing cup and cover, c.1610–20

This elaborately chased cup and cover is first recorded in the Carlton
House Inventory of Plate. It was said to have been 'presented by His
Majesty Charles the First to one of the Principals of the University at
Oxford, whilst holding the Parliament in that City' (RA GEO/Add 19/8,
f. 29).

In 1843 the cup was illustrated and described (in its original partly
gilt state) in Henry Shaw's influential publication *Dresses and Decorations
of the Middle Ages*, where an alternative account of its early history is
given. Shaw, apparently with the help of John Bridge (of Rundell, Bridge
& Rundell), records that the cup had formerly belonged to Charles II
and that he had presented it to a Master of Queen's College, Oxford, for
services to his father during the Civil War. The cup is said to have
remained in the same family until the 1820s when it was bought by
Rundells and sold by them to George IV.

Given John Bridge's involvement, Henry Shaw's account is probably
more reliable than the Carlton House inventory. It is unlikely that
Charles I would have given away such an object at a time when the Jewel
House was heavily depleted and the King had requested plate from many
individuals and institutions, including the Oxford colleges, to help
finance the royalist army.

This cup and cover is a particularly large and elaborate example of the
type of presentation vessel popular in Nuremberg in the late sixteenth
and early seventeenth centuries. With its tall, slender and organic form,
embossed bulb decoration and filigree foliage, it is typical of the neo-
Gothic style adopted by Nuremberg goldsmiths at this date.

Finial figures representing the Virtues were popular; on this cup
Fortitude is symbolised by the column. In 1606, Michel Haussner
(master 1601; about whom little else is known) supplied a similar
Knorretes Trinkgeschirr ('burred' drinking cup) to the Nuremberg City
Council, surmounted by the figure of Patience.

Silver-gilt. 58.3 × diameter 16.9 cm
Nuremberg townmark and maker's mark of Michel Haussner
RCIN 51466
PROVENANCE [Charles II; by whom presented to a Master of Queen's College, Oxford;]
Rundell, Bridge & Rundell; by whom sold to George IV, c.1820
LITERATURE Shaw 1843, II, pl. 92; Jones (E.A.) 1911, p. 6, pl. III
EXHIBITIONS Manchester 1857; London 1862a, no. 6197; London 1954c, no.
136; London 1962, no. 169

198
Attributed to HANS JACOBSZ. WESSON (born c.1616)
Ewer and basin, 1640

This ewer and basin belonged to the 'Winter Queen', Elizabeth of
Bohemia (1596–1662), whose arms are engraved in the centre of the
basin. Elizabeth, daughter of James VI and I and grandmother of George
I, linked the Stuart and Hanoverian dynasties and all British monarchs
since George I are directly descended from her. George IV's fascination
with the Stuarts probably led him to acquire this ewer and basin in
1816. He had the basin engraved with inscriptions explaining the
genealogical importance of Elizabeth in the Hanoverian succession to
the British throne. The romantic tragedy of the Winter Queen's life may
also have appealed to George IV (see no. 49).

This ewer and basin are the only known surviving items of plate
attributed to Hans Jacobsz. Wesson, a goldsmith in The Hague, where
the exiled Bohemian court found refuge after 1620 and lived for many
years in impoverished grandeur. The pieces are early examples of the
emphasis on form rather than decoration, characteristic of Dutch silver
of the 1640s. George IV erroneously believed that the basin was in the
form of the Tudor Rose; the continuous inventory of plate at Carlton
House recorded its arrival as 'a large and curious gilt Salver of White and
Red Rose & a Ewer' on 2 January 1817.

They are unlikely to have stayed in the exiled Queen's possession for
any considerable time. Until 1642 the Queen received a regular if some-
what meagre pension from her brother, Charles I. Following the
outbreak of the English Civil War this ceased and she was forced to
pawn much of her property. She also handed over many of her finest
remaining possessions to her son Charles Louis (1617–80) in return for
money, food and fuel.

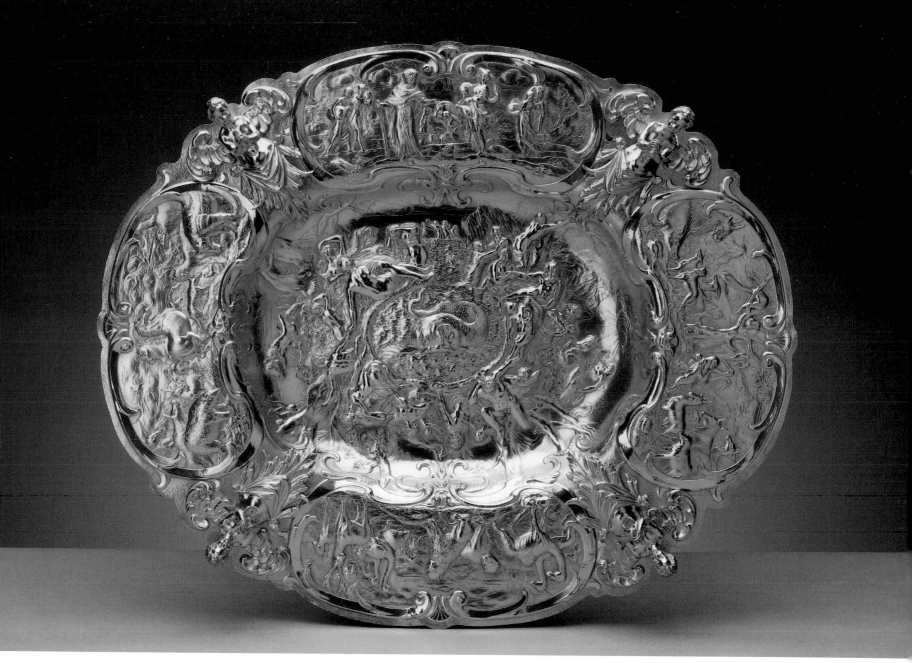

199

Silver-gilt. Ewer 27.2 × 24.6 × 14.5 cm; basin 5.4 × diameter 55.6 cm
Hallmarks for The Hague, 1640, and maker's mark attributed to Hans Jacobsz. Wesson

RCIN 51081 (basin), 51452 (ewer)

PROVENANCE Elizabeth, Queen of Bohemia, c.1640; Rundell, Bridge & Rundell; from whom purchased by George IV, 1816 (£65 3s. 10d., with repairs, gilding and engraving at a further cost of £44 16s.; bill untraced)

LITERATURE Jones (E.A.) 1911, p. 10, pl. V; Frederiks 1958, II, no. 478

EXHIBITIONS London 1862a, no. 5823; London 1929a, no. 863; London 1954c, no. 139; Birmingham 1963; London 1964, no. 153; The Hague 1967, no. 18

199
ANDREAS WICKERT I (1600–1661)
Rosewater basin, c.1650

This exuberant example of Baroque silver admirably demonstrates George IV's pioneering taste for sixteenth- and seventeenth-century silver. It was one of the earliest examples to be acquired by him and was purchased, together with a 'chased silver Ewer supported by a Satyr with Butterfly at top', in 1817. The majority of such pieces were acquired in the 1820s and like this basin came from Rundells. It is not clear whether the basin and ewer described in the account originally belonged together. They appear to have been separated shortly after their acquisition: the Carlton House Inventory of Plate (c.1825) records the existence of the basin only and the whereabouts of the ewer is unknown.

The surface of the basin is richly embossed with scenes from the story of the Deluge. Writhing bodies, struggling in the rising floodwaters, surround a dolphin in the centre of the basin. In the border, within one of the scrolling cartouches, Noah and his family are shown about to enter the Ark. The groups of exotic animals and birds within the remaining cartouches may represent the continents of Europe, Asia and Africa. The theme of water appropriately reflects the original function of the basin: it was used for the ceremonial rinsing of the hands in rosewater before dining.

A display dish in the Kremlin (inv. no. MZ–344), also by Wickert, retains its original part-gilding, a characteristic feature of High Baroque Augsburg silver. It is probable that this basin was also originally partly gilt and that the four cartouches were left ungilded. George IV came to prefer gilt to plain silver and consequently the majority of his plate (possibly including this piece) was entirely gilded by c.1820.

Andreas Wickert I (master 1629) appears to have been an Augsburg citizen of some importance. He was an elected member of the Goldsmiths' Guild, Assay Master, and a member of the Great Council of the City. The majority of surviving pieces from his workshop are mounted ivory tankards, for which Augsburg was renowned.

Silver-gilt. 8.2 × 64.6 × 54.5 cm
Hallmark for Augsburg and maker's mark of Andreas Wickert I
RCIN 51497
PROVENANCE Rundell, Bridge & Rundell; from whom purchased by George IV, 1817 (£222 18s.; PRO LC11/23, quarter to 5 July 1817)
LITERATURE Jones (E.A.) 1911, p. 8
EXHIBITIONS London 1862a, no. 6327; London 1954c, no. 141

200
GERMAN (KÖNIGSBERG)
Amber canister, c.1660

Amber, a fossilised tree resin, has been prized for its beauty and unique qualities since antiquity. It occurs in large quantities along the Baltic coasts of Germany and Poland. During the seventeenth century Königsberg and Danzig were important centres of amber carving. Many pieces were commissioned by the Brandenburg court in Berlin as diplomatic gifts; perhaps the most famous was the amber room presented to Peter the Great of Russia by Frederick the Great of Prussia.

No. 200 is of a type known in German as *Schraubflaschen* (screw-top

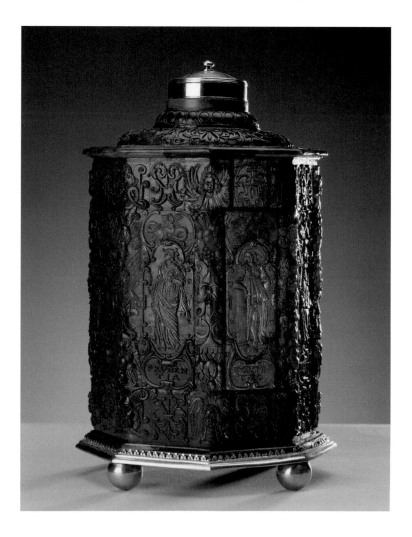

bottle). There are comparable examples in museum collections in Germany (Pelka 1920, p. 113; Rohde 1937, p. 39). Amber cups and tankards were particularly popular as it was believed that amber had the power to detect poisons. However, *Schraubflaschen* were essentially *Kunstkammer* display pieces and appear to have had no practical use.

The canister is constructed from amber panels, each carved with a figure of one of the Virtues. These include the three Theological Virtues – Faith, Hope and Charity – and the four Cardinal Virtues – Temperance, Prudence, Fortitude and Justice; Patience is also depicted. A number of mid-seventeenth-century amber tankards carved with similar figures after the same (unidentified) source or sources are known (Rohde 1937, pp. 39–40; Tait 1991, pp. 142–60), although differences in their composition, technique and quality suggest that they are not all from the same workshop. George Schreiber of Königsberg (fl.1610–50) was responsible for some of the finest vessels; no. 200, however, was probably made by one of Schreiber's followers around 1660.

Although no. 200 may have entered the Royal Collection at an early date, the first reference to it occurs in 1852, when it was placed on loan at the South Kensington Museum; the loan was terminated in 1882. Other important amber objects formerly in the collection included a large amber cabinet, looking glass and stands presented to Mary II by the Duke of Brandenburg (noted by John Evelyn, 13 July 1693). Two amber cabinets, said to have been presented to Queen Anne and Queen Caroline, were displayed in Windsor Castle in the eighteenth century (Trusted 1985, p. 14). At least one of these cabinets survived in the collection into the nineteenth century, when it was depicted in the King's State Bedchamber at Windsor in 1816 (Pyne 1819, I, *Windsor Castle*, opposite p. 161).

Amber, silver-gilt. 24 × 14 × 14 cm
RCIN 45109
PROVENANCE Royal Collection by 1852
EXHIBITIONS London 1862a, no. 7875

201
SOUTHERN GERMAN, and JOHN BRIDGE (1755–1834) for RUNDELL, BRIDGE & RUNDELL
Cup and cover, c.1700, jewelled mounts, 1824–5

The arrival in England of this superb example of virtuoso ivory carving was announced in the *Morning Post and Daily Advertiser* on 20 May 1788: 'RECENTLY brought from Vienna, and added to the Museum [the *Holophusicon*], an inconceivably beautiful effort of art ... consisting of a cup or vessel carved in ivory; the figure of Hercules dressed in the skin of the Nemean Lion forms the handle or stem'. A few weeks later one 'PROFESSOR THORKELIN of Copenhagen' attributed it to the Danish court sculptor Magnus Berg (1666–1739). A tentative attribution has since been made to the southern German ivory carver Johann Gottfried Frisch (fl.1689–1716) (communication from Dr Christian Theuerkauff).

The *Holophusicon*, Sir Ashton Lever's noted collection of natural history and ethnography, opened in Leicester House in 1775 (see King

◁ 200

1996). The collection was acquired (via a winning lottery ticket) by James Parkinson in 1786. Parkinson brought no. 201 from Vienna two years later. The *Holophusicon* was dispersed by auction in 1806 (in perhaps 8,000 lots). No. 201 was subsequently acquired by the collector William Beckford of Fonthill Abbey. The cup was illustrated in John Rutter's *Delineations of Fonthill and its Abbey* (1823), prominently displayed in King Edward's Gallery on the Borghese Table (now at Charlecote Park), flanked by two ivory vases (now British Museum). Most of Beckford's dazzling collection was sold by auction in 1823 when George IV purchased the cup for 90 guineas. The King shared Beckford's taste for virtuoso pieces in exotic materials and the cup joined a growing collection of mounted ivories at Carlton House. The original chased silver-gilt mounts were evidently too plain for George IV's increasingly flamboyant tastes and in 1824 Rundells added 'a new silver chased rim ... set with coloured stones to raise the cover' for £148 10s. (RA GEO/26327).

Ivory, silver-gilt, gemstones. 52.8 × 20.5 × 16.5 cm
Illegible (town?) mark and maker's mark DC (unidentified) on silver-gilt inner rim; London marks for 1824–5 and maker's mark of John Bridge on jewelled mounts
RCIN 50554
PROVENANCE Brought from Vienna by James Parkinson, 1788 (for the *Holophusicon* museum, London); sold King & Lochee, London, commencing 5 May 1806 'Last day of the sale' (106); acquired by R. Davies, York Street, London; by whom sold to William Beckford, 1813; by whom sold to John Farquhar; by whom sold, Phillips, Fonthill Abbey, Wiltshire, 27 September 1823 (573); acquired for George IV (90 gns)
LITERATURE Jones (E.A.) 1911, p. 54; Garrard 1914, no. 543; Paulsen 1989, p. 214, no. 26; Wainwright 1992, pp. 126–7
EXHIBITIONS Manchester 1857, p. 38; QG 1991–2, no. 160

202
JOHANN GEORGE HOSSAUER (fl.1820–1857)
The Glaubensschild, 1842–7

The *Glaubensschild* was given to the infant Prince of Wales (later Edward VII) by his godfather, King Frederick William IV of Prussia. The name means 'Shield of Faith', a reference to the Prince's future title 'Defender of the Faith'. The King had attended the Prince's baptism in St George's Chapel, Windsor, on 25 January 1842 and afterwards declared his intention to present the Prince with a shield to commemorate this event 'which in its character and design should correspond with the importance of the Act of the Church performed on that day, and likewise be worthy of the present state of German art'. The idea of the 'Shield of Faith' most probably arose from the famous passage in St Paul's letter to the Ephesians (6: 11–16) beginning 'Put on the whole armour of God', in which the 'shield of faith' is said to 'quench all the fiery darts of the wicked'.

Many artists and craftsmen were involved in the design and execution of this exemplary piece. According to the entry in the official catalogue of the Great Exhibition, 'The pictorial embellishments of the shield, the general plan for which was given by the King himself, were designed by Doctor Peter von Cornelius, and the architectural ornaments by Counsellor Stüler'. Peter von Cornelius (1783–1867), Director of the Munich Academy, and Friedrich August Stüler (1800–65), Prussian court architect, were responsible for the overall conception; they were assisted with the design by Alexis Etienne Julienne (b. 1808), a

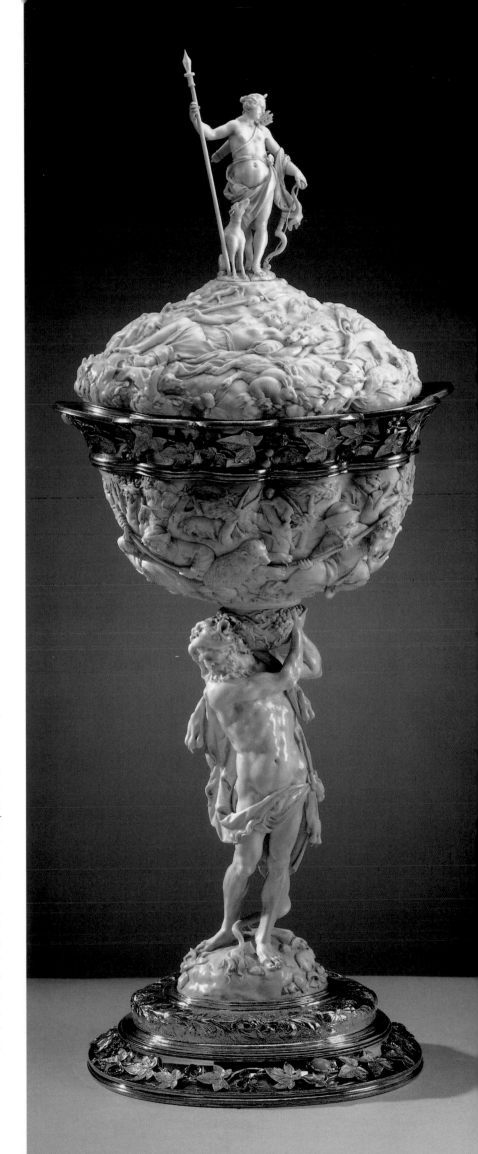

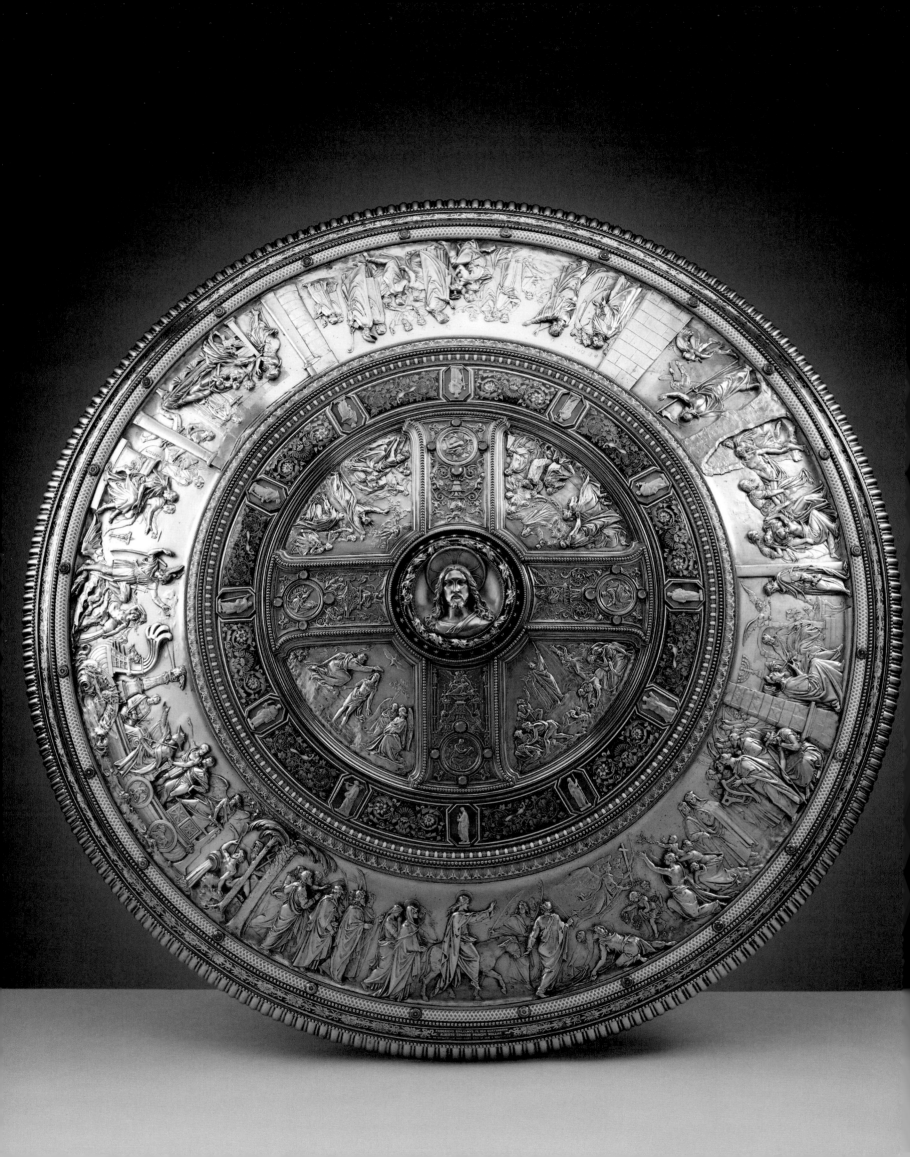

porcelain painter at Sèvres. The designs were modelled by the sculptor August Fischer (1805–66) and chased by August Mertens (c.1814–83). The court goldsmith George Hossauer was responsible for the gold, silver and enamel work, while Giovanni Calandrelli (d. 1852) carved the onyx figures of the twelve Apostles. Such was the complexity of the work that it was over five years before the completed shield was finally presented to the Prince in April 1847.

The deeply Christian iconography reflects Cornelius's membership of the Nazarene Brotherhood who, inspired by early Renaissance painting, believed that all art should serve a religious or moral purpose. The central figure of Christ is surrounded by scenes and figures from the Old and New Testaments. The low relief border around the outer edge of the shield depicts the redeeming atonement of Christ, the foundation of the Church and the reception into it by baptism. The final highly idealised scenes depict Prince Albert and the Duke of Wellington, accompanied by St George, receiving the King of Prussia on his arrival in England for the Prince's baptism. Prince Albert and Queen Victoria were delighted with the gift and wrote to thank the King for the 'herrliches Werk' (magnificent piece).

Silver, gold, enamel, onyx, chrysoprase. Diameter 89 cm
Inscribed FRIDERICUS GUILELMUS IV REX BORUSSORUM ALBERTO EDUARDO
PRINCIPI WALLIÆ IN MEMORIAM DIEI BAPT.XXV.M.IAN.A.MDCCCXLII
RCIN 31605
PROVENANCE Presented to Albert Edward, Prince of Wales, in April 1847 on behalf
of King Frederick William IV of Prussia to commemorate the Prince's baptism on
25 January 1842
LITERATURE Illustrated London News, 13 November 1847, p. 312; Schümann 1968
EXHIBITIONS London 1851a; Manchester 1857, no. 193; Berlin 1995, no. 5.7;
Berlin 1997, no. I/57

203
ANTON MICHELSEN (1809–1877);
HEINRICH HANSEN (1821–1890), designer
Gold beaker, 1864

The Danish artist Heinrich Hansen was commissioned by Christian IX of Denmark to design this beaker as a christening gift for his grandson Prince Albert Victor (1864–92), eldest son of the Prince and Princess of Wales. The beaker is accordingly decorated with iconography symbolising the historic connections between the royal houses of Denmark and Great Britain. It is supported on three Danish lions bearing the royal arms of Britain, Denmark and the Prince of Wales; around the base of the beaker there are depictions of the Danish King Sveno leading the Viking conquest of England, Sveno's son King Canute marrying the Anglo-Saxon Queen Emma, and King Canute on the seashore. Above these are portrait medallions modelled by Peter Petersen (1810–92) of Christian IX and Queen Louise of Denmark and the Prince and Princess of Wales. Four smaller medallions depict Princess Philippa of Lancaster, daughter of Henry IV, who married the Danish King Erik of Pomerania in 1406; Princess Louisa, daughter of George II, who married Frederick V of Denmark in 1743; Princess Anne of Denmark, daughter of King Christian IV, who married James VI of Scotland (later James I) in 1589; and Prince George of Denmark, son of Frederick III, who married Princess Anne, later Queen Anne, in 1683. The cover is surmounted by a British lion bearing the cypher of Prince Albert Victor.

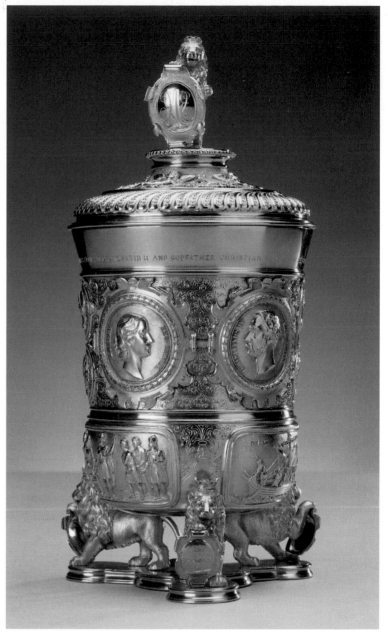

203

Heinrich Hansen specialised in painting architectural scenes; his view of Christiansborg Palace in Copenhagen was presented to Princess Alexandra by the people of Denmark on her marriage to the Prince of Wales in 1863 (RCIN 405125). Hansen's design for no. 203 is said to be based on an early eighteenth-century beaker in the Danish Royal Collection at Rosenborg Palace. The present beaker was made in the workshops of Anton Michelsen, who was appointed jeweller to the Danish court in 1848.

Gold. 22.2 × diameter 10.3 cm
Marks for Copenhagen 1864 and maker's mark of Anton Michelsen; engraved
PRESENTED TO PRINCE ALBERT VICTOR CHRISTIAN EDWARD OF WALES FROM
HIS GRANDFATHER AND GODFATHER CHRISTIAN IX KING OF DENMARK,
MARCH 10TH 1864; base inscribed A. MICHELSEN / HOF. JUVELEER / KJÖBENHAVN
RCIN 47773
PROVENANCE Commissioned by King Christian IX of Denmark and presented to his
grandson and godson Prince Albert Victor of Wales (later Duke of Clarence) on his
christening 10 March 1864
LITERATURE Jenvold 1992, p. 34

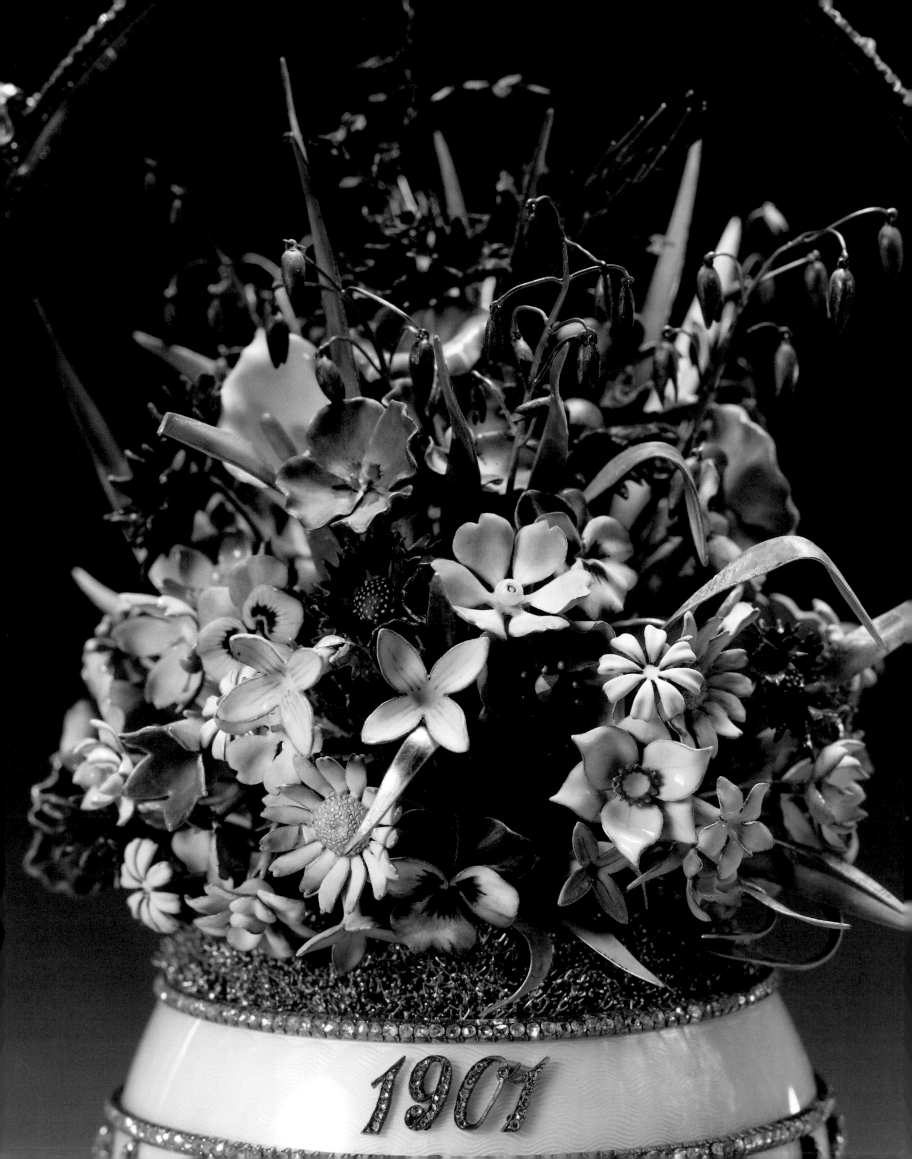

FABERGÉ

One of the most famous jewellers and goldsmiths of the late nineteenth and early twentieth centuries, Fabergé's name and reputation as an ingenious craftsman have long outlived the short period during which his workshop was principally in production – the thirty-five years between 1882 and 1917. The reasons for his fame are well documented: outstanding technical skill, the highly developed organisation of his specialist workshops, his talented workmasters and craftsmen, and above all his ability to elevate the most mundane object into a work of art. But his success outside Russia was also due in no small part to the patronage of the British royal family who – like their Russian and Danish relatives – were captivated by the imagination and skill of Fabergé's work.

Born in St Petersburg, Peter Carl Fabergé (1846–1920) followed in the footsteps of his father Gustav, who was of Huguenot origin, to become a goldsmith and jeweller. Having travelled to Dresden with his family, his father sent Carl to complete a four-year apprenticeship across Europe, in Frankfurt, Florence and Paris, after which he entered the family firm in St Petersburg in 1865. In 1872 Carl took over the business, which grew from a traditional and modest goldsmiths into an international enterprise, employing at its peak some five hundred staff.

As early as 1867 Carl Fabergé had begun working voluntarily at the Hermitage Museum, repairing antiquities and acting as an appraiser of metalwork and jewellery acquisitions. Meanwhile, from about 1866 the firm of Fabergé had also been supplying the Imperial Cabinet with 'precious objects'. Numerous attempts were made by the curator of antiquities at the museum to have Fabergé officially recognised as Supplier to the Imperial Court, but it was not until after the 1882 Pan-Russian exhibition in Moscow, at which he was awarded a gold medal, that his appointment was finally granted in 1885 as Supplier to the Court of His Imperial Majesty Tsar Alexander III. In 1900 Fabergé exhibited at the Exposition Universelle in Paris, where he was awarded the Grand Prix and was decorated with the Légion d'Honneur. By the end of the next decade, Fabergé had become the leading supplier to the Russian court of jewellery, objects and silver, overtaking competitors such as Bolin and Hahn. On 16 October 1910 Carl's son, Eugène, applied on his behalf for the title 'Jeweller to the Court' which was granted a month later.

From the outset Carl Fabergé's work was recognised by his clients as being of outstanding quality. In spite of the apparently industrial scale of his business, Fabergé regarded himself as an artist rather than a manufacturer. While certain elements of his objects were occasionally bought in from other suppliers – for example, clasps, hinges and pre-cut hardstone – the vast majority were entirely made and finished by hand in his workshops. The objects themselves were almost always unique. Very few designs were repeated and every one was carefully drawn and logged in the design or stock books of each workshop. Even during Fabergé's lifetime his pieces were regarded as being of museum quality and his exacting standards were renowned.

The endorsement of Fabergé's work through the combined patronage of Tsar Alexander III (r. 1881–94) and Tsarina Marie Feodorovna, and later of Tsar Nicholas II (1868–1918) and Tsarina Alexandra Feodorovna, ensured the success of his business as other members of the imperial family, the aristocracy, wealthy businessmen and the *beau monde* of the time sought to emulate imperial patronage. In order to match the huge demand for the wide range of products he produced, Fabergé introduced a highly organised system of separate workshops, each with its senior workmaster responsible for recruiting staff, maintaining quality and guaranteeing terms and times of delivery. In return the workmasters were allowed to mark their products with their own initials. There were also separate workshops for enamelling and for making the fitted boxes of holly wood, sycamore and maple in which the pieces were sold. In 1900 Fabergé set up his headquarters in St Petersburg's fashionable Bolshaya Morskaya Street where a showroom, the principal workshops and his own residence were housed in a new building.

The most skilled workmasters were elevated to the position of head workmaster. Under Carl Fabergé this role was held by Erik Kollin (1870–86), Michael Perchin (1886–1903) and finally Henrik Wigström (1903–17). It was in collaboration with these specialists that Fabergé further developed the styles and techniques for which he was to become so famous: exquisite enamelling, vari-coloured gold decoration and the use of carved semi-precious hardstones. These were essentially revivals of eighteenth-century techniques, but Fabergé applied them to modern-day objects. In terms of style, Fabergé, his designers and workmasters sought

inspiration in a wide variety of sources from antiquities and oriental art to the Louis XV period and the contemporary Art Nouveau movement. The assimilation of these disparate styles combined with high-quality raw materials and high standards of craftsmanship gives Fabergé's work its unique character.

Fabergé's own involvement has been much debated. In the main he took a managerial role but he was clearly the creative force behind the firm's most significant commissions. There were other designers, notably Franz Birbaum (1872–1947) – a Swiss designer and craftsman – who, according to his memoirs, was closely involved in designing some of the Imperial Easter Eggs. Carl's brother Agathon (1862–95) joined the firm in 1882 and according to Birbaum helped to revolutionise the firm's products, taking inspiration from nature and from oriental art in the Hermitage collection. Carl's sons Eugène, Agathon and Alexander also worked as designers for the firm.

Fabergé's success caused contemporary jewellers such as Cartier and Boucheron of Paris to imitate his most successful products, especially animals and flowers, some of which were hardly distinguishable from Fabergé's own pieces. Even an Imperial Easter Egg in the Royal Collection – the Basket of Flowers Egg (no. 204) – was until recently thought to have been made by Boucheron, but is in fact by Fabergé. His instinct for innovation meant that he always kept ahead of his competitors.

The increasing international reputation of Fabergé's firm caused him to establish branches in Moscow (1887), Odessa (1900), London (1903) and Kiev (1905). Fabergé's Moscow branch specialised in the production of table silver, jewellery and enamelled items in the Russian style. Occasionally the Moscow workmasters produced gold and enamelled pieces in the same vein as those also produced in St Petersburg, presumably to keep up with production. In general these pieces are regarded as being inferior in style and sometimes in quality to those produced at the main workshops, but there were exceptions, such as the cigarette case (no. 269).

The London branch was initially located in Berners Hotel. It then moved to Duke Street and in 1906 to No. 48 Dover Street, transferring finally to No. 173 New Bond Street, where it remained until 1917. Arthur Bowe, who had been working for the firm in Moscow, set up the branch; from about 1907 it was managed by Henry Bainbridge and for the following ten years it was Fabergé's most successful outlet. In addition to serving clients in England and on the Continent, annual selling trips from the London branch were made to India, Bangkok, China and Japan between 1908 and 1917.

The close family links between the Russian, Danish and English royal houses were crucial to Fabergé's success. The two Danish Princesses, Alexandra (1844–1925) and her sister Dagmar (1847–1928), daughters of Christian IX and Queen Louise, married respectively the future Edward VII and the future Tsar Alexander III, Dagmar taking the name Marie Feodorovna on her baptism into the Orthodox Church. The sisters greatly admired Fabergé's work, Alexandra presumably having been introduced to it by her sister. Edward VII shared his consort's enthusiasm for Fabergé and their combined patronage undoubtedly caused Fabergé to open his London branch, which effectively served as their private showroom. Bainbridge played an important role during their regular visits to the branch. He ensured that they could be the first to view the latest items to arrive from Russia and arranged their own commissions which involved visits to Marlborough House, Buckingham Palace and Sandringham. As Prince and Princess of Wales, the opportunity to visit Fabergé's headquarters in St Petersburg with their son George, Duke of York (later King George V), presented itself in 1894 when they attended the funeral of Tsar Alexander III, the Princess's brother-in-law, and the marriage of Tsar Nicholas II to Alix of Hesse, the Prince's niece. Their visit to Russia also coincided with the Princess's birthday on 1 December. Prince George described the contents of his mother's apartments at the Anitchkoff Palace in his diary: 'Motherdear's birthday ... Saw all the presents, she has got half Fabergé's shop.' The patronage of Edward VII and Queen Alexandra brought with it the élite of Edwardian society, many of whom formed their own Fabergé collections. Most of them viewed the objects not as works of art but as amusing trinkets which could serve as gifts for every occasion. Queen Alexandra's accounts reveal a high level of expenditure on presents: between 1902 and 1909 she spent £1,880 on gifts, compared to £566 on objects intended to be kept. It was well known that Queen Alexandra preferred animals and flowers of a modest price bracket to the more expensive of Fabergé's creations. Bainbridge describes how Fabergé went to great lengths to produce objects restrained in style and of outstanding craftsmanship but with a small price tag which would not offend the Queen. The majority of the elaborately jewelled pieces acquired by the royal couple arrived as gifts rather than as purchases or commissions. Even Edward VII's mistress The Hon. Mrs George Keppel, a notable collector of cigarette cases by Fabergé, gave Queen Alexandra a gift in the form of a holly sprig (no. 240). This piece was apparently purchased during a joint visit with the King to Fabergé's London branch in 1908. With Mrs Keppel's fondness for the King and her love of Fabergé in mind, in 1911 Queen Alexandra returned to her the magnificent cigarette case which Mrs Keppel had originally presented to Edward VII (no. 269). The Fabergé collection was chiefly located at Sandringham, in display cases arranged by the Queen. This explains why the collection has traditionally been referred to as the 'Sandringham collection'.

Queen Victoria's apparent disinterest in Fabergé is illustrated by the fact that she owned only a handful of pieces. Those that are

associated with her were received as gifts, either from her Russian relatives (for example the desk clock, no. 275), or from her staff (see under no. 238). Princess Victoria, the daughter of Edward VII and Queen Alexandra, was very fond of Fabergé's flower studies, of which she formed a small collection, including nos 241 and 247. She also owned a number of desk accessories. Some of these objects were inherited from her mother's collection. Princess Victoria never married and following her death in 1935 these Fabergé pieces were returned to King George V at Sandringham.

King George V inherited his parents' interest in Fabergé's work, judging by the relatively large number of items he purchased. These range from the Mosaic Easter Egg (no. 206) and the Kelch Easter Egg (no. 207) to desk accessories such as the seal (no. 276) and numerous animals. The King was also greatly influenced by Queen Mary's interest in Fabergé. She was to become the greatest royal collector of Fabergé after Edward VII and Queen Alexandra. With King George V she was responsible for acquiring the four Easter Eggs now in the collection, three of which are of imperial provenance.

Following the revolution and civil war in Russia, many pieces of Fabergé began to appear for sale, brought out of Russia by émigrés. In addition, in the early 1920s Soviet state-run sales organisations such as the Antikvariat (the government bureau set up by Lenin in 1921 to sell state treasures to the West) traded Fabergé objects for hard currency. Dealers such as the American Armand Hammer and Emanuel Snowman, the owner of Wartski, purchased items in Russia to sell to collectors at home. King George V and Queen Mary acquired many pieces through the firm of Wartski, who were established in London from 1911. Specialising in objects by Fabergé, they have continued to be patronised by the Royal Family, notably Queen Elizabeth The Queen Mother. The first major Fabergé exhibition in London, to which Queen Mary lent a number of pieces, was held at Wartski in 1949, to celebrate the publication of Bainbridge's book on the life of Carl Fabergé. Queen Mary continued to acquire a large number of other pieces, mainly flower studies and table ornaments. Some came directly from the Russian émigré Prince Vladimir Galitzine. In her lifetime the majority of the collection continued to be displayed at Sandringham, but during the last seventeen years of Queen Mary's life, some of her Fabergé collection was displayed with her other bibelots on small tables in her apartments at Marlborough House. The exhibition devoted to her collection at the Victoria and Albert Museum in 1954 included numerous pieces of Fabergé, among them no. 206.

King George VI acquired a number of pieces of Fabergé, notably cigarette boxes. Queen Elizabeth The Queen Mother has formed her own collection of flowers, bibelots, boxes and photograph frames. Other members of the Royal Family have inherited their forebears' fascination for Fabergé's creations: Princess Margaret, the Prince of Wales, the Princess Royal and the Duke and Duchess of Kent all own examples of his work.

The Fabergé collection now numbers over five hundred pieces, of which the examples in this exhibition are a representative selection. During the present reign, the collection has been exhibited extensively both in the United Kingdom and around the world. The most significant exhibitions include those held at Wartski in 1953 in celebration of The Queen's Coronation and at the Victoria and Albert Museum in 1977, to celebrate The Queen's Silver Jubilee. A considerable number of Fabergé loans were made from the Royal Collection to the *Great Britain USSR* exhibition at the Victoria and Albert Museum in 1967, at the height of the Cold War. More recently, two major exhibitions of Fabergé were held in The Queen's Gallery in 1985 and in 1995.

Note: Unless otherwise stated, all objects were made in St Petersburg.
The purity of gold and silver is measured in *zolotniks*: 56 and 72 *zolotniks* indicate 14 and 18 carat gold; 84, 88 and 91 *zolotniks* indicate 21, 22 and 22¾ carats for silver.

EGGS (nos 204–207)

In 1885, the same year that Carl Fabergé was appointed Supplier to the Imperial Court, he was commissioned by the Tsar to produce an Easter Egg as a wedding anniversary present for his wife, Tsarina Marie Feodorovna. This was to be the first in the famous series of fifty Imperial Easter Eggs produced by Fabergé for the Russian imperial family between 1885 and 1916.

Easter is the most important celebration in the Russian Orthodox calendar. Traditionally, hand-dyed hen's eggs are brought to church to be blessed and presented to family and friends. In the late nineteenth century this practice evolved into the exchange of costly gifts among the St Petersburg aristocracy; the eggs made by Fabergé were undoubtedly the most lavish and expensive. After Alexander III's death in 1894, the tradition of presenting the Tsarina with an Imperial Easter Egg was continued by his son, Tsar Nicholas II, and between 1895 and 1916 two were produced each year, one for Tsarina Alexandra Feodorovna and one for the Dowager Tsarina Marie Feodorovna.

Although most of the eggs had a theme for their design, generally drawn from the year's important events and achievements in the imperial household, Carl Fabergé was given freedom by the Tsar to design his *objets de fantaisie*. Most of the eggs contain a 'surprise' of some kind, the majority opening to reveal miniature models, sometimes with mechanical parts, and images of people, places and events of importance to the imperial family.

These costly eggs were to some extent atypical of Fabergé's production, but they are the greatest expression of his ingenuity and his technical ability as a goldsmith and jeweller. The design of the eggs was usually a collaborative effort and involved a number of Fabergé's designers, including Franz Birbaum (1872–1947), Alexander Ivaskev (dates unknown), Gustav Shkilter (1874–1954) and Alma Theresia Pihl (1888–1976); the latter helped to design the Mosaic Egg (no. 206). The production of the eggs, which was carried out in great secrecy, was a complex and lengthy business. Each egg took approximately one year to make. Many different craftsmen contributed, including stone carvers, gem-cutters and setters, goldsmiths, enamellers, engravers, polishers and miniaturists. The production of each egg was overseen by a head workmaster. Of the thirty-three which are marked by a workmaster, seventeen were made in Perchin's workshop, thirteen in Wigström's, two in August Holmström's and one in Albert Holmström's.

After delivery, the Imperial Eggs were seldom seen by anyone outside the Tsar's family. Only on one occasion were the Russian public able to view some of the Imperial Easter Eggs. This was at a charity exhibition under the patronage of Tsarina Alexandra Feodorovna, held in March 1902 at the mansion of Baron von Dervis in St Petersburg.

All three Imperial Easter Eggs in the Royal Collection were acquired by Queen Mary.

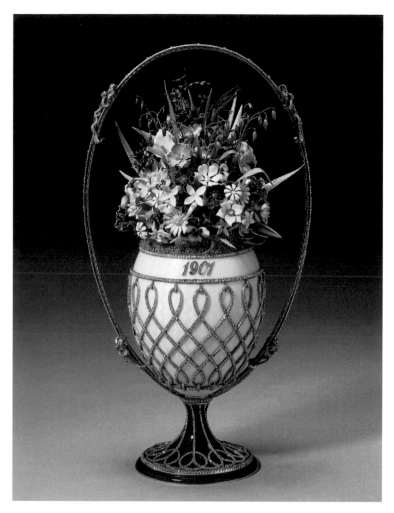

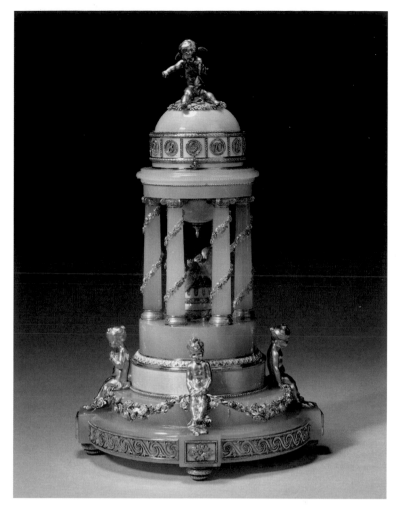

204

205

204
Basket of Flowers Egg, 1901

For many years the imperial provenance of the Basket of Flowers Egg was doubted. However, the recent discovery of Fabergé's invoice for 6,850 roubles, dated 16 April 1901, has confirmed that the egg was commissioned by Tsar Nicholas II for Tsarina Alexandra Feodorovna. The Basket of Flowers Egg is also clearly visible in photographs of the vitrines at the Von Dervis exhibition in 1902. These indicate that the egg-shaped vase was originally of oyster-coloured enamel throughout. The base of the vase was replaced and enamelled in blue some time between Queen Mary's acquisition of the egg in 1933 and the photograph of it published in Bainbridge's book in 1949. This was due to damage sustained after the Revolution. No trace of payment for the repair has been found, nor are the circumstances of Queen Mary's acquisition known precisely. The identity of the purchaser of the egg from the Antikvariat is not given on the official receipt, but it is likely to have been the American industrialist Armand Hammer.

The profusion of wild flowers enamelled on gold in the Basket of Flowers Egg demonstrates Fabergé's interest in nature. Each flower, leaf and husk is painstakingly modelled and enamelled to look as realistic as possible (see p. 282).

Silver, parcel gilt, gold, enamel, diamonds. 23 × diameter 10 cm
RCIN 40098

PROVENANCE Commissioned by Tsar Nicholas II for Tsarina Alexandra Feodorovna, 1901 (6,850 roubles); confiscated by the provisional government, 1917; sold by the Antikvariat, 1933 (2,000 roubles); (?)Armand Hammer; acquired by Queen Mary, 1933 (QMB, III, no. 88; QMPP, VII, no. 187)
LITERATURE Bainbridge 1949, pl. 3 (adjacent to p. 53); Fabergé, Proler & Skurlov 1997, p. 156
EXHIBITIONS St Petersburg 1902; Munich 1986–7, no. 620; QG 1995–6, no. 136

205
Colonnade Egg Clock, 1910

Four of Fabergé's Imperial Easter Eggs incorporate clocks in their designs, thereby giving them a practical rather than purely decorative or commemorative purpose. In this example a rotary clock by the Swiss firm of Henry Moser & Cie, who supplied the majority of movements for Fabergé's clocks, forms the Easter Egg. The symbolism behind the design of the egg is, however, its most important feature for it represents a temple of love. The pair of platinum doves symbolises the enduring love between Tsar Nicholas II and Tsarina Alexandra Feodorovna; the egg was given by the Tsar to his wife at Easter 1910. The silver-gilt cherubs seated around the base represent their four daughters, Olga (b. 1895), Tatiana (b. 1897), Maria (b. 1899) and Anastasia (b. 1901); the cupid surmounting the egg symbolises the long-awaited heir to the throne, Tsarevitch Alexis (b. 1904); all five children died with their parents in 1918.

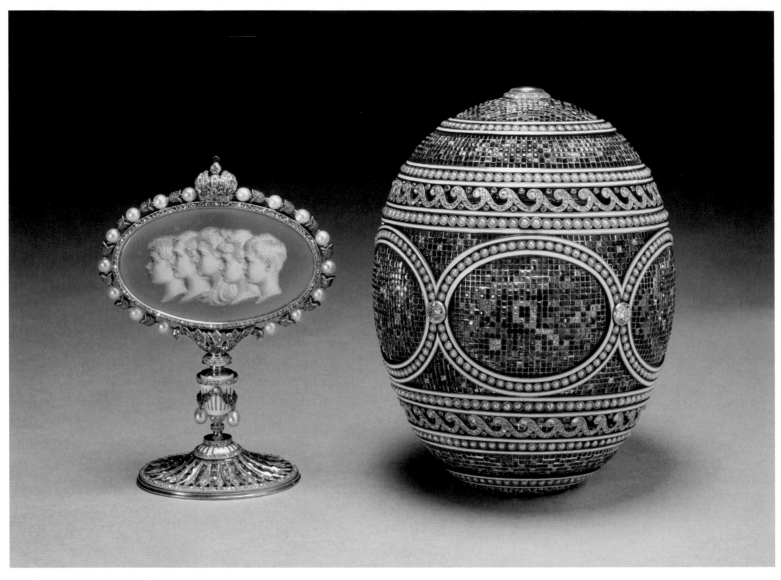

206 (surprise and egg, enlarged)

The description of the Colonnade Egg in the memoirs of Franz Birbaum, one of Fabergé's craftsmen and senior designers, states that the Tsarevitch held a silver-gilt ribbon-tied staff or twig in his right hand to indicate the time. This is confirmed by early photographs. However, by the time Bainbridge's book was published in 1949 the staff had been replaced by an enamelled rose. There is no trace of either staff or rose today.

This egg bears the mark of Henrik Wigström, Fabergé's head workmaster from 1903 to 1917, who supervised the production of thirteen Imperial Easter Eggs. The design of this egg is typical of the classical style of much of Wigström's work.

After confiscation in 1917 the egg appears on a list dated 1922 of confiscated treasures transferred from the Anichkov Palace to the Sovnarkom, a state-run organisation 'for the collection and conservation of treasures', headed by a special plenipotentiary. It was acquired in Russia and brought to Europe by the dealer Emanuel Snowman.

Bowenite, gold, silver-gilt, platinum, enamel, diamonds. 28 × diameter 17 cm
Mark of Henrik Wigström; gold mark of 56 zolotniks (1908–17); FABERGÉ in Cyrillic characters
RCIN 40084
PROVENANCE Commissioned by Tsar Nicholas II for Tsarina Alexandra Feodorovna,

for Easter 1910; confiscated by the provisional government, 1917; transferred to the Sovnarkom, by 1922; Emanuel Snowman; acquired by Queen Mary and given to King George V, 1931 (according to a manuscript annotation by Queen Mary in her copy of Bainbridge 1933, pl. V)
LITERATURE Fabergé, Proler & Skurlov 1997, pp. 194–6
EXHIBITIONS London 1953d, no. 46; Australia 1977, no. 100; London 1977d, no. F3; New York 1983, no. 57; QG 1985–6, no. 32; San Diego/Moscow 1989–90, no. 14; London 1992a; St Petersburg/Paris/London 1993–4, no. 20; QG 1995–6, no. 257; Stockholm 1997, no. 5; London 1999d, no. 1

206
Mosaic Egg, 1914

The 'petit-point' flower motif repeated on the five oval medallions of this Imperial Easter Egg was designed by Alma Theresia Pihl, who came from a distinguished family of jewellers employed by Fabergé. She was the granddaughter of August Holmström, Fabergé's principal jeweller until his death in 1903. Her father Knut Oscar Pihl was head of the jewellery workshop in Moscow from 1887 to 1897. Her uncle Albert Holmström took over August's workshop and was the workmaster responsible for the production of this egg.

Alma Pihl's watercolour design, from which the Mosaic Egg derives, appears in Albert Holmström's stock book, in the form of a circular brooch dated 24 July 1913. It is not known whether the circular brooch was ever made but an octagonal brooch with a similar floral mosaic motif was executed and is in the Woolf family collection.

Each of the tiny precious stones had to be precisely cut and calibrated to fit into the curving platinum cagework which holds them in place. The skill required to do this well illustrates the exacting levels of craftsmanship of Fabergé's workshops. At one end, the initials of Alexandra Feodorovna are set beneath a moonstone.

Concealed within the egg is an enamelled medallion surmounted by the Imperial Crown. This is the 'surprise', held in place by two gold clips. It is decorated on one side *en camaieu* with the profile heads of the five imperial children and on the reverse in sepia with their names and the date 1914 surrounding a basket of flowers. The curious mark on the pedestal of the surprise is thought to represent Carl Fabergé's tribute to his father, Gustav, as 1914 marked the hundredth anniversary of his birth.

Gold, platinum, enamel, diamonds, rubies, emeralds, topaz, quartz, sapphires, garnets, moonstone. Egg 9.5 × diameter 7 cm; Surprise 7.9 × 5.5 × 2.9 cm
Engraved on the egg C. FABERGÉ; engraved on the pedestal of the surprise G. FABERGÉ
RCIN 9022
PROVENANCE Commissioned by Tsar Nicholas II for Tsarina Alexandra Feodorovna, for Easter 1914; confiscated by the provisional government, 1917; sold by the Antikvariat, 1933 (5,000 roubles); (?)Armand Hammer; Cameo Corner, London; from whom bought by King George V, 22 May 1933, probably for Queen Mary's birthday on 26 May (£250 'half cost'; QMB, III, no. 140; QMPP, VII, no. 164)
LITERATURE Snowman 1987, p. 150; Fabergé, Proler & Skurlov 1997, pp. 219-21
EXHIBITIONS London 1954a; QG 1962-3, no. 61 (10 & 10a); London 1977d, no. F5; New York 1983, no. 105; QG 1985-6, no. 79; Munich 1986-7, no. 544; London 1987; San Diego/Moscow 1989-90, no. 23; London 1992a; St Petersburg/Paris/London 1993-4, no. 29; QG 1995-6, no. 252; Stockholm 1997, no. 8

207
Easter Egg, 1899

In addition to the fifty Easter eggs made for the imperial family, Fabergé was privately commissioned to produce eggs for members of society wealthy enough to emulate these commissions. Financiers, industrialists and businessmen formed an important part of Fabergé's Russian clientèle. Their new-found wealth, a result of the dynamic growth in industry in St Petersburg and Moscow in the early twentieth century, enabled them to place large orders with Fabergé.

Barbara Petrovna Bazanova came from a wealthy Muscovite family, which owned gold mines, railways and shipping companies. In 1894 she married Alexander Kelch, a member of a noble St Petersburg family who, among other business concerns, was involved in mining enterprises in Siberia and is thought to have supplied Fabergé with gold and other raw materials.

In 1898 Kelch commissioned the first of a series of Easter Eggs from Fabergé, which rivalled in importance those made for the imperial family. This egg is the second in the series and bears Barbara's initials under a portrait diamond at the top and the date 1899 at the bottom. The egg is divided into twelve translucent pink and blue enamel panels by chased gold borders overlaid with enamelled roses. Fabergé had used a similar division of the decoration on the surface of the egg on two

earlier Imperial Easter Eggs, the Danish Palaces Egg of 1890 and the Twelve Monograms Egg of 1895. Some of the later eggs in the Kelch series were certainly inspired by those in the possession of the imperial family, such as the Bonbonnière Egg which Barbara Kelch would have seen at the 1902 exhibition to which she lent her so-called Pine Cone Egg.

The surprise which this egg once contained was already missing when it entered the Royal Collection in 1933. It is possible that it was sold separately from the egg when it left Russia, as appears to have been the case with some of the surprises now missing from Imperial Easter Eggs.

Barbara and Alexander Kelch legally separated in 1905 and Barbara left Russia to live in Paris. The fate of her Fabergé eggs is unclear until six were offered for sale by the Parisian jeweller Morgan in about 1920. They were then acquired by Zolotnitzky of À La Vieille Russie in Paris, who sold them to an American collector around 1928. The Kelch egg in the Royal Collection was not among these six and is presumed to have been brought out of Russia by Wartski.

Gold, enamel, diamonds. 9.5 × diameter 7 cm
Mark of Michael Perchin
RCIN 9032
PROVENANCE Commissioned by Barbara and Alexander Kelch, for Easter 1899; Wartski; from whom bought by King George V, 2 December 1933 (£275); by whom given to Queen Mary, Christmas 1933 (QMB, III, no. 89; QMPP, VIII, no. 59)
LITERATURE Fabergé, Proler & Skurlov 1997, p. 77
EXHIBITIONS QG 1962-3, no. 61 (13); London 1977d, no. F1; New York 1983, no. 112; QG 1985-6, no. 71; Zurich 1989, no. 198; St Petersburg/Paris/London 1993-4, no. 185, QG 1995-6, no. 278

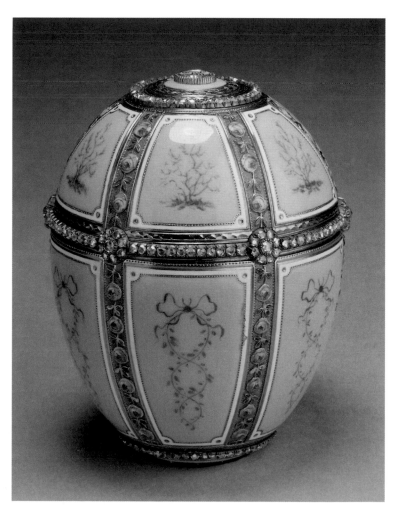

207 (enlarged)

Figures, animals, birds and reptiles (nos 208–233)

Carl Fabergé had a passion for the natural world, in particular ornithology, and his highly skilled craftsmen were capable of producing the most realistic and charming animal portraits. They selected the appropriate stone to simulate the feathers of a bird or the fur of an animal from the vast variety of hardstones available from the mines of Siberia, the Caucasus and the Urals. Fabergé cleverly incorporated tiny precious stones for the eyes of his animals. These range from diamonds, sapphires and rubies to olivines and were added not to increase monetary value as they are in themselves worthless chips, but to enliven the sculptures.

It seems likely that Fabergé drew inspiration for his animal carvings from objects he saw both during his apprenticeship across Europe in the 1860s and in the collections of the Hermitage in St Petersburg. In Germany he would have been aware of the centre for hardstone carving at Idar Oberstein and he was later to have some of his own stone supplies cut at the workshops there. He would also have seen pietra dura carving in Florence; closer to home he would have been aware of the tradition of hardstone carving in Russian centres such as Ekaterinburg.

In addition to Fabergé's use of a workshop in Idar Oberstein, a large proportion of Fabergé's hardstone was cut at Karl Woerffel's workshop in St Petersburg, which Fabergé later bought to ensure the quality of supply and production. The two most distinguished hardstone sculptors in Fabergé's employ were Derbyshev and Kremlev. The high level of demand for hardstone objects is indicated by the fact that twenty carvers were employed in Kremlev's workshop (see Tillander-Godenhielm et al. 2000). Fabergé went to great lengths to avoid repeating the same models for his animal carvings and to this end, each model was drawn in the stock books, given a reference and the drawing marked with a date of execution. His clients were clearly of the same view and Edward VII remarked 'we must not make any duplicates' when referring to the animal carvings he personally acquired (Bainbridge 1949, p. 101). Unlike the majority of objects produced by Fabergé, the hardstone animals are very rarely marked with the name of the workmaster. Only one such mark has been discovered, on a carving of a duck-billed platypus (RCIN 40298). Between 1911 and 1916 well over 30 per cent of the finished pieces from Wigström's workshop were hardstone carvings. However, there was a growing shortage of experienced carvers following the outbreak of the First World War. A number of miniature hardstone animals belonging to Grand Duchess Xenia Alexandrovna were exhibited in St Petersburg in 1902.

The single most important event in the formation of the royal Fabergé collection was Edward VII's decision in 1907 to commission for Queen Alexandra's birthday miniature sculptures of the animals kept at Sandringham. The original proposal – thought to have been suggested by Mrs Keppel, the King's mistress, and submitted by H.C. Bainbridge, the manager of Fabergé's London branch – was for portraits to be made of the favourite royal dogs and racehorses. However, Edward VII's great enthusiasm for the project resulted in many more of the domestic and farmyard animals being modelled, so that in total approximately one hundred carvings were made.

Fabergé sent his best sculptors from St Petersburg to Sandringham to model the animals, at first in wax. The team included Boris Frödman-Cluzel and Frank Lutiger, who had worked on numerous commissions for Fabergé. They stayed for several months, the length of their stay dictated not only by the number of animals to be modelled, but also by their painstaking study of each animal's character and behaviour. Once completed, the wax models were assembled in the Dairy at Sandringham for the King to approve personally, which he did after lunch on 8 December 1907. Bainbridge recalls the King's delight: 'please tell Mr Fabergé how pleased I am with all he has done for me' (Bainbridge 1949, pp. 103–04). The waxes were then despatched back to St Petersburg to be translated into hardstone carvings.

Most of the Sandringham animals appear to have entered the Royal Collection between 1908 and the King's death in May 1910. Bainbridge states that they were paid for (at an undisclosed sum) by the King or Queen and that on the arrival in London of all the pieces resulting from the commission, the balance were bought by the King as gifts for Queen Alexandra. However, it is known that some were gifts to the royal couple from close friends (see no. 209). In addition to the large group of domestic and farmyard animals, a miniature zoo of exotic animals was assembled by Edward VII and Queen Alexandra. In both cases the pieces conformed to the Queen's known preference for Fabergé's less flamboyant productions.

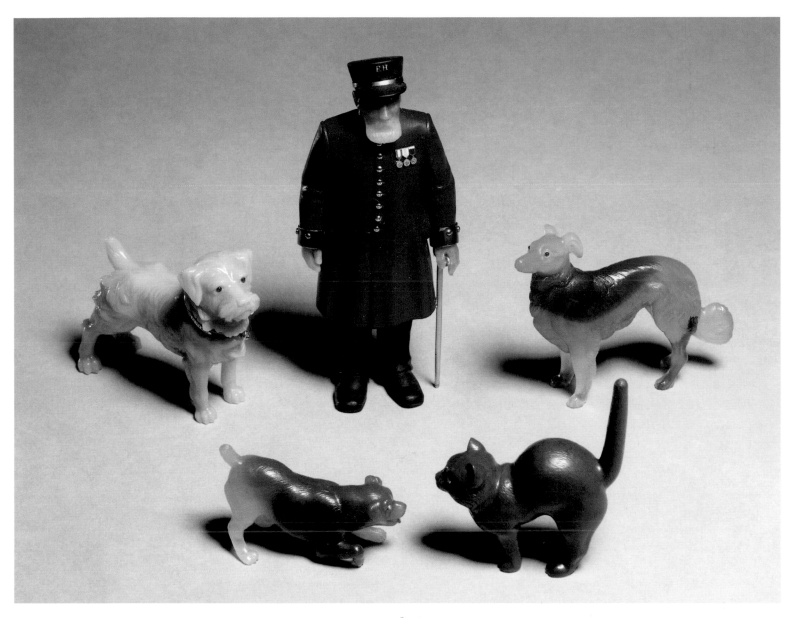

209 208 210
211 212

The animal collection continued to be enlarged in later reigns. Among King George V's earliest purchases from Fabergé's London branch were two monkeys and a donkey, bought on 17 November 1910. According to correspondence between Queen Mary (and members of her household) and Prince Vladimir Galitzine, between 1928 and 1930 Queen Mary purchased two parrots, a duck, a cockerel and an agate bird through Galitzine (archives of Princess George Galitzine).

208
Chelsea Pensioner, 1909

Carl Fabergé utilised the wealth of naturally occurring hardstones and the expertise of his craftsmen to produce a vast number of carved objects. These were principally of birds, animals, flowers and functional items, but also included a small number (no more than sixty altogether) of figurines. According to Bainbridge it was Grand Duke Nikolai Nikolaevich (1856–1929), the grandson of Tsar Nicholas I, who first suggested to Fabergé that he should make figurines. Sixteen were paid for by Tsar Nicholas II; others were purchased by Emanuel Nobel and the King of Siam. The names of the modellers are only known in a few cases, for example Georgi Konstantinovich Savitskii (1887–1947). Boris Frödman-Cluzel – who modelled several of the animals at Sandringham between December 1907 and February 1908 – is thought to have modelled at least two figures.

The majority of the figurines are of traditional Russian 'types' such as soldiers and ice-carriers. In addition actual portraits were made, for

example of the Dowager Empress Marie Feodorovna's kamer-kazak (personal bodyguard), which was assembled in Wigström's workshop. Bainbridge mentions that Fabergé made models of a few English 'types' such as a policeman and Alice in Wonderland. He refers to a 'Yeoman of the Guard' in the Sandringham collection, which is presumably identifiable with this Chelsea Pensioner, the only example of a Fabergé figure in the Royal Collection. Bainbridge also mentions that Lord Revelstoke, one of Fabergé's best customers, was the first to bring his figurines to London; Lord Revelstoke was a frequent traveller between St Petersburg and London and was a trusted friend and adviser to King George V.

The term 'Chelsea Pensioner' is derived from the 'in-pensioners' of the Royal Hospital, Chelsea, established by Charles II in 1682 for veteran soldiers of meritorious service.

Purpurine, aventurine-quartz, jasper, gun-metal, gold, enamel, sapphires.
11.2 × 4.5 × 2 cm
RCIN 40485
PROVENANCE Bought by Edward VII on his last visit to Fabergé's London branch, 22 November 1909 (£49 15s.)
LITERATURE Skurlov 1997, pp. 33–8
EXHIBITIONS London 1953d, no. 94; London 1967, no. 188; London 1977d, no. K5; New York 1983, no. 197; QG 1985–6, no. 115; Munich 1986–7, no. 385; QG 1995–6, no. 212

209
Caesar, c.1908

Edward VII's initial idea for the 1907 commission was for the favourite royal dogs and racehorses to be immortalised by Fabergé. Caesar, the King's beloved Norfolk terrier, would certainly have been one of the most important subjects to be modelled. Caesar was bred by the Duchess of Newcastle (c.1895) and of the many dogs that Edward VII owned – Basset hounds, Clumber spaniels, Chow Chows and French bulldogs – he was the favourite.

The King clearly doted on Caesar, who accompanied his master almost everywhere, even to Biarritz and Marienbad. When on 8 December 1907 the King unveiled to Queen Alexandra and the assembled guests at Sandringham the animals modelled in wax, Caesar accompanied the party to the Dairy where, among Fabergé's waxes, was his own likeness wearing a collar inscribed 'I belong to the King'.

Fabergé and his workmasters had the ability to imbue their models with personality and this expressive portrait certainly matches contemporary descriptions of the way Caesar would wag his tail and 'smile cheerfully' up into his master's eyes when Edward VII scolded him for misbehaving. Such was their mutual devotion that Caesar wandered the corridors of Buckingham Palace in search of his master for several days following the King's death on 6 May 1910. Caesar's final duty was to walk behind the King's coffin, led by a Highlander, in the funeral procession from Westminster to Paddington on 20 May 1910 (Magnus 1964, p. 456). The dog's portrait, painted at this time by Maud Earl and entitled *Silent Sorrow*, was published the following day in *The London Illustrated News*. Caesar died in 1914 and is buried in the grounds of Marlborough House in London. A carving of Caesar in marble sits at the feet of the King on his tomb in St George's Chapel, Windsor.

Chalcedony, gold, enamel, rubies. 5.1 × 6.5 × 2.2 cm
Inscribed on the collar I BELONG TO THE KING
RCIN 40339
PROVENANCE Commissioned by Edward VII, 1907; bought after the King's death by Mrs Greville at Fabergé's London branch, 29 November 1910 (£35); by whom given to Queen Alexandra
LITERATURE Bainbridge 1949, pp. 103–4; Hough 1992, p. 328; Habsburg & Lopato 1993, p. 129; Skurlov 1997, p. 35
EXHIBITIONS London 1953d, no. 21; London 1977d, no. A16; New York 1983, no. 70; QG 1985–6, no. 246; Munich 1986–7, no. 380; London 1992a; QG 1995–6, no. 345

210
Collie, c.1908

Traditionally thought to be a model of a collie, this could conceivably represent a Borzoi. There were examples of both breeds at Sandringham during the late nineteenth and early twentieth centuries. Queen Victoria had owned collies, notably one called Sharp. Queen Alexandra, who was a great dog-lover, kept both collies and Borzois with the larger breeds in the kennels at Sandringham. Borzois were exclusively bred for the Russian court during the late nineteenth and early twentieth centuries. The two most famous Borzois owned by Edward VII and Queen Alexandra (to whom they had previously been given by Tsar Alexander III) were Alex, of whom there is a painting in the Royal Collection by Benjamin Firth (RCIN 402320), and Vassilka, who was modelled and cast in silver by Fabergé (RCIN 40800).

The painting *Queen Alexandra with her grandchildren and dogs*, by Frederick Morgan and Thomas Blinks (RCIN 402302), shows the Queen outside the kennels at Sandringham in 1902, surrounded by a variety of dogs including a Borzoi and two collies. Contemporary accounts of the kennels by Lady Dorothy Nevill and Lord Knutsford describe how Queen Alexandra would feed the dogs with bread from a flat basket and knew each of the dogs' names and characters well.

Agate, rubies. 5.4 × 6.8 × 1.5 cm
RCIN 40030
PROVENANCE Probably commissioned by Edward VII, 1907
EXHIBITIONS London 1977d, no. A20; QG 1985–6, no. 233; QG 1995–6, no. 354

211
Border terrier, c.1908

The four dogs exhibited are part of a group of thirty-two Fabergé dogs in the Royal Collection. These appear to be mainly portrait studies, in some cases almost certainly modelled from life as part of the 1907 Sandringham commission. In addition to those exhibited, the identified canine portraits include Queen Alexandra's Pekinese and George, Prince of Wales's favourite French poodle Bobeche. Pekinese and pugs, of which there are several examples by Fabergé in the Royal Collection, were described as Queen Alexandra's favourite 'indoor dogs' and at Sandringham she was constantly surrounded by them, half a dozen at her side at any time.

The Border terrier, a breed which originated along the border between England and Scotland, was used as a working terrier until the

early twentieth century. It was almost certainly to be found among the many dogs kept at Sandringham.

Chalcedony, diamonds. 3.1 × 4.9 × 2.3 cm
RCIN 40444
PROVENANCE Probably commissioned by Edward VII, 1907
EXHIBITIONS London 1977d, no. A31; New York 1983, no. 71; QG 1985–6, no. 239; QG 1995–6, no. 320

212

Cat, c.1910

Jasper, gold, emeralds. 5.6 × 5 × 1.9 cm
RCIN 40294
PROVENANCE Possibly the cat bought by King George V from Wartski, 31 December 1929 (£15)
EXHIBITIONS London 1953d, no. 81; London 1977d, no. A14; New York 1983, no. 234; QG 1995–6, no. 321

213

Sandringham Lucy, c.1908

A charming and remarkably realistic portrait model of George V's Clumber spaniel Sandringham Lucy. The breed originated in France in the eighteenth century; it was first bred in England by the Duke of

Newcastle at Clumber Park, Nottinghamshire. This figure was modelled from life as part of the 1907 commission at Sandringham, where there were Clumber spaniels from the later nineteenth century, as shown in the painting by T. Jones Barker entitled A big shoot at Sandringham, 1867 (RCIN 402303). Both Edward VII and King George V used them for shooting.

Chalcedony, rubies. 4.4 × 10.5 × 3.6 cm
RCIN 40442
PROVENANCE Commissioned by Edward VII, 1907; bought by the Prince of Wales (later King George V) from Fabergé's London branch, 1909 (£102)
EXHIBITIONS London 1953d, no. 53; London 1977d, no. A24; New York 1983, no. 67; QG 1985–6, no. 255; QG 1995–6, no. 319

214

Turkey, c.1908

Obsidian, lapis lazuli, purpurine, gold, diamonds. 9.7 × 8.5 × 7.3 cm
Mark of Henrik Wigström; gold mark of 72 zolotniks (1908–17)
RCIN 40446
PROVENANCE Commissioned by Edward VII, 1907; bought by the Prince of Wales (later King George V) from Fabergé's London branch, 1909 (£55)
EXHIBITIONS London 1953d, no. 7; London 1977d, no. D21; New York 1983, no. 122; QG 1985–6, no. 262; QG 1995–6, no. 66

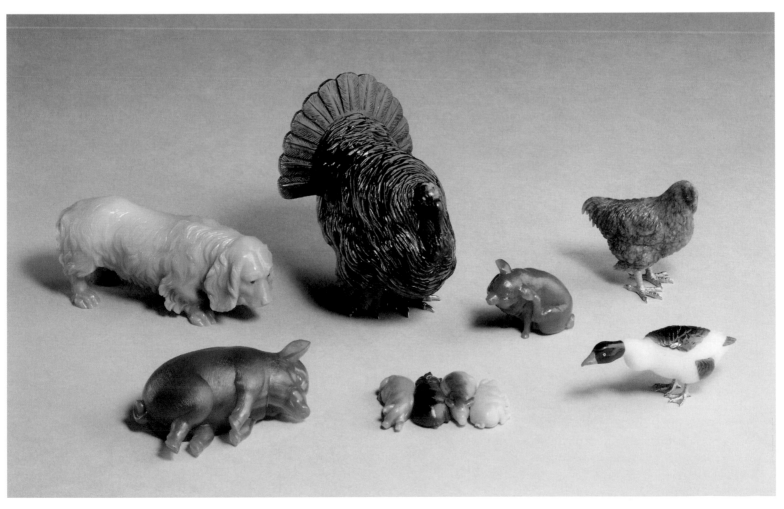

213 214 215 216
217 218 219

215
Seated pig, c.1908

The careful observation from nature of the Sandringham animals has resulted in many of them being 'caught' in characteristic poses. This is part of their charm and must have appealed to those who purchased them. There are several Fabergé carvings of pigs in the Royal Collection. With the other miniature animals acquired by Edward VII and Queen Alexandra, these were displayed by the Queen in two large glass cabinets in the Drawing Room at Sandringham.

Agate, diamonds. 3.5 × 4.1 × 2.1 cm
RCIN 40015
PROVENANCE Commissioned by Edward VII, 1907
EXHIBITIONS London 1977d, no. A42; New York 1983, no. 133; QG 1985–6, no. 293; QG 1995–6, no. 74

216
Hen, c.1908

This portrait study from the Sandringham commission combines the talent of the wax modeller in capturing the inquisitive nature of the hen, with the skill of the hardstone carver both in selecting the perfect stone and in carving and polishing it to simulate the sheen of the hen's feathers. Birbaum noted that the Sandringham carvings were generally made from natural coloured stones which matched the colouring of the bird or animal.

Agate, gold, diamonds. 5.9 × 5.1 × 2.9 cm
RCIN 40450
PROVENANCE Commissioned by Edward VII, 1907
LITERATURE Habsburg & Lopato 1993, p. 457
EXHIBITIONS London 1977d, no. D35; New York 1983, no. 118; QG 1985–6, no. 268; London 1992a; QG 1995–6, no. 76

217
Pig lying down, c.1908

Agate, diamonds. 3 × 7.4 × 4.7 cm
RCIN 40421
PROVENANCE Probably commissioned by Edward VII, 1907
EXHIBITIONS QG 1995–6, no. 75

218
Four piglets, 1896–1903

Although the carver has not marked the stone, the gold support beneath this piece bears the maker's mark of Michael Perchin. Many of the animal carvings in the Royal Collection appear to have been made during Wigström's period in charge of the workshops, but this group is one of an apparently small number made earlier in the workshop of Michael Perchin, Fabergé's head workmaster between 1886 and 1903. Another similar group of piglets is known, carved by the same workmaster but in a different stone.

Chalcedony, gold. 0.9 × 5.2 × 3.8 cm
Mark of Michael Perchin; gold mark of 56 zolotniks (1896–1908)
RCIN 40038
PROVENANCE Acquired before 1953
EXHIBITIONS London 1953d, no. 110; London 1977d, no. A36; New York 1983, no. 131; QG 1985–6, no. 292; London 1992a; QG 1995–6, no. 84

219
Goose, 1911

The design for this goose, exactly as executed and with the date 1911, appears in the album from the workshop of Henrik Wigström (Tillander-Godenhielm *et al.* 2000, p. 78). The Royal Collection also contains another model of a similar goose from the Sandringham commission, also made by Wigström's workshop (RCIN 40340).

Quartzite, obsidian, gold, diamonds. 3 × 7 × 2.3 cm
Mark of Henrik Wigström; gold mark of 72 zolotniks (1908–17)
RCIN 40323
PROVENANCE Commissioned by Edward VII, 1907
LITERATURE Tillander-Godenhielm *et al.* 2000, p. 78
EXHIBITIONS London 1953d, no. 93; London 1977d, no. D7; New York 1983, no. 120; QG 1985–6, no. 271 or 272; QG 1995–6, no. 116

220
Dormouse, c.1910

Chalcedony, platinum, gold, sapphires. 6.2 × 5.2 × 5.8 cm
RCIN 40261
PROVENANCE Bought by Queen Alexandra from Fabergé's London branch, 5 November 1912 (£33)
EXHIBITIONS London 1953d, no. 92; London 1977d, no. B25; New York 1983, no. 168; QG 1985–6, no. 263; St Petersburg/Paris/London 1993–4, no. 88; QG 1995–6, no. 315

221
Snail, c.1910

Occasionally different stones were combined by the carvers to give the most realistic effect possible, a technique described by Birbaum as 'mosaic sculpture'. Here the carving and polishing of the combined

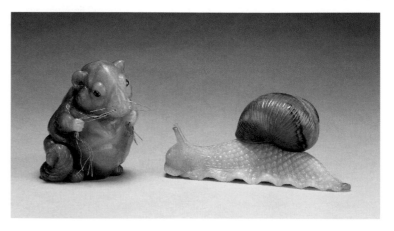

220 221

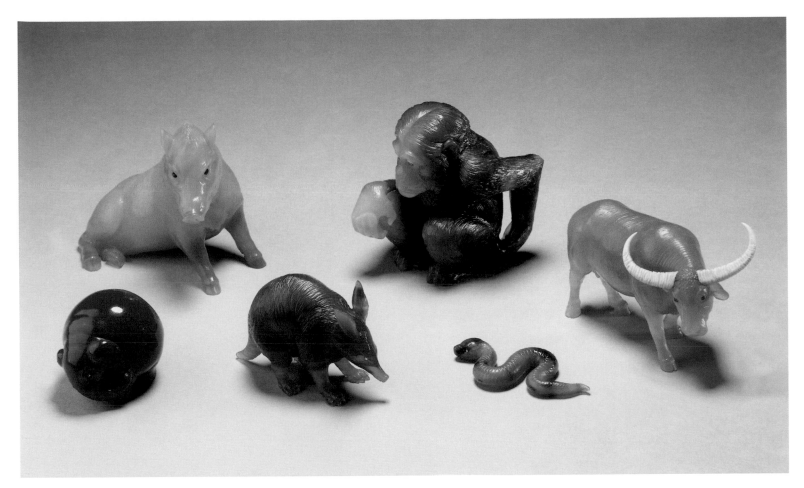

222 223
224 225 226 227

hardstones immediately evoke both the shiny hard surface of the snail's shell and the soft flesh of its body.

Chalcedony, jasper. 4.5 × 10 × 3.7 cm
RCIN 40254
PROVENANCE Probably commissioned by Edward VII, 1907
EXHIBITIONS London 1953d, no. 98; London 1977d, no. B8; New York 1983, no. 155; QG 1985–6, no. 259; QG 1995–6, no. 8

222
Wild boar, c.1908

Chalcedony, rubies. 6.7 × 8.6 × 5 cm
RCIN 40260
PROVENANCE Bought by the Prince of Wales (later King George V) from Fabergé's London branch, December 1909 (£31)
EXHIBITIONS London 1977d, no. B13; QG 1985–6, no. 213; QG 1995–6, no. 331

223
Chimpanzee, c.1910

One of several carvings of apes in the collection, this one has a pose that is particularly expressive. The stone carver has made best use of the natural striations in the single piece of agate to suggest variations in the texture of fur and the animal's colouring.

Agate, olivines. 7.5 × 6.2 × 7.6 cm
RCIN 40377
PROVENANCE Probably acquired by Edward VII; Queen Mary, by 1949
EXHIBITIONS London 1953d, no. 5; London 1977d, no. C1; New York 1983, no. 177; QG 1985–6, no. 167; QG 1995–6, no. 196

224
Elephant, c.1910

It was necessary for Fabergé's sculptors to keep the carving dense to ensure that the fragile stone did not fracture. As Fabergé's designer Birbaum mentions in his memoirs when describing animal carvings: 'it should be said that the pose was always as compact as possible, as dictated by the technique of the material' (Habsburg & Lopato 1993, p. 459). The stylised carving also clearly demonstrates Fabergé's interest in Japanese netsuke carving. Departures from naturalistic-looking animal carvings were not uncommon with Fabergé. They add a humorous quality, such as this red elephant; blue rabbits and green dogs also exist in the collection.

Unlike the majority of Fabergé's animals, his elephant models were occasionally repeated, presumably due to their popularity. Countess Torby, the morganatic wife of Grand Duke Michael Mikhailovitch (1878–1918), formed a collection specifically of Fabergé's elephants. Fabergé also produced elephant automata in silver. An elephant which walks and wags its head and trunk was presented to King George V for Christmas 1929 by his family (RCIN 40486).

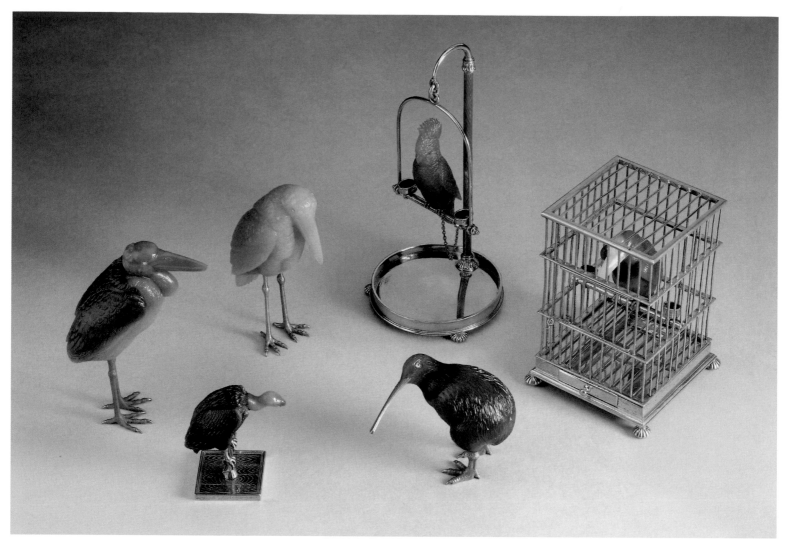

228 229 231 232
233 230

Purpurine, diamonds. 3.7 × 3.9 × 4.5 cm
RCIN 40270
PROVENANCE Bought by Queen Alexandra from Fabergé's London branch,
24 December 1912 (£11)
EXHIBITIONS London 1977d, no. C15; QG 1985–6, no. 187; QG 1995–6, no. 514

225
Aardvark, c.1910

Agate, diamonds. 4.3 × 6.8 × 2.8 cm
RCIN 40471
PROVENANCE Bought by King George V from Fabergé's London branch,
25 November 1914 (£18)
EXHIBITIONS London 1977d, no. C32; QG 1985–6, no. 194; London 1992a;
QG 1995–6, no. 330

226
Snake, c.1910

Agate, diamonds. 0.6 × 5.7 × 2.6 cm
RCIN 40253
PROVENANCE Queen Mary, by 1949
EXHIBITIONS London 1953d, no. 66; London 1977d, no. B12; New York 1983,
no. 156; QG 1985–6, no. 220; London 1992a; QG 1995–6, no. 7

227
Water buffalo, c.1913

Chalcedony, ivory, rubies. 5.9 × 8.4 × 3.3 cm
RCIN 40388
PROVENANCE Bought by King George V from Fabergé's London branch,
13 November 1913 (£41; RA PP/GV/3/3/810)
EXHIBITIONS London 1953d, no. 11; London 1977d, no. B16; QG 1985–6,
no. 171; QG 1995–6, no. 291

228
Marabou stork, 1903–08

Carl Fabergé's ornithological studies range from ordinary domestic birds
to the most exotic breeds. The models are realistically carved but their
charm lies in their vaguely humorous quality. As with the animal
carvings, in spite of the number produced it is very rare to find
identical models.

Agate, gold, diamonds. 9.3 × 6.2 × 3.1 cm
Mark of Henrik Wigström; gold mark of 56 zolotniks (1896–1908)
RCIN 40463
PROVENANCE Acquired before 1953

EXHIBITIONS London 1977d, no. D1; New York 1983, no. 92; QG 1985–6, no. 108; QG 1995–6, no. 6

229
Marabou stork, 1908–17

Many of the bird carvings have gold legs, which made it possible for the workmaster responsible to mark his work. This bird was made under Henrik Wigström's supervision. The stone carving would have been produced to Fabergé's design in the stone-carving workshop, under the direction of the manager Peter Kremlev, and then sent for mounting to Wigström's workshop. A system of internal invoicing was in operation between the workshops of Kremlev and Wigström for the cost of preparing the stone (Tillander-Godenhielm et al. 2000, p. 36).

Chalcedony, gold, diamonds. 8.7 × 5.1 × 3 cm
Mark of Henrik Wigström; gold mark of 72 zolotniks (1908–17)
RCIN 40462
PROVENANCE Acquired before 1953
EXHIBITIONS London 1977d, no. D2; QG 1985–6, no. 107; QG 1995–6, no. 32

230
Kiwi, 1908–17

Agate, gold, diamonds. 5.5 × 5.3 × 4.5 cm
Mark of Henrik Wigström; gold mark of 72 zolotniks (1908–17)
RCIN 40342
PROVENANCE Acquired before 1953
EXHIBITIONS London 1977d, no. D47; New York 1983, no. 96; QG 1985–6, no. 106; QG 1995–6, no. 38

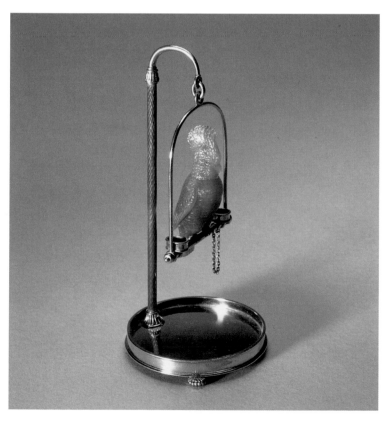

231
Cockatoo on a hanging perch, c.1900

Although the inspiration for this carving cannot be confirmed, Queen Alexandra kept a cockatoo in her own apartments at Marlborough House. There are two other carvings of cockatoos by Fabergé in the Royal Collection (RCIN 40478, 40480), one on a perch and one in a cage. In addition there are carvings of a parrot and a pair of budgerigars, both on perches.

Agate, gold, enamel, silver-gilt, olivines. 13.5 × 6.3 × 6.2 cm
Mark of Michael Perchin; silver mark of 88 zolotniks (1896–1908); FABERGÉ in Cyrillic characters
RCIN 40483
PROVENANCE Acquired before 1953
EXHIBITIONS London 1977d, no. D39; New York 1983, no. 188; QG 1985–6, no. 93; QG 1995–6, no. 450

232
Hornbill in a cage, c.1900

A humorous carving of a hornbill on a perch with two feeding bowls, the bird made from a single piece of hardstone.

Chalcedony, gold, silver-gilt, diamonds. 9.2 × 6.4 × 6.4 cm
Mark of Michael Perchin; silver mark of 88 zolotniks (1896–1908); FABERGÉ in Cyrillic characters
RCIN 40479
PROVENANCE Acquired before 1953
EXHIBITIONS London 1953d, no. 77; London 1967, no. 188; London 1977d, no. D33; New York 1983, no. 72; QG 1985–6, no. 99; St Petersburg/Paris/London 1993–4, no. 89; QG 1995–6, no. 447

233
Vulture on a perch, c.1900

One of a number of studies of birds on perches or in cages in the Royal Collection, three of which are exhibited here (see also nos 231 and 232). All three are from Perchin's workshop and therefore pre-date the Sandringham commission. It is not known who acquired them.

Obsidian, agate, gold, silver-gilt, diamonds. 4.7 × 4.2 × 2.7 cm
Mark of Michael Perchin; silver mark of 88 zolotniks (1896–1908); FABERGÉ in Cyrillic characters
RCIN 40275
PROVENANCE Acquired before 1953
EXHIBITIONS London 1977d, no. D58; New York 1983, no. 85; QG 1985–6, no. 98; St Petersburg/Paris/London 1993–4, no. 90; QG 1995–6, no. 12

FLOWERS AND PLANTS (nos 234–258)

Fabergé's flower studies demonstrate particularly well the combined skills of lapidary, goldsmith and jeweller, especially in the selection of the right stone to represent a leaf or berry, in the carving and polishing of the rock crystal pots which appear to be glasses filled with water, and in the choice of tiny gemstones that form the flower centres. The production of flowers was not restricted to a specific workmaster and several are known to have produced these objects. However, of the seven in the Royal Collection which are marked, six are by Wigström.

The sources for Fabergé's flower studies were four-fold. His love of nature was probably the primary stimulus for producing these studies. There was an album of photographs of flowers in the workshops in Bolshaya Morskaya Street, which would have been used as a source of reference. No doubt he also realised that they could serve as a permanent reminder of spring and warmer weather during the long Russian winters.

Secondly, Fabergé was clearly influenced by the eighteenth-century jewelled bouquets made for use at court, which he would have seen during his apprenticeship in France and also in the Hermitage. From the 1870s Carl Fabergé acted as an appraiser at the Hermitage and also carried out repairs there free of charge. He is known to have repaired a flower bouquet made by the court jeweller Jérémie Pauzié in the Hermitage collection. Fabergé's work in the Hermitage would also have introduced him to the hardstone flower carvings produced in the Ekaterinburg and Peterhof lapidary works.

The influence of oriental art on his flower studies is recorded by Franz Birbaum, who notes that Fabergé first became aware of Chinese flower carvings when a bouquet of chrysanthemums was brought in for repair in the 1890s. However, he also adds that Fabergé's earliest flower studies pre-date his work on the Chinese bouquet. One such example is the raspberry plant which was given to Queen Victoria in 1894 by her Lord Chamberlain. In fact it seems that Fabergé made flowers even before the 1890s: 'a hibiscus flower priced at 8,500 roubles' was among the objects exhibited by Fabergé in Moscow in 1882 (Habsburg & Lopato 1993, p. 58).

The skill and time required to make such pieces was reflected in the cost of manufacture and the sale prices, which were considerable. For the more elaborate models, according to Birbaum, the cost was as much as several thousand roubles. These incredibly delicate objects are held together with great precision by stalks and stamens of finely engraved and chased dull gold. The flower studies are usually unmarked as the gold was felt to be too fragile to punch. This has made their identification difficult, particularly in the light of later copies by other makers or of other flowers produced by contemporaries and competitors such as Cartier. While their realism is remarkable, it is clear that Fabergé considered decorative quality more important than botanical accuracy – no. 239, for example, features both blossom and fruit, which could not have been available for Fabergé to study at the same time. On rare occasions Fabergé repeated a plant or flower study. Among the present selection, duplicates are known for the wild strawberry (no. 237), the raspberry (no. 238), the rowan (no. 241), and the lily of the valley (no. 247).

The Fabergé flowers in the Royal Collection represent one of the largest collections ever formed, numbering twenty-seven (including two in the collection of Her Majesty Queen Elizabeth The Queen Mother), from the total of about eighty that he made. The principal collectors were Queen Alexandra, her daughter Princess Victoria and her daughter-in-law Queen Mary.

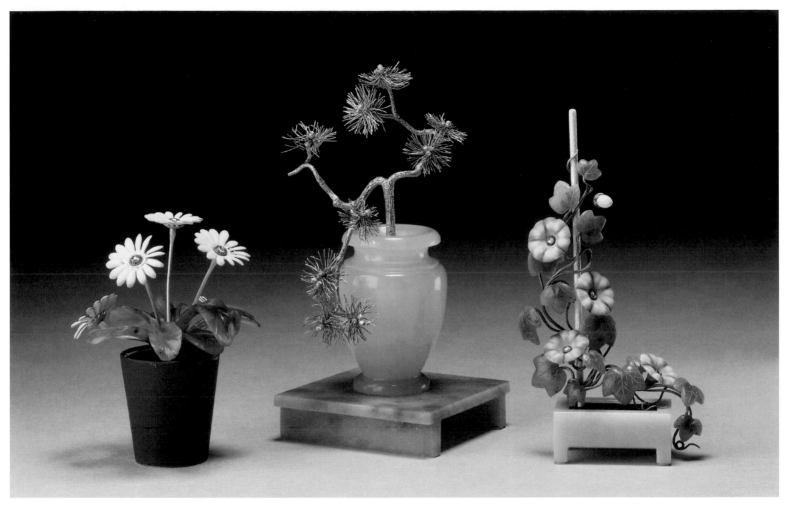

234 235 236

234
Field daisies, 1903–08

Nos 234–6 are unusual in Fabergé's flower studies as they are displayed in a metal or hardstone vase, trough or pot rather than Fabergé's usual rock crystal vases. It was therefore easier for the workmaster to add his mark.

Silver, gold, enamel, nephrite, diamonds. 7.5 × diameter 5.5 cm
Mark of Henrik Wigström; silver mark of 88 *zolotniks* (1896–1908); FABERGÉ in Cyrillic characters
RCIN 40211
PROVENANCE Probably acquired by Queen Alexandra; Royal Collection by 1953
EXHIBITIONS London 1953d, no. 51; London 1977d, no. E19; New York 1983, no. 5; QG 1985–6, no. 127; QG 1995–6, no. 154

235
Pine tree, c.1908

The influence of oriental art on Fabergé's work is notable in both his animal studies and his botanical works. This Japanese-style dwarf pine tree is traditionally thought to have been modelled from nature at Sandringham.

Bowenite, aventurine-quartz, gold. 12.3 × 6.2 × 5.8 cm
RCIN 40186

PROVENANCE Commissioned by Edward VII, 1907; bought by the Prince of Wales (later King George V) from Fabergé's London branch, 14 December 1908 (£52)
LITERATURE Bainbridge 1949, p. 95
EXHIBITIONS London 1953d, no. 43; London 1977d, no. E13; New York 1983, no. 28; QG 1985–6, no. 162; QG 1995–6, no. 528

236
Convolvulus, c.1900

It may be no coincidence that this charming miniature of one of the gardener's greatest enemies, the bindweed, formerly belonged to the *doyenne* of twentieth-century English garden writers, Vita Sackville-West (the Hon. Mrs Harold Nicolson; 1892–1962).

Photographs of this piece soon after its acquisition by Queen Mary show it mounted on a hardstone base described as being of white jade. This no longer survives.

Bowenite, gold, nephrite, enamel, diamond. 11.1 × 6.5 × 2.5 cm
RCIN 8943
PROVENANCE Bought by [–] Sackville-West from Fabergé's London branch, 30 March 1908 (£35); the Hon. Mrs Harold Nicolson; Sir Bernard Eckstein; presented by the Royal Family to Queen Mary on her birthday, 26 May 1949 (QMPP, XI, no. 71)
LITERATURE Bainbridge 1949, pl. 78
EXHIBITIONS London 1977d, no. E3; New York 1983, no. 49; QG 1985–6, no. 161; QG 1995–6, no. 213

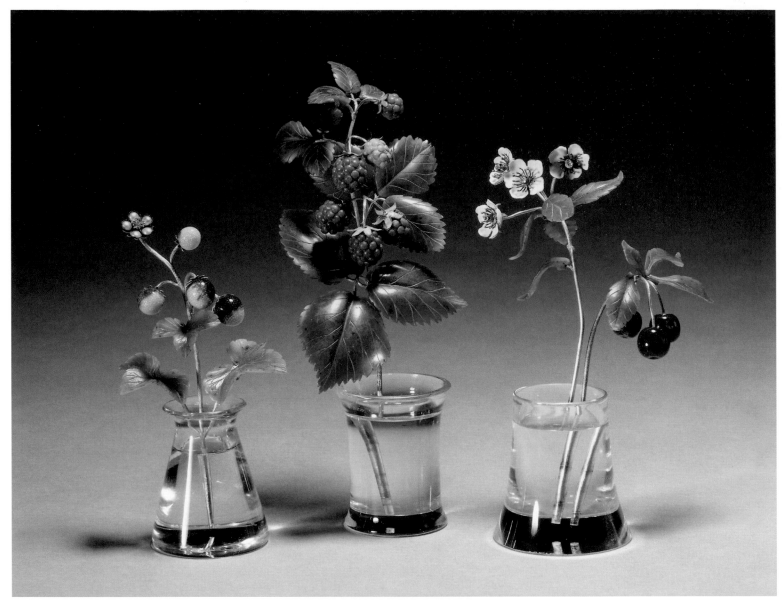

237 238 239

237
Wild strawberry, c.1900

On rare occasions Fabergé made more than one version of some of the plant or flower studies. There is an almost identical version of this group in the Wernher collection.

Rock crystal, gold, nephrite, enamel, pearl. 11.5 × 6 × 4.3 cm
RCIN 9123
PROVENANCE Probably acquired by Queen Alexandra
EXHIBITIONS QG 1995–6, no. 208

238
Raspberry, c.1900

One of two Fabergé raspberries (with RCIN 40176) in the Royal Collection. A third raspberry plant, given to Queen Victoria by Lord Carrington in 1894, was a different size; it cannot be traced today.

Rock crystal, gold, nephrite, rhodonite. 15.9 × 7.8 × 6.7 cm
RCIN 40251
PROVENANCE Acquired by Queen Alexandra, date unknown
LITERATURE Bainbridge 1949, p. 95
EXHIBITIONS London 1953d, no. 37; London 1977d, no. E9; QG 1985–6, no. 17; QG 1995–6, no. 129

239
Wild cherries, c.1900

Rock crystal, gold, nephrite, purpurine, enamel, diamonds. 13.5 × 9.2 × 4.8 cm
RCIN 40218
PROVENANCE Acquired by Queen Alexandra, date unknown
LITERATURE Bainbridge 1949, p. 95
EXHIBITIONS London 1953d, no. 45; London 1977d, no. E17; New York 1983, no. 4; QG 1985–6, no. 10; London 1992a; QG 1995–6, no. 122

240
Holly sprig, 1903–08

Rock crystal, gold, nephrite, purpurine. 14.1 × 8 × 8 cm
Mark of Henrik Wigström; gold mark of 72 zolotniks (1896–1908); FABERGÉ in
Cyrillic characters
RCIN 40501
PROVENANCE Bought by Hon. Mrs George Keppel from Fabergé's London branch,
1908 (£43); apparently given to Queen Alexandra
LITERATURE Bainbridge 1949, p. 95
EXHIBITIONS London 1953d, no. 39; London 1977d, no. E21; New York 1983,
no. 15; QG 1985–6, no. 7; QG 1995–6, no. 210

241
Rowan tree, c.1900

The rowan is one of the few models which is known to have been
repeated by Fabergé.

Rock crystal, gold, nephrite, purpurine. 22.5 × 20.5 × 7.5 cm
RCIN 40508
PROVENANCE Queen Alexandra; by whom bequeathed to Princess Victoria
(1868–1935); King George V
LITERATURE Bainbridge 1949, p. 95

EXHIBITIONS London 1953d, no. 50; London 1977d, no. E4; New York 1983,
no. 16; QG 1985–6, no. 9; London 1992a; QG 1995–6, no. 119

242
Cranberry, c.1900

In this study, the cornelian and chalcedony evoke the translucent quality
of the berries.

Rock crystal, gold, nephrite, cornelian, chalcedony. 12.2 × 6.2 × 4 cm
RCIN 40250
PROVENANCE Probably acquired by Queen Alexandra
EXHIBITIONS London 1953d, no. 30; London 1977d, no. E20; New York 1983,
no. 62; QG 1985–6, no. 8; QG 1995–6, no. 209

243
Branch with berries, c.1900

Rock crystal, gold, enamel, nephrite. 8 × 5.5 × 5 cm
RCIN 8953
PROVENANCE Probably acquired by Queen Alexandra
EXHIBITIONS QG 1995–6, no. 124

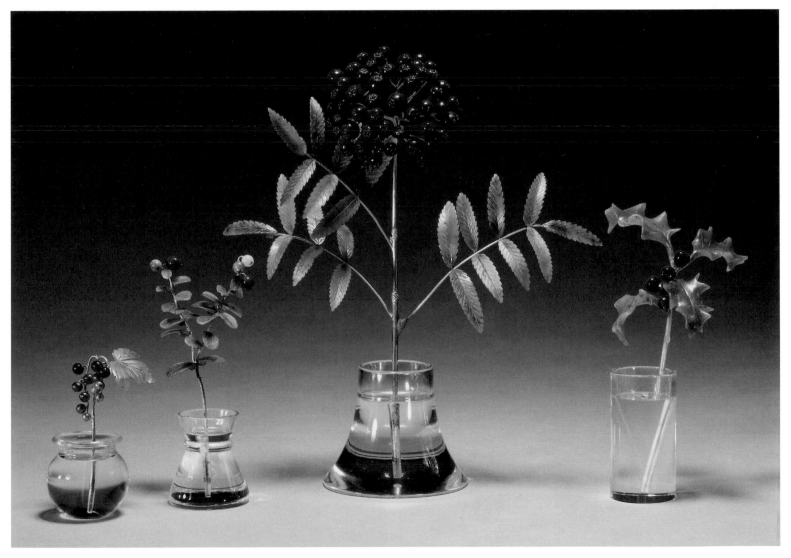

243 242 241 240

244
Pansy, 1903–08

One of three studies of pansies by Fabergé in the Royal Collection (see nos 245, 246), this flower bears the mark of Henrik Wigström. The books of Wigström's workshop contain the design for a similar pansy flower head; this was apparently executed some years after no. 244, in April 1912. Michael Perchin had earlier produced the Art Nouveau style Imperial Pansy Egg of 1899 and in 1903 he designed a miniature frame in the form of a pansy flower. This has a mechanism which, when released, opens the petals to reveal miniature portraits of the five children of Tsar Nicholas II and Tsarina Alexandra Feodorovna (Moscow, Kremlin Armoury Museum).

All three of the pansy flower groups in the Royal Collection combine the same purple and yellow colours of enamel. The similar treatment of the petals with the variations in tone and combination of matt and polished enamel suggest that they may all have originated in Wigström's workshop.

Rock crystal, nephrite, gold, enamel, diamond. 10.1 × 5.3 × 5 cm
Mark of Henrik Wigström; gold mark of 72 zolotniks (1896–1908); Fabergé in Cyrillic characters
RCIN 40180
PROVENANCE Acquired before 1953
LITERATURE Tillander-Godenhielm et al. 2000, pl. 77
EXHIBITIONS London 1953d, no. 36; London 1977d, no. E15; New York 1983, no. 24; QG 1985–6, no. 1; QG 1995–6, no. 130

245
Pansy, c.1900

Rock crystal, gold, enamel, nephrite, diamond. 15.2 × 10.2 × 4.6 cm
RCIN 40505
PROVENANCE Acquired before 1953
EXHIBITIONS London 1953d, no. 31; London 1977d, no. E14; QG 1985–6, no. 3

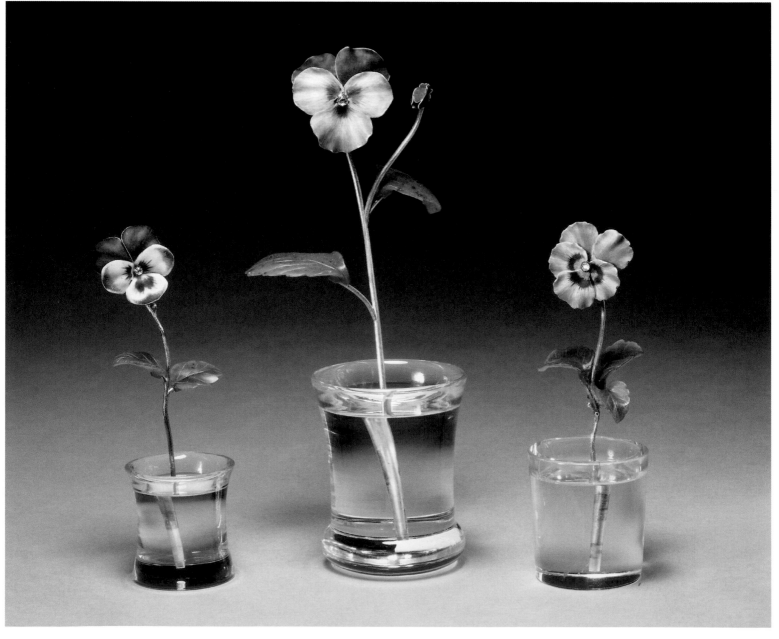

244 245 246

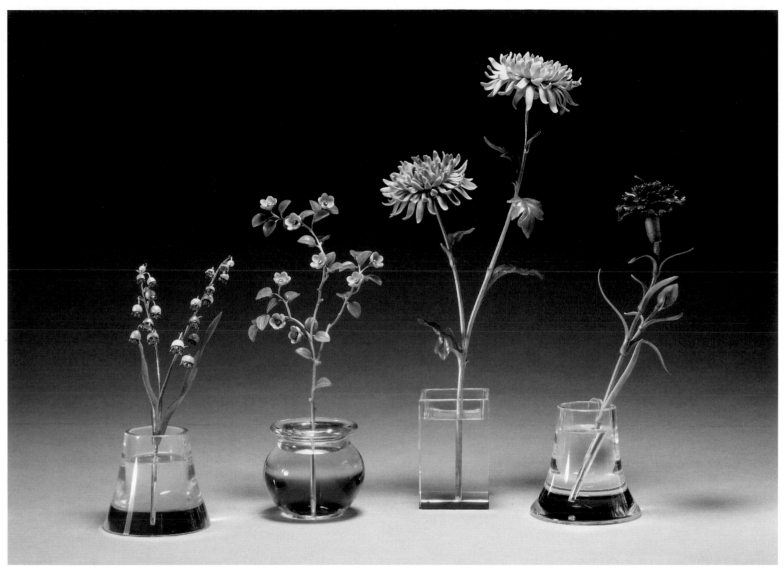

247 248 249 250

246
Pansy, c.1900

Rock crystal, gold, enamel, nephrite, diamond. 10.2 × diameter 3.3 cm
RCIN 40210
PROVENANCE Acquired before 1953
EXHIBITIONS London 1953d; London 1992a; QG 1995–6, no. 132

247
Lilies of the valley, c.1900

Fabergé made several studies of lilies of the valley, reputed to have been the favourite flower of Tsarina Alexandra Feodorovna. These range from the basket of lilies of the valley presented to Tsarina Alexandra Feodorovna in 1896 to the Lily of the Valley Imperial Easter Egg of 1898.

Rock crystal, gold, nephrite, pearls, diamonds. 14.5 × 7.8 × 5.5 cm
RCIN 40217
PROVENANCE Queen Alexandra; by whom bequeathed to Princess Victoria (1868–1935); King George V

EXHIBITIONS London 1953d, no. 33; London 1977d, no. E8; New York 1983, no. 66; QG 1985–6, no. 15; QG 1995–6, no. 120

248
Japonica, c.1907

Stanislas Poklewski-Koziell, who purchased this flower model and no. 249, was 'perhaps the most prolific present giver the world has ever seen' (Bainbridge 1949, p. 83). He was a councillor at the Russian Embassy in London and a great friend of Edward VII, and it is assumed that he gave this flower to Queen Alexandra.

Rock crystal, gold, nephrite, enamel, diamonds. 16.8 × 9 × 5.5 cm
Mark of Henrik Wigström; gold mark of 72 zolotniks (1896–1908); FABERGÉ in Cyrillic characters
RCIN 40504
PROVENANCE Bought by Stanislas Poklewski-Koziell from Fabergé's London branch, October 1907 (£52 5s.); probably presented to Queen Alexandra
EXHIBITIONS London 1953d, no. 49; London 1977d, no. E2; New York 1983, no. 18; QG 1985–6, no. 55; QG 1995–6, no. 134

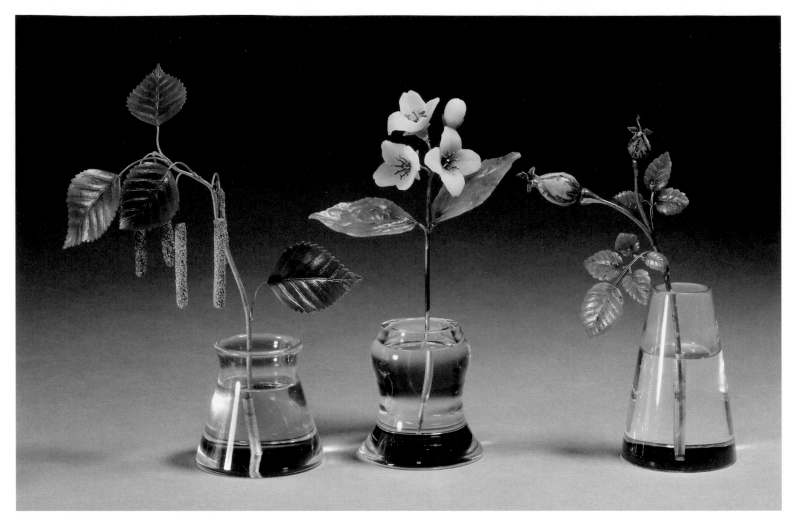

251 252 253

249
Chrysanthemum, c.1908

Rock crystal, gold, nephrite, enamel. 24.6 × 11.3 × 7 cm
Mark of Henrik Wigström; gold mark of 72 zolotniks (1908–17); FABERGÉ in Cyrillic characters
RCIN 40506
PROVENANCE Bought by Stanislas Poklewski-Koziell from Fabergé's London branch, 27 December 1908 (£117); by whom given to Queen Alexandra
LITERATURE Bainbridge 1949, p. 95
EXHIBITIONS London 1953d, no. 42; London 1977d, no. E7; New York 1983, no. 3; QG 1985–6, no. 133; London 1992a; QG 1995–6, no. 127

250
Carnation, c.1903

A remarkably realistic study which illustrates the painstaking work involved in achieving exactly the right combination of colour, shape and translucence and opaque sheen for the papery petals. Unusually, the stem is marked and indicates that the flower was produced in Wigström's workshop.

Rock crystal, gold, enamel. 17.7 × 7.5 × 5.7 cm
Mark of Henrik Wigström; date marks illegible; FABERGÉ in Cyrillic characters
RCIN 40503

PROVENANCE Acquired before 1953
EXHIBITIONS London 1953d, no. 44; London 1977d, no. E1; New York 1983, no. 38; QG 1985–6, no. 6; QG 1995–6, no. 131

251
Catkins, c.1900

This flower was made in the workshop of Fedor Afanassiev, who specialised in producing small *objets d'art* such as miniature Easter Eggs and picture frames. It is an interesting example of the use of different coloured golds, the matt red gold of the stems contrasting with the powdery yellow spun gold of the flowers.

Rock crystal, gold, nephrite. 13.2 × 11.7 × 5 cm
Mark of Fedor Afanassiev; gold mark of 56 zolotniks
RCIN 40507
PROVENANCE Acquired by Queen Alexandra, date unknown
LITERATURE Bainbridge 1949, p. 95
EXHIBITIONS London 1953d, no. 38; London 1977d, no. E11; New York 1983, no. 17; QG 1985–6, no. 14; London 1992a; QG 1995–6, no. 128

252
Philadelphus, c.1900

While the majority of Fabergé's flowers have enamelled petals, this study has carved hardstone flowerheads. Another example of the use of hardstone to replicate petals is the bleeding heart study (no. 256).

Rock crystal, gold, nephrite, quartzite, olivine. 14.2 × 7 × 9 cm
FABERGÉ in Cyrillic characters
RCIN 40252
PROVENANCE Acquired by Queen Alexandra, date unknown
LITERATURE Bainbridge 1949, p. 95
EXHIBITIONS London 1953d, no. 48; London 1977d, no. E16; New York 1983, no. 2; QG 1985–6, no. 4; QG 1995–6, no. 121

253
Rosebuds, c.1900

Rock crystal, gold, enamel, nephrite. 12.3 × 7.7 × 4.5 cm
RCIN 40216

PROVENANCE Acquired by Queen Alexandra, date unknown
LITERATURE Bainbridge 1949, p. 95
EXHIBITIONS London 1953d, no. 47; London 1977d, no. E12; New York 1983, no. 39; QG 1985–6, no. 11; QG 1995–6, no. 133

254
Cornflowers and buttercups, c.1900

Fabergé produced flower studies of both cornflowers and ranunculus individually. In this example they are combined and, unusually, a jewelled enamel bee is added to the group.

Rock crystal, gold, enamel, diamonds, rubies. 22.3 × 14 × 8 cm
RCIN 100011
PROVENANCE HM Queen Elizabeth The Queen Mother, by 1953
EXHIBITIONS London 1953d, no. 123; London 1971, no. 139; London 1977d, no. F9; New York 1983, no. 27; QG 1985–6, no. 13; Munich 1986–7, no. 394; London 1987; QG 1995–6, no. 137

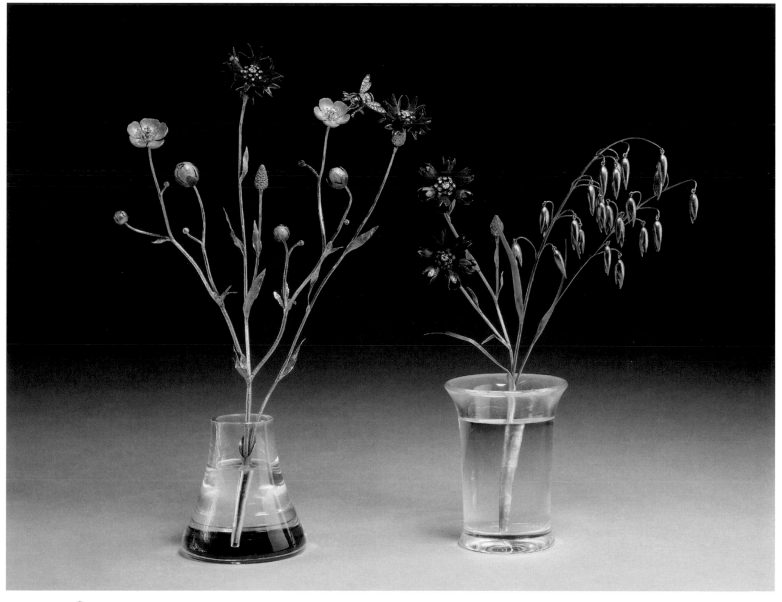

254 255

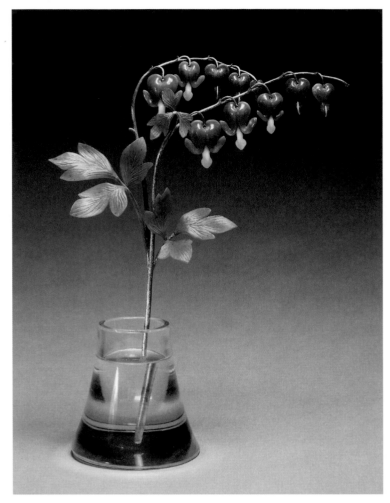

256

255
Cornflowers and oats, c.1900

In 1944 Queen Mary contributed to the purchase of 'a pretty Fabergé cornflower' for Queen Elizabeth to cheer up her shelter room at Buckingham Palace during the Second World War. Queen Elizabeth was delighted with the present and described it as 'a charming thing, and so beautifully unwarlike' (RA GV/CC 13/93 and 13/97). The oats are particularly well modelled and the husks are attached in such a way as to allow movement, thereby adding to their realistic quality.

A variant of this study exists in the Hermitage collection, indicating the way in which Fabergé satisfied the demand for certain models from his customers.

Rock crystal, gold, enamel, diamonds. 18.5 × 12.3 × 8.5 cm
RCIN 100010
PROVENANCE Bought from Wartski by Queen Mary and others, 27 June 1944; by whom presented to HM Queen Elizabeth The Queen Mother
EXHIBITIONS London 1949, no. 4; London 1971, no. 141; London 1977d, no. F8; New York 1983, no. 26; QG 1985–6, no. 12; Munich 1986–7, no. 399; London 1987; QG 1995–6, no. 135

256
Bleeding heart, c.1900

In the late 1920s and 1930s Queen Mary was actively trying to purchase Fabergé flowers; this piece appears in a list of items obtained by her in 1934 (archives of Princess George Galitzine). Curiously, Bainbridge appears to have been mistaken about its provenance since he stated that it had been in Queen Alexandra's collection.

Rock crystal, gold, nephrite, rhodonite, quartzite. 19 × 15.3 × 6.2 cm
RCIN 40502
PROVENANCE Acquired by Queen Mary, 1934 (QMB, III, no. 220; QMPP, VIII, no. 103)
LITERATURE Bainbridge 1949, p. 95
EXHIBITIONS London 1953d, no. 32; London 1977d, no. E6; New York 1983, no. 1; QG 1985–6, no. 18; QG 1995–6, no. 118

257
Wild rose, c.1900

Rock crystal, gold, nephrite, enamel, diamonds. 14.6 × 5.9 × 4 cm
RCIN 40223
PROVENANCE Acquired before 1953
EXHIBITIONS QG 1995–6, no. 125

258
Wild roses, c.1900

Rock crystal, gold, enamel, nephrite, diamonds. 14.8 × 7.8 × 6.4 cm
RCIN 8958
PROVENANCE Acquired before 1953
EXHIBITIONS QG 1995–6, no. 123

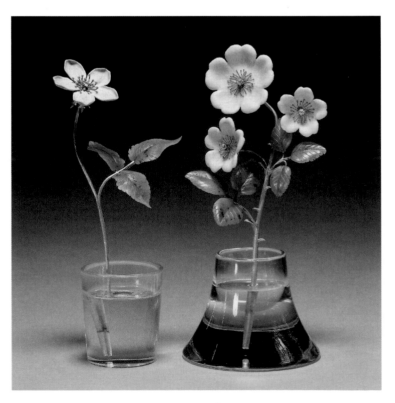

257 258

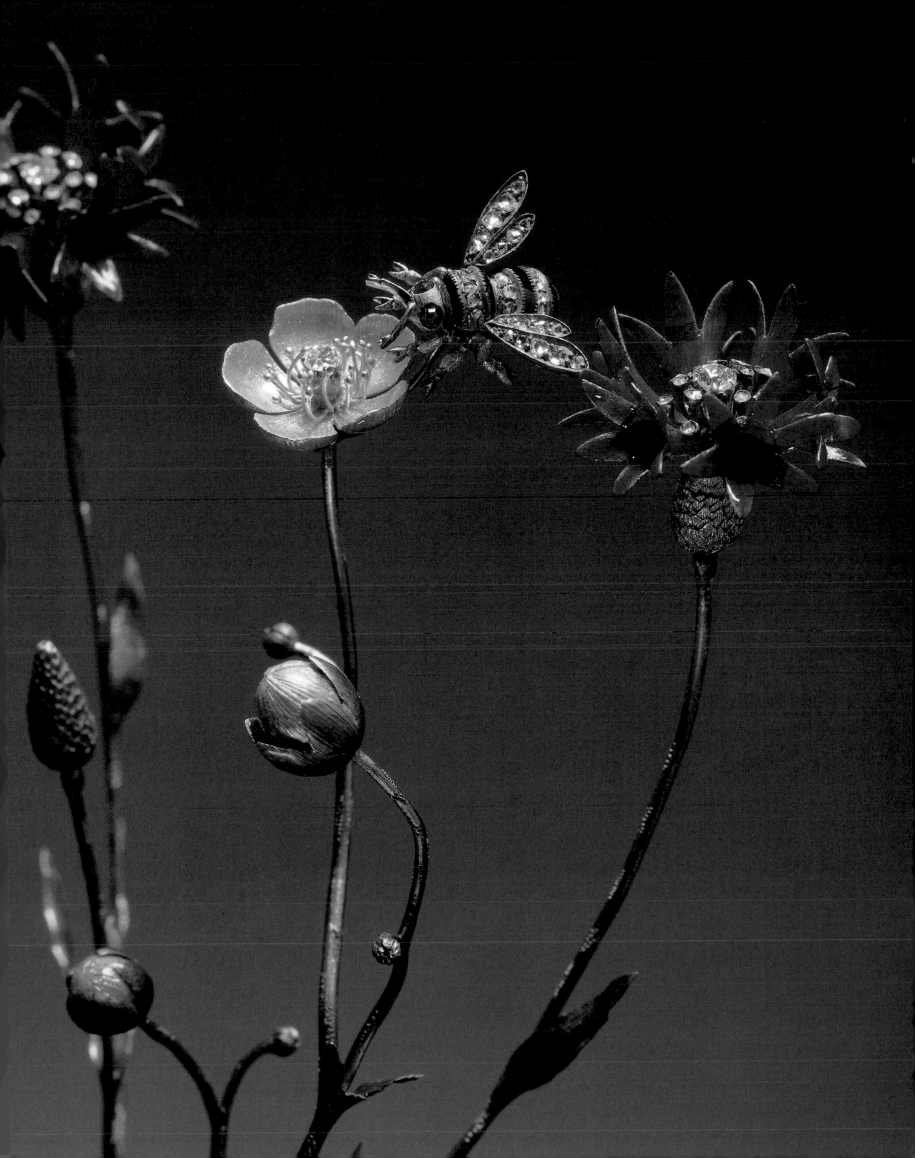

FRAMES (nos 259–264)

Fabergé's frames ranged from the most elaborate gold and jewel-encrusted ornaments to simple wooden examples mounted with silver. The most expensive frames contained official portrait miniatures of the Tsar or imperial couple painted either by Zuiev (1870–c.1917), the court miniaturist appointed by Tsar Nicholas II, c.1903, or by Zehngraf (1857–1908), Fabergé's own miniaturist; they were mounted with the Russian imperial crown in diamonds. A small number of these frames were made and given as official gifts to foreign dignitaries and heads of state. The simpler frames, which normally contain photographs, were exchanged on a more personal level between members of the imperial family; they would also be acquired by Fabergé's other clients. In addition, Fabergé also made many miniature photograph frames, possibly designed to travel with the owner, of which there are several examples in the Royal Collection. Tsarina Alexandra Feodorovna is known to have owned hundreds of these frames, which were set out in rows in her private apartments at Tsarskoe Selo and the Alexander Palace.

Each of Fabergé's frames afforded him the opportunity to experiment with design and technique and to display the best of his skills and those of his workmasters. The majority of the frames in the Royal Collection are of gold or silver-gilt with ivory backs and gold struts, enamelled in a wide variety of colours and fitted with coloured gold mounts and sometimes precious stones.

Fabergé's revival of eighteenth-century enamelling techniques is well demonstrated on the frames. Guilloché enamel was achieved by decorating the metal surface of the object with patterns using a special machine called a *tour a guilloché* (rose-engine). The engine-turned pattern remains visible through the coloured enamel, which was applied in five or six separate layers, each fired separately at temperatures in excess of 750 degrees Centigrade. The decorative motifs favoured by Fabergé were moiré, sunburst and wave designs. The quality of Fabergé's enamelling, with its smoothness and brilliance achieved by hours of delicate hand-polishing, sets his work apart from that of contemporary goldsmiths. The different coloured golds were achieved by mixing gold with silver, copper and platinum.

Fabergé prided himself on the consistently high quality of the pieces he created and, in order to guarantee the quality of objects such as the nephrite frame (no. 263), the selection of stone was

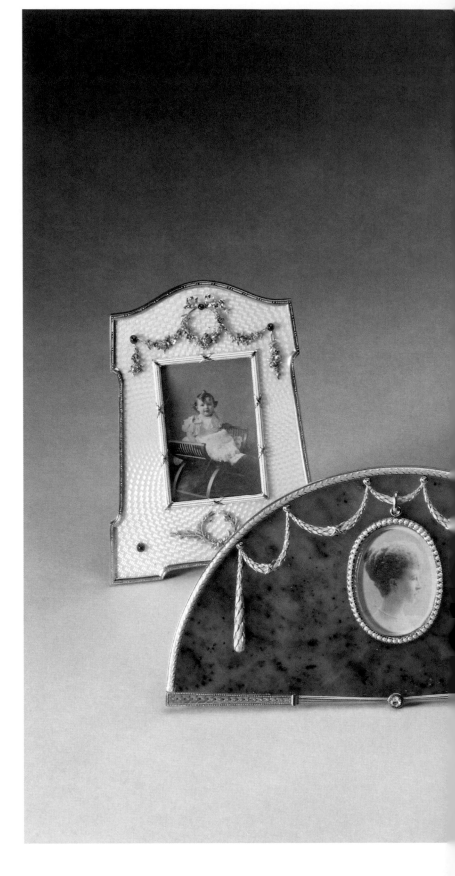

made with the greatest care to avoid the faults which could lead to cracking and fracturing during the complicated processes of preparation, including the adding of elaborate gold mounts. In addition to pearls, diamonds and other precious stones, Fabergé's

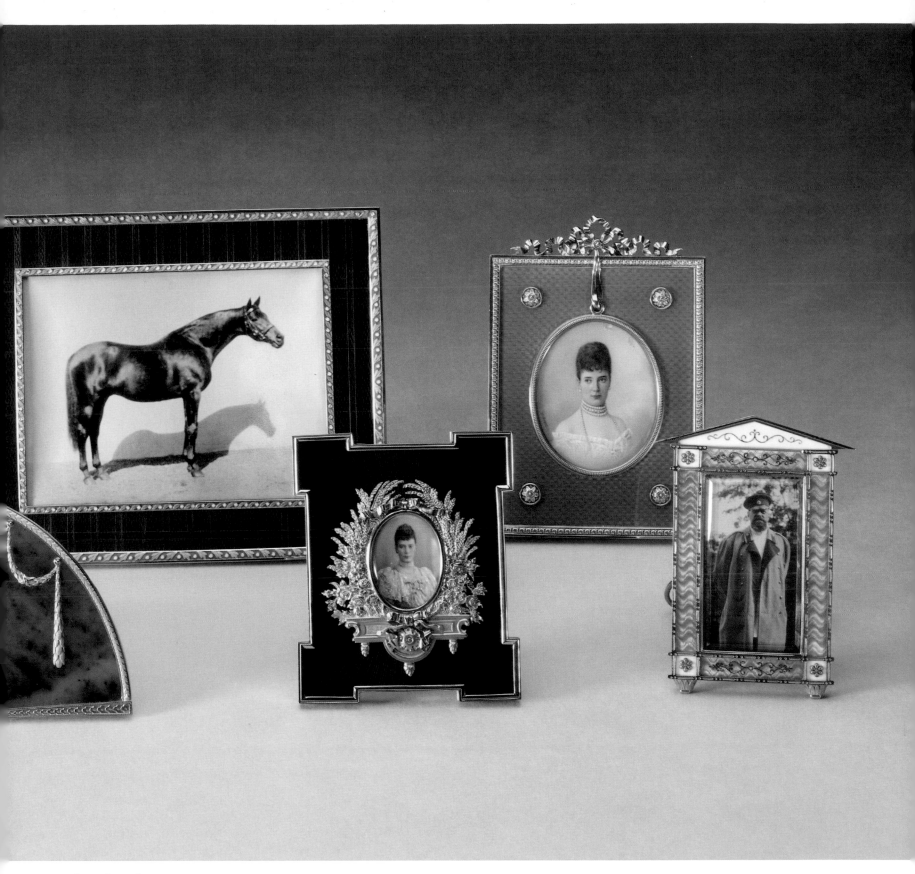

frames are typically applied with coloured gold, chased and engraved decorative mounts in the form of laurel borders, ribbon-ties, rosettes and acanthus swags. The frames in the Royal Collection were mostly acquired through exchanges of gifts between members of the royal family and their Russian and Danish cousins. The majority were collected by Edward VII and Queen Alexandra.

259

Strut frame holding a photograph of Tsar Alexander III, c.1896

Tsar Alexander III (1845–94) was the second son of Alexander II, whom he succeeded in 1881. On 10 November 1866 he married Princess Dagmar of Denmark (see no. 260), the younger sister of Alexandra, Princess of Wales. A stern and hard-working ruler, he was devoutly religious and generally lived with his family in the country away from St Petersburg at Gatchina Palace, returning to the city only for the winter social season. The Tsar's taste for Fabergé's productions, including his elaborate Easter Eggs, is one of his few known indulgences. Fabergé was formally appointed Supplier to the Court of Tsar Alexander III in 1885.

The photograph was taken very shortly before the Tsar's death on 1 November 1894. The informality of the image is complemented by the small decorative frame, which emphasises its very personal nature. The frame was made a few years after the sitter's death.

Silver, gold, enamel, ivory. 9 × 6.9 × 6.4 cm
Illegible workmaster's mark; Moscow gold mark of 56 and silver mark of 84 *zolotniks* (1896–1908); C. FABERGÉ in Cyrillic characters
RCIN 32473
PROVENANCE Presumably Edward VII and Queen Alexandra
EXHIBITIONS QG 1985–6, no. 49; QG 1995–6, no. 173

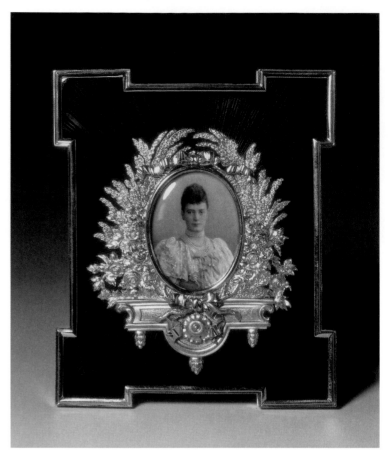

260

260

Frame holding a painted miniature of Tsarina Marie Feodorovna, c.1895

Many of the frames in the Royal Collection were acquired through exchanges of presents between the Russian, Danish and English royal families. Most contain contemporary photographs or, as in the case of nos 260 and 261, painted miniatures of members of those families. Both portraits were painted by the Danish-born miniaturist Zehngraf (1857–1908); no. 261 is based on a photograph by Pasetti of 1894.

Marie Feodorovna (1847–1928), born Princess Dagmar of Denmark, married the future Tsar Alexander III (no. 259) in 1866. In contrast to Tsar Alexander III, his wife Tsarina Marie Feodorovna enjoyed the excitement and extravagance of court life in St Petersburg. She had great admiration for Fabergé and for his artistry; in 1882 she personally endorsed his work by purchasing a pair of gold cufflinks in neo-Greek style from the Pan-Russian exhibition in Moscow. Following her husband's death in 1894, her son continued the tradition of presenting her with a Fabergé Easter Egg. In a letter dated 8 April 1914 to her sister, Queen Alexandra, she describes how on receipt of the egg for that year she told Fabergé 'vous êtes un génie incomparable'. She made annual trips to London and Copenhagen and undoubtedly brought many pieces of Fabergé with her as gifts. Even during the first decade of the twentieth century, in a period of particularly difficult political relations between England and Russia, Marie Feodorovna visited England several times, notably in 1902 for the coronation of Edward VII and Queen Alexandra.

Following the Revolution in 1917, the Dowager Tsarina escaped to the Crimea and was eventually rescued with her daughter, Grand Duchess Olga, by a British cruiser sent at King George V's insistence.

After a brief stay with her sister and nephew at Sandringham, she returned to Denmark, moving finally to Hvidøre, the villa outside Copenhagen that was shared with Queen Alexandra. Even at Hvidøre, where she was to spend the remainder of her life, she was not without objects by Fabergé, having earlier had seals made for use there, of which there is an example in the Royal Collection (RCIN 40249).

No. 260 is notable for its combination of two of Fabergé's most celebrated techniques – guilloché enamel and coloured gold decoration, in this case *quatre couleurs*; both were revivals of French eighteenth-century techniques. It was during Carl Fabergé's collaboration with the maker of this frame, Michael Perchin, that the firm first started to produce exquisitely enamelled and vari-coloured gold objects.

Gold, enamel, ivory. 9 × 7.8 × 7.3 cm
Frame: Mark of Michael Perchin; gold mark of 56 *zolotniks* (before 1896); FABERGÉ in Cyrillic characters. Miniature: signed *Zehngraf*
RCIN 40107
PROVENANCE Acquired by Edward VII and Queen Alexandra, c.1895
LITERATURE Bainbridge 1949, pp. 95–6; Habsburg & Lopato 1993, p. 179
EXHIBITIONS London 1977d, no. K3; New York 1983, no. 174; QG 1985–6, no. 135; Munich 1986–7, no. 524; Zurich 1989, no. 89; St Petersburg/Paris/ London 1993–4, no. 11; QG 1995–6, no. 248; Cardiff 1998, no. 150

261

Strut frame holding a painted miniature of Tsarina Marie Feodorovna, late 1890s

This frame was made in Fabergé's Moscow branch. See also no. 260.

Silver, gold, enamel. 11.5 × 8.3 × 8.2 cm
Frame: Mark of Anders Nevalainen; Moscow silver mark of 88 zolotniks (1896–1908); C. FABERGÉ in Cyrillic characters. Miniature: signed Zehngraf
RCIN 32472
PROVENANCE Presumably Edward VII and Queen Alexandra
EXHIBITIONS QG 1985–6, no. 130; QG 1995–6, no. 239

262

Strut frame containing a photograph of Tsarevitch Alexis, c.1905

The Tsarevitch Alexis (1904–18) was the fifth child and only son of Tsar Nicholas II and Tsarina Alexandra Feodorovna. The imperial family is symbolically represented in the Colonnade Egg (no. 205), created in 1910. The Tsar and Tsarina's joy was shortlived for within a few months Alexis showed the first signs of haemophilia. The Tsarevitch almost died in 1911 and in desperation the Tsarina asked for the help of Gregori Rasputin, a peasant monk who helped to cure her son. Following the Revolution in 1917, the imperial family were taken to Ekaterinburg in Siberia where the Tsarevitch and his sisters and parents were shot on 17 July 1918.

Silver-gilt, gold, enamel, ivory, rubies. 10.2 × 8.4 × 5 cm
Mark of Johann Viktor Aarne; silver mark of 88 zolotniks (1896–1908); FABERGÉ in Cyrillic characters
RCIN 40105
PROVENANCE Presumably Edward VII and Queen Alexandra
EXHIBITIONS QG 1985–6, no. 138; QG 1995–6, no. 501

263

Strut frame holding a photograph of the Marquise d'Hautpoul (née Hon. Julie Stonor), 1896–1903

This nephrite demi-lune frame is in the form of an open fan. Nephrite was one of the stones used most extensively by Fabergé for frames, clocks and other desk ornaments as well as for hardstone animal carvings. The frame contains a photograph, taken c.1900, of the Marquise d'Hautpoul (1861–1950), born the Hon. Julie Stonor, whose mother was lady-in-waiting to the Princess of Wales, later Queen Alexandra. In the years immediately after her mother's death in 1883, Julie and her brother spent most of their holidays with the royal children and she became the first love of Prince George of Wales, later King George V. She married the Marquis d'Hautpoul in 1891 but remained close to the royal family and continued to visit Queen Alexandra at Sandringham.

Nephrite, gold, pearls, diamond. 7.5 × 16 × 5.3 cm
Mark of Michael Perchin; gold mark of 56 zolotniks (1896–1908); FABERGÉ in Cyrillic characters
RCIN 40101
PROVENANCE Presumably King George V
EXHIBITIONS London 1977d, no. K6; New York 1983, no. 124; QG 1985–6, no. 318; QG 1995–6, no. 368

264

Strut frame holding a photograph of Persimmon, c.1908

This frame, enamelled in Edward VII's racing colours, contains a photograph of one of the King's most successful racehorses, Persimmon, winner of the Derby and the St Leger in 1896 and of the Ascot Gold Cup and Eclipse Stakes in 1897. Lord Knutsford describes how during a visit to Sandringham in 1900, the guests were given an opportunity to admire the horse, 'such a splendid bay, and in grand condition. We all took snapshots at him. The Princess promised to send me hers.' This photograph differs from those in the Royal Photograph Collection which are known to have been taken by Queen Alexandra. The groom appears to have been deliberately faded out of the print.

Persimmon was retired to stud at Sandringham where he had been bred and where he was champion sire on four occasions. In 1908 he slipped in his box and fractured his pelvis; despite every effort to save him he had to be put down. A bronze statue of Persimmon by Adrian Jones, commissioned by Edward VII, stands on the lawn outside the stud.

Persimmon was among the animals modelled from life for Fabergé during the Sandringham commission in 1907. The sculptor Boris Frödman-Cluzel prepared the wax model from which a silver statuette was made by Henrik Wigström in 1908 (RCIN 32392). The statuette was purchased by Edward VII in November 1908 from Fabergé's London branch (£135). According to the ledgers of Fabergé's London branch, a further six bronze copies of the statuette were ordered by Edward VII on 21 December 1908, presumably to be given away as none of the bronzes remains in the Royal Collection. Bainbridge describes how he successfully persuaded Mrs Leopold de Rothschild to have her husband's racehorse St Frusquin, which Persimmon had beaten in the Derby, modelled in silver by Fabergé in imitation of the King's commission. Bainbridge adds that later Mr Leopold de Rothschild had six to twelve bronze models made of the sculpture which he gave away. Leopold de Rothschild also owned photograph frames and other items made in his racing colours (Bainbridge 1949, p. 84).

Gold, enamel, silver-gilt, moonstones. 12 × 15.8 × 10.1 cm
Mark of Henrik Wigström; gold mark of 56 zolotniks and silver mark of 91 zolotniks (1908–17); FABERGÉ in Cyrillic characters
RCIN 15168
PROVENANCE Presumably Edward VII (recorded as being bought by the Queen – probably Queen Alexandra – for £70 from Fabergé's London branch; the date of purchase is not known)
LITERATURE Bainbridge 1949, p. 89
EXHIBITIONS QG 1995–6, no. 197

BOXES (nos 265–269)

Presentation boxes formed a large part of the output of all the imperial jewellers, whether Bolin, Hahn or Fabergé. Hundreds were ordered by the imperial family as official gifts to be presented to foreign dignitaries, to Russian government officials, the clergy and senior military staff. They were also made for special occasions, for example the coronation of Tsar Nicholas II and Tsarina Alexandra Feodorovna (no. 265). Most bore the Romanov double-headed eagle and sometimes, as on the boxes destined for the most important recipients, they were set with diamonds. Whenever the imperial family travelled abroad, heads of state and other important officials were regularly given Fabergé boxes or cigarette cases as a souvenir. A strict hierarchy determined the level of present received. These ranged from lavish bejewelled snuff boxes set with miniature portraits to relatively mundane enamelled commemorative badges. There are four presentation boxes in the Royal Collection including two in the collection of Her Majesty Queen Elizabeth The Queen Mother.

In addition to presentation boxes, Fabergé produced cigarette cases in an extraordinary range of designs, from plain wood to the most richly decorated boxes of gold, enamel and jewels. There are many examples in the Royal Collection, the majority collected by Edward VII, King George V and King George VI.

265
Imperial presentation box, 1896–1908

During the reign of Tsar Nicholas II (r. 1894–1917), a total of 300 snuff boxes with the diamond-set cypher of the sovereign were commissioned. These boxes were intended for presentation to ambassadors, aides-de-camp and other prominent officials in the service of foreign heads of state. No. 265 is an example of one of the grandest types of presentation box produced by Fabergé. A number of these, similarly mounted with the Tsar's cypher in diamonds, were made at the time of Nicholas II's coronation in 1896. These boxes are usually in the colours of the imperial mantle (yellow and black) and some (e.g. no. 268) are also decorated with the Romanov two-headed eagle.

This box is a very fine example of guilloché enamelling with a combined concentric circle and sunburst design. Fabergé's enamellers did not mark their work but the importance of their contribution to Fabergé's success cannot be overestimated. The separate workshop entirely devoted to enamelling was run by Alexander Petrov and his son Nicholas. Birbaum states in his memoirs that the fame of the firm's enamelling was mainly due to Nicholas Petrov.

Gold, enamel, diamonds. 3.1 × 8.3 × 8.3 cm
Mark of August Höllming; gold mark of 56 zolotniks (1896–1908); FABERGÉ in Cyrillic characters
RCIN 100012
PROVENANCE Bought from Wartski by HM Queen Elizabeth The Queen Mother, 27 June 1944
LITERATURE Bainbridge 1949, pl. 103
EXHIBITIONS London 1949, no. 5; QG 1962–3, no. 61(9); London 1977d, no. F10; New York 1983, no. 192; QG 1985–6, no. 75; Munich 1986–7, no. 511; St Petersburg/Paris/London 1993–4, no. 106; QG 1995–6, no. 147; Stockholm 1997, no. 58

266
Imperial presentation box, 1916

In the hierarchy of state gifts presented by the Tsar, gem-set presentation boxes with miniature portraits of the Tsar or the imperial couple were reserved for the highest ranks. They were normally presented to monarchs and other heads of state and, very selectively, to high-ranking officials at home and abroad.

According to a note in Queen Mary's handwriting, this box was presented to 'General Trepoff' by Tsar Nicholas II. During this period there were four Trepov brothers who came from an accomplished and distinguished family, their father almost certainly having been the natural son of Tsar Nicholas I. Three of the four became generals.

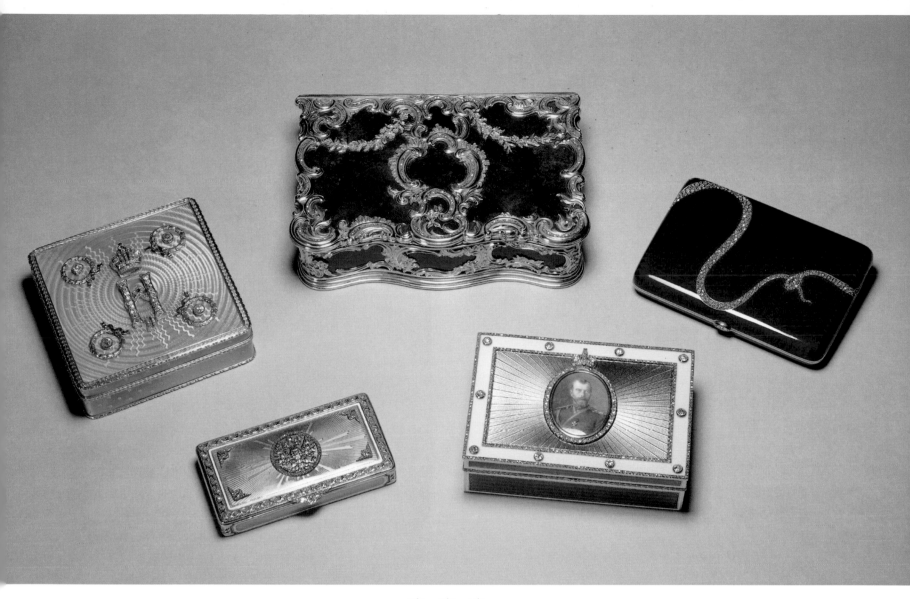

265 267 269

268 266

The recipient of this box may have been Alexander Fyodorovich Trepov (1863–1928), who joined the Russian civil service after a distinguished military career and rose to become Prime Minister briefly before he was dismissed on 10 January 1917.

The box was completed in the Wigström workshop on 30 September 1916 and was made for Imperial Cabinet stock with no particular recipient in mind. Presentation objects were often delivered to the Cabinet with spaces for miniature portraits of the Tsar to be incorporated at the time of presentation.

The miniature depicts the Tsar wearing the uniform of one of the Household Regiments and the Cross of the Order of St George which he awarded himself on 25 October 1915. The miniature is not signed but is likely to have been by Vassily Zuiev, a miniaturist working directly for Fabergé and described by Bainbridge as a painter of the first order. A similar miniature of Tsar Nicholas II in uniform and wearing the same decoration appears on an Imperial presentation box now in the Forbes collection. This was also made by Wigström and dates from the same period. Curiously, the archives of the Imperial Cabinet state that the miniature was allocated to the presentation box on 5 May 1917, after the Tsar's abdication and during the rule of the provisional government.

Gold, enamel, diamonds. 3.2 × 9.5 × 6.4 cm
Mark of Henrik Wigström; gold mark of 72 zolotniks (1908–17); FABERGÉ in Cyrillic characters
RCIN 19128
PROVENANCE Probably presented by Tsar Nicholas II to Alexander Trepov (1863–1928); acquired by Queen Mary and given to King George V on his birthday, 3 June 1934
LITERATURE Habsburg & Lopato 1993, pp. 280–1
EXHIBITIONS London 1977d, no. K22; New York 1983, no. 193; QG 1985–6, no. 77; Munich 1986–7, no. 518; QG 1995–6, no. 253

267

Bloodstone box, before 1896

Fabergé's workshops, particularly that of Michael Perchin – his chief workmaster from 1886 to his death in 1903 – produced many pieces in the neo-rococo style fashionable in St Petersburg in the 1880s. Notable among them is the Imperial Easter Egg known as the Memory of Azov Egg, dated 1891, which features the same combination of bloodstone and gold mounts set with diamonds as that used here.

Henrik Wigström, who took over as chief workmaster in 1903, continued neo-rococo ornament in some of his work (as seen in a drawing in his design books for a nephrite and gold cigarette case), but his style was lighter and more restrained than Perchin's and the neo-rococo was soon subsumed by the neo-classical in Wigström's designs.

The flamboyant rococo design of this box, mounted in gold and set with rose diamonds, is similar to a green jasper carnet in the Wernher collection, made between 1896 and 1899, also by the workmaster Michael Perchin. Another Russian carnet of similar design, dating from the late nineteenth century, exists in the Thyssen-Bornemisza collection, although it is not marked by Fabergé.

Bloodstone, gold, diamonds. 3.8 × 13.7 × 9.3 cm
Mark of Michael Perchin; gold mark of 72 zolotniks (before 1896); FABERGÉ in Cyrillic characters
RCIN 9314
PROVENANCE Marie, Duchess of Saxe-Coburg and Gotha (d. 1920); presented by her daughters to King George V
LITERATURE Somers Cocks & Truman 1984, pp. 308–09; Tillander-Godenhielm et al. 2000, p. 36
EXHIBITIONS QG 1985–6, no. 310; QG 1995–6, no. 220

268
Imperial presentation box, before 1896

The imperial provenance of this presentation box is clearly indicated by the double-headed eagle in the roundel. It was briefly in the possession of the Maharaja of Bikanir, who had been a good client of Fabergé's London branch.

Gold, enamel, diamonds. 1.7 × 8.2 × 4.5 cm
Mark of Michael Perchin; gold mark of 72 zolotniks (before 1896); FABERGÉ in Cyrillic characters
RCIN 8999
PROVENANCE Bought from Wartski by the Maharaja of Bikanir, 15 May 1937 (£95); by whom presented to Queen Mary for her birthday, 26 May 1937 (QMB, III, no. 338; QMPP, IX, no. 73)
EXHIBITIONS QG 1985–6, no. 74; QG 1995–6, no. 151

269
Cigarette case, 1908

Practical objects such as cigarette cases and boxes formed a large part of the output of Fabergé's workshop. The Art Nouveau style of this case, arguably one of Fabergé's most successful designs, is something of a departure from the restrained 'Louis XVI' classicism of the majority of Fabergé's output. Fabergé was criticised at the time of the 1900 Exposition Universelle in Paris for his neo-classical designs which the French felt compared unfavourably with the popular organic 'modern style' or Art Nouveau of the early 1890s. Probably in response to this, Fabergé produced pieces in the new style, notably three Imperial Easter Eggs as well as a number of smaller pieces. In spite of the criticisms of his designs there was universal praise for his workmanship. In no. 269 the skilfully recessed hinge allows the edges of the case to be simplified and the design of the snake to be integrated on both sides.

The cigarette case demonstrates Fabergé's brilliant handling of

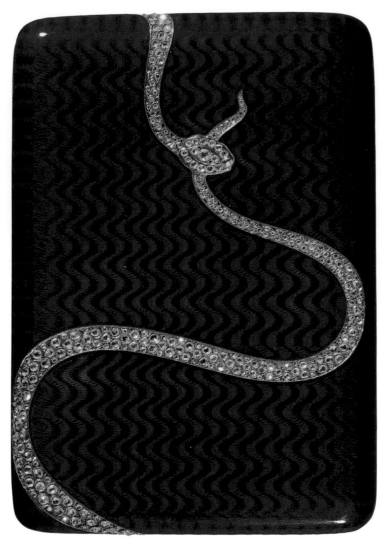

269

guilloché enamelling, the geometric moiré wave pattern being one of his favoured designs. The remarkably vivid colour of the enamel is one example from the rainbow of colours which Fabergé used. A chart of samples of enamel colours, each numbered for reference, hung in Fabergé's shop in St Petersburg.

The cigarette case was presented to Edward VII by Mrs Keppel, who was also an avid collector of Fabergé and encouraged the King's idea to commission portraits of the royal animals at Sandringham. She became the King's mistress and confidante in the late 1890s and remained close to him until his death. Both the King and Mrs Keppel shared an admiration for Carl Fabergé's work and both used cigarette cases made by him. Following the King's death in 1910, Queen Alexandra returned the case to Mrs Keppel as a souvenir. She in turn gave it to Queen Mary in 1936. It still contains the stub of one of Edward VII's cigars.

Gold, enamel, diamonds. 1.7 × 9.6 × 7 cm
Moscow gold mark of 56 zolotniks (1896–1908)
RCIN 40113
PROVENANCE Given by the Hon. Mrs George Keppel to Edward VII, 1908; returned by Queen Alexandra to Mrs Keppel, 1911; given by Mrs Keppel to Queen Mary, 1936
LITERATURE Bainbridge 1949, p. 83; Habsburg & Lopato 1993, pp. 116–23
EXHIBITIONS London 1977d, no. K2; New York 1983, no. 203; QG 1985–6, no. 313; Munich 1986–7, no. 468; Zurich 1989, no. 117; St Petersburg/Paris/London 1993–4, no. 165; QG 1995–6, no. 502; Stockholm 1997, no. 101; Cardiff 1998, no. 148

MINIATURE ITEMS (nos 270–272)

In addition to the vast array of useful objects which Fabergé produced, such as thermometers, clocks, magnifying glasses and desk equipment, he also made a number of miniature objects of a whimsical nature. Occasionally these had a practical use, for example as bonbonnières or salt cellars, and some were designed as commemorative items – particularly those with military associations. However, the majority were essentially charming decorative objects, made with minute attention to detail. They range from musical instruments and furniture to a full replica of the Russian imperial regalia in miniature. These objects afforded Fabergé's workmasters the opportunity to experiment with different styles, notably interpretations of the Louis XV or Louis XVI designs.

270
Miniature table, 1896–1903

This Louis XVI-style table is one of four pieces of miniature furniture in the Royal Collection. In its clever use of materials, no. 270 well demonstrates Fabergé's versatility. The red guilloché enamel imitates the wood veneer, the two-coloured gold mounts imitate gilt bronze, and the blue and white enamel mounts imitate Sèvres porcelain. The eight plaques above the legs have been described previously as incorporating the cypher of Tsarina Marie Feodorovna, but this is not obvious on close examination. The mother-of-pearl top, in imitation of marble, is engraved with Romanov eagles and the central shelf joining the legs is also lined with mother-of-pearl. A very similar table, also by Perchin, is in the Forbes collection and a further Louis XVI-style table by Perchin, but of different form, is in the Hermitage collection.

Gold, mother-of-pearl, enamel. 8.9 × 8.4 × 6.1 cm
Mark of Michael Perchin; gold mark of 56 zolotniks (1896–1908); FABERGÉ in Cyrillic characters

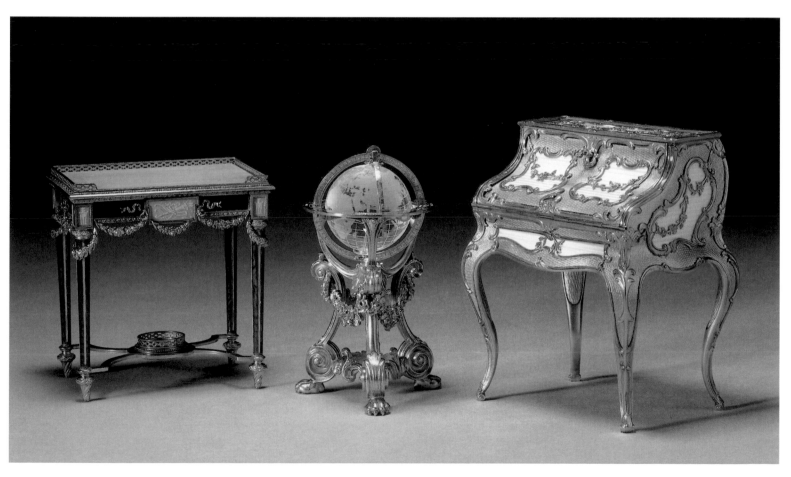

270 271 272

RCIN 9142
PROVENANCE Bought by Queen Mary from Wartski, 22 November 1947 (£650; QMPP, XI, no. 45)
LITERATURE Snowman 1962, pl. LIV
EXHIBITIONS London 1977d, no. K4; New York 1983, no. 182; QG 1985–6, no. 80; Munich 1986–7, no. 527; QG 1995–6, no. 244; Stockholm 1997, no. 148

271
Terrestrial globe, before 1886

No. 271 was produced in the workshop of Erik Kollin, Fabergé's first chief workmaster, who specialised in the production of gold objects. It is an early example of Fabergé's characteristic use of different coloured golds in combination with silver-gilt. At least two other rock crystal globes by Fabergé are known.

Rock crystal, gold, silver-gilt. 10.5 × diameter 6 cm
Mark of Erik Kollin; gold and silver marks of 56 and 88 *zolotniks* respectively (before 1896); FABERGÉ in Cyrillic characters
RCIN 40484
PROVENANCE Prince Vladimir Galitzine; from whom bought by Queen Mary, 16 December 1928 (£25 2s.; archives of Princess George Galitzine)
LITERATURE Snowman 1962, p. 164
EXHIBITIONS London 1953d, no. 108; London 1977d, no. 19; New York 1983, no. 21; QG 1985–6, no. 119; QG 1995–6, no. 258; Stockholm 1997, no. 146

272
Miniature desk, 1896–1908

The drop front of this Louis XV-style roll-top desk with rococo mounts opens by means of a miniature gold key to reveal an interior lined with engraved mother-of-pearl and divided into compartments. Although the workmaster's mark is now illegible, the neo-rococo design is reminiscent of the objects produced in Perchin's workshop. The attention to detail, particularly in the fine mauve and opalescent white enamel on such a minute scale, exemplifies Fabergé's exacting standards of workmanship.

Gold, enamel, mother-of-pearl. 11 × 8.7 × 6.5 cm
Illegible workmaster's mark; gold mark of 56 *zolotniks* (1896–1908); FABERGÉ in Cyrillic characters
RCIN 100013
PROVENANCE Bought by Leopold de Rothschild at Fabergé's London branch, 12 July 1909 (£150 15s.); acquired by HM Queen Elizabeth The Queen Mother
LITERATURE Snowman 1962, p. 165
EXHIBITIONS London 1953d, no. 122; London 1977d, no. F6; QG 1985–6, no. 78; Munich 1986–7, no. 526; QG 1995–6, no. 262; Stockholm 1997, no. 147

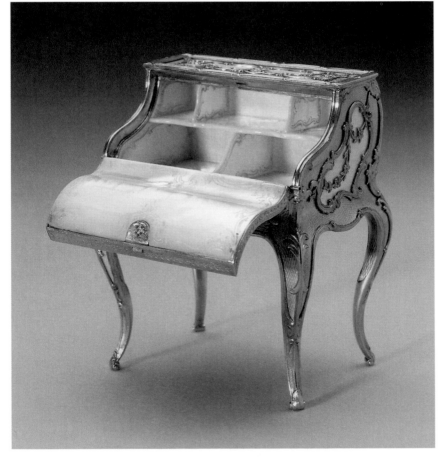

272

DESK ITEMS (nos 273–280)

Fabergé's day-to-day business was based on the supply of silver-ware. His workshops produced tea services, flatware, trays, jugs and all manner of silver and silver-mounted objects in large numbers, examples of which are in the Royal Collection. The demand for practical objects also extended to desk paraphernalia which Fabergé turned into an art form, each object being highly practical and yet exquisitely designed. The enormous range of desk accessories – also well represented in the Royal Collection – includes seals, paper-knives, glue-pots, stamp boxes and bell-pushes.

273
Seal, 1896–1903

The agate seal stone is engraved with two birds perched on the rim of a classical bird-bath.

Nephrite, enamel, gold, agate. 4.8 × diameter 2.3 cm
Mark of Michael Perchin; gold mark of 56 zolotniks (1896–1908)
RCIN 40161
PROVENANCE Acquired before 1953
EXHIBITIONS London 1977d, no. G14; New York 1983, no. 45; QG 1985–6, no. 330; QG 1995–6, no. 378

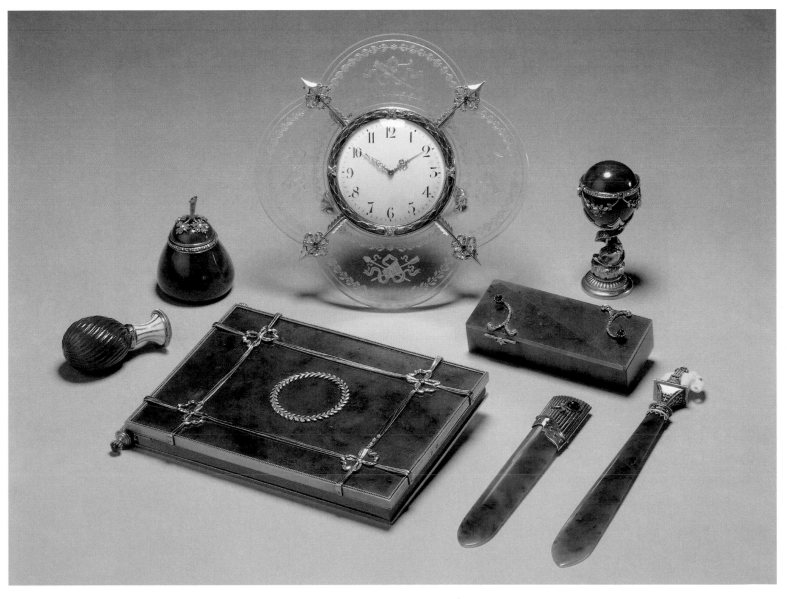

273 274 275 277 276
278 279 280

274
Pear-shaped pot and cover, 1896–1903

There are several examples in Fabergé's output of pots in the form of fruit, either carved from hardstones or made of enamelled metal. These were generally for use as glue-pots, but this example is not fitted with a brush.

Nephrite, gold, diamonds. 4.8 × diameter 3.5 cm
Mark of Michael Perchin; gold mark of 56 *zolotniks* (1896–1908); FABERGÉ in Cyrillic characters
RCIN 40208
PROVENANCE Acquired before 1953
EXHIBITIONS London 1953d, no. 10; London 1977d, no. G13; QG 1985–6, no. 25; QG 1995–6, no. 383

275
Clock, 1896–1901

The four lobes engraved with trophies are of rock crystal, a naturally occurring stone which Fabergé used extensively for both functional and decorative objects. The panels are divided by red gold arrows set with diamonds and rubies. The reverse of the movement has two fixed keys with folding handles and is engraved in Russian, indicating an eight-day movement.

Fabergé's clocks, however extravagantly decorated, were designed to be functional and easy to use. The majority of the desk clocks have opaque white enamelled dials with Arabic numerals and the bezels are usually of chased or enamelled gold laurel or acanthus, sometimes set with seed pearls.

The design of no. 275 is unusual in Fabergé's repertoire; the model most frequently produced – and well represented in the Royal Collection – was an enamelled strut clock. One of only two pieces of Fabergé known to have belonged to Queen Victoria, this clock was later placed by King George V on his desk at Buckingham Palace.

Rock crystal, gold, silver-gilt, enamel, diamonds, rubies. 11.6 × 12.5 × 9.9 cm
Mark of Michael Perchin; silver mark of 88 *zolotniks* (1896–1908)
RCIN 40100
PROVENANCE Presented to Queen Victoria by Tsarina Alexandra Feodorovna
EXHIBITIONS London 1953d, no. 13; London 1967, no. 188; London 1977d, no. 12; New York 1983, no. 10; QG 1985–6, no. 66; Zurich 1989, no. 103; St Petersburg/Paris/London 1993–4, no. 20; QG 1995–6, no. 401

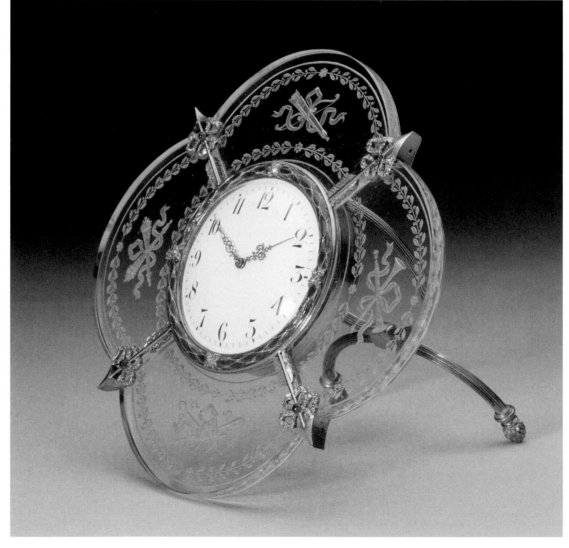

275

276
Seal, c.1900

This nephrite hand seal is engraved with the crowned cypher of King George V. The egg-shaped handle supported on a dolphin is elaborately decorated with three-coloured gold floral swags and a band of diamonds and rubies.

Nephrite, gold, diamonds, rubies. 6.4 × 2.8 cm
Mark of Michael Perchin; FABERGÉ in Cyrillic characters
RCIN 9258
PROVENANCE Probably the nephrite and gold seal acquired by King George V from Fabergé's London branch, 28 October 1912 (£19)
EXHIBITIONS QG 1995–6, no. 373

277
Stamp box, 1896–1903

No. 277 is a good example of a beautifully designed yet practical object, which shows the quality of workmanship and attention to detail which Fabergé paid to all the objects made by his firm, however insignificant and whatever their cost. The top is fitted with two lids which meet diagonally. Inside, the three compartments have sloping bases to enable stamps to be removed easily.

Nephrite, gold, diamonds, rubies. 2.3 × 7.6 × 3.2 cm
Mark of Michael Perchin; gold mark of 56 *zolotniks* (1896–1908)
RCIN 40241
PROVENANCE Acquired before 1953
EXHIBITIONS London 1977d, no. G15; QG 1995–6, no. 371

278
Notebook case, c.1908

This elegant nephrite case, fitted with a pencil concealed in the hinge, was made at Fabergé's Moscow branch, which was opened in 1887 and managed by Allan Bowe. Bowe's brother Arthur set up the firm's London branch in 1903. The Moscow branch specialised in silver objects and mounts but also produced pieces similar in style to Perchin's work in St Petersburg, such as no. 278. The notebook itself appears to be original to the case; the first page bears the handwriting of Marie Feodorovna and is dated 1908. Subsequent pages bear notes written by Queen Alexandra and a third – unidentified – hand. A similar Fabergé notebook case by Julius Rappaport, but in bowenite with silver mounts, is in the collection of the Palace of Legion of Honor, San Francisco.

Nephrite, gold, silver, rubies. 1.5 × 13 × 11.9 cm
Moscow gold and silver marks of 56 and 84 *zolotniks* respectively (1896–1908); initials CF in Cyrillic characters and FABERGÉ in Cyrillic characters
RCIN 40103
PROVENANCE Probably given by Marie Feodorovna to her sister Queen Alexandra, 1908
EXHIBITIONS London 1977d, no. G3; QG 1985–6, no. 336; QG 1995–6, no. 376

279
Paper-knife, before 1886

This paper-knife was produced in the workshop of Erik Kollin, Fabergé's chief workmaster between 1872 and 1886. Kollin's workshop specialised in producing gold objects and jewellery inspired by archaeological finds.

Nephrite, gold, diamonds, sapphire. 0.8 × 10.8 × 1.7 cm
Mark of Erik Kollin; gold mark of 56 *zolotniks* (before 1896)
RCIN 23239
PROVENANCE Princess Mary Adelaide, Duchess of Teck (1833–97); her daughter, Queen Mary
EXHIBITIONS QG 1995–6, no. 420

280
Paper-knife, before 1896

The elephant cresting probably refers obliquely to Denmark: an elephant and castle are incorporated in the design of all Danish royal insignia and Queen Alexandra and Tsarina Marie Feodorovna were the daughters of King Christian IX and Queen Louise of Denmark. Fabergé made miniature elephants and castles for Marie Feodorovna; similar miniature elephants and castles also exist in the Royal Collection, possibly acquired by Queen Alexandra.

Nephrite, gold, quartzite, enamel, diamonds, sapphire. 1 × 14.5 × 1.9 cm
Mark of Michael Perchin; gold mark of 56 *zolotniks* (before 1896)
RCIN 40204
PROVENANCE Probably Queen Alexandra
EXHIBITIONS London 1953d, no. 61; London 1977d, no. J19; New York 1983, no. 41; QG 1985–6, no. 23; QG 1995–6, no. 386

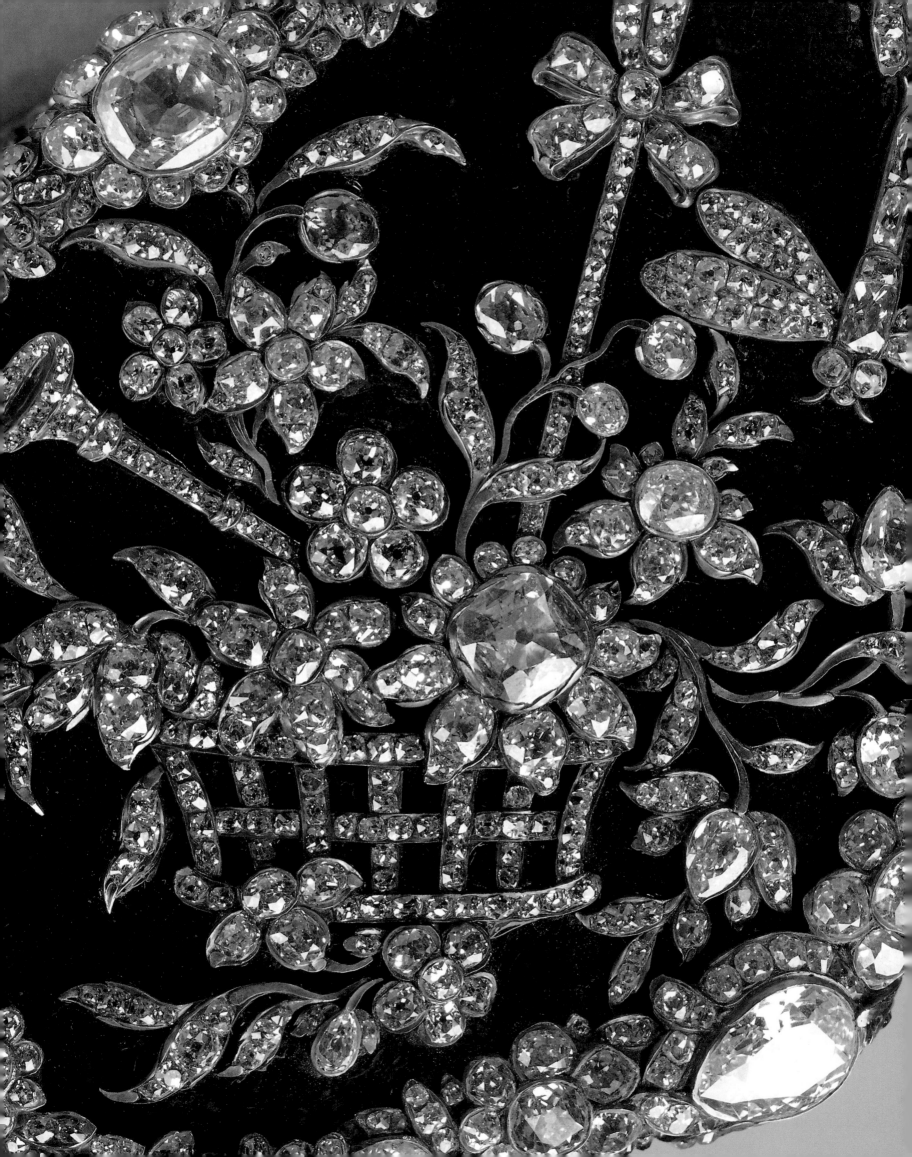

GOLD BOXES (nos 281–297)

The Royal Collection contains a rich and varied group of eighteenth- and nineteenth-century gold boxes which admirably demonstrate the wide variety of materials and techniques used in the production of these highly finished and luxurious objects. Carved hardstones, crystal, mother-of-pearl, tortoiseshell, horn, enamels and painted miniatures were all popular elements in the manufacture of gold boxes. The chased mounts often incorporated up to four different colours of gold, achieved by combinations with other metals such as copper (for red gold) or silver (for green gold). The great centre of gold box production was Paris, where the craft reached unparalleled levels of skill and virtuosity during the reign of Louis XV (see no. 291). Highly accomplished but relatively plain boxes, usually of chased gold, were also produced in London during the mid-eighteenth century, often made (or at least chased) by immigrants from the Continent. By contrast, the most spectacular boxes ever made were the magnificent carved hardstone and jewel-encrusted examples created for Frederick the Great of Prussia in Potsdam (no. 294).

Most gold boxes were ostensibly made to contain snuff – a mixture of finely ground tobacco leaves and aromatics. Although there was a great vogue for snuff-taking throughout Europe during the eighteenth century, it is doubtful whether all gold boxes were actually used for this purpose. Exquisitely worked boxes might cost the equivalent of many hundreds or even thousands of pounds and were frequently given away as diplomatic gifts. Many boxes were not used at all but were simply admired for their virtuosity and beauty.

Very little is known of the gold box collections of the British royal family in the eighteenth century. Both Queen Charlotte and George IV were keen snuff-takers. (Queen Charlotte's favourite blend was Violet Strasbourg, which contained bitter almonds, ambergris and attarju. She was said to augment this with a spoonful of green tea every morning.) Snuff boxes supplied by the royal goldsmiths and jewellers Rundells were among George IV's favoured gifts to his friends and courtiers (no. 297). He even had a blend of snuff named after him, Prince's, a blend still available today. However, neither Queen Charlotte's nor George IV's once extensive collection survives intact – 324 boxes from the latter's collection were sold by William IV to Rundells to cover the cost of additions to the state dinner services. The majority of the boxes in the collection today, including those with eighteenth-century royal connections, were acquired in the late nineteenth and twentieth centuries. Some were formerly in the collection of Queen Victoria. However, by far the most important royal collectors of gold boxes were King George V and Queen Mary. The King and Queen often gave each other boxes as gifts on birthdays and at Christmas; a number of their friends also followed this example (see no. 290). Queen Mary's almost obsessive interest in royal history led her to acquire many boxes with royal provenances, most notably the exceptional group of English gold boxes commissioned by Frederick, Prince of Wales, in the 1740s (nos 282–4). She also acquired many notable boxes from the extensive collection of her uncle George, Duke of Cambridge, which was sold at auction in 1904 (see no. 287). During the present reign one of the earliest boxes in the collection was acquired: Queen Mary II's exceptional enamelled gold and diamond patch box purchased by Her Majesty The Queen in 1963 (no. 281).

(with the Egerton estates) by John, second Earl Brownlow; by descent to Peregrine Adelbert Cust, sixth Lord Brownlow; by whom sold Christie's, London, 29 May 1963 (21); bought by HM The Queen

LITERATURE Snowman 1990, pp. 402–03

EXHIBITIONS London 1971, no. 45; London 1988b, no. M11; London 1990b, no. 106

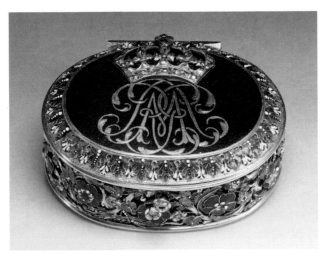

281 (enlarged)

281
ENGLISH (?)
Queen Mary's patch box, c.1694

The maker of this remarkable enamelled gold box, which bears the crowned monogram of Queen Mary II, is not recorded. However, the sophisticated use of enamels, engine-turning and engraving indicates continental craftsmanship, probably the work of a foreign jeweller in London. Queen Mary's accounts indicate that she had a weakness for jewellery and bijouterie of all kinds. The maker of this box was almost certainly the same as that of the agate and gold box discovered in Holland in the 1960s (Snowman 1990, pp. 402–03). The latter may be identifiable with the 'Gold pach box with an Agatt Stone Cover' purchased by the Queen on 10 May 1694 for £10 from the jeweller James Schuelt, whose name suggests a Germanic origin (BL Add. MS 5751A).

Patch boxes were used to contain face patches, worn from the early seventeenth century to disguise blemishes, particularly smallpox scars. By the time of the Restoration, patches had become highly fashionable accessories; as many as seven or eight were worn at a time and elaborately decorated boxes such as no. 281, with sprung and mirror-lined lids, were much in vogue. The fashion attracted criticism from moralists of the day, who considered face patches a sign of grotesque vanity. Despite the Bishop of Gloucester boasting that Queen Mary 'did not entertain such childish vanities as spotted faces' (Hamilton 1972, p. 323), her accounts show that during the last year of her life she was regularly buying 'paper for patches' costing 1s. a sheet from her milliner (BL Add. MS 57151A). Ironically the Queen died of smallpox, at the tragically young age of 32 in December 1694. It is possible that no. 281 was then presented to Anthony, eleventh Earl of Kent, one of six pall-bearers at her funeral in March 1694/5. Alternatively it may have been given to Hans Willem Bentinck, first Earl of Portland, a close confidant of William III; Portland's daughter, Elizabeth Ariana, was the grandmother of John, seventh Earl of Bridgewater.

Gold, enamel, diamonds. 2.3 × 5.2 × 4.5 cm
RCIN 19133
PROVENANCE Supplied to Queen Mary II, c.1694; possibly presented to Anthony, eleventh Earl of Kent, or to Hans Willem Bentinck, first Earl of Portland, 1694/5; thence by descent to John Egerton, seventh Earl of Bridgewater; inherited in 1849

282
ENGLISH
Gold box, c.1745

The centre of the lid is chased with an oval medallion of Frederick, Prince of Wales, below a coronet held by putti. When exhibited by the London goldsmiths Hunt & Roskell at the South Kensington Museum in 1862, this medallion was mistakenly identified as George III, the son of Frederick, Prince of Wales. However, Frederick's identity is confirmed by the Prince of Wales's feathers and motto chased on the front panel; and stylistically the box pre-dates George III's creation as Prince of Wales, following his father's death in 1751.

No. 282 belongs to a group of exceptionally fine English gold boxes made for Frederick, Prince of Wales (see nos 283, 284). The commemorative iconography on the lid suggests that like no. 283 this box was a presentation piece. The highly fashionable francophile tastes of the Prince are reflected in the design, which closely parallels that of contemporary Parisian boxes and suggests the influence of the designs of Juste-Aurèle Meissonnier, chief exponent of the rococo style.

The Prince of Wales's accounts include payments for boxes supplied by Jasper Cunst and Paul Bertrand in the 1730s. Augustin Heckel (c.1690–1770), one of the leading gold chasers working in London, appears to have designed and chased gold boxes supplied by Cunst. Similarities between no. 282 and a box signed by both Cunst and Heckel (private collection; Edgecombe 2000, p. 61, no. 8) have led to tentative suggestions that the former is also his work.

This box was a wedding gift to the Duke and Duchess of York (later King George V and Queen Mary) in 1893, from the Danish Minister at the Court of St James's, M. de Falbe, and his wife. De Falbe was a close friend both of the Danish-born Princess of Wales (later Queen

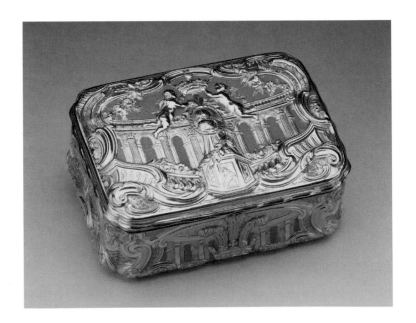

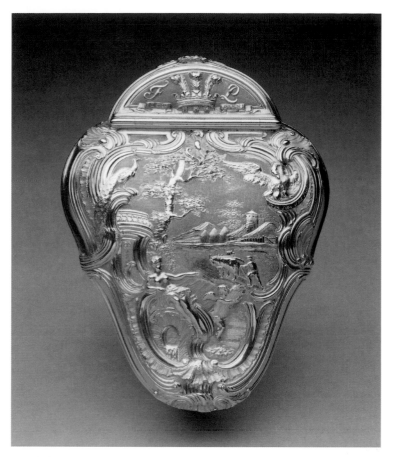

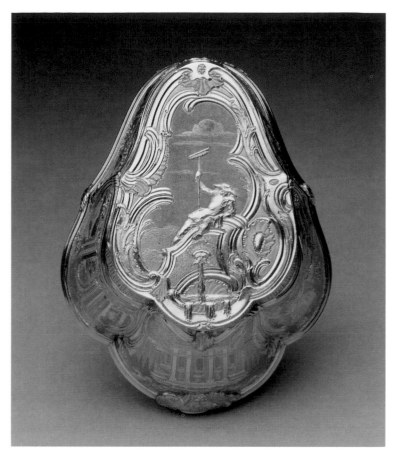

283 (top)

283 (base)

Alexandra) and of Queen Mary's mother, the Duchess of Teck. Queen Mary had been a regular visitor to Luton Hoo, the De Falbes' luxurious country house, before her marriage; her first fiancé, Prince Albert Victor, Duke of Clarence and Avondale (1864–92), King George V's elder brother, had proposed to her there in 1891.

Gold. 2.8 × 6.8 × 5.2 cm

RCIN 4047

PROVENANCE Hunt & Roskell collection, by 1862; M. and Mme de Falbe; by whom given to King George V and Queen Mary, as a wedding present, 1893 (GV Boxes, I, no. 6; RA F&V/WEDDINGS/1893 GV: Catalogue of gifts, p. 15)

EXHIBITIONS London 1862a, no. 4357; QG 1962–3, no. 61 (27); Cardiff 1998, no. 50

283

ENGLISH

Gold box, c.1749

This exceptional box, perhaps the finest of its kind, was given to Francis, Lord North (1704–90), when he was appointed governor to the 11-year-old Prince George of Wales (later George III) in 1749.

The thumb piece is chased with the North crest below a coronet; an enamel portrait of Prince George's father Frederick, Prince of Wales, by Christian Frederick Zincke (1683/4–1767) is set inside the lid and the Prince of Wales's initials, feathers and motto are chased on the arched top. Pastoral allegories on the lid and base depict scenes of sowing and the harvest – perhaps a symbolic tribute to the governor's role in ploughing the ground in preparation for a rich harvest. The symbolism continues

with the peacock and pelican (above the motto *Non Sibi Sed Suis*) on the lid, the piety of the pelican contrasting with the vanity of the peacock.

Lord North's position as governor or Preceptor to Prince Frederick's sons was a lucrative appointment. His duties were 'to go about with Prince George and appear with him in public', for which he received £1,000 a year in addition to the £500 salary he already received as a Lord of the Bedchamber to the Prince of Wales (Brooke 1972, pp. 24 and 28). The importance and responsibility of North's task is reflected in the superb quality of the box. Lord North was replaced by Lord Harcourt in 1751, following Prince Frederick's death and Prince George's sudden elevation to the position of heir apparent.

No. 283 belongs to a small group of finely chased English gold boxes supplied to Frederick, Prince of Wales, in the 1740s (see no. 282). It is probably the work of one of the immigrant Germans who dominated the London gold-chasing world during the mid-eighteenth century.

The enamel miniature of the Prince of Wales is dated by Walker to c.1742 and described as 'an exceptionally fine example of Zincke's art' (Walker 1992, no. 45). Christian Frederick Zincke was appointed Cabinet Painter to Prince Frederick in 1732 and both the Prince and the Princess of Wales formed large collections of his work.

Gold, enamel. 3.8 × 6.8 × 9 cm

RCIN 3926

PROVENANCE Given by Frederick, Prince of Wales, to Francis, seventh Baron North (later first Earl of Guilford), 1749; acquired by Queen Mary and given to King George V on his forty-ninth birthday, 3 June 1914 (GV Boxes, I, no. 31)

LITERATURE (for miniature) Walker 1992, no. 45

EXHIBITIONS QG 1962–3, no. 61 (28); Cardiff 1998, no. 48

284
ENGLISH
Gold box, c.1750

Although this box lacks any royal iconography, its shape, decoration and chasing closely resemble the same features of the box given to Lord North by Frederick, Prince of Wales, in 1749 (no. 283). It is likely that both boxes are from the same workshop; and, like Lord North's box, no. 284 may have been a royal presentation piece.

No. 284 was bequeathed to George, Duke of York (later King George V), by Emily Caroline, Countess Sydney, in 1893. Although its early provenance remains unknown, it is possible that the box was a royal gift to Thomas Townsend, later Viscount Sydney (1732/3–1800), Clerk of the Household to George, Prince of Wales, in the 1750s and grandfather of Lady Sydney's husband.

The finely chased marine scenes on the lid and sides of the box are reminiscent of the paintings of Claude Lorrain, the seventeenth-century French painter whose work reached unprecedented levels of popularity in England during the eighteenth century (see no. 12).

Gold. 3.5 × 6.5 × 8 cm
RCIN 3932
PROVENANCE Bequeathed to King George V by Emily Caroline, Countess Sydney, 1893 (GV Boxes, I, no. 2)
EXHIBITIONS QG 1962–3, no. 61 (20)

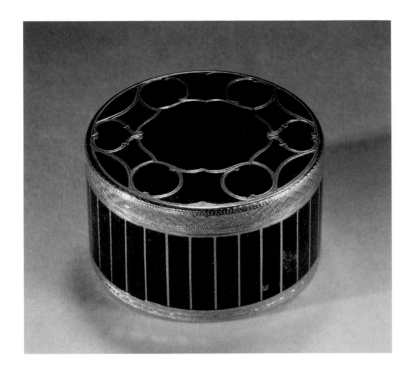

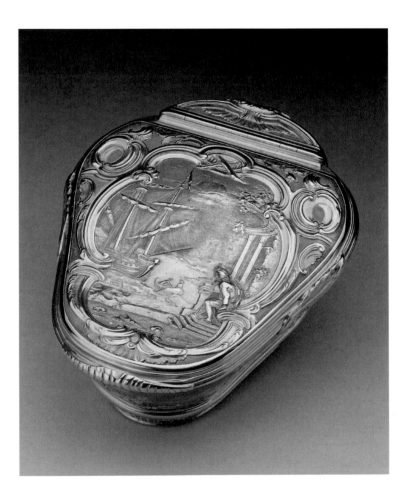

285
FRENCH
Snuff box, 1750–6

Snuff boxes incorporating semi-precious hardstones within gold cage-work mounts are usually associated with German makers, in particular the lapidaries and goldsmiths of Dresden who utilised the rich mineral deposits of Saxony. However, on this box the unidentified Parisian maker has demonstrated considerable skill in emphasising the innate beauty of the lapis lazuli imported from Afghanistan, by setting it within elegant yet remarkably restrained gold mounts.

Mrs David Gubbay gave Queen Mary this box as a Christmas present in 1939. Mrs Gubbay (d. 1968), a cousin by marriage of Sir Philip Sassoon (1888–1939) and an eminent collector, shared many of Queen Mary's tastes. At her home, Little Trent Park, Hertfordshire, she assembled an outstanding collection of eighteenth-century English furniture and ceramics, Meissen and Nymphenburg porcelain and Chinese porcelain and jade. Her collection was left to the National Trust on her death and is now displayed at Clandon Park, Surrey.

Lapis lazuli, gold. 3.5 × diameter 6.2 cm
Charge and discharge marks of the *fermier-général* Julien Berthe, Paris, 10 October 1750 – 13 October 1756, maker's mark obscured
RCIN 4423
PROVENANCE Mrs David Gubbay; by whom given to Queen Mary, Christmas 1939 (QMB, IV, no. 28)

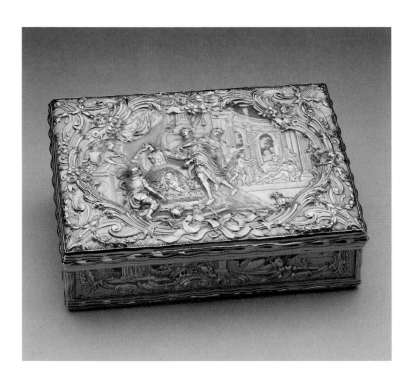

286
GEORGE DANIEL GAAB (d. 1784)
Snuff box, c.1760–70

The embossed and chased relief on the lid depicts Tomyris, Queen of a nomadic Central Asian tribe, receiving the head of King Cyrus. This event was described by Herodotus (1. 214) who recorded it as a symbolic act of justice. King Cyrus, the founder of the Persian Empire, tricked Tomyris's army – led by her son – into attending a feast, whereupon many of her followers were slaughtered. Afterwards Tomyris's son committed suicide in shame. Cyrus was killed in the ensuing battle and the Queen avenged her son's death by dipping the King's decapitated head in an urn of blood.

The source of this composition remains untraced. It is also found in an anonymous engraving, in an unfinished state, in the Courtauld Institute Galleries (inv. no. G.1972XX.1) and in a photograph of an untraced painting of the same composition attributed to Carle Van Loo, in the Witt Library, Courtauld Institute.

The lid is signed by the London gold chaser George Daniel Gaab, who may have been a member of the Gaap or Gaab family of goldsmiths from Augsburg. This relief belongs to a small group of works signed by or attributed to Gaab, who is recorded in Mortimer's *Universal Director* of 1763 as a 'Chaser in Gold and Silver, and a Designer and Modeller for Jewellers, &c, Belton-street at the bottom of Hanover-street, Long acre' (Edgecombe 2000, pp. 45–6).

Gold. 2.4 × 8.1 × 6.1 cm
Lid signed GAAB; struck with French import mark post-1893; engraved inside lid *King George V / from his wife / Queen Mary / in remembrance of / the 40th. Anniversary of their wedding day. / 6th. July / 1933*
RCIN 100015
PROVENANCE Given to King George V by Queen Mary on their fortieth wedding anniversary, 6 July 1933 (GV Boxes, IV, no. 354); HM Queen Elizabeth The Queen Mother
LITERATURE Edgecombe 2000, p. 47, no. 3

287
FRENCH
Snuff box, 1763–4

The finely chased scenes emblematic of music and the chase on this otherwise neo-classical box demonstrate the enduring influence of the artist Jean-Antoine Watteau (1684–1721) and his followers. Bucolic musical parties and *fêtes* remained popular subjects for the decoration of gold boxes throughout the eighteenth century.

An early nineteenth-century portrait cameo, identified by Queen Mary as Princess Augusta (1768–1840), second daughter of George III, has been applied to the underside of the lid. Another very similar cameo of Princess Augusta was given to Queen Mary by Constance Gaskell in 1944 (RCIN 4210); both appear to be from the same workshop.

The box was formerly in the collection of George, second Duke of Cambridge (1819–1904). The presence of the cameo suggests that it may have been a gift from Princess Augusta to her brother Adolphus, first Duke of Cambridge (1774–1850).

The Cambridge collection of plate, pictures and gold boxes was sold after the death of the second Duke in 1904, although the Duke had once promised Queen Victoria that it would be left to the Crown. Queen Mary, a granddaughter of the first Duke, had been dismayed by the lack of inventories and information about such an important collection of family things: 'Oh! dear, Oh! dear if only I could find the history of all of these things, how interesting it would be', she wrote to her Aunt Augusta (Pope-Hennessy 1959, p. 412). She purchased many items from the Duke's sons prior to the 1904 sale and continued to acquire objects as they appeared on the market for many years thereafter.

Vari-coloured gold, glazed cameo applied to lid. 3.9 × 7.9 × 6 cm
Charge and discharge marks of the *fermier-général* Jean-Jacques Prévost, Paris, 22 November 1762–22 December 1768 and warden's mark for Paris 13 July 1763–17 July 1764, indistinct maker's mark
RCIN 100016
PROVENANCE George, second Duke of Cambridge; by whose executors sold Christie's, London, 10 June 1904 (402), purchased by Gall (£105); given by Queen Mary to King George V, Christmas 1910 (GV Boxes, I, no. 17)
EXHIBITIONS London 1862a, no. 4182

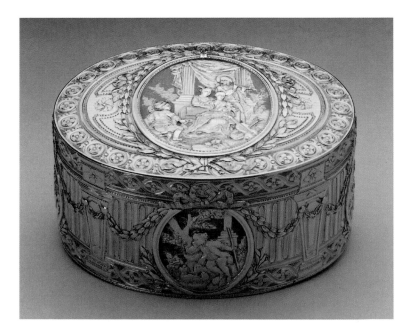

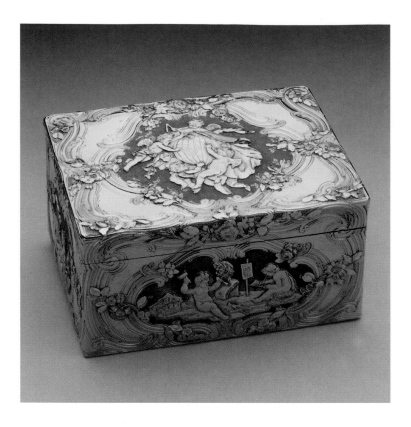

288
FRENCH
Snuff box, c.1765

Although unmarked, the superb quality of this box indicates a leading Parisian workshop. It is elaborately chased in vari-coloured gold with allegories of putti and cherubs, emblematic of the arts and sciences, against an unusual dark tinted background. The underside of the lid is set with a painted miniature of Adolphus Frederick IV, Duke of Mecklenburg-Strelitz (1738–94; see also no. 108). The Duke, elder brother of Queen Charlotte, was installed as a Knight of the Order of the Garter in 1764 and is shown wearing the Garter collar and star. A similar miniature of the Duke, perhaps by the same hand, set in a ring, was probably a gift to Queen Charlotte from her brother (RCIN 422283; Walker 1992, no. 443).

No. 288 was sent to Hugh Seton of Touch in April 1769 by Duke Adolphus Frederick in thanks for his gift of a post chaise (a four-wheeled carriage) sent from England. In the course of an audience with the Duke the previous September, Seton, a keen agricultural improver, had been entrusted with a number of letters which he was to convey to Queen Charlotte in England. Seton subsequently wrote to the Duke confirming the safe delivery of the letters (at the point of the Queen's confinement for the birth of Princess Augusta); he added that he was sending the Duke a post chaise as a mark of his attachment to him. The Duke's reply, together with the box wrapped 'in brown paper', was conveyed to Emanuel Mathias, the British Resident in Hamburg. Mathias shipped them to England, on board the *Olive Branch*, in the care of his brother Vincent Mathias. In his accompanying letter, the delighted Duke thanked Seton for his generous gift, in which he drove out daily, and begged him to accept the 'petit paquet' he was sending as a mark of his friendship.

Vari-coloured gold; lid inset with glazed miniature painted on ivory. 4.2 × 8.2 × 6.1 cm
RCIN 100014
PROVENANCE Adolphus Frederick IV, Duke of Mecklenburg-Strelitz; by whom given to Hugh Seton of Touch, 1769 (RA GEO/Add 16/96–105); probably thence by descent to Col. Sir Bruce Seton, ninth Baronet of Abercorn (1868–1932); Queen Mary; by whom given to King George V on his sixty-eighth birthday, 3 June 1933 (GV Boxes, IV, no. 349)

289
ENGLISH
Notebook, case and pencil, c.1765

The front of the case bears the diamond-set cypher and crown of Queen Charlotte, consort of George III. Neither date nor maker's name is recorded, but the fine quality of the case and its *rocaille* gold mounts suggest that it was made in a sophisticated London workshop in the early years of the King's reign. The two-colour gold 'spine' is engraved with bright-cut panels to resemble the tooled leather of a real book. The notebook inside, bound in red morocco, remains unused.

No. 289 was not included in the sales of Queen Charlotte's possessions following her death in 1818 and may have been given away during her lifetime. It re-entered the Royal Collection in the early twentieth century when presented to Queen Mary, Queen Charlotte's great-granddaughter, by Lady Mount Stephen (d. 1933). Queen Mary described her interest in works of art and historical relics associated with the royal family as 'my one great hobby' and eagerly sought to repatriate such objects to the Royal Collection. Lady Mount Stephen, a lifelong friend and fellow collector, assisted and encouraged her in this task. Lord Mount Stephen, the Canadian railway millionaire, and his wife were among Queen Mary's most generous friends and presented her with many works of art and *objets de vertu* of family interest (Pope-Hennessy 1959, pp. 409–11).

Tortoiseshell, gold, diamonds. Case 11 × 8.3 × 2.5 cm; pencil 11.1 cm long
RCIN 46707
PROVENANCE Made for Queen Charlotte, c.1765; Lady Mount Stephen; by whom presented to Queen Mary before 1920 (QMB, I, no. 510)
EXHIBITIONS QG 1974–5, no. 105; Australia 1977, no. 56; Mecklenburg 1995, no. 6.28

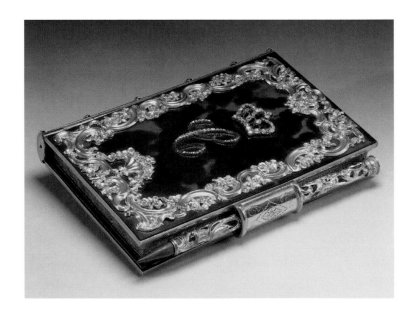

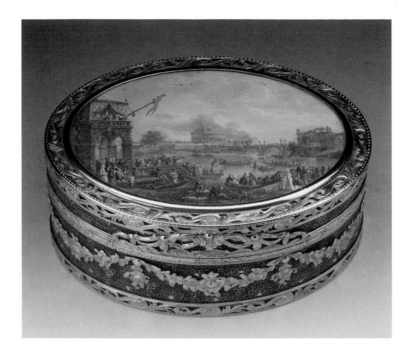

22 November 1762 – 22 December 1768; warden's mark for Paris 12 July 1766 – 13 July 1767; and maker's mark LV with a mallet (unidentified); miniature signed DE SAVIGNAC

RCIN 8968

PROVENANCE James A. de Rothschild; by whom presented to King George V and Queen Mary on their Silver Jubilee, 6 May 1935 (QMB, III, no. 267)

EXHIBITIONS QG 1962–3, no. 61 (30)

291
HENRY BODSON (fl.1763–1790)
Snuff box, 1768–9

This box is notable for both the quality of its *en plein* enamel work (enamel applied directly onto the body of the box) and its finely chased gold borders. Blue and gold flecked painted panels give the impression that the body of the box is made from the finest lapis lazuli. Oval enamel panels, on the top, bottom and sides of the box, depict marble statues with amatory themes. One panel shows Edmé Bouchardon's sculpture *Cupid making a bow from Hercules' club* (Louvre), exhibited at the Paris Salon in 1746. The compositions of two other panels are derived from non-sculptural sources: *Cupid sacrificing at the altar of Love and Marriage*, on the base of the box, is derived from the engraving *Autel de l'Amitié* by Gilles Demarteau, after a design by Boucher; *Cupid aiming his bow* is taken from *L'Amour menaçant* by Carle Van Loo, engraved in 1765 by Charles de Méchel. The gold borders display a variety of goldsmith's techniques. They are predominantly of red gold but incorporate green gold chased in low relief over *sablé* or sanded gold backgrounds. No. 291 is struck with the mark of Henry Bodson, who trained in the Louvre studio of François-Thomas Germain, goldsmith to Louis XV. Bodson was received master in 1763 and established his own studio on the pont Notre-Dame, Paris. Boxes bearing his mark survive in the Louvre, Musée Cognacq-Jay and Wallace Collection.

Two-colour gold, *en plein* enamel. 3.8 × 7.9 × 6 cm
Charge and discharge marks for the *fermier-général* Julien Alaterre, Paris, 23 December

290
FRENCH
Snuff box, 1766–7

The top of this box is inset with a painted miniature, signed by De Savignac, after Joseph Vernet's painting *Fête sur le Tibre à Rome* (London, National Gallery) which was commissioned by the Marquis de Villette in 1749 and later engraved by Jacques Daret. Edmé-Charles de Lioux de Savignac (fl.1760–89) lived in the rue Saint-Sauveur, Paris, between 1764 and 1784. He painted many scenes after Joseph Vernet, in the manner of the Van Blarenberghe family of miniaturists. In 1766 he successfully sought permission from the Marquis de Marigny, brother of Madame de Pompadour, to make miniature copies of Vernet's series *Les Ports de France*, painted for Louis XV between 1753 and 1765 (Waddesdon 1975, pp. 195–9).

The early history of no. 290 is not known, but a note in Queen Mary's hand, inside the box, records that it was a Silver Jubilee gift to King George V and Queen Mary from Mr and Mrs James A. de Rothschild in 1935. James A. de Rothschild (1878–1957), like King George V and Queen Mary, came from a family of renowned collectors of gold boxes. This box may have passed to him in 1922 when he inherited Waddesdon Manor from his great-aunt Miss Alice de Rothschild (1847–1922). Waddesdon's creator Baron Ferdinand de Rothschild (1839–98) and his sister Alice assembled an outstanding collection of eighteenth-century boxes, including a number of important works by Lioux de Savignac and the Van Blarenberghes. A closely related miniature, also after Vernet's *Fête sur le Tibre à Rome*, signed *v Blarenberghe 1754* (Waddesdon 1975, no. 109), was inherited by Baron Ferdinand from his father Anselm (1803–98). James also inherited the remarkable collection of boxes formed in Paris by his father Edmond de Rothschild (1845–1934), later confiscated by the Nazis but now also at Waddesdon.

Gold and enamel, glazed gouache miniature. 3.9 × 9.4 × 7.1 cm
Charge and discharge marks of the *fermier-général* Jean-Jacques Prévost, Paris,

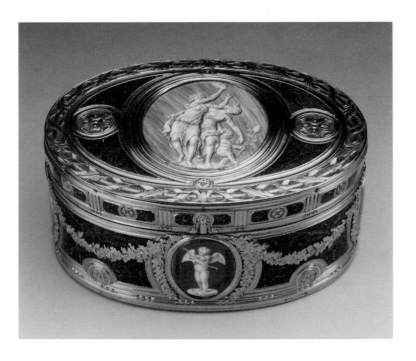

1768 – 31 August 1775; warden's mark for Paris, 13 July 1768 – 11 July 1769;
enamel plaque on the base inscribed HOTEL DE / CHIMEN ET DE / L'AMOUR [sic]
RCIN 19136
PROVENANCE Presented to King George V and Queen Mary on their Silver Jubilee, 6
May 1935, by members of the Royal Household (GV Boxes, V, no. 374)
LITERATURE Snowman 1990, pp. 213, 437
EXHIBITIONS QG 1962–3, no. 61 (21); London 1990b, no. 1

292
JAMES COX (c.1723–1800)
Nécessaire and watch, c.1770

The celebrated London jeweller and metalworker James Cox specialised
in making lavishly ornamented *objets de vertu*. These often incorporated
watches and complex automaton movements and great numbers were
made for export to India and the Far East, where they were known as
'sing-songs'. Between 1766 and 1772 Cox exported nearly £750,000
worth of goods; works by him still survive in the Chinese and Russian
imperial collections. Perhaps Cox's most famous work is a life-size swan
automaton with silver plumage (Bowes Museum, Barnard Castle). In
1772 this was exhibited at Cox's celebrated museum of automata in
Spring Gardens, Charing Cross, and immediately became one of the
sights of London.

No. 292 is typical of Cox's work and incorporates standardised and
mass-produced elements; the gold cage-work is constructed from bands
produced in strips and cut to measure. Such manufacturing techniques
enabled Cox to produce and export work on a large scale. In 1773 he
claimed to employ 1,000 workmen.

When the lid of no. 292 is opened, a watch and automaton are
revealed. The watch face is surrounded by an outer circle set with ten
jewelled roundels; these spin individually around the watch face as the
outer circle rotates. This appears to have been a favoured device and is
found on other watches and clocks by Cox, including examples sent to
the Emperor of China. A painted chinoiserie scene hides the back of the
mechanism. Below this a second compartment is fitted with various
cosmetic bottles and implements.

Portraits of George III and Queen Charlotte by Johan Zoffany hung
in Cox's museum in Spring Gardens. In view of the King's keen interest
in horology and Queen Charlotte's love of bijouterie and novelties, it is
surprising that none of Cox's creations appears to have been acquired by
them. All Cox's work in the Royal Collection today was acquired by
Queen Mary in the twentieth century.

Agate, gold, silver, coloured paste, pearls, glass, gouache. 9.6 × 10.1 × 7.4 cm
Clock dial inscribed Jas Cox / London
RCIN 6538
PROVENANCE Given to Queen Mary by George V, Christmas 1925 (QMPP, V, no. 21)
LITERATURE Le Corbeiller 1970, p. 355, fig. 13
EXHIBITIONS London 1931a

293
GEORGE III (1738–1820) and
JOHN DUVAL (fl.1748–1800) & SONS
Snuff box, c.1770

Virtuoso ivory turning was considered a suitable amateur pastime for
European kings and princes; both Louis XV and XVI owned lathes and
were skilled turners. George III was no exception: in 1769 a French lathe
(*Machine à Guilloché*) and a gold snuff box were supplied to the King by
the London jewellers John Duval & Sons (see no. 152).

An undated inscription signed by Henry Duval under the lid of this
box states that the ivory was turned by George III and presented in
1774 to the writer's grandfather (presumably John Duval), who had
supplied the lathe and an instructor. A further note, written on a scrap

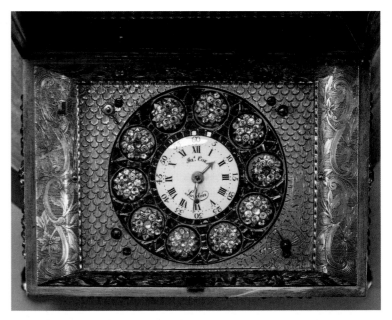

292 (open to show watch and automaton)

◁ 292

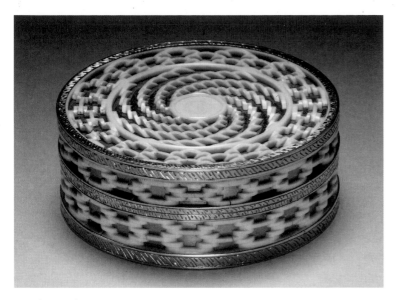

293 (enlarged)

of paper placed within the box, records that the instructor 'after two Months staying in England, was presented with £100'. The complexity of the turned trelliswork on this box confirms both the instructor's teaching ability and the King's obvious mechanical skill with the lathe.

Other turned work by George III is known. In 1772 he presented his sister Augusta, Duchess of Brunswick, with another slightly larger box (Brunswick, Herzog Anton Ulrich Museum, inv. 304); and a watch with an ivory back turned by the King was recorded at Windsor in 1837 (Inventory of Jewellery, p. 12).

Gold, ivory. 2 × diameter 5.2 cm
Inscribed inside the lid *The Ivory part / of this Box was turned by / H.M. KING GEORGE THE THIRD / and by him given to my Grandfather / JUNE 1774. / NB My Grandfather purchased the Lathe in Paris / and brought home with him a person / to instruct H.M. how to use it / Henry Duval*
RCIN 65779
PROVENANCE Gold box supplied by John Duval & Sons (£50; RA GEO/16822), ivory turned by George III; by whom presented to John Duval, 1774; Lady Mount Stephen; by whom presented to Queen Mary, Christmas 1917 (Add. Cat., p. 27A, no. 21)
LITERATURE Roberts (J.) 1987, p. 213 (n. 19), pl. 14; Truman 1991, p. 85
EXHIBITIONS QG 1990–1, no. 177

294
GERMAN
Table snuff box, c.1770–5

This spectacular bloodstone box is encrusted with nearly three thousand diamonds backed with delicately coloured foils in shades of pink and yellow. It is one of the finest of the series of boxes made in the Fabrique Royale in Berlin and associated with Frederick II ('the Great') of Prussia (1712–86). Frederick was a passionate snuff-taker and is said to have had a collection of over three hundred boxes; one box is even said to have saved his life by deflecting a bullet during battle. Jewellers flocked to Berlin to supply the King and the Prussian court with elaborate boxes of hardstone, gold and enamel. Many other boxes were made as diplomatic gifts. The brothers André and Jean-Louis Jordan and Daniel Baudesson were among the most frequent suppliers but an absence of

hallmarks on surviving examples makes it difficult to attribute individual boxes to particular makers. Many of the box designs are attributed to Jean Guillaume George Krüger, who arrived in Berlin from Paris in 1753. Frederick himself is said to have contributed to the design of many boxes.

No. 294 is unique among the surviving Frederick the Great boxes for both its elaborately chased vari-coloured gold mounts and its particularly lavish use of diamonds. Although its early provenance remains unclear, it was certainly an important royal commission and was possibly made for Frederick's personal use. It was latterly in the Russian imperial collection, which may suggest that it was a gift from Frederick the Great to Catherine the Great. However, as the box is not listed in early Russian inventories it is more likely to have belonged to Tsarina Alexandra Feodorovna (1798–1860), consort of Tsar Nicholas I. The Tsarina was the daughter of Frederick William III of Prussia, who succeeded to the Prussian throne in 1797 and is known to have presented his son Albrecht with one of Frederick the Great's boxes. One hundred and twenty-four boxes were listed in the Prussian royal palaces following Frederick's death. Many of these were subsequently given away and only fourteen remained in the Prussian royal collection one hundred years later.

Bloodstone, vari-coloured gold, foiled diamonds. 5.1 × 10.7 × 8.5 cm
RCIN 9044
PROVENANCE Made for Frederick II of Prussia; probably inherited by Frederick William III of Prussia and given to his daughter, Tsarina Alexandra Feodorovna; thence by descent to Tsar Nicholas II; seized by the Soviet authorities 1917 (inv. 1922, no. 80); by whom sold to a British syndicate; by whom sold Christie's, London, 16 March 1927 (91); bought by Levy; M. La Comtesse Alain de Villeneuve; by whom sold Christie's, London, 22 July 1932 (141); bought by Queen Mary (£1,000; QMPP, VII, no. 95)
LITERATURE Solodkoff & Habsburg-Lothringen 1983, p. 40; Snowman 1990, pl. 742; Truman 1991, p. 207
EXHIBITIONS London 1954a, p. 19; London 1990b, no. 54; Munich 1992–3, no. 123

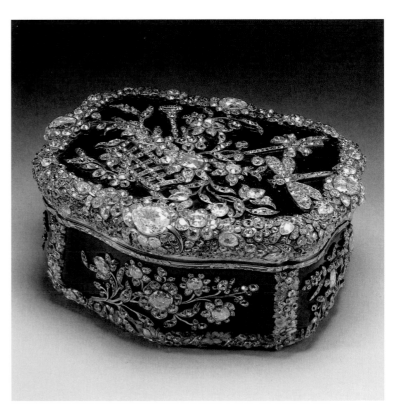

294

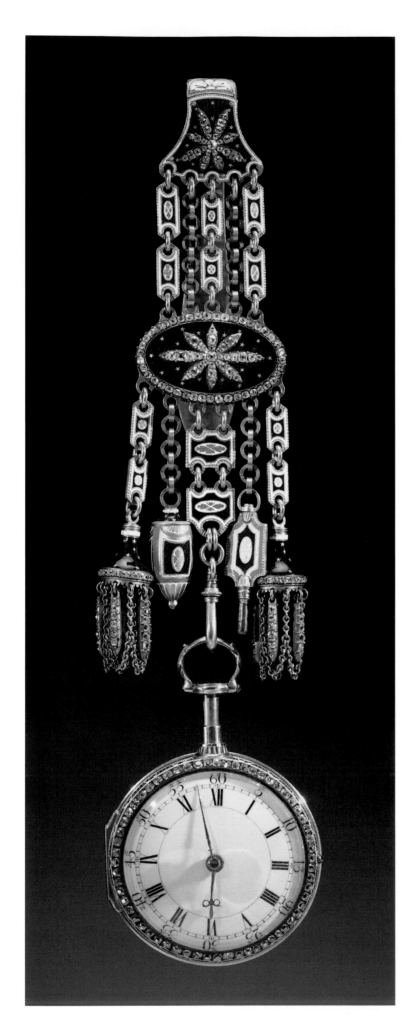

295

ENGLISH

Watchcase with chatelaine, c.1781

The crowned cypher of George III in diamonds decorates the back of the watchcase. It was reputedly given (together with a matching locket and chatelaine, RCIN 43798–9) by George III to his godson James George, third Earl of Courtown (1765–1835), Treasurer of the Royal Household in 1793 and 1806–12. The King had presented a watch and chatelaine of the same model to his close friend Simon, first Earl Harcourt, before Harcourt's death in 1777. However, no. 295 was probably made after 1781 since the matching locket contains a miniature of George III, after the portrait by Thomas Gainsborough exhibited at the Royal Academy in that year. The watch may have been given to the Earl on his marriage in 1791; the corresponding chatelaine and locket, a particularly feminine object, was perhaps a gift to his bride, Mary (1769–1823).

Lord Courtown's parents lived in Windsor Castle and had especially close links with the court. James, the second Earl (1731–1810), had been Lord of the Bedchamber to the King, when Prince of Wales, and was made Treasurer of the Royal Household in 1784. His wife Mary (d. 1810) was the Queen's 'Lady in Waiting in the Country'. In view of these connections, it is possible that the reputed provenance of no. 295 is incorrect and that the watch and locket were in fact given to the second Earl and his wife, perhaps in the early 1780s.

Although the watch movement is now missing, it was almost certainly supplied by the Swiss-born watch- and clock-maker François-Justin Vulliamy (1712–97). Vulliamy received a number of important commissions from George III, including the watch given to Lord Harcourt and a second almost identical watch, also in the Royal Collection, which belonged to the King (RCIN 65350). His son Benjamin and his grandson Benjamin Lewis later worked extensively for George IV.

Gold, enamel, diamonds (watch movement missing). Chatelaine 14 cm long; watch 7 × 5.5 × 1.5 cm
RCIN 43796 (watchcase), 43797 (chatelaine)
PROVENANCE Reputedly presented by George III to George, third Earl of Courtown; bought by King George V and Queen Mary, 1913 (£300; Add. Cat., p. 6, no. 18)

296

JOHN NORTHAM (fl.1793–c.1820) and
JACOB FRIEDRICH KIRSCHENSTEIN (1765–1838)
Gold box, 1813–14

The badge of the Garter embossed on the base of this richly decorated box by the London goldsmith John Northam suggests that it was a royal commission. Northam, like James Strachan, frequently supplied gold boxes to the royal goldsmiths Rundell, Bridge & Rundell (see no. 297). This box was perhaps supplied for the Prince Regent, although it has not been identified in any accounts.

The most striking feature of the box is the deeply chased relief, depicting an armed warrior and a lion attacking a horse, set into the lid. This

◁ 295 (enlarged)

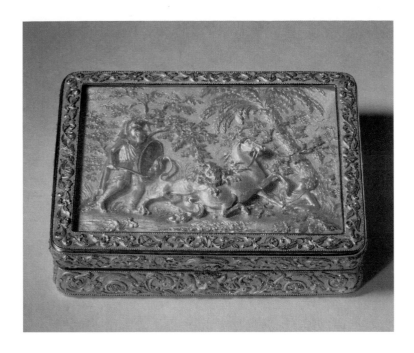

their younger daughter Maria were to be housed in great luxury at Windsor Castle.

Gold-mounted tortoiseshell snuff boxes, supplied by Rundell, Bridge & Rundell, were a favourite royal gift. The richness of their decoration varied according to the status of the recipient. This is one of the finest, and admirably reflects the Conynghams' new-found favour at court. The lid is inset with a gold medallion of George IV, after Thomas Wyon Junior (1792–1817). The surrounding border, of three-colour gold, is chased and enamelled with national emblems and the badges of the Orders of the Garter, Thistle, Bath, the Guelphic Order and St Patrick.

Rundells' accounts include a number of boxes of this type, but no. 297 is not identifiable with any certainty. A similar tortoiseshell box 'with Cameo of The King on Cover, richly mounted & lined with Gold, chased Ornaments, & enamelled, & chased Orders round' was supplied in 1821 for £81 18s. (RA GEO/26004).

No. 297 was probably made by Alexander James Strachan (fl.1799–c.1850), whose large workshop produced considerable numbers of exceptionally fine boxes. Strachan supplied the majority of boxes retailed by Rundell, Bridge & Rundell and has consequently been described as 'the "Paul Storr" of gold boxes' (Grimwade 1976, p. 673).

is signed by the renowned Strasbourg goldsmith Jacob Friedrich Kirschenstein and was probably executed a few years before the box was made. Kirschenstein, who trained in his father's workshop, specialised in virtuoso high-relief gold-chasing. He was particularly praised for his finely observed animals and later worked in Paris for Charles X. His plaques, which often depict realistically modelled hunting scenes, were exported throughout Europe for incorporation into gold boxes.

John Northam registered his mark as a goldworker in 1793. In addition to supplying boxes to Rundells, he acted as an outworker and repairer for Garrard and Wakelin. He appears to have specialised in mounting unusual materials or plaques in his own highly chased gold boxes. A box with similar mounts to no. 296 incorporates two seventeenth-century French miniatures (Gilbert collection; Truman 1991, no. 118).

Yellow gold heightened with red, rock crystal. 3.2 × 9.2 × 7 cm
Hallmarks for London, 1813–14, and maker's mark attributed to John Northam; plaque in lid signed *Kirstein* [sic] / *à Strasbourg*
RCIN 4046
PROVENANCE Acquired by Queen Mary and given to King George V on his sixty-ninth birthday, 3 June 1934 (GV Boxes, IV, no. 359)
LITERATURE Snowman 1990, pp. 288, 394, 441
EXHIBITIONS QG 1962–3, no. 61 (5); London 1990b, no. 81

297
RUNDELL, BRIDGE & RUNDELL
Snuff box, c.1820

George IV's affection for Elizabeth, Marchioness Conyngham (?1766–1861), scandalised society in the 1820s. However, the entire Conyngham family benefited enormously from this royal liaison. Her husband, the first Marquess (1766–1832), was presented – among other things – with this splendid box on George IV's accession to the throne in 1820 and in the following year he was appointed Lord Steward of the King's Household. Later in the reign, both the Conynghams and

Tortoiseshell, three-colour gold and enamel. 3.5 × 10.6 cm
Medallion inscribed GEORGIUS. IV D.G. BRITANNIARUM. REX and signed RUNDELL BRIDGE & RUNDELL; engraved within the lid THE GIFT OF / *George the Fourth* / ON HIS ACCESSION TO THE THRONE / TO THE / *Marquis of Conyngham* RCIN 3835
PROVENANCE Commissioned by George IV; by whom presented to Henry, first Marquess Conyngham, 1820; acquired by Queen Mary; by whom given to King George V, Christmas 1921 (GV Boxes, I, no. 89)
EXHIBITIONS QG 1991–2, no. 168

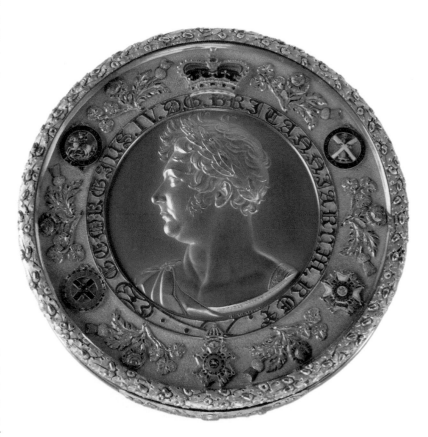

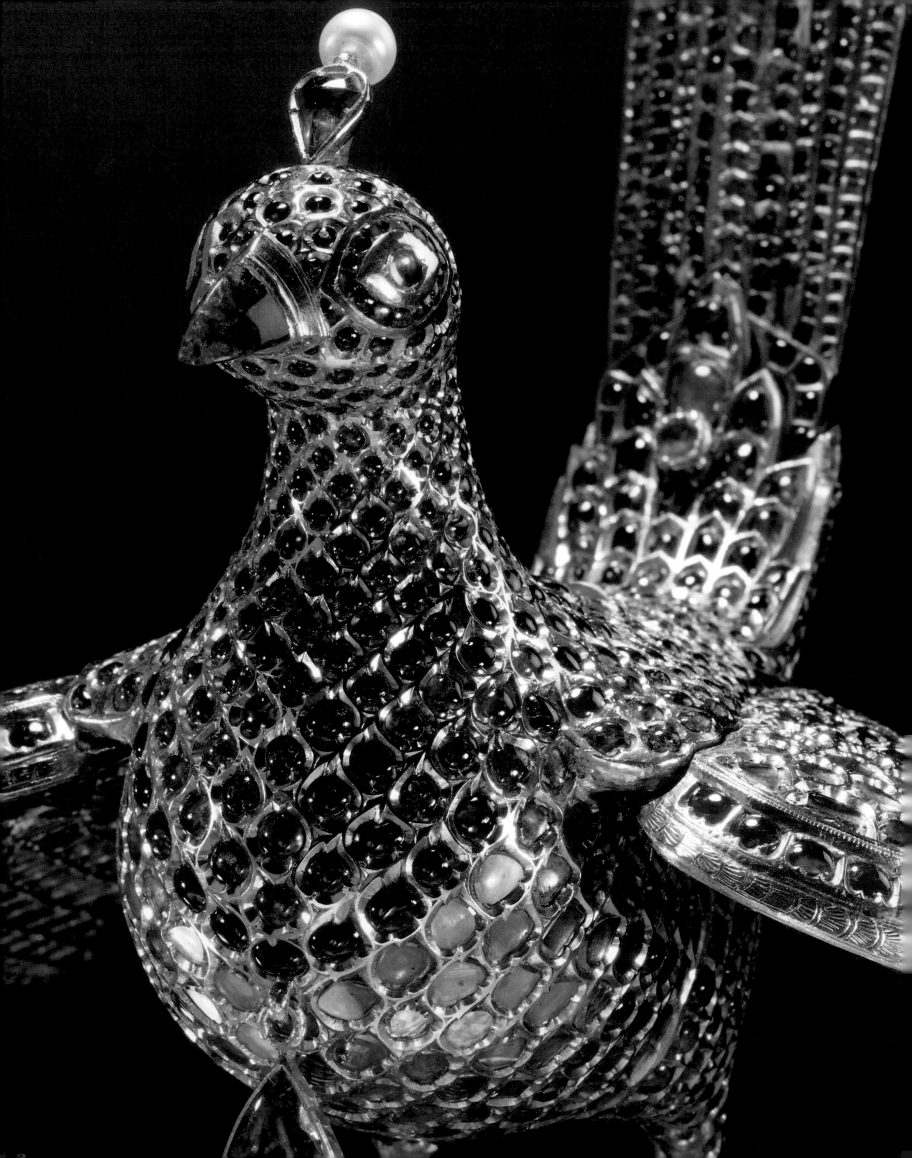

INDIAN WORKS OF ART (nos 298–308)

The majority of the Indian works of art in the Royal Collection date from the period of British supremacy in the sub-continent from the second half of the eighteenth century, and in particular from the period of direct rule between 1858 and 1948. Contacts between the British monarchy and Indian rulers began considerably earlier. Sir Thomas Roe's embassy to the court of the Mughal Emperor Jahangir in 1615–18 established commercial links that were to lead directly to an expansion of the trading and colonial activities of the East India Company, founded in 1600. In 1668 Charles II granted to the Company the territory of Bombay, which he had acquired six years earlier as part of the marriage portion of the Portuguese princess, Catherine of Braganza. It is unclear, however, how many works of art of Indian origin were to be found in the Royal Collection during the seventeenth century, partly because the term 'Indian' or 'India' was applied at this date to objects originating throughout the Far East. Abraham van der Doort's inventory of the collection of Charles I refers to an 'Indian Chamber' at St James's Palace, but this does not seem to have contained specifically Indian items; the 'Indian box wth an Indian Armor in it', for example, almost certainly contained the Japanese armour that had been presented to James I in 1613. Charles I owned seven mother-of-pearl cabinets, which may have been of the same general type as the Torgau casket (no. 195), which probably originated in the Indian kingdom of Cambay (Gujarat) and was then adapted and mounted by German goldsmiths.

It was during the eighteenth century that the interests of the East India Company expanded from purely commercial dealings to colonial administration. Following the military successes of Robert, first Baron Clive (1725–74), increasing numbers of Englishmen joined either the military or administrative branches of the Company, and great personal fortunes were made and collections formed. Among the most prominent of this new class of 'nabobs' were Warren Hastings (1732–1818, created Governor-General of India in 1773), whose wife presented some Indian ivory chairs and a bed to Queen Charlotte; Richard, Marquess Wellesley (1760–1842), elder brother of the Duke of Wellington and Governor-General from 1797, who presided over the defeat of Tipu, Sultan of Mysore, at Seringapatam in 1799 (see no. 298), and Sir George (subsequently Baron) Pigot (1719–77), who presented a cheetah to George III in 1764. (George Stubbs's

portrait of this animal with his two Indian handlers is in Manchester City Art Gallery.) Another was Alexander Wynch (d. 1781), from whose posthumous sale George III purchased a quantity of ivory-veneered furniture for Queen Charlotte (see no. 85). Nabobs would bring such pieces back to England on their retirement from the Company service, as well as solid ivory furniture of more traditional Indian form, generally from Hyderabad or Lucknow. Some examples of this type of furniture from Queen Charlotte's collection remain in the Royal Collection (for example RCIN 1197).

The defeat of Tipu, Sultan of Mysore, the implacable enemy of British interests in south India, created great interest back in Britain and 'relics' of his remarkable collections became highly sought after. Colonel Wellesley (the Governor-General's younger brother and the future Duke of Wellington) sent back the Sultan's quilted fighting armour (or 'war-coat', RCIN 67229) and a blunderbuss (RCIN 67240) as gifts to the future George IV. The blunderbuss was said to have been taken 'from the Bed-Chamber of the late Tipo Saib' and to have been 'placed there for the horrid purpose of shooting the English prisoners that might fall into his hands'. No relics were more prized than fragments from the Sultan's golden throne, which was unceremoniously broken up during the sacking of Seringapatam. The *Huma* bird which formed the finial of the throne canopy (no. 298) was reserved for presentation to the King. The throne was surrounded by a railing with nine tiger heads (the tiger was Tipu's personal emblem), of which eight were in miniature and one life size. This large head (RCIN 67212) was retained by the East India Company, and was presented to William IV in 1831. Not all the Indian treasures that entered the collection during this period were spoils of war, however. In 1797 the Nawab of Oudh presented to the bibliophile George III one of the great treasures of his library at Lucknow, the *Padshahnama* (no. 323), via the retiring Governor-General Lord Teignmouth (1751–1834), and in 1823 the Nawab sent a jewelled sword to George IV. The Carlton House Armoury also included a number of Mughal swords and daggers which George IV purchased from dealers.

The arts of India were brought before the British public to an unprecedented degree at the Great Exhibition of 1851. The Rajah of Travancore, son of Britain's closest ally in the Mysore wars,

contributed a remarkable throne, veneered with carved ivory plaques, which stood at the centre of the Indian court amidst an exotic tableau of silk shawls, metalwork and carvings. The Queen, who continued to use the Travancore throne (RCIN 1561) at Windsor throughout her reign, took an intense interest in Indian art and culture. The Maharaja Dalip Singh (1838–93, see no. 31), the last Sikh ruler of the Punjab, who came to England in 1854, was the Queen's godson. He acquired extensive English and Scottish estates. In 1850, under the terms of the Treaty of Lahore, the East India Company presented the Queen with the legendary Koh-i Nûr diamond, taken from the Treasury at Lahore after the annexation of the Punjab. It was recut in London under the supervision of the Duke of Wellington, and made into a brooch; it is now set in Queen Elizabeth The Queen Mother's crown, which is in the Jewel House of the Tower of London. The 'Timur Ruby' (no. 300) and the emerald belt of Maharaja Sher Singh (no. 299) both came from the same source at this time.

In the winter of 1875–6, with the encouragement of the Prime Minister, Benjamin Disraeli, the future Edward VII made an extensive tour of the sub-continent as the guest of the Viceroy, Lord Northbrook. The Prince of Wales was an experienced traveller, but this tour – the first time the heir to the throne had visited India – was altogether more significant than the earlier wanderings which had formed part of his education. The royal party travelled by train to Brindisi and onward by HMS Serapis via Greece to the Suez Canal, arriving at Bombay on 9 November 1875. The suite included the foreign correspondent William Howard Russell, a veteran of the Crimea, who had accompanied the Prince to the Middle East in 1869. Russell's account of the Indian tour, published in 1877, chronicles each stage of the itinerary and describes the Prince's reactions to those he met and the places he saw. The geographical scope of the tour, from Ceylon to Kashmir, was – as Russell put it – 'defined by the thermometer'. Christmas was spent in Calcutta. There the Prince received a number of the most prominent maharajas whose courts he was to visit later in the tour, and held a Chapter of the Order of the Star of India (founded by Queen Victoria in 1861). Departing from Bombay again on 13 March 1876 after a journey of ten thousand miles, the Prince had 'seen more of the country than any living man' (Russell (W.H.) 1877). Throughout the tour, he was received in the highest state by the 'Native Princes' and was accommodated by the British Residents attached to their courts. There were military parades, festivals, banquets, investitures and sporting

expeditions on an epic scale. On 6 February 1876 the Prince had enjoyed a day arranged by the Commissioner, Sir Henry Ramsay, and the Prime Minister, Sir Jung Bahadur, in which one thousand elephants and ten thousand beaters took part.

The Serapis left Bombay laden with an extraordinarily rich collection of items presented by the Indian princes (see nos 301, 303–05, 308); weapons, jewels, ivories and metalwork; and animals including tigers, elephants and ostriches, all given by the Indian princes during the tour. Recognising their importance, the Prince of Wales telegraphed to South Kensington that arrangements should be put in hand for their exhibition in London. Selections of the presents were subsequently shown in the Indian Section of the Paris Universal Exhibition of 1878, and in Edinburgh, Glasgow, Penzance, Aberdeen and York. For their permanent accommodation at Marlborough House, the Prince himself designed a series of amboyna-wood display cases (with electric lighting) which were made by the firm of Holland. A catalogue of the collection was prepared by Caspar Purdon Clarke, with an introduction by Sir George Birdwood of the India Office, which stressed the potential of the collection as a source of designs for British manufacturers. In 1902, after the Prince's accession as King Edward VII, the showcases containing the most precious items were moved to Buckingham Palace. The bulk of the weaponry and armour was sent to Sandringham, where it was arranged in trophies in the ballroom.

In March 1876, at the very end of the Prince of Wales's tour, Queen Victoria was proclaimed Empress of India. At Osborne, the marine villa built by Queen Victoria and Prince Albert, the Queen-Empress surrounded herself with Indian servants; she learnt Hindustani under the tuition of the Munshi (teacher) Abdul Karim, and in 1893 added a new wing to the house containing a large dining hall in the Indian style which became known as the Durbar Room. The work was carried out by a team of Indian craftsmen led by Bhai Ram Singh, under the supervision of Lockwood Kipling (father of Rudyard Kipling), director of the Lahore School of Art; Ram Singh had worked for Prince Arthur, Duke of Connaught, at Bagshot Park in Surrey five years earlier. The Durbar Room was not used to any extent before the Queen's death in January 1901, but it achieved a new raison d'être shortly afterwards as the setting for a display of Indian gifts, including the quantity of loyal addresses, contained in silver or enamelled caskets in great variety, which arrived from India in tribute to the Golden and Diamond Jubilees of 1887 and 1897.

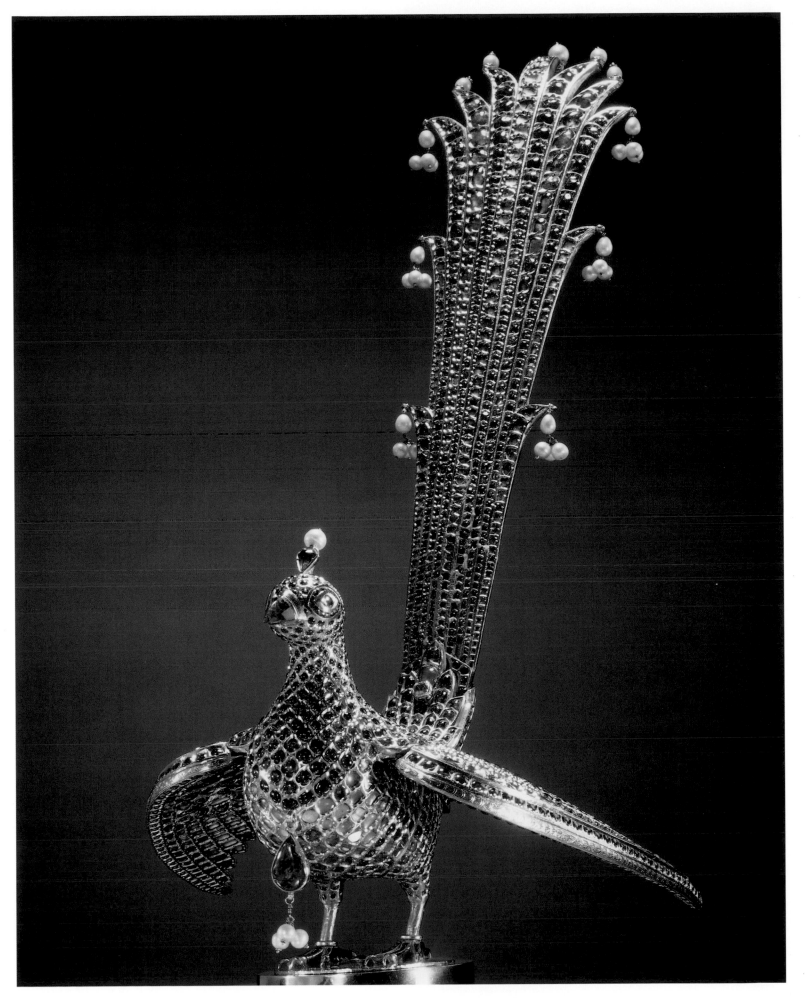

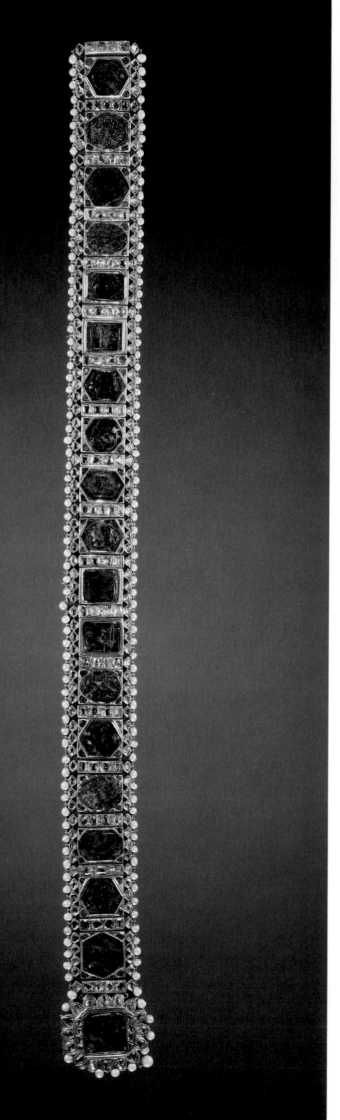

298

INDIAN (MYSORE)

Bird of Paradise (Huma) from Tipu Sultan's throne, c.1787–93

When secret despatches to Napoleon Bonaparte from Tipu Sultan (1749–99), ruler of Mysore, were discovered in 1798, the Governor-General of India, Marquess Wellesley, decided on immediate action to protect British interests. Overseen by Lord Clive, Governor of Madras, the formidably equipped British army led by General Harris stormed Tipu's citadel at Seringapatam on 4 May 1799. Tipu himself was killed and the city, the richest in southern India, was taken.

Colonel Wellesley, the Governor-General's younger brother (and the future Duke of Wellington), was installed as Governor of Seringapatam. He was instructed by his brother to preserve Tipu's magnificent throne for presentation to George III, but found that it had already been broken up and distributed as spoils of war. The throne originally consisted of a canopied octagonal dais of wood overlaid with sheet gold decorated with tiger stripes, on eight claw legs surmounted by jewelled tiger heads. At the front was a life-size figure of a gold tiger. Above the canopy fluttered the sacred *Huma*, the royal bird of happy omen supposed never to touch the ground, of which it was said that every head it overshadowed would in time wear a crown.

The *Huma*, which had already been allocated, was reacquired by Marquess Wellesley for £1,760 and with other parts of the throne was despatched to London. In 1800 the Directors of the East India Company presented the *Huma* to George III, who in turn gave it to Queen Charlotte. In 1815 Paul Storr made a silver-gilt stand for the *Huma* (not exhibited) and at the Queen's death in 1818 the bird was left to four of her daughters. They gave it to their brother the Prince Regent (George IV), extracting from him a promise that 'this jewel should never be separated from the Crown of Great Britain and Ireland' (Windsor Gold Room inventory). In 1831 the largest surviving part of Tipu's throne, the head and paws of the golden tiger, was presented to William IV by the East India Company. This is now displayed with some twenty-six other Tipu relics in the Grand Vestibule at Windsor Castle.

Gold, rubies, emeralds, diamonds, pearls. 42 × 20 × 28 cm
RCIN 48482
PROVENANCE Made for Tipu Sultan; acquired by Marquess Wellesley for the Directors of the East India Company, 1799; by whom presented to George III, 1800 (BL Indian and Colonial Collections R. 3/98, p. 477); by whom given to Queen Charlotte; by whom bequeathed to four of her daughters, 1818; by whom given to George IV, 1818
LITERATURE Archer, Rowell & Skelton 1987, pp. 27, 75, 119 and 134; Buddle 1999, p. 22 and pl. 23

299

INDIAN (LAHORE)

The emerald belt of Maharaja Sher Singh, c.1840

Together with the 'Timur Ruby' and other important jewels (see no. 300), this magnificent belt was presented to Queen Victoria by the Directors of the East India Company at the conclusion of the Great Exhibition in 1851. The Queen described the emeralds as 'wonderful & also of immense value' (QVJ, 23 October 1851), noting with some

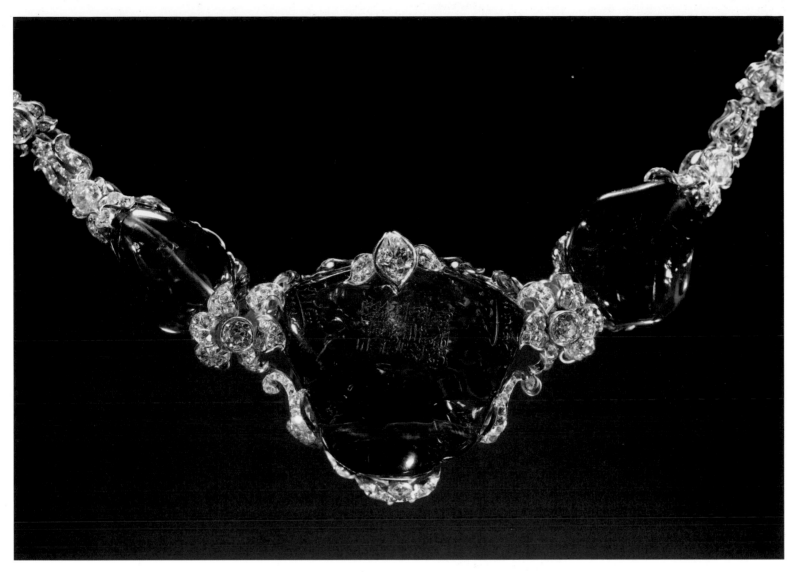

regret (since this ruled out any recutting or setting of the stones) that they were all flat-cut and that some were carved.

The belt is of the traditional form worn by Mughal grandees from the seventeenth century onwards and was made for Maharaja Sher Singh (d. 1843) in the twilight period of independent Sikh rule of the Punjab. The stones came from the Treasury at Lahore and had previously belonged to Sher Singh's father, Maharaja Ranjit Singh (1780–1839). Some of them may be of earlier date, from the seventeenth or eighteenth centuries. At the time of the Great Exhibition it was said that these emeralds were among those which had been used by Ranjit Singh to decorate his horses. This extravagantly decadent practice was described and drawn by Emily Eden, sister of Lord Auckland, the Governor-General of India, on a visit to Ranjit Singh's stud in 1838 where a horse swathed with emeralds was paraded past her (Eden 1844, p. 14).

The emeralds vary in quality and country of origin. Three of the rectangular emeralds are very fine (possibly from the Afghan/Kashmir region) and all the hexagonal stones appear to have been cut from the same stone, which may be from the Ural region. Two of the carved stones have matching designs and were probably executed by the same hand. The diamonds are either flat-cut (lasques) or more regularly faceted stones cut either in the West or in India for the Western market. The pearls are probably eighteenth century or earlier.

Emeralds, diamonds, pearls, gold, fabric and silver-gilt thread. 6.9 × 83.5 cm
RCIN 11291
PROVENANCE Made for Maharaja Sher Singh (the emeralds inherited from Ranjit Singh), c.1840; taken (as part of the Lahore Treasury) by the Directors of the East India Company, 1849; by whom given to Queen Victoria, 1851
LITERATURE Twining 1960, pl. 73b
EXHIBITIONS London 1851a; London 1999b, no. 85

300
R. & S. GARRARD & CO.
The 'Timur Ruby' necklace, 1853

At the conclusion of the Great Exhibition in October 1851, the Directors of the East India Company presented Queen Victoria with a selection from the Indian Section in recognition of her patronage of the exhibition. This gift included the collection of superb Indian jewellery taken from the Lahore Treasury at the time of the British annexation of the Punjab in 1849 (see nos 156, 299). The Queen particularly admired the 'wonderful' rubies: 'They are cabochons, uncut, unset, but pierced. The one is the largest in the world, therefore even more remarkable than the Koh-i-noor!' (QVJ, 23 October 1851). The latter diamond had been presented to the Queen by the East India Company in 1850.

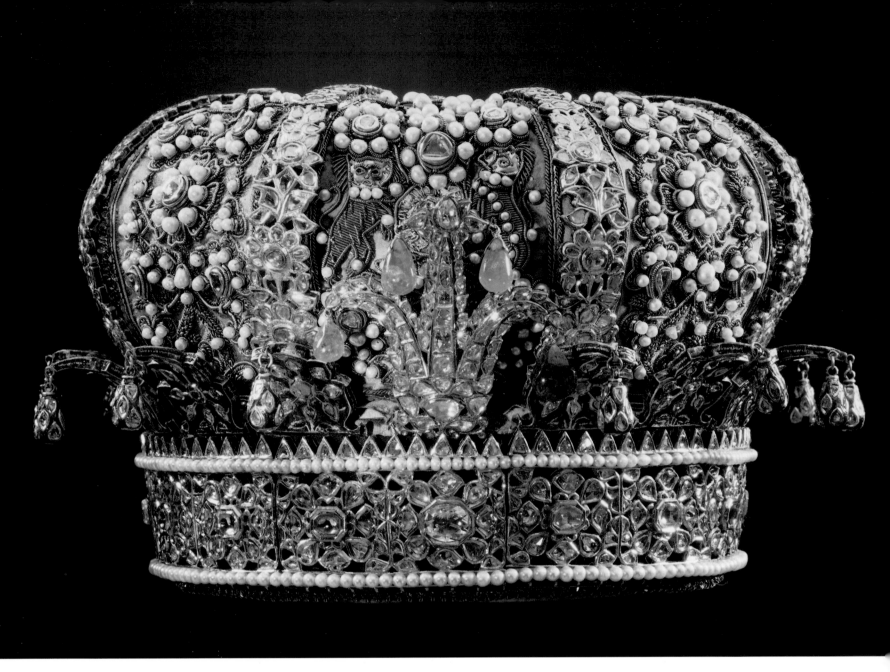

In April 1853 Garrards set four of these so-called 'rubies' in a new diamond-encrusted gold and enamel necklace 'of Oriental design', with four diamond pendants also from Lahore. At the centre of the necklace came the huge rose-pink stone of 352¼ carats that Queen Victoria had especially noted. Two months later, Garrards adjusted the necklace to allow this stone to be detached for use as a brooch and to alternate with the recently recut Koh-i Nûr.

Like the so-called 'Black Prince's Ruby' in the Imperial State Crown, the four 'rubies' are in fact spinels, similar in appearance to rubies but gemmologically quite distinct. These four were probably mined in the region of Badakhshan (modern Afghanistan and Uzbekistan). The spectacular central stone bears Persian inscriptions recording its illustrious provenance from the Mughal Emperors Jahangir, Shah Jahan, Awrangzeb and Farrukhsiyar, via Nadir Shah to Ahmad Shah. The dates range from 1612 to 1771. Owing to a misreading of one of these inscriptions early in the last century, the stone acquired an erroneous association with the great Asian ruler Timur or Tamburlaine (1336–1408), a myth which has only recently been exposed.

Queen Victoria wore the necklace occasionally, notably during the State Visit of Napoleon III and the Empress Eugénie in 1855; and three

of the diamond pendants were made detachable in 1858 (see no. 156). Queen Mary had the necklace lengthened in 1911, but it has seldom been worn since.

Spinels, diamonds, gold, enamel. 50 cm long
RCIN 100017
PROVENANCE The spinels from the Lahore Treasury, 1849; presented to Queen Victoria by the Directors of the East India Company, 1851; the necklace made for Queen Victoria, 1853 (£220 5s. and £131 17s. 6d.; Garrards Royal Ledger, f. 31) and altered for Queen Mary (RA QEII/Garrard/Ledger 1901–11, p. 167)
LITERATURE Bury 1991, I, pp. 317–18; Stronge 1996, pp. 5–11
EXHIBITIONS London 1999b, no. 84; London 2001a

301

INDIAN (?LUCKNOW)
Regal crown, c.1875

This was the only specifically royal object presented to the future Edward VII during his Indian tour, and yet the donors, the Taluqdars of Oudh, occupied a relatively low position among the 'princes and nobles of

India' who honoured the Prince with gifts. The Persian word *ta'alluqa* originally denoted an estate or dependency. Before the British annexation in 1856 of the Kingdom of Oudh (centred on Lucknow, today the capital of Uttar Pradesh), the Taluqdars (holders of *ta'alluqas*) played a key part as contractors in the collection of revenues, each controlling a group of villages. They gradually sought to give permanence to their holdings, aspiring to the position of *Raja*. After the annexation they were massively dispossessed, but in the aftermath of the Mutiny of 1857, the British administration under the Governor-General Charles Canning sought to re-establish the Taluqdars as a means of ensuring stability. Canning held durbars at Lucknow and Calcutta for this new class of noblemen, and as their titles and estates passed to the next generation, the Taluqdars were often among the quickest to emulate British traditions (Pemble 1977, p. 252).

The crown was presented to the Prince of Wales on 7 January 1876 in the throne room of the former palace of the kings of Oudh in Lucknow, which was now the seat of the British administration. During the day the Prince laid the foundation of a monument to the native soldiers who died in British uniform during the troubles of 1857, met a number of veterans and visited the main sites where the fighting had taken place. After the presentation of the crown and a loyal address, a procession of the Taluqdars made their obeisances to the Prince, and the evening concluded with fireworks and a banquet (Russell (W.H.) 1877, p. 396).

The turban-shaped crown has eight jewelled gold tapering semi-arches over a velvet cap that has lost most of its original bright purple colour. The point at which the arches meet in the middle is covered by a rosette of diamonds. The cap is applied with silver-gilt embroidery set with pearls and diamonds, with a royal coat of arms and the Garter motto *Honi soit qui mal y pense*. A row of enamelled gold stylised leaves with diamond-set pendants is sewn to the top of the circlet, which is bordered with strings of pearls enclosing a row of diamond-set enamelled gold florets. This is interrupted at the front by a trefoil aigrette-holder set with diamonds and with pendant emeralds, which was probably intended to represent the Prince of Wales's feathers. His motto *Ich Dien* is embroidered on the cap below the royal arms. The fine cotton lining of the cap retains its original bright emerald green colour.

Gold, enamels, pearls, emeralds, diamonds, velvet and cotton. 16.8 × 32 cm
RCIN 11358
PROVENANCE Presented by the Taluqdars of Oudh to Edward VII, 1876
LITERATURE Clarke 1898, no. 19
EXHIBITIONS York 1881

302
INDIAN (?JAIPUR)
Pair of bracelets (kadas), nineteenth century

Of a traditional form with crisply modelled and chased dragon-head terminals, these are probably the bracelets that were presented to Queen Victoria by Dr J. Tyler, superintendent of the Agra Jail, who selected and

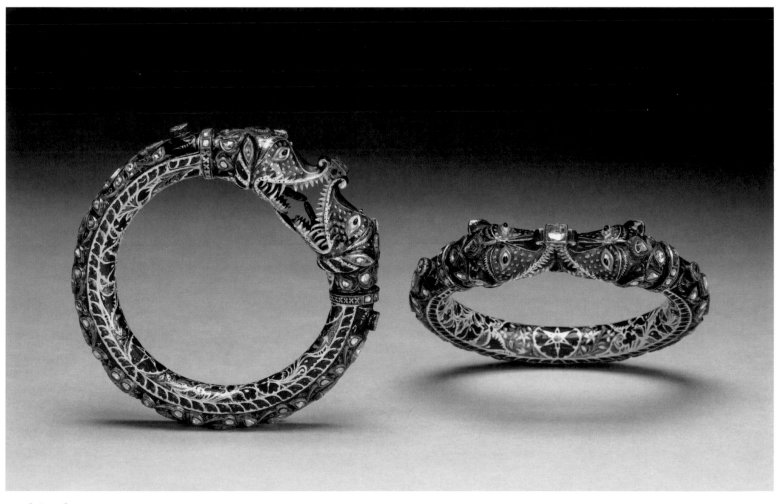

302 (enlarged)

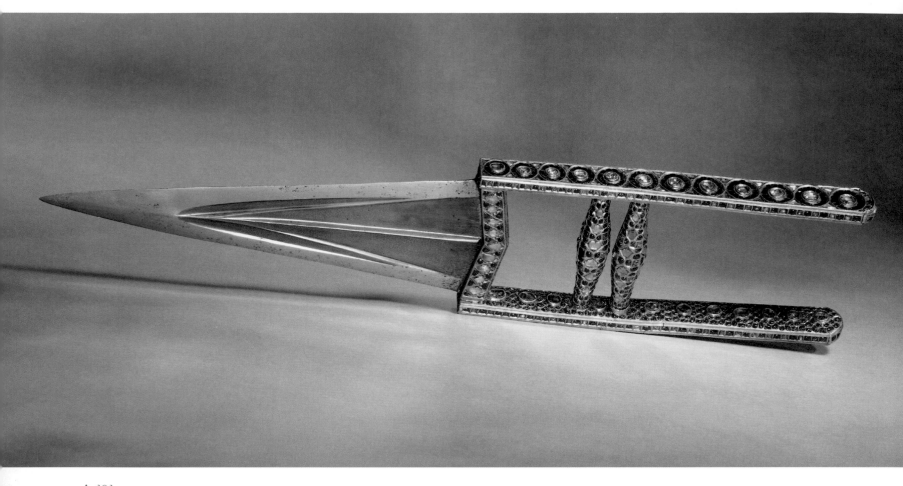

△ 303
▽ 304

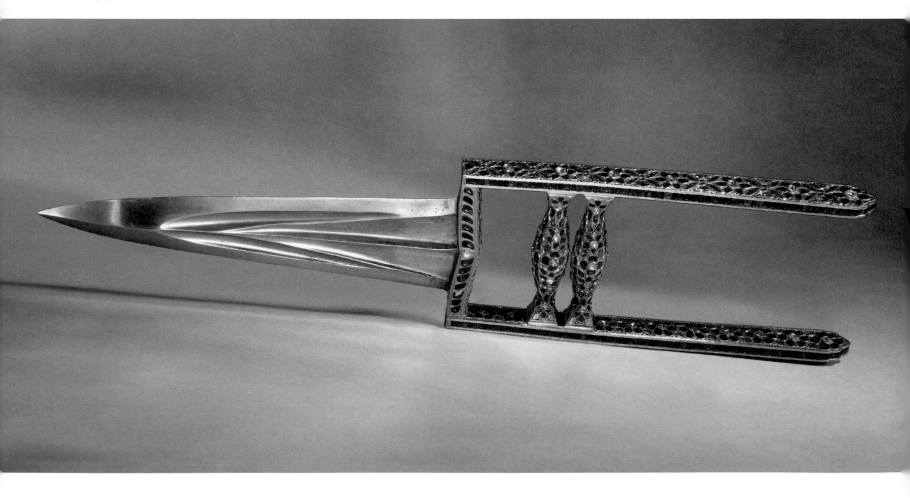

brought to London the Indian artisans who plied their trades at the Colonial and Indian Exhibition at South Kensington in 1886. The Queen, in thanking Tyler for the gift in a letter dated 20 September 1886, informed him that she had worn the bracelets the previous evening (RA VIC/L10 167). The exhibition was organised at the instigation of its Executive President, the Prince of Wales, and occupied the site of the present Imperial College. Here was laid before the London public a vast spectrum of the arts, architecture, manufactures and natural riches of the Empire. It was opened by the Queen at a ceremony in the Royal Albert Hall, at which Madame Albani sang an ode written especially for the occasion by the Poet Laureate, Lord Tennyson, and set to music by Sir Arthur Sullivan. There followed three verses of the National Anthem, of which the second was sung in Sanskrit. The exhibition made a profit of £25,000 which was put towards the foundation of the Imperial (later Commonwealth) Institute in 1893.

Gold, coloured enamels and diamonds. 6.1 × 5.8 × 1.2 cm
RCIN 11357
PROVENANCE Probably presented by Dr J. Tyler to Queen Victoria, 1886

303
INDIAN
Punch dagger (katar), (?)early eighteenth century

The term 'punch dagger' is derived from the action with which it is used, with an upright fist gripping the double crossbars. In this example the grips and side bars are made of gold, set with numerous rubies, emeralds and diamonds in floral and foliate settings in the style of early eighteenth-century Mughal work. The blade was specially etched with an inscription for presentation to the Prince of Wales. The Prince met the Maharaja of Rutlam on 9 March 1876 at the Residency at Indore, where he was the guest of the Maharaja Holkar of Indore (Russell (W.H.) 1877, p. 516).

Gold, rubies, emeralds, diamonds, steel. 39.4 cm long
Inscribed H.R.H. PRINCE OF WALES / RUTLAM A.D. 1876
RCIN 11284
PROVENANCE Presented by the Maharaja of Rutlam to Edward VII, 1876
LITERATURE Clarke 1898, no. 55
EXHIBITIONS Cardiff 1998, no. 157

304
INDIAN
Punch dagger (katar), (?)early nineteenth century

The Prince of Wales made the short journey from Benares to the old fort at Ramnagar just before sunset on 5 January 1876. His reception at Ramnagar by the Maharaja of Benares was probably the most spectacular of all the welcoming ceremonies throughout the Indian tour. The Prince was embarked in a galley with two carved seahorses at the bow which was towed by a steamer for four miles up the Ganges. The description of the veteran correspondent W.H. Russell conveys the atmosphere of the occasion: 'The river-bank was blazing with the twittering of *feux de joie*; the air lighted up by the discharges of artillery from the ancient

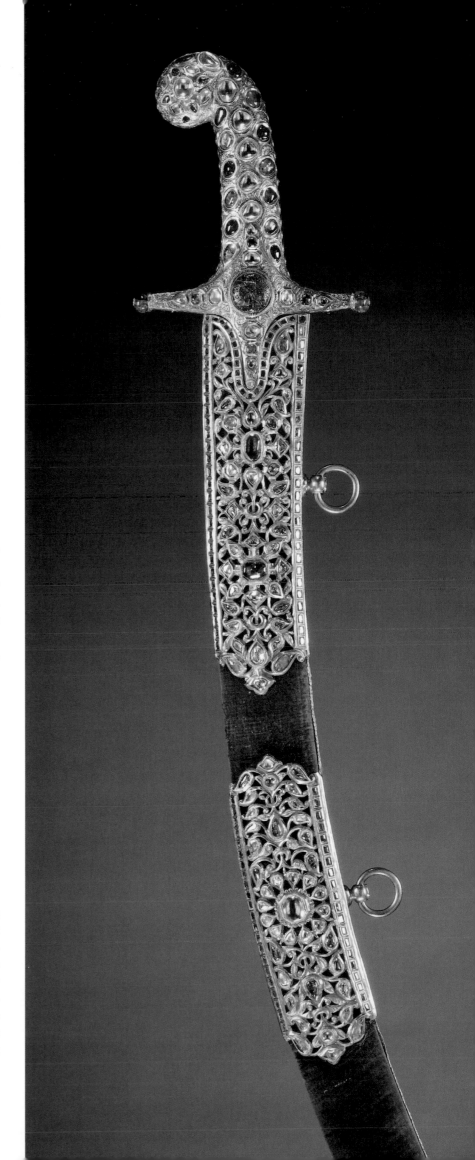

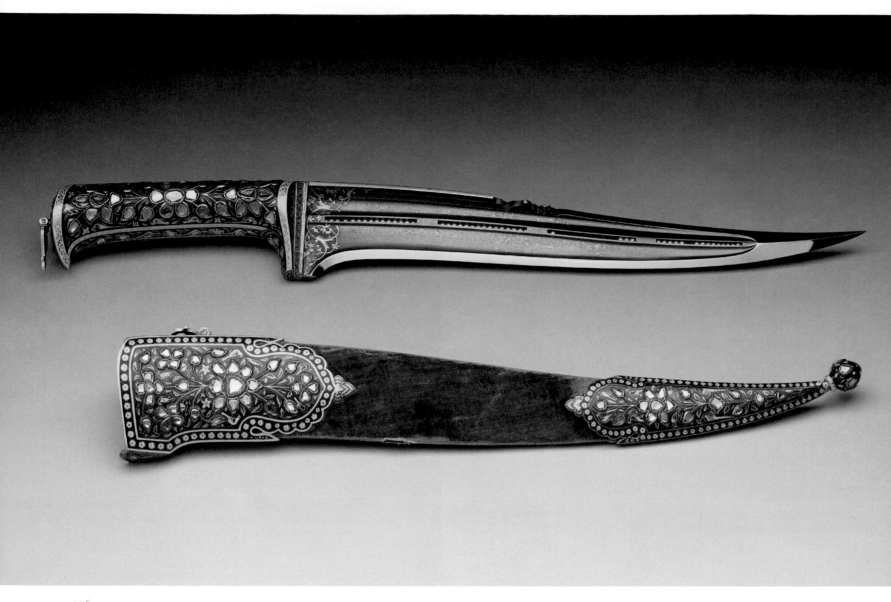

306

parapets; the battlements of the fort were illuminated. Silver flambeaux and torches were held by people on parapets, walls and river-banks, which were as light as day. Preceded by mace-bearers, spearsmen, and banners, the Prince and the Maharaja were borne in gold and silver chairs, on men's shoulders, up the ascent from the river to the castle gate, between lines of matchlockmen and cavalry. Elephants, accompanied by wild music, marched on the left, shootee sowars rode on the right' (Russell (W.H.) 1877, p. 389). After further ceremonials within the fort itself, at which presentations were made, the Prince was led up to the roof to look down on the Ganges as thousands of tiny lamps floated down on the current in his honour.

The gift of the Raja of Ramnagar on this occasion was another example of the same form of dagger as no. 303. In this case the setting of the jewels on the handle suggests a date around one hundred years later.

Gold, rubies, emeralds, diamonds and steel. 41 cm long
RCIN 11287
PROVENANCE Presented by the Raja of Ramnagar to Edward VII, January 1876
LITERATURE Clarke 1898, no. 50
EXHIBITIONS Cardiff 1998, no. 158

305
INDIAN
Sabre and scabbard, 1864

The Prince of Wales entered the hill state of Jammu, within sight of the Himalayas, on 20 January 1876, mounted on an elephant with the Maharaja of Kashmir, Ranbir Singh Sahib Bahadur. Escorted by a troop of the 9th Lancers and passing beneath hastily erected arches along a route lined with crowds, the procession eventually reached the Maharaja's palace, where a durbar was followed by a banquet and fireworks (Russell (W.H.) 1877, pp. 427–33). On this occasion, the Prince also received a cigar case, a hookah, some water bottles, cups and covers, and a magnificent enamelled shield (no. 308).

The gold hilt of this sword is encrusted with diamonds, rubies and emeralds, with a large circular engraved emerald at the centre. At the top or *forte* of the wavy-edged damascus blade is an ornamental etched panel, and an inscription on the other side records the date and the Maharaja's name.

Gold, diamonds, emeralds, rubies, steel, wood, velvet and silk.
Sword 101.4 × 13.5 × 3 cm; scabbard 91 × 6.4 × 2.4 cm
Devanagari inscription on the blade: *Maharaja Ranbir Singh Sahab Bahadur, Samvat 1921*
(i.e. AD 1864. Transliteration kindly provided by Mr Karni Singh of Jodhpur)
RCIN 11410
PROVENANCE Presented by the Maharaja of Kashmir to Edward VII, 1876
LITERATURE Clarke 1898, no. 94

306
INDIAN
Dagger (peshkabz) and scabbard, 1877

In addition to the luxurious, jewelled quality which is common to most
of the gifts presented during the Prince of Wales's Indian tour of
1875–6, this dagger boasts a blade of exceptional accomplishment. It is
of steel, with a single polished edge and with two etched shallow grooves
flanking a drilled bore in four sections which are filled with loose seed
pearls. It is all the more admirable on technical grounds for the fact that
the bore follows the curve of the blade. Such a weapon would obviously
have certain practical limitations and it must be seen instead as an
exercise in master bladesmithing.

Gold, steel, pearls, diamonds, wood and velvet. Dagger 40.6 × 4.5 × 3.7 cm; scabbard
32.1 × 5.6 × 3.4 cm
Inscribed (in Persian) *Work of Ibrahim 1877*
RCIN 11289
PROVENANCE Presented by the Maharaja of Bharatpore to Edward VII, 1877
LITERATURE Clarke 1898, no. 96
EXHIBITIONS Cardiff 1998, no. 159

307
INDIAN (JAIPUR)
Sword and scabbard, c.1902

This exceptionally rich sword and scabbard were presented to Edward
VII on the occasion of his coronation by Sawai Sir Madho Singh
Bahadur (1861–1922), Maharaja of Jaipur, one of the small group of
Indian princes and nobles invited to attend the ceremony at Westminster
Abbey in June 1902. For the journey to England, Madho Singh char-
tered a ship which was fitted with large copper vats containing sufficient
Ganges water to sustain him and his retinue of 400 followers through-
out both sea passages and whilst in England. At the eleventh hour, after
their arrival in London together with large numbers of other foreign
royalty and heads of state, the coronation was cancelled due to the
King's appendicitis. It did not in fact take place until 9 August, by which
time most of the royal guests had departed for home. The Maharaja,
however, duly attended the postponed ceremony, having spent the inter-
vening period staying at Kedleston Hall and other country houses,
closely attended at all times by his cook and his jeweller (Lawrence
1928, pp. 213–14).

The importance of the jeweller in the Maharaja's household is clear
from this coronation gift, which is set with a total of 719 diamonds
(there has been one loss, from the upper suspension ring). These include
a large number of rose-cut and brilliant-cut stones as well as the flat,
'lasque' stones more commonly used in Indian jewellery, and it is

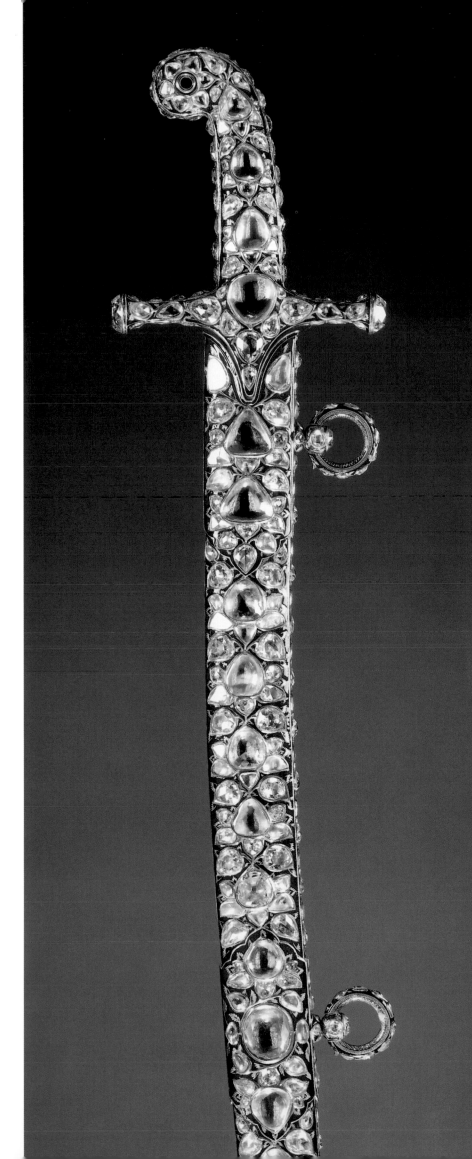

307 ▷

possible that many of them were cut in Europe. They are held in 'rub-over' gold settings and backed with silver foil, which makes it impossible to assess their total weight with precision. The largest appear to be the two mixed-cut pale yellow diamonds at the end of the quillons, one of which is estimated at thirty-six carats. The combined weight of all the diamonds is possibly in the region of two thousand carats. The scabbard and hilt are of gold, finely enamelled in dark blue, green and red. The steel blade is of markedly poor quality by comparison.

Jaipur was one of the largest and richest of the Rajput states, with 2.8 million inhabitants in 1897. During his visit in 1875–6, Edward VII had laid the foundations of the Albert Hall in Jaipur, one of a number of new public buildings erected in the capital city at the time, including libraries, art galleries and hospitals.

Gold, coloured enamel, diamonds, steel. Sword 88.5 cm long; scabbard 79.7 cm long
Inscribed (etched) on the blade A TOKEN OF THE LOYALTY OF / SAWAI MADHO SINGH / MAHARAJA OF JAIPUR / 9th AUGUST 1902; an illegible armoury mark is incised on the neck of the scabbard
RCIN 11288
PROVENANCE Presented by the Maharaja of Jaipur to Edward VII, 1902

308
INDIAN (?LUCKNOW)
Shield, early nineteenth century

Like the weapons and other articles presented to the Prince of Wales in India during the winter of 1875–6, this is a particularly elaborate and rich example of a traditional form. Shields of this type (Dhal) were usually made of hide, often painted or lacquered, with metal bosses applied at the points to which the handles were fastened on the reverse. In this instance the front of the shield is made of silver gilt, decorated overall with champlevé enamels, mounted with four bosses and inset with seven tear-shaped ornaments and a crescent motif, all of them set with diamonds. The colours employed for the enamelling, and the subject matter – numerous animals and birds, some of which are attacking one another – are characteristic of Lucknow work of the eighteenth and nineteenth centuries. The four jewelled borders around the edges are formed on segmental plates about 20 centimetres long, whose joins are disguised in ingenious ways. The thickness of the shield is probably filled with lac, and the reverse is a plain lacquered brass disc.

Silver gilt, brass, enamels, diamonds and lac. 48 cm diameter
RCIN 11278
PROVENANCE Presented by the Maharaja of Kashmir to Edward VII, 1876
LITERATURE Clarke 1898, no. 104
EXHIBITIONS York 1881; Cardiff 1998, no. 160

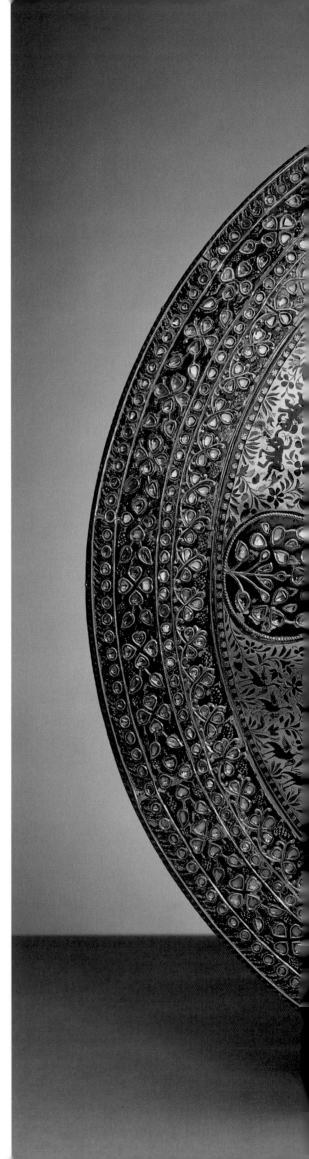

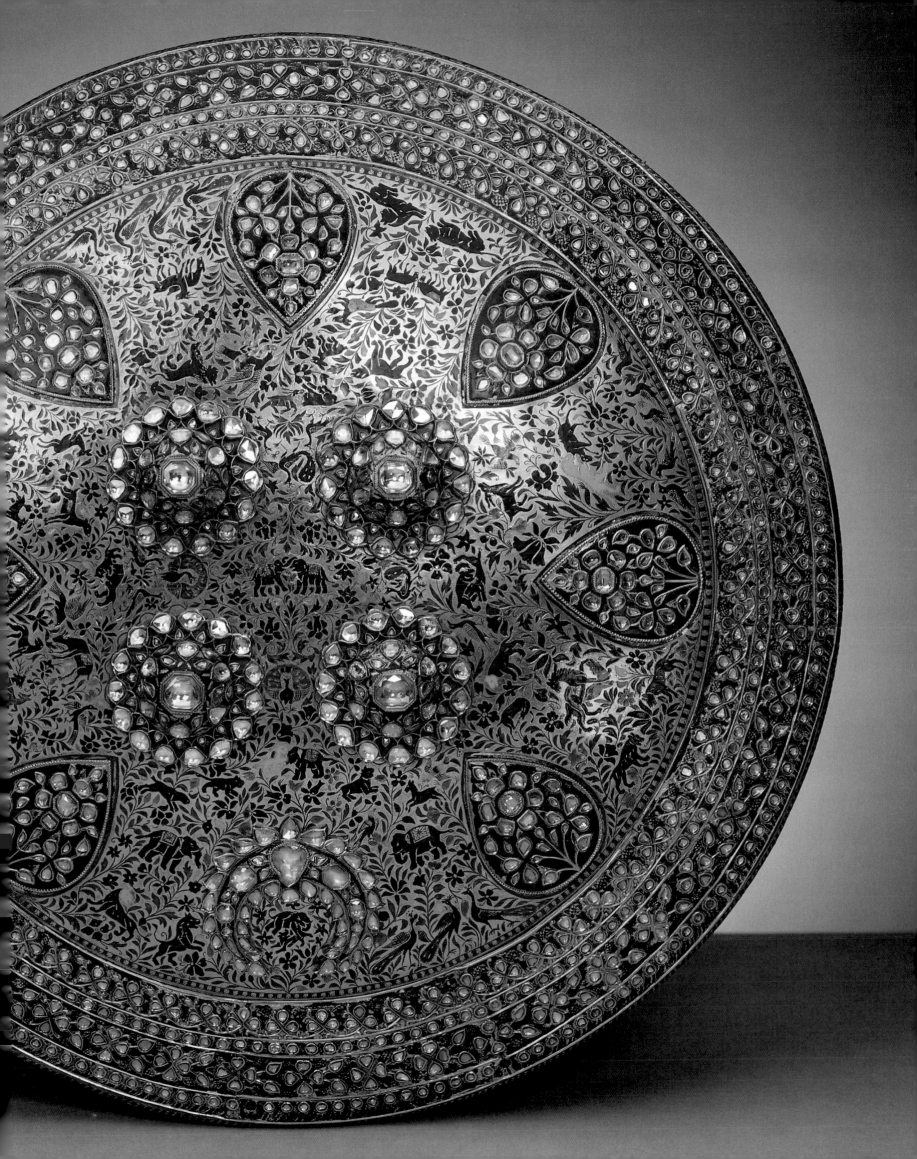

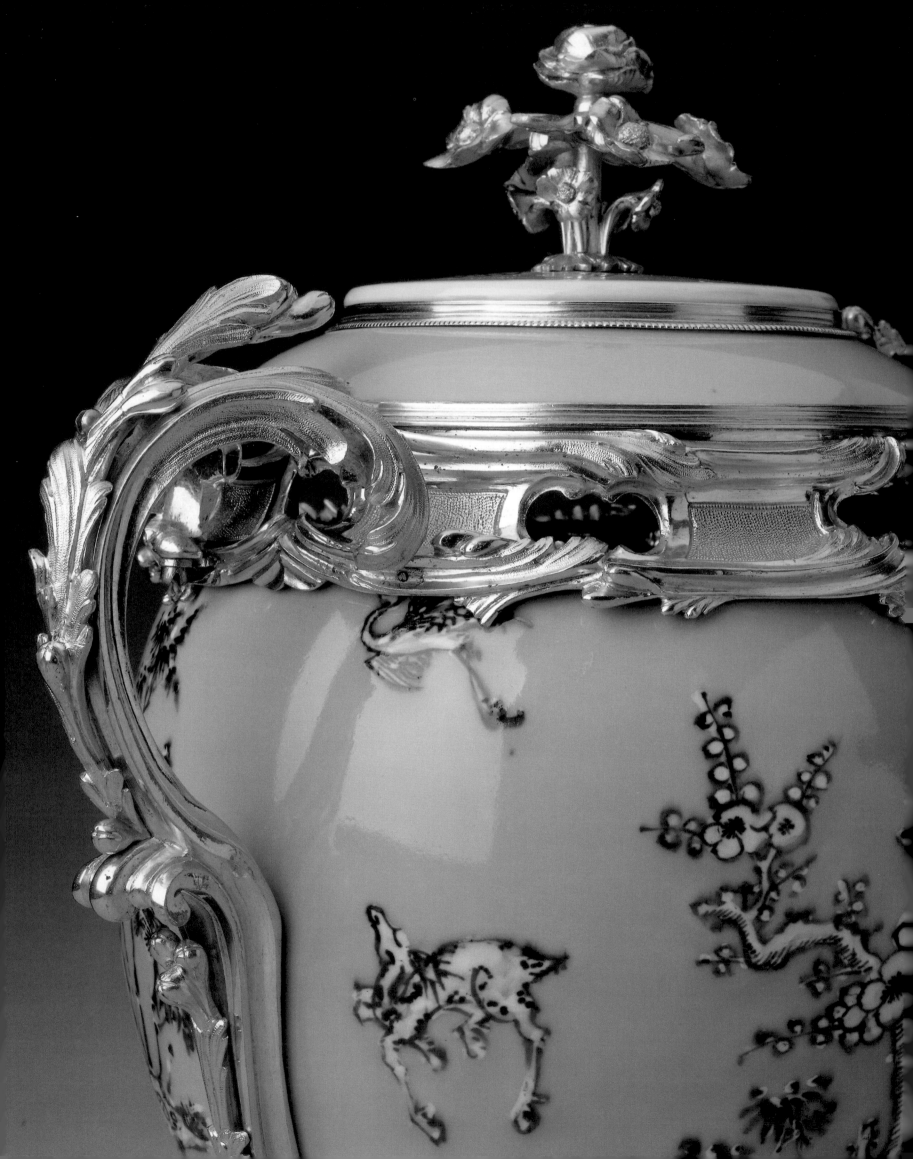

ORIENTAL PORCELAIN AND LACQUER (nos 309–317)

Oriental works of art are present in the Royal Collection in large quantities and cover almost every branch of the decorative arts of China and Japan, including lacquer, porcelain, jade, arms and armour and enamels. Elizabeth I possessed examples of blue and white Chinese porcelain mounted in silver in England in a manner which emphasised the great rarity of such objects at this date. After the foundation of the East India Company in 1600, in competition with those of the Netherlands and Portugal, large quantities of oriental porcelain appeared in the West. However, the first documented work of art to enter the Royal Collection by this means was the suit of armour presented to James I by the Shogun Tokugawa Hidetada in 1613 (RCIN 71611, on loan to the Royal Armouries, Leeds), which was probably the 'Indian armour' listed by Van der Doort at St James's Palace in 1639. Elsewhere in Charles I's inventories, various other kinds of oriental artefacts can be found. Approximately seventy pieces of oriental porcelain are noted by Van der Doort and an embassy from the States of Holland presented Queen Henrietta Maria with gifts including Chinese porcelain in 1635.

It was only at the end of the seventeenth century, however, that Chinese and Japanese porcelain and lacquer began to arrive in much larger numbers in the collections of William and Mary. It was above all Queen Mary who encouraged the taste in England for oriental porcelain vessels used decoratively (see p. 35). By the time of her death in 1694, aged only 32, she had acquired hundreds of pieces for her palaces at Het Loo in the Netherlands and at Kensington, where 780 items were listed. After her death these were given to one of the King's favourites, Arnoud Keppel, Earl of Albemarle, but several of her acquisitions survive in the Royal Collection. Among these are the hexagonal Japanese Kakiemon vases and covers which have become known in England as 'Hampton Court' vases (for example RCIN 35285).

Evidence of the practice of mounting oriental porcelain in Europe can be found as early as the fourteenth century but it was not until two centuries later that it became a standard way of emphasising the rarity or exotic quality of porcelain vessels. By the eighteenth century, such mounts were more commonly of gilt or polished and lacquered bronze, rather than silver or silver gilt. And although mounts were still considered an enhancement of the original object, with the increased familiarity of oriental porcelain

in Europe the purpose of the mounts had evolved. It was above all in mid-eighteenth-century France that the fashion for mounted Chinese porcelain took hold. Vases of traditional oriental forms such as the 'ginger jar' (no. 313), as well as those based on Western prototypes such as the square bottles (no. 312), were mounted so as to harmonise with other gilt bronze objects, for instance clocks and statuettes. Occasionally the mount would adapt the use of the oriental vessel; thus no. 313 was converted into a pot-pourri vase. Inventories and painted views of fashionable Parisian collections of the mid- to late eighteenth century invariably include pot-pourri vases on the chimneypieces. Flower petals and aromatic herbs would be steeped in spirit and placed inside the vase so that their scent could escape into the room through the 'eyes' of the neck mount. Such pieces were made in great quantities.

The mounting of porcelain, lacquer and marble vases in eighteenth-century Paris was the business of the *marchands-merciers*, men such as Simon-Philippe Poirier (who also specialised in the conversion of old Japanese lacquers as veneers for cabinets and chests-of-drawers), Thomas-Joachim Hébert and Lazare Duvaux. The last named is most often cited in connection with the trade in mounted porcelain because of the survival of his sale books or *Livre-Journal* for the period 1748–58, in which his dealings with the most fashionable clientèle, including Madame de Pompadour, are minutely documented. The *marchands-merciers* also supplied a rather more select group of collectors with Japanese lacquer, notably Queen Marie-Antoinette whose remarkable collection was entrusted to the *marchand-mercier* Dominique Daguerre for safe-keeping in 1789, passing into the hands of the state after the Queen's execution. Her collection included writing-boxes, miniature temples, vases and bowls, some of them mounted in gilt bronze like those in the Royal Collection (nos 310, 311).

Queen Charlotte may have begun to collect oriental porcelain soon after her marriage to George III, in the context of the 'Japan Room' at Buckingham House which had been created in the time of the Dukes of Buckingham. Its black and gold panelling was adapted (by George III's cabinet-maker, William Vile) for reuse in the Queen's Breakfast Room in the 1760s. Pyne's view of that room shows miscellaneous pieces of the Queen's oriental porcelain occupying the deep ledges above the door and fireplace (Pyne 1819, II, *Buckingham House*, opposite p. 20). Although both the

wall covering and the porcelain in this room have vanished, it is likely that the large group of Chinese carved red lacquers still in the Royal Collection originated with Queen Charlotte: pieces from her collection can be seen in the view of the Green Closet at Frogmore included in Pyne's *Royal Residences* (Pyne 1819, I, *Frogmore*, opposite p. 21). Some of them, which feature the imperial five-clawed dragon, may have been presented by the Emperor Qianlong.

As in other areas, George IV took full advantage of the break-up of the French *ancien régime* collections to enrich his own with mounted Chinese porcelain, carved lacquer and ivories, which he acquired either through François Benois in Paris (from such dealers as Lafontaine, Page, Rocheux and Escudier), or from specialist London dealers such as Robert Fogg, Edward Holmes Baldock, John Hall and John Crace, or from his goldsmiths, Rundell, Bridge & Rundell. Once in the King's possession, such pieces often passed through the hands of either the bronze-making firm of B.L. Vulliamy or the restorer Charles Brandt for modification. This could entail the supply of entirely new mounts or the extension of the existing ones, as can be seen on the 'Kylin' clock (no. 316).

Queen Victoria's additions to the oriental collections mainly came in the form of gifts. In the 1860s her second son Prince Alfred, Duke of Edinburgh, made a five-year tour of the Pacific, taking in Australia, New Zealand and Japan. His visit in 1869 was one of the first official contacts between Europe and Japan for more than 250 years. Prince Alfred returned with gifts for the Queen from the Emperor Meiji including armour (RCIN 61765). The oriental collections continued to grow into the twentieth century. Numerous pieces of oriental lacquer and an important group of jade carvings were acquired by Queen Mary, and in 1911 a very large pair of *cloisonné* vases (RCIN 605) was the coronation gift to King George V and Queen Mary from the 5-year-old Emperor Puyi, the last Emperor of China. After the Japan-British Exhibition at Wembley in 1910, the city of Tokyo presented the new King with a large model (RCIN 92903), at 1:10 scale, of the Taitokuin mausoleum, the temple erected at Edo in 1632 in memory of the second Tokugawa Shogun – the same individual who had presented the armour to James I in 1614.

A catalogue of the oriental works of art in the Royal Collection is being prepared by John Ayers for publication; his advice in the compilation of the following entries is gratefully acknowledged.

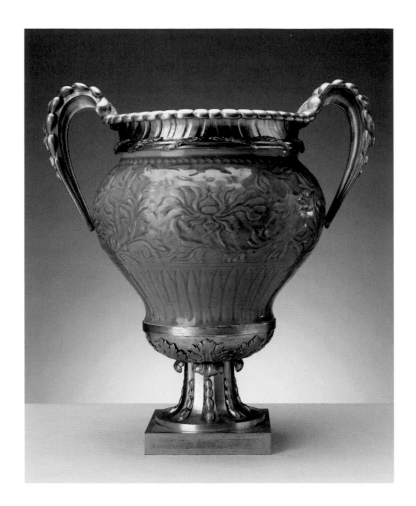

309
CHINESE
Vase, fifteenth century (French mounts, *c*.1760–70)

Among George IV's large collection of celadon porcelain (the term denotes the grey-green glaze) probably only two pieces are earlier than the eighteenth century, suggesting that the quality or rarity of the porcelain was of less concern to him than the formal variety and lustre of the metal mounts. In this instance a large and early celadon jar from Longquan, with relief decoration of scrolling flowers and foliage, has been mounted as a double-handled vase in the bold and somewhat austere *goût grec* style of the 1760s. The rim and the tapering, gadrooned handles were cast in one piece, and the raised foot is cemented to the base of the vase.

This is probably the vase listed in store at Brighton in 1826 as 'A sea green Vase, impressed scroll leaf pattern & border, ormolu rim bow handles, stem base on square plinth threaded – 20. In' (Brighton Inventory, p. 465).

Porcelain and gilt bronze. 52.5 × 47 × 32.5 cm
RCIN 2315
PROVENANCE Probably bought by George IV

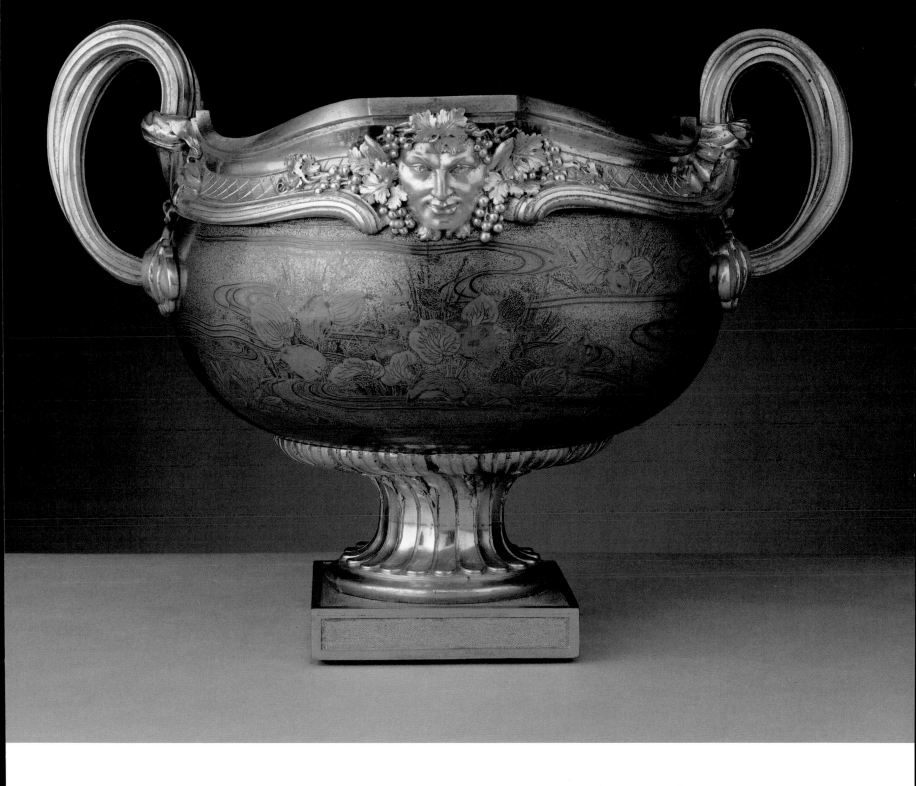

310

JAPANESE

Bowl, (?)late seventeenth century (French mounts, c.1760)

This bowl is one of a pair which combine Japanese lacquer and French mounts of equally high quality. The bowl was made by building up numerous very thin layers of lacquer on a thin wooden base. The lacquer is decorated with swirling eddies, herons and plants against a granular gold (nashiji) ground. Lacquer objects of this quality were not made for the export market and this may have reached the West by means of the private trading that officers of the various East India companies were permitted to carry on. The heavily cast and finely chased gilt bronze mounts consist of nine separate castings. The deep rim is centred on a bacchic mask surrounded by grapes and vine leaves, and appears to be tied at the sides by the thick, sinuous double handles. These terminate in a mount in the form of overlapping clouds or petals of descending sizes, a rare case in which the designer of the mounts appears to have adopted a convention of oriental art. In most cases the marchands-merciers were content either to transform the oriental vase into a Western form, or to invent spurious chinoiserie motifs. This bowl is raised on a tapering foot of a standard early neo-classical design, equally likely to be found supporting a vase or urn of Sèvres porcelain or hardstone.

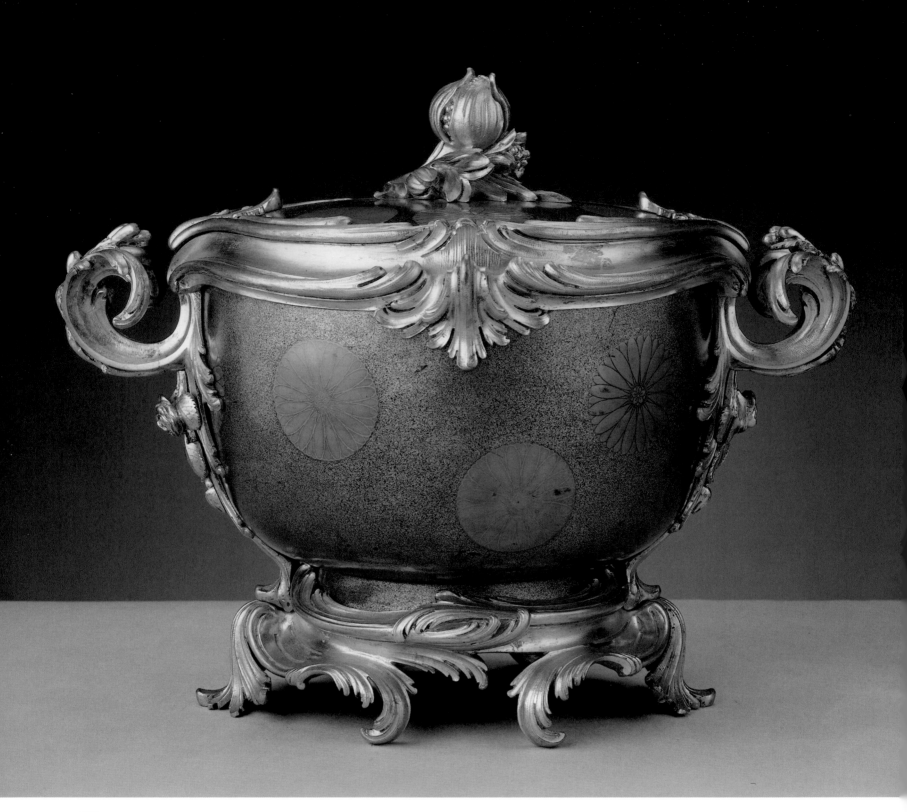

311

The bowl and its pair stood on cabinets flanking the chimneypiece in the library at Brighton Pavilion, where they can be seen in no. 428. They are listed in 1826 as '2 very fine circular gold spangled wood Japan bowls, raised leaves and flowers; finely mounted in chased scrolled rims, satyr masks with fruited Vines twisted handles, & fluted stem, on square panneled sanded bases. 1 ft. high' (Brighton Inventory, p. 157).

Lacquer and gilt bronze. 29.8 × 38.7 × 31.4 cm
RCIN 3154.1
PROVENANCE Probably bought by George IV
LITERATURE Harris, De Bellaigue & Millar 1968, p. 170
EXHIBITIONS QG 1962–3, no. 3

311
JAPANESE
Covered bowl, (?)late seventeenth century (French mounts, mid-eighteenth century)

Like no. 310, the lacquer used for this bowl was of a quality not made for export. It is decorated with stylised chrysanthemums picked out alternately in black and gold on a speckled *nashiji* ground. The inside is lacquered in red.

The bowl is mounted with four separate chased and gilt bronze castings and the lid is mounted with a knop in the form of a pomegranate.

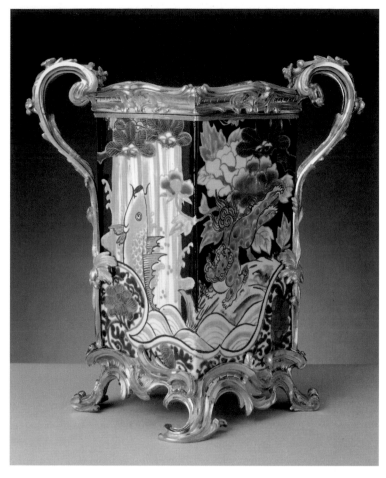

312

a lion with paeonies in underglaze blue and enamels on a black ground – is rarer on Japanese porcelain than Chinese (the so-called *famille noire* style). The French gilt bronze mounts have been designed with some care in relation to the very colourful and asymmetric decoration of the vases. Thus the short 'C'- scrolls of the foot mounts respect the curving border lines of the painted scenes, and the painted flowers seem to sprout from the gilt bronze stems which run up the handles. Similar mounts occur on a pair of Yixing red stoneware canisters at the Petit Palais, Paris (Lunsingh Scheurleer 1980, fig. 258).

The vases are probably those recorded in the library at Brighton Pavilion in 1826 as 'A pair of square Japan China Jars, with fish, flowers, Kylins & green enamelled leaves mounted diamond shape, in rich ormolu top and bottom scroll and leaf borders and handles' (Brighton Inventory, p. 157).

Porcelain and gilt bronze. 29.5 × 28 × 20.5 cm
RCIN 12.1–2
PROVENANCE Probably acquired by George IV
LITERATURE Lunsingh Scheurleer 1980, fig. 470
EXHIBITIONS London 1990a, no. 249; Berlin 1993, no. 9/30

313
CHINESE
Pot-pourri vase, c.1725–50 (French mounts, c.1750)

This single Chinese celadon jar was probably originally of the ovoid form with a raised neck and lid known as a 'ginger jar'. It has been cut at the neck and the raised section removed from both the jar and the lid. It is decorated with deer and with pine, bamboo and prunus, the 'three

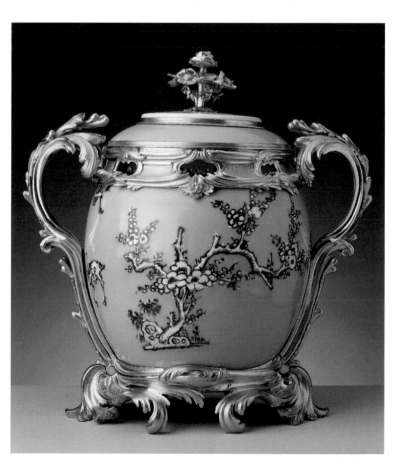

All the mounts imitate scrolling acanthus leaves, and are modelled with great vigour. An admirable lightness and mobility is achieved by the foot mount, whereby the weight of the bowl appears to be carried on the turned-over tips of leaves.

This may be the bowl purchased by George IV's pastry cook François Benois from the Parisian dealer Rocheux, which is described in his bill dated 9 November 1816 as '1 Beau Vase de laque fond avanturine a [?] rosastres avec son Couvercle le tout Montés en bronze doré ... 400 [francs]' (RA GEO/26423).

Lacquer and gilt bronze. 27.9 × 34.9 × 26 cm
RCIN 3152
PROVENANCE Probably acquired by George IV
LITERATURE Harris, De Bellaigue & Millar 1968, p. 171

312
JAPANESE
Pair of vases, c.1700–20 (French mounts, mid-eighteenth century)

These porcelain vases probably originated as flasks or canisters with low shoulders and circular mouths and lids, which were cut down for the purpose of mounting. This form of container was based on European, especially Dutch, pottery or glass spirit flasks, and was made in large numbers for export from Japan from the end of the seventeenth century. The decoration of these examples – with carp leaping in a waterfall and

friends of winter'. After importation into France the jar was mounted as a pot-pourri with six separate gilt bronze castings, probably made by the lost-wax process and very well chased and burnished. The eight 'eyes' in the neck mount allowed the escape of the scent contained within the jar.

In the inventory of Madame de Pompadour's possessions taken after her death in 1764, her apartments at the Hôtel d'Evreux in Paris contained (in the 'première antichambre') 'un pot-pourri d'ancienne porcelaine Celadon avec des desseins bleus, garnis de deux ances de bronze doré' valued at 100 livres (Cordey 1939, p. 35, no. 326). A further pair of similar vases was included in the L.-J. Gaignat sale of 1769 (lot 95). The present vase was probably that listed in store in the 1826 inventory of Brighton Pavilion as 'A Pot Pourri bowl & cover sea green, blue & white trees & flowers ormolu flower top pierced rim scroll handles & base 14 In' (Brighton Inventory, p. 465). All the mounts appear to have been regilded.

Porcelain and gilt bronze. 34.6 × 31.7 × 21.6 cm
RCIN 2306
PROVENANCE Probably acquired by George IV
LITERATURE Harris, De Bellaigue & Millar 1968, p. 186

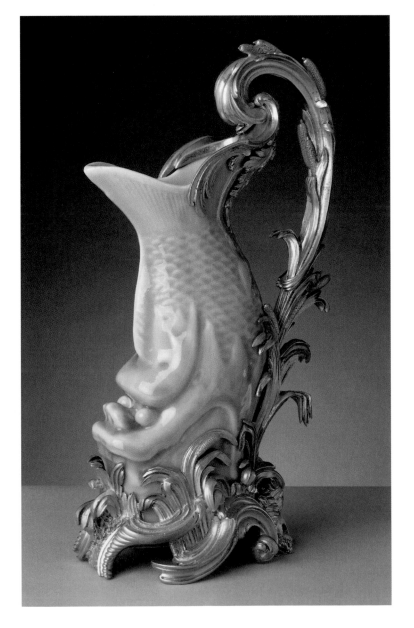

314

CHINESE
Pair of ewers, c.1740 (French mounts, c.1750–5)

These Chinese celadon vases, each in the form of grotesque carp, were made in China in around 1740 and not long afterwards were mounted as ewers in France. The two vases were not made in the same mould and their glazes are markedly different, indicating that they may have been made into a pair by the *marchand-mercier* responsible for mounting them. Their form suggests that they may in fact have been made for the purpose of mounting in the West. The gilt bronze mounts separate into six pieces (the handle, the two sides of the base, the acanthus-leaf mount of the tail, one of the shells at the back and a base plate), which are screwed together in such a way as to disguise the joins.

Vases of this type arrived in France in some numbers. A similar vase with the same design of mounts appears in a painting of the Baron de Besenval (a former owner of the Carlin cabinet, no. 103) of 1790–1 by Henri-Pierre Danloux (Paris, private collection, illus. Watson, Wilson & Derham 1982, fig. 14), and a closely related pair of ewers is in the National Gallery of Art, Washington DC (Watson 1986, no. 32). Other examples were sold at Christie's, London, 11 June 1992 (64); Christie's, New York, 26 October 1994 (44) and 23 May 1995 (121).

No. 314 are probably those mentioned in Robert Fogg's invoice for the period ending 10 October 1818 as '2 do. [China vases Sea Green Ground] Fish do. [richly mounted in ormolu]'. They were listed in the Music Room Gallery at Brighton in 1826 as '2 very fine Sea green dolphin China Jars with wide spreading tail lips, superbly mounted in scroll rush handles and scroll rush and shell bases 12. In high' (Brighton Inventory, p. 59).

Porcelain and gilt bronze. 30.8 × 17.5 × 9.5 cm
RCIN 360.1–2
PROVENANCE Probably Robert Fogg; from whom bought by George IV, 1818 (PRO LC11/26)

315

CHINESE
Mounted jar, c.1745–9 (French mounts)

This Chinese *craquelé* celadon jar, one of a pair, is probably very nearly contemporary with the gilt bronze mounts, which bear the crowned 'C' stamp applied to bronzes that were on the market in France between 1745 and 1749. The style of the vase imitates much earlier Song dynasty wares (960–1279 AD). The highly prized fine *craquelure* was achieved by the successive application of glazes with different co-efficients of expansion. The four separate mounts, in a yellow and very heavy bronze alloy, were most probably cast by the lost-wax process and then finely chiselled and burnished. The protruding porcelain handles, modelled as animal heads with rings in their mouths, seem to have given the bronze-maker some difficulty. The gilt bronze handles were modelled in two sections, with their floral sprigs separately modelled and applied. On one of the handles, two secondary screw fixings were used to retain the flower sprigs from behind. The unusually

◁ 314

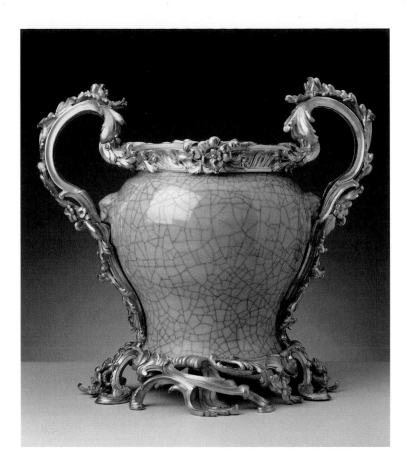

open and three-dimensional *rocaille* work of the foot mount was probably cast from a carved wooden model with the floral sprigs applied at the wax stage. The rim mount was modelled in one piece and fitted to the rim with a detachable narrow, grooved gilt brass collar.

This form of foot mount was relatively widespread (it can be found, for example, on a jar sold at Sotheby's, Monaco, 14 December 1996 (68)), but its designer and maker are not known.

The vase was probably acquired (with its pair) by George IV from the London print-sellers Colnaghi & Co., whose invoice for the quarter ending April 1818 included 'Two Crackled China Jars elegantly mounted in or Molu'. They may be those recorded in the Music Room Gallery at Brighton in 1826 as 'A pair of old Sea green crackle China jars with small mask and ring handles, superbly mounted in antique ormolu scrolled lips handles and bases 15. in.' (Brighton Inventory, p. 57; the word 'antique' was added in pencil in around 1840).

Porcelain and gilt bronze. 37 × 41.2 × 2.9 cm
Inscribed on the base, in black paint $\frac{12}{KC}$H; stamped four times with a crowned 'C' on the mounts
RCIN 2311.2
PROVENANCE Probably Colnaghi & Co.; from whom bought by George IV, 1818 (Jutsham II, p. 31)
LITERATURE Lunsingh Scheurleer 1980, fig. 323
EXHIBITIONS QG 1966, no. 21; London 1979b

316
FRENCH
The 'Kylin' clock, mid-eighteenth century (English mounts and base, 1821–3)

Entwined within an arbour of lotus, berried stems, exotic fruits and wind-blown leaves fashioned in gilt bronze, are several pieces of oriental porcelain: two large, early eighteenth-century Chinese turquoise lions support a mid-seventeenth-century Chinese *famille verte* bowl, turned on its side with the bottom replaced by a clock dial. The word 'kylin' refers to a composite mythical beast, but was probably wrongly applied to the lions during the nineteenth century. Above the dial is a late seventeenth-century Japanese Arita group of a seated, grimacing *putai* between two boys. The five panels of porcelain around the base were probably cut from a Chinese (Kangxi) teapot stand of around 1720.

This extravaganza was probably purchased by George IV for the fitting-out of Brighton Pavilion in around 1820. In the following year the royal clock-maker B.L. Vulliamy fitted a new eight-day Spring Clock movement (serial number 742) into 'a very old french Case decorated with old oriental Chinese Dragons &c & ormolu', no doubt reclaiming the original French movement in the process. The clock was placed as the centrepiece of a *garniture de cheminée* in the Saloon, designed by Robert Jones, and was further embellished to Jones's designs, so that the ornaments of the clock and chimneypiece would correspond more closely (see no. 425); the gilt bronze sunflower motifs supported on tubular branches in the upper parts of the composition were supplied by Samuel Parker (see De Bellaigue (G.) 1997, p. 29). Another clock which combines oriental porcelain with similar French mounts and retains its old movement by Pierre Le Roy (?1717–85) is in the Residenzmuseum, Munich, but the maker (or 'compiler') of neither piece is known. The Kylin clock was removed from Brighton in 1847 with the other contents of the Pavilion. Three years later it was recorded in the Pavilion Breakfast Room, Buckingham Palace (see no. 418).

Porcelain, gilt bronze. 111.7 × 81.3 × 36.9 cm
RCIN 2867
PROVENANCE Purchased by George IV, c.1820; new movement supplied by B.L. Vulliamy, 1821 (£31 10s.; PRO LC11/30)
LITERATURE Harris, De Bellaigue & Millar 1968, pp. 88, 135

317
CHINESE
Two *pagodas*, c.1810 (English additions and mounts, 1817–18)

These colossal Chinese towers, festooned with golden bells, fish and *kylin* dogs and topped with snake-entwined arrow-heads piercing winged dragons, might be said to represent the apogee or high point of the taste for chinoiserie in England. Their already exceptional size was further increased by the addition in England of their finials and bases, designed to fit them to the proportions of the Music Room at Brighton Pavilion, where the ceiling rose to a height of 41 feet [12.5 m] (see no. 427). They stood with two others of the same size against the window piers, while a slightly smaller pair (RCIN 2400.1–2) was placed on either side

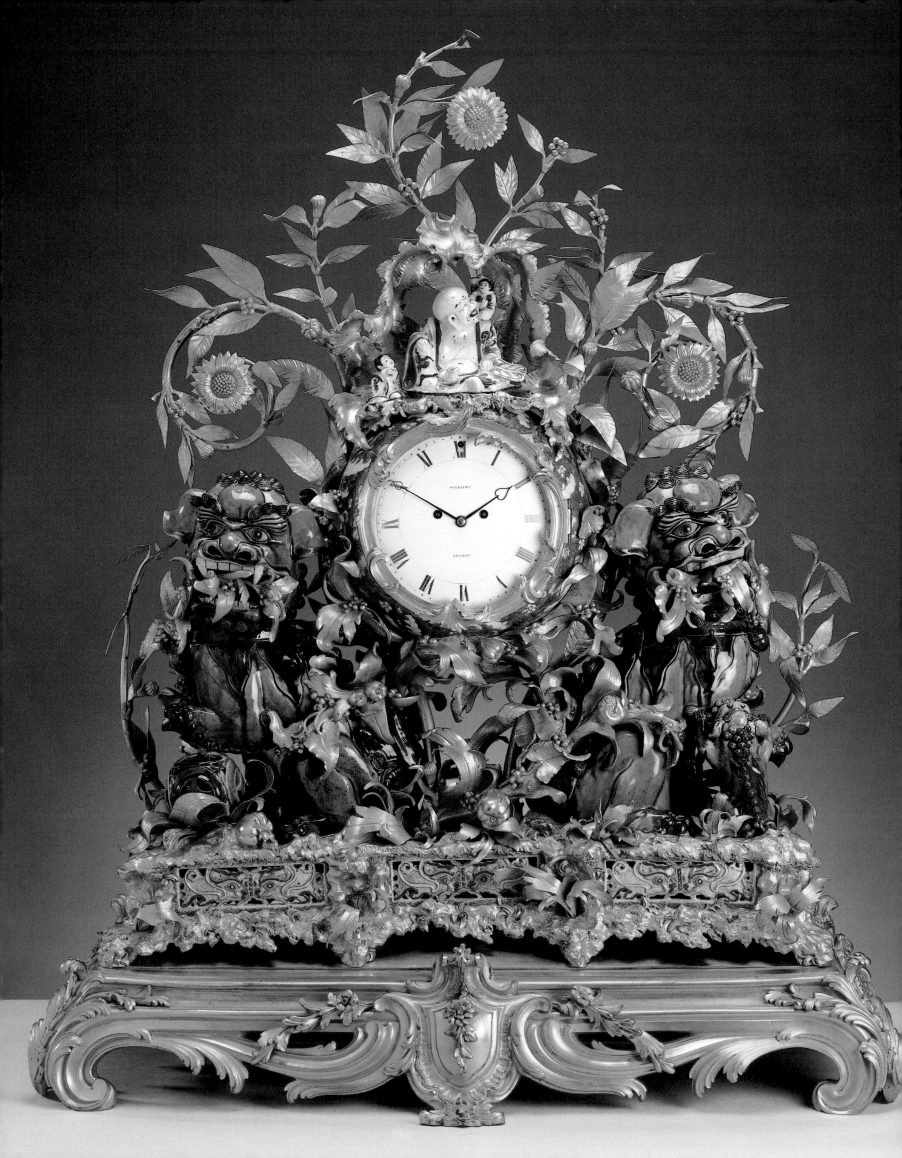

of the chimneypiece on similar bases. In the Music Room, which was decorated under George IV's direct supervision by Frederick Crace, pagodas could also be seen in the picturesque wall panels painted by Lambelet, and in the red-japanned decoration of the door panels.

In eighteenth-century European art and architecture the pagoda was perhaps the most universal symbol of the Orient. Ivory and porcelain models were exported from China to the West, and William Chambers built a full-sized English version in the royal garden at Kew in 1762, based on his own first-hand study of Chinese architecture a dozen years earlier.

These two pagodas consist of ten diminishing hexagonal tiers of Chinese *famille rose* porcelain with eight curving and protruding roofs, on a hexagonal blue and white base bordered with 'bamboo' mouldings. Three of the round-headed doors of each stage are open, and each stage is bordered by a pierced porcelain balustrade. The Chinese porcelain elements were supplied by the dealer Robert Fogg, who also provided the metal additions in four diminishing sizes. The 'dolphins' at the angles may have been copied from those that survive in porcelain on the smaller pair of pagodas. The *kylins* seem to have been loosely modelled on those which appear, rendered in gold over underglaze blue, on the porcelain 'walls' of each stage. Fogg's invoice for '192 Bells, or Molu for the large Pagodas / 192 Dolphins for – do – / 216 Dogs for – do – ' (PRO LC11/23, quarter ending 5 July 1817) does not exactly match the number of each type of ornament that was required for the four large pagodas, viz.: 216 bells, 192 dolphins and 224 kylins. Fogg charged 5s. 6d. for each of the bells, and 4s. 6d. for the dogs.

The hexagonal plinths are made up of six large rectangular panels of Spode porcelain, printed in cobalt blue with a fret pattern against a sponged ground. Each side is inset with two scenes painted on porcelain, probably copied from Chinese export watercolours. Spode made similar bases and lamp-holders for a set of Chinese Imari jars, also for the Music Room at Brighton. For the four pagoda bases Spode was paid £305 17s. 6d. The remaining elements of the overall cost of £2,004 18s. 10d. were £1,406 paid to B.L. Vulliamy for the gilt bronze mounts of the bases and the finials, and £159 1s. 4d. to Henry Westmacott for the 'blue scagliola double plinths' (Brighton Inventory, p. 69; RA GEO/34223).

In the 1840s the pagodas were transferred from Brighton to Buckingham Palace, where they were recorded in 1855 (see no. 419).

Hard-paste porcelain and bone china, gilt bronze. 518.5 × 104 × 87 cm
Marked in blue on the back of the panels of the base SPODE / STONE CHINA
RCIN 1.1–2
PROVENANCE Robert Fogg; from whom bought by George IV, 1817
LITERATURE Roberts (H.) 1939, pp. 133–7; Copeland 1987, p. 6

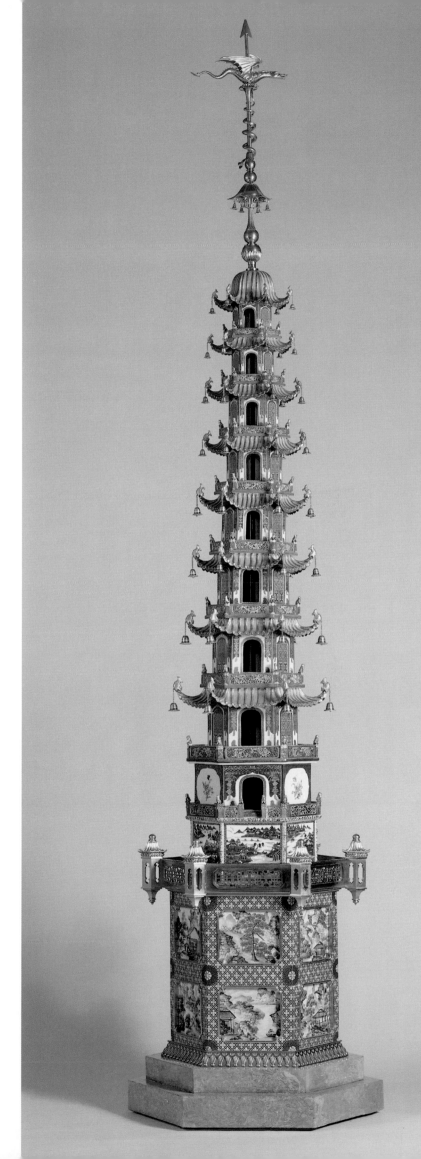

XIII

BOOKS AND MANUSCRIPTS

The majority of the printed books and manuscripts in the Royal Collection are housed at Windsor Castle. The present library was established by William IV in the early 1830s. It is, in effect, the third Royal Library although neither of the previous two was at Windsor. The first was begun by Edward IV in the 1470s and was added to by successive monarchs. It was housed in various royal residences in and near London. Known subsequently as the Old Royal Library, it was in St James's Palace from the early 1600s until the early 1700s (see Birrell 1987; Warner & Gilson 1921, I, pp. xi–xxxii). Thereafter it was moved five times until the 1750s when it lay neglected in the Old Dormitory of Westminster School. In 1757 it was given by George II to the newly founded British Museum.

The second Royal Library was created by George III, who began to acquire books in the years before his accession in 1760. Over the next fifty years he 'conscientiously built up ... one of the finest libraries ever created by one man' (Miller 1973, p. 125). This collection, afterwards and still known as the King's Library, was housed in the library wing (fig. 23), added in the 1760s and 70s to the south-west corner of Buckingham House (the future Buckingham Palace) which George III had bought in 1762 as a family residence. In the words of one of his biographers, George III made Buckingham House into 'less a royal palace than a museum and library' (Brooke 1972, p. 306). By the time of the King's death in 1820, this library held over 65,000 books as well as an outstanding collection of Old Master drawings, prints, watercolours and maps (see pp. 389–91).

George IV was not such an avid bibliophile as his father. However, as Prince of Wales and Prince Regent he formed a small library at Carlton House, his lavish London residence. No catalogue of its contents is known but the library included a considerable number of fine items, such as the Sobieski Book of Hours, a magnificent illuminated manuscript from 1420 (no. 318); the beautiful seventeenth-century *Florilegium* (flower album) of Alexander Marshal, including his 159 watercolours (see Leith-Ross 2000); and several outstanding Islamic manuscripts, including the *Divan-i-Khaqan* written by Fath 'Ali Shah, ruler of Persia (no. 324). About five thousand books from this library subsequently came to the present Royal Library.

Soon after he became King in 1820, George IV wished to

convert Buckingham House into a palace. The space occupied by George III's six library rooms was needed for other purposes. In 1823 he therefore gave most of his father's books to the British Museum, where they were housed from 1828 in the King's Library, the room specially built for them by Sir Robert Smirke (see Paintin 1989). George III's books have remained a distinct unit in the British Library (detached from the British Museum in 1973). They were transferred to the new British Library building at St Pancras in 1998 where they are still housed together in a distinctive glass-fronted tower structure.

In the early 1830s William IV decided to establish the present Royal Library and chose to locate it in three adjacent rooms on the north side of the Upper Ward of Windsor Castle. These rooms originally date from entirely different periods. The first, Room I, was built by Charles II in the 1670s as a bedroom for his Queen, Catherine of Braganza (see no. 403); the second, Room II, was originally part of the building made by Henry VII in the 1490s and included the bedroom of his Queen, Elizabeth of York; and the third, Room III (figs 24, 25), was created by Elizabeth I in the 1580s, not as a library but as a walking gallery for use in bad weather.

Fig. 23 James Stephanoff, *The Octagon Library, Buckingham House*, 1818 (RL 22147)

The conversion of the rooms, completed in 1834, cost only £15,000, primarily because many of the furnishings were taken from other residences. The map tables and octagon table came from George III's Buckingham House library (fig. 23) and were converted to match the ivory and ebony inlaid furniture from George IV's library at Carlton House which was also brought to Windsor, including display tables, four bookcases and other tables and chairs (see fig. 24 and Roberts (H.A.) 1990b).

The books in the present library derive primarily from the eighteenth and nineteenth centuries (see Patterson 1996). Some thirty of the finest items were retained from George III's Buckingham House library (The Library, ser. iii, III, 1912, pp. 422–30). These included most of the incunabula (books published before 1500, when printing was in its infancy or cradle: Latin, cunabula), particularly an important group given to George III by the collector, Jacob Bryant (1715–1804). Four other outstanding volumes retained from George III's library were the Mainz Psalter (no. 325); the only existing perfect copy of Aesop's Fables, printed by William Caxton in 1484; Charles I's Second Folio of Shakespeare (1632) which includes annotations made by the King; and a unique and superbly illustrated seventeenth-century Islamic manuscript, the Padshahnama (no. 323).

In addition to the above volumes, reserved from George III's principal library, there were initially four main sources of books for the new library at Windsor: several smaller groups of George III's books which he had kept at residences other than Buckingham House (for example at Windsor, where his edition of Clarendon's History – no. 329 – was kept); the books, maps and papers of William Augustus, Duke of Cumberland (1721–65), which had been bequeathed to his nephew, George III (see Hodson 1988); George IV's former library at Carlton House; and some of the books belonging to George III's nephew, the second Duke of Gloucester, who had died in 1834 (see MacMillan's Magazine, October 1862, p. 483).

Although no bibliophile himself, William IV gave his Librarian, John Glover, the means to make important acquisitions, such as the large purchase of books, including thirty incunabula, from the sale at Sotheby's in 1835 of the collection of the Frankfurt bibliophile Dr Kloss.

Queen Victoria also sanctioned large expenditure on books, £28,116 being spent between 1837 and 1875 (see RCIN 1127884.n). Because of Prince Albert's increasing interest in the library, including the drawings, watercolours and prints in the Print Room, spending was particularly high between 1846 and 1861. However, Prince Albert's fundamental reorganisation of the library was limited to the period between Glover's death in May 1860 and the Prince's own death in December 1861. In this he was enthusiastically aided by the new Librarian, Bernard Woodward, who was appointed in July 1860. Woodward's first report of October 1860 was very critical of many aspects of the state of the library. There was no catalogue, no classification system, no press marks or bookplates; there was a lack of space; and a great need for binding and general repair work.

Woodward also observed that there was no underlying plan or philosophy about what sort of library it should be. He recommended that 'it should consist of a complete Diplomatic and Historical Library, and a complete but select General Library, combined ... which would supply sufficient clear and minute information for the general purposes of an Educated Gentleman and for reference ... Whatever the Statesman, or the Diplomat could possibly require, should be found there ... History and all its subordinate branches of knowledge but particularly Geography, Travels, Topography, Ethnology, Genealogy, Statistics, Records, Diplomatics and Treaties ... [and] whatever can illustrate the extent, condition, progress and prospects of the British Empire' (Woodward 1860, p. 9).

Prince Albert oversaw the complete rearrangement of the books which by 1860 numbered about 39,000. He had the shelf heights altered so that the volumes could be organised by subject rather than by size; he produced more space by heightening most of the bookcases in Queen Elizabeth's Gallery and making an upper gallery in Room II together with a new ceiling. In 1860 the first bookplate was commissioned for application to books in the Royal Library; it was designed by James West and Mary Byfield. After Prince Albert's death, Woodward faithfully carried out all of the Prince's ideas and instructions to rescue the library 'from uselessness and restoring to order and service ... [its] literary and artistic treasures' (Woodward 1862). By 1865 he and his assistants had largely completed the tasks, including a card catalogue of the books (see Woodward 1865).

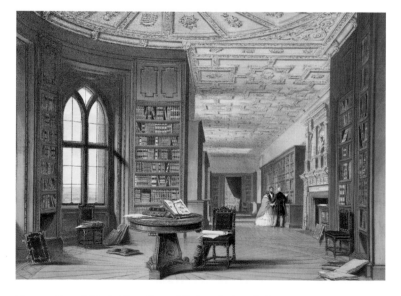

Fig. 24 Joseph Nash, The Library, Windsor Castle, 1848 (lithograph, from Nash (Jos.) 1848)

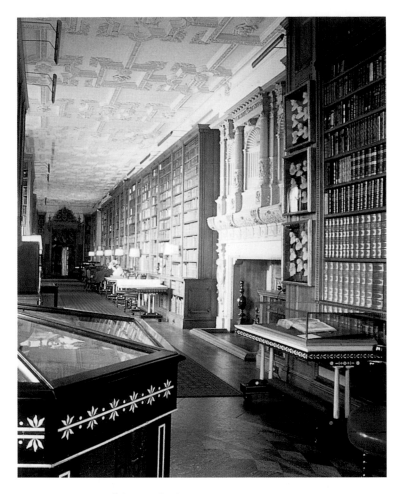

Fig. 25 Room III of the Royal Library

After Woodward's death in 1869 his post was taken by Richard Holmes, who continued in office until 1905. Expenditure on purchases continued at between £500 and £800 a year, slightly less than before. By 1879 there were about 50,000 books, compared with about 72,000 today. Throughout her long reign, Queen Victoria received numerous presentation volumes from writers including Dickens, Wordsworth, Disraeli and Gladstone. She continued to approve the purchase of valuable books, such as the Wriothesley Garter Book (no. 320), and fine bindings, Holmes's particular interest. In 1893 he published an imposing illustrated catalogue of the library's holding of such bindings (Holmes 1893). A sizeable number of books with ownership marks of sovereigns before George III were acquired (or reacquired) by 1900, including Bellarmine's *Disputationes* (no. 327), Thomas à Kempis (no. 330) and the *List of the Navy* (no. 322). These volumes may have left royal hands as gifts or perquisites, or have been sold as duplicates by the British Museum from both the Old Royal Library and the King's Library.

John Fortescue (Librarian, 1905–26) took trouble to display effectively the numerous items – apart from books – which have made their way into the library, many of which were gifts to the sovereign. As Fortescue observed, 'every description of article had a way of drifting into the Library' (Fortescue 1933, p. 124).

At the beginning of his reign, King George V increased the grant given to the library. Queen Mary also took a great interest in the library, to which she transferred numerous objects that she either bought or was given, such as the superbly bound Bible which had belonged to Charles II (no. 328) and the Duke of Sussex's Bible and Prayer Book (no. 332). About six hundred books came to the Royal Library from Queen Mary's library at Marlborough House after her death in 1953 (see RCIN 1028943.b). Her interest in books and collecting was encouraged by Owen Morshead, Librarian at Windsor from 1926 to 1958. Morshead also had a particular interest in Private Press books, which sought to revive the high standards achieved in the early years of printing (for example no. 326). A large number of these books were acquired for the library during his tenure, including Eric Gill's *Four Gospels*, printed by the Golden Cockerel Press in 1931 (no. 336).

Her Majesty The Queen, like her predecessors, has placed a number of books and other items in the library which have enriched its quality both as a library and as a museum. She also shows the library to her guests after the official dinner parties traditionally given during her residence at Windsor in April each year. On these occasions, items specially selected for Her Majesty's guests from the Royal Archives and Royal Library are put on display, an innovation of Robin Mackworth-Young (Librarian 1958–85).

The wider public was able to see many of the library's assorted treasures, all of which are now included in the Royal Collection computerised inventory, in a focused exhibition at The Queen's Gallery in 1990 (QG 1990–1). Books are often lent to exhibitions in Britain and abroad, and items from the Royal Library are included in the changing displays in The Gallery at Windsor Castle, which is open to the public. As a working library, scholarly and professional access is frequently given to the unique material contained in it; and by the same token additions are regularly made to the strongest areas including history, biography, Commonwealth subjects and reference works.

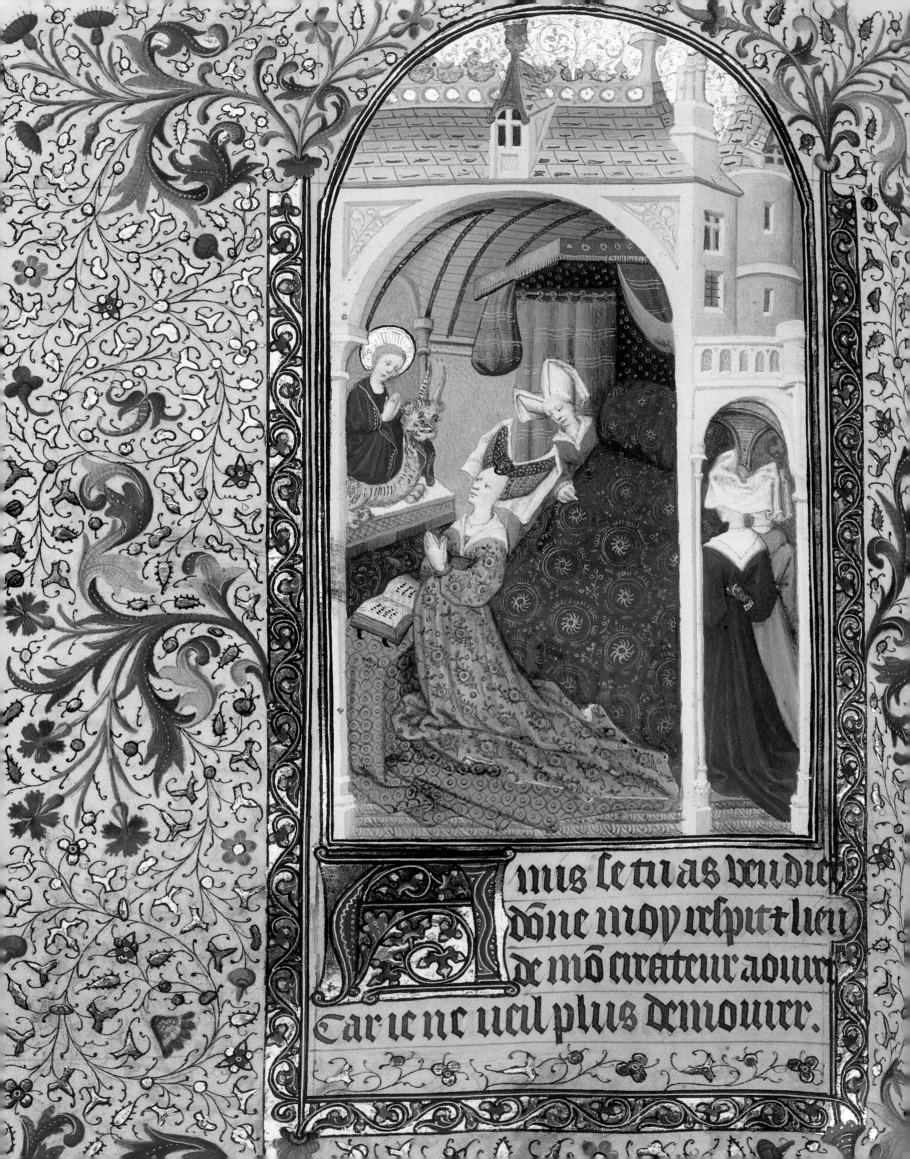

WESTERN MANUSCRIPTS (nos 318–322)

Although none of the fine manuscripts from the libraries of the medieval kings and queens remains in royal ownership, the small collection of Western manuscripts includes some of the Royal Library's greatest treasures. The library's holdings range from music and presentation copies of poems by Poets Laureate, to diagrams of military manoeuvres. Its finest illuminated manuscripts are the Sobieski Book of Hours and Cardinal York's Book of Hours, both acquired from Henry Benedict Stuart, Cardinal York (nos 318, 319). Books of Hours were intended as private prayer books for lay people, matching the hours of the liturgical day. The library's other major strength is in manuscripts relating to the Order of the Garter, reflecting the connection of Windsor Castle with the Order and its spiritual home in St George's Chapel (nos 320, 321).

318
THE MASTER OF THE BEDFORD HOURS (fl.1415–1430)
The Sobieski Book of Hours, c.1420–5
Open at ff. 162v–163r: part of a prayer to St Margaret of Antioch, with the miniature of the patroness, praying to St Margaret

This manuscript was written and illuminated c.1420–5, initially in the workshop of the Master of the Bedford Hours. He can possibly be identified as Jean Haincelin of Haguenau, whose first recorded work was in 1403 in Paris, the major centre for the production of Books of Hours in the fifteenth century. There were two other major illuminators responsible for the manuscript, the Fastolf Master (fl.1440–50 in Rouen), and the Master of the Munich Golden Legend (fl.1440–50 in northern France). The Bedford Master was responsible particularly for the miniatures introducing the life of the Virgin Mary in the Hours proper, and for the miniature shown here. This depicts a lady, probably Margaret of

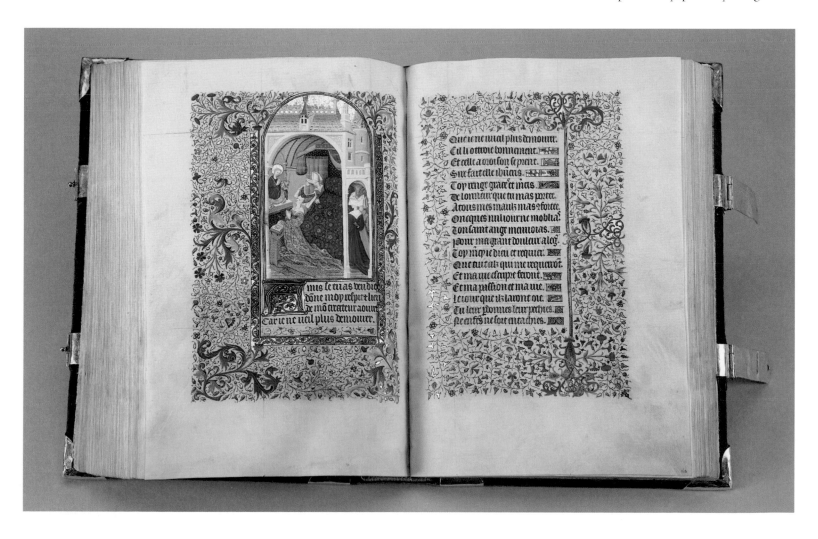

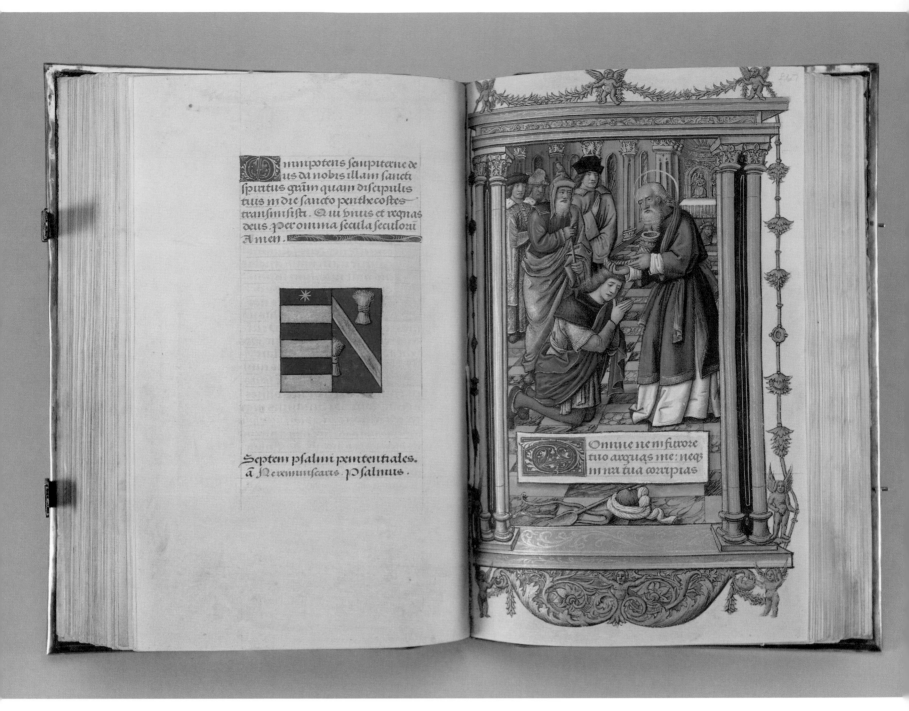

319

Burgundy, praying to St Margaret. The saint appears on the back of a dragon, her emblem (Satan in the form of a dragon swallowed Margaret during her martyrdom). It is thought that the lady is praying for a child to St Margaret, the patroness of expectant mothers. Margaret's marriage to Arthur of Richmond, younger brother of the Duke of Brittany, was childless, and the bed behind her can be seen hung with green draperies, the traditional colour reserved for ladies of the French royal house in birth chambers. Beneath the miniature is the poem *La Vie Sainte Margaret*, popular in the fifteenth century. The hypothetical identification of the kneeling lady with Margaret of Burgundy rests partly on the fact that her sister Anne, Duchess of Bedford, was the patroness of the Bedford Master.

Manuscript on vellum; miniature, decorated initial and borders in bodycolour and gold leaf; 234 ff., numbered in pencil. Bound in red velvet, with gold corner-pieces and clasps on fore-edge, oval plaques on binding with crowned JRP (*Johannes Rex Poloniorum*, John King of Poland) monogram in centre. 28.9 × 20 × 6.5 cm
RCIN 1142248

PROVENANCE Probably made for Margaret of Burgundy, eldest daughter of John the Fearless; Urban Doczy of Nagylucse, Bishop of Raab and of Erlau, Hungary, by 1492; John Sobieski (1624–96), King of Poland, by 1683; his granddaughter Mary Clementina Sobieska (1702–35), wife of the Old Pretender, c.1718; by whom bequeathed to her younger son Henry Benedict Stuart, Cardinal York (1725–1807); by whom bequeathed to George IV when Prince of Wales, 1807
LITERATURE Holmes 1893, no. 78; Spencer 1977
EXHIBITIONS QG 1966, no. 122; QG 1990–1, no. 75

319 (binding)

25.8 × 17.4 × 4.4 cm
RCIN 1005087
PROVENANCE Unidentified patron; Alexander de Ostrog, Voivode of Kiev (d. 1629; bears his manuscript *ex libris*, ff. 2r, 48v); John Sobieski (1624–96), King of Poland, by 1683; his granddaughter Mary Clementina Sobieska (1702–35), wife of the Old Pretender, *c.*1718; by whom bequeathed to her younger son Henry Benedict Stuart, Cardinal York (1725–1807); by whom bequeathed to Sir John Coxe Hippisley (1748–1825); by whom presented to George IV when Prince of Wales, *c.*1807
LITERATURE Holmes 1893, no. 80

320

SIR THOMAS WRIOTHESLEY (c.1460–1534)
The Wriothesley Garter Book, early sixteenth century
Open at f.1 of quire P: Henry VIII in Parliament, 1523

Sir Thomas Wriothesley, who from 1505 to 1534 occupied the post of Garter King of Arms (doyen of the College of Arms), is known to have compiled many books and rolls of arms, pedigree and precedence. This manuscript contains a variety of records on heraldic matters, especially the Order of the Garter, and heralds' fees and oaths.

The manuscript is open at what may be the first contemporary view of the opening of Parliament, at Blackfriars on 15 April 1523. Henry VIII is enthroned in the middle, with three earls in front of him bearing the Sword of State and the Cap of Maintenance. To the King's left are

319

UNIDENTIFIED FRENCH ILLUMINATOR
Cardinal York's Book of Hours, *c.*1500
Open at ff. 66v–67r: including the anointing of David by Samuel

This Book of Hours is a later production of the Paris workshops than the Sobieski Hours (no. 318), with its miniatures framed in the architectural borders popular at the turn of the fifteenth century. The coat of arms seen here (and on ff. 23v and 77v) was probably inserted at the time of the production of the manuscript and is likely to have belonged to the patron. The arms on the sinister, or lady's side (our right), with the sheaves of wheat, are those of the French family Francon, from the Dauphiné in the south of France; the arms on the dexter, or man's side, have not yet been identified. The earliest identified owner is Alexander de Ostrog. The opening shows the beginning of the seven Penitential Psalms, with an image of David being anointed King of Israel by the Prophet Samuel, in the presence of his father Jesse and brothers (1 Samuel 16). While decorative themes and subjects used in other portions of the Book of Hours had become somewhat standardised, the Psalms allowed for a degree of choice, though usually a scene from the life of their author, King David, was considered appropriate.

Manuscript on vellum; in bodycolour and gold leaf; 132 ff., numbered in pencil. Bound in pink velvet, with the arms of Cardinal York as Henry IX embroidered on both boards, in silk, gold thread, gilt sequins and knobs, end eighteenth century.

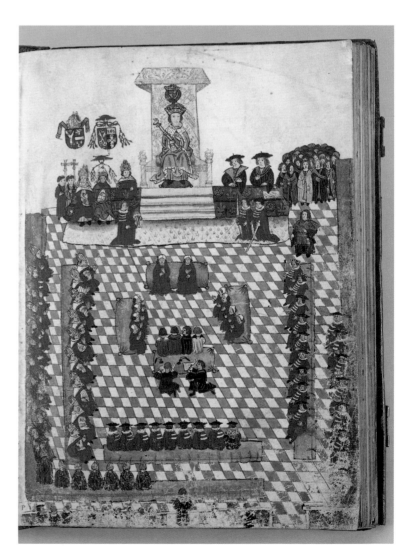

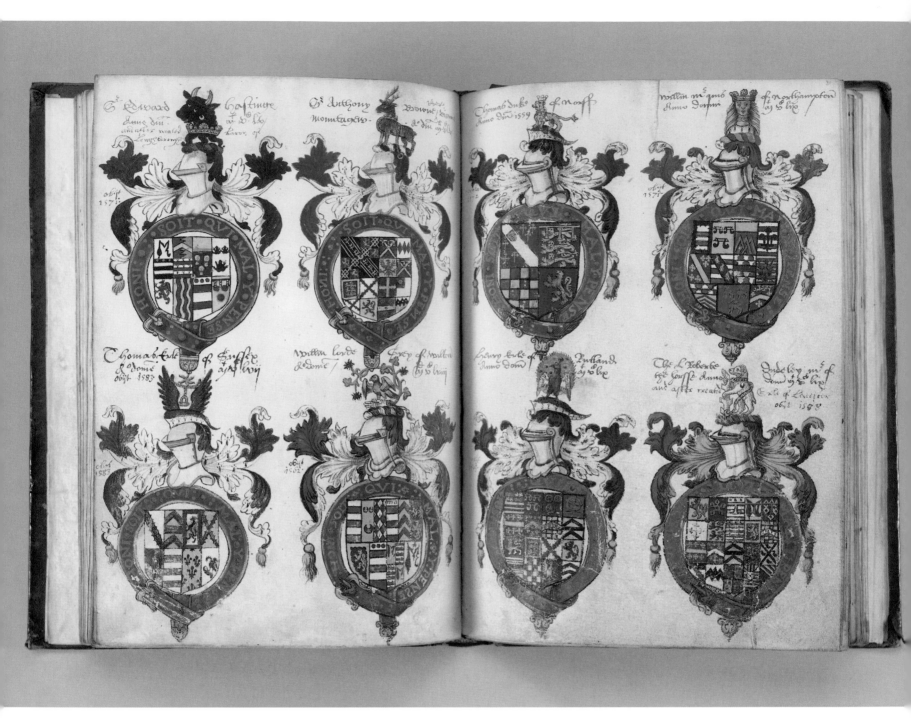

321

Garter King of Arms (Wriothesley himself, wearing the distinctive tabard of a herald) and officers of the Royal Household. To the King's right are three bishops: Thomas Wolsey, Archbishop of York, identified by the red Cardinal's hat, and William Warham, Archbishop of Canterbury (see no. 348) are seated; behind Wolsey stands Cuthbert Tunstall, Bishop of London. The arms of Wolsey and Warham are also shown. Below these, to the King's right, sit the Lords Spiritual, nine bishops with seventeen abbots behind; to his left and on the cross-bench sit the Lords Temporal, two coroneted dukes, seven earls, sixteen barons, and the Prior of the Hospital of St John of Jerusalem. The four woolsacks in the middle are a symbol of the wealth of England's wool trade, and accommodate two Chief Justices, eight judges, and four Serjeants of the law, behind whom kneel two clerks with their quills and inkpots. Behind the cross-bench,

at the bar of the House (at the bottom of the page) stands Sir Thomas More, Speaker of the House of Commons, with thirteen Members of Parliament behind him.

Manuscript on vellum; in bodycolour, with gold leaf and brush and pen linear work; 127 ff., numbered in pencil (omitting first four); quire letters in bottom inner corners, various older pen foliations; 14 ff. removed, 7 replaced and 1 inserted. Bound in brown calf, worn gold-tooling round edges. 30.8 × 22.2 × 5.2 cm
RCIN 1047414
PROVENANCE Owned, and largely written, by Sir Thomas Wriothesley, with additions by his successors as Garter King of Arms; bought for the Royal Library, 1892
LITERATURE Powell & Wallis 1968, pp. 555–7
EXHIBITIONS London 1894, no. 171; Bruges 1907, no. 51 (p. 93); London 1936, no. 5; QG 1990–1, no. 78

321

SIR GILBERT DETHICK (1519?–1584)
The Dethick Garter Book, 1551–88
Open at ff. 30v–31r: arms of Garter Knights created 1555–9

Sir Gilbert Dethick was of Dutch origin, and first entered the College of Arms at the age of 16. He held the office of Norroy King of Arms (Norroy indicating the area north of the river Trent) under Henry VIII and Edward VI, and was appointed Garter King of Arms in 1550. He was a scholar and antiquary, and several collections of his heraldic papers survive. He began this manuscript early in the reign of Edward VI and continued it through the reign of Mary into that of Elizabeth I. This was a period of great unrest, with major changes in the state religion, from Edward VI's and Elizabeth's protestantism to Mary's fervent catholicism; this is reflected in the appointments to the Order. The first part of the manuscript consists of details of business carried on during meetings of the chapter of the Order of the Garter, followed by a record of the coats of arms of all those appointed to the Order during the period. The names of appointees on this opening consist chiefly of prominent Catholics during the reign of Mary (r. 1553–8), such as Sir Edward Hastings, Sir Anthony Browne, and Thomas Radclyffe, Earl of Sussex; or favourites of Elizabeth I, such as Henry Manners, Earl of Rutland, and Robert Dudley, Earl of Leicester.

322

Manuscript on vellum; in bodycolour, with brush-and-pen linear work; 67 ff., numbered in pencil. Bound in brown calf, with blind-tooled panels, and edges, later (18th century?) gilt bookstamp of Latton of Berkshire and Esher. 28.6 × 21.2 × 3.2 cm
RCIN 1047416
PROVENANCE Owned and largely written by Sir Gilbert Dethick; Latton (of Berkshire and Esher) family, by the eighteenth century; possibly passed to Thomas Pelham, first Duke of Newcastle (1693–1768), by the purchase of Latton Manor of Esher, 1717–18; by descent; library sale of seventh Duke of Newcastle, Sotheby's, London, 14 February 1938 (1031); bought by King George VI (£40)
EXHIBITIONS London 1983b

322

ADMIRALTY OFFICE
A List of all the Ships and Vessells of His Maiesties Royal Navy, with their Rates, Number of Men and Guns in Peace and War, January 1714/15

George, Elector of Hanover, became King of Great Britain on 1 August 1714, on the death of his second cousin, Queen Anne. His mother, Electress Sophia, who predeceased the Queen by two months, had been established as the Protestant heir by the 1701 Act of Settlement, which excluded Roman Catholics from the throne. The new King arrived in England from Hanover on 18 September, and was crowned at Westminster on 20 October 1714.

This list of the state of the Royal Navy was drawn up for George I three months later, the date being expressed as January 1714/15. At that period most continental countries reckoned each calendar year from the beginning of January. Great Britain, however, continued until 1752 to calculate each year from Lady Day on 25 March. The new King would have been more familiar with continental practice, hence the dual form of the date. The First- and Second-Rate lists are headed by names in gold, the *Royal George* and the *Prince,* formerly the *Victory* and the *Triumph,* renamed to honour the new Hanoverian dynasty.

The binding seems at first glance a fine geometric binding; on closer inspection, however, the overlap of lines and irregularity of frames betray that the binder, perhaps normally employed on simpler bindings for the Admiralty, was not at ease with such elaborate tooling. The style is an unusual one, deriving its main feature, the strapwork compartments, from the fanfare style (cf. no. 327), but not following the convention of alternating rectangles and circles or ovals. George I's crowned monogram in the centre is an intertwining of GR and GR-reversed.

Manuscript in black ink, with key words in red or gold; text frame and columns ruled in red. 18 pp. Bound in dark red sheepskin, gold-tooled; all edges gilt.
23.5 × 18.5 × 1.5 cm
RCIN 1081229
PROVENANCE Compiled for George I; left royal ownership, mid-eighteenth century; re-acquired by 1860
LITERATURE Holmes 1893, no. 52
EXHIBITIONS London 1891b, no. O 29; QG 1990–1, no. 98

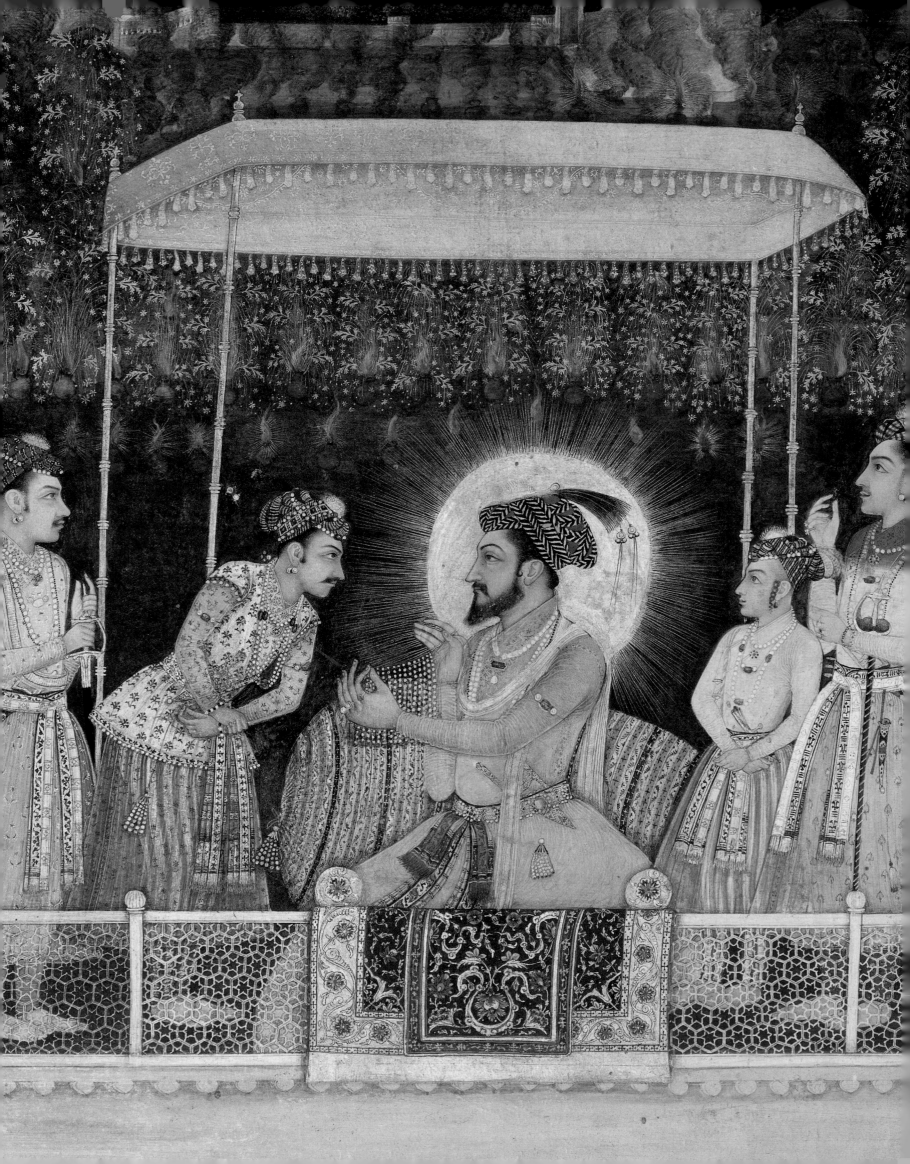

ISLAMIC MANUSCRIPTS (nos 323–324)

There are some forty Islamic manuscripts in the Royal Library. These were all acquired by gift. Many are of substantial importance and several are exceptional by any standards. The largest group is Persian but there are also Arabic, Turkish, Urdu and Mughal manuscripts. Their dates of creation range from 1492 to the nineteenth century.

Notable strengths include miniature paintings and calligraphy of the Mughal period in India (1526–1858) and the Safavid period in Persia (1501–1736). Subjects that are especially well represented include religion, poetry and history, as well as two important treatises on horses.

Queen Victoria received more of these manuscripts than any other monarch, a reflection of Britain's expanding world role; but George III, George IV (see no. 324) and Edward VII were also significant recipients.

The finest Islamic manuscript in the Royal Collection is the *Padshahnama* (see no. 323), presented to George III by the Nawab of Oudh (Lucknow, India) in 1797. Another notable manuscript is the *Shahnama* (Book of Kings; RCIN 1005014), a 1648 version of the epic Persian poem originally written in 1011. It has 149 miniatures and was given to Queen Victoria in 1839 by the Sultan of Herat.

323
Illustrations from the Padshahnama

The *Padshahnama* (or Chronicle of the King of the World) is the unique official description of part of the reign of the Mughal Emperor, Shah-Jahan (r. 1628–58). Its forty-four illustrations include some of the finest Mughal paintings ever produced. They were executed by fourteen of Shah-Jahan's court painters between 1630 and 1657 and include identifiable portrait likenesses of all the key figures at the imperial court.

RCIN 1005025
PROVENANCE Commissioned by Shah-Jahan; by descent; bought by Asafuddawla, Nawab of Oudh, by 1776; presented (via Lord Teignmouth, Governor-General of India) to George III, 1797
LITERATURE Beach & Koch 1997
EXHIBITIONS London 1947–8, no. 1216; London 1960; London 1976, no. 167; London 1982b, no. 82; New Delhi/QG/Washington/New York/Los Angeles/Fort Worth/Indianapolis 1997–8

a) [Left folio] Attributed to RAMDAS (fl.1640s)
[Right folio] BICHITR (fl.c.1615–1640)
Shah-Jahan receives his three eldest sons and Asaf Khan during his accession ceremonies in 1628, c.1630–40

The scene on the right is the most famous painting in the *Padshahnama*. It depicts one of the major ceremonies celebrating Shah-Jahan's accession to the throne. The scene in the Agra fort shows his entire court. Forty-two of those depicted can be identified. Particularly important are Shah-Jahan's three eldest sons, Dara-Shikoh, kneeling over his father's lap, and behind him, Shah-Shuja and Awrangzeb. Behind them is the Prime Minister, Asaf Khan, who was Shah-Jahan's father-in-law; many of the courtiers were Asaf Khan's relations or friends. The scene on the left includes a prominent group of musicians.

Bodycolour and gold. 81.5 × 101.5 cm
RCIN 1005025.k–l
LITERATURE Beach & Koch 1997, nos 10–11

b) ABID (fl.c.1630–1640)
The death of Khan Jahan Lodi in 1631, c.1635

The Afghan Khan Jahan Lodi was one of the most esteemed amirs (or leaders) of the Mughal Emperor Jahangir (r. 1605–27). But he fell from favour with Jahangir's son, Shah-Jahan, when he failed to support the

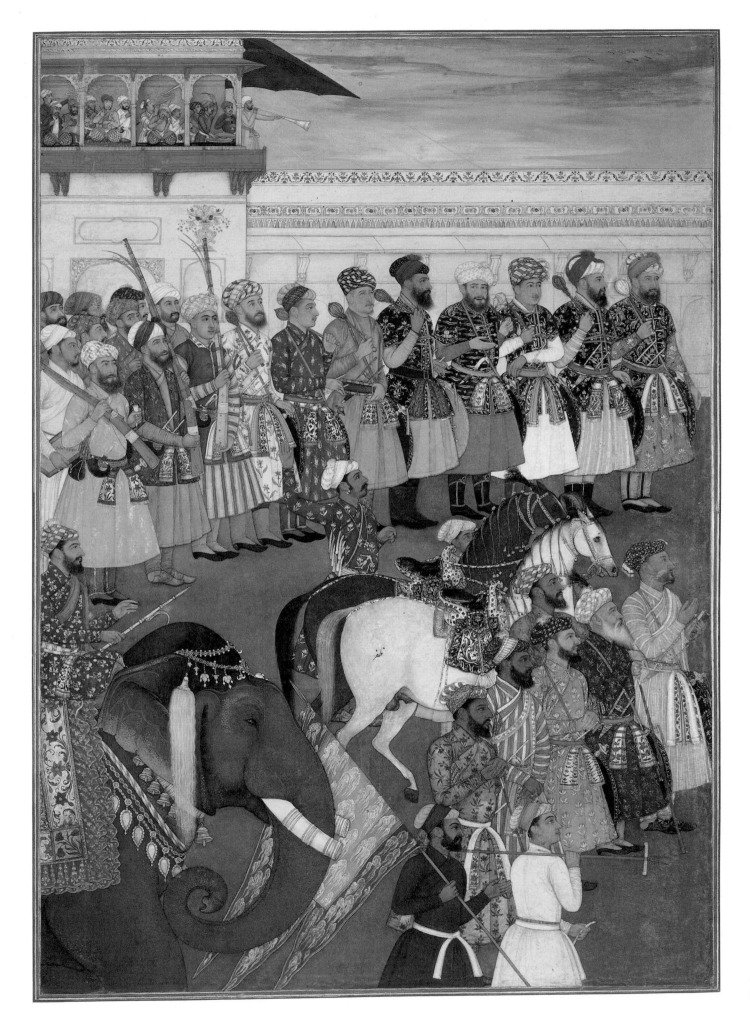

323a
(left folio)

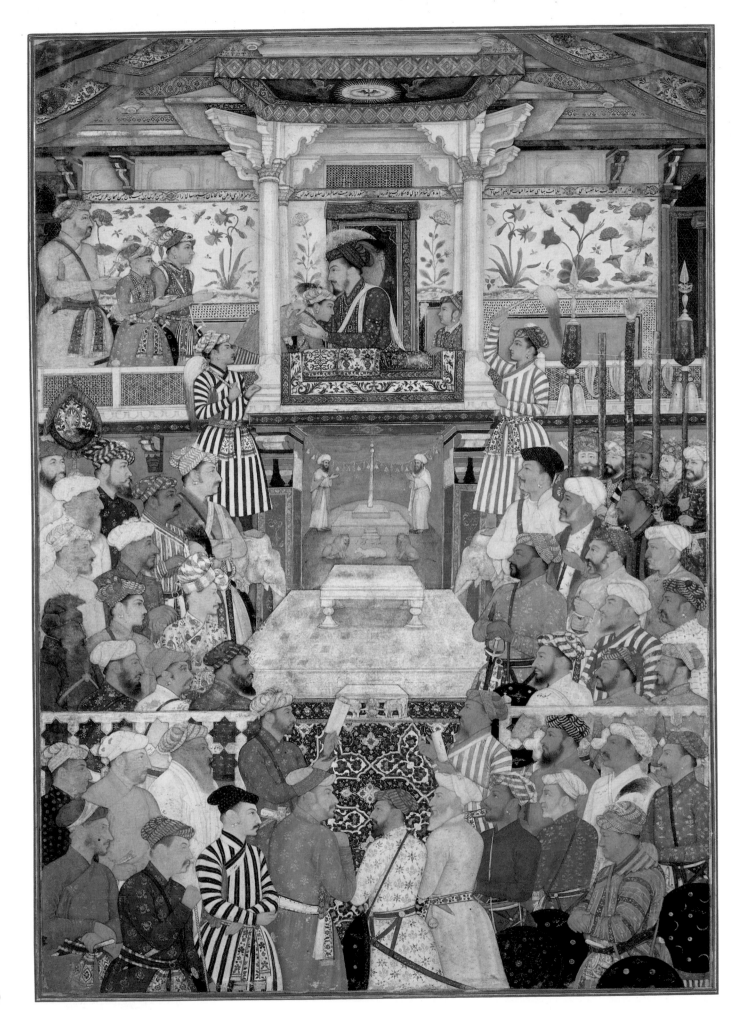

323a ▷
(right folio)

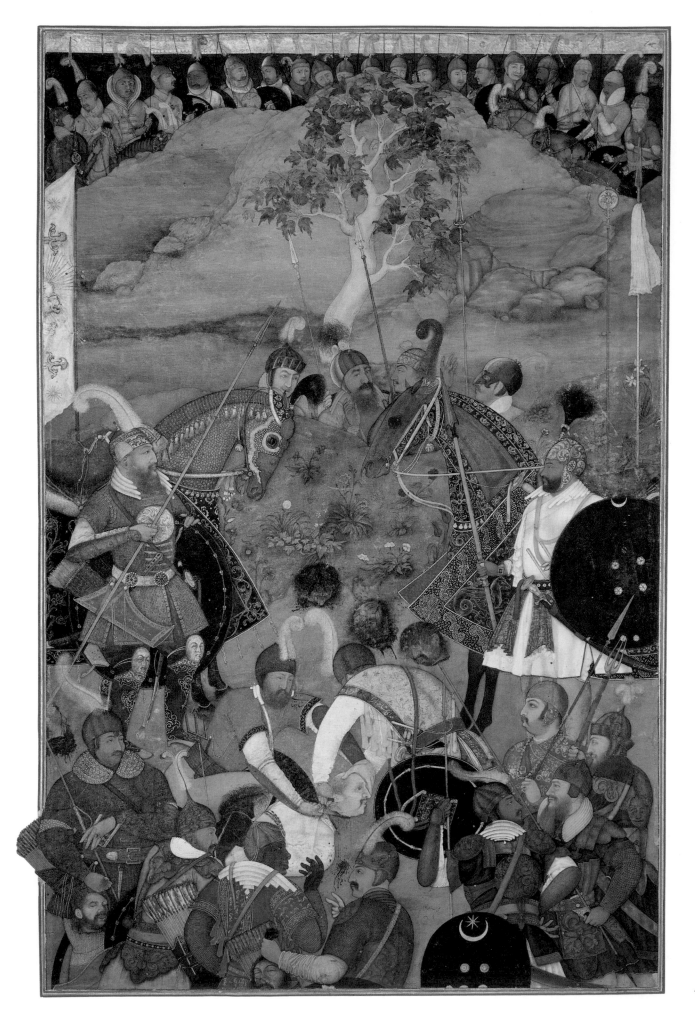

◁ 323b

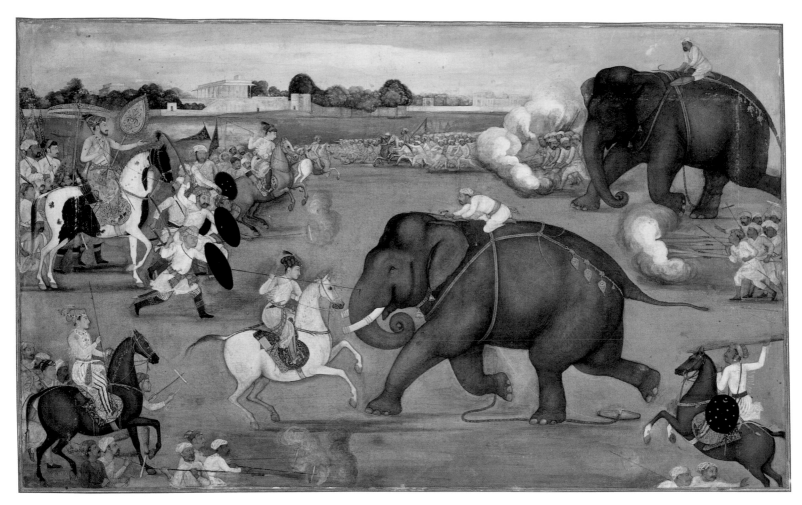

323c

latter's accession to the throne in 1628. His defection put Shah-Jahan's rule to its first great test and the Emperor had Lodi vigorously pursued and killed.

Abid was the greatest of Shah-Jahan's painters and this is 'among the most complex and original of all Mughal pictures' (Beach & Koch 1997, p. 175).

Bodycolour and gold. 81.5 × 61 cm
RCIN 1005025.q
LITERATURE Beach & Koch 1997, no. 16

c) UNKNOWN MUGHAL ARTIST
Prince Awrangzeb facing a maddened elephant named Sudhakar in 1633, c.1635

The staging of elephant fights was an imperial prerogative. This picture therefore emphasises the status of the participants. The Emperor Shah-Jahan is on the left; his second son, Shah-Shuja, is in front of him on the prancing horse; and his eldest son, Dara-Shikoh, is at the bottom left. His third son, the 15-year-old Awrangzeb, 'valiantly stood his ground' when one of the elephants broke away from the fight and charged the royal group. Great importance was attached to such displays of princely bravery. The scene is set on the banks of the river Jumna at Agra; palaces and gardens can be seen in the background on the opposite bank. The Taj Mahal was under construction further down the river at the time.

Bodycolour and gold. 61 × 81.5 cm
RCIN 1005025.ad
LITERATURE Beach & Koch 1997, no. 29

d) Attributed to BHOLA (fl.1640s)
Shah-Jahan honouring Prince Awrangzeb at his wedding in 1637, c.1640

The ceremony takes place on the terrace of the Agra fort. Shah-Jahan is about to give his son Awrangzeb an ornamental head-piece of pearls, which will hang over the bridegroom's face. Behind Awrangzeb are his brother, Shah-Shuja, and the Prime Minister, Asaf Khan. Behind Shah-Jahan are his fourth son, Muradbakhsh, and his eldest son, Dara-Shikoh. Awrangzeb, Shah-Jahan's third son, was not popular with his father.

Elaborate fireworks along the river are shown. Women are not often depicted in Mughal paintings and never those of rank and quality. Those in menial positions, such as the musicians here, are sometimes shown.

Bodycolour and gold. 81.5 × 61 cm
RCIN 1005025.at
LITERATURE Beach & Koch 1997, no. 45

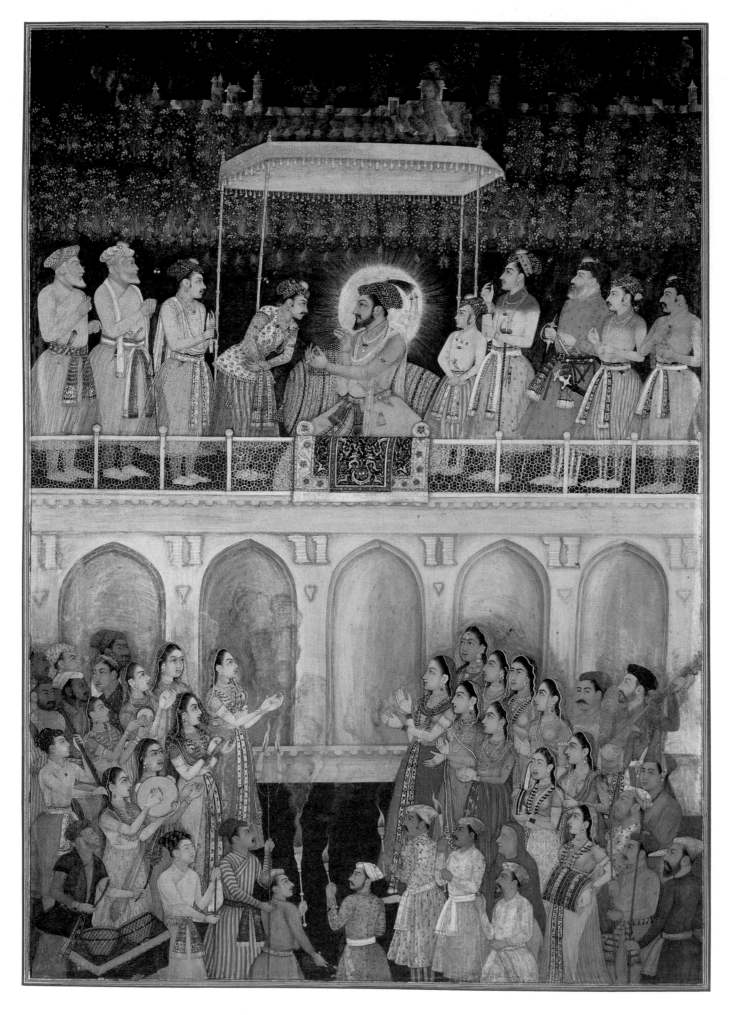

◁ 323d

324

FATH 'ALI SHAH QAJAR, SHAH OF PERSIA
(1797–1834); MUHAMMAD MIHDI OF TEHERAN
(fl.1800), scribe; MIRZA BABA (fl.1789–1810),
miniaturist
Divan-i-Khaqan, 1802

Early in his reign, Fath 'Ali Shah established a court noted for its artists
and poets, to foster a sumptuous image of the Qajar dynasty, which
ruled Persia (Iran) from 1794 to 1925. He wrote poetry himself, under
the pen-name of Khaqan. He had several copies of his *Divan* (collected
poems) written to present as diplomatic gifts. This copy was completed
in February 1802, and portraits of Fath 'Ali Shah and of his predecessor,
Aga Muhammad Khan, were added by the then Painter Laureate, Mirza
Baba. It was not, however, until 1812 that the volume was given to Sir
Gore Ouseley (see no. 328), British Ambassador Extraordinary to the
Court of Persia, to convey to the Prince Regent, later George IV. Ouseley
had spent several months in Teheran, negotiating the terms of a treaty
between Britain and Persia.

This is a late example of Islamic lacquer binding, a technique intro-
duced from Herat in the fifteenth century and perfected in the sixteenth.
The skills of miniature painters were often deployed on these bindings,
as here; the central panel is signed by Mirza Baba. The flowers and birds
are painted with lacquer coloured by pigments, and the background
lacquer contains powdered gold. Several layers of lacquer give depth to
each figure, the edges of which are defined by impressions of a fine
comb, and the top surface is raised by deliberately created *craquelure*. The
pages of the manuscript are colourful, with the text on a gold back-
ground, illuminated (i.e. decorated with gold) panels of red and blue,
and wide blue borders adorned with lively animals, birds and flowers
painted in gold.

Manuscript in *nasta'liq* script; text-area gilded; illuminated panels; blue borders with
gold animals, birds and flowers; 180 ff. Bound with lacquer boards and plain leather
spine. 43.5 × 29.5 × 6 cm
RCIN 1005020
PROVENANCE Presented by the author to George IV when Prince Regent, 1812
LITERATURE Holmes 1893, no. 152; Waley 1992, p. 11; Raby 1999, no. 111
EXHIBITIONS London 1931b, no. 726; London 1933, no. 390; London 1951b,
p. 181; London 1999a, no. 111

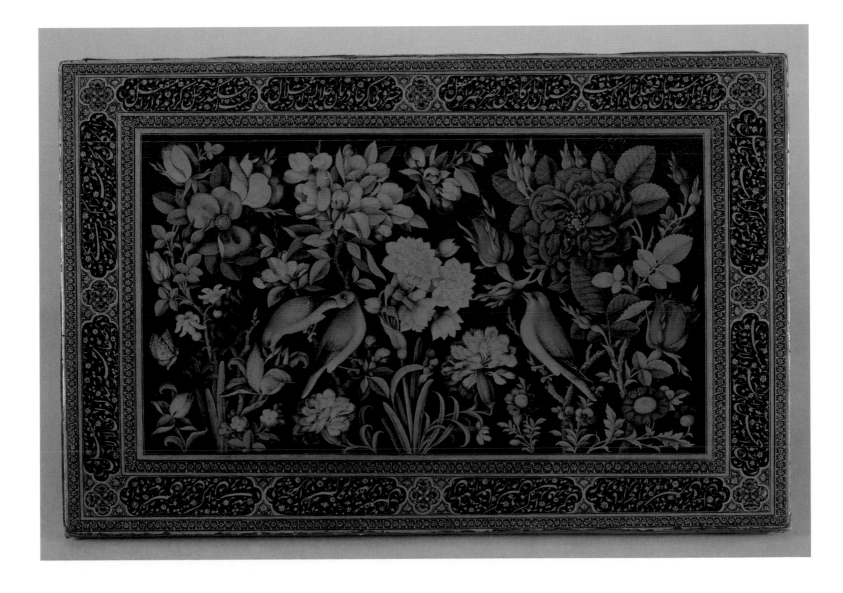

Ominum deum nostru. Venite adore² p̄ Veni
ten² Nocte surgentes añ. Quia mirabilia p̄. Cāta.

Antate dom̄io canticu nouū:
quia mirabilia fecit. Salua
uit sibi dextera eius: et brachiū
sanctum eius, Notū fecit dn̄s
salutare suum: in conspectu gentiū reuela=
uit iusticiam suam, Recordatus est mise=
ricordie sue: et veritatis sue domui israhel,
Viderūt omnes termini terre: salutare dei
nostri, Iubilate dom̄io omnis terra: can=
tate et exultate et psallite, Psallite dom̄io
in cythara in cythara et voce psalmi: in tu=
bis ductilibus et voce tube cornee, Iubi=
late in cōspectu regis dn̄i: moueaͬ mare ᴢ
plenitudo eius: vrbis terraᴢ et qui habitāt

PRINTED BOOKS (nos 325–337)

Printed books rather than manuscripts constitute the vast majority of the library's holdings, of which some groups merit individual mention. The library has over two hundred incunabula, books from the infancy or cradle (Latin, *cunabula*) of printing, before 1500. These were mostly either retained from George III's main library (see no. 325) or bought in the 1830s (see no. 326). At the other end of the timescale, fine printing is represented by a notable collection of Private Press books from the 1890s onwards (see no. 336).

The formation of the core collections and of the Royal Library itself coincided with the heyday of the production of large colour-plate books. The sections on natural history, topography and royal ceremonies (see nos 333–4) were enhanced by many of these, acquired either by subscription or by gift.

Visitors to the Royal Library cannot fail to be impressed by the rich effect created by massed leather bindings. Fine bindings are indeed one of the library's strengths, the result of both presentations and judicious purchase. The library also contains interesting examples of less usual binding materials, such as velvet and tortoiseshell (see nos 328, 332).

325
The Mainz Psalter, 1457
Open at ff. 97v–98r: including the opening of Psalm 98 (*Cantate Domino*)

This is one of only ten copies known of the second book to be printed by the system of movable metal type, the first being the Gutenberg Bible, printed in Mainz 1453–5. The Windsor copy is one of the six surviving 'short issues'; the Psalter was printed in two lengths, the longer ones (of 175 leaves, of which 4 copies survive) specifically for the diocese of Mainz, the shorter ones for more general use. It is also the first book known to have been printed in red and black. This was done with a single pull of the press, the type to be printed in red having been inked separately from the black and reinserted into the same forme (the locked frame holding the prepared type). This process meant that the two colours would be in perfect register, without any unsightly overlaps. The large two-colour initials (e.g. the large initial C) were printed from woodblocks by a similar method, the block for the letter being separable from the block for the surrounding pattern. By contrast, the large blue, red and black capitals (e.g. the blue E in *Ecce iam noctis*, f. 97v, or the red N in *Nocte surgentes*, f. 98r) were inscribed, as were some of the rubrics (words in red, usually instructions to the celebrant, or catchwords to help him find his way about the page). The music, and the words to accompany the music, were also added in manuscript. The scribe responsible wrote a beautifully even hand, which has been suggested as the model for the type, so closely do they correspond.

Mainz: Johann Fust and Peter Schoeffer
Printed on vellum in black and red, with woodblock two-colour initials, manuscript music and large coloured capitals in blue and red; folio, bound in 10s, 138 ff. (of 143; lacks ff. 137–41), numbered in pencil, 2 ff. of MS additions at end. Bound in purple velvet; appliqué gilt corner-pieces and crowned GIIIR monogram in centre; front board *Psalmorum Codex Moguntiae Mcccclvii*; floral clasps on fore-edge. 43.8 × 32.3 × 7.5 cm
RCIN 1071478
PROVENANCE Monastery of St Ursula, Hildesheim; from which bought by Friedrich Wilhelm von Duve (1707–85), 1758; from whom bought by Göttingen University, 1782; by whom presented to George III, 1800 (£400 reimbursed, 1817)
LITERATURE Masson 1954
EXHIBITIONS London 1963; QG 1974–5, no. 90; QG 1990–1, no. 72

326
FRANCESCO COLONNA (1432/3–c.1527)
Hypnerotomachia Poliphili, 1499
Open at ff. k3v–k4r: including a scene of Europa being borne off by the bull

The *Hypnerotomachia* (Strife of love in a dream) is a prose romance in two books, describing the symbolic dream of Poliphilo and his love for Polia.

325

It is widely regarded as one of the most beautiful illustrated books ever published. The illustrations, by an unknown artist, have been perfectly balanced to the text, and the overall effect of this harmony, combined with the artistry of the typographic layout and design, have led to its high reputation.

Colonna was identified as the author early in the sixteenth century, from an acrostic formed from the initial letters of each chapter: POLIAM FRATER FRANCISCUS COLUMNA PERAMAVIT (Brother Franciscus Colonna greatly loved Polia). The text was written in a deliberately obscure mixture of archaic Latinate words with an Italian syntax and Italian endings; a small but significant proportion of words were also derived from Greek. Even contemporary readers found it difficult to read. Despite its visual beauty, the book did not sell well, since war and plague were disrupting Italy during this period, and there was little market for Italian books outside Italy.

In this section Poliphilo, escorted by a beautiful nymph, is shown the first of four Triumphs, the Triumph of Europa. In Greek mythology Europa was the daughter of Agenor, King of Tyre (in the modern Lebanon), and was loved by Zeus, king of the gods, who sent a magical bull across the sea to steal her. The picture top right shows Europa garlanding the bull, which is apparently tame; the lower picture shows her being carried by the bull to Crete. Here she bore Zeus two sons, one of whom, Minos, commissioned the famous Labyrinth to house the Minotaur. The bull was eventually placed among the stars and became the constellation Taurus.

Venice: Aldus Manutius
Woodcut illustrations; folio bound in 8s, 234 ff., unnumbered. Bound in red morocco, gold-tooled (conservation work in 1980s revealed earlier, possibly contemporary, spine of brown calf under red morocco). 29.9 × 21.2 × 4.7 cm
RCIN 1057947
PROVENANCE Sale of duplicate books from the library of the Duke of Devonshire by R.H. Evans, London, November 1815 (750; £3 11s.); unknown bookseller who sold

Quella Nympha côfissa la finistra tabula côtineua, che aicenio haueа
fopra il manfueto & candido Tauro. Et quello filla p el tumido mare ti
mida, tràffretaua. SECVNDA SINISTRA:

Nel fronte anteriore, Cupidine uidi cū inumera Caterua di promi
scua géte uulnerata, mirabôdi che egli tiraffe l'arco suo uerfo l'alto olym
po. In nel fronte posteriore, Marte mirai dinanti al throno del magno
Ioue, Lamentātise che el filiolo la ipenetrabile thoraca sua egli la hauef
se lacerata. Et el benigno signore el suo uulnerato pecto gli monftraua.
Et nellaltra mano extenso el brachio teniua scripto, NEMO.
 k iiii

326

to Richard Heber (1773–1833; £6 2s. 6d.); sale of the library of Richard Heber by
Evans, March–April 1835 (3065; £3 3s.); bought by Joseph Lilly, bookseller; bought
for the Royal Library from Lilly's Catalogue, June 1835, item 419 (£4 4s.)
LITERATURE Colonna 1999
EXHIBITIONS QG 1990–1, no. 71

327
ROBERTO BELLARMINE (1542–1621)
Disputationes Roberti Bellarmini … Cardinalis … de controversiis
Christianae Fidei, adversus huius temporis Haereticos, III, 1601

Most of the Royal Library's holding of the books of James VI/I post-date
his accession to the English throne in 1603 and are fairly plain. The
form of the royal arms in the centre of this exuberant binding, the
Scottish lion rampant with two unicorn supporters, indicates that it was
bound for him while still only King of Scots. The book belongs to a
four-volume set probably dispersed in the 1890s. Volume I, formerly in
Viscount Astor's library, is now in the National Library of Scotland; its
binding is similar, but not identical, to no. 327. Volume II was on the
London market in 1996 (see Literature); the whereabouts of volume IV
is unknown.

This binding is by the binder whom Hobson calls 'Doreur au second
fer à Palmette', the best craftsman of the richest phase of the French
fanfare style (so called from its reuse in 1829 by Thouvenin in binding
a copy of *Fanfares et corvées abbadesques*, published in 1613). Characteristic
are the compartments of various shapes, delineated by strapwork with a
single line on one side and double lines on the other, giving a three-
dimensional effect. These compartments are filled with impressions of
small tools, and the ground between them with leafy sprays and
arabesques. The crowned initials IR denote *Jacobus Rex* (King James). The
set was very probably given to James VI in 1602 by Baron du Tour, the
new French Ambassador to Scotland. Haste in its binding is suggested by
the fact that two binding-shops (Simon Corberan's being the other) were
employed.

Cardinal Bellarmine was a leading Roman Catholic theologian and
his *Disputationes* contain a lucid statement of that doctrine; this volume
is on the nature of the Sacraments. He was among the Cardinals whom
James VI secretly canvassed in 1600 to support his claim to the English
throne, hinting at better treatment of Roman Catholics. Bellarmine
urged him to convert, and may have instigated this gift to influence
him. After the Gunpowder Plot of 1605, the King published various
treatises expounding the new Oath of Allegiance required of English
Roman Catholics, which were countered by Bellarmine.

327

Bohemian artist Wenceslaus Hollar (1607–77).

The binding is a late example of embroidery using metallic threads on velvet. These threads were formed by winding thin flexible strips of silver or silver gilt tightly round several strands of silk. To form thicker cords, two or more such threads were twisted together, and the coloured silks were plaited into fine cords. The decoration includes the Stuart arms and the initials CR for *Carolus Rex* (King Charles), with 2 within the C for Charles II. The embroidery was repaired about 1930 by the Royal School of Needlework, and again in 1964 by Mrs Evelyn Birkill.

The Bible and Prayer Book were found in a tin bath at St Michael's College, Tenbury, Worcestershire, in 1919, by the Reverend E.H. Fellowes, a Minor Canon of Windsor, who was cataloguing the books there. He mentioned this surprising find to Queen Mary, who helped purchase the volumes for the Royal Library. They had been in the college's large bequest of books from its founder, Sir Frederick Ouseley (1825–89). He had inherited them from his mother, *née* Harriet Georgina Whitelocke, wife of Sir Gore Ouseley (see no. 324). The bookplate of her father, John Whitelocke, is in both volumes. They may therefore be the 'coronation bible and prayer-book' reputedly given to Bulstrode Whitelocke, the Parliamentary lawyer, by Charles II in June 1660 (ten months *before* his coronation).

Cambridge: John Field for John Ogilby
1,722 pp., 7 pls, 2 vols in 1. Bound in blue velvet, embroidered with coloured silks, silver and silver-gilt wire; fore-edge painting of royal arms. 47.5 × 33 × 13 cm
RCIN 1142247
PROVENANCE With Prayer Book (RCIN 1142253): Charles II; possibly Bulstrode Whitelocke (1605–75); by descent to John Whitelocke (1757–1833); his daughter, Harriet Georgina Whitelocke, married Sir Gore Ouseley; their son, Sir Frederick Ouseley (1825–89); by whom bequeathed to St Michael's College, Tenbury, 1889; bought from the College jointly by King George V and Queen Mary, 1919 (£150)
LITERATURE Nixon 1974, p. 15; Spalding 1975, pp. 229, 296
EXHIBITIONS London 1929b, no. 248; QG 1990–1, no. 94

Ingolstadt: Adam Sartorius
1,060 pp. Bound in dark red goatskin, gold-tooled; all edges gilt. 35.5 × 23 × 7 cm
RCIN 1142246
PROVENANCE Bound for James VI of Scotland, *c*.1601; left royal ownership in seventeenth century; Sir Thomas Dick Lauder, ninth Bt (1846–1919); sale of his books, Sotheby, Wilkinson & Hodge, 26 June 1896 (98; £51); bought by J. Pearson & Co.; bought for the Royal Library, *c*.1896 (300 gns)
LITERATURE Hobson 1970, p. 23; Messrs. Maggs, catalogue no. 1212, London 1996, item 14
EXHIBITIONS London 1948a, no. 277; QG 1990–1, no. 93

328
The Holy Bible, 1659–60

This splendid Bible, and its companion Prayer Book (RCIN 1142253), were probably bound for Charles II's Chapel or Royal Closet at Whitehall, where he had two sets, Bible and Prayer Book uniformly bound, replaced every few years as part of the Chapel refurnishing. As the Prayer Book of this set is a 1660 edition, this must have been one of the earliest sets; the newly revised standard edition would have been used after 1662. This edition of the Bible, though notorious for the textual inaccuracy of John Field, Printer to the University of Cambridge, was one of John Ogilby's more splendid publications, with plates by the

329
EDWARD HYDE, FIRST EARL OF CLARENDON (1609–1674)
The History of the Rebellion and Civil Wars in England, begun in the year 1641 [to] the King's blessed Restoration … in the year 1660, III, 1704

This account of the English Civil Wars and their aftermath is of particular value for being written by a key participant. A lawyer and MP, Hyde was one of Charles I's closest advisers from 1641 until 1645. Thereafter he was with the Prince of Wales (Charles II from 1649) for much of the period leading up to the restoration of the monarchy in 1660, the year in which his daughter, Anne, married (as his first wife) the King's brother, the future James II. He was created Earl of Clarendon in 1661 but became increasingly unpopular as Lord Chancellor and his administration ended in exile for life in 1667. During this exile, he revised his *History of the Rebellion*, a chronicle of events down to 1644, originally written in 1646–8, continuing it to 1660.

This volume is from the first edition of the *History*, 1702–04, issued in three volumes, from the Sheldonian Theatre, which then housed Oxford University's Press. The book greatly benefited the university, of

328 ▷

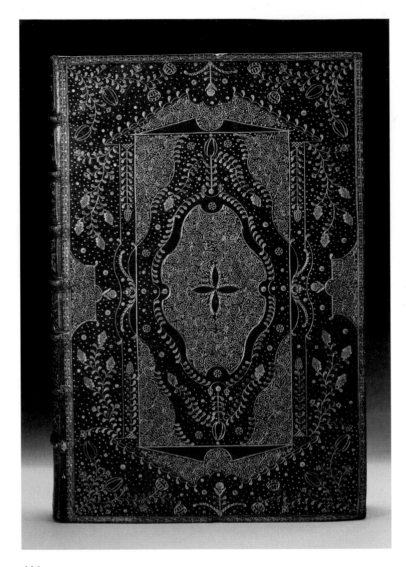

329

330

330

THOMAS À KEMPIS (c.1380–1471);
GEORGE STANHOPE (1660–1728), translator
The Christian's pattern: or, a Treatise of the Imitation of Jesus Christ, 1704

The writings of Thomas à Kempis, an Augustinian monk of Mont St Agnes at Zwolle in the Netherlands, combined mystical theology and practical Christianity. His authorship of the devotional text, *De Imitatione Christi* (Of the Imitation of Christ), has been debated for centuries, but it was first printed in Augsburg in 1471 under his name. The first English translation of 1502, by William Atkinson, was ascribed to Jean Gerson of Paris, but most of the numerous English editions cite Thomas à Kempis as author. The work was popular for its simple, clear teaching. It is not surprising to find a copy bound for Queen Anne, a devout Christian and staunch upholder of the traditions of the Church of England, who revived the custom of Touching for the King's Evil to cure scrofula, and established Queen Anne's Bounty to supplement the stipends of the poorest clergy.

The translator, grandson of George Stanhope, Chaplain to James I and Charles I, was appointed Chaplain to William III c.1697, and to Queen Anne in 1702. In March 1704, just before this edition was published, he was appointed Dean of Canterbury. This was probably a presentation copy to the Queen.

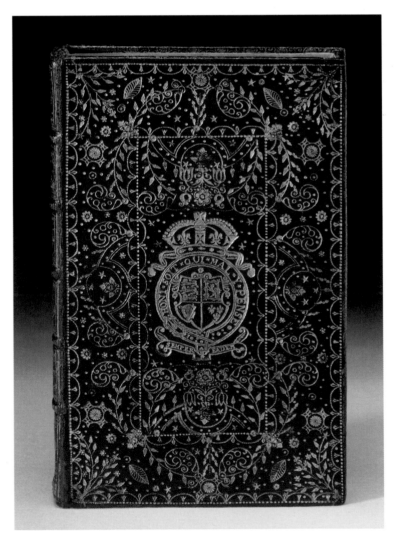

which Clarendon had been Chancellor from 1660 to 1667: the profits funded a new building for the press, designed by Nicholas Hawksmoor and completed in 1715. Since 1830 the Clarendon Building has housed the university's administration.

The three volumes of the Royal Library copy of the *History of the Rebellion* are similarly, but not identically, bound, in the cottage-roof style, one of the best-known binding styles of the late seventeenth century, but which continued well into the eighteenth (cf. no. 331). They have the three-lobed break at the apex of the 'roof' and several of the characteristic Restoration-period tools, such as the tulip, poppy, and floral volutes, used for ground-cover in the central panel and elsewhere. The bunch of grapes tool came into use around 1700. Volume I has 'WL 30' pencilled on the flyleaf, showing that the set belonged to George III's Windsor Library, his personal library, kept at Cumberland Lodge in Windsor Great Park, as distinct from his main library in Buckingham House.

Oxford: at the Theater [*sic*]
650 pp., 1 pl. Bound in red sheepskin, gold-tooled; all edges gilt. 45.5 × 30.5 × 6 cm
RCIN 1027883
PROVENANCE Original ownership unknown; George III
LITERATURE Holmes 1893, no. 110 (vol. II illustrated)
EXHIBITIONS London 1891b, no. N 5 (vol. II); Paris 1951, no. 111 (vol. I)

330

The binding does not fit into any of the well-known styles of the period but draws elements from several: a central panel with finials, common on plainer bindings during the seventeenth century; the half-moon with inverted centre, more usually found on cottage-roof bindings (cf. no. 329); the long sprays of foliage from the sixteenth-century fanfare style (cf. no. 327); and the leafy curls and flower vases from the Restoration period. The Queen's arms, a simplified form of the Stuart arms used until the Union of England and Scotland in 1707, include her motto *Semper Eadem* (Always the same woman), copied from Elizabeth I. Most English and British monarchs since Henry VI have used the motto *Dieu et mon Droit* (God and my Right).

4th edn, London: D. Brown, *et al.*
398 pp., 2 pls. Bound in dark red calf, gold-tooled; all edges gilt and gauffered.
20 × 12.5 × 3 cm
RCIN 1142243
PROVENANCE Queen Anne (possibly presented by the translator); left royal ownership in the eighteenth century; re-acquired by c.1900
EXHIBITIONS QG 1990–1, no. 97

331

The Form and Order of the … Coronation of Their Majesties King George III and Queen Charlotte, in the Abbey Church of S. Peter, Westminster, 1761

George III became King on the death of his grandfather, George II, on 25 October 1760. He married Princess Charlotte of Mecklenburg-Strelitz on 8 September 1761, just in time for her to be crowned with him on 22 September. Contemporary accounts relate considerable confusion at some stages of the coronation ceremonies, but the dignity of the royal couple and 'the reverent attention which both paid' to the service were favourably commented on. Feeling it would be wrong to receive Holy Communion wearing his crown, the King himself decided to lay it aside, since neither the order of service nor the Archbishop of Canterbury gave him guidance on this point.

Unlike the souvenir volume published after George IV's coronation (see nos 333–4), the *Form and Order* for George III's was for use on the day. John Cornish supplied fifteen copies red-ruled and bound in red leather. As this copy does not have the ribbon-ties and gold fringes of the sovereign's copies, it must be one of those for other members of the royal family. The binding is a late example of the cottage-roof style, the pitch of the 'roof' being much flatter than in earlier examples (e.g. no. 329) and with far less tooling. The tools and dentelle border roll were chosen with the coronation theme in mind. They include crossed sceptres, crowns, eagles with wings outstretched, like the ampulla for the Holy Oil, and entwined roses and thistles, emblems of England and Scotland. The royal arms, with Hanover in the fourth quarter, are as used between George I's accession in 1714 and the Union with Ireland in 1801.

London: Mark Baskett and the Assigns of Robert Baskett
94 pp. Bound in red calf, gold-tooled; all edges gilt. 24.5 × 19 × 2 cm
RCIN 1142242
PROVENANCE Member of the royal family, 1761; acquired for the Royal Library by 1860
LITERATURE *Annual Register* 1762, pp. 215–35; Holmes 1893, no. 67
EXHIBITIONS QG 1974–5, no. 104; QG 1990–1, no. 99

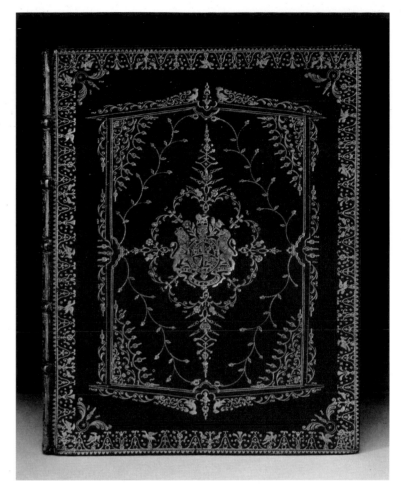

331

332

a) The Holy Bible, 1776
b) The Book of Common Prayer, and Administration of the Sacraments, … with the Psalter or Psalms of David, 1815

This set of Bible and Prayer Book is bound in an unusual material, tortoiseshell with gold inlay and gilt spine-hinges and clasps. The simpler decoration on the Prayer Book, and variations in the shape of the coronets, suggest that the bindings were not executed by the same binder at the same time.

The initials AF stand for Augustus Frederick, Duke of Sussex (1773–1843), sixth son of George III and Queen Charlotte. The most intellectual of their sons, as a young man he went abroad for his health, first to Göttingen University in Hanover, and then to Rome. There, in addition to contracting the first of his two morganatic marriages, he fostered his academic interests, predominantly theology. After returning to England in 1804, the Duke established a library in his apartments in Kensington Palace. By 1830, with judicious buying by the Duke and his librarian, T.J. Pettigrew, this magnificent collection contained over fifty thousand volumes, including about a thousand editions of the Bible. As with George III's library at Buckingham House, scholars were granted access. Pettigrew arranged it in six subject categories, and published a catalogue of the Bibles.

The fact that the 1776 Bible is not included in Pettigrew's catalogue suggests that it was a more intimate possession, for personal use. Each volume has its own gold-tooled leather box. The set was acquired by

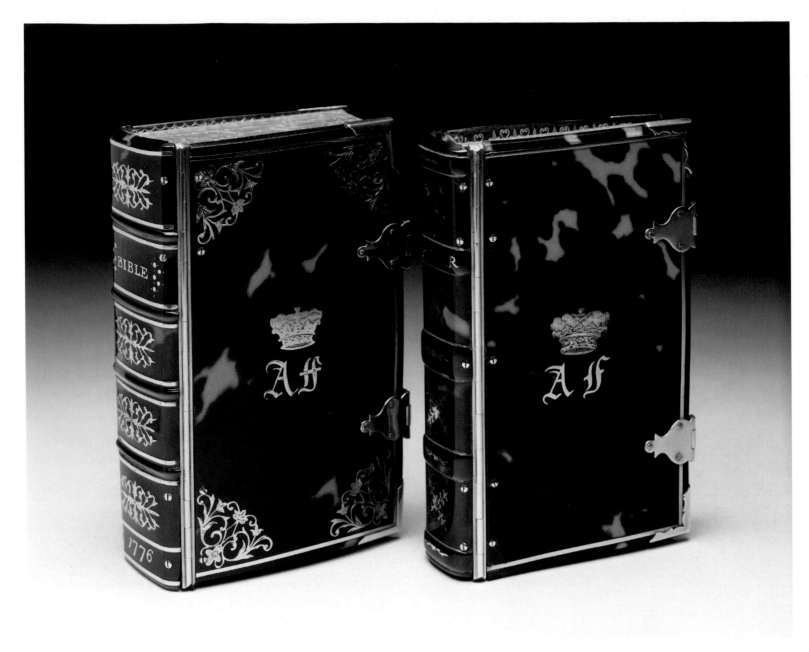

332

Queen Mary, as a note in her hand records: 'Augustus Frederick Duke of Sussex prayer books, for Windsor Library some day.' Another hand has added: 'From Q. Mary Feb. 1939.' The reacquisition of belongings of members of the Hanoverian dynasty was one of Queen Mary's abiding interests.

a) Bible
London: J.W. Pasham
1,176 pp., 2 vols in 1. Bound in tortoiseshell with gold inlay, gilt clasps and spine-hinges; all edges gilt and gauffered. 11.5 × 7.5 × 3.5 cm
RCIN 1081306

b) Prayer Book
London: J. Reeves
572 pp., 2 vols in 1. Bound as Bible. 11.5 × 7.5 × 2.5 cm
RCIN 1081307

PROVENANCE Augustus Frederick, Duke of Sussex; his sale, Christie & Manson, 26 July 1845 (415; £6 10s., bought by a Mr Cooper); acquired by Queen Mary, and by her transferred to the Royal Library, 1939

333
JOHN WHITTAKER (d. 1831)
Ceremonial of the Coronation of His Most Sacred Majesty King George the Fourth, 1823
Open at f. 7: the Banners of Scotland and Ireland, borne by the Earl of Lauderdale and Lord Beresford

This sumptuous volume was produced in the context of an equally splendid public event, George IV's coronation on 19 July 1821. Since his estranged wife, Caroline of Brunswick, was held in considerable public sympathy after George IV's attempts to divorce her, a lavish spectacle was needed to rekindle the public's loyalty towards him. Parliament voted the astonishing sum of £240,000 towards the cost of the ceremony (George III's coronation had only cost £70,000). The extravagant costumes for the procession were designed to an Elizabethan and Jacobean theme, to recall England's past heritage.

Whittaker's publication was printed in gold throughout, by a

Ceremonial of the Coronation
of
KING GEORGE the Fourth.

ORDER of the PROCESSION

Lieut.-Colonel Sir Augustus S. Frazer.	Lieut.-Colonel Sir Richard Williams.	Lieut.-Colonel Sir Ulysses Burgh.	Lieut.-Colonel Sir William M. Gomm.
Lieut.-Colonel Sir George Scovell.	Lieut.-Colonel Sir John May.	Colonel Sir Alexander J. Dickson.	Lieut.-Colonel Sir James Wilson.
Colonel Lord Fitzroy Somerset.	Lieut.-Colonel Sir Henry William Carr.	Lieut.-Colonel Sir John M. Doyle.	Lieut.-Colonel Sir Jeremiah Dickson.
Lieut.-Colonel Sir George H. F. Berkeley.	Colonel Sir Henry Hardinge.	Colonel Sir Charles Sutton.	Colonel Sir Robert Arbuthnot.
Colonel Sir Archibald Campbell.	Colonel Sir John Colborne.	Colonel Sir Colin Campbell.	Colonel Sir Richard Downes Jackson.
Colonel Sir John Maclean.	Colonel Sir Edward Blakeney.	Major-General Sir Andrew F. Barnard.	Major-General Hon Sir Charles J. Greville.
Major-General Sir George R. Bingham.	Captain Sir Thomas Staines, R.N.	Captain Sir James Alexander Gordon, R.N.	Captain Sir James Lind, R.N.
Captain Sir Thomas Lavie, R.N.	Captain Sir Michael Seymour, Bart. R.N.	Rear-Admiral Sir Edward Hamilton Bart. R.N.	Major-General Sir Henry Torrens.
Major-General Sir Richard Hussey Vivian.	Major-General Sir Colin Halkett, G.C.H.	Major-General Hon Sir Robert W. O'Callaghan.	Major-General Sir Thomas Sidney Beckwith.
Major-General Sir Robert Macfarlane, G.C.H.	Lieut.-General Sir Richard Jones.	Rear-Admiral Sir David Milne.	Lieut.-General Sir George Cooke.
Vice-Admiral Sir Davidge Gould.	Major-General Sir George Sackville Browne.	Major-General Sir Thomas Dallas.	Major-General Sir James Lyon, G.C.H.

technique developed in secret and first used in 1816. The vibrant hand-coloured illustrations give a flavour of the procession, though not its strict order. The Banner of Scotland (the red lion on a yellow background) is borne by the Earl of Lauderdale, Lord High Keeper of the Great Seal of Scotland, wearing the collar of the Order of the Thistle. The Banner of Ireland (the gold harp on a blue background) is borne by Viscount Beresford, military hero from the Peninsular War, wearing the collar of the Order of the Bath. Both are attended by pages. Behind them walk Viscount Exmouth wearing the collar of the Bath, and Viscount Sidmouth.

Six copies of this book were printed for the crowned heads of Europe, but the expense bankrupted Whittaker, despite an initial grant of £5,000. The plates, engraved from originals by the brothers James (1789–1874) and Francis Stephanoff (1790–1860), were later republished by Henry Bohn in Sir George Nayler's *Coronation of His Most Sacred Majesty King George the Fourth*, published posthumously in 1837.

London: John Whittaker
Printed on japan vellum; gold letterpress, stipple engraving with etching and aquatint, and hand-colouring; 43 ff., interleaved with blanks. Bound in brown morocco, gold-tooled, with the royal arms on both boards, rebacked. 69.1 × 60.5 × 7 cm
RCIN 1005090
PROVENANCE Probably presentation copy to George IV, 1823
LITERATURE Adams 1983, no. 232
EXHIBITIONS Birmingham 1980, no. 81; Essen 1992, no. 36

334
JOHN WHITTAKER (d. 1831)
Presentation title page to the Ceremonial of the Coronation, 1822

This title page shows the letterpress surrounded by the collar of the Order of the Garter, with the Great George, an image of St George fighting the dragon, hanging from the base of the collar. It was printed a year earlier than the book, possibly as a trial print.

Single block-printed gold foil impression on glazed and coated paper. 45.2 × 36.7 cm
RCIN 630743
(not illustrated)

335
SIR GEORGE FREDERICK WARNER (1845–1936), editor;
KATHARINE ADAMS (1862–1952), binder
Queen Mary's Psalter: miniatures ... reproduced from Royal MS. 2B.VII in the British Museum, 1912

This book constitutes an interesting link with the Old Royal Library. It comprises facsimiles of the miniatures in the manuscript known as Queen Mary's Psalter, now in the British Library (Royal MS. 2B.VII), edited by Sir George Warner, until 1911 Keeper of the Department of Manuscripts of the British Museum. The fourteenth-century volume belonged to Henry Manners, second Earl of Rutland (see no. 321). After his arrest for Protestant sympathies early in the reign of Mary Tudor, the manuscript was impounded and presented to the Queen. It was rebound in velvet embroidered with the pomegranate badge, which she had inherited from her mother, Catherine of Aragon. It had been added to

the Spanish royal arms to symbolise the reconquest of Granada from the Moors in 1492 by Catherine's parents, Ferdinand and Isabella.

In 1757 the manuscript passed to the British Museum with the Old Royal Library. By the 1870s, when Warner began work there, the study of medieval manuscripts for their illustrations rather than for their text alone was becoming acceptable, and this was one of his main interests. The manuscript was chosen for facsimile reproduction because of its large number of lively vignettes of fourteenth-century life.

In view of the artistic interests of Queen Mary, consort of King George V, and the coincidence of names, this facsimile volume was an obvious gift for her. The Trustees of the British Museum commissioned Katharine Adams, one of the foremost craft bookbinders of the early twentieth century, to bind the presentation copy. Katharine Adams, a friend of William Morris's family, trained in 1897 under Sarah Prideaux and Douglas Cockerell, before establishing a small workshop in Lechlade. She later moved her workshop to Broadway in Worcestershire. From 1899 she exhibited with the Arts and Crafts Exhibition Society; many of her bindings were on Private Press books (cf. no. 336) for friends in the Arts and Crafts Movement.

Katharine Adams designed both the bindings and most of the special tools used in their decoration. The acorns and oak leaves, here forming the border, and *pointillé* floral designs, using numerous small dots, are characteristic of her work. The central panel bears heraldic roses and pomegranates, uncial Ms and crowns like Queen Mary's 1911 coronation crown.

London: Oxford University Press for the Trustees of the British Museum
98 pp., 316 pls. Bound in dark blue levant goatskin, gold-tooled; all edges gilt and gauffered. 32 × 23.5 × 7.5 cm
Inside front board, gold-tooled on vellum: PSALTERIVM MARIAE QVONDAM ANGLIAE REGINAE ... MARIAE NVNC ... CONSORTI OBTVLERVNT MVSEI BRITANNICI GVBERNATORES A.D. MCMXII (The Governors of the British Museum have offered the Psalter of Mary, formerly Queen of England, ... to Mary, now Queen Consort ..., AD 1912)
RCIN 1080356
PROVENANCE Presented by the Trustees of the British Museum to Queen Mary, 1912
LITERATURE Tidcombe 1996, pp. 142–3
EXHIBITIONS Paris 1924

336
ERIC GILL (1882–1940)
The Four Gospels, 1931
Open at pp. 124–5: including initial with the Deposition from the Cross

This is a particularly striking example of the work of the Private Press Movement, which William Morris brought to prominence at the Kelmscott Press in the 1890s with the aim of raising the standard of printing and book production to the high levels achieved during the incunabula period (1450–1500). The Golden Cockerel Press was set up in 1920 by Harold Midgeley Taylor, and aspiring authors were initially encouraged to set the type of, and to print, their own books. After Taylor's death in 1925, the press was taken over by Robert and Moira Gibbings, whose period of control over the press was the high point in its history. It was during their management of the press that Eric Gill became involved in its artistic life.

Gill had had a conventional artist's training at Chichester Technical and Art School, working afterwards in the ecclesiastical architectural office of William Caröe, and developing his lifelong interest in lettering and its design under the calligrapher Edward Johnston. For the *Four Gospels* Gill designed both the typeface and the wood-engraved initials, and worked closely with Gibbings to decide the precise layout of the pages and the emphasis of the illustrations. It was intended that the text (using the Authorized King James version) should predominate, despite Gill's striking designs; the letterpress was therefore set up and printed before the woodblocks were cut, so that Gill could use the proofs to size his blocks. They were cut from hardwood, enabling great precision of line and finesse of detail; at the same time Gill was able to interweave the letters and illustrations to a remarkable degree. The initial A here shows an example of this; the side of the letter becomes part of a ladder, and the letter N is used to support a man taking the weight of the body of Christ.

Waltham St Lawrence: Golden Cockerel Press (no. 60 of a limited edition of 500 copies)
Printed on Batchelor hand-made paper; with wood-engraved illustrations; 269 pp. Bound by Sangorski & Sutcliffe in pigskin over cream buckram. 34.2 × 24.8 × 3.4 cm
RCIN 1052088
PROVENANCE Bought from John and Edward Bumpus Ltd, London, March 1932
LITERATURE *Chanticleer* 1936, no. 78

337
The Holy Bible, 1953

For The Queen's Coronation in 1953, Oxford University Press was commissioned to print the Bible required in the ceremony. A limited edition of twenty-five copies on fine paper was produced, of which two were specially bound. The first was used in the Coronation when the Archbishop of Canterbury administered the oath. The Queen, kneeling on the altar steps, laid her right hand on the Bible saying: 'The things which I have here before promised, I will perform and keep. So help me God.' After kissing the Bible, she signed the oath. The Bible was then formally presented to her, in a ceremony dating from the coronation of William and Mary in 1689. In 1953 for the first time it was presented jointly by the Archbishop of Canterbury and the Moderator of the General Assembly of the Church of Scotland. The Bible was subsequently placed in the library of Westminster Abbey.

The second copy of the Bible, shown here, was identically bound and was presented to The Queen by the publisher. The firm of Sangorski & Sutcliffe executed both bindings, to designs by Lynton Lamb (1907–77), graphic designer with Oxford University Press from 1930; he had studied bookbinding under Douglas Cockerell at the Central School of Arts and Crafts in London (cf. no. 335). The design 'grows' out of the spine structure, the raised bands of the spine leading to gold-tooled music staves. They are complemented by staves in black, and a restrained pattern of ER cyphers and crowns, around the central lozenge of The Queen's arms, perhaps a visual representation of the solemn music and ritual around The Queen as the central figure of the ceremony.

Oxford: University Press; no. 2 of 25 copies on Oxford India Paper
Printed on Oxford India Paper, 1,428 pp., 2 vols in 1. Bound in red levant goatskin with cream inlay, tooled in gold and black; all edges gilt. 34 × 26.5 × 6.5 cm
RCIN 1080362
PROVENANCE Presented by Oxford University Press to HM The Queen, 1953
LITERATURE Middleton 1996, p. 313
EXHIBITIONS London 1992a

◁ 337

NOW WHEN THE EVEN WAS COME

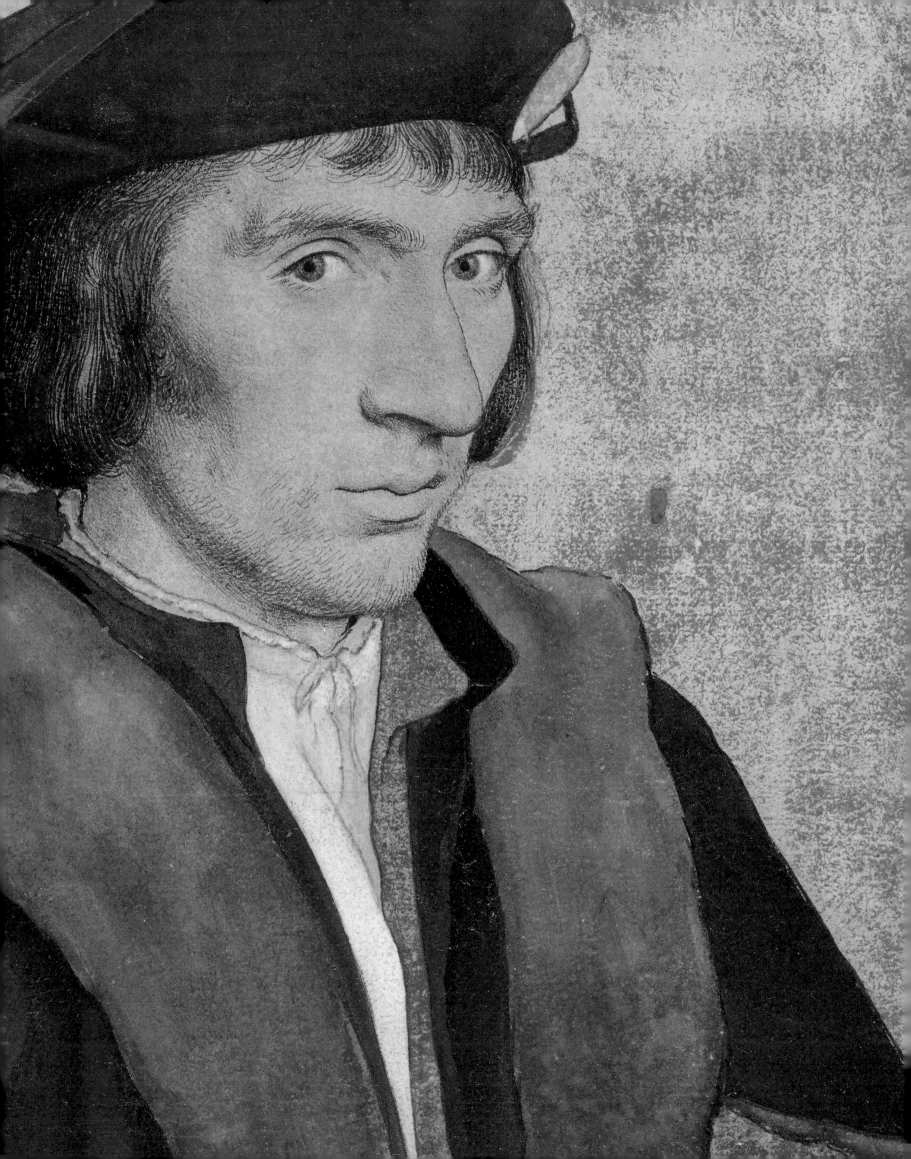

DRAWINGS, WATERCOLOURS AND PASTELS (nos 338–399)

The Royal Collection contains around 40,000 drawings and watercolours and 150,000 prints. These are mostly housed in the Print Room of the Royal Library at Windsor Castle, though over seven thousand such items (including the framed pastels) hanging throughout the royal residences are also the curatorial responsibility of the Print Room staff.

This collection has been assembled over the last five hundred years. A small number of drawings were made to be framed and hung, such as the works of Isaac Oliver (no. 357), but works on paper are damaged by the effects of light and have customarily been preserved on the pages of albums, in portfolios or in boxes, and kept with printed books in libraries. As they thus have no practical function, unlike ceramics and metalware – and even paintings, tapestries and sculpture, which were acquired to furnish a residence – drawings and prints have always been the domain of collectors of a particular character, and the most significant contributions to the Royal Collection of works on paper have been made during the reigns of just three monarchs: Charles II, George III and Queen Victoria.

The first drawings identifiable in royal ownership were the series of eighty-five portrait studies by Hans Holbein the Younger that still form one of the treasures of the Royal Library (nos 348, 349). The 'great booke' that contained these drawings was listed in the possession of Edward VI in 1547 and may well have been inherited from his father Henry VIII, who died four years after the artist. However, Holbein's drawings were of particular interest not because they were drawings but because they were portraits, and indeed for the next two centuries the Holbeins were treated rather differently from other works on paper in the Royal Collection.

The Holbeins were the one major group of drawings known to have been in the collection of Charles I, who had probably inherited them on the death of his brother Henry, Prince of Wales, in 1612, but he exchanged them in the late 1620s for a single tiny painting, Raphael's *St George and the Dragon* (now Washington, National Gallery of Art). Although he was the greatest of royal collectors, Charles I appears to have had little interest in drawings, in contrast to his contemporary Thomas Howard, Earl of Arundel, who was at that time assembling Europe's finest collection of drawings. Charles did purchase the Raphael cartoons of the *Acts of the Apostles* in 1623, before his accession, but these were appar-

ently acquired for their use in the manufacture of tapestries at Mortlake as much as for their qualities as works of art in their own right.

The first monarch who seems to have had a specific interest in drawings was Charles II (r. 1660–85). There is regrettably little documentation of his collecting activity, but the King apparently acquired the great volume of drawings by Leonardo da Vinci (nos 338–44) and reacquired that of Holbein. There are also a significant number of Italian drawings now in the collection that bear marks indicating that they were in England in the seventeenth century. As these did not apparently pass through the great private collections of the eighteenth century (formed by Jonathan Richardson senior and junior, Thomas Hudson, and Sir Joshua Reynolds, nor that of Sir Peter Lely whose collection was dispersed in 1688), it may be inferred that many of these drawings also entered the collection under Charles II (for example no. 350).

A brief inventory made around 1727 of the contents of a bureau at Kensington Palace describes albums containing the drawings by Leonardo, Holbein, Farinati and Parmigianino that can still be identified in the collection, with others only summarily listed. The collection of drawings had been relatively neglected after the death of Charles II in 1685, and the Holbeins were 'rediscovered' in 1727 by Queen Caroline (consort of George II) in the Kensington bureau. She had them framed and hung, first at Richmond and then at Kensington Palace; fortunately they did not suffer too much from exposure to light, and by 1774 they had been returned to an album in the King's Library.

It was in the mid-eighteenth century that the collection of Old Master drawings assumed the proportions that it has today. Queen Caroline's son, Frederick, Prince of Wales, was the first serious collector of the House of Hanover. Among his major purchases of drawings was an album of studies by Poussin (though this did not include no. 365, which entered the collection by a different route). But Frederick died before his father and did not come to the throne; it was his son, George III, who was able to indulge his tastes on a grand scale. In 1762 the young King purchased the collections of Consul Joseph Smith in Venice and Cardinal Alessandro Albani in Rome. At a stroke he had thus acquired large groups of drawings by Canaletto (no. 384), Sebastiano (no. 376) and Marco Ricci, Piazzetta (no. 379), Domenichino, Castiglione

(no. 369), the Carracci (nos 354, 356), Maratti (no. 373), Poussin (no. 365), Sacchi, and Della Bella (no. 370); the bulk of the Cassiano dal Pozzo collection (nos 363–4); smaller but still significant numbers by artists such as Michelangelo (nos 345, 346), Raphael (no. 347) and Bernini (no. 366); and very many miscellaneous studies by other Italian Old Masters. Richard Dalton, who held the posts of Librarian (1760–73) and Keeper of Medals and Drawings (1773–91) to George III, was instrumental in the purchase of many other drawings, including large numbers by Guercino (no. 362) and Sassoferrato (no. 368). A number of the earlier English and Northern European drawings also entered the collection during the reign of George III, but mostly as small groups and individual sheets that cannot be specifically identified in the few surviving documents. By 1783 the drawings collection was housed in the Marine Gallery at Buckingham House, 'a low gallery above stairs' added to the suite of new library rooms in 1774 (see under no. 160).

In the early nineteenth century the first surviving comprehensive inventory of the Royal Collection of drawings was made. Now known as Inventory A, this lists in detail the contents of the volumes and portfolios that then contained the Old Masters in the library of Buckingham House. It is clear from Inventory A that most of the collection had been rearranged and rebound following George III's purchases, and while this allowed a more coherent organisation of the drawings it also entailed the destruction of much physical evidence of earlier provenance in the form of mounts, backing papers and bindings.

The donation of George III's library to the nation after the accession of his son, George IV, involved the transfer to the British Museum of a number of albums of prints, together with one of the three 'documentary' sequences of prints and drawings, the Topographical Collection. The Naval Collection was initially sent to the Admiralty but since the 1840s has been gradually transferred to the British Museum (latterly British Library). However, George III's Military Collection, of over six thousand maps and views (based on the collection of the King's uncle, William, Duke of Cumberland), and the Old Master drawings (clearly seen as distinct from the collection of books) were retained.

With the establishment of the Royal Library at Windsor Castle in the 1830s, the collection of prints and drawings began to take on a distinct physical identity. The Print Room now occupies three rooms on the north front of Windsor Castle, immediately below the most westerly of the State Apartments. The main (central) room (see fig. 12) dates in its present form from the late 1850s, and was created by the Prince Consort with the assistance of the architect John Thomas. Queen Victoria and Prince Albert took a great interest in the organisation of the prints and drawings, spending many evenings in the Print Room. One of Prince Albert's many artistic initiatives was the commencement of the Raphael

Collection, an attempt to survey systematically, in photographs and prints, every work by or deriving from Raphael. Totalling some 5,500 items, this great enterprise was completed in 1876, fifteen years after the Prince's death in 1861; its forty-nine portfolios are now once again housed in the cabinet built for this purpose in the Print Room, having been on loan to the British Museum from 1973 to 2001.

During the librarianship of Richard Holmes in the last third of the nineteenth century, a small number of fine Old Master drawings were added to the collection, but in general very few such drawings have been acquired since around 1800. The major contribution of Queen Victoria and Prince Albert to the drawings collection was the sequence of many hundreds of contemporary watercolours which were pasted in to a series of volumes, including nine Souvenir Albums. These were either commissioned or received as gifts to record visits both at home and overseas (nos 389–91). Queen Victoria and Prince Albert were also enthusiastic patrons of the exhibitions organised by the various watercolour societies that flourished in Britain at the time. After Prince Albert's death the Queen took less interest in the contents of the Print Room. Her children, most notably Albert Edward, Prince of Wales (later Edward VII), and Alfred, Duke of Edinburgh (no. 392), continued to commission watercolour records, though they had less enthusiasm for the fine arts and this practice gradually lapsed with the advance of reportage photography.

In the eighteenth and nineteenth centuries the holdings of prints had been growing, through a process of gradual accumulation rather than the purchase of other collections *en bloc*. The collection as it exists today suggests that prints were chiefly collected for their documentary value rather than as works of art in themselves, and this is reflected in the organisation of the prints to this day: while there are fine groups by Hollar, Canaletto, Hogarth, Piranesi, Rowlandson, Callot, Della Bella and Nanteuil, Old Master prints are not in general well represented and the principal sequences are of British and European royal portraits, British non-royal portraits, topography, and historical events.

The second half of the nineteenth century saw the start of the gradual break-up of many of George III's albums and the individual mounting of the Old Master drawings (see pp. 53–5). This led to the discovery of important drawings on newly revealed versos, described by the energetic Royal Librarian B.B. Woodward in a series of articles in the *Fine Arts Quarterly Review*, a short-lived periodical established with the support of the Prince Consort. While contemporary watercolours had been lent to exhibitions throughout Queen Victoria's reign, individual mounting now permitted the display of Old Master drawings, of which over 150 were shown at the pioneering exhibition at the Grosvenor Gallery, London, in the winter of 1877/8. All the Holbeins were shown at the New Gallery, London, in 1890; more than fifty Italian

drawings at the same venue in 1894; and seventy-five Holbeins travelled to his fourth centenary exhibition in Basel in 1897–8.

This process of mounting and exhibiting continued apace into the early twentieth century. Under Edward VII and George V the newly mounted drawings were stamped with a small mark of ownership at the lower right-hand corner – somewhat confusingly, as most of the drawings concerned had been in the collection for over 150 years by this time. The mounting programme led to a greatly increased need for storage space. This was a bleak period financially, and during the 1920s the Librarian, Sir John Fortescue, attempted to solve both problems by recommending for disposal whole series of works on paper which were considered to be of lesser importance. Among the items disposed of were the bulk of the caricature collection, numbering some ten thousand items, sold to the Library of Congress in Washington; fifty-four portfolios of foreign portrait engravings; sixteen volumes of mainly natural history drawings from the Cassiano dal Pozzo collection; and a large group of etchings by Whistler. The depressed state of the world economy led to a relatively small price being obtained for such a huge amount of material, and the Royal Library Trust Fund had no more than a short-term effect on the running of the library. In the present reign the great importance of the Dal Pozzo collection has been realised, and over 140 of the drawings sold in the 1920s (including no. 364) have been reacquired.

Even with unlimited funds it would not have been possible to purchase Old Master drawings during the twentieth century either in the numbers or of the quality that was attainable in earlier times. In addition to the drawings from the Dal Pozzo collection, fifty drawings and watercolours by the Sandby brothers (including no. 388) and forty-five designs for the remodelling of Windsor Castle under George IV have been acquired (see nos 404 and 405), along with many miscellaneous purchases. Forty-six portraits of members of the Order of Merit have been commissioned (including nos 395, 397, 398); and very many works have been presented to The Queen on State Visits, on her Coronation and Jubilees, and by well-wishers. But the emphasis in the present reign has been on the conservation, study and presentation of the collection, through the establishment of a conservation studio and a curatorial team at Windsor, the publication of *catalogues raisonnés* (twenty-two volumes of which have appeared to date), and a vigorous programme of exhibitions.

338
LEONARDO DA VINCI (1452–1519)
A political allegory, c.1495

Leonardo da Vinci was the archetype of the Renaissance man – a painter, sculptor, architect, anatomist, engineer and map-maker, and student of geometry, optics, hydraulics and botany. Drawing was central to his researches, and the 600 sheets by Leonardo at Windsor Castle, covering all aspects of his activity, are the greatest treasure of the Royal Library.

This is Leonardo's most elaborate chalk drawing. It is generally accepted that it has a political meaning, though suggested interpretations have varied widely – an allegory on the magnetic north pole, on river navigation, or on the relationship between Pope Leo X and King Francis I around 1515–16. The eagle apparently wears the French crown, and the wolf is very probably the Pope, steering the Ship of the Church. In St Ambrose's exegesis the Ship of the Church has as its mast the Cross of Christ; rather than using a pictorially disruptive crucifix, Leonardo substituted the Tree of Life, a branch of which was planted on Adam's grave, itself growing into a tree from which ultimately the Cross was fashioned.

Close analysis of the drawing style supports a date in the mid-1490s, when Alexander VI was Pope and Charles VIII was on the French throne. The dry handling of the red chalk is that of the sketches in Leonardo's notebook known as Manuscript H (Paris, Institut de France), and the watermark is identical to that on a sheet of studies of men in action of the same period (RL 12643). The comparison with Manuscript H is not confined to style, for that notebook of c.1493–4 contains most of Leonardo's notes on animal allegories and shows that he was briefly fascinated by such symbolism. Excepting the nurturer of Romulus and Remus, the wolf is almost always a negative symbol, of gluttony, rapaciousness and corruption of all kinds – characteristics regularly associated with Alexander VI by his many enemies.

In September 1494 the army of Charles VIII of France entered Italy to press the King's claim to the throne of Naples. Though Alexander VI considered ordering the papal troops to resist Charles, his position was undermined by internal dissent and by the end of 1494 Charles was in Rome. Alexander frustrated Charles's demands to acknowledge him as ruler of Naples, but was unable to prevent him marching on the city (taking with him as a hostage the Pope's son Cesare Borgia) and usurping the throne.

This seems then to be the context of Leonardo's allegory, a weakened Alexander VI cowering before and being guided by the magnificence of the French King. In the 1490s Leonardo was artist to the Sforza court in Milan, which had been closely involved with the affairs of Alexander VI. But in 1494 Ludovico Sforza abandoned his carefully forged alliance with the papacy, realigning himself with the French and allowing the troops to march through Lombardy unopposed, and the prevailing sentiment at the Milanese court would have been openly pro-French. Leonardo's reasons for making the drawing remain unclear but the sheet was probably a finished work of art intended for a member of the Sforza court.

Red chalk. 17.0 × 28.0 cm
Verso: inscribed [...] r/[...]VI [illegible]
RL 12496
PROVENANCE Bequeathed by the artist to Francesco Melzi, 1519; bought from his heirs by Pompeo Leoni, c.1582–90; bought in Spain for Thomas Howard, Earl of

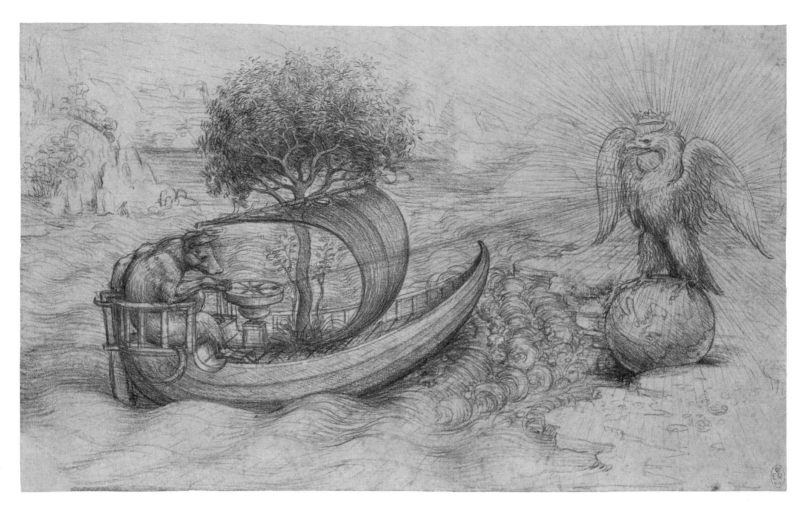

338

Arundel, c.1613–30; Royal Collection by 1690 (probably acquired by Charles II)
LITERATURE Clark & Pedretti 1968–9, no. 12496; Kemp 1981; Pedretti 1982,
no. 54; Jungic 1997; Clayton 2002
EXHIBITIONS London 1952a, no. 54; London 1959–60, no. 489; QG 1969–70,
no. 64; Malibu/NewYork/London/Houston/Milan/Stockholm/Zurich/Hamburg/Sydney/
Brisbane/Auckland/Tokyo/Barcelona/Madrid 1980–8, no. 38; London 1989a, no. 82;
Washington 1991–2, no. 189

339
LEONARDO DA VINCI (1452–1519)
A standing male nude from behind, c.1503–06

In 1503 Leonardo began preparations for the huge mural of the *Battle of Anghiari*, to be painted in the council chamber of the Palazzo della Signoria in Florence. His preparatory drawings for the composition of men and horses in violent action led Leonardo back to a prolonged study of anatomy and proportion, a subject that had first occupied him around 1490 in Milan. Leonardo made a number of drawings of male nudes standing in this tensed pose, seen directly from in front or behind, and of legs from all angles with the muscles strongly emphasised. In some cases the divisions between the muscles are so sharp that Leonardo must have intended to represent an *ecorché*, or flayed body; though there is no firm evidence that he performed human dissection until around 1507–08, he may have worked on corpses in the monastery hospitals at an earlier date.

There was no attempt here, as there was in the earlier anatomical drawings, to impose a system of proportion on the figure, or to derive such a system from measurements taken from the model. Instead Leonardo concentrated on capturing the subtleties of surface modelling, drawn rapidly with lightly hatched chalk, and of contour – the foreshortening of the hands, in particular, is masterful. The outlines were drawn repeatedly with light passes of the chalk, giving a vibrancy that transforms the image from a static illustration into a study of a living, breathing individual. That individual may be identified by the cut inscription at top left as a musician (*sonatore*) named Francesco Sinistre (though this is not a likely surname, it may have indicated a left-handed player). Leonardo occasionally annotated his studies of horses with the breed and owner, but this is the only such inscription on a human figure study.

Red chalk. 27.0 × 16.0 cm
Inscribed by the artist, upper left, in reverse, *franc sinisstre sonat*[...]
RL 12596
PROVENANCE As no. 338
LITERATURE Clark & Pedretti 1968–9, no. 12596; Keele & Pedretti 1979, no. 84
EXHIBITIONS London 1952a, no. 160; QG 1969–70, no. 74; London 1975b,
no. 91; London/Florence/Hamburg/Mexico City/Adelaide/Melbourne/New York
1977–84, no. 50; London 1989a, no. 32; Washington 1991–2, no. 176

herself, but some of the other plant studies rank among the most objective of Leonardo's drawings. They are mostly drawn with a finely pointed red chalk on paper coated with a delicate orange-brown preparation itself probably composed of ground red chalk. This red-on-red technique emphasises line at the expense of volume, and the strong outlines necessary to give structure to the oak study have occasionally been misinterpreted as later reinforcement by a different hand.

Red chalk with touches of white chalk on pale red-brown prepared paper.
18.8 × 15.3 cm
RL 12422
PROVENANCE As no. 338
LITERATURE Clark & Pedretti 1968–9, no. 12422; Pedretti 1982, no. 18
EXHIBITIONS London 1952a, no. 147; QG 1969–70, no. 60b; Malibu/New York/London/Houston/Milan/Stockholm/Zurich/Hamburg/Sydney/Brisbane/Auckland/Tokyo/Barcelona/Madrid 1980–8, no. 15; QG 1986–7, no. 15; London 1989a, no. 28

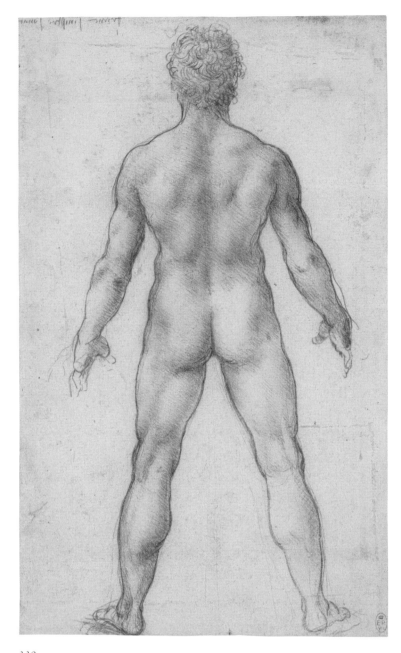

339

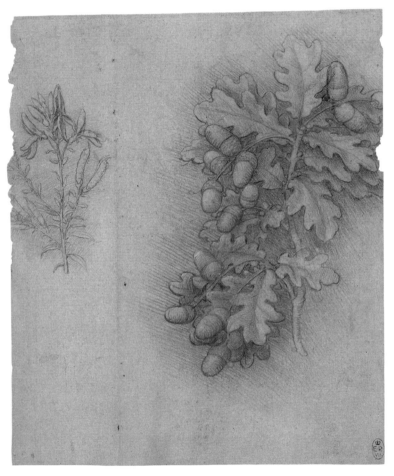

340

340
LEONARDO DA VINCI (1452–1519)
Sprigs of oak (Quercus robur) *and dyer's greenweed* (Genista tinctoria), *c.1505*

Over the last two decades of his life Leonardo worked intermittently on two versions of a composition representing the seduction of Leda by Jupiter in the form of a swan, from which union were born Castor and Pollux, Clytemnestra, and Helen of Troy. The first version proceeded no further than the preparatory drawings, but Leonardo completed a painting of the second version, destroyed around 1700 and known through numerous copies.

A common feature throughout was a foreground teeming with plants and flowers, to augment the theme of fecundity inherent in the subject matter, and in this connection Leonardo made a number of botanical studies around 1505. The famous *Star of Bethlehem* (RL 12424) is as stylised in the twisting motion of its leaves as are the sketches of Leda

341
LEONARDO DA VINCI (1452–1519)
A storm in an alpine valley, c.1508–10

A number of landscapes in red chalk by Leonardo can be dated to his second period of residence in Milan, intermittently between 1506 and 1513, in the service of the French occupiers of the city. Some are highly objective, most remarkably a view of the Alps from the roof of Milan Cathedral (RL 12410); some are documentary, such as a distant view of the fires set by Swiss troops outside Milan in mid-December 1511

He presumably made other ascents of the Lombard Alps, and there is no reason why the precipitous view in the drawing, looking down on a localised storm in a valley, should not have been based on experience.

Red chalk. 19.8 × 15.0 cm
Inscribed .137., probably by Francesco Melzi
RL 12409
PROVENANCE As no. 338
LITERATURE Clark & Pedretti 1968–9, no. 12409; Pedretti 1982, no. 5
EXHIBITIONS London 1930, no. 572; London 1952a, no. 199; London 1959–60, no. 493; QG 1962–3, no. 113; QG 1969–70, no. 107; QG 1972–3, no. 26; QG 1975–6, no. 50; Malibu/New York/London/Houston/Milan/Stockholm/Zurich/Hamburg/Sydney/Brisbane/Auckland/Tokyo/Barcelona/Madrid 1980–8, no. 4; London 1989a, no. 47

342
LEONARDO DA VINCI (1452–1519)
Studies of flowing water, c.1509–11

Water obsessed Leonardo throughout his life. His earliest dated drawing, of 1473, is a landscape showing a river cascading over rocks and streaming away down a valley; his final sheets, forty-five years later, are haunted by visions of deluges destroying the Earth. He surveyed the

(RL 12416); others are more stylised, of which this is the finest example. But the drawing is not merely, or even primarily, a work of the imagination, and it is abundantly clear from Leonardo's notebooks that he was both familiar with the Alps north of Milan and fascinated by meteorological phenomena. He made detailed descriptions (partly first-hand) and measurements (wholly so) of the valleys; he recorded fossil shells found in the mountains, from which he deduced that the Earth was much older than indicated by the Bible; he described freak clouds and storms; and in a remarkable passage in the Codex Leicester (f. 4r), of about the same date as the present drawing, Leonardo noted how the sky darkened at high altitudes:

> This may be seen, as I saw it, by going up Monte Rosa, a peak of the Alps which divide France from Italy ... No mountain has its base at so great a height as this, which lifts itself above almost all the clouds; and snow seldom falls there, but only hail in the summer ... and this hail lies unmelted there ... and in the middle of July I found it very considerable. And I saw the sky above me quite dark, and the sun as it fell on the mountain was far brighter than in the plains below. (Richter 1939, no. 1060)

The pursuit of mountaineering began in earnest only in the mid-nineteenth century, and documented earlier ascents of the higher peaks, such as Petrarch's climb of Mont Ventoux, are remarkably rare. But it is plain from this passage that Leonardo, then aged over 50, ascended Monte Rosa to some considerable altitude, perhaps 3,000 metres or more.

342

Arno for the Florentine government and planned a canal to render Florence navigable from the sea; and in the years around 1508–11 he studied hydraulics in great detail with the unrealised intention of compiling a treatise on the subject. Leonardo made hundreds of observations on the movement of water at this time, and although certain themes recur – in particular his astute analyses of complex motions in terms of linear and circular components – the superabundance of particular cases prevented him from ever realising a set of generally applicable laws.

This most elaborate of Leonardo's sheets of water studies investigates two basic themes. The first, in the upper two drawings, is the flow of water past a planar obstruction. Leonardo was struck by the fact that the patterns were stable and repeatable, evidence that the flow was not chaotic but subject to physical laws, and in notes on the other side of the sheet he attempted to frame such principles in terms of incidence, percussion and reflection. Below, Leonardo shows the fall of a stream of water from a sluice into a pool, a lucid and highly sophisticated study in which the multiple layered vortices are seen extending far below the surface, each welling current giving rise to concentric circles of bubbles that expand across each other without interference (a phenomenon that he had studied elsewhere in his investigations of wave propagation). But Leonardo was of course never a dispassionate observer, and he wrote elsewhere of the 'beautiful spectacles of rippling water' and the 'beautiful movements which result from one element [air] penetrating another [water].'

344

Pen and ink, the central drawing over black chalk. 29.7 × 20.8 cm
Extensively annotated by the artist
RL 12660v
PROVENANCE As no. 338
LITERATURE Clark & Pedretti 1968–9, no. 12660v; Pedretti 1982, no. 42r
EXHIBITIONS London 1952a, no. 230; London 1959–60, no. 478; QG 1969–70, no. 125; Malibu/New York/London/Houston/Milan/Stockholm/Zurich/Hamburg/Sydney/Brisbane/Auckland/Tokyo/Barcelona/Madrid 1980–8, no. 29; London 1989a, no. 61; Washington 1991–2, no. 182

343
LEONARDO DA VINCI (1452–1519)
The babe in the womb, c.1511

Leonardo's anatomical researches can be divided between a first phase around 1490, when he seems to have had no access to human material other than skeletal; and a second, much more significant phase between about 1507 and 1515, during which time he claimed to have dissected around thirty corpses. This figure is not contradicted by the quantity of Leonardo's surviving anatomical drawings, on some two hundred sheets held almost entirely at Windsor.

His most fruitful period of anatomical study was around 1510, when he investigated the mechanics of human muscles and bones, possibly in collaboration with Marcantonio della Torre, a young professor of anatomy at the University of Pavia. After Marcantonio's death in 1511, Leonardo concentrated on cardiology and embryology, working mainly with animal material. His dissections of the ox's heart are astonishing in their precision and understanding of function, but his embryological studies were less successful. Although he may have dissected a woman who died in childbirth and a miscarried embryo of four to six weeks,

Leonardo had no knowledge of the discoidal structure of the human placenta and believed it to be cotyledonous (formed of a number of small 'rosettes'), like that of the gravid cow that he had dissected a couple of years earlier.

The notes and smaller sketches here are concerned with the nature of the membranes enfolding the foetus and the interdigitation of the supposed cotyledons; they may be considered as glosses to the main drawing in which Leonardo synthesised his understanding of the human uterus. Despite the errors of detail, the tightly balled form of the foetus surrounded by swirling pen-work and the striking use of red chalk for the underdrawing make the sheet one of the most powerful and affective of Leonardo's late period.

Pen and ink, the main drawing with wash over red chalk and traces of black chalk.
30.5 × 22.0 cm
Extensively annotated by the artist
RL 19102r
PROVENANCE As no. 338
LITERATURE Clark & Pedretti 1968–9, no. 19102; Keele & Pedretti 1979, no. 198
EXHIBITIONS London 1952a, no. 298; Washington/Los Angeles 1976, no. 21;
London/Florence/Hamburg/Mexico City/Adelaide/Melbourne/New York 1977–84,
no. 19; London 1989a, no. 26; Washington 1991–2, no. 174; Houston/Philadelphia/
Boston/Tokyo/Nagoya 1992–5, no. 22

344
LEONARDO DA VINCI (1452–1519)
A study for the costume of a masquerader, c.1517–18

For more than half of his career Leonardo was employed as a salaried
court artist, in which capacity he would have been called upon to
provide not only paintings and sculpture but also designs for architec-
ture, pageants and stage plays. This is one of a number of costume
studies probably made towards the end of Leonardo's life, when he was
in the service of the young French king Francis I in the Loire valley.
Federico Gonzaga (1500–40), the future Duke of Mantua, was at this
time completing his education at the French court, and during January
1518 the King held a number of entertainments for his guest at the
palace of Romorantin, described in detail by the secretary Stazio Gadio
in letters back to the Mantuan court. On 11 January Federico was

> dressed as a lansquenet, with half-boots, one completely dark, the
> other less dark, edged with a white and yellow riband cut in the
> German manner, a tunic half of satin, the edge of silver cloth and
> golden cloth made into scales, with a German-style shirt worked with
> gold, and over this a cape of dark cloth fitted with a riband of gold
> and silver cloth made in the French manner. (BL, MS Harley 3462, f.
> 219v ff; reference generously supplied by Professor John Shearman.)

This description corresponds closely with another of the costume studies
at Windsor (RL 12575), and as three further studies are on paper bearing
a French watermark it seems certain that the whole series dates from
Leonardo's last years. The precise function of each drawing is a little
more elusive, as the highly atmospheric treatment of the chalk would
not have been very helpful for the tailors and seamstresses of the court;
perhaps the studies were no more than suggestions intended to convey
the overall structure and desired richness of effect of the costumes.

Black chalk. 21.5 × 11.2 cm
RL 12576
PROVENANCE As no. 338
LITERATURE Clark & Pedretti 1968–9, no. 12576
EXHIBITIONS London 1952a, no. 238; QG 1996–7, no. 90

345
MICHELANGELO (1475–1564)
A male nude with proportions indicated, c.1515–20

Michelangelo was primarily responsible for establishing the tradition in
post-classical art that conceives of the body (and especially the male

nude) as the physical manifestation of emotional and spiritual states.
Intense feeling thus requires powerful form and his figures can on occa-
sion be oppressively heavy, though they are always based on the most
attentive study from the life. The main drawing here is finished with
great care and ranks as one of Michelangelo's most majestic nudes; yet it
seems to have had a didactic function, for it is statically posed and the
proportions of various parts of the body are indicated.

The unit used is inscribed as a *testa* (head), defined in the sketch at top
right as the distance from chin to hairline or the length of a hand.
Overall the model stands eleven and a half units tall, and while this
would normally pertain to a gracefully elongated figure, this ratio is here
due to an unnaturally small head which further emphasises the breadth
of the shoulders. The musculature is anatomically accurate (though
almost grotesquely massive in the torso) and reflects the artist's lifelong
investigation of the subject, beginning with his reputed human dissec-
tions as a 17-year-old.

Michelangelo had few pupils, most of whom were inept, but he was
sporadically conscientious in providing instructional drawings for his
protégés. The style of this drawing suggests a date around 1515–20, a
period of close association with Sebastiano del Piombo (c.1485–1547),

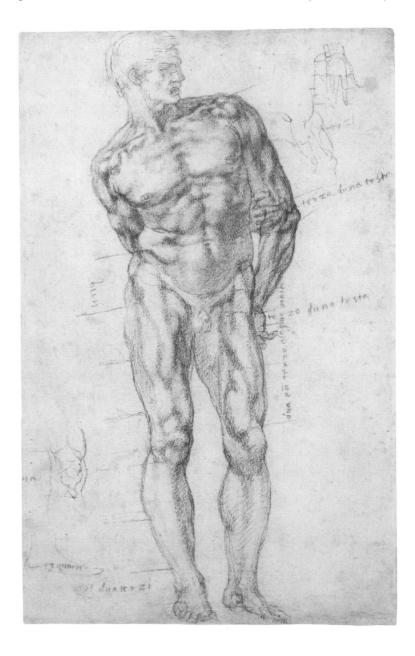

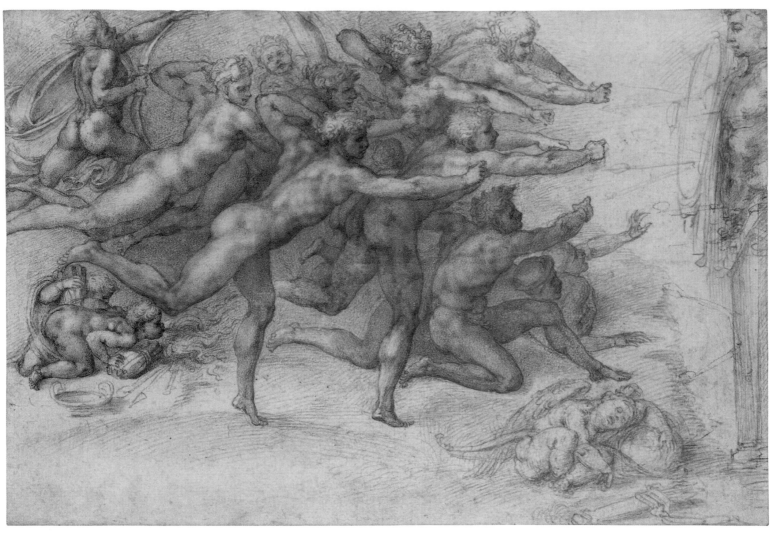

346

the most accomplished of Michelangelo's immediate followers, and it is possible that it was drawn for Sebastiano. The proportional indications are however obscure – it is difficult in most cases to discern what anatomical features Michelangelo was referring to, and the intervals thus defined seem trivial. Another drawing of a standing nude on the verso of the sheet is not didactic, and Michelangelo may have added the measurements on the recto for his own purposes. Though this is one of few surviving drawings to be so explicit, Michelangelo's biographer Ascanio Condivi stated that the artist was preoccupied with proportion, and indeed it would have been most surprising if the architect, sculptor and painter had *not* been interested in the subject.

Red chalk (two shades). 28.9 × 18.0 cm
Annotated by the artist with proportional measurements
RL 12765
PROVENANCE George III, by c.1810
LITERATURE Popham & Wilde 1949, no. 421; Dussler 1959, no. 716; De Tolnay 1975–80, I, no. 61
EXHIBITIONS London 1893–4, no. 1511; London 1950–1, no. 274; London 1953b, no. 29; QG 1962–3, no. 67; QG 1972–3, no. 32; London 1975a, no. 101; Sydney/Melbourne/Brisbane 1988, no. 15; Washington/Fort Worth/Chicago/Cambridge/QG 1996–8, no. 33; Sydney 1999–2000, no. 51

346
MICHELANGELO (1475–1564)
Archers shooting at a herm, c.1530

The handful of 'presentation drawings' that Michelangelo produced during the latter half of his life, and especially around 1530, stand at the very pinnacle of European draughtsmanship. Made as gifts for his closest friends, they were painstakingly worked and often imbued with personal meaning, the nature and full extent of which are not always clear to us. Despite their intimate nature, most were soon famous through reproduction in engravings, copy drawings, paintings, relief sculpture and carved crystals. The Royal Collection holds five of these magnificent sheets: *Tityus*, the *Fall of Phaeton*, the *Bacchanal of Children*, *Three Labours of Hercules* and the present drawing. All may have passed through the Farnese collection in Rome, but the circumstances of their acquisition, probably for George III, are not known.

No literary source has been identified for the subject of the *Archers*, but its neoplatonic meaning is so clear that it has no need of a specific source. A group of nude youths, both male and female, some hovering in the air, fire arrows (from non-existent bows) towards a target fixed to a herm. These arrows strike the herm and its base, and the edges of the target, but not its centre. Below, a winged cupid sleeps, his bow resting in his lap; to the left two putti kindle a fire. Thus mere striving – the

frenetic actions of the archers, impelled by the burning flames of passion below – cannot achieve its aim. Only that which is guided by love will succeed; the winged cupid sleeps, and so the arrows miss their mark. The most curious element of the composition, the omission of most of the bows, may simply have been intended to simplify the composition and maintain the horizontal surge of the figures.

Red chalk (two shades). 21.9 × 32.3 cm
RL 12778
PROVENANCE Giulio Clovio; by whom bequeathed to Cardinal Alessandro Farnese, 1578; George III, by c.1810
LITERATURE Popham & Wilde 1949, no. 424; Dussler 1959, no. 721; Hartt 1971, no. 362; De Tolnay 1975–80, II, no. 336
EXHIBITIONS London 1893–4, no. 279; London 1930, no. 504; Edinburgh 1947, no. 140; London 1950–1, no. 260; London 1953b, no. 90; Amsterdam 1955, no. 217; QG 1962–3, no. 72; QG 1972–3, no. 42; London 1975a, no. 127; QG 1986–7, no. 22; Washington/San Francisco/Chicago 1987–8, no. 20; Montreal 1992, no. 103; Washington/Fort Worth/Chicago/Cambridge/QG 1996–8, no. 16

347
RAPHAEL (1483–1520)
The Three Graces, c.1517

Raphael was born in Urbino, worked in Umbria and Florence, and moved to Rome in 1508 to work for Pope Julius II. His supreme talents and capacity for great productivity were quickly recognised, and by the time of his early death he dominated the artistic scene in Rome. Inundated with commissions, Raphael was compelled to delegate the execution of most of his projects to teams of assistants. He and his two most trusted colleagues, Giulio Romano and Gianfrancesco Penni, controlled these projects through their drawings – highly efficient sequences of compositional draft, figure study and full-scale cartoon. Despite the pressures that he was under, Raphael himself prepared at least some of the compositions at the most routine manual level.

This drawing of a single model in three consecutive poses is a study for the group sprinkling a libation over the married couple in the *Wedding Feast of Cupid and Psyche*, one of two fictive 'tapestries' frescoed by Raphael's workshop in the garden loggia of Agostino Chigi's villa by the

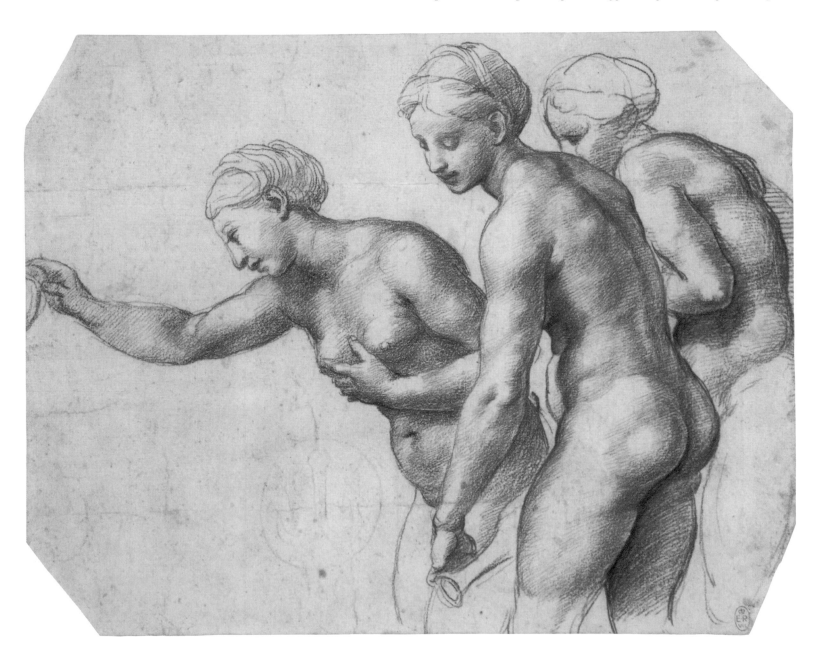

Tiber in Rome, now known as the Villa Farnesina. It is the work of an artist with a seemingly effortless understanding of bodily form and fully in control of his medium, taking the drawing as far as necessary and no further, defining highlights simply by leaving areas of paper blank. Life drawings of the female nude were rare in the Renaissance, though they are perhaps more commonly encountered in Raphael's oeuvre than in that of any other artist of the time.

All early sources credit Raphael with the invention of the Farnesina compositions, but the frescoes themselves were painted entirely by his assistants, and their coarseness, inconsistency of effect and harshness of modelling immediately attracted criticism. A letter to Michelangelo in Florence from his agent in Rome opined that the frescoes were 'a disgrace for a great artist'; this is one of the few documents associated with the project and establishes that the frescoes were finished no later than the end of 1518.

Red chalk over some stylus. 20.3 × 25.8 cm, the corners cut
RL 12754
PROVENANCE George III, by c.1810
LITERATURE Popham & Wilde 1949, no. 804; Joannides 1983, no. 408; Oberhuber & Ferino Pagden 1983, no. 553
EXHIBITIONS London 1930, no. 483; Edinburgh 1947, no. 149; London 1950–1, no. 254; QG 1972–3, no. 57; London 1983–4a, no. 162; QG 1986–7, no. 18; Washington/San Francisco/Chicago 1987–8, no. 17; QG/Washington/Toronto/ Los Angeles 1999–2001, no. 31

348

HANS HOLBEIN THE YOUNGER (1497/8–1543)
William Warham, Archbishop of Canterbury, 1527

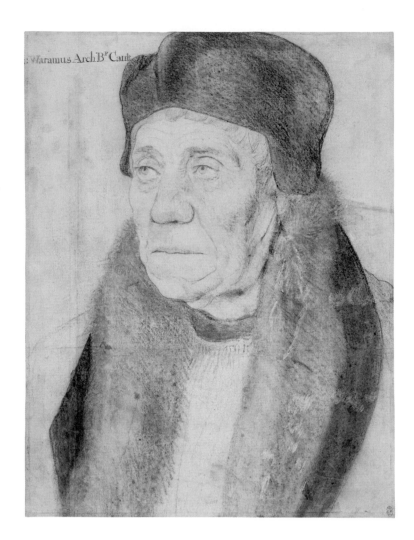

Holbein was the most important painter working in England during the Reformation, though he was born in Augsburg, trained in Basel and spent a total of only thirteen years in England, from 1526 to 1528 and from 1532 to 1543. Of the eighty portrait drawings by Holbein now at Windsor, thirty can be connected with surviving paintings, and nearly all the remainder were no doubt studies for lost works. In 1547 'a booke of paternes for phisioneamyes', probably identifiable with the Holbein series, was inventoried in Edward VI's collection. In most cases the identity of the sitter is known only from the inscriptions on the drawings, apparently copied in the eighteenth century from identifications made by Sir John Cheke, tutor to Edward VI.

William Warham (c.1455–1532) was appointed Archbishop of Canterbury by Henry VII in 1503, after a career as a diplomat and lawyer; from 1504 to 1515 he was also Lord Chancellor. The accession of Henry VIII in 1509 and his preferment of Thomas Wolsey brought Warham and Wolsey into frequent conflict over matters of ecclesiastical authority. (Warham and Wolsey, with Tunstall, Bishop of London, are shown in no. 320, in Parliament at Henry VIII's right hand.) None the less the two of them began proceedings for the King's divorce from Catherine of Aragon, and after Wolsey's fall from power in 1529 Warham assumed sole responsibility for pursuing the matter. His reluctance was apparent, and shortly before his death in August 1532 he voiced his clear opposition. Only with the subsequent appointment of Thomas Cranmer to the archbishopric was the divorce effected.

Warham was a friend and patron of Erasmus, and in 1524 Erasmus sent him as a gift his portrait by Holbein, probably the painting dated

1523 in the collection of the Earl of Radnor. On Holbein's arrival in England, Warham returned the compliment, and the present drawing is Holbein's full-scale study for the painting sent to Erasmus. That painting seems not to have survived, though a version in the Louvre is probably an autograph replica made for Warham himself. The fine version at Lambeth Palace is a later sixteenth-century copy. Though it has suffered somewhat from abrasion, the drawing retains both subtlety of modelling and great strength of characterisation. Like other portrait drawings from Holbein's earlier English visit, it is executed on unprimed paper; the studies from the later sojourn were mostly made on paper prepared with a pinkish ground (see no. 349).

Black and coloured chalks, partly washed over. 40.7 × 30.9 cm
Inscribed [...]: Waramus ArchBp Cant:
RL 12272
PROVENANCE Probably Henry VIII; Edward VI; Henry FitzAlan, Earl of Arundel, 1553; John, Lord Lumley, 1580; perhaps Henry, Prince of Wales, 1609; Charles I; by whom given to Philip, fourth Earl of Pembroke; by whom given to Thomas Howard, Earl of Arundel, c.1627/8; Charles II by 1675
LITERATURE Parker 1945, no. 12; Foister 1983, no. 12
EXHIBITIONS Dresden 1870, no. 337; London 1877–8, no. 947; London 1890, no. 494; Basel 1897–8, no. 80; Edinburgh 1947, no. 97; London 1950–1, no. 110; Brussels 1954–5, no. 91; QG 1962–3, no. 61; Rotterdam 1969, no. 101; Brussels 1973, no. 25; Tokyo 1975, no. 5; QG 1978–9, no. 14; Malibu/New York 1982–3, no. 14/11; Houston/Hamburg/Basel/Toronto 1987–9, no. 11; Edinburgh/ Cambridge/London 1993–4, no. 8; Sydney 1999–2000, no. 138

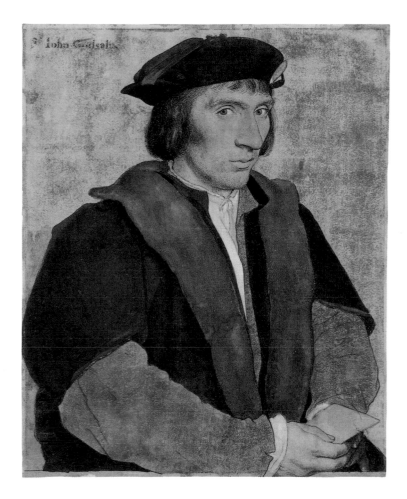

Black and red chalks, pen and ink, brush and ink, bodycolour, white heightening, on salmon-pink prepared paper. 36.2 × 29.2 cm
Inscribed Sr Iohn Godsalue, twice
RL 12265
PROVENANCE As no. 348
LITERATURE Parker 1945, no. 22; Foister 1983, no. 22
EXHIBITIONS Dresden 1870, no. 339; London 1877–8, no. 949; London 1890, no. 522; Basel 1897–8, no. 86; London 1950–1, no. 70; Brussels 1973, no. 22; Tokyo 1975, no. 6; QG 1978–9, no. 40; Malibu/New York 1982–3, no. 40/18; Houston/Hamburg/Basel/Toronto 1987–9, no. 38; Norwich 1992, no. 4; Edinburgh/Cambridge/London 1993–4, no. 14

350
PAOLO FARINATI (1524–1606)
Minerva and Prometheus, c.1560–80(?)

The large, bold and colourful drawings of the Veronese artist Paolo Farinati were among those most sought after by seventeenth-century English collectors. The Royal Collection now holds about fifty studies by Farinati and his immediate followers; all seven of those of which both sides are visible, including no. 350, bear the price inscription of the dealer William Gibson (1644/5–1702), and it is probable that these seven and most of the other Farinati drawings entered the collection during the reign of Charles II (r. 1660–85).

The subject here is given in the artist's own inscription ('Second piece: how Minerva led Prometheus to heaven, and the said Prometheus stole fire from the sun and carried it ...'). The figures were clearly intended to be seen from below as if through an oculus and the composition was thus almost certainly designed for a ceiling, though no such painting is known. The inscription also makes clear that the design was one of a series, but other drawings for ceiling paintings by Farinati (at Christ

349
HANS HOLBEIN THE YOUNGER (1497/8–1543)
Sir John Godsalve, c.1532–4

John Godsalve (c.1510–56) was first portrayed by Holbein in 1528 alongside Sir Thomas Godsalve, his well-connected father (Dresden, Gemäldegalerie). From the apparent age of the sitter, no. 349 can be dated to the early years of the artist's second English sojourn. Godsalve's acquaintance with Holbein would easily have been renewed at this time, for he had been appointed to the Office of the Common Meter of Precious Tissues in 1532, bringing him into frequent contact with the Hanseatic merchants who were Holbein's main patrons following his return to England in the same year. It was perhaps this appointment that prompted Godsalve to commission a portrait of himself alone.

The status of the present drawing is, however, problematic. It is the only one of Holbein's drawings at Windsor to be fully worked up in colours, and the subtle *trompe-l'oeil* of the right arm resting on a ledge further suggests that it was drawn as a finished work of art. It is conceivable that the drawing was intended to be pasted to a panel, thus serving the same function as a painting (some Holbein portraits of this type do survive), but the presence of the drawing at Windsor implies that it was still in Holbein's studio at his death and had not been delivered to the sitter. In the Philadelphia Museum of Art is another half-length painting of Godsalve, at about the same age, wearing similar clothes and the same cap and also holding a folded letter, but the painting does not depend compositionally on the present drawing in any detail; nor is it by Holbein, and its relationship to the present drawing remains problematic.

351

Church, Oxford, and in the Fitzwilliam and Ashmolean Museums) are octagonal and do not relate to the subject matter here.

The suggested date can thus be only approximate, for Farinati's mature style changed little, and even when a sheet can be related to a datable painting there is no certainty that the drawing was executed directly for that painting. Farinati wrote in his surviving account book (covering the period from 1573 until his death) of an album of drawings that served the function of a pattern book for future projects, and it is also known that he made drawings for sale or gift, some of which would have been based on the compositions of paintings already executed.

Pen and ink, wash, white heightening, over black chalk, on blue paper.
39.7 × 36.4 cm, top corners cut
Inscribed by the artist, lower left, partly cut, .2. / Pezo [primo cancelled] secondo come minerva co[n]duse prometo al cielo / et deto prometeo tolse il focho dal sole e lo porto / [...]. Verso inscribed by William Gibson P Farinato [?].3.
RL 5011
PROVENANCE William Gibson; probably Charles II; Royal Collection by c.1727
LITERATURE Popham & Wilde 1949, no. 316

351
DIRCK BARENDSZ. (1534–1592)
The Fall of the Rebel Angels, c.1562–6

After training as a painter under his father in Amsterdam, Dirck Barendsz. travelled to Rome and Venice, apparently working in Titian's studio for a few years. The present drawing is probably a study for an altarpiece executed shortly after his return to Amsterdam around 1562 and destroyed in the iconoclastic riots in the city in 1566. The painting was described by the early biographer Karel van Mander as commissioned by an Amsterdam shooting company, most likely the Kloveniers or arquebusiers for their guild altar in the Oude Kerk.

The casting from heaven of Satan and the rebel angels by St Michael is described in the Book of Revelation (12: 7–9), though the form of God the Father here, seated astride a globe and brandishing a thunderbolt, owes something to the classical analogue of the subject, the destruction of the rebellious giants by Jupiter. In a rather equivocal reference to the patrons of the painting, a figure to the lower right of centre aims a gun at St Michael and his allies. The tumultuous composition was probably inspired by Frans Floris's altarpiece of the same subject, painted for the swordsmen's guild in Antwerp a decade earlier and quite possibly seen by Barendsz. on his return journey from Italy. The lines of the narrow arch resting on an ogee were probably added later and obscure the wonderful perspectival surge of the figures down and outwards, headlong towards the viewer.

The uniformly high finish of the drawing suggests that it was made either for the patrons' approval before work on the altarpiece began, or (more probably, given the formal latinised signature) as a subsequent record of the composition. In the course of his career Barendsz. provided a number of designs to be engraved; the outlines of the figures here are sharply incised for transfer, though no print of the composition is known.

Pen and ink, wash, white heightening, the outlines incised. 53.2 × 33.2 cm, arched
Signed by the artist, lower centre THEODORUS. / BER. [AMSTELODA and BERNARDUS superscribed and effaced] / MUF : F.
RL 7786
PROVENANCE George III, by c.1810
LITERATURE White & Crawley 1994, no. 3
EXHIBITIONS Amsterdam 1955, no. 166; Amsterdam 1986, no. 250; Montreal/Raleigh/Indianapolis/Oxford 1994–5, no. 11

352
ALESSANDRO ALLORI (1535–1607)
A design for an overdoor with three Virtues, c.1578

Allori, the pupil and adoptive son of Bronzino, was one of the leading figures of later Florentine Mannerism. In 1578 he was commissioned by Grand Duke Francesco I to complete the decoration of the Salone of the Villa Medici at Poggio a Caiano, outside Florence. This had been begun around 1520 by artists of an earlier generation, Pontormo, Andrea del Sarto and Franciabigio, but left unfinished at the death of Pope Leo X (Giovanni de' Medici) in 1521. By July 1578 Allori was at work on the allegorical figures of Fame, Glory and Honour, and it is probable that his design of the whole cycle of Virtues had been finalised by this time.

The figures studied here were painted over the entrance door to the

353
FEDERICO BAROCCI (c.1535–1612)
The head of the Madonna, c.1582

Federico Barocci was the most innovative painter of altarpieces working in Italy in the later sixteenth century. He married the strong local colour and elaborate compositions of high Mannerism with intense observation from the life to produce a body of work unequalled among his contemporaries in its richness and variety. His influence would have been still greater had more of his paintings been readily accessible, but he was based in the small city of Urbino and many of his altarpieces were commissioned for provincial sites and thus were little known to artists working in the major centres.

A chronic illness restricted Barocci's artistic activity to short periods morning and evening, but despite (or maybe because of) this he prepared his compositions meticulously. Many hundreds of his studies survive, mostly in vigorous pen and wash or carefully blended chalks. For his head studies he exploited coloured chalks, both natural and fabricated, more extensively than any artist before the eighteenth century; this medium allowed him to determine both lighting and colour in the preparatory sheet, and thus he could use his precious painting time as efficiently as possible.

Olsen first identified the drawing as a study for the Virgin in the Vatican *Annunciation*. There are differences in the hairline, and the features as painted are less delicately angular, but the attitude and expression are almost identical. The painting was executed between

Salone. They are Fortitude, with club and lion; Prudence, with her usual attributes of mirror, serpent and double face; and Vigilance, with sun and taper for watching both day and night, and in her cloak the apples of the Hesperides (the subject of Allori's lunette in the Salone, studied in another drawing at Windsor; see also no. 182). They bestride a dragon, the globe and a military trophy, symbolising the spiritual and temporal triumph of the Medici. The figural portion of the drawing is squared for transfer but corresponds only loosely with the fresco, in which some attributes change or disappear and the figures fill out and relax their Mannerist tautness.

The stamped star at lower centre is of a type traditionally associated with Nicholas Lanier (1588–1666), a musician, collector, and agent in the purchase of works of art for Charles I (see Lugt 1921, nos 2885–6). However, an inscription on the verso of the sheet, *Jerom*, may indicate that this six-pointed star is instead the mark of Nicholas's uncle, Jerome Lanier (d. 1657), himself an amateur of art who was involved in the care of Charles I's paintings (see p. 50). But there remains no firm evidence that Charles I collected drawings, and the present sheet is not certainly recorded in the Royal Collection until the reign of George III.

Pen and ink, wash, white heightening, over black chalk, partially squared in black chalk, on paper washed buff. 45.0 × 36.8 cm
Verso inscribed in two early hands *Alessandro Allori* and *Jerom*. A six-pointed star (not in Lugt 1921) stamped on the recto
RL 6018
PROVENANCE Jerome Lanier(?); probably Charles II; certainly George III by c.1810
LITERATURE Popham & Wilde 1949, no. 59; Lecchini Giovannoni 1991, pp. 249–50
EXHIBITIONS Florence 1980, no. 17

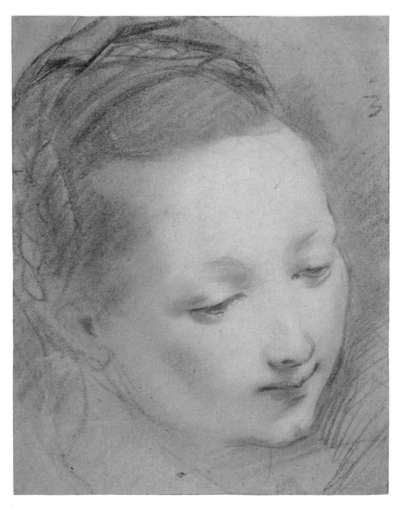

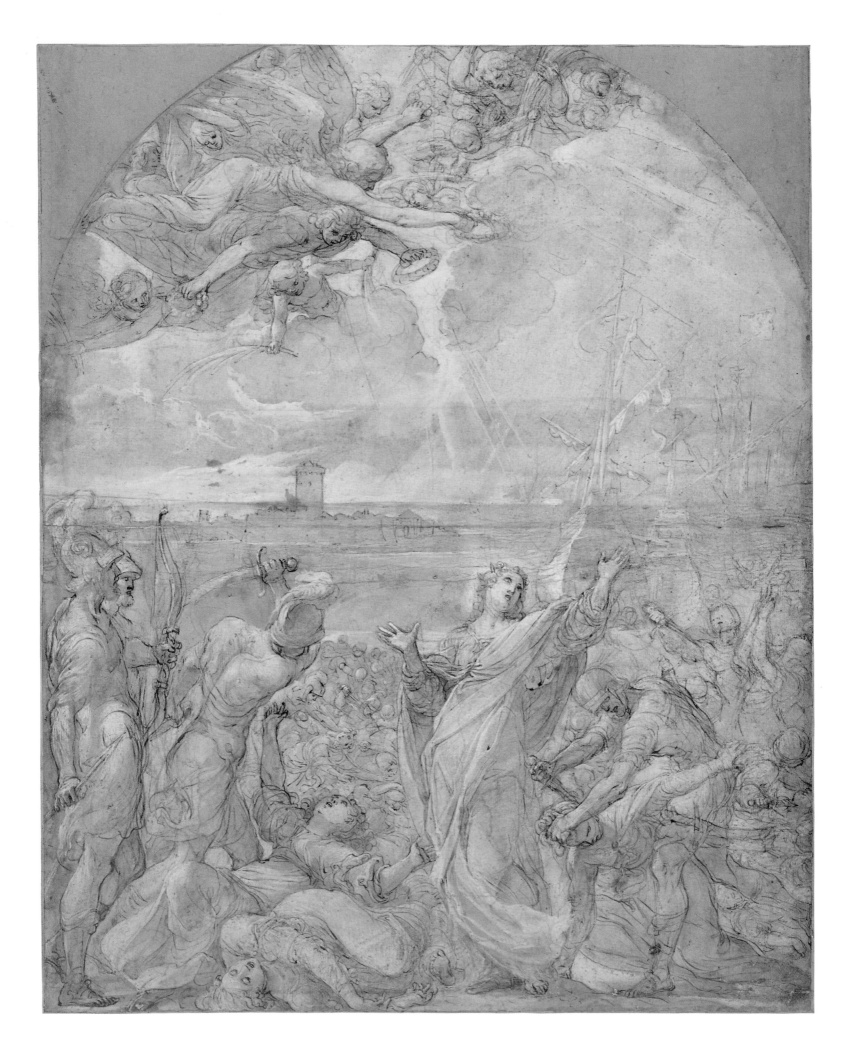

1582 and 1584 for the chapel of Francesco Maria II, Duke of Urbino, in the basilica at Loreto. It was soon reproduced in prints – an etching by Barocci himself and an engraving by Thomassin of 1588 – and thus became one of Barocci's best-known compositions.

Black, white and coloured chalks on blue paper. 29.9 × 23.0 cm, the corners made up
RL 5231
PROVENANCE George III, by c.1810
LITERATURE Popham & Wilde 1949, no. 96; Olsen 1962, p. 179; Emiliani 1985, pp. 198–209
EXHIBITIONS London 1950–1, no. 285; Manchester 1965, no. 253; QG 1972–3, no. 177; Bologna 1975, no. 149; QG 1986–7, no. 26; Washington/San Francisco/Chicago 1987–8, no. 24

354

LUDOVICO CARRACCI (1555–1619)
The Martyrdom of St Ursula, c.1615

Ludovico Carracci and his younger cousins, the brothers Agostino and Annibale (nos 7, 356), transformed the art world in Bologna, and ultimately throughout Italy, in the years after 1580. They established an academy that promoted study from the life as the foundation of artistic practice, consciously rejecting Mannerist artificiality and training many of the artists (including Domenichino, Guido Reni, Giovanni Lanfranco and Francesco Albani) who were to form the first wave of the full Baroque.

Ludovico painted the Martyrdom of St Ursula three times, for the churches of Santi Leonardo e Orsola, Bologna, in 1592 (now in the Pinacoteca); San Domenico, Imola, around 1600; and Sant'Orsola, Mantua, in 1615. Mahon first proposed that the present drawing was preparatory for the latest of these, which was commissioned by Margherita Gonzaga and disappeared after the suppression of the convent in 1782. Though no record has survived of the painting's appearance, this seems from the style of the drawing to be correct. The figures in Ludovico's works of the 1610s became increasingly stylised, even caricatural, and the bold perspectives with which he had experimented during the 1590s and 1600s gave way to a shallow space with the protagonists lined up in front of a backdrop, as here. None the less, on its own terms this is a powerful composition and displays the combination of elegance and drama that was to be so important to Ludovico's Bolognese followers.

Black chalk, pen and ink, grey and brown wash, white heightening, on buff paper. 48.9 × 38.6 cm, arched
RL 2326
PROVENANCE Silvestro Bonfiglioli (d. 1696); sold by his heirs to Zaccaria Sagredo, 1728; from whom bought by Joseph Smith, 1752; from whom bought by George III, 1762
LITERATURE Wittkower 1952, no. 1; Mahon 1957, p. 199 n. 15
EXHIBITIONS Oxford/London 1996–7, no. 19

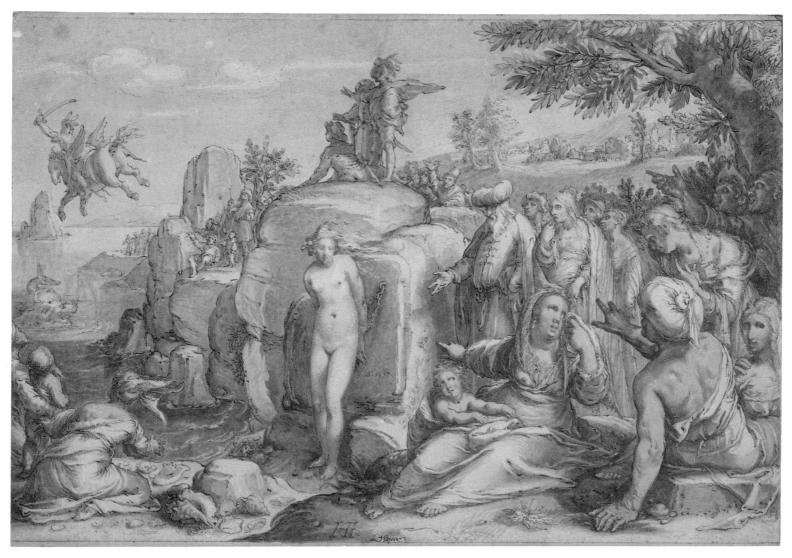

355

355

HENDRICK GOLTZIUS (1558–1617)
Perseus and Andromeda, 1597

Goltzius was one of the finest and most productive printmakers of the northern Renaissance. He made twenty-five chiaroscuro woodcuts, engraved or etched over 350 plates, and also provided many designs to be engraved by others. The present sheet was drawn as the model for an engraving by Goltzius's step-son, Jacob Matham (see no. 358), dated the same year as the drawing, and the outlines of the composition were sharply incised during the transfer of the design to the copper plate. Goltzius's use of red chalk for the flesh tones was not strictly necessary as the engraving was printed in black only, but it gives the drawing a beautifully rich effect.

As with many compositions of the Northern Mannerists, the dramatic focus of the narrative – in this case Perseus's battle with the (here rather unassuming) sea monster – is relegated to the background, while the majority of the pictorial surface is occupied by gesturing figures. The inclusion of a crowd of onlookers is, however, faithful to the version of the myth in Ovid's *Metamorphoses*, with Andromeda's parents, Cepheus and Cassiopeia, lamenting the Princess at centre right.

Pen and ink, wash, red chalk, white heightening, on buff paper, the outlines incised.
26.1 × 37.6 cm
Signed lower centre with the artist's monogram HG, and dated on Andromeda's rock
A⁰. 1597
RL 6438
PROVENANCE George III, by c.1810
LITERATURE White & Crawley 1994, no. 366
EXHIBITIONS Rotterdam/Haarlem 1958, no. 8; Montreal/Raleigh/Indianapolis/ Oxford 1994–5, no. 16

356

ANNIBALE CARRACCI (1560–1609)
Polyphemus, c.1597–8

Annibale Carracci began the decoration of the vault of the gallery of the Palazzo Farnese (now the French Embassy), Rome, in 1597, two years after his arrival in Rome from Bologna. It was to be the seminal work of the Baroque in the city, and Annibale's orchestration of differing levels of representation and illusion, explicitly based on Michelangelo's ceiling in the Sistine Chapel ninety years earlier, set the standard for the ceiling designs of the next century. In pure fresco Annibale created a fiction of mythological canvases in gilt frames, bronze medallions, stone herms, nude youths, garlands of fruit and leering masks, and putti wrestling before an open sky. Yet the Farnese Gallery was not merely a work of frivolous virtuosity, for the mythological scenes were rigorously planned and stood alongside Raphael's compositions as exemplars for the classicists of the seventeenth century.

Annibale's many able assistants absorbed his methods and propagated them assiduously in their subsequent careers, and it can be claimed that his studies for the Palazzo Farnese revived the art of life drawing in Rome. No previous artist had made such consistently large studies from the model, and this practice encouraged in Annibale an expansiveness and generosity of form that was the key to his achievement in the

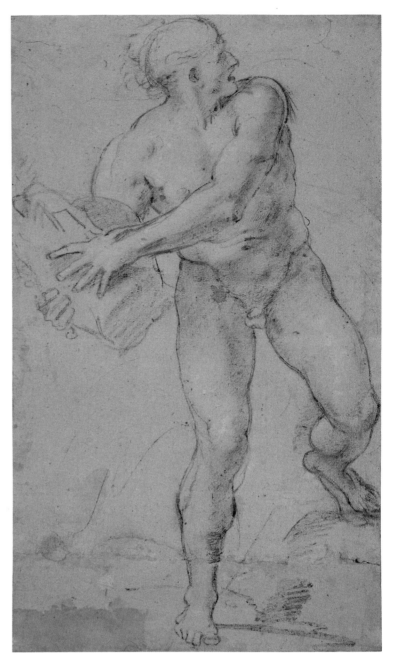

356

representation of the human figure. Here he set a heavily muscled model, holding a bundle of cloth or some other prop, in the pose required for the cyclops in *Polyphemus hurling the rock at Acis and Galatea*, the fictive painting 'hanging' in the curve of the vault at one end of the Gallery. Annibale laid down the chalk lines rapidly in long fine sweeps, reducing the form to its essentials, and distended the right shoulder to emphasise the weight of the rock. But the massive bulk is held in perfect balance, the body pivoting around the axis of head and supporting leg, at the extreme of its motion before the release of its gathered force.

Black and white chalks on blue paper. 60.9 × 35.5 cm
RL 1944
PROVENANCE George III, by c.1810
LITERATURE Wittkower 1952, no. 303; Martin (J.) 1965, no. 90
EXHIBITIONS Newcastle 1961, no. 142; Oxford/London 1996–7, no. 85

357

ISAAC OLIVER (c.1565–1617)
Nymphs and Satyrs, c.1605–10

Although Isaac Oliver is chiefly known for his portrait miniatures (see nos 47–51), several carefully finished drawings signed by the artist survive; there is no evidence that he ever painted in oils. A number of these drawings are included in early inventories of the Royal Collection. The present sheet was probably in the collection of Charles I and may well have been executed for one of his parents, James I and Anne of Denmark.

The majority of Oliver's drawings are of religious subjects, and the eroticism of the present sheet is highly unusual, not only in the artist's oeuvre but in contemporary English art in general. Possible sources in a number of Italian prints may be noted, especially Agostino Carracci's *Love reciprocated* of c.1590 which also shows couples by the banks of a woodland pool with a round dance in the distance. The subject of nymphs and satyrs by a woodland pool seems to have been chosen primarily to allow the portrayal of a classical theme and the nude form; the pursuit at far right and abduction at centre left are counterpoints to the general langour and do not point to any specific subject. The figure style and strong chiaroscuro are deeply indebted to the work of the Haarlem Mannerists such as Joachim Wtewael and Hendrick Goltzius (no. 355), and Oliver may have made a journey to the Netherlands around this time rather than simply knowing the works of these artists through their prints.

Black chalk, pen and ink, white heightening, on brown paper. 20.6 × 35.5 cm
Signed at lower right *Olliuier*
RL 13528
PROVENANCE Probably Charles I ('a large lymning Venus a Cupid & Satyrs' or 'Satyrs and venus sporting': *Vertue Notebooks*, IV, pp. 91, 93); probably James II ('a large limning; Venus, Cupid and Satyrs': Bathoe 1758, p. 45, no. 521)
LITERATURE Oppé 1950, no. 460; Finsten 1981, no. 182
EXHIBITIONS London 1934, no. 523; Amsterdam 1955, no. 228; Manchester 1964, no. 50; Tokyo 1975, no. 8; London 1983a, no. 180; QG 1986–7, no. 68; London/New Haven 1987, no. 4; London 1995, no. 113

358

JACOB MATHAM (1571–1631)
A masked ball, 1605

In a Renaissance room of inconsistent perspective, an elegant company performs a slow and stately dance, accompanied by a small group of musicians on a raised platform in the left background. (Their ghostly appearance is due to a correction of their initial positions with white gouache.) The two masked figures lounging on the floor are no more than a Mannerist device to occupy the foreground.

Jacob Matham was trained in Haarlem by his step-father Hendrick Goltzius (see no. 355), many of whose designs he subsequently engraved. The sheet was signed by Matham, but the addition of the date 1605 and *vinetia* (Venice) presents some problems. The decoration of the room does seem intended to be Venetian, and the drawing is on paper bearing an Italian watermark (a fat crescent, close to Heawood 1950,

357

358

no. 847: Rome 1597). Matham visited Venice in 1595; in 1605 he was at the height of his career in Haarlem, elected president of the guild of St Luke in that year, and an undocumented trip to Italy is improbable. The style of the drawing is, however, compatible with a date of 1605, and the handwriting does seem to be Matham's. It therefore appears that the drawing may have been made in Haarlem, coincidentally on Italian paper, as some sort of memento of Matham's Italian trip of a decade earlier.

The function of the drawing is uncertain, for its size is unparalleled in Matham's oeuvre. Such ball scenes were a popular subject in the Netherlands around 1600, and it may have been a model for an unexecuted print (compare Goltzius's 1584 *Venetian Wedding* after Barendsz., an engraving very similar in size and spirit) or – perhaps more likely given the degree of tonal and colouristic elaboration – for a domestic painting. (Thanks are due to Dr Léna Widerkehr for her comments on this drawing.)

Pen and ink, wash, red chalk and white heightening, over black chalk, on paper washed buff. 45.0 × 67.2 cm
Inscribed in Matham's hand, lower centre *Matham fe 1605. vinetia*
RL 12838
PROVENANCE George III, by c.1810
LITERATURE White & Crawley 1994, no. 391; Widerkehr 1997, no. D26
EXHIBITIONS Montreal/Raleigh/Indianapolis/Oxford 1994–5, no. 20

359
SIR PETER PAUL RUBENS (1577–1640)
Psyche, c.1612–15

This is a life study for Rubens's painting of *Cupid and Psyche* of around 1612–15 (private collection). The story is told in Apuleius's *Golden Ass*, of the second century AD: Psyche was a mortal so beautiful that Venus herself was envious, and the goddess sent Cupid to make her fall in love with someone worthless. But Cupid was himself captivated and so had Psyche brought to his palace, visiting her only after dark and forbidding her to cast eyes on him. Rubens depicted the moment that Psyche catches her first glimpse of Cupid; she is seated on the edge of the bed in which he sleeps, holding a lamp from which oil would drip and waken him.

Rubens used a male model for the study, softening his musculature in the painting into the artist's more familiar fleshy forms. The drawing owes much to Rubens's experiences in Italy (and Rome in particular), where he had spent most of the period 1600–08. The scale and media of the drawing are indebted to Annibale Carracci's studies for the Farnese Gallery (see no. 356), and the pose possibly had a source in one of the most frequently copied figures in Michelangelo's *Last Judgment* in the Sistine Chapel, at the centre of the right-hand group of the Saved.

Black and white chalks on buff paper. 57.8 × 40.2 cm
Inscribed lower centre *Del Rubens*

359

RL 6412
PROVENANCE George III, by c.1810
LITERATURE White & Crawley 1994, no. 434
EXHIBITIONS Antwerp 1956, no. 45; Brussels 1973, no. 6; London 1977a, no. 57; Montreal/Raleigh/Indianapolis/Oxford 1994–5, no. 22

360
SIR PETER PAUL RUBENS (1577–1640)
Silenus and Aegle, with other studies, c.1612–15

Most of the sketches here depict a scene from the sixth of Virgil's *Eclogues*. Silenus, found in a drunken sleep, was bound with his own wreaths while the naiad Aegle painted his face with mulberries, and was released only when he sang a long-promised song of the creation of the world. In the most finished of the studies, at lower left, the action of Aegle and the putto binding Silenus's right arm are clear. No painting of the subject by Rubens is known, though the figures find echoes in several of his works around 1612–14. The other sketches mostly develop the poses of the main study, though the group at upper right may be a first idea for the artist's *Four Continents* (Kunsthistorisches Museum, Vienna) of c.1615.

When the sheet was lifted from its old mount prior to exhibition in 1977, a number of unrelated studies were found on the verso – an *Ecce Homo*, an execution, three sketches of the Dead Christ, two figures on horseback and other single figures. These studies can mostly be related to paintings by Rubens of the period 1614–18, and suggest that the sheet was, unusually, added to over a number of years and may have been used in Rubens's studio for unpremeditated sketching and as a source of inspiration for subsequent motifs.

360

Pen and ink (two shades), wash. 28.1 × 50.8 cm

Inscribed by the artist, upper centre *Vitula gaud[ium]*, and by another hand, lower centre, inverted, *N:jjj tekeningen*

RL 6417

PROVENANCE George III, by c.1810

LITERATURE White & Crawley 1994, no. 435

EXHIBITIONS Antwerp 1956, no. 41; London 1977a, no. 58; Montreal/Raleigh/Indianapolis/Oxford 1994–5, no. 23

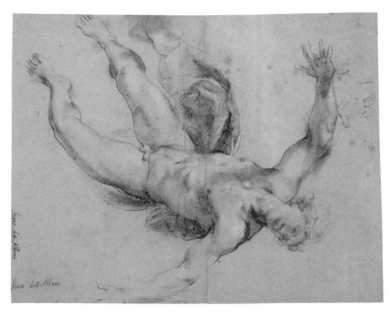

361

361
FRANCESCO ALBANI (1578–1660)
Phaeton, c.1609

Francesco Albani had been the principal assistant of Annibale Carracci (no. 356) for several years until the master's deep depression led to the total cessation of his artistic activity. Despite the early inscriptions identifying the subject as Icarus, this is a final study for the ceiling fresco of the *Gods of Olympus and the Fall of Phaeton* in the Palazzo Giustiniani (now Odescalchi) at Bassano di Sutri, outside Rome, one of Albani's first major independent commissions. The Marchese Vincenzo Giustiniani had inherited the palace in 1600 and immediately set about restoring and enlarging it. After completion of the new north wing in 1607 Albani received the contract to decorate the Galleria with mythological subjects. With a team of assistants he worked quickly, finishing the cycle in three months during the summer of 1609

and returning the following year to retouch the frescoes.

The figure of Phaeton, falling through space towards the spectator in the Galleria below, is painted in a pose very close to that of the present drawing, which must have been made from a model lying on his back. An earlier compositional sketch in red chalk for the *Fall of Phaeton* (RL 5715b) was formerly pasted on to the reverse of the present sheet,

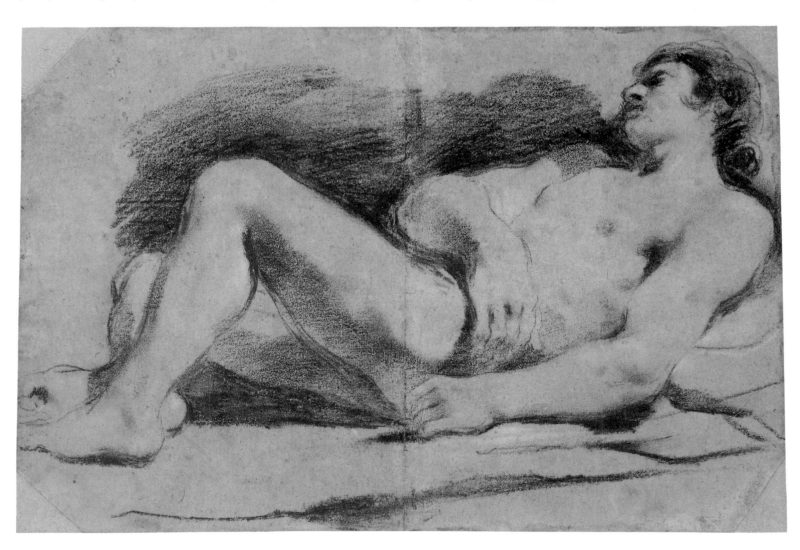

and shows Phaeton amongst a tangle of tumbling horses and a disintegrating chariot. Perhaps the elaboration of the horses' poses was too challenging, or the mêlée would have presented too great a contrast to the regular array of gods at the opposite end of the ceiling, for in the fresco the chariot is intact and the horses, though seen from below and free of their harnesses, seem simply to be rearing. Albani was aiming for a classicising clarity but the effect is rather of a lack of imagination and vitality, and the fresco shows a disappointing lack of engagement with Annibale's Farnese ceiling of ten years before.

Black chalk with touches of white chalk on blue paper. 40.3 × 51.0 cm
Inscribed *Icaro dell'Albano*, twice
RL 5715a
PROVENANCE George III, by c.1810
LITERATURE Kurz 1955, no. 2; Puglisi 1999, pp. 121–2
EXHIBITIONS Bologna 1962, no. 178a

362

GIOVANNI FRANCESCO BARBIERI, called GUERCINO (1591–1666)
A recumbent male nude, c.1618

Guercino was raised in the small town of Cento, fifteen miles north of Bologna, and began his apprenticeship at the late age of 16. The dominant influences of his first years were the works and methods of the Carracci in Bologna (nos 354, 356), and especially Ludovico's *Holy Family with St Francis and Donors*, installed in 1591 in the church of the Cappuccini in Cento (now Museo Civico); its composition and rich colouring inform all of Guercino's early paintings.

Throughout his career Guercino was a prolific draughtsman, and in 1616 he opened an academy of life drawing in Cento, emulating the Carracci academy in Bologna. The youth drawn here modelled often for Guercino around 1618 and appears in several paintings and life drawings, most notably in *Erminia discovering the wounded Tancred* of 1618–19 (Rome, Galleria Doria Pamphili) and in *St Sebastian succoured* of 1619 (Bologna, Pinacoteca). In those two paintings the reclining poses are very similar to that in the present drawing without corresponding exactly, and must depend on drawings of just this type. The technique of oiled charcoal on toned paper was a favourite of the Carracci's contemporary and rival, Pietro Faccini, whose drawings Guercino is reported to have admired. The breadth and stickiness of this medium led unavoidably to largeness of form and smoky shadows, perfectly attuned to Guercino's early figural style.

Guercino was careful to preserve his drawings and they survive in great numbers. The largest group is at Windsor, purchased from the artist's heirs a century after his death and comprising around four hundred sheets by the master himself, two hundred by his assistants and another two hundred offsets of his chalk drawings.

Oiled charcoal, some white chalk, on buff paper. 38.5 × 58.0 cm, the corners made up
RL 01227
PROVENANCE Bequeathed to Benedetto and Cesare Gennari, the artist's nephews, and by descent; from whom bought by Richard Dalton on behalf of George III, c.1760
LITERATURE Mahon & Turner 1989, no. 150
EXHIBITIONS Bologna 1968, no. 247; London 1991c, no. 16; Fort Worth/Washington/New York 1991–2, no. 6

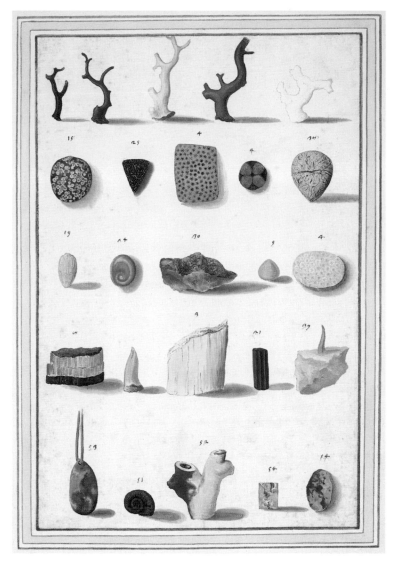

363 (within eighteenth-century line and wash border)

363

VINCENZO LEONARDI (fl.1621–c.1646)
Corals, fossils and mineral specimens, c.1630–40

Cassiano dal Pozzo (1588–1657) was one of the great collectors of seventeenth-century Rome, not so much for the magnificence of his collection (though he was Poussin's most important patron) but for its range, most remarkably his 'paper museum' of many thousands of drawings and prints, both commissioned directly and collected from other sources. He organised the sheets by subject matter to form a visual encyclopedia, especially of the ancient and natural worlds. The largest surviving portion of the paper museum is today housed in the Royal Library.

Drawings of antiquities had been made and collected in Italy throughout the Renaissance, but the early seventeenth century saw a rapid growth in the methodical study and illustration of the natural sciences. In 1622 Cassiano was admitted to the Accademia dei Lincei, the first true scientific society in modern Europe, whose members included Federico Cesi and Galileo. One of the great concerns of the Lincei, and indeed of the natural sciences thenceforward, was the classification of matter. The ancient division into animal, vegetable and

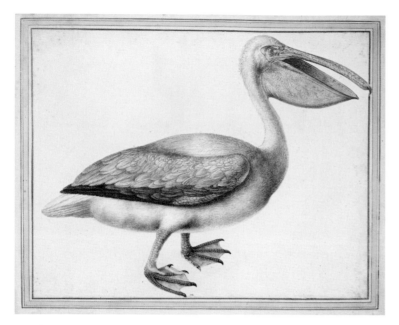

364 (within eighteenth-century line and wash border)

mineral was found generally to be adequate but there were cases that seemed to cross the boundaries, and particular attention was devoted to these.

This is one of many mineralogical sheets in the collection, executed by Cassiano's long-term collaborator Vincenzo Leonardi. Alongside the polished mineral samples are objects which seemed to combine the properties of the three kingdoms: several pieces of coral, an echinoid spine (third row, left), asbestos, a shark's tooth, ivory (fourth row, first three specimens), and a fossil ammonite. Other sheets depict gemstones, petrified wood, amber containing frogs, seeds, nuts and dried roots. There seems little order to the arrangement of the objects on the page, and though the later numbering given to most of the illustrations has not been fully elucidated, it must represent an attempt to classify the specimens at some later date, once a sufficiently large number of examples had been assembled.

Watercolour, bodycolour and gold paint over black chalk. 39.4 × 25.4 cm
The specimens numbered in a seventeenth-century hand
RL 25497
PROVENANCE Cassiano dal Pozzo; by whom bequeathed to his brother, Carlo Antonio dal Pozzo, 1657, and by descent; bought by Pope Clement XI, 1703; by whom bequeathed to his nephew, Cardinal Alessandro Albani, 1721; from whom bought by George III, 1762
LITERATURE CDP B.IX (*Minerals and Curiosities*), forthcoming
EXHIBITIONS London 1993a, no. 133; Edinburgh 1997, no. 71

364
VINCENZO LEONARDI (fl.1621–c.1646)
European or Great White Pelican (Pelecanus onocrotalus), 1635

Ornithology was probably the subject that engaged Cassiano dal Pozzo most deeply. He kept live exotic birds in his house, and on his induction into the Accademia dei Lincei in 1622 he presented to the society an ornithological treatise, the *Uccelliera* of Giovanni Pietro Olina. It is probable that Cassiano was himself responsible for part of the text. The published work was illustrated with etchings after drawings in Cassiano's

collection by Vincenzo Leonardi, who continued to provide Cassiano with natural history drawings for the next two decades.

A number of Leonardi's bird drawings were made as illustrations to small treatises or *discorsi* that Cassiano wrote on individual species. Three of these survive in manuscript – on the bearded vulture, the ruby-throated hummingbird and the pelican. The last of these (now in the Bibliothèque de l'École de Médecine in Montpellier) is the only *discorso* for which we also have some of the accompanying drawings.

The white pelican illustrated here had been shot in the marshes near Ostia in June 1635 and brought to Cassiano; two months earlier he had been presented with a Dalmatian pelican, wounded but alive, that was the subject of another drawing by Leonardi (RL 31865). The white pelican was dissected by Cassiano's friend Giovanni Trullio, professor of medicine at the University of Rome, and Cassiano wrote systematically and in great detail about the pelican's anatomy and colouring with reference to Leonardi's drawings, which included life-size details of its head (RL 19437), feet, wings, feathers and tongue.

Watercolour and bodycolour over black chalk, with gum arabic. 36.4 × 45.2 cm
RL 28746
PROVENANCE As no. 363 to the 1920s; then art market, London; Herbert Boone; by whom bequeathed to Johns Hopkins University, 1985; sale, Sotheby's, New York, 17 September 1988 (182, part); Otto Naumann; from whom bought by Hazlitt, Gooden & Fox on behalf of HM The Queen, 1988
LITERATURE McBurney 1989, pp. 44–7; Solinas 1989, pp. 128–9; McBurney 1992, pp. 12–19; CDP B.IV (*Birds*, by H. McBurney and C. Violani), forthcoming
EXHIBITIONS London 1993a, no. 99; Edinburgh 1997, no. 46

365
NICOLAS POUSSIN (1594–1665)
Bacchus discovering Ariadne, c.1634–6

Though Nicolas Poussin was French by birth, he settled in Rome in 1624 and remained there for the rest of his life, with the exception of a short and disaffected return to Paris in 1640–1. His paintings were mostly executed for private collectors and are replete with scholarly references; they represent the purest form of the classical style in Rome and, avidly sought after by his countrymen, were instrumental in the development of classicism in France. But Poussin was not a natural draughtsman, and his compositions were developed in small-scale studies that mainly impress by their rigour rather than seduce with their

effects. The collection of drawings by Poussin at Windsor is second only to that in the Louvre.

The subject of the drawing is *Bacchus discovering Ariadne*. Having helped Theseus escape the Minotaur's labyrinth, Ariadne (seated to the right of centre) was abandoned by her lover on the isle of Naxos. She was found by Bacchus (standing at left) and his train; the god is here shown proffering a bowl of wine while a female figure seated beside Ariadne intercedes on his behalf. A pair of Bacchus's followers play pipes and cymbals, while Cupid looks on, leaning on his bow. Ariadne was received into Bacchus's chariot, and they married shortly after. No corresponding painting is known.

Poussin's drawings of the mid-1630s were the freest and, to modern eyes, the most attractive of his career. Here he used no underdrawing before attacking the paper with pen and ink, untroubled by anatomical considerations – the arm of the urn-bearer at far left is little more than a scribble. Broad strokes of pale wash impart an overall rhythm, and a sequence of dabs of a darker wash defines the stances and gestures of the figures. For a copy of the drawing by John Piper, see no. 394.

Pen and ink, wash, on pink-tinged paper. 15.4 × 24.7 cm
RL 11911
PROVENANCE As no. 363
LITERATURE Friedlaender & Blunt 1939–74, III, no. 182; Blunt 1945, no. 194; Rosenberg & Prat 1994, no. 150
EXHIBITIONS London 1928, no. 9; Oxford 1990–1, no. 52; London/Houston/Cleveland/New York 1995–6, no. 33

366
GIANLORENZO BERNINI (1598–1680)
A seated male nude (Polyphemus?), c.1630

Bernini was the outstanding figure of the Italian Baroque – a sculptor, architect, painter, draughtsman and playwright, whose boundless energy, imagination and religious conviction profoundly transformed the city of Rome during the course of his seventy-year career. Most of his known drawings are related to his grand projects, but a number of independent drawn portraits and figure studies also survive. This is one of four life drawings of the same model, all in red and white chalks on a full unfolded royal-size sheet of paper, trimmed somewhat by later collectors.

To the posed model Bernini imaginatively added branches and foliage, giving the figure some context; here it is even possible that he conceived of the figure as the cyclops Polyphemus, at the moment of spying his beloved but heedless Galatea in the arms of Acis. (For Polyphemus's reaction see no. 356.) The drawing cannot however be regarded as a preparatory study. Bernini preferred to explore the complex poses of his sculptures in clay or wax, and few of his surviving figure drawings – as distinct from small sketches or studies of detail – can be related to known projects. In the absence of external evidence it is impossible to date these life drawings with any certainty, but it has been suggested that they were produced during the period of his closest association with the art academy in Rome, the Accademia di San Luca, around 1630, and this may well be correct.

The inscription on the verso records the purchase of the drawing for six *scudi* in 1682 by Michele Maglia (or Michel Maille), a French sculptor active in Rome between about 1678 and 1700. The 'Cesare Madona' from whom he bought the sheet may conceivably have been the widow of Giovanni Cesari, a sometime assistant of Bernini.

Red and white chalks on buff paper. 55.6 × 42.0 cm
Inscribed in pencil in an eighteenth-century hand *Cav Bernini*; and on the verso, in pen, *Academia del Sig.r Cavaliere Bernini / Comprata da Cesare Madona Adi 7 Aprile 1682 Scudi Sei – 6: / da me Michele Maglia*
RL 5537
PROVENANCE Giovanni Cesari(?); Michele Maglia, 1682; George III, by c.1810
LITERATURE Blunt & Cooke 1960, no. 60
EXHIBITIONS Edinburgh 1998, no. 38

367
CLAUDE GELLÉE, called LE LORRAIN (1604/5–1682)
A landscape with a dance (The Marriage of Isaac and Rebecca?), 1663

The ideal landscape had been developed by Annibale Carracci and Domenichino alongside their primarily figurative works, but Claude – who was several decades younger – devoted his whole career to the genre. Born in the Duchy of Lorraine, now in eastern France, Claude moved to Rome as a youth and worked there for most of his life. In his paintings he created an arcadia of shepherds and flocks, rustic dances, and episodes from myth, legend or the Old Testament – played out

367

before ruined temples, peaceful towns and castles, perfect trees and brooks, all bathed in a nostalgic golden light (see no. 12). Claude's many drawings fall into four distinct categories: sketches around Rome and in the countryside; compositional and (many fewer) figure studies for his paintings; records of these paintings, in his famous and unique *Liber veritatis*; and independent, highly finished sheets, of which this is one of the most beautiful examples. It was worked up with great care in a variety of media to capture the fall of light on the soft mass of foliage, and signed and dated by the artist.

The drawing has been called the *Marriage of Isaac and Rebecca*, as depicted by Claude fifteen years earlier in a compositionally unrelated painting now in the National Gallery, London; the seated patriarchal figure in profile to the right could be Abraham, but there are no specific details and in the absence of any closely associated work the subject must remain uncertain. Such iconographic questions, however, seem of little import beside the magnificence of the drawing, one of Claude's finest expressions of the autonomy of the natural world and the transience of human activity.

Pen and ink, grey and brown washes, white heightening, over black chalk, on paper washed buff. 34.3 × 44.4 cm
Signed and dated lower left CLAV– / 1663 / [?*Roma* cut]; signed on the verso CLAVDIO I.V. *fecit*, and inscribed in a different hand *Claudio Lorenese Vero*
RL 13076
PROVENANCE George III, by c.1810
LITERATURE Blunt 1945, no. 41; Roethlisberger 1968, no. 902
EXHIBITIONS Paris 1925, no. 453; London 1938, no. 498; Edinburgh 1947, no. 87; London 1949–50, no. 470; London 1952b, no. 22; Bologna 1962, no. 215; Brussels 1973, no. 1; QG 1975–6, no. 60; Washington/Paris 1982–3, no. D56; QG 1986–7, no. 81

368

GIOVANNI BATTISTA SALVI, called SASSOFERRATO (1605–1685)
Judith with the head of Holofernes, c.1630–40

Sassoferrato was one of the most intriguing artists of the seventeenth century, painting not only copies of Raphael, Perugino and other Old Masters but also his own compositions in a deliberately archaising style completely at odds with the prevailing Baroque, and more elegantly restrained even than the works of Poussin and Sacchi. He was also a fine draughtsman whose tight control never tipped over into frigidity. The Royal Collection holds the largest surviving group of drawings by Sassoferrato, sixty studies that presumably came *en bloc* from the artist's studio and were bought in Rome at some time in the later eighteenth century by Richard Dalton, George III's Librarian, for twenty Roman crowns.

This is a final study for a canvas in San Pietro, Perugia, squared for enlargement and agreeing in all details except for the head of Holofernes, here only lightly indicated. The painting is not documented but presumably dates from the period of Sassoferrato's activity in Perugia, 1630–40.

Black chalk, touches of white chalk, on blue paper. 37.3 × 25.5 cm
RL 6078
PROVENANCE Bought in Rome by Richard Dalton for George III, 1760s(?) (RA GEO/15602)
LITERATURE Blunt & Cooke 1960, no. 903; Macé de Lepinay 1990, p. 97
EXHIBITIONS London 1938, no. 407; London 1950–1, no. 439; Rome 1961, no. 89; QG 1964, no. 138; QG 1974–5, no. 62

369

368

369
GIOVANNI BENEDETTO CASTIGLIONE (1609–1664)
Moses receiving the Tablets of the Law, c.1660

Giovanni Benedetto Castiglione was born and trained in Genoa, and may have adopted the technique of drawing in oil paint on paper in emulation of Anthony van Dyck, who was in the city intermittently between 1621 and 1627. The rich, flowing strokes of the brush allowed by this technique were ideally suited to Castiglione's verve as a draughtsman; he produced many such drawings throughout his itinerant career, mostly as independent works of art rather than as studies for paintings. The Royal Collection holds over two hundred of these striking sheets.

Castiglione was something of a stylistic magpie and was particularly responsive to Rembrandt, Rubens, Ribera and the Bassani. The recurrence of certain favourite subjects – the journeys of herdsmen or the Patriarchs, other Old Testament scenes and Nativities – makes the dating of his drawings problematic, for it is difficult to associate drawings and paintings with confidence. Here the large size of the figures relative to the picture field seems to place the drawing quite late in Castiglione's career, when he was based in Genoa but also active in Mantua, Parma and Venice. Castiglione brought the celestial vision close to Earth, with the figures of Moses and God the Father very similar in both scale and appearance. The hand of God is supported by one of the angels as he inscribes the Law with his finger on the Tablets (Exodus 31: 18); other angels blow their trumpets as the heavenly host swoops down from the left. In the remaining corner of the sheet, Castiglione quickly sketched in the distant Israelites, placing Moses on a rock and thus giving space and context to the episode.

Red-brown oil paint on paper. 40.8 × 56.3 cm
RL 4037
PROVENANCE Probably Zaccaria Sagredo; from whom bought by Joseph Smith, 1752; from whom bought by George III, 1762
LITERATURE Blunt 1954, no. 128
EXHIBITIONS Edinburgh 1947, no. 169; London 1950–1, no. 374; Rome 1961, no. 30; QG 1974–5, no. 71; QG 1986–7, no. 97; Washington/San Francisco/ Chicago 1987–8, no. 48

370
STEFANO DELLA BELLA (1610–1664)
A figure in fantastic dress, c.1650–60

Like Leonardo da Vinci (see no. 344), Stefano della Bella provided many designs for costumes, festivals, theatrical performances and triumphal entries throughout his career. The six spheres that make up the costume studied here (in the hand and on the head, chest and knees) must allude to the arms of the Medici, presumably dating the drawing to one of Stefano's periods of activity in Florence. He was resident there from childhood until 1633, when he left for Rome, returning occasionally to Florence, and after a decade in Paris from 1639 he returned to his home city in 1650, working under the sporadic patronage of Ferdinando II de' Medici and serving as drawing master to the future Cosimo III.

The style of the drawing suggests that it dates from the period after 1650. In June 1661, Prince Cosimo married Marguerite-Louise d'Orléans (first cousin of Louis XIV) in Florence; Stefano made etchings of the elaborate celebrations, and he probably also had a hand in organising some aspects of the festivities. It is possible that the costume was designed for that event, but masques and balls were a staple of court life and without further evidence this cannot be confirmed.

Black chalk, pen and ink, wash, touches of watercolour. 29.9 × 20.0 cm
RL 4692
PROVENANCE George III, by c.1810
LITERATURE Blunt 1954, no. 21
EXHIBITIONS London 1950–1, no. 435; New York 1959, no. 35; Washington/ San Francisco/Chicago 1987–8, no. 50

371
PIETRO TESTA (1612–1650)
Midas, c.1640–50

A native of Lucca in western Tuscany, Pietro Testa was one of the many artists who during the seventeenth century flocked to Rome, then the most bountiful centre of artistic patronage in Europe. Like Nicolas Poussin (no. 365) he entered the circle of the antiquarian Cassiano dal Pozzo (see nos 363–4); unlike Poussin, he was more a natural draughtsman (and etcher) than a painter, but it was to the status of a great public painter that he aspired, and a succession of frustrated projects and strained relationships led to his presumed suicide by drowning in the Tiber.

This page is a fine illustration of Testa's difficult dealings with his patrons, for it is part of an undated draft letter to Niccolò Simonelli, a collector whom he had known since at least 1636 (the remainder of the letter is on a separate sheet at Windsor). The tone of the letter is rather mercurial. Testa seems to accuse Simonelli of trying to buy off their relationship, whereas Testa had thought that through the few 'bagatelles' already executed for Simonelli he could build a 'wall of benevolence' and 'enjoy the sweetness of a most precious and, by me, always-desired friendship'. He goes on to explain that in the drawing he had converted an ancient fable to modern usage: Midas was the King of Phrygia who

◁ 370

was granted a wish that all he touched would turn to gold, but he soon began to starve when his food too was transformed. Testa takes this to symbolise the tyranny of those for whom that which should nourish (friendship) is turned not to virtue but to gold (or seen in terms of money). But the draft ends in jovial mood: 'Who knows if I, too, will not one day with my pencil go to Parnassus? You see what *coglionerie* I write to you.'

Pen and ink over traces of black chalk. 20.8 × 27.2 cm
Inscribed by the artist, lower left *quel'Mida che / tanto ne tiranegga*; at upper left [...] *che coglionerie vi scrivo*
RL 5932
PROVENANCE George III, by c.1810
LITERATURE Blunt & Cooke 1960, no. 983
EXHIBITIONS Philadelphia/Cambridge MA 1988–9, no. 99

372
HENRI DE GISSEY (c.1621–1673) or workshop
Louis XIV in the guise of Apollo, 1654(?)

The ballet was the principal passion of the young Louis XIV (1638–1715). He danced the leading roles in *divertissements* until the age of 30, and one of his first acts on assuming personal rule in 1661 was to establish a royal academy of dance, which evolved into the *Opéra*. The details of the costume shown here correspond closely with those in a

APOLLON. LE ROY.

drawing accompanying a libretto of *Les Noces de Pélée et de Thétis* (Paris, Institut de France), depicting the costume worn by the 15-year-old King in a ballet performed as a series of *entrées* to that opera at its première in 1654. Though Louis did not officially adopt the sun as his emblem until 1661, comparisons between monarchy and the sun were so commonplace at the time that dressing the King as Apollo, the sun god, would have been unremarkable. None the less the richness of this costume is stunning, with gold brocade, ostrich feathers, and silks studded with precious stones.

Henri de Gissey was *dessinateur ordinaire du Cabinet du Roi* at this time, and in charge of designing the costumes for the royal ballets. The style of the present drawing is consistent with that of a number of costume designs attributed to Gissey in the Victoria and Albert Museum, the Nationalmuseum, Stockholm, and elsewhere, but although he may have designed the costume he was not necessarily the creator of the drawing. As a finished drawing on vellum, it must be a record of the costume rather than a functional design. Watercolours and gouaches intended as finished works for a patron were often executed on vellum (cf. no. 374), giving a greater saturation of colouring and an overtly luxurious effect. It was also common workshop practice in every branch of the arts to make copy drawings which served as models and inspirations for future projects; a sheet agreeing with this design in its details but distinct in style was on the art market in 1989 with an early ascription to Jean Berain (1640–1711), Gissey's pupil and successor. Thus while it seems certain that this drawing is an accurate and contemporary record of a design by Gissey, it may well have been drawn by an associate rather than by the *dessinateur ordinaire* himself.

Graphite, watercolour, bodycolour and gold paint on vellum. 30.4 × 22.5 cm
Inscribed APOLLON. LE ROY.
RL 13071
PROVENANCE Royal Collection by early twentieth century
LITERATURE Blunt 1945, no. 72
EXHIBITIONS London 1952b, no. 82; London 1953c, no. 38; Hamburg/Cologne/Stuttgart 1958, no. 41; QG 1966, no. 57; QG 1986–7, no. 77

373
CARLO MARATTI (1625–1713)
St John the Evangelist expounding the doctrine of the Immaculate Conception, c.1684

The Cybo chapel in Santa Maria del Popolo, Rome, was built for Cardinal Alderano Cybo (1613–1700) by Carlo Fontana between 1682 and 1684 as a burial chapel for Alderano and his ancestor Cardinal Lorenzo Cybo, whose original tomb had stood on the site. The project was apparently assigned initially to the aged Gianlorenzo Bernini (no. 366), who had years earlier completed Raphael's Chigi chapel directly across the nave of the church. When Fontana assumed the commission on Bernini's death in 1680, he retained the sense of engagement with Raphael's model that Bernini had presumably planned. Maratti's altarpiece, completed by 1686, was painted in oils directly on to the wall of the chapel, an unusual technique adopted in emulation of Sebastiano del Piombo's *Birth of the Virgin* in the Chigi chapel.

The altarpiece depicts St John the Evangelist (then thought to be the author of the Book of Revelation) explaining the Immaculate

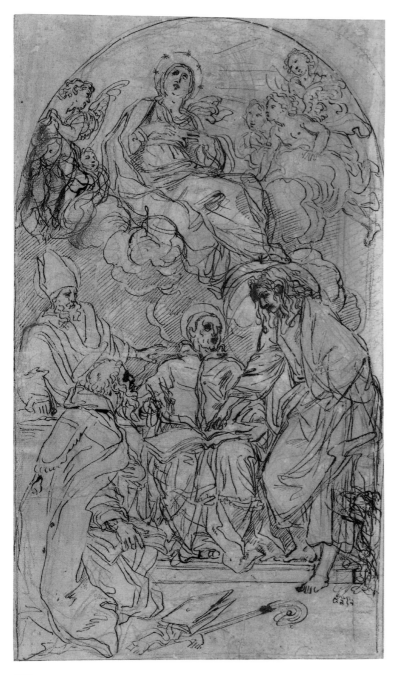

373

Pen and ink over red chalk, on paper washed pink. 50.3 × 29.1 cm
RL 4096
PROVENANCE Probably Pope Clement XI, 1713; by whom bequeathed to his
nephew, Cardinal Alessandro Albani, 1721; from whom bought by George III, 1762
LITERATURE Blunt & Cooke 1960, no. 286
EXHIBITIONS Rome 1961, no. 55; Providence 1968, no. II.2; Philadelphia 1975,
no. 31

bought in 1703 by Pope Clement XI, who probably also acquired draw-
ings from Maratti's studio after the artist's death ten years later. Clement
XI's drawings passed on his death to his nephew Cardinal Alessandro
Albani, who sold them in 1762 to James Adam acting on behalf of
George III. Maratti's collections thus form a large portion of the seven-
teenth-century Roman drawings now in the Royal Collection.

374
MARIA SIBYLLA MERIAN (1647–1717)
A branch of the banana tree (Musa paradisiaca) with a caterpillar and moth (Automeris liberia), c.1705

Maria Sibylla Merian was born in Frankfurt, the daughter of the
successful engraver and publisher Matthäus Merian. Soon after the death
of Matthäus in 1650, Maria's mother married the flower painter Jacob
Marell, who became Maria's teacher. By the 1690s Merian had settled in
Amsterdam and was established as a specialist flower painter. Inspired by
the specimens brought back to the Netherlands from the New World,

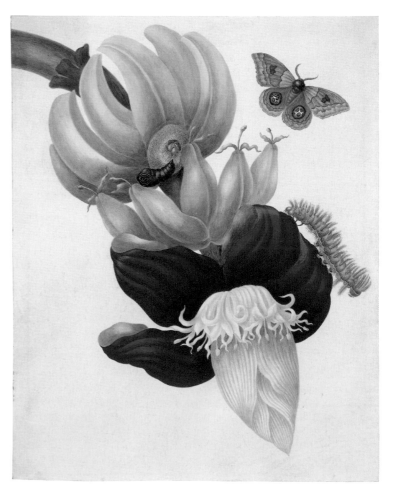

Conception to three Doctors of the Church, Saints Gregory, Augustine
and John Chrysostom. Such theological subjects were difficult to convey
pictorially as there was little opportunity for narrative, and the vocabu-
lary of gesture established by Raphael in the *Disputa* and *School of Athens*
was still found serviceable 170 years later by Maratti, Raphael's most
devoted seventeenth-century disciple. Several other compositional draw-
ings for the altarpiece survive, and show Maratti's primary concern with
the spatial clarity of the composition rather than with any unfolding
drama. He soon decided on the basic layout, with the three Doctors
standing, seated and kneeling and St John in their midst; in the final
design St John gestures upwards to the Virgin, uniting the two zones of
the composition both pictorially and conceptually.

Maratti was the leading exponent of Classicism in late Baroque Rome,
principal of the Accademia di San Luca from 1664 and the most influ-
ential artist in the city after Bernini's death. He was also a distinguished
collector; his hoard of thousands of drawings by other artists was

374

she sailed in 1699 with her daughter to the Dutch colony of Surinam, on the northern coast of South America. The Merians stayed in Surinam for two years, returning to Amsterdam with their notes and drawings, dried flowers and preserved animals.

Over the next five years Merian produced her greatest work, the *Metamorphosis Insectorum Surinamensium* (Amsterdam, 1705), comprising sixty plates etched by Merian, with accompanying texts. The specimens were arranged in a tableau of birth, procreation and death, often illustrating the mutual dependence of the animals (mostly insects) and the plants. The watercolours by Merian at Windsor are painted over first states of the sixty etchings, in outline only, printed on vellum and beautifully coloured by Merian herself (the published plates were much more extensively etched and were coloured in the publisher's workshop), together with thirty-five other images drawn entirely by hand without etched outlines. Although two of these additional images were reproduced in a posthumous edition of the *Metamorphosis*, the others illustrate European as well as American specimens and must have been conceived separately from the Surinam project.

The present watercolour corresponds to plate 12 in the *Metamorphosis*. The banana was unknown in Europe at the time; Merian remarked that

it is used like an apple, and has a pleasant flavour like apples in Holland; it is good cooked and raw ... They hang in clusters like

grapes, each tree bears only one cluster ... The blossom is a very beautiful flower with five blood-red leaves as thick as leather, covered as if with blue dew underneath. The blossom appears at the same time as the fruit. The cluster is so large that only a man can carry it.

Watercolour and bodycolour over etched outlines, on vellum. 39.5 × 31.0 cm
RL 21166
PROVENANCE Dr Richard Mead; his sale, Langford's, London, 28 January 1755 (66); bought by George III (when Prince of Wales)
LITERATURE Rücker & Stearn 1982, pp. 46, 96

375
GIUSEPPE PASSERI (1654–1714)
Christ driving the Money-changers from the Temple, c.1710

This is the modello, corresponding in almost all details, for a painting by Passeri in the Walters Art Gallery, Baltimore. Two earlier compositional studies, rougher in handling and differing somewhat in the architecture but relatively little in the figures, are in Düsseldorf (inv. KA(FP)2307) and the Louvre (inv. 14724).

Passeri was reputed to be the favourite pupil of Carlo Maratti (see no. 373). The style of his chalk studies of figures and drapery (hundreds of which survive in Düsseldorf) is strongly indebted to his master,

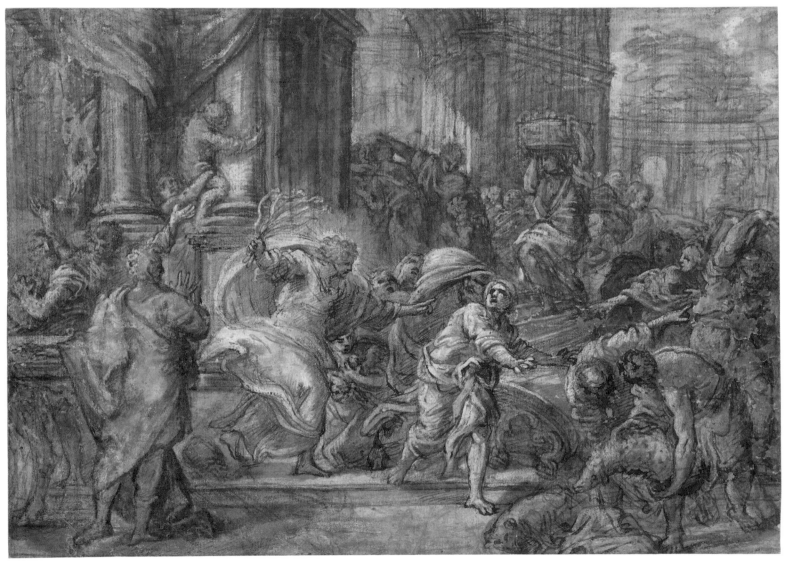

375

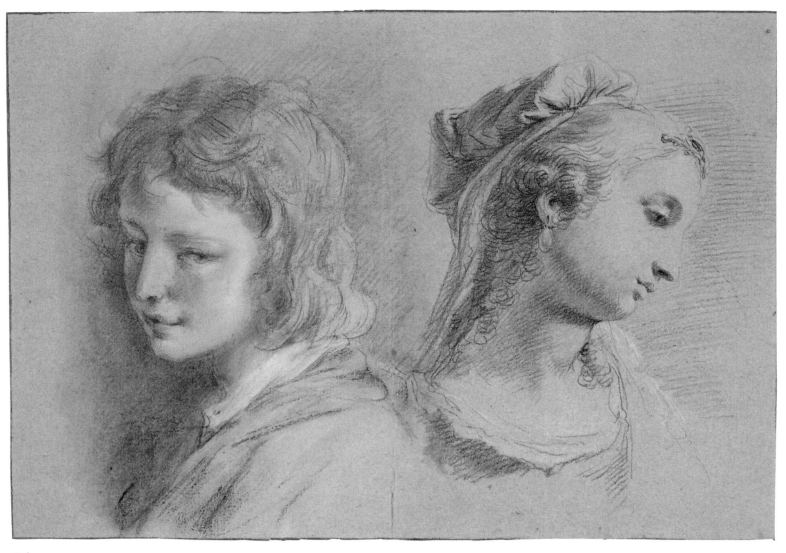

376

and through Maratti to the classical tradition of Sacchi, Domenichino, Annibale Carracci and ultimately Raphael and Michelangelo. Several of the figures in the Baltimore canvas were identified by Bowron and Graf as quotations from paintings by Maratti, and Passeri made no attempt to disguise this; indeed, academic teaching encouraged the adaptation of figures from exemplary sources, and Passeri's borrowings would have been seen as a homage to his master rather than as uninspired copying.

Passeri's compositional drawings, especially the final modellos, are however much more extravagant than those by Maratti. They are often executed in a highly colouristic technique of pen, wash and white gouache over an orange-red ground or extensive red chalk underdrawing, as here. The Baltimore painting is bright and clear in its colouring and a fine early example of what was to be the dominant mode in eighteenth-century Italian painting, the figures moving freely in space rather than locked together in a sophisticated Baroque jigsaw of forms and shadows. Although the circumstances of the painting's commission are not known, it must date from towards the end of Passeri's career.

Red chalk partly washed over, pen and ink, brown and grey wash, white heightening.
27.3 × 38.2 cm
RL 4502
PROVENANCE George III, by c.1810
LITERATURE Blunt & Cooke 1960, no. 566; Bowron & Graf 1978

376
SEBASTIANO RICCI (1659–1734)
Two heads, c.1726

The woman's head corresponds generally with that of the Madonna in Sebastiano Ricci's painting of the *Adoration of the Magi* (also in the Royal Collection and from Joseph Smith's collection; Levey 1991, no. 640), though there are differences in the headdress, the tilt of the head, and most significantly in the direction of the lighting. The boy's head may be identified with that of the page in the foreground of the painting, though in a different attitude, and the same model probably served for the study here and for that figure. Thus while the head of the Madonna may be regarded as a study for the *Adoration*, and is accordingly drawn in a tight, carefully modelled manner, the much more atmospheric head of the boy seems not to have been drawn directly for the painting. Drawings in coloured chalks are uncommon in Ricci's oeuvre, but the European fame of Rosalba Carriera (no. 378) must have acted as an impetus for other artists in Venice to experiment with the medium.

The *Adoration* is dated 1726 and was in Smith's collection in Venice by 1742, together with six other canvases by Ricci of episodes from Christ's ministry, each around 3 metres square. The scale of the series would be most unusual for a private collector, but there is no record of

the circumstances of the commission nor of any owner earlier than Smith. Levey (*loc. cit.*) suggested that the six other paintings of the series may have been an abortive project for the Turin court, subsequently bought by Smith who then commissioned the matching *Adoration*; this must remain a hypothesis.

Black, white and coloured chalks on blue paper. 29.1 × 41.9 cm
RL 7200
PROVENANCE Joseph Smith, by 1742; from whom bought by George III, 1762
LITERATURE Blunt & Croft-Murray 1957, no. 250
EXHIBITIONS Frankfurt/Fort Worth/Richmond/Edinburgh/Venice 1989–90, no. 4; QG 1993, no. 61

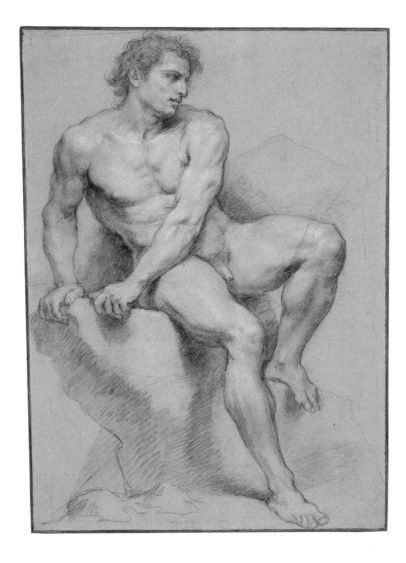

377
BENEDETTO LUTI (1666–1724)
A male nude, c.1700–20

Benedetto Luti was born in Florence but moved to Rome in 1690, where he was elected to the Accademia di San Luca in 1694 and quickly rose to prominence as one of the leading painters of the early eighteenth century. His style was a rich combination of Florentine Baroque light and colour with Roman compositional modes, but his activities as an academician, dealer and collector left him relatively little time for painting. He was however a prolific draughtsman, celebrated for his heads in coloured chalks, and in his role as an academician he frequently taught in the life classes. This is probably the origin of the present sheet, an independent drawing rather than a study for a painting, perhaps drawn by Luti as an exemplar for his students, who would have been making their own drawings from the posed model on either side of the master. He did however subsequently adapt the figure for a composition of *Hercules with the Lion*, recorded in an etching of 1793 by the Comte de Saint-Morys after an untraced drawing by Luti (published in *Disegni originali d'eccellenti pittori incise ed imitate nell' loro grandezza e colore*, 2 vols, London 1794).

Luti's collection of drawings was renowned in its day, and reputed to contain around fifteen thousand sheets. A part of his collection was bought from his heirs in 1759 by a dealer named Kent (not to be confused with the artist and architect William Kent, who had studied under Luti in Rome some forty years earlier and died in 1748). The drawings were brought to London by Kent and sold at two auctions in December 1760 and December 1762. A sketchbook in the Albertina, compiled by Luti's pupil Bartolomeo Altomonte, contains a number of free copies of drawings in Luti's collection, and the originals of many of these copies can be identified today at Windsor. However, as the lots were not described in detail in the 1760 and 1762 sale catalogues, it is not possible to confirm that these drawings were bought for George III at one of Kent's auctions.

Black and white chalks on blue paper. 55.0 × 40.5 cm (max.)
Inscribed lower centre *Benedetto Luti*
RL 5956
PROVENANCE George III, by c.1810
LITERATURE Blunt 1971, no. 229

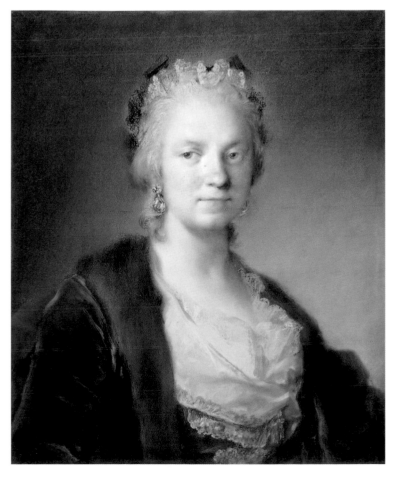

378

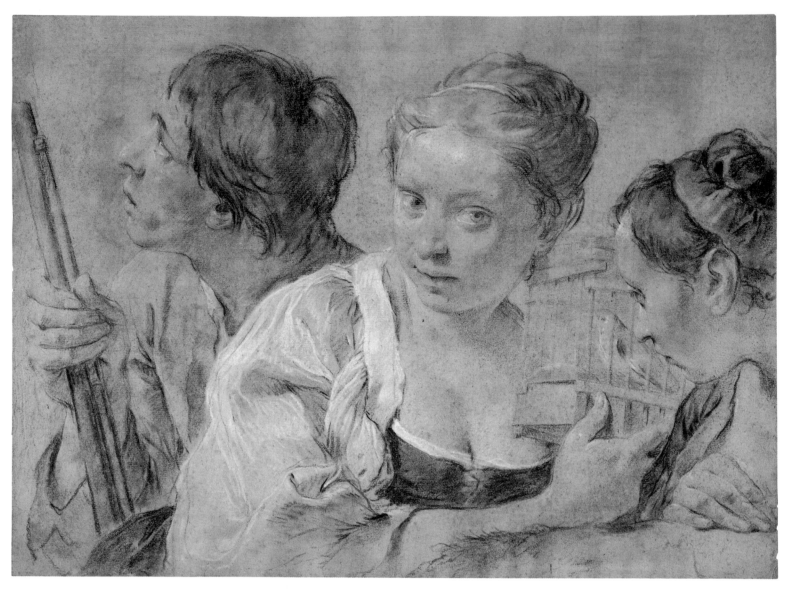

379

378
ROSALBA CARRIERA (1675–1757)
Self portrait in old age, c.1745

A contemporary engraving by Giuseppe Wagner after this portrait records that the pastel was a gift from Carriera to Joseph Smith, *Magnæ Britanniæ Cos.* (Consul of Great Britain). This has been taken as evidence that the portrait was made at the time of Smith's appointment as British consul in 1744; while the inscription certainly does not prove this, Carriera's apparent age (which is well documented through a succession of self portraits) would date the pastel to around this time, and thus establish this as one of her last works before the onset of blindness in 1746.

The theory that the pastel was made as a gift is supported by the lack of affectation in the portrait, which would imply a friendship between artist and recipient. Smith was one of Carriera's major patrons, owning thirty-eight of her works, of which five remain in the Royal Collection. He may also have acted as an occasional intermediary between Carriera and the English travellers who, along with the French and German nobility, formed the bulk of her patronage in her native city of Venice.

A respect for the sophisticated taste of the recipient is also suggested by the subdued palette and the achievement of effect through subtle variations in texture, from the smoothly blended fur to the dry crust of the lace, rather than through a more overt showiness.

Pastel on paper. 57.2 × 47.0 cm
RCIN 452375
PROVENANCE Presented by the artist to Joseph Smith; from whom bought by George III, 1762
LITERATURE Levey 1991, no. 446
EXHIBITIONS London 1946–7, no. 71; London/Birmingham 1951, no. 26; QG 1988–9, no. 66; QG 1993, no. 104; London/Washington 1994–5, no. 45

379
GIOVANNI BATTISTA PIAZZETTA (1682–1754)
Two girls with a bird-cage and a youth with a gun, c.1720(?)

Piazzetta's paintings and drawings, sombre in tone and of an insistent largeness of form, stand in stark contrast to the high-keyed and airy work of Sebastiano Ricci (no. 376) and Giambattista Tiepolo in early

422 DRAWINGS, WATERCOLOURS AND PASTELS

eighteenth-century Venice. Piazzetta was renowned for his drawings of heads in black and white chalks on a dull blue paper that has in almost every case faded to buff, for they were finished works intended to be framed and hung by their owners. Few of these heads are true portraits; they are character heads, of priests, philosophers, Moors, children and Venetian youths, and belong to a tradition that had periods of popularity throughout European art, particularly in seventeenth-century Holland. The thirty-six head studies by Piazzetta in the Royal Collection are the largest group in existence. Although their early history is not documented, they very probably came from Consul Smith's collection.

The present drawing seems to be a pendant to another of the same size and format at Windsor (RL 01251), showing an old woman attempting to procure a girl for a bravo standing behind with a bag of money. The narrative content of the *Procuress* is overt; the meaning here is less explicit, but clearly related. The caged bird was a common symbol of a girl's virginity, for once the cage is opened the bird is gone for ever. Hunting was also a standard metaphor for amorous pursuit, and the youth with a gun raises his gaze to the skies: he is hunting for birds.

There are few reference points in the dating of Piazzetta's heads, and the conscious differences in approach from sheet to sheet mask any natural evolution of style. The date of the drawing can thus be little more than a guess.

Black and white chalks on buff paper. 41.2 × 55.7 cm
RL 01252
PROVENANCE Probably Joseph Smith; from whom bought by George III, 1762
LITERATURE Blunt & Croft-Murray 1957, no. 33
EXHIBITIONS Munich 1958, no. 318; London 1959–60, no. 604; Stockholm 1962–3, no. 287; London 1966, no. 44; Brussels 1983, no. 62; QG 1986–7, no. 105; Washington/San Francisco/Chicago 1987–8, no. 54

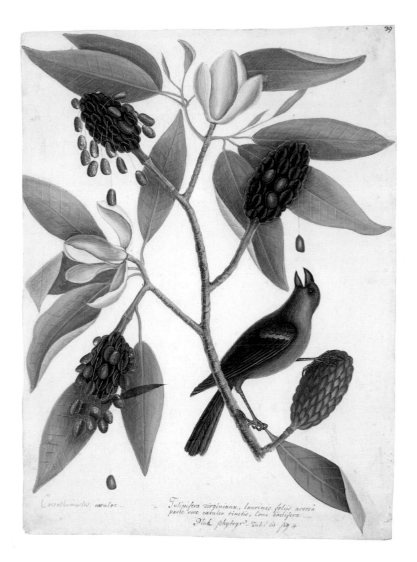

380

MARK CATESBY (1682–1749)
A blue grosbeak (Passerina caerulea) *and sweet bay* (Magnolia virginiana), *c.1728–9*

Mark Catesby was an English naturalist who made two extended visits to the British colonies in North America and the Caribbean, in 1712–19 and 1722–6. From the material assembled on these expeditions Catesby published the first fully illustrated natural history of North America, his *Natural History of Carolina, Florida and the Bahama Islands*, in two volumes issued in parts between 1729 and 1747. The first volume was dedicated to Queen Caroline, consort of George II, and the second to Princess Augusta, wife of Frederick, Prince of Wales. In 1768 George III, the grandson of Caroline and son of Augusta, purchased 263 of Catesby's studies, including nearly all the preparatory drawings for the 220 etchings in the *Natural History*.

The present drawing is the model for folio 39 of the first volume, issued as part of the second fascicule probably in January 1730. The sweet bay was one of a number of species of magnolia illustrated by Catesby. The magnolia had recently been introduced to England from the New World and was being cultivated in private gardens, as mentioned by Catesby in his notes to the plate in the *Natural History*:

'This beautiful flowring Tree is a Native both of Virginia and Carolina, and is growing at Mr Fairchild's in Hoxton, and at Mr Collinson's at Peckham where it has for some years past produced its fragrant Blossoms, requiring no protection from the Cold of our severest Winters.'

Watercolour and bodycolour over erased graphite, with gum arabic. 37.5 × 26.4 cm
Inscribed by the artist, *Coccothraustes cærulea / Tulipfera virginiana, laurinis folijs aversa / parte rore cæruleo tinctis, Coni baccifera –* / *Pluk phytogr. Tab. 68 fig 4*
RL 24853
PROVENANCE Thomas Cadell; from whom bought by George III, 1768
EXHIBITIONS San Marino/Houston/Williamsburg/Savannah/QG 1997–9, no. 7

381

ANTONIO GIONIMA (1697–1732)
The Triumph of David, c.1720–30

Antonio Gionima was perhaps the most exciting painter in Bologna in the decade before his death of tuberculosis at the age of 35. Most of his commissions seem to have been from private collectors rather than for public sites; he was thus somewhat neglected by subsequent writers, and little detail is known about the progress of his career. The son of a painter and a pupil of Aureliano Milani and Giuseppe Maria Crespi, Gionima adopted strongly expressive compositions and dramatic

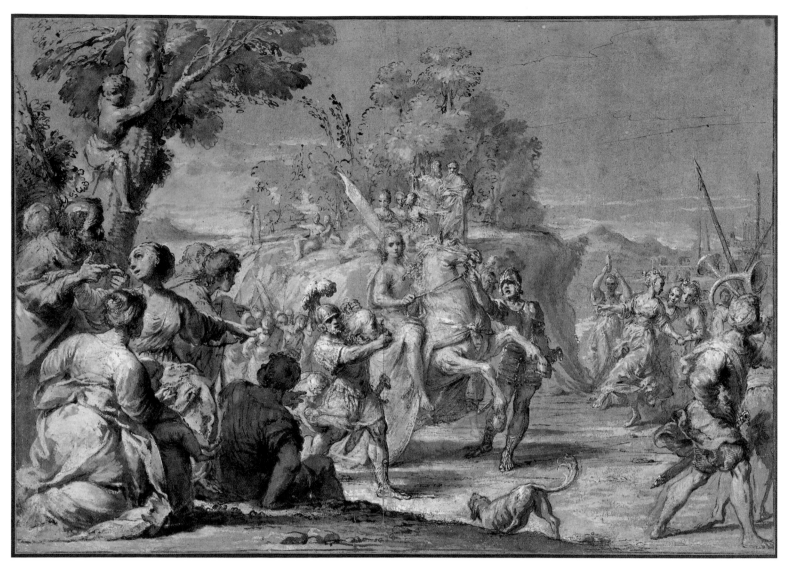

381

chiaroscuro and colour in his paintings, and an often elaborate mixing of wash and white in his drawings. He seems to have participated in the revival of interest in Mannerism among some artists in early eighteenth-century Bologna (cf. no. 385), seen here in the compositional device of placing the principal action beyond a group of large gesticulating figures in the left foreground.

Gionima's drawings were esteemed in his day and this is his most beautiful surviving sheet. It seems to be a final design for a domestic painting; scenes of biblical heroism or legendary moral rectitude including the patron's likeness were a popular subject for such pictures, and Kurz's suggestion that the head of David here was destined to be a portrait may well be correct. However, no painting has been traced and nothing else is known about the project beyond a preparatory sketch for the composition, formerly in the Methuen collection and recently on the art market.

Pen and ink, wash, white heightening, on paper washed buff. 40.5 × 57.3 cm
RL 3742
PROVENANCE George III, by c.1810
LITERATURE Kurz 1955, no. 281; Roli 1960, pp. 303–4

382
WILLIAM HOGARTH (1697–1764)
A male nude holding a spear, c.1728

The young Hogarth, having trained as an engraver, was one of the first subscribers at the art academy founded in St Martin's Lane, London, by John Vanderbank and Louis Chéron in 1720. Though the academy had a strong emphasis on life drawing, few of Hogarth's studies from a model have survived. Despite the obvious weaknesses in his handling of anatomy, these few drawings demonstrate Hogarth's embrace of a discipline that he saw as essential in the cultivation of a home-grown Grand Style, that would allow English painters to compete with the flood of imports from Europe (and especially Italy) that dominated the eighteenth-century art trade.

The drawing must date from the 1720s. It is very close in style to another study at Windsor for one of the first versions of the *Beggars' Opera*, of 1728, and is on the same rich blue paper (probably coloured with smalt in the manufacture) with the same watermark.

Black chalk with some white and red chalks on blue paper. 54.4 × 39.7 cm
RL 13488
PROVENANCE Probably Samuel Ireland (his sale, 1801); Royal Collection by 1833

LITERATURE Oppé 1950, no. 348
EXHIBITIONS Manchester 1954, no. 52; London 1971–2, no. 96; Venice 1989, no. 101

383
WILLIAM HOGARTH (1697–1764)
The Bathos, 1764

This is a vigorous study for Hogarth's last engraving (Paulson 1965, no. 216), published on 3 March 1764, less than eight months before his death. Hogarth knew that his health was failing and advertisements for the print announcing its publication stated that it was intended to 'serve as a Tail-Piece to all the Author's Engraved Works, when bound up together'.

The feelings expressed, and Hogarth's manner of expressing them, are complex. The image is a comprehensive *vanitas*: the exhausted figure of winged Time breathes his last, leaning on ruins, a sundial and a tomb-stone, with broken pipe and scythe, clutching a Last Will and Testament, at his feet a cracked bell, a broken palette, and a derelict inn-sign (inscribed *The World's End* in the print), gallows and a blasted tree beyond. The full title of the engraving is *The Bathos, or Manner of Sinking, in Sublime Paintings, inscribed to the Dealers in Dark Paintings*, with a footnote *See the manner of disgracing ye most Serious Subjects, in many celebrated Old Pictures; by introducing Low, absurd, obscene & often prophane Circumstances into them.*

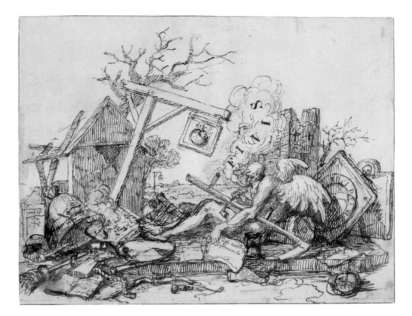

383

This is a genuinely pessimistic, even bitter sentiment. Hogarth, characteristically, saw degradation in the supposedly trivial incidental details of Old Master paintings. The sarcastic references to 'celebrated Old Pictures' and 'Dealers in Dark Paintings' are an attack on the unbroken vogue for imported Old Masters; to this he added a side-swipe at the growing taste for the Sublime in art (recently codified by Edmund Burke in his *Philosophical Enquiry* of 1756), equating the dark treatments of sublime paintings with the darkened varnish of the Old Masters. Hogarth's gloom was no doubt compounded by his own physical decline, and the deep weariness of the image reflects a recognition that his life's ambition, the establishment of a noble and independent English school of painting, had been (by his own standards) in vain.

Although there are significant differences of detail between the drawing and the print, those portions of the composition that agree are on the same scale. The sheet was rubbed with red chalk on the reverse and many of the outlines were incised to transfer the design to the copper plate; the final changes in detail must have been effected by Hogarth on the plate itself.

Pen and ink over red chalk and pencil, indented for transfer. 25.5 × 33.1 cm
RL 13466
PROVENANCE John Greenwood; H.P. Standly; his sale, Christie's, London, 19 April 1845 (884); bought by Colnaghi; Royal Collection by 1877
LITERATURE Oppé 1950, no. 356
EXHIBITIONS London 1877–8, no. 1017; London 1925, no. 4; London 1951a, no. 13; London 1971–2, no. 221; Venice 1989, no. 123

384
GIOVANNI ANTONIO CANAL, called
CANALETTO (1697–1768)
A capriccio with a terrace and loggia, c.1760

Canaletto's drawings range from closely observed and atmospheric studies made in front of the motif to highly artificial compositions constructed in the studio. In the latter he often playfully recombined elements of real topography, usually Venetian, in what had been known

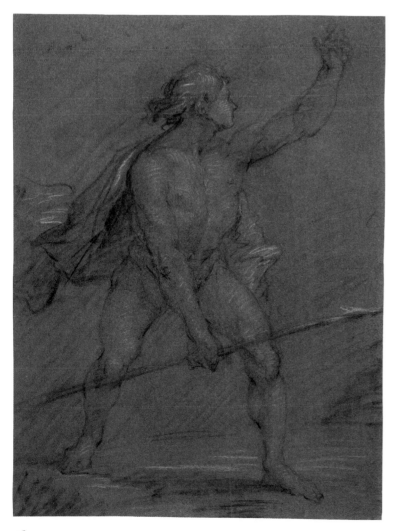

382

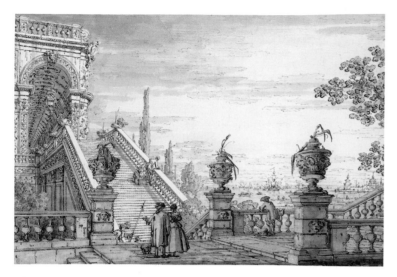

384

Pen and ink, wash, over pencil and stylus. 36.5 × 52.7 cm
RL 7564
PROVENANCE Joseph Smith; from whom bought by George III, 1762
LITERATURE Parker 1948, no. 141; Constable & Links 1989, no. 821
EXHIBITIONS Venice 1962, no. 50; QG 1980–2, no. 96; Venice 1982, no. 63;
Brussels 1983, no. 94; Washington/San Francisco/Chicago 1987–8, no. 60; New York
1989–90, no. 118; QG 1993, no. 47; London/Washington 1994–5, no. 147

since the seventeenth century as a *capriccio*, a word derived from the jumping of a goat (*capro*). Here the broad staircase is reminiscent of that in the courtyard of the Palazzo Ducale, the vaulting of the loggia resembles that of the Procuratie Nuove, while in the right background is a reworking of the view across the Bacino to the Dogana and Santa Maria della Salute.

Although the drawing seems to be an exercise in perspective, the pencil and stylus underdrawing is not so extensive as might be expected and much of the detailing has simply been elaborated around a broadly constructed framework. There is no secure relationship between the principal staircase and that immediately beyond the foreground couple, both of which lead down to some indeterminable level. An unlikely tree encroaching from the right throws the foreground into shadow. It provides a foil for the strongly lit marble staircase and loggia and the atmospheric lagoon. Canaletto added the figures in his customary shorthand of thick curling strokes; their function is no different from that of the large urns, to articulate the composition and break the hard lines of the architecture.

Suspended from the angle of the loggia is a shield bearing a chevron, the device of the Canal family and here used as a signature. The drawing was plainly an end in itself and was presumably made for Consul Smith, Canaletto's friend and greatest patron. The style is late and the sheet must have been one of the last to be drawn for Smith before the sale of his collection to George III.

385
FRANCESCO BOSIO (fl.1725–1756)
An imaginary landscape with a bridge and tower, c.1730

The drawing is one of a group in a uniform style scattered among various collections, once attributed to Domenico Maria Fratta. However, the recognition of a signed member of the group in Little Rock, Arkansas, allowed Thiem to resurrect the figure of Francesco Bosio, one of a number of eighteenth-century Bolognese draughtsmen who composed wildly romantic landscape *capricci*, in the same mode as Canaletto (no. 384) but in the language of ruins, rivers and mountains rather than the architecture of Venice and Rome.

Thiem and Czére both pointed out that Bosio's drawings were indebted to the landscapes of the more mannered artists of the seventeenth century, both Italian and Northern – such as Guercino, Callot and Sadeler – rather than to the classical tradition of landscape developed by the Carracci, where form echoes form in a harmonious assemblage of receding planes. The bold asymmetries and disjunctures of scale (though all remains ultimately in balance) are emphasised by Bosio's use of densely worked dark ink in the foreground, pale ink beyond and large areas of untouched white paper, contrasts that are seen here exactly as Bosio intended owing to the perfect state of preservation of the sheet. Given the pyrotechnics of the penwork it seems probable that Bosio's drawings were created expressly for the well-developed collectors' market in eighteenth-century Italy; no paintings by him are recorded.

Bosio's dates are known only through an entry in a dictionary of 1794 which may not be accurate. Four of his landscape drawings were etched by Ludovico Mattioli (1662–1747); those, and the present, stylistically consonant sheet, probably date from relatively early in Bosio's putative career.

Pen and ink over traces of pencil or black chalk. 30.9 × 51.6 cm
RL 3534
PROVENANCE George III, by c.1810
LITERATURE Kurz 1955, no. 262; Thiem 1987, no. 2; Czére 1991
EXHIBITIONS Stuttgart 1982, no. 72

386
JEAN-ETIENNE LIOTARD (1702–1789)
George, Prince of Wales (later George III), 1754

Jean-Etienne Liotard was one of the most celebrated and widely travelled pastellists of the eighteenth century. He trained in Geneva and Paris and worked all over Europe and the Near East, where he acquired a strong

◁ 385

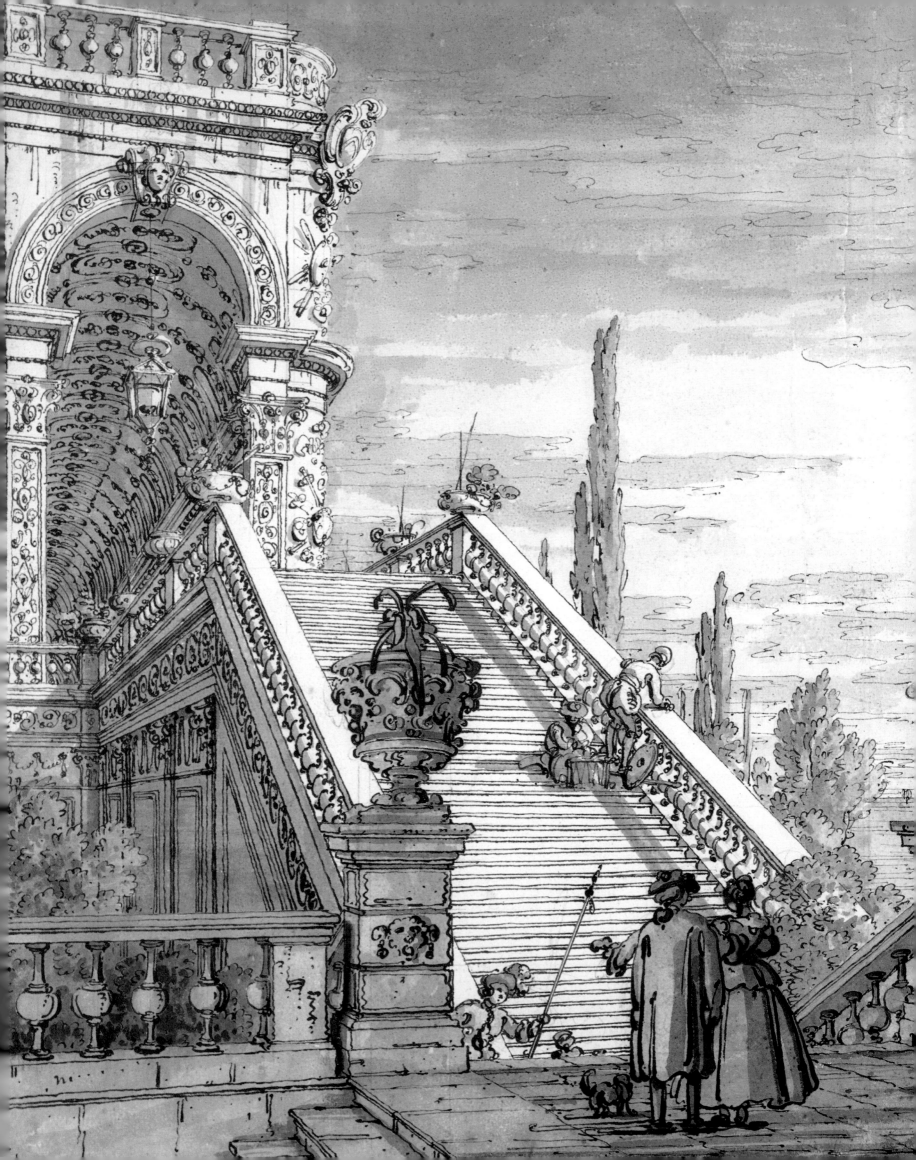

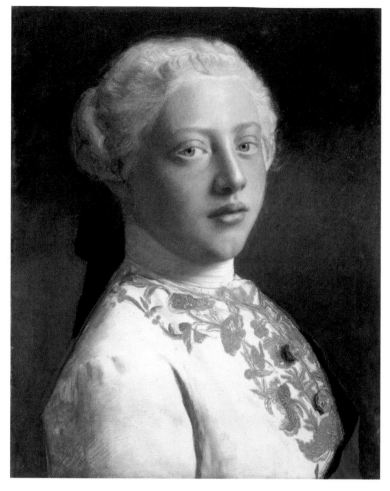

386

colours are unaffected – the vivid blue of the Garter sash and, on the buttons, touches of the permanent vermilion that Liotard used for the colouring of the face.

Pastel on vellum. 40.6 × 29.8 cm
RCIN 400897
PROVENANCE Commissioned by Augusta, Princess of Wales, 1754
LITERATURE Millar (O.) 1963, no. 581; Roche & Roethlisberger 1978, no. 177
EXHIBITIONS London 1946–7, no. 74a; QG 1983–4, no. 60

387
JEAN-ETIENNE LIOTARD (1702–1789)
Princess Louisa, c.1754–5

Princess Louisa was born in 1749, the third daughter and seventh child of Frederick, Prince of Wales. She was a delicate child and died of consumption in 1768, aged 19.

This is one of the series of eleven pastels executed for Princess Augusta in 1754–5 (see no. 386). Liotard engagingly portrayed the 5- or 6-year-old seated in an armchair too big for her, so that the arm is almost level with her shoulder and her head barely clears the chairback. Like no. 386 the pastel has suffered from fading, in a way that has exposed a variation in Liotard's pigments. The portion of the chair in the Princess's shadow, to the right, was modelled in the same fugitive lake as the Prince of Wales's coat in no. 386 over a layer of a stable earth colour, and the complete fading of the lake has exposed this flat underlayer. To the left of the Princess, however, the fabric was drawn with a combination of

taste for orientalising subjects. While in Constantinople for four years he adopted Turkish dress, an affectation he retained on his return to Western Europe.

During 1754 and 1755 Liotard was in London, where he executed a series of pastel portraits of Augusta, Princess of Wales, her husband Frederick, who had died in 1751, and their nine children. With the exception of the portrait of Frederick, which was necessarily drawn posthumously from an earlier image, the portraits have a great immediacy and charm. Augusta's head is tilted and her lips slightly parted as if about to speak, and the children, though all bust length, are presented in a striking range of poses, most with barely suppressed smiles.

Augusta's eldest son George (1738–1820) had become heir to the throne and inherited the title of Prince of Wales on the death of his father; he succeeded his grandfather George II as King in 1760. The portrait of the 16-year-old is accordingly one of the most formal of the series, his body almost in profile and his head turned to address the viewer with a direct though sympathetic gaze. A version in miniature by Liotard in the collection of Princess Juliana of the Netherlands is dated 1754; this date may presumably also be applied to the pastel.

Liotard's series of pastels has hung (in their original frames) in the royal apartments in either London or Windsor almost continuously for the last two and a half centuries, and inevitably there has been some fading from exposure to daylight (cf. no. 379). Liotard used a fugitive carmine lake for the Prince's coat, which has completely lost its colour; the brown to the left of the sleeve is a different pigment added to modulate the shadow, rather than the remains of the faded lake. The other

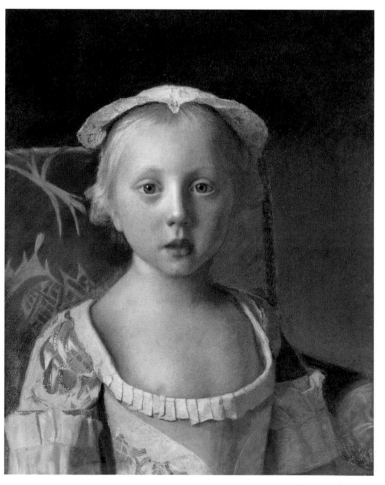

387

stable pigments. A fugitive pigment, possibly the same lake, was also used in the Princess's dress, and the arrangement of light and shadow on her right shoulder is now difficult to read; this effect has been exacerbated by the darkening of some substance in the white pastel with which the dress's embroidery was drawn.

Pastel on vellum. 40.0 × 30.5 cm
RCIN 400900
PROVENANCE Commissioned by Augusta, Princess of Wales, 1754
LITERATURE Millar (O.) 1963, no. 586; Roche & Roethlisberger 1978, no. 182
EXHIBITIONS London 1946–7, no. 74g

388
PAUL SANDBY (1730/1–1809)
The south-east corner of Windsor Castle, c.1765

Paul Sandby was trained by his elder brother Thomas in Nottingham, after which both worked as military draughtsmen to the Board of Ordnance at the Tower of London. In 1747 Paul was assigned to the Military Survey in Scotland, mapping the Highlands in the aftermath of the Jacobite Rebellion. He retained an interest in military subjects all his life, but landscape watercolours and gouaches (and some oils) soon

became his principal activity. In 1746 Thomas's patron William Augustus, Duke of Cumberland (George III's uncle), was appointed Ranger of Windsor Great Park and in 1764 Thomas became Deputy Ranger of the Park. Thereafter both Thomas and Paul spent much time at Windsor, producing many views of the castle and its surroundings over a period of fifty years.

The present gouache is of the south and east fronts of the castle on a summer's afternoon. In the foreground is the public footpath which until 1823 crossed the Little (now Home) Park from the King's Gate at the south side of the castle to Datchet bridge. By the trees are fallow deer, a common sight by the castle until 1785 when George III transferred all the deer to the Great Park, so that the Little Park could be put to better agricultural use.

The Royal Collection now holds approaching 500 works by the Sandby brothers, of which over 150 are views of Windsor or projects for work in the Windsor parks. Strangely, none of these seems to have been acquired by George III. The foundations of the collection were instead laid by the future George IV, who bought many works by the Sandbys through the dealers Colnaghi after the posthumous sales of the brothers' possessions, Thomas's in July 1799 and Paul's in May 1811. Sporadic acquisitions were made throughout the nineteenth and twentieth centuries, most notably at the sale of Sir Joseph Banks's collection in 1876. This is one of fifty Sandbys acquired during the present reign.

388

389

Bodycolour on panel. 38.4 × 55.8 cm
RL 18986
PROVENANCE Holker Hall, Cumbria (?acquired by Lord George Cavendish, d. 1792, or by Lord Richard Cavendish, d. 1873); the Holker Estates Trust; Christie's, London, 20 June 1978 (100); bought by HM The Queen
LITERATURE Roberts (J.) 1997, p. 144
EXHIBITIONS QG 1997, ex-cat.

389
JAMES GILES (1801–1870)
Lochnagar: the loch in the corrie of the mountain, 1849

In 1848 Prince Albert took a twenty-seven year lease on the Balmoral Estate, having been shown watercolour views of the property by the Aberdeen artist James Giles. Queen Victoria and Prince Albert first stayed at the estate that September and were probably introduced to Giles at that time. A year later they returned, and the royal party visited Lochnagar for the first time on 22 September 1849 (Lochnagar is the name of both the mountain and the loch below the summit). The Queen described it three days later, in a letter to her uncle Leopold, King of the Belgians, as 'one of the wildest, grandest things imaginable; the Expedition took us 7 hours; the Lake is about 1000 feet below the highest point. – & Albert thinks it very like the Crater of Mount Vesuvius.'

On 28 September Queen Victoria commissioned Giles to paint three specific views of lochs on the estate: Lochnagar, Dubh Loch (Millar (D.) 1995, no. 2107), and Loch Muick (*ibid.*, no. 2110). Giles arrived at Balmoral on 1 October and went up to the lochs on the following days. It was bitterly cold, with snow and sleet, and ice on the pools; further, Victoria had chosen steep vantage points and Giles was unable to sketch properly, even losing one of his notebooks. He left Balmoral in a black humour and did not begin to work up his studies into finished watercolours until a month later. During this time Giles managed to suppress the memory of his discomforts, and he depicted the lochs in gentle sunlight. The faint mist before the distant shadowed cliffs was captured by gently abrading the surface of the paper; the sparse foreground vegetation is less successfully drawn, and betrays the separation of the studio-bound artist from the motif.

Watercolour and bodycolour over pencil. 30.1 × 45.0 cm
Signed lower left J. Giles
RL 19623
PROVENANCE Commissioned by Queen Victoria, 28 September 1849
LITERATURE Millar (D.) 1995, no. 2108

WILLIAM WYLD (1806–1889)
Manchester from Higher Broughton, 1852

Queen Victoria had first seen William Wyld's work in 1843 in the collection of her aunt Louise, Queen of the Belgians, choosing some of these watercolours for her own collection, and Queen Louise subsequently ordered more works from Wyld to send to Victoria. The artist was invited to stay at Balmoral in September and October 1852. In a letter to a friend, he wrote 'I am well and getting on very well with Her Majesty, who altho' a Queen is one of the most amiable women I ever spoke to, and so completely does she put you at your ease that I am no more embarrassed in talking to her than to you.'

The Queen had visited Liverpool on 9 October 1851 and Manchester over the following two days, and commissioned a watercolour of each of the cities from Wyld soon after. Manchester was then the world's greatest producer of cotton textiles, and with Salford had grown rapidly to a conurbation of almost 400,000 inhabitants by mid-century. The overcrowding and slum conditions of the workers' housing were a severe social problem, and the Queen noted in her Journal: 'The mechanics and work-people, dressed in their best, were ranged along the streets in their button-holes; both in Salford and Manchester, a very intelligent, but painfully unhealthy-looking population they all were, men as well as women' (QVJ). Wyld's view of the city is however overtly romantic. The smoking chimneys serve only to accentuate the golden light of the setting sun, as in a painting by Claude, and the rustics and goats in the foreground are similarly reminiscent of the views of Italy produced in great numbers by the English watercolourists of the previous half-century.

Watercolour, touches of bodycolour, with gum arabic and scratching out.
31.9 × 49.1 cm
Signed lower left W Wyld 1852
RL 20223
PROVENANCE Commissioned by Queen Victoria, paid for in April 1852 (£73 10s., with Millar (D.) 1995, no. 5987, St George's Hall, Liverpool)
LITERATURE Millar (D.) 1995, no. 5985
EXHIBITIONS London/Nottingham 1985–6, ex-cat.

391
CARL GRAEB (1816–1884)
A distant view of Potsdam, 1858

Queen Victoria's eldest child, Victoria, the Princess Royal, married Prince Frederick William (nephew of King Frederick William IV of Prussia) in January 1858. She was only 17 years old at the time and, though the marriage had not been forced upon the young Princess, her departure was inevitably a wrench for both mother and daughter. Queen Victoria missed her greatly, and wrote letters to her every few days; the Queen's feeling of separation was compounded when she learned in May 1858

390

391

that the Princess was expecting her first child (the future Kaiser William II). A visit to Germany was quickly arranged, and in August Queen Victoria and Prince Albert set out by train from Antwerp to spend two weeks with their daughter.

The watercolour was commissioned by the Prince Consort later in 1858 as a Christmas present for Queen Victoria. Potsdam, immediately to the south-west of Berlin, was the site of a number of the country residences of the Prussian royal family, notably Sanssouci. Here the town is seen looking westwards into the afternoon sun from the park at Babelsberg, where the royal couple stayed with the Princess; the newly built Flatowturm is on the right and the wide waters of the Havel catch the light in the distance. Carl Graeb had come to the notice of Queen Victoria and Prince Albert when the Prussian King had presented them with six views by Graeb of the King's Rhineland castle Schloß Stolzenfels after their visit in 1845. A number of other watercolours of Schloß Babelsberg, Sanssouci and around Berlin were ordered from the artist following the 1858 visit.

Watercolour and bodycolour. 31.6 × 43.6 cm
Signed lower right C. Grae[b]
RL 20706

PROVENANCE Commissioned by the Prince Consort as a present to Queen Victoria for Christmas 1858 (£13 12s.)
LITERATURE Millar (D.) 1995, no. 2190

392
SIR OSWALD WALTERS BRIERLY (1817–1894)
The Lofoten Islands, 1864

Brierly studied navigation and naval architecture at Plymouth, and in 1841 began a voyage around the world as staff artist on Benjamin Boyd's ship *The Wanderer*. On reaching Australia he settled in New South Wales, developing a mining business and taking part in several Admiralty surveys. Brierly journeyed back to England in 1851–3, serving with the Baltic fleet and as a war artist for *The Illustrated London News* in the Crimea. His first work for Queen Victoria was to record the Naval Review at Spithead in 1856, and he worked intermittently for the Queen and her elder sons for the next thirty years.

Queen Victoria's second son, Alfred, Duke of Edinburgh (1844–1900), had joined the navy in 1858, serving as a cadet and

midshipman before being appointed as lieutenant on the 22-gun steam corvette HMS *Racoon* in 1863, under Captain Count Gleichen. In the summer of 1864 the *Racoon*, together with HMS *Euryalus* and *Black Eagle*, went on a tour of duty to Norway, and Brierly accompanied Prince Alfred to record the voyage. The Duke's duties appear not to have been too arduous. The furthest point of the tour, the Altafjord just south of Hammerfest on the northern tip of Norway, was the summer fishing quarters of the sixth Duke of Roxburghe and reputed to be the finest salmon waters in the world; Prince Alfred caught forty salmon totalling 563 pounds [255 kg] in three and a half days' fishing, and the Duke of Roxburghe then joined the Prince on the voyage back down the coast to Bergen. On 19 August they explored the inlets of the Lofoten Islands, an archipelago in the Arctic Ocean on the north-west coast of Norway, in the *Black Eagle*. Brierly here depicted the paddle-steamer in a heavy sea returning to open water.

Watercolour and bodycolour over pencil, with some scratching out. 32.1 × 47.0 cm
Signed lower left O.W. *Brierly*
RL 25417
PROVENANCE Painted for Alfred, Duke of Edinburgh
LITERATURE Millar (D.) 1995, no. 358
EXHIBITIONS London 1887, no. 99

393
CARL MÜLLER (1818–1893)
Christ in the carpenter's workshop, 1849

Carl Müller and his brother Andreas both trained at the Düsseldorf Kunstakademie, later becoming professors (and Carl director) of the same institution. Between 1840 and 1843 they studied in Rome, where they embraced the style and ideals of the Nazarene movement, with its emphasis on biblical subject matter and crisp drawing. After their return to Germany the brothers (with Ernst Deger and Franz Ittenbach) spent the rest of the 1840s frescoing the newly built Apollinariskirche at Remagen, south of Bonn on the Rhine, the most impressive work of the mid-century Düsseldorf school.

While working on the Apollinariskirche, Müller was also engaged by the *Verein zur Verbreitung religiöser Bilder* (Society for the Dissemination of Religious Images) to provide designs for prints. The Society had been founded in 1842 by the Archbishop of Cologne and produced around five hundred prints over the next few decades. One of its sub-contractors was the London-based publishers Hering & Remington, who wrote in a letter to Müller:

> Many of your drawings enjoy the approbation of the English public, and thus we would wish to incorporate one or two of your compositions in this enterprise. We have already secured Overbeck,

392

393

Führich, Hess etc. The intention is to disseminate salutary religious sheets among the middle and lower classes, and to furnish them with some taste for genuine good things ... We wish to make these sheets right for everyone and have joined hands with both Catholic and Protestant bishops on this undertaking. (Finke 1896, p. 56)

Müller provided several designs for the series between 1844 and 1850, including the *Annunciation* in 1848 and *Christ in the carpenter's workshop* in 1849. The latter was reproduced as a lithograph by August Dircks, printed by Day & Son (who styled themselves 'lithographers to the

Queen'), and published by Hering & Remington on 1 June 1849. Prince Albert acquired Müller's final drawings for both these compositions, giving them as presents to Queen Victoria on her thirty-first birthday (24 May 1850) and for their eleventh wedding anniversary (10 February 1851) respectively. There are two further studies for the composition in the Staatsgalerie, Stuttgart (inv. C70/2007–8).

Pencil, wash, white heightening on discoloured paper. 33.5 × 43.6 cm
Signed lower right *C. Müller fec. 1849*.
RL 12091b
PROVENANCE Given to Queen Victoria by Prince Albert on 10 February 1851, their eleventh wedding anniversary
LITERATURE Millar (D.) 1995, no. 3966

394
JOHN PIPER (1903–1992)
Bacchus and Ariadne (after Nicolas Poussin), c.1941–2

At the outbreak of the Second World War, Kenneth Clark, Director of the National Gallery and Surveyor of the King's Pictures, helped to set up the War Artists Advisory Commission. John Piper was one of those seconded from the armed forces to commemorate the war in pictures, and in 1941 Clark secured for Piper a commission from Queen Elizabeth to paint views of Windsor Castle, which was a potential target for bombing (see Cornforth 1996, pp. 74–8, and *John Piper: The Forties*, exh. cat., Imperial War Museum, London, 2000–01, nos 59–62).

Piper's drawings were intended to be records of the castle as well as

◁ 394

works of art, and he was asked to look at Paul Sandby's eighteenth-century views of the castle (see no. 388) before he began his series. He therefore had access to the Royal Library and became acquainted with the Librarian, Owen Morshead; in a letter to the poet John Betjeman of July 1942, Piper mentions 'several good rows about art with O. Morshead lately'. He must also have had time to study the Old Master drawings in the library, for this is a copy of Nicolas Poussin's *Bacchus and Ariadne* (no. 365).

Piper's mature oeuvre was almost entirely confined to darkly romantic landscape, and of his few known reworkings of Old Masters about half take as their model his landscape forerunners, such as Joachim Patinir, Richard Wilson and Thomas Gainsborough. More surprising are several variants of works by Poussin; in addition to the present sheet, Piper copied the dancing group in Poussin's *Adoration of the Golden Calf* (sale, Bonham's, London, 9 October 1990 (6)) and executed a pair of very bold renderings of the same group and of the Dublin *Galatea, Acis and Polyphemus* (dated 1952; exh. *John Piper*, Marlborough Fine Art, London, 1964, no. 103). The formalism of Poussin has appealed to many diverse artists through the centuries; perhaps it was the delight in finding such a loose, vibrant sketch by the master of classicism that led Piper to make his own version, more colourful but scarcely more dynamic.

Brush and ink with bodycolour, over pencil and grey wash with stopping-out.
21.7 × 30.7 cm
Signed lower left *John Piper*
RL 32568
PROVENANCE Christie's, London, 15 October 1993 (85); bought by HM The Queen

395
JOHN MERTON (b. 1913)
Her Majesty The Queen, 1989

John Merton has worked all his life in a meticulous technique with frequent references to the art of the Italian Renaissance, quoting specific portraits by artists such as Botticelli and Giovanni Bellini and, as here, often using the fifteenth-century medium of metalpoint. His portrait of Her Majesty The Queen is one of a number of circular images, mostly of female sitters, produced in the late 1980s and early '90s (his male portraits of the same period were usually rectangular in format). Merton has always regarded the framing of his portraits as essential to their effect, and these circular images were all enclosed by a fillet with a pronounced *craquelure* and set in a deep square frame with distressed and painted gilding, made to Merton's specifications. The portrait was commissioned as part of the Order of Merit series (see no. 397).

Photographic survey techniques have long been a fascination for Merton. During the Second World War he commanded the Army Photographic Research Unit at the Gunnery School, Larkhill, where he developed a system of photographic reconnaissance referencing known as the Gridded Oblique, and he has consistently exploited photographic methods for the portraits painted and drawn over a sixty-year career. In a short sitting Merton makes hundreds of slides of the subject with a stereo camera, exploring combinations of lighting, attitude and expression, and subsequently works from these using a binocular viewer. Once the portrait is almost complete a second short sitting allows the artist to adjust the emphases from the life.

Metalpoint on gesso-prepared board. Diameter 42.5 cm (sight)
Dated lower centre 1989
RL 29250
PROVENANCE Commissioned by HM The Queen for the Order of Merit portrait series
EXHIBITIONS London 1992c

396
PETER BLAKE (b. 1932)
Puck, 1977

Peter Blake is the best known of British Pop artists, but there has always been a divide in his work between a knowing Modernism – recycling commercial images and exploring the cult of celebrity – and a sincerely felt engagement with childhood and with a distinctly English tradition of romanticism. Between 1969 and 1979 Blake lived in the countryside at Wellow, near Bath, and he was a founder member of the Brotherhood of Ruralists in 1975.

Throughout this period Blake executed paintings and drawings of fairies and of characters from Shakespeare (particularly *A Midsummer Night's Dream*) and from Lewis Carroll's *Alice* books. These works were characterisations, not depictions of specific moments in the plays and books, and are often presented in a simple frontal pose, as here. The faces are usually based on photographs, with the features slightly enlarged to give a more engaging effect. One of the first works of this type was a painting of *Puck, Peaseblossom, Cobweb, Moth and Mustardseed*, begun in 1969 and worked on over the next decade (exh. London/Hanover 1983, no. 83/64). The features of Puck were initially based on a photograph of the 1960s pop star Del Shannon, though they evolved as Blake revised the painting during the 1970s. The present watercolour corresponds closely in facial type with Puck as seen in the painting when it was exhibited at the Hayward Annual in 1977 (no. 123); but while the watercolour was inscribed by the artist as a *Study for*

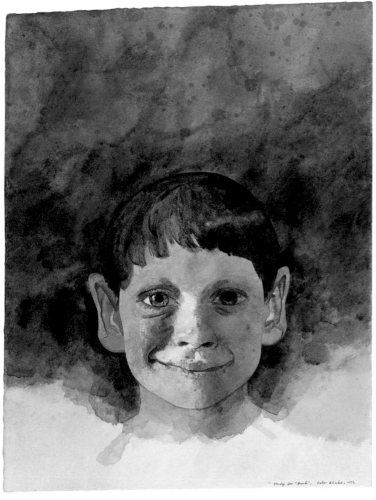

396

397

'Puck', it is clearly a finished and independent work rather than a study for the painting in the usual sense.

Watercolour and bodycolour over pencil. 37.0 × 27.8 cm
Inscribed lower right Study for 'Puck'. Peter Blake. 1977.
RL 22851
PROVENANCE Royal Academy Silver Jubilee Gift to HM The Queen, 1977
EXHIBITIONS London/Hanover 1983, no. 174/124

397
TOM PHILLIPS (b. 1937)
The Reverend Professor Owen Chadwick, 1989

The Order of Merit was founded on the coronation of Edward VII in 1902, to be 'given to such persons, subjects of Our Crown, as may have rendered exceptionally meritorious services in Our Crown Services or towards the advancement of the Arts, Learning, Literature, and Science or such other exceptional service as We are fit to recognise'. The Order is restricted to twenty-four members. Between 1907 and 1913 portraits of twenty-four of the early members of the Order were commissioned, of which fourteen were by William Strang, but this practice fell into abeyance with the outbreak of war. In 1987 Her Majesty The Queen revived the tradition with the intention that each member should be drawn by a different artist, and at the time of writing a further forty-six portraits have been added to the series.

Owen Chadwick (b. 1916) is the leading ecclesiastical historian of our time. After graduating from St John's College, Cambridge, he took Holy Orders and was elected a fellow of Trinity Hall. He was Master of Selwyn College from 1956 until his retirement in 1983, Vice-Chancellor of the University of Cambridge between 1969 and 1971, and held the chairs of Dixie Professor of Ecclesiastical History (1958–68) and Regius Professor of Modern History (1968–83). Owen Chadwick was appointed to the Order of Merit in 1983.

The artist Tom Phillips has worked in a wide range of media – visual, literary and musical – often in combination; his autobiographical Curriculum Vitae, his translation of Dante's Inferno and his extended chance-poem A Humument all explore the interrelation of word and image. Portraits have formed a large part of his painted work, in a variety of styles and sometimes openly in emulation of his School of London forerunners. Phillips is very conscious of his artistic ancestry, and has traced his lineage of teacher and pupil back through Auerbach, Bomberg and Sickert, and ultimately to Raphael.

On completion of the portrait, Chadwick described it in a letter as 'a green tough clerical Machiavelli. I hope I'm not like that inside but it is great fun to be it outside.'

Watercolour with scratching out. 41.0 × 30.9 cm
Signed lower right tom phillips LXXXIX
RL 29178
PROVENANCE Commissioned by HM The Queen for the Order of Merit portrait series
EXHIBITIONS London 1989–90, no. 135; London 1992c

398
BOB TULLOCH (b. 1950)
Ted Hughes, 1999

The poet Ted Hughes (1930–98) was born at Mytholmroyd in Yorkshire and studied at Pembroke College, Cambridge, where in 1956 he met Sylvia Plath, marrying her soon after. His dominant concern with the vitality and violence of nature was tempered by a lifelong interest in classical mythology and children's literature. He was created Poet Laureate in 1984, succeeding Sir John Betjeman.

Hughes was appointed to the Order of Merit in August 1998, two months before his death in October 1998, and his portrait for the Order of Merit series was therefore based on photographs by Jane Bown and Caroline Forbes. Bob Tulloch attended the Ruskin School of Drawing, Oxford, and the Royal Academy Schools and has exhibited at the Royal Academy, the National Portrait Gallery and elsewhere. Although he works in a wide variety of media and on very diverse subject matter, he now concentrates increasingly on portraiture.

Pencil. 44.6 × 30.2 cm (sight)
Signed lower right *Bob Tulloch '99*
RL 33520
PROVENANCE Commissioned by HM The Queen for the Order of Merit portrait series

399
HUMPHREY OCEAN (b. 1951)
Graham Greene, 1989

Graham Greene (1904–91) was one of the most popular 'serious' British novelists of the twentieth century. He converted to the Catholic Church at the age of 22, and a concern with moral and religious ambivalence pervades his works. Greene was widely travelled, publishing accounts of journeys in Mexico, Liberia and elsewhere in Africa, and his novels often set the protagonist in a conspicuously foreign environment that compels self-examination. He was appointed to the Order of Merit in 1986.

Humphrey Ocean has exhibited widely and a number of his works have been acquired by the National Portrait Gallery, London. Greene knew and admired Ocean's painting of the poet Philip Larkin (London, National Portrait Gallery), and expressed a wish that Ocean should execute his own portrait for the Order of Merit series. The drawing was completed in three sittings at the start of July 1989, at Greene's home in Antibes on the south coast of France.

Pencil. 40.7 × 31.3 cm
Signed lower right *Humphrey Ocean / Antibes 1989*
RL 29210
PROVENANCE Commissioned by HM The Queen for the Order of Merit portrait series
EXHIBITIONS London 1992c

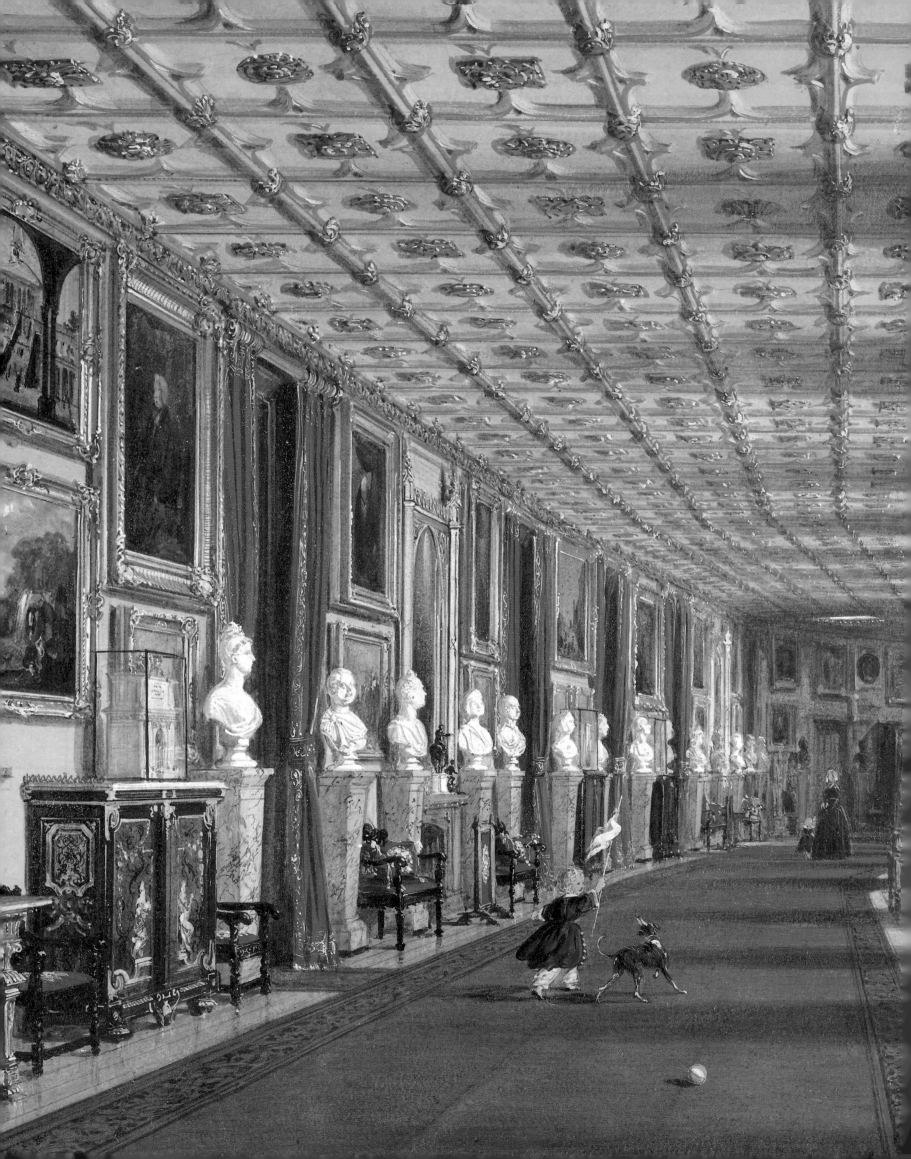

THE ROYAL RESIDENCES: INTERIOR VIEWS (nos 400–437)

WINDSOR CASTLE (nos 400–412)

400
CHARLES WILD (1781–1835)
Windsor Castle: The King's Closet, 1816

The King's Closet lies at the western end of the King's State Apartment, rebuilt by Hugh May for Charles II in 1675–8 as part of the overall modernisation of Windsor. This great project, which was completed in

1684 within a few months of Charles II's death, provided two back-to-back suites of rooms – eight for the King, seven for the Queen – mainly within the so-called Star Building on the north side of the Upper Ward of the castle. The Baroque planning and decoration of these rooms, which was entirely new in England at this date, reflected the pattern for State Apartments established at the court of the King's cousin, Louis XIV of France. Antonio Verrio was employed to paint the ceilings with an elaborate iconographic programme relating to Charles II and Catherine of Braganza, and rich carvings were supplied by Grinling Gibbons and Henry Phillips. The ceiling of the King's Closet was originally painted

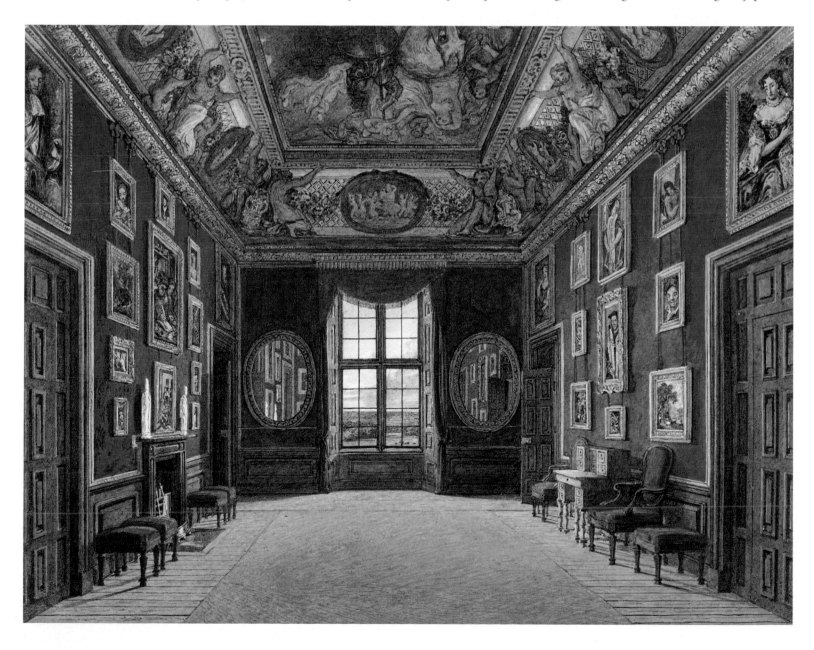

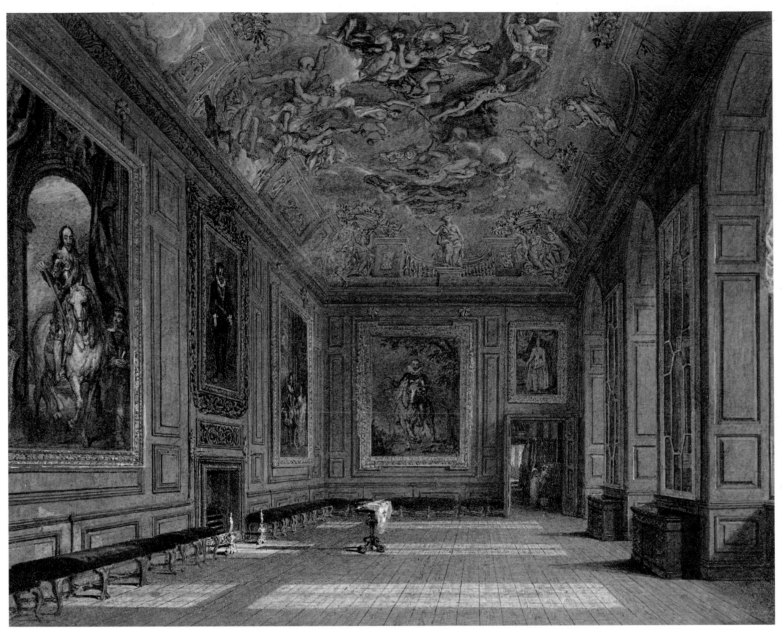

401

with scenes of Jupiter and Leda. When George III embarked on a programme of modernisation of the State Apartments in the early nineteenth century under the direction of James Wyatt, the Closet was enlarged by the addition of an ante-room to the south and a new ceiling depicting St George and the Dragon (as shown in no. 400) was painted by Matthew Cotes Wyatt in 1807. The pictures, symmetrically hung on red cloth-covered walls, included Vermeer's *Lady at the virginal* (no. 17), identified by Pyne under its old attribution of Frans van Mieris, together with a mixture of family portraits and Old Masters, some brought by George III from Buckingham House. The furniture was similarly mixed and included a seaweed marquetry desk that had belonged to William III (RCIN 35317) and a pair of oval mirrors designed by John Yenn and supplied in 1794–5 (RCIN 53003). The room was altered again by Jeffry Wyatville for William IV in the early 1830s when M.C. Wyatt's ceiling was replaced and a chimneypiece from Buckingham House was installed.

With nos 401–03, 413–14, 421–4, 429 and 433–6, no. 400 is closely associated with *The History of the Royal Residences* by the water-colour artist W.H. Pyne (1769–1843), published in three volumes in 1819. The hundred plates which illustrated Pyne's account appeared in batches of four, monthly or bi-monthly, from February 1816. The associated watercolours at Windsor, some of which are painted over first states of the associated engravings, were formerly housed in a binding similar to that used for some of George IV's books. Although Jutsham notes the arrival (at Carlton House) of instalments of the published work, no record of the delivery of the watercolours appears to have survived. Pyne's great publishing project was embarked on as an independent commercial venture. It received royal support, but no royal funding and Pyne – like Whittaker (see no. 333) – was driven to bankruptcy by the costs involved in his magnificent venture.

Watercolour with touches of bodycolour over pencil. 20.0 × 25.1 cm
RL 22104
PROVENANCE (?)George IV
LITERATURE Pyne 1819, I, *Windsor Castle*, opposite p. 135; Oppé 1950, under no. 657; Watkin 1984, p. 24

401

CHARLES WILD (1781–1835)
Windsor Castle: The Queen's Presence Chamber, 1817

The Queen's State Apartment, consisting of seven rooms on the south and west sides of the Star Building in the Upper Ward of the castle, was remodelled for Catherine of Braganza at the same time as the adjacent King's State Apartment (see no. 400). The Queen's Presence Chamber, facing south, is one of only three rooms in the castle that still retain their late seventeenth-century decoration. It remains much as it was in George III's day, when depicted by Charles Wild, with a painted ceiling by Antonio Verrio showing Queen Catherine attended by the Cardinal Virtues and with overmantel carvings by Gibbons and Phillips. The picture hang, devised for George III, included two of Charles I's most celebrated Van Dycks, the equestrian portrait (no. 11) and the 'Great Piece', both of which are now normally at Buckingham Palace. In the centre of the room stands a brass-inlaid folding-top table attributed to Pierre Gole (RCIN 35489) over which is draped a French royal flag, the annual rent from the Dukes of Marlborough for the royal manor of Woodstock.

Watercolour with touches of bodycolour and gum arabic over pencil. 20.4 × 25.1 cm
RL 22099
PROVENANCE (?)George IV
LITERATURE Pyne 1819, I, *Windsor Castle*, opposite p. 90; Oppé 1950, under no. 657; Watkin 1984, p. 20

402

CHARLES WILD (1781–1835)
Windsor Castle: The Queen's Ballroom, 1817

Occupying the west side of the Star Building (see no. 400), in the centre of the Queen's State Apartment, the Queen's Ballroom or Gallery lay between the Audience Chamber and the Drawing Room. Its wainscot panelling with carved decoration and ceiling painted by Verrio (with Charles II giving freedom to Europe) survived George III's alterations at the beginning of the nineteenth century. This view, published in 1817, shows the room adorned with four sets of silver furniture of which two sets (including no. 78) survive in the Royal Collection. The central two sets – made for George I's palace of Herrenhausen, near Hanover –

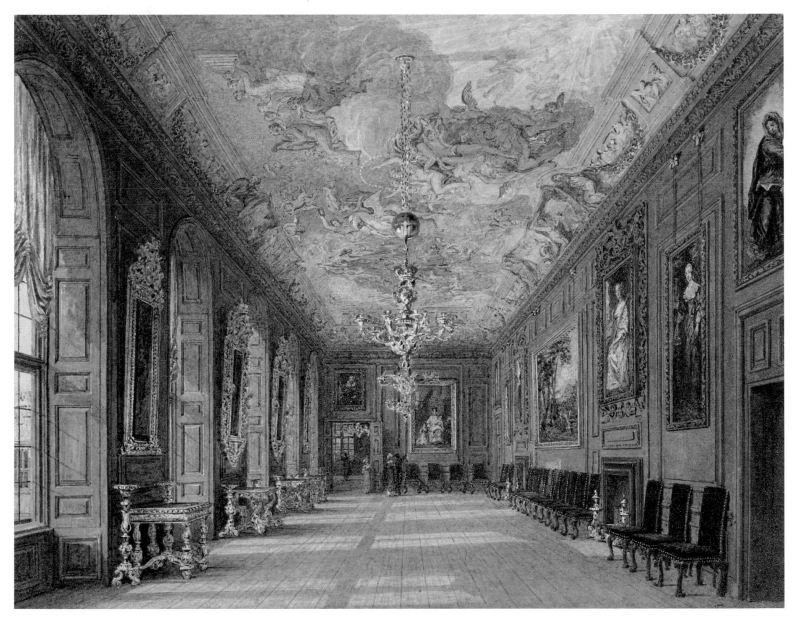

402

together with the four chandeliers in this room and two in the Drawing Room next door, were housed at Windsor during the Napoleonic upheavals but were returned to Hanover shortly afterwards. The tables, mirrors and torchères, which remained at Hanover after the separation of the Crowns in 1837, survive in the collection of the princes of Hanover at Marienburg. The picture hang included some of the Van Dyck portraits which are still in the Queen's Ballroom today, and two full-length portraits: the Ramsay of Queen Charlotte and her two eldest sons and the Copley of three of the princesses (no. 25) opposite (not visible). The room was altered by Wyatville for William IV in the 1830s and is shown in its new state in no. 408. The changes involved the removal of the painted ceiling and most of the wainscot, and the introduction of a single central marble chimneypiece from the Queen's Bedchamber (no. 403) in place of the two chimneypieces shown here.

Watercolour with touches of bodycolour and gum arabic over pencil. 19.8 × 25.2 cm
RL 22101
PROVENANCE (?)George IV
LITERATURE Pyne 1819, I, *Windsor Castle*, opposite p. 99; Oppé 1950, under no. 657; Watkin 1984, pp. 22–3
EXHIBITIONS London/Edinburgh 1991–2, no. A5

403
JAMES STEPHANOFF (1789–1874)
Windsor Castle: The Queen's State Bedchamber, 1818

Situated at the north-western end of Charles II's Star Building (see no. 400), the Queen's State Bedchamber opened westwards towards Queen Elizabeth's Long Gallery and eastwards towards the King's Apartment, to which it was connected by the Queen's Drawing Room. Like all the other rooms in Charles II's new State Apartments it was originally fitted out with painted ceiling, wainscot panelling and ornamental carvings. James Wyatt doubled the size of this room for George III by incorporating an adjacent staircase. In 1805–06 Francis Rigaud was employed to decorate the new part of the ceiling with a painted scheme of Jupiter and Diana, designed to match Verrio's original of Diana and Endymion. As shown by Stephanoff, the room is hung with a selection of Old Masters and the 'Windsor Beauties' by Lely. In the centre of the far (south) end stands the painted chest-of-drawers (no. 84), which was almost certainly acquired by Queen Charlotte. Apart from the lacquer cabinets, the other furnishing of the room acquired for Queen Charlotte probably included

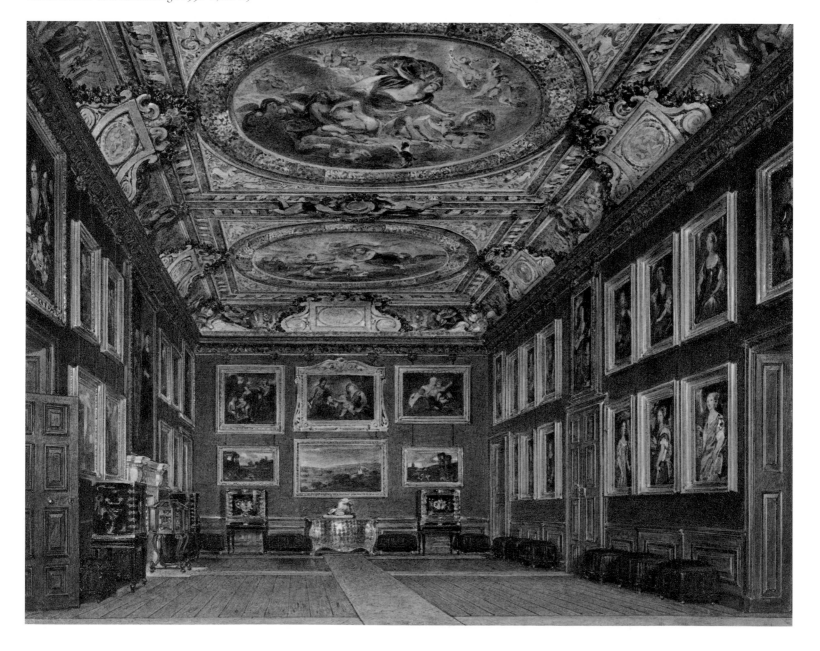

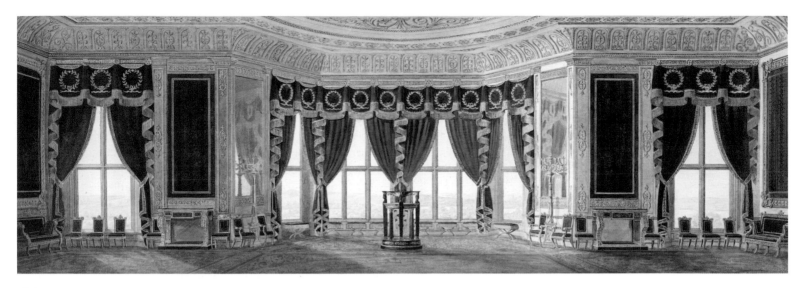

404

a state bed hung with flower embroideries at the northern end of the room (not visible), now at Hampton Court Palace (RCIN 1470). The State Bedchamber became part of the Royal Library during Wyatville's continuing alterations for William IV in the 1830s, at which time the painted ceiling was replaced.

Watercolour with touches of bodycolour and gum arabic over pencil. 20.2 × 25.4 cm
RL 22103
PROVENANCE (?)George IV
LITERATURE Pyne 1819, I, *Windsor Castle*, opposite p. 116; Oppé 1950, under no. 657; Watkin 1984, pp. 20–1

404

MOREL & SEDDON

Windsor Castle: The Crimson Drawing Room (east elevation), c.1827

The partnership between Nicholas Morel and George Seddon was formed in 1827 to supply furniture and upholstery for George IV's new Private Apartments on the east and south sides of the Upper Ward of the castle. These newly created rooms were intended to replace the old State Apartments on the north side of the Upper Ward which had not been in normal use by the royal family since the death of Charles II. As a means of obtaining the King's approval for their proposals, the partners supplied a series of 'miniature designs' showing the intended detail of curtains and upholstery and the disposition of the furniture. These miniature designs, the majority of which have been acquired by Her Majesty The Queen, first appeared at auction in 1970.

The Crimson Drawing Room, looking over the East Terrace Garden towards the Home Park, was the principal reception room in an interconnecting suite created by Sir Jeffry Wyatville within the medieval walls of the castle, on the site of apartments previously occupied by Queen Charlotte and her daughters. The layout of these rooms mirrored a very similar arrangement at Carlton House and many of the fixtures and furnishings for the Crimson Drawing Room at Windsor were taken from its namesake at Carlton House. Great attention and expenditure were lavished on the curtains, passementerie (decorative trimmings) and

wall hangings throughout the new apartments. The material shown in the 'miniature designs' was a striped poppy-coloured velvet, supplied by the mercer W.E. King at a cost of £3 13s. per yard; this was by some margin the most expensive fabric used at Windsor. The intended furniture scheme included four marble and gilt bronze tables by A.-L. Bellangé (RCIN 2415–6), purchased at the Watson Taylor sale in 1825, two of which are shown in no. 404. These were rejected by George IV and in due course reused in the Blue Drawing Room at Buckingham Palace. In the centre of the window bay stood a gilt bronze and marble 'font' (no longer in the Royal Collection), given to George IV by Pope Pius VII in 1816 in recognition of Britain's role in assisting the return to Rome of art treasures looted by Napoleon. Around the walls are shown part of Morel & Seddon's extensive suite of seat furniture (see no. 91).

The Crimson Drawing Room was almost totally destroyed in the fire of 1992 and has since been meticulously restored.

Watercolour and bodycolour over pencil. 31.3 × 90.3 cm
RL 31280
PROVENANCE Sotheby's, London, 9 April 1970 (164); bought by M.D.I.; Sotheby's, London, 15 November 1990 (30); bought by Hazlitt, Gooden & Fox for HM The Queen
LITERATURE Roberts (H.A.) 2001, p. 86

405

MOREL & SEDDON

Windsor Castle: The King's Bedroom (west elevation), 1827

This room formed part of George IV's new private suite in the central area of the east front of the castle. It originally combined the functions of both bedroom and bathroom. The bath itself was concealed beneath an elaborate cabinet inlaid with pietra dura panels (see no. 90), set in a recess on the west wall of the room. The mirror behind was supplied with a built-in oiled blind, presumably to protect it from the effects of steam. The room was loose hung, tent-like, with 'Waterloo blue flowered satin' supplied by the mercer W.E. King at a cost of £1 1s. per yard, trimmed with blue-ground buff and orange brocaded border costing £1

405

per yard. The design of this material, which was also used by Morel & Seddon in the Small (now White) Drawing Room, was copied from silk originally woven by Grand Frères of Lyons in 1823 for the Salon des Princes at the château of Saint-Cloud.

The arrangement of the room was not deemed a success and in 1829 George IV moved his bed to the adjacent room. The bath was moved elsewhere at the same time. After the death of Prince Albert in this room in 1861, the room was preserved by Queen Victoria, its George IV hangings still intact, as a shrine to his memory. With the accession of Edward VII, the room was stripped out and all traces of its previous use were obliterated.

Watercolour over pencil. Sheet size 37.1 × 24.6 cm
RL 18396
PROVENANCE Sotheby's, London, 9 April 1970 (193); bought by Zarach; Sotheby's, London, 23 March 1971 (119); bought by Weinreb; from whom bought by HM The Queen
LITERATURE Roberts (H.A.) 2001, p. 148

406
JOSEPH NASH (1808–1878)
Windsor Castle: St George's Hall, 11 October 1844

When George IV died in June 1830, Wyatville's great project to modernise Windsor was only half complete. The new Private Apartments were ready and in occupation but work on the State Apartments, including St George's Hall, remained unfinished. In creating this enormous new space, Wyatville had demolished the finest part of Charles II's work at the castle, the old St George's Hall and Private Chapel. These two rooms, which lay end-to-end along the north side of the Quadrangle, had in their turn replaced the massive timber-roofed hall and chapel constructed by Edward III in the 1360s and 70s. The loss of these two spectacular Baroque interiors, painted by Verrio and adorned with some of Grinling Gibbons's finest carvings, has frequently been regretted and Wyatville himself was not in favour of throwing the two areas together, fearing that the overall length of the new room would not be in proportion to the height. However, the poor condition of the roof structure in particular convinced George IV that rebuilding was necessary; and he was in any case attracted by the idea of a new and enlarged hall to act as the secular centre of the Order of the Garter.

Wyatville's new hall, decorated in the baronial fashion with the shields of Garter Knights, stained glass and armour, became the regular setting for state banquets, as shown in Nash's view which was made during the State Visit of Louis-Philippe, King of the French, in 1844. On such occasions, at both the east and the west ends of the hall temporary giltwood structures in the Gothic style were erected on which some of George IV's magnificent collection of gold plate was displayed. This was intended to complement the cavalcade of gold on the dining table (including nos 187 and 191), much of which is still in use today on similar occasions.

St George's Hall was very badly damaged in the 1992 fire. During the restoration, Wyatville's roof of oak-grained plaster was replaced by a more steeply pitched construction of green oak, designed by Giles Downes, and at the same time a modern Gothic oak screen was installed at the east end.

Watercolour and bodycolour with touches of gum arabic over pencil. 37.6 × 31.0 cm
RL 19791
PROVENANCE Commissioned by Queen Victoria (£25)
LITERATURE Nash (Jos.) 1848, pl. 9; Millar (D.) 1995, no. 3984
EXHIBITIONS Edinburgh/Aberdeen/Manchester/Windsor 1991–4, no. 2; Edinburgh/Kendal/Bath, 1998–9

407
JOSEPH NASH (1808–1878)
Windsor Castle: The Waterloo Chamber, 5 June 1844

The genesis of the idea for a 'Waterloo Gallery' goes back to George IV's earliest plans for rebuilding Windsor, evolved during discussions with his principal artistic adviser Sir Charles Long, later Lord Farnborough. In Jeffry Wyatville's various schemes for the Upper Ward of the castle, submitted in 1824, provision was made for such a space in a number of alternative locations, but the room was not created until the 1830s, during the reign of George IV's brother and successor William IV. The

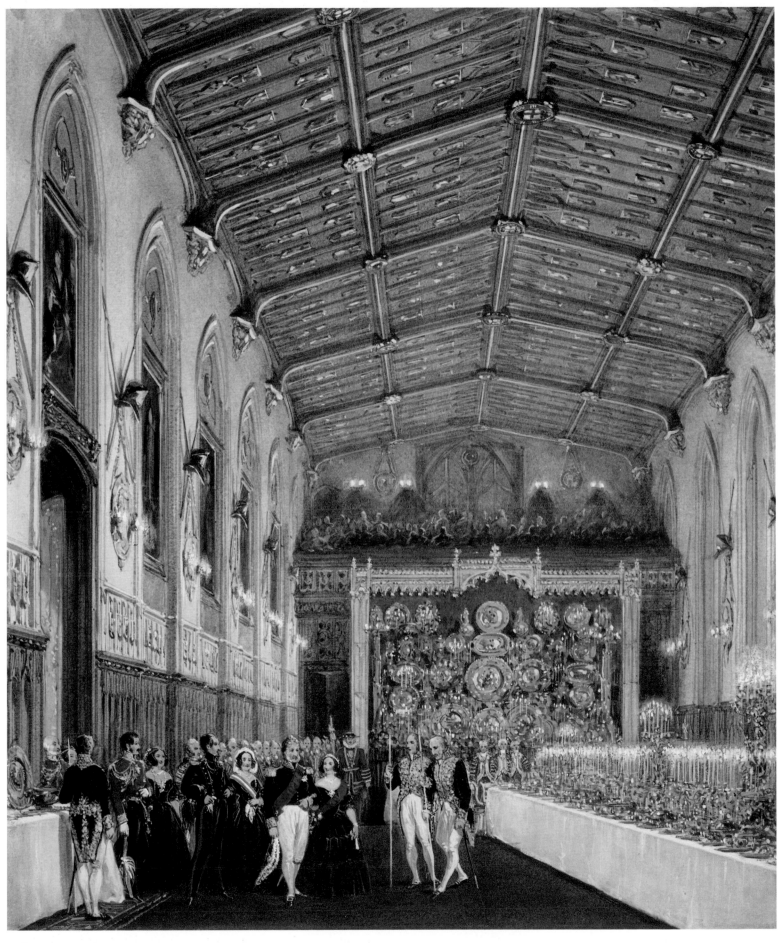

406

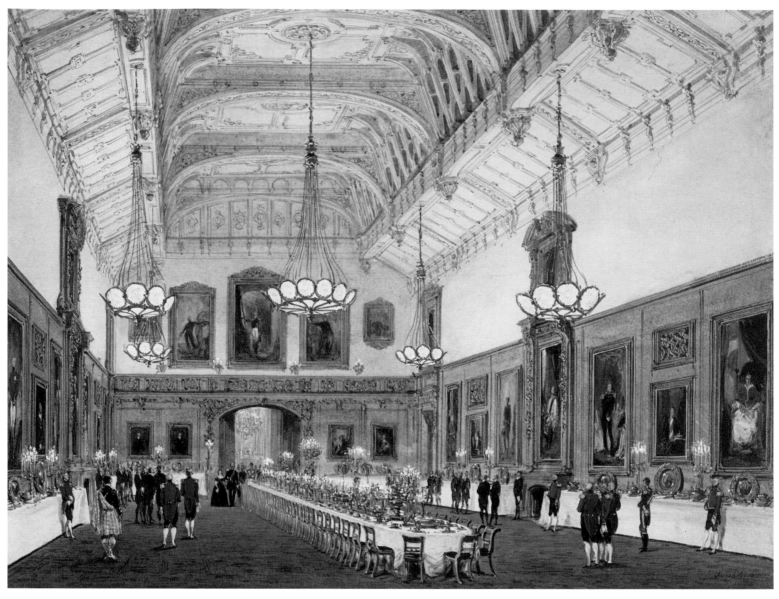

407

new room, with its pierced and fretted timber ceiling and panelled walls embellished with Gibbons carvings (salvaged from the former chapel), occupies the central area of the building on the north side of the Upper Ward. It was constructed in what had hitherto been an open space known as Horn Court. The series of full- and half-length portraits by Sir Thomas Lawrence, for the display of which the room was created, was begun as early as 1814 when George IV had formed the idea of commissioning Lawrence to paint the allied sovereigns, military commanders and statesmen most closely associated with the overthrow of Napoleon. This great project, delayed by the escape of Napoleon from Elba, was resumed in 1815 after the victory of the allied forces at the Battle of Waterloo. Between 1818 and 1820 Lawrence travelled round Europe to complete the series, which included his masterpiece, *Pius VII* (no. 28). Further embellishment of the upper walls (which are shown plain in this drawing) and of the roof was undertaken by the decorating firm of J.G. and J.D. Crace in 1860.

Wyatville's remodelling of the State Apartments had created a series of rooms very well suited to the elaborate rituals of a State Visit and from the 1840s Queen Victoria put them to regular use for this purpose (see also no. 411). To left of centre in no. 407 Queen Victoria leads the

Emperor Nicholas I of Russia in to dinner, in the course of his State Visit (see no. 137). The larger rooms, including the Waterloo Chamber, continue to be used in this way to the present day.

Watercolour and bodycolour over pencil. 28.2 × 36.8 cm
Signed and dated *Joseph Nash 1844*
RL 19785
PROVENANCE Commissioned by Queen Victoria (£17 10s.)
LITERATURE Nash (Jos.) 1848, pl. 8; Millar (D.) 1995, no. 3978
EXHIBITIONS Brighton 1981, no. N26

408
JOSEPH NASH (1808–1878)
Windsor Castle: The Queen's Ballroom (Van Dyck Room), 1846

The room, recorded by Charles Wild in 1817 (see no. 402), is shown here with the geometrically patterned plaster ceiling, silk-hung walls and central chimneypiece introduced by Wyatville in the 1830s. The dense hang of pictures by Van Dyck includes the equestrian portrait of Charles I

(no. 11) at the north end. Thematic arrangements of this type, which survive to this day in several rooms of the castle (including the Ballroom), were instigated in George III's reign. Prince Albert continued this style of arrangement as part of his methodical reorganisation of the paintings in the Royal Collection.

Watercolour and bodycolour over pencil. 32.5 × 47.5 cm
Signed and dated *Joseph Nash 1846*
RL 19787
PROVENANCE Bought from Sawyer, 1934
LITERATURE Nash (Jos.) 1848, pl. 4; Millar (D.) 1995, no. 3993
EXHIBITIONS Brighton 1990, no. 75; London/Edinburgh 1991–2, no. A6

409
JOSEPH NASH (1808–1878)
Windsor Castle: The angle of the Grand Corridor, 1846

The Grand Corridor, constructed by Wyatville on the east and south sides of the Upper Ward between 1824 and 1828, was George IV's most extensive and novel addition to the castle. It was 137 metres long and 4.6 metres broad, providing a new means of access to the adjacent royal and visitors' apartments and, more significantly, a place for the King to display some of the choicest paintings, furniture and *objets d'art* in his collection. It has remained little changed to this day.

The views of the Corridor by Joseph Nash (see also no. 410), painted eighteen years after it was completed, provide the earliest visual evidence of George IV's decorative scheme and arrangement of contents. The latter was devised with the help of two of the King's favourite artists, the painter Sir David Wilkie and the sculptor Sir Francis Chantrey. The sculpture – chiefly busts – was chosen to commemorate British monarchs (see nos 63, 68, 74), historical personages (see nos 60, 61), friends and contemporaries. The paintings included a magnificent group of Venetian views by Canaletto, Zuccarelli and the Riccis, purchased from Consul Smith by George III; some of Frederick, Prince of Wales's hunting pictures by Wootton; and a selection of late eighteenth- and early nineteenth-century portraits. The picture frames were either specially made or carefully adapted to suit this new setting. The furniture included an outstanding group of Boulle (see nos 96, 99), a number of clocks (no. 100), several examples of English giltwood (no. 80), oriental lacquer, Indian ebony chairs, and modern oak stools and benches in the Gothic style (designed by A.W.N. Pugin), together with a rich selection of cabinet bronzes and *objets d'art* (nos 69–71).

The decoration, carried out by Morel & Seddon (see no. 404), included the provision of forty-one pairs of curtains made of red and cream 'English tapestry' (also used on the seat furniture), a red Gothic-pattern carpet and forty-nine yellow scagliola pedestals for the busts. Lighting was provided by forty-two gilded iron torchères in the Gothic style, also designed by the younger Pugin. The richness of the contents

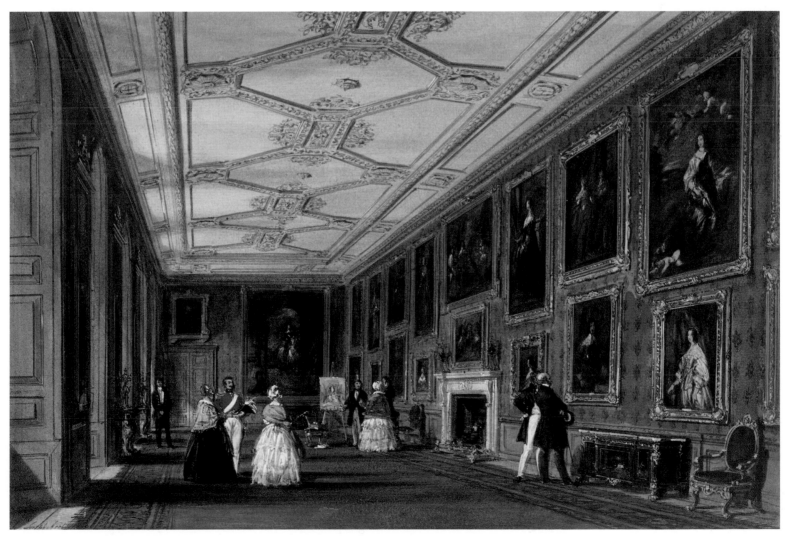

408

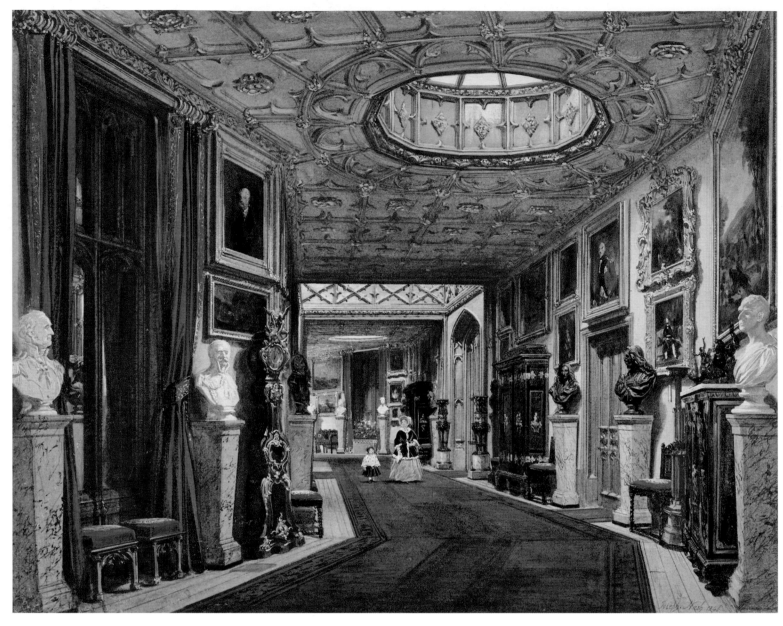

409

made – and continues to make – a striking contrast with Wyatville's restrained Gothic detailing, which suggests something of the character of a Tudor long gallery.

Watercolour and bodycolour over pencil. 33.0 × 41.5 cm
Signed and dated *Joseph. Nash. 1846*
RL 19781
PROVENANCE Leggatt Bros; from whom bought by HM Queen Elizabeth The Queen Mother, 1943
LITERATURE Nash (Jos.) 1848, pl. 14; Millar (D.) 1995, no. 3988
EXHIBITIONS London/Edinburgh 1991–2, no. A7

410
JOSEPH NASH (1808–1878)
Windsor Castle: The east section of the Grand Corridor, 1846

See no. 409. Clearly visible in this arrangement of the Corridor are the giltwood table attributed to Thomas Pelletier (no. 80), the pair of medal-cabinets (no. 99) and the three models of triumphal arches (nos 69–71).

Watercolour and bodycolour with touches of gum arabic over pencil. 32.5 × 41.4 cm
Signed and dated *Joseph Nash 1846*
RL 19783
PROVENANCE R. Haworth, Blackburn; from whom bought by Queen Mary, 1928
LITERATURE Nash (Jos.) 1848, pl. 15; Millar (D.) 1995, no. 3989

411
JAMES ROBERTS (c.1800–1867)
Windsor Castle: The King's State Bedchamber, 1855

Lying on the north side of the Star Building in the Upper Ward of the castle (see no. 400), the King's Bedroom was one of the eight rooms in the King's State Apartment created by Hugh May for Charles II in the late 1670s.

The original ceiling painting by Verrio, portraying Charles II in triumph, was replaced by Wyatville in the 1830s with a plaster ceiling modelled with heraldic devices, and an eighteenth-century white marble chimneypiece from Buckingham House was introduced. Further changes took place in 1854–5 when, at Queen Victoria's wish, the King's and

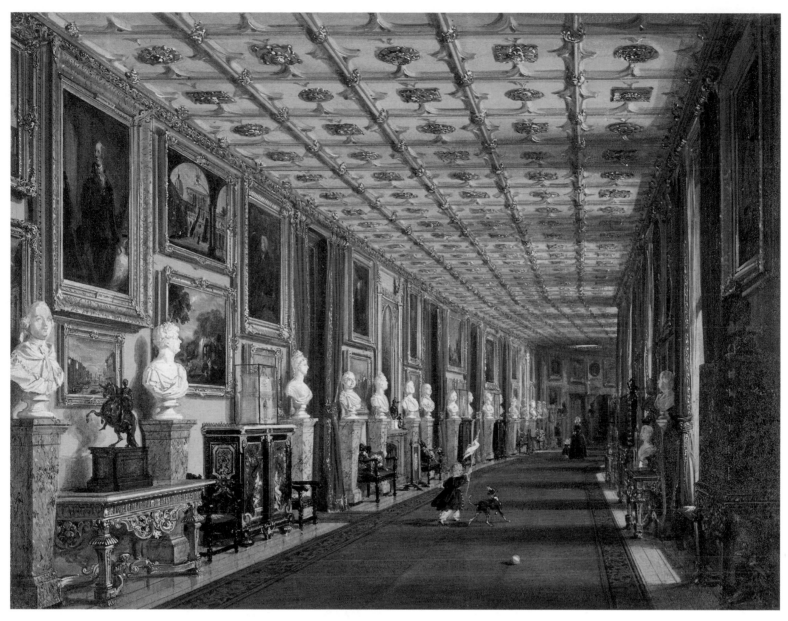

410

Queen's State Apartments were elaborately redecorated and refurnished by the firm of J.G. and J.D. Crace for the visit of the Emperor Napoleon III and the Empress Eugénie. The Craces introduced luxurious new silk for walls, curtains and upholstery; new fitted carpets and new gilding and colouring in the ceilings. For the Empress's bedroom (no. 411), red walls and carpet were complemented by new green and purple silk (the imperial colours) for the bed hangings; and these were enriched with panels of late eighteenth-century embroidered flowers probably taken from the throne canopy in George III's Audience Room nearby. The bed itself, attributed to Georges Jacob, was almost certainly acquired for Carlton House by George IV through Dominique Daguerre and was transferred to Lady Conyngham's bedroom at Windsor after refurbishment by Morel & Seddon in 1827. Among the paintings introduced to the room when it was adapted for the use of the Empress was the Claude View of the Campagna (no. 12); the Riesener commode of French royal provenance (no. 104) was moved to the room at the same time.

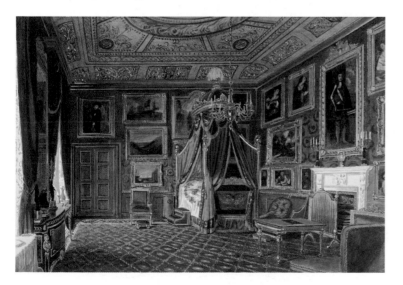

411

Watercolour and bodycolour with gum arabic. 26.0 × 36.3 cm
RL 19796
PROVENANCE Commissioned by Queen Victoria (£12)
LITERATURE Millar (D.) 1995, no. 4616
EXHIBITIONS Brighton 1990, no. 77; Edinburgh/Aberdeen/Manchester/Windsor 1991–4, no. 5

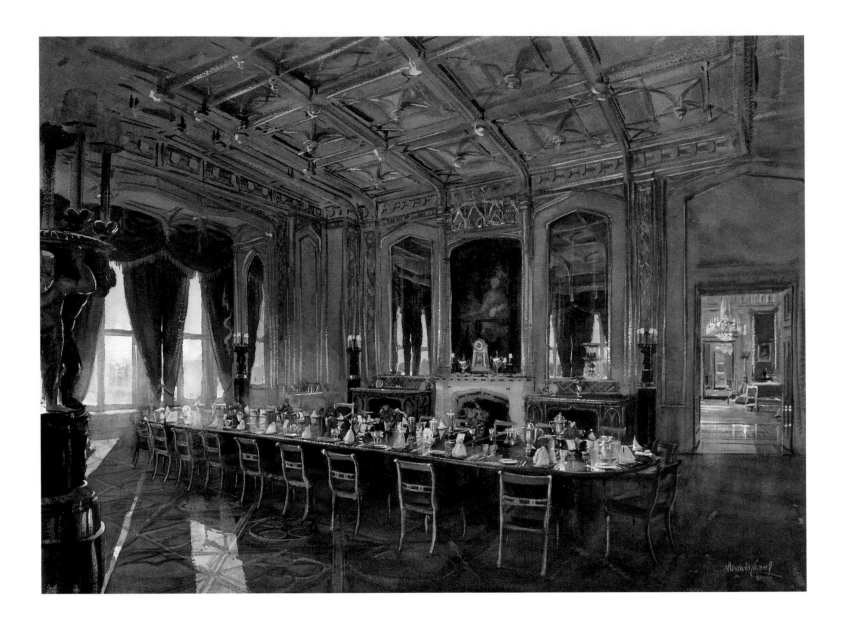

412

ALEXANDER CRESWELL (b. 1957)
Windsor Castle: The State Dining Room, 1998

The fire at Windsor broke out in the morning of 20 November 1992 and was finally extinguished fifteen hours later. One hundred and fifteen rooms were destroyed or very badly damaged by the fire and over a million gallons of water were pumped into the fabric of the building. The process of clearing, drying out, rebuilding and redecorating the damaged structure was completed exactly five years later, in time to mark the Golden Wedding anniversary of Her Majesty The Queen and the Duke of Edinburgh.

Alexander Creswell, who specialises in architectural watercolours, was commissioned to record the principal rooms as they were in the aftermath of the fire early in 1993, and again in 1998 when the restoration was complete. The two series of Creswell views contain eleven and ten drawings respectively. The State Dining Room, contained in the Prince of Wales's Tower at the north-east corner of the Upper Ward, was among the most seriously damaged rooms. After the fire nothing remained of the elaborate plaster decoration in the Gothic style, introduced by Wyatville for George IV in the late 1820s. However, with the exception of the large sideboard at the west end of the room, the furniture made for the room – by Morel & Seddon, to the designs of A.C. and A.W.N. Pugin – had survived, and the decision was therefore taken to put the room back to its original appearance. This work was supervised by Donald Insall & Partners. At the same time new and richly decorated curtains were made, to the designs of Pamela Lewis, in order to re-create the sumptuous effect originally intended by George IV, and a new carpet was woven to the original pattern.

The room is shown prepared for one of the lunches given by Her Majesty The Queen in June at the time of the Royal Ascot race meeting.

Watercolour and bodycolour over pencil. 56.0 × 76.0 cm
RL 33494
PROVENANCE Commissioned by HM The Queen
LITERATURE Creswell 2000, p. 25
EXHIBITIONS Windsor 2000

BUCKINGHAM PALACE (nos 413–420)

413
CHARLES WILD (1781–1835)
Buckingham House: The Blue Velvet Room, 1817

Buckingham House was built c.1702–05 by John Sheffield, Duke of Buckingham, probably to the designs of William Talman. After its purchase by George III in 1762, the King occupied the ground floor and Queen Charlotte the first floor. The principal enfilade of the Queen's rooms overlooked the west or garden front. From 1762 to 1768 the Blue Velvet Room, in the south-west corner of the apartment, functioned as the Queen's bedroom; thereafter until about 1812 it served as the Queen's dressing room. With the confirmation of the Regency by Parliament in that year, Queen Charlotte was given her own establishment at Buckingham House and her apartment was redecorated and refurnished in the style of the day, with brighter and richer colours, new curtains, carpets and upholstery and bolder gilding. This is the period represented in the views of Buckingham House, published by W.H. Pyne

shortly before the total transformation of the building undertaken by John Nash for George IV (see also no. 414). In the course of this work, Nash swept away the Queen's rooms, including the Blue Velvet Room, to form the nucleus of the new Picture Gallery (no. 420).

The Blue Velvet Room, furnished with light blue silk for the walls and deeper blue velvet for the curtains and the upholstery of the elegant gilt-wood chairs, may have continued in use as a dressing room for the Queen, although the 'dressing table' below the pier glass, flanked by a pair of 'King's Vases' (no. 86) on torchères, is unusually high and the arrangement of the furniture suggests a different, less intimate use. The Boulton vases may well have remained in the Queen's rooms from the time they were delivered in 1771; it was the chimneypiece of her bedroom that Queen Charlotte had been particularly anxious to garnish with a selection of Boulton's wares. The fitted geometrically patterned blue and buff carpet with matching hearth rug indicates the Queen's personal taste for comfort and warmth, one not shared by George III who generally disapproved of carpets as injurious to health. Most of the pictures, which include among the group of landscapes Claude's *View of the Campagna* (no. 12), were transferred from the King's dressing room on the floor below.

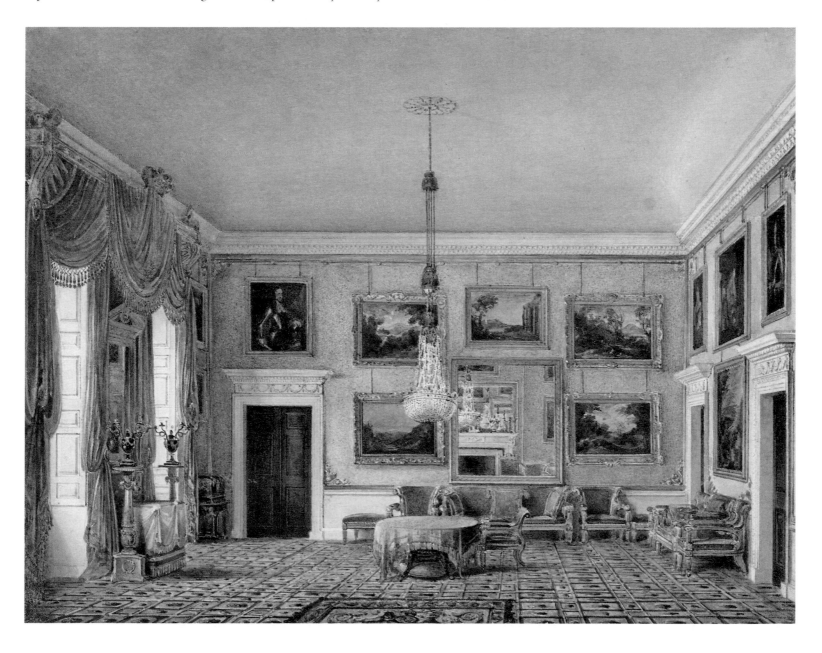

Watercolour and bodycolour over pencil. 19.6 × 24.9 cm

RL 22144

PROVENANCE (?)George IV

LITERATURE Pyne 1819, II, *Buckingham House*, opposite p. 18; Oppé 1950, under no. 657; Watkin 1984, p. 87; Jackson-Stops 1993, pl. X

EXHIBITIONS QG 1974–5, no. 176

414
JAMES STEPHANOFF (1789–1874)
Buckingham House: The Crimson Drawing Room, 1817

The Crimson Drawing Room lay at the centre of the west front on the first floor of Buckingham House, opening eastwards into the Saloon (where Queen Charlotte's throne and canopy can be seen through the open doors in no. 414). In the early eighteenth century the room was lined with lacquer panels, which Queen Charlotte moved in 1763 into the adjacent Breakfast Room, where they were refitted by William Vile. The neo-classical ceiling, designed by Robert Adam and painted by G.B. Cipriani, was also introduced in the 1760s, as were the doorcases. The

latter were designed by George III himself and were incorporated in the alterations at Buckingham House under the direction of the King's former architectural tutor, now his chief architect, Sir William Chambers (Chambers 1996, pp. 48–9, fig. 69). Originally hung with red damask, the room had been updated (like the Blue Velvet Room, no. 413) by the time Stephanoff's view was drawn. Probably around 1812, the walls were rehung with crimson satin and new giltwood seat furniture, matching that in the Blue Velvet Room, was introduced. The pictures included the Van Dyck *St Martin dividing his cloak* and the Studio of Rubens *Equestrian portrait of Philip II*, both of which had been moved up from the King's rooms below as part of the modernisation of the Queen's rooms. On the chimneypiece can be seen the 'King's Clock' by Matthew Boulton (see no. 87), together with a further pair of vases, perhaps also by Boulton.

Watercolour and bodycolour over pencil. 20.3 × 25.3 cm

RL 22142

PROVENANCE (?)George IV

LITERATURE Pyne 1819, II, *Buckingham House*, opposite p.14; Oppé 1950, under no. 657; Jackson-Stops 1993, fig. 1, pl. VI

EXHIBITIONS QG 1974–5, no. 175

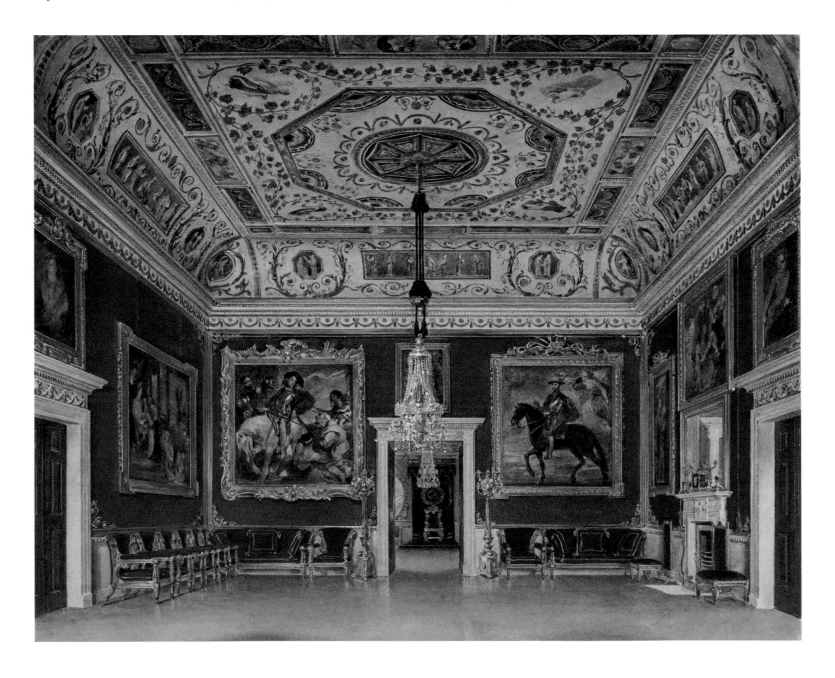

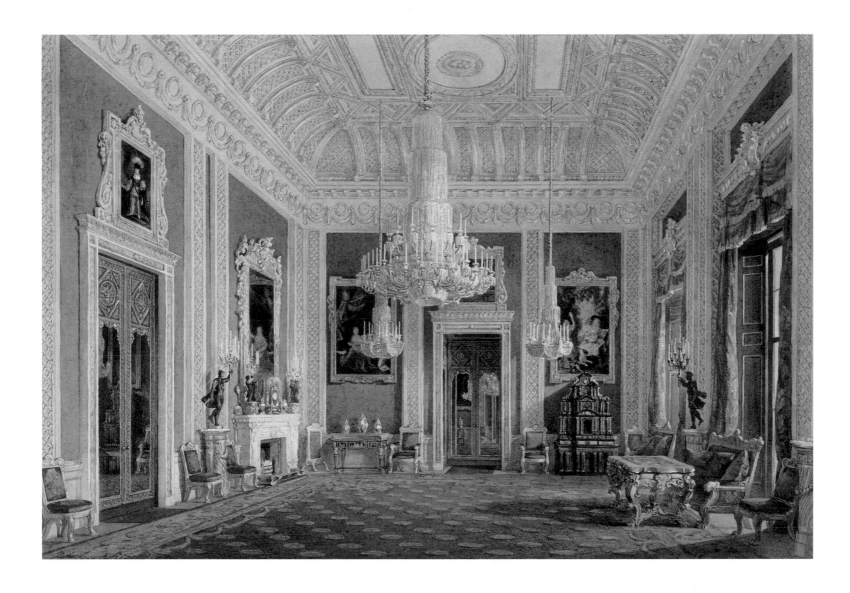

415
DOUGLAS MORISON (1814–1847)
Buckingham Palace: The Green Drawing Room, 1843

This was originally the Duchess of Buckingham's Saloon, the largest room on the first floor of old Buckingham House, in the centre of the east (entrance) façade. Under the direction of Sir William Chambers in the early 1760s it was remodelled for Queen Charlotte. These alterations included the introduction of a new painted ceiling, possibly designed by James 'Athenian' Stuart, and a marble chimneypiece (now in the Queen's Presence Chamber at Windsor) designed by Robert Adam. At this date, the principal decoration consisted of the celebrated Raphael Cartoons, brought for the purpose from Hampton Court Palace. When the cartoons were removed to Windsor in 1787, the room was redecorated with *trompe-l'oeil* friezes and pilasters, a scheme which survived unaltered (except for the introduction of a throne and canopy for Queen Charlotte during the Regency) until the room was remodelled once more by John Nash for George IV. Apart from the introduction of a new richly modelled plaster ceiling, Nash's main structural alteration involved the replacement of Adam's chimneypiece on the north wall with a doorway leading to the Throne Room and the creation of a matching new doorway opposite, leading to the staircase.

The decoration and arrangement of the room, carried out in the main in the early 1830s under the supervision of Lord Duncannon, Chief Commissioner of the Office of Woods and Forests, included the provision of green silk hangings, made in Ireland at Queen Adelaide's suggestion, and an Axminster carpet woven in tones of russet and gold with the national emblems. To the right of the door leading to the Throne Room may be seen Copley's *Three youngest daughters of George* III (no. 25); prominent among the furniture are the chairs and sofas by Morel & Seddon, part of the very large set originally made for the Crimson and White Drawing Rooms at Windsor (no. 91).

Watercolour and bodycolour over pencil. 27.6 × 40.2 cm
Signed and dated *Douglas Morison* 1843
RL 19899
PROVENANCE Commissioned by Queen Victoria (15 gns)
LITERATURE Millar (D.) 1995, no. 3938
EXHIBITIONS London 1844, no. 223

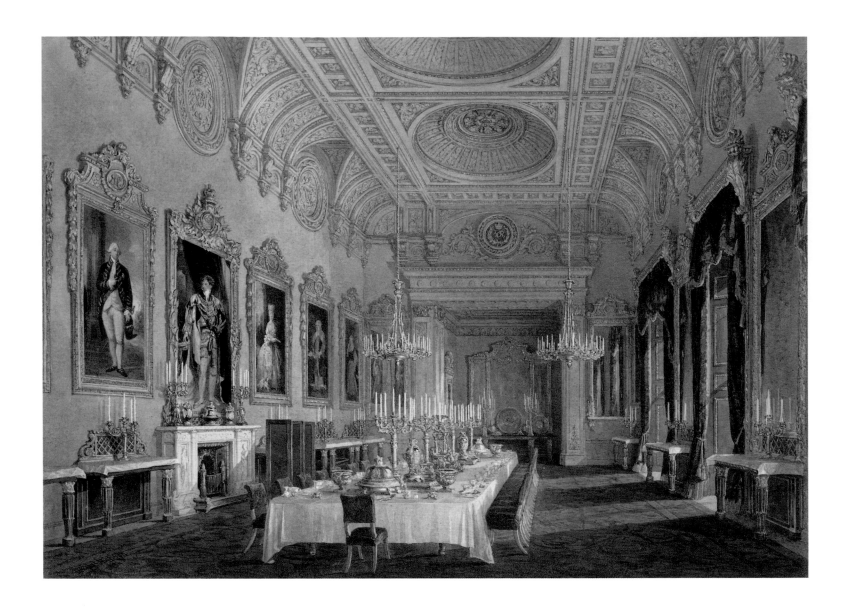

416

DOUGLAS MORISON (1814–1847)

Buckingham Palace: The State Dining Room, 1843

In John Nash's plans for the palace, the south end of the new Picture Gallery on the first floor was intended to open into a music room, mirroring an identical arrangement on the floor below where the Marble Hall was designed to open into a dining room. Although the new Music Room (and the Dining Room below) were well advanced at the time of Nash's dismissal in 1830, Nash's successor Edward Blore was asked by William IV to provide a new State Dining Room on the first floor, linked directly to the enfilade of new rooms constructed by Nash on the west (garden) front of the palace. This decision entailed taking down and rebuilding the Music Room as a dining room on a new site approximately 6 metres further west. Building work was carried out in 1833–4, but the decoration and fitting-out of the room continued into the early years of Queen Victoria's reign. The picture hang in the new room, which dates from *c*.1840, included Gainsborough's full lengths of George III and Queen Charlotte (replaced in 1950 with Ramsay's State Portraits of the same sitters) and the same artist's portraits of the Duke and Duchess of Cumberland, bequeathed to the future William IV by the Duchess of Cumberland in 1808. In the first fifteen years of her reign,

Queen Victoria used the State Dining Room for dinners for up to sixty guests, often in connection with a ball. On such occasions, the table and buffet at the south end were used for magnificent displays of gold plate, much of it from George IV's enormous collection (nos 188, 191), supplemented on occasions by pieces that the Queen and Prince Albert had acquired themselves. The buffet arrangement was swept away in the early 1850s to make a route through to the new Ballroom, designed by Sir James Pennethorne and built by Thomas Cubitt under Prince Albert's direction. Thereafter this enormous room took the place of the Picture Gallery for large entertainments (see no. 420).

Watercolour and bodycolour over pencil. 27.2 × 38.1 cm

Signed and dated *Douglas Morison. / 1843*

RL 19898

PROVENANCE Commissioned by Queen Victoria (12 gns)

LITERATURE Millar (D.) 1995, no. 3940

EXHIBITIONS London 1844, no. 232; London 1981, no. 376; Edinburgh/ Aberdeen/Manchester/Windsor 1991–4, no. 8

417

DOUGLAS MORISON (1814–1847)
Buckingham Palace: The Private Chapel, 1843/4

Built by John Nash in the 1820s as one of two matching conservatories on the west (garden) side of the palace, this temple-like structure with a framework of cast iron was converted in 1842–3 by Edward Blore into a private chapel with seating for about two hundred. An earlier attempt to provide Queen Victoria with a chapel in the shell of George III's Octagon Library had proved unsatisfactory. The light blue and gold decorative scheme in the new chapel was introduced under Prince Albert's direction. The ceiling was later altered by Pennethorne to include a raised central lantern. On 13 September 1940 the chapel was destroyed in a German bombing raid, one of nine 'hits' suffered by Buckingham Palace during the Second World War. Originally King George VI had wanted the chapel rebuilt, but in view of the post-war building restrictions and the many other calls on funds, this plan was shelved. A new scheme, devised by the Duke of Edinburgh, to convert the chapel into an art gallery open to the public – while leaving a small part of the original private chapel in use – evolved under the direction of Lord Plunket in the late 1950s and the original Queen's Gallery was opened to the public on 25 July 1962. In the new Queen's Gallery the space shown in no. 417 has been reworked as the Nash Gallery and the private chapel has been relocated within the south-eastern part of the palace.

Watercolour and bodycolour over pencil. 27.7 × 39.6 cm
RL 19912
PROVENANCE Commissioned by Queen Victoria (12 gns)
LITERATURE Millar (D.) 1995, no. 3942

418

JAMES ROBERTS (c.1800–1867)
Buckingham Palace: The Pavilion Breakfast Room, 1850

Queen Victoria was the first sovereign to occupy the newly rebuilt Buckingham Palace. She soon found it inconveniently planned and lacking in space for her growing family and in 1845 she pressed her Prime Minister, Sir Robert Peel, to do something about it as a matter of urgency. In 1846 work started on the new East Wing, using Thomas Cubitt as contractor and Edward Blore as architect, under the close personal supervision of Prince Albert and the six parliamentary commissioners appointed by Peel. The cost of the new work, estimated at about £150,000, was to be offset by the sale of Brighton Pavilion and was to be further reduced by the incorporation into the new wing of many of the fixtures, fittings and furnishings which had been removed from Brighton. Three rooms at first-floor level were destined to receive the principal chinoiserie decorations removed from Brighton, of which the Pavilion Breakfast Room in the north-east corner (now known as the

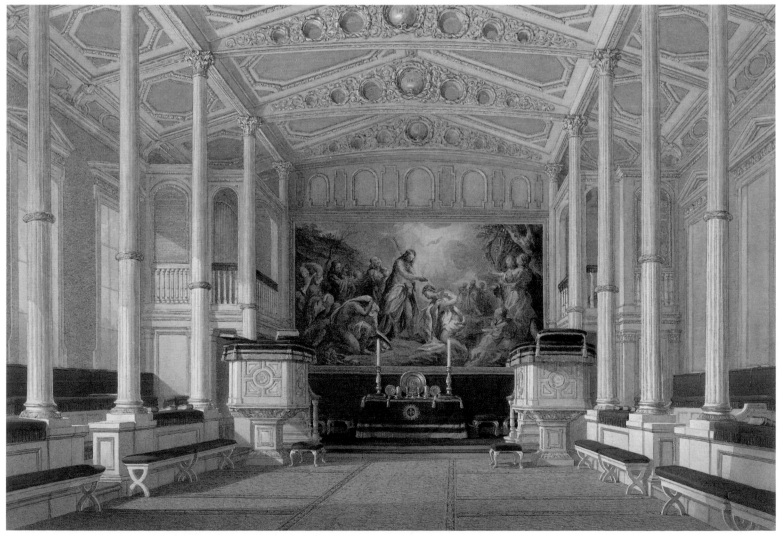

417

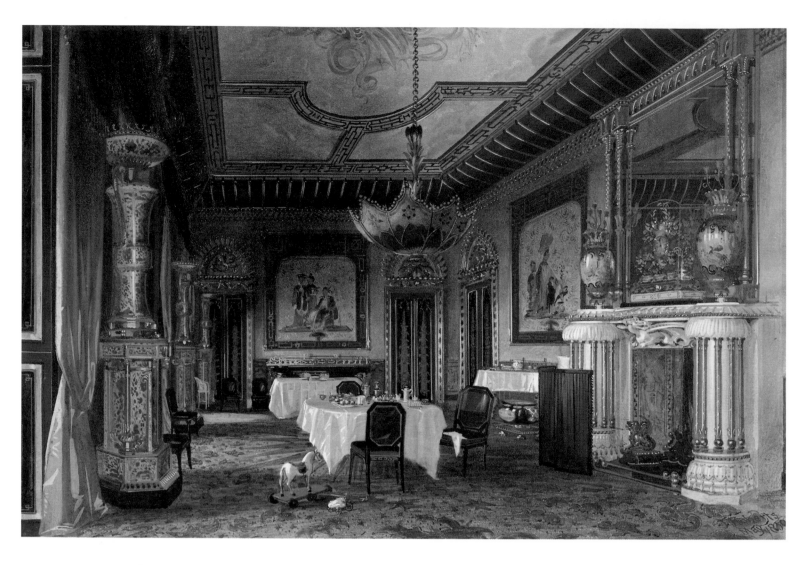

Chinese Dining Room) was the first to be completed, in June 1849. From the Music Room at Brighton (no. 427) came four from a set of eight Chinese porcelain vases on Spode bases, a painted glass lily chandelier and a spectacular marble chimneypiece carved by Richard Westmacott. On the chimneypiece stand a pair of Chinese porcelain candelabra vases, also from the Music Room, flanking the 'Kylin' clock (no. 316) from the Saloon (no. 425). Around the walls are paintings by Robert Jones and beneath them sideboards made by Bailey & Sanders. These and the set of dining chairs came from the Banqueting Room.

Watercolour and bodycolour with gum arabic. 25.6 × 38.0 cm
Signed and dated JRoberts / May 1850
RL 19918
PROVENANCE Commissioned by Queen Victoria (7 gns)
LITERATURE Millar (D.) 1995, no. 4609
EXHIBITIONS Brighton 1981, no. N27; London 1983–4c;
Edinburgh/Aberdeen/Manchester/Windsor 1991–4, no. 11

419
JAMES ROBERTS (c.1800–1867)
Buckingham Palace: The Yellow Drawing Room, 1855

Like the Chinese Dining Room (no. 418), the Yellow Drawing Room was intended to contain some of the more extravagant fixtures and

fittings from Brighton Pavilion. It occupies the south-east corner of Blore's new wing at first-floor level, looking out over the forecourt and interconnecting with the adjoining suite of visitors' bedrooms and dressing rooms. The magnificent chimneypiece, designed by Robert Jones, came from the Saloon at Brighton (no. 425), as did the pair of mounted Chinese celadon candelabra on it. The 'Rock Clock' however was originally in the Music Room at Brighton (no. 427), as were the pair of Chinese porcelain pagodas on Spode bases, matching a larger set of four

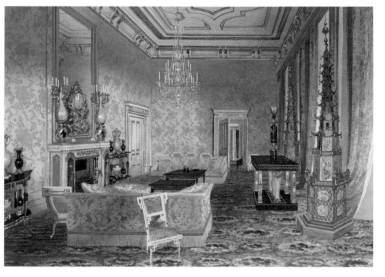

419

(see no. 317). Either side of the chimneypiece stand a pair of chinoiserie tables, one French, c.1780 and originally from the Chinese Room at Carlton House, the other an English copy made by Edward Bailey in 1819 for the Music Room Gallery at Brighton. From the Banqueting Room Gallery came the set of chairs by Bailey & Sanders, and from the Banqueting Room itself came the Spode lamp in the far corner. Between the pagodas stands a centre table with pietra dura top made by Morel & Seddon for the Crimson Drawing Room at Windsor.

The Yellow Drawing Room was redecorated and hung in richly figured yellow silk for the State Visit of the Emperor Napoleon III and the Empress Eugénie in 1855. The imperial couple spent three days at Windsor (see no. 411) before moving on with Queen Victoria for a further three days at Buckingham Palace. In the years after the First World War, Queen Mary rearranged the room and installed a fine early nineteenth-century Chinese wallpaper that she had discovered in store. Today the room is frequently used by Her Majesty The Queen and other members of the Royal Family for portrait sittings.

Watercolour and bodycolour over pencil. 27.4 × 38.0 cm
Signed and dated Js Roberts / 1855
RL 19924
PROVENANCE Commissioned by Queen Victoria (7 gns)
LITERATURE Millar (D.) 1995, no. 4612
EXHIBITIONS Edinburgh/Aberdeen/Manchester/Windsor 1991–4, no. 13

420
LOUIS HAGHE (1806–1885)
Buckingham Palace: The Picture Gallery, 28 June 1853

When George IV decided to make Buckingham House into a state palace, one of the stipulations was that his architect John Nash should provide a suitable gallery, particularly for his larger pictures. The drawback of Carlton House had been that it possessed no room large enough for big pictures; and even Wyatville's new gallery at Windsor, the Grand Corridor (nos 409, 410), could only hold pictures of a relatively modest size. At Buckingham Palace, Nash contrived an enormous new space by throwing together all of Queen Charlotte's suite of rooms on the west side of old Buckingham House to create a gallery over 45 metres in length, top-lit by two rows of glazed saucer domes running down either side. The sub-divided central lantern was added by Blore in the 1830s and altered by Pennethorne in the 1850s. Until the building of the new Ballroom in the early 1850s, the Picture Gallery served as the setting for state banquets and large official or family gatherings. On such occasions the table was laid (as for banquets today) with silver gilt from George IV's collection; for Prince Leopold's Christening Banquet held on 28 June 1853, the Rundell shell tureens (no. 189) were in use.

The picture hang in the new Gallery, established by Prince Albert early in Queen Victoria's reign, combined large and small paintings in

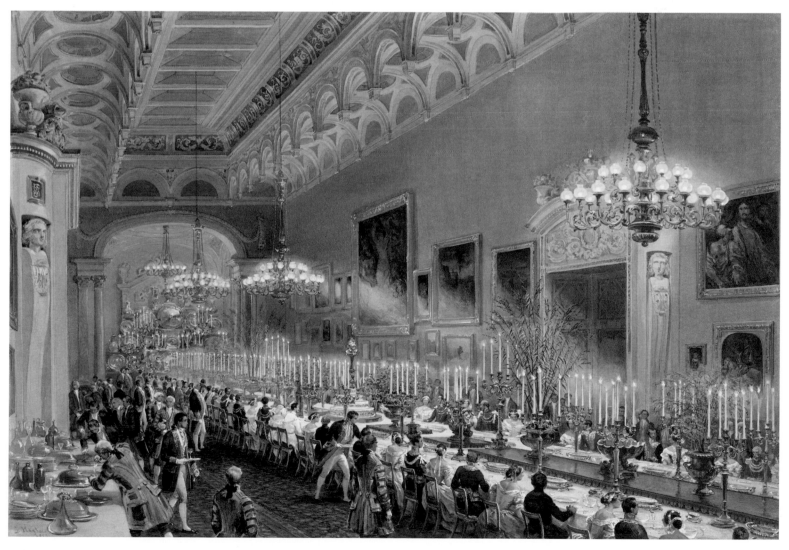

420

anything up to four rows, drawn mainly from George IV's incomparable collection of British, Dutch and Flemish genre pictures, but also including portraits by Reynolds and Zoffany's *Tribuna* (no. 24). By 1851, most of the British paintings had been removed and the arrangement made more uniform and permanent by the provision of matching gilt composition frames. Since the death of Queen Victoria, hanging styles have varied greatly, ranging from the density of Edward VII's rearrangement to the sparser hang characteristic of the late twentieth century. The wall treatment has been equally varied. In the 1840s the Gallery was hung with yellow silk; by 1853 a violet or dove-coloured paint was in use; and in 1914, when the roof was entirely remodelled and other alterations made, the walls were changed to green silk. In modern times a pink flock paper has been in use. (See also pp. 29–30.)

Watercolour and bodycolour over pencil. 33.0 × 47.4 cm
Signed and dated *L. Haghe. / 1853*
RL 19917
PROVENANCE Commissioned by Queen Victoria (£40)
LITERATURE Noble 1993, pp. 102–03; Millar (D.) 1995, no. 2347
EXHIBITIONS Edinburgh/Aberdeen/Manchester/Windsor 1991–4, no. 12; Berlin 1997, no. I/47; Edinburgh/Kendal/Bath 1998–9

CARLTON HOUSE (nos 421–424)

421
CHARLES WILD (1781–1835)
Carlton House: The Blue Velvet Room, 1816

Like most of the rooms at Carlton House, the Blue Velvet Room and the adjoining Closet (no. 422) underwent a considerable number of changes of decoration and nomenclature from the time that George IV took up residence in 1783 to the time he abandoned the house to the demolition contractors in 1826. The two rooms lay next door to each other on the south (garden) side of the principal floor, at the beginning of a series of six interconnecting reception rooms facing St James's Park. In nos 421–2, painted for Pyne's *Royal Residences*, Wild recorded both rooms in their final incarnation, by which time the larger room – the Blue Velvet Room – was generally in use by the Prince Regent as an audience room. The Garter blue velvet panels on the walls were installed c.1806 under the direction of the decorator Walsh Porter. Enrichments to the gilt frames round the velvet were added between 1811 and 1814 by Edward Wyatt and Fricker & Henderson. Seat furniture, upholstered in blue and gold fleur-de-lis satin, was supplied in 1812 by Tatham & Co., who also provided Brussels carpets of the same pattern in 1813. Other alterations included the installation in 1810 of the Vulliamys' white marble chimneypiece, originally made for the adjacent Bow Room. This, together with many of the carved ornaments, was reused by Wyatville at Windsor in the late 1820s. In the centre of the room stood a magnificent desk by Tatham, probably given away by William IV to the second Marquess Conyngham, son of George IV's favourite, Elizabeth, Marchioness Conyngham. The room contained some of George IV's most important Dutch paintings: Rembrandt's *The Shipbuilder and his Wife* hung on the west wall and Cuyp's *The Passage Boat* (no. 16) was paired with *St Philip and the Eunuch* by Jan Both on the north wall.

Watercolour with touches of bodycolour and gum arabic over pencil. 20.1 × 25.2 cm
RL 22184
PROVENANCE (?)George IV
LITERATURE Pyne 1819, III, *Carlton House*, opposite p. 45; Oppé 1950, under no. 657; Watkin 1984, pp. 122–3
EXHIBITIONS QG 1979–80, no. 156; QG 1991–2, no. 196

422
CHARLES WILD (1781–1835)
Carlton House: The Blue Velvet Closet, 1818

The histories of this room and of the adjoining Blue Velvet Room (no. 421) are closely entwined. In the 1780s there was a dressing room and bedroom on the site of this room, with neo-classical painted decoration carried out under the direction of Henry Holland. Subsequently the two rooms were combined and a new scheme of decoration consisting of blue velvet in gilt panels, fleur-de-lis-patterned silk and carpet was installed between 1811 and 1814, in sequence with and by the same suppliers as that in the adjoining Blue Velvet Room (no. 421). At the same time, a French chimneypiece was moved here from the Blue Velvet Room. On the walls were hung some of George IV's extensive collection of Dutch paintings, including works by Cuyp, Ruisdael, Wouwermans, Van de Velde and Maes. In the centre stands one of a pair of Boulle marquetry tables by Thomas Parker, purchased in 1814, and either side may be seen the pair of Boulle medal-cabinets (no. 99).

Watercolour and bodycolour with gum arabic over pencil. 20.2 × 25.0 cm
RL 22185
PROVENANCE (?)George IV
LITERATURE Pyne 1819, III, *Carlton House*, opposite p. 48; Oppé 1950, under no. 657
EXHIBITIONS QG 1966, p. 105; QG 1991–2, no. 197

423
CHARLES WILD (1781–1835)
Carlton House: The Throne Room, 1818

The Throne Room was the largest of the seven south-facing rooms on the first floor of the house and was used by George IV as his principal drawing room from the 1780s until 1811. Unlike that in most of the rooms in Carlton House, where change was always in the air, the decoration and arrangement of the Throne Room changed relatively little over time. The architectural framework of the room survived more or less intact, including Henry Holland's delicate neo-classical ceiling and the rhythmic arrangement of richly carved and gilded Corinthian pilasters, dating from 1788–92. From the same period came two richly mounted French chimneypieces at either end of the room. These were probably imported by Dominique Daguerre, then working with Holland on the interior decorations. In Wild's view, the chimneypiece at the far (west) end of the room is concealed behind the crimson velvet of the throne canopy, moved here from the old Throne Room at the inauguration of the Regency in 1811. At this point the Great Drawing Room was officially renamed the Throne Room. In 1813 the original blue velvet chair covers and hangings were changed to crimson, an alteration which coincided with the installation of the pair of council chairs (no. 89).

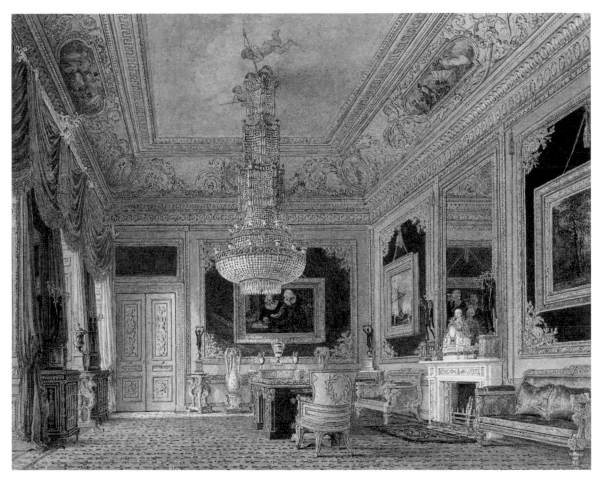

421

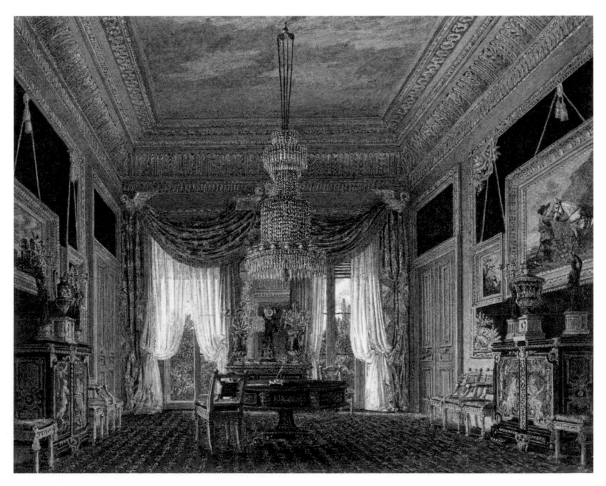

422

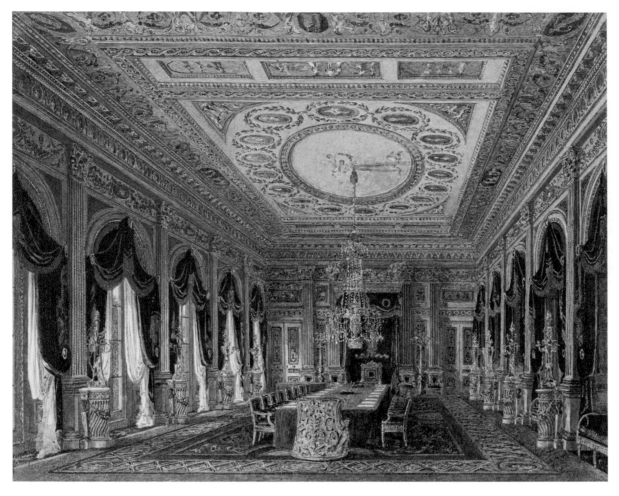

423

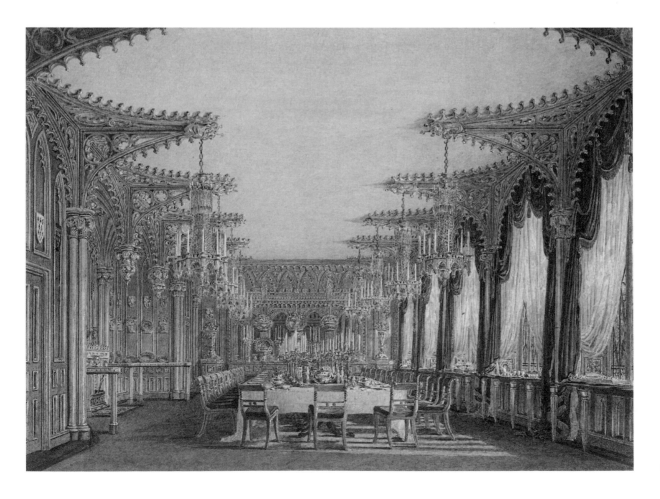

◁ 424

However, the Moorfields carpet, dating from 1792 and woven to a design suggested by George IV, survived in situ, as did the set of eight giltwood pedestals supporting gilt bronze candelabra which were supplied under Daguerre's direction in 1794.

Watercolour with touches of bodycolour and gum arabic over pencil. 20.1 × 25.2 cm
RL 22178
PROVENANCE (?)George IV
LITERATURE Pyne 1819, III, *Carlton House*, opposite p. 25; Oppé 1950, under no. 657; Watkin 1984, pp. 114–15
EXHIBITIONS QG 1979–80, no. 153; QG 1991–2, no. 195

424
CHARLES WILD (1781–1835)
Carlton House: The Gothic Dining Room, 1817

Because of the sloping site on which Carlton House stood, the south or garden front was built on three floors, whereas the north or entrance front had only two. The basement or lower ground floor on the garden front consisted of a suite of eight interconnecting rooms; the interiors of the rooms at the eastern and western extremities – the Dining Room and the Conservatory – were entirely Gothic in style. The Conservatory had been built to the designs of Thomas Hopper c.1807–09 in an extravagant neo-Perpendicular style, modelled in part on Henry VII's Chapel at Westminster Abbey. The Dining Room, which was the last major addition to the house, was built in 1814 to the designs of John Nash using an eccentric mix of Gothic forms which included eight angled, pierced and crocketed ceiling brackets suspending chandeliers, an elaborate

scheme of heraldry, and a series of brackets, shelves and tables for the display of plate. This last element was the feature that distinguished the room in the eyes of visitors, overwhelmed by the richness and profusion of George IV's collection of silver gilt. As shown by Wild, the table was thickly laid with plate including a massive parade of candelabra (no. 183 perhaps among them); the buffet was arranged in tiers at the far end, flanked by pedestals which may have been designed to hold nos 181–2; and further displays were placed on brackets round the room, set against the polished and partly gilded wainscot panelling. The sparkling effect would have been greatly enhanced by the multiple reflections from the large expanses of inset mirror glass.

Watercolour with touches of bodycolour and gum arabic over etched outlines. 19.5 × 26.3 cm
RL 22189
PROVENANCE (?)George IV
LITERATURE Pyne 1819, III, *Carlton House*, opposite p. 63; Oppé 1950, under no. 657
EXHIBITIONS QG 1991–2, no. 198

BRIGHTON PAVILION (nos 425–428)

425
JAMES TINGLE (fl.c.1820–1860) after
AUGUSTUS CHARLES PUGIN (1769–1832)
Brighton Pavilion: The Saloon, 1823

The Saloon lies at the centre of the east front of the Pavilion. In its form (but not its decoration) this is the sole survivor from the building works

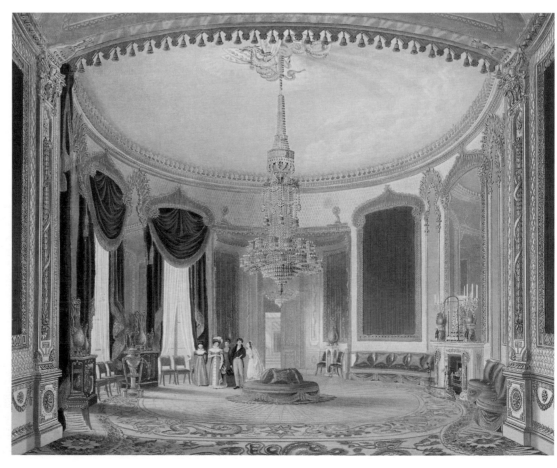

425

of 1787, the date at which Henry Holland turned the original 'superior farmhouse' into a 'marine villa' for George IV by adding to it a matching southern wing, connected by this imposing circular room. Like almost every room at the Pavilion, the Saloon underwent a series of internal changes, reflecting the royal patron's increasingly florid and exotic tastes. The first scheme, by Biagio Rebecca in the neo-classical style, was discarded in 1802–04 in favour of a delicate chinoiserie fantasy in blue, red and yellow. This was altered in 1815–16 and entirely replaced in 1822 under the direction of John Nash by a rich crimson, silver and gold scheme of Mughal inspiration, designed by Robert Jones and recorded in Pugin's view published in the following year. Around the room can be seen part of George IV's magnificent collection of Chinese celadon vases mounted in gilt bronze and on the chimneypiece – removed to the Yellow Drawing Room at Buckingham Palace for Queen Victoria (see no. 419) – stands the 'Kylin' clock (no. 316) under a glass case, its gilt bronze sunflower motifs picked up in the decoration of the room.

Etching with aquatint, printed in colours and hand coloured. 26.4 × 32.2 cm
RCIN 1150260.au
PROVENANCE Christie's, London, 3 February 1928 (54); bought by King George V after the sale (£42)
LITERATURE Nash (J.) 1826, pl. 20; Jackson-Stops 1991, p. 88

426
HENRY WINKLES (fl.c.1820–1840) after
AUGUSTUS CHARLES PUGIN (1769–1832)
Brighton Pavilion: The Gallery, 1824

In 1815 Nash considerably widened Holland's original insignificant corridor on the ground floor of the Pavilion, adding a theatrical note by introducing top lighting in the central section and at either end, above the cast-iron staircases. Like the Grand Corridor at Windsor (nos 409, 410), the Gallery in this new incarnation functioned both as a means of communication through the centre of the Pavilion and as an area to promenade, sit or talk. The original decoration, carried out by Frederick Crace, consisted principally of painted panels of blue bamboo on a pale pink ground, painted glass in the skylights, painted hanging lanterns and pierced fretwork borders. This scheme was modified in 1822, again by Crace, at which time some of the chinoiserie elements were eliminated and a more eclectic note struck by the introduction of modern rosewood sofa tables, a Turkish-style fitted carpet and the suite of Indian ivory furniture (no. 85), purchased by George IV at the posthumous sale of the property of his mother, Queen Charlotte, in 1819.

Etching with aquatint, hand coloured. 21.6 × 29.8 cm
RCIN 1150260.an
PROVENANCE As no. 425
LITERATURE Nash (J.) 1826, pl. 14; Jackson-Stops 1991, p. 72

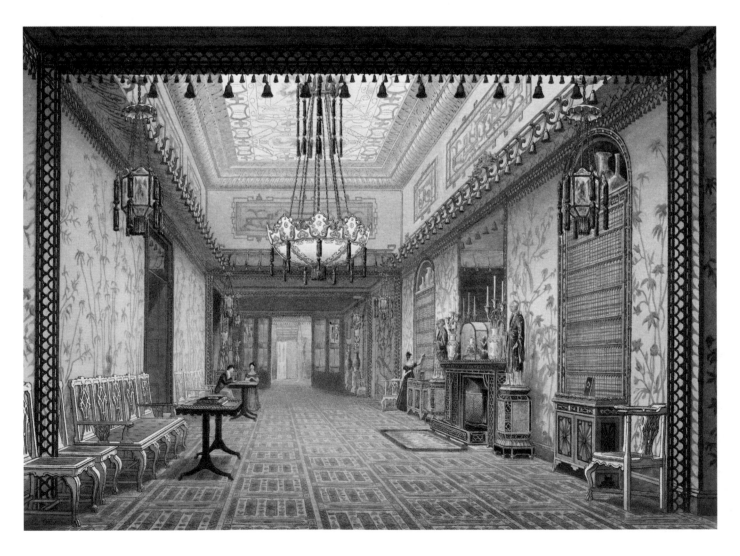

◁ 426

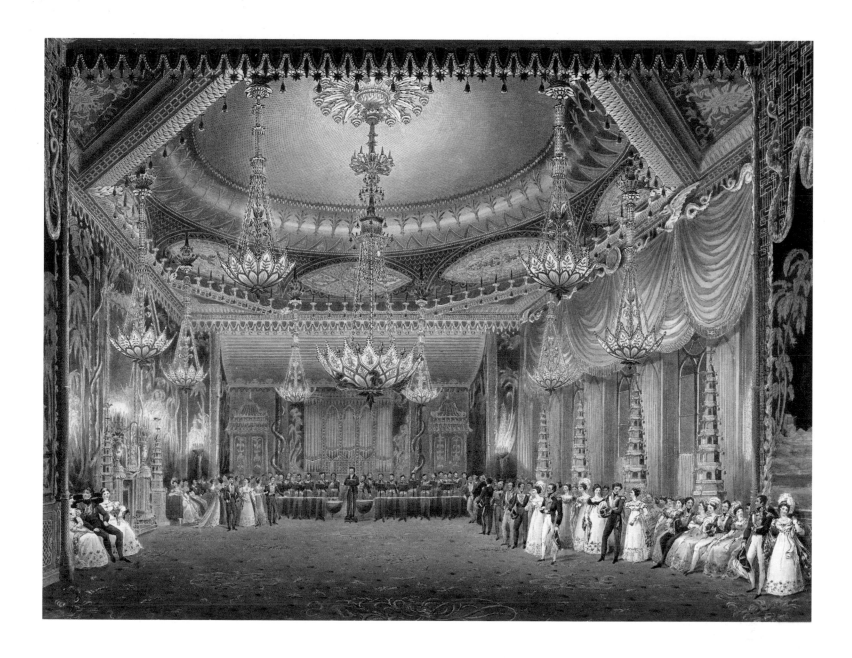

427

JOHN AGAR (c.1770–c.1835) after
AUGUSTUS CHARLES PUGIN (1769–1832) and
JAMES STEPHANOFF (1789–1874)
Brighton Pavilion: The Music Room, 1824

This magnificently theatrical room was created for George IV in 1818–20 to the designs of John Nash, Frederick Crace and Robert Jones. It stands at the north-east corner of the Pavilion and represents the most fully developed phase of George IV's infatuation with Chinese decoration. Lit by nine painted glass 'water-lily' chandeliers, with newly introduced gas, as well as by candelabra round the room, the walls lacquered red and gilded with Chinese landscapes and every surface writhing with ornament, it provided a sumptuous setting for concerts designed to gratify the King's great passion for music. It has been suggested that Pugin and Stephanoff's view might show the concert of 20 December 1823, conducted by the celebrated Italian composer Giacomo Rossini. This was attended by the King, who is seen seated on the left, flanked by Lady Conyngham and her daughter.

When the Pavilion interiors were dismantled, the dragon chimney-piece was installed in the new Pavilion Breakfast Room at Buckingham Palace (see no. 418), the Chinese pagodas (no. 317) were placed in the Principal Corridor and Yellow Drawing Room (no. 419) and the celebrated organ built by Henry Lincoln, greatly enlarged by Gray & Davidson, was eventually reused in the new Ballroom of the Palace.

Etching with aquatint, printed in colours and hand coloured. 26.5 × 34.8 cm
RCIN 1150260.ap
PROVENANCE As no. 425
LITERATURE Nash (J.) 1826, pl. 17; Jackson-Stops 1991, p. 84

428

HENRY WINKLES (fl.c.1820–1840) after
AUGUSTUS CHARLES PUGIN (1769–1832)
Brighton Pavilion: The Private Library, 1824

George IV's new private suite at Brighton – consisting of ante-room, dressing room, bathroom, bedroom and two interconnecting libraries –

428

was constructed by Nash on the ground floor of the secluded north-west corner of the Pavilion and was linked by a private stair to Lady Conyngham's room above. It replaced his old and more public suite of rooms on the first floor of the east front. Work started in 1819 and the decoration, overseen by Robert Jones, was still under way in 1822. By contrast with the exuberant and theatrical appearance of the principal rooms in the Pavilion, the new private rooms were decorated in a surprisingly sober and restrained style. The bedroom and library were hung *en suite* with a green-ground 'dragon damask' wallpaper designed by Jones, the ceilings were 'skied' and only subdued traces of Gothic, Indian and Egyptian design appeared in the architectural detail. The furnishings in the library, although eclectic, complemented the discreet tonality of the decoration. They included a range of lacquer cabinets, bamboo-pattern chairs with yellow upholstery matching the curtains, and a group of black-glazed Sèvres vases and oriental lacquer mounted in gilt bronze, including the superb lacquer bowl (no. 310).

Etching with aquatint, printed in colours and hand coloured. 20.5 × 30.1 cm
RCIN 1150260.bc
PROVENANCE As no. 425
LITERATURE Nash (J.) 1826, pl. 25; Jackson-Stops 1991, p. 104

FROGMORE HOUSE (nos 429–430)

429
CHARLES WILD (1781–1835)
Frogmore House: The Green Pavilion, 1817

Frogmore House, lying less than a mile to the south of Windsor Castle, was purchased by George III for Queen Charlotte in 1792. The house and its extensive grounds were to be used by the Queen and her daughters as a retreat for the peaceful pursuit of their favourite studies, including music, painting, drawing, needlework and botany. The Queen employed James Wyatt to modernise and enlarge the house and by 1795 he had added an open colonnade to the west front overlooking the garden, flanked by two matching pavilions to north and south. The former contained the room known as the Green Pavilion, opening

southwards towards the colonnade and looking out over the pleasure grounds. The restrained neo-classical decoration, elegant but simple furniture, cluster of family portraits and richly draped chintz curtains perfectly characterise the Queen's taste in the years around 1800. Little was done to the room thereafter and when the decision was taken in the 1980s that the house should be restored and opened to the public, this room was singled out to represent Queen Charlotte's period of ownership. Some of the original furniture survived and was replaced in the room, including the pair of tables flanking the door to the colonnade, the chandelier and some of the pictures that had belonged to Queen Charlotte. Traces of the original green paint were found and carefully matched and new curtains were created to reproduce the effect shown in Wild's view.

Watercolour and bodycolour over pencil. 20.0 × 27.4 cm
RL 22121
PROVENANCE (?)George IV
LITERATURE Pyne 1819, I, *Frogmore*, opposite p. 13; Oppé 1950, under no. 657; Watkin 1984, p. 96; Cornforth 1990

429

430
JAMES ROBERTS (c.1800–1867)
Frogmore House: The Duchess of Kent's Sitting Room, 1857

After the completion of the Green Pavilion (no. 429), Queen Charlotte made further additions to Frogmore with Wyatt's help, including a drawing room (no. 430) together with domestic offices at the north end and a dining room and library at the south end of the house. These were completed c.1804. After the Queen's death in 1818, the house passed to her eldest unmarried daughter Augusta, who died in 1840. Thereafter Frogmore became the country residence of Queen Victoria's mother, the Duchess of Kent. The Duchess undertook a considerable amount of redecoration during the twenty years of her occupation. In her sitting room, where she is shown in Roberts's view seated by the window with her dog Boz, she introduced a soft lilac colour to the walls and new red carpet and curtains. The furniture, however, seems mainly to have remained as it was in Princess Augusta's day, including the pair of pier

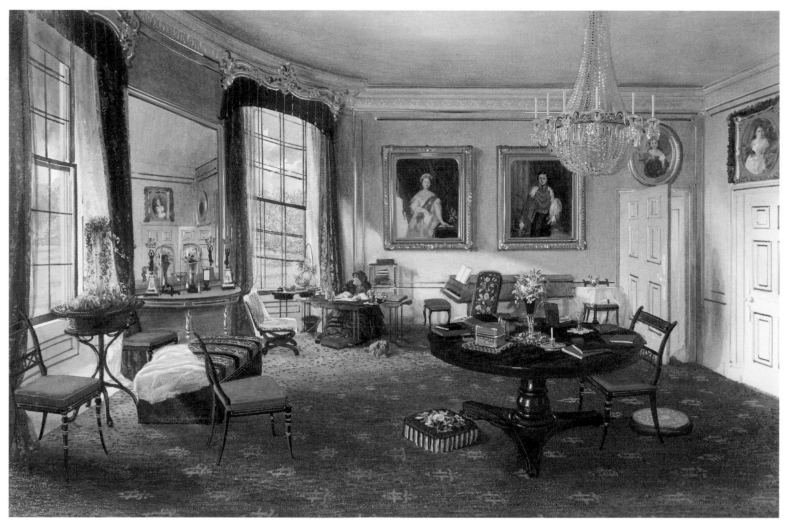

430

glasses and gilt tables with painted tops between the windows. Shortly after this view was made, the Duchess changed the curtains to yellow silk and the carpet to one of brightly coloured Persian design. This second scheme was re-created when the room was restored in the late 1980s. The Duchess's picture hang consisted entirely of family portraits and these have been reinstated. Prominent on the wall behind her are images of her daughter and son-in-law by John Partridge.

Watercolour and bodycolour. 25.6 × 38.5 cm
Signed, dated and inscribed *Js Roberts / Decr / 1857 / Frogmore*
RL 19734
PROVENANCE Painted for the Duchess of Kent; by whom given to Queen Victoria, Christmas 1857
LITERATURE Millar (D.) 1995, no. 4619; Cornforth 1990

BALMORAL CASTLE (no. 431)

431
JAMES ROBERTS (c.1800–1867)
Balmoral Castle: The Drawing Room, 1857

Queen Victoria laid the foundation stone of the new castle at Balmoral, designed by William Smith of Aberdeen, on 28 September 1853. Two

years later, when the building was finished and the interiors were almost complete, Lady Augusta Bruce, lady-in-waiting to the Duchess of Kent, looked in to inspect progress on the day of the arrival of the Queen and Prince Albert (7 September). In the Queen's apartments, she noted: 'The general woodwork is light coloured, maple and birch chiefly, with locks and hinges etc. silvered, and the effect is very good – besides there are beautiful things – Chandeliers of Parian; Highlanders [no. 94], beautifully designed figures, holding the light, and which are placed in appropriate trophies – table ornaments in the same style, and loads of curiously devised and tasteful, as well as elaborately executed articles; the only want is a certain absence of harmony of the whole.' Later, after the fashionable Mount Street decorator and upholsterer Holland had been at work all day, she returned to find everything finished: 'the carpets are Royal Stuart Tartan and green Hunting Stuart, the curtains, the former lined with red, the same dress Stuart and a few chintz with a thistle pattern, the chairs and sofas in the drawing room are "dress Stuart" poplin. All highly characteristic and appropriate, but not all equally *flatteux* to the eye' (quoted in Millar (D.) 1985, p. 70).

Much of Holland's distinctive furnishings made for the 'dear Paradise' remains in situ, although the Stuart tartan curtains have given way in the Drawing Room (and some other rooms) to Balmoral tartan, a grey and red pattern probably designed by the Queen and Prince c.1850. With the advent of heating, Prince Albert's insistence on hanging Landseer prints rather than oil paintings (which he thought might be

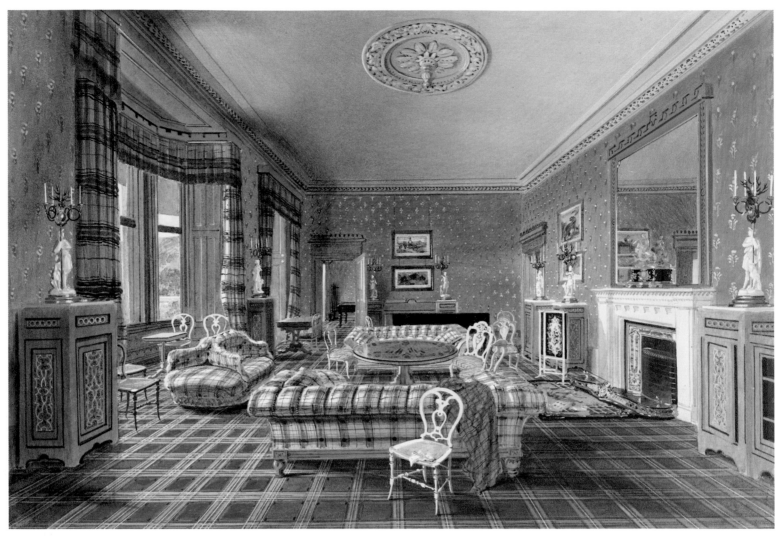

431

injured by the climate) has been relaxed and most of the principal rooms now contain either oil paintings or watercolours.

Watercolour and bodycolour over pencil. 26.1 × 38.3 cm
Signed, dated and inscribed *Balmoral / Sept 1857 / Js Roberts*
RL 19477
PROVENANCE Commissioned by Queen Victoria (11 gns)
LITERATURE Millar (D.) 1985, pl. XI; Millar (D.) 1995, no. 4644
EXHIBITIONS New York 1988–9; Edinburgh/Aberdeen/Manchester/Windsor 1991–4, no. 23; Coburg 1997, no. 9–21

PALACE OF HOLYROODHOUSE (no. 432)

432
ALEC COBBE (b. 1945)
The Palace of Holyroodhouse: Design for re-presenting the Bedchamber of Mary Queen of Scots, 1994

The Queen of Scots' Apartment on the second floor of the sixteenth-century James V Tower at Holyroodhouse owes its status as one of the most famous tourist attractions in Scotland to its association with the dramatic events of Queen Mary's life, and in particular with the blood-thirsty murder of her secretary David Rizzio by Lord Darnley and his fellow conspirators in 1566. From the end of the eighteenth century until the mid-nineteenth century the rooms were shown to the public by the housekeeper to the Duke of Hamilton, Hereditary Keeper of the Palace. At that period, hardly a single object in the rooms was in reality connected with the Queen of Scots, but the carefully guarded and highly seductive air of melancholy and faded decay appealed strongly to the romantic imagination and continued to fuel interest in the Queen's tragic life. In 1855 responsibility for showing the rooms passed to the Office of Works and over the next century the rooms were gradually purged of their spurious relics and stripped back to a state of sterile emptiness.

432

In 1994 Alec Cobbe was commissioned to devise a re-presentation of these rooms. The intention was to enhance the handful of objects which have a genuine association with Mary, Queen of Scots – such as the Clouet miniature (no. 43) and the Darnley Jewel (no. 143) – while restoring the visual impact and picturesque resonance of the rooms through additions to the picture hang, adjustments to the decorations and the installation of appropriate furniture and display cases. These cases, designed by Cobbe, now house the collection of Stuart memorabilia from Windsor, formed largely by Queen Mary, consort of King George V.

Acrylic over pencil. 29.2 × 51.7 cm
Inscribed by the artist on the mount *Suggested scheme for Mary Queen of Scots' Bedchamber / using appropriate furniture from within the palace to restore something of its appearance in former times / The bed could be realized using crewel-work hangings in store and in the palace*
RL 33590
PROVENANCE Commissioned by HM The Queen, 1994
LITERATURE Gow 1995; Cobbe 1996, p. 43, fig. 45
EXHIBITIONS London 1996b

HAMPTON COURT PALACE (nos 433–434)

433
JAMES STEPHANOFF (1789–1874)
Hampton Court Palace: The Cartoon Gallery, 1818

William III's new State Apartments at Hampton Court Palace were begun in 1689. Constructed to the designs of Christopher Wren at the south-east corner of the old Tudor palace around two sides of a new courtyard, the King's rooms faced south over the Privy Garden and the Queen's faced east over the Fountain Garden. The King's or Cartoon Gallery lay on the inner north-facing side of the King's range, parallel to the suite of interconnecting rooms forming the main axis of the King's Apartment. Work on fitting out the Gallery was under way in 1691 but this and all other work at Hampton Court came to an abrupt halt with the sudden death of Queen Mary II in 1694. Nothing further was done until 1698 when John Norris, Joiner to the Privy Chamber, was employed to install the celebrated Raphael Cartoons in the elevated positions specifically designed to fit them. By the end of the following year,

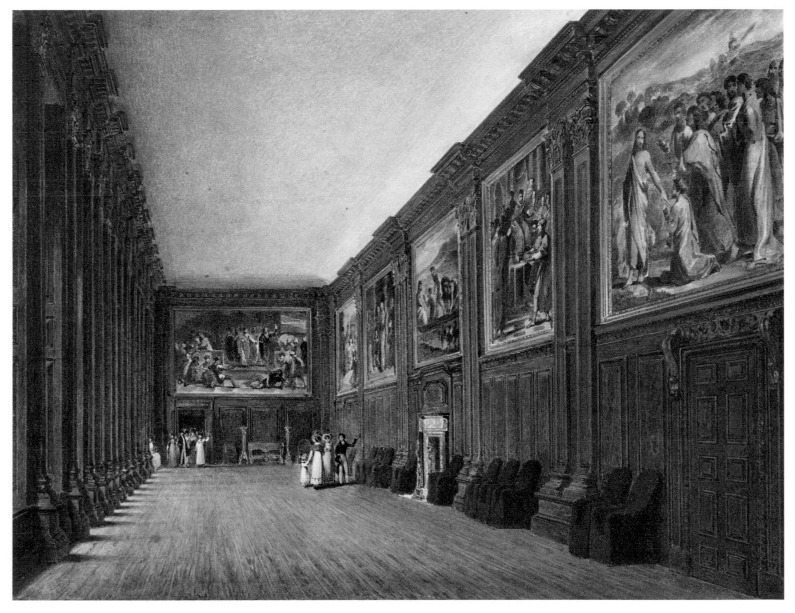

433

William Talman having supplanted Wren, the rest of the King's State Apartment was finished, although decoration and furnishing continued over the next two years. For this brief period until his death in 1702, William III used the Cartoon Gallery for meetings of the Privy Council. There were no significant changes to the Gallery before the accession of George III in 1760. Thereafter Hampton Court Palace ceased to be used by the royal family and the arrangement of the State Apartments became more haphazard as furniture and pictures were taken to other palaces and the State Apartments lost their significance (see p. 29). The pier table and torchères (nos 81, 82) shown in Stephanoff's view at the far end of the Gallery are likely to have been made originally for the Prince of Wales's Apartment. The Raphael Cartoons are in situ, although they had moved twice since their original installation in 1698: first to Queen Charlotte's Saloon in Buckingham House, then to George III's apartments at Windsor Castle. At the King's suggestion they were returned to Hampton Court in 1804. In the 1820s John Nash thought of moving them again to Buckingham Palace to hang in George III's Octagon Library, which he proposed to convert into a private chapel, but they remained at Hampton Court until 1865 when they were deposited by Queen Victoria on loan to the new South Kensington Museum – now the Victoria and Albert Museum – where they remain (see pp. 29, 45–6). Early in the twentieth century, a set of eighteenth-century Brussels tapestries woven with the *Acts of the Apostles* (based on the Raphael Cartoons) was placed in the Gallery; and after the fire of 1986 the opportunity was taken to replace the tapestries with late seventeenth-century painted copies of the cartoons lent from the Ashmolean Museum, Oxford.

Watercolour with touches of bodycolour over pencil. 19.9 × 25.7 cm
RL 22136
PROVENANCE (?)George IV

LITERATURE Pyne 1819, II, *Hampton Court*, opposite p. 77; Watkin 1984, p. 47
EXHIBITIONS London/Edinburgh 1991–2, no. A1

434
RICHARD CATTERMOLE (?1795–1868)
Hampton Court: The Queen's Gallery (The Ballroom), 1818

The Queen's Gallery or Ballroom, occupying the southern end of the Queen's State Apartment of Hampton Court Palace, was begun to the designs of Christopher Wren in 1689 for Queen Mary II. After the Queen's sudden death in 1694, when the fitting-out of her new rooms was only partially finished, all work was suspended. Six years later, in 1700, William III decided to take over the Queen's Gallery for his own use and by the middle of the following year the room was substantially complete. The elaborately carved overmantel by John Nost in the centre of the west wall was removed from the King's Great Bedchamber and new furnishings were ordered from Jean Pelletier, including a pair of pier tables and two pairs of torchères (no. 79). In George I's reign the Queen's Apartment was taken over by the Prince and Princess of Wales (the future George II and Queen Caroline) and it was probably in this period, c.1715–16, that the fine set of early eighteenth-century Brussels tapestries depicting the *History of Alexander* was set up. Over the last two decades these tapestries have been washed and conserved at the Textile Conservation Studio at Hampton Court Palace.

Watercolour and bodycolour over pencil. 20.2 × 26.3 cm
RL 22135
PROVENANCE (?)George IV
LITERATURE Pyne 1819, II, *Hampton Court*, opposite p. 69; Watkin 1984, p. 46

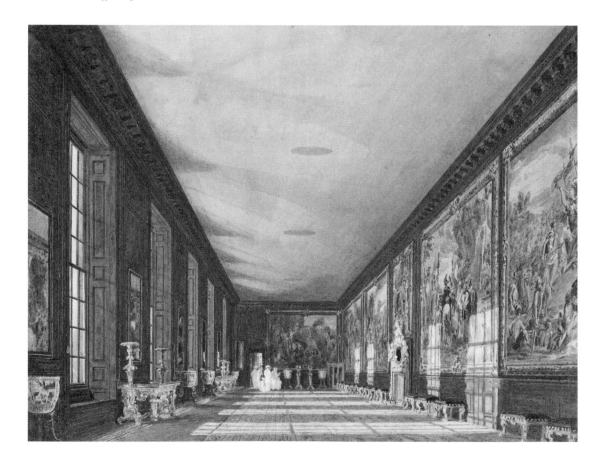

◁ 434

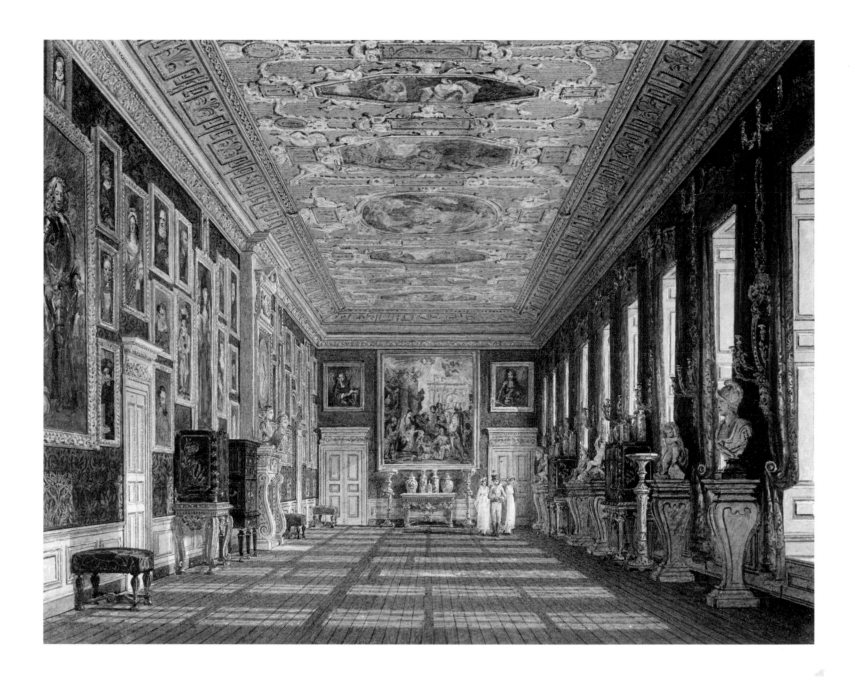

KENSINGTON PALACE (nos 435–436)

435
CHARLES WILD (1781–1835)
Kensington Palace: The King's Gallery, 1816

William III purchased the early seventeenth-century villa, Nottingham House, which he renamed Kensington Palace, in 1689. In three main phases between then and 1695, under the general direction of Sir Christopher Wren, the King completely transformed and vastly extended the original modest house. The last of these phases involved the construction of a new south front, perhaps to the design of Nicholas Hawksmoor. The King's Gallery, intended for the display of paintings, was situated on the first floor of this new wing and was originally fitted up with architectural carvings by Grinling Gibbons, a wind dial over the chimneypiece, green velvet hangings on the walls and white damask curtains. In the final phase of enlargement at Kensington Palace

(1718–27), which took place in the reign of George I, the internal alterations and redecoration were in the hands of William Kent. A new painted ceiling (depicting scenes from the Odyssey) was added to the Gallery by Kent in 1725–7 and, as part of the same programme of modernisation, a new chimneypiece and doorcases in the Palladian style were introduced, the woodwork was painted white and gilded and crimson damask was used for the walls and curtains. After the accession of George III in 1760, Kensington Palace became a backwater, and by the time the Wild view was painted the picture hang – carefully designed by Kent to include new frames in the Palladian style – had long since been dispersed and replaced by a miscellany of family and other portraits. Some of the original furnishings, including perhaps the giltwood pier table and torchères (attributed to James Moore) and the onyx marble pedestals (no. 98) supporting marble groups by Camillo Rusconi, remained. In the early nineteenth century the Gallery was divided into three to provide rooms for the Duchess of Kent and her daughter, the future Queen Victoria. After this change was reversed at the end of the nineteenth century, several more or less successful attempts were made to

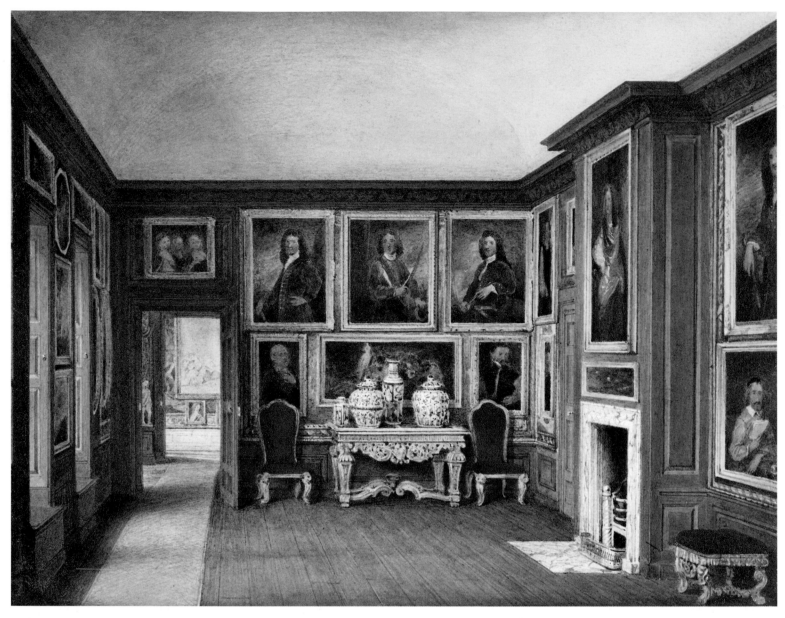

436

re-establish the eighteenth-century appearance of the room. The most recent and thorough re-presentation, involving the replacement of crimson silk, repainting of the woodwork and reintroduction of some of the paintings hung here in the George II period, was undertaken in 1993–4.

Watercolour with touches of bodycolour and gum arabic over etched outlines.
19.8 × 25.0 cm
RL 22158
PROVENANCE (?)George IV
LITERATURE Pyne 1819, III, *Kensington Palace*, opposite p. 78; Watkin 1984, pp. 72–3
EXHIBITIONS London/Edinburgh 1991–2, no. A2

436
JAMES STEPHANOFF (1789–1874)
*Kensington Palace: Queen Mary's Drawing Room
(The Admirals' Gallery)*, 1817

The Queen's Apartment, in the north-east corner of the new palace of Kensington, was considerably enlarged for Queen Mary II in 1690 by the addition of a new staircase, a gallery and a series of smaller rooms. These adjoined the Queen's Drawing Room and Bedchamber, which had been added to the original Nottingham House the previous year. The neighbouring rooms in the King's Apartment, to the south and east, were reconfigured by William Kent in the reign of George I. George II and Queen Caroline used Kensington regularly but made few alterations to the fabric and after 1760 the palace fell into disuse. Stephanoff's view records a miscellaneous hang of pictures including a series of portraits of admirals after Kneller, copied from the originals then at Hampton Court Palace. Against the south wall stands a table attributed to Thomas Pelletier, probably made for Queen Anne *c.*1704 (no. 80).

Watercolour over pencil. 19.9 × 25.1 cm
RL 22152
PROVENANCE (?)George IV
LITERATURE Pyne 1819, II, *Kensington Palace*, opposite p. 53

OSBORNE HOUSE (no. 437)

437
JAMES ROBERTS (c. 1800–1867)
Osborne House: Prince Albert's Dressing Room, 1851

Queen Victoria and Prince Albert purchased the Osborne estate on the Isle of Wight in 1845 with the intention of establishing there a family home by the sea with more privacy and freedom from ceremonial life than could ever have been provided by George IV's Indo-Chinese extravaganza at Brighton. Work on a new house, designed by Prince Albert, started immediately. The iron-framed and cement-rendered three-storey Pavilion for the royal family, constructed by the successful London master builder Thomas Cubitt, was completed fifteen months later, in September 1846. Designs for the decoration of the principal rooms were provided by Ludwig Gruner, the Prince's artistic adviser, and plain mahogany furniture was supplied by Thomas Dowbiggin and Holland & Sons of Mount Street, London. The adjoining Main and Household Wings, to the east of the Pavilion, were completed in 1851 and the Durbar Wing, the last addition to the house, was built in 1890–1.

Prince Albert's suite, adjoining that of the Queen, lay on the first floor of the Pavilion. His Dressing Room, in the north-west corner, looked out over the garden towards the Solent, a view that reminded him on sunny days of the Bay of Naples. In this plainly painted and simply detailed room the Prince assembled a major part of his pioneering collection of early Italian paintings, some of which had been acquired with Gruner's assistance. The group included both the Duccio triptych (no. 1) and the Daddi panel (no. 2), although neither is visible in this view.

After Queen Victoria's death, Edward VII gave the house and estate to the nation (the contents were excluded from the gift) and part of the house was until recently used as a convalescent home. Her Majesty The Queen sanctioned the opening to the public of Queen Victoria's and Prince Albert's private rooms for the first time in 1954 and since then the original decorative schemes and room arrangements have been reinstated in many of the rooms that are open to the public, most recently the Durbar Room, under the direction of English Heritage.

Watercolour and bodycolour with touches of gum arabic over pencil. 24.6 × 36.9 cm
Signed, dated and inscribed *Osborne / J. Roberts / Mar 1851*
RL 26224
PROVENANCE Commissioned by Queen Victoria (£9); left royal ownership in early twentieth century; Mrs N. Kay; Hove Auction Rooms, 16 May 1986; James MacKinnon; from whom bought by HM The Queen, September 1986
LITERATURE Millar (D.) 1995, no. 4634
EXHIBITIONS Coburg 1997, no. 9–22

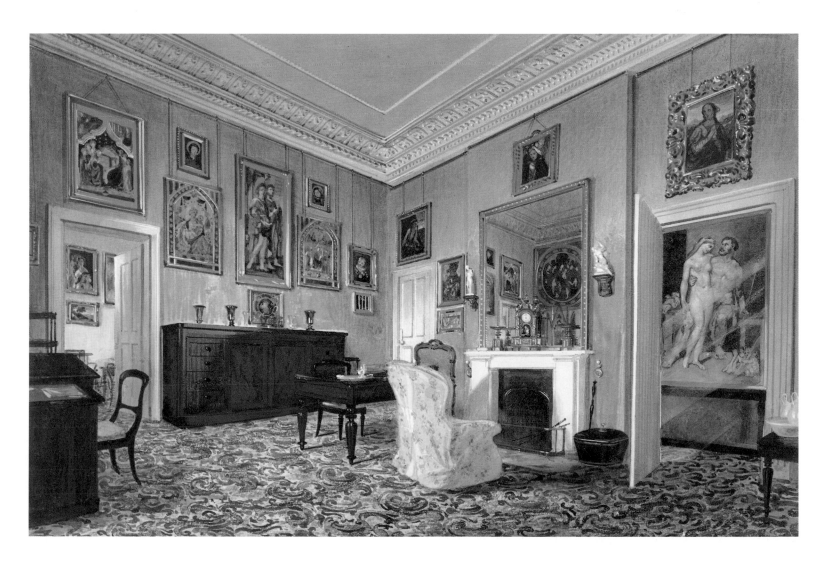

Exhibition abbreviations

This list includes only those exhibitions to which items in the present exhibition have been lent. Other exhibition catalogues are listed in the Bibliography and abbreviations (p. 479). In the following list 'QG' indicates The Queen's Gallery, Buckingham Palace, London.

1704
Paris 1704
Salon

1780
London 1780
Royal Academy

1785
London 1785
Royal Academy

Paris 1785
Salon

1790
London 1790
Royal Academy

1802
London 1802
Royal Academy

1813
London 1813
Pictures by the late Sir Joshua Reynolds, British Institution

1814
London 1814
Pictures by the late William Hogarth, Richard Wilson, Thomas Gainsborough and J. Zoffani, British Institution

1815
London 1815
Pictures by Rubens, Rembrandt, Vandyke, and Other Artists of the Flemish and Dutch Schools, British Institution

1818
London 1818
Pictures of the Italian, Spanish, Flemish, Dutch and French Schools, British Institution

1819
London 1819a
Royal Academy

London 1819b
Pictures of the Italian, Spanish, Flemish and Dutch Schools, British Institution

1821
London 1821
Pictures of the Italian, Spanish, Flemish and Dutch Schools, British Institution

1822
London 1822
Pictures of the Italian, Spanish, Flemish and Dutch Schools, British Institution

1826
London 1826
His Majesty's Collection of Pictures from Carlton House Palace, British Institution

1827
London 1827
His Majesty's Collection of Pictures from Carlton House Palace, British Institution

1829
London 1829
Royal Academy

1830
London 1830
Works of the late Sir Thomas Lawrence, PRA, British Institution

1840
Edinburgh 1840
Royal Scottish Academy

London 1840
Royal Academy

1842
London 1842a
Works of the late Sir David Wilkie, RA, together with a Selection of Pictures by Ancient Masters, British Institution

London 1842b
Royal Academy

1844
London 1844
Old Watercolour Society

1846
London 1846
British Institution

1851
London 1851a
The Great Exhibition of the Works of Industry of all Nations, Hyde Park

London 1851b
Royal Academy

1853
London 1853a
British Institution

London 1853b
Specimens of Cabinet Work and Studies from the School of Art Exhibition, Gore House, Kensington

London 1853c
Department of Practical Art, Marlborough House

1854
London 1854
Royal Academy

1857
Manchester 1857
Art Treasures of the United Kingdom

1861
Dublin 1861
Exhibition of Fine Arts and Ornamental Art, New Hall, Kildare Street

London 1861
Antiquities and Works of Art, Ironmongers' Hall

1862
London 1862a
Special Loan Exhibition of Works of Art of the Medieval, Renaissance, and More Recent Periods, South Kensington Museum

London 1862b
The International Exhibition, South Kensington

1863
London 1863
Special Exhibition of Works of Art, Gore House, Kensington

1865
Dublin 1865
International Exhibition of Arts and Manufactures, Exhibition Palace

London 1865
Special Exhibition of Portrait Miniatures, South Kensington Museum

1866
Brussels 1866
Exposition Générale des Beaux-Arts, Salon

1868
Leeds 1868
National Exhibition of Works of Art, Leeds General Infirmary

1870
Dresden 1870
Holbein-Ausstellung, Zwinger

1872
Dublin 1872
Arts, Industries and Manufactures and Loan Museum of Works of Art, Exhibition Palace

London 1872
Works of the Old Masters together with Deceased Members of the British School, Royal Academy

1873
Baden 1873
Winterhalter, Kunsthalle

1874
London 1874
Landseer, Royal Academy

1875
London 1875
Works by the Old Masters and by Deceased Masters of the British School, Royal Academy

1876
London 1876
Works by the Old Masters and by Deceased Masters of the British School, Royal Academy

1877
London 1877
Works by the Old Masters and by Deceased Masters of the British School, Royal Academy

1877–8
London 1877–8
Winter Exhibition of Drawings by the Old Masters and Watercolour Drawings by Deceased Artists of the British School, Grosvenor Gallery

1879
London 1879
Works by the Old Masters and by Deceased Masters of the British School, Royal Academy

1880
London 1880
Works by the Old Masters and by Deceased Masters of the British School, Royal Academy

1881
London 1881
Works by the Old Masters and by Deceased Masters of the British School, Royal Academy

York 1881
Summer Exhibition of the Prince of Wales's Indian Presents, Yorkshire Fine Art Institute

1882
Glasgow 1882
Italian Art Loan Exhibition, Corporation Art Galleries

1883
Edinburgh 1883
Loan Exhibition of Works of Old
Masters and Scottish National
Portraits, Royal Scottish
Academy, The Mound

1884
London 1884
Works by the Old Masters and by
Deceased Masters of the British
School, Royal Academy

1887
London 1887
Loan Exhibition of Works by Sir
Oswald Brierly, Pall Mall Gallery

Manchester 1887
Royal Jubilee Exhibition

1888
London 1888
A Century of British Art
1737–1837, Grosvenor
Gallery

1889
London 1889a
Portrait Miniatures, Burlington
Fine Arts Club

London 1889b
The Royal House of Stuart, New
Gallery

London 1889c
Works by the Old Masters and by
Deceased Masters of the British
School, Royal Academy

Paris 1889
Claude Monet, A. Rodin, Galerie
Georges Petit

1890
London 1890
The Royal House of Tudor, New
Gallery

1891
London 1891a
The Royal House of Guelph, New
Gallery

London 1891b
Bookbindings, Burlington Fine
Arts Club

London 1891c
Works by the Old Masters and by
Deceased Masters of the British
School, Royal Academy

1892
London 1892
Works by the Old Masters and by
Deceased Masters of the British
School, Royal Academy

1893–4
London 1893–4
Early Italian Art from 1300 to
1550, New Gallery

1894
London 1894
The Heraldic Exhibition,
Burlington House

1894–5
London 1894–5
Venetian Art, New Gallery

1895
London 1895a
Works by the Old Masters and by
Deceased Masters of the British
School, Royal Academy

London 1895b
Loan Collection of Pictures, Art
Gallery of the Corporation of
London

1896
London 1896
Works by the Old Masters and by
Deceased Masters of the British
School with a Selection of Works
by Deceased French Artists, and a
Collection of Plate and Other
Objects illustrating the Sculptor–
Goldsmith's Art, Royal Academy

1897
London 1897
Loan Exhibition, Corporation of
London Art Gallery

1897–8
Basel 1897–8
Ausstellung von Werken Hans
Holbeins d. J., Kunstmuseum

1898
Amsterdam 1898
Rembrandt, Stedelijk Museum

London 1898
Art Metal Exhibition, Royal
Aquarium and St Stephen's
Hall, Westminster

1899
London 1899
Works by Rembrandt, Royal
Academy

1900
Birmingham 1900
Annual Exhibition, City of
Birmingham Museum and
Art Gallery

1901
London 1901
Silversmiths' Work of European
Origin, Burlington Fine Arts
Club

1901–2
London 1901–2
The Monarchs of Great Britain
and Ireland, New Gallery

1902
St Petersburg 1902
Artistic Objects and Miniatures by
Fabergé, Baron von Dervis
Mansion

1903
London 1903
Works by the Old Masters and by
Deceased Masters of the British
School, Royal Academy

1904
London 1904a
Pictures of the School of Siena and
Examples of the Minor Arts of that
City, Burlington Fine Arts Club

London 1904b
Works by the Old Masters and by
Deceased Masters of the British
School including a Special
Exhibition of Works by Sir
Thomas Lawrence, PRA, Royal
Academy

1907
Bruges 1907
Exposition de la Toison d'Or,
Palais du Gouvernement

1911
London 1911
Works by Old Masters with
Deceased Masters of the British
School, Royal Academy

1924
Paris 1924
Arts Décoratifs de Grande-Bretagne
et d'Irlande, Musée du Louvre

1925
London 1925
Humour Exhibition, Spring
Gardens

Paris 1925
Le paysage français de Poussin à
Corot, Petit Palais

1928
London 1928
Exhibition of Drawings by Nicolas
Poussin and Claude Lorrain,
Magnasco Society

Paris 1928
Claude Monet, Galerie Durand-
Ruel

1929
London 1929a
Dutch Art, 1450–1900, Royal
Academy

London 1929b
Loan Exhibition of English
Decorative Art, Lansdowne
House

London 1929c
Queen Charlotte's Loan Exhibition
of Old Silver – English, Irish and
Scottish, Seaford House,
Belgrave Square

1930
London 1930
Italian Art, 1200–1900, Royal
Academy

1931
London 1931a
The Four Georges, 25 Park Lane

London 1931b
International Exhibition of Persian
Art, Royal Academy

Paris 1931
Claude Monet, Musée de
l'Orangerie

1932
London 1932
Charles II, 22–23 Grosvenor
Place

1933
London 1933
Persian Miniature Painting, Royal
Academy

1934
London 1934
British Art, c.1000–1860,
Royal Academy

1936
Amsterdam 1936
Exhibition of Ancient Art
belonging to the International
Trade, Rijksmuseum

London 1936
Heralds' Commemorative
Exhibition 1484–1934,
College of Arms

Paris 1936
Rubens et son temps, Orangerie
des Tuileries

1937
New York 1937
An Exhibition of Paintings by John
Singleton Copley, Metropolitan
Museum of Art

1938
London 1938
Seventeenth-century Art in Europe,
Royal Academy

1943
London 1943
Paul Nash, Arthur Tooth Gallery

1945
Paris/Prague 1945
Contemporary British Art, British
Council Touring Exhibition to
Paris and Prague

1945–6
Arts Council 1945–6
Portraits, Arts Council touring
exhibition, Wildenstein & Co.
Ltd, London; subsequently
toured to Bristol,
Middlesbrough, Leeds,
Warrington, Shipley,
Wakefield, Chester, and
Geffrye Museum, London

1946
Arts Council 1946
British Painters 1939–45, Arts
Council touring exhibition

London 1946
American Painting, Tate Gallery

1946–7
Chicago/Toronto/New York/
London 1946–7
Masterpieces of British Painting,
Art Institute of Chicago 1946;
Art Gallery of Toronto 1946;
Metropolitan Museum of Art
1946; Tate Gallery 1947 (as
Hogarth, Constable and Turner)

London 1946–7
The King's Pictures, Royal
Academy

1947
Edinburgh 1947
The King's Pictures, Royal
Scottish Academy

London 1947
Nicholas Hilliard and Isaac
Oliver, Victoria and Albert
Museum

1947–8
London 1947–8
Art chiefly from the Dominions of
India and Pakistan, 2400 BC to
1947 AD, Royal Academy

1948
London 1948a
A Thousand Years of French
Books, National Book League,
7 Albemarle Street

London 1948b
Paul Nash. A Memorial
Exhibition, Tate Gallery

The Hague 1948
Meesterwerken der Hollandse
School uit der verzameling van
Z. M. de Koningin van Engeland,
ter gelenheid van het 50-jarig
regeringsjubileum van Koningin
Wilhelmina, Mauritshuis

1949

London 1949
*A Loan Exhibition of the Works
of Carl Fabergé Jeweller and
Goldsmith to the Imperial Court
of Russia*, Wartski

Port Sunlight 1949
Art and the Theatre, Lady Lever
Art Gallery

1949–50

London 1949–50
Landscape in French Art, Royal
Academy

1950

Birmingham 1950
*Some Dutch Cabinet Pictures of the
Seventeenth Century*, City Art
Gallery and Museum

Edinburgh 1950
*Exhibition of Rare Scottish
Antiquities*, 7 Charlotte Square

1950–1

London 1950–1
*Works by Holbein and Other
Masters of the Sixteenth and
Seventeenth Centuries*, Royal
Academy

1951

Harrogate/London 1951
William Powell Frith, RA,
Corporation Art Gallery;
Whitechapel Art Gallery

Liverpool 1951
George Stubbs, Walker Art
Gallery

London 1951a
William Hogarth, Tate Gallery

London 1951b
Persian Painting, Victoria and
Albert Museum

London 1951c
British Painting, Lion and
Unicorn Pavilion, South Bank

London/Birmingham 1951
Eighteenth-century Venice,
Whitechapel Art Gallery; City
Art Gallery

Paris 1951
*Le Livre Anglais. Trésors des
Collections Anglaises*,
Bibliothèque Nationale

1951–2

London 1951–2
*The First Hundred Years of the
Royal Academy*, Royal Academy

1952

London 1952a
*Leonardo da Vinci. Quincentenary
Exhibition*, Royal Academy

London 1952b
*French Drawings from Fouquet to
Gauguin*, Arts Council Galleries

1952–3

London 1952–3
Dutch Pictures, 1450–1750,
Royal Academy

1953

London 1953a
*Kings and Queens, AD
653–1953*, Royal Academy

London 1953b
Drawings by Michelangelo,
British Museum

London 1953c
*Versailles: The Château and its
History in Books and Pictures*,
French Embassy

London 1953d
*Carl Fabergé Special Coronation
Exhibition*, Wartski

London 1953e
British Life, New Burlington Art
Galleries

Venice 1953
Lorenzo Lotto, Palazzo Ducale

1953–4

London 1953–4
Flemish Art, 1300–1700,
Royal Academy

1954

Brighton 1954
The Regency Exhibition, Royal
Pavilion

London 1954a
Queen Mary's Art Treasures,
Victoria and Albert Museum

London 1954b
Claude Monet, Marlborough
Galleries

London 1954c
*Royal Plate from Buckingham
Palace and Windsor Castle*,
Victoria and Albert Museum

Manchester 1954
William Hogarth, 1697–1764,
City Art Gallery

1954–5

Brussels 1954–5
L'Europe humaniste, Palais des
Beaux-Arts

London 1954–5
*European Masters of the Eighteenth
Century*, Royal Academy

1955

Amsterdam 1955
Triomf van het Manierisme,
Rijksmuseum

London 1955
Antique Dealers' Fair, Grosvenor
House Hotel, Park Lane

Venice 1955
Giorgione e i Giorgioneschi,
Palazzo Ducale

1956

Antwerp 1956
Tekeningen van P.P. Rubens,
Rubenshuis

Bologna 1956
Mostra dei Carracci, Palazzo
dell'Archiginnasio

1956–7

London 1956–7
British Portraits, Royal Academy

1957

Edinburgh/London 1957
Claude Monet, Royal Scottish
Academy; Tate Gallery

London 1957
*Antique Dealers' Fair and
Exhibition*, Grosvenor House
Hotel, Park Lane

1957–8

Amsterdam/Rome/Geneva
1957–8
Engels Zilver 1660–1920,
Rijksmuseum 1957; *Argenti
Inglesi 1660–1830*, Palazzo
Venezia 1957–8; *Orfèvrerie
Anglaise 1660–1830*, Musée
d'Art et d'Histoire 1958

1958

Copenhagen 1958
Engelsk Solv 1660–1830, Det
Danske Kunstindustrie
Museum

Edinburgh 1958
*Paintings and Drawings by Sir
David Wilkie*, National Gallery
of Scotland

Hamburg/Cologne/Stuttgart
1958
*Französische Zeichnungen von den
Anfängen bis zum Ende des 19.
Jahrhundert*, Kunsthalle;
Wallraf-Richartz-Museum;
Württembergischen
Kunstverein

London 1958
Sir David Wilkie, Royal
Academy

Munich 1958
The Age of Rococo, Residenz

Rotterdam/Haarlem 1958
Hendrick Goltzius als tekenaar,
Museum Boymans-van
Beuningen; Teylers Museum

Stockholm 1958
Engelskt Silver 1660–1830,
Nationalmusei

1959

London 1959
The Romantic Movement, Tate
Gallery

New York 1959
*Great Master Drawings of Seven
Centuries*, M. Knoedler and
Company

Paris 1959
*Le Siècle de l'Elégance. La demeure
anglaise au XVIIIe siècle*, Musée
des Arts Décoratifs

1959–60

London 1959–60
Italian Art and Britain, Royal
Academy

1960

Basel 1960
Die Malerfamilie Holbein in Basel,
Kunstmuseum

Birmingham 1960
*An Exhibition of Gemstones and
Jewellery*, Birmingham Museum
and Art Gallery

Johannesburg 1960
Rand Easter Show, Milner Park
Showgrounds

London 1960
Prince Henry the Navigator,
British Museum

Moscow/Leningrad 1960
British Painting 1700–1960,
Pushkin Museum; Hermitage
Museum

1960–1

London 1960–1
The Age of Charles II, Royal
Academy

1961

Birmingham 1961
Sir Joshua Reynolds,
Birmingham Museum and Art
Gallery

London 1961
Sir Thomas Lawrence, Royal
Academy

Manchester 1961
German Art, 1400–1800, City
Art Gallery

Newcastle 1961
*The Carracci. Drawings and
Paintings*, Hatton Gallery

Rome 1961
*Mostra di disegni delle Collezioni
Reali d'Inghilterra a Windsor
Castle*, Palazzo Venezia

1962

Bologna 1962
*L'Ideale classico del Seicento in
Italia e la pittura di paesaggio*,
Palazzo dell'Archiginnasio

Haarlem 1962
Frans Hals, Frans Hals Museum

London 1962
*Exhibition of Royal Gifts in Aid of
the Young Women's Christian
Association*, Christie's

Venice 1962
Canaletto e Guardi, Fondazione
Giorgio Cini

1962–3

Glasgow 1962–3
Paintings from Windsor Castle,
Art Gallery and Museum

QG 1962–3
*Treasures from the Royal
Collection*

Stockholm 1962–3
Konstens Venedig,
Nationalmuseum

1963

Birmingham 1963
Exhibition of Gold and Silver,
Birmingham Museum and Art
Gallery

London 1963
Printing and the Mind of Man,
British Museum

1963–4

QG 1963–4
Royal Children

1964

London 1964
The Orange and the Rose,
Victoria and Albert Museum

Manchester 1964
The Age of Shakespeare,
Whitworth Art Gallery

QG 1964
Italian Art

1965

Amsterdam 1965
*Het Nederlandse Geschenk aan
Koning Karel II van Engeland,
1660*, Rijksmuseum

Edinburgh 1965
British Portrait Miniatures,
Scottish Arts Council Gallery

London 1965
*Antique Dealers Fair and
Exhibition*, Grosvenor House
Hotel, Park Lane

Manchester 1965
Between Renaissance and Baroque. European Art 1520–1600, City Art Gallery

Ottawa 1965
Paintings and Drawings by Victorian Artists in England, National Gallery of Canada

1965–6
Washington/New York/Boston 1965–6
John Singleton Copley 1738–1815, National Gallery of Art 1965; Metropolitan Museum of Art 1965–6; Museum of Fine Arts 1966

1966
Birmingham 1966
An Exhibition to Commemorate the Bicentenary of the Lunar Society of Birmingham, Birmingham Museum and Art Gallery

London 1966
Life in Eighteenth-century Venice, Kenwood House

QG 1966
George IV and the Arts of France

1966–7
QG 1966–7
Animal Painting – Van Dyck to Nolan

1967
London 1967
Great Britain USSR, Victoria and Albert Museum

The Hague 1967
Haag zilver uit vijf eeuwen, Gemeentemuseum

1967–8
QG 1967–8
Royal Review of the British Soldier

1968
Bologna 1968
Il Guercino: Disegni, Palazzo dell'Archiginnasio

London 1968a
France in the Eighteenth Century, Royal Academy

London 1968b
Antique Dealers' Fair and Exhibition, Grosvenor House Hotel, Park Lane

Providence 1968
Visions and Revisions, Rhode Island School of Design

Sheffield 1968
Victorian Paintings 1837–1890, Mappin Art Gallery

1968–9
London 1968–9
Bicentenary Exhibition 1768–1968, Royal Academy

QG 1968–9
Van Dyck, Wenceslaus Hollar and the Miniature-Painters at the Court of the Early Stuarts

1969
Rotterdam 1969
Erasmus en zijn tijd, Museum Boymans-van Beuningen

1969–70
London 1969–70
The Elizabethan Image. Painting in England 1540–1620, Tate Gallery

QG 1969–70
Leonardo da Vinci

1970
London 1970
Charles Dickens, Victoria and Albert Museum

1970–1
QG 1970–1
Gainsborough, Paul Sandby and Miniature-Painters in the Service of George III and his Family

1971
Brighton 1971
Follies and Fantasies, Brighton Art Gallery

Düsseldorf 1971
Europäische Barockplastik am Niederrhein, Kunstmuseum

London 1971
A Thousand Years of Enamel, Wartski

1971–2
London 1971–2
Hogarth, Tate Gallery

QG 1971–2
Dutch Pictures from the Royal Collection

1972
London 1972a
Masque of Beauty, National Portrait Gallery

London 1972b
The Age of Neo-classicism, Royal Academy and Victoria and Albert Museum

Paris 1972a
Georges de la Tour, Orangerie des Tuileries

Paris 1972b
La peinture romantique anglaise et les préraphaélites, Petit Palais

Sheffield 1972
Landseer and his World, Mappin Art Gallery

1972–3
London 1972–3
The Age of Charles I: Painting in England 1620–1649, Tate Gallery

QG 1972–3
Drawings by Michelangelo, Raphael and Leonardo and their Contemporaries

1973
Birmingham 1973
Birmingham Gold and Silver 1773–1973, Museum and Art Gallery

Brussels 1973
Dessins de la collection de S.M. la Reine Elizabeth II, Château de Windsor (Europalia 1973), Palais des Beaux-Arts

London 1973
Aelbert Cuyp in British Collections, National Gallery

Paris/Ottawa 1973
École de Fontainebleau, Grand Palais; *Fontainebleau, Art in France 1528–1610*, National Gallery of Canada

1974
London 1974
Samuel Cooper and his Contemporaries, National Portrait Gallery

Paris 1974
Louis XV. Un moment de perfection de l'art français, Hôtel de la Monnaie

The Hague 1974
Gerard ter Borch, Mauritshuis

1974–5
QG 1974–5
George III, Collector and Patron

1975
Bologna 1975
Federico Barocci, Museo Civico

Edinburgh 1975
'A King of Gentle Painting'. Miniatures by the Elizabethan Court Artists Nicholas Hilliard and Isaac Oliver, Scottish Arts Council Gallery

London 1975a
Drawings by Michelangelo, British Museum

London 1975b
The Rival of Nature: Renaissance Painting in its Context, National Gallery

London 1975c
The Georgian Playhouse. Actors, Artists, Audiences and Architecture 1730–1830, Hayward Gallery

London 1975d
Paul Nash. Paintings and Watercolours, Tate Gallery

Philadelphia 1975
Carlo Maratti and his Contemporaries, Pennsylvania State University Museum of Art

Tokyo 1975
English Drawings from the Collection of HM Queen Elizabeth II at Windsor Castle, National Museum of Western Art

1975–6
QG 1975–6
Landscapes. Paintings and Drawings from the Royal Collection

1976
London 1976
Paintings from the Muslim Courts of India, British Museum

Rotherham 1976
Rockingham 150, Art Gallery, Brian O'Malley Arts Centre

Washington 1976
The Eye of Thomas Jefferson, National Gallery of Art

Washington/Los Angeles 1976
Leonardo da Vinci: Anatomical Drawings from The Queen's Collection at Windsor Castle, National Museum of History and Technology; County Museum of Art

1977
Australia 1977
The Royal Silver Jubilee Exhibition, in four carriages of a special train, travelling 11,250 km in four months, with numerous stops on a route Sydney–Brisbane–Melbourne–Adelaide–Perth–Sydney

London 1977a
Rubens Drawings and Sketches, British Museum

London 1977b
Johann Zoffany 1733–1810, National Portrait Gallery

London 1977c
Gainsborough and his Musical Friends, Kenwood House

London 1977d
Fabergé 1846–1920 Goldsmith to the Imperial Court of Russia, Victoria and Albert Museum

1977–8
Dordrecht, 1977–8
Aelbert Cuyp en zijn familie: schilders te Dordrecht, Dordrechts Museum

QG 1977–8
Silver Jubilee Exhibition. The Queen's Pictures. The Story of the Royal Collection from Henry VIII to Elizabeth II

1977–84
London/Florence/Hamburg/Mexico City/Adelaide/Melbourne/New York 1977–84
Leonardo da Vinci: Anatomical Drawings from the Royal Collection, Royal Academy 1977; Palazzo Vecchio 1979; Kunsthalle 1979; Museo del Palacio de Bellas Artes 1981–2; Art Gallery of South Australia 1982; National Gallery of Victoria 1982; Metropolitan Museum 1984

1978–9
Paris 1978–9
Les Frères Le Nain, Grand Palais

QG 1978–9
Holbein and the Court of Henry VIII

1979
London 1979a
John Flaxman, RA, Royal Academy

London 1979b
Somerset House Art Treasures Exhibition, Somerset House

1979–80
London 1979–80
Sir Thomas Lawrence 1769–1830, National Portrait Gallery

QG 1979–80
Sèvres Porcelain from the Royal Collection

Stockholm 1979–80
1700-tal. Tanke och form i rokokon, Nationalmuseum

1980
Birmingham 1980
British Coloured Books 1738–1898, National Exhibition Centre

Florence 1980
Firenze e la Toscana dei Medici nell'Europa del Cinquecento. Il primato del disegno, Palazzo Strozzi

1980–1
London 1980–1a
Princely Magnificence. Court Jewels of the Renaissance 1500–1630, Victoria and Albert Museum

London 1980–1b
Thomas Gainsborough, Tate Gallery

1980–2
QG 1980–2
Canaletto. Paintings and Drawings

1980–8
Malibu/New York/London/Houston/Milan/Stockholm/Zurich/Hamburg/Sydney/Brisbane/Auckland/Tokyo/Barcelona/Madrid 1980–8
Leonardo da Vinci: Nature Studies from the Royal Library, Windsor Castle, J. Paul Getty Museum 1980–1; Metropolitan Museum 1981; Royal Academy 1981; Museum of Fine Arts 1982; Castello Sforzesco 1982; Nationalmuseum 1982–3; Kunsthaus 1983–4; Kunsthalle 1984; Art Gallery of New South Wales 1984; Queensland Art Gallery 1984; City Art Gallery 1984–5; Seibu Museum of Art 1985; Centre Cultural de la Fundació Caixa de Pensions 1987; Sala de Exposiciones de la Fundación Caja de Pensiones 1987–8

1981
Brighton 1981
Eat, Drink and be Merry, Brighton Museum and Art Gallery

London 1981
Royal Westminster Exhibition, Royal Institute of Chartered Surveyors

1981–2
Philadelphia/London 1981–2
Sir Edwin Landseer, Museum of Art 1981–2; Tate Gallery 1982

1982
London 1982a
Leslie Durbin. Fifty Years of Silversmithing, Goldsmiths' Hall

London 1982b
The Art of the Book in India, British Library

Stuttgart 1982
Bolognesische Zeichnungen 1600–1830, Staatsgalerie

Venice 1982
Canaletto: Dipinti, disegni, incisioni, Fondazione Giorgio Cini

1982–3
London 1982–3
Van Dyck in England, National Portrait Gallery

Malibu/New York 1982–3
Holbein and the Court of Henry VIII, J. Paul Getty Museum 1982–3; Pierpont Morgan Library 1983

Washington/Paris 1982–3
Claude Lorrain 1600–1682, National Gallery of Art 1982–3; Grand Palais 1983

1983
Brussels 1983
Dessins vénitiens du dix-huitième siècle, Palais des Beaux-Arts

London 1983a
Artists of the Tudor Court. The Portrait Miniature Rediscovered, Victoria and Albert Museum

London 1983b
Heralds and the Order of the Garter, Tower of London

London/Hanover 1983
Peter Blake, Tate Gallery; Kestner-Gesellschaft

New York 1983
Fabergé Jeweller to Royalty, Cooper-Hewitt Museum

1983–4
London 1983–4a
Drawings by Raphael, British Museum

London 1983–4b
The Genius of Venice 1500–1600, Royal Academy

London 1983–4c
Prince Albert, His Life and Work, Royal College of Art

QG 1983–4
Kings and Queens

1984
London 1984
Rococo: Art and Design in Hogarth's England, Victoria and Albert Museum

Philadelphia/Berlin/London 1984
Masters of Seventeenth-century Dutch Genre Painting, Museum of Art; Staatliche Museen, Gemäldegalerie; Royal Academy

1984–5
London 1984–5
George Stubbs, 1724–1806, Tate Gallery

1985
Norwich 1985
Norfolk and the Grand Tour, Castle Museum

1985–6
Leicester 1985–6
Masterpieces of Reality, Leicestershire Museum and Art Gallery

London/Nottingham 1985–6
Bonington, Francia and Wyld, Victoria and Albert Museum 1985; University Art Gallery 1986

Paris/London 1985–6
Reynolds, Grand Palais 1985; Royal Academy 1986

QG 1985–6
Fabergé

Washington 1985–6
The Treasure Houses of Britain. Five Hundred Years of Private Patronage and Art Collecting, National Gallery of Art

1986
Amsterdam 1986
Kunst voor de beeldenstorm, Rijksmuseum

Leeds 1986
Great Paintings of Victorian Daily Life, City Art Galleries

1986–7
Munich 1986–7
Fabergé, Kunsthalle der Hypo-Kulturstiftung

QG 1986–7
Master Drawings in the Royal Collection from Leonardo da Vinci to the Present Day

1987
Edinburgh 1987
The Queen's Image. A Celebration of Mary, Queen of Scots, Scottish National Portrait Gallery

London 1987
Burlington House Fair, Royal Academy

London/New Haven 1987
Drawing in England from Hilliard to Hogarth, British Museum; Yale Center for British Art

Nottingham/Edinburgh 1987
Genial Company. The Theme of Genius in Eighteenth-century British Portraiture, University Art Gallery; Scottish National Portrait Gallery

Raleigh/New Haven 1987
Sir David Wilkie of Scotland 1785–1841, North Carolina Museum of Art; Yale Center for British Art

1987–8
London/Paris 1987–8
Franz Xaver Winterhalter and the Courts of Europe 1830–70, National Portrait Gallery; Petit Palais

Washington/San Francisco/Chicago 1987–8
Italian Master Drawings from the British Royal Collection, National Gallery of Art 1987; Fine Arts Museum 1987; Art Institute 1987–8

1987–9
Houston/Hamburg/Basel/Toronto 1987–9
Drawings by Holbein from the Court of Henry VIII, Museum of Fine Arts 1987; Kunsthalle 1988; Kunstmuseum 1988; Art Gallery of Ontario 1988–9

1988
London 1988a
Armada 1588–1988, National Maritime Museum, Greenwich

London 1988b
Fantastic Fancy: Fine and Decorative Arts from the Reign of William III and Mary II, Kensington Palace

New York 1988
Courts and Colonies, Cooper-Hewitt Museum

Sydney/Melbourne/Brisbane 1988
A Study in Genius: Master Drawings and Watercolours from the Collection of Her Majesty The Queen in the Royal Library, Windsor Castle, Art Gallery of New South Wales; National Gallery of Victoria; Queensland Art Gallery

1988–9
New York 1988–9
Tartan, Fashion Institute of Technology

Philadelphia/Cambridge MA 1988–9
Pietro Testa 1612–1650. Prints and Drawings, Museum of Art 1988; Arthur M. Sackler Museum, 1989

QG 1988–9
Treasures from the Royal Collection

1989
London 1989a
Leonardo da Vinci, Hayward Gallery

London 1989b
Frans Hals, Royal Academy

Venice 1989
William Hogarth: Dipinti, disegni, incisioni, Fondazione Giorgio Cini

Zurich 1989
Carl Fabergé, Museum Bellerive

1989–90
Boston/Chicago/London 1989–90
Monet in the 90s. The Series Paintings, Museum of Fine Arts 1989; Art Institute 1990; Royal Academy 1990

Frankfurt/Fort Worth/Richmond/Edinburgh/Venice 1989–90
The Consul Smith Collection. Schirn Kunsthalle 1989; Kimbell Art Museum 1989–90; Virginia Museum of Fine Arts 1990; National Gallery of Scotland 1990; Fondazione Giorgio Cini 1990

London 1989–90
Tom Phillips. The Portrait Works, National Portrait Gallery

New York 1989–90
Canaletto, Metropolitan Museum of Art

San Diego/Moscow 1989–90
Fabergé. The Imperial Eggs, San Diego Museum of Art 1989; Armoury Museum, Kremlin 1989–90

1989–91
Bristol/Cardiff 1989–91
The Royal Collection: Paintings from Windsor Castle, Bristol City Art Gallery 1989–90; National Museum of Wales 1990–1 (part of an exhibition tour involving sixty paintings from the Grand Corridor at Windsor Castle, shown in small groups at six regional galleries; they were united for the final showing at Cardiff, to which the published catalogue relates)

1990

Brighton 1990
The Craces. Royal Decorators,
Brighton Museum and Art
Gallery

London 1990a
Porcelain for Palaces, British
Museum

London 1990b
A Loan Exhibition of Eighteenth-
century Gold Boxes, Wartski

1990–1

Hampton Court 1990–1
Henry VIII: Images of a Tudor
King

London 1990–1
The Raj. India and the British
1600–1947, National Portrait
Gallery

Oxford 1990–1
Drawings by Poussin from British
Collections, Ashmolean Museum

QG 1990–1
A Royal Miscellany from the
Royal Library at Windsor Castle

1991

Edinburgh 1991
The Art of Jewellery in Scotland,
Scottish National Portrait
Gallery

London 1991a
The Queen's Pictures. Royal
Collectors through the Centuries,
National Gallery

London 1991b
Henry VIII: A European Court in
England, National Maritime
Museum

London 1991c
Drawings by Guercino from British
Collections, British Museum

1991–2

Berlin/Amsterdam/London
1991–2
Rembrandt: The Master and his
Workshop, Gemäldegalerie
SMPK at the Altes Museum
1991; Rijksmuseum 1991–2;
National Gallery 1992

Fort Worth/Washington/
New York 1991–2
Guercino Drawings from Windsor
Castle, Kimbell Art Museum
1991–2; National Gallery of
Art 1992; The Drawing
Center 1992

London/Edinburgh 1991–2
Palaces of Art: Art Galleries in
Britain 1790–1990, Dulwich
Picture Gallery 1991–2;
National Gallery of Scotland
1992

QG 1991–2
Carlton House. The Past Glories of
George IV's Palace

Washington 1991–2
Circa 1492. Art in the Age of
Exploration, National Gallery
of Art

1991–4

Edinburgh/Aberdeen/
Manchester/Windsor 1991–4
Royal Residences of the Victorian
Era, Palace of Holyroodhouse
1991–2; City Art Gallery
1992; Whitworth Art Gallery
1993; The Gallery, Windsor
Castle 1993–4

1992

Essen 1992
Metropole London, Villa Hügel

London 1992a
Sovereign: EIIR. A Celebration of
Forty Years of Service, Victoria
and Albert Museum

London 1992b
The Swagger Portrait: Grand
Manner Portraiture in Britain from
Van Dyck to Augustus John,
1630–1930, Tate Gallery

London 1992c
The Order of Merit. New Portrait
Drawings from the Royal
Collection, National Portrait
Gallery

Montreal 1992
The Genius of the Sculptor in
Michelangelo's Work, Museum of
Fine Arts

Norwich 1992
Norfolk Portraits, Castle
Museum

1992–3

Munich 1992–3
Friedrich der Grossen Sammler und
Mäzen, Kunsthalle

1992–5

Houston/Philadelphia/Boston/
Tokyo/Nagoya 1992–5
Leonardo da Vinci: The Anatomy
of Man, Museum of Fine Arts
1992; Museum of Art 1992;
Museum of Fine Arts 1992–3;
Teien Metropolitan Museum
1995; Aichi Prefectural
Museum 1995

1993

Berlin 1993
Japan und Europa 1543–1929,
Berliner Festwochen, Martin-
Gropius-Bau

London 1993a
The Paper Museum of Cassiano
dal Pozzo, British Museum

London 1993b
The Monarch in Portrait
Miniatures from Elizabeth I to
Queen Victoria, D.S. Lavender
Antiques Ltd

QG 1993
A King's Purchase. King George
III and the Collection of Consul
Smith

1993–4

Edinburgh/Cambridge/London
1993–4
Holbein and the Court of Henry
VIII. Drawings and Miniatures
from the Royal Library, Windsor
Castle, Scottish National
Portrait Gallery 1993;
Fitzwilliam Museum 1993–4;
National Portrait Gallery 1994

St Petersburg/Paris/London
1993–4
Fabergé. Imperial Jeweller, State
Hermitage Museum 1993;
Musée des Arts Décoratifs
1993; Victoria and Albert
Museum 1993–4

1994

QG 1994
Gainsborough and Reynolds.
Contrasts in Royal Patronage

1994–5

London/Washington 1994–5
The Glory of Venice, Royal
Academy 1994; National
Gallery of Art 1995

Montreal/Raleigh/Indianapolis/
Oxford 1994–5
Dutch and Flemish Drawings from
the Royal Library, Windsor Castle,
Museum of Fine Arts 1994–5;
North Carolina Museum of Art
1995; Museum of Art 1995;
Ashmolean Museum 1995

Wellington/Canberra/Ottawa
1994–5
The Queen's Pictures. Old Masters
from the Royal Collection,
National Gallery of New
Zealand 1994–5; National
Gallery of Australia 1995;
National Gallery of Canada
1995

1995

Berlin 1995
Friedrich Wilhelm IV, Künstler
und König zum 200. Geburtstag,
Neue Orangerie im Park von
Sanssouci

Chicago 1995
Claude Monet 1840–1926, Art
Institute

London 1995
Dynasties: Painting in Tudor and
Jacobean England 1530–1630,
Tate Gallery

Mecklenburg 1995
1000 Jahre Mecklenburg, Schloss
Güstrow

1995–6

London/Houston/Cleveland/
New York 1995–6
Poussin: Works on Paper.
Drawings from the Collection of
Her Majesty The Queen, Dulwich
Picture Gallery 1995;
Museum of Fine Arts 1995;
Museum of Art 1995–6;
Metropolitan Museum of Art
1996

QG 1995–6
Fabergé

The Hague/Washington
1995–6
Johannes Vermeer, Mauritshuis
1995–6; National Gallery of
Art 1996

Washington/Houston 1995–6
John Singleton Copley in England,
National Gallery of Art
1995–6; Museum of Fine Arts
1996

1996

London 1996a
Making and Meaning. Rubens's
Landscapes, National Gallery

London 1996b
Creations and Recreations. Alec
Cobbe: Thirty Years of Design and
Painting, The Prince of Wales's
Institute of Architecture

1996–7

London 1996–7
Sir William Chambers: Architect to
George III, Courtauld Gallery

London/Rome 1996–7
Grand Tour. The Lure of Italy in
the Eighteenth Century, Tate
Gallery 1996–7; Palazzo delle
Esposizioni 1997

New York/San Marino/
Richmond/QG 1996–7
Masterpieces in Little. Portrait
Miniatures from the Collection of
Her Majesty Queen Elizabeth II,
Metropolitan Museum of Art
1996–7; The Huntington
Library, Art Collections and
Botanical Gardens 1997;
Virginia Museum of Fine Arts
1997; The Queen's Gallery
1997

Oxford/London 1996–7
Drawings by the Carracci from
British Collections, Ashmolean
Museum 1996–7; Hazlitt,
Gooden & Fox 1997

QG 1996–7
Leonardo da Vinci. One Hundred
Drawings from the Collection of
Her Majesty The Queen

1996–8

Paris/Windsor/Edinburgh
1996–8
Royal Insignia. British and
Foreign Orders of Chivalry from
the Royal Collection, Mona
Bismarck Foundation 1996;
Windsor Castle, The Gallery
1997; The Palace of
Holyroodhouse 1997–8

Washington/Fort Worth/
Chicago/Cambridge/QG
1996–8
Michelangelo and his Influence:
Drawings from Windsor Castle,
National Gallery of Art
1996–7; Kimbell Art
Museum 1997; Art Institute
1997; Fitzwilliam Museum
1997; The Queen's Gallery
1998

1997

Berlin 1997
Victoria & Albert. Vicky & The
Kaiser. Ein Kapitel deutsch-
englischer Familiengeschichte,
Deutsches Historisches
Museum

Coburg 1997
Ein Herzogtum und viele Kronen.
Coburg in Bayern und Europa,
Schloß Callenberg

Edinburgh 1997
Cassiano dal Pozzo's Paper
Museum. Drawings from the
Royal Collection, National
Gallery of Scotland

London 1997a
Hogarth the Painter: A Celebration
of the Tercentenary of his Birth,
Tate Gallery

London 1997b
London's Monets, National Gallery

QG 1997
Views of Windsor. Watercolours by Paul and Thomas Sandby

Rotherham 1997
A Celebration of Yorkshire Pots, Clifton Park Museum

Stockholm 1997
Carl Fabergé Goldsmith to the Tsar, Nationalmuseum

Washington 1997
The Victorians: British Painting 1837–1901, National Gallery of Art

1997–8
London 1997–8
Making and Meaning. Holbein's Ambassadors, National Gallery

New Delhi/QG/Washington/ New York/Los Angeles/Fort Worth/Indianapolis 1997–8
King of the World. The Padshahnama, An Imperial Mughal Manuscript, National Museum 1997; The Queen's Gallery 1997; Arthur M. Sackler Gallery 1997; Metropolitan Museum of Art 1997–8; County Museum of Art 1998; Kimbell Art Museum 1998; Museum of Art 1998

1997–9
San Marino/Houston/ Williamsburg/Savannah/QG 1997–9
Mark Catesby's Natural History of America, Huntington Library 1997; Museum of Fine Arts 1997; De Witt Wallace Gallery 1997–8; Telfair Museum of Art 1998; The Queen's Gallery 1998–9

Washington/Bergamo/Paris 1997–9
Lorenzo Lotto: Rediscovered Master of the Renaissance, National Gallery of Art 1997–8; Accademia Carrara di Belle Arti 1998; Grand Palais 1998–9

1998
Cardiff 1998
Princes as Patrons. The Art Collections of the Princes of Wales from the Renaissance to the Present Day, National Museum of Wales

Edinburgh 1998
Effigies and Ecstasies: Roman Baroque Sculpture and Design in the Age of Bernini, National Gallery of Scotland

London 1998
Antique Dealer's Fair and Exhibition, Grosvenor House Hotel, Park Lane

1998–9
Amsterdam/Stockholm/ Los Angeles 1998–9
Adriaen de Vries 1556–1626: Imperial Sculptor, Rijksmuseum 1998–9; Nationalmuseum 1999; J. Paul Getty Museum 1999

Brussels 1998–9
Albert et Isabelle 1598–1621, Musée Royal d'Art et d'Histoire

Edinburgh/Kendal/Bath 1998–9
Queen Victoria's Travels and Family. Watercolours from the Royal Collection, Palace of Holyroodhouse 1998–9; Abbot Hall Art Gallery 1999; Holburne Museum 1999

QG/Barnard Castle 1998–9
The Quest for Albion: Monarchy and the Patronage of British Painting, The Queen's Gallery 1998; The Bowes Museum 1998–9

1999
London 1999a
Royal Persian Paintings: The Qajar Epoch, 1785–1925, The Brunei Gallery

London 1999b
The Arts of the Sikh Kingdoms, Victoria and Albert Museum

London 1999c
Chelsea China, Chelsea Town Hall

London 1999d
Countdown to the Millennium. Fabergé, Tessier

1999–2000
QG/Edinburgh 1999–2000
The King's Head. Charles I – King and Martyr, The Queen's Gallery 1999; Palace of Holyroodhouse 1999–2000

Sydney 1999–2000
Michelangelo to Matisse. Drawing the Figure, Art Gallery of New South Wales

1999–2001
QG/Washington/Toronto/ Los Angeles 1999–2001
Raphael and his Circle, The Queen's Gallery 1999; National Gallery of Art 2000; Art Gallery of Ontario 2000; J. Paul Getty Museum 2000-1

2000
Amsterdam 2000
The Glory of the Golden Age. Dutch Art of the Seventeenth Century. Painting, Sculpture and Decorative Art, Rijksmuseum

Augsburg 2000
Adriaen de Vries (1556–1626): Augsburgs Glanz, Europas Ruhm, Maximilianmuseum

Philadelphia/Houston 2000
The Splendor of Eighteenth-century Rome, Philadelphia Museum of Art; Houston Museum of Fine Arts

Windsor 2000
Out of the Ashes. Watercolours of Windsor Castle by Alexander Creswell, The Moat Road Gallery, Windsor Castle

2000–01
York/London/Norwich 2000–01
Eat, Drink and Be Merry: The British at Table 1600–2000, Fairfax House 2000; Kenwood House 2000; Assembly Rooms 2000–01

2001
London 2001a
Treasury of the World: Jewelled Arts of India in the Age of the Mughals, British Museum

London 2001b
Inventing New Britain: The Victorian Vision, Victoria and Albert Museum

Salford 2001
Unseen Landscapes, The Lowry

Bibliography and abbreviations

Ackermann 1808–11
R. Ackermann, *The Microcosm of London*, 3 vols, London

Ackermann's *Repository*
R. Ackermann, *The Repository of Arts, Literature, Commerce, Manufactures, Fashions and Politics*, 40 vols, London, 1809–28

Adams 1983
B. Adams, *London Illustrated 1604–1851: A Survey and Index of Topographical Books and their Plates*, London

Add. Cat.
Catalogue of Additions to the King's Audience Room, 1914 (typescript; RCIN 1115976)

Adler 1982
W. Adler, *Corpus Rubenianum Ludwig Burchard: XVIII, I – Landscapes*, London

Alexander 1957
B. Alexander, *Life at Fonthill, 1807–22*, London

Altick 1985
R.D. Altick, *Paintings from Books. Art and Literature in Britain 1760–1900*, Ohio

Anderson 1997
J. Anderson, *Giorgione. The Painter of 'Poetic Brevity'*, Paris and New York

Annual Register 1762
The Annual Register for the Year 1761, London

Arbuthnot Journal
Journal of Mrs Arbuthnot, ed. F. Bamford and the Duke of Wellington, 2 vols, London, 1950

Archer 1976a
M. Archer, 'Pyramids and Pagodas for Flowers', *Country Life*, 22 January, pp. 166–9

Archer 1976b
M. Archer, 'Delft at Dyrham', *The National Trust Year Book 1975–76*, London, pp. 12–18

Archer 1984
M. Archer, 'Dutch Delft at the Court of William and Mary', *Handbook of the International Ceramics Fair and Seminar*, London, pp. 15–20

Archer, Rowell & Skelton 1987
Treasures from India: The Clive Collection at Powis Castle, eds M. Archer, C. Rowell and R. Skelton, London

Ashton 1841
H. Ashton, *Illustrations of Windsor Castle by the late Sir Jeffry Wyatville RA*, London

Aspinall 1938
The Letters of King George IV 1812–1830, ed. A. Aspinall, 3 vols, Cambridge

Aspinall 1963–71
The Correspondence of George, Prince of Wales, 1770–1812, 8 vols, London

Avery 1982
C. Avery, 'Hubert Le Sueur, the "Unworthy Praxiteles" of King Charles I', *Walpole Society*, XXXVIII, pp. 135–209

Baetjer & Links 1989
K. Baetjer and J.G. Links, *Canaletto*, New York

Bainbridge 1933
H.C. Bainbridge, *Twice Seven. The Autobiography*, London

Bainbridge 1949
H.C. Bainbridge, *Peter Carl Fabergé. His Life and Work 1846–1920*, London

Baldwin 1990
D. Baldwin, *The Chapel Royal Ancient and Modern*, London

Ballew Neff 1995
E. Ballew Neff, *John Singleton Copley in England*, London

Ballot 1919
M.J. Ballot, 'Charles Cressent: Sculpteur, Ebéniste, Collectionneur', *Archives de l'Art Français*, n.p. X

Baratte et al. 1999
S. Baratte, G. Bresc-Bautier, S. Castelluccio, S. Descamps-Lequime and A. Lefébure, *Les Bronzes de la Couronne*, Paris

Barocchi & Ragionieri 1983
P. Barocchi and G. Ragionieri, eds, *Gli Uffizi, quattro secoli di una galleria*, 2 vols, Florence

Barr 1980
E. Barr, *George Wickes, Royal Goldsmith 1698–1761*, London

Bathoe 1758
A Catalogue of the Collection of Pictures etc. belonging to King James the Second; to which is added, A Catalogue of the Pictures and Drawings in the Closet of the late Queen Caroline ... and also of the Principal Pictures in the Palace at Kensington, printed for W. Bathoe, London

Bätschmann & Griener 1997
O. Bätschmann and P. Griener, *Hans Holbein*, London, 1997

Baulez 1995
C. Baulez, 'Les "Vases Chinois" Bleu Lapis de Madame Adélaïde', *Revue du Louvre*, IV, pp. 70–3

Bazin 1963
G. Bazin, *The Museum Age*, Paris

Beach & Koch 1997
M.C. Beach and E. Koch, *King of the World. The Padshahnama, An Imperial Mughal Manuscript from the Royal Library, Windsor Castle*, London and Washington

Beard 1970
G. Beard, 'William Kent and the Royal Barge', *Burlington Magazine*, CXII, pp. 488–95

Berthoud 1982
R. Berthoud, *Graham Sutherland. A Biography*, London

Bertram 1955
A. Bertram, *Paul Nash. Portrait of an Artist*, London

Bewer 2001
F. Bewer, 'The Sculpture of Adriaen de Vries: a technical study', in *Small Bronzes in the Renaissance*, ed. D. Pincus, New Haven and London, pp. 159–93

Bickham 1742
G. Bickham, *Deliciae Britannicae: or, the Curiosities of Hampton Court and Windsor Castle, Delineated*, [London]

Binns 1877
R.W. Binns, *A Century of Potting in the City of Worcester, being the History of the Royal Porcelain Works from 1751 to 1851*, 2nd edn, London and Worcester

Birrell 1987
T.A. Birrell, *English Monarchs and their Books: From Henry VII to Charles II. The Panizzi Lectures 1986*, London

BL
British Library

Blackmore 1968
H. Blackmore, *Royal Sporting Guns at Windsor Castle*, London

Blair 1970
C. Blair, 'A Royal Swordsmith and Damascener: Diego de Çaias', *Metropolitan Museum Journal*, III, pp. 149–98

Blair 1974
C. Blair, *The James A. de Rothschild Collection at Waddesdon Manor. Arms and Armour and Base Metalwork*, Fribourg

Blunt 1945
A. Blunt, *The French Drawings in the Collection of His Majesty The King at Windsor Castle*, London

Blunt 1954
A. Blunt, *The Drawings of G.B. Castiglione and Stefano della Bella in the Collection of Her Majesty The Queen at Windsor Castle*, London

Blunt 1971
A. Blunt, 'Supplements to the Catalogues of Italian and French Drawings', in E. Schilling, *The German Drawings in the Collection of Her Majesty The Queen at Windsor Castle*, London and New York, pp. 45–239

Blunt & Cooke 1960
A. Blunt and H.L. Cooke, *The Roman Drawings of the XVII and XVIII Centuries in the Collection of Her Majesty The Queen at Windsor Castle*, London

Blunt & Croft-Murray 1957
A. Blunt and E. Croft-Murray, *The Venetian Drawings of the XVII and XVIII Centuries in the Collection of Her Majesty The Queen at Windsor Castle*, London

Bode 1902
W. von Bode, 'Die Bemalte Thonbüste eines Lachenden Kindes im Buckingham Palace und Meister Konrad Meit', *Jahrbuch der Königlich Preussischen Kunstsammlungen*, XXII, pp. iv–xvi

Boschloo 1974
A.W.A. Boschloo, *Annibale Carracci in Bologna. Visible Reality after the Council of Trent*, 2 vols, The Hague

Bowron & Graf 1978
E. Bowron and D. Graf, 'Giuseppe Passeri's The Cleansing of the Temple and a Group of Preparatory Drawings in Düsseldorf', *Journal of the Walters Art Gallery*, XXXVII, pp. 37–49

Bowron & Rishel 2000
E. Bowron and J. Rishel, eds, *Art in Rome in the Eighteenth Century*, London

Bray 1851
A.E. Bray, *Life of Thomas Stothard, RA*, London

Brighton Inventory
Inventory of the Contents of Brighton Pavilion, 1826 (MS; RCIN 1114926)

Brooke 1972
J. Brooke, *King George III*, London

Broughton 1909
Lord Broughton (John Cam Hobhouse), *Recollections of a Long Life*, 2 vols, London

Brown (C.) 1996
C. Brown, *Making and Meaning. Rubens's Landscapes*, London

Brown (D.) 1985
D.B. Brown, *Sir David Wilkie. Drawings and Sketches in the Ashmolean Museum*, London

Brown, Kelch & Van Thiel 1991
C. Brown, J. Kelch and P. van Thiel, *Rembrandt: The Master and his Workshop*, New Haven and London

Brunet & Préaud 1978
M. Brunet and T. Préaud, *Sèvres des origines à nos jours*, Fribourg

Bryant 2001
B. Bryant, '"Stalwart Young Men": the first public Picture Conservation Studio', *English Heritage: Collections Review*, III, pp. 128–37

Buddle 1999
A. Buddle, *The Tiger and the Thistle. Tipu Sultan and the Scots in India 1760–1800*, Edinburgh

Bury 1962
S. Bury, 'The Prince Consort and the Royal Plate Collections', *Burlington Magazine*, CIV, pp. 352–4

Bury 1966
S. Bury, 'The Lengthening Shadow of Rundells. Part 2: The substance and growth of the Flaxman tradition', *Connoisseur*, CLXI, pp. 152–8

Bury 1991
S. Bury, *Jewellery 1789–1910*, 2 vols, Woodbridge

Bury & Snodin 1984
S. Bury and M. Snodin, 'The Shield of Achilles by John Flaxman, RA', in *Sotheby's Art at Auction 1983–4*, London, pp. 274–83

Campbell (C.) 2000
C. Campbell, *The Maharajah's Box*, London

Campbell (L.) 1985
L. Campbell, *The Early Flemish Pictures in the Collection of Her Majesty The Queen*, Cambridge

Campbell (T.) 1994
T. Campbell, 'William III and "The Triumph of Lust"', *Apollo*, CXLI, pp. 22–31

Campbell (T.) 1998a
T. Campbell, 'Romulus and Remus Tapestries in the Collection of Henry VIII', *Apollo*, CXLVII, pp. 42–50

Campbell (T.) 1998b
T. Campbell, 'The English Royal Tapestry Collection 1485–1547', 2 vols, unpublished PhD thesis, Courtauld Institute, University of London

Carlton House 1991
Carlton House. The Past Glories of George IV's Palace, ed. G. de Bellaigue, London

Casteras & Parkinson 1988
S.P. Casteras and R. Parkinson, eds, *Richard Redgrave 1804–1888*, New Haven and London

Causey 1980
A. Causey, *Paul Nash*, Oxford

CDP
The Paper Museum of Cassiano dal Pozzo: a Catalogue Raisonné. Drawings and Prints in the Royal Library at Windsor Castle, the British Museum, the Institut de France and other Collections, ed. F. Haskell, J. Montagu and A. MacGregor, 5 vols, London, 1996– (continuing)

CHAC
A Catalogue of Arms. The Property of HRH The Prince of Wales at Carlton House, compiled by Benjamin Jutsham, late eighteenth century–1827, 7 vols (MS; RCIN 1113358–64)

Chambers 1996
Sir William Chambers, Architect to George III, ed. J. Harris and M. Snodin, New Haven and London

Chanticleer 1936
Chanticleer: A Bibliography of the Golden Cockerel Press, April 1921–August 1936, London

Chantrey Ledger
A. Yarrington, I.D. Lieberman, A. Potts and M. Baker, 'An Edition of the Ledger of Sir Francis Chantrey, RA, at the Royal Academy, 1809–1841', *Walpole Society*, LVI (1991–2), 1994

CHI, vol. H1
A Liste of Furniture &c. which did belong to Carlton House in the Years (sic) 1826 (MS; RCIN 1114768)

Chomer 2000
G. Chomer, *Peintures françaises avant 1815. La collection du Musée de Grenoble*, Paris

CHPI
A Descriptive List of His Majesty's Ornamental Seve Porcelain at Carlton House, 1826 (MS; RCIN 1114753)

Churchill 1933–8
W.S. Churchill, *Marlborough, His Life and Times*, 3 vols, London

Clark & Pedretti 1968–9
K. Clark and C. Pedretti, *The Drawings of Leonardo da Vinci in the Collection of Her Majesty The Queen at Windsor Castle*, 2nd edn, 3 vols, London

Clarke 1898
C.P. Clarke, *Catalogue of the Collection of Indian Arms and Objects of Art presented by the Princes and Nobles of India to HRH the Prince of Wales ... now in the Indian Room at Marlborough House*, London

Clayton 2002
M. Clayton, 'Leonardo's Gypsies, and the Wolf with the Eagle', *Apollo*, August (forthcoming)

Clifford 1985
T. Clifford, 'John Bacon and the Manufacturers', *Apollo*, CXXII, pp. 288–304

Cobbe 1996
A. Cobbe, *Creations and Recreations. Thirty Years of Design and Painting*, London

Cole 1884
H. Cole, *Fifty Years of Public Work*, 2 vols, London

Colonna 1999
F. Colonna, *Hypnerotomachia Poliphili: The Strife of Love in a Dream*, transl. and ed. by J. Godwin, London

Constable & Links 1989
W.G. Constable and J.G. Links, *Canaletto*, 2nd edn, 2 vols, Oxford

Copeland 1987
R. Copeland, 'Jars for the King; Spode's Contributions to the Brighton Pavilion', *Recorder. A Publication of the Spode Society*, I, pp. 2–6

Coppel Aréizaga 1998
R. Coppel Aréizaga, *Museo del Prado. Catálogo de la Escultura de Época Moderna, Siglos XVI–XVIII*, Madrid

Cordey 1939
J. Cordey, *Inventaire des Biens de Madame de Pompadour redigé après son décès*, Paris

Cornforth 1990
J. Cornforth, 'Frogmore House, Berkshire', *Country Life*, 16 August, pp. 46–51 and 23 August, pp. 42–5

Cornforth 1996
J. Cornforth, *Queen Elizabeth The Queen Mother at Clarence House*, London

Corp 2001
E. Corp, *The King over the Water. Portraits of the Stuarts in Exile after 1689*, Edinburgh

Cowling 1989
M. Cowling, *The Artist as Anthropologist. The Representation of Type and Character in Victorian Art*, Cambridge

Cox 1975
A. and A. Cox, 'The Rockingham Dessert Service for William IV; a Royal Extravaganza', *Connoisseur*, CLXXXVIII, pp. 90–7

Cox 1983
A. and A. Cox, *Rockingham Pottery and Porcelain 1745–1842*, London

Creswell 2000
Out of the Ashes. Watercolours [by Alexander Creswell] of Windsor Castle, London

Cripps 1899
W.J. Cripps, *Old English Plate*, London

Crown Jewels 1998
The Crown Jewels. The History of the Coronation Regalia in the Jewel House of the Tower of London, ed. C. Blair, 2 vols, London

Cust 1925
L. Cust, 'Guido Mazzoni (Paganino)', *Apollo*, II, pp. 311–17

Cust 1930
L. Cust, *King Edward VII and his Court*, London

Cuzin & Rosenberg 1997
J.P. Cuzin and P. Rosenberg, *Georges de La Tour*, Paris

Czére 1991
A. Czére, 'Francesco Bosio, Ludovico Mattioli and Antonio Maria Monti: Eighteenth-century Bolognese Landscape Drawings', *Master Drawings*, XXIX, pp. 385–409

De Bellaigue (G.) 1975
G. de Bellaigue, 'Chinoiserie at Buckingham Palace', *Apollo*, CI, pp. 380–91

De Bellaigue (G.) 1985
G. de Bellaigue, 'George IV: His Approach to Furniture', *Furniture History*, XXI, pp. 203–07

De Bellaigue (G.) 1986
G. de Bellaigue, *Sèvres Porcelain in the Collection of Her Majesty The Queen. The Louis XVI Service*, Cambridge

De Bellaigue (G.) 1997
G. de Bellaigue, 'Samuel Parker and the Vulliamys, Purveyors of Gilt Bronze', *Burlington Magazine*, CXXXIX, pp. 26–37

De Bellaigue (S.) 1998
S. de Bellaigue, 'Courts and History I. The Royal Archives Windsor Castle', *Court Historian*, III, pp. 11–21

De Bellaigue & Kirkham 1972
G. de Bellaigue and P. Kirkham, 'George IV and the Furnishing of Windsor Castle', *Furniture History*, VIII, pp. 1–34

Deelder 1999
T. Deelder, 'Andrew Moore of Bridewell; almost Forgotten and Disguised', *Silver Society Journal*, XI, pp. 178–84

Defoe Tour
D. Defoe, *A Tour through the Whole Island of Great Britain, 1724–6*, ed. G.D.H. Cole, London 1927

Dempsey 1986
C. Dempsey, 'The Carracci Reform of Painting', *The Age of Correggio and the Carracci. Emilian Paintings of the Sixteenth and Seventeenth Centuries*, Washington, pp. 237–54

De Quincey 1853
T. de Quincey, *Autobiographical Sketches*, 2 vols, London

De Tolnay 1975–80
C. de Tolnay, *Corpus dei disegni di Michelangelo*, 4 vols, Novara

DOEFM 1986
Dictionary of English Furniture Makers 1660–1840, ed. C. Gilbert and G. Beard, Leeds

Donnithorne & Warnes 2001
A. Donnithorne and M. Warnes, 'The Conservation of Iron Gall ink drawings in the Royal Collection', *The Postprints of the Iron Gall Ink Meeting*, ed. A.J.E. Brown, Newcastle, pp. 59–65

Dow 1960
H.J. Dow, 'Two Italian Portrait Busts of Henry VIII', *Art Bulletin*, XLII, pp. 291–4

Dussler 1959
L. Dussler, *Die Zeichnungen des Michelangelo. Kritischer Katalog*, Berlin

Eden 1844
E. Eden, *Up the Country. Letters from India*, London

Edgecombe 2000
R. Edgecombe, *The Art of the Gold Chaser in Eighteenth-century London*, Oxford

Edwards & Jourdain 1955
R. Edwards and M. Jourdain, *Georgian Cabinet-makers, c.1700–1800*, 3rd edn, London

Egerton 1998
J. Egerton, *National Gallery Catalogues. The British School*, London

Emiliani 1985
A. Emiliani, *Federico Barocci*, 2 vols, Pesaro

Eriksen 1968
S. Eriksen, *The James A. de Rothschild Collection at Waddesdon Manor. Sèvres Porcelain*, Fribourg

Eriksen 1974
S. Eriksen, *Early Neo-classicism in France*, London

Erkelens 1996
A.M.L.E. Erkelens, ''Delffs Porcelijn' van Koningin Mary II*, Apeldoorn

Evans 1970
J. Evans, *A History of Jewellery 1100–1870*, 2nd edn, London

Evelyn Diary
The Diary of John Evelyn, ed. E.S. de Beer, 6 vols, Oxford, 1955

Fabergé 1985
A Souvenir Album of Fabergé from the Royal Collection, London

Fabergé, Proler & Skurlov 1997
T. Fabergé, L.G. Proler and V.V. Skurlov, *The Fabergé Imperial Easter Eggs*, London

Faraday Correspondence
The Correspondence of Michael Faraday, 1832 – December 1840, ed. F.A.J.L. James, 4 vols (to date), London

Farington Diary
The Diaries of Joseph Farington, ed. K. Garlick, A. Macintyre and K. Cave, 16 vols, London and New Haven, 1978–84 (Index volume, 1998)

Fermor 1996
S. Fermor, *The Raphael Tapestry Cartoons: Narrative, Decoration, Design*, London

Fermor & Derbyshire 1998
S. Fermor and A. Derbyshire, 'The Raphael Tapestry Cartoons Re-examined', *Burlington Magazine*, CXL, pp. 236–50

Field 1987
L. Field, *The Queen's Jewels*, New York

Finke 1896
H. Finke, *Carl Müller, Sein Leben und künstlerisches Schaffen*, Cologne

Finsten 1981
J. Finsten, *Isaac Oliver: Art at the Courts of Elizabeth I and James I*, 2 vols, New York and London

Foister 1983
S. Foister, *Drawings by Holbein from the Royal Library, Windsor Castle*, London and New York

Fortescue 1933
J. Fortescue, *Author and Curator*, Edinburgh and London

Fraser Tytler 1843
P. Fraser Tytler, *Historical Notes on the Darnley Jewel*, London

Frederiks 1958
J.W. Frederiks, *Dutch Silver: Wrought Plate of North and South Holland from the Renaissance to the End of the 18th Century*, II, The Hague

French 1985
A. French, *John Joseph Merlin the Ingenious Mechanick*, London

Friedlaender & Blunt 1939–74
W. Friedlaender and A. Blunt, *The Drawings of Nicolas Poussin*, 5 vols, London

Friedländer & Rosenberg 1978
M.J. Friedländer and J. Rosenberg, *The Paintings of Lucas Cranach*, London

Fulford 1968
R. Fulford, ed., *Dearest Mama. Private Correspondence of Queen Victoria and the Crown Princess of Prussia 1861–1864*, London

G&J
Catalogue of Gems and Jewels at Windsor Castle, 1909 (illustrated typescript; RCIN 1115689)

Garlick 1989
K. Garlick, *Sir Thomas Lawrence. A Complete Catalogue of the Oil Paintings*, Oxford

Garrard 1914
Garrard & Co., *Descriptive Inventory of the Various Services of Plate, etc., at Windsor Castle and Buckingham Palace*, London

Gaskell & Jonker 1998
I. Gaskell and M. Jonker, eds, *Vermeer Studies*, New Haven and London

Gere & Turner 1983
J.A. Gere and N. Turner, *Drawings by Raphael*, London

Gilbert 1978
C. Gilbert, *The Life and Work of Thomas Chippendale*, 2 vols, London

Gilbert 1996
C. Gilbert, *Pictorial Dictionary of Marked London Furniture 1700–1840*, Leeds

Giometti 1999
C. Giometti, 'Giovanni Battista Guelfi: New Discoveries', *Sculpture Journal*, III, pp. 26–43

Glanville 1990
P. Glanville, *Silver in Tudor and Early Stuart England: A Social History and Catalogue of the National Collection*, London

Goodison 1968
N. Goodison, *English Barometers: 1680–1860*, London

Goodison 1974
N. Goodison, *Ormolu: The Work of Matthew Boulton*, London

Goodison 1990
N. Goodison, 'William Chambers' Furniture Designs', *Furniture History*, XXVI, pp. 67–89

Gordon 1830
P.L. Gordon, *Personal Memoirs*, London

Gori 1767
A.F. Gori, *Dactyliotheca Smithiana*, 2 vols, Venice

Gow 1992
I. Gow, *The Scottish Interior*, Edinburgh

Gow 1995
I. Gow, 'Holyroodhouse, Edinburgh', *Country Life*, 23 November, pp. 50–3

Gray & Gent 1999
H. Gray and M. Gent, 'The Rehousing of Queen Victoria's Private Negatives', in *Care of Photographic, Moving Image and Sound Collections*, pp. 129–35

Grimm, Ericksen & Brockhoff 1994
C. Grimm, J. Ericksen and E. Brockhoff, *Lucas Cranach – Ein Maler-Unternehmer aus Franken*, Augsburg

Grimwade 1969
A. Grimwade, 'Crespin or Sprimont? An Unsolved Problem of Rococo Silver', *Apollo*, XC, pp. 126–8

Grimwade 1974
A. Grimwade, *Rococo Silver 1727–1765*, London

Grimwade 1976
A. Grimwade, *London Goldsmiths 1697–1837*, London

Grimwade 1977
A. Grimwade, 'The Altar Plate of the Chapel Royal', *Connoisseur*, CXCV, pp. 111–14

Grimwade 1990
A.G. Grimwade, *London Goldsmiths 1697–1837. Their Marks and Lives*, 3rd edn, London

Grove Dictionary 1996
The Dictionary of Art, ed. J. Turner, 34 vols, London

Guattani 1815
G.A. Guattani, *I Tre Archi Trionfali di Costantino Severo e Tito, eseguiti dai Sig.ri Belli*, Rome

Gunnis 1968
R. Gunnis, *Dictionary of British Sculptors 1660–1851*, rev. edn, London

GV Boxes
Inventory of Snuff, Patch and Other Boxes in the Collections of Queen Victoria, King Edward VII and King George V, 6 vols, 1929–35 (typescript; RCIN 1112523, 1114513, 1114515–18)

Habsburg & Lopato 1993
G. von Habsburg and M. Lopato, *Fabergé Imperial Jeweller*, Washington

Hackenbroch 1979
Y. Hackenbroch, *Renaissance Jewellery*, London, Munich and New York

Hamilton 1972
E. Hamilton, *William's Mary: A Biography of Mary II*, London

Harman 1999
R. Harman, ''Musica Laetitiae comes' and Vermeer's Music Lesson', *Oud Holland*, CXIII, no. 3, pp. 161–6

Harris, De Bellaigue & Millar 1968
J. Harris, G. de Bellaigue and O. Millar, *Buckingham Palace*, London

Hartt 1971
F. Hartt, *The Drawings of Michelangelo*, London

Haskell 1989
F. Haskell, 'Charles I's Collection of Pictures', in MacGregor 1989, pp. 203–31

Haskell 2000
F. Haskell, *The Ephemeral Museum. Old Master Paintings and the Rise of the Art Exhibition*, London

Haydon Memoirs 1926
The Autobiography and Memoirs of Benjamin Robert Haydon (1786–1842), ed. T. Taylor and A. Huxley, 2 vols, London

Hayes Tucker 1989
P. Hayes Tucker, *Monet in the '90s. The Series Paintings*, New Haven and London

Hayward 1976
J. Hayward, *Virtuouso Goldsmiths and the Triumph of Mannerism 1540–1620*, London

Hazlitt 1873
W. Hazlitt, *Essays on the Fine Arts*, ed. W.C. Hazlitt, London

Heawood 1950
E. Heawood, *Watermarks Mainly of the 17th and 18th Centuries*, Hilversum

Heleniak 2000
K.M. Heleniak, 'Victorian Collections and British Nationalism. Vernon, Sheepshanks and the National Gallery of British Art', *Journal of the History of Collections*, XII, pp. 91–107

Henry VIII Inventory
The Inventory of King Henry VIII, ed. D. Starkey, I (transcript), London 1998

Hentzner Journey
Paul Hentzner: A Journey into England in the Year MDXCVIII, ed. H. Walpole, Strawberry Hill 1757

Hinton & Impey 1998
M. Hinton and O. Impey, eds, *Kensington Palace and the Porcelain of Queen Mary II*, London

Hobson 1935
G.D. Hobson, 'A Seventeenth-century Monogram', *Antiquaries Journal*, XV, pp. 134–43

Hobson 1970
G.D. Hobson, *Les Reliures à la fanfare*, reprint with suppl. by A.R.A. Hobson, Amsterdam

Hodson 1988
Y. Hodson, 'Prince William, Royal Map Collector', *Map Collector*, XLIV, pp. 2–12

Holmes 1893
R.R. Holmes, *Specimens of Royal Fine and Historical Bookbinding, Selected from the Royal Library, Windsor Castle*, London

Hough 1992
R. Hough, *Edward and Alexandra. Their Public and Private Lives*, London

Howarth 1989
D. Howarth, 'Charles I, Sculpture and Sculptors', in MacGregor 1989, pp. 73–113

Hughes (G.) 1998
G. Hughes, *Gerald Benney, Goldsmith: The Story of Fifty Years at the Bench*, Alfriston

Hughes (G.B.) 1960
G.B. Hughes, 'Masterpieces of Chelsea Porcelain: A Famous Table Service at Buckingham Palace', *Country Life Annual*, pp. 28–36

Hughes (P.) 1996
P. Hughes, *The Wallace Collection. Catalogue of Furniture*, 3 vols, London

Humfrey 1997
P. Humfrey, *Lorenzo Lotto*, New Haven and London

Hussey 1930
C. Hussey, 'Silver Furniture at Windsor Castle', *Country Life*, 6 December, p. 752

Hussey 1962
C. Hussey, 'The New Gallery at Buckingham Palace', *Country Life*, 26 July, pp. 192–3

Impey & Parnell 2000
E. Impey and G. Parnell, *The Tower of London. The Official Illustrated History*, London

Ingamells 1997
J. Ingamells, *A Dictionary of British and Irish Travellers in Italy 1701–1800*, New Haven and London

Irwin 1979
D. Irwin, *John Flaxman 1755–1826: Sculptor, Illustrator, Designer*, London

Jackson 1911
C.J. Jackson, *An Illustrated History of English Plate*, 2 vols, London

Jackson 1988
C.J. Jackson, I, *English Goldsmiths and their Marks*, rev. edn, ed. I. Pickford, London

Jackson-Stops 1991
John Nash. Views of the Royal Pavilion, ed. G. Jackson-Stops, London

Jackson-Stops 1993
G. Jackson-Stops, '"A noble simplicity". Pyne's Views of Buckingham House', *Apollo*, CXXXVIII, pp. 112–24

Jaffer 2001
A. Jaffer, *Furniture from British India and Ceylon. A Catalogue of the Collections in the Victoria and Albert Museum and the Peabody Essex Museum*, London

Jameson 1842
A. Jameson, *A Handbook to the Public Galleries of Art in and near London with Catalogues of the Pictures*, 2 vols, London

Jenkins 1994
S. Jenkins, 'A Sense of History: The Artistic Taste of William III', *Apollo*, CXL, August, pp. 4–9

Jenvold 1992
B. Jenvold, *Heinrich Hansen: Kunstner I tid og rum*, Haderslev

Jewitt 1878
L. Jewitt, *The Ceramic Art of Great Britain*, 2 vols, London

Joannides 1983
P. Joannides, *The Drawings of Raphael, with a Complete Catalogue*, Oxford

Jones (E.A.) 1907
E.A. Jones, *Catalogue of the Collection of Old Plate of Leopold de Rothschild, Esquire*, London

Jones (E.A.) 1911
E.A. Jones, *The Gold and Silver of Windsor Castle*, London

Jones (J.) 1993
J. Jones, *Minton*, Shrewsbury

Jungic 1997
J. Jungic, 'Savonarolan Prophecy in Leonardo's Allegory with Wolf and Eagle', *Journal of the Warburg and Courtauld Institutes*, LX, pp. 253–60

Jutsham I
An Account of Furniture &c. Received and Deliver'd by Benjamin Jutsham on Account of His Royal Highness the Prince of Wales at Carlton House, 31 December 1806 – 21 June 1816 (Receipts); 7 January 1807 – October 1820 (Deliveries) (MS; RCIN 1112484)

Jutsham II
Ledger of Furniture &c received by Benjamin Jutsham, 23 June 1816 – 7 December 1829 (MS; RCIN 1112775)

Jutsham III
Ledger of Furniture &c delivered by Benjamin Jutsham, 23 October 1820 – 4 February 1830 (MS; RCIN 1112485)

Kagan 1996
Y. Kagan, 'Engraved Gems in Britain: The Russian Perspective', *British Art Treasures from Russian Imperial Collections in the Hermitage*, ed. B. Allen and L. Dukelskaya, New Haven and London, pp. 138–49

Keele & Pedretti 1979
K. Keele and C. Pedretti, *Leonardo da Vinci. Corpus of the Anatomical Studies in the Collection of Her Majesty The Queen at Windsor Castle*, 2 vols and facsimiles, London and New York

Kemp 1981
M. Kemp, 'Navis Ecclesiae: An Ambrosian Metaphor in Leonardo's Allegory of the Nautical Wolf and Imperious Eagle', *Bibliothèque d'Humanisme et Renaissance*, XLIII, pp. 257–68

Kendall 1989
R. Kendall (ed.), *Monet by Himself. Paintings, Drawings, Pastels, Letters*, London

Kind 1991
H. Kind, 'Friedrich Wilhelm Duves Inkunabelsammlung', *Gutenberg-Jahrbuch*, pp. 353–63

King 1989
J. King, *Tudor Royal Iconography. Literature and Art in an Age of Religious Crisis*, Princeton

King 1996
J. King, 'New Evidence for the Contents of the Leverian Museum', *Journal of the History of Collections*, VIII, pp. 167–86

King's Works
The History of the King's Works, ed. H.M. Colvin, 6 vols, 1963–73, London

Kitson 1978
M. Kitson, *Claude Lorrain: Liber Veritatis*, London

Kowalczyk 1998
B.A. Kowalczyk, 'I Canaletto della National Gallery di Londra', *Arte Veneta*, LIII, pp. 72–99

Kurz 1955
O. Kurz, *Bolognese Drawings of the XVII and XVIII Centuries in the Collection of Her Majesty The Queen at Windsor Castle*, London (reprinted with appendix by H. McBurney, Bologna 1988)

Laking 1904
G.F. Laking, *The Armoury of Windsor Castle*, London

Laking 1905
G.F. Laking, *The Furniture of Windsor Castle*, London

Laking 1907
G.F. Laking, *Sèvres Porcelain of Buckingham Palace and Windsor Castle*, London

Laking 1922
G.F. Laking, *A Record of European Armour and Arms through Seven Centuries*, 5 vols, London

Lane 1949
A. Lane, 'Daniel Marot: Designer of Delft Vases and of Gardens at Hampton Court', *Connoisseur*, CXXIII, pp. 19–24

Larson 1989
J. Larson, 'A Polychrome Bust of a Laughing Child at Windsor Castle', *Burlington Magazine*, CXXXI, pp. 618–24

Law 1891
E. Law, *A History of Hampton Court Palace*, 3 vols, London

Law 1898
E. Law, *The Royal Gallery of Hampton Court Illustrated: being an Historical Catalogue of the Pictures in the Queen's Collection of that Palace with Descriptive, Biographical and Critical Notes*, rev. edn, London

Law 1903
E. Law, *Kensington Palace, the Birthplace of Queen Victoria illustrated, being a Historical Guide to the State Rooms, Pictures and Gardens*, London

Lawrence 1928
W.R. Lawrence, *The India we served*, London

Lecchini Giovannoni 1991
S. Lecchini Giovannoni, *Alessandro Allori*, Turin

Le Corbeiller 1970
C. le Corbeiller, 'James Cox: A Biographical Review', *Burlington Magazine*, CXII, pp. 351–6

Leith-Ross 2000
P. Leith-Ross, *The Florilegium of Alexander Marshal*, London

Levey 1971
M. Levey, *Painting at Court*, London

Levey 1972
M. Levey, *Art and Architecture in Eighteenth-century France*, London

Levey 1990
M. Levey, *The Soul of the Eye. An Anthology of Painters and Painting*, London

Levey 1991
M. Levey, *The Later Italian Pictures in the Collection of Her Majesty The Queen*, 2nd edn, Cambridge

Levine 1994
S. Levine, *Monet, Narcissus, and Self-reflection. The Modernist Myth of the Self*, Chicago and London

Lieven Correspondence
Correspondence of Princess Lieven and Earl Grey, ed. and transl. G. Le Strange, 2 vols, London, 1890

Lincoln 1975
W.B. Lincoln, 'The Emperor Nicholas I in England', *History Today*, XXV, pp. 24–30

Links 1994
J.G. Links, *Canaletto*, new edn, London

Lloyd 1991
C. Lloyd, *The Queen's Pictures. Royal Collectors through the Centuries*, London

Lloyd 1992
C. Lloyd, *The Royal Collection. A Thematic Exploration of the Paintings in the Collection of Her Majesty The Queen*, London

Lockett 1972
T.A. Lockett, *Davenport Pottery and Porcelain 1794–1887*, Newton Abbot

Lockett 1973
T.A. Lockett, 'John Davenport and his Wares', *Transactions of the English Ceramic Circle*, IX, no. 1, pp. 19–35

Lockett & Godden 1989
T.A. Lockett and G.A. Godden, *Davenport: China, Earthenware, Glass*, London

Lugli 1990
A. Lugli, *Guido Mazzoni e la Rinascita della Terracotta nel Quattrocento*, Turin

Lugt 1921
F. Lugt, *Les Marques de Collections de Dessins et d'Estampes*, Amsterdam

Lunsingh Scheurleer 1980
D.F. Lunsingh Scheurleer, *Chinesisches und Japanisches Porzellan in europäischen Fassungen*, Brunswick

McBurney 1989
H. McBurney, 'Cassiano dal Pozzo's Drawings of Birds', *Quaderni Puteani 1: Il Museo Cartaceo di Cassiano dal Pozzo. Cassiano Naturalista*, Milan, pp. 37–47

McBurney 1992
H. McBurney, 'Cassiano dal Pozzo as an Ornithologist', *Quaderni Puteani 3: Cassiano dal Pozzo's Paper Museum*, II, Milan, pp. 3–22

McClure 1998a
I. McClure, 'History of Structural Conservation of Panel Paintings in Great Britain', *The Structural Conservation of Panel Paintings*. ed. K. Dardes and A. Rothe, Los Angeles, pp. 237–51

McClure 1998b
I. McClure, 'The History of Painting Conservation and the Royal Collection', in *Studies in the History of Painting Restoration*, ed. C. Sitwell and S. Staniforth, London, pp. 85–96

MacGregor 1989
The Late King's Goods: Collections, Possessions and Patronage of Charles I in the Light of the Commonwealth Sale Inventories, ed. A. MacGregor, London and Oxford

Maclelland 1994
A. Maclelland, *Inventing the Louvre: Art, Politics and the Origins of the Modern Museum in Eighteenth-century Paris*, Cambridge

Macé de Lepinay 1990
F. Macé de Lepinay et al., *Giovan Battista Salvi, 'Il Sassoferrato'*, Cinisello Balsamo

Magnus 1964
P. Magnus, *King Edward the Seventh*, London

Mahon 1957
D. Mahon, 'Afterthoughts on the Carracci Exhibition', *Gazette des Beaux-Arts*, XLIX, pp. 193–207, 267–98

Mahon & Turner 1989
D. Mahon and N. Turner, *The Drawings of Guercino in the Collection of Her Majesty The Queen at Windsor Castle*, Cambridge

Mallet 1969
J.V.G. Mallet, 'Rococo English Porcelain, a Study in Style', *Apollo*, XC, pp. 100–13

Mallet 1996
J.V.G. Mallet, 'A Painting of Nicholas Sprimont, his Family and his Chelsea Vases', *Cahiers de Mariemont*, XXIV–XXV, pp. 77–95

Mann 1962
J.G. Mann, *Wallace Collection Catalogues: European Arms and Armour*, 2 vols, London

Mannings 2000
D. Mannings, *Sir Joshua Reynolds, A Complete Catalogue of his Paintings*, London and New Haven

Mansel 1984
P. Mansel, *Pillars of Monarchy: An Outline of the Political and Social History of Royal Guards 1400–1984*, London

Marillier 1962
H.C. Marillier, *The Tapestries at Hampton Court*, London

Marshall 1991
R. Marshall et al, *The Art of Jewellery in Scotland*, Edinburgh

Martin (F.) 2000
F. Martin, 'Camillo Rusconi in English Collections', in *The Lustrous Trade. Material Culture and the History of Sculpture in England and Italy*, ed. C. Sicca and A. Yarrington, London and New York, pp. 49–66

Martin (J.) 1965
J.R. Martin, *The Farnese Gallery*, Princeton

Martindale 1979
A. Martindale, *The Triumphs of Caesar by Andrea Mantegna in the Collection of Her Majesty The Queen at Hampton Court*, London

Masson 1954
I. Masson, *The Mainz Psalters and Canon Missae 1457–1459*, London

Megow 1987
W.-R. Megow, *Kameen von Augustus bis Alexander Severus*, Berlin

Mette 1995
H.-U. Mette, *Der Nautiluspokal: Wie Kunst und Natur miteinander speilen*, Munich

Meyer 1996
A. Meyer, *Apostles in England. Sir James Thornhill and the Legacy of Raphael's Tapestry Cartoons*, New York

Middeldorf 1975
U. Middeldorf, 'On some Portrait Busts attributed to Leone Leoni', *Burlington Magazine*, CXVII, pp. 84–91

Middleton 1996
B.C. Middleton, *A History of English Craft Bookbinding Technique*, 4th edn, London

Millar (D.) 1985
D. Millar, *Queen Victoria's Life in the Scottish Highlands Depicted by her Watercolour Artists*, London

Millar (D.) 1986
D. Millar, 'Headquarters of Taste', *Country Life*, 4 December, pp. 2762–6

Millar (D.) 1995
D. Millar, *The Victorian Watercolours and Drawings in the Collection of Her Majesty The Queen*, 2 vols, London

Millar (O.) 1960
O. Millar, 'Abraham van der Doort's Catalogue of the Collection of Charles I', *Walpole Society*, XXXVII

Millar (O.) 1963
O. Millar, *The Tudor, Stuart and Early Georgian Pictures in the Collection of Her Majesty The Queen*, 2 vols, London

Millar (O.) 1967
O. Millar, *Zoffany and his Tribuna*, London

Millar (O.) 1969
O. Millar, *The Later Georgian Pictures in the Collection of Her Majesty The Queen*, 2 vols, London

Millar (O.) 1977
O. Millar, *The Queen's Pictures*, London

Millar (O.) 1986
O. Millar, 'Documents for the History of Collecting: 2. George IV when Prince of Wales: His Debts to Artists and Craftsmen', *Burlington Magazine*, CXXVIII, pp. 586–92

Millar (O.) 1992
O. Millar, *The Victorian Pictures in the Collection of Her Majesty The Queen*, 2 vols, Cambridge

Miller 1973
E. Miller, *That Noble Cabinet; A History of the British Museum*, London

Mitchell 1999
D. Mitchell, 'Marks, Manwarings and Moore: The Use of the AM in Monogram Mark 1650–1700', *Silver Society Journal*, XI, pp. 168–77

Morel & Seddon Accounts
MS volume of accounts of work undertaken by Morel and Seddon at Windsor, 1826–30 (RCIN 1115977)

Murdoch 1997, 1998
T. Murdoch, 'Jean, René and Thomas Pelletier; a Huguenot Family of Carvers and Gilders in England 1682–1726', *Burlington Magazine*, CXXXIX, pp. 732–42 and CXL, pp. 363–74

Murray (?)1836
(A.E.C. Phipps, Lady Murray,) *A Journal of a Tour in Italy*, 5 vols, London

Nash (J.) 1826
J. Nash, *The Royal Pavilion at Brighton*, London

Nash (Jos.) 1848
J. Nash, *Views of the Interior and Exterior of Windsor Castle*, London

Nash (P.), 1988
P. Nash, *Outline. An Autobiography*, London

Nightingale 1881
J.E. Nightingale, *Contributions towards the History of Early English Porcelain, from Contemporary Sources*, London

Nixon 1974
H.M. Nixon, *English Restoration Bookbindings: Samuel Mearne and his Contemporaries*, London

Noble 1993
C. Noble, 'The Picture Gallery's Changing Hang', *Apollo*, CXXXVIII, pp. 170–8

Norman (forthcoming)
A.V.B. Norman, *Arms and Armour in the Royal Collection. I and II: Armour and Edged Weapons*

Norman & Barne 1980
A.V.B. Norman and C.M. Barne, *The Rapier*, London

Oberhuber & Ferino Pagden 1983
K. Oberhuber, S. Ferino Pagden, et al., *Raphael. Die Zeichnungen*, Stuttgart

Offner 1989
R. Offner, *A Critical and Historical Corpus of Florentine Painting: The Fourteenth Century. The Works of Bernardo Daddi*, III (3), new edn, ed. M. Boskovits, Florence

Olsen 1962
H. Olsen, *Federico Barocci*, Copenhagen

Oman 1931
C. Oman, 'A Silver-gilt Cup from Queen Elizabeth', *Burlington Magazine*, LIX, pp. 194, 198

Oman 1934
C. Oman, 'An XVIIIth-century Record of Silver Furniture at Windsor Castle', *Connoisseur*, XCIV, pp. 300–03

Oman 1957
C. Oman, *English Church Plate 597–1830*, London

Oman 1958
C. Oman, 'Caddinets and a Forgotten Version of the Royal Arms', *Burlington Magazine*, C, pp. 431–5

Oman 1966
C. Oman, 'A Problem of Artistic Responsibility: The Firm of Rundell, Bridge and Rundell', *Apollo*, LXXXIII, pp. 174–83

Oman 1970
C. Oman, *Caroline Silver 1625–1688*, London

Oman 1978
C. Oman, *English Engraved Silver 1150–1900*, London

Oppé 1947
A.P. Oppé, *The Drawings of Paul and Thomas Sandby in the Collection of His Majesty The King at Windsor Castle*, London

Oppé 1950
A.P. Oppé, *English Drawings, Stuart and Georgian Periods, in the Collection of His Majesty The King at Windsor Castle*, London

Oresko et al. 1997
R. Oresko, G.C. Gibbs and H.M. Scott, eds, *Royal and Republican Sovereignty in Early Modern Europe*, Cambridge

Ormond 1973
R. Ormond, *National Portrait Gallery. Early Victorian Portraits*, 2 vols, London

Ormond 1981
R. Ormond, *Sir Edwin Landseer*, Philadelphia

Paintin 1989
E. Paintin, *The King's Library*, London

Parker 1945
K. Parker, *The Drawings of Hans Holbein in the Collection of His Majesty The King at Windsor Castle*, London (reprinted as ... Her Majesty The Queen... with an appendix by S. Foister, London 1983)

Parker 1948
K. Parker, *The Drawings of Antonio Canaletto in the Collection of His Majesty The King at Windsor Castle*, London (reprinted as ... Her Majesty The Queen... with an appendix by C. Crawley, Bologna 1990)

Parnell 1993
G. Parnell, 'Arming the Tower: The Small Armoury at the Tower of London', *Apollo*, CXXXVII, pp. 82–5

Parnell 1994
G. Parnell, 'The King's Guard Chamber; A Vision of Power', *Apollo*, CXL, pp. 60–4

Patterson 1996
S. Patterson, 'The Royal Library at Windsor Castle', *El Libro Antigua Espanol III: El libro en Palacio y otros estudios bibliograficos*, pp. 201–23

Paulsen 1989
Å. Paulsen, *Magnus Berg: ein kunstner ved korgens hoff*, Oslo

Paulson 1965
R. Paulson, *Hogarth's Graphic Works*, 2 vols, New Haven and London

Paulson 1975
R. Paulson, *Emblem and Expression: Meaning in English Art of the Eighteenth Century*, London

Paulson 1993
R. Paulson, *Hogarth. Art and Politics 1750–1764*, Cambridge

Pechstein 1981
K. Pechstein, 'Zum Jupiter-Trinkgeschirr von Nikolaus Schmidt: eine neuaufgefundene Goldschmeidezeichnung', *Monats Anzeiger Museen und Ausstellungen in Nürnberg*, VIII

Pedretti 1982
C. Pedretti, *The Drawings and Miscellaneous Papers of Leonardo da Vinci in the Collection of Her Majesty The Queen at Windsor Castle. I: Landscapes, Plants and Water Studies*, London and New York

Pelka 1920
O. Pelka, *Bernstein*, Berlin

Pemble 1977
J. Pemble, *The Raj, the Indian Mutiny and the Kingdom of Oudh 1801–1859*, New Jersey

Penny 1992
N. Penny, *Catalogue of European Sculpture in the Ashmolean Museum, Oxford*, 3 vols, Oxford

Penzer 1954
N.M. Penzer, *Paul Storr: The Last of the Goldsmiths*, London

Peters 1997
D. Peters, *Decorator and Date Marks on Eighteenth-century Vincennes and Sèvres Porcelain*, London

Phillipps 1846
T. Phillipps, 'Account of the Ceremonial of the Marriage of the Princess Margaret', *Archaeologia*, XXXI, pp. 326–38

Phillips (J.G.) 1970
J.G. Phillips, 'Canova's Reclining Naiad', *Metropolitan Museum of Art Bulletin*, XXIX, no. 1, pp. 1–10

Phillips (S.) 1854
S. Phillips, *The Portrait Gallery of the Crystal Palace: Official Handbook*, London

Phillips & Sloane 1997
A. Phillips and J. Sloane, *Antiquity Revisited: English and French Silver-gilt from the collection of Audrew Love*, New York

Physick 1970
J. Physick, *The Wellington Monument*, London

Piacenti & Boardman (forthcoming)
K. Aschengreen Piacenti and J. Boardman, *The Antique and Renaissance Gems and Jewels in the Collection of Her Majesty The Queen*

Pictorial Inventory
George IV Inventory of Clocks etc [Drawn and Painted Records of Works of Art in George IV's Collection, particularly at Carlton House, made for the King in the late 1820s], 3 vols (MS; RCIN 933559–61)

Pignatti & Pedrocco 1999
T. Pignatti and F. Pedrocco, *Giorgione*, Milan and New York

Platter Travels
Thomas Platter's Travels in England, 1599, ed. C. Williams, London 1937

Plon 1883
E. Plon, *Benvenuto Cellini, Orfèvre, Médailleur, Sculpteur*, Paris

Plon 1887
E. Plon, *Leone Leoni et Pompeo Leoni*, Paris

Pope-Hennessy 1959
J. Pope-Hennessy, *Queen Mary 1867–1953*, London

Popham & Wilde 1949
A.E. Popham and J. Wilde, *The Italian Drawings of the XV and XVI Centuries in the Collection of His Majesty The King at Windsor Castle*, London (reprinted as ... Her Majesty The Queen ... with an appendix by R. Wood, London 1984)

Postle 1991
M. Postle, 'Gainsborough's "Lost" Picture of Shakespeare "A Little out of the Simple Portrait Way"', *Apollo*, CXXXIV, pp. 374–9

Powell & Wallis 1968
J.E. Powell and K. Wallis, *The House of Lords in the Middle Ages: A History of the English House of Lords to 1540*, London

Pradère 1989
A. Pradère, *Les Ebénistes Français de Louis XIV à la Révolution*, Paris

Pradère 1997
A. Pradère, 'Les armoires à médailles de l'histoire de Louis XIV par Boulle et ses suiveurs', *Revue de l'Art*, CXVI, pp. 42–53

Préaud 1989
T. Préaud, 'Sèvres, la Chine et les "chinoiseries" au XVIIIe siècle', *Journal of the Walters Art Gallery*, XLVII, pp. 39–52

Pressly 1987
W.L. Pressly, 'Genius Unveiled: The Self-portraits of Johann Zoffany', *Art Bulletin*, LXIX, pp. 88–101

PRO
Public Record Office, Kew

Puglisi 1999
C. Puglisi, *Francesco Albani*, New Haven and London

Pyne 1819
W.H. Pyne, *The History of the Royal Residences of Windsor Castle, St James's Palace, Carlton House, Kensington Palace, Hampton Court, Buckingham House, and Frogmore*, 3 vols, London

QMB
Catalogue of Bibelots, Miniatures and Other Valuables. The Property of HM Queen Mary, 4 vols: I, 1920; II, 1921–31; III, 1932–7; IV, 1938–45 (illustrated typescript; RCIN 114504–09)

QMPP
Inventory of the Private Property of HM The Queen [Mary], 11 vols: I–VI, 1912–32(?); VII, 1933; 1912–33; VIII, 1936; IX, 1936–8; XI, 1946–8 (illustrated typescript; RCIN 114193–503)

QVJ
Queen Victoria's Journal (MS), Royal Archives, Windsor Castle

RA
Royal Archives, Windsor Castle

Raby 1999
J. Raby, *Qajar portraits* [additional works of art included in the London showing of the exhibition, Royal Persian Paintings, 1785–1925], London

Rackham 1928
B. Rackham, *Catalogue of English Porcelain, Earthenware, Enamels and Glass collected by Charles Schreiber Esq.*, I, London

Ramsden 1958
C. Ramsden, 'Bookbinders to George III and his Immediate Descendants and Collaterals', *The Library*, XIII, 1958, pp. 186–93

RCIN
Royal Collection Inventory Number

Reynolds 1999
G. Reynolds, *The Sixteenth- and Seventeenth-century Miniatures in the Collection of Her Majesty The Queen*, London

Richter 1939
J.P. Richter, *The Literary Works of Leonardo da Vinci*, 2nd edn. 2 vols, Oxford

RL
Royal Library inventory number (for drawings and watercolours in the Royal Collection)

Roberts (H.) 1939
H. Roberts, *A History of the Royal Pavilion, Brighton*, London

Roberts (H.A.) 1990a
H.A. Roberts, 'Ingenious Miniatures', *Country Life*, 22 March, pp. 164–5

Roberts (H.A.) 1990b
H.A. Roberts, 'Metamorphoses in Wood. Royal Library Furniture in the Eighteenth and Nineteenth Centuries', *Apollo*, CXXXI, pp. 382–90

Roberts (H.A.) 2000
H.A. Roberts, '"Quite Appropriate for Windsor Castle". George IV and George Watson Taylor', *Furniture History*, XXXVI, pp. 115–37

Roberts (H.A.) 2001
H.A. Roberts, *For the King's Pleasure: George IV's Apartments at Windsor Castle*, London

Roberts (J.) 1987
J. Roberts, *Royal Artists from Mary Queen of Scots to the Present Day*, London

Roberts (J.) 1988
J. Roberts, *A Dictionary of Michelangelo's Watermarks*, Milan

Roberts (J.) 1997
J. Roberts, *Royal Landscape. The Gardens and Parks of Windsor*, New Haven and London

Roche & Roethlisberger 1978
L. Roche and M. Roethlisberger, *L'opera completa di Liotard*, Milan

Roethlisberger 1961
M. Roethlisberger, *Claude Lorrain: The Paintings*, 2 vols, London and New Haven

Roethlisberger 1968
M. Roethlisberger, *Claude Lorrain. The Drawings*, 2 vols, Berkeley and Los Angeles

Rohde 1937
A. Rohde, *Bernstein, ein Deutscher Werkstoff. Seine Künstlerische Verarbeitung vom Mittelalter bis zum 18. Jahrhundert*, Berlin

Roli 1960
R. Roli, 'Per Antonio Gionima', *Arte Antica e Moderna*, XI, pp. 300–07

Ronfort 1984
J.-N. Ronfort, 'Art et Horlogerie à l'époque de Ferdinand Berthoud: du rocaille au néo-classicisme', in *Ferdinand Berthoud 1727–1807, Horloger Mécanicien du Roi et de la Marine*, La Chaux-de-Fonds, pp. 103–24

Rorschach 1990
K. Rorschach, 'Frederick, Prince of Wales (1709–1751) as Collector and Patron', *Walpole Society*, LV (1989–90), pp. 1–76

Roscoe 1999
I. Roscoe, 'Peter Scheemakers', *Walpole Society*, LXI, pp. 163–304

Rosenberg 1993
P. Rosenberg, *Tout l'oeuvre peint des Le Nain*, Paris

Rosenberg & Prat 1994
P. Rosenberg and L.-A. Prat, *Nicolas Poussin 1594–1665. Catalogue raisonné des dessins*, 2 vols, Milan

Rowlands 1985
J. Rowlands, *The Paintings of Hans Holbein the Younger*, Oxford

Rücker & Stearn 1982
E. Rücker and W. Stearn, *Maria Sibylla Merian in Surinam*, London

Ruland 1876
C. Ruland, *The Works of Raphael Santi da Urbino as represented in the Raphael Collection in the Royal Library at Windsor Castle*, privately printed

Russell (F.) 1987
F. Russell, 'King George III's Picture Hang at Buckingham House', *Burlington Magazine*, CXXIX, pp. 524–31

Russell (W.H.) 1877
W.H. Russell, *The Prince of Wales' Tour: A Diary in India*, London

Sandon (H.) 1978
H. Sandon, *Flight and Barr Worcester Porcelain 1783–1840*, London

Sandon (J.) 1993
J. Sandon, *The Dictionary of Worcester Porcelain. Vol. I: 1751–1851*, Woodbridge

Sassoon 1991
A. Sassoon, *The J. Paul Getty Museum. Vincennes and Sèvres Porcelain*, Malibu

Savill 1988
R. Savill, *The Wallace Collection. Catalogue of Sèvres Porcelain*, 3 vols, London

Scarisbrick 1994
D. Scarisbrick, *Jewellery in Britain 1066–1837*, Norwich

Scharf 1858
G. Scharf, 'On the Manchester Art Treasures Exhibition, 1857', *Transactions of the Historic Society of Lancashire and Cheshire*, X, pp. 269–331

Schröder 1935
A. Schröder, *Leipziger Goldschmiede aus fünf Jahrhunderten (1350–1850)*, Leipzig

Schümann 1968
C.-W. Schümann, 'Clipeus virtutis oder der Glaubensschild', *Munuscula Discipulorum Festschrift für Hans Kauffmann zum 70. Geburtstag*, Berlin, pp. 287–305

Scott-Elliot 1959
A.H. Scott-Elliot, 'The Statues from Mantua in the Collection of King Charles I', *Burlington Magazine*, CI, pp. 218–27

Second Report 1831
Second Report from the Select Committee on Windsor Castle and Buckingham Palace, London

Severne MacKenna 1952
F. Severne MacKenna, *Chelsea Porcelain. The Gold Anchor Wares*, Leigh-on-Sea

Sèvres 1989
A Souvenir Album of Sèvres from the Royal Collection, London

Shaw 1843
H. Shaw, *Dresses and Decorations of the Middle Ages*, 2 vols, London

Shearman 1972
J. Shearman, *Raphael's Cartoons in the Collection of Her Majesty The Queen and the Tapestries for the Sistine Chapel*, London

Shearman 1983
J. Shearman, *The Early Italian Pictures in the Collection of Her Majesty The Queen*, Cambridge

Sitwell & Staniforth 1998
Studies in the History of Painting Restoration, ed. C. Sitwell and S. Staniforth, London

Skurlov 1997
V.V. Skurlov, 'Boris Frödman-Cluzel, Fabergé Firm Artist', in *Carl Fabergé Goldsmith to the Tsar*, ed. E. Welander-Berggren, Stockholm, pp. 32–8

Slive 1989
S. Slive, *Frans Hals*, London

Smith (H.C.) 1931
H.C. Smith, *Buckingham Palace, its Furniture, Decoration and History*, London

Smith (J.T.) 1895
J.T. Smith, *Nollekens and his Times*, ed. E. Gosse, London

Snowman 1962
A.K. Snowman, *The Art of Carl Fabergé*, London

Snowman 1977
A.K. Snowman, *Fabergé 1846–1920*, London

Snowman 1987
A.K. Snowman, 'Two Books of Revelations: The Fabergé Stock Books', *Apollo*, CXXVI, p. 150

Snowman 1990
K. Snowman, *Eighteenth-century Gold Boxes of Europe*, 2nd edn, Woodbridge

Solinas 1989
F. Solinas, 'Percorsi puteani: note naturalistiche ed inediti appunti antiquari', in *Cassiano dal Pozzo. Atti del Seminario Internazionale di Studi*, ed. F. Solinas, Rome, pp. 94–129

Solodkoff & Habsburg-Lothringen 1983
A. von Solodkoff and G. von Habsburg-Lothringen, 'Tabatièren Friedrichs des Grossen', *Kunst & Antiquitäten*, CI, pp. 36–42

Somers Cocks 1989
A. Somers Cocks, 'The Non-functional Use of Ceramics in the English Country House during the Eighteenth Century', in *The Fashioning and Functioning of the British Country House*, ed. G. Jackson-Stops et al, Washington, pp. 195–215

Somers Cocks & Truman 1984
A. Somers Cocks and C. Truman, *The Thyssen-Bornemisza Collection: Renaissance Jewels, Gold Boxes and Objets de Vertu*, London

Souchal 1973
F. Souchal, 'La Collection du Sculpteur Girardon d'après son inventaire après décès', *Gazette des Beaux-Arts*, LXXXII, pp. 1–112

Souchal 1977–93
F. Souchal, *French Sculptors of the Seventeenth and Eighteenth Centuries: The Reign of Louis XIV*, 4 vols, Oxford

Spalding 1975
R. Spalding, *The Improbable Puritan: A Life of Bulstrode Whitelocke, 1605–1675*, London

Spencer 1977
E. Spencer, *The Sobieski Hours: A Manuscript in the Royal Library at Windsor Castle*, London

Støckel
J.F. Støckel, *Haandskydevaabens Bedømmelse*, 2 vols, Copenhagen, 1938–43; repr. 1964

Stratford 2000
J. Stratford, 'Manuscript Fragments at Windsor Castle and the Entente Cordiale', in *Interpreting and Collecting Fragments of Medieval Books*, ed. L.L. Brownrigg and M.M. Smith, Los Altos Hills and London, pp. 114–35

Stronge 1996
S. Stronge, 'The Myth of the Timur Ruby', *Jewellery Studies*, VII, pp. 5–12

Stronge 1999
The Arts of the Sikh Kingdoms, ed. S. Stronge, London

Stuart 1939
 D. M. Stuart, *The Daughters of George III*, London
Stuckey 1995
 C. Stuckey, *Claude Monet 1840–1926*, Chicago
Symonds 1951
 R.W. Symonds, *Thomas Tompion – His Life and Work*, London
Tait 1962
 H. Tait, 'Historiated Tudor Jewellery', *Antiquaries Journal*, XLII, pp. 226–46
Tait 1991
 H. Tait, *The Waddesdon Bequest in the British Museum, III: The Curiosities*, London
Thiem 1987
 C. Thiem, 'Francesco Bosio: A Forgotten Bolognese Landscape Artist', *Master Drawings*, XXV, pp. 272–6
Thomas 1962
 B. Thomas, 'Die Münchner waffenvorzeichnungen des Étienne Delaune und die Prunkschilde Heinrichs II von Frankreich', *Jahrbuch der Kunsthistorischen Sammlungen in Wien*, LVIII, pp. 102–68
Thuillier 1978
 J. Thuillier, *Les Frères Le Nain*, Paris
Thurley 1993
 S. Thurley, *The Royal Palaces of Tudor England: Architecture and Court Life, 1460–1547*, London
Thurley 1995
 S. Thurley, 'Hampton Court, Middlesex', *Country Life*, 1 June, pp. 80–5
Thurley 1999
 S. Thurley, *Whitehall Palace. An Architectural History of the Royal Apartments, 1240–1698*, London
Tidcombe 1996
 M. Tidcombe, *Women Bookbinders 1880–1920*, London
Tillander-Godenhielm et al. 2000
 U. Tillander-Godenhielm et al., *Golden Years of Fabergé: Drawings and Objects from the Wigström Workshop*, Paris
Timbs 1885
 J. Timbs, *Curiosities of London*, London
Truman 1991
 C. Truman, *The Gilbert Collection of Gold Boxes*, Los Angeles
Trusted 1985
 M. Trusted, *Catalogue of European Ambers in the Victoria and Albert Museum*, London
Twining 1960
 Lord Twining, *The Crown Jewels of Europe*, London
Tyack 1992
 G. Tyack, *Sir James Pennethorne and the Making of Victorian London*, London
Uglow 1997
 J. Uglow, *Hogarth. A Life and a World*, London
Vasari
 G. Vasari, *Le vite de' più eccellenti pittori, scultori ed architettori italiani*, ed. G. Milanesi, 9 vols, Florence, 1878–85
Venn 1924
 J. Venn and J.A. Venn, *Alumni Cantabrigiensis*, pt. 1, III, Cambridge
Verdon 1978
 T. Verdon, *The Art of Guido Mazzoni*, New York
Verlet 1955
 P. Verlet, *Möbel von J.H. Riesener*, Darmstadt
Verlet 1987
 P. Verlet, *Les Bronzes Dorés Français du XVIIIe Siècle*, Paris
Verlet 1990
 P. Verlet, *Le Mobilier Royal Français. I: Meubles de la Couronne Conservés en France*, 2nd edn, Paris

Verlet 1994
 P. Verlet, *Le Mobilier Royal Français. III: Meubles de la Couronne Conservés en Angleterre et aux États-Unis*, Paris
Vertue Notebooks
 The Notebooks of George Vertue, I–VI, Walpole Society, XVIII, XX, XXII, XXIV, XXVI, XXX, 1930–55
Vigée Le Brun 1989
 The Memoirs of Elisabeth Vigée Le Brun, transl. S. Evans, London
Vollenweider 1966
 M.-L. Vollenweider, *Die Steinschneidekunst und ihre Künstler in spätrepublikanischer und augusteischer Zeit*, Baden-Baden
Von Erffa & Staley 1986
 H. von Erffa and A. Staley, *The Paintings of Benjamin West*, New Haven and London
Waagen 1838
 G. Waagen, *Works of Art and Artists in Great Britain*, 3 vols, London
Waddesdon 1975
 S. Grandjean, K. Aschengreen Piacenti, C. Truman, A. Blunt, *The James A. de Rothschild Collection at Waddesdon Manor: Gold Boxes and Miniatures of the Eighteenth Century*, Fribourg
Wainwright 1992
 C. Wainwright, 'Patronage and the Applied Arts in Early Nineteenth-century London', in *London – World City 1800–1840*, ed. C. Fox, New Haven and London, pp 111–28
Waley 1992
 M.I. Waley, 'Islamic Manuscripts in the Royal Collection: A Concise Catalogue', *Manuscripts of the Middle East*, VI
Walker 1992
 R. Walker, *The Eighteenth and Early Nineteenth-century Miniatures in the Collection of Her Majesty The Queen*, Cambridge
Wallis 1862
 G. Wallis, *The Art-Manufactures of Birmingham and the Midland Counties in the International Exhibition of 1862* (reprinted from the *Midland Counties Herald*), London
Walpole 1928
 H. Walpole, 'Journal of Visits to Country Seats, &c.', ed. P. Toynbee, *Walpole Society*, XVI, pp. 9–80
Walpole Correspondence
 The Yale Edition of Horace Walpole's Correspondence, ed. W.S. Lewis, 48 vols, 1937–83
Ward-Jackson 1993
 P. Ward-Jackson, 'The French Background of Royal Monuments at Windsor and Frogmore', *Church Monuments*, VIII, pp. 63–83
Waring 1863
 J.B. Waring, *Masterpieces of Industrial Art and Sculpture at the International Exhibition*, London
Warner & Gilson 1921
 G. Warner and J. Gilson, *Catalogue of Western Manuscripts in the Old and King's Collections*, London
Watkin 1984
 D. Watkin, *The Royal Interiors of Regency England*, London and Melbourne
Watson 1957
 F.J.B. Watson, 'Canova and the English', *Architectural Review*, CXII, pp. 403–06
Watson 1970
 F.J.B. Watson, *The Wrightsman Collection. III. Furniture, Gold Boxes*, New York
Watson 1986
 F.J.B. Watson, *Mounted Oriental Porcelain*, Washington
Watson, Wilson & Derham 1982
 F.J.B. Watson, G. Wilson and A. Derham, *Mounted Oriental Porcelain in the J. Paul Getty Museum*, Malibu

WC Paintings 1990
 The Royal Collection: Paintings from Windsor Castle, Cardiff
Webb 1954
 M.J. Webb, *Michael Rysbrack, Sculptor*, London
Weber 2000
 G. Weber, 'Caritas Romana. Ein neu entdecktes Bild im Bild von Johannes Vermeer', *Weltkunst*, LXX, pp. 225–7
White 1982
 C. White, *The Dutch Pictures in the Collection of Her Majesty The Queen*, Cambridge
White 1987
 C. White, *Peter Paul Rubens, Man and Artist*, New Haven and London
White & Crawley 1994
 C. White and C. Crawley, *The Dutch and Flemish Drawings of the Fifteenth to the Early Nineteenth Centuries in the Collection of Her Majesty The Queen at Windsor Castle*, Cambridge
Whitley 1928
 W.T. Whitley, *Artists and their Friends in England*, 2 vols, London
Widerkehr 1997
 L. Widerkehr, 'Jacob Matham – un maître du burin et son oeuvre dessiné', PhD thesis, 3 vols, Strasbourg
Wildenstein 1996
 D. Wildenstein, *Monet. Catalogue Raisonné*, 3 vols, Cologne
Wilson 1977
 M.I. Wilson, 'Gainsborough, Bath and Music', *Apollo*, CV, pp. 107–10
Wittkower 1952
 R. Wittkower, *The Drawings of the Carracci in the Collection of Her Majesty The Queen at Windsor Castle*, London
Wood 1994
 L. Wood, *The Lady Lever Art Gallery: Catalogue of Commodes*, London
Woodward 1860
 B.B. Woodward, First Report of the Royal Library, Windsor Castle, October 1860 (MS; RCIN 1127884.a)
Woodward 1861
 B.B. Woodward, Additional Report on the Collections of Prints and Drawings, April 1861 (MS; RCIN 1127884.d)
Woodward 1862
 B.B. Woodward, Third Report of the Royal Library, Windsor Castle, October 1862 (MS; RCIN 1127884.c)
Woodward 1865
 B.B. Woodward, Memorandum of a Communication made in Conversation with HRH Prince Alfred at Windsor Castle, 14 April 1865 (MS; RA/VIC/Add J/1430)
Wormser 1984
 A. Wormser, 'Claude Monet et Georges Clemenceau: une singuliére amitié', in J. Rewald and F. Weitzenhoffer (eds), *Aspects of Monet, A Symposium on the Artist's Life and Times*, New York, pp. 188–217
Wright 1837
 G.N. Wright, *The Life and Reign of William IV*, 2 vols, London
Young 1968
 S. Young, *The Queen's Jewellery*, London
Zaretskaya and Kosareva 1963
 Z. Zaretskaya and N. Kosareva, *La Sculpture française des 17–20èmes siècles au Musée de l'Ermitage*, Leningrad

Concordances

a. with Royal Collection Inventory Number (RCIN)

RCIN	EXH. NO.	RCIN	EXH. NO.	RCIN	EXH. NO.	RCIN	EXH. NO.	RCIN	EXH. NO.
1.1–2	317	9123	237	35322.1, .3	98	40463	228	52283	151
12.1–2	312	9142	270	35323	61	40471	225	57012.2–3	108
237	106	9258	276	35325	60	40479	232	57013.1	108
253.2	134	9314	267	35486.1–2	99	40483	231	57014.2	108
298.1–2	127	11278	308	35548	126	40484	271	57015.8, .28,	
360.1–2	314	11284	303	35594.2	129	40485	208	.44, .48	108
487.12	85	11287	304	36071	121	40501	240	57022.1	108
488.1–2	85	11288	307	36073	123	40502	256	57023.1	108
489.1	85	11289	306	36076.2	131	40503	250	57024.6	108
588.1–2	88	11291	299	36096	133	40504	248	57028	108
597.2	81	11357	302	36099	120	40505	245	57029.1–2	79
600	80	11358	301	36109.1	128	40506	249	57201.8, .9,	
1083.1–2	115	11410	305	40015	215	40507	251	.12, .16	111
1085.1–2	116	12143.1–2	94	40030	210	40508	241	57203.1	111
1087.1–2	82	15168	264	40038	218	41230	137	57208.2, .8	109
1233	77	15941.1–2	192	40084	205	43778	148	57215.1–2	109
1269.2	95	15956	166	40098	204	43796	295	57961	62
1382	97	19128	266	40100	275	43797	295	58377.8	113
1562	93	19133	281	40101	263	43916	70	58381.2	113
2039	72	19136	291	40103	278	43917	69	58382.3	113
2042	73	19605	117	40105	262	43918	71	58393.4, .6,	
2136	74	20549	101	40107	260	44191	64	.60, .66	112
2292	130	20559	101	40113	269	45040.2	135	58394.2	112
2299	124	21213	104	40161	273	45109	200	58396.3	112
2306	313	21220	84	40180	244	46707	289	58401.1, .11,	
2311.2	315	21641	66	40186	235	46984.2	185	.31, .36, .40	110
2315	309	21642	96	40204	280	47773	203	58403	110
2344.2	136	21653	119	40208	274	48482	298	61101	161
2360	122	21669.1–2	86	40210	246	49162.1	175	61316	159
2412.9–10	92	23239	279	40211	234	50044	168	62978	160
2582.8–9	91	28181	143	40216	253	50278.1	186	62994	162
2588	103	29115	194	40217	247	50279.4	189	62995	164
2629.1–2	89	29761.80, .86		40218	239	50282	178	65175	147
2752	83	.89, .100	113	40223	257	50554	201	65186	144
2867	316	30028	87	40241	277	50603	196	65238	140
3152	311	30035	100	40250	242	50825.3	184	65249	142
3154.1	310	30240	118	40251	238	50827.14	183	65254	145
3835	297	31169	67	40252	252	50843.1	190	65255	149
3926	283	31207	105	40253	226	51081	198	65256	150
3932	284	31605	202	40254	221	51102.1	191	65600	139
4046	296	31610	68	40260	222	51259.1–2	180	65740	146
4047	282	31618	75	40261	220	51266	188	65779	293
4423	285	31628	76	40270	224	51271.2–3	180	67142	163
4605	102	31702	154	40275	233	51277	169	67259	158
4962.2	132	31736	176	40294	212	51368.1–4	179	73197	59
4966	125	31756.1	170	40323	219	51392.1–2	179	73279.1	111
6538	292	31773	165	40339	209	51393.1–2	179	74428	90
8943	236	32472	261	40342	230	51452	198	90208	113
8953	243	32473	259	40377	223	51466	197	90209	113
8958	258	33401	107	40388	227	51491	167	92008.1	177
8968	290	33464	65	40421	217	51492	167	92009.1	173
8999	268	33467	63	40442	213	51497	199	92012	171
9022	206	35060	114	40444	211	51539.3	174	93145	114
9032	207	35064	114	40446	214	51654	187	100000	34
9044	294	35301	78	40450	216	51976	182	100001	33
		35302	78	40462	229	51977	181	100002.1–2	138

100003	156	400900	387	405776	5	420644	57	1005090	333
100004.1–2	156	401208	20	405934	19	420645	58	1027883	329
100005	157	401229	43	405944	13	420891	52	1047414	320
100006	172	401405	25	406768	2	420931	44	1047416	321
100007	172	403219	30	406983	24	421029	46	1052088	336
100008.1–2	193	403843	31	406988	27	422293	40	1057947	326
100009	195	404556	26	407252	35	422294	41	1071478	325
100010	255	404688	12	407294	3	422295	42	1080356	335
100011	254	404770	7	407298	23	441143	155	1080362	337
100012	265	404946	28	407508	21	441145	152	1081229	322
100013	272	405068	32	420019	38	441151	153	1081306	332a)
100014	288	405091	29	420020	45	442208	141	1081307	332b)
100015	286	405322	11	420026	51	452375	378	1142242	331
100016	287	405333	8	420031	49	452457	54	1142243	330
100017	300	405344	16	420034	47	630743	334	1142246	327
100130	36	405346	17	420045	55	1005020	324	1142247	328
400001	6	405349	9	420058	50	1005025.k–l	323a)	1142248	318
400025	4	405352	14	420060	53	1005025.q	323b)	1150260.an	426
400095	1	405462	10	420088	56	1005025.ad	323c)	1150260.ap	427
400106	22	405532	15	420639	48	1005025.at	323d)	1150260.au	425
400897	386	405682	18	420640	37	1005087	319	1150260.bc	428

b. with RL numbers (for drawings and watercolours)

RL	EXH. NO.								
01227	362	6412	359	12778	346	19898	416	22158	435
01252	379	6417	360	12838	358	19899	415	22178	423
1944	356	6438	355	13071	372	19912	417	22184	421
2326	354	7200	376	13076	367	19917	420	22185	422
3534	385	7564	384	13466	383	19918	418	22189	424
3742	381	7786	351	13488	382	19924	419	22851	396
4037	369	11911	365	13528	357	20223	390	24853	380
4096	373	12091b	393	18396	405	20706	391	25417	392
4502	375	12188	39	18986	388	21166	374	25497	363
4692	370	12265	349	19102r	343	22099	401	26224	437
5011	350	12272	348	19477	431	22101	402	28746	364
5231	353	12409	341	19623	389	22103	403	29178	397
5537	366	12422	340	19734	430	22104	400	29210	399
5715a	361	12496	338	19781	409	22121	429	29250	395
5932	371	12576	344	19783	410	22135	434	31280	404
5956	377	12596	339	19785	407	22136	433	32568	394
6018	352	12660v	342	19787	408	22142	414	33494	412
6078	368	12754	347	19791	406	22144	413	33520	398
		12765	345	19796	411	22152	436	33590	432

Index

492 INDEX

Royal genealogy

Only individuals mentioned in the text, and other offspring who survived beyond their
fifth birthday, are included. The dates given in brackets are those of birth and death.

TUDOR

HENRY VII = Elizabeth of York
(1457–1509) 1486 (1466–1503)

(1) **JAMES IV**, = Margaret = (2) Archibald Douglas,
King of Scots 1503 (1489–1541) 1514 6th Earl of Angus
(1473–1513) (c.1490–1557)

(1) Catherine = **HENRY VIII** = (2) Anne Boleyn = (3) Jane Seymour = (5) Catherine 1s, 1d
of Aragon 1509 (1491–1547) 1533 (1500/1–36) 1536 (c.1509–37) 1540 Howard
(1485–1536) (c.1521–42)

Mary of Guise = **JAMES V**, King of Scots Margaret = Matthew Stuart,
(1515–60) 1538 (1512–42) (1515–78) 4th Earl of
Lennox
(1516–71)

Philip II, = **MARY I** **ELIZABETH I** **EDWARD VI**
King of Spain 1554 (1516–58) (1533–1603) (1537–53)
(1527–98)

(1) Francis II = **MARY**, Queen of Scots = (2) Henry, = (3) James Hepburn,
(1544–60) 1558 (1542–87) 1565 Lord Darnley 1567 4th Earl of Bothwell
s. of Henry II, (1545–67) (c.1535–78)
King of France

STUART

JAMES VI & I = Anne
(1566–1625) 1589 (1574–1619)
d. of Frederick II,
King of Denmark

Henry, Elizabeth = Frederick V, **CHARLES I** = Henrietta Maria
Prince of Wales (1596–1662) 1613 King of Bohemia (1600–49) 1625 (1609–69)
(1594–1612) (1596–1632) d. of Henry IV,
King of France

Rupert, Ernest = Sophia 7s, 2d **CHARLES II** = Catherine Mary = William II, (1) Anne = **JAMES II** = (2) Mary 1s, 2d
Prince Palatine Augustus, 1658 (1630–1714) (1630–85) 1662 of Braganza (1631–60) 1641 Prince of (1638–71) 1660 (1633–1701) 1673 (1658–1718)
(1619–82) Elector of (1638–1705) Orange d. of d. of Alfonso IV,
Hanover d. of John IV, (1626–50) Edward Hyde, Duke of Modena
(1629–98) King of Earl of
Portugal Clarendon

1d

HANOVER

GEORGE I = Sophia Dorothea 5s, 1d
(1660–1727) 1682 (1666–1726)
d. of George William,
Duke of Brunswick-
Lüneburg and Celle

WILLIAM III = **MARY II** **ANNE** = George
(1650–1702) 1677 (1662–94) (1665–1714) 1683 (1653–1708)
s. of Frederick III,
King of Denmark

James Francis = Mary
Edward, 1719 Clementina
'The Old Sobieska
Pretender' (1702–35)
(1688–1766)

GEORGE II = Caroline 1d
(1683–1760) 1705 (1683–1737)
d. of John Frederick,
Margrave of
Brandenburg-Ansbach

1s

Charles Edward Henry Benedict,
'The Young Pretender' Cardinal York
(1720–88) (1725–1807)

Frederick, = Augusta William, 5d
Prince of Wales 1736 (1719–72) Duke of Cumberland
(1707–51) d. of Frederick II, (1721–65)
Duke of Saxe-
Gotha-Altenburg

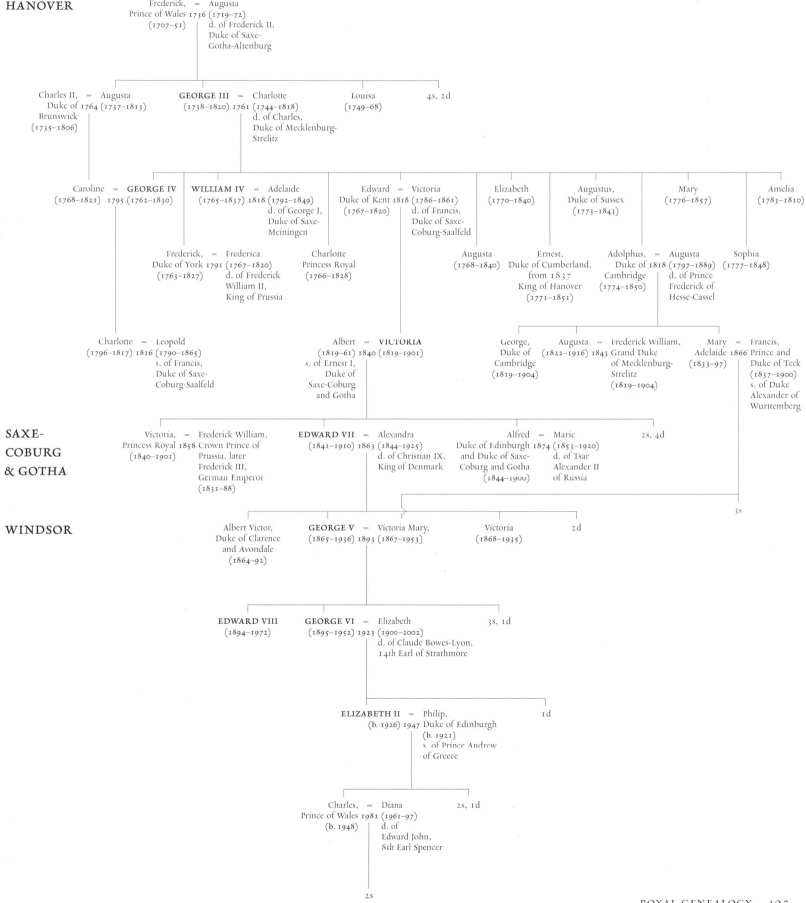

Frederick, = Augusta
Prince of Wales 1736 (1719–72)
(1707–51) d. of Frederick II,
 Duke of Saxe-
 Gotha-Altenburg

Charles II, = Augusta **GEORGE III** = Charlotte Louisa 4s, 2d
Duke of 1764 (1737–1813) (1738–1820) 1761 (1744–1818) (1749–68)
Brunswick d. of Charles,
(1735–1806) Duke of Mecklenburg-
 Strelitz

Caroline = **GEORGE IV** **WILLIAM IV** = Adelaide Edward = Victoria Elizabeth Augustus, Mary Amelia
(1768–1821) 1795 (1762–1830) (1765–1837) 1818 (1792–1849) Duke of Kent 1818 (1786–1861) (1770–1840) Duke of Sussex (1776–1857) (1783–1810)
 d. of George I, (1767–1820) (1773–1843)
 Duke of Saxe- d. of Francis,
 Meiningen Duke of Saxe-
 Coburg-Saalfeld

 Frederick, = Frederica Charlotte Augusta Ernest, Adolphus, = Augusta Sophia
 Duke of York 1791 (1767–1820) Princess Royal (1768–1840) Duke of Cumberland, Duke of 1818 (1797–1889) (1777–1848)
 (1763–1827) d. of Frederick (1766–1828) from 1837 Cambridge d. of Prince
 William II, King of Hanover (1774–1850) Frederick of
 King of Prussia (1771–1851) Hesse-Cassel

Charlotte = Leopold Albert = **VICTORIA** George, Augusta = Frederick William, Mary = Francis,
(1796–1817) 1816 (1790–1865) (1819–61) 1840 (1819–1901) Duke of (1822–1916) 1843 Grand Duke Adelaide 1866 Prince and
 s. of Francis, s. of Ernest I, Cambridge of Mecklenburg- (1833–97) Duke of Teck
 Duke of Saxe- Duke of (1819–1904) Strelitz (1837–1900)
 Coburg-Saalfeld Saxe-Coburg (1819–1904) s. of Duke
 and Gotha Alexander of
 Wurttemberg

Victoria, = Frederick William, **EDWARD VII** = Alexandra Alfred = Marie 2s, 4d
Princess Royal 1858 Crown Prince of (1841–1910) 1863 (1844–1925) Duke of Edinburgh 1874 (1853–1920)
(1840–1901) Prussia, later d. of Christian IX, and Duke of Saxe- d. of Tsar
 Frederick III, King of Denmark Coburg and Gotha Alexander II
 German Emperor (1844–1900) of Russia
 (1831–88)

 3s

Albert Victor, **GEORGE V** = Victoria Mary, Victoria 2d
Duke of Clarence (1865–1936) 1893 (1867–1953) (1868–1935)
and Avondale
(1864–92)

EDWARD VIII **GEORGE VI** = Elizabeth 3s, 1d
(1894–1972) (1895–1952) 1923 (1900–2002)
 d. of Claude Bowes-Lyon,
 14th Earl of Strathmore

 ELIZABETH II = Philip, 1d
 (b. 1926) 1947 Duke of Edinburgh
 (b. 1921)
 s. of Prince Andrew
 of Greece

 Charles, = Diana 2s, 1d
 Prince of Wales 1981 (1961–97)
 (b. 1948) d. of
 Edward John,
 8th Earl Spencer

2s

Acknowledgements and List of Contributors

A large number of people have assisted in the preparation of this volume. Particular thanks are due to the authors of Royal Collection catalogues raisonnés, including those reponsible for volumes which are currently in production (Sir Geoffrey de Bellaigue, the late A.V.B. Norman, Dr Kirsten Aschengreen Piacenti and Sir John Boardman, John Ayers, Claude Blair and Henrietta Ryan).

The following have also provided valuable assistance: Susanne Atkin, Jenny Band, Gerald Benney, Adam Bowett, Christopher Cavey, Derek Chappell, Claire Chorley, Errol D. Clark, Alec Cobbe, Harry Collins, John Collins, Alexander Creswell, David Dawson, Theo Deelder, Pete Dolton, Katherine Duerden, Ian Eaves, Richard Edgecombe, Sebastian Edwards, Geoffrey Field, Michael Fitzgerald, Michael Gregory, Susanne Groom, John Hardy, Edeen Hill, Michael Hobbs, Hugh Honour, Peter Howell, Michael Hunter, Edward Impey, Nicola Turner Inman, Amin Jaffer, Alan Jobbins, David Joll, Rose Kerr, Jenny Knight, Tony Littlechild, Agneta Lundström, Marvin Lyons, David McCall, Kieran McCarthy, Lynda McLeod, Joanna Marschner, John Merton, Tessa Murdoch, Eva Ottilinger, Stephen Parkin, Tamara Préaud, Helmut Rohlfing, Janice Sacher, Maria Jesú Herrero Sanz, John Shearman, Lynsay Shephard, Karni Singh, Valentin Skurlov, Alexander Stoddart, Susan Stronge, Keith Taylor, David Thomas, Alexis de Tiesenhausen, Ulla Tillander-Godenhielm, Bob Tulloch, Aasha Tyrrell, Michael Warnes, David Watkin, Debbie Wayment, Ulrike Weinhold, Léna Widerkehr and Rosamonde Williams.

And, within the Royal Household: Karen Ashworth, Robert Ball, Anthony Barrett, Al Brewer, Paul Briggs, Dominic Brown, Simona Brusa, Sarah Calvert, Irene Campden, Heather Caven, Stephen Chapman, Julian Clare, Pamela Clark, Jacky Colliss Harvey, Siân Cooksey, Jean Cozens, Paul Cradock, Steven Davidson, Richard Day, Sheila de Bellaigue, Allison Derrett, Frances Dimond, Alan Donnithorne, Frances Dunkels, Henrietta Edwards, Gemma Entwistle, Rupert Featherstone, Scott Furlong, Helen Gray, Robert Hamilton, Geraldine van Heemstra, Edward Hewlett, James Jackson, Angela Kelly, Jill Kelsey, Annaleigh Kennard, Roderick Lane, Karen Lawson, Marie Leahy, Oliver Millar, Paul Miller, Theresa-Mary Morton, Stephen Murray, Elaine Pammenter, Shruti Patel, Stephen Patterson, Viola Pemberton-Pigott, David Rankin-Hunt, Rosanna de Sancha, Jane Sharland, Stephen Sheasby, James Smith, Stuart Stacey, Christopher Stevens, Prudence Sutcliffe, Nicola Swash, Richard Thompson, Kate Toyne, Shaun Turner, David Westwood, Margaret Westwood, David Wheeler, Paul Whybrew, Eva Zielinska-Millar.

Contributors

BW BRIDGET WRIGHT (Bibliographer)
CdeG CAROLINE DE GUITAUT
 (Assistant to the Director and Loans Officer, Works of Art)
CL CHRISTOPHER LLOYD (Surveyor of The Queen's Pictures)
ES EMMA STUART (Assistant Bibliographer)
GdeB GEOFFREY DE BELLAIGUE
 (Surveyor Emeritus of The Queen's Works of Art)
HR HUGH ROBERTS
 (Director of the Royal Collection and Surveyor of The Queen's Works of Art)
JM JONATHAN MARSDEN (Deputy Surveyor of The Queen's Works of Art)
KB KATHRYN BARRON (Assistant Curator, Paintings, and Loans Officer)
LW LUCY WHITAKER (Assistant to the Surveyor of The Queen's Pictures)
MC MARTIN CLAYTON (Assistant Curator, Print Room)
MW MATTHEW WINTERBOTTOM (Research Assistant, Works of Art)
OE OLIVER EVERETT (Librarian and Assistant Keeper of the Royal Archives)

PAINTINGS (nos 1–36) – CL (essay and nos 4, 36); LW (nos 1–3, 5, 7, 11, 17, 19, 23, 24, 28–30, 32); KB (nos 6, 8–10, 12–16, 18, 20–2, 25–7, 31, 33–5); HR (no. 36)
MINIATURES (nos 37–58) – CL
SCULPTURE (nos 59–76) – JM
ENGLISH FURNITURE (nos 77–94) – HR (essay and nos 77, 79–84, 86–94); MW (no. 78); JM (no. 85)
CONTINENTAL FURNITURE (nos 95–107) – HR (essay and nos 96–106); JM (nos 95, 107)
ENGLISH CERAMICS (nos 108–14) – JM
CONTINENTAL CERAMICS (nos 115–38) – GdeB (essay and nos 117–36, 138); JM (nos 115–16, 137)
ANTIQUE AND RENAISSANCE GEMS AND JEWELS (nos 139–51) – HR
PERSONAL JEWELLERY AND INSIGNIA (nos 152–7) – HR
EUROPEAN ARMS AND ARMOUR (nos 158–64) – JM
EUROPEAN SILVER AND GOLD (nos 165–203) – MW
FABERGÉ (nos 204–80) – CdeG
GOLD BOXES (nos 281–97) – MW
INDIAN WORKS OF ART (nos 298–308) – JM (essay and nos 299–308); HR (no. 298)
ORIENTAL PORCELAIN AND LACQUER (nos 309–17) – JM
BOOKS AND MANUSCRIPTS (nos 318–37) – OE (essay, Islamic manuscripts note and no. 323); BW (Printed books note, nos 322, 324, 327–32, 335, 337); ES (Western manuscripts note, nos 318–21, 325–6, 333–4, 336)
DRAWINGS, WATERCOLOURS AND PASTELS (nos 338–99) – MC
INTERIOR VIEWS (nos 400–37) – HR